THE ECONOMICS OF TASTE

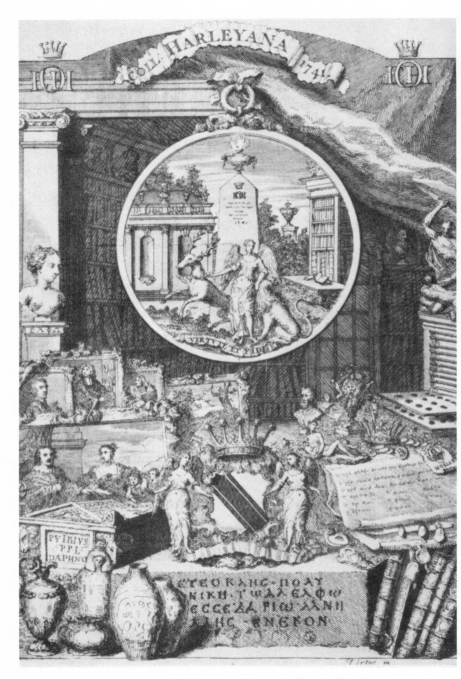

Vertue's engraved frontispiece to the Earl of Oxford's sale 1741

GERALD REITLINGER

THE ECONOMICS
OF TASTE

The Rise and Fall of
Picture Prices 1760–1960

Volume II

HACKER ART BOOKS
New York
1982

First published 1963 by
Barrie & Rockliff (Barrie Books Ltd.) London
© 1962 Gerald Reitlinger

Reissued 1982 by
Hacker Art Books, Inc. New York

Library of Congress Catalogue Card Number 82-80311
International Standard Book Numbers: Set 0-87817-288-2
Vol. 1 0-87817-292-0, vol. 2 0-87817-293-9
Vol. 3 0-87817-294-7

Printed in the United States of America

The Three Ages of Collecting

A LA PAGODE, Gersaint, marchant jouaillier sur le pont
Notre Dame, vend toute sorte de clainquaillerie nouvelle et
du goût, bijoux, glaces, tableaux de cabinet, pagodes, vernis
et porcelaines du Japon, coquillages et autres morceaux
d'histoire naturelle, cailloux, agathes, et generalement toutes
marchandises curieuses et etrangères, à Paris, 1740.

The adresse, *or trade card, of the dealer, Gersaint.*

A salt glaze teapot with portrait (and inscription) of Admiral
Vernon—very *desirable*, very *ugly* and very *dear*. He wants £5
for it and of course I must have it.

Lady Charlotte Schreiber's journal, 1884.

Immaculate Heart College, Department of Fine Arts,
 Los Angeles.
We wonder if you, dear reader, would like to add to our
collections. Your gifts are tax-reductible, not only here,
BUT ESPECIALLY IN HEAVEN.

An advertisement, 1961.

CONTENTS

Preface xiii

PART ONE

Chap. One. Genius and Craftsmanship, a Tale of Two Markets 1

Two. The Contemporary Objet d'Art, 1750–1820 22
 1. The Account-books of Lazare Duvaux: the Porcelain
 Market 22
 2. Royal and Inflationary Prices 37

Three. Antiquarian and Eclectic Taste, 1741–1842 55
 1. Two Trends: Antiques and Curiosities 55
 2. The Antiquarians and the Gothic Revival, 1741–1842 67
 3. Horace Walpole and William Beckford 75

Four. Romantic Taste and the Victorian Age, 1791–1895 89
 1. The Collectors' Revolution, 1791–1861 89
 2. From the Fonthill Sale to the Soltykoff Sale, 1823–61 100
 3. Russians, Rothschilds, and Renaissance Art, 1861–95 112

Five. The Return of the Eighteenth Century. Part One: Furniture 124
 1. French *Ébénisterie*, 1815–70 124
 2. High Tide, Recession, and Recovery, 1870–1900 134
 3. The Louis Drawing-room and the Rise of English Furniture 144

Six. The Return of the Eighteenth Century. Part Two: Porcelain,
Tapestry, and Sculpture 155
 1. The Ascendancy of Sèvres, 1802–1910 155
 2. The Market for European Porcelain, 1802–1910 163
 3. French Tapestry and Sculpture of the Eighteenth Century:
 the Market from 1760 to 1914 174

Seven. The Orient rediscovered, 1815–1915 189
 1. Till the Looting of the Summer Palace, 1860 189
 2. In the Days of the "Blue Hawthorns", 1860–1915 202
 3. The Discovery of Japan 215

Eight. The Apogee and Decline of Ritzy Taste, 1900–29 225
 1. America and the Objet d'Art Market 225
 2. The Grand Climacteric, 1910–18 236
 3. The False Boom, 1919–29 247

Nine. The Long Depression and the Paper Recovery, 1929–63 259
 1. Till the Second World War 259
 2. War and Economic Isolation, 1939–53 271
 3. The Impact of Inflation, 1953–62 279

PART TWO

SALES ANALYSIS OF SELECTED TYPES OF OBJETS D'ART SINCE 1750

Note to the Sales Analysis 296
Arms and Armour 297
Carpets, European 307
Chinese Art:
 Porcelain and Pottery, Mediaeval 310
 Porcelain, Ming Dynasty, 1368–1644 313
 Porcelain, Chi'ng Dynasty, 1644–1912 320
 Porcelain, Chi'ng Dynasty, Mandarin Vases and Rose Garnitures 333
 Mounted Chinese Porcelain 336
 Bronze Objects 341
 Cloisonné Enamels on Copper 344
 Jade Carvings 347
 Screens, Paintings, Lacquer, Textiles, etc. 351
Classical Art:
 Marble Sculpture and Fragments 355
 Bronze, Ivory, Silver, Hard Stones, Glass, etc. 362
 Greek Painted Vases and Clay Figures 369
Crystal Objects of the Renaissance 374
Delft Ware (including Tin Glaze, Salt Glaze and Slipware from All European factories) 380
Egyptian, and Ancient Near Eastern Art: Persia, Babylonia, etc. 385
Enamelled Jewels of the Renaissance 389
Furniture:
 English Furniture, 1660–1800 393
 English Furniture, Regency and Later 401
 Late Gothic and Renaissance (before 1700) 404
 French Furniture, *Ébénisterie*, Louis XIV to Louis XVI, mainly 18th Century 412
 French Furniture: Drawing-room Suites 430
 French Furniture: Smaller Objects in Gilt Bronze, etc. 437
 French Furniture: Lustres and Chandeliers 444
 French Furniture: Clocks 446
Glass, European 452
Henri Deux Ware, or St Porchaire Faience, Sixteenth Century 457
Hispano Mauresque Pottery 459
Illuminated Manuscripts, Eighth to Sixteenth Centuries 463
Illuminated Miniatures (Separated) 475
Ivory, European Renaissance and Later 479

Japanese Art:
Lacquer, Sculpture, Metalwork, Ivory, etc. 483
Pottery and Porcelain 487
Screen Paintings 491
Limoges Enamels, Fifteenth to Seventeenth Centuries 492
Maiolica, Italian Faience, Fifteenth to Seventeenth Centuries 500
Medici Porcelain, Sixteenth Century 507
Mediaeval Art (see also Furniture, Sculpture):
Enamels, Metalwork, Crystal 508
Ivory (including Whalebone) 515
Miniatures (including Enamel), mainly portraits 521
Near-Eastern Art (Islamic):
Carpets 526
Enamelled Glass 530
Excavated Pottery, Persia, Syria, etc. 532
Illuminated Manuscripts and Miniatures 534
Metalwork, Ivory, Crystal 537
Turkish and Later Persian Faience 540
Negro Sculpture 543
Palissy Ware (French Sixteenth-century) 545
Porcelain, English:
Chelsea and Bow 548
Worcester and Bristol, etc. 558
Wedgwood Jasper Ware 561
Meissen 563
Other Continental Factories: Germany, Italy,
Austria, France, etc. 569
Sèvres 574
Sculpture, European
North European, Gothic and Renaissance 587
Italian Renaissance, Marble and Terracotta 592
Italian Renaissance, Larger Bronzes and Bronze Busts 597
Italian Renaissance, Smaller Bronzes 600
Italian Renaissance, Della Robbia Ware 606
French Seventeenth and Eighteenth Centuries 609
Neo-classic, Late Eighteenth and Early Nineteenth Centuries 619
Modern Sculpture (after 1860) 622
Silver, European
Continental, before 1660 625
English, before 1660 634
Mounted Coconuts and Ostrich Eggs 640
Mounted Stoneware Jugs and Tankards 642
Mounted Wooden Mazers and Hunting Horns 644
Continental, 1660–1820 646
English, 1660–1820 650

Snuffboxes 659

Stoneware, Continental (mostly German):
 Sixteenth and Seventeenth Centuries (including Hafner Ware 666

Tapestry:
 Late Gothic and Renaissance, before 1550 669
 Late Renaissance, 1550–1660 676
 Louis XIV to Louis XVI (mostly Gobelins and Beauvais, some Brussels
 and English included) 679

Bibliography 691

Index 695

List of Illustrations

Frontispiece Frontispiece to the Earl of Oxford's sale 1741 engraved by Vertue.

Facing page 48 Cistern of 16th-century French faience, Bernard Palissy ware, rescued for the Nation in 1884 at a cost of £1,102 10s.

Facing page 49 Romanesque bookbinding, 11th century, one of four, bought by the Earl of Leicester in 1818 for a hundred guineas and sold in 1912 for £100,000.

Facing page 64 The Rothschild ballroom at 148 Piccadilly, before 1937.

Facing page 65 The Empress Catherine's writing desk, 1782. At close on £4,000 the costliest piece of furniture sold in the 18th century.

Acknowledgements

I have again to thank Messrs Christie, Manson, and Woods, this time for an exceedingly prolonged use of their muniment room and also for facilities for working in comfort. To my friends, Mr F. J. B. Watson and Mr George Savage, I am more than ever indebted; to the former for his advice and for the use of rare priced French catalogues in the Wallace Collection Library; to the latter for the loan of a quite formidable collection of priced English and American catalogues and for helping me in my research. I would also thank Mr John Hewett for the loan of rare early catalogues from his collection, and Mrs Imber for again typing the first part of my manuscript. Reviewers may rest assured that all the misspelt foreign names are in the part which I typed myself.

A Note on the Value of Money
at Different Periods

In the first volume of this book I terminated a short Introduction to this problem with an exceedingly tentative table of exchange rates for the traveller in time. This table is cited in a number of places in the present volume. Even when it is not cited, it should always be kept in mind. So for the convenience of the majority of readers who will not have Volume I close at hand, I repeat it here:

The pound in terms of 1963 values

1750–1795	Multiply by 12.
1795–1815	Fluid period: multiply by 12 to 10.
1815–1850	Fluid period: multiply by 10 to 8.
1850–1914	Multiply by 6.
1914–1921	Fluid period: multiply by 6 to 3.
1921–1939	Multiply by 3·7.
1939–1948	Fluid period: multiply by 3·7 to 2.
1948–1963	Fluid period: multiply by 2 to 1.

PREFACE

In attempting to write a sequel to the first volume of *The Economics of Taste*, the problem has been how to define an objet d'art. If the second volume were to be devoted to everything which passes through the art salerooms, apart from the paintings and drawings which formed the subject of the first volume, then certain things would have to be included which are not commonly regarded as artistic at all. Such are the first editions of nineteenth- and twentieth-century authors, autograph letters, and historical documents of all periods and matters of purely literary interest. One would also have to include things that are only marginally artistic—postage stamps, rare revolvers, microscopes, and watch-movements. Decorative art may play its part in each case, but their merit and rarity is of an order, quite different from that of normal decorative objects and one which demands a different order of understanding.

Should one, at the other end of the scale, include as objets d'art portrait miniatures and illuminated manuscripts which are in every sense pictures, though on a very small scale? Should one include illustrated books or prints and engravings that are nothing more nor less than pictures and drawings reproduced in quantity? By the strictest interpretation, they belong to the category of fine art rather than applied art, and should have been handled in my first volume. And, of course, all sculpture is held to be fine art. But the case of sculpture shows the impossibility of fixing any frontiers at all. A bronze figure, cast from a model by Falconet, gilded and attached to a clock, is an objet d'art. When it has been knocked off its clock with the gold partly rubbed away and one foot attractively missing, it is no longer an objet d'art, but a work of sculpture. And then there is jewellery. A diamond necklace worth a hundred thousand pounds and more is unquestionably a work of art, and of the most laborious kind. Yet the money is not paid for its artistic qualities. Nor is the rise in the value of a diamond necklace over the ages related to the movements of taste, nor to the growth of aesthetic perception, nor to the love of this period or that. It will almost certainly have been remodelled.

On the other hand, £10,000 may be paid for an enamelled

Renaissance jewel of which the natural materials are not worth £100. Should the reason for exclusion be that the cost of the natural materials exceeds the value of the workmanship? That would cut through the middle of some categories. For instance, a snuff-box with enamel paintings by Blarenberghe would be in, while a snuff-box studded with diamonds on heavy chased gold would be out.

The distinction between high art or fine art on the one hand and industrial or applied art on the other is not only recent (see page 7) but even recently the distinction has been applied with varying degrees of vigour and also with varying logicality. Illuminated manuscripts, even framed and separated pages, are commonly included, not in picture sales, but in book sales. Long histories of schools of painting are written in which they are barely mentioned, though in northern Europe till near the end of the fifteenth century the masterpieces of several of the greatest painters of the day were embodied in illuminated manuscripts. In the most modern times the price of such manuscripts shows that their classification as books is a fiction. They are in fact valued as old master paintings.

Most difficult to decide is the case of impressions reeled off—in thousands maybe—from dies, blocks, or plates, the case of medals, ancient coins, and every kind of print. A painting may become the more valuable because only three or four works by the same hand have survived or have been identified. At the same time, it must be a hand of sufficient merit. Yet a unique and fabulously priced coin can be absolutely worthless, both technically and artistically. And at the present moment there is scarcely any Rembrandt etching or Dürer engraving in existence, in however rare a state, which is worth more than the first crude engraving to be made on the American Continent or even than certain misprinted postage stamps, semi-photographically produced at that and infamously designed.

The beauty of ancient Greek coins and of *Quattrocento* medals needs no stressing, yet even in this market rarity as a quality in itself is as strong a factor as with postage stamps. The movements of price have become an internal matter, unrelated to contemporary currents of aesthetic taste. On the other hand, the same can by no means be said of pottery and porcelain figures, though these too are produced in series. Here fashion is the operative factor, and the extreme rarity of a figure may be overlooked simply because of the unpopularity of the school or the style.

I doubt whether these essential differences will be held to justify me in excluding coins, medals, prints, and books from *The Economics of*

Taste. My best excuse is that these markets are far too specialized for an all-round survey and far too complicated to be grasped in the light of aesthetic judgement alone. Those who collect porcelain or pottery of one kind or another are not necessarily indifferent to the quality of a silver coffee-pot. A collector of French furniture need not be blind to the merits of ancient Chinese bronzes. He can see what makes the market tick, whereas only a specialist can be conversant with the vagaries of books, prints, coins, and medals. These should form the subject of a third volume, the work of better qualified, because more instructed, minds.

On the same grounds, I have rejected jewellery (except for Renaissance and earlier jewellery), scientific and musical instruments, and watches. I have retained sculpture of all kinds, including classical and pre-classical sculpture. I have retained portrait miniatures and illuminated manuscripts, though, like sculpture, these trespass on the realm of individual genius. I have done this simply because between craftsmanship and genius there are no real frontiers.

In this volume the various categories of objet d'art take the place of schools of painting. A somewhat different treatment is therefore demanded. I have nevertheless endeavoured, as in the first volume, to restrict the main text to the broader movements of collectors' taste, while relegating the closer study of the prices in each category to a sales analysis, which forms the second half of the book. I have been confirmed in this decision by the reception which was accorded my first volume. In the main, the purpose of the sales analysis was understood and its obvious limitations were accepted. Only two critics leapt to the conclusion that these lists were an attempt to serve up price-movements as something scientifically established which could be presented as a graph. Such was never my intention. The lists showed the best prices for each painter's work which were paid in specific years, though in some cases I introduced less highly priced examples because the subsequent adventures of these particular examples could be traced. In this way, at least, the periods in which a painter's work was most fashionable, were made apparent. The lists cannot, like a stock-exchange list, reveal the absolute value of a painter's work at a given moment. Quite apart from the questions of condition and pedigree, none but a journeyman painter produces works which are all of the same standard.

Lists of objets d'art on the same lines must be subject to even stronger reservations. The sale of a Chippendale writing table in New York in 1961 for £25,000 cannot in any sense be taken to mean that £25,000 is the value at the present moment of any Chippendale writing table.

Even in the brave days, when a Louis XV drawing-room suite could make £28,000 in the saleroom, there were plenty of suites, answering superficially to the same description, which could be had for less than a thousand pounds. Those who collect porcelain know only too well that in some instances the appearance of a hair-crack on the lip of a faultless piece can knock as much as an entire decimal point off its value. In 1957 two versions of the Chelsea group, *The Tyrolese Dancers*, two versions from the same mould, made £273 and £3,600 respectively.

It may be wondered why in the face of such objections I have included these lists at all. But the main point is that the price can be of interest in itself. If it is barely possible to create a price-graph for even the most normal of collectors' items, how much less is this so for things that are virtually unique, such as the *crystal of King Lothair* or the *Veroli Casket*? And yet how exciting it is to realize that the treasures which have racked the brains of generations of art historians who have written long monographs round them, cost the nation 250 and 400 guineas respectively.

Or take the case of the objets d'art that sometimes appear in late eighteenth-century sale catalogues—a group of maiolica dishes, for instance, at less than a pound apiece. We don't know what sort of maiolica dishes they were, whether perfect or whether of fine quality. We only know that this was the best that could be got for what was very rare at the time, a specialist's collection. But my list also shows that a man already born into the world at the time when this collection was sold at Christie's, could easily have lived to see a piece of Italian maiolica fetch £1,000. This is what I have elsewhere called a "posthumous biography", and I do not think that the lists need any further justification for their inclusion.

April, 1963.

Genius and Craftsmanship, a Tale of Two Markets

The purchasing power of money two hundred years ago is a subject deserving a whole book, but, so far as I know, it has not been honoured with one. A few pages were devoted to it in the first volume of the present work, the subject being limited to the price of pictures in relation to the general cost of living. The problem to be considered was this: How was it that, while the bare necessities of life in the 1760s had cost about a twelfth of what they cost in the 1960s, the richest men in the world were not prepared to spend anywhere near a twelfth part of what they might spend nowadays on the dearest kind of picture? How was it that even in 1913, when the necessities of life had multiplied their value not by twelve, but by little more than two, the same question could be asked? For, while the expenditure of a thousand pounds on a picture bordered on the fabulous in the 1760s, in the year 1913 a private collector challenged the Tsar of Russia at £310,000 for Leonardo's *Benois Madonna*. The loaf of bread and the pound of cheese might have doubled their value since the eighteenth century, but the *Benois Madonna* had probably multiplied its value a thousandfold.

The answer is, of course, that the value of a work of genius bears no relation at all to the basic cost of living. The factor that has governed the rise in the price of certain pictures is not the reduced value of paper money in recent times, but the much higher proportion of the real resources of the world that can find its way to a single individual or government buying agency. Thus Henry Clay Frick, on the eve of the First World War, could find a million and a half gold standard dollars ready to hand for the purchase of the *Benois Madonna*. Though there was no vestige of inflation, it was a moment when capital was even

more fluid and abundant than now, since the 2,500,000 dollar Erickson Rembrandt of 1961 and the £800,000 Leonardo cartoon of 1962 were only 400,000-dollar pictures in terms of the greater purchasing power of 1913.

It will be noticed in the course of this work that no such prices as these have been paid for objets d'art, that while the value placed on genius is limited only by the fluid capital available, there seems to be a point of retreat for works of pure skill. One reason for this is that an objet d'art must have had at some time or another a calculable basic cost, compounded of time and materials, whereas the work of genius has never been regarded in that way. Even at the moment of creation, it is cheap or dear according to the artist's reputation rather than for its size and elaboration. Generally when a picture is stolen from a collection or a gallery it at once becomes, in the language of the popular Press, "priceless", though as often as not it is something that can be priced only too easily. Fundamentally, however, this word is perfectly sound, for the stolen picture has no commodity value. It can only be priced in terms of yesterday, never of today. Possibly no one wants to give ten pounds for it, but tomorrow someone is stimulated by overwhelming desire to pay a thousand.

The objet d'art will have retained during a great part of its history a value in relation to the cost at which men work and live, but it will be a much higher cost than that at which most men work and live. In some cases the original basic cost of a work of skill, which has now become an "antique", will be found to have been astonishingly high. That is because it was made for a class of patron whose cost of living has risen over the ages much less than the general cost of living has risen for the world at large. Whilst the cost of necessities may have multiplied itself twelve times over the past 200 years, the cost of luxuries has certainly not done so. Two hundred years ago it cost more to obtain a cup of tea or a smart suit of clothes than it costs now, even in our devalued currency. It cost more in 1763 to travel by stage coach than it costs in 1963 to travel by British Railways. To endure for months on end the discomforts and danger of a leaky, unseaworthy East Indiaman with no Board of Trade certificate cost more than a magic-carpet voyage on a jet air-liner.

In 1763 it was only the submerged, bare-subsistence classes (in fact, the bulk of the population of the world) who could satisfy their wants at a twelfth of today's cost. For the man of fashion life was almost as dear as it is now, while the proportion of his wealth which he spent on adorning his home was actually very much bigger. Consequently, the

cost of furniture, tapestries, clocks and pier-glasses was higher than the picture prices of the period would lead one to expect. They were the real status symbols of a certain class among whom old master paintings were scarcely status symbols at all.

The hou-ha in 1962 over the Royal Academy's Leonardo cartoon showed that nowadays the biggest status symbols of all are valued on a national level, something the eighteenth century knew only in a very rudimentary form. Perhaps the King of Saxony's *Sistine Madonna* and *Penitent Magdalen*[1] were the only genuine eighteenth-century instances. But today, standing above the head of the modern collector who can write a cheque for a quarter of a million pounds and collect his picture the same morning there are the treasures of the great governments of the world, where tens of millions of pounds are spent every day as a matter of course. Should another of the best-known masterpieces come, by some remote chance, on to the market, one knows that the million-pound picture would be a thing of the past. Even the two-million-pound picture is not unthinkable—the *Benois Madonna* of 1914 cost very nearly that in modern currency terms. But is there any objet d'art in existence, not a painting, that could cost a million pounds? In 1900 it was believed that Edmond de Rothschild had paid Prince Metternich 1,200,000 francs, equivalent to £48,000 then and £290,000 now, for the *Bureau du Duc de Choiseul*.[2] But in 1963 it is unlikely that £290,000 could be paid either for this or for any other piece of French furniture, or indeed for any objet d'art at all, unless it might be some extremely famous mediaeval illuminated manuscript, which is regarded not as a piece of craftsmanship, but as a whole gallery of the early masters of painting.

Disturbing as it may be to those who know of art prices only through newspaper headlines, the value of several of the dearest sorts of objet d'art has fallen in the present century quite heavily. "Four thousand guineas for a commode", one reads in a headline ½in high, but they were paying four thousand guineas for a commode a hundred years ago. "Australia reached in sixty-five days" would not be less up-to-date news. In terms of actual purchasing power, the highest price-levels which are achieved today for French furniture and objets d'art of the eighteenth century are not a fraction of what they were fifty and even eighty-five years ago. The sum of £25,000, the equivalent of not more than £4,200 in 1912, and perhaps even less in 1878, is an enormous price in the early 1960s for the most splendid piece of English or French

[1] See Vol. I, pages 5–6. [2] See *infra*, page 138.

furniture. Yet it is not nearly enough to buy the sloppiest and most perfunctory of the few still available oil sketches of Renoir and Cézanne. It is barely sufficient to buy even the most mindless of abstract paintings that happens to have the right signature or label.

I have chosen the case of eighteenth-century furniture because this is the dearest habitual item in today's impoverished market for objets d'art. The fall in real value has been very much greater in the case of certain once-fashionable kinds of Chinese porcelain, and greatest of all in the case of European tapestries of the fifteenth and mid-eighteenth centuries. Since the Second World War (and, in fact, since 1928) not more than three or four tapestry panels have exceeded the price of £10,000 each in the saleroom, but in the middle of the 1920s at least half a dozen tapestry panels made prices ranging from £50,000 to £80,000 each in terms of today's purchasing power. Of course much higher prices were paid privately for these tapestries, since auction sales are only the beginning of a transaction. The highest of all were paid before 1914.

In 1902 a gold-ground tapestry panel of about the year 1500—the *Adoration of God the Father* or *Mazarin Tapestry*[3]—cost J. Pierpont Morgan certainly not less than £65,000 and possibly £72,000, the equivalent of £400,000 or more in the money of today.[4] Yet in 1902 only two pictures had reached the price of £70,000 in the entire history of collecting. The *Ansidei Madonna* had cost the British Government that sum in 1884, while a second Raphael altarpiece, the *Colonna Madonna*, had just been bought for £100,000 by J. Pierpont Morgan himself. The second dearest picture in the world in 1902 was, therefore, not an original work at all, but a copy made faithfully inch by inch by sweated, ill-used artisans, following an exact instruction. Even the cartoon was a derivative work, which had borrowed from other Flemish paintings, in one instance a painting over sixty years old.[5] On the other hand, no Flemish primitive painting in the galleries of the world in 1902 was 18ft long and intricately built up with threads of gold and silver. The great Pierpont Morgan's money was paid avowedly for patience, hard labour, and richness of material, as if these things were the highest essence of art.

It would have seemed very, very much more illogical to millionaires of Pierpont Morgan's generation to spend £40,000 or £50,000 on the

[3] See also pages 122, 230.
[4] W. G. Thomson, *A History of Tapestry*, 1930, page 174. Francis Taylor, Pierpont Morgan as patron, New York, 1954.
[5] Thomson, page 174.

kind of modern painting that could be finished in a day or two, or in a few hours, than to spend it on these vast expanses of drudgery which cost a man almost a year of his life for every square yard. In fact, in 1902 the present constantly widening gap between the value of skill and the value of reputed genius was only just beginning to be noticeable.

If we go back a little further in time, we find in the year 1880 that Karl Meyer Rothschild had just paid £32,000 for a parcel-gilt and enamelled standing cup, made about the year 1550 by the Nuremberg silversmith, Wenzel Jamnitzer.[6] This inconceivably hideous object was, it was remarked, the costliest work of art that had ever been sold, since the dearest *picture* in 1880 was still Murillo's *Immaculate Conception* in the Louvre, which Napoleon III had bought in 1852 for £24,600. In 1880 only half a dozen pictures, ancient or modern, had made as much as £10,000 apiece since the dawn of collecting.[7]

Now, if we go back another generation to that incredibly cheap collecting era which ended in the 1850s, we find the things which we should now call "antiques" rating very much lower. To make as much as £1,000, an object had either to be quite new or to incorporate a sufficient amount of bullion. It was much more common to spend £4,000 on a new service of porcelain or plate than on an old master painting, and the same was true even of the 1860s, when there was already a mania for objets d'art of the past century. The dearest things came from the Exposition Universelle[8] of 1867. The de Goncourt brothers sat down to dinner that year in front of a silver *surtout de table* which had cost the notorious Mme de Paiva £3,200. Yet such an expenditure on a new table decoration would have been equally typical of the late eighteenth century, when money was far less plentiful. Nor was it confined to objects that incorporated vast loads of bullion. Between the years 1760 and 1769 a writing table by Oeben and Riesener cost Louis XV £2,515. Another, completed in 1778 for Louis XVI, cost £3,200, while in the 1780s royal or semi-royal extravagances such as these became almost commonplace. A price of £3,000 or more was paid twice by Mme du Barry for a commode and a toilet table respectively, heavily garnished with Sèvres plaques. For a Roentgen *bureau à cylindre* to outrival that of Louis XVI, the Empress Catherine paid 25,000 roubles, something in the region of £4,000.

Even more remarkable for an age when Holbein's masterpiece, the *Portrait of Georg Gisze*, could be valued at £6, was the French royal furniture budget, taken over a period of years. Between 1775 and 1784

[6] *Chronique des Arts*, 3 December 1880.
[7] See *infra*, page 116.
[8] See *infra*, page 131.

Riesener alone supplied the French Court with £36,000 worth, while between 1779 and 1785 Roentgen's bills came to more than £40,000. By a curious coincidence, the aggregate of these two accounts could almost have bought the Houghton Hall and Orleans galleries, which were then considered the most important collections of old master paintings in the entire world. The former was sold in 1779 for £40,000, the latter in 1792 for £44,000.[9]

The French Revolution created only one change in this form of royal expenditure—namely, that the years of war and economic blockade made the cost of production even higher. Thus in 1808 Napoleon spent £4,800 on the hangings of a bed for the Empress Marie Louise. In 1817 the Prince Regent spent £5,613 on a crystal chandelier for Brighton Pavilion, but as a King in 1829–30 he did even better, spending £8,500 on a single silver wine-cooler by Rundell, Bridge, and Rundell, an object whose vulgarity is barely credible and weighing 7,000oz. And William IV, a much less flamboyant person than George IV, spent £5,000 on a Rockingham dinner service in the same year.

These were the standards which the richest men in Europe had before their eyes in the 1850s when they began to compete for the former *mobilier* of the French crown. If in 1878 a French commode cost more than any old master painting that had ever been sold,[10] it had also cost almost as much as any old master 100 years earlier, when it left the workshop. In fact, this kind of object had been so highly esteemed that the dearest pictures sold in late eighteenth-century Paris had been those that matched the furniture. In England, it is true, the "broad, free manner" of Raphael and Guido Reni had excited the greatest admiration among the art-snobs of the Grand Tour at this time, but in practice the broad, free manner seldom reached the saleroom. In Paris no one tried any longer to look for such things. Rembrandt and Rubens might indeed advance in value, but the dearest pictures of all were those whose neatness and glossiness came nearest to the surfaces of Sèvres porcelain and furniture mountings. The remarkable auction prices of a thousand to fifteen hundred pounds were only attained by the works of Gerard Dou, Teniers, van Huysum, and Pietro da Cortona. And the prim enamelline portraits of Mme Vigée-Lebrun commanded three or four times the price of a Gainsborough whole-length or the value of dozens of unwanted Watteaus.

Today a great deal of French eighteenth-century furniture has fallen in value, even in terms of paper pounds, since the early 1880s. And yet present-day prices for this commodity strike the non-specialist as

<hr>

[9] See Vol. I, pages 21 and 30. [10] See *infra*, page 136.

monstrously high. It is easier for him to assimilate the idea of a million-pound picture than the idea of a £35,000 table. It is inconceivable to a man of some artistic education that the *Portrait of Georg Gisze* should have been valued at £6 in a decade when Roentgen could charge more than £3,000 for a writing desk. But, having assimilated that idea, it is much easier for him to understand that the one has multiplied its value perhaps by 120,000 than it is for him to suffer the other to have multiplied its value possibly by ten.

Such is the result of the widening gap between the value of skill and the value of genius. It is, as we have seen, of relatively recent creation. Even the distinction between skill and genius has not existed very long in the minds of men. Nor do we know at what precise moment it came about. One can only say that, since the Renaissance, art has been considered as a matter of components. First there were the liberal arts and the applied arts, the former comprising literature, drama, philosophy, and music, the latter those creations of man which could be touched and seen. In the eighteenth century applied art was further subdivided. On the one hand there was fine art or high art, and on the other the mechanical or industrial arts. One may doubt whether the conception of fine art existed at all in the Middle Ages and earlier Renaissance. Even throughout the sixteenth century there were no distinct frontiers. The great masters accepted commissions for the design of jewellery, armour, pottery, and plate, even for clothing and fortifications. Benvenuto Cellini kept an ordinary shop, opening on to a crowded street, adjoining his workrooms.[11]

One may be certain that Leonardo da Vinci, whose battered, browned, overworked, and fuzzed cartoon is believed to be worth a million pounds, would not have objected to designing a piece of furniture and that he would have been outraged by the suggestion that this piece of furniture must be worth far less than his working sketch for a picture. In the present age, therefore, when individual pretentiousness in the arts has progressed far beyond what were once deemed the frontiers of sanity, the lack of intellectual snobbery of the early sixteenth century seems particularly endearing and splendid. Unhappily, this form of innocence has not proved to be an invariable or normal symptom of every flourishing civilization. One has to admit the possibility that the division between fine art and mechanical art is very much older than the late Renaissance. If the Greeks hadn't a name for it, the Greeks of the fifth century B.C., at least, suffered from intellectual snobbery, and there seem to have been others. The Chinese of the Sung

11 Edmond Bonnaffé, *Causeries sur l'Art et la Curiosité*, Paris, 1878.

Dynasty knew it in an extreme form, since they found a particular virtue in amateurishness, preferring the paintings and calligraphies of gentlemanly, leisured scholars, and even retired Cabinet Ministers, to the work of the professional.

This, however, is an extreme instance of the autograph passion, since normally, the attitude of the patron is to prefer the finished product to the initial study, even though the finished product is entirely the work of disciples or artisans. The artist who chalks the words "All my own work" on the pavement makes a claim which Rubens would never have made. The complaint of Lord Danvers in 1621[12] that Rubens "hath sent hither a peece scarse touched by his own hand" was the complaint of a man little conversant with the practices of the Continent. The modern autograph passion for the untouched work of the master-hand certainly existed in 1621, but it was not for kings and not for the very rich. Originally it had been the creation of painters who, then as now, bought each other's studies, either in disinterested admiration or in order to borrow from them. One of the first painters to do this in the sixteenth century had been Vasari, who collected some of the original drawings of the painters whose lives he described: but only the most discriminating collectors have followed Vasari's lead, and to this day a wealthy man is much more likely to desire a completed painting, with all its implications of school work, scraping, and restoration, than an untouched old master drawing.

It is even uncertain whether the Greeks of the fifth century B.C., who developed a fair-sized personality cult for the artist, really possessed the autograph passion. The Romans, to whom they transmitted their taste, certainly did not possess it. No nation except the Chinese has exceeded the Roman passion for copies of the same original, endlessly repeated over the centuries. Strange to say, the Romans developed this habit through excessive intellectual snobbery and not through the lack of it. Both the Republican and the Imperial Roman of taste was brought up to believe that the applied arts were inferior to the liberal arts; that the only arts fit for a gentleman or patrician were oratory and letter-writing; that the only professionals with whom he could consort were philosophers, poets, orators, and historians. To the wealthy Roman, the armies of artisans and designers who provided for his highly ornate style of living were nothing more than hungry Greeks. Both his sculpture and his paintings came from a factory.

Partly, this mania for copies was defensive. Since the forms of applied art had become more or less frozen in the fourth and third centuries

[12] Vol. I, page 110.

B.C., the Roman world could only found a personality cult on the distant past. The Periclean age was as far from the Antonines as the Trecento is from the present day. But the art of the small Greek city states had survived on too small a scale to make antiquarian collecting a practicable proposition. The result of this was to reduce collecting to a cult for extremely rich and costly contemporary, or near-contemporary, craftsmanship. The several surviving fragments of knowledge concerning auction sales and collectors in the 1st century B.C. and 1st century A.D. suggest something very like eighteenth-century Paris and also the Paris of Lord Hertford and the Rothschilds.

Thus Cicero viewed with disapproval the auctioning of a bronze statuette at 120,000 sesterces, or 1,000 sovereigns. Three citrus-wood tables of good pedigree fetched from 1,000,000 to 1,400,000 sesterces on different occasions in the first century A.D.—£8,000 to £12,000, as it were, and rather more than the prices of the Hamilton Palace sale. Martial, at the end of the century, complained in hexameters of silver at eighty shillings an ounce. Generally it seems to have been chased silver or silver-gilt vases, furniture in rare woods, bronze tripods, candelabra, and incense-burners that commanded the high prices.[13]

Thus Edmond Bonnaffé, in reprinting these scraps of ancient knowledge in 1878, the year of Edmond de Rothschild's £30,000 commode, might have been happily commenting on the last season at the Salle Drouot, for these are the normal symptoms of great private wealth in all ages. Buying the names of illustrious painters and sculptors, dead or living, is another symbol of an age of wealth, but till recent times it has been a less expensive symptom. The seventeenth-century teaching academies began the process of lifting the painter from his tradesman status, but they did not greatly increase his rewards. In the age of Rubens, Vandyck, Guido Reni, Claude, and Poussin, any painter's fee over 100 guineas was something worthy of remark. Yet who knows what was paid for the heavily encrusted furniture of the period. In 1693 John Evelyn was told that an amber cabinet, given to Queen Mary by the Duke of Brandenburg, was worth £4,000.

Throughout the eighteenth century and the first half of the nineteenth the remuneration of artists increased very much faster than the purchasing power of money fell. In other words, the artists improved their status. But never in history have the living painters' rewards advanced more rapidly than between the years 1860 and 1890. This was the first time that the estimation of "genius" really kept pace with the estimation of craftsmanship. A painter's fee of a thousand guineas

[13] Bonnaffé, *op. cit.*, pages 59–78.

was considered very high in 1860,[14] but by the early 1890s sums of £40,000 and more were being paid for works of the recently deceased Jean François Millet, while in 1890 the painter Meissonier, aged 75, heard the news that a version of his historical composition, *1814*, had been bought by Chauchard from a dealer for £34,000. Since this was the third most costly work of art in the world in 1890,[15] we can regard that year as the moment of equilibrium, for while much lesser painters than Meissonier—painters who could not stand a figure on its feet—could then make £10,000 a year with ease, the highest classed objet d'art market was actually declining.

The year 1890 was, of course, the high-water mark of Victorian hero-worship, the heyday of the belief that work which was popular and easily intelligible was therefore great and good. Since 1890 we have seen what amounts to an abrupt decline in objets d'art of the millionaire class. We have also seen a fall in the merchant-prince status of the living painter. But, because the status of the painter—the *avant-garde* painter and not the painter of the Establishment—began to recover in a remarkable way after the Second World War, we get the result that the gulf between skill and genius is now wider than ever.

Under the new dispensation, genius—or what passes for it—wins all along the line, and yet one may wonder whether the hero-worship, which was such a natural, obvious thing in my schooldays, is really part of the spirit of the present age. In these days of the cheaply produced, synthetic public personality, living reputations are likely to impress themselves on the human memory less than at any period in history. It is as easy to create artistic reputations as it is to create a television-screen personality. A syndicate of Paris dealers can discover a genius overnight. More and more, the kind of art that receives this publicity becomes standardized and keyed to the single, overworked gimmick. More and more, one is reminded that throughout all but the smallest part of the history of civilization the artist's identity has been of far less consequence than the job asked of him. The artist has, therefore, remained anonymous. One is reminded of this fact extremely forcibly at those numerous smart exhibitions where the works are listed in a catalogue, not under titles, but under combinations of letters and numbers, like the registration plates of cars—with only this difference: the car is not signed.

When the subconscious takes over in art, why should anyone go to the trouble and expense of buying individual names? The world is fast passing from hero-worship to the worship of collective symbols—and

[14] Vol. I, pages 91, 151. [15] *Chronique des Arts*, 31 May, 1890.

singularly sterile, dreary ones at that. The hunt for personal genius, nevertheless, goes on, bewildered, relentlessly exploited and yet more trustful than at any other period in history. It is essentially a sentimental and nostalgic activity, unlike the hunt for skilled workmanship, which fulfils a real and desperate want. The genius-hunter follows the hounds of fashionable criticism, unaware that in the last generation, in the generation before, and in a generation still earlier the hounds were on a false scent. When an early work of Picasso, insipid, derivative, and immature, is sold for £80,000, the chronicler of artistic values can think only of those living reputations of late Victorian times who commanded still higher prices in terms of real money. But the moral of the comparison lies not only in the fact that those prices have fallen. It has also to be perceived that the boom in modern reputations in the 1880s and 1890s which in some sort superseded the great mid-Victorian boom in objets d'art, was itself superseded by a second boom in objets d'art even more fantastic than the first.

There was a time when the value of an objet d'art in fine condition was what it cost to replace. If this happened to be more than the cost of a Raphael, no paradox was perceived. During the 1860s thousands of pounds could be spent on copying a piece of eighteenth-century furniture, but what they were copying was something very fashionable. Consequently, at this stage a really enormous increase in the value of the original piece became inevitable, because to the cost of making a copy there had to be added, sooner or later, the values of rarity, personal or romantic associations and, finally, antiquity. Hence the enormous prices for French eighteenth-century objets d'art and Renaissance objets d'art which were paid towards the year 1880, and again in the years preceding the First World War.

Since 1914 this tide has receded, and yet there is no logical reason why the elements which create the value of an objet d'art should have come to mean any less in the past half-century. The initial element, replacement cost, has in practice multiplied itself many times over. The objects themselves have become rarer since 1914, and their kind still more desired. Why, then, have some of the most persistently fashionable objects fallen in terms of real money?

The reason is to be found in a sense of shame. What has occurred since the First World War is a change in the philosophy of art, a change which modern critics agree almost unanimously in regarding as the revelation of the true light, but which an art historian has to accept as a phase that can be no more permanent or exemplary than any other. The changed philosophy began with the general acceptance, soon after

1900, of the French Impressionist painters. For more than thirty years the Impressionists had despised surface finish and had boldly and effectively exposed the anatomy of their work—but without rejecting academic training. That rejection was only the next stage, and in the 1920s, when it came, it was made impossible for an advanced intellectual to pay for a work of skill without encountering this sense of shame. We can see its consequences. No one in the 1960s is surprised when persons, who are supposed to know, describe the contents of Picasso's studio as being worth a million pounds. But the imagination of the common man is altogether defeated by the sale of a dead-plain silver Queen Anne coffee-pot with a wooden handle at a price which might be more than that of his idiotically designed and indolently constructed car.

They were rather less obsessed with self-expression 100 years ago, when the first high prices began to be paid again for objets d'art of the French eighteenth century. The collectors of the day quite simply went back another 100 years and relived the past, unperturbed by the thought that they ought to be paying out their good money for genius untrammelled, and not for furniture. Far from seeking supreme originality, they paid most for what most suited their own homes. For this reason, the great Gobelins and Beauvais tapestry suites after Boucher, Oudry, and Coypel were the last of the eighteenth-century *mobilier* to achieve millionaire prices, whereas Sèvres porcelain was the first.

Between the late eighteenth century and the middle nineteenth this *mobilier* had gone through the usual vicissitudes of second-hand and unfashionable goods. But in the Paris of the 1860s the grandsons and even the sons of the old craftsmen were still alive; the cost of production could be verified by simply having a copy made. Thus the first four-figure prices for objets d'art of the past were paid in some cases for things made in the memory of living men, because comparable workmanship cost that to procure.

In the 1860s the Marquess of Hertford paid the firm of Dasson £3,600 for a copy of the *Bureau du Roi Louis XV*. At that time £3,600 would have bought any piece of furniture in the world. But in 1878 the Baron Edmond de Rothschild was believed to have paid £30,000 for one of Mme du Barry's Sèvrified commodes.[16] In this case a new

[16] The figure, which was first quoted in *Chronique des Arts* in 1880, is debatable. In 1878, the year of this sale, Bonnaffé wrote enigmatically in his *Causeries sur l'Art:* "On paye 600,000 francs [£24,000] pour une commode." It is significant that he repeated this sentence in his essay on the Spitzer Collection in 1893 without mentioning the higher figure of 750,000 francs (see *infra*, page 136).

element had clearly contributed to the price: that of unique personal association. So also at the Hamilton Palace sale of 1882 an association with Marie Antoinette forced some not specially spectacular furniture up to price-levels which were not reached again in the saleroom for half a century.

But personal association has an exceedingly volatile merit which varies with the *Schwärmerei* of each decade, or with the historical dream-worlds of successive millionaires. In 1901, when once again the intoxicating auction prices of the 1870s and early 1880s returned with the Duke of Leeds's commodes, romantic personal association played but a small part in procuring 15,000 guineas, for in 1901 the eighteenth century was no longer the last century, but the penultimate century. French eighteenth-century furniture was now "antique".

But antiquity, like personal association, is not such a simple component as replacement cost. A dynastic Egyptian carving can prove expensive indeed, but it is not worth more than an eighteenth-century table simply because it is thousands of years older. In mid-Victorian times antiquity as a quality in itself was only just beginning to receive financial recognition. It was not only the lavish Marquess of Hertford who spent thousands of pounds on a modern copy. In 1869 the Victoria and Albert Museum spent £2,750 out of its own funds in order to acquire a French ebony cabinet with intricate inlays of many woods, which had been made for the recent Exposition Universelle. The cabinet cost the museum even more money than Prince Soltykoff's twelfth-century *Eltenburg Reliquary*, the wonder of the age when it was bought for £2,130. And if you wanted fine furniture in 1869, the sum of £50 would have bought you almost any Chippendale carved table or Florentine cassone in the world. It was not thought extraordinary that the imitation should cost many times as much as the original, since the museum had just paid £800 for a newly completed satinwood cabinet, inlaid with Wedgwood plaques in Sheraton style, the original article being worth less than £100.

In the same year, 1868, the museum paid £2,000 for a parade shield in silver and damascened iron, made by Messrs Elkington to illustrate Milton's *Paradise Lost*. In 1868 gentlemen in ceremonial dress, whether civil or military, no longer sported parade shields. But design in industry was in sore need of encouragement, and it was hoped that others might be induced to follow the example of Messrs Elkington in trying to rival the Milan armourers of the sixteenth century. In this case it was a period cult by proxy, for it was not the manufacturers whom the example encouraged, but the collectors. Within less than

two years Ferdinand de Rothschild had to bid as high as £6,800 to get the San Donato parade shield, an original work of the year 1554, and in all probability (though only for a little while) the most costly objet d'art ever sold.

These curious experiments of the 1860s proved that it could cost several thousands of pounds to copy or imitate a lavish piece of French furniture or sixteenth-century armour. Barely a generation earlier no one had given a thought to this basis of valuation, because objects of the most recent past were simply not wanted at all. In the eighteenth century a second-hand object became almost worthless unless it could be "mounted-up" to look like something else. One of Mme de Pompadour's two tapestry suites of furniture, barely a dozen years old, was valued, at her death in 1764, at about £3 a chair, though the tapestry panels alone must have cost her six to eight times as much.[17] Even objects in precious materials simply reverted to their bullion value or less, once they became unfashionable or worn. In the late eighteenth century the price of such objects as enamelled jewels or rich Renaissance constructions in carved rock crystal and parcel gilt, today rarely to be found in the saleroom, was something that seems to us barely credible. Generally these things were bought by scholars; much more rarely by Rothschilds and tycoons. It was only when the competition of the latter became frequent that some thought was given to production cost.

Imagine a man born in Paris about the year 1830, the son of a sort of Cousin Pons, who bought the plunder of the French Revolution which still drifted about among the Parisian *brocanteurs* for another generation. As a boy, growing up in the 1840s, he would have seen his father gather up mediaeval reliquaries and ivories, early tapestries, illuminated manuscripts, and what you will, probably never spending more than fifty to a hundred pounds. By the middle of the century he would have seen his father's possessions just beginning to approach their replacement value, but only just beginning. Now imagine this young man living to the age of 80 and more—living right through the heyday of Duveen and Pierpont Morgan to the First World War. He would have seen the element of antiquity and extreme rarity added to the element of costly craftsmanship. He would have seen his inheritance multiply its value in many instances by a thousand times and more, and, if his father had discovered a panel from the great Angers Apocalypse Tapestry, perhaps by ten thousand.

But by no means all of this inheritance would have increased its value in the same proportions. The collector of the 1830s and 1840s might

[17] See *infra*, page 148.

well have bought Carolingian ivories and fifteenth-century tapestries for a few pounds apiece. But he would certainly have bought spurious Graeco-Roman cameos and intaglios (the work of Signor Pistrucci) for anything up to 100 guineas each, and he would have to have been a very wise man to avoid the equally spurious Renaissance bronzes, which could have run him into thousands. He would also have bought Bernard Palissy ware, an example of which was sold at Strawberry Hill in 1842 for £26 and at Sotheby's 100 years later for £12 10s.

In this case an extra hundred years of antiquity proved positively detrimental, for when antiquity became a desirable and marketable quality in an object, it still had to be antiquity of the right kind—the antiquity of an age with which the present believed that it had some spiritual affinity. The San Donato shield had just the right sort of antiquity in 1870, and it had become two and a half times as dear as Messrs Elkington's experiment. But in 1963 not many people seem to like the paraphernalia of the mid-sixteenth century, Palissy's crawling lizards and the *Bouclier de San Donato* least of all. On the other hand, the products of the French eighteenth century are more congenial than ever, particularly among the wealthiest buyers. For them this is antiquity of the right kind because the most elaborate creations of the eighteenth century were nothing as remote as shields or chasses, but objects that were essentially domestic. Also because in our age, when genius appears to be divorced from craftsmanship and material, and even from rudimentary competence, the most elaborate forms of craftsmanship are likely, sooner or later, to become the most desirable. Thus the newest snob-cult of the abstract work of art is accompanied by a revival of all that was once thought fussy and vulgar.

And so, in the 1960s, as in the 1860s, we come back to the first element in an object of the past to give it a new market value—namely, the high initial cost or high replacement value. It has played a part, not only in the revaluation of the *dix huitième*, of which so much is known, but also in the revaluation of much more remote periods. In the days when the Renaissance and the Middle Ages could still rival the *dix huitième* in the affections of the rich, it was the tapestries rather than the reliquaries, sculptures, and ivories that became the costliest objects of these periods, because their initial value could be gauged from the incredibly high cost of restoration and from the constant association between tapestries and the extravagance of kings.

Sometimes, as in the case of the Raphael Vatican tapestries, the initial cost is known. In certain rare cases we possess a full break-down of the figures involved. For instance, in the year 1554 the master weaver,

Willem Pannemaker of Brussels, completed the great tapestry suite which is still in the former Royal Palace of Madrid, the *Conquest of Tunis*. The twelve panels, each nearly forty feet long, contained 936 square yards of fine silk weaving, or 1,246 Flemish ells. Working with seven men to each of the twelve looms, and employing a night-shift, Pannemaker got the suite completed for Philip II of Spain in an exceptionally short time—namely, rather more than five years. The working cost came out at twelve florins a Flemish ell, or 14,925 florins in all, but the silks cost another 6,637 florins, and the King himself had to supply the gold and silver thread. The total cost to the King was probably in the region of 30,000 florins, or 3,000 gold pounds of the period,[18] certainly enough to purchase all the Raphaels and Titians which the King could lay his hands on.

As to the equivalent of all this in modern paper money, the further one goes back in time the harder it becomes to equate the outrageously cheap things with the outrageously dear, so as to produce a rate of exchange applicable to our own day. Perhaps one should call the £3,000 of 1554 the equivalent of £90,000 in present-day money or £15,000 in the static gold currency of the first years of this century. Very probably this is more than the value of the *Conquest of Tunis* in 1903 and 1963 respectively, for the suite is of a type that never became fashionable. It was, moreover, the fate of tapestries until much less than a hundred years ago to become worthless, when they were faded, damaged, and out of keeping with the prevalent *décor*. Under these conditions, all traditions of their enormous cost were temporarily lost.

If it took a long time to create a market for objects such as tapestries, whose high production cost was perfectly obvious, it took even longer to establish a high antiquarian value for much earlier, rarer and more exciting objects, since, in their case, the initial cost was something unknown and incalculable. Who could say in what monetary terms mediaeval owners valued their illuminated books, enamelled chasses, and crystal reliquaries when coinage was something that could be produced in every degree of adulteration at any castle or abbey, when the pound or the livre was a hypothetical thing, based on an ever-varying silver equivalent, when even the standards of assay differed with the decrees of successive rulers? The very strong English early Victorian cult of the Age of Faith paid these venerable objects due homage, yet they had little appeal at this period for the man with an unlimited cheque-book. And for the same reason the primitive periods of art remain habitually undervalued, even today, when high finish

[18] Thomson, *A History of Tapestry*, 1930.

and intricacy have long ceased to be the only standards of appreciation in an objet d'art. The vigour of early civilizations has long established itself as a quality in demand, yet there still remains a prejudice in favour of the object that is strictly priceable in its kind.

We have already noticed the much swifter widening of the gap between the valuation of craftsmanship and the valuation of genius since the Second World War. That this gap may be eliminated by a revulsion against the entire cult of personality is an eventual possibility, at any rate in the case of living art. But before that happens the gap is likely to widen still more, for it has certainly not grown in keeping with the strides of present-day aesthetic standards. In fact, the salerooms of the 1960s remain Victorian survivals, except on those occasions when the modern French school of painting comes under the hammer. Normally it is the rather girlish porcelain and the swirling ormolu swags and glossy bombé surfaces that reign supreme. Outside the salerooms, those sanctuaries of mid-Victorian or Second Empire taste, buildings are going up everywhere in the form of cubes, devoid of ornament, devoid of re-entrant angles, ground plan, or elevation. Posters are almost abstract, fashion-display dummies recall African sculpture with their long, black, oval faces. Curtains are glimpsed through windows that portray the adventitious effects of tree bark, gravel, or plum pudding, the faithful companions of the works of Jackson Pollock, as sold with appropriate certificate to millionaires.

What has been the effect of this whirlwind on the auction prices of objets d'art? Gasps of astonishment and dismay, such as were heard in 1953 when the Nigerian Government paid £5,500 for a Benin bronze, well known since 1897 and a most memorable work of sculpture by any standard. Of course, this could not buy one corner of the £35,700 Llangattock table of 1958, but the gasps can still be heard.

In this respect, the situation in 1963 is not different from that of 1855, when the treasures of Ralph Bernal, the first truly historically-minded collector in this country, came under Christie's hammer. Far and away the most expensive lot in that thirty-two-day sale was a pair of Sèvres urns on ormolu plinths with tiresome pink cupids on white panels, reserved on *rose Pompadour* grounds. The urns (not in the present Wallace Collection) cost the Marquess of Hertford a sum which must have been among the three or four highest ever given for *old* objets d'art in 1855—namely, £1,942 10s, plus commission. On the other hand, the miraculous ninth-century engraved crystal mirror of King Lothair was acquired by the British Museum at this sale for no more than £267.

Today one would have to think in terms of hundreds of thousands to find a value for the crystal of King Lothair. It would seem, therefore, that the disparities of 1855 are not the same as the disparities of today, particularly since Lord Hertford's urns, which *The Times* in 1886 believed to be worth £10,000, are of a type which is now much less popular. Almost certainly they would not be worth as much in terms of our devalued currency as Lord Hertford paid for them more than a hundred years ago.[19] The point, however, remains that Bernal's eighteenth-century French porcelain was far more expensive than his mediaeval objects, which fetched the price of primitive works even though the climate of 1855 was thoroughly in their favour.

This supremacy of the French eighteenth century could be equally true of any year's art sales in the far less abundantly provided 1950s and 1960s. When newly discovered ages and nations found their way to the objets d'art collector's repertory, as they did not long after the Bernal sale, the eighteenth century retained its primacy, and even increased it. The later nineteenth century saw many artistic invasions. If the invasion from Japan, which began in the 1860s, had spent its force by the early 1900s, the same is not true of the Islamic Middle Ages, a discovery of the 1870s; nor of Chinese excavated bronze and jade, Sung pottery and T'ang figures, a discovery of the early 1900s; nor of African sculpture, a discovery of the late 1890s which, however, hardly registered with collectors before the 1920s. These markets are now from forty to a hundred years old, and therefore thoroughly acclimatized. No Mayfair flat is complete without a T'ang camel, its back unbroken by that very last of straws; no smart Chelsea studio is complete without a wooden fetish.

Yet which of these primitive and exciting schools can produce an object comparable in price with a perfectly preserved Nymphenburg figure, or a pair of Ch'ien Lung pheasants, let alone a smart bit of Louis XVI *ébénisterie*. Only very recently have the finest Sung wares or the Chinese blue-and-white porcelain of the fourteenth century reached the thousand pound mark, whereas fifty years ago Chinese porcelain in the most lavish eighteenth-century taste, such as *famille jaune* and *famille noire*, could make prices which approached £200,000 for a single vase in terms of today's money.

Not that the *dix huitième* has always set a gold standard for the art market. There were serious declines in the 1830s and early 1840s, and again in the early 1890s. In the slump year, 1933, it would have been difficult to sell any piece of eighteenth-century French furniture in

[19] See page 161n.

London for 300 guineas. But periods of financial buoyancy have never failed to bring this furniture to the forefront again. Its former rivals, the enamels, crystals, ivories, faience, bronzes, and tapestries of the Renaissance have failed to recover the position which they held before the First World War, whereas in the 1960s the same *décor* is as much in demand as in the 1760s, when M. Blondel de Gagny furnished his salon in the Place Royale. The bergère that contained his corpulent person still suits the figure that goes with high finance. If the problem of installing a nice piece of marquetry which will hide a chamber-pot no longer causes concern, there is still the worry as to which *commode bombée* contains the cocktail bar and which encoignure the television.

A well-established cost tradition is not in itself sufficient to account for the special continuity of *dix-huitième* taste. The significant fact to be borne in mind is that French eighteenth-century furniture was dearer than today in the 1870s, when it had hardly yet become "antique" according to present-day Board of Trade definitions. In those days the taste was not an antiquarian tradition of collecting, but, if the alliteration can be pardoned, an anti-antiquarian tradition. It was the tradition of discarding the inherited family furniture in order to create a *décor* in the latest fashion. Those who in the 1860s paid thousands of pounds for Louis XV and Louis XVI furniture, and just as much for copies, were doing precisely that. But they did more than merely revive the fashions of the mid- to late eighteenth-century. The incredible Victorian prices were also a projection of the arrogance and prejudice of that previous age, an age which had parted company with its past and which could see nothing as good as its own reflection in the mirror. For it is a fact that, while enormous prices had been paid in the auction rooms of eighteenth-century Paris for contemporary craftsmanship, the art of the Renaissance, even the very late Renaissance, was worth appreciably less, while Graeco-Roman sculpture and Greek painted vases were left chiefly for English noblemen to spend their money on.

The schools taught the Roman classics, but no history. That France herself had known other golden ages was something quite inadmissible before the days of that odd product of the French Revolution, Alexandre Lenoir. Voltaire had shown in *Le Siècle de Louis Quatorze* that civilized manners had been invented after the Peace of the Pyrenees, and that was good enough for the age.

While the French *ébéniste*, with his professional traditions, knew perfectly well what models he was using, the client neither knew nor cared. Yet in the smart new Paris interiors of the mid-eighteenth century every object betokened its forefathers. The tortoiseshell and

brass inlays of the Boulle school derived straight from sixteenth-century Florentine or Milanese furniture, resplendent with inlays of precious marble and agate on ebony or patined iron. The caryatid and support figures on the most up-to-date commodes and bookcases, cast and chiselled in gilt bronze, recalled, and often in the most vivid fashion, the bronze candlesticks and andirons of sixteenth-century Venice. Sometimes they came even closer to the sculptures of the school of Jean Goujon, carved on the fronts of sixteenth-century French walnut chests and cupboards. The sixteenth century was in the very bones of the French *ébénistes*. Moreover, even the great gleaming Sèvres chimney-piece garnitures retained something of the heavily built-up shapes of Limoges enamel, of maiolica, of Palissy and Henri Deux ware. In France such things were still occasionally bought by craftsmen and artists who respected their masters and could afford to spend a few livres, but the Paris salerooms had little use for venerable relics that, on the one hand, were not Greek or Roman, and, on the other hand, could not be sent off to be mounted in ormolu or dolled up with silly little porcelain flowers on wires or converted into a clock that played tunes.

If they reached the salerooms at all, mediaeval and Renaissance objects tended to come from the *cabinets des curieux*—the collections of scholars and of men who had retired from worldly affairs. There were plenty of these cabinets in eighteenth-century Paris. In 1873 Louis Courajod published a sort of directory of them.[20] Most of the cabinets were filled with rare minerals, fossils, natural curiosities, scientific instruments, and ship models, those of the more artistically disposed with coins, medals, and engraved gems, which, however, they kept firmly locked in cupboards. Some, like the Marquis de Paulmy, bought illuminated manuscripts, but display there was none, not even an Italian primitive on the walls, bought for a few livres. For the *amateur des curieux* lived, monkish and austere. In the satirical prints of his day, he was shown in the company of mummies and stuffed crocodiles.

Nevertheless, among the accounts of the extremely fashionable Paris dealer, Lazare Duvaux, between 1748 and 1758, quite a number of objects—and not cheap ones either—are described as *ancien*, old lacquers of Japan, old porcelain of China, old *pagodes*, old *magots*, old celadons, old Boulle furniture. And most of them, one finds, were destined for one person, Jeanne Antoine Poisson [1721–1764], who, as Marquise de Pompadour, ruled the affairs of Louis XV for close on twenty years. Mme de Pompadour's personality supplied perhaps the

[20] In the long introductory volume to *Le Livre Journal de Lazare Duvaux*, 1873.

strongest link of all between the *dix huitième* and the modern saleroom. For nothing could be more modern than that lady's activities. When one sees all these old or second-hand objects turning up in Duvaux's accounts, one knows at once where they will end: wrapped or smothered in gilt-bronze swags, wired-up with porcelain flowers, inlaid into furniture panels—in short, made into something else. And it was done in the grand manner to the tune of many thousands a year, filling half a dozen châteaux and hôtels and outrivalling the feats of the Empress Catherine in the next generation. But had the Marquise lived in this more competitive age, she would have been just as happy in the Portobello Road, rummaging for mid-Victorian chiffoniers and credenzas, pickling them, bleaching them, gilding them, painting them white, pea-green or what you will.

The first of all the smart women decorators in history has certainly had a remarkably long run for the fashions that she introduced. If we compare the present eighteenth-century vogue with the eighteenth-century vogue of the 1870s and 1880s, one thing emerges very strikingly. In the former age French eighteenth-century furniture and *lavis* were not on a lonely pinnacle. The taste which had been created during the Romantic movement for Limoges enamels, sixteenth-century furniture and faience, was also at its very height at this time. The Hamilton Palace Collection and the San Donato Collection were profuse in both elements. At one and the same sale, record prices would be achieved for Sèvres porcelain and sixteenth-century armour, for mounted drawing-room sculpture and sixteenth-century faience.

It is difficult to imagine the same situation today. Most Renaissance objets d'art are wildly unfashionable, except among museum curators. The new, international race of millionaires are expected to own Impressionist pictures. They may be permitted their modern abstractions, but outside of all that someone, it seems, tells them to stick pretty close to Mme la Marquise. Possibly it is the Marquise herself, whose powerful posthumous personality has enabled the time-snobbery of the Rothschilds and the de Goncourts not only to survive a second hundred years, but to gather strength. Certainly that strength derives from the peculiar character which Mme de Pompadour gave to taste during her reign over the arts. For, in the late 1740s "good taste" became for the first time in history the kind of taste that is dictated by women for women. On one side of the Atlantic, at any rate, and possibly on both, there can be today no higher commendation of any period than that.

The Contemporary Objet d'Art
1750–1820

*1. The Account-books of Lazare Duvaux; the Porcelain Market —
2. Royal and Inflationary Prices*

1. The Account-books of Lazare Duvaux; the Porcelain Market

In 1792, when the commissioners of the French Revolution began the slow sale of the enormous artistic possessions of the French Crown, it is probable that among them scarcely a dozen pieces of furniture and not a single piece of silver plate was as old as the reign of Louis XIV. In the recesses of the Bibliothèque Royale or in the Chambre des Comptes there might lurk heirlooms of the House of Capet dating from the Middle Ages. But kings were not expected to display worn or second-hand articles in their palaces, unless they had been transformed into something else at a cost greater than that of the original production. Smart Parisians imitated their King. In a subsequent chapter I shall give some account of the antiquarian market of eighteenth-century Paris such as it was, but the true passion of the age—and an unexpectedly healthy one, considering the sickness of the body politic—was for the objet d'art that was both rich and new.

The financial side of this fashionable market is singularly well documented. There is little that is not known concerning methods of costing, price of materials, auction fluctuations, and the decline of out-of-date designs in the Paris of the second half of the eighteenth century. The age is not so far away that the figures cannot be equated with the general cost of living as compared with today's. Moreover,

from the very beginning of the period we possess a document which provides a compendium of the entire subject—namely, the account-books of Lazare Duvaux for the years 1748–58. All the objects sold by this extraordinary man are familiar today and exceedingly popular in the saleroom. Sometimes in perusing the accounts there is the thrill of finding an object that is actually identifiable. And sometimes one finds a price that accords surprisingly well with its present degree of estimation.

Not in every case, however. If the casting of plate glass and the gilding of large surfaces involved specially costly hazards in the eighteenth century, the laborious inlaying of minute particles of wood was by comparison very cheap. To understand "pre-industrial" prices, one must realize the enormous difference in their structure from today's. One may take, for instance, the case mentioned in the last chapter, of the cost of making a tapestry in the middle sixteenth century (see page 16). It will be recalled that the cost may even have been greater in terms of real money than the present value of the object. But whereas the cost of copying the tapestry in the 1690s would be more than nine-tenths a wages bill, the bill paid by Philip II of Spain was made up to the extent of a half or more by the cost of the materials. At that period the wages of the weaver were so low that it is useless to attempt to equate them with the earnings of a modern weaver. But the economic evolution of Europe in the next two centuries raised the standards of living of the kind of skilled worker who was most in demand. In the later eighteenth century the highest paid wage-earners could make four livres a day, about 3s 6d at the rate of exchange of the times and about £2 in the purchasing power of our present money. A truly skilled man in almost any trade would expect to make at least double that in 1963, so that, in estimating the cost of copying an eighteenth-century tapestry or piece of furniture today, one would have to multiply the labour-cost twenty-five or even thirty-five times, whereas the actual materials might be worth, even in our devalued pounds, no more than they had cost in the eighteenth century.

When it is considered—to use the yard-stick adopted in this book—that the necessities of life 200 years ago may have cost a twelfth of what they cost today, the expenses of a smart standard of living seem to us to have been inordinately high. To understand them one must seek such analogies as the life of a Westerner in China before the Second World War. In China the Westerner was surrounded by masses of people living—or failing to live—on the barest subsistence. Mere human life, he perceived, was the cheapest commodity on earth. The

cost of labour and the cost of the native products of the soil were, therefore, incredibly low. On the other hand, the comforts of life to which he was accustomed had either to be made to his special order or else to be imported from abroad at great cost. On balance, his budget would certainly be a lot lower than at home, but not miraculously so, in spite of the fact that the Chinese day-labourer may have earned not much more in a year than the Western labourer earned in a fortnight.

What happens before the outbreak of revolutions seems much the same everywhere. During the period of our study the French livre or franc was unquestionably losing its purchasing power, but, contrary to the belief that this only began to happen under Clemenceau, it had been falling since the time of Charlemagne. To find its value in the eighteenth century, it is useless to equate it with the "old franc" of the present century, which fell, in little more than a generation, from twenty-five to a gold sovereign to more than 5,000. Barely intelligible even to a French reader, such an equation would be quite meaningless to any one living outside France. The only reasonable yardstick is the sovereign or equivalent gold coin.

The history of the eighteenth-century silver, franc or livre, with which we are concerned, goes back to the ninth century, when the livre tournois—the Tournai pound—was a big gold coin equivalent to rather more than three modern sovereigns. During most of the Middle Ages, however, the livre tournois was used purely as a unit of account-ing, being taken as the value of 1lb of silver. After numerous arbitrary changes in the currency equivalent to this hypothetical pound of silver, the livre ended in the late seventeenth century by becoming an actual currency unit, but by this time it had been devalued to a small silver coin worth little more than a shilling. By 1726 it was a very adulterated silver coin worth about twenty-four to the sovereign. From now on and until the Revolution the fluctuations of the livre or franc on the international exchanges were not violent. In 1750 the livre may have fallen as low as twenty-seven to the sovereign, but on the whole it is safe to base one's calculations on a single rate, apart from the temporary printing of paper money during the revolutionary period—that is to say, the twenty-five livres or francs to the pound which remained current till 1919.

The diminishing power of the livre was not reflected in the foreign-exchange markets. To the foreigner, France in the eighteenth century simply became a more expensive country. The conclusion reached by the Vicomte d'Avenel in the 1890s was that between 1750 and 1792

land doubled its value and that the cost of goods went up fifty per cent.[1] But the very luxurious goods that we are studying went up a great deal more than the common index. There was a strong element of speculation in their acquisition, and the expression of an unspoken fear of the devaluation of money. The actual coinage of the French kingdom had been debased within human memory, while the financial crisis created by the failure of Law's Mississippi Scheme in 1720 had revealed the absence of sound public companies in which money could be invested. In the last years of the *ancien régime* the wealthy derived their income, not from investments, but mostly from rents which failed to rise with the increased value of land. Many of the rents were farmed at a serious discount and, despite the inequitable fiscal privileges of the nobility, which helped to bring about the French Revolution, no one enjoyed a safe, assured income.

The richest men of all, and the greatest speculators in objets d'art, were the *fermiers généraux* and *intendants généraux*, who farmed the unstable revenues of a thoroughly inefficient government. Since they knew the vulnerability of property values better than anyone else, this important class of financiers may have been the first to buy objets d'art as an investment. As much as the Royal Family and Mme de Pompadour, they were responsible for the rise in art prices. At the beginning of our period the profits made on objets d'art could not have been very high, but gradually the highest prices of all acquired a degree of artificiality, showing that spare money which could not be invested profitably and safely was becoming abundant.

Our guide, Lazare Duvaux, was one of those men of many resources in whom Western society still abounded. Besides being a practising goldsmith and jeweller, he acted as a general purveyor of objets d'art for the Royal Family and the Court. He also sold the same things to such of the nobility and rich *bourgeoisie* as could afford them. Lazare Duvaux did not stand on his dignity about it. He would contract for a vast Vincennes dinner service, a present for some royal ally of France, or he would provide Chinese paper fans or feather dusters for a few sous. But the largest part of his business between the years 1748 and 1758 seems to have been to refurnish the many châteaux and hôtels of Mme de Pompadour, whose dominion over the King had begun in 1745.

Naturally, these accounts show a considerable gulf between the cost of standard articles and the cost of special orders for Mme de Pompadour or the Court. The biggest disparity is to be found in the orders for

[1] *Vicomte d'Avenel, La Fortune privée à Travers les Siècles*, Paris, 1895, especially pages 35–6, 42, 59.

furniture. In 1749, for instance, the prices for commodes in marquetry, with their marble tops and mounts of standard design, could be as low as £2 15s a pair. Clearly, these were second-hand articles, perhaps in the style of the beginning of the century and therefore out of fashion, or perhaps merely worn. But even new commodes need cost no more than £8 or £9 apiece. In 1749 specially fine commodes were sold for £28 8s and £38, the latter being also the price of an elaborate writing table with a cartonnier. Very much higher prices were paid when the furniture incorporated lacquer panels, not the *vernis Martin*, which was made in France, but the imported Chinese and Japanese black and gold lacquer panels, very often pillaged from screens and coffers, which Mme de Pompadour's preference had made so rare. In 1750, for instance, M. La Fresnaye paid £64 for two corner cupboards in *lacq ancien*. Two large *commodes à pagodes*—that is to say, with subject-picture lacquer panels, probably Chinese—cost Mme de Pompadour £96 and £120. In 1751 she paid £52 15s simply to acquire a newly-made stand for a Japanese lacquer coffer which she already possessed.

Very small and delicate Japanese lacquer objects sometimes found their way to the French mounters, but the lacquer market was governed by the need for large panels. Thus in 1753 Mme Pompadour paid Lazare Duvaux no less than 5,000 livres or £200 for a single piece. This may have been either the Maria van Diemen casket, a long flat deed-box which had been ordered in Japan as far back as 1636–1644, or the Mazarin coffer, a late seventeenth century piece, mounted as a cupboard on a carved stand. The much smaller van Diemen casket was the most highly valued. Appraised at £84 in 1764 after Mme Pompadour's death, it rose to £276 at the Randon de Boisset sale of 1777. Both pieces were acquired in 1801 by William Beckford and both re-appeared on the market at the Hamilton Palace sale of 1882. It was now the larger, richer and less delicate Mazarin casket which made most money, namely £682. How much the eighteenth century had appreciated the refinement of the smaller lacquers is shown by the fact that in 1882, when all London was going Japanese, the van Diemen casket at £315 was only a little dearer than in 1777.[1a]

In 1757 Mme Pompadour again paid £200 for a piece of Japanese lacquer, but this had been mounted up as a *secrétaire à abattants*, an elaborate writing desk. Nowhere in Lazare Duvaux's accounts is there an instance of a commode or secrétaire costing more than a fifth of

[1a] Both have been in the V & A since 1916. The problems of their history are discussed by Mr. F. J. B. Watson in Gazette des Beaux Arts, February, 1963.

this price unless lacquer was used. It is true that the *corps d'armoires* delivered to the Inspector of Finance, M. la Live de Jully, in 1756, cost £480, but it comprised a whole range of bookcases to line his library and all of it in the richest boulle inlay of brass and tortoiseshell, which was much dearer than other inlays. In 1751, a new boulle-style bureau, surmounted by a clock, cost £60.

The costliest element in the furniture in the newest taste, apart from the rare Japanese lacquer panels, was the gilding of the bronze mounts and fittings. Gilding by mercurial evaporation cost a heavy toll in lives. A man who habitually performed this operation, might not last three years, and death came in the disgusting form of *fossy jaw*. It appears[2] that in 1787 gilders were paid four livres a day, which was no more than the highest rate for skilled day labour, though in 1771 Gouthière paid his gilders five livres, to include the cost of food, when working away from home. The trouble was that gilders were hard to find. Probably less than half the bronze mounts which look so attractive today with a little gold adhering to them, were gilded in the eighteenth century. The rest were merely lacquered or polished. Only the kings of France could afford to send their furniture mounts to be re-gilded every few years.[3]

Naturally, objects which were made entirely of gilt-bronze were, for their size, the dearest of all. There was, for instance, a gilt-bronze lantern for which Lazare Duvaux charged Mme de Pompadour £172 in 1751. It was 4½ft high, and it took six men to carry it to Bellevue, one of them remaining to rig it. The whole operation cost £1. But in 1758, when the King wanted a similar lantern, the charge was £198. The cost of marble, turned and polished, made ormolu-mounted objects dearer still. In 1767 a pair of finely-mounted porphyry brûle-parfums were auctioned for £520. In 1782 Marie Antoinette paid £480 for a single mounted brûle-parfum in jasper, but the price bore no relation to the production cost in 1772, which was £60.[4]

The dearest piece of furniture sold in Paris during the decade of Lazare Duvaux does not figure in his accounts. The Duc de Tallard's lustre, composed of 160 pieces of imported crystal, was auctioned in 1756 for no less than £640. M. Villaumont's lyre-shaped lustre, being made only of glass, was supplied by Lazare Duvaux in 1749 for the still impressive price of £187. In the light of the legend of the fabulous cost of plate glass in the eighteenth and early nineteenth centuries, it comes

[2] Piere Verlet, *Le Mobilier royale français*, 1945, Vol. I, page xviii.
[3] F. J. B. Watson, *Louis XVI Furniture*, London, 1960, page 12.
[4] *Wallace Collection Catalogue*, F292. An interesting biography: 1772, £60; 1782, £480; 1831, £48; 1865, £1,265.

as a shock to read that in 1753 Lazare Duvaux could supply a 9ft-high, two-panel pier-glass in its mountings for only £48. Yet in 1771 at an ordinary Christie sale, an imported French two-panel pier-glass of slightly smaller dimensions could make £400. That, however, was part of a long history. Snobbery demanded a "French plate" of glass in every London drawing-room. The Excise took advantage of snobbery by imposing a duty of one hundred and fifty per cent., and only the French could make glass plates sixty-five inches long. In the dreariest of eighteenth-century London house-sales, where scarcely a lot made over £5, there would still be a "French plate" at over £100. Mr James ·Christie the First used to sell them, newly consigned and unmounted. In 1773 he declared before a Parliamentary commission that he had once sold three pairs of glass plates for £2,500.[5]

It is to be concluded that in Lazare Duvaux's day, inlaid and mounted wooden furniture, though already exceedingly opulent, did not yet compete with such exotics as crystal lustres and porphyry urns, unless lacquer was used; still less did porcelain, which comprised far the greater part of Lazare Duvaux's trade, even when he sold it ready mounted, as he usually did. Except in the case of matching Chinese celadon and other monochrome pieces, which were specially sought after for their mounting qualities, the value of the porcelain had little relation to the price of the mounted object, and at the period of Lazare Duvaux's accounts it was often very low.

A few years before the first entries in the accounts, practically all the European porcelain which reached Paris had come from the single factory of Augustus the Strong of Saxony at Meissen near Dresden. Known as *porcelaine de Saxe*, it was imported up till 1757 when it had become much cheaper than *porcelaine de France*. Made since 1738 at Vincennes, the latter was gradually evolved into a very rich style with heavy gilding on top of grounds of coloured enamel. To the extremely ostentatious taste encouraged by the French Court, this was much more tempting than the more sober decoration of Meissen. Transferred from Vincennes to Sèvres, the *porcelaine de France* became still more ostentatious, and its supremacy over all other European porcelain was assured till well into the present century. In Lazare Duvaux's accounts we can follow the beginnings of an episode in the history of taste so astonishing that later I shall give an entire section to it.

In the 1740s the Vincennes factory achieved a further triumph. It broke the monopoly of the little porcelain flowers which the Meissen factory had shipped all over Europe. By 1749 Vincennes supplied

[5] R. W. Symonds in the *Connoisseur*, 1936, pages 243–8.

annually £1,500 worth. The labour was not of the highest order of skill, and its low cost is illustrated by the fact that in order to earn £1,500 a year the factory employed forty-six women and children. The flowers were attached with wires to trees or stems of ormolu, for which another part of the factory supplied jardinières or figure-groups. Despite the vogue for these, the silliest toys of the period, the factory was always in difficulties. In 1753, after its removal to Sèvres, it was partly financed by Louis XV, who in 1759 bought the whole concern. For the next thirty years the French Crown tried to run Sèvres as a porcelain monopoly for the whole country—unsuccessfully, and at exorbitant cost.

Sèvres porcelain, produced under these conditions, became some-what more expensive towards 1760, but it was frequently outdistanced by the astonishing prices paid for Chinese monochrome porcelain, particularly in the colours known as *bleu céleste*, Mazarin blue and *flambé*, the colours most favoured for mounting. Dresden porcelain, however, remained a good deal cheaper than any of these products. The Chinese decorated wares, which were to become known in the nineteenth century as blue and white, *famille verte*, and *famille rose*, were cheaper still. This order of preference was not changed till the 1860s.

Duvaux's unmounted French porcelain was mainly restricted to dinner services or to tea and bedside breakfast sets (cabarets and déjeuners). Vincennes porcelain in 1749 had not entirely lost that quality of innocence which was to make it almost worthless for two centuries, but highly desired after the Second World War. The price of these early Vincennes products was therefore innocent too, when compared with what was demanded for the royally-produced Sèvres, the *porcelaine à émaux* of a generation later. Thus in 1749 a tea cabaret for six people cost the painter Boucher only £9 12s. It must be added that a Dresden cabaret of the same size cost £4 6s. There was no sales snobbery concerning modelled figures of people and animals at this period. The cult dates only from the middle of the nineteenth century. The Vincennes parakeets on tree trunks, now worth several thousands of pounds apiece, cost eighteen livres, or fifteen shillings, in 1749. The largest type of figure-group, the *Flute Player*, after Boucher, cost £5 17s. Twenty-two years later the Chelsea imitation, known as the *Music Lesson*, cost £8. Purple ground *seaux* with miraculously painted landscape panels, possibly the dearest kind of Vincennes today, were being sold in 1753 for thirty livres, or twenty-five shillings, each. But removal to Sèvres caused an abrupt rise in these prices. In 1755 a little milk goblet, painted on a lapis blue ground, cost £6 5s.

Still more remarkable prices followed in Lazare Duvaux's ledger in the course of the year 1755. A *jatte*, or small flower vase, with panels *en camaieu*, cost £13, while another with flowers in relief was sold to Mme de Pompadour for £24. A little déjeuner on grounds of *bleu céleste* with its two cups and its matching porcelain tray cost £19 3s. Finally, the year 1755 is crowned with two oviform urns, *bleu céleste*, but garnished with those horrible little flowers on wire, at no less than £112. A pair of tureens in the same style, unmounted, cost the Comte d'Egmont £76 16s, while £52 10s was paid for a single example of the largest type of all, a round tureen and cover, known as a *pot à l'oille* or *pot à l'oglio*.

In 1758 the plates of a tea service already work out at £2 10s each. The same customer, M. Laborde of Bayonne, paid Duvaux £3 17s for each cup and saucer, £4 7s for a teapot, £9 for a sugar caster on its platter, and £14 8s. for a big slop bowl. A huge dinner service, ordered by Louis XV in the same year for despatch to the King of Denmark, had this in common with M. de Laborde's service: that the plates cost £2 8s 4d. each, though the work sounds more elaborate, being decorated with figures, flowers, and birds, and gilded green borders. The whole service cost £1,381 16s and included a *pot à l'oille* at £60, two tureens at £48 each, and salad bowls at £14 8s. The mounts for the *pot à l'oille* and the tureens came to £48. In modern terms, this service may have cost over £15,000 but it was by no means the most expensive of a number of royal gifts which the Sèvres factory was to supply before the Revolution, nor was it the largest single service. After her death in 1764, it was believed that Mme de Pompadour had spent over £10,000—perhaps £120,000 of our money—in equipping her tables exclusively with porcelain displaying the new *rose Pompadour* background.

Plates that were even more costly than the King of Denmark service were often produced at Sèvres between 1759 and 1790. Those that were thought worthy of royal and noble dining tables were not always the dearest, one of the most famous being relatively cheap. This was the service made for the Prince Cardinal de Rohan in 1772 at a cost of £831. In 1870, a few months before the fall of the Second Empire, some 172 pieces surviving from the original 360 were bought by the Earl of Dudley at the San Donato sale for £10,300 at a single bid, which was the wonder of the age. Amid all this saleroom glamour, the Baron Davillier observed that in the original accounts of the factory, dessert plates had worked out at thirty-six livres each, or £1 9s 6d.[6]

6 Baron Charles Davillier, *Les Porcelaines de Sèvres de Mme du Barry*, Paris, 1870.

Some of these Rohan plates in *bleu céleste* and gold have recently changed hands in the United States at £1,300 apiece.

Modern prices, when enhanced by the rarity or the royal associations of a particular design can be deceptive. The original basis of the prices was piece-work. A plate was more expensive when it was painted with an individual centre-piece, differing from the others. A Sèvres model which was still in production in 1793 depicted the stuffed birds of M. Buffon's collection and cost seventy-two livres a plate (see page 156). One particular set of plates cost Mme du Barry £5 12s apiece, but the dearest set of all was ordered by Prince Bariatinsky in 1777 for the Empress Catherine of Russia. It comprised 744 pieces and was charged at £13,120. Each plate cost 240 livres, or £9 12s, which was normally the price of a tureen or punch-bowl. In 1877 one of the Empress's turquoise, gold, and grisaille plates, then celebrating their hundredth birthday, was sold at Christie's for £148. But, according to Emil Hannover, two Empress Catherine plates were sold in Germany on the eve of the First World War for £1,500 each, equivalent to £9,000 today.

Sèvres porcelain offers the classical example of a tradition of costliness which was handed down to posterity, but the legend was sometimes singularly inapplicable. In 1870 the Baron Davillier noted that one of the big flower vases known as *vaisseaux à mâts*, the most sought-after of all Sèvres models, was then worth 30,000 francs, or £1,200. In fact, the price paid by the Earl of Dudley for a *vaisseau à mâts* four years later was more than four times as much as this. With malicious glee, the Baron went on to observe that the *vaisseau à mâts* belonging to the Marquis de Menars had been sold at auction in 1782 for £11. Within the memory of man, Louis XVI's own *vaisseau à mâts* had been valued by the commissioners of the National Convention in 1793 at 1,000 *livres assignats*, which was then equivalent to £16. The simple fact was that this most rococo of all shapes, made in the late 1750s, had gone out of fashion long before the 1780s.[7]

Mid-Victorian taste, however, honoured the paired neo-classic Sèvres urns of the period 1768–90, some of them made in the new hard paste, almost as highly as the earlier *vaisseau à mâts* with its two satellite jardinières. In the 1860s, when it was not uncommon to pay well over a thousand pounds for a single neo-classical urn which might not now fetch as much even in our inflated money, the bidding was sometimes defended by invoking the expensive craftsmanship. But the high prices which we have seen in Lazare Duvaux's accounts after the Vincennes

[7] Davillier. *Les porcelaines de Sèvres de Mme du Barry*, page 14.

factory had moved to Sèvres, were brought down to earth by a form of mass production for every part of the work, except those niggling little paintings after popular masters. A fine discovery: in the 1770s the undisputed lords of the mid-Victorian, late Victorian and Edwardian salerooms were cheap by any comparison. In 1771, for instance, two of those famous urns, painted in miniature against a deep blue ground, cost Louis XV no more than £15 and £29. A *vase d'ornament* at £48 included the heavy cost of gilt-bronze mounts. Second-hand goods, even in the fashionable style, were cheaper still. In 1781 the Duchesse de Mazarin's garniture of three urns and covers with military scenes against a *gros bleu* ground made £44. The fanatical Sèvres worship of the 1860s and 1870s, one of the most perverse movements in the history of taste, evidently overlooked the original base purpose of the heavily burnished gilding which was so much admired and imitated. For, in the case of the larger urns, seaux and jardinières at any rate, it had been adopted in order to save the cost of ormolu mounts.

Modern taste, which puts the highest values of all, not on the garniture urns but on the larger items from the best dinner services, is actually much more in line with the eighteenth century. As early as 1758, a *pot à l'oille* in the Maria Theresa service had been charged at £72 with stand and cover. A service, which was begun for Louis XVI in 1783 and which was still in course of production in 1792, included soup-tureens at £120 each, complete, and a punch-bowl at £192.[8] It is, however, probable that the persistent Victorian tradition of the high cost of Sèvres was based not on these prices but on the sales, held at Versailles under the king's direction in the last years before the revolution. Yet the objects which the nobility had been obliged to buy at these sales in order to please the King, were of a kind that had become exceedingly unpopular in mid-Victorian times—namely, *porcelaine à émaux*, or jewelled Sèvres. It was studded with glassy knobs of enamel to look like rubies and sapphires, and was doubtless intended to match Tippoo Sultan's ivory fauteuils, enamelled hookahs, and mechanical tiger. Even the 1860s could not quite swallow this last aberration of *ancien régime* taste.

The prices for this article had been formidable indeed. In 1782 a garniture of three urns and two beakers, *porcelaine à émaux*, had cost the King himself £240. In the 1780s there were several such garnitures, working out at £40 to £60 a vase, the latter price being paid in 1784 for a present to the King of Prussia.[9] Even a little cabaret with its single

[8] *Les grands services de Sèvres.* Catalogue, Sèvres Museum, 1951.
[9] Davillier, page 35.

cup and saucer, *porcelaine à émaux*, cost Mme de Vergennes £96, ten times as much as one of Lazare Duvaux's cabarets thirty years earlier.

But the real cost of Sèvres porcelain a generation after Lazare Duvaux's accounts is not to be judged by the Versailles sales and the snob cult of *porcelaine à émaux*. A very good yardstick is the London auction market before the Revolution. England was a good customer for Sèvres, despite the fact that in theory porcelain paid the same 150 per cent. excise as plate glass. In 1775 the long-lapsed duty was applied for a time in good earnest as a result of Edmund Burke's efforts to protect the Bristol hard-paste factory of his friend, Champion. One consequence was that Horace Walpole, disembarking at Dover, was made to pay seven and a half guineas duty on top of the five guineas which he had paid for a "common set of coffee things".[10]

Considering the contraband nature of the traffic, London prices could reasonably be expected to be higher than those of Paris, but Christie's sales between 1771 and 1792 show no great difference. The famous neo-classic urns with the miniature paintings vary from fifteen guineas for a set of three, unmounted, to fifty guineas for a pair, mounted. Dinner and dessert services sell steadily at the rate of ten to eighteen shillings a unit, newly consigned from the factory; biscuit busts and figures at £7 to £10. Speculative prices, appreciably higher than the production costs, were not paid for Sèvres porcelain in London till the first let-up in the wars with France in 1801.

During the short period in which it was shipped abroad commercially, Meissen porcelain had not been as dear as this, and its secondary grading has determined the "antiquarian" market for Meissen almost up to the 1960s. In 1749 Lazare Duvaux could supply Meissen dessert plates in the more costly pierced-border style at 17s 6d each, and a cup and saucer in delicate miniature style for £2 17s 6d. Single Meissen figures cost only fifteen francs each, and animals from five to ten francs. In 1752 two huge tureens simulating cauliflowers cost, with their stands, £22 8s. In 1756 cabbage-leaf plates in the same tiresome taste cost forty-eight francs each.

If Dresden or Meissen ranked lower than Sèvres, English porcelain, which was hardly likely to reach Paris in Duvaux's time, ranked lower still, but the commodity was not easy to sell even on the home market. Bow figures in 1756 cost from two to nine shillings each, and a pair of large "sprigged and enamelled" dessert dishes fifteen shillings. In 1767 Christie's sold two Chelsea groups of the *Four Continents* series for one guinea, and a white group, *Hercules and Omphale*, an example of which

[10] *The Letters of Horace Walpole*, Cunningham Edition, Vol. VI, page 268.

fetched £950 in 1953, for half a guinea. A rabbit-shaped tureen with its cover and stand (£4,280 in New York, 1957) made a guinea and a half. Statuettes at this sale cost five shillings each; dessert and dinner plates, sold in services, less than two shillings. As in the case of Sèvres, Royal orders bore little relation to the open-market value. The huge general service given by George III to the Duke of Mecklenburg in 1763 was believed by Horace Walpole to have cost £1,200.[11]

The lowly status of English porcelain ended in the Gold Anchor and Chelsea-Derby periods, the 1760s and 1770s, when Chelsea, like Worcester, was entirely given over to the imitation of Sèvres models. The more lavish English Sèvres types, rare on the market today, out-stripped the price of Sèvres itself on several occasions between the 1870s and the 1920s, in spite of their derivative nature and the inferiority of the material. In this case the Victorian tradition of high initial cost, though lost for a long time, was well grounded. Some of the later Chelsea models were as dear, and in one or two cases, even dearer than the Sèvres originals, An essence-jar or *brûle-parfum*, the largest model that was made at Chelsea, was bought-in at Christie's 1771 sale for £85. This was when Duesbury took over the management and sold the old stock af the Chelsea factory in Lawrence Street. At the next sale in 1773 the jar was allowed to depart at forty guineas, but Morgan, the "china man", actually paid sixty guineas for the *Triumph of Bacchus* vase. However, the novelty prices of 1771 and 1773 could not be maintained. The last clearance sale in 1783 of Duesbury's stock, left over at Chelsea long after the departure of the last workmen for Derby, showed heavy falls, with tall garnitures of five urns at twelve guineas and even the smart imitations of *rose Pompadour* at five shillings a dessert plate. Morgan, the "china man", had to sell his dearly bought *Triumph of Bacchus* vase, on its third appearance in the saleroom, at nine guineas. Not only were the severe new neo-classic shapes ousting the rococo, but, on top of that, Wedgwood's cheaply produced cream-ware had killed the English porcelain market. Not till the sale of Queen Charlotte's porcelain in 1819 did Chelsea acquire a rarity value, and even that was much below Sèvres.

The flood of cheap Chinese enamelled porcelain imports, which became enormous after the middle of the eighteenth century, made it impossible for the European factories to continue economically except for the sale of large articles in the luxury class. The flood was not serious in Lazare Duvaux's day, though Chinese porcelain accounted for a very large portion of his trade. The scale of values, as revealed in his accounts,

[11] *Letters*, Vol. IV, page 58.

is extremely important, because it dictated the character of this taste in Europe for more than a century. In England the fragility of the native soft-paste imitations of the real material ensured a better sale for the purely commercial Chinese products than in France, where there were two completely different markets. The monochrome porcelain in Chinese taste, being in demand for its mounting qualities, was very much dearer than the white ware, enamelled in an immense variety of designs at Canton, which the Sèvres fashion had made less than aristocratic. One can see the difference in Duvaux's accounts for 1750. On the one hand, two magots, *terre des Indes*, probably seated figures of the gods delicately painted on the biscuit, cost £9 12s, whereas three plain vases of green crackle porcelain, suitable for mounting, cost £31 8s.

In 1751 the common blue-and-white, with which the Dutch had once flooded Europe, is represented by three chamber pots (very small, considering the size of Dutch tankards) for fifteen francs, whereas an unmounted celadon vase cost £38 8s. Four tall powder blue vases cost M. de Julienne £23, to which is added the sum of £8 12s for cutting their necks down to receive an ormolu swag or two. Seven tall blue-and-white vases cost only sixty francs between them, but vast size commanded a special price; thus two huge fish-bowls, enamelled and in relief, cost Mme de Pompadour £60 16s. The painter Boucher bought what was clearly a *famille noire* jar and cover, an affair of £10,000 or more, on the eve of the First World War, for £4 17s. In 1753 the celadon-mounting mania was at its height and Mme de Pompadour paid £200 for five assorted, unmounted vases. In the following year we find a celadon *magot* with head and hands left *en biscuit*, clearly a Ming piece, for £13 8s.

In 1755 the shortage of large monochrome pieces is such that the Duc d'Aumont is prepared to mount blue-and-white porcelain, paying a price equivalent to £6 apiece for a beaker, two rouleaus, and two urns. Other types seem to have been almost worthless: two tall vases in green and yellow for £4, two Imari urns with flowers in relief at £2 10s. Objects made of the beautiful *blanc de Chine*, the soft white porcelain of Tê Hua in Fukien, seems to have been the cheapest of all, since a variety of small pieces—dogs of Fo, statuettes of the goddess Kuan Yin, and libation cups in the shape of a rhinoceros horn—cost six francs each. And yet these were essentially a French taste. In Blondel de Gagny's famous salon there was a garniture of "this very rare white porcelain of ancient China", mounted (probably in the previous century) in silver. In 1748 two dogs of Fo in *blanc de Chine* had cost the

Duc de Chaulnes £7 16s—as much as the largest Meissen groups. The only intelligible reason for the low prices of 1755 seems to have been that the pieces were too small to mount.

The mount-makers, for whom Lazare Duvaux acted as agent, worked during this period very much in the rococo style, with ormolu swags, lilies, and monsters often smothering the unhappy objects. While Mme de Pompadour at least preferred to mount monumental Chinese monochrome pieces, all sorts of odds and ends were liable to receive the same beauty treatment. The list includes coloured German and Bohemian glass, Japanese lacquer and Chinese jade, crystal vessels of the sixteenth century and newly imported objects of Derbyshire spa or "root of amethyst", fashioned at Soho, near Birmingham, by Messrs Bolton and Fothergill. Even the *cabinets des curieux* were ransacked by the mounters. One entry in Lazare Duvaux's accounts specifies Persian bottles. Two huge sixteenth-century Urbino maiolica cisterns in rocaille mounts were bought by Horace Walpole at the Earl of Strathmore's sale in 1777. There were also Italian sixteenth-century bronzes and French sixteenth-century Limoges enamel caskets mounted in this way. Among the freaks may be mentioned a fourteenth-century Gothic ivory casket, and an enormous Spanish-Arab vase of the Alhambra type of the same century, which found its way to Drottningholm Castle in Sweden with one great ear-shaped handle replaced with the finest Louis XV ormolu.

The singularly adaptable Chinese monochrome porcelains had not been available in the 1720s, when this fashion started. At the Fonspertuis sale in 1748 Mme de Pompadour paid the high price of £44 for a Chinese crackled vase, decorated with flowers. It had been converted into a potpourri pot and cover, and, since it had been given by the Prince de Condé in the early 1730s to Mme Verrue, it must have been a *famille verte* piece. How ill-suited for rocaille mounts such pieces could be is shown by two mounted spherical jars, which were sold in Paris in 1903 for the very high price of £3,720, equivalent to £23,000 today. In reality the jars were trumpet-necked vases hopelessly cut down. They were made in a coarse *famille verte* style, probably as early as 1670, and they must have been already seventy or eighty years old when they reached the hands of the mounter.

However badly mangled, the monture multiplied the value of the object many times over, and it continues to do so today. For instance a Meissen Kändler figure of a shepherd carrying a lamb, worth probably no more than two or three pounds in 1748, could rise to £38 8s when equipped with swirling ormolu base, ormolu branches, and a

mass of little flowers, while a Dresden basket cost £60 after the same treatment. Jardinières of different kinds were particularly suitable for these floral effects. In 1749 a big one from Vincennes, profusely furbished, cost M. de Julienne £57 12s.

At this stage the mounting of Chinese monochrome porcelain was not appreciably dearer. For instance, Mme de Pompadour paid £144 for a mounted garniture of four celadon vases, two shaped like fishes and two with trumpet mouths. Lapis blue, later known as Mazarin blue, was the most popular colour, since a single mounted vase cost Mme de Pompadour £52 15s. But two mounted vases, sold to Mme de Pompadour in 1753 for £144, suggest that *flambé* or mottled porcelain was becoming dearer still, and the dearest of all were sold actually after her death. In 1766 two dogs of Fo on their pedestals, mottled *bleu céleste* and purple, made £192 at auction, without mounts. In the 1850s, when Chinese porcelain began to achieve fashionable prices after a long period of abeyance, these mottled wares, the greatest prize of the *ancien régime*, became the greatest prize again (see page 193). It is even possible that the cult of the mediaeval prototypes, including the big prices paid for Chun ware of the Sung Dynasty in Paris in the 1920s, were due to Mme de Pompadour.

2. *Royal and Inflationary Prices*

In 1758 we lose our faithful guide, Lazare Duvaux. But the loss is partly compensated by a much greater number of printed and priced sale catalogues. And some of these catalogues give us a glimpse of prices that are not restricted to new or newly-adapted objets d'art, but embrace the superannuated and the unfashionable as well.

The professional auctioneer, fulfilling a function of public trust, as opposed to the dealer who merely organized an occasional auction sale for his own wares, was a product of the very advanced commercial organization of seventeenth-century Holland. Art sales seem to have come to London with the advent of a Dutch King in 1689, and were apparently far more frequent in the reign of William III than at any time in the subsequent half-century. Dr Frits Lugt has recorded the existence of ninety-six printed English catalogues for the years 1691 and 1692 alone, the sales being almost exclusively of pictures, but he can trace no Paris catalogues before 1699, and only three in the next twenty-five years.[12] In the France of Louis XIV's last years, public

[12] Frits Lugt, *Répertoire des Catalogues de Vente, 1600–1825*, The Hague, 1938.

sales were a novelty, and not altogether a desired one. The guild spirit was still dominant. Painters tried to assert the right to be sole vendors of paintings, cabinet-makers to be the sole vendors of furniture, and so on. But in the end the trade corporations failed to establish the privileges to which they laid claim, whereas the painters were astonishingly successful in keeping the entire art auction business in their own fraternity. Till the French Revolution and beyond, Paris auctioneers were invariably painters or former painters, who sometimes edited their catalogues with a love and care that was rarely seen in the nineteenth century.

In the period following the Lazare Duvaux accounts the saleroom habit made great strides in Paris. The subject was studied in 1874 by Gustave Victor Duplessis when not all the catalogues mentioned by Dr Lugt had been traced.[13] Out of 2,158 catalogues printed in the course of the eighteenth century, Duplessis found that more than half were Dutch. He discovered that between 1701 and 1750 only 30 out of 215 catalogued Continental sales were held in Paris—only three printed catalogues to every five years. But between 1751 and 1760 there were four Paris catalogues a year, between 1761 and 1770 there were thirteen catalogues a year, between 1771 and 1775 there were twenty-eight, and between 1776 and 1785 there must have been close on two catalogues printed every week during the sales season, since the yearly average was forty-two. But at the end of this period the acute shortage of money of the pre-Revolution years had already begun to make itself felt. Over the period between the years 1786 and 1800 the average dropped from forty-two printed catalogues a year to nineteen, while the average price of the lots dropped considerably more. During those years the single London firm of Christie's far outstripped the entire Parisian annual output of printed catalogues.

The total of forty-two printed catalogues a year between 1776 and 1785 seems formidable when it is considered that the number of people in Paris who bought pictures and objets d'art could only have amounted to the most minute percentage of what it is today. And in such a narrow and enclosed circle of buyers the perils of the knock-out and the ring (already known in those days as the *revision*) must have been very much greater than today. Moreover, any unpredicted public event in so small a city as eighteenth-century Paris might drain the saleroom of its clients. In spite of all this, it is certain that the new mania for auction sales raised the price of the articles most in demand and that the anxieties of the artisan corporations had been groundless.

[13] G. V. Duplessis, *La Vente des Tableaux au Dix-huitième Siècle*, Paris, 1874.

Lazare Duvaux, in his generation, could not have obtained some of the Paris auction prices for objets d'art in the taste that he purveyed.

Taking the last category to be discussed, that of mounted Chinese porcelain *en rocaille* in the taste of Mme de Pompadour, we find that the auction prices were actually higher after 1764, the year of her death. For instance, at the Gaignat sale of 1768 a sum little short of £100 was bid for a single celadon *lisbet*, or baluster vase with flowers in relief, mounted *en rocaille*. In 1776 Blondel de Gagny's *blanc de Chine* elephant, 10in by 11in, made £240 with its stand, a price equivalent perhaps to close on £3,000 of our money, and still not the dearest piece of mounted porcelain to be sold under the *ancien régime*. Even the smaller and more frilly Dresden objects responded to the new prices for mounted articles. Following in the footsteps of the master mind, the financier Randon de Boisset had bought Mme de Pompadour's little mounted figure of a cat on a cushion. At Randon's sale in 1777 it was sold for £60. The highest prices were paid for Randon's mounted Japanese urns and covers. In 1881 du Sartel noticed how easy it was to recognize these urns from the sale catalogue. The size and shape, and the two figures under a parasol, identify them as a type that we now call "Kakiemon", but which was then called *première qualité de Japon*. (see pages 222–3). Of the two pairs of these vases, the pair with the mounts fetched no less than £244, but in 1809, though prosperity had returned to Paris at the high tide of the Empire, the price of this pair was only £40.

Mme Pompadour's predilection for mounted celadons seems still to have set the fashion on the very eve of the Revolution. Two barrel-shaped garden-seats, hardly attractive in themselves but mounted by the great Gouthière, were valued in a dispute with the heirs of the Duc d'Aumont in 1782 at £261 each, the gilding alone at £72.[14] In 1788 a pair of celadon vases, made up as six-branch candelabra were sent by the French Ambassador, the Comte d'Adhemer, to Christie's. They were bought-in, apparently, at the quite extraordinary nominal bid of £451 10s. Two months later the candelabra vases found a buyer—but a French buyer—in the person of the expatriate former Chancellor, M. de Calonne, who paid £183 5s. No such prices were paid again for montures till 1851. Even so Francophile a collector as Beckford was not tempted, in 1814, by the offer of a pair of mounted celadon bottles

[14] Georges Wildenstein, *Les rapports d'experts, 1712–1791*, Paris, 1921, pages 16–17.

at £140.[15] Between 1790 and 1850 any pair of mounted Chinese vases could have been bought for 50 to 100 guineas.

The heyday of mounted Chinese porcelain, as of all objets d'art, was in the early 1900s, when a single vase could fetch close on £5,000, or £30,000 of our present money. These objects scarcely belong to our *Zeitgeist*, yet in 1962 £6,000 could be paid for a heavily encased pair of celadon *rouleau* jars, which looked about as happy as two ducks in waders. Sinologically addicted persons continue to look aghast when such sums are spent on objects whose original purity has been defiled. In fact the price, high in their eyes, but very low in the money terms of previous generations, is the price of scarcity and of snobbery.

Judging from the quantity of mounted porcelain in the ten years of Duvaux's accounts, the *ancien régime* must have produced such articles in brisk supply. And yet all but a very small percentage of the mounts that one encounters today on Chinese or European porcelain of the eighteenth century are modern or nineteenth-century accretions. The loss of objets d'art during the revolutionary years was incalculable. In those times of stringency, when Riesener's workmen were turning out musket-butts, it was not unusual for the gold to be scraped off the mounts and sold, and the bronze melted down for the metal, while the porcelain, damaged both in the mounting and the dismounting, became worthless. The garnitures with porcelain flowers strung on wires had been made in particularly vast quantities, but have survived in very small quantities today, and invariably they have been restored. It is easy to imagine how these frail confections must have responded to long years of neglect.

The dearest of the *montures* that have survived are nowadays certainly those in the rocaille style, as supplied by Lazare Duvaux. But the highest initial prices were paid a full generation after Lazare Duvaux, and for articles in the far more sober taste of Pierre Gouthière (1744–1814). There is something enigmatic about this great craftsman, who worked almost exclusively for three patrons; who could charge commoners more than he dared charge a king and who became for all that a bankrupt years before the French Revolution.

In 1782, on the death of the Duc d'Aumont, we find Gouthière's bill in dispute and subjected by the Court to the valuation of appointed experts. The original bill, which was approved by one of the experts, was for approximately £4,000, principally the cost of nine objects. Four remarkable wall lights, not less than 6ft high, were assessed at

[15] Boyd Alexander, *Life at Fonthill*, 1958, page 151.

£396 each, £144 for the gilding alone. Two slabs of jasper, mounted at tables came to £600 each in addition to £96 for the models. A clock was assessed at £291 and the two celadon garden seats, which we have already met, at £261 each. The second expert was Jean Claude Duplessis, a formidable rival practitioner who reduced the bill by twenty-five per cent and this the heirs had to pay.[16] Within the year, the numerous mounted marble objects, made for the Duc d'Aumont by Gouthière, were put into the saleroom. It was the most fashionable of all such events, since it was virtually a royal command to attend the sale of the King's late Gentleman of the Bedchamber. The King and Queen bid lavishly, Gabriel de St Aubin drew the heads of the by-standers on the margin of his catalogue, and on this occasion at least, Gouthière's charges were almost justified, since Julliot bid £960 for the two jasper tables on behalf of the Queen, while the King paid £800 in a private deal after the sale for the four wall-lights.[17] The Frick foundation now has the jasper tables, the Paris Rothschilds have the wall-lights. In 1893 Edmond Bonnaffé recalled that they had paid £4,000 apiece for them.[18]

But Gouthière's most interesting client and perhaps his first on the monumental scale was Mme Pompadour's successor, Mme du Barry. An account for two years' work, which was settled in December, 1773, shows that, ten years before the death of the Duc d'Aumont, Gouthière's charges had been just as high. Mostly they related to the *salon carré* of the Pavillon de Louveciennes (now an American serviceman's cafe-teria). Wall lights were already being charged for at the rate of £837 for three and £480 for a pair; fenders with lovely riding bronzes at £240 to £280 each, door mounts at £167. Even three door-knobs with their fittings could cost £149. It seems however that the favour-ite's appetite had only been whetted. It is well known that after the outbreak of the Revolution Mme du Barry owed large sums to her *fournisseurs*, who were afraid to invoke the aid of the law and were still more so after the lady's execution. There was in fact no hope of collecting anything from Madame du Barry's heirs till after the restored French Monarchy had decreed the restitution of the confiscated properties. Thus the unhappy Gouthière died in a hospice for the aged in 1814 without daring to claim his rights. The case between the heirs to the two parties was not settled till 1836, when the final judgement of the *première chambre* reduced a monumental claim for the sum of

[16] Georges Wildenstein: *Rapports d'experts, 1712–1791*, Paris, 1921, pp 16–17.
[17] Jean Robiquet, *Gouthière, sa vie, son œuvre*, Paris, 1912, page 108.
[18] Introduction to the catalogue of the Spitzer sale, 1893.

£30,240 to a mere £1,384. This terrible lawsuit ruined altogether the younger Gouthière, who died in a hospice, like his father before him.

Gouthière's truly historic bill for 756,000 francs raises problems which may lie altogether outside the "economics of taste". Did Mme du Barry really consent to pay the prices of the 1960s or was Gouthière's demand fraudulent? The judgement of the court of 1836 declared that the charges were such as to "cause terror to those who had to settle the account"—and small wonder. The cost of the gilt-bronze adornments on a single statue-pedestal came to £6,460 and those on three other pedestals to £16,800. Gouthière had only been prepared to reduce his bill to £25,280 in virtue of certain pieces which he had not completed. Strange to say the bill related to work begun in the year 1772 when Mme du Barry had paid many decorators' bills and, as M. Vatel observed, kept meticulous accounts. And Gouthière had eighteen years in which to press his claim.[19]

Whatever the truth of this story, it becomes clear at least that royalty and royal mistresses could be subjected to charges that bore not the least resemblance to normal costs. We have already noticed the case of Marie Antoinette's lovely mounted jasper *brûle-parfum*. If it cost her £480 in the heady atmosphere of the Duc d'Aumont's sale of 1782, it had cost the Duke no more than £60 in 1772, the year when Gouthière allegedly asked £6,460 for decorating a pedestal. To what extent then were the prices for *ebénisterie* and *monture* in the 1770s and 1780s due merely to the exploitation of squandermania and to what extent to genuine international competition for Parisian products? After 1758 there is nothing so comprehensive as the Lazare Duvaux account to give one the right perspective.

It is at least certain that public auction prices became higher towards 1770. At the Blondel de Gagny sale of 1776 a crystal lustre was bought-in at £720, while at the Randon de Boisset sale in the following year a second-hand article, a commode made by André Charles Boulle in the first quarter of the century, fetched £200. Next to lustres, the most expensive objects for mere subjects of the Crown were sculpturally adorned clocks. These had become more and more elaborate. In 1766 M. Marmontel paid £480 for a *bureau à cylindre* and a huge regulator clock, while in 1771 the *Avignon Clock*, a splendid allegorical construction in the Wallace Collection, cost, when presented to the Marquis de Rochechouart, £456 10s. Yet in 1695 it had been an act of truly royal extravagance when William III paid Thomas Tompion £95 for the

[19] Robiquet, page 140, Charles Vatel, *Madame Du Barry*, Versailles, 1889. Appendix to Vol. II.

great ebony long-case regulator clock which he gave to the Bey of Algiers.[20]

In the 1760s commodes became larger and more ornate, despite the passing of the rococo style. A higher order of prices appears in 1769, when Mme Victoire paid £189 to Roger van der Kruse or Lacroix best known by his initials RVLC, for a commode that was already halfway to being neo-classic. In 1772 the Prince de Condé paid Leleu £428 12s for a 6ft commode, while in 1775 Louis XVI paid Riesener more than £1,000 for the most elaborate commode ever made,[21] a work of sculpture as much as a piece of furniture, which is now in the Musée Condé. In addition to newly commissioned works, second-hand purchases for the *Garde meuble* were occasionally made from members of the Royal Family. The most extravagant was that of the four commodes which were bought from the Duc de Provence in 1786. Though they cost only £60 each, they did not please the Queen, and the cost of changing the design came to £240 for each commode.[22]

The two *bureaux à cylindre*, or roll-top desks, which were made for Louis XV and Louis XVI, had only one thing in common—namely, their incredible cost. An almost completely rococo object, the *Bureau du Roi Louis XV* was made by Oeben and completed by Riesener between 1760 and 1769. The price of £2,515 was the result of a prodigious number of preliminary drawings and models, which were due to the changes of the royal mind during the long period of gestation of this famous, though not precisely elegant, object. Conceivably a similar price was paid for the writing desk in the Wallace Collection which looks so like it, for the *Bureau du Roi Stanislas* was made by Riesener at about the same time. If Beckford really paid £760 in the distracted Paris of 1792, the original price was certainly several times as much.[23]

As to the *Bureau du Roi Louis XVI*, which has disappeared, both its price and its nature are somewhat legendary. The German *ébéniste*, David Roentgen of Neuwied, had appeared in Paris in 1774, but did not become a Court protégé till five years later. In 1785 Roentgen was appointed officially *Ebéniste mécanicien du Roi et de la Reine*, the emphasis being on the word *mécanicien*. In the rococo period Roentgen's furniture had incorporated complete pictures simulating elaborate chiaroscuro in inlaid woods. His new style, restricted to the sobriety of

[20] R. M. Symonds, *Masterpieces of English Furniture*, 1940, page 128.
[21] Pierre Verlet, *Le mobilier royal français*, Vol. II, page 108.
[22] F. J. B. Watson, *Louis XVI Furniture*, London, 1959, page 110.
[23] *Wallace Collection Catalogue of Furniture*, F102. See also *infra*, page 133.

neo-classicism, made up for it by intense ingenuity. He was incapable of producing a piece of furniture that did not play a tune or perform some trick at the touch of a button, and in 1785 he produced for Marie Antoinette a writing table surmounted by the realistic figure of a lady of quality in real clothes, which played several well-known arias on a little clavichord.

In 1779, when he made the *Bureau du Roi*, Roentgen had already the reputation of the greatest *ébéniste* in Europe, yet in the 1860s, 1870s, and 1880s, the Marie Antoinette *Kitschkult* always associated the Queen's taste with Riesener. It is much more likely that she preferred the virtuoso tricks of Roentgen's essentially Germanic tradition, a tradition which was at least as old as the sixteenth century and the automata of Wenzel Jamnitzer, and to which she had been accustomed at the Viennese Court of her mother, the Empress Maria Theresa. It was said that the French Royal Family spent nearly £40,000 on Roentgen's heavy, inelegant productions between the years 1779 and 1785, and this was even more than their expenditure on Riesener. But no one questions who was the better *ébéniste* today.

The royal bureau, which cost 80,000 livres, or 3,300 louis-d'or, or 3,200 gold sovereigns, could not have been an attractive object if it was anything resembling that cathedral-like construction, the size of a service flat, in the Hermitage Museum, which Roentgen made for the Empress Catherine in 1784, and for which he received 25,000 roubles (about £4,000) and a golden snuff-box.[24] It may, on the other hand, as Mr F. J. B. Watson suggests, have resembled the monstrosity in the Louvre which Marie Antoinette presented to the Empress in 1786, and which looks rather like the Crystal Palace. Louis XVI was not the first monarch to put such a high valuation on the *Neuwied furniture*, for it was also in 1779 that Frederick the Great ordered a *bureau mécanique* for 12,000 reichstalers, or £1,800. Moreover, after her 25,000-rouble purchase of 1784, the Empress Catherine ran up a bill with Roentgen for 72,704 roubles, or £12,000, in less than two years. Among the items in Roentgen's account were another huge bureau or *pupitre mécanique*, which cost £3,200 when the cost of transport was included, and two clocks which contained an entire mechanical orchestra at £1,500.[25]

In 1799, when he wanted to start up a new workshop in Brunswick in order to revive a business that had been ruined by revolution and war, Roentgen declared to the Prussian Government that his Neuwied

[24] Hans Huth, *Abraham und David Roentgen*, Berlin, 1928, page 55, Plate 2.
[25] Hans Huth, pages 54–7.

furniture had earned 2,000,000 reichstalers or £300,000 in foreign currencies. But in 1794 an obscure Paris *ébéniste* had offered for sale a very fine bureau "provenant du feu Louis Capet, estimé 100,000 livres". The livre assignat had fallen to a quarter of its face value in 1794. At a thousand pounds more or less, this sounds like the famous *Bureau du Roi*. It has also been suggested that this title belongs to another bureau which was sold in 1794, but which reappeared in the saleroom in the equally unpropitious year 1942 at £472.[26]

In studying the prices of royal *ébénisterie* one is once more brought into contact with the collecting adventures of Mme Du Barry. Tradition has made this plebeian mistress a less civilized and less discriminating figure than her predecessor, Mme de Pompadour. But on furniture at least her influence may have been even stronger, since Mme du Barry was the first to pay high prices for the new fashion of porcelain-inlay, a fashion which has always come back whenever French furniture has been in demand. The marketing of the original Sèvres plaques and their adaptation to furniture was largely the work of Simon Philippe Poirier, a successor to Lazare Duvaux, from whose shop in the Rue St Honoré, Horace Walpole made his first Sèvres purchase in 1768. What Duvaux had been to Mme Pompadour, Poirier was to Mme du Barry.

It was Poirier who sold Mme du Barry, the *Three Graces* clock in 1769 when she moved into her new quarters at Versailles. The Sèvres inlaid furniture was first bought while she was renovating the Pavillon de Louveciennes. Among her purchases of 1772 for instance there was a table with picture-plaques after Le Prince, which cost Mme du Barry £220. In 1774 a truly luscious commode, which is still in existence, cost with its three glittering door-plaques after Watteau and Van Loo not less than £390.[27] And yet the dearest purchases were made years after the death of Louis XV when Mme du Barry was banished from the court, even though she had been allowed to return to Louveciennes. These spectacular purchases from the royal factory were doubtless a bid to preserve the favour of the new king. For instance in 1782 the Sèvres factory produced for Mme du Barry a combined dressing-table-secrétaire with a mirror, which seems to have been encrusted all over with *porcelaine à emaux*, at the price of £3,000.[27a] Furthermore a commode lined with Sèvres plaques, probably the one which Edmond de Rothschild was believed to have bought for

[26] Cyril Blunt in the *Connoisseur*, 1942; Huth, page 58.
[27] Georges Wildenstein, *Gazette des Beaux Arts*, September, 1962.
[27a] Davillier, *Les porcelaines de Sèvres de Mme du Barry*, page 37.

£24,000 or £30,000 in 1878, cost Mme du Barry £3,200 in the early 1780s, as much as Roentgen's *bureau du roi*.

It may be that between 1779 and 1785 at least five pieces of French furniture were sold for £3,000 apiece or more, prices which were not repeated again till another 80 or 90 years had passed. But it must not be inferred that the kind of French furniture which costs most today, ever belonged to this class, for it is a class that no longer reaches the market. Nor is lavishness any longer the only yardstick of price. On the one hand the heavy and over-ornate marble-inlaid commode from Powis Castle, which made £33,000 in 1962, probably typifies the personal taste of Louis XVI. A *nouveau riche* like Watson Taylor may have paid a thousand guineas for this sort of enriched commode even in the 1820s (see page 127). On the other hand, the Llangattock writing table which made £35,700 in 1958 earned this price for its extreme lightness and elegance—qualities which were less expensive in the days when the little table came out of Oeben's workshop. It is quite likely that this, the dearest piece of furniture to pass under the auctioneer's hammer since the last war, was produced for less than £100—but that was quite a lot of money 200 years ago.

One should not, however, leap to the opposite conclusion; namely that, while kings, queens and ex-royal mistresses were being fleeced, fine French furniture for the ordinary purchaser stayed as cheap as it had been in Lazare Duvaux's day. Young and other English travellers testify how badly the purchasing power of money had fallen in France during the pre-Revolution years. Furthermore, everyone had to pay the price of snobbery. While £40 had been high for a commode in 1750 and £8 the price of an average good one, this was far from the case in the first year of the Revolution—to judge from examples which are of a high class, but by no means outstanding. For instance, in 1791 Lord Spencer of Althorp bought from the dealer Daguerre a furniture consignment which must have been the last to leave Paris directly for England for ten years to come. The pieces are still at Althorp, a pleasant enough lacquer commode by Saunier at £100 and two uncommonly plain console sideboards from the same workshop at £83 the pair. The latter are certainly no finer than the beautiful curved mahogany sideboards which the firm of John King supplied in the same year at £17 each.[28]

With a somewhat routine lacquered French commode at £100, one may contrast the prices charged by Chippendale in the 1760s—namely, £2 to £6 for his carved chairs and £18 to £35 for commodes and

[28] *English Homes*, Vol. VI, 1926, page 314.

sideboards. One of Chippendale's acknowledged masterpieces, the great Nostell Priory writing table of 1767, cost no more than £72 10s. At about the same time a quite breathtaking glass-cabinet bookcase was ordered by George III from William Vile at a price that was the wonder of the age—namely, £100.[29]

Of course, this was plain, carved furniture. English furniture became rather dearer with the introduction of inlaid woods in the French manner. A basically satinwood commode cost Edward Lascelles £86 in 1773, and this seems a little nearer to the Parisian scale of prices.[30] But the incredible charges made for furniture by Riesener and Roentgen can be judged best against the background of *The Cabinet-makers' London Book of Prices* of 1788. The book has been ascribed to Thomas Shearer, but many of the designs contained in it were by Hepplewhite and Sheraton. One has to guess the cost of the extra trimmings and the retailer's profit, but it seems that basically a knee-hole writing table could be made at a cost of £2 8s to £8, a horseshoe dining table 7ft long for £2 5s, an elegant curving cellaret sideboard for £3, and a truly magnificent writing desk surmounted by a glass cabinet for £5 15s. The price of the glass for the curved tracery panels came to nearly as much again. How, one wonders, could any writing table in the 1770s and 1780s have cost £3,000, even if it required a small army of skilled men employed at the wage rates which were embodied in such prices as Thomas Shearer's? Even the great Riesener, summoned to Versailles in 1787, charged only twenty-four livres, or less than £1, for the loss of a day. For a visit of two days, accompanied by a skilled workman, his charge was sixty livres.[31] Gouthière charged even less for the use of his time. In presenting Mme du Barry with a bill of 116,000 livres in 1771, he entered his visits to Louveciennes at twelve livres each.[32].

But the wonder of the £3,000 commodes and bureaux is lost in a still greater wonder, for in a minute of the year 1781, M. Necker, the Finance Minister, declared that the annual expenditure of the Court could support a third of the French Army. Louis XVI appeared (but only appeared) to adopt the ideas of his minister three years after he had dismissed him, for the spending spree with Riesener and Roentgen ceased, at least, to be continuous in 1785. In that year Riesener's outstanding orders for the Court amounted to £3,200. Far from being

[29] Symonds, page 52.
[30] Percy MacQuoid, *A History of English Furniture: the Age of Satinwood*, 1908, page 63.
[31] Verlet, Vol. I, 1945, page xviii.
[32] Charles Vatel, *Madame Du Barry*, Vol. II, page 432.

cancelled altogether nearly half of them were executed during the next two years. And in the meantime there began another costly furnishing account with the team of Hauré and Benemann. In 1787 more than £3,000 were spent on a new state bed for the Queen at Fontaine-bleau, and £2,700 on new furniture and hangings for the King's bed-chamber. In 1788 it was the turn of the even less used palace of St Cloud, where the King's bedchamber cost £2,300 and the Queen's £1,680.[33]

The Revolution itself could not bring the royal furniture mania to a halt. The Queen resumed her patronage of Riesener at a time when the nobility were already selling their furniture for what they could get, as a prelude to emigrating. There was, for instance, a two-decker writing table, now at Waddesdon Manor, which made saleroom history at Christie's in 1882 at £6,300 (see page 137), having been delivered by Riesener to the *Garde Meuble* in 1783. In 1790 and 1791 Riesener put his signature to a commode and an upright secrétaire, which formed pendants to this writing table, though the over-ornate style was ludicrously out of date. Both pieces bear the cypher of the Queen, who was virtually a prisoner at Versailles during these years.

After the execution of the King and Queen, the cost of royal taste had to undergo the most unfair test of the Versailles and Paris auction sales, as conducted by the commissioners of the Terror and the Directoire. In June 1793, the famous *Bureau du Roi Louis XV* was sold. Two encoignures in Riesener's best style, which are now at Windsor, went with it. The combined cost had been about £3,300, but the three pieces now made no more than £200 between them.[34]

In the following November all the Queen's clocks were taken from Versailles and sold for £315. In 1794 the Queen's roll-top desk and writing table, made by Riesener perhaps twelve years earlier in her favourite mother-of-pearl inlay, were sold for 20,000 and 6,000 livres. Nominally, these prices meant £800 and £240, but since payment at that time was stipulated in devalued paper assignats, the whole price was probably less than £300.[35]

The contemptuous treatment which the commissioners of the Revolution are alleged to have accorded the royal furniture is a legend that does not stand up to the facts. First and foremost, it must be remembered that the kind of prices which were paid by the French Royal Family would not have held in the Paris auction rooms at the

[33] Verlet, pages 105–10. [34] Watson, *Louis XVI Furniture*, page 113.
[35] Baron Charles Davillier, "La Vente du Mobilier de Versailles pendant le Terreur", in *Gazette des Beaux Arts*, 1876, pages 146 and 251.

An extinct taste.

Cistern of 16th-century French faïence, Bernard Palissy ware, bought for the Victoria and Albert Museum in 1884 for £1,102 10s, equivalent to close on £7,000 today. Over three feet wide and very coarse in execution.

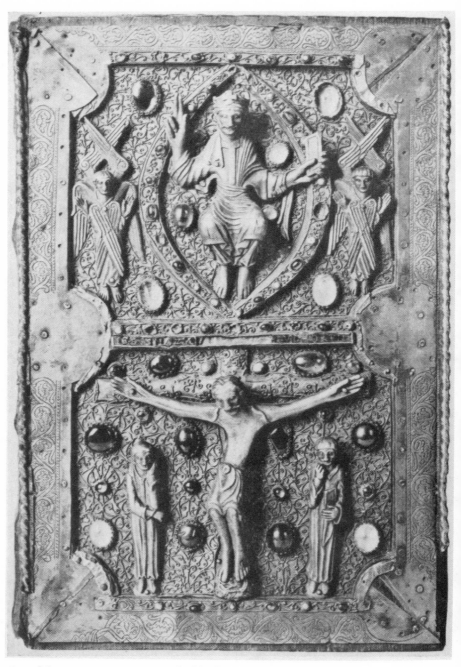

One of the Weingarten Romanesque bookbindings.

Four 11th-century manuscripts in their original jewelled bindings looted by Napoleon's troops at Weingarten. Sold to the Earl of Leicester in 1818 for 100 guineas and to J. Pierpont Morgan in 1912 for £100,000.

very best of times. In the 1780s, furniture in a fashion which was only a few years out of date had fallen as abruptly as anything in the Versailles sales. The prejudice against curves was old at the time of the Revolution. In 1794 the newly appointed *conservatoire* of the Louvre were really being quite stuffy and conventional when they voted against the retention of the "detestable tables with disagreeable and baroque legs" as stands for ancient marbles. At first the legs were to be hidden with green cloth so that public taste should not be ruined by the sight of such objects. Later it was decided to replace the disagreeable and baroque tables with plain pedestals. Taste had turned full circle since those quite recent times when it was the pagan Roman columns in the early Christian churches of Italy and not the gilded capitals that had to be concealed[36] in purple velvet trousers.

In spite of the "detestable and baroque" legs, the sale of the contents of the royal palaces was conducted with a view to getting reasonable prices. In fact, considering the circumstances, the prices might have been a great deal lower. Some of the better pieces were even kept to furnish the offices of the new masters. The truly total collapse of French furniture prices dated, not from 1793, but from 1795, when, in order to finance the war against the Concert of Powers, the Directoire government decreed the compulsory sale of the confiscated possessions of the *émigrés*. Since there were no foreign buyers in Paris, recourse was had to enemy trading. The practice was to ship the better objects to the neutral ports of Genoa and Hamburg, where the proceeds of the sales served to buy supplies for the armies of the Republic. "Recently consigned from Hamburgh" first appears in Christie's catalogues in 1796, with pairs of Sèvres urns fetching lively prices in the region of fifty guineas, but that was no indication of the price received by the commissioners.

Under the Directoire knock-out sales were conducted all over the country. Pillaged woodwork panels were sold for fuel, fine bronzes for the cannon-foundries, tapestries for tarpaulins. The memory of those terrible sales helped to debase the Paris market for the next fifty years, just as the rediscovery of the first cost of the *Bureaux du Roi* and their companions helped to raise it. There is, for instance, in the journal of the de Goncourt brothers a description of a literary dinner in 1857, at which the future Inspector of Fine Arts, Paul de Saint Victor, wakes up from a torpor to find the conversation turning on the French Revolution. "If only one could live again in those times," he cries, "only for

[36] Louis Courajod, *Alexandre Lenoir, son Journal et le Musée des Monuments Français*, 1878, Introduction, page lxviii.

three days." And the liberal-minded company echoes him: "Yes, yes. Only to see all that." But back comes the answer: "No, no. Just to buy, to buy everything and to pack it up. What a feat that would be."

But the packing up had been destined mainly for England. Nothing could be more instructive than Christie's catalogues as printed between 1790 and 1802. At first we get consignments of porcelain, which had come straight from the Sèvres factory, and in 1791 a fashionable furniture dealer, Daguerre, sends his new models by preference to Christie's. After 1793, war and blockade are perceptible in the catalogues. The goods are no longer "newly arrived from Paris", but "lately consigned from the Continent". There are also sales of the possessions of a foreign lady of quality (actually Mme du Barry), a nobleman, lately emigrated, or goods seized at sea on board a French ship.

There are signs of sagging prices. Sèvres dessert plates, which could not, by their nature, have been plain, and of which the most routine services used to work out at twelve to eighteen shillings a plate, now sold for five or six shillings a plate. A hundred pounds bought an enormous combined service; £30 a pair of the showiest garniture urns. In 1794 a pair of unusually grand commodes cost £78 15s. But the picture changed perceptibly with the open admission of enemy trading in 1796. The first Hamburg consignment at Christie's included, besides those fifty-guinea pairs of urns, a quite new dinner service from the factory that was once the Duc d'Angoulême's (£108 7s). By the year 1800 a *bureau à cylindre* with an alleged royal pedigree could make as much as 200 guineas.

During the Peace of Amiens (1801–3), a horde of wealthy English tourists flocked to Paris. Their appetites had already been whetted on the Hamburg sales. Now they were whetted again by Paris dealers happily unloading stocks that had been unsaleable for twelve years. In this shabby, down-at-heel city, something like London after the Blitz, Poussins, Murillos, and Claudes were surprisingly cheap (see Vol. I, page 48). Less is known about the buying of objets d'art, except that prices went up in London during the brief peace. For instance, in 1802 the Countess of Holderness's two boulle cabinets made £441. After 1803 and during the twelve years of resumed war with Napoleon, London prices for French objets d'art were at times even higher than at the crack sales of the *ancien régime* (see page 126).

But in Paris the objets d'art of the eighteenth century were destined to remain a depressed market for two entire generations—the age of *Le Cousin Pons*. Apart from a few dealers who occasionally managed to despatch their stocks to England through the neutral ports, the buying

of expensive objets d'art of any kind at all in France during the next twelve years was largely confined to Napoleon, his Marshals and his family, and theirs was not the market of the *ancien régime*. As an emperor, Napoleon was delighted with the many royal possessions, which the revolutionary commissioners had so obligingly left where they belonged, but he did not add to them objects that were in kind. Instead, he patronized the cumbrous style of his own time which he helped to form. Napoleon was not in the market for older works by Oeben and Riesener, but at least he knew how to spend like a king and to surpass all previous kings. In 1805 a new throne for the Tuileries cost him £2,800, while in 1808 a jewel cabinet for the Empress Marie Louise cost £2,200 and the hangings for the Empress's bed £4,800. Even though it was now possible to buy Riesener's finest commodes and secretaires for £40 or less, the firm of Jacob Desmalter & Co. could charge £480 for a boat-like Empire settee and £160 for a single massive fauteuil, supported by Pharaohs and Sphinxes. Enormous toilet mirrors, designed in the heavy architectural manner of Fontaine and Percier, were a favourite taste of the Court. A perfect monster at Fontainebleau cost £800.[37] For the Empress Josephine, Odiot made one of these mirrors, completely encased in silver, of which metal there was nearly a hundredweight. Together with forty matching toilet articles, it was sold in Berne in 1959 for £80,000.[38]

In 1804 the Sèvres factory, which had been a royal property almost to the moment that Louis XVI went to the guillotine, became an imperial property. Under the direction of the erudite M. Brogniart, Sèvres was to achieve its worst and dearest products. The new types, the sombre, menacing Medici vases and Etruscan urns by Sweebach and Bergeret after the paintings of Gérard, cost, at the very least, £120. One of the largest was a Medici vase with biscuit reliefs on a blue ground, after the drawings of Isabey. Taking three years to make, it depicted the grandiose ceremony of Napoleon's second marriage, and it cost £1,200. Béranger's *vase étrusque* depicted, after the manner of a Greek frieze, the entry of the looted art treasures into Paris. It was 3ft high, and it was said to have cost £2,000.

The *Table des Maréchaux* was one of the furniture plaques that had been a Sèvres speciality since the 1760s. At that time it had been a risky undertaking even to produce a saucy little bunch of posies on a 12in plaque, but this was fully 40in across, and it contained portraits of Napoleon and thirteen marshals, painted by Isabey on a background of

[37] Max von Boehn, *Das Empire*, Berlin, 1925, pages 386–7.
[38] Now Stavros Nearchos collection.

gold and Etruscan brown, designed by Fontaine and Percier. It was completed in 1810 and it cost £1,400.[39]

In 1807 Napoleon ordered the *Olympic service* for presentation to the Czar of Russia. It was painted with classical cameo scenes as a rival to the Empress Catherine service which was now thirty years old. But at £14 8s each, the plates were half as dear again as the Empress Catherine plates, though they were precisely in that swarthy Etruscan brown and heavy gold style that inspires little but long faces today. Nor are the Napoleonic Sèvres monsters, though the rarest of visitors to the sale-rooms now, any more welcome for that. It may be noticed that in February, 1961, Messrs Sotheby sold a 22-in ormolu mounted urn, with a portrait of the Empress Marie Louise among a forest of emblems, for £150. The object must have cost considerably more to produce, and one wonders how much the high price of Napoleonic Sèvres was due to wartime inflation. In this case, at least, the high cost has not been transmitted to posterity. Nevertheless, Napoleon's prodigality set an example for other royal purchases, those of Louis XV and Louis XVI being reduced to the commonplace. In 1822 George IV's furniture for the banqueting-room at Brighton Pavilion cost £42,000. Seven side-boards of satinwood, supported by fantastic dragons, cost £4,192 3s. Eight atrocious candelabra of gilt bronze, nearly 10ft high and mounted on drums of Spode china, imitating the Sèvres *bleu du roi*, cost £5,322 4s. A chandelier made by Messrs Perry, in 1817, measuring 26ft by 14ft and weighing 1 ton, cost £5,613 9s. Fogg, the china merchant, supplied two 12ft pagodas made of newly-imported Chinese porcelain plaques for £420. The carpet cost £724 10s, while thirty-eight dining room chairs, japanned in imitation of ebony, cost £17 each.[40] Plain and somewhat inelegant though they may be, these chairs were dearer than the splendid carved frames of the *Fauteuils à la Reine* which were supplied for St Cloud in 1787.[41] Other kings spent just as lavishly. In 1819 Frederick William of Prussia presented to the Duke of Wellington the Berlin porcelain dinner service commemorating his battles, part of which is exhibited at Apsley House. It cost 28,450 reichsthalers, or £4,260.

[39] It was falsely reported to have been destroyed in 1814, and its survival was not disclosed till the present century. In 1929 the *Table des Maréchaux* was bought by Joseph Duveen at the Ney sale (Princesse de Moscova) for £3,850, including taxes. Duveen generously ceded it to a body of subscribers for £2,400, and it is now in the Malmaison Museum.

[40] Accounts published by Henry D. Roberts in *A History of the Royal Pavilion, Brighton*, 1939, pages 127–52.

[41] Watson, 1960, page 141.

The present-day value of such works in the taste of a period, which our age is only beginning to accept, still falls short of their high production cost. The essential difference between the art patronage of George IV and that of the two French kings is that George IV did not influence posterity at all. Subsequent ages remembered only the King's vulgar extravagances. In the early 1900s it would have been difficult to sell the Brighton Pavilion chairs at more than a pound apiece, whereas chairs like the *Fauteuils à la Reine* were being sold in America at two or three thousand pounds each. For the supremacy of the tastes of the Prince Regent and Napoleon, expensive though they were, was short-lived. As early as 1830, long before there was any general fashion for the art of the *ancien régime*, only one style was thought suitable for the table of an English king, and that was the style of John Wager Brameld, creator of the two outrageously rococo *Rhinoceros Vases* of 1827.[42] The dinner service which Brameld designed, and which the Rockingham factory supplied to William IV for £5,000, depicted castles and country houses, but with orthodox Sèvres borders, gilded on full colour.[43]

Put in its simplest terms, it could be said that the *ancien régime* lingered on in English taste, because England had been for twenty-three years the most consistent opponent of the French Revolution and of its heir, Napoleon. In 1807 the hostility towards Thomas Hope's *Household Furniture*, a book of designs which owed an obvious debt to Percier and Fontaine, was largely political. Hope was a cosmopolitan Dutchman and his furniture had the taint of republicanism; it was *collaborateur* furniture. Yet the survival of *ancien régime* French taste in England was not altogether such a simple matter as this, because Hope's designs were quickly adopted as the style which is now spoken of with bated breath as Regency, and which lasted pretty well a full generation. But almost to the end the Regency style typified middle class furniture. The style was disliked by the fashionable, not so much from political prejudice, which had never been strong and which was soon forgotten, but because of the disgust inspired by the heaviness of the French Empire style. The Sheraton influence had created an elegance and femininity in English furniture, with which the owners were loath to part. In the Victorian *dix-huitième* revival, Sheraton came back to fashion a full generation ahead of Chippendale, for this very reason.

However, in the late 1820s the influence of Scott's novels created a dark, plushy, baronial sort of interior from which the light satinwood

[42] Over 3ft high and possibly the most hideous objects in the universe. In 1949 one of the two vases was sold for £290.
[43] J. F. Blacker, *An ABC of Collecting Old English China*, 1915, pages 297–8.

furniture must needs be banished. For a few more years, furniture with gaudy marble inlays, like the Powis commode and the Italianate pieces collected by Beckford and Watson Taylor, managed to hold its own, and so too the furniture, which was provided with Sèvres porcelain inlays that relieved the romantic gloom. Even during the 1830s and 1840s, the least art-conscious of decades and the dullest in the London salerooms, the decline in the taste for the *dix-huitième* was not total. The *ancien régime* was granted, though precariously, another lease of life. It was quite an old gentleman's point of view which W. S. Gilbert ridiculed in 1881 in the words "art stopped short in the cultivated court of the Empress Josephine".

There has, in fact, been no time when the decorative arts of the period 1740–90 did not retain some of their magic, either in France or in England. The age had attracted to Paris most of what there was of skill and taste in Europe. The values of the modern salerooms reflect not only the preferences of that half-century, but also the cost of its technical and economical difficulties, the private whims of some of its personalities, and above all the essential silliness of its polite society. The *ancien régime* had not hesitated to demand the cleverest designs and the soundest craftsmanship for purposes as trivial as a velvet-lined kennel for a lap-dog or as base as an ormolu-encrusted bidet, or the Duc de Condé's *chaise percée* in Japanese lacquer. This is probably the most natural reaction of man towards art when man has the purse to command art.

Antiquarian and Eclectic Taste
1741–1842

1. *Two Trends; Antiques and Curiosities* — 2. *The Antiquarians and the Gothic Revival* — 3. *Horace Walpole and William Beckford*

1. *Two Trends; Antiques and Curiosities*

The limitations of art collecting in late eighteenth-century England were on the whole less severe than those of the France of the *ancien régime*. Islands must always be thirsty for importations. In this case it was importations from Italy, a land which, in that age of travel snobbery, could do no evil. Italy-worship was stronger in England because there was a less lavish range of native products, and consequently a less complacent admiration for native skill.

In so far as foreign schools were admired in France, the preference was for the Dutch and the Flemish rather than the Italian. Since the reign of Louis XIV, Italian pictures had been very little bought, apart from the collection of the Regent, Prince Philippe, Duke of Orleans, in the first quarter of the century. On the other hand, the Italian paintings in the Louvre, the Palais-royal, and the Richelieu Collection constituted a tremendous national property, such as did not exist in England. But in England the small number of Italian works of real merit was still capable of being increased in the second half of the eighteenth century. Putative Guido Renis and Correggios were imported and bought at the price of royal writing desks. Better still, in the 1770s the painters Zoffany and Gavin Hamilton acquired in Italy three Raphaels and a Leonardo.

But the greater part of the imports from Italy consisted of classical sculpture. There was a species in England that did not exist in France, a kind of classically obsessed squire, who would spend up to two thousand guineas on a statue from Rome or Tivoli. Invariably his treasure would be rivetted together from Graeco-Roman and other less-reputable odds and ends. It would be yellowed with candle-smoke, and, to crown all, lavishly spread with putty in order to marry the combination to the wrong head. Then, too, among this fashionable merchandise there would occasionally obtrude such less-esteemed Italian products as bronze figures, wildly attributed to Michelangelo, Giovanni Bologna, Sansovino, or Benvenuto Cellini. Baskets of "Raphael's ware," even a bit of marble of the *Quattrocento* or a roundel relief in Della Robbia ware were not impossible.[1]

The publication by Charles Blanc in 1858 of a number of smart French eighteenth-century sales, followed by Courajod's publication in 1873 of the account-books of Lazare Duvaux, may between them have created a misleading impression of the scope of the eighteenth-century art market. It is the impression that there was nothing between the contemporary or near-contemporary objet d'art and the Graeco-Roman. If, however, we follow Christie's sales from their inception in 1766, we find a number of sales of London jewellers' stocks which abounded with Renaissance objects of all kinds, and in which medi-aeval objects, though only dimly recognizable from the descriptions, are not unknown. The same objects are even to be found in the monotonous catalogues of the house sales of the period—sales of furniture and ordinary effects. This suggests that the oddities were to be seen occasionally on the library table if not in the drawing-room.

A complete analysis of French and Dutch sales during the second half of the eighteenth century would almost certainly produce much the same picture, including the quite ridiculous low prices which were paid for Renaissance objects like carved rock-crystal vessels and enamelled jewellery. Although such things were promoted in the next century to the rank of antiques, in the eighteenth century they were generally acquired as the cheapest way of lining a nest and nothing more. Very rarely in the Christie catalogues of the late eighteenth century does one come across the collection of a specialist of sorts, a Richard Bateman, a Dr. Dalton, a Gustavus Brander or a Lord James Manners. But specialist in the modern sense is far too strong a

[1] Fitzhugh sale, 1785: three models of heads for eight guineas, "by Luke de la Robia who lived a hundred years before Michael Angelo."

word. Even if the objects sought by these collectors make Horace Walpole's tastes seem less unique, their methods were no more systematic.

These and a few others, such as the Duchess of Portland, followed in the footsteps of Sir Hans Sloane, whose collection had become the nucleus of the British Museum after his death in 1753. They were the equivalent of the *amateurs des curieux*[2] of eighteenth-century Paris. It was they who, among the minerals and natural curiosities, the savage weapons, stuffed birds, beetles, butterflies, scientific instruments and pressed plants, secreted the odd mediaeval ivory or reliquary, some Raphael's ware, a rock-crystal biberon, or a Limoges enamel casket. In the 1790s, when they could sometimes be knocked down under Mr. Christie's hammer for less than a pound, these objects generally formed part of a collection which would be described as "a curious museum". And invariably it was a collection made on strict seventeenth-century and even sixteenth-century principles, dating from a time when the discovery of the New World and the East Indies was new, a time when mineral specimens and savage ornaments were the latest marvels, the precious *trouvailles* of early adventurers.

The Natural History Museum has long been separated from the British Museum, but "curious cabinets" are still to be found in 1963 in the provincial museums of most European countries, and no doubt they will be found there still in the twenty-first century. May there always be the Postlethwaite Collection of dried heads and the Durbar Room, that repository of the more readily discardable Indian gifts to Royalty. If a few Gothic stone fragments intrude, or a piece or two of maiolica, it is for the same reasons that they might have intruded in an eighteenth-century private museum. They have either been assembled anthropologically, or in order that the mayor and corporation may encourage mankind to persevere.

There was really nothing aesthetic about the inclusion of old European objets d'art in the curious museum. Originally they were the poor relations and not the rivals of the exotic products of the Indies. In late eighteenth-century England those carved crystals, enamels, ivories, and faiences for which the mid-Victorian collectors were to pay thousands of pounds apiece were merely discarded possessions old enough to be quaint, but devoid of that sense of novelty which only

[2] "He [Sir Hans Sloane] valued it at fourscore thousand; and so would anybody who loves hippopotamuses, sharks with one ear, and spiders as big as geese! It is a rent-charge to keep the foetuses in spirits!" Horace Walpole to Sir Horace Mann, 1753, *Letters*, Vol. II, page 320.

the East could still produce. Nowhere was this sense of novelty more appreciated than in England, which had become before the French Revolution the overlord of a third of India, of the Eastern seas, and of most of the Eastern commerce. It was in the 1770s that English collectors began to take the Indies and the Far East seriously. By the end of the wars, when a breath of wind from the Continent had made Renaissance art expensive and fashionable, the English market was still paying more for the latest Oriental oddities. In fact, the first decade of the nineteenth century had a distinct resemblance with the 1870s, when Chinese blue-and-white porcelain became more sought after in England than the maiolica and Limoges enamels that were then at the height of fashion on the Continent (see page 117).

It may, for instance, be noticed that in 1798 and 1799 the Cantonese water-colour paintings on silk from the Bradshaw and van Braamen collections, insipid performances at that and in an Europeanized style, cost from £100 to £200 for each album—as much as Rembrandt's *Susanna and the Elders*. In 1809 one of those horrible Cantonese ivory houseboat models, intended for Napoleon, but intercepted at sea, was sold for £252, which is possibly as much as it would fetch today. In the same year the striking price of £80 was paid for a Chinese jade wine-pot, but still more interesting prices were paid for works of a frankly scholarly and bibliophile appeal. Thus £200 were paid for an album of Mughal portraits, once the property of Suraj ed-Douleh, Nawab of Bengal, while £185 was the price of a Persian Koran from the same source. In the following year, 1810, the Swinton Collection of Arabic and Persian manuscripts was sold at Christie's with the titles printed in the catalogue by William Bulmer in Arabic type. An illuminated *Khamsa* of Nizami fetched £27 15s 6d, a *Shah Nameh* £17 6s. 6d. No such prices were paid again for Persian miniatures till the beginning of the present century, nor have there been any further displays of Arabic type in Christie's catalogues. English collectors were nearly a century ahead of the Continent in their interest in Persian and Indian miniature painting.

These things were even a noble and fashionable taste. In 1771 the Indian miniatures which the boy William Beckford was found copying at Fonthill had been destroyed by his tutor on the advice of the Earl of Chatham.[3] Nevertheless, an album was bought by the Marquess of Blandford in 1809 for £60. It is interesting that Mughal paintings should have appealed to a man of such strong bibliophile tastes, but the prices suggest that at this period the interest of the literary text rated

[3] Boyd Alexander, *England's Wealthiest Son*, London, 1962, page 42.

high, and that the paintings were valued in so far as they illustrated the subject-matter.

In this respect the collectors of Indian and Persian manuscripts were not so much *amateurs des curieux* as antiquarians, a race apart, of whom more later. In the meantime it is specially interesting to see how the price of Asiatic objects compared with European objets d'art at the beginning of the nineteenth century. In 1807 Persian carpets fetched as much as ten shillings a foot, and were from five to ten times as dear as the best products of the Savonnerie and Aubusson factories. In 1810 a hideous brass *Vishnu*, 22in high, was sold at Christie's for £21, the price in those days of a fair-sized bronze figure after Bernini or Giovanni Bologna—or the price of a whole collection of *Quattrocento* sculpture.

The late eighteenth-century tradition of the expensive Oriental curio, bought for its intricacy and exoticism, survives faintly today in the market for Chinese jade, which remains an expensive taste, but not outrageously so in relation to the general cost of art. But the grotesquely disproportionate values which had been created in the late eighteenth and early nineteenth centuries lingered a surprisingly long time. Nothing seems to have excited the eighteenth-century English more than the perfectly horrible silver filigree work of India, the taste for which was as old as the 1760s. In 1780 a newly shipped filigree toilet service, straight off an East Indiaman, was auctioned at Christie's for £268 18s, or twenty-four shillings an ounce. A still bigger service of "dressing plate", with its mirror, was sold by a noble proprietor two years later at Christie's for £381, the two filigree jewel caskets costing thirty shillings an ounce. In 1800 we find £72 9s paid for a single filigree salver, taken as a prize off a French ship.

The prices for silver filigree were the beginning of a long and peculiarly English tradition. One would have thought, for instance, that as late as the 1870s, when English eighteenth-century silver had achieved antiquarian status, and when "Queen Anne" had become a fashionable cult, this base and horrible silver would have been put in its place. Not at all. At Sir George Webbe Dasent's sale in 1875, Christie's sold an Indian silver filigree betel-box and stand which had been sent to the Great Exhibition in 1851, for £46 10s. None of Dasent's seventeenth-century London silver tankards or fifteenth-century mounted wooden mazers which were sold that afternoon fetched as much as this. And yet in 1875 Indian filigree work was decidedly old hat. Since the early 1860s the revival of the Japanese trade had flooded England with novelties of even more horrifying intricacy.

It will be seen from the foregoing examples that in England, at any

rate, the curious museum or curiosity cabinet lost its humble status in the later eighteenth century as the Indian trade developed. After the Napoleonic Wars the Eastern curios retained the higher market rating of drawing-room art. Yet it was just at this time (and perhaps for this reason) that *all* objets d'art collecting came to be despised by those intellectual snobs who were imbued with the exclusive worship of high art, by which they meant painting and sculpture alone. The outlook of *The Times* towards Horace Walpole's heirlooms in 1842 and of William Hazlitt towards Beckford's Collection in 1823 are outstanding examples of this snobbery. It should also be noticed that the word "curiosity" or "curio" acquired that peculiar pejorative significance which outlasted the nineteenth century just at the moment when liberal taste was beginning to take the Middle Ages and early Italian Renaissance seriously. For instance, in 1853 Sir Charles Eastlake, describing the affairs of the National Gallery some ten years earlier, told a committee of the House of Commons: "I am bound to say that Sir Robert Peel rather opposed the purchase of works by the early Italian masters; his expression always was: 'I think we should not collect curiosities.'"[4]

One forgets how much words have changed their meaning. Dickens's *Old Curiosity Shop* of the 1840s would nowadays proclaim its existence with the word "Antiques" in letters of neon flame. But in the eighteenth century and most of the nineteenth, antique meant the ancient world and nothing later. Nevertheless, the word "curiosity" or "curio" has survived in its pejorative sense. For instance, in the 1930s the *Connoisseur* continued to describe African sculpture as curios just as firmly as Sir Robert Peel had described Italian primitive paintings as curiosities a century earlier.

The sneer in the word "curio" implied that the objects made by man in the various curiosity cabinets or curious museums were no more works of art than the minerals and the dried plants. It accounts for the very low market rating of these objects, unless they happened to be Greek or Roman. They were damned by a further form of art snobbery which was a product of the neo-classic generation. The neo-classics pontificated over all European art according to what they believed to be the principles of the ancient world. Even Reynolds, who was no neo-classic, became affected by them in his Academy *Discourse* of 1771 (see Vol. I, page 4). The neo-classics did not direct their scorn against the oddities who bought Chinese ivory house-boats for £250.

[4] Sir Charles Holmes and E. C. Baker, *The Making of the National Gallery,* 1924, page 8.

They directed it against the Renaissance. In the last forty years of the eighteenth century Titian and Veronese were looked upon coldly in these circles, ostensibly because they lacked monumental form, but in reality because the painters of the last generation, who had not seen the Grecian light, were so much indebted to them.

When it came to the objets d'art of Titian's day, the prejudice was even more extensive. It was felt that the Greeks and the Romans would have appreciated Michelangelo's Sistine Chapel and Raphael's *stanze* and *loggie*. But what would they have made of all that top-heavy furniture, smothered in marble mosaics and ivory? Even the early fathers of the Renaissance, drunk with classic notions of bodily perfection, had never tried to make a chair or couch fit for a republican Roman in a state of Davidesque nudity to sit on.

Nevertheless, during the neo-classic period one extremely belated form of Renaissance furniture did, as we have seen in the last chapter, continue to enjoy high favour. The brass- and tortoiseshell-inlaid furniture made by Charles André Boulle [1642–1732] and his many followers became one of the most interesting of saleroom mysteries. From the 1660s to the early 1900s it never ceased to be admired and imitated. Boulle's delightful grotesque decoration, almost completely sixteenth century in feeling, found its best imitators in the reign of Louis XVI at the very height of neo-classicism. In early nineteenth-century London, the original Louis XIV models were copied almost slavishly by le Gaigneur and others. A survival rather than a revival, the Boulle adaptations pleased both extremes; the old, who yearned for the uninhibited court taste of their youth, and the young, who recognized in Boulle's flat, vertical decorative schemes the inspiration of Raphael and, beyond Raphael, the decorative frescoes of Roman Imperial times, which were being imitated everywhere. In this way boulle furniture, both the original and the copy, became very expensive in Paris in the 1770s, but it was one of the few permissible forms of worship of the past. To go back a little further, to the sixteenth century, which was to become the heroic age of the French romantics, meant sharing the interests of the antiquarian with his much lower scale of prices, whatever the material might be.

One would naturally expect Greek and Roman art to provide the market prizes of the neo-classic period. But in Paris classical art had a restricted market, whereas in England, where neo-classicism scarcely touched the native school of painting, it was bought passionately. The tradition of this form of collecting dated back to the reign of James I, but the truly remarkable English market for classical antiquities seems

not to have got under way till after 1764, the year of the publication of Winckelmann's *History of Ancient Art*. The English cult for classical marbles reached its height in the 1770s, the delusive cameo and *intaglio* cult in the 1780s, and the Greek vase cult in the 1800s.

There seems to be little doubt that the excesses of this cult delayed the rediscovery of the European past which was to be the guiding star of the romantic period. The record of the salerooms suggest that in the 1790s all sorts of Renaissance objects which had formerly been better appreciated both in England and in France—maiolica, Limoges enamels, armour, and carved crystal—declined steeply even from the very modest levels of Horace Walpole's collecting days. Mme de Deffand, who had bought for Walpole the so-called Benvenuto Cellini armour of Francis I at the Crozat sale of 1772 for fifty Louis or £40, had expostulated to her faithful correspondent that the object was "très belle, très rare, mais *infiniment chère*.[5] In 1797, the year of Walpole's death, such a price would have been thought outrageous rather than dear.

Yet in 1772 the sum of £40 had been something quite derisory when it was a matter of concocted Graeco-Roman or even Late Roman works. The remarkable products that passed for classical art could be as dear as any works on the market. In that year Joseph Nollekens, the sculptor, sold a statue of Minerva, which he had composed from many Roman fragments, to a Mr William Weddel of Newby Hall, Yorkshire, where it still resides, for 1,000 guineas, and that was far from the top limit, since another cannibalized product, in which Nollekens had a share, a Venus once partly in the Barberini Palace, was sold to Weddell by the banker-painter Thomas Jenkins for £2,000 in ready cash and an annuity of £100 a year for life.[6]

Then there was the *Warwick Vase*, a porridge of fragments imported into England by Sir William Hamilton in 1774. As redesigned by Piranesi, the fragments, which Gavin Hamilton had found near Tivoli, formed a vase 18½ft in circumference, excluding the handles. Quite apart from the huge cost of transportation, it cost the Earl of Warwick £600. It was housed in a specially designed conservatory at Warwick Castle, where it inspired numerous wine-coolers and Sheffield plate salt-cellars for two generations ahead. A second vase, almost as big, was concocted in the same way, and was installed at Woburn in 1800. It cost the Duke of Bedford £700.[7]

[5] *Horace Walpole's Letters*, Cunningham's edition, 1906, Vol. V, page 346, footnote.
[6] William Farington, *Diaries*, Vol. I, page 125. J. T. Smith, *Nollekens and His Times*, Vol. I, page 12, 1920 edition.
[7] N. M. Penzer, "The Warwick Vase", in *Apollo*, 1955 and 1956.

Such prices for classical antiquities could not fail to be reflected on the open auction market, though Christie's in the late eighteenth century was generally filled with Rowlandsonian characters, all booted and spurred and bidding for loads of hay or dung, for a fine jenny ass or 250 light dragoon sabres, made to the new regulation. But at the end of every picture sale catalogue one finds ancient marbles and bronzes, and sometimes the prices are remarkable. Thus, in 1784 a Roman copy of the *Discobolus* is bid up to £577, while in 1797 a Roman Bacchus makes £420. Shop-made Roman copies, brought up to date by the improved methods, quite often fetch £200 or £300. The price that a great nobleman, like the Marquess of Lansdowne, would have to pay in the late eighteenth century for a life-size marble statue which was believed to have begun life in ancient Greece was £500 or £600 (see *infra*, pages 245–6). But ambition sometimes urged the vendor to put on much higher reserves, based on the prices paid by William Weddell—without success. Thus, in 1778 Henry Constantine Jennings bought-in the "renowned dog of Alcibiades" at £1,000,[8] while in 1786, at Skinner's, the Duchess of Portland's cameo vase was bought-in at £1,029 (see page 172).

Cameos provide quite a history of their own. The Duchess of Portland's Augustus cameo cost George III no less than £236 at this sale, a price all on its own till 1863, but thirty to forty guineas were quite often paid for a cameo in the late eighteenth century, though the greater part were Italian copies made in Renaissance and even modern times. Greek vases, too, became dearer than at any time before the 1850s: £25 was a moderate price for a good-sized amphora, prices of £40 to £60 were paid at several London sales, while in 1812 William Chinnery's Patroclus vase far surpassed the costliest of Sèvres garnitures at £180 12s.

There was no question in the last years of the eighteenth century of paying Greek vase prices for maiolica, or of building conservatories to house *quattrocento* or even *cinquecento* sculpture, but there was considerable respect both in France and England for sculpture which had escaped the excesses of the rococo by being made a little too soon. This cult embraced the works of Fiammingo, Algardi and Bernini and the sculpture of the Louis XIV court school of Puget, Girardon and Coyzevox. In France the cult denoted simply that in the 1760s the rococo had begun to go out of fashion. In England, where there had never been a rococo, it was a form of provincialism. At the end of the

[8] Later sold for 1,000 guineas to Charles Duncombe of Duncombe Park, Yorkshire.

eighteenth century Bernini and Fiammingo were still the chief inspira-
tion of official sculpture as they had been for more than a hundred
years. In 1792 Reynolds's bronze fountain figure by Bernini, the
Neptune and Glaucus, was sold to Lord Yerborough for the price of an
important Roman statue, namely £500. While Flaxman, the neo-
classic bought Greek vases, Nollekens the established sculptor of the
Anglo-Flemish tradition, bought Fiammingo terracottas. By the turn
of the century the very conservatism of this cult helped to pave the way
to a revival of the taste for High Renaissance sculpture among English
collectors.

As to the High Renaissance or *Cinquecento*, late eighteenth-century
England admired it mainly by proxy. The works that were commonly
designated as those of Michelangelo, Sansovino, or Benvenuto Cellini
were generally of the very late sixteenth and seventeenth centuries and
North European rather than Italian. Cellini was credited with Augsburg
silver statuary, Nuremberg enamelled jewellery, and even German
ivory tankards. A weird rosary could fetch, under the name of Cellini,
no less a sum than 100 guineas in the year 1794, something incredible
for any piece of Renaissance goldsmith's work.

Instinctively, English collectors looked beyond the rococo, which
had hardly taken root in the country, to the baroque, to the Rubenesque
and corpulent *amorini* of François Duquesnoy, known as Fiammingo
[1594–1643]. To Fiammingo more often than to Cellini were attributed
the German ivory tankards of the late seventeenth century, richly
encased in parcel gilt, and protuberant with naked nymphs and satyrs.
There was a distinct rise in this market as early as the 1770s, when
heavily mounted tankards made from 25 to 32 guineas. By the end of
the Napoleonic Wars, the ivory tankards, sometimes truly hideous,
were among the costliest objets d'art in the London salerooms. A
climax was reached in 1819, when William Beckford paid £497 for
two so-called Fiammingo ivory tankards belonging to his cousin, the
English-born Margravine of Ansbach. With this may be compared the
tremendous fuss made by the sculptor Nollekens in the 1780s, when he
was required to pay fifteen shillings for an original Fiammingo terra-
cotta model.[9] But for at least another half-century such terracottas

[9] *Betew:* Fifteen shillings is the money I want for it.
Nollekens: No; ten.
Betew: Now, my old friend, how can you rate art in that manner? You would
not model one for twenty times ten, and if you did, could not think of
comparing it with that. Why, you are obliged to give more at auctions
when Lord Rockingham or Mr Burke is standing by you. No; I will not
bate a farthing. J. T. Smith, *Nollekens and His Times*, Vol. I, page 160.

64

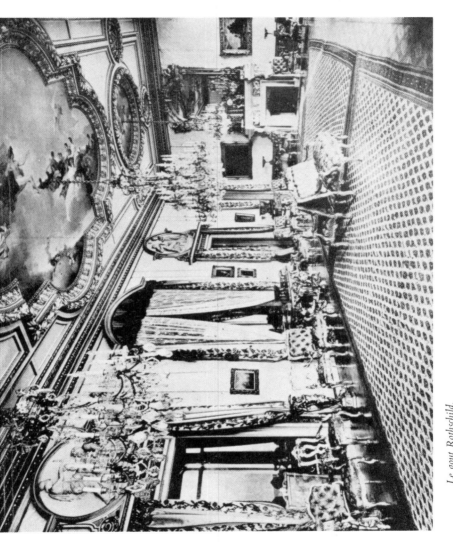

Le goût Rothschild.
The ballroom at 148 Piccadilly before the dispersal of the Victor Rothschild furniture in 1937.

Royal extravagance in the late 18th century.

The Empress Catherine's writing desk, now in the Hermitage Museum. Made by David Roentgen in 1782 for 25,000 roubles, equivalent to close on £4,000, and a gold and diamond snuff box.

could be bought for even less than fifteen shillings. Like the drawings of the old masters, which were mostly bought by painters, sculptors' preliminary models were of interest only to working sculptors. The beginnings of an autograph cult are scarcely to be traced before the few terracottas which Sir Thomas Lawrence's executors tried to sell with his collection of drawings in 1830. And even these alleged *modelli* of the great masters of the Renaissance proved a delusion.

It was still high finish and precious materials which were wanted in 1830, rather than the authentic handwriting of genius. Yet the neo-classic prejudice had been so strong in the 1790s that even objects which had been quite obviously very costly to produce were devalued. There was, for instance, Lord James Manners, who had collected Renaissance objects since the 1750s and who owned twenty-two mounted crystal vessels. The dearest in the Christie sale of 1791, a carved chalice mounted in gold, was sold for £6 8s, while in 1796 a jeweller's stock, which was sold under the same hammer, included "a crystal bottle of uncommon magnitude, curiously engraved and mounted in gold" at five guineas. This simply had to end. During the *Völkerwanderung* of works of art which was provoked by Napoleon's conquests, the invaders' remarkable respect for precious materials paved the way to a new aesthetic. The *Schatzkämmer* of the German princes were still rich in mounted crystal objects and enamelled baroque jewels of the sixteenth century, to which the owners remained intensely attached. On the rare occasions in eighteenth-century Germany when they were put on the market, as at the sale of the Princess Augusta of Baden-Baden in 1775,[10] these things would fetch several times as much as in London or Paris. The chased silver and rock crystal objects, which remained a Rothschild family taste throughout the nineteenth century, had an old history behind them as the most easily transferable asset and the most convenient form of pledge with the banking houses of Frankfurt and Cologne. The instability of the Napoleonic Wars brought some of them to London —such objects as Beckford's topaz vase, which was sold in 1823 for £630. Once such things were established, it was easy enough to accept the faience and enamels and bronze figures that went *en suite* with them.

The same process of recovery governed the return to favour of High Renaissance furniture. All through the eighteenth century Italy had supplied the marble tops for commodes and console tables in the contemporary French taste. But the English nobility, who actually travelled to Italy, were capable of bringing back, not only table tops,

[10] Of which a most interesting priced selection will be found in Charles Blanc, *Trésor de La Curiosité*, Paris, 1858, Vol. I, pages 253–5.

but the table as well. Among the mainly classical cargo that they shipped home there might lurk a *stipo* of the sixteenth century, an architectural inlaid ivory and ebony cabinet, or a *credenza* carpeted in precious stones and marbles. This kind of furniture was not entirely unknown in the Paris of the *ancien régime*. Some of it was certainly circulated on the market by the diplomatic corps. The Conte d'Adhemer, for instance, tried to sell his amber cabinet at Christie's in 1788, but the high figure of £68 10s, was only a nominal buying-in price. The real market for Italian Renaissance furniture began with the French occupation of most of Italy at the end of the century. The fact that Italian Renaissance furniture was inelegant by eighteenth-century Parisian standards was now in its favour, even though it still looked unsuitable for the drawing-room of the mother of the Gracchi, as painted by David.

It is difficult to trace the market value of this furniture in the sale catalogues of the period. Even the words "in *Cinquecento* taste" are no certain indication that the piece was ancient. The ebony commodes and cabinets, "inlaid with Florentine gems," which the Paris dealer Daguerre sent to Christie's in 1791, could hardly have been anything but the latest French models. Possibly the "Florentine gems" were marble mosaic panels of the previous century, incorporated in the manner of the commode by Beneman which was sold by Sothebys in 1962 for £33,000. On the other hand such a description thirty years later would have meant either a Renaissance work or an imitation. The "Florentine cabinet" for which Beckford paid £540 in 1821 was in fact of the sixteenth century.

This kind of furniture, which was for so long out of fashion, may have been even more expensive to make in its day than the French royal furniture of the eighteenth century. But in the seventeenth century the taste for furniture inlaid in precious stones had expanded from Italy to Germany, and the isolation of the German market in the next century caused this extraordinary furniture to be neglected almost everywhere except in Holland. How depressed the market had become in the eighteenth century may be judged from John Evelyn's description in 1693 of the Duke of Brandenburg's present to Mary II, a cabinet fitted with a mirror and frame, entirely inlaid in amber and "worth £4,000." With this one may compare the cabinet of lapis, agate, crystal, and amethyst which Christie's failed to sell in 1776. It was attributed to Michelangelo himself, though as likely as not it was German and not 100 years old. It was stated to have cost £11,000 to make, but it was bought-in at twenty guineas.

The time was not so far away when these Germanic treasures were to be sold under their own name, and none the less costly for that. For during the Napoleonic Wars the German states emerged from their isolation. Prussia became a world power, and a unified Germany a historic possibility. It was more significant in the history of English taste that for long periods of the war this was the only part of the Continent to remain accessible to Englishmen. By the year 1815 German Renaissance objets d'art not only competed on the London market with French eighteenth-century objets d'art, but the market itself began to wear a German look. German objects in ivory, silver-gilt, carved crystal, and enamelled gold began to replace the Indian silver filigree and other Oriental wonders. An important landmark was the Duke of Norfolk's sale at Christie's in 1816, but, high as the prices were, some of the prices which the Duke was reputed to have paid during the Napoleonic Wars were even higher, an Augsburg silver-gilt tankard and a carved ivory flagon having cost him 150 guineas each. By the beginning of Queen Victoria's reign the German ivory-cutters of the late seventeenth century enjoyed a fame that they have never regained, for nowadays the names of Ignaz Elhafen, Magnus Berg, Arthur Quellinus, and Bernhard Straus are nothing to conjure with, even in the most over-expertised catalogues.

2. *The Antiquarians and the Gothic Revival, 1741–1842*

During the Napoleonic Wars a Germanic taste was adopted piecemeal by English collectors, partly as an expression of antagonism to France. But in the German states themselves during these years taste was already in the process of Romantic evolution. German painters had started to imitate the Flemish and German primitives as well as the Italian *Quattrocento* (see Vol. I, page 123). In the 1840s the Pre-Raphaelite tendencies of the schoolmasterish *Nazarener* painters reached England and even France, still haunted though it was by neo-classicism. It will be remembered that the imaginary collection of *Le Cousin Pons* in 1844 had as the keystone of its arch a Dürer portrait. True romantic taste gradually discarded the dowdy German seventeenth-century taste, which had survived as a form of provincialism. By the third quarter of the nineteenth century the ugly great ivory tankards were becoming frumpish in Germany and the insignia of the *bourgeois* establishment in France, the favoured treasures of the illiberal M. Thiers, who had bought one in 1865 for 500 guineas.

The romantic and German-inspired taste of the early nineteenth

century had built into it a sort of second Gothic revival with roots quite different from those of the Gothic taste of Horace Walpole and the Marquis de Paulmy. Despite its obvious influence on architecture, this Gothic aspect of romantic taste was extremely slow in attracting the rich collector. Mediaeval ivories and reliquaries were not objects of millionaire competition before the Soltykoff sale of 1861. The 2,000-guinea purchase of the Eltenburg reliquary at that sale belongs to the England of Rossetti and Burne-Jones, and not to the England of the Eglinton Tournament. The early nineteenth-century market had been no kinder to such things than the eighteenth century. In 1818, for instance, four manuscripts in magnificent jewelled Romanesque bindings, which had been looted by the French at Weingarten, arrived at Holkham in the care of the driver of the Thakenham coach, having cost no more than 100 guineas between them.[11] Even that was the specially high-priced market of the aristocratic bibliophile of the period. Nothing like it was paid for other mediaeval objets d'art. In 1824, at a very smart sale, Christie's disposed of a thirteenth-century enamelled chasse and two Gothic stone fragments for £1 11s 6d, a price that might have tempted Horace Walpole half a century earlier, when a chasse at over £5 and ciborium at nearly £8 had damped his ardour at the sale of his rival, Dickie Bateman.

Yet in 1824, when you could buy a thirteenth-century chasse for a matter of shillings, there was the strongest possible sympathy in England for Gothic remains. It had existed for the best part of a century, but it had never been exploited commercially, for all the time there was a wide gap between romantic curiosity and serious investment in art. In the 1780s Lord Torrington, on his travels, found stone carvings and stained-glass fragments lying about for the taking. Unfortunately, he did not take them. In those days neglect and indifference could be as lethal as deliberate destruction. The latter was practised then, as now, by those whom we call "planners" and "progressive authorities," but whose services to society were as yet unhonoured. Generally known as "jobbers," their operations were even more thorough than those of their successors today, because there was nothing in the materials of an ancient building, nothing even in its interior furnishings, that was worth reselling. For instance, in the year 1778, when it was demolished, the contents of Old Somerset House were simply thrown out on the street, among them an Arras or Tournai tapestry of the late fifteenth century, which was shortly afterwards on offer "at Walker's shop in Harp Alley" at a guinea and a

[11] Leon Dorez, *Les MSS. et Peintures à Holkham Hall*, Paris, 1909, pages 6–7.

half.[12] The tapestry measured 20ft by 10ft, and it depicted the story of Haman and Mordecai, with verses in old French, the kind of panel that could have been sold to J. Pierpont Morgan at the beginning of this century for 20,000 gold sovereigns.

This was far from being a freak case. Ancient tapestries might still adorn the long galleries of great houses, serving to keep out a few of the draughts, but it was no use trying to sell them. In 1782, a few years after the demolition of Old Somerset House, the Cathedral Chapter of Angers attempted to sell what is now the most famous tapestry suite in the world—the fourteenth-century French panels in the Angers Museum, which depict the episodes of the Apocalypse. Not a single offer was made for them. As late as 1843, when most of Europe was suffering from Gothic reconstruction, those of the seven panels which had not been cut up to make hassocks and seat covers still served to lag a greenhouse in winter. The Municipality of Angers, who had inherited the tapestries from the Revolution, were glad to sell them to the Bishop, Mgr Angebault, for 300 francs—£12 for the greatest of all pictorial monuments of the earlier Gothic period, forming originally a frieze 468ft in length. It was fortunate that the Apocalypse tapestries contained very few gold or silver threads, since the usual practice in the 1790s had been to burn tapestries in a furnace in order to recover the metal.

Raphael himself was not immune from such metallurgic operations, although the only ancient tapestries which were still admired at the end of the eighteenth century were the ten huge panels illustrating the Acts of the Apostles, which he had designed for the Sistine Chapel. Their fame had always been secure. They were so rich in precious materials that even in the years 1516–19 the tapestries had cost 1,500 ducats, or £750, a panel to weave—possibly three times as much in cost per foot as any work of that age (see pages 16 and 174). In the late eighteenth century, seven of the original cartoons were at Hampton Court, having served as models almost continuously since Raphael's day. Under those very special circumstances the commissaries of the French forces which occupied Rome in 1797 were able to obtain 1,200 scudi, or £300, a panel for the original Vatican tapestries in a public auction. Yet, after all that a further Raphael tapestry, which was stolen from the Vatican and smuggled to Genoa, was burned in the first year of the new century in a fruitless attempt to separate the gold.[13]

[12] William T. Whitley, *Artists and Their Friends in England, 1700–1799*, 1928, Vol. I, page 275.
[13] E. Muntz, *Chronique des Arts*, 1877.

If there were no silver and gold in an ancient tapestry, it might be reprieved for a more lingering death. If it was exceedingly large, it might be used as a tarpaulin to cover a wagon or a hay-stack. This explains why fragments from the earliest French tapestries, such as the *Nine Worthies* series in the Cloisters Museum, New York, continued to turn up in French farmhouses well into the nineteenth century. These were, of course, Gothic tapestries. For tapestries of the seventeenth and eighteenth centuries there remained a feeble market throughout the neo-classic period, despite great changes in the domestic *décor*. The Gobelins and Beauvais rococo suites after Boucher, Oudry, or Coypel had become practically worthless in the 1780s, but late seventeenth-century tapestries designed by Charles Lebrun retained a very modest market, chiefly in London (see page 177).

Strange to say, the London auctioneers at the end of the eighteenth century were able to do quite a good business in stained-glass windows —not, of course, in those fragments of pre-Reformation glass which survived in England, but in glass made since the Renaissance and imported since the plunder of the churches by the French revolutionaries. In 1786 a complete window of four Scriptural panels cost only £5 at Christie's, but in 1808, when stained-glass sales were a seasonal feature, an 8ft panel from the Church of St Jean, Rouen, representing the Last Supper and dated 1542, could make as much as £131 5s.

From all this there emerges an image of the turn of the century as a moment of transition in taste, expressed by a preference for the baroque over the rococo, and by a vigorous market for certain objects of the High Renaissance, almost rivalling the market for classical antiquities. And to this must be added a still negligible market for mediaeval objects, apart from the more sumptuous illuminated manuscripts. True archaeology concerning the monuments of the Middle Ages had remained singularly static since the first half of the century, for the neo-classic revival had been destructive of the old humanism, which sometimes honoured the relics of the past, even if the humanist was too poor or too drunk to save them. Whereas it required the Napoleonic pillage of the treasures of Italy to revive the "primitive" painters, the names of many *Quattrocento* artists had been remembered in the first quarter of the eighteenth century. For instance, the banker, Pierre de Crozat, the patron of Watteau, was capable of including fifteenth-century examples among his collection of old master drawings. He also collected maiolica and other sixteenth-century objets d'art. Crozat had his followers. The Englishman, Sir Andrew Fountaine, Master of the Mint under Anne and George I (1672–1753), had been a

great traveller and cosmopolitan. He owned a splendid group of drawings by the Flemish primitives as well as a very large collection of maiolica, French sixteenth-century faience, and Limoges enamels. The latter were in such completely mid-Victorian taste that in the year 1884, when they came under Christie's hammer, they fetched prices that have never been surpassed since (see pages 119-120).

More serious than the *amateur des curieux*, more important in his eventual influence on collecting and much rarer as a person, was the antiquarian, who interested himself in all ages of history. The type figure—and he had several English and French imitators in a more modest way—was François de Gaignières [1642-1715]. The *Recueil Gaignières* was not, strictly speaking, an art collection. In keeping with the old conception of an antiquarian, his portfolios and his walls illustrated history, costume, ceremonies, genealogy. But among the possessions of Gaignières was the fourteenth-century portrait of John II of France from the Château d'Oiron, and Jean Foucquet's portrait of Charles VII, which was sold with another fifteenth-century French portrait after Gaignières' death for 3s 2d.[14]

As opposed to the *amateur des curieux*, with his minerals and natural specimens, the antiquarian had his own habits of collecting. His interest in local families, in pedigrees and armorial quarterings, caused him to accumulate mediaeval manuscripts, which tended to be illuminated. Sometimes he would buy them for himself, sometimes for the libraries of noble persons who were proud of the record of their ancestors. Gaignières may have acquired the famous Book of Hours of Etienne Chevallier, which returned to France in 1892, but only in fragments. Acquisition was easy. The *Sherbourne Missal*, a magnificent English book of paintings of the late fourteenth century, was given him as a compliment for paying a social call on the Bishop of Evreux.

There was a continuity in the collecting of illuminated manuscripts, both in France and England, from the time of François de Gaignières. In the formation of a taste for mediaeval art for its own sake, this continuity of tradition had some importance. Bibliophily had become a normal French aristocratic taste by the mid-eighteenth century. Out of snobbishness, even Mme de Pompadour owned a few illuminated manuscripts, though she was unable to mount them in ormolu. But the very finest rated far below the value of the rarest early printed books, and continued to do so till the beginning of the present century.

[14] Charles de Grandmaison, *Gaignières, ses correspondents, et ses collections de portraits*, Niort, 1892.

In 1812, when fifteenth-century painted panels could still be bought for a few shillings, the Marquess of Blandford paid 2,000 guineas at the Duke of Roxburghe's sale for the *Valdarfa Decameron*. This printed book was, therefore, as dear as a Raphael altarpiece, or as dear as a huge silver *surtout de table*, weighing 5cwt, the only sort of objet d'art which could make 2,000 guineas in 1812.

More than half a century was to pass before an illuminated manuscript rivalled the price of the *Valdarfa Decameron*, but in the late eighteenth century illuminations provided a link between the romantic taste in literature and the future romantic taste in art, the former being, of course, much older. England in the 1760s already had its Ossian, Bishop Percy, and Chatterton; France had its Marquis de Paulmy, who published a library of modern versions of the *chansons de geste*, and who seems to have been inspired by the illuminated books of romances in the library of his uncle, the Duc d'Argenson, some of which he eventually bought. Since the collection is today almost intact in the Bibliothèque de l'Arsenale, including several of the greatest masterpieces of French fifteenth-century painting, the prices paid by the Marquis de Paulmy in 1764 are of some interest.

The *Boccaccio of Jean sans Peur* cost the Marquis £10, the *Terence of Jean, Duc de Berri*, cost £29, the *Romuleon* of 1490 as much as £40, probably because the paintings were Italian, and almost contemporary with the young Raphael. In 1792 the former Paulmy library was seized from the Duc d'Artois by the commissioners of the Revolutionary Government, who valued it only a little higher. It was the tradition of aristocratic bibliophily that made them appraise the huge *Josephus* at thirty shillings a miniature. Had the miniatures been painted on wood, they might well have been destroyed.[15]

In England, where there was no confiscation of royal and noble libraries and where Gothic romanticizing was a more fashionable amusement than in Paris, there was scarcely a better market for illuminated manuscripts. It was very rare for truly mediaeval illuminations to fetch as much as those of the post-Raphael period, which were nearly always attributed to Giulio Clovio. In the late eighteenth century the attraction of mediaeval illuminations was severely antiquarian, and not at all aesthetic. In 1783 one of Francis Barnard's illuminated books was sold at Christie's for the then enormous price of £115 10s, simply because it was written in Hebrew. In 1808 the quite staggering price of £372 15s was paid by a London bookseller for a plain 13th-century

[15] Henri Martin and Philippe Lauer, *Les principaux Manuscrits à Peintures de la Bibliothèque de l'Arsenale*, Paris, 1929.

Greek manuscript of the minor orators, the *Codex Crippsianus*, but the text had just been collated by the great Porson. Most exceptionally a price of this kind was once paid for a manuscript on account of its illuminations. This was at the Duchess of Portland's sale in 1786 when George III paid £213 3s for the *Book of Hours of the Duke of Bedford* (*not* the *Bedford Book of Hours*, which did not become national property till 1929) and this was a truly mediaeval book, painted in 1423. The price was created by the enormous number of fully illuminated pages in this not quite top-rank manuscript, and more still by the fact that an English King was paying for a book presented to a former English King—namely, Henry VI.[16]

It was characteristic of the antiquarian market, with its only occasional appeal to aristocratic purses, that some of these eighteenth-century prices could not be maintained, even when romantic taste had become popularly established. For instance, a late fifteenth-century illuminated manuscript, the *Missal of Sixtus IV*, fell from £231 10s in 1804 to £160 at the Esdaile sale of 1838. It is possible that no truly mediaeval illuminated manuscript surpassed the prices of the 1790s and 1800s till the sale in 1850 of the ill-fated *Pontifical of Jouvenel des Oursins* for £400 (see page 102).

In addition to illuminated manuscripts, all those objects of the romantic European past which were sought by the early and mid-Victorians were certainly drifting round the salerooms in the late eighteenth century, but they are not always clearly recognizable. Limoges enamels, a fairly common item, were generally described as ancient enamels or Roman enamels, and attributed to the inspiration of Giulio Romano. The earliest identification with Limoges that I have found in Christie's catalogues is in 1827; even then it is due simply to the inscription on the piece. Palissy ware was certainly known in England, since, almost within human memory, the *Fecundity* dish had been tolerably copied at Lambeth. In the late eighteenth-century sale catalogues an item which appears under the name of "old embossed pottery," and which never cost more than £1, may well have been Palissy ware, the rage of the 1860s. As to Italian maiolica, it was a very frequent item, but it passed under a whole variety of names—Raphael's ware, Raffaele pottery, old Roman pottery, and Tuscan pottery.

It is strange that a ware which was attributed to the inspiration and even the hand of Raphael should have been a casualty of neo-classicism.

[16] Only a little less had been paid by the Duchess of Portland at the Lavallière sale in Paris in 1781, where the young Beckford formed the nucleus of the great Hamilton Library.

In the middle of the century, when it was still a favourite aristocratic import from Rome and Florence, there were actually signs of a rising market. For instance, if we go back to 1667 and the death of Cardinal Richelieu, we find that four big *istoriato* dishes were worth no more than 120 livres, or £6, between them, less than the Cardinal's newest crockery from Rouen and Nevers. But in 1757, among the maiolica of the Antwerp sculptor, Peter Scheemakers, as sold by Langford of Covent Garden, prices of £2 a dish were common, while Lord James Manners paid as much as seven guineas for a large Urbino vase depicting *The Judgement of Paris.*[17] In 1780 Christie's could still get over £15 for a pair of such vases, but in 1791, when they sold Lord James Manners' Collection, the débâcle was complete. There were fifty-two examples, sold in nineteen lots, and they made no more than £21 between them, though James Christie the Second took exceptional pains, carefully transcribing the signatures and dates, which extended from 1518 to 1545. It had been no better in Paris in 1780 at the sale of M. Picard, an obscure *amateur des curieux*, where one of those big Urbino dishes with grotesque figures "after the designs of Raphael" was sold for fifteen francs.

As M. Bonnaffé was the first to observe, this was one of the very rare Paris sales of the eighteenth century where mediaeval as well as Renaissance objects came under the hammer.[18] Their disposal created a tricky problem for the auctioneer, Jean Baptiste Glomy, who was a naturalized Italian and, like most art dealers of the period, a painter. As a painter, M. Glomy was inspired to make propaganda for the latest art fashions of the day, but as an auctioneer he had to praise the objects which were entrusted to him for sale. So he hit on the nice compromise of writing down the cheap unfashionable lots in such a way as to draw attention to the merits of the others. Here is an unusually long-winded example of the ingenuity of M. Glomy.

> Lot No. 200. Two bas-reliefs in alabaster. One represents the Annunciation and the other the Martyrdom of St Bartholonew. The first (which is partly coloured and gilded) is remarkable on account of the figure of God the Father at the top of the composition, where one may see the Holy Ghost coming out of his mouth. The angel holds a scroll on which is written the angelic greeting. These pieces can only excite curiosity on account of their antiquity and singularity of composition in the same way as all the Gothic

[17] George Redford, *Art Sales*, 1888, Vol. 7, page 28.
[18] *Causeries sur l'Art et la Curiosité*, 1876.

pieces which have for so long disfigured the arts, and which have extended even as far as Greece, the ancient homeland of painting, sculpture and architecture—and whose yoke has been cast aside at last to follow the good taste from which we have strayed so long.[19]

The bidders certainly did not stray very far from the good taste of M. Glomy, for in the margin one may read the words "6 livres, 1 sou". How eloquent is that sou! Even the timid challenge of an extra half-penny could not tempt the intrepid bidder who had risked all of five shillings on two alabaster panels, absolutely unfaked and unrestored, which would nowadays face the hammer with a reserve of several thousands on them.

After that one need feel no wonder at the prices at which the commissioners of the French Revolution were prepared to part with the relics of feudalism, once it was decided no longer to destroy them. In 1794 the *citoyen* Percheron paid two guineas for the marble tomb of Francis I. In 1805 Alexandre Lenoir was able to rescue for his museum the two thirteenth-century statues of Clovis and Clothilde from the Abbey of Corbie for £2 17s 6d. It would be idle to pretend that there was any better demand for mediaeval sculpture in London at the turn of the century, except that there was no wholesale seizure of the relics of tyranny and feudalism to glut the market. Furthermore, though they pulled them down whenever they had the chance, Londoners were permitted to tolerate and endure the familiar images of the age of superstition, provided that they were not holy. And that, perhaps, explains why in the year 1805 the two pairs of giants, Gog and Magog, from the old Guildhall, fetched no less than £49 7s and £47 5s after they had been removed as perquisites by Thomas Bankes, the sculptor.

3. *Horace Walpole and William Beckford*

This isolated incident of the sale of the Guildhall figures belongs to the eighteenth-century taste for Gothic fantasies, rather than to the Romantic Movement, which till the 1860s inclined collectors to the Renaissance, late and early, and very little to the Middle Ages. Of the taste for Gothic fantasies, the type-figure is Horace Walpole [1717–97]; of the romantic taste, William Beckford [1760–1844]. The one collected as early as 1741, the other as late as 1844, yet for a very few years their collecting must have overlapped.

[19] The unique catalogue is in Amsterdam. For a photo-copy I am indebted to the Wallace Collection Library.

Horace Walpole's purchases of 1741 were made at the sale of the Earl of Oxford in Covent Garden—a very showy event. The objects of his choice show such a continuity of collectors' tradition that, apart from the prices and the method of description, they could equally have been bought in the 1840s, at the end of Beckford's life. They included a "sweet bronze vase by Fiammingo" at sixteen guineas (it was sold for only four guineas more in 1842), a deep Roman copper dish with a Cupid painted on it, presumably a Limoges enamel at two guineas, and two curious antique Tuscan urns, presumably maiolica, at £2 3s.[20]

In 1741 Horace Walpole was twenty-four years old. He did not begin to furnish Strawberry Hill till five years later, but the more serious side of his taste had already been formed. His purchase of Gothic and Renaissance objets d'art in the course of the next fifty years made him the forerunner, in his peculiar way, of Alexandre Lenoir, of Revoil, and of du Sommerard, the French pioneers, who had possibly never heard of him. He built a Gothic house, wrote a Gothic novel, collected material on the painters of the Middle Ages, and filled Strawberry Hill with stained glass. It is therefore a question whether Walpole was not the very founder of the taste of the Romantic Movement.

But to attempt to decide that question is to beg a still bigger one. What was romantic taste? In terms of the too well co-ordinated late eighteenth century, the Romantic Movement meant that landscape had to be wild and elemental; that passions were only interesting as wild, uncontrollable passions; that colour had to be brilliant, startling colour, bringing out the contrasts of shadow, despair and poverty. And if man could still survive amid all this fury as the highest example for art, it was not for his Greek and godlike body, but for his pride and bad temper. In order to keep up with that idea, the collector of the romantic period had to possess not a Graeco-Roman nude statue, but a menacing suit of armour, rigged up to the life and guarding the door to his library.

Such a suit of armour Walpole certainly possessed. He had horrified Mme de Deffand in 1772 by his readiness to bid £40 for the alleged Cellini armour of Francis I, but he bought it, as he bought almost everything else, for its personal associations, a cult somewhat peculiar to Walpole. He was not particularly in love with the notions of chivalry and combat, which, under the inspiration of Scott's novels, were to make armour a popular market in the 1820s and 1830s. Furthermore, before the full impact of neo-classicism, armour had been

[20] George Redford, Vol. I, page 29. *Letters of Horace Walpole*, Vol. I, page 145: to Horace Mann, 22 March 1742.

a traditional North European collectors' taste, going back to the late sixteenth century and the Archduke Ferdinand's Collection at Schloss Ambras. In 1728, when the wearing of ceremonial armour was still a possibility, an Italian parade shield could make as much as £100 at a London auction, though in the neo-classic 1790s the alleged armour of Henry V was knocked down at Dr Dalton's sale for £2 12s 6d.

It is now generally realized that the eighteenth-century Gothic cult was not founded by Horace Walpole and that he was not unique among his contemporaries. Gothic yearnings went back to the English Reformation. Gothic antiquarianism, wistful though bibulous, had been typical of the seventeenth century, and Aubrey's *Brief Lives* its most living expression. In the last quarter of the eighteenth century the habit of musing among derelict abbeys and castles and painting the odd water-colour or two had become almost fashionable. It is curious that while the neo-classic taste was growing more rigorous and exclusive, the passion for Gothic ruins should have spread so fast. The rambles of Lord Torrington in the 1780s in search of abbeys and castles whose existence had been forgotten, even in the neighbouring villages, still savoured a little of the eccentric. Yet a generation later, in Jane Austen's day, such excursions were commonplace. Short of eloping with penniless subalterns, they seem to have been the only permissible recreation for squire's daughters. One can scarcely imagine a neo-classic coffee service, however severe and rectilinear its outlines, without a ruin painted on it—and as likely as not a Gothic ruin. But the ruins were not the kind that are cleaned up, on occasion floodlit, and run by the National Trust with an admission fee of a shilling. And if the Gothic building had not been in ruins, it would not have been painted on the coffee service at all. Hence the two alabaster retable reliefs for five shillings and a halfpenny.

Some have argued that Horace Walpole and those hardy excursionists who imitated Lord Torrington were seeking an escapist world such as was created in the next century by the Pre-Raphaelites; that they were already after the Holy Grail. But they themselves called the object of their search "the picturesque", because it was easy to make a picture of it according to the recipes of the day. Any suggestion that they were trying themselves to live in this fragment of the past would have been deeply resented.

But it was a queer quirk of Fortune that Walpole's accumulations should have reached the salerooms in 1842, when the Eglinton Tournament had been attended (but not fought) by gentlemen in full armour, and when the Holy Grail of the Pre-Raphaelites was so near at hand. A

hundred years had passed since Walpole's first purchases; more than fifty years since his last. Walpole now belonged to the penultimate age, the basest form of antiquity. In the present century it has become the fashion to praise Walpole as a collector, just because the romantic early Victorian generation found him so trivial. The smart world of 1842 did indeed pay up—Queen Victoria herself bought the *Lennox Jewel* and *Anne Boleyn's Clock*—but they damned the owner's taste. They fastened on the fact that Robins's catalogue was filled with tiresome and frequently dubious personal relics of heroes and villains of the past— such things as Cardinal Wolsey's hat. And they failed to see anything exciting in the thought that, a hundred years before, a man could have bought just the things that the age now took for granted.

According to *The Times*, "there was nothing for which a good judge would have travelled a step out of his road. . . . The sale went off without energy and without display; there was little animation and nothing to excite." But *The Times* miscalculated, since the Strawberry Hill sale made £33,450 11s 9d, and the sale of the prints and drawings in London made £29,614 6s 6d. When it became clear that these very high figures were within reach, *The Times* began to change its mind, deciding that it was "an enormous sum, when the absolute worthlessness of hundreds of the lots is considered, but comparatively very moderate, when ignorance, credulity and bad taste are put in the opposite scale."[21]

This sort of writing belonged to the intellectual snobbery of the age, which, in the rhetoric of Macaulay and the silences of the dictatorial Mrs Jameson, denounced everything that was not "high art" as gewgaws and baubles. The last man who should have joined this hue and cry was surely William Beckford, yet even to Beckford Strawberry Hill was just a "high puff sale". In later years he was to tell Cyrus Redding: "Some things I might have wished to possess; a good deal I would not have taken as a gift. The place was a miserable child's box; a species of Gothic mouse-trap; a reflection of Walpole's littleness." Yet Beckford bid lavishly for Walpole's books and drawings. The real prejudice was against Walpole's person rather than his belongings, which had been left in 1797 to Walpole's great-nephews, so Beckford believed, in order that he should not be able to bid for them.[22]

The Gothic mouse-trap was Strawberry Hill—Walpole's daring experiment in the English Perpendicular style. Despite the present appearance of Strawberry Hill, its contents in the year 1842 were

[21] Redford, Vol. I, pages 131, 134.
[22] Lewis Melville, *Life and Letters of William Beckford*, London, 1910, page 299.

nothing like as Gothic as one would suppose. Apart from the numerous stained-glass windows (to be removed at the expense of the purchaser), very few mediaeval objects were sold in 1842, and even the windows were mostly of the Renaissance. Apparently Walpole had not owned a single Gothic tapestry, and though he had some Gothic furniture made to order, his predilection seems to have been for allegedly Elizabethan carved oak furniture (probably Jacobean) and Italian Renaissance cabinets in ebony and marble inlay, though he had also bought a fair amount of contemporary French furniture in marquetry and ormolu, in lacquer or in boulle work or carved and gilded. Perhaps the largest impact of Walpole's personality on an age which he did not live to see, was the fact that his Renaissance furniture fetched much more than his French furniture. But French furniture had barely passed its lowest ebb in 1842.

Beckford, who had made his Gothic experiment at Fonthill sinister and awesome, could well be contemptuous over Walpole's Gothic palace, which had to house endless old-ladyish bibelots, among which the few Renaissance objects were swamped. Beckford also expressed the not very sensitive outlook of the age. In 1842 the fashionable *décor* was dictated by suits of armour and trophies of antlers and weapons, the same *décor* that survived sixty years later, in my own childhood, in country hotels that always smelt of mulligatawny soup. It was too male a setting for a snuff-box in the shape of Mme de Deffand's pug-dog.

Yet Horace Walpole's attitude towards history, snobbish and gossipy though it might have been, had produced stupendous portfolios of engravings and a collection of portrait miniatures that set the highest standard of prices for the next thirty years. Far less worthy of Walpole as an antiquarian were his illuminated manuscripts. Disconcertingly, one finds that his treasures were nothing like as Gothic as those of the Marquis de Paulmy. The dearest was a post-Raphaelesque psalter, illuminated in 1537 by Giulio Clovio, and bought at the Duchess of Portland's sale in 1786 for £169 1s. In 1842, when almost any truly mediaeval illuminated manuscript could have been had for 150 guineas, this work made £441. The mannerist and eclectic painters of the Roman school were still in fashion and Giulio Clovio was the rage. In 1833 Sir John Soane had had to pay very much more than this for the Duke of Buckingham's Giulio Clovio manuscript—in fact, £735 with two unimportant Books of Hours thrown in.

Horace Walpole's *Hours of la Reine Claude*, of about the same date and in a magnificent enamelled gold binding, measuring only 3in. by

2¼in, must be considered more as a Renaissance jewel than as an illuminated manuscript. Walpole had bought it at Dr Meade's sale in 1755 for £48 6s, and it now made £115 10s, not, one would say, a very exciting advance considering the revolution in taste since Dr Meade's day. In 1921 this miniature book was sold for £2,100 and in 1942 for £2,400, but in between these sales it was said to have cost Lord Rothermere £8,500. How much, one wonders, would that other Renaissance work, the *Lennox Jewel*, with its four allegorical figures, be worth today? Certainly a great deal more than £8,500, but at £136 it was a truly Royal purchase for the year 1842—and possibly the wisest Queen Victoria ever made.

Walpole's ghost would have been amazed to see his expensive French furniture and porcelain fetch less than his Renaissance furniture and his armour under Mr Robins's hammer. The so-called Cellini armour of Francis I, which had been *infiniment chère* at £40, was bid up to £336, a very high price for 1842, but not the highest, since in Paris in 1838 King Carlo Alberto of Savoy had paid £450 for the man-and-horse suit of Francesco Sforza. These prices were, however, of recent growth. Napoleon had included very little armour among his pillage of the Continent, though in 1814 M. de Hebray began to form a collection which he intended to give to the French nation. In England the very low rating of armour in the late eighteenth- and early nineteenth-century sales received some stimulus in 1819 with the publication of *Ivanhoe*, a book which has probably influenced domestic taste throughout the world more than anything that has ever been written: a grim thought. Even so, in the 1820s and 1830s, when the great armour pioneer Samuel Rush Meyrick, formed his collection, the most important suits could still be bought for £25 to £35, and sometimes even less. Not unnaturally, the real rise in the value of armour began about the year 1838, when the mediaeval political mysticism of the Young England Movement attracted those smart members of society, who were to take part in the ridiculous Eglinton Tournament (see page 109).

Of all Renaissance objects, Walpole's maiolica had probably advanced most since his collecting days—in some cases twenty times over. Whatever *The Times* thought about it, the prices for maiolica were the age's warmest tribute to Walpole's pioneering activities. The two great vases by Orazio Fontana, which the Earl of Strathmore had bought from the Pitti Palace in 1763 and which he had had mounted *en rocaille*, fetched 100 guineas. Two monstrous great Urbino cisterns were bought by Miss Burdett Coutts for £81 and £84. Dishes

which could barely have made fifteen shillings in 1797, the year of
Walpole's death, were now fetching nine guineas. Limoges enamels
were going up just as fast. The St Hubert hunting horn, destined to
make 6,300 guineas fifty years hence, was sold for a price that in the
light of 1842 was even more startling—namely, £141 5s. An Eliza-
bethan cabinet made £157 and Elizabethan chairs 28 guineas each,
though Walpole's white-and-gold and damask fauteuils of the Louis
XV period were sold for little more than a guinea apiece. During the
Edwardian mania for drawing-room suites, they might have worked
out at 1,000 guineas for each portly behind.

Apart from the rising market in Renaissance art, the Strawberry Hill
sale of 1842 reflected the depressed condition of one of the dullest
periods in saleroom history, a period which extended continuously
from 1830 to 1848. Many things at the sale might have been dearer
twenty years earlier, and even during the Napoleonic Wars. Yet the
man who had made those prices possible was still alive, and, in his
eighty-third year, bidding at the sale. The chief impact on the market
of William Beckford [1760–1844] at all periods of his life had indeed
been that of his capacity to spend, rather than that of his remarkable
personality.

Whatever the early Victorians may have thought of Beckford as an
ill-tempered fossil-survivor of the *dix huitième*, he had been a romantic
in his youth. And being a romantic (as well as being very much richer),
he had collected with far more passion than Horace Walpole, hardly
tolerating curiosities unless he could project them in his imagination
into something greater. Beckford's active span of life was stupendous,
his adult years bridging the gulf between Sir Joshua Reynolds's
Discourses and Ruskin's first lectures. He was brought up among his
father's Hogarths with the smell of paint still on them, his own portrait
was painted both by Romney and Reynolds, and he died coveting a
dear little doggy picture by Landseer called *Suspense*.

Beckford must have amassed at one time or another—for he was
constantly selling—a collection such as has never been seen under one
roof, but this aptitude to sell conquered his originality, making it
inevitable that the man who had once bought daringly should become
a stuffy art investor. Beckford had indeed bought the young Turner's
ambitious *Fifth Plague in Egypt*, the more horrific works of Benjamin
West, and even Blake's drawings because they had something in
common with his own genius, but these were the works of which he
tired the soonest.

This constant disposition to sell suggested that Beckford had

abandoned the pursuit of "high art" for the works of skill and elabora-
tion that were the temptations of the rich. Thus he incurred the moral
homilies of the critics of the romantic generation—the generation
whom he himself had anticipated. The voice of that generation was
William Hazlitt, who wrote the following diatribe in 1823, the year
when the Fonthill sale revealed the nature of some of Beckford's
treasures:[23]

> "He seems not to be susceptible of the poetry of painting, or else he
> sets his face against it. It is obviously a first principle with him to
> exclude whatever has feeling, imagination; to polish the surface
> and suppress the soul of art, to proscribe by a sweeping clause . . .
> to reduce all nature and art to the level of a China dish, smooth
> glittering, void and unfeeling."
>
> "Poelemburg's walls of amber, Mieris's groups of steel, Vander-
> werff's ivory flesh, these are the chief delights of the late proprietor
> of Fonthill Abbey! Is it that his mind is a volcano burnt out and
> that he likes his senses to repose and be gratified with Persian
> carpets and enamelled pictures?"

That Hazlitt's outburst was rankly unfair sprang from his peculiar
prejudices. The objection to the Dutch painters was at least reasoned.
This was the Hazlitt who could on occasion see good in Turner and
who despised the frozen neatness of the contemporary French school.
But Hazlitt's objection to China dishes and Persian carpets lacked
sensitivity. Confronted with objets d'art, Hazlitt invoked the "sublime"
and the "grand manner", the same trappings of false genius which he
denounced in the works of Benjamin West, Haydon and Hilton. In
fact Hazlitt detested all objets d'art. He quoted long passages in the
Fonthill sale catalogue in order to show that Beckford was an indus-
trious *bijoutier*, an accomplished patron of unproductive labour, an
enthusiastic patron of expensive trifles. With his own disarming brand
of illogicality he taxed Beckford with foreswearing romance, while
rating him for not buying, like any eighteenth-century squire,
marble copies of classical statues or Egyptian hieroglyphics and
mummies.

Even more unfair was Hazlitt's concealment of what was known to
everybody, namely the fact that Philips, the auctioneer, had salted the

[23] *London Magazine*, October 1823. Centenary edition of Hazlitt's *Works*,
1934, Vol. XVIII, pages 173–80. Critical analysis in Boyd Alexander,
England's Wealthiest Son, 1962, pages 251–3.

Fonthill sale with "introductions", cheap lots belonging to other owners.[24] But nothing stales more quickly than criticism. Within seventy years of this onslaught, "China dishes, smooth, glittering and unfeeling" were fetching over a thousand pounds each, enamel pictures from Limoges up to 7,000 guineas, and, most despised of all, a Persian carpet was sold for £16,000.

At least Hazlitt admitted that Beckford's mind had been a volcano, but in 1823 the visionary Beckford of the 1780s had become the lonely Khalif, recreating the tower of his brain-child, *Vathek*, and at the same time filling it with the playthings of a King Farouk. The artistic prejudices of the young Beckford had in reality been extraordinarily like Hazlitt's, as, for instance, when the Pompadour period had presented itself to his vision as "a row of long-waisted dowagers, pink and yellow, all seated on fauteuils composed of the stiffest tapestry"; or in the person of Voltaire's niece, Mme Denys, "looking like a Frenchified commode both in shape and hues".[25] The painters who "polished the surface and suppressed the soul of art" had come in for their share too. Beckford had dealt with them at the age of seventeen in his pastiche guide to his father's "gentleman's furnishing pictures", with its charming biography of Professor Sucrewasser of Vienna, in whom it is not difficult to recognize Zuccarelli, a painter who is once again depressingly fashionable among the exceeding smart.

The trouble was that Beckford was both Vathek and Vathek's creator at the same time. The Khalif had to be surrounded by all that shone and glittered—gold and crystal or what most resembled them. "Polishing the surface of art" was a reproach that had some substance in it. Even Beckford's bibliophile tastes tended towards the absolutely fresh and perfect copy rather than to the battered work of extreme rarity. Apparently he was not much addicted to the prevalent aristocratic taste for illuminated manuscripts. Very little of the magnificent Hamilton manuscripts, which went to Berlin in 1881, came from the Beckford inheritance. Beckford liked the kind of manuscript that went with his Italian primitives but nothing earlier.

[24] Similarly George Robins, the auctioneer, had been accused of salting the Strawberry Hill sale in 1842.

"I suppose there will be a few introductions," remarked Mr Shallow, with a very sly peep out of the corners of his eyes.

"You'd scarcely believe it," returned Mr George Bobbins, laughing inwardly, "but one of my rascals proposed to introduce a very ancient cradle that has been kicked about upstairs for years, as the very one that Horace Walpole was rocked in. Ha, ha, ha!"

John Mills, *D'Horsay, or The Follies of the Day*, 1844.

[25] J. W. Oliver, *Life of William Beckford*, 1937, pages 26, 188.

In 1813, when he bought three Romanesque or Byzantine miniatures, Beckford wrote: "between ourselves these things don't amount to much".[26] In 1818 the Earl of Leicester was offered the four Romanesque manuscripts in their original silver-gilt ivory and jewelled bindings which General Thiebault had looted from Weingarten, and which went to Pierpont Morgan for £100,000 in 1912 (see page 231). The Earl was warned not to hesitate too long, because Mr Grenville, Mr Heber, and the Marquess of Douglas would all fall upon the treasure if they saw it.[27] No mention of Beckford here.

The clue to this side of Beckford's collecting lies, I think, in the sale of the Chevalier Franchi in 1827. Franchi had been Beckford's devoted servant-companion since 1788, and the numerous objets d'art in this inexpensive sale must have come almost entirely from his patron. Poorly catalogued though they are, several early mediaeval objects of enamel and ivory can nevertheless be recognized—objects that would have made immense prices in the Pierpont Morgan era. In parting with them, Beckford may have shared the opinion of the age that these things were only curios. The claim that his tastes were in advance of his contemporaries rests mainly on Beckford's wonderful *Quattrocento* pictures, his Botticellis, Bellinis, Peruginos, and his Mantegna. But Vivant-Denon had acquired the best *Quattrocento* paintings for the Louvre in the 1790s, at which period several Englishmen, including Charles Greville, William Roscoe, and the Bishop of Bristol, were also collecting them. Beckford's acquisitions were made considerably later.

Beckford's collecting was at its height in the years immediately following the peace of 1815, but by the standards of the French collectors, du Sommerard and Debruge Dumenil, he was already outdated. His outlook remained *dix huitième*. While the curious museum, with its minerals and stuffed crocodiles, was not in Beckford's line, neither was its successor, the *musée comparé* of many styles and periods, knowingly labelled. Beckford was no lover of museums and no improver of public taste. The notion of instructing the common man disgusted him. In 1841, when he tried to sell a selection of his most imposing pictures in order to raise money for his second tower at Lansdowne, he "heartily wished that he would be saved the disgrace of letting the *Lobbingall* [National] Gallery have them".[28]

Beckford is not an easy collector to study. He did not possess the cataloguing instinct, he wrote no description of his treasures like

[26] Boyd Alexander, *Life at Fonthill*, page 99. [27] Dorez, page 7.
[28] Melville, page 345.

Walpole, and he was constantly selling them or buying them back. At the Fonthill sale of 1823 the highest priced objects, the Cornaro topaz vase, the Fiammingo ivory tankards, the great Florentine cabinet had all been bought in the past five years. There are legends that Beckford had bid for the ancient treasures of the French Crown, which included many mounted mediaeval and Renaissance objects, as early as 1793, when he was certainly living in Paris under the Terror. There are possibilities that he obtained some of his famous rock-crystal objects in Paris during the peaceful intervals of 1802 and 1814. But apart from his illuminated manuscripts, two of which he certainly bought as early as 1781, there is no convincing evidence that Beckford departed from the normal repertory of French *ancien-régime* taste till a year after Waterloo, and that, moreover, was a significant moment in collecting, when the pioneer collectors of the *Cousin Pons* generation were already influencing the market. Yet he does not seem to have maintained any contacts with this circle, except perhaps indirectly, for Beckford was certainly acquainted with that very *mondain* character the Baron Vivant-Denon [1747–1825], whom he visited in Paris during the Peace of Amiens in 1801, when Vivant-Denon was Napoleon's Commissary for the Fine Arts. This painter-politician had distilled the pure milk of republican classicism under Jacques Louis David and the National Convention, but under Napoleon he had built up a collection of Italian primitives for the Louvre and formed a small collection of mediaeval and Renaissance objets d'art on his own account, while rather furtively buying up the works of Watteau and his followers, who were then anathematized.

Nor are we any better informed of the prices that Beckford paid before the post-Napoleonic period. The prices, depressed by artificial circumstances, of most of the lots at the Fonthill sale of 1823 are no indication of Beckford's own expenditure, even when we are certain which were his own and which were Philip's "introductions". Furthermore, quite a number of the finest contents of Fonthill were not among them.

The story is somewhat bizarre. In 1822, faced with the ruin of his West Indian estates, Beckford had sold the Tower of Fonthill, his newly completed and completely foredoomed monster, together with part of its incredible furnishings, for a lump sum of £350,000. The buyer, one John Farquhar, had made a millionaire's fortune in India by selling gunpowder to whomsoever wanted it. His income was estimated at £40,000 a year, but, finding that he had spent too much money, Farquhar, who was not a man of taste, emptied the Tower. Beckford

and his son-in-law, the 10th Duke of Hamilton (1767–1852), used this heaven-sent opportunity to buy back a number of things at less than the original cost-price. This is the explanation of the recurrence at the great Hamilton Palace sale of 1882 of so many of the lots which had figured in the 1823 catalogue.

These recurring objects can all be accepted as undoubted Beckford purchases. When grouped together, it is surprising how much the list resembles the Strawberry Hill sale of 1842, even though Beckford affected to despise Walpole's taste even though the gulf in time between the two collections could be as great as eighty years in some instances. One of the most obvious points of contact was the marble-inlaid Renaissance furniture, Beckford's examples, however, being much dearer than Walpole's and presumably a great deal richer. A vast architectural cabinet, inlaid in lapis, jasper, and agate, made £572 10s, but it had cost Beckford £540 as recently as 1821, a purchase on the scale of the French Royal Family's disbursals in the days before the Revolution. Probably in the London of Beckford's youth, when that great tapestry was sold for a guinea and a half, the cabinet would have been bought-in at thirty pounds or less.

It should be noticed that, apart from the Empress Marie Louise's table of Egyptian marble, which was barely ten years old and which was sold in 1823 for £262 10s, the next most expensive piece of furniture was, albeit French and royal, in the taste of the Italian Renaissance. It was a great armoire made for Louis XV in the red tortoiseshell inlay, which had been invented in the previous century by Charles Boulle. The price was £236 5s. On the other hand, the rococo *Bureau du Roi Stanislas*, now in the Wallace Collection, was sold for £178 10s. It had been offered to Beckford in Paris in 1792 for £760. Nothing can illustrate better the change that had taken place in taste than the fact that the bureau, which may have cost £2,000 in its day, was allowed by Beckford and his son-in-law to depart in peace. It was bought in the 1860s by Lord Hertford for at least £4,000.

The objects that fetched the highest prices in the 1823 sale were mostly in a taste which is now thought vulgar. It is strange to find that Chinese "ruby-backed" egg-shell saucer-dishes in the most delicate style made from eight shillings to a guinea each. For the past sixty years these saucer-dishes have seldom fetched less than £400 to £500 a pair. Yet Beckford's huge and doubtless hideous pair of "mandarin" vases from Portugal were sold for £131 5s. Two mounted celadon bottles fetched only £2 15s, though nine years earlier Fogg, the china dealer, had asked Beckford 140 guineas for a pair. On the other hand, two

garish Imari garnitures, of which Beckford had a poor opinion, each of five urns and beakers, made £38 17s and £43 (see page 221).

The dearest objects, apart from pictures, were those that were inlaid with rare marbles or contrived out of crystal or precious stones. The dearest of all was a bowl, carved from a single mass of Hungarian topaz, allegedly made for Caterina Cornaro by the great Cellini, but in fact a work of the late sixteenth century on an enamelled stand, which with its forest of C-shaped scrolls could only be German and of the next century. Somewhat clumsy though perfectly epitomizing the newest fashion, it found a buyer at 600 guineas, but what a fuss was made. It was challenged by the fashionable silversmith, Kensington Lewis of St James Street, as no true topaz but a crystal. But what seems to have annoyed Mr Kensington Lewis was the fact that the "vase" had been twice bought-in at auction sales for £300, and that Beckford had acquired it from Baldock's shop in Bond Street within the previous five years for less than that sum (in fact £285). Apparently the author of *Vathek* was expected to have found his vase in the Halls of Eblis.[29]

Indignation at the cost of art seems frequently ludicrous when seen in the perspective of history. The Beckford topaz vase, once in the possession of the Rothschild family and now in the United States, must today be worth many thousands of pounds. What one has to realize is that the Fonthill sale swarmed with dealers, who had seen the finest rock crystal vases sold for five or six guineas—and that not much more than twenty years earlier. To find a true comparison, one must imagine some piece of silver plate which was sold for £30 during the Blitzes on London and for 3,000 guineas in 1963.

The best of Beckford's jade, crystal, and marble objects did not face the saleroom till 1882, when the 12th Duke of Hamilton put them into Christie's and the prices were appreciably higher (see pages 136–7), but typical objects in the Beckford taste at the Fonthill sale included Tippoo Sultan's jewelled jade hookah at 209 guineas, and the two boisterous ivory tankards in the Fiammingo style which had cost Beckford £497 in 1819. These he bought back at £294. Beckford could not resist over-carved objects in highly polished materials: a part at least of the gravamen of Hazlitt's charge remains sound. Had Beckford lived in the poverty of today's market, he would perforce have been a client for fussy Chinese spinach-jade brush-washers and screens at five or six thousand pounds each or Fabergé barley-sugar peasants at £8,000 a head.

[29] W. Whitley, *Art in England*, 1820–37, quoting *The Times*, 4 November 1823.

No man is wholly master of his own taste. The persistent disregard of elegance and true sensitivity was the age's rather than Beckford's. Craftsmanship in 1823 was going furiously downhill; ornamental accessories were already coming off the machine line. The age liked the things that avoided the indefinable touch and could still be reproduced. The words "engine-turned" now appeared in Christie's catalogues as a term of commendation. Beckford had withheld some of his more elegant favourites from the clutches of Farquhar, but he could not resist the pleasure of buying the rest back cheap. One marvels that he should have let the Chinese porcelain vase in a fourteenth-century mount go at all, even if he had the good fortune to buy it back at forty-four guineas (see page 191).

It is easy to see bad taste in a sale catalogue, which can convey no impression of the original ensemble. To picture the effect of the collections at Fonthill and Strawberry Hill, one must first imagine the contrast they would have made to the collections of the later nineteenth century with their serried ranks of much too similar objects. One must picture the effect of wholly unexpected, and slightly dotty, objects among all the richness and historic importance. For those were the days when collectors had no experts to fuss them. How pleasant to be conducted round the two great houses in their prime; to discover the Bellini *Agony in the Garden* and that great Japanese lacquer chest, the van Diemen marriage casket, among the immensely tall purple and yellow curtains of Fonthill; to watch the evening light from the meadows of Twickenham filtering through the Henry III window at Strawberry Hill (from Bexhill of all places) on to a Sèvres déjeuner and Cardinal Wolsey's hat.

Romantic Taste and the Victorian Age
1791–1895

1. The Collectors' Revolution, 1791–1861 — 2. From the Fonthill Sale to the Soltykoff Sale, 1823–61 — 3. Russians, Rothschilds, and Renaissance Art, 1861–95

1. *The Collectors' Revolution, 1791–1861*

The curious museum or *cabinet des curieux* of the eighteenth century died out with the growth of public museums as distinct from private collections. By the third quarter of the nineteenth century the man of taste was no longer impelled by sheer sense of duty to collect either dried plants, insects, or mineral formations. It was his works of art and not his curiosities which now began to resemble a public museum. Comparative collecting had arrived along with categories and catalogues. The model which the collector was expected to follow was intended to instruct, even if it instructed only himself.

Like all notions of popular education, the comparative museum of styles and periods was a child of the French Revolution, but its development, particularly in England, followed a course which the revolutionary fathers would not have predicted. They indeed turned the Royal collections at Louvre into a public gallery, but, as Louis Courajod was able to show eighty years later, the first intention had not been to instruct the masses, but to entertain them. In 1793, shortly before taking his own life, Jean-Marie Roland, the Minister for Interior, informed the new Inspectorate of the Louvre that the distinction of schools was of no importance, that comparison was sterile, and that a museum was a

parterre to be illuminated in the most brilliant colours in order that the entire world might enjoy it.[1]

Roland, who really understood social revolution, had anticipated *son et lumière*—a most far-seeing man. Courajod, however, rejoiced that the immense loot which came from Italy some years later had proved too much of a challenge to the fathers of the Revolution. They decided for the classified museum after all. But under the Terror and the Directoire the *Conservatoire* of the Louvre did their utmost to obstruct its creation. On one pretext or another, they endeavoured to prevent the confiscated treasures of the Church and the Royal Family from entering the Louvre. Monuments of tyranny and feudalism were to be destroyed unless a little could be made without much effort by finding a buyer for the least compromising of them.

At this singularly unpropitious moment a dump of unwanted and condemned objects was saved by the action of a single man, and turned into the first public museum, which was neither a picture gallery, nor a curiosity cabinet, nor an antiquarium of ancient marbles, but a true, comparative museum of the country's historic past. The name of this man was Alexandre Lenoir. He was a young painter in the approved neo-classic taste of Jacques Louis David, but it was a time when a painter had to find some other way of making a living. In 1791 there began the dismantlement of the church monuments in the Paris region. Lenoir was put in charge of a reception depot, but he was not allowed to know what fate was intended for the objects under his care; not that there could be much doubt, for when Lenoir's staff needed fuel for the winter, he was told by the appropriate commissioners to burn a selection of mediaeval wooden statues. Nevertheless, by claiming them for his depot in the convent of the Petits Augustins, Lenoir was able to prevent the immediate destruction of many shrines and tombs. Precious metals and even bronze he was unable to save. They went straight to the foundries. After the Reign of Terror, the Government of the Directoire began to look indulgently on Lenoir's activities. The nation was at war. Patriotism had to be encouraged and the triumphs of earlier dynasties of kings could safely be commemorated. In October 1795, when the depot was recognized as a museum of French monuments, Lenoir had collected some 500 pieces of sculpture, including the tombs of Louis XII, Francis I, and Henri II. The effigy of Cardinal Richelieu had cost him a bayonet wound in the shoulder in a tussle with patriots of the National Guard.

[1] *Alexandre Lenoir, son journal et le Musée des Monuments Français*, Vol. I, page clxxii.

In 1812, when the *Grande Armée* perished in Russia, Lenoir published his three-volume catalogue. The Musée des Monuments Français was then the only museum of its kind in the world, and his catalogue the model for all such works of instruction for a long time to come. But the Petits Augustins was very like a French museum of the present day, since it was only open between the hours of ten and two on Thursdays and between ten and four on Sundays (three o'clock in winter). In 1814 many of the contents were damaged by a fire. In 1816, after the Bourbon restoration, they were dispersed, some of them to their original homes.

Lenoir used great ingenuity in transforming into a museum of art history a collection which the authorities had intended as a sort of Pantheon, commemorating individuals of fame and merit. Some objects he saved by disguising them as fictitious tombs. Thus a tomb was created from the kneeling figure of Diane de Poitiers, part of a fountain from Anet. But no *prie-dieu* could be found to turn the figure of Diane into a funeral effigy, so Lenoir substituted the statue of a dog as an emblem of fidelity.[2]

In the revolutionary period it was permissible to glorify heroes or simply the godlike body of man. It was more difficult to persuade the powers of the day that the arts of pure design were also worthy of preservation. Even after the first revolutionary fervour had subsided, Lenoir had to use circumspect language. Writing in *Le Journal des Arts* of the 5th of Fructidor in the year VII (1799), he apologized for the fact that such arts had ever existed:

L'objet principal que l'homme s'est proposé dans les arts dependant du dessin, c'est l'homme; cependant il a quelquefois negligé cette étude profonde et sérieuse pour s'occuper des arts relatifs à la décoration des palais et des temples.

Yet there were all those reliquaries and ritual vessels drifting about France, doomed to wanton destruction by the ignorant if something was not done to protect them. One way was to display them as objects of ridicule. There was an alabaster jar, perhaps an Egyptian canopic vase, which had been venerated as the miraculous wine-jar of the marriage feast of Cana. It would have been a miracle in any age, Lenoir declared in his catalogue, to have poured wine from a jar which required two men to lift it.[3] Under the protection of that wise-crack,

[2] So described in Vol. I of the 1812 edition of the *Catalogue of the Musée des Monuments Français*.

[3] *Ibid.* Vol. I.

the jar was suffered to survive. The Baron Vivant-Denon went even further. Although he was aide-de-camp to the *farouche* David, he had acquired a most suspect object, a thirteenth-century Limoges chasse of unusual dimensions, the former repository of the bones of a saint. Vivant-Denon filled it with secular relics suitable for the Age of Reason, bones from the reputed bodies of Le Cid, Abelard and Heloise, Molière, and La Fontaine, a drop of blood from Napoleon and part of the shroud of Turenne. This story is not just one of those chestnuts popular with writers on art. It comes from the catalogue of Vivant-Denon's decease sale of 1826.

As the climate became more tolerant towards objects of mere instruction, Lenoir was able to persuade the authorities to allow a very few pounds to be spent on works of art of a more portable kind which were not in the taste of the *ancien régime*. Thus, in 1805 he acquired a series of Limoges enamel plaques by Pierre Courteys, depicting the attributes of the gods. Like many of his acquisitions, they are now in the Musée Cluny. No less than 5ft high, they are traditionally supposed to have been made in 1559 as part of a facing for the Château de Madrid, which had been begun by Francis I. Since these were authentic monuments of the age of Diane de Poitiers, Lenoir used them to decorate that extraordinary synthetic tomb. It was rather like planting a few geraniums on a grave.

But Lenoir, who often had his tongue in his cheek, could never have imagined the snowballing force of the simple association of ideas that he had created. Because of the loves of Henry II and the fair Diane, not only late and repetitious Limoges enamels, but also the faience of the Bernard Palissy factory and of St Porchaire, together with sixteenth-century French furniture and stone chimney-pieces, became the prizes of the entire European collecting world. That provincial backwater, the Italianizing French school of the middle sixteenth century, for a time eclipsed the Italian Renaissance itself on the art market. In the 1870s, when the last of those collectors who had profited from the cheaply sold sequestered treasures of the Revolution had all died, the prices for this sort of art became outrageous. Even in the 1920s they were still too high. While other countries in the nineteenth century, England, Germany, and the Netherlands, were not slow in developing their own regional markets, French patriotic taste ruled them all, just as it ruled Russia and America, where regional art was still undiscovered. In 1884 wagon-loads of Renaissance mantelpieces and sideboards went to Russia with the Basilevski Collection. At Christie's in the same year French sixteenth-century faience and enamels became a saleroom epic.

In 1837, when Lenoir's private collection was sold, there were at least half a dozen French imitators of his methods. The ravaging of Italy during the Napoleonic Wars had expanded the original nationalist repertory without supplanting it. One such collection, formed by Revoil, another breakaway pupil of Jacques Louis David, had become national property as early as 1828. Unable to decide whether to classify the collection by period or by material, the Louvre authorities scattered the faience and enamels at random among the old master paintings and the classical antiquities, thereby inaugurating a century and a third of chaos.

The French example spread. Between 1830 and 1832 the Berlin Kunstkammer and the Vienna Belvedere Palace, the Dresden *grüne Gewölbe* and the Munich royal collections became public musuems. In 1843 the French Government bought the Hôtel de Cluny, where Edmond du Sommerard had accumulated a remarkable mediaeval collection, on which he had worked since 1807, when he retired from the Army of Italy to become a Treasury official. Du Sommerard had been inspired by the wholesale ransacking of Italy for art treasures. Under the direction of Vivant-Denon, this activity had been transformed from the ancient notion of dynastic pillage to the rarefied French Revolution notion of pillage in aid of national instruction. Thanks to Vivant-Denon, a large number of Italian primitives reached Paris under this pretext, although in those days their rating as loot was so insignificant that they were not reclaimed, even after the defeat of Napoleon (see Vol. I, pages 119–20).

The disciple of du Sommerard and the owner of a mediaeval collection, which must have been even finer than the present Musée Cluny, was Debruge Dumenil. The achievement of this rather obscure man illustrates the continuity of the curious museum as we have seen it in the previous chapter, since as a merchant in the Far East, he had begun by collecting Oriental art (see page 190). He died in 1838 when 250 francs were still a lot of money for even the best of chasses, ivory diptychs, and carved retables. In 1847, when the heirs of Debruge Dumenil proposed selling an accumulation of 6,000 objects, the art historian Jules Labarte was commissioned to write a catalogue such as Walpole and Beckford had never known. It filled 850 pages. But the pick of the collection was sold *en bloc* after the bloodthirsty Paris rising of June 1848, when it was feared that the private ownership of property had no future in France. The purchaser, the millionaire Russian Prince, Peter Soltykoff, put this part of the Debruge Dumenil Collection into the Paris saleroom in 1861. There was now for the

first time open competition for mediaeval art at millionaire prices. Some of the prices were destined not to be equalled till the collecting days of Pierpont Morgan nearly half a century later. Some might barely be surpassed today, and the dearest lots were bought by the British Government.

We have proceeded from 1791 to 1861 in this briefest possible summary of the history of the comparative museum and the comparative art collector. Yet this is the first mention of England. For England was the last great nation to absorb the new attitude towards collecting. In 1844 Beckford died, still the greatest English collector and blissfully untouched by Continental theories. Apart from some of the curiosities inherited in 1753 from Sir Hans Sloane, the British Museum was still little more than an antiquarium, while the National Gallery in 1844 contained no pictures older than the sixteenth century. In the year 1848, when the dispersal of the Debruge Dumenil Collection began, English collecting was typified by the great Stowe sale—the sale of a giant collection largely in the romantic taste of the time but a collection from which the Middle Ages and the *Quattrocento* were conspicuously absent.

It is worth while casting a short glance at the Stowe Collection, the greater part of which had been formed by the second Duke of Buckingham and Chandos since the accession of Queen Victoria, and which had, in fact, ruined its owner. The sale lasted, like the biblical Flood, for forty days, and it realized, quite apart from the library, the unprecedented sum of £75,560. And the prices were in general high for that very insecure year, though the Duke had certainly paid more for almost every single object, including even Rembrandt's *Unmerciful Servant*, which was to cost Lord Hertford £2,300.

Christie's fully priced catalogue of the Stowe sale was reprinted in a large edition with much information concerning the bidding and some unspeakable illustrations. The transitional, somewhat makeshift nature of the collection emerges clearly enough from this well-known work.[4] Thus, French furniture and porcelain are almost as cheap as they had been at the Strawberry Hill sale in 1842; Renaissance and pseudo-Renaissance furniture is abundant and much dearer; late sixteenth-century silver, ivory, and enamelled jewellery are once again as dear as they were at the Fonthill sale of 1823, but the dearest objects of all, whether of silver or ormolu, are huge, vulgar, and quite new. In other respects, it is an inherited collection, formed strictly on late eighteenth-century lines, with a cabinet of natural curiosities, a gallery of classical

[4] *The Stowe Catalogue*, priced and annotated by Henry Rumsey Foster, London, 1848.

statuary and Greek vases, and a number of Oriental novelties, including some bits of Indian sculpture.

As to prices, pride of place went to the modern silver *surtout de table* by Robert Garrard, representing the *Death of Sir Bevil Grenville* (nearly 1,600oz of bullion metal) which went back to its maker at £828 18s 7d. If those terrible table sculptures after Scott's novels set the tone at Stowe, one should also notice the prices which were paid in 1848 for the most overloaded products of the north European Renaissance—for instance, £232 19s 8d for a silver ewer and dish by Vianen of Utrecht, £169 17s 4d for a pair of mounted nautilus shell cups, and £184 16s, which was paid by Alphonse de Rothschild for a purchase quite worthy of Disraeli's Sidonia, a grotesquely mounted bulbous ivory tankard. Then there was a fairly modern lifesize bronze copy of the *Laocoon*, which may have cost William Beckford £2,000 and which could still make £567, while two enormous gilt-bronze candelabra of the Regency period, towering 10ft high on drums of *bleu du roi* porcelain, fetched £246 15s. By contrast, two of Mme de Pompadour's candelabra of the finest *ciselure* were sold for £39 18s.

Imputations of bad taste, like moral judgements on history, are nowadays disapproved of by the academic Establishment, yet bad taste would certainly have been the verdict on Stowe between, say, the 1890s and 1940s. I am sure there are thesis-writers who are prepared to love the Robert Garrard silver *surtouts de table* and the pseudo-Cellini items, such as the solid silver nymph with the shell at £342 8s 6d. Historically, the important thing to notice is that in 1848 all this lushness had already a tremendous popular appeal. Whereas, in 1842, *The Times* noticed the sparse attendance at the Strawberry Hill sale, omnibuses were now hired to take the Cockneys out to Buckingham-shire. The Aubusson carpets were worn out day after day by these tourists, who were not put off by a catalogue costing fifteen shillings, though it gave only four people the right to view. Some of them may have belonged to that quite new class, the small collector, for whom the *Old Curiosity Shop* existed, and for whom, as Balzac had just noticed, the number of Paris *brocanteurs* had multiplied itself ten times in twenty years. But the real attraction of the journey to Stowe must have been its congenial *décor*. To a middle-class family, living among domestic gods that ranged from a sideboard straight out of Martin's *Belshazzar's Feast* to a papier-mâché work table imitating Chinese lacquer, it must have been reassuring to know what a duke could do.

The arbiters of taste in 1848 were not altogether happy about this matter. The English collectors' revolution was still some way off, but

its roots existed. Whereas that revolution had begun on the Continent fifty years earlier with the idea of patriotic art history as spread by Napoleon's armies, in England it was to begin from the utilitarian angle of improving the modern industrial arts. Art as an example to modern industry was a notion that was destined to govern the British Government's purchases of objets d'art till the end of the century. Strange to say, the very causes of the decline in modern decorative art in the 1840s namely the admiration and emulation of too many historic styles, were to be treated henceforward as the only possible remedy for the disease.

It was unfortunate that Members of Parliament, a class blissfully unaware of it today, should have been so conscious of the decline of decorative art or, as they then called it, the industrial arts. As early as 1835 there had been William Ewart's Select Committee of the House of Commons on Arts and Manufactures. Largely concerned with an examination of the affairs of that very ambiguous institution, the Royal Academy, the Select Committee ended by recommending the creation of a Government school of design, which was to be housed willy-nilly in the Royal Academy's old rooms at Somerset House. In the beginning the pupils had to give their word to the academicians not to become artists, but this profoundly wise and wholly admirable plan was abandoned, never to be resumed.

The industrial arts refused to respond to the rule of taste. The cure accentuated the disease still more after 1847, when, armed with a Royal Charter secured for them by the Prince Consort, the resurrected Society of Arts began its annual series of exhibitions of arts and manufactures. The dynamic force behind these exhibitions in London and the manufacturing towns was Henry Cole [1808–82], an official in the Records Office who painted in his spare time, and who designed a tea service for Mintons. As so often happens, an aesthete had crept from behind the carapace of a civil servant, and what can be more dangerous than that? The child of the marriage between State patronage and the worship of historic styles—Henry Cole's brain-child—was the Great Exhibition of 1851.

This tremendous debacle—which modern historians show an unaccountable disposition to praise—represented a very important watershed in the history of nineteenth-century taste. Before the Great Exhibition, the rule of taste meant the High Renaissance, with the early Renaissance and the Middle Ages not even a poor second. But within a few years of the Great Exhibition there were symptoms of revolt against the wedding-cake aesthetics of which it had been the expression, and of which there was no lack of critics. The frantic plunges into the

aestheticism of the Far East were not far away. But the Government's action in 1851 in opening its glass palace in Hyde Park to the products of the world had a still bigger impact on collectors' taste. In 1851 the basis of collecting on the Continent was still chauvinistic or else romantic rather than truly eclectic, as indeed it had been since the Napoleonic Wars. The Great Exhibition taught the museums of the Continent that *every* school of the past was an example for the industrial arts. And through the museums a new race of collectors, such as George Salting and Frederick Spitzer, acquired that stamp-collecting outlook, from which Walpole and Beckford had been so singularly free.

Although the future Victoria and Albert Museum started fully a generation late by Continental standards, French critics were obliged to admit, within ten years of the Great Exhibition, that the English were building up the best museum of applied arts in the world. Yet the origins had been extremely humble. As head of the Government School of Design at Somerset House, Henry Cole was allowed to spend £5,000 at the Great Exhibition on objects which, in the words of the 1835 Select Committee, "might extend the taste for art among the people, especially the manufacturing classes". There was no room for this collection, which was known as the Museum of Ornamental Art, at Somerset House, so Queen Victoria lent part of Marlborough House in order to give it a home. And there it remained till 1858, when a specially designed museum building was ready for it in the vast *Cité universitaire* at South Kensington, which had been built out of the unexpected profits of the Great Exhibition.

In the meantime, however, the scope of Marlborough House had widened. In 1852, under the advice of Richard Redgrave, the painter, the Bandinel Collection of pottery and porcelain was bought, while in 1854, on the same advice, the sum of £8,583 was spent on part of the Ralph Bernal Collection. In 1855, when the rest of Bernal's immense collection of mediaeval, Renaissance, and French eighteenth-century objets d'art came under Christie's hammer, the Government spent something like £20,000.[5] The driving force was now John Charles Robinson, who in 1847, as a struggling artist twenty-five years of age, had become the head of the first Government school of design in the Midlands. The product of a generation, when the keeper of the National Gallery could be both buying agent for the Government and an art dealer at the same time, J. C. Robinson was destined to become a figure of controversy. In 1869 he had to abandon the Museum which

[5] *Inventory of objects in the Art Division of the Museum at South Kensington,* Vol. I, 1852–61.

he had done so much to create, but he re-emerged in 1881 as the Keeper of the Queen's Pictures. Knighted by Queen Victoria, he lived past the age of ninety to the eve of the First World War, having bought the finest mediaeval and Renaissance objects that the nation owns today at prices which, to a market attuned to the presence of J. Pierpont Morgan, must have seemed like something out of a fairy story.

One of Robinson's first pioneering activities was in 1856, when he published the catalogue of a French collection of mediaeval and Renaissance art which had been formed in the 1830s and 1840s, the collection of Jules Soulages of Toulouse. He also persuaded the executors of Soulages's estate to deposit these treasures in London, and for the next nine years they were absorbed, bit by bit, into the new Museum. In the meantime a surplus, still available from the Great Exhibition profits, enabled Robinson to secure some of the best of the Debruge Dumenil treasures at the Soltykoff sale of 1861.

On this occasion Henri Darcel wrote in *Chronique des Arts* that he was convinced that the British Government had not been animated by the love of art in outbidding the Louvre for the *Eltenburg Reliquary* at £2,130. The British, being utilitarians, were preoccupied with manufacture. The British Government was only able to spend all this money on examples for the industrial arts because of the strong manufacturing interest. And that was where the French manufacturer was so weak. He left these matters to artists and collectors.

Darcel failed to mention the disadvantages. The Museum became a sample house, as it still is for the most part, for working artisans, arranged according to crafts and materials and not according to historic schools. Still worse, the Museum was obliged to encourage the manufacturers who imitated these samples. Despite the energy which Robinson displayed during the 1860s in mopping up the legacy of the past, when it could be had for very little money, the largest sums of all were spent by the Museum in order to acquire exemplary modern products. It was under the rule of J. C. Robinson that the Museum bought the fantastically priced modern furniture and chased metalwork described in the first chapter of this book (see page 13).

In the 1870s, when Robinson no longer controlled the purchases and when the profits of the Great Exhibition were exhausted, the lack of collectors' bequests began to be felt very seriously. It is surprising how few English collectors had followed even Beckford's hesitant example in probing the Middle Ages and the *Quattrocento*. In the formative 1820s and 1830s, the only English rival to du Sommerard and his

generation of French collectors had been the somewhat cosmopolitan Ralph Bernal, whose possessions were scattered in 1855. The great English collectors of mediaeval and Renaissance art began extremely late—Drury Fortnum and Hollingworth Magniac not till well into the 1840s, Wollaston Franks and Robinson himself in the 1850s, and George Salting in 1862.

The reason is not far to seek. During the wars with France and the incredibly cheap opportunities which they created, the travelling Englishman had been virtually debarred from the Continent, except for a brief let-up in 1801–3. In the enemy land of France, where the property of the Church had stayed intact till the Revolution, the wealth of these objects was still enormous, and most of it survived the wanton damage of looters and patriots. But as to buying such things at home, there was the hard fact that England had suffered not from one Reformation, but three. The iconophobia of Wycliff's followers had curbed the artistic genius of the country in the fourteenth century. The remains of religious art which escaped destruction under Henry VIII and Edward VI were not allowed to survive Cromwell.

And so in early Victorian times you could not hope to pick up a Romanesque jewelled book-cover, a chasse, or an ivory diptych in Wardour Street, as you could in the Faubourg St Honoré. Even such rare English survivors as the candlestick of Thomas de Pocé of Gloucester and the Bury St Edmunds whalebone Adoration plaque, had to be retrieved in 1861 from Prince Soltykoff in Paris. For the stay-at-home collector there was little to be had outside the native bric-à-brac of the eighteenth century. Consequently, the typical, ageing English collector of later Victorian times was to compare disadvantageously with his French opposite number.

Both, bless their hearts, were provincials, living remote from the great sales of Christie's and the Salle Drouot. The French collector would be surrounded with elegantly carved *boiseries*, torn out for firewood from neighbouring châteaux, and bought by his father for 100 francs assignats in the winter of the year IV. Looking rather like Clemenceau, and tended in old age by a bonne, straight out of a picture by Chardin, he would greet you in a skull-cap and a black silk jacket, lightly powdered with white dust from the woodworm in his walnut *meuble à deux corps*. He would have little Ritzy Sèvres to show you, but much worthy faïence of Moustiers, Rouen, and Nevers, the odd piece or two of maiolica perhaps and—yes—the missing leaf of a famous sixth-century consular diptych or the cover of a Carolingian Gospel book.

His English opposite number lived in the Midlands, a great lover of the lesser ceramic factories in one of which his father might have been employed. His appearance would be brisk, somewhat military and empire-building, designed, one felt, to refute the grave suspicion that he might be artistic. He would be far more addicted than his French counterpart to the acquisition of stamp-collector's items—the rare model, you know, with the mark scratched behind the rabbit's left ear. Salt-glaze teapots, Staffordshire figures, Toby jugs, the rarest of them stuck together with good, thick brown Seccotine, all would be hidden most effectively in his top-heavy glass cabinets. Wild-eyed and voluble, he would pronounce the names of Ralph and Enoch Wood with deep devotion, eventually dropping the surnames. But the consular diptych and the Carolingian book-cover—alas, no.

2. From the Fonthill Sale to the Soltykoff Sale, 1823–61

As we have seen in the previous chapter, the most marked advance in the value of objets d'art in the romantic taste—that is to say, of the late Renaissance—occurred at the end of the Napoleonic Wars. At Beckford's Fonthill sale of 1823 objects of ivory, silver-gilt, and carved crystal, as well as marble-inland furniture, could fetch prices in the region of 200 to 600 guineas. But there were odd disparities. In 1823 Beckford's Limoges enamel triptych, attributed to Nardon Penicaud, could make as much as forty guineas, but six years later in Paris you could still buy a Bernard Palissy oval dish—and they weren't faking such things in 1829—for twenty-five shillings.

As to objets d'art of the Middle Ages and *Quattrocento*, the moment simply had not arrived. In 1820 the six great fifteenth-century tapestries from the Painted Chamber at Westminster were bought by Mr Yarnald for £10.[6] In 1842 Horace Walpole's marble relief of Leonora d'Este made £6 15s 6d. In 1846, at the smartest of Paris sales, the early fifteenth-century pall-bearers of the tombs of the Dukes of Burgundy from Dijon were bought by the 11th Duke of Hamilton for about £10 apiece. Gothic tombs were doubtless too big for gentlemen's libraries, but in the 1840s of all decades one would have expected a better market for the smaller mediaeval objects. Yet in 1843 the Duke of Sussex's silver Romanesque bookbinding was exceptionally dear at £21 10s 6d. In Paris in 1846 the chasse of Philippe le Bel barely made £20. Ivory objects were only a little dearer. In 1846, however, the

[6] W. G. Thomson, *A History of Tapestry*, 1930.

Romanesque ivory *Chasse de St Ivet* was actually sold in Paris for £50 12s.

The turning-point, both for mediaeval art and the art of the Italian *Quattrocento*, seems to have been the year 1850, not because romantic enthusiasm, already strong, had become any stronger, but because in 1850 a generally depressed period for almost the entire art market was drawing to an end. In that year two Romanesque enamelled chasses were sold for as much as £80 each in London and Paris, but the most spectacular sale was that of Debruge Dumenil's marble bust of Beatrice d'Este attributed to Desiderio da Settignano. It was bought for the Louvre at £256.

This was a remarkable purchase, because in the 1840s even such events as Lord Dudley's purchase of the Fra Angelico *Last Judgement* from the Fesch Collection at £1,500 (see Vol. I, page 123), failed to arouse any interest in the contemporary fathers of Italian sculpture, whose bronzes and marbles still lay in ruined and neglected buildings for anyone to take away. The early nineteenth century failed signally to understand the significance of *Quattrocento* sculpture. Collectors expected the sleekness of neo-classical sculpture or the high degree of finish and anatomical comprehension of the past century. When they met the real thing, they saw chisel-marks in the marble and modellers' fingers in the bronze, and imagined that this could not conceivably be the finished product.

Of course, there were exceptions. In 1822 Sir George Beaumont was believed to have paid £1,500 in Rome for the Royal Academy's lovely unfinished roundel relief, unquestionably by Michelangelo and now believed to be worth two millions. But in 1830 Christie's hesitated to value it for probate at more than £600. Sir Thomas Lawrence's terracotta *modelle*, which he had attributed to Michelangelo, were sold after his death that year for prices ranging from fifteen to sixty guineas, but his alleged Donatello, a terracotta *St John*, for only twenty-four shillings. In 1835, on the other hand, highly finished bronzes reached Christie's through the dealer, James de Ville. They had been obtained in Italy by the commissioners Vivant-Denon and de la Grange during Napoleon's first campaign, under the impression that these were the acknowledged works of the masters. Apparently this impression persisted in 1835, for the best lots were withdrawn. For two supposed Donatello bronze groups of great size there was an offer of £1,166, for an alleged *Hercules and Omphale* by Michelangelo, £875, and for an alleged Cellini sculptured urn, £980.

It is not certain that the offers were genuine, since at the second de

Ville sale of 1846 a *Hercules and Omphale*, attributed to Michelangelo, was bought-in at no more than £45. The market for the big, showy bronzes at the 1846 sale showed all the signs of disillusionment, hardly anything exceeding sixty guineas. In that year, the pioneer collector, Eugène Piot, had to part temporarily with a whole collection of true *Quattrocento* sculpture in order to settle an £8 bill for his lodging in Florence.[7] Among the collection were the following: a Madonna in relief by Rossellino, a Child's Head by Donatello, the bust of Diotisalvi Neroni by Mino da Fiesole and three other fifteenth-century busts and reliefs. Most of these pieces fell into the hands of the younger Joseph Duveen in 1930 when he bought the Gustave Dreyfus collection for near on a million pounds. Diotisalvi Neroni, now in the Cloisters Museum, may have cost J. D. Rockefeller, Jnr., something like £100,000 in 1934.

But in 1848 Piot, having bought back the little collection, failed to tempt the Louvre with Diotisalvi Neroni at 1,500 francs, or £60, or with the Rossellino relief at the same price, and he was equally unsuccessful with the Verrocchio marble relief-head of Scipio at £150.[8] In 1859, under the much-criticized régime of the Baron de Neuwekerke, it was different. Scipio now cost the Louvre £500.

Yet what a humble affair was the first Debruge Dumenil sale of 1850, which released the upsurge of prices for early art! Comparing it with the £75,000 sale at Stowe two years earlier, one finds that it took twenty-four days to dispose of 2,061 lots, and that barely £20,000 were realized. A tremendous assembly of enamelled Renaissance jewels, fifty-three items, made only a little more than £1000, while a most elaborate baroque pearl pendant, attributed to Cellini himself, could be bought for £66 8s. The most expensive object was the early fifteenth-century *Pontifical of Jouvenel des Oursins* at £396. In 1850 it was perhaps the dearest work of mediaeval illuminations ever to have been sold, and today it is one of the greatest losses to French art. Having been resold to the Paris Hôtel de Ville at the Soltykoff sale of 1861 for £1,460, it perished in 1871, when the Hôtel de Ville was set on fire by the Communards.

Since he had lived much in the Far East, Debruge Dumenil collected the novelties which had attracted English collectors during the Napoleonic Wars and which only became a Parisian taste during the second half of the nineteenth century. So we find mediaeval Islamic metalwork, Mughal miniatures, Chinese jade, and cloisonné enamels

[7] Bonnaffé, *Etudes sur l'Art et la Curiosité*, 1902, page 180.
[8] *Ibid.*, page 184.

in the 1850 sale. But the mainstay of the collection was late Renaissance art, and even in this respect Debruge Dumenil had been exceedingly up to date. In the last year of his life he had bought a few examples of the newly discovered "Henri Deux ware" from the Château d'Oiron. Little though these fetched at his sale, a fine great sculptural flambeau of this truly extraordinary ware was sold in Paris later in the year 1850 for £196—as much as even the most fashionable Sèvres at that time.

Of the pioneering generation who had been inspired by Lenoir and Vivant-Denon, little outside the Soulages and Sauvageot collections remained in their owner's hands after the Debruge Dumenil sale of 1850. Yet no comparable collection specializing in mediaeval and Renaissance art had come on the market in England. But in 1855, when Ralph Bernal's collection reached Christie's, the sale easily surpassed Debruge Dumenil's. It lasted thirty-two days; it comprised 4,294 lots; it realized £63,000, and a very large part of it went to the creation of the present Victoria and Albert Museum and the British and Mediaeval Department of the British Museum. Yet this famous sale, which inaugurated a new English collecting era, contained few revolutionary prices, except in the case of Bernal's Sèvres porcelain and Maiolica. Many of the prices, particularly for Renaissance silver, were still typical of the very static condition of the market between the 1820s and 1840s, when Bernal had done his collecting.

Bernal had certainly anticipated that mid-nineteenth-century notion of the museum as a repository of design and instruction. He owned scarcely any sculpture in the round, and it was said that he had bought his 360 pictures, mostly indifferent portraits (though there were two El Grecos among them), as illustrations of costume. Yet it does not seem that Bernal had intended his collection to become a public museum or that he was interested in the improvement of the industrial arts, though in 1835 he had been Chairman of the House of Commons Ways and Means Committee. There is some suggestion that, despite his liberal politics, Bernal disliked this movement. His own son, Captain Bernal Osborn, MP, was a vigorous opponent of the Great Exhibition, and in 1850 the *Art Journal* complained because Bernal had not been invited to join the Exhibition executive.

Ralph Bernal was born in London in 1786. His father, a prosperous West India merchant and a member of the London Portuguese Jewish community, had quarrelled that year with the elders of the Synagogue. Ralph Bernal was consequently baptized in the Church of England. In the manner of Disraeli, he studied at Cambridge, was called to the Bar, and became a Member of Parliament. One of his granddaughters

married the Duke of St Albans. The story seems to have the ring of wealth about it, but Bernal was neither a Rothschild nor a Beckford and his collecting was only a modest second interest. Between the years 1818 and 1852 he spent £66,000 in fighting elections, but his collection probably cost him less than £20,000, in spite of his extravagant addiction to Sèvres porcelain. With Lady Charlotte Schreiber and *le Cousin Pons*, Bernal ranks among the great pioneers of bargain-hunting.

As in the case of the Stowe sale, a fully priced and illustrated catalogue was reprinted, with the added merit of some very informative comments by Henry Bohn, the porcelain collector and publisher of the Victorian schoolboys' crib.[9] Unfortunately, Christie's catalogue entries, like the illustrations, were designed, in the manner of the day, to tell as little as possible. Nowadays such a collection would be split up over several years into eighteen or twenty separately organized sales, each with a bulky catalogue containing twenty or thirty pages of photographs. And the total might be not £63,000 but several millions, even when allowing for certain Sèvres porcelain lots that may not have gone up at all.

There were no less than 254 lots of Sèvres porcelain, but of maiolica there were 374, out of which Marlborough House bought 125 and the British Museum sixty-five. Bernal's somewhat excessive cult of maiolica emulated the contemporary French collectors—Soulages and Sauvageot in particular. But, as we have seen, it had been a native English taste throughout the eighteenth century, though a very cheap one. At the Strawberry Hill and Stowe sales in the 1840s prices were higher than in Paris, but all previous records for maiolica were more than doubled at the Bernal sale when that great collector of Italian *Quattrocento* paintings, Alexander Barker, gave £420 for a disquieting pair of late sixteenth-century Urbino ewers, heavily masked and voluted, in what was then the popular taste. Barker had spent less money than that on what are now the National Gallery's Botticellis (see Vol. I, pages 127–8).

Alongside this fashionable purchase, it may be noticed that in 1855 the future Victoria and Albert Museum had to give as much as £60 for a sober Caffaggiolo pitcher without any pictorial subject. Bernal's taste had even extended to the fifteenth century, from which there were perhaps a dozen specimens. A 20in Florence dish of about the year 1450 cost Marlborough House £6 5s. It is not the finest dish of this class, but the type is so rare that it would certainly command

[9] *A guide to the knowledge of Pottery, Porcelain, etc.*, comprising an illustrated catalogue of the Bernal Collection, 1857.

several thousands today. So too would the lovely Faenza dish of 1480, inscribed O *quanta crudelta*, which cost the museum £2 5s.

One may notice two other examples from this overpowering collection of maiolica. (Heaven knows how Bernal displayed 374 pieces, all orange and green!) The first, which cost Marlborough House £120, is now attributed to the Caffaggiolo factory and the year 1510 more or less.[10] It had been bought-in at the Stowe sale in 1848 and sold privately to Bernal for £5. The subject depicts a maiolica painter making the portrait of a young couple. Unable to resist the *schwärmerei* of the 1840s, Bernal had decided that the couple were Raphael and La Fornarina (even Turner had painted that), and that the dish was by the hand of Raphael himself. Did this influence Henry Cole in paying the very unusual price of £120? Apparently not, for he inventoried it simply as "a maiolica painter in his studio, painting a plate in the presence of two persons of distinction"—or was that only Henry Cole's delicacy?

The second piece with an interesting history was a Gubbio lustre plate after an engraving by Cristofero Robetta, known as the *Allegory of Envy*. Because of its close resemblance to the tremendously imitated *Three Graces* of Raphael, on which the Earl of Dudley had recently spent several thousands of pounds, Henry Cole had to go as high as 137 guineas. The Museum board refused to ratify the purchase and the dish found its way to Paris, where two years later it was auctioned for £420. In 1861 it was bought by Andrew Fountaine from the dealer Roussel for £480. In 1884 it was back at Christie's, where it was bought for George Salting at £819 and in 1910 it was finally left to the Museum, which should have had it in 1855.[10a]

In this way the so-called *Three Graces* dish multiplied its value nearly six times between 1855 and 1889. And yet Joseph Marryat, an indispensable guide to the collecting of this period, listed in 1868 a number of falls in the price of maiolica since the Bernal sale, including his own acquisitions.[11] He blamed the large grant of purchase from the Government for forcing up the bidding. The high prices he thought, had also been due to Bernal's sound reputation as a buyer, since the forgery of maiolica had already become an alarming Italian industry.

A profusion of objects, smothered with frogs and lizards, had appeared at the Great Exhibition in 1851, commemorating the fact

[10] Bernard Rackham, *Catalogue of Italian Maiolica*, 1940, Vol. I, page 107 and Plate 51, No. 307.
[10a] *Ibid.*, pages 226–7, Plate 106, No. 674.
[11] Joseph Marryat, *Porcelain and Pottery*, page 99, 1868.

that it was already possible to spend well over £60 on a Bernard Palissy dish. One of these reptile-infested dishes now went to Gustave de Rothschild for no less than £162 15s, though it had been smashed to pieces and bought by Bernal in that state for £4. Henry Bohn commented as follows:

> These matters are better understood, and the day has paassed when rarities of surpassing interest might be purchased for trifling sums.

Whether that day has passed even in 1963, many people may take leave to doubt. But there is no doubt at all that this smashed object would not make £162 15s in gold sovereigns in 1963, or even fifty paper pounds. But Bohn knew his market. Barely four years later, a Palissy dish was sold in Paris for £232, nearly as much as the £267 which the British Museum paid at the Bernal sale for the ninth-century crystal mirror of King Lothair, which Bernal had bought at Pratt's shop in Bond Street for £10. To value the crystal mirror today one would probably have to consider £200,000 as a bedrock figure (see page 17). It is an extreme example of changed aesthetic values, and yet Palissy ware was destined, within the next thirty years, to multiply its value more than ten times over.

The incongruous relationship of prices at the Bernal sale is not really difficult to understand. The French High Renaissance was a fashionable market with half a century's history behind it in 1855, whereas it was not till 1861 that the art of the earlier Middle Ages, of which the crystal mirror of King Lothair was such a stupendous example, began truly to attract the interest of the up-to-date sale-watchers.

It was well in keeping with the standards of 1855 that the 11th Duke of Hamilton should pay £232 10s for two rather crude Tudor brass-enamelled flower vases which figure in the portrait of Sir Thomas More at Hampton Court. For a little more than a quarter of this price—namely, £88—the British Museum secured the early fifteenth-century reliquary of Philippe le Bon. It had trebled its price since 1846 and, next to the famous crystal, it was the dearest of Bernal's mediaeval objects. But the Age of Faith was still a literary concept and not for the common man, whom Ruskin perceived to have become even more common. In the year 1855 mediaeval objets d'art and primitive paintings tended to be bought by pale-faced younger sons who had entered the Church, or by a few professional political romantics from both extremes, who foreshadowed William Morris. It is significant that some of the best of Bernal's mediaeval treasures, including a thirteenth-century enamelled brass chasse which depicted the murder of St Thomas à Becket (at

£28 17s 6d), were bought by Colonel Charles Sibthorp, the ultra-conservative Member for Lincoln and adversary of the Great Exhibition, who died in the following year. Popular history books, based on the goodness and inevitability of mechanical progress, have made a silly man out of Colonel Sibthorp, who preferred the Middle Ages to 1851, yet Don Quixote among his windmills is still the most sympathetic character in the book.

In marked contrast were the prices paid for Bernal's Limoges enamels, of which there were 109 lots. Limoges had now reached the Rothschild market. Thus the Baron Gustave de Rothschild gave 400 guineas for a somewhat outsize portrait plaque, 18in by 12in, not, it is true, of Diane de Poitiers, but at any rate of Catherine de Medici. A complete casket made £252, but this was the fastest advancing market of all. Five years earlier such a casket might have failed to make £50, and five years later it could make over £1,000. And twenty-nine years later, when forgeries already abounded, the same Gustave de Rothschild bought a Limoges oval dish at Christie's for 7,000 guineas and a commission.

Nowadays the highest prices for Limoges enamels are paid for the late fifteenth-century pieces which are painted in the style of the illuminators of manuscripts, and in a much less depressing colour scheme than those middle and late sixteenth-century pieces which so delighted the Victorians and Edwardians. Apart from the excessive romantic cult of the age of *Henri and Diane* (though many of the enamels were a generation or two later), there was not much to be said aesthetically for these imitative and repetitive products. If they were not copied directly from well-known Italian engravings or from French portrait paintings, they were cannibalized from almost everywhere. Yet the names of the plodding Limoges craftsmen were sorted out by the experts with the greatest care—the Penicauds, the Reymonds, the Didiers, the Courts, and the Courteys—names of dynasties of skilled hands rather than of artists, till we come to the tinselly Suzanne Court, of whom Dr Johnson might have said: "It is not done well; but you are surprised that it is done at all."[12]

One thing must not be forgotten. The rediscovered Limoges enamels were first put into the public auction rooms in noticeable quantities at a time when all old master paintings were habitually soupy-brown. There was therefore much merit in *la peinture imperméable*. Those ewers, dishes, tazzas, plaques, and caskets might flake a bit in places, but they never lost their somewhat sublunar colour or their glossiness. It took a

[12] "On a Woman Preaching," Boswell's *Life*, 31 July 1763.

Hazlitt to protest against "polishing the surface of art", and we have long forgotten how deeply that polishing was desired. Two or three years ago there was a competent miniature enamel copy of Titian's *Bacchus and Ariadne*, about 18in long, sitting in a London dealer's window. This copy had been sold by its maker, Henry Bone, RA, in 1825 to a Mr Bowles for £2,310, which was not a great deal less than Lord Kinnaird had paid for the original Titian picture in 1806.[13]

I cannot leave the Bernal sale without returning to the subject of armour, that highly specialized and scholarly form of collecting which causes so few eyes to glitter nowadays. At the time of the Bernal sale, armour had already been part of the standard wealthy *décor* for a whole generation. But except in Bernal's own case, armour did not yet appeal to the self-made or ancestorless man, who was beginning to command the largest purse. This may explain why, in spite of Bernal's recognized good judgement, his armour fetched no more than it might have done in 1842 or even 1838. The dearest lot was an Italian cap-à-pie suit of about the year 1530, which cost Lord Londesbrough £315 and which was destined to keep company with Landseer's *Monarch of the Glen*. A German suit of 1510 was sold for £157 10s and a Spanish suit of 1550–60 for £102 18s. But among the 444 lots of armour which it took Christie's four days to sell there were fifteenth-century swords at a pound or two each. A swept-hilt sixteenth-century rapier, which fetched £7 10s, was sold in 1910 for £1,575. A French "bastard" sword of about the year 1470 was sold for six guineas, but in 1922 it was destined to make saleroom history at £3,097 10s. The late Renaissance emphasis on richly decorated surfaces, rather than on fine steel, intended for hard knocks, was characteristic, not only of the Bernal sale, but of armour sales for at least a generation to come. The hunt for fifteenth-century armour and earlier, for armour that might have been worn in battle, belongs to the pith helmeted, empire-building 1880s.

To appreciate this taste of the romantic period one must realize that in the beginning it had followed strictly Renaissance lines. A collection of armour was almost a wardrobe, and there might just conceivably be occasions when a gentleman could wear it. In 1833 the rhetorical Mr Robins had sold "lot 100. A tilting suit, used by the King's Champion at the Coronation of George IV and by a young gentleman at the fancy dress ball given by Lady Hyde Parker."[14] At that curious occasion,

[13] Wilfred Whitten in *Nollekens and His Times*, 1930 edition, Vol. II, page 224n.
[14] F. H. Cripps-Day, *A Record of Armour Sales, 1881–1924*, London, 1925, page lix.

Lord Eglinton's Tournament of 1839, most of the suits were supplied by that somewhat dangerous assembler of odds-and-ends, William Pratt, and some of them, including a suit worn by the future Emperor Napoleon III, Pratt later resold. A suit worn at the Eglinton Tournament by the second Earl of Craven was sold in 1922 with the unusual observation that it had been worn by another Earl of Craven at the Earl's Court Shakespeare Triumph of 1912. And there was the Baron de Cosson, who was reputed in 1885 to have gone to the Quat's Arts ball in one of his famous fluted Maximilian suits.

It was not a common practice in 1855 to wear one's armour, but there still existed an implication that one could show off a highly decorated suit that way. The learned specialist who might give £1,000 for a single enamelled fifteenth-century spur was a long way off. And still further off were the days when man was so little glorified that armour was thought dreary, and chimpanzee paintings commanded a price. The Victorian armour fever was a true return to the values of the Renaissance, when man had been accepted without question as the highest achievement of creation, when the finest ironmongery could only be intended to clothe his person, and the finest cutlery to carve it up.

For some of the types of art that he collected, Bernal's sale soon became a legend of cheapness. The 1850s were the decade in which Eastlake acquired the finest Italian primitives for the National Gallery and J. C. Robinson the finest *Quattrocento* sculpture for the Victoria and Albert. It was the decade of the Pre-Raphaelites in England and the Post-Delacroix school in France, exaggerated historical cults which could not fail to raise the price of early European art. Samuel Rogers's Romanesque enamelled diptych at £251 in 1856, the Earl of Shrewsbury's triptych at £450 in 1858, a French fourteenth-century ivory polyptych bought by the Victoria and Albert Museum in the same year for £350—these were prices that left Bernal's treasures far behind. But the most impressive year was 1861, which saw the Soltykoff sale and the dispersal of the Campana Collection.

A very remarkable man, this ennobled Marchese Campana. Since the 1830s he had directed the Roman Monte di Pietá, the public pawnshop of the Papal Government. To a collection of 3,800 Greek vases, 1,900 terracotta figures, 1,600 ancient pieces of jewellery, and everything else in proportion, the Marchese began in the 1850s to add paintings and sculptures of the fifteenth century—all this with a very good eye. In 1857 it was discovered that he had appropriated the entire funds of the Monte di Pietá in order to finance more than a quarter of

a century's collecting. The Marchese was condemned to the galleys, but pardoned in 1859, dying in Rome at a great age in 1880.[15] In the meantime the Government of Pio Nono tried to recover the missing money by selling the collection, and eventually succeeded in getting about £207,000. In 1861 the sum of £207,000 was the largest ever to have been realized by a single collection. It was more than treble the total of the Bernal sale, and more than double the King of Holland's sale in 1850. Napoleon III spent £175,000, most of it on antiquities, the rest on *Quattrocento* paintings, of which the Louvre had received virtually nothing since the days of Napoleon I and Vivant-Denon. The Victoria and Albert bought the Italian sculpture for £5,930; the Russian Government paid £26,000 for 582 Greek vases and some bronzes.

The British share was small, but it included one of the greatest masterpieces of the early Renaissance—Donatello's shallow marble relief of the body of Christ, supported by angels in the sepulchre. The price, £1,000, was truly historical, but it is amazing what the Museum could get for £100 in 1861 in the way of original terracottas and glazed Della Robbia groups. It is also worthy of note that one of Campana's terracotta busts, attributed to Donatello, was a forgery, an early arrival among an illustrious series which were to find their way into the great national museums before the century was out.

The Soltykoff sale was less majestic at £72,000, but there were only 1,100 lots as against the 4,294 of the Bernal sale, which had made £63,000. While this meant an impressive advance in values, it was nevertheless a sale that showed no profit, since the collection had been bought at the last moment for only a little less by Achille Seillière, a Government contractor. Seillière bought back many of the lots for his own collection, which was sold in 1890.

The Victoria and Albert Museum spent a second sum of £6,000. During the sale the Salle Drouot, not yet the rough and tumble that it was to become in the 1880s, was filled with fashionable people, and Henri Darcel noted that mediaeval art was now the mode. The huge *Eltenburg Reliquary* cost the Victoria and Albert Museum £2,130. A mass of barbaric splendour, combining copper-gilt, cloisonné enamels and ivory, this outstanding achievement of the Rhineland craftsmen of the twelfth century might not have made £200 six years earlier at the Bernal sale. And yet today one would say that the Museum bought it very cheaply, even when the figure is multiplied by at least six to meet the purchasing power of modern money.

[15] The best account is in Professor A. Michaelis, *A Century of Archaeological Discoveries*, 1908, pages 72–6.

It was thought even more remarkable that the Louvre should have spent £1,208 against this formidable competition on a single French thirteenth-century ivory group of Christ crowning the Virgin. It is, of course, a lovely and unique work, an object in a quite different class from the ivory triptychs, caskets, and mirror-cases which fourteenth-century France had produced in enormous quantities and which nineteenth-century France was beginning to imitate with fair success—so much so that a Soltykoff ivory, sold in 1861 for £300, might not have made any more seventy years later.

It seems astonishing that by spending not much more—namely, £422—one could have bought in 1861 the exciting ivory diptych of the Consul Gennadius Orestes, dated 530 A.D.; that for no more than £218 the Victoria and Albert Museum acquired the unique twelfth-century English whalebone plaque of the *Adoration*. But the discrepancy between the high price of the over-finished fourteenth-century product and the low price of unique early monuments was to continue right into the present century. Writing in the year 1905, Alfred Maskell[16] remarked that there were less than fifty Consular Diptychs, fragmentary or complete in the world, that the number known had probably not increased since the subject was first studied in 1759, and that, without exception they were preserved in Museums and Cathedral Treasuries. The arrival on the market of an entirely newly-discovered diptych would, therefore, be "an interesting matter, in more senses than one, for speculation". In 1905 Maskell was probably thinking in terms of the £3,800 *Vierge de Boubon*, but today the £422 diptych of Gennadius Orestes might find a museum home at £100,000 at the very least.

Far different would be the fate of the High Renaissance objects which had been among the dearest at the Soltykoff sale in 1861. Would a modern American museum be prepared to give even as much for that top-heavy Milanese toilet table and mirror of damascened iron, for which the Victoria and Albert paid £1,220? The much more elegant chess table, which was to reach them in 1885, cost the Duke of Hamilton £800. James de Rothschild paid £1,196 and a commission for a pair of Limoges enamel flambeaux, while a single Limoges casket by Martin Didier achieved the historic price of £1,120. But we are only at the beginning of the Limoges frenzy. Perhaps the most striking advance of all was in enamelled Venetian glass of the fifteenth century, which Debruge Dumenil had absorbed in surprising quantities. The highest price in the 1850 sale had been £13 10s, but in 1861 one of the still numerous survivors went to England for £236.

[16] *The Connoisseur's Library: Ivories*, page 70.

3. *Russians, Rothschilds, and Renaissance Art,* 1861–95

Throughout the 1860s and earlier 1870s the Victoria and Albert Museum was still the greatest buyer of mediaeval objects and *Quattrocento* sculpture. But the level of prices of the Soltykoff and Campana dispersals was no more than maintained during those years. A glance at my sales analysis will show what incredibly famous treasures of Byzantine and early Christian ivory could be had in the 1860s for 400 guineas each. But soon after 1870 this market became much less well supplied, remaining so till 1893, when the Spitzer dispersal paved the way for a new wave of competition between the German museums and J. Pierpont Morgan. While the Spitzer Collection was still under one roof, there could not be much else of the same kind and quality. Except for the fine, costly reliquaries of the two Castellani sales of 1884 and the illuminated manuscripts of the three great Firmin Didot sales of 1878–81, the mediaeval market, which had looked so promising, lost its momentum. Interest shifted back to the Renaissance, and particularly to the French Renaissance. This was the paradoxical result of the capture of the French Emperor and the occupation by the Prussians in 1871 of a large part of France.

At first these disasters had produced far different symptoms. The troubles of the Commune in 1871 induced the Comte de Neuwekerke, Napoleon III's Superintendant of Fine Arts, to sell the whole of his collection of armour and French Renaissance furniture and objets d'art to Sir Richard Wallace. In 1852 Neuwekerke had been responsible for the wonder of the age, the Louvre's purchase of the Murillo *Immaculate Conception* for £24,600. He had also landed the Louvre with those expensive forgeries, the busts of Benvieni and Philippo Strozzi. By the end of 1871 Paris had been drained of the Neuwekerke Collection, the Carrand collection and much of the combined collections of Sir Richard Wallace and the Marquess of Hertford. This exodus to Florence and London looked like the drop curtain of the art fever of the Second Empire.

But the Salle Drouot reopened in the winter of 1871, when the smuts and dust still drifted round the burnt-out shells of the Tuileries and the Hôtel de Ville. Paris was again the bazaar of Europe. The editorial of *Chronique des Arts* declared in the self-pitying mood of the day that here at least was something the Prussians could not take away. The Paris dealers now made their greatest effort to sell all that was in the patriotic romantic taste. And to that taste the expatriate Englishmen,

Russians, and Americans remained loyal. The craze for the French Renaissance in the 1870s and 1880s, following the greatest political and military collapse the nation had ever known, had something in common with the craze for the French Impressionist painters in the 1950s, which followed a still greater collapse.

A tremendous leap forward of prices for everything in the French taste had taken place a few weeks before the outbreak of that catastrophic war. The last event of the carefree Paris season of 1870 had been the sale of the San Donato Collection. The name San Donato dominates mid-Victorian collecting, but in fact there were at least five sales under this name between 1863 and 1884. San Donato was a villa near Florence where Prince Anatol Demidoff kept his omnivorous collection. He died in the course of the 1870 sale, whereupon his nephew, Prince Paul Demidoff, started another collection, which was sold in Florence in 1880. The Demidoffs bought even more lavishly than Soltykoff and in the 1870 sale there were absolute record prices for every kind of art. The Earl of Dudley paid £10,200 for the remains of the Cardinal de Rohan's Sèvres dinner service. The sum of £2,440 was bid for a crystal lustre and £1,560 for a pair of Chinese fish bowls in French mounts. As to armour, the £6,800 damascened shield by George de Gys, which was bought by Ferdinand de Rothschild, had multiplied its value precisely seven times in seven years, and twenty times in twenty-eight years.[17] A sword which was reputed to be of the thirteenth century and which might have made £5 at the Bernal sale was bought by Basilevski for £800, while a pair of wheel-lock pistols made £708. Among the Renaissance furniture from San Donato, £1,280 were paid for a most unattractive inlaid and damasceneb mirror-frame of the early seventeenth century. Florentine ebony and ivory-inlaid cabinets that inspire no lyrics today were going for £700 and £800.

The pioneer collectors of French Renaissance art, who had followed the lead of Alexandre Lenoir, had died by 1870. The dispersal of their collections gave the auction rooms new glamour. In 1875 the Couvreur sale showed that French sixteenth-century furniture could fetch as much as the heavily-inlaid Italian pieces which appealed to the Byzantine atavism of Soltykoff and Demidoff. About this time the new Russian star in the firmament, Count Basilevski, was reputed to have paid Carrand of Lyon no less than £4,000 for a carved walnut *meuble à deux corps*. But in 1884, when it sailed for Russia, the meuble was believed to have been valued at £10,000.

[17] Now Waddesdon Bequest, British Museum.

In those days the chief purveyor of this sort of furniture and carving was Frederick Spitzer and the chief rival to Basilevski was the German-born Maurice de Hirsch. With these larger fishes in view, a syndicate of dealers hit on the notion of bringing an entire Renaissance *château* to Paris and selling it in lots. For even at the end of the previous century Alexandre Lenoir had been able to save the triumphal gate of Diane de Poitiers by transporting it forty miles from Anet to Paris.

But the Château de Montal, built in 1527–34, was nearly four hundred miles away in Gascony. For the time being the speculators had to be content with the grand staircase and part of the *cour d'honneur*. And even that required a train half as long again as a normal train. Pulled by two canary-coloured engines of the old Orleans Company, straight out of *La Bête humaine*, it chugged across a landscape that was already beginning to look Impressionist rather than Barbizon, trailing along with it a chain of unprotesting granite heads, grim and bearded.

The Baron de Hirsch paid £1,000 for a sculptured chimney-piece which was to fetch £1,680 at his succession sale in 1906. Spitzer spent £1,500 on two more chimney-pieces, but they fell to £1,120 in 1893. Further mutilations of the ruins of Montal occurred in 1903, when roundel busts and door-surrounds made from £600 to £700 each. The objects were so big that they had to be auctioned on the spot in an assembly workshop in Levallois-Perret. When I was a boy, bits of the Château were to be seen over the garden wall of the eccentric deserted house of Dr Phené in Chelsea, *la renaissance du Château de Montal*. As to the remains of the original Château which had been left standing, a new proprietor offered them to the French Government in 1913 on condition that the Louvre returned its share of the spoils. It was then discovered that the Metropolitan Museum owned two doorways, the Victoria and Albert Museum a round window, and Berlin a portrait bust.

After the passage of a quarter of a century, spent in encouraging the industrial arts, a lack of fastidiousness, a passion for the wholesale, had descended on museums and collectors alike. In the later 1870s the Victoria and Albert Museum bought no more *Quattrocento* sculpture. For a time Breton lace bibs and Norwegian peasant headdresses shared the honours with newly imported atrocities from Japan, empire-building souvenirs from remote islands, cigar-boxes of plaited fibre, and gold passes for the Petersburg-Moscow Railway. It was the dawn of the age of Eastern metalware in the home, of Anstey's *The Brass Bottle* and *The Garuda Stone*.

The ball was passed to Spitzer and the German museums. In 1875

Spitzer paid the astounding price of £4,000 for a somewhat dull, sepulchral monument in twenty-eight slabs, attributed to Antonio Lombardi. In 1878 two marble busts by Desiderio da Settignano, which might have been bought in the 1840s by Eugène Piot for a few pounds, cost the Berlin Museum £2,000 each. The young Dr Wilhelm Bode was already helping to build up the finest of all collections of *Quattrocento* sculpture. But the greatest sums were paid in Germany for native art, even for the stoneware jugs of the Rhineland, nowadays so little desired. In the 1830s the new nation of Belgium had bought them patriotically as *grès de Flandre*; and in the 1870s the new nation of Germany bought them as German. In 1886 a Siegburg pitcher could cost as much as £712.

After the Franco-German War, all German Gothic and Renaissance art gradually became a patriotic taste, which sold better in Germany than in Paris. It was forgotten how much this art had dominated international taste in the 1840s and 1850s, even Paris itself, where the frigid affectations of the *Nazarener* school had found admirers and imitators. In 1850 Debruge Dumenil's *Speckstein* relief by Hans Dollinger had been one of the dearest things in the sale at £164, and the same price was paid at the Rattier sale of 1859 for a wooden relief, attributed to Dürer, as great a name to conjure with then as Michelangelo, for in 1847 Balzac could find no better treasure for the collection of *le Cousin Pons* than a companion to the portrait of *Hieronymus Holzschuher*. In 1884 the Prussian Government at last got possession of that picture—for £50,000, according to *Chronique des Arts*, but, as Dr Bode thereupon pointed out, in reality only £16,000. It was, nevertheless, the second dearest old master picture in the world, but the price was less extraordinary than the £2,700 which were paid by the Bavarian Government in 1887 for another German *Speckstein* relief of the sixteenth century, as much as any Desiderio or Donatello.

The German Renaissance market had had the support of the Rothschilds since at least the 1820s. The Rothschild taste had made it international, not the taste for German late Gothic and Renaissance sculpture, to which military triumphs and national unification had given strength, but the traditional German bankers' taste for rich plate and enamelled jewels. The chief market in early Victorian times had been London, where German Renaissance silver had become the dearest of all forms of silver plate, on account of the successful auctioning of the possessions of the House of Hanover in 1827 and 1843. At the magnificent sale of the Duke of Sussex in 1843 several Augsburg or Nuremberg pieces made from £150 to £200 each. By 1860 a terrestrial globe standing-cup

could make as much as £370. At the San Donato sale of 1870 Spitzer paid nearly £800 for a tall nautilus-shell cup, the kind of article that could sometimes be bought for £15 in the 1850s. At the next San Donato sale, the Florence sale of 1880, Karl Meyer Rothschild bought the most Germanic of all German treasures, Wenzel Jamnitzer's clockwork silver automaton of Diana hunting. It had been sold in London in 1771 for twenty-three and a half guineas, and now it cost £2,280. And next year in London Ferdinand de Rothschild gave £2,340 with commission for the Lyte enamelled jewel. At the Hamilton Palace sale of 1882, Beckford's two parcel gilt "columbine cups", which had cost him 200 guineas a few years after Waterloo, went to Charles de Rothschild for £3,500.

Karl Meyer Rothschild, who lived in Frankfurt, was the most regular buyer of these objects. At his succession sale in 1911 there were some twenty examples of Augsburg silver at more than £1,000 each, while a *Bocale double* by Hans Petzoldt of Nuremberg made the all-time saleroom record price of £4,600 (over £27,000 in modern money). But the collection may well have cost him as much or more in the 1870s and 1880s. One extraordinary transaction had indeed been made public in May 1880 by *Chronique des Arts*. It was disclosed that Karl Meyer Rothschild had paid the Merkel family of Nuremberg 800,000 francs, or £32,000, for a single parcel-gilt standing cup by Wenzel Jamnitzer. It was of enormous dimensions, plastered with both sorts of enamel and swarming with the solid figures of reptiles and insects, an outstanding display of Stowe or Great Exhibition taste and a generation out of date (see page 5). In 1880 the defeat of Sedan had not altogether wiped out the heavy Germanic bias of French taste. Edmond Bonnaffé admitted that in the view of many people the Jamnitzer cup was overdone, but he decided that the rarity of the object and the high degree of skill justified it in becoming the most expensive work of art ever sold—dearer than the Murillo *Immaculate Conception*.

It is curious that today the best of the English Elizabethan standing cups and salts should be worth at least two or three times as much as their Augsburg or Nuremberg equivalents. In 1880 no piece of English sixteenth-century silver was worth much more than £300. The Bacon salt of 1553 was actually sold at Christie's in 1875 for £200. It must be appreciated that in 1880 Anglo-Saxon snobbery did not dominate the international market. When the Americans came in, silver, which had been ordered for English noble houses or for Chancellors of the realm, became more sought-after than the silver that had been designed for

German Bankers. After 1930 the fall in German Renaissance silver was precipitous. Fifteen years ago the mounted nautilus-shell cups that used to cost hundreds of pounds in the 1870s, could be bought for as little as £30 (see page 267).

In the 1870s there was also a brisk advance in the value of maiolica, French faience, and Limoges enamels, though not at the breathless pace of silversmith's work in the Rothschild taste. In the twenty years following the Soltykoff sale prices doubled or trebled. In 1877, a Limoges portrait plaque cost the Victoria and Albert Museum £2,000, their last single purchase on this scale for the rest of the century. A tazza and cover by Jean Penicaud figured in the Hamilton Palace sale at 2,000 guineas. Maiolica was not quite as expensive, if only for the fact that it had survived in such enormous quantities. But as early as the 1840s there had been the beginning of a maiolica fever. Forgery is the surest indication of popularity. There is a dish in the Victoria and Albert Museum on which a fraudulent portrait of the painter Perugino has been refired. Yet it had been bought by Jules Soulages not later than 1850, and possibly before 1840.[18] This fits in well with Joseph Marryat's description of the quantities of spurious maiolica which were sold to tourists in Florence in 1857. In his next edition (1868) Marryat complained that his warnings had depreciated the value of his own maiolica, bought with the fine guarantee of the Bernal Collection.[19]

Notwithstanding such setbacks, the first thousand pound bid for a piece of maiolica—an Urbino basin—was made at the Castellani sale of 1878. Prices of £600 to £900 were then fairly frequent for a commodity that had seldom fetched £60 in the 1840s. In 1881, when the Basilevski Collection went to Russia for the sum of £250,000, it was believed that its owner had refused to let Spitzer have his Faenza dish with the portrait of the Emperor Charles V at £2,000. Nevertheless, Mr Woods of Christie's gave it as his opinion that "the run on Chinese blue-and-white" had made maiolica out of fashion (see page 58).

But the truth was that in 1881 England had become very insular in these matters. In that year there were probably only two English collectors of maiolica who could challenge the highest Continental competition—namely, Sir Richard Wallace and a man of the next generation, George Salting. London had ceased to be the market for Renaissance art. And then suddenly in 1884, a quite legendary collection

[18] Bernard Rackham, *Victoria and Albert Museum Catalogue of Maiolica*, 1940, Vol. I, page 322.
[19] Marryat, *Pottery and Porcelain*, 1868 edition, page 91.

came on the market, an English collection to be sold in London. The original Sir Andrew Fountaine of Narford Hall [1672–1753] has already appeared in these pages (see page 71). His collection, acquired when £5 was a high price for almost anything, had been enriched by another Sir Andrew Fountaine, who died in 1873 and who was capable of paying £480 for the *Three Graces* dish alone.

In 1884 the Treasury was too paralysed by the impending negotiations for the Duke of Marlborough's Raphael to pay any attention to the desires of the British Museum and the Victoria and Albert. As to possible rich benefactors, it seemed that they were all busy telegraphing £6,000 and £7,000 bids to Christie's for the works of Landseer and Edwin Long. According to J. C. Robinson, who had just been made Keeper of the Queen's Pictures, the Fountaine treasures were in danger of going to the Rothschilds or the Vanderbilts (see Vol. I, page 176). With the aid of Wollaston Franks and a few others, Robinson then got busy. Some City personalities were induced to underwrite a sum of £24,000. With this guarantee, Robinson's committee of taste or syndicate, as they called themselves, hoped to rescue the best lots, to offer them at cost price to the British Museum and Victoria and Albert and, if declined, to turn them back to the underwriters for resale.

It turned out to be a serious underestimate. The sale surpassed all records for Renaissance objets d'art, bringing in £91,113 for 565 lots. The syndicate spent no more than £9,924, because they found their limit consistently passed by the Paris dealers. And the Government would not meet even this amount. The underwriters were left with a pair of Palissy candlesticks at £1,510, at which price Sir Richard Wallace, who had bid against the syndicate, took them over.

Of the 270 pieces of maiolica at Narford Hall, at least half a dozen passed the £750 mark, and among them the Victoria and Albert Museum obtained from the syndicate the dearest piece of maiolica that had ever been publicly sold, and very nearly the ugliest, an Urbino oval dish of about the year 1570, well covered with *grottesche*, at £1,333 10s. The syndicate also got them the largest piece of earthenware to have been fired by Bernard Palissy, an oval cistern or wine-cooler, 37in by 20in, for the price of £1,102 10s. But the slightly smaller though richer companion to this cistern cost the Louvre the all-time record price of £1,911. The Louvre also bought a Palissy ewer, based on a pewter model by Briot, for £1,365.

There may have been men at the Fountaine sale who had seen such things sold in their boyhood for £5 or less. It was indeed the very

height of the Palissy fever, for no such prices were ever paid again. But as is invariably the case with objets d'art, the highest prices were paid when the most advanced taste was already turning away. In the early 1860s there had been a deluge of Royal Academy and Salon pictures—*Bernard Palissy at His Kiln*, *Bernard Palissy rescued on St Bartholomew's Eve*, *Bernard Palissy and Diane of Poitiers*. But all this fruitiness had no place in the Whistlerian and Rossettian aestheticism of 1884, or even in Edmond de Goncourt's fussy *Maison d'un Artiste*. Nevertheless, in terms of 1963 the Louvre paid at least £12,000 for their cistern, but one wonders whether nowadays it would make a tenth of that. One of Fountaine's Palissy dishes which fetched 700 guineas in 1884 was sold in 1940, in the week of Dunkirk, for £10.

But the victor's laurels of the Fountaine sale went, not to maiolica or Palissy ware, but to Limoges enamels and Henri Deux ware. Though collectors had only discovered Henri Deux ware in 1839, the original Sir Andrew Fountaine must have acquired his pieces more than a century earlier, and probably at the same place—the Château d'Oiron. He had esteemed them highly even in those days, wrapping them in rare Chinese yellow silk and keeping them in a drawer at Narford. Here was so much romance that the great George Salting, who had astonished everyone at the Hamilton Palace sale of 1882 by paying £1,218 for a biberon, failed to get the Fountaine flambeau, supported by cherubs. It was bought by a Paris dealer for Gustave de Rothschild at £3,675, a price that has only twice been exceeded for Henri Deux ware since 1884. As to the syndicate, they failed even to obtain a biberon and mortar at 1,000 and 1,500 guineas.

A Limoges enamel oval dish, 19in across and signed by Leonard Limousin, with the date 1555 and containing the recognizable figures of Henri II, Catherine de Medici, and Diane de Poitiers at the Feast of the Gods. What could be more romantic than that? So too, was the price paid by Samson Wertheimer on behalf of Gustave de Rothschild —namely, 7,000 golden guineas. But the dish looks an inelegant thing in Christie's photograph, and it is clearly concocted of many stock elements. It would rank, said *The Times*, in future histories of the follies of buyers by the side of the Duke of Hamilton's Riesener table.[20] But the "Thunderer" was not well posted on Limoges—nor on Riesener either. Before 1873, when he died, Sir Andrew Fountaine had been offered £6,000 by James de Rothschild for that oval dish and the sum had surprised no one, since it was about this time that Basilevsky refused Adolphe de Rothschild's offer of £10,000 for an outsize

[20] Redford, Vol. 1, 385.

Limoges triptych by Jean Penicaud. The triptych was actually valued at that price in the sale of Basilevsky's collection to the Tsar in 1884. And that was not the end. At the Hollingworth Magniac sale of 1892, Horace Walpole's Limoges hunting horn was to make £6,615, while several pieces changed hands at well over £5,000 each in the years just preceding the First World War (see pages 270-1).

The strangest price of all at the Fountaine sale was paid for an object without a pedigree, of no attributable school, and not illustrated in Christie's special catalogue. It was a carved ivory hunting horn, hopefully called sixteenth century and wishfully believed to be French rather than Italian. It was bought by a Vienna dealer for Alphonse de Rothschild at £4,452, surely the most expensive Renaissance ivory object that has ever been sold. What had made it so dear? Sir Richard Wallace denied firmly that he had been the under-bidder.

The Fountaine sale, itself the product of new legislation to relieve landowning distress (see Vol. I, page 176), marked the beginning, not of a boom, but of a three-year depression. In France this depression extended almost into the 1890s. A collection of considerable importance, that of Ernest Odiot, was sold in Paris in 1889 in some 900 lots, which made only £15,000. Mediaeval reliquaries were plentiful, and none made more than £300; even a Limoges triptych by Jean Penicaud failed to reach £600. But prices, at any rate for the greatest favourites of all, recovered their swing at the Hollingworth Magniac sale at Christie's in 1892. In four days 1,554 lots were sold for £103,040. Horace Walpole's Limoges hunting horn at £6,615 was the hero, but there was also a great Henri Deux ware ewer, or *hanap*, which made the absolute record price of £3,990.

But the fury of the late 1870s and early 1880s had not returned, and did not return till the last year or two of the century, when Pierpont Morgan entered this market. The decline was still apparent in 1893, when the long-looked-for dispersal of the Spitzer Collection took place. Some falls in price at this sale can be checked from the record of earlier sales, but many other falls must have been bigger, for Spitzer bought in private as dearly as he sold. The memoir which Edmond Bonnaffé contributed to the two-volume folio-sized catalogue implies that transactions in the £10,000 region had been quite common.

The cost to Spitzer will never be known. Without counting the armour which was not sold till 1895, the 3,369 lots made over 9 million francs or £365,000 and it took thirty-eight days to sell them. The armour brought the total up to £430,000, the equivalent of at least two and a half millions today. While the Hamilton Palace sale of 1882

remains probably the finest single collection ever to have come under the hammer, the Spitzer Collection must be considered the most valuable in cash terms at the time of the sale, with the exception of the Doucet sale of 1912. It will be recalled that the Bernal sale of 1855 was larger by nearly a thousand lots. Apart from the pictures and porcelain, it was comparable in kind with the Spitzer sale and almost certainly finer. Yet it had produced no more than £63,000.

Most extraordinary of all was the setting of the Spitzer sale. It was held in the huge hotel in the rue de Villejuste in the smart new Passy quarter where Spitzer had installed himself in 1878, the year of the Second Universal Exhibition. The building was in the François Premier style and the stone was probably still white. The lots were sold in the *salle d'armes*, a chamber guarded by twenty cap-à-pie suits of armour, lighted by seven German stained-glass windows, and hung with the famous *Vierge de Sablons* tapestries. Thirty eight days of that must have seemed quite enough to M. Paul Chevallier, the *Commissaire priseur*. But how pleasant to arrive at two o'clock and watch him sell less than 100 lots in an afternoon, after lunching with great discrimination for four francs.

A German suit of armour could now make over £3,000, a German rock-crystal hanging bowl £2,800, a Spanish enamelled jewel, £1,840, a seventeenth-century Lyons walnut dresser, £1,400, a pair of Limoges portrait plaques, £3,000, a fourteenth-century parcel-gilt chalice, £1,640, a thirteenth-century ivory-plated saddle, £3,400, a German sixteenth-century bronze statuette, £1,760, and a wonderful bronze horseman by Riccio, £1,800. Yet, though these were the costliest things in the sale, few of the prices were specially remarkable in terms of the 1870s and 1880s. Spitzer, if he had consented to sell such things at all, would have demanded several times as much. His Antonio Lombardi monument, which had cost him £4,000 in 1875, was actually sold for £2,000.

The armour sale of 1895 established no new records, except, as was typical of Spitzer, for its quantity. There were 505 lots, which made £64,000. Most of the dearest lots were bought by the Duc de Dino, and many are now in the Metropolitan Museum. At first Bonnaffé recorded surprise at the knowledge of Spitzer, a man who had never possessed *l'archaeologie des armes*[21] and who had bought a great deal of the armour en bloc from Carrand in 1871. Later, Bonnaffé discovered that Spitzer must either have known much less and permitted himself to be exploited, or had known too much, inasmuch as almost everything

[21] *Chronique des Arts*, 1895.

had been made up with additions from other sources. The Swiss executioner's sword was a complete hotch-potch. The half-suit which was claimed to be the original Strawberry Hill armour, bought for Horace Walpole by Mme de Deffand (see pages 62, 76, 80), is now considered to be a copy, made from the ruined original for the aged, though still dangerous Pratt at some time after 1874. Yet both the sword and the half-suit made over £1,000 each.

In one respect alone the Spitzer sale showed a new sort of valuation—namely, that of tapestry, which had been the Cinderella of the Renaissance and mediaeval art market until quite recent years. A single Flemish tapestry panel, woven in 1518, the *Arrival of the Image of Our Lady of Sablons in Brussels*, was bought by the Belgian Government at the Spitzer sale for £3,280, and that was three times as much as any late Gothic or early Renaissance tapestry had ever fetched at an auction. Another Flemish panel, a *Riposo* of about the year 1490, made £2,800, and a Ferrarese *Adoration* of the early sixteenth century, £2,040. Less than ten years were to separate these purchases, then considered sensational, from Pierpont Morgan's purchase of *The Adoration of God the Father* for £65,000 or £72,000, but in fact the growth in popularity of early tapestries, as distinct from eighteenth-century tapestries, had been extremely sluggish before 1893.

In the previous chapter I described the complete worthlessness of such tapestries at the end of the eighteenth century, citing the Angers *Apocalypse* suite to show how this worthlessness persisted far into the period of romantic and mediaevalist taste. Even in 1856 the future Victoria and Albert Museum was able to obtain an important and attractive south German panel of the fifteenth century for £10. Exceptionally, a fine gold-thread Flemish *Adoration* of the early sixteenth century made £84 at the Baron sale in Paris in 1846, but thirteen years later the same panel commanded no higher price.

During the 1850s and 1860s the price of an early sixteenth-century panel varied from £10 to £25, according to size, very rarely £30 or £40, and if of an earlier period, even less. The San Donato sale of 1870 sent up the price of a Brussels panel of about the year 1550 to £60, but in 1872 a really strong movement became apparent, when one of the best of the Victoria and Albert panels, the partly silk *Susanna and the Elders* of 1510, cost the museum £200. Five years later, the cost of early sixteenth-century tapestries on an important scale shot up suddenly in Paris to more than £1,000 a panel at the sale of the Duke of Berwick and Alba. The fact that a revival of tapestry-weaving was now beginning to play a part in the English mediaevalism of Rossetti,

Burne-Jones, and William Morris had probably nothing to do with this sudden movement in prices. The real clue lay in the incredible late Gothic and Renaissance palaces which were being constructed in New York, Chicago, and San Francisco by the first generation of million-aires. The same panels, which might under exceptionally favourable circumstances make about £1,000 at a Paris auction, were sold by the Duveen Brothers in New York for many times that figure. Whether the millionaires bought Brussels or Tournai tapestries of the early sixteenth century or, as they did rather later, tapestries designed by Boucher in the mid-eighteenth century, depended only on the architect or interior decorator whom they employed.

Despite this El Dorado, there were not many sixteenth-century tapestries which had fetched as much as £1,000 a panel in Paris or London in 1893. As to tapestries which still retained a genuinely mediaeval feeling, the only tapestries that are universally appreciated today, they fetched but a small fraction of these prices. At the Salle Drouot in 1878 a French fifteenth-century panel, which sounds particu-larly attractive, made £50, a price which astonished the vendor, who had bought it from a farmer who for many years had used it as a shelter for his donkey. Nor need one be surprised by that. As recently as 1872, Philippe Burty had described to Edmond de Goncourt an early piece of tapestry in a rag-merchant's shop in Nemours. A few days previously the man had sold a whole attic-ful to a tanner, who needed something to cover up his vats.[22]

Even that spell-binding suite, *La Dame au Licorne*, was bought by the Musée Cluny in 1883 for not more than £166 a panel. Forty years later J. D. Rockefeller, Jnr., was to spend 240 times as much on the much-inferior version, which is now in the Cloisters Museum, New York. One must not underrate literary influences. The Musée Cluny's acquisition of 1883 inspired Guy de Maupassant to write the most charming description of a fifteenth-century tapestry of *Pyramus and Thisbe* in the opening chapter of *Une Vie*. It must have inspired more than one reader to consider that he too might own a mediaeval tapestry. At any rate the price of a tapestry-panel, comparable with *La Dame au Licorne*, at the Somzée sale eighteen years later, was not £166 but £780. Yet, strange to say, in that year 1901, the greatest mediaeval tapestry suite of all, the Duke of Devonshire's four hunting panels of the years 1420–30, were still cut up in strips and hanging as curtains at Hardwicke Hall.

[22] Goncourt, *Journal*, Vol. V, page 22.

The Return of the Eighteenth Century
Part One: Furniture

1. *French Ébénisterie, 1815–70* — 2. *High Tide, Recession, and Recovery, 1870–1900* — 3. *The Louis Drawing-room and the Rise of English Furniture*

1. *French Ébénisterie, 1815–70*

The vogue for English eighteenth-century portraits, which lasted from the 1850s to the early 1930s, has been treated in the first volume as a separate episode. The outlines of the story are simple. The value of portraits by the great masters of the late eighteenth and early nineteenth centuries slumped at the death of the painters, if they had not already done so at the deaths of the sitters. The entire European eighteenth-century school fell into abeyance about 1830, the year of the death of Sir Thomas Lawrence. The only exceptions in the next two decades were the sentimental maidens of Greuze, the sentimental fancy portraits and subject pictures of Reynolds, and some of Gainsborough's landscapes. Then, after the passage of more than a generation, a very different sort of Reynolds cult began with the Samuel Rogers sale of 1856 (see Vol. I, pages 79, 182). This sale brought the straightforward eighteenth-century portrait into fashion. It pin-pointed the beginning of a revival which culminated in the second Joseph Duveen's fantastic transactions of the 1920s.

Such was the return of the eighteenth century in the market for English painting. In the market for objets d'art there was this difference: that the objects were not English at all, but French, and that prices

reached a very high level in the 1820s, although French painting of the *ancien régime* was only a little less neglected in England at that time than it was in France. The subsequent adventures of this market did, however, conform with the taste for English eighteenth-century painting. That is to say, it fell heavily in the 1830s and early 1840s, and its revival only became really interesting after the Samuel Rogers sale of 1856.

The advent of the French Revolution found England the best customer for French furniture, porcelain, and *lavis*. The reasons for the protraction of this cult during a generation, when it was completely neglected in France, have been discussed in Chapter Two. It must, however, be remembered that while prices were sometimes impressive, the actual number of people anxious to acquire French decorative art was never very large. The most important factor in determining the market was the participation of George IV, both as Prince of Wales and as King, and of the small set surrounding him.

The King's advisers in purchasing furniture and porcelain were the third Marquess of Hertford, Robert Heathcote, Walsh Porter, and the Baring brothers, all of them collectors themselves. The King's own taste seems to have fluctuated during the course of his life, but it was always French rather than English. Even George IV's passion for paintings of the Dutch school was Parisian. The return of the French rococo style in the early nineteenth century was a decidedly English contribution to European taste and, as the principal buyer, George IV may be accorded a large part in it. But *ancien régime* taste had not always been his predilection. In 1805, as Prince of Wales, he explained to Lady Bessborough that he had adopted Chinese decorations at the Brighton Pavilion "because at that time there was such a cry against French things, etc., that he was afraid of his furniture being accused of Jacobinism".[1] This charge could hardly be levelled against the highly pictorial furniture which George IV bought in the 1820s. But in 1805 Henry Holland was feverishly furnishing Carlton House for him with English adaptations of the Directoire style.[2] This was clearly the "Jacobin" furniture to which the Prince referred, his earlier and more Whiggish taste before his rich friends got at him.

The ornate and sometimes rococo furniture which was bought in the 1820s, when the Prince had become King, often passed through the saleroom at prices quite comparable with those paid by Louis XVI. The most conspicuous example of such royal bidding was at the Watson Taylor sale at Christie's in 1825, for this was reputed to be the finest

[1] Henry D. Roberts, *A History of the Royal Pavilion, Brighton*, 1939, page 50.
[2] Margaret Jourdain, *Regency Furniture*, 1934, page 5.

collection of French domestic art in the country. Like William Beck-ford, Watson Taylor had spent a large fortune, based on West Indian sugar plantations, in buying up the loot of the French Revolution. But the King had not used the opportunities of the Fonthill sale of 1823 to bid for the goods of the disgraced Beckford, and so the prices of 1825 were much higher. The royal purchases at the Watson Taylor sale included two ormolu candelabra, mounted on bronze figure groups, at £246 15s and £241 10s, a *bureau à cylindre* with sconces, which had been made for Louis XVI, at £107, and two marble pier-tables, mounted on caryatid figures in the full rococo style of Louis XV, at the very robust prices of £514 and £430. To this list one may add, in the words of Christie's catalogue, "a *chef d'œuvre* of the ingenious Riesener, sold by the Commissaries of the French Convention in the early period of the Republic". It was a cabinet with the royal arms of Louis XVI, and it made £420.

The King may also have been the purchaser in the same year of one of the costliest pieces of eighteenth-century furniture to have been sold since the days of David Roentgen's royal commissions. It was a commode-sideboard of unusual length; with Sèvres and Vienna porce-lain plaques on the doors, and it fetched no less than £565 at Christie's at the sale of the Rev. Charles North of Alverstoke. It was also the dearest piece of French furniture to be sold in London for the next twenty-five years, since the late 1820s were remarkable for a series of bank failures and for a general shortage of money on the art market. But French furniture remained in demand at any rate as long as George IV was alive, and the real fall in prices did not become noticeable till after 1832.

Thus in 1829 an upright secrétaire with Sèvres plaques could still make £215 5s at Christie's at the sale of Lord Gwydyr. This was a sale particularly rich in French eighteenth-century objects, but much higher prices were expected from the last of the Watson Taylor sales in 1832. The sugar magnate, unluckier than Beckford, had gone bankrupt with liabilities totalling £450,000. The fact that the entire contents of Erlestoke Park were entrusted to the over-colourful George Robins suggests that, in spite of a maligned reputation (see footnote, page 83), Robins must have been the most successful auctioneer of that time. Robins sold the Wanstead House Collection in 1822, Robert Heath-cote's French furniture in 1823, Benjamin West's pictures in 1829, and Thomas Hamlet's "Cellini" dishes in 1834. His last triumph was the Strawberry Hill sale of 1842.

Robins announced the Watson Taylor Collection as "of the most

gorgeous kind, with silver fire-irons and chairs, and sofas of burnished and matted gold". The Collection was apparently the envy of Beckford, who failed to get a Paul Potter cow picture at £787 10s, but the furniture disappointed the prophets. Two quite extraordinary objects, described as console tables inlaid with precious stones and mounted in ormolu, were expected to make 2,000 guineas; but Hume, the dealer who had sold them to Watson Taylor, bought them back at £608. Once again we meet the same baffling description as in Daguerre's sale of 1791. The precious stones were certainly Italian marble inlays, but was the framing ancient Italian or recent French? (see page 66). Was the figure of 2,000 guineas based on the sum that Watson Taylor had originally paid to Hume? What kind of taste was it that made the fashionable world of 1832 think in terms of a thousand guineas for a console table? In actual fact the dearest piece of furniture in the 1832 sale was neither of these, but a table with a circular marble mosaic top, for which the Duke of Buccleuch paid £378.[3]

If Watson Taylor's marble-inlaid furniture was of eighteenth-century French design, it would have been the only kind of French furniture to stir the enthusiasm of the romantic period, for in the year 1832 French furniture, bought for its more truly furniture-like qualities, was already going out, both rococo and neo-classic, Louis XV and Louis XVI alike. At the Brook Greville sale of 1836, a Sèvres-inlaid toilet table, attributed to Riesener, fetched only £5 10s. At the Acraman sale of 1842, Beckford's furniture from the Fonthill sale was going very cheap indeed, a pair of lacquer-fronted upright secrétaires at only eleven guineas each. The Strawberry Hill sale of the same year was indeed a "high puff sale", as Beckford called it, but even here we find the nadir of the French furniture market. A porcelain-inlaid table makes under £30, whilst the dearest piece, a boulle coffer and stand, is sold for £44 2s.

Boulle was less adversely affected by the romantic reaction than any other form of French furniture. At this very moment in 1842 it was being imitated furiously. A large quantity of early Victorian boulle is still to be found today, looking the very essence of the taste of the period. But actually the English boulle mania was much older, and the better English imitations had been made by French cabinet-makers in London under the Regency. A kneehole writing table in the Wallace Collection, made by Louis le Gaigneur of Queen's Street, Edgware Road, is such a good copy that it was formerly considered to be a Louis XIV piece. About the year 1815, a companion to this table, newly

[3] W. Whitley, *Art in England, 1820–1837*, Vol. II, pages 240–1.

completed for the Brighton Pavilion, cost the Prince Regent the very lively sum of £250.[4]

The origins of the English boulle cult are obscure, except that it coincided with the increase in the popularity of the late Renaissance.[5] In 1771, when a fine piece of boulle cost £200 in Paris, the cult could not have begun, since Christie's got no more than £39 10s for an eloquently described boulle bookcase. It does, however, seem probable that the two big cabinets with glass doors which made £441 at the Countess of Holdnernesse's sale in 1802 were some kind of boulle imitation.

The high market for boulle furniture, which began towards the end of the Napoleonic Wars, owed much to the competition of William Beckford against the third Marquess of Hertford, the father of the great collector, who bought for himself as well as for the Prince. It is probable that Beckford bought the two royal boulle cabinets, which were to make £12,000 in 1882, from the painter Lebrun when he was in Paris during the hundred days' peace in 1814. In the same year, Beckford was offered another pair "of a Solomonian richness"[6] by the dealer Hume for £400, quite possibly a pair which had been bought-in at Christie's earlier in the year for £577 10s among the profusion of boulle pieces in Lady Mansfield's sale. Still another of Beckford's boulle cabinets was sold at Fonthill in 1823 for £236.

It will be noticed that boulle was not quite the dearest of French furniture in the 1820s, but it was to be the first to recover from the general art-market depression of the 1830s. For instance, at the Duke of Sussex's sale of 1843, where prices in general were much higher than at the Strawberry Hill sale, a pair of boulle commodes made £136 10s, and a writing table £97 10s. We are now at the beginning of the second market revival in eighteenth-century furniture, but it is international, and its centre is not London, but Paris, for all three of these pieces were bought by the Paris dealer, Roussel. And at the Stowe sale of 1848 it was again Paris that called the tune. Whereas two handsomely-mounted Louis XVI writing tables made the still depressed prices of £38 5s and £59, no less a sum than £246 was paid by the Baron Meyer de Rothschild for a boulle cabinet, so heavy that it was judged to be German. For a companion table the 4th Marquess of Hertford paid £183 15s. Furthermore, he gave £210 for a much-restored, though very splendid, cabinet by Charles Boulle himself, well known

[4] Notes by F. J. B. Watson, *Wallace Collection Catalogue of Furniture*, F.479.
[5] See *supra*, Chapter Three.
[6] Boyd Alexander, *Life at Fonthill*, 1958, page 151.

for its bronze reliefs, illustrating Ovid's *Metamorphoses*.[7] This was but the beginning. At the Earl of Pembroke's sale at Christie's in 1851 the Marquess bought a boulle *commode en tombeau* for £231 and at the Bernal sale of 1855 a boulle pedestal for £205.

So far, it will be noticed, the prices have been static and not higher than they had been in the 1820s, furthermore, a newly-made copy could cost just as much. But at the second sale of the Earl of Pembroke, which was held in Paris in 1861, an early boulle console table fetched £780, while at the Ricketts sale at Christie's in 1867 an extraordinary spirally-fluted urn with inlays by Charles Boulle was sold for £687 15s. This sudden advance betokened a much more intense international competition for French furniture. The chief competitors were the Rothschilds, the Parisian Russian princes and the Parisian English peers, Dudley, Pembroke, Hamilton, and Hertford. But the centre of this market had been shifting back from London to Paris as early as 1840, the year when the Prince de Beauvau paid the revolutionary price of £140 on the Quai Voltaire for the lacquer-inlaid *bureau de dame* of Marie Antoinette—that bureau which the Empress Eugénie was to buy for £2,400 at the Prince's sale in 1864.

Better than any sale catalogues of the period with their generally ambiguous descriptions, one may trace the return of the *dix huitième* to the Paris market in the 1840s in a work of fiction. Balzac's *Le Cousin Pons* was published in 1847, but the action takes place in the years 1844–5. I shall now follow this action, though it may be protested that one should not accept seriously the collecting adventures of so unreal a character as Silvain Pons. How was it possible, it will be asked, that a man who could so cleverly wheedle a fan, painted by Watteau, from a cunning Auvergnat dealer, should at the same time be so calamitously innocent among the scheming sharks who surrounded him?

In fact, this portrayal of infallible expertise and absolute innocence in one person is itself a tribute to Balzac's quite intuitive understanding of collectors. It will be recollected that Silvain Pons was a composer of second-rate operetta music of the First Empire. Out of fashion both in his work and in his appearance, he lived obscurely in the 1840s on the salary of a *chef d'orchestre* at a Parisian theatre. Like Du Sommerard, Pons had begun to collect during a residence in Rome at the time of the Napoleonic Wars. With a collecting budget of 2,000 francs, or £80 a year, he had been able to buy for ten francs things that fetched £40 to £50 in the 1840s. The *chef d'œuvre* of the Pons collection was a companion portrait to the *Hieronymus Holzschuher* of Albrecht Dürer, the

[7] *Wallace Collection Catalogue*, F.61.

picture for which three kings had been prepared to pay £8,000, and which was destined to be bought by the Prussian Government in 1884 for £16,000. But, in addition to his paintings of the Renaissance, Pons bought miniatures, fans, and snuff-boxes, and there were a few examples of French eighteenth-century furniture among his Italian ebony cabinets and credenzas of an earlier vintage. It was his lament—and he was certainly alluding to the Prince de Beauvau's bureau of Marie Antoinette—that a piece of furniture by Riesener cost nowadays 3,000 or 4,000 francs.

But it was through telling a *brocanteur* this true value of a Riesener commode, which the man had just picked up at a demolition sale, that Pons obtained for a few pounds the Watteau fan that lay hidden in one of the drawers. This fan in Balzac's novel becomes a sort of image of the new international taste. For while it was a completely meaningless object to Mme Camusot de Merville, the smart Parisienne, its value was appraised at sight by Brunner, the Frankfurt banker, and by Elie Magus, the Jewish dealer. The latter is thought to be an unflattering portrait of Charles Mannheim, the agent of the Rothschilds, who had opened his shop in the Rue de la Paix in 1841.

Balzac did not live to see the vindication of his hero's taste, for he died in 1850, when the international market for the *dix huitième* was only in its opening stage. In the 1850s the sixty-year-old prejudice of French literary artistic circles against the *ancien régime* still enabled the de Goncourt brothers to buy their drawings of the Fragonard genera-tion for a pound or two. Moreover, at the beginning of his reign [1852–70] Napoleon III, like Napoleon I, had not been at all partial to memories of the last years of the *ancien régime*. The official style of the Second Empire was decidedly High Renaissance. Parisian styles of architecture during the building mania of the 1860s tended to be early sixteenth or middle seventeenth century, the former for Government offices and private palaces, the latter for the newly planned Paris boulevards. New furniture, in France as in England, fluctuated between sixteenth-century models and a sort of bastard Louis XIV style. Purism there was none under the Second Empire. The "Louis drawing-room", with its carefully matched materials, which remained so long the outward expression of the influence of Paris throughout the world, belongs entirely to the Third Republic. In the Paris of 1870 it was probably unknown, and it was not widespread even in 1880.

Napoleon III's Exposition Universelle of 1867 was hardly less crammed with heavy shapes, overburdened with ornament, than the Great Exhibition of 1851. However, while this is scarcely recognizable

in the horrible illustrations, a fair proportion of the exhibits paid hom-
age to the eighteenth century, which had certainly not been the case in
1851. But how little eighteenth-century proportions were understood
can be seen in the huge inlaid cabinet by Fourdinois, for which the
British Government paid £2,730. Nevertheless, the misinterpreted
dix huitième of 1867 was a true reaction against the unendurable
bulbosities of 1851.

Some reaction there had to be, for France was the land of State art, of
the rigid Salon and the Ecole des Beaux Arts. The first nation to prac-
tise the brainwashing of genius still paid homage in 1867 to the ghost of
David and the living presence of Ingres. Strict classicism, the tyrant of
the art schools, should have led the ornamental arts away from all this
fruitiness—but it didn't. Few people wanted to return to the Grecian
and Egyptian pedantries of the First Empire. A great deal of very ugly
furniture in this taste was certainly made in the 1850s and 1860s, but it
was not encouraged even by the Court. The reaction of "good taste"
tended, instead, to follow the halfway classicism of Louis XVI's reign.
Writing in *Chronique des Arts* in 1862, M. Julliot put his finger firmly
on the reason:

> In our days Louis XVI triumphs all along the line. At one moment
> it was thought that the influence of the Campana collection [see
> pages 109–10] would react on furniture. Nothing of the kind
> happened. When it is a matter of furnishing a drawing room, the
> mistress of the house has the say, and the Antique has been
> formally declared incompatible with the crinoline.

It should be noticed that it was not Louis XV furniture—furniture
that had been made in the first place to go with the crinoline—which
triumphed all along the line, but Louis XVI. The fashionable hostess of
1862 was already one move ahead and thinking in terms of the bustle
skirt, which did not yet exist. The next step after inventing the correctly
decorated woman was the correctly decorated room to go with the
chairs. It is possible that this second impetus may have been assisted in
1869, when the Victoria and Albert Museum paid £2,100 for the
fittings of the boudoir of Mme Serilly, lady-in-waiting to Marie
Antoinette. In this case, however, the intention was not to re-create a
characteristic period room, but to preserve an unusual experiment,
since the designer, Rousseau de la Rottière, had combined the stern
angularities of 1780 with copies of Raphael's *grottesche* from the Vatican.

It may be remarked that, five years after the purchase of the Serilly
boudoir, Lady Charlotte Schreiber was shown in Ghent a completely

furnished Louis XVI room which could be bought with its hangings, marble chimney-piece, and removable parquet flooring for a similar price—namely, £2,000.[8] In the same year, 1874, Ferdinand de Rothschild began the construction of that sanctuary of French eighteenth-century taste, Waddesdon Manor. But the building was a reproduction of a François Premier château on strict Second Empire lines, and the period rooms, so different from the exterior, were not completed till the 1880s. I suspect that even as late as 1881 the riotous confusion of periods and continents, described in Edmond de Goncourt's *Maison d'un Artiste*, was much more typical of the fashionable Parisian interior than all this careful matching, for it was only at the Leopold Double sale in that year that the first really monumental prices were paid for tapestry-covered drawing-room suites.

In 1840, the landmark year of the Prince de Beauvau's purchase of the bureau of Marie Antoinette, a matching period *décor* was the last thing that was wanted. The preference for boulle furniture, as well as for furniture inlaid with porcelain plaques, showed clearly that the intended background for this furniture was the plushy gloom of the romantic period, as in Leslie's picture of the library at Holland House. In the 1840s the cult of richly coloured furniture became even more accentuated than in the 1820s, and stronger still in the 1850s. Thus in 1851, at the first sale of the Earl of Pembroke, a lady's secrétaire by Martin Carlin, with numerous Sèvres plaques, fetched £651. The buyer was believed to be the wildly extravagant Prince Demidoff of San Donato, but the secrétaire was probably the one sold in the Marquis de Villafranca's sale in 1870 for £1,188. The Marquess of Hertford quickly followed suit. In 1852 he bought in Paris a *secrétaire à abattants* in this style which cost him £400—more than he had spent on any of his boulle pieces. But in 1858 he was prepared to spend three times as much again. A Sèvres-inlaid secrétaire by Weisweiler of no special distinction except for its large Teniers-like plaque, cost him £1,207 10s. Still more remarkable was the fact that this piece, the first article of furniture to make a thousand pounds at an English auction, had been put into an anonymous Christie's sale with a reserve of £250.[9]

In 1868, when the Marquess desired another and comparable secrétaire in his favourite style, the price was nearly doubled for him.[10] In fact, he paid Durlacher 2,000 guineas; but during the 1860s, spurred on by Paris and London dealers, who played the Rothschilds and the

[8] Lady Charlotte Schreiber, *Journals, 1869-1885*, 1911, page 258.
[9] *Wallace Collection Catalogue of Furniture*, Introduction, page xv.
[10] *Ibid.*, F.327.

Russian princes against him, the Marquess had been made to pay much higher prices than this for his larger and more showy pieces of furniture, which he now collected as if he were founding a museum, being, perhaps, the first to do so. Thus, both the *Bureau du Roi Stanislas* (see pages 43, 86), and a specially magnificent neo-classic table, which had been sold for £400 in the days of the third Marquess, cost the fourth Marquess from £4,000 to £5,000 each—nothing extraordinary when he was willing to pay Dasson £3,600 for a mere replica. There was also the boulle-inlaid Londonderry cabinet, a bookcase 20ft long, for which Durlacher bid £3,990 at Christie's in April 1869, and for which the Marquess paid at least £4,500.

These were probably not the only purchases of the Marquess of Hertford in the 1860s to cost £4,000 each and more, but they bore no real relationship to the state of the market. The Marquess would instruct his agent, Mawson, from Paris to go to any limit he pleased in order to get a piece that he particularly desired. And, not unnaturally, it tended to be known when the Marquess was bidding. Before 1870 and the very high prices of the San Donato sale, the true state of the French furniture market had been less exciting. In the combined salerooms of London and Paris barely half a dozen pieces of furniture passed the limit of £1,000. In the 1860s the most important examples were quite likely to be sold at £250 to £400, just as they had been sold in the 1820s. One four-figure example, however, was not sold to the Marquess of Hertford, but to John Jones, the tailor of Piccadilly. It was a Sèvres-inlaid *bonheur du jour*. Having been bought for £1,155 at the Bulteel sale of 1870, it entered the Victoria and Albert Museum with the Jones Bequest in 1882.

Apart from the Jones Collection, the number of collectors resident in England who bought French furniture in the 1860s could probably have been counted on the fingers of one hand. Consequently, in the absence of a commission from Paris, prices at Christie's might wilt altogether. London dealers did not, apparently, make a big normal profit on French furniture. For instance, after the sale of the furniture of the late Sir Edward Page Turner in 1903, W. E. Roberts was able to publish the accounts of Messrs Annoot and Gale of Bond Street, who had provided most of it in the 1860s.[11] The accounts are rather surprising. In 1903 the sum of £1,680 was bid for a *bonheur du jour*, a lady's occasional desk only 21in wide. This was a very exceptional price at Christie's in 1903 for a piece of this kind. It must, therefore, have been of extreme refinement, and on that account likely to make a five-figure

[11] *Connoisseur*, 1903.

price today. Yet, only thirty-five years earlier, in the year 1868, Page Turner had been charged £21—and in Bond Street.

The history of this piece shows that even if "Louis XVI triumphed all along the line" in the 1860s, the market for the extremer kind of elegance was yet to come. A *bonheur du jour* might indeed have been bought for another year or two for £21, but objects in the rich and heavy Stowe taste now cost Hertford and the Rothschilds twenty times as much as they had had to pay in 1848. And after 1870 the advance became general for all French art of the eighteenth century, particularly furniture. Thus one finds that another object in the Page Turner sale of 1903 had a very different history. It was a Louis XVI lyre-shaped clock on a *bleu du roi* porcelain base. It was sold for £420, but it had been bought at the Robert Napier sale of 1877 for £2,100.

The quite astonishing market for sculptural clocks in the 1870s and 1880s was certainly the creation of the 4th Marquess of Hertford, with whom clocks had been nothing less than an obsession. The most sumptuous of all sculptural clocks, the *Avignon Clock* of Gouthière and Boizot had cost the town of Avignon close on £500 in 1768–71 (see page 42). Although he bought the Avignon clock before 1864, Hertford may well have paid more than £2,000 for it. In 1866 a long-case boulle clock, recently sold by the Swiss municipality of Yverdon for £400, cost him £1,800. A clock famous for its elegant reclining nymph, and sold to him by Charles Mannheim in the last weeks of his life, had been bid up to £1,860[12] at the San Donato sale of 1870. But the real height of the sculptural clock market was reached more than a decade after the Marquess's death, at the Leopold Double sale of 1881, when Falconet's *Three Graces Clock*, which had cost only a fifth as much to produce as its contemporary, the *Avignon Clock*, was bought by Isaac Camondo for £4,040, the equivalent of at least £25,000 in the currency of 1963.

2. *High Tide, Recession, and Recovery, 1870–1900*

Apart from the Marquess of Hertford's part in spreading the fashion for collecting clocks, the bigger French furniture prices of the 1870s were due to the scale of bidding at the San Donato sale where, more than at any previous sale, millionaire competition came out into the open. Among other things, the remains of the Rohan dinner service fetched £10,200, a pair of boulle cabinets which had cost Prince Demidoff only £70 in 1808, were sold in 1870 for £4,440, a pair of mounted Chinese fish-bowls for £1,560.

[12] *Wallace Collection Catalogue of Furniture*, F.42 and F.93.

It was the highest pitch of Second Empire extravagance, yet only a few months later the Emperor was a prisoner and Paris itself was besieged by the Prussians. But if art collectors were menaced with the hazards of bombardment and foreign occupation, the destruction that followed afterwards with the brief establishment of the Paris Commune and its suppression was still worse. As we have seen in the previous chapter, these events determined Sir Richard Wallace to take the quite unexpected course of moving to England a very large part of the Hertford collection, which he had inherited. One of the lesser results of Napoleon III's miscalculations (and perhaps also of Karl Marx's theories as applied in 1871) was that French eighteenth-century taste was destined to become better represented in London than in the Louvre. It was the strangest of paradoxes, since, even if Wallace continued after 1871 to spend in the grand manner of the Marquess, the new generation of English art-buyers, the industrialists, would have nothing to do with the art of the past, being entirely absorbed in uncritical patronage of living English painters.

But the market for the *dix huitième* no longer depended on English patronage. It weathered the siege of Paris and the Commune; it weathered the growth of British insularity. As in the parallel case of Renaissance art (see page 42), the apparent military and political decline of France created an even greater craving for the relics of the French past. In these years Wallace and his rivals had to spend more than ever before.

In November 1871, for instance, immediately after the end of the Commune, the Baron Davillier was willing to sell his twelve-light chandeliers from the Royal Palace of Parma through a dealer. The price was £6,000, but Wallace offered £3,200. It then transpired that Adolphe de Rothschild [1823–1900], the head of the Naples branch of the family, had already acquired the wall-lights that went *en ssuite* with the chandeliers. So the price went up and up again, and in the end Wallace had to pay £8,400 (over £50,000 today) for a pair of rococo gilt-bronze chandeliers, made in 1751 by Jacques and Philippe Caffieri. Beautiful certainly, but perhaps not quite breathtaking. In 1874 the great fire at the London Pantechnicon Depository reduced the finely-chiselled and gilded swags to the appearance of old iron bedsteads. Wallace claimed the insurance money, but later the insurance company had the chandeliers scraped and regilded and Wallace bought them back.[13]

In 1872 Wallace paid £3,150 for a pair of little tables, inlaid on

13 *Wallace Collection Catalogue of Furniture*, F.83–4.

patinated iron, and made in the 1770s, perhaps by Weisweiler. In 1872 he gave £3,600 for the marriage coffer of Marie Antoinette, in reality a commode. But, a few years later, when Ferdinand de Rothschild [1839–90] was filling his new palace at Waddesdon,[14] £4,000 was no longer enough to deter competition. In 1880 the strangely clumsy and unattractive marriage coffer of the Grand Dauphin, made by Charles Boulle for Louis XIV, was bid up to £6,000 at the Florence San Donato sale (Paul Demidoff). This was a seventeenth-century piece and already somewhat behind the real fashion, for which £6,000 was nothing at all. As to the real fashion, in 1878 Baron Edmond de Rothschild was believed to have paid £30,000 for a Sèvres-encrusted commode that had been made for Mme du Barry.[15] Perhaps this legend explains why George Redford foresaw with such confidence, writing in *The Times* in 1882, that the Marie Antoinette writing-table from Hamilton Palace would fetch 7,000 to 10,000 guineas.

The great Hamilton Palace sale of 1882 was unquestionably the most magnificent sale of a single collection that has ever been held anywhere. It will be recalled that it took thirty-five days to sell Bernal's collection in 1855, and that it brought in less than £63,000. The 2,213 Hamilton Palace lots were sold in fifteen days, but the sum realized on the pictures and the objets d'art was £397,672, equivalent to two and a half million of our money. One wonders what would be the real value. It is certain that some of the French furniture, which startled the market in 1882 will not have kept up with the pace of inflation. We have even had an example which failed in the year 1960 to reach its original price. On the other hand, the Velazquez *Philip IV* is worth at least a million and the Antonello da Messina *Portrait* will have multiplied its £514 by nearly a thousand. That outlay of £397,672 in 1882 should have converted itself, not into two and a half million, but into something well in excess of ten million.

The bidding of 1882 was enormously stimulated by the fact that this was one of the wealthiest and noblest of houses. The glamour of the sale lay in the name of Hamilton and not in the name, now rarely mentioned and only with distaste, of William Beckford, to whom many of the objects had once belonged. But in most cases it was impossible to disentangle Beckford's purchases from those of his son-

[14] Apart from pieces that were acquired at public auction, no record was kept of the prices paid by Ferdinand de Rothschild. He is alleged to have destroyed the bills as soon as they were paid, so that his children should never know the extent of his extravagance.

[15] Or was it £24,000? See *supra*, pages 6, 12, *Chronique des Arts*, 3 December 1880.

in-law, the 10th Duke of Hamilton, who died in 1852, or those of the 11th Duke, who died in 1862, having married a cousin of Napoleon III and having spent much of his life in Paris, buying very expensive High Renaissance objects. Beckford himself was believed to have bought a number of sequestered royal possessions in Paris in 1801 and 1814, and a few even in 1793, when he lived mysteriously in the Paris of the Terror. But, apart from such matters of conjecture, there was the actual stamp of the *Garde Meuble*, which identified certain pieces as royal possessions. This was all that was required to satisfy the decidedly Walpolian taste, which had been adopted by the Rothschilds, four of whom were present on the viewing day.

On the third day of the Hamilton Palace sale, three of these pieces, with the cypher of Marie Antoinette and the signature of Riesener, made between them no less than £15,000 in the course of ten minutes' bidding. One of them, a little writing-table at £6,300, was bought by Samson Wertheimer for Ferdinand de Rothschild, and is still at Waddesdon Manor. This was the table for which *The Times* had forecast a price of 7,000 to 10,000 guineas, yet the companion-piece, which Riesener had almost certainly delivered to the Queen on the same day, an upright secrétaire, had been bought by the Marquess of Hertford[16] at the Didier sale of 1868 for no more than £412. The two other Riesener pieces, which completed the suite, though they had been delivered by Riesener as late as 1790 and 1791, made close on £9,000 between them. After passing through several hands, they gravitated in 1912 to Pierpont Morgan. In 1915, when most of Morgan's furniture was bought *en bloc* by Joseph Duveen, the commode and secrétaire were valued at £51,650.[17] What Henry Clay Frick paid Duveen for them is a matter of fearsome conjecture.

On the sixth day of the sale, Samson Wertheimer, acting for Ferdinand de Rothschild, made a still more spectacular bid, obtaining for £12,075 Beckford's pair of boulle armoires, possibly the pair which had been bought back at the Fonthill sale of 1823 for £193 15s.[18] Royal properties, obtained by Beckford from the painter Lebrun at the end of the Napoleonic Wars, they were in the heaviest and most grandiose Louis XIV taste, and they stood 9ft 6in high. In the 1850s, though boulle was then rather more in fashion, they might not have made £500; but 1882 was absolutely the last year in which a single boulle cabinet could have made £6,000 in gold sovereigns.

On the eighth day of the sale, Wertheimer failed to obtain the bureau

[16] *Wallace Collection Catalogue of Furniture*, F.302.
[17] According to *American Art News*. [18] Since 1957 in the Louvre.

of the Duc de Choiseul. Surmounted by a large clock and looking in Christies' photograph as if it badly needed dusting, this rather austere piece was bought by Colnaghi for £5,565. The real client was the Duc d'Aumale, the son of the late exiled French King Louis Philippe. But this bureau must be distinguished from a more famous *Bureau du Duc de Choiseul*, which Edmond de Rothschild bought from Prince Metternich towards 1900, reputedly for £48,000.[19] In fact, no two bureaux could look less alike. The Rothschild bureau is one of the strangest pieces of furniture ever made—a long, serpentine table, shaped rather like a grand piano with a sort of wedding cake perched at the narrow end. Smothered in rococo mounts by the Caffieri family towards the year 1740, its successive nineteenth-century owners, Talleyrand and Prince Metternich, must have had the greatest difficulty in using it without spearing their trousers or knee-breeches on a trident, a Cupid's dart, or a Fury's hair.[20]

In fact, there was little of the Hamilton furniture that was violently rococo. The best piece in this style is a bulbous commode at Waddesdon with huge sculptured *amorini* in gilt-bronze by Charles Cressent. It was bought by Wertheimer on the fourteenth day of the sale for £6,247, but the Baron spent most of his money on Marie Antoinette's furniture with straight lines and flat decoration, not because this was his own predilection, but because the Hamilton's had so much of it.

Louis XVI furniture, as we have seen, had become a smart decorator's taste in the early 1860s. But the special glamour of the Marie Antoinette cypher had a more personal origin. This sentimental cult began with the Exposition Universelle of 1867, when the Empress Eugénie had helped in arranging an exhibition of Marie Antoinette's possessions. These were displayed at Versailles in her favourite building, the Petit Trianon. As the foreign-born consort of a tottering crown, the Empress may have felt some affinity with the unhappy *Autrichienne*. After 1870 this cult for an exceptionally silly woman spread to the fashionable anti-republican circles of the Faubourg St Germain. Among collectors it threatened to outdo even the *Schwärmerei* that had once surrounded Raphael and La Fornarina, and which still surrounded Henri II and Diane de Poitiers. A great deal was expected of Marie Antoinette at the Hamilton Palace sale, and expectations were more than fulfilled. For on the eleventh day, when another suite of three pieces bearing the Queen's cypher made, not £15,000, but £24,360, *The Times* had to

[19] Maurice Rheims, *La Vie mystérieuse des Objets*, 1960, page 118.
[20] Described by Molinier in *Le Mobilier*, 1898, as still belonging to Prince Metternich.

admit that all forecasts had been surpassed and that even the most experienced dealers were taken by surprise. The three pieces comprised a cabinet, upright secrétaire, and commode of ebony wood, with splendid inlaid gold lacquer panels. Yet they had none of the frilly gaiety of the Riesener writing table, being funereally black and of an almost Napoleonic austerity of outline. For the cabinet and the commode Wertheimer paid £5,460 and £9,450, but the upright secrétaire was suffered by the Baron Ferdinand to depart abroad through the hands of the dealer Davis, also at £9,450.[21]

Thus, two by no means exceptional pieces of furniture established a saleroom record at 9,000 guineas each, which was not destined to be broken till 1926, and even in 1926 the new record was made with guineas that had little more than half the purchasing power of 1882. Stranger still, these two pieces of furniture in 1882 were not even antiques, being less than a century old. Their age at that time was no more than the present age of much of the fascinating bamboo furniture that we find in seaside boarding-houses and lodgings. But the 18,000 guineas of 1882 represent a purchasing power equivalent to perhaps £114,000 in 1963. Who would now pay £114,000 for a secrétaire and commode of the year 1870, bearing the cypher of Queen Victoria and the inventory numbers of Balmoral Castle?[22]

But to understand this cult, one has to realize how much more remote and romantic the *ancien régime* had become in 1882 than the mid-Victorian age is today. The gulf in time was so much wider than the measure of the intervening years. Lord George Hell, in Max Beerbohm's *The Happy Hypocrite*, was "clad in Georgian costume, which was not yet fancy dress". And fancy dress is what those Regency lords and ladies in William Quiller Orchardson's *Her First Dance* seem to wear with such manifest discomfort; yet the picture was shown in the year of the Hamilton Palace sale and the subject, which looks as depressingly Kensington as its title, was placed in a period barely thirty years before the dear fellow was born. Orchardson's sham eighteenth-century and sham Regency replaced the memory of an age that was now lost. It had dimmed with the railways, the gas-light and the whisky and soda, and now in the world of Mr Pooter it was extinguished by lawn tennis, bicycles, and even the telephone.

[21] Later, all three pieces were acquired by Cornelius Vanderbilt. Now in the Metropolitan Museum.
[22] "An interesting lot, which sold for £40, was a set of mid-nineteenth-century chairs in mahogany, all branded Frogmore House, 1871, and with Queen Victoria's monogram and crown" (*Apollo Magazine*, 1956).

It is significant, however, that the handsome bound edition of the Hamilton Palace sale catalogue was lettered in Gothic script in two shades of gold on Rossettian sage green with an alleged Fra Angelico angel in one corner.[23] That was another form of fancy dress, but nearer to the hearts of English escapists than sitting down in one's coat-tails among the *garde meuble* of Marie Antoinette.

The truth was that while half a dozen of the most expensive lots in the Hamilton Palace sale comprised French furniture, that commodity was coveted by the home market no more than in the 1860s. When Continental millionaires were not in competition, such articles were not all expensive. A Louis XVI writing-table could be had at the Hamilton sale for £115 10s, a pair of pier-tables with green marble slabs for £157 10s, and a Louis XVI carved gilt settee for £78 15s, though another settee of this kind, an absolute monster 13ft long, which had once been at Versailles, returned to Paris at £1,176—the dearest settee that had ever been sold.

The feverish climate of the Hamilton Palace sale was not maintained. In 1883 the Duke of Marlborough sent a writing-table by Martin Carlin to Christie's. It was believed that an offer of £18,000 from Edmond de Rothschild had already been refused.[24] It was nevertheless bought-in at £6,300, the price of the Hamilton Palace table, which it closely resembled. And then, in the year 1884, there began an English financial depression which lasted three years (see Vol. I, page 160). Some of the Hamilton Palace treasures, which had stayed in the country, fared very badly during these years. One of the few English buyers to acquire any of the furniture was Christopher Beckett Dennison who had spent quite £100,000 at the sale, though without obtaining the most breathtaking lots, and who died very suddenly on a visit to Ireland. So in 1885 a tremendous collection, rapidly thrown together at all the sales of the past ten years, came to Christie's. It took twenty-one days to sell 3,400 lots, and yet the collection made no more than £67,000. Furniture from Hamilton Palace provided the worst casualties. A boulle cabinet, crowned with a gilt-bronze medallion of Louis XIV, fell from £2,310 to £997 10s. A gilt-wood suite which had cost £1,517 fell to £997 10s, though in 1913 it was sold for £9,240. The famous late sixteenth-century Milanese chess table, made of iron inlaid with marbles and gems, fell from £3,150 to £1,491, the price at which the Victoria and Albert Museum acquired it.

[23] *The Hamilton Palace Collection, Illustrated Catalogue*, London, 1882.
[24] *Chronique des Arts*, 7 July, 1883. The commode is now in the Huntington Library, San Marino, California.

In 1887 the end of the depression was signalled by the sale of a Louis XV writing table for £1,837 10s. For the next eight years, each successive season at Christie's saw from two to six pieces of French furniture sold for £1,000 and more. The sales of Lord Frederick Cavendish Bentinck in 1891, of the Earl of Essex in 1893, and of Mrs Lyne Stephens in 1895 were particularly rich in French furniture, which occasionally reached prices of £2,500 and thereabouts. Most of it went abroad.

Between 1896 and 1901 the quantity of fine French furniture that appeared in the London salerooms diminished considerably. The market appeared to have shifted elsewhere. And then in 1901 came the Duke of Leeds's sale, where two splendid Louis XV commodes by Joseph, with mounts by Caffieri, made £15,000 the pair, the first furniture prices in London to rival the Hamilton Palace sale of 1882. London sale viewers had become so unused to these prices in the past twenty years that they were outraged. They were chided in the very first number of the *Connoisseur*, which was published that month. It was pointed out that such prices were not at all abnormal, that even the original cost of manufacture of the articles had been very high, and so on. But the truth was that prices such as these had only been paid in the 1890s by the Rothschilds in competition with the new American buyers. They were not found in the open saleroom till after the First World War, when something like the levels of the Hamilton Palace sale were reached again.

In Paris in the 1880s and 1890s French furniture actually fetched lower prices than in London, except for two sales in 1896–7. Furthermore, in the year 1887, when the financial depression affected all Europe, furniture prices in Paris were lower than at any time since the 1840s. There could hardly have been a more romantic sale than that of the Hôtel Bernard in that year—or a more wretched one. If the house that was demolished at the intersection of the Boulevard St Germain and the Rue du Bac was not actually the original residence of Louis XIV's great banker, Samuel Bernard, at least his descendants had lived there for nearly two centuries, and there was hardly anything in the place that did not date from the *ancien régime*. But the *boiseries* had been saved from the scrap-merchants by Adolphe de Rothschild, while the great marble chimney-piece went to Waddesdon Manor. And then, it seems, the Rothschilds lost interest.

One would have thought that in the age of miraculous transportations, which had seen in 1881 the removal of the *cour d'honneur* of the Château de Montal from Auvergne to Paris, the entire Bernard

establishment might have crossed the Atlantic to be reconstructed by a Marquand, a Vanderbilt or a Collis P. Huntington. But in 1883 the U.S. Government had clapped its ridiculous tariff of 30 per cent on the import of all works of art, and it took some years for the millionaires to acclimatize themselves to it or to find loopholes of evasion. In 1882 France had exported works of art to the USA to the tune of 10 million francs. In 1883 the figure fell to less than 7 millions, and in 1884 to 3½ millions. As to the Victoria and Albert Museum, which had begun to collect entire rooms and façades in 1869, it was to be hit for many years by a phase of Government parsimony, which followed Mr Gladstone's spending spree at the Blenheim Palace dispersal of 1884-5 (see Vol. I, pages 178-9). Moreover, in Paris the 1880s had begun with a ten per cent tax on the purchaser at the State-controlled auctions, a tax that has since grown to a scale that runs as high as twenty-one per cent. The slow decline of Paris as an international market dates from 1881 (see *infra*, Chapter Eight, pages 249-50).

The result of this accumulation of ill-fortune was that at the Bernard sale of 1887 more than 200 French eighteenth-century lots were sold for less than £10,000. The highest-priced object was an elaborate *bureau à cylindre* by Saunier at £228. It was not till 1890 that there was some improvement in this market, but even the 1890s, which saw the most legendary private transactions with Edmond de Rothschild, were not very conspicuous years in the Paris salerooms. There was more than one reason. While splendid accumulations of eighteenth-century objets d'art were made by *nouveaux riches*, like Chauchard Lelong and Camondo, the snobs of the Faubourg St Germain remained indifferent to this national heritage, much as Balzac had described them in *Le Cousin Pons* in 1847. So too the native middle classes. Chauchard and the other collectors of his kind, who helped to make the millionaire market, were very exceptional. The French *commerçant* was not a snob in these matters. Most French furniture possessed in some degree that Ritzy look which was accepted as a class symbol in the America of the 1880s, as easily as it had been accepted in the Germany and Russia of the eighteenth century. But to the Frenchman the bulbous surfaces and ormolu swags were just part of the magpie's nest in which he normally dwelt. His furniture might include old, dilapidated pieces or modestly-priced recent imitations. He scarcely bothered to decide which was which. They simply found their place with the gun-metal Arab on his steed, the bust of composition marble, inscribed *Je t'Aime*, and the *art-nouveau* gasolier, smothered in flies, the house-gods of the normal home.

The taste for the pure *dix huitième* was thought rather foreign and vulgar when pushed to the extremes of exclusiveness and expense, but the other sort of collecting, which had been no more than scholarly in the 1830s, was now wildly fashionable. The century of François Premier and Henri Deux was at last as popular as the age of Marie Antoinette. We have seen in the previous chapter what happened after the deaths of the old provincial collectors who had absorbed the pillage of the French Revolution. Their possessions had become dearer in the 1880s than they have ever been in all history.

The state of the Paris market towards the end of the century seems all the more extraordinary because the 1880s and 1890s were essentially a domestic period in collecting among the very rich, and you could hardly fill a fashionable drawing-room with *meubles à deux corps* and Limoges retables. It was the period when the vogue for enormous drawing-room suites spread to the USA, a vogue which had begun with two £4,000 suites in the Paris saleroom in 1881. Why were such saleroom prices as these not repeated? Why were the prices higher in London, which was a mere entrepôt, whence the French furniture went off to the USA or back to Paris?

I suggest this reason. In London the sales at Christie's were fashionable events. Contemporary illustrations show them to have been highly decorous, with a fair sprinkling of bonnets among the top-hats. Not so Paris. Unless the State-licensed auctioneer, or *commissaire-priseur*, was granted permission to sell a specially important collection on the spot,[25] everything had to go to the dirty, dilapidated, and overcrowded Hôtel Drouot, which had been used since 1854, and that was torment indeed.

"No one", *Le Temps* complained in 1886, "could imagine the result of women going to the Salle Drouot. Their skirts with twelve flounces would not stand up to the dirt and the clumsiness of the porters." Three years later, when the crowd at a fairly big sale had to be broken up by the police, *Le Temps* declared that it had constantly demanded improvements in the installations, but in vain:

> The *commissaires-priseurs* have a monopoly. One is compelled to sell at the Hôtel Drouot. They make enough money there to spend a little in order to prevent such scandalous scenes as were witnessed yesterday occurring at every sale. In no country do the public sales cost so much as in France, and in no country are the arrangements so bad.

[25] For instance the Secrètan sale, 1889, and the Spitzer sale, 1893.

In 1892 some reconstruction of the Salle Drouot was at last begun. A special entrance was provided, by which ticket-holders could reach their seats without passing through a mob, whose presence was mandatory under the Law of the 29th of Ventose of the year IX. But the damage had already been done. If fashionable women could not go to the Salle Drouot, scholarly collectors, at least, had been able to put up with it. Paris, therefore, remained the market for mediaeval and Renaissance art, whereas London, except for the great international fairs of the Hamilton Fountaine (1884) and Magniac (1892) sales, was a mere backwater. But in 1896 a big Viennese collection, that of Martin Heckscher, was sent to London and not to Paris. *Chronique des Arts* predicted that the international market would shift to London completely. The Paris salerooms had been outdistanced, and perhaps by their own fault.

3. *The Louis Drawing-room and the Rise of English Furniture*

I suppose we are a dwindling band who remember the Louis drawing-room. As a rule, it dated from 1900; by the 1920s, if it survived at all, it looked mournfully shabby. Some of the younger, more voguish proprietresses may already have removed the oyster-white paint from the frames and pickled them. But what an institution it had been! Everyone had lived up to the Louises. In Bayswater the distinction between *chaises courantes* and *chaises meublantes*—chairs at which you looked and chairs on which you sat—had been observed as rigorously as at the Court of Versailles.

To a child born at the beginning of the Edwardian era, the Louis drawing-room symbolized all adult life. The gloomy, sand-coloured upholstery was intended to simulate Beauvais tapestry, which, though no one knew it, had once shimmered with the very brightest of colours on its white silk background. But antiquity was the last thing that this *décor* suggested. The oyster-white paint and the trotting, bandy legs had clearly been intended for certain flounced creatures in huge hats, who on rare occasions sat on them, and who could be detected manœuvring at least seven veils in order to insert a small chocolate éclair therein.

They were not, of course, *real* Louis chairs. With its tapestry covers you could hardly expect to buy an eighteenth-century French drawing-room suite in the early 1900s at the rate of less than £200 to £500 for a single fauteuil. For the tapestry covers alone, sufficient for two little settees and a chair, someone in 1903 bid over £2,000. Yet the drawing-

room suites had never ranked as the dearest *mobilier* of the eighteenth century. However fine the carving and gilding, however perfect the design, wood that was not veneered and inlaid ranked as *menuiserie*, a poor relation of *ébénisterie*. Upholstery in silk tapestry and even in cheaper materials frequently cost more than making the settee or chair itself. A very special *fauteuil à la Reine*, made by Jacob for the Duc de Provence in 1785, cost 540 francs, or about £22. A pair of *fauteuils à cabriolet*, made by Séné, cost Marie Antoinette barely £18 between them. For the very finest of Parisian workmanship, £9 for a chair-frame and £20 for a settee-frame seem to have been normal prices. The great suite made by Foliot for Mme Elizabeth at Fontainebleau in 1778 worked out at about £13 10s a unit, including a settee and a fire-screen. The fine brocade covers would possibly cost as much again, but Gobelins or Beauvais silk tapestry covers might cost three times as much.

Considering the impeccable taste and workmanship of these chair-frames, the prices seem very low for a decade when royal writing-desks could cost over £3,000 each. Yet, compared with Chippendale and Sheraton furniture, the charges were tremendous. An English noble-man would have to pay at least twenty guineas apiece for his French fauteuils, whereas the native product cost him a quarter of that. There was a much stronger vogue for French furniture in England in the late eighteenth century than is generally supposed. However much he deplored it, Lord Torrington in the 1780s saw plenty of it on his country explorations. As in the case of the costly French pier-glasses, the gentry were prepared to pay an enormous tariff and high transportation costs as well. A specially fine suite which reached Heythrop Hall before 1778 was reputed to have cost the Earl of Shrewsbury ninety guineas a settee and thirty guineas a fauteuil. Apparently the price included the gilding, which was done in England, but not the yellow figured-silk covers, for the suite was then upholstered simply in "tent stitchwork".[26]

Nothing like such a price could be expected at an eighteenth-century English auction. A richly carved suite, upholstered in damask or tapestry, was worth "second-hand" from £8 to £10 a unit, some-times as little as £4. The Comte d'Adhemer's crimson damask suite in 1788 was quite exceptional at £11 a fauteuil. Within a few years, the emigration from France was to depress the second-hand market still further, so that in 1795 Field-Marshal Conway's French suite, complete with those Gobelins tapestry panels which were to drive the early

[26] *Wallace Collection Catalogue of Furniture*, F.219, F.232.

1900s quite demented, made only £41 8s.—and this was the price of two settees, four fauteuils, and four bergères.

From this point onwards, the drawing-room suites follow the same saleroom pattern as French *ébénisterie*. During the Napoleonic Wars they rose so steeply that in 1823 Beckford's gilt and purple damask fauteuils from Fonthill could make £30 each. But within twenty years, at the Strawberry Hill sale of 1842, we get the absolute nadir of the French drawing-room suite. A tapestry-covered suite, bought by Walpole in the reign of Louis XV, made barely £3 a unit, including its settee, while six other tapestry-backed fauteuils were sold for eight guineas the lot.

The recovery of the 1850s again follows the familiar pattern. In 1852 the Duc de Stacpoole's Louis XVI suite from Fontainebleau makes over £18 a unit. In 1856 the Earl of Orford's suite at Christie's makes £16 a unit, and in 1857 the Earl of Shrewsbury's suite as much as £27 a fauteuil and £115 for a settee. It will be noticed in the last case that the prices are approximately those that were paid before 1778 by the Earl of Shrewsbury of the day. The same can also be said of the Duke of Stacpoole's suite, which was first ordered in 1786. All these suites, however, were bought for the Marquess of Hertford, who hoarded furniture as in a safe-deposit and who was not concerned with matching curtains and carpets, and still less with what was compatible with the crinoline. In reality, fauteuils at £27 apiece in 1857 were in advance of their time. For another twenty years £16 to £20 a unit was to remain the price of the most coveted sort of drawing-room suite—that is to say, the suites with subjects woven in silk tapestry. Only at the Vaux-Praslin sale in Paris in 1876 do we find a substantial advance. A Louis XV damask suite now fetches £63 for a fauteuil and £190 for a settee. But the year 1876 was still only the eve of American competition since at the Leopold Double sale of 1881, suites in Beauvais tapestry soared far beyond these regions. The famous *Mobilier des Dieux* worked out at £1,000 for a settee—£300 for a fauteuil, £200 for a chair.

We are now at the beginning of the great Louis drawing-room cult which was to bring the Faubourg St Germain to the shores of the Pacific. The timing should, however, be noticed. While the stage of "replacement cost" was reached in one case in the early 1850s, this furniture failed to keep up with the truly exciting market for *ébénisterie* —for boulle and Sèvres-inlaid furniture in particular. It meant simply that the faded gold or oyster-white woodwork, the white-ground silk tapestries or damasks did not go with the heavily plushed and panelled

early Victorian or Second Empire interior. The *meubles de salon* came into their own fairly late in the 1870, when the light background began to be favoured almost universally.

This light background could be associated with the Japanese style, with *art nouveau*, with William Morris and Old English, or with the strictest eighteenth-century English and French purism. It was, in reality, an instinctive revulsion against the dark and heavy early Victorian *Zeitgeist*, and it was tied to no aesthetic canon. Even so, the Louis drawing-room imposed itself very slowly. Not every smart rich woman wanted to surrender so rigorously to the interior decorator. The greatest demand for the matching suites came therefore from a country where the smart rich woman was something quite new.

The Louis drawing-room in America was not strictly speaking early Fifth Avenue. Most significantly, there is no eighteenth-century French furniture among the elephantine colour plates of Edward Strahan's *Mr Vanderbilt's House and Collection*, published in Philadelphia in 1884 (see page 228). It is in 1887 that we get some idea of what an even newer kind of American market could do. In that year the elder Joseph Duveen bought a suite of furniture in Antwerp, upholstered with tapestry panels after Boucher, which matched Mme de Pompadour's *Jeux d'Enfants* suite of 1751. The price seems to have been several times as high as anything recorded in the saleroom, but Duveen knew his American market. For two settees, six fauteuils, six chairs, two bergères, and two fire-screens he was charged £18,000. Nevertheless, Duveen contrived to sell the suite to Collis P. Huntington of California for £30,000, and in 1890 he was willing to buy it back at £45,000. On the same authority, we learn that Duveen sold a single settee in this style in the early 1890s for £15,000.[27]

A hundred pounds would have been a high price for any settee, fully gilded and upholstered, in the Paris of Louis XVI. But such enormous advances as these were only achieved by furniture which possessed the all-essential tapestry panels. One must realize what it meant towards 1900 to own a suite that had survived with two settees, eight to twelve fauteuils and bergères, and perhaps a tabouret or two and a screen. It meant owning something at least as rare as a Raphael. But to own the set in its original upholstery and tapestry covers, covers that formed a pictorial series woven after Boucher or Oudry under the direction of the painters—that was to own something miraculous. You could, of course, own the *Book of Kells*, or the *Crystal of King Lothair*, but this

[27] James Duveen, *The House of Duveen*, 1954, pages 85–8.

might not mean much in the Chicago or San Francisco of 1900, whereas a Boucher-Beauvais suite of furniture would convey your financial standing to your guests the moment they saw the drawing-room.

Unfortunately—though this was by no means the cause of the market decline of the tapestry drawing-room suite since the 1920s—the reasoning was counterfeit coin. "A Popular Fallacy re-examined" is the down-to-earth subtitle of a recent inquest by Mr Francis Watson,[28] who shows that the output of tapestry panels for furniture in the eighteenth century had been very small, both at Gobelins and at Beauvais. At Gobelins, a royal factory, only thirty-five sets had been ordered before 1792, of which a third had gone abroad to be fitted to foreign frames. At Beauvais, a commercial factory, 197 orders were taken between 1723 and 1793. Furthermore, though this meant less than three orders a year, most of the orders were for a single item and not for sets. Considering that thousands of carved giltwood chairs were produced every year in Paris alone, it is not surprising that tapestry covers are seldom mentioned or depicted in French eighteenth-century works.

Apparently this taste did not remain fashionable for long, since the only tapestry suites to be owned by Mme de Pompadour were to be found at the time of her death in 1764 in minor apartments. As to the famous *Fables of La Fontaine* suite which made £4,400 in 1881, Christie's had sold a set of eight fauteuils with these panels in 1769 at four guineas each. De Maupassant, writing just after the 1881 sale, was not far out in placing such a suite in the decayed Norman château which figures in *Une Vie*, since generations must have passed during which these objects were not cherished at all. The *Jeux d'Enfants* suite of 1751 had been driven out of fashion within a few years of its completion because of the changing shape of chairs. In 1764 the suite was valued for Mme de Pompadour's executors at less than £3 a fauteuil, though the tapestry panels alone must have cost from six to eight times as much to make.

Still worse, Mr Watson quotes the authoritative Pierre Verlet to show that the most famous of all these furniture suites, the *Mobilier des Dieux*, which was bought by Isaac Camondo in 1881 for £4,000 and left to the Louvre in 1911, had no tapestry on it in the year 1786, but only crimson-and-gold damask.[29] Nor was tapestry the only addition.

[28] *Connoisseur*, October 1961, *French tapestry chair coverings, a popular fallacy re-examined.*
[29] Pierre Verlet, *Le Mobilier Royale Français*, Vol. I, 1945.

Since the dispersal of the royal *garde meuble* at the Revolution, the suite had been augmented by three fauteuils and a settee.

Already the affair begins to look farcical. Even if one chooses to ignore the practical certainty that the tapestry panels fell into neglect after the shapes had gone out of fashion, even if one assumes the contrary—namely, that the tapestry-covered chairs have at all times been treated with loving care—only the most scientific precautions will enable the silk to have survived at least 175 years, in some cases 240. A tapestry seat-cover which is moved about, sat on, and constantly dusted looks old after a generation or two. A patina of the most satisfying kind must therefore have descended before the year 1900 on countless covers, which had simply been copied at Gobelins to suit the still modest revival of this taste in the middle of the century.

I have reproduced and (if he will forgive me) extended Mr Watson's argument because the reader will find under the heading "Drawing-room Suites" in my sales analysis some fifty or sixty suites, allowing for cross-references, all of which made four-figure and some of them five-figure prices. Nor is that list intended to be anything more than a specimen list. In the years immediately before and immediately after the First World War more than twenty such tapestry suites of furniture could sometimes be sold in London and Paris in the course of one season for £1,000 and more. Where did they all come from? Mr James Duveen has described in his inimitable way the aura of excitement and intrigue which surrounded his chance discovery at the end of the last century of a set of concealed chair-backs and seat-panels. He has depicted the moment of rapture when he felt the crisp, hard, silken sheen beneath the modern covers. Yet who knows that the panels had not been re-woven?[30]

One wonders whether at any time enthusiasm for objects of the past has been quite so uncritical as it was at the eve of the First World War. In 1898 the famous M. Chauchard, who bought the works of Millet and Meissonier at £30,000 to £45,000 apiece, spent £18,600 on a tapestry-covered suite of two settees and ten fauteuils. In 1912 Chauchard's heriress, Mme Bourson, presented the suite to the Louvre, having just refused, so it was said, an offer of £73,200 from the dealer, Charles Lowengard, who had originally sold it to Chauchard.[31]

It is not easy to imagine even in the 1960s that a dealer would pay the equivalent price—that is to say, about £450,000—for a furniture suite on which he hoped to make a profit. Nowadays the sum of

[30] James Duveen, *Secrets of an Art Dealer*, London, 1937.
[31] As told by A. C. R. Carter in *The Year's Art*, 1913.

£30,000 may not be too much for some fashionable blobs and splashes on the bathroom wall, but, as Queen Alexandra is alleged to have observed of one of Duveen's furniture suites, it is a lot of money for one person to sit down on.

In the seven years preceding the First World War six French drawing-room suites were sold at £10,000 to £18,000 each in the open saleroom, all but one of them in Paris. And the mania survived Armageddon, for eight suites were sold between 1923 and 1928 at prices from £9,000 to £28,000. The Michelham suite of 1926 worked out at £2,300 for a fauteuil—and the pound was then on the gold standard—but that was the high tide. In 1928 a suite which had been bid up to £18,000 in 1907, was sold in New York for no more than £12,000. Ten years later this suite had fallen to £3,800.

If the market fell in the 1930s, it was not for lack of confidence in the objects, but because of the lack of money and the lack of accommodation. With the advent of inflation, prices began to catch up with the glorious past, though only on paper. And so in 1956 two bergères without any tapestry could again make 4,000 guineas of a sort. But it is open to doubt whether we are going to see any more of those huge, uniform suites. Some of them may even have been split up to make them more saleable, instead of receiving additions to the family, so heretical have we become.

Victorian England, where the new industrialists opposed a Low Church resistance to everything French, succumbed in the end to the Louis drawing-room, but only towards 1900. In the 1870s it was absolutely unknown, except for Ferdinand de Rothschild's Waddesdon Manor and Sir Louis Harcourt's newly-decorated house in Brook Street, now the Savile Club (the Lulu Quinze style). Despite the popularity of Orchardson's pictures, the Louis drawing-room failed to become truly general even in the 1880s and 1890s. Why did the suite have to include a screen? Most suspicious. It could only be that those serpentine glass panels in the otherwise senseless folding screens were for watching women undress.

There were also more compelling reasons for the delayed arrival of the French drawing-room in England. Unlike the 4th Marquess of Hertford, most rich Englishmen refused to buy furniture as collector's pieces. Furniture which is in use is part of a style of living, and style changed rapidly in Victorian England. You could not pay the prices which the Marquess of Hertford paid in the 1860s or which the American tycoons paid in the 1880s if you were expected to change your drawing-room every few years. Except for a brief, impetuous

interlude in the reign of Edward VII, fashionable enslavement to the rule of the interior decorator produced the result that the French style had to fight against the rival choices of walnut and Queen Anne, of bamboo and Japan, of oak and chintz and William Morris, of *art nouveau*, of Scottish baronial and pitch-pine, of bankers' Renaissance with its carved mahogany panelling and its embossed wallpapers in imitation of stamped leather or brocade.

Between the late 1860s and the early 1880s the same movement which had created a rage for English eighteenth-century portraits, extended itself to architecture and interior decoration. The short-lived Queen Anne style, so-called, was evolved. At first this brought back the English walnut and mahogany and satinwood furniture which went with the light panelling. But Queen Anne was a confused style, which soon drifted into fantasies of Japanese inspiration, dominated by the craze for blue-and-white china. This had a retarding effect on the market for English eighteenth-century furniture. In many houses it still lay hidden in attics at the very end of the century, when the best of Chippendale's mahogany suites were not worth a tenth of the most run-of-the-mill French suites, or even of spurious French suites.

The very low price of English furniture at the end of the eighteenth century has been described in Chapter Two. Furniture so pretty and so reasonably priced as Hepplewhite's and Sheraton's was not to be discarded in a hurry. During the latter years of the Napoleonic Wars and for at least ten years afterwards, the landed gentry tended to ignore the furniture which we now call Regency and to cling to the furniture of their fathers. Very good imitations of eighteenth-century inlaid satinwood furniture were still being made in the 1820s. But towards the end of that decade all forms of neo-classicism in furniture went into decline. If old English furniture was wanted at all, it had to be Elizabethan, or at latest early Jacobean. If new and smart, it leaned heavily on the adaptation of boulle and other seventeenth-century Continental models. The movement which produced Sir Walter Scott in popular literature and Wilkie and Leslie in popular painting dealt even harder with English eighteenth-century furniture than it dealt with the French *dix huitième*. Thus, at the Strawberry Hill sale of 1842 Horace Walpole's four-poster bed with fluted columns in the Chippendale style was sold for £2 12s 6d. A remarkable Gothic table with a jasper top, designed for Walpole by Bentley in the 1750s, did soar as high as nineteen guineas, but Bentley's trellised Gothic bookcases, beautifully designed to fit the curves of the Strawberry Hill round tower, could be had for thirty shillings and even twelve shillings.

At the Stowe sale of 1848, a rare suite of six George I chairs and two settees in white carved gesso made twenty guineas all told (£2,310 in 1939). But it was pre-Cromwellian furniture that was wanted. Even so, Lady Jersey was able to buy the Duke of Buckingham's silver table and silver mirror, the rivals of the much later set at Knole, for sixty-one and eighty guineas. In his notes on the sale, Romsey Forster complained that the legs were too meagre—an odd criticism, one would say, of furniture of the reign of Charles I, but legs were truly legs in 1848.

Like the furniture at the Stowe sale, the furniture at the Bernal sale of 1855 was mostly French eighteenth-century or late Renaissance Italian, but very notable were the English pier-glasses by Chippendale, carved and gilded in the contemporary French taste, with figures of dogs and caryatids. Yet, though these pieces made as much as £36 10s, £50, and £78, it was no tribute to Chippendale, but a memory of the high production cost of plate glass in eighteenth-century England, and of the fifty per cent Excise duty that had been paid on it as late as 1845.

The 1850s and 1860s, which saw such an impressive advance in the value of paintings of the English eighteenth-century school, produced nothing that was comparable in the English furniture market. In 1857 the Earl of Shrewsbury's Chippendale kneehole writing-desk at fifty-two guineas and his Jacobean marquetry cabinet at £65 10s, represented something less than the production or copying cost of the article. In fact, in 1870 Christie's sold a copy of a Chippendale kneehole writing-table of the Nostell Priory type, made by Annoot of Bond Street, for £68 5s. But there was a different order of prices in the 1860s for English marquetry furniture, which owed something to late eighteenth-century French taste. Thus in 1864 a roll-top desk with ormolu mounts, described rather oddly as "early English", made £108 3s.

Although nothing like the French porcelain-inlaid furniture had been produced in eighteenth-century England, there had been some rare satinwood pieces, painted with designs after Angelica Kaufmann or inlaid with plaques of Wedgwood jasper ware. The latter were indeed so rare that it was found necessary to invent them. Thus, in 1868, the Victoria and Albert Museum spent £800 on a satinwood cabinet, which had been exhibited at the Exposition Universelle in the previous year and for which the Wedgwood factory had designed new jasper-ware plaques. The taste for satinwood furniture in early Victorian England had not declined as completely as the taste for walnut or carved mahogany, but the price of the original commodity had fallen much

below that of the reproduction. In 1870 the Museum paid for a bow-fronted cabinet with Wedgwood plaques not £800, but £200 and the same sum for a most remarkable mirror-dressing table with silver fittings and cameo paintings after Angelica Kaufmann. A cabinet in the same style was sold at Christie's in 1880 for close on £300, probably a saleroom record for any piece of English furniture till the following century. Comparable prices for satinwood furniture, paid in the early 1880s, and particularly at the Hamilton Palace sale, reflect a vogue which was extremely short-lived. One may equate the craze for furniture, inlaid with Wedgwood plaques (see page 172), with the neo-Graecisms of Leighton and Alma Tadema; the taste for light-coloured veneers and simple lines with the "Queen Anne" houses of Webb and Norman Shaw and the whole set-up with Orchardson's wishy-washy conversation pieces. But the doom of this cult was the fresh wave of eclecticism, which had spread from Japan after the Imperial restoration of 1868 (see page 219), and which smothered England in bamboo faster than the satinwood imitations could come off the lines.

Plain carved furniture stood up even less well to Orientalism. At the Hamilton Palace sale of 1882, two English satinwood and ormolu corner cupboards at 235 guineas the pair were humble intruders among the treasures of the *garde meuble*; but the price was grandiose when compared with that of English carved furniture. There were, for instance, six William and Mary or Queen Anne high-backed walnut chairs, together with two armchairs in all the glory of their damask covers, for 50 guineas. An elaborate carved mahogany Chippendale writing table on lions' feet cost fifty-eight guineas. Today it might even be a question whether this or the 9,000-guinea Marie Antoinette secrétaire would be worth the most.

The 1880s saw, nevertheless, a moderate revival of interest in Chippendale and carved wood furniture in general, possibly as a by-product of the arts and crafts movement. James Duveen recounts how in 1889 he bought an unusually fine Chippendale serpentine table at a country auction for £65. After some years, he was able to sell it for £500, and by 1910 the table had changed hands in the USA at £3,000.[32] This faithfully recorded transaction confirms the evidence of the salerooms as to the belated advance of Chippendale furniture at its best. For instance, most of the Chippendale furniture lots at the Sir John Dean Paul sale of 1896 were bought by Henry Hirsch for £882. In 1934, not a good year for furniture prices, they were sold at Christie's for £5,500.

[32] James Duveen, *The House of Duveen*, 1954, pages 99–101.

It is possible that the opening of the Wallace Collection to the public in 1897 may have had a retarding effect on the English furniture market. It had been an axiom for so long that the best French furniture was sold in England but shipped abroad that people no longer expected to see it. It was perhaps not a coincidence that the mania for gilt-wood and tapestry matching suites made its conquest of the English upper middle classes within a year or two of this event. It is certain, at any rate, that in 1900 the sum of £100 was still very high for any piece of English eighteenth-century furniture. Soon, however, the shops were filling up with a commodity that had become fashionable, though only lately rescued from the attics and lumber-rooms to which it had been banished in the 1840s or 1850s. Then in 1902 two richly carved Chippendale armchairs were bid up to £1,050. They had been expected to fetch from £200 or £300 on account of their exceptional quality, but someone wanted them to complete a set, and a desperate dealers' duel established a new precedent in prices. Before the year was out, a Chippendale table had been sold at an obscure house sale in Bayswater for £550.

In 1904–8 Percy Macquoid published his *History of English Furniture*, with colour plates such as have never been surpassed since, with a magnificent selection of examples, and with sweeping judgements that condemned everything after the year 1800 to the utmost Limbo. It is a curious fact that the dozen finest things in those classical four volumes would not have made more than £400 to £650 each had they come under the hammer in 1904–8. But the publication of Macquoid undoubtedly revolutionized the English furniture market. The change came abruptly early in 1909, when a Chippendale carved settee of incredible magnificence with English embroidery, illustrated by Macquoid, made £2,047 10s at the H. Percy Dean sale.[33] Two Chippendale cabinets were also sold for £1,470 and £787. The price-gap had almost been closed between *menuiserie* and *ébénisterie*, between the carved but plain English style and the heavily mounted and inlaid French style. At the end of the First World War the gap had ceased to exist. The still numerous sale-goers who remembered the bidding at the Hamilton Palace sale of 1882 might notice that among the highest prizes of the second Hamilton Palace sale of 1919 were two Chippendale tables at £1,837 10s, tables which would not have made sixty guineas the pair at the first sale.

[33] Percy Macquoid, *History of English Furniture, the Age of Mahogany*, London, 1906, Fig. 121.

The Return of the Eighteenth Century
Part Two: Porcelain, Tapestry, and Sculpture

1. *The Ascendancy of Sèvres, 1802–1910. — 2. The Market for European Porcelain, 1802–1910 — 3. French Tapestry and Sculpture of the Eighteenth Century; the Market from 1760 to 1914*

1. *The Ascendancy of Sèvres, 1802–1910*

The collector of European porcelain is most likely to want to know the prices that were paid during the nineteenth century for the porcelain that fetches such fashionable prices today; the Nymphenburg figures by Bustelli, the rococo tureens and jardinières of Vincennes; the early Chelsea pieces of the raised and red anchor periods; *magots* from Chantilly Mennecy and St Cloud; Meissen with the Augustus the Strong mark; early Capodimonte groups—in short, the rare incunabula of porcelain-collecting. But he will find it hard to find them, or at any rate to recognize them in the terse catalogues that satisfied our forefathers. And if he finds them at all, he will be astonished to see that a large proportion of them were worth very little money; that the big prices—and we today, with our three-shilling pounds, just don't know what big porcelain prices are—were paid for a kind of porcelain that he never sees and which, if he looks for it in a museum, he will not like.

For it is a fact that the European porcelain market was dominated well into the present century by the more monumental sort of Sèvres chimney-piece garnitures, and by those not too happy products of other factories that tried to imitate them. As we have already seen, this sort of Sèvres porcelain had not been as expensive to produce as later

legend made it out to be. The most famous models, like the *vaisseaux à mâts*, went out of fashion and became cheap long before the fall of the *ancien régime*. And under the Revolution and the First Empire, French art-fanciers actively disliked them. Yet, when combined together, all these negative factors encouraged a most powerful taste for Sèvres in England.

The cult seems to begin during the Peace of Amiens in 1801–3, when a great deal of Sèvres must have been bought-up by English visitors in Paris. It is certain that the tall chimney-piece urns, which had normally cost from £20 to £50 a pair in the late eighteenth-century London salerooms, were appreciably dearer at the Matthew Higgins sale in 1802, one pair costing £136 10s and another £122 17s. There was certainly no such demand for Sèvres of the *ancien régime* in Paris. On the other hand, the newest sort of Sèvres was excessively dear, and under the Empire it was to become dearer still (see pages 51–52). According to Joseph Marryat,[1] an English tourist in Paris paid 3,600 francs, or about £145, in 1802 for a single porcelain plaque after Brenet's picture, *The Death of Dugesclin*. But though the picture had been painted fifteen years earlier, in 1787, the subject was in the true patriotic taste of the Consulate, making the plaque worth far more than the very best of the earlier soft-paste pieces.

Between 1803 and 1814 expensive Sèvres was scarce at Christie's, though it was certainly being smuggled in from France. At this time the Prince Regent was busy accumulating the Sèvres services which are still in the Royal collections. One of the first was a dessert service, bought at Robert Heathcote's sale in 1805 for £315, a very high price for its time, since in the 1790s Christie's had sold numerous services, brought to England by *émigrés*, at the rate of five or six shillings a unit. But before the end of the war services were selling at £4 a unit or more. For instance, in 1814 the 3rd Marquess of Hertford, acting for the Prince Regent, bid £777 at Christie's for a service of 182 pieces. The property of an English Ambassador, it was not by any means a royal service, but one painted at Tournai from a series of models based on M. Buffon's stuffed birds. As we have seen in Chapter Two, the Sèvres version of the series was still in production in 1793, and obtainable from the factory at rather less than £3 a plate.[2]

Higher prices per plate must have been paid by Lord Gwydyr for one of the rare *rose Pompadour* services which reached England through the blockade in 1809. The cost of the whole service, according to Mary

[1] Joseph Marryat, *Porcelain and Pottery*, 1868, Vol. 2.
[2] In Paris in 1962 two cache-pots from a Buffon service made £1,800.

Berry, who saw it in Fogg's shop in Bond Street, was £630. After Lord Gwydyr's death in 1829, seventy-seven survivors of this service were sold at Christie's for £350. We shall follow their further adventures later, but, remarkable though they were, it must not be supposed that the advance of Sèvres in the nineteenth century was continuous. The glamour of smuggled goods, the competition of the Prince Regent, and an element of wartime inflation bolstered up a market which fell to normal late eighteenth-century levels after Waterloo and the Peace. Thus in 1823 the best of Beckford's Sèvres urns by Dodin after Vernet made only £47 5s, the pair.

The market rose when the Prince Regent began a second bout of buying towards the end of his reign as George IV. At the Gwydyr sale of 1829 a single urn and cover, with a ground of Mazarin blue, cost him £163 15s, while two urns on a pea-green ground cost £263 11s. It must also have been in 1829 that the King sent the auctioneer Crockford to Calais in order to negotiate for the Sèvres porcelain of his onetime favourite, George Bryan Brummel, now a dying man, a bankrupt, and an exile. According to Brummel's biographer, Captain Gesse,[3] a pair of mounted urns cost the King £315, and a cabaret of six cups and saucers £210.

The death of the King inaugurated an era of rather more humdrum prices for Sèvres, though it was still the costliest section of the porcelain market. In the early 1830s Ralph Bernal bought a famous pair of *rose Pompadour* vases which were destined to make nearly £2,000 in 1855. According to Henry Bohn, Bernal bought them from Henry Baring for £200. According to Joseph Marryatt, he bought them from Henry Baring's elder brother, Lord Ashburton, the owner of the Montcalm vase, for £150. In keeping with this somewhat reduced scale of prices, the much puffed *bleu du roi* dinner service brought to England by the Spanish Pretender, Don Carlos, cost less than £2 a unit in 1836. Prices were scarcely raised by the special glamour of Horace Walpole's Sèvres at Strawberry Hill in 1842, for a pair of richly mounted urns by Dodin after Vernet cost £168.

The turn of the tide occurred at the Earl of Pembroke's sale in 1851 rather than at the Stowe sale in 1848. It began when a set of three of the Dodin-Vernet urns was bought by Lyne Stephens for £1,020, a commoner paying more than George IV had ever paid. But on Mrs Lyne Stephens's death in 1895 the set was sold for five times this price.

How was it that a pair of mounted urns, not specially lavish and worth not more than £150 to £200 at the time of the Strawberry Hill

[3] Marryatt, Vol. 2.

and Stowe sales, should suddenly soar to nearly £2,000 at the Bernal sale of 1855? The explanation appears to be that three collectors, the Marquess of Hertford, Samuel Addington, and Meyer Rothschild, were determined to have Bernal's showiest Sèvres, and that they fought each other to the limit, the Marquess carrying off all but one of the dearest prizes. But freak auction combats of this kind invariably create precedents. The prices of 1855 were never out of collectors' minds, even if there was to be nothing comparable with the highest of them for nearly ten years.

It is surprising that Bernal, an amateur of mediaeval and Renaissance art and a man sufficiently original to buy El Greco and Frans Hals and to patronize the unappreciated genius of John Sell Cotman, should have owned enough Sèvres to fill 254 stuffy lots. Still more surprising that such a redoubtable bargain-hunter should have paid the prices of the wealthy Baring family. But these dearest of Bernal's purchases were perhaps his best investment, since half a dozen of his Sèvres pieces made more than all his mediaeval collection put together.

Foremost among them was a pair of *rose Pompadour* vases which are not in the Wallace Collection—those vases with the sinister sprouting rims which cost the Marquess of Hertford £1,942 10s, plus a buyer's commission.[3a] The Wallace Collection contains a more classical pair of urns on *bleu céleste* grounds for which the Marquess paid £1,417 10s, and a single *gros bleu* urn with extravagant ormolu handles for which he gave £871 10s. There may have been another dozen among Bernal's 254 Sèvres lots which achieved prices proportionate to these, some of them eight to ten times as high as the prices of 1848. For instance, a little *déjeuner* with its *plateau*, something far less in the monumental taste of 1855 than the urns, cost the Marquess of Bath £465, though at the Stowe sale it had cost Bernal only £65.

The prices of the next ten years were not due to a decline in the excitement over Sèvres, but to a lack of the showiest examples. A pair of urns which had cost the Marquess of Bath only £590 at the Bernal sale because the lids were modern replacements, nevertheless cost Jones, the tailor, £1,034 at the Marquess's sale in 1859.[4] It was a period of consolidation, during which the eventual monumental rise in the value of Sèvres was made possible by Paris at last coming into line with

[3a] Although they have disappeared from view, they were illustrated by Edouard Garnier in *La Porcelaine tendre de Sèvres*, 1889, plate 32.

[4] Victoria and Albert Museum, *Catalogue of the Jones Collection*, page 20, Plate 18.

London. The impact of this was felt at the Lygon sale in 1864, when two of the famous Vernet seascape urns made £1,365. It was felt even more at the Ashburton sale of 1869, when one of the Montcalm vases achieved the price of £1,732 10s on its own. Bought by Francis Baring during the Napoleonic period, this *rose Pompadour* urn and cover, depicting military triumphs, had been given by Louis XV to the Marquis de Montcalm in 1757 in gratitude for his Canadian conquests. It was bought by Lyne Stephens, but twenty-six years later its value had advanced only £250, and one may doubt whether today, nearly a century after the Ashburton sale, it will have advanced in keeping with the true devaluation of money.

In the year 1870, when at least six lots of Sèvres were sold for more than £1,000 each in London and Paris, this record was almost rivalled at the great San Donato sale, where an urn whose lid was surmounted with a finely-modelled crown, denoting the ownership of Louis XV, was bought by Lord Dudley for about £1,600. Yet the Paris market had disdained the English taste for eighteenth-century Sèvres during the first sixty years of the century, and Paris prices had almost invariably been lower, except—if we are to believe *Le Cousin Pons*—for dinner services (see page 130). Quite a fuss was made in 1862 when the Duc de Gallièra paid £590 for a pair of rose Pompadour *jardinières en éventail* with the coveted Vernet seascapes. Though this was nothing like the Marquess of Hertford's prices, it was well up to the London levels of 1862.

Symbolically, it was a French buyer who carried off one of the dearest things in the sale of 1862, a painting by the so recently despised Lancret at more than £1,000. As late as the Pâtureau sale of 1857, Lord Hertford's purchases of paintings of the French eighteenth-century school had reduced Charles Blanc, *Directeur des Beaux Arts*, to a state bordering on apoplexy (see Vol. I, page 284). In Mr Francis Watson's opinion, the Pembroke sale of 1862 marks the moment when the taste for the *dix huitième* penetrated to the French manufacturing and commercant class.[5] Henceforward the English love of Sèvres was to be shared, not only by the Rothschilds and the Russians, but by a formidable contingent of Perrières, Schneiders, Secrètans, Chauchards, and Lelongs.

In 1870 the English Sèvres cult ceased to be dominated by the Marquess of Hertford. The 3rd Earl of Dudley had competed against Hertford as long ago as the Stowe sale of 1848. In 1869 he gave £945

[5] F. J. B. Watson, "The Taste of Angels", *Times Literary Supplement*, July 1960.

for the *Venus and Adonis* urn which Sigismund Rucker had acquired at the Bernal sale of 1855 for no more than £225 13s. But even after his triumphs at the San Donato sale of 1870, his acquisition of the £1,600 crowned urn and the £10,200 Rohan dinner service, Dudley still lacked the keystone of the arch, a *vaisseau à mâts*, of which there were less than a dozen in the world.

This highly original object was a galley- or gondola-shaped flower-holder with a tall, pyramidal pierced cover, simulating rigging and tumbling sails, an allusion to the arms of the city of Paris, and made only in the late 1750s. In this rococo of all rococos, painted in panels on grounds of rose, apple-green, or deep blue, the swirling curves of the *vaisseau à mâts* brought out the soft richness of the *pâte tendre* as never before, in spite of the prim, governessy painting. It had long been forgotten that neo-classic taste had once made the *vaisseau à mâts* almost valueless (see page 31). In 1870 the Baron Davillier believed that a *vaisseau à mâts* was worth £1,200,[6] but the price which Dudley had to pay in 1874, when the Earl of Coventry's *vaisseau à mâts*, with its two satellite jardinières, reached Christie's, was £10,500. *The Times* called it the most extraordinary price ever known, yet at the death of Charles Goding in 1875 the Earl repeated his performance, buying a weird-looking pair of pot-pourri jars and covers for a price reputedly in the same ratio—namely, £6,825.

In terms of the money of 1963, the Earl of Dudley had spent more than £100,000 on five Sèvres vases. But let us look at it another way and imagine that Dudley had spent his £17,235 of 1874–5 on the kind of porcelain which Lady Charlotte Schreiber used to buy for a few pounds apiece. Such a disbursement would certainly be worth not £100,000 today, but several millions. And what would the five vases be worth? To arrive at that, it is best to follow what actually happened to them.

The £10,500 garniture of a *vaisseau à mâts* and two jardinières was not included in the sale which followed the Earl of Dudley's death in 1886. It had been bought privately by the firm of Goode in South Audley Street. In 1895, after Goode's death, it was bought-in at Christie's for £8,400. About 1910 it was bought by Joseph Duveen, Snr., and sold to Pierpont Morgan. In 1915, after Morgan's death, it was taken over by the Metropolitan Museum at a valuation of £15,500.

Thus, in close on forty years we get a very moderate advance of just

[6] Charles Davillier, *Les Porcelaines de Sèvres de Mme du Barry*, Paris, 1870, page 14.

fifty per cent. The fact was that in 1910 and 1915 even Pompadourian Sèvres had been far outstripped by the price of Chinese "blue hawthorn" and *famille noire* vases. To carry the estimate onwards into our own time is much more difficult, because all these things have become shy beauties in the saleroom. It is hard even to guess at their present value. There was a moment when the Dudley garnitures might have seemed a good investment. In 1938 the rival *vaisseau à mâts* garniture of the Hillingdon family was sold by Duveen to Walter Chrysler for a price which was rumoured to be £120,000. Perhaps that story should be discounted in favour of a more concrete piece of evidence—namely, the sale of a fine *rose Pompadour* soup-tureen at Parke-Bernet's in New York in 1957 for £10,360. On that basis the Earl of Dudley's five vases might just be worth £100,000, the equivalent of £17,235 in 1874–5, though some will call this an optimistic estimate even for 1963. The *vaisseau à mâts* at least should be worth a lot more than a mere soup-tureen. Someone might even care to change it for a Jackson Pollock at £30,000.[6a]

It must be borne in mind that present-day collectors are far less obsessed with the complete chimney-piece garniture than were the late Victorians and Edwardians, who in their turn were singularly free of snobbery towards the merely rare or exceptionally early. If nowadays we fail to comprehend the hou-ha that went on over the perfectly matching hawthorn vases and *famille noire* urns, our forefathers would be equally puzzled by the thousands that are paid today for the utilitarian shapes of cabbage-dishes and sauce-boats. In the great days of the chimney-piece garniture cult, particularly in the 1870s, Sèvres pieces that had formed parts of famous dinner or dessert services could be bought quite cheaply. Superficially, it appears amazing that in 1878 the fifty-seven survivors of the Gwydyr dinner service (see page 157) should be sold for £4,034 13s, but out of this total £1,103 10s were accounted for by two *seaux* because they could be used as chimney-piece decoration. In 1878 the dessert plates of the service, painted by Thevenet, worked out at no more than thirty guineas each, though in 1902 eighteen plates from the service were sold at Christie's for £3,360. Even the £10,200 Rohan service of the San Donato sale worked out at about the same level as the Gwydyr service. Some of the

[6a] Or perhaps not. On 26 February, 1963, after this book had gone to press, the two pot-pourri jars, which had cost £6,825 in 1875, appeared at Sothebys after half a century in storage. They made £5,800—no more than a single Nymphenburg figure which in 1875 might have cost Lady Charlotte Schreiber £10. The sale suggests that the present aggregation of the five Dudley vases might be nearer £30,000 than £100,000.

plates which cost little more than thirty guineas each in 1870 have changed hands in America in the last decade at £1,300 each.

After the Earl of Dudley's purchases of 1874-5, the prices for Sèvres at the great Hamilton Palace sale of 1882 were an anticlimax and a portent of recession. Samson Wertheimer paid £1,585 for an urn by Dodin, while a finely-mounted pair of plain blue urns fetched £1,680. Something of this order of prices was still being paid in 1884, though this was in the afternoon of the disastrous Skipper sale, the harbinger of a three years' slump in which even the mighty Turner fell. Among "other properties", a pair of the coveted *jardinières en éventail*, painted by Dodin after Teniers on a *rose Pompadour* ground, made, if not a Dudley price, a Bernal price—namely, £1,627, while a third jardinière, presented by Louis XVI to Tippoo Sultan and looted at Seringapatam, made £619 10s. No wonder Redford wrote in *The Times*, that, though modern pictures might be falling, it seemed that fine old Sèvres china kept its value and was as good as banknotes in the right quarter."[7]

But Redford was wrong concerning the permanent value both of Sèvres and of banknotes. In 1886, when the Earl of Dudley's death brought Sèvres urns and jardinières under Christie's hammer in great abundance, the costliest things were bought-in or else they showed a loss. The two Goding pot-pourri jars were bought-in at £2,625, barely forty per cent of their cost. A second garniture of a *vaisseau à mâts* and its flanking jardinières, a less sumptuous example in apple green, had been bought by the Earl from Alexander Barker in the 1860s. Whether its sale at £2,787 10s meant a loss is not certain. A third garniture of three had bought by the Earl as recently as 1884 for £1,995, a cheap purchase in a slump period, but it made only £1,732 10s. The *Venus and Adonis* urn which the Earl had bought for £945 in 1869 was sold for £861.

The height of the boom had passed in 1886, and there were to be no Sèvres prices comparable with Dudley's purchases of 1874 till the beginning of a second boom in 1905. The highest prices in the 1890s were those of the Lyne Stephens sale in 1895, when the Pembroke garniture of 1851 rose from £1,020 to £5,250, whereas the Montcalm vase of the 1869 Ashburton sale rose only to £1,995. Reunited with its two *jardinières en éventail*, it was to produce £9,450 in 1910. After 1886 Sèvres garniture urns were at best a static market, whereas odds and ends from famous services continued to advance. The Empress Catherine service (see page 31), part of which reached England

[7] George Redford, *Art Sales*, 1888, Vol. 1, page 381.

from Russia shortly before the Crimean War, provides a barometer. In 1856, in the heyday of the Bernal sale, "Marlborough House" (see page 97) were able to acquire two dessert plates from the service for £15. The price seems quite ludicrously low, but it must be borne in mind that isolated plates were very little esteemed in 1856, compared with more or less complete cabarets and déjeuners, and that even complete dinner services were still cheap. A pair of important Sèvres services had been sold at Christie's in 1847 at £3 12s a unit and £1 17s a unit respectively

In 1867 a single bowl from the Empress Catherine service went for £21, which was still less than its original cost, but in Paris in 1875 a single plate fetched £96. At the Leopold Double sale of 1881 the cost of a large Empress Catherine dish with its monogram and cameo paintings was £256. In London in 1886 a cup and saucer were worth £131 5s, a dessert plate £148—thus a twenty-fold increase in thirty years. According to Emil Hannover, Empress Catherine plates were fetching about £1,000 each in Germany before 1914.

The garniture urns began to lose their supremacy in the Sèvres market towards the year 1900, when biscuit figures after Falconet and other French sculptors began to make £1,000 apiece and more. In 1903, 2,000 guineas were paid for a single cabaret, in 1908 £3,050 for a jardinière, and in 1910 £2,835 for two Empress Catherine ice-pails In the present-day market the emphasis is all on the *incunabula* of Vincennes. In 1961, one of the earliest biscuit statues was sold in Paris for £2,280, but in the market for fully developed Sèvres one may contrast a *rose Pompadour* soup tureen, sold in New York in 1957 for £10,350, with a pair of the Vernet seascape urns, typical prizes of the mid-Victorian market, sold for £1,000 at Sotheby's in 1962.

2. *The Market for European Porcelain, 1802–1910*

The rise in the value of odds and ends from Sèvres dinner or dessert services, cabarets, and déjeuners reflected the increased importance in the 1860s and 1870s of the small collector, the amateur of bric-à-brac. As a class, bric-à-brac collectors certainly dated as far back as the 1820s, when their number included Henry Fauntleroy, who was hanged for forgery, Lady Blessington with her Capodimonte china, and Lady Bagot with her pioneer collection of glass. There were many small collectors trying their luck at the great Stowe sale of 1848, for it was then the right thing to own a china cabinet. Both Gladstone and

Disraeli found time to collect. Disraeli, a somewhat rococo figure himself, of course collected Meissen, whereas Gladstone, with his Homeric interests, favoured Wedgwood jasper ware, which had, moreover, a sound Midland Radical tradition behind it. With one exception, the other Continental factories roused little enthusiasm. In fact, Lady Charlotte Schreiber was able to do her unbelievably cheap shopping as late as the 1880s.

It was towards the year 1870 that the founder-collectors of the bric-à-brac movement began to die. Hence a spate of porcelain sales in the 1870s, such as those of Sigismund Rucker, Alexander Barker, Robert Napier, Henry Bohn, Romaine Callender, the Duc de Forli, Lord Lonsdale, and Charles Dickins. After these showy sales there was a much more lively interest in the cheaper things. But the century ended with the emphasis still on the same objects. Figures were more esteemed if they had a background *en bosquet*—which had to be cleaned with a toothbrush and which cut the fingers—or if they were fitted with branches of ormolu and brass wire, bearing innumerable porcelain flowers. A rococo base of contorted swags, either of porcelain or ormolu, was essential. It was after the Second World War that hungry eyes perceived the flat early bases with satisfaction, that Vincennes was preferred to Sèvres, Chelsea red anchor to Chelsea gold anchor, and that Nymphenburg figures could make 11,000 guineas a pair, naked of all metallic excrescences.

The long series of sales which began in 1869 created a revolution in the home. Though Sèvres mounted urns were out of the question, no mantelpiece was complete at the end of that decade without a garniture of some kind or another.[8] In addition to mantelpiece china, there appeared in most middle-class households those kidney-shaped and glass-topped vitrine tables in "the Louis style", which accommodated a snuff-box or two, a Chelsea toy, and perhaps a walking-stick handle. Moreover, from the 1840s onwards the general spread of collecting encouraged a great deal of commercial copying. The huge number and variety of mid-Victorian copies which have survived is a measure of the happy enthusiasm of the times.

Then there were the downright fakes. There had been forgeries of maiolica, and probably of Sèvres too, as early as the 1850s. In the 1870s faking establishments abounded. In the year 1877 Lady Charlotte Schreiber visited a "white china" factory at St Amand which made every sort of Sèvres, Chelsea, and Worcester shape, ready for the

[8] If Charles Keane's drawing was based on life, they sometimes contained the ashes of the dear deceased.

appropriate decoration to be applied in the Faubourg St Martin.[9] But many of the fakes of today were never intended to be anything more than commercial copies of popular styles. Samson of Paris copied everything from Rouen to Satsuma, but always in hard-paste porcelain, and in 1876 Edmond Bonnaffé wrote (with little justification) that "Parisian *famille verte* was irreproachable". Mintons, somewhat astonishingly, copied "Rhodian" faience and Henri Deux ware in porcelain, but their Sèvres copies were specially good. In the famous Dickins *v.* Ellis case of 1909 it came out that the unfortunate J. Dickins had bought a pair of Minton-Sèvres tureens for £8,000.

In the case of many classes of porcelain, a generation or two had to pass before these clever mid-Victorian copies were worth a fortune to the unscrupulous, because the original product remained so ridiculously cheap. This was true even of Meissen. At the Fonthill sale of 1823 Beckford's Prince of Orange service had cost £271 15s for 363 pieces. In 1869 some of the plates came into Henry Bohn's possession at £3 to £5 each. At his sale in 1878, decidedly a porcelain-minded year, they still made only £13 each. The advance in Meissen figures was rather more striking, because at the beginning of the nineteenth century they had been worthless. In 1805 three Kändler figures were sold at Christie's for thirty-three shillings. One would have thought that the early Victorians at least would have appreciated the more frilly Meissen figures, but this cult arrived very late indeed, as if Winckelmann's gibe at "idiotic puppets" had hung over it like a curse. The rather overrated grotesque figure of *Count von Brühl's Tailor riding a Goat* did succeed in making nearly £10 in 1833, but ten years later the Duke of Sussex's Kändler figures were still worth only £4 each. At the Stowe sale of 1848 white figures were worth less than £1 each, though two years later in Paris, three large Kändler groups made £24. At the Bernal sale of 1855, where two elaborate candelabra from the "Swan" service achieved the very high price for the times of £231, there were no figures at all among the 153 lots of Meissen, except for a pair, mounted as candelabra, which cost Sir Anthony Rothschild £63.

Higher prices for unmounted Meissen may be held to begin in London with a pair of the much-copied groups of horses with Turkish attendants. Having been worth twenty guineas in 1779, a pair was sold in 1869 for £95 11s, but the best yardstick of the growing mid-Victorian market is provided by the large, showy "crinoline groups", a model which was much more in demand than it is today. In 1877

[9] *Lady Charlotte Schreiber's Journals*, 1911, Vol. II, page 12.

The Countess de Koesel and Her Pugdogs may have been the first of these groups to reach a three-figure price at Christie's—namely, £215. At the Charles Dickins sale of 1879 the crinoline group of a lady and gentleman at a spinet fetches £347, but in 1902 the same model costs £1,102 10s at the Lord de Grey sale, while in 1908 a second group fetches the same price—equivalent to £7,000 today—at the J. Dickins sale. It may be added that the price of a crinoline group at Munich in 1960 was only £685, while two baby-girl busts, which made £609 in 1901 and £1,207 10s at the 1908 Dickins sale, barely achieved the last-named figure at Berne in 1958. The modern taste no longer favours this fruity rococo style. On the other hand, the somewhat innocent and peasant-like early Meissen figures, birds, and animals which now fetch from £1,500 to £3,000 each could have been bought in late Victorian times for a very few pounds.

Apart from Sèvres, the popular sort of Meissen, and occasionally Capodimonte, the products of all the early Continental factories remained within the reach of the small collector till the end of the nineteenth century. But the prices at smart Christie sales in the 1870s were horrifying to a truly energetic collector like Lady Charlotte Schreiber, who could generally obtain the same thing for a pound or two by getting up at four in the morning and changing trains three times in order to chance a little shop being open in Gouda or Arnhem. But even at a smart Paris shop like Oppenheim's, things of the greatest rarity could be had for next to nothing. A tall white Fulda statue of the Virgin, a landmark of the Victoria and Albert Museum, was bought there in 1875 for £13.[10] From the same shop in 1869 came an exceedingly impressive garniture from the Vezzi factory, five ice-pails for £50. Some of the lesser factories were virtually Lady Charlotte Schreiber's own discovery, like the Nove factory near Bassano, whose products she acquired for a few shillings each. But collector's discoveries are fated quickly to be shared, for in 1878 Christie's sold a Nove *écuelle* and cover for £61 10s.

More was paid for those products of the "other factories" which had first found a market in England during the Napoleonic Wars, when the newest Sèvres models were either too republican or too Napoleonic to be respectable. The emphasis was on Vienna and Berlin dinner services and garnitures of the neo-classic period. After the Napoleonic Wars, this Vienna and Berlin porcelain of a fairly recent creation retained its lately won supremacy. In 1819 a Vienna déjeuner

[10] *Lady Charlotte Schreiber's Journal, 1869–1885*, edited by Montague J. Guest, Vol. I, pages 56, 360.

for two in the classical cameo style was sold at Christie's for £93 9s. In 1838 Bram Hertz's pair of royal Berlin vases made £70 7s, while in 1847 two others cost £105 in the Grenville sale. In 1868 two huge urns by Nicholas Kounilow, "the Russian Wouwermans", made £147. At Henry Bohn's sale in 1878 this neo-classic preference persisted. At about £20 each, the Vienna plates in the cameo style of the Sorgenthal period were much dearer than the beautifully painted grisaille pieces of the du Paquier period. As late as the Lanna sale of 1911, a cup and saucer in the Sorgenthal style could cost £400.

In late Victorian times the neo-classic preference still helped to debase the market for the early German figures which are so sought after today. In 1878, for instance, four Frankenthal figures could be bought for £16 15s, while Nymphenburg figures cost from a guinea to three and a half guineas each. Possibly these were not the coloured Bustelli figures that are today the most costly porcelain figures in the world, but in 1878 the famous *Lucinda* and *Capitano Spavento* would not have been very much dearer. In the 1890s the best of the Nymphenburg figures were worth from £30 to £40, but in 1905, according to Emil Hannover, the Munich National Museum paid £270 for a copy of the *Impetuous Suitor*, a price that remained standard for the very finest specimens till after the Second World War.

In the 1840s and 1850s the porcelain of Capodimonte, near Naples, was dearer than that of most German factories—not the more familiar white figures and groups, but vessels made in extravagant shapes or encrusted with sea-shells which suggested the popular Bernard Palissy ware. Most of these pieces had not been made at Capodimonte at all, but at the Florentine factory of La Doccia, which still belonged to the Ginori family, who went on using the original eighteenth-century moulds. Doubts concerning the age and provenance of the alleged Capodimonte porcelain were fully confirmed in 1867, when the Marquis Ginori showed samples in Paris at the Exposition Universelle.[11] By that time prices for his products had become lively. At the Bernal sale in 1855 half a dozen alleged Capodimonte lots, mainly cups and saucers, made from £30 to £50 each. In 1867, the year of the exhibition, a ewer was sold at Christie's for £70, a large group for £69 4s, and four plaques, taken from the old Doccia moulds, for £103 10s.

The real Capodimonte products had been discovered at Portici in the 1820s by Lady Blessington, one of the first of the china-collecting women; hence an exaggerated snob value. This market weakened when

[11] Marryatt, page 469.

the Doccia deceptions were exposed in Marryatt's revised edition of 1868. His own weird-looking, shell-encrusted ewer and basin were sold for £190 in 1867, just in time. Henceforward even the true Capodimonte remained cheap. In 1878 single figures were worth up to £10 each, and the rare coloured groups no more than £33 12s, which still seems some way off from the £4,000 *Rabbit Catchers* of 1961.

Compared with German and Italian porcelain, the market for English porcelain between 1850 and 1910 was one of much more violent contrasts. When English porcelain imitated the more fashionable kinds of Sèvres, it could be as dear as the original, and on at least one occasion dearer. But the market for English figures was extremely humble, even for the coveted large groups *en bosquet*, which were worth only a fraction of the price of the Meissen crinoline groups. The charm of English eighteenth-century porcelain today lies in its naïve aspect, in its suggestion that, though the material is a sort of near-porcelain, it is really peasant pottery, decidedly folky, and blood-brother to Morris dancing. This quality, which finds buyers for scent bottles at about £1,000 an inch, was something which the Victorian collector wished particularly to avoid. But in cultivating "English Sèvres", in spite of its derivative nature, he bought a shabby provincial product, lacking both the perfection of the white surface and the brilliance of the enamel of the French *pâte tendre*. The odd thing is that it took the richest kind of collector so long to find this out.

It will be recalled (see page 34) that imitation Sèvres urns and vases, when sold from the factory under Duesbury's management in 1771, had been dearer than Sèvres itself, but that with the extinction of the Chelsea factory the value of its products had declined. At the beginning of the nineteenth century, those rather gaudy urns were hardly worth £2 or £3 apiece, figures were worth less than twenty shillings and dinner services a few shillings a plate. The first rarity prices can be found, rather sooner than one would suppose, precisely in the year 1819, when several examples which had been in the late Queen Charlotte's Collection came to Christie's. Among them was an easily identifiable model, a pair of bottle-necked ewers, moulded with bunches of grapes in gilded relief on royal blue and first made in the "gold" anchor period towards the year 1765. The pair were bought by William Esdaile, the banker-collector, for £38 17s. This was half as much again as the price of this model at Christie's in 1770, when it had appeared at Sprimont's factory sale. The fact that John Thomas Smith found these ewers worthy of notice when he visited Esdaile's house at

Clapham in 1829 can be regarded as a sign of the times.[12] Six years later, in 1835, Christie's had already begun to catalogue their lots, not as Chelsea, but as "rare old Chelsea", though some of them could not have been more than sixty years old. By the year 1850, a pair of late Chelsea urns could achieve the price of fifty guineas. As to the Bernal sale of 1855, Samuel Addington's 105-guinea pair of urns was certainly the beginning of a new cycle of prices, for in 1860 a single late vase, painted after Greuze, made £219, while another urn imitating Sèvres was sold in 1865 for £262 10s.

In 1868, when Joseph Marryatt revised his *Pottery and Porcelain*, this kind of Chelsea porcelain was already fetching "extravagant prices", by which Marryatt meant such things as Lady Cadogan's 250-guinea vase of 1865. Marryatt did not know that a vase belonging to the Foundling Hospital, which he reproduced in a creditable colour plate, was already under negotiation with the Earl of Dudley at 3,000 guineas. This very large and to modern eyes far too late Chelsea vase was destined to be the first acquisition in a series, which paid tribute to the Earl's pertinacity and daring rather than to his taste. Known to the wits of Dudley's day as the "Seven Deadly Vases", the series had been among the first as well as the largest to be made in Chelsea in the imported French taste of Nicolas Sprimont. Ordered by George III in 1762 as a present for Lady Liverpool, the Dudley vases vary in shape, but are all at least 24in high and, with their pierced necks and contorted handles, exceedingly rococo. Decorated with nymphs and goddesses after Watteau, Boucher, and Hondekoeter, they could hardly look less like the quaint little nursery articles from the early days of the factory which demand such a solid bank-account today.

Having given a charitable donation of 3,000 guineas in order to obtain the Foundling Hospital vase, Lord Dudley bought the remaining six vases in the early 1870s from the Earl of Chesterfield and the Hon. P. J. Locke King, MP. The four, which were put into his decease sale in 1886, included the Foundling Hospital vase, and were said to have cost him £10,000, or nearly as much as the Coventry garniture. But the *Daily News* thought that, as native products, they were of greater interest than the finest of all Sèvres. Surely the nation ought to have them?[13]

In fact, the four vases were bought-in at £4,200, which may have been their true value in 1886, since a single, rather smaller vase found a

[12] W. B. Honey, *Old English Porcelain*, 1928, Plate 17, pages 65–7.
J. T. Smith, *Book for a Rainy Day*, 1845, page 249.
[13] Quoted in Redford, Vol. I, page 53.

genuine buyer at £945. Fifty years were to pass before the market caught up with the prices which Dudley had originally paid, though there was another spending spree at the end of the century. For instance, in 1899 Lord Methuen's three Chelsea vases made £2,992, and in 1901 Lord Henry Thynne's two vases on a deep blue ground £3,255, while a garniture of four painted on a mottled crimson ground soared to £5,400. The highest price, almost the swan-song of this taste and the sign of its virtual disappearance from the market, was paid after the First World War. In 1919 two 20-in vases painted after Lancret's *L'Escarpolette* and *Blind Man's Buff* made £4,620 (see page 247).

But the most adventurous of all the Chelsea-Sèvres vases were the three that Lord Dudley's executors did not put in the saleroom in 1886. They descended by inheritance through Lord Tweedmouth to Lord Burton, who decided about the year 1912 to sell the vases, because a guest had not been able to resist the temptation of hanging his hat on them.[14] Among so much pink and regal nudity one hopes at least that it was a panama.

According to the same legend, the three vases were sold to Lord Astor for £20,000, and that in 1912 was not impossible, even for hatstands. Mysteriously, the vases reappeared at Christie's in 1920, catalogued without reference to their history as "the property of a gentleman". The dealer who bought them believed that no one had recognized the Dudley vases. Even so, the price was £6,510, and quite in line with the two "English Sèvres" vases which had been sold the previous year. All seven Dudley vases are now on loan at the Victoria and Albert Museum, a monument to an extinct taste, to which no value can be put, because it is more than a generation since the market has seen such things.

To a lesser extent, the fortunes of the Chelsea Sèvres vases were shared by the hexagonal vases and covers, often of great size and in a basically Sèvres style, which had been made at the Worcester factory. In the beginning these had been a very much cheaper product. In 1768 a garniture of three urns and covers, newly obtained from the Worcester factory, had been sold at Christie's for £8 5s. As late as 1834 an exceptionally showy pair was worth only £7 15s, but at the Stowe sale of 1848 a pair of hexagonal urns was sold for twenty-five guineas. In 1860 a pair passed the 100-guinea mark, and in 1879 a garniture of three, with subjects after Wouwermans, cost £566 at the Charles Dickins sale.

[14] H. C. Mariller, *Christie's, 1760 to 1925*, London, 1926.

The real fashion for the Worcester hexagonal urns was in the early 1900s, when the best were worth from £500 to £600 each, but it was said that the Earl of Warwick, who died in 1895, had paid £10,000 for an example 20in high with the familiar blue-scale pattern between the panels.[15] In the saleroom the highest price was paid in 1922—£2,730 for a most attractive urn, with figures in contemporary dress by Donaldson. But in 1950 the Dickins garniture was sold for £1,260, having only doubled its price since 1879, despite devaluation.

From these Olympian heights we descend to the Chelsea and Bow figures, which had been made in the 1750s and 1760s at a few shillings a pair for single figures and £1 or £2 for groups. For this most popular form of Victorian bric-à-brac collecting, the surest guide—and such a sympathetic one—is Lady Charlotte Schreiber. In Paris in 1869 we find her spending £15 on two of her most elaborate Chelsea-Derby groups, smothered in *bocage*. Two more of these were bought in Brussels in 1873 for £25 (very dear!). In 1874 a figure called *Justice*, 15in high, costs £12 10s, but the single figure of *Milton*, bought in Amsterdam, now costs £25 (outrageous!). In 1875 the Bow figures of *Woodward* and *Kitty Clive* are bought at Christie's for £31 10s the pair,[16] but a visit to Hamburg in 1880 can still produce a Chelsea bird and a group, *Time clipping the Wings of Love*, all for £5.

Very large groups were from the beginning beyond Lady Charlotte Schreiber's budget. *Una and the Lion* had made 100 guineas as early as 1865, the *Hurdy-gurdy* group reached £202 in 1870. By 1896 the *Music Lesson*, after Boucher (see page 29), wrongly attributed to Roubilliac, made £483. At the Blenheim sale of 1886 the single figures began to catch up, the *Gardener* and the *Lady in the Flowered Dress* making £68 5s the pair; but from now on this market became rather provincial, restricted to small collectors and so static that the best prices for most Chelsea and Bow figures were no higher than this a few years before the First World War. For instance, a specially good selection of figures was sold at Derby with the Bemrose Collection in 1909 at much the same prices as roused Lady Charlotte Schreiber's indignation in the early 1880s. In 1909 the best cost from thirty to fifty guineas each, but ten years later it was possible to pay £1,522 for a pair of Chelsea single figures and £3,780 for two Bow groups.

It must not be supposed that in the 1860s and 1870s, when this taste became established, the collecting of English ceramics was entirely obsessed with the rococo. Pre-eminently this was the age of the Royal

[15] A much repeated legend; for instance, by Blacker, page 76.
[16] In 1961 the figure of *Woodward* made £450.

Academy subject-pictures of Lord Leighton and Alma Tadema, the heyday of an expensive and dangerous cult for cameos and Tanagra figures in the home and of an unnaturally prolonged saleroom homage to the sculpture of Canova and his English imitators, though except for the insipidities of John Gibson and Hiram Power, this school had been completely dead since the 1850s. The mid-Victorian classical cult was more than a mere hangover from the taste of the first quarter of the century. A revival of interest in the neo-classic movement was part of the general revolt against Early Victorian baroque. But true porcelain in England had all but gone out of production at the end of the eighteenth century. The English contribution to the neo-classic period in ceramics had been Wedgwood's jasper ware, a vitreous paste which could be tinted in various sombre colours to take a white-slip decoration in relief.

The ware had been devised in 1774 for the reproduction of the Graeco-Roman gems of jasper, onyx, and cornelian, either carved in intaglio or inlaid in shell cameo, which filled the cabinets of the patrons of the day. In the 1870s these cheap copies became singularly dear ones—dearer than today at four to twenty-five guineas each. Much was due to the feat of Mr Bromilow of Battlesden Park in 1875, when he had won at a single bid of £36,750 the Duke of Marlborough's collection of 739 Graeco-Roman cameos and intaglios, more than half of which were imitations of the sixteenth, seventeenth, and eighteenth centuries, to say nothing of the more recent creations of Signor Pistrucci. Another factor was Marc Louis Solon, who began in 1870 the production of his quite unspeakable *pâte sur pâte* plaques for Messrs Minton, a combination of Wedgwood and M. Bouguereau.[16a]

For the addicts of this market it was essential to own a copy of the *Portland Vase*. These copies of the Duchess of Portland's unique Roman cameo vase from the Barberini Palace (see page 63) were first made by Wedgwood in a perfected jasper ware in 1791. Till the year 1845 it was held that Wedgwood had rediscovered the secret of the Romans, whatever that might have been. But in that year a poor maniac, a member of the only section of society to have a true perception of the diabolist qualities of the British Museum, smashed the *Portland Vase* to smithereens. The *Portland Vase* was then discovered to be made of glass.

In 1849 a Wedgwood reproduction of the *Portland Vase*, which had been sold from the factory in 1791 for £35, was worth only £20. But

16a A pair of Solon's vases in this style was sold in March, 1963, for £1,250. They had been made in 1875.

the escapade of poor Mr Lloyd created only a temporary depression of the market. The copy belonging to Samuel Rogers was sold in 1856 for £135 7s, nearly as much as his dearest ancient Greek vase. By the 1860s the market for jasper ware was already lively, vases and large plaques costing £25 to £70 apiece. Whether John Keats's "foster-child of silence and slow time" had been a Staffordshire or an Attic product remains debatable, but neo-classicism among Victorian collectors had a more pragmatical ring than that, remaining both Midland and Radical. Few hearts could have been moved to Keats-like ecstasy by Mr Gladstone's address when laying the foundation stone of the Wedgwood Institute at Burslem in 1863, doubtless in a steady downpour of rain:

> Great care has been bestowed upon the mechanical arrangement with a view to the preservation of the pen and the economical and cleanly use of the ink. The prices are from sixpence to eight shillings according to size and finish. I have one of these, not, however, black as mentioned in the catalogue, but of his [Wedgwood's] creamy white ware. I should guess that it must have been published at the price of a shilling or less.[17]

Suddenly the homely Midland picture changed. In 1875 a copy of the *Portland Vase* was sold for £189, while in 1877 Webber's huge black jasper vase, *The Apotheosis of Homer*, fetched £735, just as if it were part of a Sèvres garniture by Dodin and Morin. This was at the sale of Dr Sibson, who owned nothing but jasper ware—in fact, more than £7,000's worth. *The Times* declared that, since Wedgwood ware was as completely extinct as Henri Deux ware, the prices were not by any means extravagant.[18] And this was only the beginning of a boom in Wedgwood jasper ware which lasted till the First World War and which acquired strength, particularly in the case of the larger plaques and complete mantelpieces, from the Edwardian predilection for the Adam style of interior decoration. But the *Portland Vase* copies are the best barometer; £173 in 1872, £215 in 1892, £399 in 1902, and that was as good as £2,400 today. Yet the last perfect copy was sold in 1956 for no more than £480.

[17] Quoted in Marryatt, Vol. II, 1868. [18] Redford, Vol. I, page 268.

3. *French Tapestry and Sculpture of the Eighteenth Century; the Market from 1760 to 1914*

In 1772 the Government of Louis XV was in debt to the Royal Gobelins tapestry factory to the tune of about £9,000. Instead of payment, royal permission was given to sell seven sets of *Les Tentures de François Boucher*, a newly completed suite of four panels in the height of the new fashion for subjects in medallions and, let it be said, exceedingly beautiful. All were taken up by noble or at least wealthy English land-owners, one of them being Beckford's father, the Alderman.[19]

Since the factory recouped the sums owing to it through these sales abroad, it might be presumed that the panels were sold at 300 guineas apiece at the least. But to clear the debt, several other tapestries had to be sold abroad and the Boucher suites were accompanied in some cases by matching suites of chair covers. And yet, even at 300 guineas, the panels would probably have been sold at a loss. In 1761 Paul Saunders of Soho had charged £265 6s for making and setting up a vastly less lavish work, a 240ft armorial tapestry for the Court of Chancery.[20] In 1761 the very best English tapestries used to cost from fifteen to twenty shillings a foot to make, and that was no more than in Charles I's time. Gobelins and Beauvais silk tapestries must have cost quite considerably more than this. The weavers earned three or four livres a day and took near on a fortnight to weave a square foot. On top of that there was the cost of the original full-size cartoons. In 1747 Charles Coypel received £240 for the largest size, the King paying for the stretchers.[21] Since normally not more than six or seven sets and only very exceptionally twelve sets of a tapestry suite would be woven before the model went out of production, the artist's share might add £40 to the cost of a panel. The largest Boucher suites, made at Beauvais, which were to fetch £25,000 a panel and more in the present century, must have cost from £300 to £500 a panel to produce.

These figures must be kept in mind when considering the astonishing prices which were paid for eighteenth-century tapestries in the early twentieth century. Tapestry is a form of art of which the original production cost and the replacement cost can be calculated fairly closely (see page 16), inasmuch as both the Gobelins and the Beauvais factories remain in production today. In spite of the early

[19] W. G. Thomson, page 450. [20] *Ibid.*, page 490.
[21] Louis Courajod in the introductory volume to *Le Livre Journal de Lazare Duvaux*, page clii.

twentieth-century prices, which seem higher than for any other form of art, the most expensive ancient tapestries did not recover their "replacement cost" till well past the year 1880 and some have never recovered it at all. There are exceedingly few ancient tapestries in their habitual faded and patched condition which could achieve "replacement cost" in the salerooms at the present day, since in 1962 the cost of production at Gobelins was reckoned at no less than £220 a square yard.[22] This would mean £5,280 for *any* panel measuring twelve feet by eighteen—and since the Second World War very few tapestry panels have achieved as high a price as that. The real replacement cost is much higher because at £220 a yard the weaving is less close than in the eighteenth century and the pace, five yards a year for each weaver, is considerably faster. Moreover the French government is virtually the only customer both at Gobelins and Beauvais. If there were something like the competition and the private demand of the seventeenth century, the present-day cost of copying would certainly be much higher.

Except for a few Gothic tapestries, the millionaire market of the early 1900s was dominated by the light-background silk tapestries of the François Boucher period. These tapestries, though certainly the most sumptuous, have not always been the most popular. In fact, until the 1890s the classical age of tapestry-weaving was considered to be the reign of Louis XIV, who had established the Gobelins factory in 1662. Moreover, the Boucher panels were produced at a period when tapestry itself was going out of fashion, in France most of all. Consequently, in 1772, when the Gobelins factory had to look for private buyers for the royal suites of tapestry, which had not been paid for, it was England which provided most of the customers. Tapestry in France was the taste of kings, and no longer the taste of nobles and commoners. The nobility who might have had the space for a suite measuring say 1,400 square feet, did not have the money. The *intendants de finance* and *fermiers généraux*, who had the money, did not have the space. But it was the age of the great English country house, an establishment bigger than the palaces of most Continental kings and much better cared-for. The house-proud owner, having received two or three pounds from the rag-merchant for the Arras hangings, which had been there since the reign of Henry VIII, was free to spend two or three thousands on his shimmering, silken splendours from Paris.

It was another matter when an English owner had to part with them. Most of the tapestries in English country houses, apart from the

[22] *The Times*, 26 September 1962.

completely worthless early sixteenth-century panels, belonged to the middle seventeenth or early eighteenth centuries. Those that reached Christie's may have been in bad repair, but even practically new tapestries made no more than £5 to £7 a panel, the cost in 1772 of three panels from the *Tenture chinoise* suite. Sometimes a Lebrun or Teniers suite, 50 to 100 years old and apparently the most popular model, might make £25 a panel. Sometimes a reserve might be fixed in the region of £100 to £150 a panel, the amount which had been paid by the owner's grandfather, but the bidding never reached it. One of the most interesting tapestries to be sold in London before the Revolution was an almost new Gobelins suite of four, *The Quarters of the Globe*, belonging to the French Ambassador, Count d'Adhemer. Measuring 14½ft by 13½ft for each panel, the buying-in price was £483, but the real price of the suite, when the owner was forced to accept the best bid in the hopeless year, 1793, was £45 10s.

The habitual low prices are easily explicable, because the reweaving of even the lightest damage had to be done in France at great expense, while after 1790 it could not be done at all. Furthermore, the neo-classic style of decoration was either ultra-austere or else it favoured painted wall panels in the Pompeian style. It had no place for large tapestries. All over Europe the private demand for new tapestries virtually disappeared at the beginning of the reign of Louis XVI. Gobelins and Beauvais were kept going by a limited demand for commemorative suites, ordered by the Crown. These queer-looking productions were intended to be historical and didactic, in keeping with the proto-Ruskinian views of Diderot and the *Encyclopédistes*. They were the very antithesis of rococo tapestry subjects, pagan, riotous, and undressed. Certain suites made in the 1780s were quite in the taste of the French Revolution. Thus, Brenet's *Death of Dugesclin* was honoured on the loom as well as in porcelain. The *Death of Leonardo da Vinci* sounds like the subject of a Salon picture of the Second Empire.

Between 1789 and 1795 tapestry production at Gobelins and Beauvais trickled to a standstill. In 1793 the Paris Committee of Public Safety ordered the destruction of most of the Gobelins stock of cartoons as being too much in the spirit of the recent past. In 1795, however, the Government of the Directoire was at least disposed to rescue the industry from extinction, but in their present state of finance they could find no better way of doing so than by burning 180 tapestry panels from the royal *Garde meuble* in order to extract the gold and silver.

Cutting off royal heads has seldom provided encouragement for the arts, yet the English royal tapestries had presented a simpler problem after the execution of Charles I. In 1651-2 Cromwell's commissioners made many thousands of pounds from their sale, obtaining, for instance, £750 for two Mortlake suites at the rate of a full £1 a foot.[23] But at least the gold-melting operations of 1793 saved Gobelins from immediate liquidation. The factory has in fact never been abandoned, though under Napoleon and the restored monarchy the output of official tapestries was small. Till the 1850s the private taste for tapestry in Europe was as good as extinct. In France, it was extinct for something like eighty years. It would be claiming too much to assert that the English vogue for *ancien régime* taste, which began during the Napoleonic Wars, extended to tapestry, though thirty-six Gobelins panels which had been woven for Louis XV, and which had escaped destruction, were bought for the royal palaces by George IV in Hamburg in 1825.[24] They had been sent to Hamburg with the blessing of the Directoire Government (see page 49), but for thirty years no one had wanted them. The fact that certain Louis XIV tapestries in the Wanstead House (1822) and Fonthill (1823) sales had been rather dear by eighteenth-century standards was probably due to the glamour of these sales alone, for no rise in the market followed. The Wanstead House sale included panels from the much-repeated *Triumphs of Alexander* of Charles Lebrun at twenty-five to sixty guineas a panel, but at the Fonthill sale the dearest panel from this suite did not rise above forty guineas, and its subsequent fortunes were wretched. It was resold in 1834 for £9 9s 6d and in 1838 for £2 12s 6d.

During the depressed 1830s and 1840s there was little interest in Boucher suites, since in 1834 a panel from the *Tenture des Dieux*, was sold at Christie's for seventeen guineas. There was no real Boucher cult before the 1880s, but most exceptionally two panels from *La Noble Pastorale*, the largest, finest, and rarest of the Beauvais suites, were sold in Paris at the Duc de Stacpoole's sale in 1852 for close on £500 the pair. In 1916 Henry Duveen sold five panels from this suite to Henry Huntington for £103,300, which was at that time a standard price for millionaires; but the unique bid of £248 a panel for an eighteenth-century tapestry suite in 1852 was destined not to be repeated for twenty-five years, though it was probably much less than half the production cost of *La Noble Pastorale*. The fact was that before the opening up of the American market by the Duveen brothers towards the year 1880 the demand for big tapestry panels, intended for palaces,

[23] Thomson, pages 314, 351, 453. [24] *Ibid.*, page 438.

was negligible. London was now a worse market than Paris. Even the finest Boucher suites were worth less than at the end of the eighteenth century. For instance, the panel, *Europa and the Bull*, from Boucher's *Les Amours des Dieux*, another example of which was sold by the Soviet Government in Berlin in 1928 for £5,750, was bought-in at Christie's in 1864 for £13, and sold privately to the dealer Pratt for £20. In 1868 the London market was just as indifferent. A suite of four after Coypel's cartoons of the *Iliad* was sold for £70 5s.

In the 1850s and 1860s the highest prices were paid for narrow panels to hang in front of doors or between windows. In 1857 the de Goncourt brothers noted in their journal that a set of Gobelins *lambrequins* now cost £140, an allusion to the sale of the hangings of the ex-King Louis Philippe from the Chateau d'Eu, when Christie's disposed of a large collection of curtains, portières, and narrow fitted panels, all, however, made within the nineteenth century. In 1862 Lord Hertford spent £320 on four portières in the Boucher style. The same order of prices held good in 1868, when six narrow panels, woven under the direction of the Scotsman Nielson at Gobelins in 1778, fetched £656. But in Paris in 1873 even a Boucher suite cost no more than £46 a panel.

The American demand for tapestries began shortly before 1880, at first for sixteenth-century suites to go with the earlier architectural styles of Messrs McKim, Meade, and Whyte. It may have been American demand that forced up some sixteenth-century panels to the £1,000 limit in 1877 at the Paris sale of the Duke of Berwick and Alba (see pages 122–3). It was at this sale, too, that a Louis XV Gobelins suite, the *Tenture des Indes* after Desportes, achieved a record price for an eighteenth-century tapestry, but at no more than £250 a panel.

One of James Duveen's most interesting recollections of his uncle, Joseph Duveen the elder, concerns an American transaction which must have taken place not later than 1880, and perhaps a little earlier. It is, of course, the recollection of an octogenarian concerning conversations of his early youth. One feels, therefore, some reservation regarding the figures and dates, but it seems that about the year 1879 Joseph Duveen bought a suite of four panels from a noble English owner, none other than one of the seven sets of *Les Tentures de François Boucher*, which the Gobelins factory had exported in 1772. Duveen is alleged to have paid the barely credible sum of £12,000, but he sold the suite in New York to a total stranger. Fortunately, for Duveen, Collis P. Huntington had never bought a work of art in his life, while California was beyond the range of the early Florentine predilections

of Messrs McKim, Meade, and Whyte. So Huntington paid £30,000, and lost the tapestries in the San Francisco earthquake.[25]

These sound more like the figures of the early 1900s than of the year 1880, but there is no question that in 1880 the demands of the new millionaires had made a tremendous impact on the eighteenth-century tapestry market. At the Marquis de Salamanca's sale at Christie's in 1881, four Gobelins panels of the *History of Jason*, by Cozette and Audran after de Troy, were sold for £4,882 10s, thereby quintupling all previous records for eighteenth-century tapestry. In the following year two Louis XIV panels, depicting allegories of *Fire* and *Water* after Le Brun, were removed from the old *Garde meuble* to the new Paris Hôtel de ville, which replaced the building destroyed by the Communards in 1871. Surprisingly, they were valued for insurance, according to *Chronique des Arts*, at £2,720 and £2,900, though in the 1860s they might not have succeeded in making £100 between them.

Till well into the 1890s prices in the saleroom rarely exceeded £1,500 a panel, and Louis XIV dominated the market, not Louis XV. A new record was achieved in 1896, when £3,200 were paid in Paris for a Charles Le Brun panel from *The Triumphs of Louis XIV*. It may be remarked that this panel, which commemorated Louis XIV's Treaty with the Swiss, was in a taste wholly different from the Boucher-inspired designs which were destined to become the only admissible taste of the 1900s. In 1896 the finest of these, such as the panels from the *Tenture des Dieux*, were still making from 1,000 to 1,500 guineas each. The stage of "replacement cost" had barely been reached. In 1894, when there was a request from America for copies of *Venus and Adonis* and *Vertumnus and Pomona* from the original cartoons of this suite, which were still available at Gobelins, the authorities asked a deposit of £1,200, but would not commit themselves to the final figure.[26]

The second wave of American buying, which was to send the price of French eighteenth-century tapestry up to the region of £20,000 a panel in no more than twelve years, must have owed a great deal to Pierpont Morgan. There was indeed hardly any section of the objets d'art market in the early 1900s where Morgan did not call the tune, though the first open-auction price of over £5,000 a panel was not in fact paid on Morgan's behalf, but by Henri de Rothschild. In 1900 ignorance still kept the market within limits. Even when a collector

[25] James Duveen, *The House of Duveen*, 1954, pages 57–9.
[26] *Chronique des Arts*, 1894.

had been able to complete a suite, he could never be sure that other complete suites from the same cartoons had not survived. No such doubt surrounded the *Orlando furioso* suite, which Monmerqué and Le Febure had woven from Charles Coypel's designs in 1762. The four panels had been given by Louis XV to the Pallavicino-Grimaldi family of Genoa, and the family still owned them. And so in the year 1900 the set cost Henri de Rothschild £23,400 or £5,850 a panel.

Precisely the same amount was paid in London three years later for the four panels of Boucher's *Fêtes italiennes*. In 1905 a single panel from the *Noble Pastorale*, worth exceptionally £250 in 1852, rose to £12,000 at the Cronier sale. But all these prices were outdistanced at the Polovtseff sale in Paris in 1909, when a single panel from *Les Amours des Dieux* was sold for £19,100. In addition to *Bacchus and Ariadne*, four other panels from the suite were sold, and the total came to £41,550 including tax. Only forty-five years had passed since *Europa and the Bull* from the same suite had been bought-in at Christie's for £13, and yet the commodity was not so rare. Louis XV had ordered at least six sets. For another half century panels from *Les Amours des Dieux* continued to reach the salerooms at intervals, the last being sold in 1957 for £3,400 in devalued money.

The Polovtseff prices were soon exceeded. The many *Don Quixote* tapestries which still appear at intervals in the saleroom are mostly derived from a single Gobelins series of twenty-eight episodes, of which no complete set exists, but which was evidently woven in several editions. The cartoons had occupied the industrious Charles Coypel throughout his long working life, the first of these medallion compositions on large ornamental fields having anticipated in the early 1720s the rococo style and even the neo-classic. The four panels at the Château d'Epinay were not necessarily the best, but they enjoyed the huge advantage in the early twentieth century of having just been inherited by the King of Spain. In 1910 these four panels were offered, through an agent, to W. G. Thomson[27] at £15,000 a panel. In fact, they were bought by the younger Joseph Duveen for £64,000, and sold to James Pierpont Morgan for a price that certainly exceeded £80,000.[28]

Pierpont Morgan died in 1913, and during the early war years, while Duveen struggled with a lengthy law-suit brought against him by a rival, the *Don Quixote* panels were in the Metropolitan Museum, but, like Morgan's porcelain, they were not destined to remain there. In the year 1915 they formed part of an inconceivable block purchase from

[27] Thomson, page 443. [28] James Duveen, *Secrets of an Art Dealer*, 1937.

Morgan's executors by Messrs French of New York. The deal comprised forty tapestry panels for 2½ million dollars, then equivalent to £515,000, and in the purchasing power of today's money to something more than 3 millions sterling. It is certain that the four *Don Quixote* panels and the six *Comedies of Molière* panels cost Messrs French more than £20,000 each. It is to be supposed that they were resold for considerably more than that.

I cannot refrain from anticipating the next chapter, in which the decline of this extraordinary market is examined. I record, therefore, that three of Pierpont Morgan's four *Don Quixote* panels were sold in New York in 1957 for £30,000 of devaluation money. But in 1954 the largest series of the *Don Quixote* suite ever to have been sold had appeared in a Paris sale, where it made £29,000, the cost of fifteen panels. That would have meant no more than £5,000 in the money of 1915, when a set of fifteen would have cost too much for any single buyer to have taken it over. In separate transactions, the suite could have made from £300,000 to £500,000.

In these days of Rembrandt philosophers and Leonardo charcoal cartoons at £800,000 each, it would doubtless be thought ridiculous to pay the equivalent of £480,000 for four woven imitations of the work of a painter who was second-rate to start with. One must remember that in 1910, when Pierpont Morgan bought the *Don Quixote* tapestries, American multi-millionaires had not begun to receive those highly tangible inducements to buy the things that museum curators would most like to receive as bequests. The most general motive for buying something expensive was to excite the jealousy of other millionaires. As we have seen in the last chapter, the tapestry-backed furniture suites were the standard articles that fulfilled this function. So also, while rooms stayed big enough to hold them, were the wall tapestries that went *en suite* with the furniture.

At the beginning of the present century a situation had been reached in which the most expensive form of private taste had almost entirely parted company with the text-book teaching of art-history—not that this teaching was likely to reach the most prominent buyers. The veneration of the French eighteenth century in 1910 was much less noticeable among the expert hierarchy. Though Boucher triumphed everywhere, though all these high-sounding *tentures* ruled the saleroom, there was only one Boucher painting in the National Gallery. It had arrived as a gift in 1880, and the 1929 edition of the catalogue noted with an easily legible sniff that Boucher was well represented in the Wallace Collection.

What bright schoolboy, brought up on the names of Pheidias and Praxiteles, Michelangelo and Donatello, could have believed in 1912 that the first piece of sculpture in the world to make £20,000 in the saleroom belonged neither to ancient Greece nor to the *Quattrocento*, but to that decadent pre-revolutionary Paris, of which all liberal English historians disapproved. Nor was that the end of this disconcerting valuation. In 1928, when our Macaulayesque schoolboy must have become a classical don, he could have learnt that this same work, Houdon's marble bust of his ten months' old baby, was again the dearest piece of sculpture in the world, but this time at £50,000.

Of course, French sculpture of the late eighteenth century was the very perfection of drawing-room art. It was also about the most technically accomplished and anatomically knowledgeable sculpture that has ever been made. But even in academic circles, which encouraged technical accomplishment and anatomical knowledge to the exclusion of all else, there was some misgiving concerning this school. In Ruskinian England it was considered downright immoral. Marie Antoinette had been represented in *biscuit de Sèvres*, nursing the Dauphin in the nude. In France, where Houdon, Clodion, and Falconet were the fathers of a still perceptibly living tradition, the school came under bitter attack before the end of the nineteenth century and long before the really stupendous saleroom prices began to be paid. Under the influence of the Impressionists and of Rodin, this sort of sculpture was denounced as sugary in its charm, and small-minded in its conception; it was wedding-cake sculpture, *patisserie*, or whatever you wanted to call it. Nevertheless, the smart tastes of the Second Empire remained unshaken by *avant-gardisme*. After they had penetrated to the Middle West, they became apparently immortal as well.

Yet the Parisians of the reign of Louis XVI had suffered from no delusions that they had surpassed the Greeks or even the Romans. Far otherwise, for a sizeable marble statue of Cleopatra by Clodion was sold in Paris in 1782 for £40. Royal commissions for commemorative monuments, taking years to complete, could, of course, run into thousands, but most of the fine modelling of Falconet, Clodion, Houdon, Pigalle, and Pajou was destined for candelabra, vase-supports, and clocks, which were many times more costly than the original terracotta figures. In 1783 Clodion sold off the *modelli* in his studio at from twenty to twenty-five shillings each. Modelled groups, attractively finished in tinted clay and mounted on plinths as drawing-room objects, were, of course, dearer, but these desirable treasures, which could cost £9,000 apiece in 1912, seldom reached £40 in the

Paris auctions of the eighteenth century. Generally, they cost no more than £5 to £10.

Old-fashioned taste preferred the baroque sculpture of Louis XIV's reign. Up-to-date taste preferred copies from the antique. The Louis XVI school only really came into their own in the gilt-bronze furniture market, a legacy from the previous reign. One of the first extravagances of Mme du Barry in 1768 after achieving the entry into the royal bed, was her purchase from Poirier of the famous Three Graces clock. It may be assumed that the share of the sculptor Falconet in Poirier's bill of £96 was quite small (see page 45). The same would have been true of Pajou, who supplied the model for a wild boar on Gouthière's marvellous fender, for which Mme du Barry paid £280. In 1781 Marie Antoinette paid what was probably a normal price to the *maitre doreur*, Piton, for four 10-in gilt-bronze candlesticks, namely £112.[29] If the caryatid figures were the work of Pajou himself, as seems likely, his fee must have been modest indeed. Drawing-room sculpture, for all that it meant in the early twentieth century, was pot-boiling work. To make real money a royal commission for a public monument was necessary. Thus for making the *modello* for the equestrian statue of Frederick V of Denmark the decidedly imitative Jacques François Saly received it was believed, more than £6,000.

It was the fate of most of the Louis XVI sculptors to live on into the nineteenth century. Houdon did not die till 1828; Marin not till 1834. Houdon was not too old to receive commissions from Napoleon, but under the Empire the whole school was swept aside by the fashion for the extreme neo-classicism of Canova. Houdon's bronze group, *Le Baiser*, could be bought in 1806 for £12, while in 1808 his famous bronze bust of the aged *Voltaire* made £31, as compared with the £66 which were paid in 1812 for Voltaire's walking-stick and the £472 10s for Canova's imaginary bust of *Condé* [30] sold at Christie's in the same year.

This was to remain the pattern of the market till the 1850s. Though objets d'art in general were now collected according to the romantic or Renaissance taste, contemporary sculpture was firmly bound to classicism; not the rationalist, satyrical and at times too truthful half-way neo-classicism of the Louis XVI sculptors, but the peculiarly sentimentalized version as propagated by Canova and Thorwaldsen. As late as the Aguado sale of 1843 Canova's over-life-size *Magdalen* could fetch £2,380. It was the most expensive work of art that had ever been in

[29] *Wallace Collection Catalogue*, F.164.
[30] Charles Blanc, *Le Trésor de la Curiosité*, 1858, page 244.

the Paris salerooms. It must have cost as much as the entire collection of *Le Cousin Pons*.

Canova was equally revered in England. In 1816 the Duke of Wellington paid him 2,500 guineas for a vast joke, a full-length marble statue of Napoleon in a state of Grecian nudity.[31] Till the 1860s the English sculpture market was dominated by Canova and by tepid English imitators, such as Wyatt and Gott, but the movement of taste, which exalted Sèvres porcelain and eighteenth-century French furniture, did extend in some degree to French sculpture. As late as the 1840s French dealers were inclined to dispose of it in London. Bronze was preferred to marble, and Louis XIV was much preferred to Louis XV. Provided the object was large, prices could exceed £100. In 1801 an equestrian bronze of Louis XV cost £95. In 1813 the 3rd Marquess of Hertford paid £199 10s for two of the numerous bronze replicas of Coustou's Marly horses, originally made in 1740–45. In 1825 Watson Taylor's late seventeenth-century bust of Vauban by Courevoix made £106. The year 1840 saw a particularly costly consignment of this kind of sculpture at Christie's. It consisted of life-size garden sculpture from formerly confiscated *châteaux*, the two bronze lions from Neuilly costing £372 15s. In 1814 the 4th Marquess of Hertford paid £500 for the Earl of Pembroke's pair of Louis XV bronze *Bacchantes* by Coustou, but this sale was the beginning of a new cycle of prices for all French eighteenth-century art.

Sculpture of the later eighteenth century, sculpture that was to cost tens of thousands of pounds in the present century, was rather less esteemed, though it had a much higher value in London than in Paris. In 1802 a marble Cupid by Falconet, which had been sent over from Paris during the Peace of Amiens, cost forty guineas at Christie's. At Watson Taylor's 1825 sale Houdon's marble bust of Voltaire cost £69 6s the same price as a Clodion bronze group, imported by a French dealer in 1833. But now the early Victorian mood began to assert itself, for in 1842 Christie's had to withdraw an alleged Mme du Barry in the nude at £30 9s.

By the middle 1840s, prices for sculpture of the Houdon generation were no higher in London than in Paris, but the art market of the last days of *Le Cousin Pons* was still not very partial to Louis XVI. Those highly appetizing tinted terracotta groups by the great Clodion still cost from £10 to £15 each even at the most famous sales. Within thirty years their value was to be multiplied fifty times over, but even

[31] Charles Saunier, "Les Conquêtes artistiques de la France sous Napoléon", in *Gazette des Beaux Arts*, XXV, 1901.

more remarkable was the acquisition of the Louvre version of Houdon's life-size marble *Diana* in 1845 for £61 12s, not much more than a thirtieth of the price of the Canova *Magdalen*.

It is also instructive to compare the price of Houdon's *Diana* with the price of £136 10s, which was paid at Stowe in 1848 for Roubiliac's bust of Matthew Prior. For Roubiliac this price was not even exceptional. Apart from ranking as an English sculptor, his work belonged to the Louis XIV tradition, rather than to the rococo. Two years after the Stowe sale there occurred in Paris the dispersal of the great Debruge Dumenil collection. On this occasion Pigalle's bronze head of a baby— and as we have seen, babies were to achieve a very high status in this market—made no more than £2 8s.

The clue to the prices was the demand for sculpture treated as furniture—in particular figures bearing candelabra and torchères. There was a marked fall in this demand after the exceptional prices of the Watson Taylor sale in 1825, when candelabra groups made nearly £250 the pair. In the 1830s and 1840s such prices were paid only for massive and horrible constructions of recent creation. In the 1830s some obviously important eighteenth-century items were bought-in at apparently high prices, but in 1836 we get the pathetic entry in a Christie's catalogue: "Two tripod candelabra from the boudoir of Marie Antoinette, £8 18s 6d."

The Pembroke sale of 1851 again asserts itself as a landmark, since two elaborate bronze candelabrum figures made £178 10s. At the Alton Towers sale of 1857 two "black boulle candelabra" cost £315, a reminder that the Louis XIV preference died hard. But in Paris the same year saw four Louis XVI bronze candelabrum figures fetch nearly £100 each at the sale of the Duchesse de Montebello. The moment for pure unadorned drawing-room sculpture came next year at the Veron sale, when two marble busts by Houdon, *Mme Victoire* and *Sophie Arnaud*, were sold for something quite new and extraordinary— namely, £477 10s and £552.

In 1865 a pair of single-figure candelabrum bronzes after Clodion made a still higher price—namely, £644. At the great San Donato sale of 1870 a small Falconet bronze made £320 on its own. At the Baron Thibon's sale in 1875 one of Clodion's terracotta groups, tinted an attractive rose colour and mounted on a drum as a definitely drawing-room object and not as a sculptor's working model, made the then incredible sum of £564. This was the beginning of a strong Parisian cult for unglazed groups, Clodion's terracotta *Autumn* making £780 in the 1880 San Donato sale and Pajou's *Marie Antoinette* nursing the

Dauphin in Sèvres biscuit porcelain, £816. These, however, were only saleroom prices. Edmond de Goncourt[32] describes an astonishing tinted terracotta by Clodion, representing the Montgolfier balloon of 1783, smothered in Cupids. It was shown at the Paris Exhibition of 1867 by Alfred Beurdeley, who at this early date had paid £1,000 for it. But at about the year 1850 it had been knocked down in a sale at the then usual price of £20.

The lovely tinted terracottas were not destined to fetch £1,000 and more in the open saleroom till the early 1900s. It is, however, possible that these prices, which would have been thought very high in 1875–80 for any piece of classical or *Quattrocento* sculpture, were paid for the terracotta and biscuit groups quite simply because they were collected as ceramics, something equivalent to the then booming Wedgwood jasper ware, but rarer and finer. In fact, one of the new models, produced by Messrs Minton in 1873, was "the Clodion Venus, which combines the colour of terracotta with the advantages of vitrified porcelain", but it cost as much as the price in 1849 of a pair of original Clodion *Bacchantes*.[33]

At this stage the tinted terracottas were not yet as costly as the bronze sculptures mounted as furniture, which reached the highest values that have ever been put on them, since this was the extraordinary period, 1878–82, when almost all French eighteenth-century craftsmanship was dearer in terms of real money than it is today. Multiplying by at least six, we may recall once again that at Leopold Double's sale in 1881 Falconet's *Three Graces* clock, which cost Mme du Barry £96 in 1768, cost M. Isaac Camondo £4,040. In his famous essay on the Spitzer Collection in 1893, Edmond Bonnaffé recalled that £4,000 a piece had once been paid by the Rothschilds for four wall lights by Gouthière (see page 41), and even that was not very much higher than the auction prices paid in 1880 at Prince Paul Demidoff's sale in Florence. Two torchères with bronze figures after Falconet were sold for £4,400, a pair of wall lights after Clodion for £3,200, a pair of small candelabra after Clodion for £1,448. It is true that in 1920 two candelabra supported by Falconet's bronze figures were sold in Paris for £3,720, but that was a year in which the purchasing power of the pound had fallen at least 50 per cent. The fact is that the mania for combinations of lacquered bronze and gilt-bronze never again became what it had been in the early 1880s. Though, after a long international financial

[32] Edmond de Goncourt, *La Maison d'un Artiste*, 1881, Vol. I, page 185.
[33] *Inventory of the objects in the Art Division of the Museum at South Kensington*, 1871–5, Vol. 4.

depression, prices for all eighteenth-century craftsmanship advanced again in the late 1880s, there have been no more torchères at £4,400 (gold) the pair.

1881 was an equally remarkable year for conventional sculpture without ormolu adjuncts. The excitement over the piecemeal sale of the Château de Montal was surpassed by the removal of the rococo fountains and garden statues from the Château de Menars. Sold in the full fury of Rothschild competition, these mid-eighteenth century works were far and away the costliest statues ever to have reached the saleroom, and considerably dearer than the two glorious fifteenth-century marble busts by Desiderio da Settignano, which the young Bode had negotiated for the Berlin Museum in 1878 (see page 41). And yet not one of the statues from Menars was by a sculptor of the first rank. Among the Rothschild family purchases there was a fountain group by Adam l'Aîné at £3,040, a statue of *Aurora* by Vinache at £2,442, two carved urns by Pigalle at £3,800 the pair, and Lemoyne's group, *The Fear of Love*, at £2,560. However, before the general break in values in 1884, prices in the same proportion were paid for portrait busts, £1,050 for Houdon's marble *Voltaire* at the Hamilton Palace sale and £1,760 for his *Marie Adelaide Servat* at the Ginzbourg sale in Paris.

There was no advance on these price levels till the beginning of the present century. Thereafter, and particularly between 1902 and 1914, French eighteenth-century sculpture underwent the same frenzied bidding-up as the rest of the limited repertory of fashionable taste. Conventional sculpture was now far ahead of candelabra and wall lights, and was surpassed only by the prices paid for the tapestry of the period. The movement began with Lord Grimthorpe's terracotta baby girl's head by Pigalle at £3,100 in 1902 and with Mme Lelong's Pajou marble bust of *Mme Fourcroy*, at £4,220 in 1904.[34] Then, at the Yerkes sale in New York in 1910, another of Houdon's marble versions of his *Diana* stupefied the art world at £10,200. Two years later Duveen bought the same sculptor's marble head of his daughter, the *Baby Sabina*, at the Jacques Doucet sale for £19,800, and sold it to Elbert Gary for £22,700. It was certainly one of the chief wonders of 1912, that collectors' *annus mirabilis*, for in addition to the Houdon baby, thirteen pieces of Louis XVI sculpture at the Doucet sale made over £2,000 each (see page 238). A tinted Clodion terracotta, *l'Ivresse du Baiser*, which had cost £184 in 1883 was sold for £8,910. In the

[34] In 1810, on the death of the Comtesse de Fourcroy, the family sold her Pajou terracotta group, *Les œufs cassés*, for twenty-two francs. Charles Blanc, 1858, Vol. 2.

following year Houdon's two marbles, *The Bought Kiss* and *The Given Kiss*, were valued for the Pierpont Morgan estate on the basis of these prices at over £10,000 each.

The record of those three remarkable years which preceded the first of the two world cataclysms shows that Pajou, Clodion, Falconet, and Caffieri had reached the £6,000 to £9,000 level. Only Houdon had soared beyond it. Yet Houdon had made dozens of heads and busts of his children at different ages, while Sabina at ten months seems, to say the least to have been a bit pudding-faced. Why then the furore? It seems that the whole thing had been the work of Joseph Duveen, Jnr. At the time of the Doucet sale he had secured, according to Mr S. N. Behrman,[35] no less than fifteen Houdon busts. Houdon had been to America at the invitation of Jefferson in 1786, and he had made a portrait of Washington in old age. Had he made a portrait of Julius Caesar or William the Conqueror, there would not have been so much to it. But, when a nation is less than 140 years old, any work by the author of a founder portrait can be a gold mine in the right hands. So Houdon was not to be contained within the £25,000 limit. In July 1917 Jacques Seligman took a whole collection of sculpture to New York as part of a wartime device to raise foreign currency for the French government. A Houdon bronze bust, *la Frileuse*, was sold to Henry P. Davison for a sum which the American press reported at £35,000 and even at £55,000. M. Germain Seligman says that they were wrong but he is too coy to say how wrong.[36] Possibly the truth lay in between. At all events at Elbert Gary's sale in 1928 Duveen failed to get the *Baby Sabina* back even at £50,000. And in the following year he charged Andrew Mellon £52,500 for the marble version of the Washington portrait. Finally, Houdon's *Duchesse de Sabran* was sold in New York in 1930 for £16,000. And that is still final today, for in 1930, after close on a year's financial depression, the whole *dix-huitième* market was beginning to wilt.

[35] S. N. Behrman, *Duveen*, 1952, page 160.
[36] Germain Seligman: *Merchants of Art*, New York, 1961, page 111.

The Orient Rediscovered
1815–1915

1. *Till the Looting of the Summer Palace, 1860* — 2. *In the Days of the "Blue Hawthorns", 1860–1915* — 3. *The Discovery of Japan*

1. *Till the Looting of the Summer Palace, 1860*

This chapter begins strictly as a continuation of the last, since the taste which brought back French objets d'art of the eighteenth century brought back Chinese art with it. Or, rather, it brought back precisely the kind of Chinese art which had become built-in as part of Pompadourian taste. But in the 1850s, when this happened, there were more sinister influences at work, which eventually gave the taste a very different direction, and these were none other than the first rash bites at the Tree of Knowledge.

The eighteenth-century Garden of Eden had been a simple place, and the Oriental part of its vegetation altogether too simple. Notoriously, the nature of the collecting classes of the *ancien régime* had been frivolous. If the curiosities that they sought were not frivolous in the first place, they knew well how to make them so. And in later generations this taint of frivolity remained. Things that had been turned into a sort of ballet *décor* were odious, not only to the drastic minds of the Revolution, but to the earnest, romantic minds of the Europe of the aftermath. So throughout the first half of the nineteenth century most forms of *chinoiserie* and *japonaiserie* were badly out of fashion, except for a brief revival in Regency England.

The purveyors of taste of the Paris of Mme de Pompadour, even

such intelligent and perceptive men as Gersaint and Jolliot, had refused outright to take Far Eastern art seriously. Very much like their Parisian successors of the Space Age, who produce expensively illustrated *livres de salon* in the light of intuition alone, they carefully avoided any suspicion of being *Gelehrter*. Occasionally they would pause in their description of an object's appearance to repeat some corny piece of *comprador* information, such as the legend of the forbidden yellow colour of the Chinese Emperors, but their curiosity stopped well short of the subjects and the inscriptions. To them a Buddha or an Arhat was just a *magot*. The Eight Immortals were *pagodes*, the Maiden Goddess Hsi Wang Mu was nothing but a *Long Eliza*.

A little more curiosity was shown at the very end of the century after several abortive diplomatic missions had actually visited the Court of Peking, but the spread of truly popular knowledge concerning Chinese civilization was linked with the arrival of the first Protestant missionaries in Canton in the 1830s. A large exhibition was arranged in Philadelphia in 1841 by Nathan Dunn, and in the following year it was transferred to London. It is curious that at a time when dishonourable terms were being exacted from the Chinese Imperial Government, and when the xenophobia of a thoroughly sordid war hung on, enormous crowds were attracted to William Langdon's pseudo-Chinese pavilion in St George's Place. The catalogue, a mixture of naïve observations and stale, unsound hypotheses, bore a title, set up in Chinese characters, *Ten Thousand Chinese Things*.

It was a warning that the Chinese language was soon to have its influence on connoisseurship. In the Debruge Dumenil catalogue of 1847 Jules Labarte (see page 93) included correct translations of some of the porcelain marks as well as descriptions of the subjects depicted. The publication may even have inspired the anonymous hero who catalogued the porcelain for Christie's in the great Stowe sale of 1848.

But the real demons of perplexity and false conjecture were yet to come. The fatal year was 1856, when M. Stanislas Julien of the Sorbonne added to his achievements in translating popular Chinese classics a French translation of a Chinese handbook on ancient pottery and porcelain, the *Ching-té Chên Tao Lu*. The original book had been published in Chinese in 1818, a summary of traditional potters' knowledge rather than a work of research. It is, nevertheless, to the *tao lu* that we owe most of our present-day classifications, not only the easily invoked monosyllables that slide nimbly off the tongue, like *T'ing* and *Kuan* and *Ko* and *Chun* and *Ju*, but those gems of saleroom erudition,

the bowl painted in semi-boneless bean enamels in almost *Ya shao p'i* style; the *hsiao wa wa* with *man tiou shan* on a field of *hui hui wen*.[1]

Occasionally in the nineteenth century attempts were made to identify the art of the early dynasties, as described in the *tao lu*. In the later 1850s the combined result of Julien's publication and Robert Fortune's sales was the belief that the Chinese of the Sung Dynasty had, like Mme de Pompadour, been very fond of *bleu violette* and *bleu céleste*. Later on, the collectors became more sophisticated. In 1881 Edmond de Goncourt described a prism-jar, which he owned, a ts'un as it would now be called, perhaps of Kuan ware. Similar vessels, he was informed, had been found in T'ang tombs, and M. Frandin had been asked £192 in Pekin for one of them.[2] In 1882 the Dublin Museum paid the large sum of £27 7s for an ugly battered celadon-like bottle in the Hamilton Palace sale. Richard Doyle must either have known, what was not apparent in the catalogue, that this was the Beckford vase, pillaged of its fourteenth-century mounts, or he must have recognized its true antiquity to have paid such a price. Generally, however, such things were not honoured before the twentieth century. In 1882 the Victoria and Albert Museum acquired a number of excavated specimens through Dr Bushell of Peking, some of them correctly described as *T'ing*, *Lung Chuan*, and *Honan* and some of them for four shillings apiece.[2a]

But the worst of all the troubles that flew out of Pandora's box, when the inscriptions began to be read, was the six-character reign mark, or *nien hao*. During the enormously long reign of K'ang Hsi [1662–1722], and to some extent earlier, it had been a common practice in China to use the mark of the Emperor Ch'êng-Hua [1465–87]. There was no attempt to copy the porcelain of the fifteenth century and it is doubtful whether any deception was intended. The most likely explanation is that from time to time a well-known edict forbidding the use of the reigning Emperor's name, was strictly enforced, though at other times it lapsed. But the potters liked to stick on a *nien hao* as a way of saying that the piece was good enough for a king, so they used the name of a reign that had been particularly distinguished for its porcelain products.

But how was anyone to know that? As early as 1862 Jacquemart and

[1] *Histoire et Fabrication de la Porcelaine chinoise*, 1856.
[2] *La maison d'un artiste*, 1881, page 228.
[2a] Discussed by Bernard Rackham in proceedings of the Oriental Ceramic Society, 1923–4.

Le Blant noticed the Ch'êng-Hua mark on a quite modern piece of *famille rose* porcelain decorated in Canton. They decided that caution was necessary, but that the Ch'êng Hua mark on a really fine piece was a certain sign of its dating from the fifteenth century.[3] Thus, at the Mitford sale of 1875, a huge eighteenth-century fish-bowl (£85) was attributed to the fifteenth century on the strength of the Ch'êng-Hua mark, an unusual practice for Christie's in the 1870s, but the owner had supplied learned notes.

In 1881 M. Osmond du Sartel, author of *La Porcelaine de la Chine*, was less self-assured than Jacquemart. A fine piece might bear the mark of Ch'êng-Hua, but one exactly like it might bear the mark of K'ang Hsi. He was led to conclude that George Salting's *famille noire* beaker with the former mark was a fifteenth-century piece, copied in K'ang Hsi's reign.[4] But if that were so, then everything in the *K'ang Hsi* style must be a copy of something of the fifteenth century. Everyone was now in such a muddle that there was a sort of gentlemen's agreement not to talk about it any more. In 1898 W. G. Gulland's *Chinese Porcelain* quietly ignored the existence of anything earlier than the sixteenth century, though as late as 1911 Dr Bode of Berlin praised the *famille jaune* pedestal jars "of the Ch'êng-Hua period" in the Benjamin Altmann collection. The problem of the genuine early Ming pieces of the fourteenth and fifteenth centuries still awaits a completely watertight solution even in the year 1963, though the Ch'êng-Hua myth was exploded early in this century. The trouble was that in the 1840s knowledge had come too soon and in too small a dose.

At first no one had been seriously bothered by literary references, because in the 1850s they still collected by eighteenth-century standards. For instance, between 1852 and 1862 Christie's held a series of sales of the objects which had been imported by Robert Fortune, the botanist and tea-planter. Fortune had lived in Peking, and he had absorbed a certain amount of rule-of-thumb knowledge from dealers who served the mandarin class. There were many objects in this collection which could have been elucidated with the aid of the *tao lu*. Even the bleak catalogues contained surprising references. In the 1857 sale there was a "bulb bowl, mottled purple and grey with spots of crimson inside, of great antiquity and highly-prized by the Chinese". Could this have been a piece of numbered *Chün* ware of the Sung Dynasty? If so, Fortune had anticipated fashion by half a century.

[3] *Histoire artistique, industrielle et commerciale de la Porcelaine*, 1882, page 169.
[4] Osmond du Sartel, *La Porcelaine de la Chine*, 1881, page 167.

Of the first Fortune sale in 1852, Joseph Marryatt remarked that Fortune had "not been aware that the taste of the English public was not like the Chinese as to merely ancient and rare specimens, which did not fetch the prices he had expected". By this Marryatt meant that nothing in the sale had exceeded £4. In 1856 it was different. An 18in turquoise crackled vase fetched a price that even today seems pretty lively—namely, £131—and this within a few months of the great Bernal sale, where four of the famous ruby-backed saucers were sold for twelve guineas the lot. It will be recalled that turquoise or *bleu céleste* was precisely the kind of porcelain that had fetched high prices in Mme de Pompadour's day, because of its suitability for mounting. In so revivalist a year as 1856 there was no need for any other reason for paying high prices for *bleu céleste* (see page 37).

But is there not something of a mystery about the original eighteenth-century prices? At the Julienne sale of 1766 a pair of dogs of Fo, seated on pedestals, all in mottled purple and violet, had been sold for no less than £192, unmounted. It may be answered that, apart from their desirability for mounting, such things in 1766 were also in demand among the wealthy Chinese. But why should objects in Chinese official taste have come out of China at all at a time when vulgarities suitable for the Foreign Devils were being profitably mass-produced at Ching-tê Chên to be decorated in the Canton shops?

Since the Dutch buyers never ventured beyond the ports, there was no particular reason why this kind of product of Ching-tê Chên, which was meant for circles close to the Emperor, should ever have reached the coast. It may even have been an accidental delivery that started the eighteenth-century vogue for crackled, or *truité*, porcelain,[5] for turquoise or *bleu céleste* monochrome pieces and for the most treasured of all, the mottled or *flambé* porcelain. Or it may have been a contraband traffic. There is an astonishing passage which Joseph Marryatt quotes from the (ghosted) mémoirs of the Marquise de Crequy [1710–1803], which were published in 1834:

> The Princesse de Vaudemont had a number of precious Chinoiseries of such rarity that the "China Kaufmann" to whom she sold them loaded a ship to re-export them to China, where national curiosities of this kind have kept a value a hundred times as high as they have in Europe. It is moreover a habitual trade

[5] The pleasant English habit of calling it "cracklin" lapsed in the early nineteenth century.

among the Dutch brocanteurs, who are always good judges in matters of chinoiserie and who, as soon as they have bought a curious piece put it on one side in order to ship it back to China and this makes them a profit of from 300 to 400 per cent.[6]

The second part of this reference may well be a comment by the editor or ghost on conditions prevailing in 1834, rather than in the eighteenth century, but there is no reason to doubt that the monochrome wares, sought by the French mounters, were very expensive in late eighteenth-century China. This was the time when the Emperor Ch'ien Lung [1736–95] was buying up pieces in the mediaeval tradition, which were sold to him as genuine antiques. Till the present century this was the only ground on which the tastes of Europe and the austere taste of the Chinese official classes met.

Compared with all other forms of Chinese porcelain, the price paid for monochromes in London and Paris in the 1850s became truly formidable. In 1857 one of Robert Fortune's turquoise crackle vases fetched £210. In 1867 a pair of "gambolling carp" vases in violet and blue, similar to an example which had been looted from the Summer Palace, cost £308 at Christie's. In all probability, no such prices for eighteenth-century monochromes and mottled wares have been paid since then, not even in the inflationary 1950s.

I have suggested that the prices, paid by Mme de Pompadour a century earlier, may have been dictated by the prices paid by the Court in China. Those mottled dogs of Fo, which had been sold in 1766 for £192, may have actually reappeared in the Paris saleroom in 1860 at almost precisely the same price—namely, £200. But, in spite of Robert Fortune's "Peking taste", it is unlikely that the demand for Chinese monochromes in the 1850s paid any true homage to the Chinese classical canons. Nor do these prices genuinely indicate the aesthetic superiority of the 1850s and 1860s over subsequent decades, when the prices of monochromes fell, and when, as Henry Bohn observed in 1876, "porcelain bought in Beckford's day would not sell for half the money".[7] The truth was that in the 1850s and 1860s the imitation of Louis XV mounts *en rocaille* was exceedingly popular and technically at its best. It is likely that by 1870 most of Robert Fortune's monochromes and those of the Emperor Hsien Fêng, which had been abandoned to the enemy in the Summer Palace in 1860, had changed

[6] Marryatt, Vol. II, page 258, quoting Vol. II, page 283, of the original memoirs.
[7] Redford, Vol. I, page 239.

their identity to *garnitures de cheminée*, mounted as in the days of Mme de Pompadour.[8]

In 1870 nascent English aestheticism expressed itself in a taste, not for monochromes, but for "blue hawthorn" jars. The brief monochrome revival was therefore the last symptom of restraint among European lovers of Orientalia for close on two generations. The cluttering-up of the English middle-class home with the flatulent mass-production of India and Japan began in the 1860s. Its spread was inevitable. As early as the beginning of the seventeenth century some of the Chinese export porcelain had been adversely affected by late Renaissance European taste. Consequently after two centuries of familiarity with a corrupted style, the public accepted profusion of ornament as the keynote of all Asiatic art, unaware that China and Japan had adopted it in the first place only in order to compete for European custom. Moreover, the superior valuation which the eighteenth-century salerooms had put on porcelain of fine quality, such as Kakiemon, disappeared after the Revolution. By the year of Waterloo the only *unmounted* Oriental porcelain that was not dirt cheap was unquestionably the largest, gaudiest, and newest.

With the collapse in the 1860s of the revived eighteenth-century taste for monochromes, the porcelain, and indeed the entire art of the Far East, was completely reappraised—one might almost say rediscovered. The philistinism of this reappraisal or rediscovery is today even more remarkable than the vast breadth of its repercussions. Ignorance of a country which was only rarely penetrated by foreigners may partly excuse the early nineteenth-century cult for coarse-quality "mandarin" vases. It can hardly excuse the incredibly expensive cult for *famille noire* vases a full hundred years later. Still less can ignorance be held an excuse for the annual wholesale purchases of bazaar junk by such institutions as the Indian section of the Victoria and Albert Museum far into the present century. In India the English careerists, Eldorado-hunters, and mercenary soldiers of the eighteenth century made a better aesthetic showing than the generations of civil servants and their families who succeeded them. In 1831 "Hindoo" Stuart's early Buddhist sculptures from Gaya and Kanara were sold at Christie's for as much as thirty guineas for a single fragment. But in 1876 the surviving bulk of Stuart's collection could not even find a buyer. We have

[8] Since writing this, I have been informed that a jade elephant from the Summer Palace, presented to Queen Victoria in 1860 and later presented by her to her son-in-law, the last Kaiser, exists somewhere in Germany in a beautiful rocaille mount.

seen how in 1808 a Persian Koran could cost £185 and a Mughal album of portraits £199 11s. It is to be added that in 1850 the British Museum bought one of the greatest treasures of early Islamic painting, the late fourteenth-century *Diwan of Kwaju Kirmani*, for thirty-two shillings.

The inference from these prices and from others which will be found in my lists is that in the early nineteenth century the mediaeval past of Asia had some commercial value, but that in the middle part of the century it had none. The English Nabob, who had occasionally sought the company of native scholars, had been succeeded by the *memsahib*, shopping in the bazaar with a *puggaree* and a green umbrella. More destructive still than this social change among the conquering race was the growth of the museum spirit, the spirit of the utilitarian or industrial museum as the mid-nineteenth century knew it. If museum curators in the 1880s considered a coconut-fibre cigar-case from the Andaman Islands a valuable object of emulation for the artisan, why should the private individual be blamed for desiring more and more Benares brass trays, Mushrabiyyah tables, and brocaded Satsuma vases?

Under the impact of this tidal wave, it was naturally the most highly decorated Chinese porcelain that became popular. But the cult of *famille verte* and *famille rose*, so named for the first time in the 1860s, was a reversal of all previous trends. *Famille rose* in particular had overflooded Europe in the late eighteenth century. Made in an international *table d'hôte* style, it had been cheaper than the products of any of the European factories, and inferior to most of them. It had become so debased in value that by the end of the Napoleonic Wars the Chinese production of the ordinary domestic enamelled porcelain, "Oriental Lowestoft," or *Compagnie des Indes*, had died out. At a time when an "egg-shell" service of 127 pieces could be sold at Christie's for £6 10s, it was no longer worth the trouble to send the white wares to the enamellers in Canton. Only the still cheaper "blue Nankeen" or East India Company sets continued to be produced, dingy in colour and grey in paste, but in early Victorian times these utilitarian imports came to an end too. Their place was taken by transfer-printed blue-and-white earthenware from a number of domestic factories. At the great Stowe sale of 1848 the unwanted "blue Nankeen" was going at eighteen shillings for a lot of 100.

It must not be inferred that Chinese porcelain was all as cheap as that in 1848. At the Stowe sale the larger jars and covers in the overloaded enamels of the end of the eighteenth century could make as much as £12 each, while 5ft mandarins could cost over £60, but these, the

highest prices at the most famous of sales, marked the nadir of *chinoiserie* in England. *Chinoiserie* had revived briefly under the leadership of the Prince Regent towards the end of the Napoleonic Wars, but nothing could have been deader in 1848 than Brighton Pavilion taste. It was probably the year when Macaulay wrote his description of the china cabinet of Mary II at Hampton Court, and one wonders whether that was not the fruit of a visit to Stowe. Macaulay spoke of the "gewgaws, the hideous images, the vases painted in defiance of the laws of perspective". He taxed the poor Queen with the spread of this "frivolous and inelegant fashion" till every house became "a museum of grotesque baubles", till even statesmen and generals—gracious heavens, what next!—became judges of teapots and dragons.[9]

The late Arthur Lane[10] suggested that, fundamentally, as a Whig and a Puritan, Macaulay disapproved of art of *any* kind. But Macaulay was in line with well-informed taste in this matter. In the 1820s his comments would certainly have met with the approval of Hazlitt and partly, at any rate, with the approval of Beckford. For what had wounded Beckford most in Hazlitt's attack was the assumption that the "Chinese furniture" (the taste of Prinny) at the 1823 Fonthill sale had been his.[11] And in 1855, when Macaulay's famous passage was finally published, it would have entirely fitted in with the views of Ruskin.

The censure of the early Victorian purists could not prevent the continuance of a subdued market for mere size or for rich European metal embellishments—that is to say, the market for mandarin vases and for garnitures in French mounts. The former had occasionally been ordered in the past century in order to stand on a staircase or in a wall-niche. It had been possible to make them as big as 5ft high, but beyond the technical achievement of firing hard-paste porcelain on such a scale, there was not much to be said for the mandarin vases. Generally, they are found to be insensitively painted and in a coarse material. Seen at a distance in a lighted niche, they look attractive enough, but they were not meant for close inspection. Of course, they had been very costly to make. A country squire who wanted to show off in this way could hardly expect to lay out less than 100 or 200 guineas for a pair, shipped with monstrous freight and insurance charges from Canton by the next monsoon. That highly esteemed commodity, size, was not to be found on the home market. Even in 1827 the Rockingham rhinoceros vase

[9] *A History of England*, Chapter XI (Vol. III, page 1362 in Firth's edition, 1914).
[10] In *Transactions of the Oriental Ceramic Society*, 1949–50, Vol. XXV, pages 21–2.
[11] Melville, page 320, as reported by Cyrus Redding.

was far and away the largest piece of porcelain to have been made in England and it was only 44in high (see page 53).

Between the end of the Napoleonic Wars and the great Stowe sale of 1848, the English price of a pair of mandarin vases of the largest size remained steadily round the £100 level. That this was purely the price of size is shown by the fact that the only other Chinese pieces that came anywhere near them in this depressed period were also a bit larger than life. These were newly imported celadon jars, with flowers in relief, described as enamelled, but actually painted in blue, peach-red, and white under the glaze. Beckford sold a single jar in 1817 for £70 17s 6d, but in the 1820s, 1830s and 1840s prices of £30 to £60 were more usual, and perhaps these products of the reign of the Emperor Tao Kuang [1821–50] will make no more than that today.

It appears that the real market for mandarins was in Paris. According to *Le Cousin Pons*, in the year 1844 a pair of vases and covers *"grand mandarin ancien"* could cost from £240 to £400. But Sylvain Pons added for the information of his imperceptive cousin that the Chinese were still making them for 200 francs, a qualifying statement which should inspire some needful reflection. The Government of the Emperor Hsien Fêng [1851–61] failed to send its exhibits to the Crystal Palace in 1851. Their place was taken by loans from English dealers and collectors. The illustrations reveal vases that appear to have been even bigger than the 53in standard mandarin, but of a well-known and perfectly godless nineteenth-century design, having no resemblance with the still reasonably well-designed eighteenth-century product. But, at £400 a pair, there must have been a temptation to have true copies made, and doubtless this could be done, for the porcelain painter of the reign of Tao Kuang was as skilful as his counterpart, the Parisian mount-maker of the Louis Philippe period.

From the 1840s onwards the progress of *"grand mandarin ancien"* continued without pause. It was not as dear as the Sèvres garnitures, but for a whole generation it was dearer than any other form of ceramics. Neither the cult of blue-and-white in mid-Victorian times nor the search for rich pieces with black or yellow backgrounds in the "Salting" taste stood in the way of the mandarin vases. In 1860 a pair made £672, in 1870 £1,100, in 1882 £1,239, in 1890 £1,732, and in 1903 £3,200. To the distant rumble of the Battle of the Somme, a pair were knocked down to Duveen in 1916 for £5,670. And then they began to slip. For another thirteen years the rather better-painted jars with *rose Pompadour* backgrounds continued to command these prices. It seems that only the slump of 1929–33 could bring home the lesson that the

biggest stood the least chance of being the best. During the next generation £500 could have bought any pair of mandarin vases, but recently inflation has created a *simulacrum* of the old prices. In 1962 a specially good pair were sold by Christie's for £2,310.

On 6th October 1860 there were certainly no mandarin vases to be seen or anything remotely resembling that purely export product when a mixed French and British force broke into the Yuan Ming Yuan, the Summer Palace in the Western Hills of Peking, whence the Emperor Hsien Fêng and his Court had fled. But it was an extremely brief encounter with Imperial taste, since the three principal buildings of the Yuan Ming Yuan were rapidly looted by all and sundry and then set on fire. It was a sordid gesture, however horrible the provocation might have been, but it had some significance in the history of taste. For the indiscriminate nature of the pillage filled Europe with objects such as had never left China before. The expedition of General Cousin-Montauban and General Sir Hope Grant was not, of course, accompanied by art experts. In 1860 the words would not have been recognized. It was, therefore, the largest and least fragile sort of object that was likely to survive this form of pillage, though a human skull, plated with gold, appeared in one of Christie's catalogues as "brought back by one of Fane's cavalry". A great deal of the loot was certainly disposed of in China, but several enormous cloisonné enamelled incense-burners came to rest in the officers' messes of English regimental depots. They no longer burned incense in them, but they became the objects of a still more mystic cult, being polished daily by appointed acolytes—100 years of Brasso!

As to the objects from the Summer Palace which reached the sale-room, they tended naturally to be of the kinds that were already in demand, though the elaborate altar furniture in porcelain of the late Ming period attracted some attention because of its great size. The foundation of the Grandidier Collection was formed in this way, but the impact of Chinese sixteenth-century taste, which one would have thought had much in common with Palissy and Henri Deux ware, was almost negligible. Till the eve of the First World War even the most sumptuous Ming enamelled porcelain was regarded as technically too crude.

Auction sales in London and Paris followed closely on the looting of the Summer Palace, but they caused little excitement. The political Opposition professed a sense of shame—one of the pleasures of being out of office. Sections of the French Press protested in 1861, when the objects "brought back" by General Montauban were exhibited at the

Pavilion de Marsan. Montauban had been at pains to explain that he had not been a party to the firing of the Yuan Ming Yuan, part of which, by a singular practical joke of Destiny, had been designed by French missionaries in the style of the Petit Trianon. However, among the dignified anger and the manly tears, gifts to royalty were not refused. For the second Crystal Palace (the 1862 structure) there was a special exhibit, a jewel coffer and its contents, which were said to have belonged to the Empress. The adoptive owner, Captain Jean Louis Negroni, afterwards made the mistake of selling the treasure twice over, but as it turned out that neither client had paid him, the Captain escaped with nothing worse than a fine of £120 and a month's sentence of prison. He was, General Montauban declared, a model officer.[12]

The Summer Palace sales created a prolonged rise rather than an immediate revolution in prices. Both jade and cloisonné enamels went up in value, but they had been fashionable since the 1840s, when many articles not normally exported had reached the newly-opened treaty ports. Jade, which had occasionally reached Europe in the eighteenth century, had always been relatively expensive. In the 1850s, when new examples arrived from China, showy carvings could sometimes fetch from £80 to £100. But in 1862 a vase from the Summer Palace, sold in Paris, made as much as £204. Not only was this eight times as much as the best of the Debruge Dumenil pieces, which had been sold in 1850, but it was almost as high as any price paid for Chinese jade before 1930, for the novelty of the Summer Palace sales wore off within a few years.

Cloisonné enamels advanced more than jade; perhaps because they had not been known in Europe for so long, the craze proved slightly more enduring. A few examples of this essentially religious article, by no means intended for the foreigner, may have reached London at the beginning of the century. The first important price was paid at the Stowe sale of 1848—£63 for a big incense-burner which had been smuggled aboard an English warship at Amoy in 1841 during the Opium War. In 1855 Robert Fortune was able to obtain £210 for a pair of cloisonné vases at one of his Christie sales. To get that purchase into perspective, one should recall that six years later Piero della Francesca's *Baptism of Christ* cost the National Gallery only thirty guineas more. But the real market for cloisonné enamels was in Paris, where the Summer Palace sales created an extraordinary cult, doubtless because the turquoise backgrounds and the gilt *cloisons* created an

[12] As reported in *Chronique des Arts*, 1863.

illusion of the more depressing kind of Sèvres *bleu céleste* backgrounds and borders. At the second Paris sale of loot in 1862, a pair of big incense-burners and covers were sold for £360, in 1863 two covered boxes, surmounted with kylins, made £456 12s, while in 1865 one of those enormous jardinières, supported on a kneeling figure of heavily gilt copper, made £450 on its own account. This was the very height of the cult. Close on ninety years were to pass before an important piece of cloisonné could again make £200 or thereabouts.

Why this revulsion from Chinese jade and cloisonné? The objects had been thoroughly in the taste of William Beckford, whose mounted Indian jades could still make much more than this at the Hamilton Palace sale in 1882. Stylistically, both jade and cloisonné enamel could hardly have fitted better into the creepy-crawly aesthetic of Bernard Palissy, which achieved its absolute triumph in 1884. The trouble was that in the 1870s and 1880s, when late Renaissance taste was in such demand, Renaissance rock-crystals and mounted hardstone vessels were still to be had. In the late eighteenth century these unevocative feats of dexterity from the Yuan Ming Yuan would have been preferred to all the precious heirlooms of the Holy Roman Empire. Not so the collectors of the Salting generation. They were prepared to pay thousands for late Chinese porcelain, but while there were Renaissance rock crystals and Limoges enamels on the market, they were not inclined to bid excessively for jade and cloisonné enamels from the East.

The present markets for Chinese jade and cloisonné enamels are somewhat distinct from each other, since the highest prices for jade are no longer paid for the most intricate kind. But with cloisonné, except for the only slightly less intricate, albeit cheaper, Ming pieces, there is no choice in the matter. It is the excessively ornate or nothing. Enthusiasts there certainly are, but who would echo today the thoughts of M. Philippe Burty in 1868?[13]

> Cashmire shawls and sixteenth-century Persian carpets hold nothing more harmonious. Their lapis blue recalls the depthless ether of summer nights and the turquoise the palpitations of the sky when the dawn is born.

In 1963 cloisonné may be in again, but eulogiums in the manner of Théophile Gautier are definitely out.

[13] *Chronique des Arts*, 1868, page 41.

2. *In the Days of the "Blue Hawthorns"*, 1860–1915

Seldom in the course of art history has it been possible to trace a taste of truly universal appeal to a single man or woman. Mme de Pompadour and her mounted Chinese monochromes may be an instance. Should the painter Whistler and his blue-and-white hawthorn vases be considered another?

On first consideration one would say emphatically, "Yes". In 1863 Whistler was apparently a lone buyer, but in 1880 the pieces which he had sold to his few patrons had already reached the thousand-pound mark, and the craze did not end till after the First World War. But quite a different picture is obtained, when the year-to-year Chinese porcelain prices at Christie's are examined in the original catalogues. It transpires that blue-and-white, though not the sort of blue-and-white that Whistler favoured, was already going up impressively in the 1860s. A pair of jars and covers made £69 6s in 1860, another in 1864 made £120, while in 1866 a pair made £140. Furthermore, the pair which made £120 in 1864 had been sold at the tremendously puffed sale of the Duke of Sussex in 1843 for no more than £29.

These pairs of vases possessed one thing in common. They were all from 4ft to 5ft high. One would have said that this was no more than the normal homage which was paid in those days to extravagant size, were it not that blue-and-white had never enjoyed the slightest repute in England, in the 1840s least of all. Decoration in underglaze blue which required only one firing was cheaper to produce than overglaze enamelling. New dinner services, shipped in the late eighteenth century from Canton, were often auctioned in London at the rate of a shilling a unit. In the 1840s these superannuated services could be had for twopence a piece. As to blue-and-white porcelain of real age and quality, it was then often a matter of shillings rather than pounds.

Moreover, the advance was not confined to blue Mandarins. A garniture of three 24in jars and covers, sold in 1866 for £14 5s, would not have made anything like as much at the time of the Stowe sale of 1848. Even in his earliest collecting days, Whistler must have been buying on a rising market. In 1867 Joseph Marryatt's magnolia vase, a decidedly Whistlerian piece, as Marryatt's illustration reveals,[14] fetched nine guineas, but at the Strawberry Hill sale of 1842 it had cost him less than £2.

Whistler spread the cult of Chinese blue-and-white porcelain as a

[14] Marryatt, Vol. I.

decorator's taste, but in the early 1860s it was already part of a decorator's taste, though of a kind quite different from Whistler's. Oak panelling and oak sideboards had long been established as part of the early Victorian domestic scene. It was discovered that they went well with the fashionable maiolica, Limoges enamels, and German stoneware. It was also perceived that old blue-and-white Dutch Delft ware, which in the 1840s was only a little dearer than kitchen crockery, went very well with oak that had been blackened. Blue-and-white hardpaste porcelain does indeed go decidedly less well with this background than Delft, but it looks richer. The distinction soon became quite clear; Delft for the provinces, Chinese blue-and-white for London and the great country houses.

Whistler's contribution was to make Chinese blue-and-white part of a revolutionary scheme of decoration, the very reverse of sombre neo-Elizabethan and blackened oak. In 1863, when he furnished his rooms in Lindsay's Row, Chelsea, Whistler chose very light tones for his walls, broken by hanging fans and framed Japanese colour prints. The sparse shelves of blue-and-white china provided the one note of strong colour.[15] This accounts for the peculiar kind of blue-and-white which Whistler was to make popular, not the usual jumbled salad of motifs in Dutch taste, hardly distinguishable at a distance from Delft ware, but pieces decorated with bold masses of glossy crystalline blue pigment. The right blue had been in production for only a short period, probably between 1690 and 1710. History, however, did not come into the matter, art history least of all. Whistler needed this colour note for his painting, so he looked about till he found it; for it was during his first years in London in the 1860s that Whistler introduced Chinese blue-and-white into such finely balanced pictures as the *Lange Leizen of the Six Marks*, the *Princesse du Pays de Porcelaine*, and the *Gold Screen*.

Very quickly the taste spread to Whistler's patrons. The process is admirably illustrated in Treffrey Dunn's recollections of Dante Gabriel Rossetti.[16] As a romantic and by no means an aesthete, Rossetti was in love with the darkened-oak background, and he kept a few bits of Delft to match it. Whistler won him over to the true Chinese article. About the year 1867 the dealer Murray Marks offered Rossetti a consignment of blue-and-white, newly shipped from Holland, at £50. Rossetti could not afford to spend so much at one moment, so Marks

[15] Recollection of Arthur Severn in Joseph Pennell, *Life of Whistler*, 1908, Vol. I, page 116.
[16] *Recollections of D. G. Rossetti and His Circle*, 1903.

passed the consignment on to Whistler's patron, Louis Huth, whom he had brought along with him. This was possibly the beginning of that famous collection of blue-and-white which was to obtain such breath-taking prices at Christie's in 1905.

It is surprising that in 1863 Whistler should have brought this taste with him from Paris, where he had lived in a circle which preferred Japanese art to Chinese. In fact the blue-and-white cult never really caught on in Paris. On the face of things, it is equally remarkable that Whistler should appear to influence English taste so much, seeing that he was quite incapable of finding clients who would pour tens of thousands into his banking account, as more than a dozen mediocre London painters were able to do in the next decade. The surprise becomes less, when the London auction-room prices for blue-and-white between the 1840s and the 1860s are brought into the picture.

It may be somewhat incomprehensible today that the craze for blue-and-white should have begun as a decorator's taste. Of all porcelain, K'ang Hsi blue-and-white seems the least adaptable to a European room in the lighter tones which were then coming into fashion. Whistler himself revised his principles totally in the famous Peacock Room of 1876, where Frederick Leyland's blue-and-white collection, ranged in a forest of fussy, gilded bamboo shelves, was given without the owner's consent a distracting background of deep blue and gold. In the 1880s and 1890s the blue-and-white lovers generally created agitated backgrounds for their treasures, though W. G. Gulland may have hit on the best solution when he proposed, "India red, or terra-cotta".[17] None of the original collectors adopted the modern museum practice of the white or off-white wall. In fact the high prices for blue-and-white fell precisely when white walls became fashionable.

The greater part of the blue-and-white porcelain which was collected in England from the 1860s onwards had to be bought in Holland. The Dutch, who had imported this ware in the reign of K'ang Hsi [1661–1722], seem to have passed little of it on to other countries. And yet at the end of the Ming Dynasty, particularly in the 1630s and 1640s, they had flooded Europe with a different sort of Chinese blue-and-white. Most of the blue-and-white which survived in English country houses in the 1860s belonged to this earlier importation. It is not quite true to say that at the height of the blue-and-white craze English collectors paid hundreds and thousands of pounds for objects that had been familiar in their own homes for generations. There was an element of novelty in the kind of blue-and-white which Whistler selected. The

[17] W. G. Gulland, *Chinese Porcelain*, 1898, Vol. I, page 244.

beaker which Joseph Marryatt had bought at the Strawberry Hill sale in 1842 was indeed a Whistlerian object, but it was clearly regarded by Marryatt as very unusual. The Blenheim Palace blue-and-white, which was sold in 1886, had all been acquired in the eighteenth century, and the absence of "Mayflower" vases was found worthy of comment. In fact, there was only one example of the famous hawthorn pattern among some hundreds of lots which averaged about five guineas each. It is probable that much of the "transition Ming" which is so eagerly sought today comes from the Blenheim dispersal.[18]

The blue-and-white, which could be bought from simple middle-class homes in Holland in the late 1860s at a few pounds a piece for even the best examples, was destined, most ironically, to become the symbol of aestheticism and of art for art's sake. But Whistler's excessive praises of K'ang Hsi blue-and-white dated only from the time when the ware had already become so socially acceptable as to serve as an object lesson for his attacks on Ruskin and the prevalent English identification of art with morals. Had not these things been made in an age when the Chinese had been conquered by the Manchus? Whistler deliberately exaggerated the decadence of the reign of K'ang Hsi, maintaining, as he did in the "Ten o'Clock Lecture" of 1885, that the caresses of "Art, the jade" had always been capricious. For instance, she had ignored the industrious and liberty-loving Swiss, who had only produced the cuckoo clock, but—

> Art, the cruel jade, cares not and hardens her heart and hies her off to the East, to find among the opium-eaters of Nanking, a favourite with whom she lingers fondly—caressing his blue porcelain, and painting his coy maidens with her six marks of choice—indifferent in her companionship with him, to all save the virtue of his refinement.[19]

It could have been retorted, even in the light of knowledge of 1885, that no blue-and-white had ever been made in Nanking, that in the reign of K'ang Hsi opium had been used in China only as a medicine, and in rare quantities, and that the six marks of choice were nothing more than a fraudulent fifteenth-century date. But it took the experience of two more generations to spot the real objection to the activities of Art, the jade, who had cohabited with opium-eaters in so un-Ruskinian a fashion. Critics in the 1920s could see how hopelessly the individual touch of the Chinese porcelain painter had been lost

[18] Redford, Vol. I, page 421.
[19] *The Gentle Art of Making Enemies*, 1890, pages 156–7.

towards the end of the seventeenth century, how accurately the soul-destroying mass-production methods of that period had been described by that honest eyewitness, le Père d'Entrecolles. But it could have been noticed a little sooner that the Chinese textbooks had not found K'ang Hsi blue-and-white worthy of mention, that hardly any of it survived in China, and that the favourite shapes and decoration had been devised to tickle the Western palate.

But so long as K'ang Hsi blue-and-white fitted in with the fashion-able forms of interior decoration, it was proof against historical com-parisons with the more vital periods of Chinese porcelain. Twenty years after the "Ten o'Clock Lecture", when Louis Huth's hawthorn jar and cover made £5,900 at Christie's, much the same language was used by Mr A. C. R. Carter of the *Daily Telegraph* in a passage, with which he was so pleased that he reprinted it at intervals right up till the 1940s:

> So all gave gifts, but the mandarin's was the richest of them all. For months an artist had laboured in delight over the fashioning and glazing of a jar. On its vibrating ground of pellucid blue, pencilled over with reticulations of darker blue lines. . . .

—but enough of that. There had been no mandarin and no artist labouring in delight, but only an assembly-line team, one among hundreds in grimy, toiling Ching-tê Chên. And the jar, possibly filled with trade ginger, had gone off with a Dutch buyer's consignment of similar jars, invoiced at a few florins each. The great Huth hawthorn jar had in fact been sold for 12s 6d as late as the 1860s.

Of course, not all the blue-and-white porcelain of the inconceivably prolific reign of K'ang Hsi soared into the hundreds and thousands. In actual fact, high prices were paid far less frequently than the present-day legend would have us believe. To achieve saleroom success, flawlessness had to be wedded to an absolutely even pitch of colour and an impres-sive size. Great importance was attached to sets and garnitures, but the highest prices of all were invariably paid for one particular type, almost completely standardized and not particularly elegant. It was a near-globular ginger-jar with a skull-cap cover, displaying some white sprigs of prunus blossom—miscalled hawthorn—on a blue background of crackled ice. Quite apart from the numerous modern imitations which the English and the American cult encouraged, the design was one of the commonest. The whole point of the high prices of the blue hawthorns resided in the quality of the blue. Much less was paid for those very handsome trumpet vases decorated with lilies or magnolias in white

with faint blue surrounds to give them relief. And as to the tall vases with elongated ladies, the *Lange Leizen* or *Long Elizas*, which Whistler had loved so much, they were never the top prizes of this market.

The strongest factor in making blue-and-white popular was that there was enough for everybody. The fact that every suburban home eventually acquired a few cheap bits of Chinese blue-and-white helped to enhance the value of the exceptionally fine examples. But it was such a limited sort of fineness. On a small scale, the chosen pieces could make an exceedingly attractive display, but the monotony of large accumulations could be very deadly. There was, for instance, the collection of the American, James Garland, which had been formed mainly in the 1880s. A photograph, taken towards 1902, when the collection was displayed on loan in the Metropolitan Museum, New York, conveys a most depressing image with its grim stacks of identical shapes and patterns mostly very large and standing on the floor. Yet this collection, on which Garland had spent £120,000, had probably cost J. Pierpont Morgan in 1902 fully £200,000 or £1,200,000 in our present money.[20]

The Garland Collection was acquired largely through Henry Duveen who set up shop in Boston in 1876 and in New York in 1879. The high prices were created mainly through the competition of the two Duveen brothers with the far more discriminating and tasteful Murray Marks, who bought for George Salting. The Duveen brothers had entered the Chinese blue-and-white market via the English Midland taste for Delft ware, which their mother had been buying up in Holland since the 1850s. In 1867, when Duveen and Barnett formed their first partnership in Hull, it was still the big blue-and-white urns and covers, 4ft or 5ft high, that made the most money; but the Duveens created so strong a competition that in a little more than twelve years and before the taste had spread to America the quite small hawthorn jars were making 600 guineas at Christie's.

There was, of course, a further element which contributed to this vertiginous ascent, and that was the general rise in all Chinese art which followed after, but not immediately after, the sack of the Summer Palace. A potent factor was the first attempt to classify the forms of Chinese porcelain-decoration made by Jacquemart and Le Blant in 1862. It was they who invented the terms that we still use, *famille verte* and *famille rose*, though the authors themselves declared that their grouping was *tout empirique*.[21] Under these attractive new names the

[20] James Duveen, *The House of Duveen*, page 166.
[21] Jacquemart and Le Blant, page 67.

enamelled Chinese porcelain, which the eighteenth-century French market had always treated as a poor relation of the mountable mono-chromes, was now bought seriously.

Jacquemart's illustrations of 1862 already show the Victorian preference for those pieces, exceedingly unfashionable today, on which the *famille verte* enamelled panels are inlaid against a solid background of *bleu soufflé*, or powder blue. The taste for powder blue was destined to run parallel with the taste for blue-and-white and was for many years considerably dearer because of the appeal of those prim little enamelled panels. The prices for powder blue in the 1860s probably reflect the competition between the painter James Orrock and the formidable Australian millionaire, George Salting. In 1866 a pair of very large blue-and-white jars and covers could make £140 at Christie's, but two powder-blue jars with flowers in medallions were sold that year for £509, while a pair of cisterns, powder blue and gold on the outside, enamelled with fishes within, made £330 15s.

True blue-and-white did not reach these levels till the late 1870s, when Joseph Duveen, Snr, moved from Hull to London. For instance, if one may rely on the lively memoirs of his nephew, James Duveen, written in 1956 when he was 83 years old, a blue hawthorn jar and cover, which entered the Victoria and Albert Museum with the Orrock Bequest in the present century, was sold to Orrock by Joseph Duveen, Snr, shortly before the year 1879 for £1,200.[22] The jar had been bought in Holland for £400. One has to accept the dates and figures with the reservations as well as the respect due to an octogen-arian's boyhood memory, but they are not intrinsically impossible. One can trace the progress of the cult in Lady Charlotte Schreiber's diary. In 1869 she notices the quantities of blue-and-white shipped to London by the firm of Hamburger of Utrecht. In 1873 "we find every-where that Bernard [Barnett] and Duveen of Hull have been before us making wonderful purchases". In 1876 the railway station at The Hague "is crowded with people owing to the craze for blue-and-white, now so prevalent in England". The rage for blue-and-white she finds "truly ridiculous" and yet, even as late in the day as this, two pedestal vases with chrysanthemums are offered to her for £30, while Mr Tooth buys two bottles for £25, which he does not expect to sell for more than £35 in London. At Amsterdam in 1878 Lady Charlotte finds that "blue-and-white is driving everything else away". Even the blue-and-white which used to be in the hotel has found its way to Christie's.

[22] James Duveen, *The House of Duveen*, 1957, page 36.

At The Hague a garniture of five vases, not blue-and-white, but powder blue, costs something between £800 and £1,000.

But blue-and-white was now worth more than that in the London saleroom. Not less than 160 lots of it came up at Christie's in March 1880 with Dr E. B. Shuldham's collection, including a fine set of three hawthorn vases and a pair of beakers. "The prices to which these were run up were preposterous beyond all precedent, scarce as these old jars may be, one being knocked down at £620 and another at £650, in neither case reaching the reserve price."[23] Three more hawthorn jars and covers were sold outright for £410 11s, £325 10s, and £232. Evidently the high reserves had been fixed in the light of experience, since two months later, at Sir Henry Thompson's sale, similar prices were actually realized for two hawthorn jars and covers—namely, £630 and £525.

Most of the blue-and-white in this sale had belonged to Whistler. At some time in the 1870s it had been taken back by Marks and resold to Thompson, but not for long. As a prelude to the Christie sale, the collection had been exhibited in 1878 by Marks, who also published a catalogue containing twenty-six autotype illustrations in brown and blue, nineteen of them after Whistler's own brush drawings. Like everything connected with Whistler in the unhappy year of his libel action and bankruptcy, even the catalogue, which is nowadays immensely rare, was a failure. Marks could not sell an edition of 220 copies, but the favourite objects, with which Whistler had parted years ago, did marvellously.[24]

Seventeen years were to pass before a hawthorn ginger-jar could again make 600 guineas at Christie's. For instance, the purchases of the Victoria and Albert Museum at James Orrock's first sale in 1886 were at a more modest level, though when multiplied by six to equate them with today's money they still seem quite grotesque. The best of the three hawthorn jars cost the Museum, with commission, £383 6s 8d.

Prices were to fall lower than this. In 1894 at the Malcolm sale the firm of Duveen paid £588 for an extremely important blue-and-white garniture of three covered jars and two beakers, which had come into their hands once before, about the year 1890, for not more than £30. Traditionally, the garniture was supposed to have belonged to Everard Jabach, the Cologne banker, who had bought Charles I's pictures for Cardinal Mazarin, and who had died in 1695. The price was low by the standards of 1880, as indeed were most things in the early 1890s. But at the end of the century Joseph Duveen bought back the garniture at

[23] Redford, Vol. I, page 307. [24] Pennell, Vol. I, page 216.

£2,200 and resold it to Sir William Bennett for £4,200. In 1905 it was said to have cost Gaspard Farren of South Africa £10,000. Magnificent and almost miraculous in its kind, but of a kind so little coveted today, this garniture in 1963 might fail to reach even the depressed auction price of 1894.[25]

It will be noticed that the birth of a new century created another tremendous upturn in Chinese porcelain prices. A second looting in 1900 by an allied punitive expedition to Peking, this time the Winter Palace, or Forbidden City, certainly played a part. It may have influenced Pierpont Morgan in buying the tedious, undiscriminating Garland Collection from Duveen, and this transaction in turn affected a market that had been given new life through the deaths of former collectors. At James Orrock's decease sale in 1904 a hawthorn ginger-jar made £1,312 10s, but this was a mere curtain-raiser to the sale in the following year of the Louis Huth Collection. The famous 18in hawthorn jar, which looked very like any other ginger-jar except for its unearthly blue, and which had been bought in Bristol in the 1860s for 12s 6d and by its late owner in the 1880s for £25, was sold to Mr Robert Partridge for £5,900. It was said that the jar remained with the firm for several years and was finally sold at a loss to Lord Astor.

The blue-and-white fever did not end with the deaths of Orrock, Garland, Huth, and Salting. In 1907 a very ordinary pair of blue haw-thorns made £1,260 at Christie's, but the American millionaire market had shed some of its English aestheticism. It was now more interested in enamelled wares of the *famille noire* and *famille jaune*. Blue-and-white may have shared some of the reflected glory—for instance, among the Pierpont Morgan items from the Garland Collection which Duveen sold to Widener, Frick, and Rockefeller in 1915–16 for nearly £700,000. It may safely be assumed that valuations fully as high as the £6,000 of the Huth jar were put on some of this blue-and-white, but in 1914–15 the sum of £6,000 was something quite modest compared with the prices that were paid for *famille noire*, the highest porcelain prices in all history.

A faint echo of these extraordinary sales was heard at the Stotesbury sale in New York in 1958, when a wonderful blue hawthorn long-necked bottle, almost the double of Salting's bottle in the Victoria and Albert Museum, was sold for £607. In 1958 a whole generation must have passed since a blue hawthorn had achieved the price of £600, but the sale paid tribute to the past. It was believed that Stotesbury had paid

[25] James Duveen, *Secrets of an Art Dealer*, 1937, page 49.

Henry Duveen as much as £10,000 for this bottle towards the beginning of the First World War.

But all this was a swan-song. Even in 1914 the right *décor* for blue-and-white was already receding. The savage austerity of the post-war domestic interior arrived quickest of all in America. In 1925 two 10-inch blue hawthorn jars and covers with all the right points could still make £693 at Christie's. In 1935 a much better matched pair cost £650 in New York—and thereafter condemnation *in absentia*.

We come to the famous *famille noire* porcelain, which, though it was technically a much more laborious product than the single-fired blue-and-white, was for a long time actually cheaper. Since these objects have not been very familiar to sale-visitors in the post-war period, it is best to explain that *famille noire* porcelain exhibits the same range of enamels as *famille verte*, except that the background is not white, but black, applied either over the white glaze or directly on the biscuit. The natural dullness of the black enamel is overcome by superposing a greenish glaze, and the general effect is that of a piece of handsome, glossy lacquer.

In the case of *famille noire*, the cult for which was almost as odd as the cult for the contemporary K'ang Hsi blue-and-white, we do not even know how the fashion began. The black background was not a great rarity. It was much more common than the yellow and the light green backgrounds. The style of painting, moreover, was much coarser than that of the best of the considerably cheaper *famille verte* on a white ground. The subjects, too, were severely limited. In most cases it was a standard combination of prunus, peony and chrysanthemum, decidedly overcrowded. But there were also the "black hawthorns" which were both rarer and invariably the highest priced. It will be admitted by all but fanatics that a big, well-designed trumpet vase with only the white blossoms and a little tinting against the black looks astonishingly beautiful at the right distance. Whether this gives the black hawthorns a title to being far and away the most expensive porcelain that has ever been sold is another matter.

Moderately high auction prices for *famille noire* were first paid at the great Hamilton Palace sale of 1882, where a pair of 17½in *potiche* jars and covers made 400 guineas, but that was only a fraction of the price paid for two mandarin vases. The examples of *famille noire* which had been sold previously at the Marryatt (1867) and Paul Morren (1879) sales had been quite cheap. In the 1880s the *famille noire* market was dominated by Salting and Garland, but eventually the Americans acquired the lion's share. The cellars of the Metropolitan Museum are

said to bulge with *famille noire*, whereas George Salting's Bequest to the Victoria and Albert Museum ensures that his considerable portion remains permanently on view. There is no better place to study these fallen favourites.

The prices were run up against Salting, not only in the USA, but possibly in China too, though, like K'ang Hsi blue-and-white, *famille noire* had not been thought worth the notice of the Chinese textbooks. According to a tradition which I heard in Peking a generation ago, *famille noire* porcelain had been much sought after by Tzu Chi, the Empress Dowager who virtually ruled China between the 1860s and the early 1900s. Black was her natal colour, and the palace eunuchs were commissioned to buy up all that they could lay their hands on. The supply was short, so *famille verte* pieces of the large standard shapes were blacked in, and later *famille noire* was deliberately forged.

On the other hand, there was certainly some genuine black-ground porcelain in Europe which had left China in the early eighteenth century, since in 1751 the painter Boucher bought from Lazare Duvaux a precisely described *potiche* and cover for £4 17s (see page 35). In the Princessehof at Leewarden there is a good collection of *famille noire* coffee cups and saucers which the late Dr Nanne Ottema bought at the end of the last century from the cupboards of the neighbouring Frisian farmers. It was the largest pieces which naturally tempted the forger, and it was believed that some of the best copying was not done in China at all. Two pedestal-shaped vases in the Burleigh House sale of 1888 were said to have fetched a price so moderate as £341 15s only because the story had got round that they were the work of Samson of Paris. But Joseph Duveen continued to believe in the vases and he was said to have offered £20,000 for them in the early years of this century.[26] Visitors to the Rijksmuseum in Amsterdam can form their own opinion.

The growing number of forgeries and semi-forgeries contributed to the by no means precipitate fall of the *famille noire* market in the 1920s. In 1923 Emil Hannover noticed that it was possible to plane down a sound blue-and-white pedestal vase to the biscuit and start the firing of colours afresh.[27] Less easy to detect and possibly undetectable are the genuine *famille verte* vases, to which the black has been added. Perhaps even the Salting Bequest is not exempt from these semi-forgeries.

In the 1880s Salting was probably able to obtain his finest *famille noire* vases for not more than £300 each, though Garland in America was

[26] James Duveen, *The House of Duveen*, page 80.
[27] Emil Hannover, *Pottery and Porcelain*, 1925, Vol. II, page 170.

prepared to pay far more. He was said to have spent £100,000 in ten years on his Chinese porcelain. It was Garland who gave the earliest recorded four-figure price for *famille noire* that I have been able to find. For, according to James Duveen, it was in 1891 that Salting let his famous red hawthorn vase go in exchange for a fifteenth-century Italian bronze. The vase was then sold to Joseph Duveen by Murray Marks for £1,500 and it was passed on to Garland for considerably more. We shall pursue its further adventures later.[28]

By the year 1894 Joseph Duveen, Snr, was prepared to give £5,000 apiece for the two Burleigh House vases, which had passed as forgeries in 1888. Still higher prices must have been embodied in the £200,000 which Pierpont Morgan was reputed to have paid in 1902 for the entire Garland Collection. The impact of this transaction was such that in 1905 a *famille noire* jar with a smashed neck and no cover was sold in Paris for more than £2,000, while Duveen raised his offer for the Burleigh House vases to £20,000. In 1912 a *famille noire* pedestal vase, exhibited in the plushy *décor* and hothouse heat of the Plaza Hotel, New York, was sold by the meteoric rival of the Duveens, Edgar Gorer, for a price that *The American Art News* reported as £12,400. Another pedestal vase, but *famille jaune*, which was generally cheaper than *famille noire*, was bought by Duveen at the Taylor sale at Christie's for 7,000 guineas (see page 240).

These price-levels for the porcelain of one single overrated and over-productive period had been created by J. Pierpont Morgan. But in 1914 Morgan was dead, and many of his possessions, which had been intended for the Metropolitan Museum, were most unexpectedly on the open market, including his porcelain. It was a monopoly collection, made with all the meteoric conservatism of high finance according to a taste which was doubtless considered as firmly based as a rock, but which had been nothing more than a fad forty or fifty years ago, when it was new. By all the normal rules, this part of the Pierpont Morgan Collection was due for a drastic fall. But there were no normal rules, because three multi-millionaires who had failed to break Morgan's monopoly wanted the porcelain. And the porcelain had fallen into the hands of a single man, Henry Duveen, who spent £2,000,000 on the Morgan Collection. Eventually Morgan's porcelain, including all the Garland items, was bought by J. D. Rockefeller, Henry Clay Frick, and P. A. B. Widener. The transaction was not completed till 1916. If we accept Mrs Saarinnen's figures,[29] the three shares totalled 3,350,000

[28] *House of Duveen*, page 94.
[29] Aline Saarinnen, *The Proud Possessors*, New York, 1958, pages 111, 345.

dollars, or something like £690,000 gold standard. One may compare this wholly fantastic price with the £120,000 (forty per cent devalued) which the British Government failed to raise even with the aid of a heavy public subscription in 1935-8 for the incomparably more interesting and more artistic Eumorfopoulos collection. One may also translate £690,000 gold into today's inflated currency, which means more than four millions and at the same time reflect that all this was spent on late and semi-mass-produced Chinese art, including many sets of identical objects, among which not even the most brilliant specimens would be found very exciting today. It should be added that the dearest porcelain in all collecting history was sold when three-quarters of the world were at war and when the American market had no international competition to sustain it—and when, in any case, international taste was already two moves ahead of what might have been the latest thing in the days of the greenery-yallery Grosvenor Gallery, but was now merely Middle Western.

Some of Duveen's valuations for outstanding pieces in this transaction have survived. When multiplied by six, they reduce our £2,000 Chelsea scent-bottles and 5,000-guinea Nymphenburg dollies to something less than life-size. Firstly, that red hawthorn vase which had once been Salting's and is now the Metropolitan's cost P. A. B. Widener a reputed £30,000 (150,000 dollars). Two *famille verte* vases, which had been sold to Salting in 1888 for only £600, were bought back by the Duveens for £15,000. A *rose verte* figure of the Goddess Kuan Yin, no less than 43in high and badly damaged, had been sold by Henry Duveen to Garland as far back as 1888. This too was valued at £30,000. Then there is a very muddled turquoise-and-yellow vase, with dragons, in the Metropolitan Museum, for which Widener had to pay over £20,000.[30]

It must be added that those who were excluded from this feast were asked just as much for *famille noire* and *famille jaune* outside it. In 1912 Edgar Gorer paid £200,000 for the collection of Reginald Bennett of Thornby Hall, which he placed on exhibition in Bond Street—400 items which, if the catalogue of the exhibition means anything, must have been of devastating monotony. Shortly afterwards the collection was bought by Lord Leverhulme for £275,000, but after a complicated lawsuit the sale lapsed, and Gorer tried to get rid of the collection piecemeal in America.

Interest now attaches itself to the last item of all in Gorer's Bennett

[30] The figures from James Duveen, *The House of Duveen*, and from *American Art News*, 1914-15.

catalogue of 1913, a pair of seated figures of the Buddhist deity Vajrapani, 32in high in a sort of basically *famille noire* style. In 1913 you did not go all out for a jackpot by cataloguing learned comparisons and cross-references. *Ipse dixit* was quite enough:

> These figures are admittedly the greatest examples of Chinese ceramic art the world has ever seen and they have been put by a great art connoisseur on the same plane of merit in ceramics, as the celebrated Venus de Milo in statuary.

Allegedly the figures had been made in the Ming period (when there was no *famille noire*), but the illustration, provided by James Duveen, amply supports his opinion that the figures displayed a chronological jumble of styles and were therefore modern. It was, nevertheless, put around that Gorer had refused £30,000 from Pierpont Morgan himself for the ceramic equivalent of the *Venus de Milo*. In 1915, at the moment of Gorer's death on the *Lusitania*, the two figures were on offer in the USA at £40,000. The same price, it was said, had also been asked by Gorer for a single yellow-ground vase, but the sale was challenged as a result of one of those adverse comments which were to play such a part in the life of the younger Joseph Duveen.[31]

With a second lawsuit on his hands, Gorer met his death, pursued, it would appear, by a singular malignant destiny. At the same time there was something symbolical in the manner of his death, since the torpedoing of the *Lusitania* was destined to bring the whole world into the war and in the end to destroy three empires. Of course, it did not destroy the millionaire empires, but somehow millionaire taste emerged with a new look. Henceforward a hostess, who changed her walls, ceiling, carpets, furniture, and curtains to celadon green in order to match two Ming dishes, would have to hide even the telephone directory.

3. *The Discovery of Japan*

While Chinese art underwent what was only a reinvestigation in the days of Stanislas Julien and Jacquemart, Japanese art was treated as a completely new discovery. The range of Japanese products which reached Europe in the eighteenth century had been of so limited a kind and the Japanese themselves had isolated themselves so completely from foreign contacts that it had not been possible to create much of a Japanese mystique. Furthermore, the distinction between Japanese and Chinese

[31] James Duveen, *Secrets of an Art Dealer*, page 262.

art had been extremely vague. It was not even thought worth while in many eighteenth-century sale catalogues to attempt to draw a distinction at all, and porcelain was often sold simply as *porcelaine des Indes*. The expression *nouvelle porcelaine de Chine* and *seconde qualité Japon* were often used to describe the same objects, while typically Japanese lacquer tended to be called Chinese if it displayed coloured figures. Even so, eighteenth-century attributions were sometimes more accurate and intelligent than those of Jacquemart and Le Blant in 1862, who babbled of Persian, Siamese, and even Indian porcelain.

The discovery of romantic Japan by literary tourists began some years after 1868 and the restoration of Imperial power, but the craving for Japanese objects started immediately after the signing of the commercial treaty of 1854. So many things began now to come out of Japan that were completely novel, particularly the colour prints and the small personal objects, the *inru* and *netsuke* and sword furniture, that the Japanese came to be admired in Europe in a manner altogether different from the cult of *chinoiserie*. Even in orthodox classical circles it was conceded that the Japanese resembled the ancient Greeks in their love of myth, drama, and the fine arts.[32] But it was the broad-minded and the ultra-discerning who had led the way, and for them, as usual, posterity has reserved her most back-handed blows.

Let us take a look at Edmond de Goncourt in January 1875,[33] so sensitive, so fastidious, and so almighty smart. The sage has before his eyes a newly-imported bronze duck, looking, he believes, extraordinarily like some of the excavated bronzes in the Vatican Museum, but it has cost him £5, whereas a Roman bronze would have cost him £400. Then his eyes turn to an ivory monkey, dressed up in warrior's armour —a Cellini jewel! "Just imagine," he cries, "what it would have cost if Cellini had signed it!" And, after all, who knows if the artist who signed that netsuke was not just as famous *là-bas* as Cellini is with us, though at present the value of his signature in France is twenty francs."

I suppose that one should not be too surprised that Benvenuto Cellini, who for a century past had been credited with the least callipygous of German beer-mugs, should have been thought capable of perpetrating a netsuke. But the invocation of this most magical of names was highly significant. It explains why in the year 1875 the influence of Japan on the applied arts of the West was already far more extensive and far

[32] For instance, H. B. Walters in the *Art of the Greeks*, 1906: "Of the Greek, more than of any other people, except perhaps the Japanese, it may be said: *nihil quod tetigit, non ornavit.*"

[33] Edmond and Jules Goncourt *Journal des Goncourts, Mémoires de la Vie littéraire*, Vol. V, page 133.

more pernicious than the *chinoiserie* of the eighteenth century had ever been. For now at last the subconscious flight from the ancient Greek canons that lay behind all the excesses of nineteenth-century taste had found the perfect refuge.

Of course, not all that came out of Japan in the first quarter-century of emancipation was evil, and not all its influence was pernicious. On the credit side of the account, it has to be conceded that the Japanese colour print had a fresh and invigorating impact on European graphic art. Borrowing from this source did not harm artists who already possessed the power to select, like Whistler, Manet, Van Gogh, and Toulouse-Lautrec. But on those whose gift of selection was weak or non-existent—namely, the designers of furniture, porcelain, and small objects—Japanese influence was deadly—*et vice versa*. The Japanese had achieved mass production even before they possessed the machines. In 1859, when the Samurai and the feudal system still ruled Japan, long, long before the first goggle-eyed tourists wrote about the land of cherry blossom, Christie's announced the sale of 10,000 lacquer trays, received in a single shipment. They were sold in lots of twelve at about a guinea a lot. A warning signal, indeed. Yet in the late 1860s, when the true economic revival of Japan began, it was believed throughout Europe that the mass-produced "brocaded Satsuma" pottery represented the best in Japanese taste and that the monstrous ivory carvings, bronzes, and cloisonné objects, which poured out of the country, were the things that the art-loving Japanese kept in their own homes. In *Japanese Pottery and Porcelain*, 1875, Messrs G. Audsley and J. Bowes spread the legend of Satsuma to the accompaniment of large and costly colour prints. And yet these authors knew Japan and must have been aware of the austerity of even the richest Japanese home and its innate sense of unostentatious arrangement.

The outlook of informed taste towards Japanese art remained till the end of the century thoroughly obscured and thoroughly inconsistent. It would be very foolish to describe Edmond de Goncourt as altogether insensitive or altogether pretentious. Like Whistler, and many others of his contemporaries, he could at times recognize the refined sense of balance and economy of expression in quite ordinary objects from Japan. The trouble with these intellectual devotees was that they invariably lost their heads when the Japanese craftsmen set out seriously to give value for money. At the Japanese Pavilion of the Exposition Universelle of 1878, de Goncourt's choice went decidedly "to the fire-screen with the silver heron and the folding screen with all those flowers in lacquer, in hard stones, ivory and porcelain. For me they are

the two finest objects of furniture that the industrial art of any nation has produced since the beginning of the world. How could Rothschild have let them go on selling that even for five minutes?"[34]

Evidently the arbiters of taste of this our nation thought the same. Three years later, two copper vases from the Japanese Pavilion of the Exhibition, over two feet high, with realistic silver dragons in high relief, reached the Victoria and Albert Museum at £700. In 1883 the Museum gave no less than £1,586 7s 2d for a modern bronze incense-burner, supported on a realistic tree-root, 7½ft high; all this in a year when the Trustees had very little money to spend, and when £1,000 could sometimes buy more than £100,000 can buy today.

The few critical voices were singularly ignored. As early as 1867 Philippe Burty, who became deeply infected with the Japanese fever, but without losing his sanity, had some harsh things to say on the consignment of porcelain and pottery which had been sent to Paris by the Daimyo of Hizen:[35]

> To judge from this consignment of the porcelain of Hizen and from some examples of Satsuma pottery, quite deliberately painted on a ground fissured rather than crackled, but in the shape of shoe-blacking jars, one may wonder whether thanks to European influence, Japan is not in full decadence.

In 1880, when the Satsuma vogue was in all its fury, Sir Augustus Wollaston Franks, Keeper of Antiquities in the British Museum, wrote in the plainest of terms that "most of the specimens sold as old Satsuma have been made at Ota and Awata in recent times". Franks's liberal and intelligent contribution to the fight against all this vulgarity and miscomprehension was to enlist the help of the Japanese themselves. The Japanese Government had sent a collection of ceramics, uninfluenced by foreign taste, to the Philadelphia Exhibition of 1878. Franks persuaded the Victoria and Albert Museum to buy the collection. He himself edited the catalogue, most of which was written for him by two Japanese scholars named Shioda and Ninagawa. But the scholars and their interpreters let Franks down very badly. Both the selection of the objects and the attributions were inadequate and misleading, despite the practical appearance of the work.[36] The two Japanese had relied on book learning of an indiscriminate quality, and, moreover, they appeared to have very little feeling for the actual objects. But

[34] de Goncourt, Vol. VI, page 20. [35] *Chronique des Arts*, December 1867.
[36] South Kensington Museum Handbooks of Art: *Japanese Pottery*, a Native Report, edited by A. W. Franks, 1880.

these matters, which have become a commonplace in Japanese ceramic studies today, were nothing new even in 1880. As early as 1864 it had been noticed that the Japanese trade delegation which visited the Museum at Sèvres were quite incapable of distinguishing Chinese porcelain from Japanese, and that their greatest admiration was reserved for the latest Sèvres models, such as they were in 1864.

It is forgotten today how completely the cult of Japan bedevilled native English attempts to restore sobriety and balance to the industrial arts. Very soon, no doubt, we shall have a lot of veneration for the *art nouveau* of the 1880s and the 1890s, which owed so much to Japan. But in the 1870s the Japanese cult most certainly killed the "Queen Anne" movement, a most salutary catharsis which had begun tentatively to restore the values of the English eighteenth century (see page 153). In some roundabout way, things that had been intended originally to be far otherwise became Orientalized. Empire-building novelties, such as Bombay blackwood furniture and Egyptian inlaid fretwork tables, played their part too. In this way Messrs Druce's "Early English Cabinet" of 1880 (£18 10s) became about as early English as the throne of the great Mogul, with its fussy little shelves and railings and its amorphous mirrors. But nothing could be more typical of the style of the 1880s.

For a whole generation a self-styled Japanese drawing-room was fashionable, but even if you were unfashionable you could not avoid the Japanese-inspired knick-knacks. All this had to end somewhere, but not till the 1890s were the signs manifest that the Japanese cult was on the way out. Perhaps the success of the Gilbert and Sullivan opera, *The Mikado*, of 1885 played a part, since each successive performance made the alleged feudal splendours of Japan more stale and more ridiculous.

Strange to say, the highest prices for one exceedingly important branch of Japanese art were paid, not during this fever, but, if one considers the real value of money, in the eighteenth century. Lacquer was then the only form of Japanese art, apart from porcelain, which was known in the West and so highly esteemed that, as we have already seen, the Van Diemen casket cost £287 in 1777. In the absence of ivory, metal-work, prints, and paintings, the popular European image of Japan was obtained through lacquer alone. The identification of the country with lacquer was so thorough that the word "Japan" was used both in France and England to denote all lacquer, whether Chinese, Japanese, or European, just as the word "China" came to denote porcelain of all kinds. Little drawer-cabinets and writing-boxes, as light

as a feather, often cost from £40 to £80. Naturally, the frail, glossy surfaces that had been the delight of kings and royal mistresses shared abundantly in the later prejudice against the *ancien régime*. But at the time of the reopening of the Japanese ports, this prejudice was disappearing, because there was again a demand for furniture with Japanese lacquer panels. At the Duchesse de Montebello's sale in Paris in 1857, a little drawer-cabinet could make as much as £82. Two brand new drawer-cabinets, imported from Japan in 1861, cost £70 each, while in 1868 a coffer, looted in the Japanese Civil War and considered to be of the seventeenth century, but a much smaller affair than the Van Diemen casket, cost the Victoria and Albert Museum £140.

But the revival of Japanese lacquer, though impressive, fell very far short of mid-Victorian standards of price-appreciation. Somehow those 10,000 lacquer trays which had met the Western demand so promptly in 1859 cast their shadow. The highest eighteenth-century prices for lacquer were only surpassed at the Hamilton Palace sale of 1882, when Beckford's treasures were finally dispersed, and these are still probably the highest prices for Japanese lacquer that have ever been paid at a European sale. The Mazarin and Napoleon coffers made £682 10s and £735, but the famous Van Diemen marriage casket, which was to enter the Victoria and Albert Museum in 1916, made only £315 (see page 26).

If we turn to ceramics, we find the same situation. The Japanese furore subsided too soon for any Satsuma or Imari piece to share the astonishing fortunes of the blue hawthorns and the *famille noire* vases. Moreover, the mystique of the Japanese ceramic factories was too confused and complicated to tempt true millionaire competition, except in Japan itself. It is indeed a rather odd thing to record that in 1882, at the very height of the craze for brocaded Satsuma and red Kaga, the European market should have been dominated by the extremely standardized Japanese export porcelain of the mid-eighteenth century.

Known in these days as *seconde qualité de Japon*, this porcelain was now called Imari, after its original port of shipment. In all its monotonous combinations of brick-red and blackish-blue on a very grey paste, it had been recopied on a large scale as soon as the ports were reopened. It is none too easy to distinguish this nineteenth-century recopying. Moreover, during the first half of the present century the export Imari ware remained so unpopular that the question of chronology scarcely bothered anyone till recent years. Considering that these coarse and top-heavy garnitures must at one time have graced every

squire's drawing-room in the country, the late Victorian prices seem truly astonishing. K'ang Hsi blue-and-white in the 1860s was at its best almost a novelty, little known outside Holland, but everyone must have been familiar with Imari.

Bad taste in England began earlier than is supposed. The large Imari garnitures that could barely make three guineas a vase in late eighteenth-century London, could make as much as fifteen guineas a vase in 1807 and the ensuing years. Beckford, who owned much of it, was well aware of the inferiority of export Imari to the beautiful *première qualité de Japon*, which we now call Kakiemon. In 1817 he wrote to his friend, Franchi:[37]

> Genuine beautiful Japanese porcelain is hardly ever seen; what is called Japan is an inferior variety, heavy, coarse and much more like faience. The Japanese import much of their ware from China, their own products being horribly dear; they have very few makes of the best quality and it takes a long time to manufacture them.

What did Beckford mean by "horribly dear"? At the sale of his former possessions at Fonthill six years later, Imari garnitures of five made from 15 to 40 guineas the set, and these prices were far and away the dearest of Beckford's unmounted Oriental porcelain. However, by 1854, when the Japanese ports were reopened, the value of Imari had fallen considerably, and it was some years before it responded to the new craze. For instance, at the John Graham sale of 1857 two of Beckford's tall beakers from Fonthill made only £9 15s, whereas in 1860 Murray Marks paid as much as £119 10s for a pair of 27in jars and covers. The prices at the Hamilton Palace sale of 1882 were truly extraordinary. Pairs of covered jars, such as those which Murray Marks had bought in 1860, fetched from £315 to £420. At the Burleigh House sale of 1888 the Imari ware was as dear as the *famille noire* porcelain, a single 24in vase making £231. Today this vase might not be worth more than £50.

In the general discredit of Japanese ceramics in the early twentieth century, the fall in the value of these garnitures was smaller than one would expect. In Paris in 1909 an unmounted garniture of five Imari jars and beakers achieved what is probably still a record price—namely, £780. The German prices at the Johanneum sale at Dresden in 1920 need not be taken too seriously. If a pair of Imari jars could attain the price of £375, it was because in Germany the flight from falling currency had already begun and because the Germans had no

[37] Boyd Alexander, *Life at Fonthill*, page 285.

modern tradition of this sort of collecting. Garnitures of five could probably have been bought for £100 or less in 1920. Not so many years ago, a standard Imari jar and cover, over 2ft high, could have been bought almost anywhere for £10 or even £5.

One reason for a boom in the original export Imari porcelain of the eighteenth century in the 1880s and 1890s may have been the rarity of the ware in Japan, where only a few factory models had survived. In 1880 Franks noticed that "old Imari" was "seldom now received from Japan", where sets of vases would be useless in a Japanese house. Nevertheless, a single oviform vase with a repaired cover, nearly 3ft high, was included in the Philadelphia Exhibition consignment in 1878, and Franks noticed that it had been priced by the Japanese at £80 13s.[38] Since those days a certain amount of old export Imari may have returned to Japan, where it certainly costs more at present than in Europe.

On the other hand, the highest prices in Japan have always been paid for the deliberately primitive and often unsymmetrical earthenware, which is associated with the artist potters. And in this class the highest prices of all are given for pieces which have been sanctified by passing through the hands of famous masters of the Tea Ceremony. Prices running into thousands of pounds for pieces that mean next to nothing in the eyes of the Western world must be regarded as something outside the "economics of taste" in the sense of this book. In Paris a moderate cult for the work of the artist-potters does, however, date back to the Hayashi sales of 1903, but it has never been an exciting market.

Before leaving the confused subject of Japanese ceramics, a final word must be said concerning the finest-quality Japanese porcelain of the late seventeenth and early eighteenth centuries, the wares of Kutani and the Kakiemon wares of Arita. The fate of the latter, the most truly aesthetic of all porcelains, has been unique. Probably no other wares have suffered such oblivion and neglect as the porcelain made by the Sakaida or Kakiemon family. In the eighteenth-century Paris sale catalogues it can be recognized more clearly than any other ware. At the Angran de Fonspertuis sale of 1748 four octagonal long-necked bottles in mounts made £24, two hexagonal urns and covers with paintings of cranes £19 12s (*article très recherché en Hollande*), while two more hexagonal urns in mounts made £48. At the Randon de Boisset sale of 1777 two oviform jars and covers, 2ft high, painted with a well-known scene of two figures under an umbrella, made £140, while a similar pair, handsomely mounted, made £244. Here

[38] W. Franks, *Japanese pottery, a Native report.*

we have three of the most characteristic types of Kakiemon porcelain, *première qualité de Japon*, or *ancien Japon de la meilleure sorte*, as it was then called. And the prices, as will be seen by referring to Chapter Two, were quite outstandingly high for the period.

This was not surprising, since the peculiarly white and translucent paste, which was the unique production of this small Japanese factory, had been the envy of the earliest porcelain-makers of Europe. In the 1720s and 1730s fairly close adaptations of Kakiemon types were turned out at Meissen and Chantilly, while quite slavish copies were made at Chelsea in the 1750s. And yet in the next century the very existence of this ware was forgotten. In 1862 Jacquemart and le Blant decided that, since this porcelain was so unlike export Imari, it could not be Japanese. Relying on the statements of Japanese writers that the first porcelain-makers in Japan had been Koreans, they attributed the work to Korea. In 1881, however, du Sartel noticed how accurately Jolliot's description of *première qualité de Japon* had tallied in 1777 with existing specimens of this ware.[39] Franks had already pointed out that there was no evidence whatever concerning Korea. He himself built up a most discriminating collection of Kakiemon which has made the British Museum the best of all places of study, and yet apparently the two Japanese authors of Franks's "native report" of 1880 had never heard of the name of Kakiemon. Franks still called the ware "Old Japan".

A fairly accurate identification of Kakiemon ware and its history appeared in W. G. Gulland's second volume in 1900,[40] and apparently it was derived from Franks. But the general mystification continued. At the Taylor sale of 1912 two excellent bottles were labelled simply as Hizen, after the province. Till very recent years a country dealer would be likely to throw his Kakiemon into the waste-paper basket when persuaded that it was not Chelsea of the red anchor period. Serious recognition of the importance of Kakiemon began only with the £850 paid for the figures of a stag and doe at the Burleigh House sale of 1959 and the £1,155 paid for a more perfect pair a year later. But by this time, since the museums had become well stocked-up when the commodity was cheap, good Kakiemon had almost disappeared from the market.

If one tries to sum up the Japanese vogue between the 1860s and the early 1900s, it is not the prices of the objects in the eighteenth-century tradition, like export Imari and lacquer boxes, that are the most

[39] Du Sartel, *La Porcelaine de la Chine*, 1881, page 18.
[40] W. G. Gulland, *Chinese Porcelain*, Vol. II, page 378.

interesting, though these prices were certainly the highest. Rather it is the things which were then new discoveries, to which fashionable writers like Edmond de Goncourt attached an exaggerated importance. Inru, Netsuke, and Tsuba have long settled down to a quiet specialist cult which, though it is both cheaper and more aesthetic than stamp-collecting, does not seem to appeal very highly to artistic natures. There is even something rather military about this cult. But how different was the whole aura in 1875, when the possessions of A. B. Mitford, author of *Tales of Old Japan*, came up at Christie's. The story of each netsuke was told in full in the catalogue, which was worth reading for the sake of *Daruma and the Wasp* alone. And a single netsuke of quails and millet by Okitomo made nineteen gold guineas, or 120 of our latest thing in pounds.

The great art of the classical ages of Japan avoided the European market altogether, the portraits on silk from the monasteries, some of them as old as the thirteenth century, the noble mediaeval sculpture, the great painted screens from the feudal castles, the scroll paintings of the masters. In the early throes of the Japanese civil war and revolution, there had been a disposition to sell and even to destroy the relics of feudalism and national isolation. It is astonishing how closely the pattern of the French Revolution was followed. It was Europeans like Hearn and Fenelosa who persuaded the Japanese to protect their own heritage, which they did the more readily when it became evident how much could be made from the sale of rubbish. Then at the end of the century the Japanese Government became aware that their indiscriminate exports had debased the reputation of their national culture. At the 1900 Paris Exhibition the Japanese Government refrained from unloading more hoards of ivory dexterities and Satsuma pottery. Furthermore, the Government needed foreign currency. In 1902 and 1903 the exhibits were put into the Salle Drouot by Hayashi, the Paris Japanese dealer, who had arranged the Japanese Pavilion. The description of the lots seems most enticing today and the prices very moderate, with fine mediaeval statues at £300 and less. Things of this sort are nowadays negotiated privately with museums at very high prices, whereas the saleroom remains a repository of netsuke, inru, and other small curios of the usual kind. It seems a stale end to the high frenzy that once Orientalized every seaside boarding-house.

The Apogee and Decline of Ritzy Taste
1900–29

1. America and the Objet d'Art Market — 2. The Grand Climacteric, 1910–18 — 3. The False Boom, 1919–29

1. America and the Objet d'Art Market

The period 1910–14 may be compared with the period 1878–85, for these are the two high-tide marks of the objets d'art market. Some of the highest prices which were paid in gold in 1878–85 were never repeated again, but there were certain things, such as tapestries, eighteenth-century sculpture, and silver, which were then only at the beginning of their long advance. Consequently, the high prices of 1910–14 were paid for a much wider range of objects. Furthermore, it was a general advance in prices, and not merely the advance of a particular fashion. There was next to nothing in the collector's repertory of this period that did not have its share in the prosperity of the times.

Today the first years of the century may seem more interesting on account of the things which were new to the market and which could not therefore compete with Sèvres garnitures, royal eighteenth-century furniture, Boucher tapestries, Limoges enamels, *famille noire* vases, and Augsburg silver. The more scholarly or the more adventurous collectors were already buying T'ang figures and Sung pottery, Islamic miniatures and excavated faience, Buddhist sculpture, prehistoric Chinese bronzes, and even African fetishes. The hunt for the *early* had begun. Following the lead of Wilhelm Bode, the most advanced of the maiolica collectors now sought the fifteenth century

rather than the sixteenth; some of the porcelain collectors were on the lookout for rare incunabula. Yet, in spite of all that, the highest prices of all were always paid for something that had been collected for at least forty years. Elaboration and intricacy were as much sought after in Edwardian times as they had been in the middle of the reign of Queen Victoria. The aesthetics of the High Renaissance were still the dearest. If sparse and Spartan taste had its place, it was at relatively sparse and Spartan prices. While one is lost in wonder today at the prices which were paid for Limoges enamels, French drawing-room sculpture, or *famille noire* vases, one is equally amazed at the very small sums that were needed to form a collection of plain Queen Anne silver or the rarer European porcelain figures.

In one respect, the earlier seven-year boom of 1878–85 had been different. Except in the case of modern French painting and of certain tapestries, American competition had played only a small part. The saleroom combats were waged mainly between the older families of finance, like the Rothschilds, and those few European industrialists who had become art-conscious. It would be idle to pretend that in 1910–14 these powerful groups no longer went for the dearest things, but the levels had been created for them by competition between American collectors, who had become at once more formidable in their resources and less simple-minded in their tastes than they had been thirty years earlier. So strong was the American support of the art market in 1910–14 that it virtually cushioned it from the world cataclysm which followed.

The First World War had a much less lasting effect on the art market than the European recession which had loomed on the horizon in 1885, the year of the Blenheim Palace sales. After 1885 it can be said that wealth derived from land no longer played any significant part in the saleroom. In England the nobility were henceforward seldom to appear in the market as buyers, but incessantly as sellers. The flow of old master paintings into America became a concealed form of payment for the cheap American wheat, which had driven English land out of use without as yet enriching home industry (see Vol. I, page 176). These economic difficulties of the 1880s have solved themselves over the years, only to be succeeded by others, but the changed status of the big landowner has proved to be permanent in all countries, save those where he has been abolished altogether.

In Russia the First World War abolished the ownership of private capital. In Germany and Central Europe it immobilized it for many years to come. Yet, because it had become so much an appendage of

the American economic system, the European art market was very little affected by these calamities. Thus, the First World War created no slump, but only a drop in the volume of business. The first general fall in art prices did not begin and could not begin till 1929, when the crisis of capital occurred in the USA itself.

In the second half of our century surplus spending power abroad is something that seems to shift from one country to another overnight. Today it may be Italy, tomorrow Japan. The legend of American omnipotence, nevertheless, survives, though nowadays America is no longer the unique goal that it was for the dearest treasures of the sale-room. One reason for the persistence of the legend is its great age. Few may realize that as long ago as the 1870s the Americans had fantastically outbid all the capitalists of Europe for the fashionable French painting of the day—just as they would like to do now for another sort of painting.

How was it possible, it may be asked, for members of a pioneering and painfully provincial society to swallow so much Paris *salon* vulgarity in spite of their own Puritanism, and to spend more than the richest Parisians? A reasonable question, but the answer is "Why not?" It was precisely because of the prolonged backwoods character of American life that such expenditure was possible. In 1865, when the Civil War ended, there were very few works of art in America apart from the prim family portraits and the surprisingly good native furniture, some of it barely a generation old. One may contrast this situation with the revolutionary Napoleonic period, when England had played the same rôle in absorbing the art of the continent of Europe. England's advantage had been the relatively secure state of her private fortunes in a stormy world. Her disadvantage had been her long familiarity with collecting and the surfeit which followed a few years of unique buying opportunities. Some of our collector-speculators went bankrupt before the end of the wars (see Vol. I, pages 47, 52, 55). But had England in those days been as empty of works of art as was the USA in the late nineteenth century and as generally respectful towards the much-mocked notion of culture, the craving for more art of the past would have been stronger. The market would have gone very much higher and the break in prices would have come very much later.

In some ways, the earliest American adventures in collecting seem the most remarkable. As early as 1876, when the new prosperity from the opening up of the West was still very young, the William Tilden Blodgett Collection of paintings by living French artists could make

over £200,000 at a New York auction sale. The driving force of the bidding was A. T. Stewart, and no wonder. He had just spent £16,500 at the Vienna Exhibition on Meissonier's *1807*, one of those tailor's reconstructions of a Napoleonic battle at which the painter excelled. Besides being five times as much as anyone had ever paid for a Meissonier, it was also the second highest picture price in human history.[1] The tradition was continued by Cornelius Vanderbilt, who bought three French pictures at the Stuart sale of 1887 at £10,000 to £13,000 each. In 1890 he would have paid £30,000 for Millet's *Angélus*, but Chauchard bid even higher.

Objets d'art played little part in this sudden flow of American money. It is true that William Vanderbilt had bought a Gobelins tapestry at the San Donato sale of 1880, but, as those spellbinding folios, *Mr. Vanderbilt's House and Collection* (1884), reveal, the interior decorators had left precious little room for objets d'art at all. What there was of them was Japanese against a *décor* fluctuating between *art nouveau* and *The Last Days of Pompeii*—in fact, the early Fifth Avenue style. We have seen how, during the 1880s, Henry Duveen wooed his clients away from this kind of Trimalchian domesticity to the Louis drawing-room with its matching tapestries and fauteuils. But in the earlier 1890s the comparative collecting of objets d'art of the great periods of the past was restricted in the USA to the impressive old master paintings of Henry Marquand and the libraries of one or two scholars, like Robert Hoe, who bought mediaeval objects, illuminated manuscripts, and printed books. Then there was Benjamin Altmann, who bought rock-crystal vases and other Renaissance objects at the great Spitzer sale in 1893, but he was an immigrant with a Continental background. Isabella Stewart Gardiner should perhaps be considered the first true American to form a comparative collection of European art, embracing the earlier schools as well as the later, an activity which began no earlier than about 1892, and which was carried out with only moderate means by American standards.[2]

The American domination of the world art market in the early 1900s was the work of a single man. It cannot be doubted that James Pierpont Morgan formed the greatest single private collection comprehending all ages that there has ever been. The latest canonical history of Morgan's collecting activities, that of Francis Henry Taylor,[3] does

[1] René Brimo, *L'Evolution du Goût aux Etats-Unis*, Paris, 1938, pages 51–2.
[2] Brimo, pages 81–6.
[3] F. H. Taylor, *Pierpont Morgan as Collector and Patron*, New York, 1957, page 36.

not hesitate to accept a popular newspaper estimate of the year 1913, which put the total value of the collection at £12½ millions, gold. In spite of today's fiscal inducements, a private individual can scarcely be imagined who could spend the present-day equivalent, say 75 millions. And the whole of this amount, with the most insignificant exceptions, was spent between the years 1890 and 1913. At least four-fifths of it, and very likely more, were spent after 1900, possibly at the rate of five millions a year in modern money. If 1912 or 1913 was the *annus mirabilis* of the objets d'art market, when almost every category reached prices that cannot be equalled today, it may fairly be said that the personal whims of James Pierpont Morgan had as much to do with it as the prosperity of the times.

The strange thing is that Pierpont Morgan had been born in 1837. He was an elderly man when he began to pay any serious attention to collecting. In Edward Strahan's *Art Treasures of America* Morgan appears in the year 1886 as an amateur of second-rate modern painters, such as von Kaulbach and Gallegas. It must be admitted that in 1883 he had printed a catalogue of his library, a worthy library befitting his station, but containing none of the incredible illuminated manuscripts, early printed books, and autograph documents with which the public foundation known as the Pierpont Morgan Library has long been associated. It has been said that Morgan was only able to collect seriously after 1890, because it was then that his patrimony of £2,600,000 came to him. But in fact he had been rich enough to collect the great art of the past all his life and to collect it at a time when much of it was dirt cheap. With the £110 which the young Morgan spent in Rome in 1857 he could have bought bronze and marble of the *Quattrocento* which might have cost him £50,000 to £100,000 at the end of his life (see page 102). In fact, he spent his £110, like any other early Victorian tourist, on a mosaic paperweight, a lava inkstand, a coral necklace, a copy of a Guido Reni, and some horrible cheap replicas of the Vatican statues.[4]

The clue to Morgan's incredible collecting lies in the nature of the monstrous game of monopoly which he played on the financial stage in the last twenty years of his life. The collecting bug only really got him when he was a tycoon of tycoons, commanding the resources to summon up another Louvre or British Museum and waft it across the Atlantic at a touch of his cheque-book. Like the American nation itself, he became conscious of his real strength extremely late and, like the American nation, he made up for lost time.

[4] Taylor, facsimile diary on page 12.

In the first volume of this book, I have followed some of Morgan's expenditure on pictures, but this was a relatively small portion of the whole. If one accepts the valuation of 12½ millions in gold pounds, which *The Times* published in 1913, one must also realize that the cost to Morgan may have been very much higher. What this meant in practice can be seen in the following short selection of a few of Morgan's higher-priced purchases:

Objets d'Art

(The plus sign means that this is merely the sale room price paid by a dealer who subsequently sold the object to Pierpont Morgan.)

£

1902	Through Duveen brothers, the "Mazarin" tapestry panel, *The Adoration of God the Father, c.* 1500 (see page 4).	65,000 or 72,000
	Richard Bennett Collection, Manchester. About 100 MSS. and 600 books, mainly 15th cent.	144,000
	Garland Collection of Chinese porcelain, per Henry Duveen (see page 213). About	200,000
	The *Armada Jewel*, miniature in a locket	5,250+
	Bronze statuette of *Hercules*, attributed to Pollaiuolo. Bought through Duveen, Stephano Bardini sale	6,300+
1903	French 14th-cent. ivory retable, *La Vierge de Boubon*	3,800+
1903	Through Duveen Brothers, suite of 4 *Don Quixote* tapestries (see page 180)	80,000
	Mrs. Pemberton. Miniature attributed to Holbein	2,750+
1906	The *Ange de Lude*, a bronze weather-vane figure, 15th cent., from the roof of the Sainte-Chapelle, and a silver-gilt statuette of the 13th cent. 2 for	40,000
	Eight leaves from a 13th-cent. *Bible Moralisée*	8,000
1907	Purchases through Duveen Bros. from the Rodolphe Kann Collection. 5 *Quattrocento* sculptures, 3 Memling portraits, and a Van der Weyden Annunciation 9 for	262,500
	Morgan was said to have offered for the small marble Donatello of the Martelli family (St John the Baptist)	120,000
1908–10	The Coventry Sèvres garniture (see page 160) Valuation	15,500

£

1911	The Sevenigorodskoi enamels, 9 Byzantine 11th-cent. medallion-shaped plaques and other fragments	31,160
	The Knole late Gothic tapestry suite of 8	67,100
	Caxton's *Morte d'Arthur*, printed on vellum, from the Robert Hoe sale	8,800
1911	The Hoenschel Collection, European sculpture etc.	160,000
1912	From the Earl of Leicester. 4 Romanesque MSS. in 12th-cent. jewelled metal bindings (see page 84)	100,000
	From Taylor sale via Duveen. Italian enamelled diptych, 15th cent.	6,930+
	Two Houdon marble statuettes: *The Bought Kiss* and *The Given kiss* Valuation over	20,000
	Two 16th-cent. Brussels tapestry panels from the Dollfuss sale	12,000
	The Nine Worthies, group of 14th-cent. tapestry panels and fragments from Les Aygalades, per Duveen About	100,000
1913	The Negroli casque, an elaborate chased gilt Italian helmet, *c.* 1500, per Duveen About	20,000
1915	40 of Morgan's tapestries sold by French & Co.	515,000
1915–16	Morgan's Chinese porcelain, sold by Henry Duveen to Widener, Frick, and Rockefeller (see pages 213–4)	690,000

Pictures

(For further details, see Index to Volume I, under Morgan, J. P.)

£

1894	Constable's *White Horse on the Stour* from the Hemming sale	6,510+
	Reynold's *Mrs Delmé and Her Children* from the Delmé sale, per Wertheimer	11,150+
1898	Fragonard's 10 panels, *Roman d'Amour de la Jeunesse*, per Agnew	64,000
1900	Lawrence's *Nelly Farren* and *Miss Croker*, each believed to have cost	20,000
1901	Raphael's Colonna altarpiece, per Sedelmeyer	100,000
	Hobbema landscape, bought from Sir George Holford	25,000

£

1902	Alleged Gainsborough, *Duchess of Devonshire*	30,000
		or 35,000
1907	Frans Hals portraits of *Meinheer and Vrouw Bodolfe*.	40,000
	Believed to be Ghirlandaio, portrait of Giovanna	
	Tornabuoni, ex Rodolphe Kann, per Duveen	18,000
1909	Andrea Castagno, *Il Condottiere*, ex Oskar Hainauer,	
	per Duveen	15,000
1911	Botticelli, cassone panel from the *Life of St. Zenobius*,	
	from Abdy sale	11,550+
	Gainsborough, *The Beggar Boy and Girl*, from Lord	
	Sackville, Knole	37,200

I have included a dozen of Morgan's more outstanding purchases of
pictures, though these have already figured in Volume I. They
illustrate a very important point. Some of the pictures have subse-
quently reappeared on the market at vastly enhanced prices. In fact, in
the 1930s, when Andrew Mellon was forming his collection, these
prices looked extremely low. On the other hand, the objets d'art were
bought at prices that have never been repeated since. When these
figures are multiplied by six to meet the present degree of devaluation
of money, it will be seen at once that this is so. Would any private
individual today spend £400,000 on a tapestry panel? I have discussed
in Chapter One the reasons for this disparity—namely, the higher
traditional rating of skill which has dwindled with the growing cult of
individual genius. Morgan may have been obsessed with the import-
ance of pure craftsmanship, but the prices were not simply invented by
dealers who knew his personality. There were always competitors; at
first only Benjamin Altmann, later Henry Clay Frick and P. A. B.
Widener, and at the end J. D. Rockefeller, Jnr, and Henry Huntington.

One should also notice the character of the purchases—unadven-
turous. Morgan had given up buying minor modern Continental
paintings of the Establishment, the innocent acceptances of American
collecting in the backwoods period, but he bought none of the already
booming Manets, Degases, and Renoirs. He bought the past, but a very
orthodox past. No El Grecos, Goyas, Blakes, or even Vermeers. His
Chinese porcelain was rigorously late seventeenth- and eighteenth-
century. He bought few objects of the Asiatic Middle Ages, and those
exclusively Islamic. Morgan's taste fluctuated between that of a
Renaissance Italian merchant prince and that of an eighteenth-century
Parisian *intendant de finance*. With a very fine eye for quality, but too

impatient to be proof against fraud, he remained thoroughly conservative.

It should also be noticed that Morgan kept most of his collection in London. Probably he intended from the beginning to leave it to the American nation, though, as events turned out, this wish was only partially fulfilled. In the meantime, the collection stayed in London, so long as the ridiculous thirty per cent duty existed on the import of works of art into America. Having been increased in 1883, the duty was not repealed till 1909, but the removal of the Morgan Collection from London did not begin till 1913. The multi-millionaire may have had a premonition that this was the last year of his life. What is more certain is that Mr Lloyd George was planning a big increase in death duties.

The storing of most of the Pierpont Morgan treasures in London had an important effect on the art market. In the 1890s London had certainly not been the centre of the art-collecting world, but Morgan soon made it so. One must visualize the situation towards the year 1900, when he began seriously to buy mediaeval and Renaissance objets d'art, which were then preferably sold in Paris see (page 144). The London sales seasons had hardly ever been poorer or the art trade more querulous than it was at this time. In 1898 they complained that the Spanish-American War kept the millionaires out of the London art market. In 1900 it appeared that the Boer War had cast the same shadow. In *The Year's Art*, Mr A. C. R. Carter drew attention eloquently to those hard-hit Royal Academicians who were not collecting their 5,000-guinea commissions. In 1901, the year of the death of Queen Victoria, not a single English art sale exceeded £20,000.

On top of all this the year 1902, the year of the Coronation, came in with a roar. The English sixteenth-century silver at the Dunn Gardner sale staggered everyone. A single standing cup was run up to £4,200. At the Bardini sale a Florentine bronze statuette cost £6,300. There was the miniature of Queen Elizabeth, known as the *Armada Jewel*, at £5,250 and a Louis XV commode at £4,305. The hand of J. P. Morgan was everywhere.

The year 1903 was a landmark, because it saw the birth of the National Art Collections Fund, "with £200 in its pocket to fight the multi-millionaires of the New World". Its *raison d'être* was made evident by Christie's feat in selling more than £100,000's worth of works of art in a single afternoon, something that had not happened even at the epoch-making Hamilton Palace sale of 1882. In modern money, the sum of £105,845, which was realized by the Reginald

Vaile, E. W. Beckett collections, and "other properties", was as good as £640,000, a remarkable day's total, one would say, even in 1963, but it included Boucher's Beauvais tapestry suite, *Les Fêtes italiennes*, four panels which rivalled the Pallavicino-Grimaldi suite of 1900 (see page 180) at £23,400.

In the same year—the last but one, as it turned out, when such a thing was possible—Paris had a sale which actually surpassed the 9-million-franc Spitzer sale of 1893. But the whole tempo of art-collecting had already succumbed to Transatlantic hustle, for, while it took thirty-eight days to sell £365,000's worth in 1893, it took seven days to sell Mme Lelong's £380,000's worth ten years later. To be fair, however, Mme Lelong's lots were fewer and much juicier—none of those pages and pages of locks and keys, but four *Régence* fauteuils at nearly £7,000, Pajou's marble bust of Mme Fourcroy at £4,220, and two mutilated *famille verte* vases mounted *en rocaille* at £3,720.

1904 was the year of the Hawkins snuff-box at £6,400, a Duveen-Morgan purchase, and also of the Gabbitas biberon, a truly hideous late sixteenth-century rock-crystal vessel, shaped as a duck, which put the final crown to the Beckfordian crystal market at £16,275. And it was resold to Baron Schroeder for £20,000—or should we say £120,000 of our money. Beckford's comments would have been worth reading, but it was the final crown in every sense, because in 1910 the biberon was bought back by the vendor, Charles Wertheimer, for £10,500 and auctioned again at his death in 1912 for £3,800. In the 1930s it might not have made £1,000.

The year 1905 is best remembered by the sale of Louis Huth, the patron of Whistler and doyen of aesthetic mid-Victorian collectors. It was a triumph for what had recently been *avant-garde* taste, but a most ephemeral triumph. Neither Huth's fine Turkish faience bowls, dishes, and tankards at 500 to 600 guineas each nor his famous £5,900 Chinese blue hawthorn jar and cover (see page 180) will have caught up today with the devaluation of money. Perhaps the occasion can best be brought into focus by recalling that at Christie's six weeks later the Baring family Botticelli, *The Holy Family with Singing Angels*, was sold for only 200 guineas more than the ginger-jar.[5]

1906 was pre-eminently a year in the annals of Meissen collectors. For the Fischer Collection, which was sold in Cologne, there was an English catalogue on art paper which even listed the boat-trains. But Meissen had to keep its place, as in Lazare Duvaux's day. The dearest lot, a double one at that, fetched less than £500, whereas in London a

[5] Now in the Baltimore Museum.

single Sèvres urn, painted by Dodin, achieved, with its cover and ormolu stand, the absolute record auction bid of £4,200, a price worthy of the Earl of Dudley in the 1870s. But as to the real and ultimate price of this sort of Sèvres, which had once been sold from the factory for £20 an urn or thereabouts, it was believed that Asher Wertheimer was selling the Cheramatieff garniture of three for £20,000—that is to say, £120,000 of our present money.

Brushing aside an £18,000 drawing-room suite of chairs and a £16,000 set of four Bérain tapestries, which were Paris's big contribution to the year 1906, we may follow true art history-book taste at Duveen's shop in Bond Street, where the first of Joseph Duveen, Jnr's, bloc purchases was exhibited, the Oskar Hainauer Collection from Berlin. The names of Donatello and Cellini still sang through the air freely in 1906, for it was only at this exhibition that the young Duveen even set eyes on Berenson. But the quarter-million that had gone into the Hainauer Collection was recouped from Pierpont Morgan alone. And yet this year, which smelt of millionaire's money, was a bad one for picture sales, only a Romney, a Hoppner, and a Turner passing the 5,000-guinea mark in London. A. C. R. Carter surely hit the nail on the head when he suggested that too many things were under private negotiation with America.[6]

But before we have done with 1906, I must notice one substantial reversal of values among the £20,000 Sèvres garnitures and French drawing-room suites, for it was in this year that Henry Yates Thompson bought the *Life and Miracles of St Cuthbert*, that little masterpiece of English Romanesque painting with its forty-six touchingly simple illuminations which cost only £1,500 at the Lawson sale at Sotheby's. At Yates Thompson's sale in 1920 the manuscript was to cost the British Museum £5,000, but today an estimate of £150,000 might well be below its real value. Those illuminations, which worked out at about £30 each in 1906, might not be dear in 1963 at £3,000 apiece.

1907 must surely go on record as the year when Saturday afternoon sales ceased. The snobbery (still with us) which forbids the truly smart to be seen in London after twelve o'clock of a Saturday was probably late Victorian in origin rather than Edwardian. More significant was the implication that the art sales could not go on without the presence of the truly smart.

But what a year was 1909. Holbein's *Duchess of Milan* was saved from going to Henry Clay Frick by a last-minute miracle which got the Duke of Norfolk his £72,000, more than the Ansidei *Madonna* had

[6] In *The Year's Art*, 1907.

cost in 1885. And the Treasury—yes, even the Treasury—contributed £10,000, while Pierpont Morgan himself added £5,000 to stop Frick getting it. But the American import tax on works of art more than a hundred years old was repealed almost at the same moment, and Duveen had bought half a million's worth of all that was most fashionable in the way of Rembrandts, Frans Halses, and Bouchers from the Maurice Kann Collection. It was going to take something more than passing round the hat for £72,000 to stop these season's models from crossing the Atlantic, which almost all of them did. *The Year's Art*, sadly perturbed by a Millais landscape which had just shed two-thirds of its purchase price since 1892, took comfort in the thought that "some astute judges avow their belief that the changes in the American tariff will stop the revision of prices of early Victorian pictures".

It must have taken very astute judges to believe that. The philistine Press found greater comfort in the thought that Dr Wilhelm Bode's £9,000 Leonardo da Vinci bust, enthroned in the Kaiser Friedrich Museum, but bought in Southampton for thirty-five shillings, had been unmasked as a nineteenth-century work and not even the best of a long and illustrious line of impostors for which the British Museum, the Victoria and Albert, and the Louvre had fallen at various times (see Vol. I, pages 198, 201). The more civilized could at least obtain some real consolation after the death of George Salting at the end of the year. For that most convenient of collectors had had few family commitments, and he had made his will at a moment when death duties had not begun to be intolerable. No future government of the nation was to obtain such a collection of objets d'art as this through the death of a single man—or to deserve it.

2. *The Grand Climacteric, 1910–18*

After the repeal of the American tariff, a bad year was foreseen for the mere domestic dregs of the market which would be left on this side of the Atlantic to face the mercies of the saleroom. "Has America at last got it all?" demanded *The Year's Art*. The answer at the end of 1910 was an absolute record turnover of £1,300,000 by Christie's and Sotheby's combined, the equivalent today of close on eight millions. But it is unlikely that these lots would be worth even £1,300,000 in 1963. To start with, the fourteen dearest lots of Sèvres in the Schroeder and Coope sales (including the Dudley and Montcalm vases) which made £48,000 between them, would certainly not make £300,000 and perhaps not £30,000. As to Justice Day (a famous flogging judge)

and his £130,000's worth of French and Dutch Barbizon school land-scapes, these were already dropping behind the fashion even in 1910, and in 1963 they will not yet have recovered 1910's prices; still less the English Victorian subject pictures in the Armstrong and other sales, which accounted for more than half the year's turnover.

As to Renaissance art in 1910, Duveen's purchase of a Siena maiolica dish at the Coope sale at £3,700 was a breathtaking performance, but it would be even more so today. Bernal's celadon vase in a rocaille mount which rose from £60 in 1855 to £4,700 (Duveen again) would, I fancy, just about hold its price, whereas the Limoges enamel tazza by Suzanne Court at £2,050 would at the present moment stand little chance of doing that. Isaac Falcke's 3,000- and 4,000-guinea Italian bronzes would certainly fare better than Limoges enamels, but they will not have multiplied their value anything like six times, important though they were. One may wonder still more whether the sixteenth-century Venetian bronze bust in the Lowengard sale of the following year would keep its auction price of £7,400—that is to say, £45,000—or the German equestrian relief of the Emperor Maximilian its price of £3,625 (£21,700) in the von Lanna sale in Prague.

Even less exciting investments would have been provided by the German sixteenth-century silver collected by Carl Meyer Rothschild of Frankfurt, mainly in the booming 1870s and early 1880s. There were eighty-nine lots, sold in Paris in 1911, fourteen of them at over £1,500, but the *bocale double* by Hans Petzoldt of Nuremberg (£4,600) would have to reach £27,000 today even to stay level. This character-istically Rothschild branch of collecting, perhaps the earliest taste of the dynasty, provides a perfect yardstick for the decline of the wedding-cake style in late Renaissance art. Advancing a quarter of a century, we find Victor Rothschild's Augsburg and Nuremberg silver in 1937 still keeping fairly close to the 1911 level of prices. 1940, on the other hand, was no year for fruity Germanic art, so Anthony Rothschild's rose-water dish and ewer by Christoff Lenker, which would surely have been a £3,000 piece in 1911, made only £245. But in 1946 Lionel de Rothschild's terrestrial globe cups of 1622 achieved £2,600 at Sotheby's, and in the following year a rose-water ewer and dish which were once Pierpont Morgan's made £4,375. To judge from the price of a fine rose-water ewer and dish in 1962, £4,000 for an example dated 1560 and weighing 1080z, this is not an advancing market.

Paris in 1912 saw the costliest art sale in the history of collecting—nothing less than that—since the 13,884,460 francs which were pro-duced by the Jacques Doucet sale were the equivalent of £607,000,

including the ten per cent tax, and would now be equivalent to more than £3,600,000. But I use the word *costliest* rather than *greatest*, for there can be no question of comparison with the Hamilton Palace Collection of 1882. That would have been worth not £600,000 in 1912, but already several millions. In fact, the prices of the Doucet sale were an indication of the rapidity with which American fashion had inflated this market even since the Lelong sale of 1903.

The Doucet sale had another significance beyond mere price-rises. In the Paris of 1912, *dix huitième* taste was only sixty years old. It was none the less "establishment" and extremely stuffy in the eyes of the avant-garde. Doucet, the smart *couturier* not only got rid of all his collection, but he moved out of an eighteenth century *hôtel* into a modern villa in Neuilly, filled with art nouveau wrought ironwork and Lalique glass panels as a setting for Cézannes and Rousseaus and even a cubist Picasso. Although fifteen years were to pass before the smartest Parisians lost faith in the strict eighteenth-century *décor*, Doucet's metamorphosis was a warning to the market of what might happen when everyone shared his notions.[7]

As to the Doucet sale itself, the £20,000 Houdon baby and the long parade of drawing-room sculpture at four-figure prices need no second description. The Latour pastel portrait at £26,400, the set of six Louis XV fauteuils which cost nearly £10,000, the £6,000 Boucher tapestry panel—these were all good pace-keepers, but what, one wonders had happened in 1912 to the price of *ébénisterie*? There were well over a dozen four-figure prices, among them nearly £4,000 for one of Roentgen's great *bureaux à cylindre* and £3,500 for an elaborate writing-table of the *Régence*. But how much lower were these prices than those of the Hamilton Palace sale. It must be borne in mind that hardly more than half a dozen examples of French *ébénisterie* succeeded in making as much as £6,000 or £7,000 in the first quarter of our century. The real return to Hamilton Palace prices—and an extremely short-lived episode at that—was not till well into the 1920s. So long as tapestry-rooms and tapestry suites of chairs were the rage, the market for even the finest *ébénisterie* was decidedly capricious, though in the first year of the century, when Edmond de Rothschild bought the *Bureau du Duc de Choiseul* (see page 138), there had been distinct signs of another price leap in the salerooms.

Of this there was an odd reminder in this very year 1912. Seldom can there have been a more lavish sale of a deceased dealer's stock than that of Charles Wertheimer. It realized nearly £200,000 (say, £1,200,000

[7] Germain Seligman, *Merchants of Art*, New York, 1961, pages 151–2.

today). Three French clocks made nearly £3,000 each, eleven snuff-boxes were sold at four-figure prices, a tapestry drawing-room suite of six chairs and a settee punctiliously made its £13,650. And all these very expensive things must have been on offer for much more, since they had remained on Charles Wertheimer's hands. But the famous rock-crystal biberon was not the only object to drop to a fraction of its former standing. A writing-table and a commode, which had once been attributed to Riesener, made only £819. But according to A. C. R. Carter,[8] Wertheimer had bought these about the year 1902 as his unhappiest investment at no less than £44,000. With the sale of the *Bureau du Duc de Choiseul* still sending out echoes, he had believed that he had found something to rank with the legendary Hamilton Palace Riesener furniture.

Less dramatic, but equally suggestive of the precariousness of the French *ébénisterie* market, was the case of the dearest piece of furniture sold in London in this year, 1912. It was a commode, made in the 1780s by Saunier, and it was bought by Duveen brothers at the John Edward Taylor sale at Christie's for £5,040—in fact, the record price in London for French furniture since 1901. Yet at the Elbert Gary sale of 1928, a highly puffed New York sale of a millionaire collection held many months before the great slump, this commode was already down to £2,800. In 1939, in the general debacle of Randolph Hearst's whole-sale accumulations and in the panic of the times, it made only £1,112.

The John Edward Taylor sale was not only the second world auction event of 1912, but at £368,000 it was the first English sale in thirty years to approach the Hamilton Palace sale total. Even to this day it has been only very closely rivalled by the two Holford picture sales of 1927–8. The total of the Holford sales was £572,300, but, though the pound had gone back to the gold standard in 1925, its real purchasing power was only sixty per cent of the pound in 1912. In present-day terms, the two Holford sales brought in £2,150,000, and so did the Taylor sale, and that for a single collection is something we have not yet seen in the 1960s.

Taylor, the proprietor of the *Manchester Guardian*, was a collector much after the George Salting style, buying at the same period, and in some respects buying much better. Like all the more scholarly collectors of his day, works of the Middle Ages and the *Quattrocento* had been his favourites at a time when they were still procurable without unnecessary fuss and probably at less cost than some of his other treasures. But the year 1912 was the culmination of Pierpont Morgan's adventures

[8] *The Year's Art*, 1913 and 1921.

into these periods, and now they were truly a millionaire's market. For instance, a twelfth-century enamelled pyx in the form of a dove, which had cost less than £300 in Paris in 1884, was bought by Duveen for £3,255. Duveen also paid £3,675 for an Italian ivory diptych of about the year 1400, £4,310 for the late fifteenth-century enamelled jewel known as the *Caradosso morse*, and £6,930 for a singularly ugly Italian enamelled diptych on silver of the same date. All these could have but one destination—namely, Pierpont Morgan.

But art of the later Renaissance showed—in keeping with the true taste of 1912—even higher evaluations. Two big and protuberant, Venetian bronze andirons by Allessandro Vittoria, hardly earlier than 1600, made £9,660 as against £2,040 at the Spitzer sale of 1893. A Limoges enamel candlestick of about the year 1550, which had cost £294 in 1892, was bought by Duveen for £4,305, a singularly stuffy taste to have advanced fifteenfold in thirty years, but now perilously near its decline. Maiolica was still preferred in its richer and later variations, for, while a fifteenth-century Faenza jar did succeed in making 900 guineas, the victor's palm went to that highly rated but not so rare product, a Maestro Giorgio lustre dish of 1524 at £2,835. A plain-looking stoup of the rare sixteenth-century proto-porcelain, known as Medici ware, was sold for £1,995, having been bought in Rome in 1884 for less than £200. Seligman also bought a Gothic tapestry panel, small enough to go into a cottage, for £8,190, and that, I think, can really be called £50,000 today.

As usual in a sale of this period which contained both elements, the paintings seem incredibly cheap, compared with the objets d'art. What would the National Gallery have to pay today for the two Mantegna grisaille panels which were thought so outrageous at £16,275. A quarter of a million might be extracted from the public funds without so much as the rolling of a choleric eyeball. Far otherwise the yellow-ground Chinese pedestal vase bought in 1895 in emulation of the tastes of George Salting for a modest £175, and now departing at £7,245. The year 1912 was, as we have seen in the last chapter, only the beginning of the *famille noire* and *famille jaune* craziness. Doubtless the pedestal vase changed hands in the USA within the next few years for double, even treble its price, but it would be a rash man who would take it today at even a quarter of £7,245.

Saleroom records continued furiously in 1913, a year that ended in glory with the return of the *Mona Lisa* to the Louvre, twenty-eight months after it had been stolen; a year that also ended with the Czar of Russia finding the £310,000 which was necessary to prevent Henry

Clay Frick getting the *Benois Madonna* (see Vol. 1, page 202). In London the earliest-dated English silver salt, the *Ashburnham Salt* of 1508, fetched £5,600. Jane Burke's Bristol china teapot, a most unassuming object, cost £1,522 10s. A brown-and-yellow mottled jug of mysterious origin, in an Elizabethan mount that had nothing special, cost the Baron Schroeder over £2,000. Two Limoges enamel salt-cellars, only 4in high, rose from £451 10s at the Fountaine sale of 1884 to £3,675. At the Oppenheim sale, seven Chinese vases in Mazarin blue, well wrapped-up in rocaille mounts, cost Duveen Brothers a total of £17,220, the equivalent of more than £100,000 of our money and probably the most expensive mounted Chinese pieces that have ever been seen in an auction room. But, dear as they were, it was unmounted Chinese porcelain that now commanded the highest prices (see pages 214–5).

Compared with Chinese porcelain, the orthodox market for the European *dix huitième* was rather more static in 1913, though when multiplied by six the prices seem gigantic. At the Oppenheim sale one of those raffish-looking screens with painted panels after Watteau made £6,825; at the Murray-Scott sale the Falconet bronze group, *Cupide menaçant*, made £7,350, while in Paris a tapestry suite of six fauteuils and two settees cost £17,000 as a matter of ordinary routine, though everyone knew that they had been regilded. As to *the other taste*, at the New York Lydig sale a plain, carved-walnut Florentine cassone made £2,120 and a Hispano-Mauresque dish £1,653. When multiplied by six these are very much above present-day values. But how should one value a Carolingian Gospel book of the tenth-century Tours school, with five full-page miniatures, which fetched £500 at the best Sotheby manuscript sale of 1912? In 1958 a less important manuscript of that kind cost £39,000.

The First World War is sometimes represented as a watershed of the history of taste. An attractive over-simplification tends to regard the buying of the paintings of the Impressionists and the moderns, as well as the mediaeval art of the Near Eastern and Far Eastern countries, as a post-war symptom. The same over-simplification would treat the *dix-huitième* and High Renaissance tastes as pre-war symptoms, which now declined. But in fact the one taste had made huge strides before August 1914 and the other staged a most powerful come-back in the 1920s. Already in the pre-war season, 1913–14, the Rouart, Marx, and Nemès sales revealed Impressionism and Post-Impressionism as decidedly fashionable preferences. As to Oriental art, despite the monotonously repeated black hawthorns and blue hawthorns, which could now

make the passage to America in five days, it had been in a state of re-appraisal quite fifteen years before the outbreak of the First World War.

Some of the prices paid for a taste which was then still in the adventurous stage seem formidable indeed when multiplied by six at the present rate of exchange. For instance, the Louvre paid £2,200 in 1899 for a tenth-century Hispano-Arab ivory cyst and £1,684 in 1900 for a Persian silver-inlaid bronze ewer of the year 1190. At the Hayashi sale of 1902 a Sung bowl of the Chun or *flambé* type, though almost a complete novelty, cost £156, while an early mediaeval Japanese Budd-hist statue (not at all a de Goncourt object) cost £324. A supposed Sung white crackled vase cost £320 at the Bing sale of 1906, while in 1913 at the Aynard sale a late fifteenth-century Ming vase of the Fa hua type cost £662, possibly its present-day value. Chinese ancient bronzes of the Chou period already cost £280 in 1902 and 1903, as much as in the 1950s. On the very eve of the war, during the 1914 season, the Sambon sale revealed an enthusiasm for mediaeval Persian art which seems to be lacking today. A Rayy beaker in the Minai style of the early thirteenth century, cost £1,639, but already in 1909 a restored lustre dish had cost £1,120 in a Paris sale, while in New York Kelekian was reported to have paid that year £2,500 for a Persian dish of the same kind. The Sambon sale of 1914 also contained a Persian illuminated manuscript, a Diwan of Ha'afiz with paintings by Mirak and Sultan Muhammad at £2,860 and a Chinese stone statue of the T'ang period at £422.

None of these objects was sold in London. Persian and Indo-Persian painting never again became such a smart English taste as it had been during the Napoleonic Wars, while it was only in the post-war period that London became the market for Chinese art of the T'ang and Sung periods. This, however, became and still remains a distinctly English form of collecting, the true successor to the late blue-and-white porce-lain as collected during the Aesthetic Period. But Islamic art, which had failed so signally to convey its true message in the age of Delacroix and Fromentin, when every smart young man had his smoking divan with its hookahs and damascened weapons, became more an American taste than an English or even a French taste.

These exotic currents, particularly when they led to such expensive quarters as Kelekian and Charles Lang Freer, may have been something of a brake on the limitless upsurge of the *dix huitième*. The remarkable prices for Asiatic art in the Sambon sale of 1914, following on the well recognized motives behind the Doucet sale, created a sense of transition. Compared with 1912 and 1913 the top market for established taste was

certainly rather flat in 1914 and this was not due to political anxiety, since the first suspicion of war occurred when the season was practically finished. On the other hand the few really fine objets d'art that found their way to the Paris and London salerooms during the war years showed no change in the existing trend. The background was the skilfully managed disposal of a large portion of the Pierpont Morgan Collection among Frick, Widener, Rockefeller, Huntington, and other millionaires. We have already seen what happened to the Morgan Chinese porcelain, to his late Gothic and Boucher tapestries, and to the panels of his Fragonard room. For Morgan's Riesener commode and secrétaire from the *Garde meuble* of Marie Antoinette and the Hamilton Palace sale the younger Joseph Duveen was reported in 1915 to have paid £51,650, and still to have made some profit when he sold them to Frick. Of course, the austere atmosphere of Christie's in wartime could hardly live up to that, but in 1917 the Riesener commode of the Breadalbane family made £4,725 and a Caffieri commode £4,410.

In 1916 a pair of Chinese mandarin vases were sold to Duveen at Christie's for £5,670, while in Paris a Limoges enamel triptych by Nardon Penicaud made £3,212. In 1917 Christie's sold a ewer of Henri Deux ware for the second highest known price, £3,780. The purchasing power of the pound had diminished little in 1916–17, and these prices in modern terms were many times what the objects would be worth now. The year 1917, which saw the first successful revival of armoured warfare since the late Middle Ages, was also a most exceptional year for collector's armour, the beginning of a new and wholly American cycle of high prices under the feudal enthusiasm of Clarence McKay the cable and telegraph king, and William Randolph Hearst, the newspaper king. Whole suits and half-suits, bought by the Marquess of Breadalbane at the Bernal sale of 1855 for prices of 45 to 150 guineas, now made over £2,000 each, while a round Renaissance shield in splendid relief cost £3,570. To America there also went the supposed Montmorencey and Montpensier suits from Wilton House at an unknown price, arranged privately. They had been sold by Sotheby's at £14,500 and £10,500, but the sale was cancelled following a controversy concerning their attribution.

That was not the only auction-room excitement of 1917. For the first time since the great Stowe sale of 1848, a big collection of classical marbles which had been founded according to the principles (or absence of principles) of late eighteenth-century collecting, came under the hammer. And by this is meant not learned-looking Greek archaic fragments from German excavations, but whole statues in the round

from Ostia or the Roman princely palaces, or dredged from the Pantanello at Tivoli to be brought to England by Jenkins or Gavin Hamilton and smartly furnished up with a good deal of putty by Nollekens (see pages 62–3).

Thomas Hope, author of *Anastasius* and *Household Furniture*, 1808, had been a Grecian of Grecians, albeit a Dutchman. For more than a hundred years his sculpture gallery had remained undisturbed in the great house which he had adapted to it at Deepdene, near Dorking. In late Victorian times this collection might not have fetched a great deal more than in the late eighteenth century, since excavations in Greece tended to debase the traditional market for the merely Graeco-Roman. But with the new century came American competition and quite astonishing prices for works of art, admittedly of the Roman period: £14,000 in 1904 for the Sciarra bronze statue of Septimius Severus, £18,000 in 1907 for the *Anzio Priestess*, an early imperial marble statue.

None of the prices of the 1917 Hope sale disappointed. Much was paid for avowedly Roman factory-produced work, but most extraordinary was the valuation that could still be put on thoroughly unsound literary traditions concerning the Greek sculptors of the Periclean Age. The life-sized *Athene* which had been found at Ostia in 1797 "thirty feet down", had been recognized by Flaxman "with the unerring eye of genius" as the work of Pheidias. And with the unerring eye of genius, Professor Furtwängler, who edited the catalogue, Mr Gordon Selfridge, who paid out £7,140, and the Greek Government, who underbid him, were disposed to agree. No one asked how a work of Pheidias, which must have been much rarer in late Imperial times than a Leonardo is today, could have found its way to the town dump of so humdrum and commercial a place as the port of Ostia.

Sixteen years after the Hope sale, the classical sculpture market was in a more *rusé* mood, perhaps because in 1933 there were fewer people around who could quote classical texts at you. It was, of course, not till 1950 that M. Charbonneaux of the Louvre advanced the theory that the Pheidian or Praxitelean *Venus de Milo* was no older than the first century B.C., but in 1932 the evidence (or, rather, its absence) was cunningly analysed in Reginald Wilenski's *Meaning of Modern Sculpture*, where it was deduced that no works whatever had survived from the hand of Pheidias, who had worked only in clay and bronze. It was possibly no coincidence that next year at Lady Cowdray's sale the £7,140 Hope *Athene* was bought-in for £200, having fallen as heavily as any Landseer.

Another allegedly classical Greek work from Ostia, a *Hygeia* which made £4,200 at the Hope sale af 1917, did at least escape the slump, but even in the recovery year of 1936 it made no more than £589 10s in Lady Melchett's sale, while at the Earl of Lincoln's sale in 1937 one of Hope's admittedly Roman statues, a *Minerva*, fell from £1,470 in 1917 to £95—just that. This was far from being the dearest of the Roman statues in the Hope sale. A life-size marble statue of *Antinous*, the favourite of the Emperor Hadrian, whose podgy charms had created a sculptural vogue in the middle of the second century A.D., was sold for £5,880. A statue such as this would have fallen even more heavily by the 1930s, since a much less restored *Antinous* in the character of Hermes cost only £315 in the Lansdowne sale of 1930.

It is, I suppose, an inexcusable leap in time to consider the Lansdowne sale while we are still in the middle of the First World War, but, taken together, the Hope and Lansdowne sales offer such perfect illustrations of the progressive decline of the old, traditional, schoolroom acceptances. The Lansdowne marbles were already famous in the days when Hope started to collect, and most fortunately we know what was paid for nearly all of them. The collection, substantially as it appeared at Christie's in March 1930, had been sold by the 2nd Marquess of Lansdowne to Lord Wycombe in 1792 for £7,000. It had been sold back by Lady Wycombe to the 3rd Marquess in 1810. The Canova statues and the Assyrian reliefs were bought later, but the main collection, as acquired in 1810, cost £10,680, and in 1930 about £63,000. Thus we get a sixfold advance in 120 years, but in reality it was little more than a threefold advance, because in 1930 a single statue accounted for nearly half the total, having advanced a hundred-and-fortyfold.

A mere threefold advance in 120 years, readers will already have perceived, is not at all an uncommon instance in the history of art prices. In fact, the present-day situation of classical sculpture of this kind is even more extraordinary. In 1961 the Roman marbles from Wilton made from 600 to 1,100 guineas each at the best. It is therefore even possible that some of the Lansdowne marbles would fetch no greater number of paper pounds than they cost in the golden guineas of the late eighteenth century—and that is only a twelfth part in real values.

The exception in 1930 was the life-sized statue called the *Wounded Amazon*, the most costly piece of classical sculpture that has ever been sold at auction in this country. It was bought by Brummer of New York for £28,350 and sold later in America to J. D. Rockefeller, Jnr.

Yet it had been one of the cheapest of the Lansdowne marbles. In 1773, when it had been shipped from Rome by Gavin Hamilton, the 1st Marquess had found the *Wounded Amazon* too dear at £200. During the next fourteen years he was on the lookout for a purchaser. In 1787 he sent it back to Rome, but since no one would buy it in Rome either, he recovered the statue in 1799 after the departure of the French, and shipped it again to England.

What, then, was wrong with the *Wounded Amazon*? It had the habitual frigid and sterilized appearance of a Greek work of the late fourth century B.C., but, with disarming frankness, the sale catalogue of 1930 cited the observations of Professor Michaelis from *Ancient Marbles in Britain*, 1882. All that Michaelis knew for certain was that the *Wounded Amazon* had come from a temple of the late first century A.D., and that Gavin Hamilton had supplied the plinth and most of the limbs. Not much, one would say, for £28,350 gold.

In the days of the 1st Marquess it had been the huge standing *Hercules* which counted most. Esteemed the work of Lysippus, it was bought from Charles Towneley's Collection in 1792 for £600. In 1816 Payne Knight testified before a Parliamentary Commission that the *Hercules* was far better than any of the Elgin marbles, and worth £1,000 at least. In 1930 it fetched £4,830. Its companion, the *Standing Hercules*, which had cost Lansdowne £500 in 1792, made only £2,100 in 1930, because the statue that had seemed to Payne Knight everything that was true Greek had been so worked-over as to look a completely eighteenth-century object. On the other hand, two very small un-restored fragments of Attic reliefs of the fourth century B.C., bought by Thomas Jenkins in Naples in 1771 for £10 the pair, now cost £5,250 and £2,205.

A *Stooping Hermes* provides the most interesting of all examples of declining confidence in the donnish aesthetics of the past. In 1771 Gavin Hamilton recognized in some fragments which he had assembled from the Tor Colombaro a replica of a statue in the Vatican. At a later stage another unerring eye of genius, in this case Canova's, supplied Thomas Jenkins with the valuable expert opinion that this was not a replica of the Pope's statue, but the original. For this too in 1792 the Marquess paid his £600. In 1816 Payne Knight declared that the statue had been bought cheap, because the Pope had relinquished his option, not wanting another like his own. The true value of the *Stooping Hermes* was, he thought, £1,400. Yet in 1930 it was sold for only 1,500 guineas. At the Hope sale of 1917 it would certainly have cost more than £5,000.

3. *The False Boom*, 1919–29

In November 1918 no one had any reason to think—as in 1945 everyone had reason to think—that the rationing and irksome wartime controls would continue for years, even without the excuse of a war. There was a genuine mood of jubilation and, one might also add, a genuine sense of deliverance, for less than four months had passed since the Germans had crossed the Marne, threatening to head south of Paris. The London sales season opened four days after the Armistice, and for paintings, at any rate, it proved the most successful season that had ever been known, with 100 works sold at upwards of 1,400 guineas each, with Reynolds's *Tragic Muse* which was bought-in at £54,600, and Romney's *Beckford Sisters*, which was permitted to leave Hamilton Palace at the same exalted price.

For objets d'art the season was nearly as remarkable as 1912 or 1913. Between them Christie's and Sotheby's sold no less than twenty-one lots of tapestry at four-figure prices. Four-figure prices were also paid for fifty-two furniture lots, more than half of them being French drawing-room suites, one of which made £8,925 at the Neumann sale. There were all those wartime fortunes itching to be invested in the Louis drawing-room, for which commodity the rosy future seemed to portend a never-ending demand. So too for *ébénisterie*, an even more vigorous market, being international. At the Ruxley Lodge sale Duveen gave £9,870 for two Louis XV corner cupboards, or encoignures. At the Neumann sale Partridge gave £6,190 for a *bureau à cylindre* by Riesener. The Marchioness of Graham's two Persian silk rugs cost Duveen £13,650.

English furniture, porcelain, and silver did exceptionally well in the season of victory. In those days they were bought only by the English-speaking world, but that was good enough. An Adam satinwood commode was sold for £1,785 and two Chippendale chairs for £1,837. A pair of gold anchor Chelsea vases in the French style cost £4,620, a Queen Anne silver service by Mettayer cost £5,584, while a great, dowdy silver epergne, made by Lamerie in 1743, cost the Victoria and Albert Museum £2,970. At the Wood sale a pair of Bow figures, *Summer* and *Autumn*, worth possibly £100 thirty years earlier, rose to £3,780. (For present-day equivalents multiply by three.)

As to earlier art—art of the Pierpont Morgan taste—there was Henry Yates Thompson's ravishing fourteenth-century French illuminated manuscript, the *Hours of Jeanne II of Navarre*, which fetched the highest

price hitherto achieved by an illuminated manuscript in the saleroom, a price that was not exceeded for another ten years—namely, £11,800. In Paris a pair of early sixteenth-century tapestry panels cost £12,000, a trifle compared with the five great panels from Boucher's *Story of Psyche* suite, which Duveen was alleged to have sold that year to Mrs Hamilton Rice for £155,000. There was only one flaw in all this magnificence. The pound in 1918–19 bought barely half of what it bought in 1914, the franc not even a third.

Soon the troubles began to fly out of the box. The soaring prices in the Allied countries upset the external balance of payment. The wartime pegging of the money-exchange rates had to be abandoned in the summer of 1919. By the middle of January 1920, the pound had fallen from its normal 4·86 dollars to 3·36 dollars, while the franc had fallen from twenty-five to the pound to forty-seven (in round figures, from five to the dollar to fifteen). The year 1920 was very grim, and 1921 even worse, with sharp falls in prices and wages, with strikes on the one hand and unemployment on the other; with prolonged warlike commitments in Eastern Europe, rebellion in Ireland, hopeless dissensions between the wartime Allies, and above all the looming spectre of German bankruptcy. It was, of course, not yet realized, though it is so abundantly apparent today, that victory is just a hideous mistake and that there is absolutely no tonic for getting a nation on in the world comparable with unconditional surrender and the total occupation of its territory by an enemy. In 1920 they did not know all that. They only perceived dimly that the fruits of victory were delusive. What was the sense in collecting reparations from the vanquished if it meant that you could not sell your own coal?

It might be noticed in that unhappy summer of 1920 that a picture called *Looking for a Safe Investment* had fallen from £651 to £310 since 1887. In May Lord Methuen's big Romney group, *Sir Christopher and Lady Sykes*, achieved what the *Morning Post* considered to be a beggarly price at £28,350 (at least £90,000 in today's money). This calamity was attributed to Parliamentary debates on a possible revival of the excess profits tax and even a tax on wartime capital gains, a riotously popular notion among those who hadn't made any. Birket Foster water-colours, the rewards of wartime self-help, drifted like snowflakes through the salerooms in 1920 and 1921.

In reality, it was only the most overrated of the Victorian paintings whose fall proved permanent. In 1921 all those kinds of English art that had become a bi-national taste were firmly supported by the top American market. Although the USA was not immune from the

world business recession, the pound cost less than 3·50 dollars at the beginning of the year. Consequently, the Americans were paying not much more than two-thirds of the apparent prices. Thus in June 1921 the rather inelegant Greenwich suit of armour, made for the 2nd Earl of Pembroke, went to Clarence McKay after Duveen had bid £25,000 at Sotheby's. In the same season Chippendale's famous commode from Raynham, which was to cost £25,000 in New York in 1960, achieved the price of an important French commode at £3,900.

English furniture of the eighteenth century could hardly fail to find buyers in the year 1921, when Huntington gave £148,000 for Gains-borough's *Blue Boy*, but the French market was in distress. At the sale of the stock of Asher Wertheimer, who had died in 1916, a pair of Louis XV tables which had cost £2,000 at the 1912 Oppenheim sale made £367 10s. A Sèvres urn and cover by Morin, bought at the dearest possible sale—the Baron Schroeder sale of 1910—for £2,362 10s, fell to £420. This fall was exceptionally drastic, since it was part of a dealer's unsold stock, but it was indicative of the future. There were to be no more 5,000-guinea Sèvres vases, or £20,000 garnitures, with one notable exception in 1938 (see page 161). Collectors in the 1930s wanted something less fussy, so that £1,000 came to mean a fortune for any piece of Sèvres and £100 quite a lot.

For French furniture the depression did not go anything like as deep as this, and it was largely confined to France itself. But the background to this strange anomaly was highly emotional. Among the measures which were intended to balance the French Budget and prevent a further fall of the franc was a tax which was passed by the Chambre des Députés in May 1920. All works of art made before 1830 or by painters who had died before 1900, were to pay an export tax of fifty per cent. In the case of sales over 100,000 francs, then worth about £2,000, it was to be one hundred per cent., an exceedingly effective method of preventing much-needed foreign currency entering the country. The Senate refused to ratify the decree, but in the meantime the sale of an important Belgian collection which had been arranged before the war was cancelled. The Beurdeley and Orloff sales showed depressing results, even though, at the risk of losing the art market altogether, the French nation was enriched by a Dürer drawing for the modest price of £560. In July a new decree lowered the levy to a scale of from fifteen to twenty-five per cent. Subsequent amendments in August 1920 and January 1922 knocked the export tax out of existence. But the tax on auction sales was raised from ten per cent. to the present scale, which extends from eighteen to twenty-two per cent.

This in itself was not enough to kill the Paris art market. Its real adversary was the falling franc. More or less stable till November 1921 at forty-seven to the pound, the franc then drifted down again, reaching 170 to the pound in August 1926. In the following February it was stabilized at 125 to the pound, or twenty-six to the dollar. The franc remained firmly linked to the gold standard till 1935. But during the five years in which the rate varied from day to day any delayed settlement after an auction sale could mean an unknown loss to the vendor, who therefore made every effort to avoid the saleroom. In 1923 the English auction record of 1901 was surpassed when Fosters sold the two Martin Carlin commodes from Brocket Hall for £15,435, but in Paris an exceptionally fine rococo commode in coloured lacquers cost only £300, and that was the dearest of the year. The market for *dix-huitième* art only returned to Paris with the Dutasta sale of 1926, when there was not only a stabilized franc, but also a world-wide stock exchange boom.

In 1926, 1927, and 1928, three remarkable years, the international art market *partly* recovered the buoyancy of 1912 and 1913. The word "partly" is stressed because the pound now bought less. After a severe fall from the very high cost of living in the summer of 1920, the pound was left at the end of 1921 with a purchasing power no longer six times that of today, as in 1914, or three times, as in 1919, but about 3·7 times. Even at this modified exchange rate, a great many things seem to have been dearer in the 1920s than they are now. In Europe the years 1922–9 were an age of considerable commercial expansion, even though the real volume was much less than appeared on the surface. France only achieved a stable currency late in 1926, but already at the end of 1923 Germany had been made temporarily solvent. In 1925–31 a British pound note could in theory (but only in theory) be converted into a gold sovereign. Yet, despite stability in Europe, the key to the movements of the art market was to be found in America. For instance, the year 1926, which saw the famous Duveen prices bid openly in London at the Michelham sale, was in reality a depression year in England. In May the general strike had fizzled out after ten days, but in November, the month of the Michelham sale, the disastrous miners' strike had lasted nearly seven months. And ever since April 1925 the nation's export trade had been bedevilled by the over-valued gold-standard pound.

Against that apprehensive background the accepted image of America was rosy in the extreme. In the *Burlington Magazine* Mr R. A. Tatlock pointed out that in the past year (1925) American museums

had benefited from private benefactions to the amount of 16 millions, the equivalent of Britain's first annual repayment on the American loan. Kansas City alone had received a benefaction worth £1,800,000. In 1925 Henry Huntington must have spent half a million simply on English eighteenth-century portraits including the Gainsborough and Reynolds portraits from Althorp. For another four years, the annual balance of payments was assisted by the ferrying of ancestors across the Atlantic. It was the height of Duveen's market, with Lawrence's *Pinkie*, auctioned at £77,700 in 1926, and Gainsborough's *Market Cart*, auctioned at £74,400 in 1928. But this was not the only kind of traffic. Objects in the Pierpont Morgan taste, the taste for the Renaissance and Middle Ages, were almost as much in demand. Those favourite objects of the more scholarly taste of the times are nowadays infinitely rarer than they were in the 1920s, yet the impact on their value of years of uncontrolled inflation has been much less than that of the delusive American stability or false boom of 1920-9. When the following examples are multiplied by the necessary 3·7 times, I think they will show that not even the collectors and curators of the expense-account era esteem them as much as did their predecessors 25 to 30 years ago.

To begin with, in 1920-9 at least eight lots of armour were sold in London at upwards of £4,000 each, including the £25,000 Wilton suit. A "bastard" sword, which was sold in 1921 for £3,097 10s, and a pair of Maximilian "puffed sleeves" at £5,670 in 1925 give an even better idea of this now extinct American market. In 1924 the magnificent early silver of the Swaythling family was sold for £82,000 (about £300,000 today). The *Leathersellers' Bowl* of about the year 1500 was bought for the Victoria and Albert Museum at £10,000, the fifteenth-century *Rodney Cup* cost £7,600, and an ostrich egg in English late sixteenth-century silver mounts cost William Randolph Hearst's bidder £5,700, though in 1951 it was sold for £4,240.

Islamic art, so little heard of today, reached its apogee during this period when Charles Lang Freer had several enlightened successors among the millionaires of the day. Four-figure prices for Persian carpets were paid every year. In 1927-8 three sixteenth-century Ispahan carpets were sold in New York and London at from £20,000 to £23,000 each. Albums of Mughal miniatures cost £3,950 and £10,000 in 1925 and 1929. At the second Doucet sale in Paris in 1930 a single lovely Timurid portrait miniature cost £1,265 (equivalent to £4,300). In 1924 an Isnik faience mosque lamp—damaged at that— made £1,640 in Paris at the Testart sale. In 1922 Dr Fouquet's Syrian lustre jar made £1,380.

Chinese mediaeval pottery, the essentially *avant-garde* form of collecting of the 1920s, scarcely stepped into the shoes of the £20,000 and £30,000 black hawthorns of the early war years. Much of it, however, reached its highest valuation during this period. At £1,890, the equivalent of £7,100 in 1963, a Chun ware jardinière of the Sung period at the Robert H. Benson sale of 1924 may have been the dearest piece of Chinese mediaeval pottery that has ever been sold. A glazed T'ang figure of a horse at the same sale must also be considered a record at the moment of going to press, having cost £577 10s (£2,130).

But the dearest pieces at the Benson sale and pretty well the dearest Chinese ceramics to be sold between 1919 and 1945 were of the Fa Hua kind, a mysterious stoneware in polychrome relief, basically aubergine and turquoise in colour and made in the late fifteenth and sixteenth centuries. Of this ware two long-necked bottles on a turquoise ground made £6,720 at the Benson sale, while a hideous double-gourd vase with a meshed decoration made £4,305. But these and several other four-figure prices were altogether freakish and never to be repeated again, having been due solely to the competition of two American collectors. The real value of Fa Hua ware in the 1920s was barely a fifth as much. But in the 1960s, strange to say, the opulent-looking Fa Hua ware is cheaper than it was in the 1920s though early Ming blue-and-white porcelain, at that time unknown or worthless, now fetches up to £8,000 for single jars and dishes.

The boom in this particular kind of Ming pottery in the 1920s was in reality already out of date. Fa Hua pottery had been admired and imitated by De Morgan and others in the 1880s, and indeed it fitted extremely well with the aesthetics of Bernard Palissy. Not surprisingly, the Rothschild family figures among the pioneer collectors, but this High Renaissance sort of taste was doomed already before the great crash of 1929 struck the market. The decline can be followed in the price of maiolica, though its momentum affected all High Renaissance art.

In the early 1920s maiolica prices were still fully as high as in 1912. In 1921 Duveen bought the Duke of Newcastle's fine Casteldurante armorial dish of the year 1508 for £3,255 and a Gubbio dish by Maestro Giorgio, painted after a Dürer engraving, for £2,520. This dish had fallen to less than a quarter of its value by 1942. In June, 1923, *Beaux Arts* reported that the three very late Urbino vases by Frappio Fontana had fetched 101,000 dollars in the Salomon sale in New York. The price was then equivalent to £7,250 each. But at the Cook sale of 1925 this market began to wilt. Not only was this the great Doughty

House collection of Sir Francis Cook, but it had been largely bought in 1870 from Alexander Barker, the most opulent collector of maiolica of his day. There were no more £3,000 dishes. About half a dozen pieces made from £1,000 to £1,500 each, all of them relatively early. Between 1927 and 1946 only the Henry Oppenheimer sale of 1936 showed prices on this scale. At the Mortimer Schiff sale in New York in 1946, a first-rate selection of very early pieces, prices were hardly higher than in the early 1920s, in spite of the fall in purchasing power. As to the revival of late maiolica, the rich and fruity wares of the Fontana family, that only began with the Italian industrial revolution in the 1960s.

In the case of Limoges enamels and Palissy ware, which had been grotesquely overvalued in the 1870s and 1880s, the fall was greater, though the enamels put up a longer resistance. In 1921 at the Duke of Newcastle's sale a triptych by Jean Penicaud cost £2,910 and an oval dish by Jean Reymond £2,415. Prices exceeding £1,000 continued to be paid in the 1920s, and in 1933 a very large plaque by Jean Limousin could still cost £1,390 in New York. After that there were no more four-figure prices till 1951, when there began a recovery which has so far extended only to the late Gothic group of 1480–1520. At the Mortimer Schiff sale of 1938 (Sothebys), enamels which had been bought in 1910 and 1912 had fallen to a fifth and even an eighth of their cost.

Palissy ware had already fallen at the time of the Spitzer sale of 1893. A huge fountain-shaped vase and its dish in the Holford sale of 1927 was as dear as anything sold in the present century at £399, but during the Second World War Palissy ware became almost worthless, and the same fountain and dish were sold in 1957 for £100, though in 1884 they might well have made £2,500.

Renaissance furniture followed a different pattern. At the Taylor sale of 1912 French walnut furniture of the sixteenth century ranked almost as high as in the 1880s, a Lyons credenza making £1,470. At the Swaythling sale of 1924 an important Lyons *meuble à deux corps*, dated 1579, made £2,205. The commodity had become extremely scarce in the saleroom. On the other hand, there was a strong revival in the 1920s for sixteenth-century oak furniture, generally destined to be pickled. English Elizabethan buffets and drawer tables, shockingly rough furniture, sometimes crossed the Atlantic, having been bid up to £1,000 and more. But those who wanted truly expensive Renaissance furniture at this period naturally favoured the *early*. Thus the Florentine carved oak or walnut cassone had its brief period of glory as the

successor to the marble-inlaid cabinets of the late Renaissance, which had long disappeared from the high-class market. The apogee of the plain, unpainted cassone was in 1923, when Duveen bought a pair in Paris for £4,500. Another pair made £2,415 at Christie's as late as 1934, but during the Second World War the American market seems to have been in full revolt. Parke Bernet sale catalogues show a pair at £44 in 1944 and a cassone, dated 1500, at £12 in 1946.

It was naturally the painted cassones of the fifteenth century which fetched most at this period. In the 1890s it would have needed an example, painted by Botticelli himself, to realize £500, and even in 1923 the sum of £1,260 for a subject-painted cassone at the Craven sale was quite exceptional. But several cassones at the Holford sale of 1927 at 5,000 and even 7,000 guineas showed that this very important dispersal of objects in the enlightened Victorian taste had created a revaluation for fifteenth-century painted furniture. Precisely as in the case of illuminated manuscripts, the cassones, with their painted panels, ranked from now onwards as works of the Italian primitive masters.

With the tapestries of this period the case was rather different. In the 1920s they no longer sustained the extraordinary prices of the last years of Pierpont Morgan. Nevertheless, the increased cult of the primitive masters saved the top-class market in Gothic tapestries from any serious decline. For instance, in 1923 J. D. Rockefeller, Jnr, paid a reported £240,000 for the six much inferior versions of the *Dame au Licorne* suite which are now in the New York Cloisters Museum (see page 123). Auction prices were, of course, much lower. Only a very few Gothic panels in the 1920s made from £5,000 to £8,000. Nevertheless, in 1930 a gold-thread Tournai tapestry which invited comparisons with Pierpont Morgan's so called Mazarin tapestry was auctioned in Vienna for £20,000 in the famous Albert Figdor sale.

Suites and even single panels of tapestry in the 1920s were no longer essential to every wealthy home. In 1909 Victorien Sardou left not less than thirty-six panels of tapestry to face the Paris salerooms, whereas in the 1920s a smart and successful playwright might have been at a loss to find space for his single Fragonard. Those problems of space and staff must have become acute soon after the return of the warriors, for in the two seasons 1919–20 there were fifty-three lots of tapestry sold in London at upwards of £1,000 each, but in 1921 and 1922 only seventeen. For some years even the millionaire market for the best Boucher period suites was affected by this rebellion against vast and dictatorial objects. In the early 1920s the stupendous prices, paid by Messrs French at the dispersal of Pierpont Morgan's Collection, were

not repeated. Whereas in 1919 Duveen sold Boucher's *Story of Psyche* at £30,000 a panel, in 1925 the single panel, *The Toilet of Psyche*, was sold in Paris at £8,300, including tax—a most exceptional price, since very few tapestries made £5,000 in the saleroom in the immediate post-war years.

The change which came in 1926 was part of a revaluation of all *dix-huitième* art following a bout of American buying during the false boom which ended in 1929. It is doubtful whether it denoted a real return to the taste of the early 1900s. The adventures of one particular Boucher suite illustrate very well what happened. In 1903 Sir Joseph Robinson bought Reginald Vaile's set of *Les Fêtes italiennes*. At £23,415 for the four panels, the suite rivalled the Pallavicino suite as sold in 1900 (see page 180), but in 1923 this suite was bought-in at Christie's at £18,900. In the meantime single panels had been sold in 1912 and 1921 at £5,960 and £5,680. In Paris in 1926 the single panel, *La Curiosité*, made £4,550 on its own in the Dutasta sale, and the next year its companion, *La Danse*, made almost exactly the same sum. At this sale the complete six panels of *Les Fêtes italiennes* achieved a total of £48,000 (or £178,000 in our money). But one should particularly notice the second dearest panel, *La Musique*, which made £12,400. In 1938 an example of *La Musique* at the Ogden Mills sale in New York made only £352. This is, of course, not the final word. Late in the 1950s fine eighteenth-century French tapestries made a partial come-back. Yet on a balance of probabilities the example of *La Musique* from the Paris sale would make no more in 1963 than it made in 1927—that is to say, a little more than a quarter of its price in real money.

It was indeed the briefest of booms, lasting barely three years and owing much to Henry Walters of Baltimore. The highest price at a public action was paid not in Paris, but in London, at the astonishing Michelham sale of 1926, when *Orlando furioso*, a panel from a suite after Charles Coypel similar to the Pallavicino-Grimaldi suite which had been sold in 1900, was bought by Duveen for £19,950. In addition to this, at least six lots of eighteenth-century tapestry exceeded £11,000 each in the London and Paris salerooms in 1926-8. But these bore no relation to the prices charged in private deals in the USA. It was said, for instance, that in October 1929, after the first cold breath of the Wall Street crash, Henry Walters of Baltimore cancelled an order from Messrs French for the panel *Jupiter and Antiope* from that old favourite, *Les Amours des Dieux*, apparently at over £50,000. According to his latest biographer, Paul Getty regarded his own feat in purchasing this

panel in 1931 at £13,450 as a bargain,[9] yet in 1957 an example of *Jupiter and Antiope* was sold for £3,400. Low as this price was compared with the 1920s, it was most exceptional even in the late 1950s. After October 1929 it was quite an event for any eighteenth-century tapestry panel to make over £1,000 at auction for the next twenty-five years.

The period which I have called the false boom is typified by the Michelham sale of November 1926 (see also Vol. I, page 195), where Lawrence's *Pinkie* was bought by Duveen for £77,700. It was the first sale at which the furniture prices of the Hamilton Palace sale of 1882 were exceeded, though only nominally so. In spite of a gold-standard pound, the £10,237 which were paid for a Louis XV upright secrétaire by van Riesenberg (BVRB), were equivalent to no more than £6,000 in the purchasing power of 1882. And in 1936 this secré-taire had fallen to £1,312 10s at the Buckland sale. That, however, does not diminish the impressive nature of the Michelham sale, where four more pieces of *ébénisterie* made from 4,000 to 8,000 guineas each, and where three tapestry-covered drawing-room suites made over £10,000 each, the Boucher Beauvais Suite costing £27,825 for six fauteuils and two settees. Then there were the two gilt-bronze urns by Thomire at £3,570 and the Falconet bronze nymph at £5,040, echoes (at any rate on paper) of the prices of 1912.

In the USA the counterpart to this sale was the Elbert Gary sale of 1928, where Duveen ran Knoedler up to £50,650 for Houdon's marble bust of the baby Sabina (see page 188). A writing table by Oeben and Lacroix with the arms of Mme de Pompadour was sold for £14,640 and a drawing-room suite by Jean Baptiste Sené with Beauvais tapestry backs for £12,350. The first remained a record price for French *ébénisterie* till the year 1959, the second was much less impressive than it sounds, for the suite had been sold in Paris in 1907 for £18,000, while in London in 1938 it was to fail to find a buyer at £3,288.

The brief boom in French furniture extended to hardly more than a half-dozen important sales, such as the Michelham, Elbert Gary, and Mme de Polés sales, the Paris sale of the ex-Empress Eugénie, and the Berlin sale of the Soviet Government. The boom was already over in October 1929, when the American crash began to hit the European stock markets, but there was no general decline for at least another two years. The exception, the Founès bankruptcy sale in Paris, was actually held some months before the crash. Prices for the very highest class of French furniture simply fell back to the normal levels of the early

[9] Ralph Hewins, *Paul Getty*, 1959.

1920s. A small escritoire by RVLC (Lacroix) fetched £3,674 at Christie's as late as 1930. But as the recession spread to Europe, currency controls isolated the markets. By about the summer of 1932 it had become virtually impossible to sell fine-quality French furniture in London, and so it remained for nearly five years.

The effects of the depression on the objets d'art market were complex. Though, as we have seen, it gave the *coup de grâce* to things that were already on their way out, the buyers did not lose faith in fashionable objects as they did in investments. As the depression dragged on, the modern notion of something "better than shares" gained in popularity. Thus certain price records were achieved when the volume of the world's business was at its lowest. This was perhaps implicit in the character of the depression, which must be distinguished from the Wall Street crash. The latter, which took place in the autumn of 1929, was over within a few weeks and, despite its heavy repercussions in Europe, a false sense of security followed. But the depression must be considered to have lasted till the outbreak of the Second World War. In the USA it kept from 8 to 13 million people jobless, while in Europe it created a series of crises of credit, of which the British flight from the gold standard in the autumn of 1931 was only one example.

The original Wall Street crash of September–November 1929 had halved the value of American industrial shares, but between June 1930 and July 1932 their value was again reduced, ending up at barely an eighth of what they had been worth in the summer of 1929.[10] It required the passage of an entire generation, a Second World War, and a universal bout of inflation to recover the stock-market values of that now legendary summer. In the art market the year 1929 remained for many years the watershed between old and new valuations until in the general *mêlée* of inflation the high prices of the 1920s ceased even to be a memory. I have treated 1929 as a landmark in this book, though I regard the burst of high prices in 1926–8 as artificial and concealing a decline from the true price watershed of 1912–13. The money that was being spent on works of art at the outbreak of the First World War was not merely true money, based on gold, but its copiousness was a sound indication of the capacity of the white man's industrial output to expand and to find fresh markets. There was no such warrant for spectacular prices in 1928, when more than £50,000 were spent on the Houdon baby. Such money could be found by selling shares, but the shares had been over-valued beyond all measure by marginal buyers and by brokers, financed at high interest rates by the banks. Since these

[10] J. K. Galbraith, *The Great Crash, 1929*, London, 1955, page 130.

shares were destined to fall to an eighth or less, it was already a form of inflationary buying.

But the real sickness of the times was not merely an unbounded faith in the expansion of all investment. "At some point in the growth of a boom", John Kenneth Galbraith writes,[11] "all aspects of property ownership become irrelevant, except the prospect for an early rise in price." The trouble was the nature of property ownership. Put in a simple mathematical form, more than ninety per cent. of the world's capital in the late 1920s was employed in producing goods which much less than 10 per cent. of the world's population could afford. The long years of the depression in the 1930s were the years in which this simple fact was at last recognized, the years in which the plant which produced the things that not enough people could buy, simply lay idle —the true cause of the Second World War.

It seems rational enough in the 1960s for the man who makes a motor-car to own one, but in the 1930s, at any rate in Europe, that was very rare. The modern remedy is to create more spending power through higher wages, paid even though the machine does most of the work, or by advancing money to underdeveloped countries in order that they can buy goods which in the end will probably not be paid for at all. Another method is to employ men in making weapons which become obsolete within a year or two. In this way both prices and wages are kept high and the art market responds by believing in the existence of a boom, just as it responded in the 1920s, when the mere fact of competition for shares created something out of nothing—or appeared to.

Whether the second is as dangerous a fallacy as the first we have still to find out.

[11] *Ibid.*, page 29.

The Long Depression and the Paper Recovery
1929–63

1. Till the Second World War — 2. War and Economic Isolation, 1939–53
3. The Impact of Inflation, 1953–63

1. *Till the Second World War*

It is difficult to make much of a pattern out of objets d'art prices in the ten years preceding the war. In the case of pictures, the difficulty is more easily surmounted. While most prices for eighteenth- and nineteenth-century pictures reflected both the original crash of 1929 and the long years of depression, the market for the earlier old masters recovered in the middle 1930s through the competition of men like Andrew Mellon, Samuel Kress, and Jules Bache, making new saleroom records possible. In 1935 there were even one or two bright occasions for those English eighteenth-century portraits which the slump had hit hardest. The real casualties were the kind of pictures for which the aesthetic climate was proving unfavourable before the slump had even begun (see Vol. I, pages 210–14).

This, as we have seen, had already happened before 1929 to French tapestries and furniture and also to High Renaissance art. At first it was not a serious downward drift, but a failure to repeat the very high and very artificial prices of 1925–9. There was no weakness of the entire objet d'art market till after the autumn of 1931 and the crisis of the pound. But before this second stage in the depression there were some striking differences of pattern. It is, for instance, instructive to compare the market for mediaeval European art, which now made too infrequent

an appearance in the saleroom to be altogether vulnerable, with the continuously well provided market for Chinese porcelain. It was clear already before the First World War that this market had become ideologically split. In the middle twenties the advance of early Chinese ceramics in the avant garde taste came to a halt, while the later wares in Edwardian and Victorian taste actually fell. Being sustained largely by the conservative American market, they toppled at the first breath of the cold wind of October, 1929, whereas early tapestries, mediaeval metalwork and armour were good for another two years of prosperity.

Thus the most expensive objets d'art to be sold in 1929, the year of the great crash, were neither in the Chinese *famille noire* and *famille jaune* taste nor in the French *dix-huitième* taste, which had seemed so invulnerable during the First World War. In the two great London salerooms the most prominent objets d'art were the *Bedford Book of Hours* at £33,000, the *Luttrell Psalter* at £35,000, the Ashbridge Chapel sixteenth-century stained-glass panes at £27,000, and the *Portland Vase*, which was bought-in at £30,450. The two illuminated manuscripts were a rather special case, since they were bought by J. Pierpont Morgan, Jnr, and held till the British Museum could raise the money from the Treasury. This was in the middle of July, a full two months before the first rumblings of the crash. Had they been offered during the winter sales season, it is conceivable that there would have been no American support and that the manuscripts might have been withdrawn. But all should have straightened itself out within a year or two, because the climate was still favourable to such purchases.

In June 1930 it was clear that the rally from the great October crash had failed to sustain itself on Wall Street, but in that month a brass fifteenth-century aquamanile was sold at the Berlin Figdor sale for the record price of £5,000, while at the Vienna Figdor sale a gold-thread late fifteenth-century tapestry panel was sold for about £20,000. On the 17 July Sotheby's sold the two Romanesque enamel chasses from Malmesbury and Croyland for £9,000 and £4,800. The former sum, being equivalent to £33,000 today, must still be regarded as the highest auction price ever paid for one of these articles, which were still numerous in the saleroom in the first years of this century. But the summer season of 1931, the eve of the British financial crisis, saw further transactions in the same field which were just as striking. Another gold-thread Gothic tapestry was sold to Prince Paul of Serbia at Christie's for £17,850 and a French fourteenth-century ivory Virgin was sold in Paris at the Octave Hamburger sale for £2,800. In May 1931, the Duke of Norfolk's remarkable composite late mediaeval

reliquary, known as the *Howard Grace Cup*, was bought by Lord Wakefield for £11,000 and presented to the Victoria and Albert Museum. Two months later this feat was capped by an American, as if to bid defiance to the affairs of Wall Street. For in July 1931, at the end of the last prosperous London season for the next four years, E. S. Harkness bid £10,000 at the Harewood sale for the *Canning Jewel*, an early sixteenth-century work, surrounded with romantic legends, which had been bought at the Canning sale of 1863 for £300. This also was given to the Victoria and Albert Museum.[1]

The crisis of the pound in September 1931 had an immediate impact on the following sales season. I have already referred to the attempt to take advantage of the cheap pound by selling the Lothian illuminated manuscripts in New York (Vol. I, page 210). In fact, this was putting one's head in the lion's mouth. On 21 January 1932 the pound stood at 3·48 dollars. The beautiful English fourteenth-century illuminations of the *Tickyll* or *Tickell Psalter* were not unreasonably expected to fetch as much as the £33,000 *Bedford Book of Hours* (160,000 dollars in July 1930). But instead of making something in the region of 160,000 dollars, the *Tickyll Psalter* was allowed to go for 62,000 dollars.

This was possibly one of the worst casualties of the slump, for since the later 1920s the present-day basis of valuation for illuminated manuscripts had become established—that is to say, they were now regarded as old master paintings of the early schools rather than as manuscripts. This revaluation had begun with the Northwick (1925) and Holford (1927) sales, containing the remains of the pioneer collections of separated illuminations which had been formed by Celotti and Young Ottley in the early nineteenth century, and whose value had stayed hitherto almost static.

With these sales may be contrasted the two Chester Beatty sales in the summers of 1932 and 1933. Though less magnificent than the Yates Thompson sales of 1919–21, the Chester Beatty sales certainly merit comparison with the Dyson Perrins Collections, which was sold nearly thirty years later. It might be fair to say that the best of these manuscripts were only bid up to a third of what had been their value in the 1920s and a twentieth of their present value. The dearest of the Chester Beatty manuscripts, the *Hours of Prigent de Coetivy*, which was bought-in at £5,000, might now be nearing the six-figure region. To take actual concrete instances, the *Mostyn Gospels* fell from £2,250 in 1920 to £1,500, while a *Naples Breviary*, which had fetched £3,300 at the

[1] Bought in India by Charles, Earl Canning (1812–62), and said to have been a gift to the emperor Akbar from the Medicis of Florence.

1925 Northwick sale, now made £1,250. At £1,500 a *Carolingian Gospels* with illuminated canons had scarcely advanced in price since 1909.

The subsequent adventures of this market show that the finest illuminated manuscripts had certainly not been over-valued in 1929, even though recovery from the long slump of the thirties proved to be very slow. The most striking casualties of the slump were, as I have already suggested, the late Chinese porcelain for which several millionaires had competed during the First World War, but which no longer inspired unbounded faith. As late as the Elbert Gary sale of 1928, it was still possible in New York for a Chinese black hawthorn vase to make £6,180. It was not a quarter of some of the millionaire prices of 1914–16, but it was nevertheless a typical *famille noire* price, though the last for seventeen years. Much lower prices were paid in London in June 1931, more than three months before the British crisis, when a typical *famille noire* 11in beaker made only £1,313 10s and two smaller *famille jaune* beakers £1,102 10s between them. In 1933, at the Edison Bradley sale at Christie's, two trumpet-necked vases over two feet high, the most expensive sort of *famille noire*, made £1,155 and £1,680, but during the war years prices of this order were halved on several occasions.

In the 1920s mounted Chinese pieces and outsize mandarin vases, preferably with rose-coloured backgrounds in the Pompadour taste, had fared better than *famille noire* and *famille jaune*. Their fall was even worse. In 1929 a celadon bowl, mounted and signed by Caffieri as an elaborate bonbonnière, made only £178 10s at Christie's, though on the very eve of the war it recovered to £580. It was not till the late 1950s that French *monture* became a four-figure market again. As to the mandarins, in March 1929 Lord Crawford's garniture of five rose-ground urns and beakers, an exceptional set from the Ercolani Palace, Bologna, could still make 5,000 guineas. By 1934 two rose-ground vases and covers, 54in high, could be bought at Sotheby's for £200, while in 1936 Christie's sold two others at the Alfred Morrison sale for £142. Even in 1957 a pair, which Duveen had sold E. T. Stotesbury for a reputed £10,000 in 1914, was sold at Parke Bernet's for no more than £427.

Unlike Chinese porcelain in the richest eighteenth-century taste, early European porcelain was destined to make a recovery after the war at prices which sometimes outstripped the pace of inflation. In its early stages the fall was not nearly so drastic and the turning point was once again, not 1929, but 1931. English porcelain had not been a

flourishing market in the 1920s. After the astonishing prices which had been paid in 1919 and 1920 for Chelsea gold anchor period garniture vases in the Sèvres style, the market fell very flat. The imitative rococo style was less in fashion, while the folky, English-looking early pieces were slow in becoming a truly rich man's taste or an international taste, as they are today. Nevertheless, in 1930 Hurcombs could sell a tall pair of Chelsea figures *en bosquet* and with scrolling rococo bases in the true Lady Charlotte Schreiber taste for £3,250. On the whole, Chelsea stood up to the depression years fairly well, because it was an almost totally insular market. The worst stage did not begin till the barren, unpredictable war years. An interesting example of the effects of the depression is the cost of the set of figures, known as *Apollo and the Nine Muses*. A complete set was bought by Lord Bearsted at the R. M. Wood sale of 1919 for £2,625. In 1932, after the crisis of the pound, Humphrey Cook's set, with one of the Muses missing, was bought-in at £892 10s, to be sold outright in 1936 for £680, or only £75 a figure.

The Sèvres market had failed to survive the First World War. The best prices at one of the smartest sales of the "false boom", the Carnarvon sale of 1925, were well below the standards of the 1890s and early 1900s, though a tall pair of *rose Pompadour* urns achieved £2,825. Long before the full impact of the depression, which made it impossible for any piece of Sèvres to fetch more than £250 for about fifteen years, the price of a dinner service had fallen lower than at any time since the 1830s. The Founès service of 147 pieces with gold and green borders was bought by Duveen in Paris in May 1929 for £1,045. Two services which were sold at Christie's in 1930 cost the one £483 for fifty pieces, the other £1,050 for ninety-two pieces. Lest it be thought that these services, which worked out at from seven to ten guineas a unit, were inferior wares, it should be added that the £483 service dated from 1757 and that thirty-six plates of the Founès service were sold in New York in 1959 for £21,420, or close on £600 a plate.

In Germany in 1931 the fear of another bout of runaway inflation produced a much stronger porcelain market. At the first Goldschmidt-Rothschild sale a *rose Pompadour* tureen and cover soared far beyond its dinner service value at £1,160, but in 1957 it was to make no less than £10,360 at the Walters sale in New York. Meissen porcelain at the Berlin sale of 1931 did even better with two vases in Watteauesque style on claret grounds at £2,200, whereas in London two of the famous white porcelain statues of animals from the Dresden Japanese Pavilion made no more than 100 and 200 guineas, under a tenth of

their present value. Two of Bustelli's Nymphenburg Italian comedy figures were sold at Christie's in the 1932 season at £399 and £246 15s.

French furniture became a weak market everywhere between 1932 and 1937, but between 1929 and 1931 it simply stayed level. On the other hand, English furniture, which had begun towards 1920 to rival French furniture, now for the first and only time overtook it. An extremely strong market extended from 1928 to the summer of 1931, remaining completely impervious to the first stage of the depression. It is quite an interesting exercise to compare the prices of these four seasons with the next boom period, which can be placed between 1957 and 1961, remembering to multiply the former by 3·7. The prices of 1928–31 come out considerably higher, but the difference in character is more significant than the difference in price. In the first list, items of Queen Anne walnut furniture are far more numerous than in the second, while items of the Sheraton satinwood period are much fewer and Regency items do not figure at all.

One wonders whether Earl Howe's Queen Anne console table with matching wall-mirrors and torchères, which was sold in the summer of 1928 for £10,605, would be worth £41,000 today. Would Lord Brownlow's suite of six Queen Anne walnut chairs and a settee with tapestry panels by Bradshaw of Fulham be worth £31,000, the equivalent of the £8,400 which it made in 1929. One may wonder, for in New York in 1960 the much more written-up Maddingly Hall suite of eight Queen Anne chairs in singularly attractive *petit-point* embroidery made only £6,070 at the Walter Chrysler sale.

Another extremely interesting feature of the boom in English furniture was the strong American support, which continued well after the beginning of the depression. At the Flayderman sale in New York in 1930 a lady's desk by John Seymour, made about the year 1760, cost £6,230 (roughly £23,000 in present-day money). A Chippendale tea table, shipped to New England in 1763, cost £5,860 (over £20,000) while a cabinet desk, a native product made in New England, cost £2,575. This was one of the first high prices for colonial furniture and a foretaste of the prices in the region of £4,000 which were paid in the 1950s before the American market for furniture went rigorously French again.

The present-day cost of English silver of the late seventeenth and earlier eighteenth centuries never ceases to astonish. There are such items as the two Charles II ginger-jars with their trays and covers which were sold in 1962 for £18,000. This meant about 5,000 shillings an ounce, but normally the price of the very finest silver of this most

attractive of periods is from 1,500 to 2,000 shillings an ounce. Allowing for the multiplication scale of 3·7, this is less than the price of several examples which were sold in 1929–31. For instance, in 1938 two ewers by Samuel Pantin, dated 1713, were sold for £1,800, but in 1929 they had cost Randolph Hearst £4,200 at Lord Brownlow's sale. Hearst was a considerable buyer in the first two years of the depression, and here again the American salerooms came into line. At the Flayderman sale in New York in 1930 a pair of two-handled cups and covers, made by Robert Leake in 1695, cost him £3,990. The last expensive piece of plate to be sold in London before the autumn crisis was at the Page-Croft sale in 1931—another pair of these very popular two-handled cups and covers, dated 1685, at £3,038.

Silver was heavier hit than most categories in the second wave of the depression, partly because of the fall in its bullion value, partly because silver plate is seldom a very aesthetic market. In 1933 this fall was almost incredible. For instance, Horace Walpole's two square waiters, made by Lamerie in 1728 and in the Hillingdon family since the Strawberry Hill sale, were sold for £263, or less than £5 an ounce. On the other hand, Elizabethan silver, having been supported by the incredible collecting mania of William Randolph Hearst, remained cushioned so long as he was in the market. It should be noticed that in 1930 the market was very nearly as high as it is today, even when ignoring the 3·7 multiplication scale. The *Wilbraham Salt* of 1585, a strange, gourd-shaped construction, was actually sold in 1930 for £3,275 5s, or 3,300 shillings an ounce. In 1960 it realized only £2,700. The break in Elizabethan silver prices hardly began before 1938, but recovered towards the end of the war, to remain one of the most static of markets.

Elizabethan silver is an extremely individual case, in which the pattern was created almost entirely by a single man, but it shows the difficulty in assigning any fixed length to the period of the great depression in the art market. Judged purely on stock market values, the very worst was past in July 1932. But from the point of view of social history the whole of 1933 was a crisis year both in Germany and the USA, while 1935 was a crisis year in France. In Volume One I spoke of the world recession of 1929–33 and the financial recovery of 1933–6. But there is a strong case for regarding the entire decade 1929–39 as a recession, inasmuch as neither the stock markets nor the volume of international trade had recovered their 1929 position at the outbreak of war. I also pointed out that in the case of the favourite millionaire market, the portraits of the English eighteenth-century school, the sharpest falls occurred in 1934, which was technically a year of recovery

(Vol. I, page 211), and that the lowest level of the market was reached in the course of the war.

One has to distinguish between the temporary casualties, which were due only to the depression, and the casualties which remain casualties to this day. In the former case certain sales stand out as landmarks. In the USA pre-slump conditions seemed to have returned to the market at the Thomas F. Ryan sale in November 1933. In London one would hesitate between the Solly Joel sale in May 1935, where Duveen rallied in such a spectacular manner to the defence of the English eighteenth-century school, and the James Pierpont Morgan Junior sale two months later, where some of the great Pierpont Morgan's portrait miniatures fetched prices that must have satisfied his shade. But even after these dates recovery was ragged and without discernible currents.

London at any rate had four dreary sale years between 1931 and 1935, but in that respect it was by no means isolated from the Continental stream. The troubles of the crisis of the pound of 1931 spread everywhere. Each country had its devaluation, its "new deal" in varying degrees of success, its exchange controls, its fear of war, its forbidden thought that an arms race was the only economic solution for the world. Under the governing force of these factors, markets tended to become isolated. High international competition flared up but rarely.

Mr A. C. R. Carter summed up the year 1932 in *The Year's Art* as the worst he could remember in the saleroom since the early 1880s, when he began recording sales. The dearest picture of the year in London, a Frans Hals portrait, was sold by Sotheby's for only £3,600. The internal economic systems of the nations of the world were so firmly locked-up that there was no rush of foreign bidders to take advantage of a pound that had fallen from 4·86 to 3·45 dollars and from 125 francs to 70, more or less. To take the case of French furniture, a *bureau à surprises*, a typical construction of David Roentgen, did make as much as £2,000 in the Grand Duke of Saxony's sale at Sotheby's, but that was a higher price than the Paris market was now capable of, though equivalent only to £1,400, gold standard. Nowadays a successful London season is expected to yield half a dozen lots of French furniture in the £5,000 to £35,000 class. In 1932 only sixteen lots exceeded 200 guineas each, and in 1933 only four. In 1934 the best piece sold in London, a *bonheur du jour* with the coveted mark of RVLC (Lacroix) cost £262 10s. To find another year as bad as that, one would have to go back to the early 1860s.

The early 1930s also marked the nadir of the market for Italian bronzes of the Renaissance. In four first-class sales, those of Henry

Hirsch (1931), Sir John Ramsden (1932), Leopold Hirsch (1934), and Henry Oppenheimer (1935), nothing reached £800. Paduan bronze inkstands of the Riccio school, which might have cost in the region of £3,000 in the great year 1912, were sold for £131 5s. in 1933 and for £84 and £52 10s in 1934, a fall as great as that of the Hope statue of *Athene*, which was sold for £200 in July 1933 (see page 244). But in the market for sculpture the very exceptional could still count. At the Thomas F. Ryan sale in New York in November 1933 Duveen was in the market for the Laurana coloured bust of a *Princess of Aragon*. He paid £21,000, but was said to have sold it to J. D. Rockefeller, Jnr, in the following year for more than £100,000. At this sale even the Limoges enamels displayed resiliency with a single and unusually charming plaque by Jean Limousin at £1,200. The sale was held at a moment of strong optimism. After his first year of office, President Roosevelt's New Deal had shown some results. It was also the eve of the repeal of prohibition.

The symptoms were certainly not repeated in London. In the following May two Limoges enamel salts by Jean Limousin, which had been sold for £3,675 in 1913, were allowed to go for £378. A signed tazza by Jean Court, rather less than perfect, cost only twenty-eight guineas. And in this same month of May a category so rare that one would have thought it foolproof—namely, French Renaissance silver—took a fall. A pair of Paris tazzas, nearly 1ft wide and dated 1599, were sold at Christie's for 1,400 guineas, having made 3,400 guineas in 1919. But still more remarkable was the reappearance of an early nineteenth-century favourite, one of the silver-gilt dishes or tazzas supporting solid statues of the twelve Caesars, which had once been attributed to Benvenuto Cellini. In 1834 they had made history when the celebrated George Robins had sold all twelve of them for 1,000 guineas. At the Spitzer sale of 1893 six of the Caesars were sold as late sixteenth-century South German works for £2,770. At the Earl of Ashburnham's sale in 1914 a single tazza with the figure of the Emperor Titus cost £1,680 on its own. But in 1922 it fell to £580, and now in March 1935, among all the symptoms of recovery, it made only £280, and at the very end of the war the tazza was sold again for £230.

A queer "posthumous biography" for an object once esteemed in the very highest class. The inference is not very obvious. Mainly, these singularly attractive tazzas, two of which are exhibited in the Victoria and Albert Museum, suffered from the realization that they were not by Cellini and not even Italian. They also had the fate to be sold in bad years. The sales of 1935 and 1914 show something further—namely, the

unpredictable nature of the silver market when there is neither Anglo-Saxon nor Parisian snob value to be exploited.

The summer of 1935 revealed further heavy casualties in the traditionally Pierpont Morgan market, though Pierpont Morgan's miniature portrait of the Holbein school, *Mrs Pemberton*, cost Duveen £6,195 (£2,750 in 1905). Thus an enamelled thirteenth-century chasse could be bought for £996, a dated Maestro Giorgio dish for £609, while the Fitzwilliam Museum acquired a Hispano-Mauresque fifteenth century ewer, which might have cost three times as much in the middle 1920s, for £346 10s. Most significant of all was the fate of an elaborate fruit-stand of Henri Deux ware. It had been bought-in just before the crisis of the pound in 1931 at £2,000. Two to three thousands would certainly have been its value in the 1920s. But in June 1935 it was allowed to go at £787 10s. In 1952 a hexagonal salt-cellar of Henri Deux ware, the very last of this rare band to come under the auctioneer's hammer, was sold for £1,102 10s. And now we simply do not know what its value would be.

December 1935 bore the mixed look of a new sort of art market emerging from the ruins of the old. The dearest print in the world, Rembrandt's etching of *Jan Six reading at a Window*, had been bought from Colnaghi for £9,000 in 1928. It was bought back by Colnaghi at the Innes sale for £2,735. At Anderson's, New York, a pair of "blue hawthorns," £5,000 beauties maybe when the century was in its teens, were sold for £650, and that must have been a sentimental price with New Year's Eve so near at hand. But Anderson's got more than £3,000 for Van Gogh's *Printemps près d'Arles*.

The mixed look continued, more puzzling perhaps in retrospect than it appeared at the time. In the summer of 1936 the art market was healthy enough to be capable of absolute records. Duveen was nearing the completion of his greatest deal, selling forty-two pictures to Andrew Mellon for 21 million dollars. Small wonder that in July the late Henry Oppenheimer's quite spell-binding old master drawings were sold by Christie's at prices out of some dream. Whoever had heard of a pencil sketch at £10,710, when two thousands were something stupendous for any drawing on earth? (see Vol. I, page 218). And yet the casualties still lay by the roadside. The Michelham secrétaire, signed BVRB, had been the first £10,000 piece of furniture in any saleroom in November 1926, but in 1936 it was down to £1,312 10s. In the same year, The Earl of Dalhousie's mid-thirteenth-century *Evesham Psalter* was bought for the British Museum, ludicrously underpriced at £2,400. The Quilter Beauvais tapestry suite

after the grotesques of Jean Bérain made £5,220, the first expensive tapestry in the London salerooms in six years, but at perhaps a third of its value in the 1920s.

The Victor Rothschild sale of April 1937, held in all the Disraelian magnificence of No. 148 Piccadilly, showed that once again it was possible, though only briefly, to bid £8,000 for a secrétaire by Martin Carlin and £2,900 for an ostrich egg in a fine sixteenth-century German mount. But even at this highly glamorous sale the Dutch paintings were depressed, while the Arab enamelled glass bottle at £480 and the Henry Deux ware biberon at £600 were decidedly underpriced. A squatting buffalo in jade of the Ming period, which was to cost £3,000 in December 1948, and which might be worth £10,000 today, sounds very cheap at £560, but it was possibly the only object in the sale to have doubled its value since 1912.

Elsewhere the year 1937 saw interesting rectifications. The high-class tapestry market of New York returned with £26,000 paid for three early sixteenth-century Tournai panels at the Brady sale. Something more like full justice was done at last to mediaeval illuminations with £13,500 paid for the *Hours of Isobel of Brittany* (*c.* 1400) from Clumber. An absolute record for eighteenth-century silver was achieved in New York, where £6,200 were paid for a Monteith punch-bowl of 1722, the work of John Coney of Boston. That not very outstanding object cost in modern money terms £23,000, or about 5,000 shillings an ounce. In reality, it might not be worth much more than its original price without the multiplication.

"Ins and outs" are again the chief interest of the first of the Mortimer Schiff sales, held by Christie's in June 1938, a little before the Czechoslovak crisis and the age of *Angst*. Bouchardon's marble group, *Cupid bending His Bow*, had made the somewhat run-of-the-mill price of £3,750 at the Wimborne sale of 1923. Now it showed a slight increase at £3,885.[2] Yet in the previous April a *Baigneuse*, which had cost £3,350 under the attribution of Falconet at the Taylor sale of 1912, had made only £241 10s at Christie's sale of Durlacher's stock. Again it was high Renaissance objects which showed the least response to the general recovery. Two Limoges enamel tazzas, sold in 1910 and 1912 for £2,050 and £1,732 10s, were now sold for £283 10s and £315, the former being the work of the once so romanticized Suzanne Court. A Celliniesque object, a heavily mounted rock-crystal nautilus shell, might not have seemed extravagant to Beckford 120 years earlier at its present price of £472 10s. But in May Sotheby's had sold

[2] Kress Foundation, Washington, since 1950.

something even more Beckfordian, a gold-mounted rock-crystal biberon from the former Royal Collection in Dresden for no more than £600, a long way from the £20,000 biberon, of 1905.

As to the unloading of the huge accumulations of William Randolph Hearst in London in December 1938 and in New York in January 1939, the sad fate of a famous commode by Saunier has received attention in the last chapter (see page 239), but the newspaper millionaire was more generally known for his silver and armour collections. Hearst had bought most of his English silver of the sixteenth to eighteenth centuries in the last few years of his life, filling a castle in Wales and a palace in Florida. The manner of his collecting and the anxiety of the times were hardly propitious for a good sale, but it is surprising that there was no out-and-out landslide. It is less surprising that the New York sale, which disposed of the most expensive objects, showed the worst falls, such as two Elizabethan flagons, £3,500 in 1905 and now £1,475, two Elizabethan scalloped dishes, £3,300 in 1929 and now £1,405. Most of the lots, sold in London, which had been bought at the prices of the 1930s, fell about a third, but the Galway Corporation sword and mace of 1709, for which Hearst had paid £5,250 in 1935, was bought-in at £1,995.

The summer season of 1939, the season when everyone anticipated war, ended on a less propitious note, but not as badly as one might imagine. Even in April 1939 a secrétaire by RVLC (Lacroix) could command £6,500 at Sotheby's, but in July the tapestry *Bacchus and Ariadne* from the Boucher suite *Les Amours des Dieux* fell into the hands of Paul Getty at no more than £2,700 (see page 180). At the Clarence McKay sale at Christie's in the same month, the same buyer paid £6,300 for a very well-known sixteenth-century Ispahan carpet. Ten years earlier the price might have exceeded £20,000. Among McKay's armour in the London sale was that greatest of rarities, a Tyrolese pig-faced bascinet of the fourteenth century, which went to the Tower Armouries at £2,730. This was one of the very few expensive objets d'art sold in a distracted season and the purchase did not escape the notice of the press, but the price bore no relation to the importance of a relic of true mediaeval armour, to which there were not half a dozen companions in the world. It was believed to have cost McKay several times as much in 1924.

The Otto Pringsheim collection of Italian maiolica was on so big a scale as to occupy Sotheby's for two days in June 1939. In the present decade, when pieces which then cost £20 or £30 have risen to as many hundreds, the very name of this sale has become a byword for a

landslide. In fact the best of the prices were much higher than during the slump—higher, for instance, than at the Glogowsky sale of 1932. Maiolica had already been a depressed market for fifteen years when the war broke out.

2. *War and Economic Isolation*, 1939–53

There is no need to re-emphasize the essential differences between the two world wars in their impact on the art markets. In so far as they relate to pictures, they are discussed in Vol. I. For objets d'art the situation in the first four years of the war was even more drastic. The recovery of 1935–9 had already trembled in the balance during the last summer months. After Dunkirk the existing stagnation quickly became a landslide. A museum or two might still want to pick up a picture on the cheap, keeping it in storage for the duration of the war, but who wanted anything that could be broken? In all probability, there has never been such a fall in values in history.

By a singular trick of destiny, the finest sale of Asiatic art in all the annals of modern collecting took place at Sotheby's between 28 May and 6 June 1940. That is to say, it covered the six days of crisis, during which the British forces were evacuated from the Dunkirk beaches. A large part of the Eumorfopoulos Collection had been acquired for the nation through subscribers in 1935–8. Consequently, the objects which faced the saleroom after the owner's death were for the most part a second collection, but they had nevertheless been bought with the same scholarly bias towards the earlier ages and towards the first recognizable prototypes—the bias which had been a characteristic of the advanced collectors of 1912 and thereabouts. The sale has become a legend of calamity, but not altogether with justification. Many of the prices appear low today, because these are the kind of objects that have appreciated more on the post-war market than any others. In 1940 some of these prices were in fact not low at all. The catalogues had gone out in April, and sufficient interest had been shown by American bidders to determine the executors not to cancel the sale as the bad news came in. These particular objects did well, and for the period they constituted quite a formidable list. Nevertheless, much had to be bought-in and at £36,000 in actual receipts the collection was certainly sacrificed.

The subject is a little too specialized for detailed analysis in this chapter, and in any case a fair number of prices will be found in my lists. In general, Chinese mediaeval wares were well supported, but the Near Eastern section of the sale, apart from a few American purchases,

fared lamentably. Some of the worst falls were among Eumorfopoulos's Ming wares—those of the rich cloisonné or Fa Hua type fetched about a tenth of their value in the early 1920s. For instance, a turquoise-ground jar in meshed relief went for £35, to be resold in 1953 at £800.[3] Those of the early Ming blue-and-white type, which Eumorfopoulos had bought only in the last few years of his life, were mostly sold for less than £20 each. Few of them would fail to reach four-figure prices today. Against these can be offset certain absolute record prices among the American purchases: a prehistoric bronze wine vessel from An Yang at £1,400, a headless early Khmer stone torso at £1,600, and a thirteenth-century Islamic damascened bronze pilgrim bottle at the same price.

The situation for early Asiatic art was actually worse a year later. The H. K. Burnet sales were held at the beginning of April 1941, just as the German bombing raids had begun again with the big attacks on Bristol. Fine Chou and Shang bronze vessels at from £100 to £230 were probably cheaper than at any time during the century. A pre-historic jade prism vase cost £125, six T'ang pottery dancing maidens, an excellent set, today worth certainly a four-figure price, cost £58. In June Major Macaulay's Persian miniature by Bihzad, a posthumous portrait of Timur Leng on cotton, cost £440, a tribute at least to its extreme beauty and rarity, but probably not a twentieth of its present value. The same month saw a pair of the once so coveted Chinese rose-ground urns and covers sold for £262 10s.

The worst decline in the second summer of the war was in the normally safest, because least international, of markets. The Bellamy Gardner Collection of English porcelain was considered first-rate, but the prices of June 1941 were possibly the lowest since the time of the great Bernal sale of 1855 (see page 169), simply because porcelain was easily breakable. A Chelsea asparagus tureen, illustrated by Hobson and King, cost £36. The last example of this type of tureen to have been sold cost £1,450 in March, 1963. A pineapple tureen (£800 in 1956) cost £32. Important Chelsea figures in fine condition cost from £42 to £155 a pair, the latter price being paid for two figures en bosquet of a kind that could have made £3,000 or £4,000 immediately after the First World War. One of the simpler early Chelsea products, a white head of a baby boy in the style of Fiammin-go, cost £16. In 1962 three copies of this head were sold for £2,000, £1,250, and £1,200 respectively.

The summer of 1941 marked the true bedrock of the objets d'art

[3] For Fa Hua ware in 1924, see page 252.

market in wartime London, and it was perhaps English porcelain which made the swiftest recovery. In fact, by 1944 Chelsea figures had reached the highest prices since 1920. It is worth adding that June 1941 was by no means a month of world depression in the art market. In the middle of the best New York sales season since the slump, the Henry Walters Collection was sold for close on 650,000 dollars, or £162,000, with French commodes and drawing-room suites at £3,000 and more, and with four Chippendale armchairs at £2,700.

Silver, being more easy to protect, was nowhere near so serious a wartime casualty as porcelain. The sale of Lord Rothermere's silver on 3 December 1941 was an historic event, because it was the first sale at Christie's, where all the lots were sold "all at"—that is to say, the practice of selling silver plate by weight as if it were cheese, having survived the Roman Empire (see page 9), the Middle Ages, and the Renaissance, was now totally abolished. The prices at this sale were not altogether bad, since the times were less stringent. No bombing raids, no German capture of Moscow, and the panics of Pearl Harbour and Singapore all to come. Some of the Rothermere pieces have reappeared on the market since the growth of inflation, and their resale indicates how much more late seventeenth- and eighteenth-century English silver has advanced than the silver of the earlier periods. For instance, in December 1941 a sideboard dish of the year 1707 was sold for £460, but in 1960 it made £4,100. The two wine-coolers by Mettayer, dated 1714, which had fallen from £880 to £660 between 1939 and 1941, will have advanced between 1941 and 1963 in at least the same proportion as the sideboard dish. On the other hand a spice-box and cover, shaped like a scallop-shell and dated 1610, advanced only fivefold between 1941 and 1960, namely from £600 to £3,000. Even in 1941 later Stewart silver was a rising market, since the dearest Rothermere piece, a tankard of the year 1671, which weighed close on ten pounds, had risen from £767 to £1,900 since 1962.

By contrast, the important collection of George A. Lockett, which was sold in the dismal month of April 1942, showed drastic falls in High Renaissance silver. The Francis Drake terrestrial globe-cup, made by Gessner of Zurich in 1571, had been bought in 1919 for £3,800 (equivalent to £10,600 today). It was now acquired for the Plymouth Art Gallery at £2,100. Two other terrestrial globe-cups made in Nuremberg in 1620, fair examples of enemy art, made only £980 the pair. There were many Renaissance objets d'art in the Lockett Collection from the Margam Castle sale of 1921. A Maestro Giorgio lustre dish fell from £1,627 10s to £556 10s and a Limoges enamel dish by

Jean Courteys from £819 to £173 5s. Finally, so excessively rare a piece of armour as a *salade à queue* of about the year 1460 cost £315. During the American armour craze of 1921 this had cost Lockett £2,047 10s as one of the cheapest lots from Margam Castle.

A pair of Chinese celadon vases in the shape of leaping carp in mounts worthy of the Caffieri family cost £309 5s, surely the lowest price for such luxurious favourites in at least three generations. But the French *dix huitième*, a market which always requires the presence of foreign buyers, was now at the lowest ebb of all. At Lockett's furniture sale in the following June a pair of encoignures, closely matching the Duke of Leeds' commodes which had made 15,000 guineas in 1901 (see page 141), cost only £630. An elaborate *bureau à cylindre* by Roentgen, which, it was suggested, might even have been the original *Bureau du Roi Louis XVI*,[4] was sold for 450 guineas.

Before the battles of Alamein and Stalingrad had marked the turn of the tide, some American museum-buying on a small scale helped to rally the market. In October the Cleveland Museum paid £820 for a Maestro Giorgio armorial dish of 1524, while Lord Rothermere's Egyptian Old Kingdom limestone statues cost £2,000 and £2,400, and James de Rothschild's Book of Hours in the style of Pol de Limbourg £5,800. This was the dearest objet d'art sold since the outbreak of war, but well under a tenth of its present probable value. Nor did the mood of confidence which followed the big German retreats in Russia and North Africa go far to revive the market. In May 1943 a pair of tall *famille verte* baluster vases in the richest of "Salting taste" cost £370. In the following October Viscountess Harcourt's *famille noire* oviform vase cost £756, and in the same sale that once so much coveted object, a suite of eight Louis XV gilt-wood chairs and a settee, upholstered with tapestry panels after Huet, was sold for £378. One would have to go back to the depression of the middle 1880s to find a price like this for a tapestry-covered suite, whatever its dubieties and imperfections.

Again it was the silver market which was the least depressed. In the winter of 1943 an English spoon of the year 1481 was sold for the absolute record price of £1,400. The last English fifteenth-century spoon to make a record price had been a spoon of the year 1488, sold in the famous Dunn Gardner sale of 1902 for £690. Another item from that sale actually reappeared in 1943, the extraordinary Elizabethan construction of silver-gilt, crystal, and precious stones known as the

4 Cyril Blunt in the *Connoisseur*, September 1944.

Stonyhurst Salt. Sold in 1902 for £2,000, it made £2,800 in 1943 and £4,500 in 1957; on paper an advance—in reality a steep decline.

The real recovery in English prices begins, I think, in April 1944 with the furniture of J. Pierpont Morgan, Jnr, from Wall Hall, Aldenham. The prices were far from level with wartime inflation, but at least they were as good as in America, with Sheraton satinwood commodes and cabinets at about £800 each. More remarkable was Pierpont Morgan's English porcelain. Three Worcester hexagonal vases and covers cost something approaching a normal price at £504. As to Chelsea, *The Music Lesson*, after a Vincennes model, designed by Boucher, had always been one of the more expensive groups of figures. In 1770 a copy, straight from the factory, had been auctioned for the high price of £8. In 1896 an example cost £483, in 1911 £1,837 10s, but in 1930 as little as £568. At the Humphrey Cook sale in February 1944 an example of *The Music Lesson* cost £1,890, to be beaten two months later at the Pierpont Morgan sale by yet another at £2,047 10s. In reality this was not the beginning of a boom, but the revival of a waning taste, for it is doubtful whether in these days of £4,000 tureens and £2,000 scent bottles, this imitative group would make as much as in 1944. Perhaps the same can be said for Pierpont Morgan, Jnr's, 250-guinea Sèvres cup and saucer in *porcelaine à émaux* by Leguay, for jewelled Sèvres had not been popular even in mid-Victorian times (see page 32).

In the winter of 1944, with not a vestige of French or American competition in the market, an important Louis XVI commode in the style of Weisweiler could make no more than £682 10s. However, at the beginning of 1945 the normal price levels of the late 1930s had returned, if not for *dix-huitième* taste, at any rate for almost everything else. For instance, in February 1945 a wonderful Chou period bronze vessel could make as much as £1,080 at the Lionel Edwards sale, and a table screen of green jade £735, which was also the value of such an article in 1935.

The R. W. M. Walker sale of July 1945 was held in an optimistic atmosphere. It was only on the last day that the nation received the news that it would be governed for years ahead by a swinging Labour majority. Moreover, the sale was held a few weeks before the spectre of Hiroshima began to bedevil the affairs of man. The sale made £156,000, no more than £50,000 was worth in 1914, but nevertheless the first event on this scale since a time far back in the 1930s. The pound in July 1945 bought twice what it buys in 1963, and in this light some of the prices seem higher than those of the inflation era, particularly

the little English rock-crystal and silver-gilt salt of 1549 at £5,700 (£11,400), a flagon of 1594 and a tankard of 1578 at £3,100 and £3,300.

Among the Chinese porcelain of the Walker sale, all in the lavish taste of the first years of the century, a pair of figures of phoenixes or crested birds on rocks made £2,100, for it is only the paired birds that have been spared by the modern reaction against this taste. In the 1960s a pair can cost £9,000 and more, but during the recession years of the 1930s they were sold for as little as £230. The two phoenixes in the Walker sale have had a smart follow-up; not so the two *famille noire potiche* jars and covers at £13,125. Of course, in terms of the year 1914, when such a pair could easily have been bid up to 15,000 guineas, gold standard, this sum of money would have been equivalent to no more than £4,500. And yet there has been nothing like it in the last seventeen years of the London salerooms. As far back as June 1924, when a *famille noire* pedestal vase had figured in the Testart sale, Seymour de Ricci recorded his belief that the American millionaires had drained the market long ago.[5] Yet the assumption that all these accumulations are frozen off has proved false. In December 1962, two 20in pedestal vases appeared at Parke Bernet's, New York. The hawthorn vase made only 1,000 dollars or £355, the livelier dragon vase 5,500 dollars or £1,966 10s. Since the necks had been repaired in both cases, it is a fair estimate that the £13,000 pair of 1945 have stayed level but they will hardly have advanced (see page 291).

One significant point which emerged at this very important sale of July 1945 was that collectors' taste in objets d'art had become much more feminine. For instance, the sale saw the beginning of the meteoric advance of the Nymphenburg Bustelli figures with the Victoria and Albert's purchase of *Ottavia* at £567. This was about double the best previous prices for Bustelli figures and about a tenth the record price of 1954. On the other hand, the thirteenth-century Arab glass beaker, enamelled with horsemen (£735), and the Hispano-Mauresque armorial dish of 1460 (£420) were sold at a mere fraction of the best gold prices of the past. At the present moment it would apparently take a very fine example of either kind to rival a Chelsea scent bottle.

The period 1945–53 is hardly one of the most interesting in the annals of the objets d'art market of this century. There is no need to emphasize the characteristics of that very recent slice of time—the fact that the rationing of food, clothing, and petrol continued, that the controls over the entry of foreign currency and the departure of sterling remained

[5] *Chronique des Arts.*

vigorous, that business profits were checked, and that stock exchanges were unresponsive. A Conservative Government took over the reins early in 1951, but another two years passed before much change was noticeable. In the meantime, the purchasing power of the pound, halved at the end of the war, was all but halved again. In 1953, at the end of this eight-year period, the pound bought barely a fifth of what it bought in 1914, yet the only response of the market to this high degree of inflation was to keep most prices at the levels of the later 1930s. Catching up with inflation only began on a general scale with the changes in the American fiscal system and the British Government's freeing of the movements of foreign exchange in the case of art sales in 1956 (see Vol. I, page 229).

During these first eight post-war years the international market was not yet dominated by the apparently limitless resources of American museums. Nor was there the present alacrity to prevent or at any rate to obstruct objects deemed to be important from leaving England. Objects of the greatest historic rarity failed therefore to attract the fanciful prices that are now demanded for them. For instance, in the prosperous year 1928 a very small early fifteenth-century tapestry which its former owner, Sir Hercules Reed, had good reason to believe to be uniquely English, had been sold for £4,200. In November 1946 it was resold for £5,400, the equivalent of less than £3,000 in 1928. The *Psalter of Bonne de Luxembourg*, with fourteen miniatures of the fourteenth-century French school, got rather nearer its 1929 value in 1948, when it cost £16,000. Its present value can be guessed from the fact that a missal much in this style, which was sold in 1950 for £5,000, made £22,000 in 1961.

The greatest rarities certainly did not attract the degree of fuss that surrounds them at the present day. In October 1949 a saucer of the ultra-rare Medici proto-porcelain, possibly the last that could reach the market, went to America at £1,000. In June 1951 a salt-cellar of the almost as rare Henri Deux ware departed at £861. Two lost leaves from Jean Foucquet's *Hours of Etienne Chevallier* went to join their companions at Chantilly, having cost £2,900 and £1,300 in December 1946. One cannot imagine what such a rescue operation would cost today with a dozen American museums clamouring for tax-reclaimable gifts of such immense historic importance.

On the other hand, there were certain exceptions to the general pegging of the value of most types of objet d'art in the years 1945–53. Among European porcelain figures, already a booming market in 1944, Chelsea birds played a most inordinate rôle. Chinese carved jade

of the eighteenth century, which had been a singularly flat market since the days of the Summer Palace sales in the 1860s, seemed to glide into the £3,000 or £4,000 class almost overnight, sharing the company of Fabergé toys and King Farouk's glass paperweights. Emphatically this market was not shared by French furniture, tapestries, or *sculpture de salon*, and it was barely shared by a sudden, renascent American cult for Sèvres. The prescription which triumphed in 1945–53 was women's magazine taste, efficiently disseminated throughout what was still merrily described as the Free World. However, on a plane more creditable to the age, there was a corresponding advance in the cost of plain Queen Anne or George I silver.

Some of the new tendencies were already apparent at the sale of the Swaythling heirlooms in July 1946. To start with, a thirteenth-century chasse at £1,627 10s and a Gubbio lustre dish at £798 showed the dull, level market for the Middle Ages and the Renaissance, but the *rose Pompadour* écuelle and stand of 1760 at £504 and the Arab fourteenth-century glass mosque lamp at £630 were, at their opposite poles, even lower priced. On the other hand, a plain Queen Anne silver tea-kettle, lamp, and stand of the year 1707 showed quite a new price-level at £2,100. This can be compared with a similar article of the year 1703 sold in 1942 for £760.

In the same month another wealthy assemblage of the earlier years of the century, that of the late Alfred de Rothschild, pointed still more clearly the respective paths of established taste. French furniture returned (but only on paper) to pre-war levels with a very rococo commode at £3,990, against which two Dresden parrots at £2,310 the pair, with their rocaille mounts, showed an almost revolutionary trend in the Continental porcelain market. An oviform urn with elephant handles in true Wallace Collection taste, the dearest in the London salerooms since 1925, showed a distinct recovery in Sèvres porcelain at £1,680. But in real-money terms this urn did not fetch a sixth of its pre-First World War value.

The relative depression of the High Renaissance market appeared in the £2,600 which were paid for two of the famous Nuremburg terrestrial globe-cups and the £892 10s paid for a set of twelve Limoges enamel dishes by Pierre Reymond. And with these may be contrasted a totally modern trend, a Ming jade buffalo sold by Sotheby's in the previous May for £3,900. However, in the light of the prices which are now paid for the rare surviving examples of fourteenth-century Chinese blue-and-white porcelain, it is interesting to note that the David Foundation acquired the second of the two documentary

vases of the year 1351 at the Russell sale of 1946 for £330, which was £20 less than the price of the first vase when bought in 1933. These two vases might be worth as much as £20,000 today. A fifteenth-century blue-and-white "palace dish" was also in the 1946 sale at £88, and this would certainly be worth over £2,000 now.

A glance at my lists will show how very small was the increase in value of the *incunabula* of Chinese porcelain between the Eumorfo-poulos sale of 1940 and the year 1954 or thereabouts. But this, of course, unlike the *famille noire* and blue hawthorn cults of the first quarter of the century, was a scholarly rather than a smart taste, and the market only rose when the American museums began seriously to compete. For the fashionable porcelain market of 1945–53 we should consider the case of Chelsea figures of birds. For instance, in 1949 a pair of Chelsea "little owls" made £3,200, a pair of 5in swans with the raised anchor mark £4,400. More of those rare owls brought their profound message to the saleroom in 1951, one of them achieving £3,400 on its own. As to Bow and Chelsea figures in the best condition, £1,000 now became almost a minimum price. In 1953 a rare fisherman figure cost £2,250.

In 1953 prices for Meissen figures and birds had risen in almost the same proportion, but the highest Chelsea prices belonged to London's years of semi-isolation. Since the year 1953 there has been little advance in this market, except in the case of scent-bottles. The sudden rise in English porcelain after the war was due to the formation of a few new collections in America, and largely also to the activity of a single dealer. None the less, the quite unpredicted new prices have established a sort of equilibrium in a field that has never been conspicuously static in the past.

3. *The Impact of Inflation, 1953–62*

We come to the decade of the domination of the modern French school of painting, the decade of the spectacular sales which began with the Gabriel Cognacq sale of 1952 and ended with the Korda and Somerset Maugham sales of 1962; the decade of a £220,000 picture by Cézanne, who died in this century, and of an £80,000 picture by the still-working Picasso. In this decade the sum of £30,000 could be spent on a picture painted between forty to eighty years ago with about the same ease and frequency that £5,000 was spent in the first twenty years of the century on the work of the Barbizon school, the Pre-Raphaelites and their successors, or the French historical romantic painters who

culminated with Meissonier. But, as we know, all the latter categories have fallen—most of them disastrously.

It is useless to seek any parallels to these television-screen entertainments in the objets d'art market. There has been no millionaire snob cult in the 1950s corresponding to the Boucher tapestries and *meubles de salon*, the *famille noire* vases, and the Sèvres and Chelsea *garnitures de cheminée* of the first fifteen years of the century. The reasons for this have been discussed in the first chapter of this book. The cult of personal genius has left the market for style and skill far behind. Few, few indeed in these years of inflation have been the porcelains, European or Chinese, which have achieved the saleroom price of £4,000, the equivalent of a mere £650 in 1900–15. Only two pieces of furniture have passed £30,000 in the auction room, the equivalent of the £5,000 piece of furniture in the years of gold. Since the war no tapestry has come within a tenth or even a twentieth of some of the real values which were paid in America before 1929.

Such is the present-day record of the very top market for objets d'art —a market whose prizes are mainly substitutions for things that have long been frozen off. There are no more pedigree commodes and secrétaires from the French Royal *Garde meuble*, no complete suites of fifteenth- or early sixteenth-century tapestry, possibly no complete suites of the Boucher period either; no 2ft constructions, resplendent in parcel-gilt and enamels by Wenzel Jamnitzer or Hans Petzoldt, no rose-coloured *vaisseau à mâts* with its rollicking attendants. And for the substitutions of today no one wants to pay nearly as much as the richest men of thirty-five to sixty years ago paid for the things of their choice.

But for the more ordinary wares of the market every old collector and even every middle-aged collector knows that this simply isn't true. When the important pieces advance in price, the poorest things in the same category move with them in the end, but they are a great deal less likely to fall back when the very important pieces slump. As you get more down to earth, there is a measure of protection. When stock exchange prices are sliced to a fraction and the highest art prices are slashed with them—as happened in the early 1930s—the cost of a new kitchen table goes down only a very little and the cost of a pound of cheese not at all. It will be remembered that during the war years, when fine objets d'art were sold at what now appear to have been bargain prices, very ordinary carpets, glass, china, and cutlery became excessively dear, because one had to seek at an antique shop the articles of the modern showroom, which under war conditions were either not worth buying or not to be had.

This peculiar wartime and post-war symptom was only a forced exaggeration of something that had been going on for a century and more. As long ago as the 1830s Christie's were selling china which had been made within human memory as "rare old Chelsea" (see page 169), simply because it was of better quality than the contemporary product. However, until very recently it has been the common fate for objects only sixty years old to drift downwards to the poorest homes. At eighty years of age they may have achieved the status of quaintness; at a hundred years they were worth taking to a shop. In this way the more modest products of the late eighteenth century and early nineteenth century have advanced according to a system of promotion, which has been steadier and less dramatic than that of their rich relations and much less affected by booms and recessions. Fifty years ago one might have found at any small country antique shop one or two objects which would be considered worthy of an illustration today in the catalogues of Messrs Sotheby and Christie. Even twenty-five years ago such a shop might have been stocked quite plentifully with eighteenth-century objects, whereas today one sees antique shops in which literally nothing is older than the latter half of the nineteenth century and in which the greater part of the objects are not even hand-made. And an old collector will return from his shopping expeditions happily clasping a Chinese armorial teacup which has cost him £3, forgetting that there was a time when he used to see them on sale for half a crown and when he would not have dreamed of owning one.

I have prefaced this section with a rather long, cautionary tale because I want to emphasize that my description of a delayed and inadequate response to inflation, beginning about 1953, applies to the top market alone. Many readers will have experienced this for themselves. Almost everyone will own something which is worth more than he has paid for it. A few who bought a Regency card-table or some Regency chairs during the war years for £10 may already have watched their ewe lambs depart at a hundred or two and they may think that the whole of the objet d'art market is like that.

In the higher regions of the market the extremely delayed response to inflation was, of course, due to the restrictions of the various governments on the export of their currency, and also to the relatively longer time which it took for middle-class incomes to catch up with the cost of living. But the failure of the objets d'art market since the 1950s to compete with the high publicity market for modern painting goes deeper. There has been a very notable diminution in the desire to form

a collection for its own sake. By the 1950s this desire had become so rare that it might have proved impossible for the prices of objets d'art to keep pace with inflation at all, had it not been for the opportune creation of new concealed forms of State purchase. In England there was the valuation of works of art which could be accepted by the Treasury in payment of death duties. In the USA there was the profitable income-tax relief on objects bequeathed, but not yet given, to public museums.

These conditions give the period which began in the 1950s an unreal quality that is quite lacking in any past period of collecting. Of course, there has never been an age when the collecting of the very highest-priced works of art has been wholly disinterested, but the ulterior motive has been of a different nature. There must have been multi-millionaires in the early years of the century who never allowed the notion of re-selling their treasures to cross their minds. It may even be said that they paid higher prices than anyone had ever dreamed of paying simply for the hell of it—out of ostentation, out of the craving for public recognition, out of plain, childish jealousy. Cosy and endearingly human those motives may seem in the grizzly vacuum of the speculator's world but they must not be confused with the love of art. In their time, however, even motives such as these made the notion of "art as an investment" sound very contemptible. Not so today. By the middle of the 1950s, after two world wars, a world financial depression, and a world wave of currency inflation, "art as an investment" had lost any stigma that it might once have possessed. The prospect of resale became something that not even multi-millionaires could ignore any longer, particularly when something as good as a resale could be obtained while one still enjoyed the object for the rest of one's life.

It does not require a cynic to find the latest Maecenases a little less than romantic—nothing, for instance, like Samuel Rogers. In 1855, when he died at the age of 92, it was believed that this truly great collector had obtained an oil sketch by Paolo Veronese, a *Magdalen at the Feet of Christ*,[6] after the Hope sale of 1816 "by actually crawling on his hands and knees for it". What a touching gesture for the sake of a picture which had been knocked down at £90—and at 53 years of age and in such tight breeches. They don't do that sort of thing for any £100,000 tax-recovery Renoir, sold with a certificate and several free glasses of champagne.

[6] *Athenaeum*, 1855; quoted in Redford, Vol. I, page 151. The picture is in the National Gallery, Toronto.

Having said quite enough concerning the artificially stimulated climate, I shall now deal very briefly with some of the principal changes in the value of objets d'art since 1953, deliberately abandoning the chronological sale-to-sale method of narration. For in this decade the sales have been less frequently those with names that have been distinguished in the annals of collecting or that have been associated with the heirlooms of this or that wealthy or ancient house. Despite the efforts of Press reporters to give them glamour, the sales of objets d'art have become perfunctory rites. Almost their only interest derives from the oddity of their scale of values.

To begin with, the counterpart of the high prices which are paid for nineteenth-century French pictures has been the return to favour on the international market of eighteenth-century French furniture. That this recovery has not approached the highest prices paid at several periods of the past is a matter that has been sufficiently discussed already (see page 3). Moreover, it is doubtful whether run-of-the-mill French furniture has kept pace with the advance of the most important examples. In 1960 there were ten pieces of French furniture in the London and Paris salerooms at £6,000 (the equivalent of £1,000 in 1914) and over. In 1961 there were eleven. There would certainly have been far more pieces at £1,000 and over in each of the two memorable years 1912 and 1913, and probably the standard would have been at least as high as that of the £6,000-and-over pieces in 1960. But it is not possible to make valid generalizations on this subject, because some of the changes in the fashion for *ébénisterie* have been quite arbitrary. For instance, a somewhat unusual tall secrétaire which Christie's sold in 1962 for £17,325 had cost, not an equivalent £3,000, but only £367 at the decidedly "high puff" Oppenheim sale of 1913, when the unusual was not liked.

This recovery has been extremely recent because the boom in French furniture of the 1920s was not repeated after the great financial depression. Nor were prices in the seven post-war years any better than in the later 1930s. In fact, by reason of the fall in money, they were not half as good. Nothing that could be called an advance beyond the prices of the 1920s occurred before the Cassel von Doorn sale in Paris in 1956, when a Louis XV writing-table with the popular signature BVRB fetched £20,245, including taxes. Since then the high limits have been set by the Llangattock table of 1958 at £35,700 and the Powis Castle commode of 1962 at £33,000. Only the first was a really exceptional work; the second would hardly have been a £5,000 piece in the 1920s or before the First World War. We do not therefore

know the present-day value of the kinds of furniture that have been most esteemed in the past—for, instance, the Riesener furniture from the Royal *Garde meuble* in the Hamilton Palace sale of 1882: certainly more than £35,700 apiece, but how much more?

Actually, in the year 1960 furniture from the Hamilton Palace sale was at Christie's again. Two Louis XIV pedestals from the workshop of Charles Boulle had been sold for £1,575 in 1882, and were now sold among the Hillingdon heirlooms for £1,155. But this is not a fair comparison, because Boulle had been out of fashion since a time very soon after the Hamilton Palace sale. A revival of interest hardly began before 1962.

One would also be intrigued to know the present value of those complete drawing-room suites with tapestry covers for which £20,000 to £30,000 could be paid in the first years of the century and even in 1926. Comparable matching suites have not returned to the market. The work of the great Parisian *menuisiers* has become so rare that it is generally a matter of single fauteuils, pairs, odd settees, or broken sets of five or six at most, and without tapestry panels. Greater rarity has not meant higher prices. For a fauteuil £1,200 is an exceptionally high price and for a settee £3,500—prices which are equivalent to £200 and £600 in 1914.

Mounted objects in porcelain and hardstone have had an even duller record in the past decade. The recovery from the worst may have begun with the finely mounted Meissen parrots which fetched £2,310 in the Rothschild sale of 1946, but it has not progressed very far. In terms of the pre-First World War era, there can be nothing exciting in the notion of a £6,000 pair of mounted celadon rouleau vases (£1,000). At present there is little to lead one to suppose that the seven mounted Mazarin blue vases for which Duveen paid £17,250 in 1913 would fetch the equivalent in modern money—namely, £103,500.

English furniture is no longer dearer than French furniture, as it was briefly in the late 1920s. The pre-depression prices did not return till the £4,200 Ashburnham writing-table of 1953, a specially fine achievement of William Vile which by every indication should be already worth several times as much today. After 1953 there were few pieces of English furniture in this class till the remarkable year 1961, when Thomas Chippendale's Rainham commode was sold in New York for £25,000 (£3,900 in 1921). On paper, four pieces of English furniture exceeded the price of £7,500 each in the course of that year, but the "rate of exchange" must be kept in mind.

More interesting in comparison with past values is the rise in the

price of English furniture of the early nineteenth century—furniture which before the 1950s was not part of the richest market at all. Seeing that it was already close on 150 years old, it seems remarkable that the very best of Regency furniture should have been a novelty at £1,000 in 1951, particularly when one remembers that the two pieces of furniture which made 9,000 guineas each at the Hamilton Palace sale of 1882 were less than a century old (see page 139). The fact that to some extent Regency furniture had been produced by untraditional methods which already savoured of mass production made its promotion very difficult. In the early 1900s Percy Macquoid, though himself a pioneer in the appreciation of English furniture, could not find a single good word for Regency furniture, even when it was made under Sheraton's own direction. A few daring pioneers bought the incredibly cheap Thomas Hope furniture from Deepdene in 1917, but it was not till the early 1930s that Regency furniture became "arty", penetrating to Chelsea and Hampstead.

The post-war mania for Regency furniture is not simply a promotion by seniority. It is a genuine revulsion of taste to the prejudice of earlier periods. It is true that the highest prices, at least half a dozen in the region of £2,000, have been paid for Carlton House desks which retain an eighteenth-century appearance. On the other hand, the sharpest advance is that of furniture, abundantly inlaid with brass, and even of English furniture imitating boulle. Obviously this is the beginning of the promotion of "early Victorian". Barely one in ten of the reputable pieces of English furniture which now pass as Regency could have been made before 1820 and the accession of George IV.

If we turn next to the market for European porcelain, the Chelsea boom was almost at its height in 1953, and the emphasis has tended to shift in the past eight years to the rarer Continental factories. But the prices at the Rovensky sale in New York in 1957 deserve to be recorded. A Chelsea tureen with its cover and stand in the form of a rabbit was sold for £4,280—four times as much as the example which had been sold in London six years earlier and a thousand times as much as the example bought by Lady Charlotte Schreiber in the 1870s. In 1767 the price of a second-hand set, a few years old, had been £1. 11. 6. In 1957 they also paid the extraordinary price of £3,750 for a tureen in the form of a pair of pigeons. Also to be noticed is a very derivative Chelsea group, *The Tyrolese Dancers*, after the Meissen model of Eberlein. The price, £3,600, was all the more remarkable because an only slightly less perfect example had been sold a few months earlier for £273.

Personal vagaries of this kind are always to be expected in a market that has so little to do with intrinsic merit. For instance, Chelsea pocket scent-bottles, eight for five guineas in 1772, were considered to have become outrageously dear at £300 or £400 in 1959. The prices ranging from £850 to £2,200 which were paid at the Blohm sale of 1961 were apparently due to the incursion of a film-star.

The very high prices paid for Meissen porcelain in the past eight years have generally been associated with mounted pairs—as indeed they have been throughout the history of Meissen. In New York in 1957 a pair of heavily mounted woodpeckers by Kändler cost £6,750 and a pair of mounted gourd bottles in the rococo style £5,750. However, in 1959 a pair of Kändler cockatoos cost £4,400, unmounted. In 1960 and 1961 two most seductive tureens from the Count von Brühl's *Swan Service* cost £3,530 and £3,800. Most remarkable of all, in 1960 one of the earliest Meissen objects—and these have never been in the rich man's repertory—was sold at Sotheby's for £3,000. This was a plain, polished red stoneware figure of *Harlequin* made for the Böttger factory in 1710.

It is, of course, too early to draw conclusions from the long list of high prices for Continental porcelain in 1959–62. The larger part came from the Otto Blohm collection, so much distinguished for its perfection and magnificence that there is some speculation whether it leaves anything comparable to come after it. Given a sufficiently frequent supply, it seems that a precedent can be relied on to work again. Thus the Nymphenburg Italian comedy figures by Bustelli continued an advance, which we have already followed, till 1954, when nine figures at the van Zuylen sale at Christie's cost £35,647. In the early 1930s such a group of figures might have made at most £2,500 and in the late nineteenth century barely £200. The pair, *Harlequin* and *Lalage*, achieved what is still the record saleroom price for any vitrine-size pair of figures of any place or period—namely, £11,130—but even this is possibly not up to date, since the cheapest figure in 1954, *Pantaloon*, which was sold for £1,622 5s, rose to £3,150 in 1962. In 1954 *Lucinda*, slightly damaged, went to the Victoria and Albert Museum at £2,500, but in 1956 another *Lucinda*, technically damaged, since a finger was missing, cost £4,830. In 1962 at a Phillips sale *Harlequin's* companion cost £5,000.

Nothing has quite rivalled the Bustelli figures. Their success seems to be due to a combination of the popular rococo look with an uncomplicated naïve character that appeals to museum curators, the ultimate arbiters of everything that comes on the market now. And, of course,

they are exceedingly feminine. Perhaps the elevation of Capodimonte figures may rival them, if there are any left of the appropriate kind. At the first Blohm sale in 1960 *The Spaghetti Eaters* cost £2,000, but £3,400 at the third sale in 1961. At the second sale in the same year *The Rabbit Catchers* cost £4,000. The popularity of the more simple-minded sort of European porcelain figure is not merely a matter of keeping up with inflation. Like Regency furniture, it is a reversal of taste, to the detriment of other values. This is shown by the fate of the Meissen groups which fitted in with the lavish taste of the pre-1914 period, the "crinoline groups", which in real values have been reduced to a tenth (see page 166).

Only very partially can it be said that the *dix-huitième* taste is "in", since the most flourishing section of this market before the great depression—namely, tapestries and drawing-room sculpture—has had no part in the recovery. I imagine that the former take up too much wall-space to be desired as bequests for American museums, and that the latter must detract from the lead-foil and bent-wire beauties of what is termed "a modern sculpture gallery". There has certainly been no repetition of the £50,000 Houdon marble busts of 1928–9 (£185,000 each in modern money). In fact, the dearest piece of eighteenth-century French sculpture since 1930 was sold in Paris in 1955, a specially splendid terracotta group of Bacchantes by Clodion at £7,550 (equivalent to £1,260 in 1914).

The £20,000 to £30,000 tapestry panels of the American market of 1915–19 are even more conspicuously absent, though Pierpont Morgan's three Oudry panels after Molière reappeared in 1957 at Parke Bernet's. To have stood their ground they would have had to be sold at something like £450,000 (see page 181). In fact, they fetched £29,360, and that was an unique occasion, since it is doubtful whether as many as six other French eighteenth-century panels have made £5,000 each in the salerooms in close on thirty-five years. The prices are those of an impoverished market, and presumably it would only require a few more tapestry panels of the Pierpont Morgan quality to end the stagnation. But have they all been frozen off in American museums?

As compared with objets d'art of the eighteenth century, the situation of Renaissance objects is far more complex. The basic creed that the *Quattrocento* must be better than the *Cinquecento* survives from late Victorian times, but perhaps with rather less certainty. Of *Quattrocento* sculpture, little except scraps and fragments reaches the saleroom. There are none of those £100,000 portrait busts such as Duveen

handled in the 1930s, and one wonders what their fate would be. The dearest work in the open saleroom has been a white glazed tympanum relief of Andrea Della Robbia, *St Michael holding the Scales*. It cost £4,400 in Berlin in 1930 and £14,280 in New York in 1960. This splendid work has therefore kept nearly level with inflation, but still seems underpriced, seeing that it cost precisely the same amount as Brancusi's *Blonde Negress*, a sort of magnified brass automobile mascot which was sold in the same season and in the same place.

Italian bronzes, whether of the early sixteenth or later sixteenth centuries, remain a depressed ill-understood and ill-appreciated market. The best prices for works of the Riccio school were paid recently at the Gilou sale at Sotheby's, but showed little advance in the past ten years, and in real values were perhaps a sixth of the pre-1914 prices. There has been some interest in monumental works of the baroque age. In 1950 the Victoria and Albert Museum paid £15,000 for Bernini's bronze fountain group, *Mercury and Glaucus*. In 1960 a very Italianate bronze bust by Le Sueur, a portrait of Lord Herbert of Cherbury, dated 1631, cost £6,200. Gothic sculpture too has its moments of triumph, mostly the result of regional patriotism. Thus a French fourteenth-century wooden statuette of the Virgin was sold in Lucerne in 1957 at £8,300, a wooden relief by Tilmann Riemenschneider went for £6,200 at Sotheby's in 1960, and a Catalan late Gothic alabaster retable fetched £5,713 in New York in the same year.

The most striking thing about the market for the later Renaissance and the Northern Renaissance is the virtual disappearance of its background *décor*, now that fashion no longer demands it. What has happened to all the Italian ebony and marble-inlay furniture, the cabinets lined with precious stones, the vast architectural tabernacles or *stipe*, the prizes of the early nineteenth-century market? What has happened to all the sixteenth-century Lyons walnut furniture, prizes in their turn of the mid-nineteenth century market? A *meuble à deux corps* from the great Holford Collection, sold in 1954 for £147, suggests a good enough reason for shyness. Even those bun-legged Elizabethan oak tables which were still good for £1,000 at the end of the war seem to have vanished.

The smaller objets d'art, the lesser stage properties of the Alexandre Dumas school, are rather more in evidence, particularly those bulbous, silver-mounted ivory tankards, now so suspect that they look positively raffish. Who would think that they were once the most expensive objets d'art that money could buy? For most of the present century they have been dear at £100. But an important documented example

sold in Stockholm for £1,100 in 1955, suggests that somewhere among the northern mists there are still devotees of the taste of M. Thiers.

Still more extraordinary than the vanished marble-inlaid furniture are the vanished Limoges enamels. Where are all those huge oval dishes and outsize portrait plaques? The climate is very much more favourable for them than it was in the 1930s. In 1959 a tazza in the full, fruity mid-sixteenth-century style of Jean Courteys cost £800, whereas in 1935 a tazza of this type was worth only £152 5s. Perhaps they are not so much frozen off the market as waiting their time, since the earlier triptychs and plaques of the Monvaerni school, which are worth considerably more, do not fail to make an annual appearance.

The healthiest section of the Renaissance market would seem to be maiolica. It is certainly not the taste of the age, which finds the early wares too scholarly and austere and the later wares too riotous. But there are plenty of American museums to support the early wares, and now it seems that there is a market for the later wares among rich Italian industrialists who like them that way. Since the badly supported Damiron and Pringsheim sales in 1938 and 1939, the London market has not been very abundantly supplied. There has, for instance, been nothing like the very select and specialized Mortimer Schiff Collection, which was sold in New York in 1946 at prices some of which still remain the highest in their kind. Although a big increase in the value of average-quality maiolica began in 1953, the very high prices of the early 1920s were not repeated even in nominal terms till 1959, when a singularly attractive and rare late fifteenth-century inkstand, ascribed to Citta di Castello, made £3,500 at Sotheby's. A mid-fifteenth-century two-handled albarello from the Florence factory, by no means an unusual type and not much different from one which cost £120 in 1949, was sold on the same day for £2,100.

The most remarkable increases in value have been those of the crowded, rather jammy Urbino *istoriato* dishes of the mid-sixteenth century. In the summer of 1962 the *History of Coriolanus*, painted in 1540 by Guido Merlino, returned to Italy after a long exile at £1,785. At the Pringsheim sale of 1939 it had made £20 as one of a number of Urbino dishes in this price-range. A dish with the arms of Piero Pucci, the date 1532, and the signature of Fra Xanto Avelli, was one of a type which had fallen to bedrock since the heyday of its popularity in late Victorian times. It had cost £36 before the war, and now it cost £2,735. Probably the only parallel to such a phenomenal advance in a

class of ceramics which is not particularly rare is that of something with which Urbino has nothing in common at all—namely, early blue-and-white Ming porcelain.

Before concluding with earlier European objets d'art, a word must be said of illuminated manuscripts. Since the 1920s these have been bought as paintings of the primitive masters rather than as books or bibelots. Consequently, the strict limitations of the present-day objets d'art market do not apply to them. The disposal of the Dyson Perrins library of illuminated manuscripts in 1958–60 realized £1,084,000. In nominal money, it was the costliest single English collection of any kind ever to have come under the hammer. In reality, of course, it was equivalent to no more than £165,000 in 1914 or £360,000 in 1919. Even on that basis it brought in more than twice as much as the Yates Thompson sales of 1919–21, though the Yates Thompson Collection was larger and finer. In mere paper terms, the dearest single objets d'art, apart from pictures, that have ever been sold at an English auction were the Dyson Perrins thirteenth-century *Apocalypse of Matthew Paris* at £65,000 and his early thirteenth-century Swiss or South Bavarian *Psalter* at £62,000. Yet these prices give little idea what such treasures as the *Luttrell Psalter* and *Bedford Book of Hours* would be worth today. It would certainly be many times the purchase price of 1929 and well into the hundred thousands. In fact, the £62,000 Swiss or German *Psalter* in the 1960 sale was the work of a secondary school, not comparable artistically with its English contemporary, the *Evesham Psalter*, though it had rather more miniatures. But the *Evesham Psalter* was bought by the British Museum in 1936 for £2,400.

Apart from the simple thrill of looking at more than thirty five-figure prices in a single collection, the Dyson Perrins sales provide an interesting commentary on the history of taste. Out of sixteen manuscripts which made from £15,000 to £65,000 each, only four belonged to the highly developed post-van Eyck school of late mediaeval painting, which still remained the highest esteemed on the market at the beginning of the war. In this field, the museum-inspired cult of the early schools has wrought enormous changes. A German eleventh-century *Gospels* with four paintings, which made £39,000 in 1958, would have been worth £1,500 at most at the Yates Thompson sales. The fragment of a *Bestiary* of the same age, which cost £17,000 in 1960, would have been worth only a few hundred pounds forty years earlier. I myself can remember liturgical manuscripts of the twelfth century with simple rubrics, but no illuminations, which could be bought in the early 1920s for £10 in fine condition. Today they are

worth something in the region of £1,000, only for the simple fact of their being as old as the twelfth century.

There can be no better instance of the influence of the ever-acquisitive museum curators on the present art market. Perhaps Chinese art offers the second best, for the days are past when an eighteenth-century Chinese enamelled porcelain vase could be dearer than almost any picture or statue on earth. Models of pheasants at £8,000 a pair and cranes at £5,000 a pair are no better than a pre-war valuation trying to catch up with inflation. Nevertheless, a *famille verte* figure of Kuan Yin, no less than 45in high, together with a smaller figure of a boy, was sold by Parke Bernet in December 1962 for 85,000 dollars or £30,355. It was believed that the price had been created by the valuations of American museums, based on a closely similar Kuan Yin figure which had been valued at £30,000, or 150,000 dollars in the Pierpont Morgan dispersal of 1915–16 (see page 214).

The really big advances in the 1950s and the 1960s have been made by blue-and-white and kindred porcelains of the fourteenth and fifteenth centuries—types that were either unknown or unidentified before the middle 1930s. In 1935 a big blue-and-white *potiche* jar, which was not yet recognized as a fourteenth-century piece, was bought at the Russell sale for the seemingly outrageous price of £105. In 1951 it was bought for the British Museum at £2,500, but remission of death duties may have brought the total to £5,000. Similarly, a late fifteenth-century yellow-ground dish of a very standardized kind was dear at £140 in 1947, but it made £1,600 in 1961. In 1962 a rather better example went to Japan at £5,500, while a 14th-century ewer, decorated in underglaze red, went to Hong-Kong at £8,800.

Of course, there has been an enormous advance in Chinese carved jade, and even in cloisonné enamels, the "polished surface of art", to which Hazlitt took such exception. Not everyone who has the purse to command, aspires to be mistaken for a man of sensibility. The devastatingly *kitsch* Swiss Russian peasant figures of Karl Fabergé (pre-collective farm) still take up their position in the vitrine above the cocktail cabinet, executed in a combination of barley sugar and liquorice all-sorts, £8,000 each or £14,000 a pair, and there is no reason why the entertainment fee should not be raised. In the USA it is possible to pay over £4,000 for one of the porcelain copies of birds of America, modelled for the Royal Worcester factory by Miss Dorothy Doughty who died in 1962. But under the impact of present-day tax and death-duty concessions, expensive collectors' taste tends more and more to abandon virtuosity in favour of the educative and meaningful.

Almost all that is primitive is on the upward slope. In the case of the early mediaeval sculpture of Asia and of ancient Chinese paintings, the biggest transactions take place outside the saleroom in negotiation with the great museums. The very few such things as are sold in public convey no notion of the top values. It is arguable that the real objet d'art market of our time is this very secret market, where things that were worth a few pounds at the beginning of the century now change hands at tens of thousands; that the apparently spectacular market for French furniture and English silver, which gets duly reported in the Press, has not risen in the way that many imagine and is a mere survival.

In the early 1920s African sculpture, rating as "curios" or "ethnographic objects", had little value. But with the acceptance of the modern painting and sculpture which it had inspired, African art was already becoming an expensive taste at the end of the decade. By 1930 a pair of Benin brass leopards could make 700 guineas, while in 1931 a wooden Pahouin figure cost £480. For some years the slump mitigated this enthusiasm. In 1939 it cost the National Art Collections Fund only £100 to present to the British Museum one of the most startling works of art to come out of Africa, the bronze head from Ife. There was nothing like a recovery till 1953. In the last decade several four-figure prices have been paid for works in bronze and ivory, while quite modest wooden masks cost over £300 each. In 1960 the Allman ivory mask from Benin cost £6,200. The prices for African art are peculiarly unpredictable. It would seem that there is no more genuine tribal art to come out of Africa, but the objects themselves may not be very old, and the tradition of bold primitive craftsmanship can be stimulated by art teachers. The market is therefore loaded with imitations.

Since the 1950s there has been a corresponding rise in the little that is left on the market of classical and pre-classical art. The fully-restored, full-sized, vaguely Graeco-Roman statue was already in decline at the Lansdowne sale of 1930, and the decline seems to be continuing (see page 245), but bits and pieces of Egyptian, Assyrian, or archaic Greek sculpture do very well. Occasionally fine Greek painted vases have been sold in Switzerland since 1953 for about £2,000 each— nothing very extraordinary, seeing that they were paying £1,000 for a Greek vase as early as 1884. But legend has it that the omnivorous American museums are buying up the best of what is left at far higher prices—£12,000, even £18,000. The appetite of American museums is also reflected in the high cost of the smaller handicrafts of the Roman Empire—in particular, glass. In 1962, Sotheby's sold a little Sidonian unguent-bottle in the shape of two human faces for

£200—a particularly striking example, since in the early 1920s these could be bought for about £4.

At the end of my first volume I remarked that a crystal ball should form no part of the library equipment of a historian of taste. Having attempted to summarize the trend in objets d'art in the past decade, I find this caution more necessary than ever. Certain currents are apparently flowing much faster than others. How long will they flow? The past year (January 1963) has been mainly one of recession, a diminution of world trade, a lowering of stock exchange values, the most depressing business year since the war. It is generally observed that the art market has not been affected—not even the dizzy-headed market in modern painting and sculpture. It is, of course, too early to draw any inference from that. But if one assumes that the most expensive works are being bought from the point of view of museums and galleries and what they will accept against tax or death-duty concessions, then the financial situation of the times becomes less important than the political situation. A bad slump might not end the revenue concessions which keep the art market alive. But a political change could end them almost from one day to another.

SALES ANALYSIS OF SELECTED TYPES OF OBJETS D'ART SINCE 1750

NOTE TO THE SALES ANALYSIS

Although in this second volume English sales are barely in the majority, I have used the same system as in Vol. I. That is to say, Christie sales are indicated simply with a C and Sotheby sales with an S. Continental and American sales are indicated generally by the name of the city alone, but in some cases, where the vendor is not named, I have inserted the name of the auctioneer. In all other cases the first name is that of the vendor. The names of present owners, when known, are given in parentheses. Price in pounds are calculated according to the exchange rates of the day, though in periods of fluctuation, particularly between 1919 and 1958, absolute accuracy is not guaranteed. French prices are inclusive of tax.

£

1728 Dr John Woodward (Bateman and Cooper, auctioneers).
Italian shield in chased gilt-bronze, depicting Rome burnt
by the Gauls (see 1768). 100

1762 Duc de Sully, Paris. A whole collection of armour,
including 4 suits and many weapons. 29 10s

1767 Julienne, Paris. A chased shield with a fabricated pedigree,
going back to Scipio Africanus (sold to Neuwekerke in
1867 for £1,000) 16 8s
Arquebus in ivory and jasper. 12
Scimetar-pistol. 2 4s

1768 Colonel Richard King, London. The Woodward shield
(see 1728). 42

1770 Lady Betty Germaine (sale in Covent Garden). Henry
VIII's dagger, said to have been designed by Holbein,
bought by Horace Walpole. 52 10s

1772 Crozat, Paris. Half-suit in chased gilt-bronze, late 16th
cent., alleged to have been made by Benvenuto Cellini for
Francis I, bought by Horace Walpole (see 1842, 1868, 1893) 40

1773 James West. C. Cromwell's body armour (see 1806). 5 15s

1778 Harrache, jeweller. C. An Oriental coat of mail, inlaid
with gold (half-suit and helmet). 13 10s

1786 d'Ennery, Paris. 2 pistols with silver barrels by Keller,
Hervin, and Bertault. 20

1789 "Oriental curiosities." C. Helmet, target, coat of mail
with studs and 6 other objects, inlaid with gold, Persian or
N. Indian. 37 16s

1791 Richard Dalton. C. (The King's Librarian, 1715-91.)
The armour of Henry V, taken by Charles II out of the
Tower. 2 12s 6d

1794 John Hunter. C. Breastplate and other parts of an
engraved and inlaid suit. 8 8s
Swords of Charles I and Prince Henry, 1616, inlaid gold
hilts, bought by Earl of Warwick. 5 12s 6d

1801 C. Gold-mounted sword, worn by the late Tippoo
Sultan. 15 15s
Persian sword worn by his brother-in-law. 7 7s

1817 C. A pikeman's iron half-suit. 7 7s
Horseman's armour, corselet, cuisses, and helmet, con-
signed from Italy. 25 10s

1821 The Gothic Hall, Pall Mall. C. Cap-à-pie suit. 33 1s 6d
Elizabethan suit with helm. 31 10s
James I suit. 28 17s 6d

£

1821	Horseman's black armour, time of Charles I.	13	15s
	Cross-bow "of great power".	14	10s
	Henry VIII half-suit.	15	15s
	Chanfron (horse's visor).	7	12s
1827	Late Duke of York. C. Spanish 16th-cent. rapier, chased gilt pommel, by Francesco Ruiz of Toledo.	6	10s
	Burmese krees, richly chased hilt, brought back from the First Burma War.	32	
1831	Person of fashion. C. Breastplate, helm, and shield with engraved arms of Spanish origin.	6	2s
	Rapier and dagger (Milanese) of Philip II (possibly thefts from the Madrid Armoria).	8	10s
1834	C. 2 Bavarian fluted (Maximilian) tilting suits.	{ 30 { 33	19s 6d 11s
	Horseman's plain suit with helmet and gauntlets, bought-in.	17	6s 6d
	German black suit, helmet, and gauntlets, bought-in.	13	13s
	Pike-head chased and engraved with likeness of Henri IV.	12	12s
	Half suit, helmet and gauntlets, bought-in.	14	3s 6d
	Tippoo Sultan's silver saddle, shaped like a swan, bought-in.	32	0s 6d
1838	Mention and Wagner, Paris (ex de Hebray). Maximilian man-and-horse suit, made for Francesco Sforza, c. 1520, bought by King Carlo Alberto of Savoy.	450	
	Gothic suit, part restored (Musée de l'Armée).	110	
	Suit of John, Duke of Saxony.	182	
	Engraved suit.	160	
1839	Armour from Spain. C. Stolen from the Armoria, Madrid. The whole sale made only £983.		
	The Bartolommeo Campi stirrups (see 1896).	5	10s
	Burgonet by Caremolo.	25	
	Tilting suit by Wolf of Landshut (see 1884).	95	11s
	Second ditto (see 1921).	96	12s
	Chanfron and part of a horse's trappings in "Primaticciesque taste".	74	0s 6d
1840	C. Horseman's fluted steel armour (? Bavarian; ex Duke of Hesse-Homberg).	47	5s
1841	Masseroni, Florence. C. Horseman's armour of Malatesta Baglione, with his dagger and rapier (reserve, £240), bought-in.	189	
1842	At Oxenham's Rooms (Pratt). Suit of "secret Jaserine armour".	126	
	Tilting suit, bought by Tower armouries.	94	10s
	Spanish engraved and gilt suit, Marquess of Westminster.	79	16s
	Waldegrave, Strawberry Hill (ex Walpole). The so-called Francis I suit (see 1772, 1863, 1893).	336	
	16th-cent. chased shield, inlaid in gold and silver (see 1870).	42	
	Painted tournament shield by Polidoro.	10	10s

£

			£	
1844	Henry Briggs. C. Horseman's suit, undescribed, bought-in.		13	13s
	Thomas Thomas. C. Helmet surmounted with a dragon, richly ornamented in the style of Cellini, bought-in (possibly the Negroli casque; see 1912).		22	1s
1846	Baron, Paris. Fluted Maximilian suit, looted by General Amielle from Schönbrunn.		66	8s
1850	Debruge Dumenil. Sword and dagger dated 1580 (see 1875, 1899).		49	4s
	16th-cent. North Italian shield with figures and grotesques in inlay and relief.		36	4s
	16th-cent. gold damascened sword, bought by Marquis de Saint-Seine (see 1875).		60	4s
	Arquebus à rouet, Henri II period (see 1875).		16	
	Pistolet à rouet, late 16th cent.		19	
1851	Earl of Pembroke. C. Armlet from a chased suit.		12	12s
1852	"The Maximilian Collection." C. Complete man-and-horse suit in russet and gold inlay with shield, sword, spurs, etc., alleged to be the armour of Galeazzo Sforza.		46	4s
1853	Alexandre Decamps, Paris. Arquebus à rouet.		12	12s
	2 Louis XIV pistols.		13	15s
1854	Boecke. C. Embossed Medusa shield by Georg Sicman of Augsburg, inscribed 1552, relief borders, 24in diam.		210	
1855	Bernal. C. 444 lots of arms and armour, sold in 4 days.		315	
	Italian suit, 1530 (see 1888).		157	10s
	German suit, 1510 (see 1917).		47	5s
	Spanish demi-suit, 1545 (see 1917).		102	18s
	Spanish cap-à-pie suit, 1550–60 (see 1917).		71	8s
	Cap-à-pie suit, 1535 (see 1917).		155	
	Spanish breastplate, heavily gilt and chased (see 1888).		12	12s
	Engraved and silver-inlaid halberd.		107	
	2 French Louis XVI duelling pistols, bought for V & A.		53	11s
	Pair of gauntlets, chased (see 1888).			
1857	Earl of Shrewsbury, Alton Towers. C. 302 lots of arms and armour. in all,		714	3s 6d
	German fluted cap-à-pie suit, c. 1550.		95	11s
	Spanish cap-à-pie tilting suit, c. 1550.		87	13s
	Engraved tilting suit, including a marteau d'armes.		86	2s
	Man-and-horse armour, mounted on a model with a shield bearing the Talbot device.		74	11s
1858	David Falcke of Bond Street. C. Pair of chased spurs.		22	11s 6d
1860	Courval, Paris. Sword of Sixtus V, by Gasparo Mola.		150	
	Arquebus, presented by town of Laon to Henri IV.		1,000	
1861	Mathew Uzielli. C. Suit with bands of arabesque, engraved and gilt.		73	
	Mosselmann, Paris. Armour for man and horse, c. 1600.		120	
	2 "Maximilian" cap-à-pie suits.		{48, 32}	
	Damascened arquebus, Henri II.		28	

£

1861	Prince Soltykoff. Paris. The whole collection of armour and weapons bought by Napoleon III for £10,000.		
1863	Allègre, Paris. Inlaid shield with 5 relief figures, signed Georg de Gys (see 1870).	1,000	
	Earl Canning. C. dagger N. Indian, handle in jewelled jade.	28	
	Khanda, ceremonial sword, jewelled and gold-inlaid scabbard, from Indore.	110	
	Indian shield, steel inlaid with gold, 18in diam.	100	
1864	Paris. Damascened sword with sculptured pommel and guard, 16th cent.	214	
1865	Earl of Cadogan. C. State martel (marteau d'armes?) in pierced and chased steel, N. Italian, 16th cent.	88	4s
	V & A purchases painted tournament shield *en pavoise*, late 15th cent., from the Guadagni Palace, Florence.	40	
1866	Ditto. Milanese iron shield, *c.* 1550, embossed with Hercules and the Nemean lion.	263	2s
1867	William Sandes. C. Oriental gilt damascened steel shield and helmet. 2 for	88	10s
1868	Ditto. Shield made by Messrs Elkington for the 1867 Paris Exhibition, embossed with subjects from *Paradise Lost*, silver and damascened iron.	2,000	
	Prince Demidoff, Paris (1st San Donato sale). The Horace Walpole Francis I suit (see 1772, 1842, 1893).	900	
1870	San Donato, Paris (2nd sale). The Georg de Gys shield (see 1842, 1863), dated 1554, bought by Ferdinand de Rothschild (BM, per Waddesdon Bequest).	6,800	
	Templar sword, gilt damascened hilt, late 14th cent., bought by Count Basilevski (Hermitage Museum, Leningrad).	804	
	Couleuvrine or miniature chased bronze cannon, 44in long, made by Mazerolli, 1688, for Cosimo III of Florence (Wallace Coll.).	484	
	2 wheel-lock pistols, Italian, 16th cent. 2 for	708	
1873	Ladurie, Paris. French 16th-cent. sword, gold inlays.	340	
1875	Séchan, Paris. Venetian 16th-cent. scimetar-pistol with straight blade.	2,000	
	Marquis de Saint-Seine, Paris. 16th-cent. Italian gold-and-silver damascened sword (see 1850).	1,340	
	A 2nd ditto, dated 1586, with dagger (see 1850, 1899).	664	
	Wheel-arquebus, 16th cent. (see 1850).	800	
	Mariano Fortuny, Paris. Italian chased and gilded casque.	480	
	Courreau, Paris. Buckler, silver and gold inlays.	304	
	2nd ditto.	320	
1877	Paris. Marriage dagger of Henri IV.	500	
1879	Pratt. C. Breastplate of Philip III of Spain.	1,010	
	Paris. Gold inlaid gauntlet.	400	
1883	Beurdeley, Paris. The Oldefredi suit, gold-and-silver damascened.	260	

		£		
1883	Rusca, Florence. Casque of embossed and chased steel.	980		
	N. Italian shield and casque, heavily chased and gold-inlaid, arms of Rosmini, Udine. 2 for	2,400		
1884	Andrew Fountaine. C. Mentonnière, arms of Spain, bought by Wallace and ceded to Alfonso XII.	262	10s	
	Spanish cap-à-pie suit (see 1839).	472	10s	
	Paris. Reported that Count Basilevsky paid £2,400 for a musket à pied de biche.	2,400		
1885	Marquess of Stafford. C. Fluted suit, c. 1530, bought by Baron de Cosson (see 1893).	504		
1886	Henry, Paris. Embossed three-quarters suit, alleged to have belonged to Henri IV, bought-in.	4,000		
	Charles Stein, Paris. Pair of gauntlets, heavily chased, bought by Spitzer.	364		
1888	Lord Londesborough. C. Italian chased shield (Metropolitan Museum), ex Horace Walpole (£10 10s in 1842).	451	10s	
	Pair of steel gauntlets, heavily chased (V & A) (Bernal sale, 1855, £53 11s).	577	10s	
	Mentonnière, arms of Saxony (Bargello Museum) (bought 1854 for £56).	651		
	Italian suit, c. 1530 (see 1855) (Metropolitan Museum).	1,050		
	Pig-faced bascinet, Tyrolese, late 14th cent., from Schloss Hulshoff, Bavaria (Metropolitan Museum) (for others, see 1891, 1903, 1939).	425	5s	
	Suit of 16th-cent. Spanish tilting armour.	430	10s	
	Engraved broad-sword, Italian, c. 1470 (£6 6s at Bernal sale, 1855) (see 1921).	410		
1890	Eugène Piot, Paris. Embossed casque by the Negroli brothers (bought from Basilevski for £480).	188		
	Baron de Cosson. C. 2 German fluted suits, c. 1515.	{375		
		⎨350		
1891	Paris. Hounskull, or pig-faced bascinet, Tyrolese, late 14th cent. (compare 1888, 1903, 1939).	484		
1892	Hollingworth-Magniac. C. French demi-suit, elaborately chased, c. 1550.	740	10s	
	Spanish tilting suit.	861		
	Milanese suit, 1570.	740	10s	
	Breastplate by Negroli, Milan, 1530.	420		
1893	V & A buys German wheel-lock pistol, 1579	1,081	2s	9d
	Cosson. C. Fluted Maximilian suit, c. 1530 (see 1885).	1,680		
	Part-suit, Missaglia of Milan (Metropolitan Museum).	792	15s	
1894	Gutterburg-Morosini, Venice. Ceremonial gilt-chased casque (somewhat under attack).	940		
1895	E. J. Brett. C. (ex Meyrick Collection.) German three-quarter suit, 1540 (see 1947).	787	10s	
	German fluted Maximilian half-suit.	630		

2nd Frederick Spitzer sale, Paris. The alleged Horace Walpole Francois Premier suit (see 1772, 1842, 1868).

£

1895	Actually a copy made by Pratt after the fire of 1874 (Metropolitan Museum).	1,100
	Italian classical style helmet, said to have belonged to Andrea Doria (bought by Carrand in Genoa, 1834), bought for Prince Liechtenstein.	2,440
	Half-suit by Lucio Picinino, late 16th cent. (Metropolitan Museum).	2,080
	Field-harness by Frans Scroo, c. 1550 (Metropolitan Museum).	3,040
	Jousting suit (ex Carrand Collection), fittings added by Spitzer (Metropolitan Museum).	1,640
	Arquebus à rouet, Italian 16th cent., much restored (Spitzer paid £2,800).	1,400
	2nd ditto, French.	1,040
	Maximilian suit, restored (Metropolitan Museum).	2,040
	French jousting suit, 16th cent. (see 1918).	980
	Marteau d'armes (Metropolitan Museum).	1,000
	Executioner's sword, Swiss, late 15th cent., signed Hans Kasn (made up from many objects).	1,060
	Girdle-sword, signed by Brach of Solingen.	2,200
	£64,000 sale. Most of the dearer lots were bought by the Duc de Dino, from whom they went to the Metropolitan Museum.	
	Kuppelmayer, Munich. Miniature model of fully armed man and horse in perfect detail, c. 1530, bought by Munich Landesmuseum.	1,440
1896	Earl of Warwick. C. Pair of damascened iron stirrups by Bartolommeo Campi, 1541, bought by George Salting (since 1910, V & A) (see 1839).	1,491
1897	V & A buys German 17th-cent. wheel-lock arquebus.	250
	Zschille of Berlin. C. (862 lots.) Embossed and damascened casque.	300
	Cinquedea, late 15th cent. (£173 5s in 1888).	275
1898	Gurney. C. Presentoir, German, c. 1570.	246 15s
1899	Charles Stein, Paris. Sword and dagger dated 1580 (see 1850, 1875) (£600 at Spitzer sale, 1895).	520
	Forman. S. Morion (Currie Bequest, V & A).	1,400
	Pair of Venetian enamelled stirrups, c. 1490 (Luton Hoo, Wernher Trust).	2,700
1902	Stefano Bardini. C. Milanese damascened gun-rest, late 16th cent.	850
1903	Seguier. C. Buffe from the Colbert casque (Metropolitan Museum) (see 1922).	315
	Thewalt, Cologne. Inscribed dagger of Philippe le Bon of Burgundy, c. 1460.	250
1904	Hefner-Alteneck, Munich. 15th-cent. composite German suit.	1,050
	Suit from Schloss Jettenbach.	910

£

1904	Hounskull, or pig-faced bascinet, Tyrolese, 14th cent. (compare 1888, 1891, 1939).	1,005
1905	Marquess of Anglesey. S. 15th-cent. Italian sword.	400
1906	Ledger. C. German demi-suit, *c.* 1530.	997 10s
1907	Wencke, Hamburg. Italian ceremonial buckler, mid-16th cent., figures in relief, part-gilt.	1,180
1910	Octavus Coope. C. Swept-hilt rapier with engraved equestrian figures, dated 1570 (Bernal sale, 1855, £7 10s).	1,575
1912	Kocheleff-Besborodko, Paris. Chanfron from the Radziwill suit by Kunz Lochner (Metropolitan Museum).	1,105
	Paris. The Negroli casque, Milan, *c.* 1540, in the form of a monster's head (said to have been sold in the Pierpont Morgan dispersal in 1916 for £20,000), bought by Duveen.	5,150
1917	Grenville-Gavine. C. See Bernal sale, 1855, for all items.	
	German suit, 1510.	2,415
	Spanish cap-à-pie suit (1550–60).	2,205
	Demi-suit, Nuremberg, 1535.	756
	Spanish demi-suit, 1545.	1,732 10s
	Rondache in high relief, with figures in style of Giulio Romano, *c.* 1550.	3,570
	Earl of Pembroke. S. Montmorency three-quarter suit, French, 16th cent. (Metropolitan Museum).	14,500
	Montpensier suit (Metropolitan Museum).	10,500
	Sale subsequently cancelled; sold later privately.	
1918	S. A. Kennedy. C. French 16th-cent. tilting suit (see 1895).	4,305
	Italian 16th-cent. sword.	1,365
1920	Baroness Zouche. S. Late 15th-cent. German suit, bought by Lord Zouche in Genoa in 1840, but much made up since.	4,600
	Venetian salade, 1480.	1,300
	Sir Guy Laking. C. 3 Milanese salades by Missaglia, late 15th cent, at £1,260, £1,102 10s and £735	
	Venetian salade, gilt-copper scrollwork.	1,575
	A single copper-gilt spur, 15th cent., enamelled tags.	892 10s
	Pair of French spurs, *c.* 1400, traces of bronze-gilt, dredged from a moat.	1,680
1921	Morgan-Williams, Margam Castle. C. Cap-à-pie suit, transitional Gothic, perhaps by Koloman Colman.	4,835
	"Bastard" sword, *c.* 1470, bought by Duveen (Bernal, 1855, £6 6s; Londesborough, 1888, £141 15s; Fraser, 1905, £400).	3,097 10s
	Salade à queue, *c.* 1460 (see 1942).	2,047 10s
	Horse's armour.	2,310
	Engel-Gros, Paris. Chanfron, Milan, *c.* 1560, in the style of Picinino.	1,100
	Beardmore. C. Spanish tilting suit (see Armoria sale, 1839).	3,150
	Earl of Pembroke. S. Suit for man and horse, bought-in.	9,700

303

£

1921	Greenwich 16th-cent. suit by Jacob (still the auction record price for armour, paid by Duveen, who sold it to Clarence McKay, New York).	25,000
1922	William Meyrick. C. Single elbow-guard.	346 10s
	Pair of toe-caps, perhaps by Colman, c. 1525.	273
	Countess of Craven. C. Engraved and gilt Italian 16th-cent. suit, worn by the Earls of Craven at the Eglinton Tournament, 1839, and the Earl's Court Shakespeare Pageant, 1912.	1,896
	C. 14th-cent. Italian bascinet.	1,575
	Newall. C. Colbert casque (Metropolitan Museum). (Part only was sold at this sale, a buffe or visor of the Louvre school, c. 1570 (see 1903).)	2,835
1923	3rd Pembroke sale. S. Greenwich suit, mid-16th cent.	4,600
1925	Mappin. C. Tyrolese 16th-cent. engraved harness.	1,680
1926	C. Metropolitan Museum buys a pair of Maximilian puffed sleeves.	5,670
	Pageant breastplate, c. 1500.	1,060
1927	Whawell. S. Armour for £39,000.	
	Spinola sword, Brescia, c. 1620.	3,000
	Salade, early 16th cent.	1,250
	Greenwich suit (£148 in 1923).	1,250
	Spanish armet à rondelle.	3,900
	Damascened arquebus, 1583.	1,050
1928	Cluny MacPherson. S. The Medusa targe-shield, silver appliqué work on leather, French, c. 1745, presented to the Young Pretender.	4,000
	S. Viking sword, 11th cent., found in the Thames.	430
1929	Baron de Cosson. S. Italian late 15th-cent. helmet (armet à rondelle) (see 1946, 1962).	490
	Comte Pepoli, Paris. Venetian ceremonial helmet, late 15th cent., shape of a griffin's head.	1,570
	Late 15th-cent. sword, finely damascened.	2,475
1930	S. Pair of Brescia flintlock pistols, c. 1680. 2 for	970
	2 16th-cent. brigandines, Italian and Spanish.	⎰650 ⎱780
	16th-cent. sword-stick, Saxony.	660
1931	Farnham Burke. C. Almost complete suit by Arrigolo d'Arconate, N. Italian, c. 1440.	3,780
	Cap-à-pie Maximilian suit.	567
	S. Suit of tilt-armour from Schloss Siegmaringen by Pfeffenhauser (d. 1608).	1,250
	Back-plate with arm-defences, c. 1500, mixed German and Italian.	720
1932	Erbach-Erbach, Lucerne. Cap-à-pie suit, 1520–30.	2,035
	16th-cent. armour of Julius, Duke of Brunswick, with chased and gilded breastplate.	1,700
1933	Brougham and Vaux. C. Augsburg suit, c. 1480, fairly complete.	892 10s

£

1934	S. Saxony suit, 16th cent.	3,400
1935	S. German 16th-cent. tilting armour, Augsburg guild mark.	2,400
	Maximilian fluted suit, c. 1530.	1,850
1936	R. H. Lyall. S. German 16th-cent. part-suit with helmet.	3,900
	Tilting armet, S. German, c. 1500 (Tower Armouries).	1,000
1937	S. Half-suit parade armour by Kunz Lochner of Nuremberg, c. 1550.	1,000
	Vamplate for a tilting lance, Nuremberg, c. 1550.	290
	Swept-hilt rapier, Toledo, c. 1560.	220
1939	Clarence McKay. C. Augsburg etched suit with partly gilded shield, 16th cent.	1,365
	Tyrolese late 14th-cent. Hounskull, or pig-faced bascinet (bought by Tower Armouries; see 1888, 1891, 1904).	2,730
	Augsburg engraved 16th-cent. suit.	365
	Black 16th-cent. suit from Dresden Armoury.	598 10s
	Foot-jousting suit, c. 1591 (see 1959).	651
1942	Lockett. C. Salade à queue, c. 1460 (see 1921).	315
	Full suit, Nuremberg, 16th cent.	199 10s
1946	S. Italian late 15th-cent. helmet (armet à rondelle), bought-in (see 1929, 1962).	65
1947	Edward Ledger. C. German three-quarters suit, arms of Bavaria, c. 1540 (see 1895).	2,100
	German three-quarters suit, etched, made up from other sources (£74 in 1895).	1,575
	S. 15th-cent. salade or barbute.	350
1949	S. Fluted Maximilian suit, S. German.	920
	Part-suit from Schloss Churburg, c. 1480, by Tomaso and Antonio Missaglia (valued at £5,000 in 1929).	3,000
	2 late 15th-cent. barbutes by Antonio Missaglia.	{300
1950	S. The Dreux sword, 14th cent. (Whawell sale, 1927, £430).	{360
		530
	German suit (ex Hermitage Museum, 1931), early 16th cent.	520
1951	S. Maximilian fluted suit, c. 1520, from the Hermitage Museum, 1931.	450
1953	W. Randolph Hearst, New York. Engraved burganet helmet, Augsburg, 1565.	1,140
	(166 lots were withdrawn and sold to Tower Armouries for £14,800.)	
1955	Fischer, Lucerne. Half-suit and casque, Milan, c. 1560, heavily chased and inlaid with silver and gold (ex Louis de Rothschild).	2,015
1957	Fischer, Lucerne. Complete field harness, Nuremberg, c. 1510, part fluted (ex Randolph Hearst).	1,550
1958	Fischer, Lucerne. Brunswick three-quarter suit and helm, dated 1556.	2,550

£

1958 C. Silver-barrelled chased flintlock fowling-piece, French,
c. 1680. 2,205

1959 R. W. Lloyd. C. Suit of foot-jousting armour, 1591
(see 1939), bought for Tower Armouries. 3,570
 Boy's suit of armour. 304 10s

1960 C. Plain 13th-cent. sword (excavated). 441 10s

1961 Dunraven Limerick Estates. S. Fluted and etched
Greenwich half-suit, c. 1570. 850
 S. Milanese barbute or gladiator-style helmet, late 15th
cent. 1,100
 German wheel-lock petronel, 1581. 2,100
 Italian wheel-lock pistol, c. 1530. 360
 (Both bought by Tower Armouries).

1962 S. Armet à rondelle, Italian late 15th-cent. helmet (see
1929, 1946). 620

1962 S. Wheel-lock petronel-fowling-piece, 1612. 2,600

1963 S. 2 wheel-lock pistols, Brescia, 1640. 2 for 2,550

CARPETS, EUROPEAN

(For Oriental carpets, see Near Eastern Art and Chinese Art)

		£		
1756	Court valuation (for M. Bouret de Vallevorde). Aubusson, about 300 square feet at 45 livres the aulne or ell.	59	10s	
1766	C. English needlework carpet, 15ft× 13½ft	52	10s	
1768	Stephen, Paris. C. Embroidered velvet carpet, 15ft× 24ft, together with matching backs and seats for 24 chairs. all for	80	17s	
	"Gobelins" carpet (Aubusson?), 11ft× 9ft.	16		
	Ditto, 17ft× 12½ft	28	17s	6d
1769	Count de Sielern. C. Needlework carpet, 21ft× 14ft.	32	11s	
1788	Comte d'Adhemer. C. French carpet (cut), 18ft× 21ft.	31	10s	
1808	C. Used carpets at average prices:			
	Axminster, 19ft× 14½ft.	26	5s	
	Brussels, 33ft× 20½ft (the hearth cut out).	28	7s	
	Slightly smaller, cut	26	5s	
1823	Farquhar, Fonthill (*ex* Beckford). Brussels, crimson ground, 19ft× 17ft.	10	10s	
	Ditto, 37ft× 18ft.	14	14s	
	Aubusson carpet, 25ft× 14ft, ordered by Napoleon in 1814 for St Cloud.	246	15s	
1829	Lord Gwydyr. C. Savonnerie; figures round centre in chiaroscuro.	21		
1834	Viscountess Hampden. C. Axminster, 27ft 10in× 18ft.	76	14s	
1842	Waldegrave, Strawberry Hill (*ex* Walpole). Axminster, 13ft× 10½ft, made in the middle 18th cent. to match Walpole's china.	8	8s	
	Another Axminster, 18ft square.	7	7s	
	Moorfields carpet, made in the 1780s, 51ft× 10ft, bought by Robinson, Oxford Street (for another Moorfields carpet, see 1959).	3		
1848	Duke of Buckingham, Stowe. Aubusson armorial carpet, 29ft× 16½ft (see 1960).	21		
1855	Bernal. C. Brussels, crimson and drab, 34ft× 19ft.	6	15s	
	Ditto, 30ft× 21 ft 6in.	9		
1869	V & A buys Italian velvet carpet, arms of Pope Leo XI, dated 1605, 12ft 9in× 11ft.	50		
1876	German tapestry carpet, 1720–4, arms of Innocent XII.	100		
1893	Frederick Spitzer, Paris. Italian 17th-cent. carpets:			
	Embroidered petit-point carpet, 10ft× 8ft.	123		
	Red velours, 10ft× 9ft	59		
	Silk with embossed ornaments, 7ft× 4ft.	79		

£

1903	Mme Lelong, Paris. Savonnerie carpet, early 18th cent., Sunray design on black ground.	1,212
1912	Charles Wertheimer. C. Savonnerie, Louis XIV, 25ft× 17ft.	2,730
1910	Lowengard, Paris. Régence Savonnerie carpet.	1,220
1911	Paris. Savonnerie carpet with royal monograms of Louis XVI.	1,880
1912	Jacques Doucet, Paris. Savonnerie carpet, Régence.	2,288
	Savonnerie carpet, Louis XIV, small.	830
1927	C. English needlework carpet, late 18th cent., 12ft 6in× 10ft 9in.	714
1928	S. English needlework carpet, dated EM, 1743, 9ft 2in× 5ft 8in.	720
1930	Mrs d'Oyley (at Honiton). Savonnerie carpet, Royal insignia, Louis XVI, 29ft× 17ft.	367 10s
1932	Capel Manor, Horsmonden (Knight, Frank). English Adam carpet (Moorfields?), 22½ft× 10½ft.	510
	Duc de G., Paris. Aubusson carpet, late 18th cent., 15ft× 12ft.	560
1933	Viscount Dillon. S. English needlework carpet, only 2½ft× 9ft, perfect condition.	610
1938	Mortimer Schiff. C. Louis XIV Savonnerie carpet, 23ft× 14½ft.	2,205
	Ditto, 9ft× 5½ft.	1,260
	C. Tufted Axminster carpet, c. 1820.	283 10s
1939	Earl of Rosebery. C. 2 Savonnerie carpets, made for Louis XV, with arms of France and Poland, bought-in.	2,310
1943	Robinson and Fisher. Savonnerie carpet, early 19th cent., 20ft× 12ft.	283 10s
1945	Earl of Londesborough. C. Berlin needlework carpet, c. 1840, 26ft× 13½ft.	861
1946	C. Needlework carpet, 1843, made by the Belfast Ladies' Association.	892 10s
1947	C. Savonnerie carpet, early 19th cent., 29ft× 24ft.	1,207 10s
	Aubusson carpet, mid-19th cent. 32ft× 15ft.	735
1948	C. English hand-tufted carpet, c. 1820, 38½ft× 28½ft.	1,522 10s
1949	Earl of Abingdon. C. Savonnerie carpet, made for Marshal Ney, early 19th cent., 20ft 3in× 12ft 8in.	1,029
1950	Baroness Lucas of Dingwall. S. Swiss table carpet, early 18th cent., 13ft× 8ft.	7,000
	S. Needlework carpet, 1811, made partly by the Empress Marie Louise.	924
	Lord Dovedale. C. English tufted carpet, early 19th cent., 23ft 7in× 11ft.	1,050
1951	S. English needlework carpet, 1843, arms of the Bishop of Gloucester and Bristol, 22ft× 14ft 10in.	1,800
1954	Ramsbury Manor. S. English (Axminster?) late 18th cent., 25ft 5in× 21ft 8in.	1,700

£

1957	Parke-Bernet, New York. Floral Savonnerie carpet, Louis XIV, 18½ft× 13ft.	11,780
1958	Paris. Savonnerie carpet, *tete de négre* ground, *c.* 1790, 12ft× 13ft.	11,920
1958	Paris. An enormous Savonnerie carpet given by Louis XVIII to the Eglise du Temple in 1817	9,200
	Directoire style Savonnerie carpet, rose ground, 18ft 4in × 14ft 4in.	3,440
1959	Chrysler-Foy, New York. Louis XIV Savonnerie carpet, 9ft 10in× 8ft 2in.	9,270
	Ditto, 9ft 8in× 7ft 8in.	10,750
	Earl of Shrewsbury. S. Moorfields carpet from Ingestre, *c.* 1780, bought-in.	12,500
	Executors, Stephen Knight. S. The Lewknor table carpet, made by the Sheldon weavers, 1562, 16½ft× 7½ft (strictly speaking, a tapestry).	16,500
1960	Walter Chrysler, New York. The Stowe Aubusson armorial carpet, *c.* 1795 (see 1848), much repaired.	715
	Penard y Fernandez, Paris. Beauvais carpet, Louis XVI.	10,640
	Sir Arthur Elton, Bt. S. Axminster carpet, *c.* 1820, 21ft× 13ft 3in, green ground.	
	(Francis Dupont Museum, Winterthur, Maryland.)	2,100
1961	Berberyan, Parke-Bernet, New York. Bessarabian Aubusson, *c.* 1835, 20ft 5in× 13ft.	3,570
	Savonnerie carpet, early 18th cent., 17ft 3in× 14ft.	3,215
	Axminster carpet, *c.* 1790, 28ft 9in× 18ft 10in.	3,400

PORCELAIN AND POTTERY, MEDIAEVAL,
INCLUDING THE TANG, SUNG, AND YÜAN PERIODS, 618–1368

£

1823 Farquhar, Fonthill (Philips) (*ex* Beckford). Beckford buys back his pear-shaped bottle of Ch'ing Pai ware, *c.* 1300, mounted in the 14th cent., the so-called Beckford Vase (see 1882). 40 8s 6d

1857 Robert Fortune. C. (Pieces acquired in China.) Bulb-bowl, 8¾in diam., 3¼in high, mottled purple and grey, with spots of crimson inside "of great antiquity and highly prized by the Chinese". This was either an example of the famous Sung Dynasty Chun ware or a copy. 14

1881 Edmond de Goncourt, in *La Maison d'Un Artiste*, describes a pale green prism-vase which he owns: "M. Frandin told me that he had been asked £192 for one of these vases in Peking, where they are believed to come out of graves of the T'ang Dynasty."

1882 Hamilton Palace. C. The Beckford Vase, robbed of its mounts and its identity forgotten, bought by the Dublin Museum as a celadon bottle. 27 7s

1883 V & A purchases nine pieces, described as Sung and Yuan, including white T'ing ware and Lung Ch'uan celadon and brown-glazed ware (per Dr Bushell, Peking) 4s to 2 12s

1902 Hayashi, Paris. The first mediaeval Chinese pottery to be sold as such at an European auction:

 "Vase bursaire", 13th cent. 74
 Chun ware bowl and cover. 156
 Examples of Korean Koryu porcelain. 8 to 25

1906 S. Bing, Paris. Tall white crackled vase, believed Sung. 320

1920 Paris. T'ang figure of a dancing girl, specially large. 324

1921 Sequèstre Worch, Paris. T'ang *potiche*-jar, flambé glaze. 58
 Tzu-Chou jar, incised pattern. 48
 Ditto, painted design, Mei Ping shape. 72
 Temmoku bottle, splashed decoration (age somewhat doubtful). 142
 Tzu-Chou vase, Mei Ping shape, with painted figures. 142
 Chun ware 6-sided jardinière, numeral 9 962
 Ditto, another more elongated, numeral 7 490
 Chun ware trumpet-neck incense-burner, numeral 6. 652
 Chun ware, others. 200 to 350

1922 Erskine. S. T'ang saddle-horse cream glaze. 68

		£	
1924	Benson. C. Chun ware jardinière, numeral 6.	1,890	
	Ditto, bulb bowl, numeral 1.	840	
	Tzu-Chou oviform jar, incised type.	230	
	Glazed T'ang horse, 28in. high.	577	10s
	Other T'ang figures. £7 10s to	29	
1925	G. P. Crofts. S. Han period clay model of a tower, 38in.	80	
	Clay model of buffalo cart, Sui Dynasty.	118	
	2 T'ang pawing horses. 2 for	310	
	Single T'ang horse, flambé glaze.	260	
1927	Mackinnon-Wood. S. Chun ware bulb bowl.	900	
1931	William Alexander. S. Tzu-Chou vase.	480	
	Pai T'ing saucer with 2 ducks (see 1948).	290	
	Chun ware stem cup.	730	
	Chun ware 8-sided jardinière.	600	
	Chun ware saucer-dish.	780	
1933	Stephen Winkworth. S. Chun ware conical bowl.	180	
1938	Stephen Winkworth. S. Kuan ware pear-shaped bottle.	180	
1940	Eumorfopoulos. S. Bottle, lavender Ju ware.	900	
	Chun ware bowl.	460	
	Another ditto.	280	
	Chun octagonal jardinière.	310	
	Chun lobed dish.	520	
	Chun plain dish.	345	
	Tzu-Chou Mei Ping vase, incised type.	195	
	Ko ware 2-handled vase.	410	
	Ko ware pear-shaped bottle.	500	
	T'ang horse, cream glaze, pawing, 16½in.	90	
1941	H. K. Burnet. S. 6 T'ang dancing maidens. 6 for	58	
1943	Sir Daniel Hall. S. Kuan ware octagonal bottle (see 1953).	550	
1946	S. Celadon baluster vase, Yüan period.	360	
1948	Steiner. S. Pai T'ing conical bowl with 2 ducks, 8in.	860	
	2 T'ang dancing girls, 6½in. 2 for	340	
	T'ang statue of a falconer, 15in.	330	
1949	Joseph Homburg. S. Pai T'ing lotus-pattern saucer.	155	
1951	Montague Meyer. S. Chun lotus-bud water-pot (£30 at Eumorfopoulos sale, 1940; see 1959).	240	
1953	Robert Bruce. S. Kuan ware long-necked bottle (see 1943).	2,400	
	Chun octagonal jardinière (Bristol City Gallery).	580	
1955	Schoenlicht. S. Chun vase, plain, Mei P'ing shape (Louvre).	2,180	
	Chun lotus-shaped bowl.	1,350	
	Mrs E. Bennett. S. Chun ware basin.	1,700	
	T'ang glazed ewer of Sassanid shape.	300	
1956	Franco Vannotti. S. Pai T'ing wine-ewer.	520	
	An American collector. S. Pai T'ing saucer with fishes.	400	
	Tzu-Chou baluster vase (neck does not belong).	660	
1957	Traugott. S. Pai T'ing bowl with incised lotus.	450	

		£
1958	S. Chun ware bulb bowl.	270
1959	Kolkhorst. S. Chun ware lotus-bud water-pot (see 1951).	500
	Pai T'ing dish with lotus flower.	750
	T'ang saddle horse.	370
	Wei period unglazed horse (£38, Eumorfopoulos sale, 1940).	320
	T'ang camel.	210
1960	S. T'ang galloping horsewoman.	380
	Charles Russell. S. Kinuta celadon vase with solid dragons.	1,750
	2 Sung celadon bowls.	{1,200 {1,100
1961	S. 2 small light-glazed T'ang horses.	{620 {600
	Ju ware narcissus bowl on 4 feet.	2,200
	C. Light-glazed pawing T'ang horse.	892 10s
1962	S. T'ang horse in mottled glaze, bought by Princessehof Museum, Leewarden.	600
	T'ang horse and rider, lightly glazed.	600
	Porter and his pack, lightly glazed.	580
	Large T'ang glazed Bactrian camel, bought by Aberdeen University Museum.	580
	C. Mei P'ing-shaped vase of Ying-Ch'ing ware, 13th cent.	2,310
	S. T'ang horse and rider with drum, light glaze.	660
	Han wine-vase, iridescent green glaze.	580
	C. Pair of T'ang pottery lady musicians.	1,260
	Pair of mounted polo players, T'ang, 13½in.	1,260

PORCELAIN, MING DYNASTY, 1368-1 44

		£		
1751	Sold by Lazare Duvaux, 2 vases, white relief on brown, mounted. 2 for	14	8s	
1754	Celadon figure of Shang T'ai with biscuit face and hands, described as a *magot*, sold by Lazare Duvaux.	13	8s	
1848	Duke of Buckingham, Stowe. Late Ming blue-and-white brush-pot (described as a cup), mounted in London *c.* 1660 with a greyhound on the lid (was on the London market about 12 years ago).	24	3s	
1859	Lady Webster. C. 13in celadon dish from the Sultan's palace, Constantinople.	1	16s	
1862	V & A buys octagonal blue-and-white wine-pot, playing boys, English parcel-gilt mount, year mark 1585.	75		
1864	William Russell. C. "A rare yellow basin", diam. 7¼in, with mark of the "Siouente" period of the Ming Dynasty.	1	10s	
1882	Hamilton Palace. C. 6 sea-green dishes with raised flowers. 6 for	4	14s	6d
	Oviform jar, 14in, dragons in relief under green-brown glaze, probably 16th cent., bought by V & A.	75		
1883	V & A buys *Fa-hua potiche*-jar with the 8 immortals in mesh-relief, 15–16th cent.	16		
	Pair of *Fa-hua* jars with reliefs on turquoise ground, Mei P'ing shape. 2 for	24		
1888	Marquess of Exeter. C. Late 16th-cent. blue-and-white bottle and saucer-dish with contemporary English parcel-gilt mounts (Metropolitan Museum, per Pierpont Morgan). 2 for	2,040		
	Blue-and-white bowl, frieze of deer, English Elizabethan mounts (Fitzwilliam Museum).	630		
1903	Brenot, Paris. 2 trumpet-mouthed vases, mark of Wan-Li, 1572–1621, *Wu-tsai* enamels. 2 for	172		
	Page Turner. C. Celadon vase, mounted by Duplessis, described as early Ming.	861		
1906	S. Bing. Paris. *Potiche*-jar in cloisonné or *Fa-hua* enamels.	62		
1913	Aynard, Paris. *Fa-hua* vase, elephant handles, relief dragons (see 1945).	662		
1916	S. E. Kennedy. 16th-cent. vase, *Wu-tsai* enamels with temple dedication.	441		
	Trevor Lawrence. C. Reign of Chia-Ching, 1522–66, *potiche*-jar and cover with fishes and water-plants, *San-tsai* enamels (see 1953).	136	10s	

£

1921 Sequèstre Worch, Paris. *Fa-hua* or cloisonné enamelled stoneware, 15th–16th cent., pair of elephant-handled vases.
 2 for 882
 Ditto, *Yen-yen* shaped vases at £602, 500 and 480.

1922 Sir R. F. Glyn. S. Wan-Li blue-and-white bowl, Elizabethan mount. 100

1924 Robert H. Benson. C. A collection of 215 pieces, partly of the *Fa-hua* or cloisonné type:
 2 long-necked bottles, Buddhist symbols, on turquoise ground. 2 for 6,720
 Potiche-jar, 8 immortals on turquoise ground. 1,050
 Turquoise jar with reliefs, floral handles. 892 5s
 Basin-jardinière, aubergine ground. 2,205
 Turquoise double-gourd vase, figures and trees in mesh-work. 4,305
 Swaythling heirlooms. C. Reign of Wan-Li, blue-and-white bowl in an Elizabethan mount. 290
 Another in mount dated 1575 (bought by Randolph Hearst). 357

1927 John Love. C. Chia-Ching blue-and-white *potiche*-jar. 220 10s
 Jardinière, *Fa-hua* enamels, Chêng-tê mark. 462
 Small *Fa-hua potiche*-jar. 378
 Reign of Wan-Li, oblong ink-palette, *Wu-tsai* enamels. 294
 Reign of Chêng-Hua (1466–88) incised polychrome vase (cut down: see 1962). 262 10s
 Mackinnon-Wood. S. *Fa-hua* enamelled Mei P'ing vase, meshed decoration. 800
 Ditto, small jardinière, late 16th cent. 330
 Baluster vase, incised enamels, Chêng-Hua reign. 275

1928 Henry Willett. *Fa-hua* enamelled Mei P'ing vase, meshed decoration, 13in. 475

1930 Marcus D. Ezekiel. C. Hexagonal vase, *Wu-tsai* enamels, Lung-Ch'ing mark (1566–72) (see 1953). 273

1932 Paul Huo Ming Tsu, Paris. Enamelled stoneware statue of an empress. 370
 2nd statue, Lao-tzŭ seated on a lotus. 305

1931 William Alexander. S. Bowl with Chia-Ching mark, polychrome decoration on yellow ground. 240
 Henry Hirsch. C. *Potiche*-jar, *Fa-hua* enamels. 588

1933 Edison Bradley. C. Reign of Wan Li, altar vase, yellow ground, 26in. 588
 Another, cut down. 238 10s
 Fa-Hua beaker, elephant handles. 252
 Fa-Hua double-gourd vase, 14in (see 1940). 672
 Stephen Winkworth. S. Blue-and-white *potiche*-jar with meshwork, 14th cent., catalogued as early 16th cent. (David Foundation). 350
 Enamelled bowl, dated 1433 (see 1953). 220
 Underglaze-red bowl, 14th cent. 170

£

1933	Hot-water bowl with enamelled figure, 15th cent.	110
	Late 15th-cent. enamelled vase, cut down.	120
1935	Charles Russell. S. The first of the dated blue-and-white vases (A.D. 1351) of the David Foundation (see 1946).	360
	Blue-and-white *potiche*-jar with peacocks, 14th cent. (BM; see 1961).	105
	Potiche-jar and cover (1522–66), blue-and-white.	225
	12in blue-and-white box and cover (1572–1619).	180
	Flattened ewer and cover (1522–66).	115
	Blue-and-white Mei P'ing jar and cover, 14th cent.	110
1936	S. 2 15th-cent. petalled dishes, bunches of grapes, blue-and-white. 2 for	136
1937	"A well known collector resident in Peking" (Wu Lai Chi). S. 109 lots of blue-and-white enamelled or white-glazed porcelain of 15th cent., mostly fetching from £20 to £50. Some have changed hands in recent times at more than £1,000 a piece—for instance, a dish with bunch of grapes (see 1946, 1961).	35
	Blue-and-white pilgrim bottle with birds (no longer considered 15th-cent.).	150
1938	Stephen Winkworth. S. 2 yellow dishes, aubergine and green, imperial dragons, Wan-Li (1572–1619). 2 for	96
1940	Harcourt Johnstone. S. *Fa-hua* double gourd vase, turquoise ground (see 1933).	340
	Eumorfopoulos. S. 57 lots of 15th-cent. blue-and-white:	
	Reticulated cup in shape of a lichee.	95
	Hsüan-Tê (1426–33) shallow bowl.	90
	The remainder made from £2 to £50 each and averaged less than £20.	
	A Palace dish, fine quality.	20

Fa-hua cloisonné enamelled pieces

	Chrysanthemum vase, turquoise with floral handles.	150
	Mei-Ping vase, aubergine ground.	200

16th-cent. overglaze enamel pieces

	Incense burner vase, aubergine on yellow, Wan-Li (1572–1619).	88
	16th-cent. bowl, medallions on red ground.	240
	White bowl with enamelled fishes (1522–66).	200
	Chêng-Hua small bowl (1466–88), soft enamels.	230

15th-cent. white wares

	Incised bowl, mark of Yung-Lo (1409–24).	345
	Monk's-hat ewer, Yung-Lo.	120
	Hsüan-tê stem cup with red fishes (1426–35).	180
1942	Charles McKann, New York. 2 large *Fa-hua* statues, 36in, of guardian deities. 2 for	154
1945	Lindley Scott. C. *Fa-hua* vase with elephant handles (see 1913).	900

£

1945 Wan-Li pear-shaped vase, enamelled on white. 200
Yellow and green glazed pottery statue of Wen-Chang,
20in, dated 1659. 280
Fa-hua, turquoise ground, 4-lobed jardinière. 530
E. O. Raphael. S. Mei P'ing jar in *Fa-hua* enamel mesh-
work. 420
Reign of Wan-Li, double-gourd vase, aubergine ground. 500

1946 Lindsay-Hay. S. Several 15th-cent. blue-and-white
palace dishes. 42 to 88
62 15th-cent. blue-and-white lots,
Hsüan-Tê (1426–35) pilgrim bottle (see 1954). 290
Ditto, dragon bowl. 190
Lien-tzu bowl, Chêng-Hua period (1466–88). 150
W. J. Holt. C. Enamelled wares of the Wan-Li period
(1572–1619):
Vase with elephant handles. 609
Ewer with cover. 315
Charles Russell. C. (2nd sale.) The 2nd blue-and-
white vase dated 1351 (David Foundation). See 1935. 330
Palace dish with water-plants. 88

1947 Constantinidi. S. 2 late 15th-cent. dishes, blue on
yellow, Hung-Chih mark (compare 1956 and 1960). $\begin{cases} 170 \\ 140 \end{cases}$
12in bowl, mark of Chia-Ching (1522–66). 230

1953 Mrs Alfred Clark. S. Chia-Ching blue-and-white *potiche*
jar. 520
Underglaze red bottle, 14th cent. 460
Chia-Ching double-gourd vase, turquoise ground. 520
Wan-Li (1572–1619) pear-shaped bottle, enamels. 1,400
Shallow bowl, 14th cent., white on blue (V & A). 570
Chia-Ching *potiche*-jar and cover, *San-tsai* enamels (see
1916). 1,900
Enamelled bowl dated 1433 (see 1933). 380
Reign of Wan-Li lobed bowl, rich enamels. 610
Lung-Ch'ing (1566–71) hexagonal jar, enamels (see 1930). 620
2nd Chia-Ching double-gourd vase, green ground, red
enamels. 540
Robert Bruce. S. Turquoise *Fa-hua* jar, Mei P'ing shape,
meshed relief (Eumorfopoulos sale, 1940, £35), bought by
Liverpool Art Gallery. 800

1954 Martin Button. S. Palace dish, blue-and-white, 15th
cent. (see 1937, 1961). 180
Brenda Seligmann. S. 2 Stem cups in soft enamels
(*T'ou-tsai*), with marks of Chêng-Hua (1466–88). $\begin{cases} 720 \\ 450 \end{cases}$
Red-and-yellow box and cover, mark of Chia-Ching
(1522–66). 520
Plain white stem cup, Yung-Lo mark (1403–24). 360

£

1954 Woodthorpe. S. Hsüan-tê (1426–35) blue-and-white
pilgrim bottle (see 1946, similar piece). 700
 15th-cent. palace dish. 190
 Ditto, conical bowl (Hsüan-tê mark) (see 1956). 340
1955 Mrs Warwick-Bryant. C. *Fa-hua potiche*-jar with its own
cover (*ex* Benson). 210
 Schoenlicht. S. Wan-Li bowl in all-over red and yellow,
5¾in. 600
1956 Langdon-Down. S. Blue-and-white saucer-dish with
rouge-de-fer, late 15th cent. 330
 Woodthorpe S. Conical blue-and-white Hsüan-tê bowl. 870
 Ellington. S. Plain yellow saucer-dishes, Hung-Chih
(1488–1506) and Chêng-tê (1502–22) marks (see 1947, 1960).
each 220
 S. Palace dish, blue-and-white, 15th cent., with mark of
Moslem owner. 385
 27in blue-and-white 15th cent. dish, Ardabil type with
growing flowers (for somewhat similar 25in dish, see
1962), bought for the Freer Gallery, Washington. 2,400
 S. 15th-cent. blue-and-white pilgrim bottle, unmarked. 320
 Palace dish, 15th-cent., with water-plants (see 1959). 260
1957 Turner-Henderson. S. Underglaze-red Kendi bottle,
14th cent. 420
 Reign of Chia-Ching scrap-bowl, tomato ground. 370
 Clare de Pinna. S. Unique blue-and-white pilgrim flask,
early 15th cent., unrecorded type (Freer Gallery, Wash-
ington). 2,600
1958 de Moleyns. S. Round box and cover, Chia-Ching,
Wu-tsai enamels, mark of Wan-Li (1572–1619). 450
 S. Red-ground enamelled saucer 300
 Soame Jenyns. S. 8in platter, underglaze red, 14th cent. 490
 S. Damaged 14th-cent. blue-and-white dish with
pheasants. 330
 Morris Whitehouse. S. Wan-Li bowl in English parcel-
gilt mount, 1629, "Franciscus Particella" (£60 in 1947). 280
 15th-cent. palace dish. 270
 S. 15th-cent. blue-and-white palace dish, bunch of grapes
pattern, mark of Moslem owner. 385
1959 D. M. Hubrecht. S. 15th-cent. palace dish, blue-and-
white. 230
 Kolkhorst. S. Chêng-tê (1506–21) blue-and-white arrow
vase. 750
 Holiday. S. Ewer with Portuguese coat of arms and
mark of Chia-Ching, blue-and-white (1522–66). 340
 S. Plain yellow dish, 8½in, Hung-Chih mark (1488–1506). 640
 14th-cent. blue-and-white dish with swimming carp,
slightly damaged. 1,200
 S. Reign of Chia-Ching, marked blue-and-white jar.
Attached to it is a totally unconnected London parcel-gilt

£

		£
1959	mount off a German tiger-ware tankard with English inscription and mark, *c.* 1560 (Metropolitan Museum).	3,500
	15th-cent. blue-and-white palace dish with water-plants (see 1956).	520
1960	Léon Wannieck, Paris. 2 important-looking *Fa-hua potiches* of the Benson type (see 1924).	{724 {875
	S. Dish, underglaze blue on yellow, mark of Hung-Chih (1488–1506).	1,050
	Ditto, with mark of Chêng-tê (1506–22).	750
	Rosio. S. Typical 15th-cent. blue-and-white palace dish, medium quality.	800
	C. Massive blue-and-white Kuan jar, 14th cent., bought by B.M.	2,520
	(with commission, 2,800)	
	Peter Boode. S. White stem-cup with the rare stamp-collector's mark of the emperor T'ien-Shun (1457–64), bought for Rijks-Museum, Amsterdam (4½in).	2,600
1961	B.M. buys the Russell 14th-cent. jar (see 1935). With remission of death duty, the price may have been over £5,000.	2,500
	Decroos. C. 18in 14th-cent. underglaze red dish.	2,730
	C. 15in 15th-cent. blue-and-white palace dish, bunch of grapes, good quality (record price).	1,150
	S. Blue-and-white 16th-cent. bowl with Portuguese emblems.	1,800
	Much-damaged 16th-cent. ewer with the arms of Portugal upside down.	500
	S. 15th-cent. blue-and-white Mei P'ing vase (1954, £95).	880
	14th-cent. copper-red saucer dish, 7¾in.	780
	Sir Harry Garner. S. Cut-down 14th-cent. bottle in underglaze red.	520
1962	S. Blue-and-white stem-cup, mark of Hsüan-tê, under 2½in	310
	C. Incomplete polychrome baluster vase, late 15th cent. (see 1927).	442
	David Nathan. S. 14th-cent. blue-and-white saucer with spout, under 7in.	2,700
	14th-cent. underglaze red saucer-dish with dragons incised under the red.	2,100
	Sir Percival David. S. 15th-cent. blue-and-white dish with stylized landscape, 25in diam.	2,700
	S. Standard yellow-ground 15th-cent. "three fruits" dish (Hung-Chih; compare 1950).	1,600
	Octagonal jardinière, 15th-cent. blue-and-white.	1,100
	Fa-hua potiche-jar with reticulated figures.	580
	Reginald Palmer. S. Ewer, underglaze red, 14th-cent. 13in high.	8,800
	Blue-and-white palace dish, 15th-cent., 17in.	2,600
	14th-cent. blue-and-white saucer, 7¾in diam.	1,400

£

14th-cent. underglaze red saucer, 7¾in diam. 1,300
Dragon dish, green on white, reign of Hung-Chih, *c.*
1500, 7in diam. 1,700
A ditto bowl, reign of Chêng-tê, *c.* 1520. 1,900
3-colour ginger-jar, mark of Chia-Ching, *c.* 1550, 4½in
high, flying horses. 1,900
5-colour brush-rest, mark of Wan-Li, *c.* 1580. 1,500
Oviform three-colour jar, mark of Chia-Ching, *c.* 1550,
fishes and water-plants, height 9in. 4,200
2 underglaze blue-and-yellow ground dishes, mark of
Chêng-Tê, *c.* 1520. 8in 1,800
 11½in 5,500
S. Blue-and-white dish, mark of Chêng-tê, Arabic in-
scription, *c.* 1520. 2,200
Plain white dish, 15½in, supposed 15th cent. 900
Tonying, New York. Pair of *Fa-hua* vases, turquoise
ground, elephant handles, 17in. 2 for 1,607

CHINESE ART

(Mostly late 17th and 18th centuries)

(For mounted porcelain, mandarin vases and garnitures, see separate sections)

£

1748 Angran de Fonspertuis, Paris. 6 *trembleuse* cups with their
fitted saucers, *blanc de Chine*. 6 for 9 10s
 Garniture of 6, green crackle ware. 6 for 6
 Garniture of 4, blue mottled vases. 4 for 8 16s
 2 figures riding tigers with detachable tails (biscuit?).
 2 for 7 13s
 Male figure on horseback (biscuit?). 1 for 17
 Pair of eagles (probably phoenixes) on rocks, gilded
 wooden bases (the earliest known sale of these birds;
 compare 1962). 2 for 32 8s
 Blanc de Chine, 2 dogs of Fo. 7 16s

1748– Unmounted pieces in Lazare Duvaux's account-books
55 (some may be Ming). 2 17s 6d

1749 A White cock. 13 8s
 2 *magots*, *terre des Indes*, movable heads.

1750 3 urns, green celadon, *truitée* (Ko ware). 31 8s
 2 old celadon bottles, unmounted. 6 16s

1751 A large unmounted celadon vase. 38 8s
 4 powder-blue vases *à cartouches*. 23

1752 An urn and cover, *famille noire*, bought by the painter
Boucher. 4 7s
 Mme Pompadour buys 5 assorted celadon vases for
 mounting. 5 for 200

1755 Tall blue-and-white garniture of 5. 5 for 30
 2 tall vases decorated on yellow ground. 4

1764 Elector of Cologne, Paris. 5 pieces, underglaze blue with
yellow enamel. 5 for 36

1766 First Chinese porcelain at Christie's. Punchbowl with
figures and horses (possibly an English hunting scene). 3 3s

1767 Julienne, Paris. (Nearly £4,000 worth of Chinese and
Japanese porcelain).
 Long-necked celadon bottle, 33in, sold to M. Julliot
 (dragons in relief). 80
 2 dogs of Fo on pedestals, *bleu celeste* with violet splashes,
 19in high (see 1768). 2 for 192
 Stewart and Turner. "Nankeen" blue-and-white
 dinner service. 25 4s

£

1768	Gaignat, Paris. 2 dogs of Fo, mottled blue-and-violet (see 1767).	60
	2 bottles, 21in, mottled blue-and-purple.	70
1777	Randon de Boisset, Paris. 2 fish bowls painted with 3 dragons and entrelacs, border of cranes (possibly blue-and-white, Ming?). 2 for	50 10s
	2 eagles (phoenixes) on rocks and wooden stands. 2 for	44
	2 figures of falcons, red-and-grey. 2 for	19 14s
	2 *famille verte* (presumed) vases with lids. 2 for	36 8s
1781	Duchesse de Mazarin, Paris. Cat, violet-and-blue, mounted on ormolu cushion.	72
	2 celadon *magots* with heads *en biscuit*, mounted on a lacquer palanquin, 14in high.	48
	Magot in turquoise and blue.	13 12s
	Second cat on ormolu cushion, *bleu celeste*.	60
1782	William Devisme's Oriental Museum. C. "Nanking" pagoda, gilded, 5ft high.	9 9s
	Dinner and dessert service, "leaf pattern, Japan and enamelled"(*famille rose*, tobacco-leaf pattern). 126 pieces for	31
1786	Duchess of Portland (Skinner, auctioneer). Group of carp on purple ground with pea-green scroll-work (compare 1862 and 1867).	27
1790	C. "Nanking" blue-and-white table service, 170 pieces.	26 15s 6d
1794	"The valuable museum." C. Pair of powder-blue enamelled jars and covers, ormolu pedestals. 2 for	21
	Charles Bond, "Chinaman of Wardour Street". C. Several "Nanking" blue-and-white services, working out at 1s to 1s 6d a piece.	
1798	James Bradshaw. C. "Nanking" blue-and-white services, virtually new:	
	261 pieces.	36 15s
	142 pieces.	17 17s
	309 pieces.	53 11s
	(From 2s to 3s a piece. By 1848 they were worth hardly more than 2d a piece).	
1804	Eastabrook. C. Armorial table service, 265 pieces.	22 1s
1807	A collector of taste. C. Mandarin punch-bowl with typical cameo border.	2 4s
	2 figures of josses, enamelled. 2 for	27 6s
	Grey crackle bowl, dragon and phoenix in brilliant colours (no size given, but certainly a big fish-tank or cistern).	52 10s
	Earl of Halifax. C. Cistern, chrysanthemums in relief, fishes on inner side, described as "raised Japan", probably Chinese.	15 15s
	2 jars and covers, probably *famille verte*. 2 for	16 6s
	C. A large bottle of the rare sea-green colour, white relief decoration, sold with some enamelled dishes for	105

£

1810 Hon. Charles Greville. C. 2 sea-green and veined
bottles. 2 for 60 18s

1817 William Beckford. C. 21in punch-bowl, Canton china
with an English fox-hunt (not Beckford's taste; must have
been his father's; worth today from £500 to £800 if
perfect). 7 10s

"A noble bottle and cover of the sea-green mandarin
china", plants raised in coloured enamel (probably
celadon with underglaze red-and-blue). 70 17s 6d

1819 C. Pair of celadon garden stools of the usual barrel shape,
pierced and in relief (conceivably worth no more in 1963).
 2 for 64 1s

1821 Mortlock (a dealer's stock). C. Table service in Oriental
eggshell with enamel pattern (so called "Oriental Lowes-
toft", 1s a piece, and going out of fashion). 127 for 6 10s

1822 Wanstead House (Robins). Pair of 36in sea-green bottles
and covers with white flowers in relief. 48 6s

1823 Farquhar, Fonthill (*ex* Beckford). 2 rouleau vases, powder-
blue and *famille verte* panels. 12 12s

 8 ruby-backed *famille rose* saucers. 8 for 4 1s
 6 ruby-backed saucers, double borders. 6 for 6 6s
 2 figures of hawks on light mounts. 10 10s
 2 jars and covers, rose ground (see also Mounted Porce-
lain). 9 9s

1838 William Esdaile [1758–1837]. C. Ruby-backed *famille
rose* saucers, 8 with conversation subjects, 2 with flowers.
 10 for 5

1842 Waldegrave, Strawberry Hill (*ex* Walpole). *Lac-bargeauté*
vase. 4

 2 celadon bottles. 10 10s
 2 turquoise brush-washers in the shape of bundles of
reeds. 12
 Blue-and-white cistern in which Walpole's cat was
drowned (Lord Derby, Knowsley) (see also Mounted
Porcelain). 42

1843 Late Duke of Sussex. C. 2 blue-and-white vases and
covers, 48in high, with kylins on the lids (see 1864). 2 for 29
 2 celadon vases, 35in high, with flowers and ornaments
raised in white. 2 for 39

1844 Jeremiah Harman. C. 2 sea-green bottles, enamelled
flowers. 2 for 32 11s

1845 William Beckford (at Bath). 2 eggshell cups and saucers
"of the yellow ground". 8 8s
 2 pairs of yellow saucers. 4 for 12 18s 6d

 Ruby-backed plates (see 1823). {3 3s
 {4 4s

1847 Edward Harman. C. Jar and cover, powder blue,
figures and flowers in *famille verte* on white panels. 32

£

1848 Duke of Buckingham, Stowe. C. (See also Mounted Porcelain and Mandarin Vases.) 5 jars and covers of compressed shape, with figure subjects (late 18th-cent. export ware) (see 1856). 5 for 59

 2 modern enamelled vases, 48in high (bought in Macao for £84). 2 for 25 4s

 A noble blue-and-white jar, 30in high. 4

1849 C. 2 of Beckford's ruby-backed saucers (see 1823, 1845). 2 for 12 5s

1852 William Hutton. C. Pair of powder blue jars with *famille verte* panels, 34in high, with giltwood stands. 2 for 20 9s 6d

 Robert Fortune, 1st sale. A number of crackled and monochrome pieces in Chinese taste, bought in Peking. The dearest barely exceeded £4.

1853 C. Garniture of 2 beakers and 3 jars and covers, "background of dark green foliage". 5 for 21

 Garniture of 3 jars, "old grey crackle", with bronzed (i.e. darkened biscuit) ornaments (a late 18th- or early 19th-cent. type, today worth no more). 3 for 27 5s

1854 C. 3 vases and covers, 24in high, panels of Chinese figures on crimson ground (probably quite recent) with 2 matching beakers. 5 for 53 11s

 Dinner service, all with numerous figures of mandarins (end of 18th cent.), bought-in. 150 for 51 19s

1855 Bernal. C. Marlborough House (now V & A) buys 5 ruby-backed *famille rose* saucers. 5 for 12 12s

 Also buys K'ang Hsi biscuit group, kylin supporting ewer. 7 17s 6d

 Ruby-backed plate (compare 1823, 1849). 4 15s

 See also Mounted Porcelain.

1856 Robert Fortune [1813–80], 2nd sale of objects bought in Peking. C. Turquoise crackle vase, 18in, with carved wooden stand. 131

 Ditto, 12in. 48 16s 6d

 Long-necked bottle, gold decoration on powder blue. 32 11s

 Colonel Sibthorp. C. Grey crackle vase, 22in, brown (biscuit) collar and masks (see 1853). (In 1963 this vase would be worth less than £20). 63

 2 sea-green bottles with enamelled (i.e. underglaze blue-and-red) flowers, 16in. 2 for 46 4s

 A smaller pair in this style, mounted. 2 for 101

 Rev. William Angerstein. C. 5 flat jars and covers, gold-scroll borders (see 1848) (Oriental Lowestoft) 21½in, bought by Sir Anthony Rothschild. 5 for 246 17s

 Samuel Rogers. C. Fish-bowl or cistern 24in diam., powder blue and gold. 50

1857 Duchesse de Montebello, Paris. 2 unmounted celadon *potiche*-jars. 2 for 96

 James Goding. C. 2 turquoise crackle vases, 11in. 2 for 85

£

1857 Robert Fortune, 4th sale. C. Turquoise crackle bottle,
 double-gourd shape, 12in. 57
 2 square-sectioned beakers, turquoise crackle. 51
1859 Robert Fortune, 5th sale. C. Turquoise bottle in relief,
 15in. 75
 Second ditto, 9½in. 70 7s
 Robert Fortune, 7th sale. C. Bottle, pale turquoise
 crackle, 17in. 131
 14in vase, turquoise crackle, relief dragons. 210
1860 Louis Fould, Paris. 2 kylins, mottled blue-and-violet. 2 for 200
 Sir Charles Lamb. C. Pair of jars and covers, 5ft high,
 "old blue-and-white" landscapes, etc. 2 for 69 6s
1861 C. 2 jars, pink ground, delicately engraved, birds and
 plants, enamelled in panels. 2 for 99 15s
1862 From the Summer Palace. C. 13in vase, cylindrical
 handles, flowers enamelled on crimson ground (modern or
 late 18th cent.). 155
 Perforated double-gourd vase, 8 handles with masks, en-
 amels on yellow ground (modern?). 99 15s
 2 cylindrical turquoise crackle vases, 19in. 2 for 152 5s
 From the Summer Palace, Paris. Figure of carp, violet-
 and-blue, playing among water-plants (according to
 Jacquemart). - 120
1863 Lourette, Paris. *Famille verte* rouleau vase. 82
1864 Lord Lyndhurst [1772–1863]. 2 "Nanking" blue-and-
 white vases and covers, dragons on panels, 46in high (see
 1843). 2 for 120
 Sir Charles Price. Single ruby-backed plate (compare 1823
 and 1855). 25
1866 Henry Farrer. C. 2 "Nanking" blue-and-white jars and
 covers, 58in high, including stands and wooden knobs.
 2 for 140
 Blue-and-white garniture, 3 jars and covers, 24in high.
 3 for 14 5s
 C. Pair of blue-and-white vases and covers, 40in high,
 brought back by Lord Macartney from China in 1792. 2 for 90
1867 Joseph Marryatt. C. 3 of Beckford's ruby-backed
 plates (see 1823). each 15 10s
 17in beaker, blue-and-white magnolia pattern (*ex* Straw-
 berry Hill). 9 9s
 Pair of urns and covers, powder blue in relief, from
 Strawberry Hill, 42in high. 2 for 97
 2 *famille noire potiche*-jars and covers, chrysanthemum
 pattern, 16in. 2 for 43
1867 Lady Webster, 2nd Sale. C. 2 powder-blue jars and
 covers with *famille verte* medallions, bought-in. 2 for 485
 2 powder-blue and *famille verte* fish-cisterns. 2 for 304 10s
 Powder blue garniture, 3 bottles, 2 beakers. 5 for 112

£

1867 Captain Charles Ricketts, R.N. C. Pair of blue-and-white "Nanking" jars and covers, landscapes and figures.
2 for 80

David Falcke of Bond Street, 2nd sale. C. Pair of vases shaped as fishes among water-plants, mottled turquoise-and-violet, wrongly catalogued as Sèvres (see 1862). 2 for 308

1868 C. Pair of blue-and-white "Nanking" jars and covers from Alton Towers. 2 for 95 11s

1870 Lord Auckland. C. Pair of enamelled fish-cisterns (*famille rose?*). 2 for 241

Ditto. 2 for 199

Blue-and-white large jar and cover, "old Nanking". 16 16s

Henry Wigram. C. "Blue-and-white" (classed as such and sold under this heading for the first time) globular bottle, dragons on waves. 45 3s

2 pairs of hexagonal blue-and-white garden seats. 2 for 20 9s 6d

John Bulteel. C. Enamelled fish-cistern. 215 5s

Charles Dickens (the novelist). C. Pair of blue-and-white gourd-shaped bottles with figures. 2 for 24 13s 6d

Pair of ditto with Hundred Antiques pattern. 2 for 20

1875 A. B. Mitford. C. 2 turquoise kylins on pedestals. 2 for 199 10s

2 large fish-cisterns, enamels, Chêng-Hua marks (then believed to be of that period). {82 / 65

Sang de bœuf bottle, described as Lang ware. 16 10s

1876 Henry Bohn. C. *Sang de bœuf* bottle ("Porcelain, bought in Beckford's day, will not sell for half the money" —Bohn's Introduction to the catalogue). 31 10s

1878 van Gelder, The Hague. Lady Charlotte Schreiber sees a garniture of 5 powder-blue vases priced at. 5 for 800

1879 Blue-and-white hawthorn jar and cover bought in Haarlem by J. Duveen, Snr. (Orrock Bequest, V & A). 400

Lord Lonsdale. C. 2 celadon fish-shaped vases, unmounted. 2 for 100

Paul Morren. C. Ruby-backed saucers. 21 to 36

Square green-and-yellow pillow on biscuit. 89 5s

Famille verte pierced lantern. 85

Famille noire dish. 61

1880 E. B. Shuldham. C. Blue-and-white: "The much sought-after hawthorn jars, some with covers complete ... preposterous beyond all precedent." 2 hawthorn jars and covers, both bought-in. {620 / 650

2 other hawthorn jars and covers. {410 11s / 325 10s

Sir Henry Thompson. C. 2 hawthorn jars and covers, bought through Whistler, who had illustrated them in 1878. {525 / 630

1881 C. Sackville-Bale. C. Ruby-backed saucer (E. de Goncourt, *Maison d'Un Artiste*, 1881: "Plates with 7 borders cost at present £72 each". 76

£

1881	Prinsep. C. *Famille verte* trumpet vase, 30in.		150	
1882	Hamilton Palace. C. *Famille verte* rouleau vase, 19in.		199	10s
	2 *famille noire* jars and covers (see 1885).	2 for	420	
	Square-shaped grey crackled vase.		90	
	Apple-green crackled bottle.		76	13s
	2 powder-blue vases with *famille verte* panels, 20in.	2 for	472	10s
1885	Beckett Denison. C. 2 *famille noire* jars and covers (see 1882).		288	16s
1886	Blenheim Palace. Globular blue-and-white hawthorn vase no cover (Duveen, thence Garland and Pierpont Morgan).		136	10s

2 powder-blue-and-white jars and covers, 42 in. Hundred Antiques pattern, not enamelled. 2 for 367

Collection of blue-and-white formed at the end of the 18th cent. and sold at an average of 5 guineas a lot—not the fashionable types. Probable that many were Late Ming.

James Orrock. C. Purchases by V & A. Pair of long-neck bottles, blue-and-white reserved on powder-blue.

		2 for	126	10s
	Pair of hawthorn blue-and-white jars and covers.	2 for	460	
	Single hawthorn blue-and-white jar and cover.		383	6s
	3 blue-and-white rouleau vases.	3 for	253	
	Famille verte pedestal vase, Chêng-Hua mark.		100	
1888	Marquess of Exeter. C. *Famille noire* jar and cover, 26in.		185	15s
	Famille noire rouleau vase, 17in, bought by George Salting (since 1910, V & A).		325	10s
	2 *famille noire* square pedestal vases, bought J. C. Drucker, and given to the Rijksmuseum, Amsterdam, in the early 1900s (see 1895, 1905).		341	15s
1899	André, Paris. 2 ruby-backed saucer dishes.	each	112	
1890	William Wells. C. Blue-and-white hawthorn vase, with cover.		204	
	2 *famille noire* trumpet vases.	2 for	661	

1891 The Red Hawthorn Vase. A *famille noire* trumpet-necked vase with white prunus blossoms tinged with red (*ex* Salting Coll.). Sold by Murray Marks to Joseph Duveen and by him to James Garland (see 1915). 1,300

1894 Malcolm. C. Pair of hawthorn blue-and-white vases.
2 for 570

Garniture of 5 blue-and-white vases and covers, the Jabach Garniture, bought by Joseph Duveen (see 1905).
5 for 588

1895 Joseph Duveen, Snr, is said to have offered for the Exeter *famille noire* vases (see 1888, 1905). 2 for 10,000

Mrs Lyne Stephens. 2 *famille jaune* pedestal vases (see 1912). 2 for 351 15s

1897 C. 2 blue-and-white hawthorn jars and covers. 2 for 1,281

1902 Henry Duveen buys the Garland Coll., mainly blue-and-white, for £120,000 and sells it to Pierpont Morgan.

£

1903	Mme Lelong, Paris. 2 figures of crested birds. 2 for	1,040	
1904	James Orrock. C. Blue-and-white hawthorn jar and cover.	1,312	10s
	Ruby-backed saucers now fetching each	95	12s
1905	Faulotte, Paris. *Famille noire potiche*-jar with the neck smashed.	2,047	10s
	Cronier, Paris. *Famille verte* baluster vase.	920	

H. C. Huth. C. An 18in hawthorn jar and cover, sold in
Bristol in the 1860s for 12s 6d and bought by Huth in the
1880s for £25. Bought by Partridge, but sold some years
later to Lord Astor at a lower price. 5,900

Garniture of 3 vases, enamelled on biscuit, green ground
(bought by Huth in 1893 for £200). 2,700
Garniture of 5 blue-and-white vases. 1,550
2 eggshell pierced lanterns, *famille rose*. 1,200
Pair of powder-blue jars and covers, 19in. 756

Gaspard Farren buys the "Jabach" blue-and-white garniture
of 5 (see 1894), according to James Duveen. 5 for 10,000

1905 J. Duveen, Snr, offers for the 2 Exeter *famille noire* vases
(see 1888, 1895), according to James Duveen. 2 for 20,000

1906 Sir Charles Price. C. Pair of ruby-backed saucers. 441
4 22in powder-blue dishes sold by Duveen to J. P.
Morgan. 4 for 3,500
C. 2 *famille noire* pedestal vases. 2 for 3,885

1907 C. Single *famille verte* pedestal vase, flowers of the four
seasons. 1,732 10s
Famille noire beaker. 1,155
2 biscuit enamelled figures of Kuan-Yin. $\begin{cases}1,050 \\ 1,312 \quad 10s\end{cases}$
2 blue-and-white hawthorn jars and covers. 2 for 1,260
Ditto, oviform vase. 1,050

1910 Octavus Coope. C. 3 triple-gourd vases, enamelled red
on green. 3 for 1,942 10s

1911 C. 2 oviform powder-blue vases (one of them had a Spode
cover). 1,365

1912 J. E. Taylor. C. 2 hawthorn jars and covers. 2 for 672
Yellow-ground pedestal vase (see 1895). 7,245

Edgar Gorer exhibition at the Plaza Hotel, New York. A
famille noire pedestal vase, said to have been sold for
(*American Art News*). 12,400

Jacques Doucet, Paris. 2 dogs of Fo, enamelled *famille
verte* on biscuit. 2,084

1913 Prince Kung Pu Wei. C. 9in apple-green *potiche*-jar. 1,300
17in *sang de bœuf* vase. 1,320

1914 According to *American Art News*, J. D. Rockefeller, Jnr,
paid Gorer £72,000 for 25 pieces, mostly hawthorn jars and
famille noire.
C. (bought by Edgar Gorer.) 2 *famille noire* square jars
and covers. 2 for 3,990

£

Famille noire vase, Mei P'ing shape.	5,040
Famille noire vase, rouleau shape.	4,620

Edgar Gorer sells 2 seated figures of Vajrapani in various enamels, reputed to be Ming, 32in high. The sale was contested on the grounds of authenticity, but, according to James Duveen, the price was for each figure 20,000

The highest porcelain prices ever recorded, 1914–16. For present-day equivalents multiply by 6.

The Pierpont Morgan Coll. (basically the Garland Coll.) was bought by Henry Duveen and sold to P. A. B. Widener, J. D. Rockefeller, Jnr, and Henry Clay Frick for £690,000, including the following valuations:

The red hawthorn vase (see 1891) (Metropolitan Museum, per P. A. B. Widener). 30,000

2 *famille verte* vases (originally sold to George Salting in 1888 for £600). 2 for 15,000

Figure of Kuan-Yin, 43in high, mixed *rose verte* enamels (sold to Garland in 1888 reputedly for £13,000). 30,000

30in vase, dragons in aubergine, black-and-yellow on turquoise ground (Metropolitan Museum, per P. A. B. Widener). Price according to *American Art News*, 1914. 20,280

1916 E. S. Kennedy. C. Figure of Negress, enamel on biscuit. 1,155
Famille noire bowl, damaged. 945

1918 Red Cross sale. C. 2 figures of crested birds (see 1946). 1,680

1919 *Famille noire* vase, bought by Partridge in Hanover and sold to J. D. Rockefeller, Jnr. 12,000

1920 Ruxley Lodge. C. 2 powder-blue vases, 17½in. 1,995
Queen Amelie of Portugal. C. Biscuit figure of a lady, 25in. 1,837 10s
Hunter, New York. Peach-bloom vase, Mei P'ing shape, bought by Parrish-Watson. 1,280
Royal Coll. (Johanneum), Dresden. Pair of long-necked mirror-black vases, gold decoration. 2 for 1,100

1921 Sequèstre Worch, Paris. A hopelessly cut-down *famille noire* vase. 888

1922 C. 18in *famille verte* vase, bought by Partridge. 2,835

1923 C. 28in *famille noire* trumpet vase, bought by Parrish-Watson. 5,040
2 small *famille jaune* pedestal vases. 1,680
Famille noire pedestal vase. 1,575

1924 Testart, Paris. A very badly damaged *famille noire* baluster vase. 1,600
Benson. C. *Famille noire* baluster vase, lacking the entire neck. 420
C. Pair of rolling and kicking horses, *émail sur biscuit* (see 1955). 99 15s

£

1925	C. Approximate pair blue-and-white hawthorn jars and covers, 10in (symptoms of decline).	2 for	693
	Woodman. S. *Famille verte* baluster vase, 29in.		500
	Biscuit-enamelled group, pack-horse and groom (for a similar group, see 1956).		340
	Seligmann, Paris. 4 4ft blue-and-white jars and covers (sold in 1900 for £1,200).	4 for	363
1926	Robinson, Fishers. Pair of hexagonal jars and covers, *famille jaune*.	2 for	1,522 10s
1928	Sir C. Hercules Reed. S. Ruby-backed saucer-dish.		210
	Elbert Gary, New York. Black hawthorn vase.		6,180
	Green hawthorn vase.		4,325
1929	Marcus Hare (Fosters). Garniture of 5 *famille jaune* vases.	5 for	7,875
	Robinson, Fishers. Pair of hawks on rocks.	2 for	420
	C. Pair of cocks on rocks, 13½in.	2 for	567
	Punch-bowl with hunting scenes.		220 10s
	Johnstone. C. *Famille verte* bowl, 15in diam.		3,750
	Peach-bloom bottle (record price).		2,100
	Biscuit figures, 8 immortals.	8 for	2,047 10s
1930	Sir Walter Trevelyan. C. *Famille noire* bowl, 7½in.		1,207 10s
	Pair of hawks on rocks, 12in.	2 for	630
1931	William Alexander. S. *Blanc de Chine* Buddha statuette.		225
	C. 2 14in figures of crested birds.		231
	Henry Hirsch. C. 2 *famille jaune* beakers.		1,102 10s
	Famille noire beaker.		1,312 10s
	2 biscuit figures.	2 for	1,522 10s
1932	Sir R. Paget. C. 2 13½in pheasants.	2 for	451 10s
	S. 2 figures of cranes (see 1955).	2 for	240
1933	Lord Howe. C. 2 figures of crested birds (see 1958).	2 for	630
	Stephen Winkworth. S. 28in *famille verte* vase.		150
	Edison Bradley. C. 2 large *famille noire* trumpet vases.		1,155
			1,680
	C. A ruby-backed dish at a slump price (November) (see 1962).		115 10s
1934	Lady Mary Morrison. C. 33 ruby-backed *famille rose* saucer-dishes made		2,947
	Including a pair, beautifully painted with quails.	2 for	378
	Spicer S. 2 apple-green vases.	2 for	1,180
1935	C. 2 figures of crested birds, 26in.	2 for	1,837 10s
	Anderson's, New York. 2 blue-and-white hawthorn jars and covers.	2 for	650
1937	Heukelom. S. 2 long-necked *famille verte* bottles with kylins on white.	2 for	540
	Famille verte dish with black reserves.		580
	2 "Augustus the Strong" blue-and-white jars and covers, 3ft 5in high.	2 for	140
1938	Jacob Goldschmidt. C. Pair of *famille jaune* jars and covers.	2 for	1,575

£

1938	Pair of figures of phoenixes on rocks.	2 for	651	
	Pair of hawks.	2 for	388	10s
1939	C. 2 biscuit figures of saddle horses.		{168 / 210	
1940	Eumorfopoulos. S. Pear-shaped bottle, enamels on light green.		250	
	Small *famille noire* baluster vase.		300	
1943	Viscount Harcourt. C. *Famille noire* vase and cover.		756	
	Leonard Gow. S. 2 tall *famille verte* trumpet vases. 2 for		370	
1945	R. W. M. Walker. C. 2 *famille noire* jars and covers.	2 for	13,125	
	Smaller ditto with 2 mirror-black beakers.	3 for	3,045	
	2 dancing girls, *émail sur biscuit*.	2 for	1,470	
	Famille noire bowl.		735	
	2 phoenixes on rocks.	2 for	2,100	
	2 ruby-backed saucer-dishes.	2 for	441	
	E. O. Raphael. S. 2 falcons on rocks.	2 for	560	
1946	Charles Russell. S. Lavender vase with poem by T'ang-Ying (see 1953).		560	
	K'ang-Hsi birthday plate.		185	
	S. Pair of biscuit equestrian figures, *c.* 1700.	2 for	1,400	
	W. J. Holt. C. *Famille noire* oviform vase.		462	
	Pair of Yung-Chêng period saucers in Chinese taste. 2 for		378	
	Lady Ludlow. C. 2 figures of crested birds (see 1918).		1,417	10s
1947	Henry Brown. S. Pair of ruby-backed *famille rose* saucer-dishes.	2 for	390	
1951	New York. Green-ground baluster vase with white hawthorn pattern.		1,620	
1953	Hon. Robert Bruce. S. The T'ang-Ying lavender vase (see 1946).		1,700	
	Famille rose pear-shaped bottle, Chinese taste.		620	
	13in *famille rose* bottle with fruiting peach tree, reign of Yung-Chêng (compare Tonying sale, 1962) all these in Bristol City Gallery.		1,000	
	Ethel Locke-King. S. 2 figures of cranes on rocks. 2 for		1,200	
	Sir Harold Harmsworth. C. Another pair of cranes, 17in.		1,470	
1954	Woodthorpe. C. 2 *famille noire* tall cups.	2 for	600	
	Yung-Chêng (1722–36) bowl, fruiting peach tree.		290	
	Highfield-Jones. 2 *famille rose* figures of Lohans, 17in.		750	
1955	Mary Jane Trapnell. C. 2 K'ang-Hsi dishes, 10in, pomegranates, green, yellow, and aubergine.	2 for	294	
	S. Pair of cranes on rocks (see 1932).		450	
	Large group of Dutch man and woman, *famille rose*.		340	
	Mrs Warwick-Bryant. C. 2 figures of rolling horses *en biscuit*, 4¼in (see 1924).	2 for	1,050	
	Parke-Bernet, New York. *Famille verte* baluster vase, 28½in high, with relief figures of the 18 Lohans (*ex* Pierpont Morgan).		1,800	

£

1955	Paris. Garniture of 3 K'ang-Hsi period statuettes, *émail sur biscuit*. 3 for	1,430
1956	Schoenlicht. C. Pair of ruby-backed saucer-dishes. 2 for	560
	Peach-bloom rouge-box and cover, under 3in.	450
	C. Collection from USA. 2 eggshell bowls, 8½in, *famille rose* figures of cocks. 2 for	1,312 10s
	Pair of figures of cranes, 16½in. 2 for	2,520
	Pair of *famille rose* vases and covers, 24½in. 2 for	1,732 10s
	Single ruby-backed saucer-dish.	577 10s
	Pair of biscuit horse-and-groom groups (compare 1925). 2 for	4,410
1957	Parke-Bernet, New York. Triple-gourd vase, 19½in, yellow ground, incised dragons.	3,216
1958	Blake. S. *Famille rose* bowl, 5¾in, Chinese taste, mark of Yung-Chêng (1722–36).	900
	2 *famille verte* saucer-dishes, fighting scenes, very pure Chinese taste, *c.* 1700. 2 for	540
	C. 2 figures of crested birds on rocks. 2 for	4,410
	Lord Hastings. S. 2 late 18th-cent. tureens in the shape of recumbent carp. 2 for	880
	Stotesbury, New York. Long-necked blue-and-white hawthorn-pattern bottle, the pair to the Salting Bottle, and probably sold by Duveen in 1913–15 for over £10,000.	607
1959	Kolkhorst. S. 35in *blanc de Chine* statue of Kuan-Yin (£41 in 1943).	480
	S. *Blanc de Chine* figure of Kuan-Yin, 10in.	390
	Famille verte Monteith punch-bowl.	280
1960	S. Another late 18th-cent. punch-bowl with a fox-hunt.	350
	S. K'ang-Hsi bowl, under 6in, with etched dragons and green, yellow, and aubergine enamels. (In 1956 these fetched £170 a pair, perfect. At the end of the war they could be had for under £10.)	210
	2 pheasants on rocks (compare 1748). 2 for	8,800
1961	Wannieck, Paris. 2 armorial tureens, Compagnie des Indes, *c.* 1760. 2 for	2,660
	2 octagonal *famille verte* vases and covers. 2 for	1,100
	2 K'ang-Hsi *bleu celeste* parrots. 2 for	1,450
1962	Earl of Northesk. C. Armorial dinner service, arms of Carnegie, 110 pieces, *c.* 1760–70 110 for	5,460
	S. 2 small figures of cranes, mid-18th cent. 2 for	1,100
	2 28in figures of cranes, mid-18th cent. 2 for	5,000
	18in K'ang-Hsi *famille verte* dish, showing imperial audience.	680
	C. Pair of ruby-backed saucers, Chinese taste (£157 in 1934). 2 for	682 10s
	Pair of *famille rose* cocks. 2 for	1,260
	Paris. Pair of cock birds, 10½in (40,500 francs and tax).	3,575
	Pair of falcons, 11in. 2 for	3,476

£

1962 E. J. S. Ward. C. Late 18th-cent. enamelled figures, a
boy and a lady, 42in high. 2 for 2,310
Reginald Palmer. S. 2 *famille rose* dishes, Chinese taste, ⎰1,100
reign of Yung-Chêng. ⎱1,000
Tonying, New York. *Famille rose* peach-tree bottle, 21in,
Yung-Chêng mark (compare Bruce sale, 1953), *ex* Pierpont
Morgan. 1,338
 Famille noire vase, hawthorn pattern, 19½in, damaged. 355
 Ditto, dragon pattern, 19½in, damaged. 1,996
 Turquoise baluster vase in fine relief, 22½in. 821 10s
Mme I-min Chang, New York. *Famille verte* statue of
Kuan-Yin, 45in, with boy companion, 22in ($85,000).
 2 for 30,335

CHINESE ART

£

1807	C. Pair, birds and flowers, 51in.	2 for	49 7s
1814	A nobleman. C. 2 sea-green mandarin bottles and covers, described as in relief and richly enamelled. 2 for		95 11s
1816	C. Pair of richly enamelled jars and covers, 44in, with hexagonal wooden stands. 2 for		92 18s 6d
1823	Farquhar, Fonthill (*ex* Beckford) (Phillips, auctioneer). 37in vase, red ground.		27 16s
	Pair of mandarin vases from Portugal, illustrating the manufactory of porcelain. 2 for		131 5s
1843	Late Duke of Sussex. C. Pair of enamelled vases and covers, 53in high. 2 for		94 10s
1847	*Le Cousin Pons*: "deux vases de grand-mandarin ancien, du plus grand format, valent six, huit, dix mille francs".		
1848	Duke of Buckingham, Stowe. C. Pair of mandarin vases, 52in, with lids, bought by Lord Ward (Dudley). 2 for		122 17s
	Garniture of 5 rose-ground urns and beakers. 5 for		59
1857	John Graham. C. 2 octagonal mandarin jars and covers, 3 ft high. 2 for		61
	2 mandarin vases and covers from the Escorial Palace, 4ft high. 2 for		200
	Earl of Shrewsbury, Alton Towers. C. Pair of mandarin jars and covers, 50in. 2 for		162 15s
1859	Lady Webster. C. 2 hexagonal jars and covers, panels on gold trellis borders, 65in with stands, bought-in. 2 for		220 10s
1861	Everington. C. Pair of 51in mandarin vases and covers from the Escorial Palace (see 1865). 2 for		472 10s
1865	Robert Bristowe. C. Pair of jars and covers with pheasants, flowers, etc., on a white ground, the lids surmounted with kylins. 2 for		672
	Samuel Cartwright. C. Pair of vases, unusual size, plants and birds on white ground, covers. 2 for		264 12s
	Duc de Morny, Paris. 2 vases from the Escorial Palace (see 1861). 2 for		400
1870	San Donato, Paris. 2 mandarin jars and covers, 53in. 2 for		1,100
	Two others, same size. 2 for		856

£

1879	Paul Morren of Brussels. C. 2 mandarin vases and covers, 4ft high (one of them repaired).	2 for	432	12s
	Two rose-ground urns and covers.	2 for	404	10s
1882	Hamilton Palace. C. Single octagonal mandarin jar.		200	
	2 mandarin jars and covers, 53in.	2 for	1,239	
	2 rose-ground urns and covers, 51in.	2 for	966	
	2 typical mandarin vases, over 4ft (see 1885).	2 for	603	15s
1885	Beckett Denison. C. The last-named pair of vases made	2 for	288	15s
1886	Paris. Garniture of 5 rose-ground urns and beakers.	5 for	2,720	
1890	William Wells. C. 2 mandarin vases, 48in.	2 for	1,732	
	2 rose-ground jars with covers.	2 for	798	
1891	Lord Haldon. C. 2 mandarin jars and covers.	2 for	1,071	
1895	Mrs Lyne Stephens. C. 2 mandarin jars and covers.	2 for	1,123	
1903	Mme Lelong, Paris. 2 mandarin vases and covers, 4ft high.	2 for	3,200	
1905	H. C. Huth. C. 2 rose-ground urns and covers, 42in.	2 for	1,942	10s
1906	C. 2 tall beakers on rose ground.	2 for	3,255	
	2 50in mandarin vases and covers.	2 for	1,732	10s
1907	2 mandarin vases and covers.	2 for	2,205	
1913	J. M. W. Oppenheimer. C. Pair of 52in mandarin jars and covers.	2 for	1,102	10s
	Rochelle Thomas advertises, offering £3,000 for a rose-ground urn to make a pair.			
1916	Gosling. C. 2 4ft mandarin jars and covers.	2 for	5,670	
1921	Lady Leveson. S. 2 rose-ground vases and covers, 52in.	2 for	860	
1922	Sir John Dashwood. S. Single rose-ground rouleau vase, bought by Duveen.		4,600	
	Gerard Lee Bevan. C. Rose-ground garniture, 5 18in vases and covers.	5 for	1,050	
1926	Lord Michelham (Hampton's). 2 rose-ground urns and covers, 53in high, bought by Duveen.	2 for	3,780	
	2 others, 36in.	2 for	1,050	
1928	Medlycott. S. Rose garniture of 5, 25in, part-damaged.	5 for	980	
1929	Crawford of Balcarres. C. Garniture of 3 rose-ground vases.	3 for	5,250	
1934	Spicer. S. 2 rose-ground vases and covers, 54in.	2 for	200	
1936	Alfred Morrison. C. Garniture of 3 urns and covers, 25in high, painted with cockerels, *famille rose* colours.	3 for	1,680	
	Other rose-ground vases, 54in high.	2 for	142	
	Edward Farmer. S. 2 18in rose-ground vases.	2 for	500	
1941	C. Two 16in ruby-ground jars and covers.	2 for	262	10s
1953	Sir Oliver Welby. C. 2 mandarin jars with lids, 60in high.	2 for	388	10s

£

1957 Parke-Bernet, New York. 2 rose-ground vases, 53in high
(sold by Duveen to E. T. Stotesbury about 1914 for
£10,000). 2 for 427

1962 Lord Bruce. C. Pair of mandarin jars and covers, white
ground, phoenixes, flowers, etc., kylins on lids. 2 for 2,310

1963 S. Rose-ground garniture, 3 covered urns, 24½in, 2 beakers,
19 in. 5 for 1,850

CHINESE ART

£

1748 Angran de Fonspertuis, Paris. Pot-porri a double couvercle, "truitée à fleurs de couleurs", probably *famille verte*, bought by Mme Pompadour. 44

Account-books of Lazare Duvaux, 1749–55

1749	A pair of vases, *ancien Chine*, with ormolu handles.	2 for	48
1750	2 celadon vases, mounted by Duplessis.	2 for	120
1751	2 mounted celadon vases in the shape of fishes.	2 for	48
1753	2 mottled vases, blue-and-red, rich mounts.	2 for	144
1754	2 celadon vases, mounted, with covers.	2 for	119 16s

1755 Single celadon vase, *brodée en relief*, mounted for Mme Pompadour; *end of Lazare Duvaux items*. 1 for 60

1768 Gaignat, Paris. A single mounted celadon vase, flowers in relief, *forme Lisbet*. 1 for 100

1776 Blondel de Gagny, Paris. *Blanc de Chine* elephant, 10in×11in, with ormolu stand *en rocaille*. 1 for 240

1781 Duchesse de Mazarin, Paris. Cat in *ancien violet* on an ormolu cushion (see 1787). 1 for 72

1782 Duc d'Aumont, Paris. 2 celadon garden seats mounted as vases by Gouthière and valued at £533; bought by Louis XVI and now in the Louvre. 2 for 300

1787 Comte de Vaudreuil, Paris. The Mazarin cat (see 1781). 36
2 lions or chimaeras in blue-and-violet on ormolu plinths, "on connoit le valeur de ces beaux morceaux". 2 for 40

1788 Comte d'Adhemer. C. "A pair of rare old olive-colour Japan vases" (Chinese celadon) supporting 6-branch candelabra, "singularly fine rich ormolu", bought-in at £451 10s nominal. Put-up again two months later and sold to M. de Calonne. 2 for 183 5s

1807 A collector of taste. C. Pair of bowls and covers, seagreen and crackled, mounted in ormolu in the handsome French taste. 60 18s
Pair of sea-green bottles, mounted in ormolu. 2 for 23 2s
Earl of Halifax. C. Fish-bowl mounted on bird's-claw feet. 21

1809 2 mandarin figures, mounted as light-holders. 2 for 31 10s

1814 Beckford is offered 2 celadon bottles with ormolu stands and stoppers. 2 for 140

£

1823	Farquhar, Fonthill (*ex* Beckford). 2 mounted celadon bottles, 11in high. 2 for	3 15s
	2 lotus-shaped celadon bowls, mounted with lids as potpourris. 2 for	14 3s 6d
	(For the Beckford-Gaignières vase in 14th-cent. mount, see Pottery and Porcelain, Mediaeval.)	
1825	G. Watson Taylor. C. 2 20in celadon bottles, ormolu handles, etc. 2 for	72 9s
1827	Late Duke of York. C. 2 grey crackle vases, ormolu plinth and handles. 2 for	58 16s
1842	Waldegrave, Strawberry Hill (*ex* Walpole). 2 Mazarin blue beakers in splendid ormolu mounts, 42in high. 2 for	55 13s
1848	Duc de Richelieu. C. Pair of globular vases, deep blue, richly mounted, bought-in. 2 for	105
1851	Earl of Pembroke. C. Pair of mounted cisterns, 20in diam., Chinese objects and symbols on a green chrysanthemum background (*mille fleurs* pattern?), mounted on lions' heads and feet. 2 for	158 11s
1852	Duc de Stacpoole, Paris. Pair of celadon crackled vases, Louis XV mounts. 2 for	100
1855	Bernal. C. Celadon double-gourd bottle, Louis XV mounts (see 1910).	63
	2 *famille rose* bowls mounted as potpourris. 2 for	52 5s
	Jar and cover, Kuan crackle ware, Louis XV mounts.	50
1857	Duchesse de Montebello (Maréchâle Lannes), Paris. 87 lots of mounted Chinese porcelain:	
	2 vases, *celadon bleu*. 2 for	131 12s
	2 celadon bottles with blue-and-white medallions, Louis XV mounts. 2 for	170
	2 small vases, panels on engraved rose ground, Louis XVI mounts. 2 for	128
	John Graham. C. Rouleau vase, crimson ground, blue dragon and other decorations; on silver-gilt griffins, 21½in high (*ex* Beckford, who may have had this mounted as a modern piece).	56
1859	Lady Webster. C. Fluted celadon vase, 21in, Louis XIV mount (*ex* Watson Taylor Coll.). 1 for	95 11s
1861	Earl of Pembroke, Paris. Pair of celadon vases with flowers in blue relief, Louis XV mounts. 2 for	139
	2 spherical vases on rocaille feet. 2 for	182
	2 celadon vases mounted with covers as potpourris, Louis XV. 2 for	209
1863	William Russell. C. Pair of crackled grey vases in the form of double fish, Louis XV mounts. 2 for	110
	Countess of Ashburnham. C. Pair of mottled blue cats on ormolu stands, mounted as candelabra "at a far subsequent date". Given originally by Louis XV to Mme de Mirepoix in 1769 as a bribe to introduce Mme du Barry at Court, presumably a symbolic gift. 2 for	367 10s

£

1865 Samuel Cartwright. C. 2 *lacq bargeauté* vases, handles,
rims, and feet in ormolu. 3 for 155

1866 W. G. Morland. C. Bowl and cover, sea-green crackle,
Louis XV style mount. 75 12s

1870 San Donato, Paris (Demidoff). 26 pairs of mounted
Chinese vases:
Pair of tall vases with medallion decoration on blue
ground, mounted as torchères to a height of 88in. 2 for 400
2 fish-bowls in enamelled relief mounted on Régence
tripods to a height of 40in. 2 for 1,560
2 unusual rose-ground bowls mounted with pierced
covers, etc., as potpourris (Wallace Coll.). 2 for 200

1877 Sir Robert Napier. C. Celadon vase, formed of 2 lotus
flowers, mounted (possibly an incense-burner). 315

1878 P. J. Dering. C. 2 lavender vases, Louis XV mounts.
2 for 420

1879 Paul Morren. C. Pair of Mazarin blue rouleau vases,
Louis XV mounts. 2 for 125

1881 Sackville-Bale. C. 2 matching celadon vases, 7½in. 2 for 420

1882 Frances Leybourne Popham. C. Single celadon vase in
a Louis XV mount. 2,415
Hamilton Palace. C. Pair of flat celadon bottles. 2 for 850 10s
Peculiar tall *famille verte* vase, mounted on feet as a cistern. 472 10s

1884 Baron d'Ivry, Paris. 2 celadon bottles, Louis XVI mounts.
2 for 1,480

1887 Orme. C. Celadon bowl, Louis XV mounts. 320 5s

1890 Achille Seillière, Paris. 2 powder-blue vases, Louis XVI
mounts. 2 for 1,100
2 red-and-blue *flambé* bottles, Louis XVI mounts. 2 for 880

1893 Earl of Essex. C. Garniture of 3 mounted celadon
bottles, Louis XVI. 3 for 1,470

1895 Earl of Clifden. C. Somewhat similar garniture of 3.
3 for 1,785

1897 Marquis de Fleury, Paris. 3 celadon and underglaze
coloured vases, Louis XVI mounts (see 1912, 1927). 2 for 1,520

1898 Gontrant-Biron, Paris. 2 *famille verte* baluster vases, cut
down and mounted as spherical jars on ormolu stands,
c. 1740 (see 1903). 2 for 1,880

1903 Mme Lelong, Paris. The same as the last. 2 for 3,720
C. The "Roche-Aymon" pair of Mazarin blue vases,
Louis XV mounts. 2 for 3,832 10s
Sir E. Page Turner. C. An alleged early Ming celadon
vase, mounted by Duplessis. 861

1904 C. Mazarin blue vase, Louis XV mount, bought by
Duveen. 1,885

1907 Chappey, Paris. Garniture of 5, Mazarin blue, Louis XV
mounts. 5 for 3,280
Single celadon vase, Louis XVI mount. 1,204

£

1907	Rikoff, Paris. 2 *famille rose* eggshell vases with figures, Louis XVI mounts.	2 for	1,380	

1910 Octavus Coope. C. 2 *famille verte* vases, Louis XV mounts. 2 for 1,942 10s

 Celadon gourd bottle, Louis XV mount (see 1855), apparently still (1962) the record price for a single mounted vase of Chinese porcelain. 4,700

1912 J. E. Taylor. C. 3 vases, celadon and underglaze colours, Louis XVI mounts (see 1897, 1927). 3 for 3,150

 Jacques Doucet, Paris. 2 powder-blue spiral, voluted vases with blue-and-white medallions, Régence mounts.
 2 for 4,400

 2 celadon vases, Régence mounts. 2 for 2,310

 2 celadon vases, mounted as brûles-parfums, Louis XVI.
 2 for 2,244

1913 Murray-Scott. C. Green crackled beaker, Louis XV mounts. 1 for 1,837

 H. M. W. Oppenheim. C. 3 Mazarin blue vases, Louis XV mounts. 3 for 5,250

 2 ditto with covers, bought by Duveen. 2 for 7,665

 Another pair without covers. 2 for 4,305

 (7 pieces for £17,220; equivalent to £103,000 in 1963.)

1920 Sigismond Bardac, Paris. 2 lavender-coloured gourds, Louis XV mounts (63,800 francs). 2 for 1,290

 2 hexagonal blue vases, Louis XVI mounts (72,000 francs).
 2 for 1,535

 Arnold. C. Garniture of 3 celadon bottles, mounted as a fountain, and 2 ewers, Louis XV. 3 for 1,650

 Harland-Peck. C. 2 powder-blue rouleau vases, Louis XV mounts. 2 for 1,680

1923 Earl of Brownlow. C. Celadon ewer, Louis XV mounts, 15in. 1 for 1,470

 2 Mazarin blue vases, Louis XV mounts, 14½in. 2 for 2,100

 E. F. L. Wood. C. 2 pottery eagles on rocks (Japanese, Bizen?), mounted as candelabra, Louis XV. 2 for 546

1927 Sir George Holford. C. 3 Mazarin blue vases mounted *en rocaille*, Louis XV. 3 for 3,045

 Joseph Bardac, Paris. 3 celadon vases, mounted for Philippe Egalité, Louis XVI (see 1897, 1912). 3 for 2,480

 2 turquoise bottles, Louis XVI mounts. 2 for 2,680

1929 C. Celadon bowl fitted with cover and mounted as a bonbonnière, stamped Caffieri, 9in high (*ex* Carnarvon Coll. See 1939). 178 10s

1930 Earl of Balfour. C. 2 Louis XV potpourris, formed of fine *famille rose* bowls with sampan scenes in panels. 2 for 756

1939 S. Celadon bowl and cover, Louis XV mounts (see 1929). 580

1942 Lockett. C. 2 celadon leaping fishes mounted in Caffieri style. 2 for 309 15s

£

1957 Coll. J. B., Paris. 2 blue-and-white cut-down jars with covers, late Louis XIV mounts, *c.* 1700, with caryatid handles. 2 for 3,820

1960 The Misses Milligan. C. 2 figures of hawks in Louis XVI mounts. 2 for 7,510

1962 Lady Powis. S. 2 celadon rouleau vases in Louis XVI mounts. 2 for 6,000

C. Pair of *famille verte* jars in Louis XV rocaille mounts. 2 for 945

CHINESE ART

BRONZE

		£		
1741	Earl of Oxford (Cock, auctioneer). Chinese man from the life, in a glass case.	4		
1750	Crozat, Paris. Pair of figures of boys riding buffaloes. 2 for	5		
1770	Erasmus van Harpe. C. 2 Chinese bronze teapots. 2 for	1	7s	
1788	C. Bronze figure of a Chinese buffalo.	6	12s	6d
1805	C. 2 Chinese hieroglyphic bronzes 2 for	2	12s	6d
	6 Chinese ornaments in bronze. 6 for		14s	
1820	A gentleman returned from China. C. 62 lots sold for £412 17s, with a specially written Preface:			
	Incense-burner (published in Hager, *Numismatique chinoise*, 1805).	19	19s	
	16in vase with a kylin on the lid.	15	15s	
	20in vase with 28 constellation signs.	28	7s	
	Globular 2-handled vase, 8½in diam.	19	19s	
1823	Officer of the East India Company. C. Beaker, tortoise-shell ground, ribbed water-plants.	17	17s	
1846	de Ville. C. 2-handled vessel, characters, etc.	6	10s	
	Lozenge-shaped vessel, projecting bosses.	5		
	De Guignes, Paris. "Bronze à parfums, forme lozenge."	27	5s	
	Tripod incense-burner.	28		
	2 candelabra, mounted on kylins. 2 for	32	3s	
	Cornet-shaped vase: "dont l'usage remonte jusqu'a sous la dynastie des Chang, qui ont regne 1400 ans avant J.C."	18		
1856	Robert Fortune. C. Tall vase, 20½in, handles, masks, etc.	20		
1859	Bram Hertz. S. 5 bronze statues, including a figure of Kuan Yin from a temple, 4 ft 6 in high. 5 for	225		
1860	C. Pair of globular vases, pierced covers, old Peking bronze, 20in. 2 for	41		
1861	From the Summer Palace. C. Pair of figures of storks, 64in high. 2 for	53	11s	
1863	William Russell. C. Square vase, 25½in high, ring-handles, ornaments in different colours in relief: "presumed about 1,200 years before the Christian era".	32	11s	
	Vase, 11¾in high, ring-handles, ornaments of inlaid silver, "very early specimen".	44		
1899	Bushell Coll. V & A purchases P'an, or sacrificial bowl, nearly 2ft high, with inscriptions relating to 632 B.C.	80		
	Alleged Shang period wine-vessel.	12		
	Han period figure of a bird on wheels.	8		

£

1899	Han period T'ing, or tripod vessel.	30
	War-drum, dated A.D. 199, 2ft wide.	35
	Rhinoceros-shaped wine-vessel, pre-Han.	40
1902	Hayashi, Paris. Alleged Chou libation vase.	280
1903	Hayashi, Paris. Cistern with inscriptions, alleged Shang period (others at £100 to £150).	284
1923	BM buys dish, late Chou Dynasty.	1,750
1924	Paris. Figure of a rhinoceros, believed Ming.	416
1930	Sauphar, Paris. 2 Scytho-Chinese figures of deer. 2 for	400
1936	S. Supposed Chou cauldron, or T'ing.	92
1940	Eumorfopoulos. S. Shang Dynasty covered wine-vessel from Anyang.	1,400
	2 bronze pole-finials in the form of mules' heads (see 1960). 2 for	820
	T'ang Dynasty censer.	195
1941	H. K. Burnett. S. Chou bronze beaker, bought by Barber Institute.	230
	About 12 important pieces. all under	200
1943	Norman Collie. S. Circular cauldron, or T'ing, on tripod.	100
1944	S. Trumpet-shaped vase, Chou Dynasty.	195
1945	Lionel Edwards. S. Tall wine-vessel, c. 200 B.C., lid in form of owl's head.	1,080
	4-legged cauldron, Chou Dynasty.	800
	Oval-section cauldron with loop-handle, Shang Dynasty, from Anyang.	660
1947	Henry Brown. S. Very lavish Kuei vessel with bird handles, Chou Dynasty.	520
	2 square vessels and covers. 2 for	500
1949	Joseph Homburg. S. Cauldron on tripod, Chou Dynasty.	450
1951	S. Buffalo-shaped vessel on wheeled carriage, Chou period.	250
	Cauldron with cover in shape of a horned monster, late Chou period.	250
1953	Robert Bruce. S. Tripod vessel, Shang Dynasty.	640
1952	Hauswedel, Hamburg. Oval sacrificial vessel and cover, Chou Dynasty.	256
1955	Mrs E. Bennett. S. Figure of a stallion, 4½in high, Han Dynasty, from Ordos.	240
	Bronze mirrors in relief, T'ang Dynasty.	{260 {220
	Dr Lochow of Peking (at Berlin). Sacrificial wine-vase, Shang Dynasty.	2,065
	Bowl with high foot-ring, Chou Dynasty.	780
1957	Parke-Bernet, New York. Ritual vessel in form of a tapir-like animal, middle Chou period.	2,115
1960	S. 2 bronze finials in the shape of mules' heads (see 1940). 2 for	4,800

		£
1960	Libation cup, Shang Dynasty.	550
1962	C. Kuei, 2-handled food-vessel and cover, early Chou Dynasty, bought for Japan.	2,990
	T'ing, tripod vessel, Shang Yin Dynasty, with inscription.	1,575
	Gilou. S. Gilt-bronze figure of Kuan Yin, 13th cent., 7in.	520
	Piao bell, Han Dynasty, plain, with tiger finial.	500
	d'Ajeta. C. Gilt-bronze statuette of Matreya, dated A.D. 492.	2,310
	S. Han figure of tiger, 8½in × 3½in, fragment.	540
	Tonying, New York. Gilt-bronze Buddha statuette, inscription dated A.D. 556, 10in with pedestal.	1,000
1963	S. Allegedly Chou wine vessel, shaped as a goose, bt. for Aberdeen University.	1,200
	Shriro. S. Kuei, 2-handled vessel, early Chou period, 7in high.	10,000

CHINESE ART

Mainly 18th–19th-centuries (some, 15th–17th centuries, included)

		£		
1805	C. Fine ancient Chinese vase and cover "of blue enamel on copper and ormolu".	6	12s	
1848	Duke of Buckingham, Stowe. C. Incense-burner and cover with elephant handles. Bought in Amoy by Captain Johnson of the *Wolverine*, who later reacquired it for £73.	63		
1850	Debruge Dumenil, Paris. Ewer, 16in.	28		
	Another with Imperial dragons.	32		
	Pair of incense-burner ducks. 2 for	17		
	Incense-burner mounted on elephants' heads, with mark of Ching T'ai (1450–7).	32		
	Vase mounted on kylins.	30		
1855	W. W. Hope, Paris. Vessel described as a bottle.	80		
1856	Robert Fortune. C. Pair of vases, 15¼in high, with chased brass handles. 2 for	210		
	Globular vase, 21in, turquoise ground.	71		
	Pair of altar candlesticks, mounted on birds, with a circular vessel. 3 for	135		
	Square vase, 18in.	48		
	"Collection of early Chinese enamels." C. 44 lots:			
	Imperial incense-burner, 27in high	66	3s	
	21in dish with scalloped edge, 5 dragons.	94		
	Pair of 11in censers. 2 for	64		
	Flat, oval-shaped bottle, figures and flowers.	77	14s	
	Colonel Sibthorp. C. Tripod vessel with a pierced cover.	68		
1858	V & A buys 30in salver on chased brass feet.	100		
	David Falcke. C. Globular vase, animals on waves, turquoise ground "of the time of the Ming Dynasty" (probably a 15th-cent. reign mark).	28		
1859	Baron de Cordes. C. 2-handled vase, 30in high, enamelled butterflies and flowers on turquoise ground (probably almost modern).	99	15s	
1860	Louis Fould, Paris. 2 pear-shaped vases, 2ft high. 2 for	71		
1861	From the Summer Palace. C. 2 vases on tripod, elephant heads. 2 for	91	7s	
	Altar set, incense-burner, 2 candlesticks, 2 beakers. 5 for	72	19s	6d
	2 11½in bottles, bought by Webb for Ferdinand de Rothschild. 2 for	68		

		£	
1861	Table screen, view of buildings in a garden.	35	10s
	From the Summer Palace, Paris. Incense-burner, 20in.	31	10s
1862	From the Summer Palace. C. About 70 lots in 3 sales:		
	2 double-gourd vases, 17½in high.	⎧68	5s
		⎩70	17s
	2nd sale of looted objects, Paris. 2 brûles-parfums. 2 for	360	
	Incense-burner with Hsüan-tê mark (1426–35).	185	
	Small objects enamelled on solid gold, incense-burner.	280	
	Ditto, cup.	320	
1863	Lourette, Paris. 2 boxes and covers with dragons on lids.		
	2 for	456	12s
1864	From the Summer Palace. C. Pair of 28in tripod incense-		
	burners. 2 for	157	10s
	Earl of Elgin. C. Incense-burner mounted on kylins, 38in high.	79	
1865	Duncan Fletcher. C. Single globular incense-burner and cover.	147	
	Lourette, 2nd sale, Paris. Jardinière, supported by kneeling figure, 42in diam.	450	
	Duc de Morny, Paris. Round box and cover, 14in diam.	160	
1866	C. Cylindrical vase, cranes on black background (Japanese?).	176	
1869	V & A buys 2 moon flasks, 15in high. 2 for	200	
1870	Recently exhibited at South Kensington. C. Incense-burner, pierced cover, dragon handles.	116	
1872	Paris. 2 incense-burners. 2 for	336	
	2 vases. 2 for	372	
	Allègre, Paris. 2 vases from the Summer Palace, enamelled on gold, 5¼in. 2 for	1,008	
1874	Paris. 2 brûle-parfums. 2 for	388	
1875	A. B. Mitford. C. 2 flat bowls with covers. 2 for	135	
	Cauldron from the Summer Palace.	152	5s
	2 figures of storks.	194	5s
1876	Henry Bohn. C. Figure of a bird on wheels from the Summer Palace (see 1916).	30	9s
	V & A purchases 2 basins, 27in wide, from the Summer Palace. 2 for	260	
	Incense-burner surmounted by a dog of Fo, 28in high.	218	
1879	Garfunckel, Paris. Single beaker vase.	134	
1882	Hamilton Palace. C. 2 incense-burners with kylin figures. 2 for	168	
1884	V & A purchases vase, 28in high.	160	
1886	Soltykoff decease sale, Paris. 2 statues, nearly 4ft high.		
	2 for	220	

Between the late 1880s and the early 1950s Chinese cloisonné enamel was out of fashion. The following were specially highly priced:

			£	
1916	Trevor Lawrence. 3 incense-burners with kylins on the lids.		367 189 304	10s 10s
	Vessel in the shape of a bird on wheels from the Summer Palace (see 1876).		315	
1925	C. Elephant and howdah, 45in high.		189	
1926	Michelham (Hampton's). Pair of Koros.	2 for	357	
1932	Sir John Ramsden. C. 2 elephants supporting vases, 31in high.	2 for	189	
1933	Stephen Winkworth. S. Box and cover, Ming Dynasty.		110	
1936	C. Figure of a recumbent ram.		119	10s
1937	Victor Rothschild. S. Elephant on marble plinth.		160	
1943	C. 2 tall vases with beaker necks, brass handles and feet.	2 for	199	10s
1954	Duke of Gloucester. C. Horse and rider, 25in high, late 18th cent., unique piece; still (1963) a record price.		1,522	10s
	20in elephant.		1,029	
1960	C. Pair of figures of cranes.	2 for	1,522	10s
	Kitson. S. Huge bowl in shape of a double peach.		700	
	2 candlesticks, mounted on figures of rams.	2 for	1,550	
1961	Kitson. S. Box and cover said to be of the Ming period.		780	
	2 dwarfs over 2ft high.	2 for	1,500	
	Pair of pricket candlesticks, 8in.	2 for	750	
	S. 2 cranes standing on tortoises, 24in high, believed Ch'ien Lung period.	2 for	2,700	
	2 elephants supporting vases, 13in.	2 for	950	
1962	Sir Percival David. S. Ritual disc, believed to be early Ming (£24 in 1933).		1,400	
	S. A pair of cranes, 62in high, 19th cent., much restored.	2 for	2,600	

CHINESE ART

JADE CARVINGS (INCLUDING INDIAN JADE)

£

1791 Auguste Lebrun, Paris. Mughal jewelled jade cup, 5¾in × 6in, on a rocaille ormolu mount in the form of a chimaera. 15 6s

1794 "The valuable museum." C. A curiously wrought teapot and stand, a large salver, all formed of jade stone and curiously wrought. 3

Nephrite cup "of a fine green colour, presumed to be unique". 9 9s

1819 C. Teapot (wine-pot) and lid, lotus petals in relief, inscriptions, lizard handles. 37 5s 11d

Teapot (wine-pot), circular compressed shape, carved with dragons, lizard handles. 82 8s 7d

1820 C. 3 small vessels in lapis lazulae in a case. 3 for 64 1s

1823 Farquhar, Fonthill (ex Beckford). Sceptre given by Emperor Chien Lung to George III through Lord Amherst, 1816. 18 18s

Tippoo Sultan's jewelled jade hookah-base (Indian Mughal). 219 19s

1838 "Nobleman of high rank." Oval jade bowl, scalloped leaves, raised from surface. 28 10s

Basin of green jade of unusual size, fine colour. 27 6s

"Monsieur Hertz." C. Mirror, perforated work of flowers, studded with rubies and mounted (Indian?). 24 3s

1850 C. Vase of compressed shape with lizard handles. 35 3s 6d

Jade seal with long inscription, bought-in. 7 7s

General J. Macdonald. C. Bell-shaped cup and cover, jewelled (Indian Mughal). 39

Scalloped green jade salver with European mount (Mughal). 16 5s 6d

Debruge Dumenil, Paris. Flat wine-ewer in high relief. 26 4s

Lotus cup. 12

Spinach jade octagonal box and cover. 15 13s 6d

Spinach jade ink-screen, pierced-work relief. 5 15s

1854 Samuel Woodburn. C. Fluted cup with cover and stand, emerald green. 3 for 95

1857 Robert Owen. C. Green jade vase, 10½in. 80 17s

1858 George T. Braine. C. White fluted cup, leaf-handle, enamelled gilt metal stand. 84

Brush-washer with landscape carving. 60

1859 John Fischer. C. Pilgrim bottle and stopper, 12in. 34

£

1860	Louis Fould, Paris. Cup in shape of a lotus, "verdâtre".	46 5s	
1861	From the Summer Palace. C. Rock-crystal vase with foliage.	54 10s	
	The Emperor's great seal of state.	16 5s 6d	
	Cup, emerald green, carved wood stand.	178 10s	
	Bottle, 8in, dragons in relief.	82 19s	
1862	From the Summer Palace, Paris. Square vase, emerald jade.	204	
1863	Earl Canning. C. Cup and cover, green aventurine (see 1866).	57 15s	
	Pilgrim bottle, 10in.	64 1s	
1865	Duncan Fletcher. C. Large white incense-burner, ring handles.	131	
	Duc de Morny, Paris. 2 brûle-parfum vases. 2 for	100	
1866	Robert Goff. C. Cup and cover (see 1863).	42	
1870	Lord Auckland. C. Indian Mughal fluted cup with bird's head handles, set with rubies and emeralds.	105	
1877	V & A buys flat bowl and cover with bat handles.	84 17s 6d	
1878	T. Greenwood. C. Indian jade box, studded with rubies, etc.	155	
1882	Hamilton Palace. C. Oval-shaped bowl, Indian jade, jewelled and gilded.	315	
	Oval bowl of pale green jade.	133 7s	
	2-handled bowl, pale green.	199 15s	
	Shell-shaped cup, pale green.	22 1s	
	2 jewelled jade hookahs (Mughal) in elaborate English Regency mounts (see 1956).	1,522 10s	
1885	Beckett Denison. Flat vase and cover, bought by Salting.	85	
1894	Walkinshaw. C. Flat vase and cover.	100	
	Spinach green bowl.	273	
	Magnolia-shaped vase.	147	
1912	Marquise Landolphe Carcano, Paris. Jade sitting buffalo (Ming?).	240	
1916	Sir Trevor Lawrence. C. 14in jar and cover, dark green.	325 10s	
1924	S. Figure of Shou Lao, mounted on a water-buffalo, 18th cent., 9in × 7½in.	185	
	S. Pair of snuff-boxes made of jewelled and mounted jade in the Louis XVI style, alleged gift to the Emperor Ch'ien-Lung. 2 for	205	
1925	C. Spinach green table-screen.	94 10s	
	Sir Francis Cook. C. Mughal bowl, 7¼in, 17th cent. (India).	231	
	MacAndrew. C. Two bowls and covers. 2 for	420	
	2 archaic-shaped vases, 15½in and 10in. each	273	
1929	Ballantyne. C. Spinach green table-screen, high relief.	189	
	At Hurcomb's rooms. Recumbent horse, 13in.	190	
1930	Barnet Lewis. C. Dark green Koro and cover, 7½in high.	323 10s	

£

1930	J. A. Morrison. C. Pale green bowl, 7¾in diam., masks and emblems.	420
1932	Sir J. Mullens. C. Dark green bowl, 8in.	283 10s
1933	Viscountess Cowdray. S. 2½in statue of Kuan Yin.	310
1935	S. Spinach jade carved table-screen.	810
	Oval bowl, emerald green, double handles. Possibly the first piece of jade to make over £1,000.	1,200
1936	Edward Farmer. S. 13in figure of a Lohan, green.	285
	Carved bowl with bat handles.	255
	17in Kuan Yin (coral).	380
	Elaborate carving in lapis.	270
	S. Square wine-pot with inscribed Ming poem (no cover).	145
	C. Sitting buffalo, Ming.	378
1937	Heukelom. S. Sitting buffalo, Ming (compare 1962).	300
	Victor Rothschild. S. Spinach jade table-screen.	520
	Sitting buffalo (see 1948).	560
1938	S. Incense-burner, 7½in high, black speckled.	660
1940	Eumorfopoulos. S. Pendant in shape of a bear, Chou Dynasty.	80
1941	H. K. Burnett. S. Prehistoric prism jar or Tsung.	125
1943	Norman Collie. S. Chou Dynasty Tsung (about 6th cent. B.C.).	130
	Translucent mottled brush-washer.	165
1944	S. 2 grey-green squatting ponies. 2 for	710
1945	William Starkie. S. 2 figures of seated Buddhas. 2 for	520
	Lionel Edwards. S. Spinach green carved table-screen.	750
	R. W. M. Walker. C. White shell-shaped bowl.	525
	Emerald bowl, 4in diam.	525
1946	Mrs Reginald Nicholson. S. Sitting buffalo, Ming.	3,900
1947	Henry Brown. S. Biberon and cover, Ch'ien Lung period, said to have come from the Summer Palace, 1860.	1,600
	2 "sodden snow" bowls. 2 for	1,100
	Spinach green brush-washer.	900
	Pair of carved Indian bowls and covers, 4in, Mughal period. 2 for	880
1948	Sir Bernard Eckstein. S. Sitting buffalo, Ming (see 1937).	3,000
	Spinach green brush-pot.	3,400
	Ditto Koro and cover.	1,150
1949	Atterbury. S. Another sitting buffalo (see 1960).	1,400
1952	Mrs Jackson. S. Sitting buffalo, Ming.	1,550
	Lord Cunliffe. S. Flat vase, inscribed with date, 1789.	1,200
	New York. 2 mauve jade vases in archaic bronze shapes. 2 for	1,325
	S. Ming water-buffalo.	1,350
	Ming recumbent horse.	980
1953	Major R. Hotchkiss. C. Sitting buffalo, 12in.	2,730
	S. Spinach green brush-washer, reliefs, horses of Hsi Wang Mu (see 1947).	2,520

£

1954 Duke of Gloucester. S. Spinach green table-screen. 1,029
 Carved lapis table-screen, 9½in. 546
 Tozer. S. Spinach green bowl, 10in wide, 18th cent. 370
 Catherine Butterworth, New York. 2 bowls and covers,
 3¾in high. 2 for 2,140
 Stewart-Sandeman. C. Sitting buffalo, Ming Dynasty,
 11½in long. 2,415
1955 Ralston Welsh. S. Dark green vase, archaic bronze
 shape, 13½in. 1,300
 Emerald-tinted vase and cover, Chia Ch'ing (1796–1821). 880
 Mrs E. Bennett. S. Hound, 3in long, T'ang Dynasty
 (excavated). 340
1956 Heywood-Lonsdale. C. Beckford's heavily mounted
 Indian hookahs (see 1882), bought for B.M. 2 for 3,885
1958 S. 2 recumbent horses, Ming. 2 for 9,000
 Paris. 2 pierced flower baskets, white jade, splashed with
 green. 2 for 7,200
1960 S. Sitting buffalo (see 1949). 6,000
 Kitson. S. Spinach green cylindrical brush-washer. 5,000
1961 Kitson. S. Spinach green bowl. 3,600
 Brush-holder with relief landscape. 5,800
 Bowl with fishes in relief. 2,400
 Mughal jade bowl and cover. 2,100
 White jade pilgrim bottle, 12in. (3 others at over
 £1,500). 2,000
 "Sodden snow" jade vase, 15in. 2,800
 Unnamed sale. 16½in flat vase, Ch'ien Lung, grey-green,
 with reliefs. 2,300
1962 V & A buys Mughal shell-shaped bowl with ibex handle,
 ownership inscription of Shah Jehan, 1657. 8,650
 M. A. Johnson. S. Sitting bull, Ming, 13in long, grey
 jade. 9,500
 S. Elephant, 18th cent., grey jade. 1,100
1963 Major R. W. Cooper. C. Spinach-green bowl with
 bat handles. 4,725
 Pair of green incense cylinders. 2 for 3,360
 Bottle-vase with poem of Emperor Ch'ien Lung. 2,730
 40 lots made £41,853.

CHINESE ART

£

1748 Account-books of Lazare Duvaux. 6-leaved screen, papier des Indes.

3 12s

1766 C. 4 fine India pictures, painted on glass.

3 12s

1770 Count de Sielern. C. "An exceedingly fine 8-leaved Japan screen" (Chinese, of the type later known as Coromandel).

42

1775 Mariette, Paris. An album of 23 Chinese paintings of industries and celebrations, with descriptive notes by Mariette.

10 8s

1782 William Devismes, Oriental Museum. C. "India pictures", Cantonese paintings on silk of ceremonies and landscapes.

per pair { 2 10s
to 3 10s

Chinese album of plants and insects.

10 10s

Plate of glass, 27in × 37in, painted with Chinese landscape and musical figures.

4 10s

Large India painting on glass, 49in × 39½in, with carved gilt frame.

51 9s

1783 Francis Barnard. C. 8-leaf screen of "the fine old India Japan".

5 7s 6d

1788 Comte d'Adhemer. C. 6-leaf screen "of the old indented Japan".

6 12s 6d

1794 John Hunter. C. 8-leaf screen "fine old India Japan".

12 12s

6-leaf ditto.

13 2s 6d

1798 James Bradshaw. C. Chinese paintings, about 20 lots:

Chinese josses and temples, album of 88 drawings.

169 1s

Birds and flowers of China, 86 drawings.

115 10s

Manufacture of porcelain, 24 drawings.

84

Culture of tea, 53 drawings.

57 15s

Large picture, view of the factories, river, etc., at Canton.

42

Another smaller picture.

23 2s

Whole-length of a mandarin and his lady.

24 3s

5 large Chinese "conversations" on their original rollers.

5 for 21

1799 van Braamen. C. Several albums of Chinese landscapes by a Cantonese painter at £50 to £100. Given by the Marquess of Lansdowne to the BM, 1807.

351

£

1807 Amos Newton, "Chinaman". C. Canton enamel, 2
large flat dishes, golden dragons on a sky-blue background,
clouded (a well-known type). 2 for 19
6-leaf screen, raised lacquer. 68 5s

1809 Captured at Rio de la Plata. C. 6ft model in ivory of
"a Chinese yacht" (house-boat), a present intended for
Bonaparte. 252

1819 C. 8¼yds of embroidered satin, the vest of a Chinese
mandarin, not made up. 84

1822 Wanstead House, Robins. 6-leaf Coromandel screen,
11ft× 7ft. 66

1831 General Stewart. C. Buddhist mediaeval sculpture (not
Chinese, but Indian):
Basalt relief from Gaya, standing Buddha, 9 attendant
figures. 22 1s
Seated Buddha, attitude of princely repose. 33 12s

1843 Prince Paul Leven. C. 8-leaf Chinese Japan screen. 25 4s

1845 C. Pair of dwarf screens, mother-of-pearl inlays. 2 for 9 10s

1848 Duke of Buckingham, Stowe. C. Ewer and salver,
Canton painted enamels. 12 12s

1849 C. 2 rhinoceros-horn libation cups. 2 for 10 10s

1851 Nathan Dunn, "Chinese Museum". C. Large view of
Canton by a Chinese artist. 7 15s

1857 Robert Owen. C. 8-leaf "Japan" screen. 25 14s 6d

1861 From the Summer Palace, Paris. A Manchu general's
ceremonial robes. 35

1862 From the Summer Palace. C. 6-leaf Japan screen, battle
scenes, etc., in black and gold. 50 8s
Silk carpet from the Summer Palace, 19½ft× 9ft (see
1879), bought-in. 320 5s

1864 P. M. Tait. C. Human skull, entirely lined with gold,
"taken from the Summer Palace by one of Fane's cavalry". 327

1869 V & A buys 5-leaf screen, 5ft 6in high, in Kossu silk
embroidery. 120

1870 Lord Auckland. C. 8-leaf lacquer screen. 51

1879 Barbet de Jouy, Paris. Chinese imperial carpet, looted
from the Summer Palace (see 1862). 504

1882 Hamilton Palace. C. 12-leaf Coromandel screen. 189

1883 V & A buys 2 3ft red lacquer beaker vases, looted in 1860
from the Summer Palace (1735–95). 2 for 325

1885 V & A buys 21ft Coromandel screen, 12 leaves. 1,000

1889 V & A buys 19½ft ditto. 700

1904 C. 6-leaf lacquer screen. 189

1908 Ismay. C. 6-panel lacquer screen. 273

1914 Arthur Sambon, Paris. Supposed Sung or Yuan painting
of a flying swan. 225
T'ang stone statue of Kuan Yin. 422

1921 Sequèstre Worch, Paris. 17th-cent. lacquered cabinet,
7ft high. 580

		£	
1921	12-leaf inlaid lacquer screen, nearly 20ft long.	496	
	Another, slightly bigger and even finer.	1,530	
	Other screens from £220		
	13ft Chinese Turkestan carpet, 18th cent.	620	
	T'ang marble statue of Kuan Yin, 3ft high.	350	
	Winter landscape painting, Hui Tao Ning (attributed).	192	
1922	Erskine. S. Alleged Imperial portrait on silk, Sung Dynasty(?).	105	
	Small 6-leaf 18th-cent. Coromandel screen.	240	
1923	Stange. S. 2 lacquer pictures, 3ft 6in long, said to have been made for the Emperor Ch'ien Lung to commemorate the defeat of the Formosans (in 1926 they fell to £260 and £220).	{2,200 {1,600	
1924	C. Wooden statue of Kuan Yin, 5ft high, believed T'ang.	136	10s
1925	Duchess of Rutland (Puttick's). 12-leaf Coromandel screen.	399	
	Crofts. S. Marble Buddha, T'ang Dynasty, 36in.	265	
1926	Late Lord Michelham (Hampton's). 12-leaf Coromandel screen.	819	
1928	Medlycott. S. 12-leaf Coromandel screen.	500	
	Lord Glenarthur. C. 17th-cent. carpet, 6ft × 4ft 3in.	840	
	Lord Cunliffe. C. Carpet, gold and silver thread, 18ft × 4ft.	1,417	10s
	Companion piece, same size	735	
1930	Sauphar, Paris. Wooden Sung Bodhisatva statue.	708	
	Jacques Doucet, Paris. Supposed Yuan period painting on silk of Mongol horseman.	420	
1932	Paul Huo Ming Tsu, Paris. 8-leaf screen, painted on silk.	670	
	Sevadjan, Paris. Limestone Bodhisatva, 5th cent., from Yung Kang Caves.	450	
	Red marble torso, Mathura (Indo–Buddhist), 3rd cent. A.D.	1,420	
	Painting ascribed to Hui Huan, Tibetan lion playing with a ball.	224	
1933	Winkworth. S. Set of 4 18th-cent. paintings on glass in semi-European style, original frames. 4 for	245	
1940	Eumorfopoulos. S. 6th-cent. limestone figure of Buddha, standing.	440	
	Red lacquer toilet-box, 3rd cent. B.C. (BM).	880	
	7 gold objects from a 15th-cent. Imperial tomb.	1,450	
	12-leaf inlaid lacquer screen.	140	
1946	S. Sung painted wooden statue of Kuan Yin.	400	
1947	S. Album of 50 drawings in outline of Taoist deities, attributed to Li Lung Mien of the Sung Dynasty.	750	
	Henry Brown. S. T'ang period silver dish, gold-engraved.	610	
1951	Baudoin, Paris. Miniature 12-leaf Coromandel screen, only 20in high.	840	

£

1952	S. Mirror picture, European style, early 19th cent.	560
1953	Robert Bruce. S. Silver-gilt dish, T'ang Dynasty.	1,100
1954	Mrs E. Bennett. S. T'ang period engraved silver ladle.	320
	Ditto, shell-shaped box.	350
	Hauswedel, Hamburg. Summer mountain landscape, signed Huang Ting.	385
	New York. Stone Buddha's head, Northern Wei Dynasty, 37½in high.	1,850
1960	Parke-Bernet, New York. 23-ft Coromandel screen, 12 leaves.	2,409
1961	S. Painting on silk, imitating a French conversation piece in the manner of Boucher.	320
	C. 12-leaf Coromandel screen.	1,312 10s
1962	S. 9 panels of 18th-cent. papier peint Chinois. 9 for	580
	4 18th-cent. glass paintings. 4 for	1,750
	Sir Percival David. S. Red lacquer relief bowl, dated 1778.	820
	Red lacquer dishes, 15th and 16th cent.	⎰650 ⎱900
	Red lacquer vase and cover in Ming style, Hsüan-tê mark, inscription of 1776.	1,300
	S. Canton cabinet of padouk wood, inlaid with 13 mirror paintings, c. 1760.	2,300
	Canton knee-hole lacquer dressing table.	1,250
	E. J. S. Ward. C. 16 panels of 18th-cent. Chinese wall-paper (papier peint Chinois).	1,470
	3 Cantonese paintings on glass.	⎧2,520 ⎨1,995 ⎩1,575
	Tonying, New York. Dragon carpet, 22ft× 20ft 9in (ex Pierpont Morgan).	1,288
	So-called tile carpet, 20ft× 11½ft.	966 10s
1963	Norton. S. Red lacquer box, 8½in diam., attributed c. 1400.	5,200
	Parke Bernet, New York. Late Ming landscape scroll, seals of Ming Shan T'ang and others.	645

CLASSICAL ART

MARBLE SCULPTURE AND FRAGMENTS

£

1742 Earl of Oxford (Cock, Covent Garden). Head of Apollo, Parian marble. 14 14s
 Sarcophagus of Publius Vibius. 10

1747 Duc de Pontchartrain, Paris. Porphyry busts of Vespasian and Titus, 30in. 2 for 195
 Roman inscribed bust of Asiaticus, a Greek physician. 62
 18in statue, Jupiter tonans. 20

1750 Crozat, Paris. Life-size marble statue of Bacchus, the arms and legs by Duquesnoy (Fiamingo), bought-in (see 1772). 96

1771 Lansdowne marbles. Thomas Jenkins buys in Naples two authentic Attic relief fragments of the 4th cent. B.C. (see 1930). 2 for 5

1772 Crozat, Duc de Tugny, Paris. Life-size statue of Bacchus, restored (see 1750). 48

1773 Lord Lansdowne's purchases from Gavin Hamilton (see 1930):
 The Wounded Amazon, alleged Periclean Greek work. 200
 The Sitting Juno—in fact, a Roman matron with a fitted head. 230
 Adam Bros. (from Rome). C. Full-length statue of the Empress Livia as Juno from the Vatican, bought by Duke of Northumberland. 210
 The Muse Erato, full-length "finely draperied". 99 15s
 Flora, full length, from the Barberini Palace. 90 6s
 (Both of these bought by the sculptor, Nollekens.)
 Ganymede and the Eagle, small marble. 52 10s
 Carved cinerary urn. 50 18s
 Bacchante, "Graecian workmanship". 157 10s
 Scipio Africanus as Consul, nearly 8ft. 246 15s
 Emperor Augustus, nearly 7ft. 283 10s
 (Both of these bought by the Duke of Northumberland.)
 Silenus, 5ft 5in. 210

1774 The Warwick Vase, much-restored Roman marble work, over 5ft diam., bought by the Earl of Warwick from Sir W. Hamilton. 600

1777 Prince de Conti, Paris. Marble relief of a sacrificial bull. 48 15s
 Randon de Boisset, Paris. Polychrome marble busts of Augustus and Vespasian, with gilt bronze garlands and boulle pedestals. 2 for 308

£

1777	Porphyry basin on granite column, 21in × 22in.	144
	Thomas Wyndham. C. Colossal statue of a Bacchante.	267 15s
	Whole-length Bacchus.	52 10s
1778	H. C. Jennings ("Dog Jennings"). C. "The renowned dog of Alcibiades, an extraordinary production of the famous Myron", withdrawn. The reserve had been put at £1,000. It was subsequently sold to Charles Duncombe for	1,050
1780	(About.) Mr Weddell of Yorkshire buys from Thomas Jenkins a torso of Venus from the Barberini Palace to which the veiled head of Agrippina had been riveted. The price, £2,000 and an annuity of £100 a year for life. Also buys from Jenkins and Nollekens a cannibalized Minerva for £1,000.	
1782	C. Marble relief, sacrifice of a boar, bought by Lord Bessborough.	6 6s
1783	Matthew Nulty. C. Marble bust, Lucius Verus.	24 3s
	Ancient sepulchral monument, restored by Piranesi.	28 7s
1785	Fitzhugh. C. Copy of Venus de Milo.	60 18s
	Venus Victrix, full-length statue.	99 15s
	Marble bust of Atalanta.	99 15s
	Marble copy of the Discobolus (see 1793).	577 10s
	A nobleman (ex Gavin Hamilton, Rome). Marble processional Silenus.	64 1s
	Hygeia, found at Pompeii.	44 2s
	Diana, restored by Cavaceppi.	102 18s
1786	Duchess of Portland (Skinner and Dyke). Green basalt head, Jupiter Serapis (see 1842).	173
1790	Robert Adair. C. 2 fine Grecian heads on therms. 2 for	30 9s
1791	Lord James Manners. C. Whole-length Antinous on plinth.	9 19s 6d
	Lebrun, Paris. Marble busts of Hadrian and Diva Faustina, 25in high, from the Tuileries. 2 for	80
1792	Lord Lansdowne's purchases from Thomas Jenkins (see 1930):	
	7ft Hercules from Hadrian's villa.	600
	Standing Hermes, ditto.	600
	Stooping Hermes, ditto, both life-size.	500
	Cannibalized copy of Discobolus.	200
1793	"A man of fashion" (Thomas Rumbold). C. Apollo and Harpocrates, statues from Ostia on pedestals. each	7 17s 6d
	C. Copy of the Discobolus, origin not revealed, bought by Mr Duncombe (see 1785).	378
1797	Benjamin Bond Hopkins. C. "Graecian" figure of Minerva, 4ft 4in (see 1825).	57 15s
	Bacchus 7ft 4in, with pedestal, "bought in Rome by the Hon. Mr Hamilton at an expense of upwards of £2,000".	420
	12 marble busts of the Caesars. 12 for	89 8s

£

1800	C. Bas-relief from the Villa d'Este, Tivoli. Apollo and the Four Seasons, 5ft 3in × 3ft 9in.	273	
	Lord Cawdor. C. Reconstructed 2nd-cent. marble vase, about 5ft diam., bought by Duke of Bedford.	700	
1801	"A noble earl deceased" (Bessborough). C. Sarcophagus lid in relief.	105	
	Colossal porphyry foot.	99 15s	
	Porphyry busts, Marius and Sylla. 2 for	89 5s	
	Marble sleeping Hermaphrodite, bought by Townley.	95 11s	
	Pan instructing Apollo, life-size, bought by Earl of Egremont.	126	
	Torso of Venus, found near the Pantheon.	199 15s	
	Huge vase of Egyptian granite from Baths of Augustus, bought by Earl of Carlisle.	115 10s	
	2 porphyry vases and covers on pedestals. 2 for	304 10s	
	Sir William Hamilton. C. Marble bust from Cicero's villa at Formica.	105	
	Porphyry head of Nero from Naples.	89 5s	
	Egyptian lion in basalt from Augustus's villa.	57 15s	
1809	Sir William Hamilton. C. Replica of the Venus de' Medici.	204 15s	
	De Hoorn, Paris. Pluto Serapis, green basalt bust.	104	
1810	Hon. Charles Greville. C. Restored marble Pudicitia.	140 14s	
	Marquess of Lansdowne. C. Bust of Claudius.	10 10s	
1816	The Elgin Marbles from the Parthenon, purchased for the BM.	35,000	
	The purchase was attacked by Payne Knight, who valued the Lansdowne Marbles (see 1930) as follows (1816):		
	The Hadrian's Villa Hercules.	1,000	
	The Standing Hermes.	1,400	
1819	C. Marble relief, slaughtered lamb on an altar slab.	118 13s	
1820	Duke of Richmond. C. Pair of 10ft red marble columns. 2 for	115 10s	
1822	Wanstead House (Robins). Pair of 8ft Egyptian marble spiral columns from Alexandria. 2 for	525	
1824	Page Turner. C. Death of Patroclus. Bas-relief from the gate of Ephesus, 18ft × 3½ft.	210	
1825	Nollekens. C. Faun, bust in rosso antico, bought by Tatham in London in 1798 for £1 (see *Book for a Rainy Day*, 1834, p. 248), bought by Duke of Newcastle.	160	
	Full-length marble Minerva, the helmet added by Nollekens (see 1797).	162 15s	
	Bust of Commodus (early 3rd cent. A.D.).	336	
	Head of Mercury, esteemed Greek (*ex* Lord Bessborough).	147	
1830	The late Sir Thomas Lawrence, RA. C. Marble foot of Apollo.	15 4s 6d	
	Colossal marble foot.	63	
1838	William Esdaile. C. 2 Roman portrait busts in basalt combined with alabaster (*ex* Lord Bessborough). 2 for	60 18s	

£

1838 "Monsieur Hertz." C. Meleager kneeling on the wild
 boar's head. Porphyry, under 7in high, regarded as Greek,
 bought-in. 35 14s
1839 Count Poniatowsky. C. Bust of Apollo, believed Greek. 79 16s
1842 Earl of Upper Ossory. C. Male head, winged headdress,
 believed Greek. 39 18s
 Complete Roman high-relief sarcophagus with lid. 28 7s
 Waldegrave, Strawberry Hill (Robins). Basalt head of
 Jupiter Serapis (see 1786). 78 15s
 Colossal head of Vespasian and pedestal (bought in 1740
 for £22) (see 1882). 220 10s
 Marble eagle, mounted on a Roman altar, from Baths of
 Caracalla, 1742 (see 1854). 210
1848 Duke of Buckingham, Stowe. C. Venus combing her
 hair, life-sized, much-restored Roman work, bought for
 Queen Victoria. 163 16s
 Full-sized Roman consul, bought in Italy, 1829, by
 Duke of Hamilton. 168
 Tragic Muse, restored Greek statue. 90 6s
 Agrippina, life-sized. 47 5s
 Lucius Verus, colossal statue. 37 16s
 Empress Julia sacrificing. 46 4s
 Chimaera, found at Tivoli, 1817. 64 1s
 Faun carrying a goat. 67 4s
1854 Gardner, Bottisham Hall. C. Horace Walpole's eagle
 (see 1842). 556
1856 Samuel Rogers. C. Bust, called Cincinnatus, from
 Ostia, restored for Rogers by Flaxman. 107 2s
1863 Evans-Lombe, Paris. Faun, 4ft high, rosso antico. 362
1864 J. W. Brett. C. Colossal bust of Augustus, several
 Marbles. 44 2s
 E. W. Anderson. C. Life-sized Adonis (ex Earl of Lich-
 field). 60 18s
1865 Pourtalès, Paris. BM buys the Justiniani head of Apollo. 1,880
 Greek funerary stele. 244
 Marble faun, nearly 5ft. 612
 Porphyry busts of Caesar and Nero. 2 for 800
 Duc de Morny, Paris. Pair of porphyry urns, carved
 handles. 680
1878 Louvre buys Venus accroupie, Roman statue, excavated at
 Vienne. 1,120
1879 Museo Guarnacci, Volterra. C. Large statue of Hercules,
 bought-in. 1,000
1882 Hamilton Palace. C. Walpole's porphyry Vespasian (see
 1842). 320
 Augustus (with added metal mounts). 1,732 10s
 Tiberius, porphyry. 525
1884 Castellani, Rome. Colossal female marble head from
 Sicily. 1,080

£

1885	Greau, Paris. Graeco-Roman marble goddess, bought by Basilevsky.	1,520
	Ditto, bust of Alexander the Great.	1,100
	Livia as Juno, bust bought by BM.	600
1890	Eugène Piot. Paris. A bronze arm, fragment of a large Greek statue, bought by BM.	3,000
1893	Life-size statue of Trajan from Ostia, bought by Geneva Museum.	3,000
1898	Tyszkiewicz, Paris. Archaic sandstone Diana, 6th cent. B.C.	800
1899	Hoffman, Paris. Head of a Greek athlete, over life-size.	440
1904	Somzée, Brussels. The Ludovisi Warrior, marble, over life-size.	2,600
	The Emperor Septimius Severus, bronze, over life-size, from the Sciarra Palace.	14,000
	The Rospigliosi Poetess, marble.	800
1907	Italian Government buys from Prince Sarsina the Anzio statue of a priestess, probably early Roman Imperial in Hellenistic style.	18,000
1910	Paris. Hellenistic head of Hermes.	424
	Louvre buys a 5th-cent. B.C. Attic relief, companion to the Ludovisi altar at Boston.	800
	Also archaic Greek male torso.	920
1911	Nelidow, Paris. Aphrodite Anadyomene (small figure), 3rd cent. B.C., found at Panderma in 1884.	3,604
1912	Paris. Louvre buys Graeco-Roman female torso, replica of the Farnese Flora.	1,200
	Large Roman bas-relief.	1,600
	2 Roman sarcophagi in relief.	600
1914	Arthur Sambon, Paris. Colossal bust of Caracalla, early 3rd cent. A.D.	1,474
	Statuette of a faun, Hellenistic, much restored (see 1927).	400
1917	Hope heirlooms. C. Life-sized statue of Athene, a restored work of the 2nd cent. B.C., found at Ostia, 1797, and recognized by Flaxman, "With the unerring eye of genius" and the concurrence of Fuertwangler, as by Pheidias, bought by Viscount Cowdray, the Greek Minister underbidding (see 1933, 1937).	7,140
	Full-length Antinous, 2nd cent. A.D.	5,880
	Full-length Hygeia from Ostia, 1797, "the restorations unimportant" (but see 1936).	4,200
	Bacchus and Ceres, life-sized Roman group from the Aldobrandini Palace.	3,510
	Archaic dedicatory Greek statue, much restored.	3,570
	An Apollo with the wrong head.	1,837
1924	Lord Brownlow. S. Head of Hercules, 1st cent. A.D., Graeco-Roman.	200
1925	Sir George Donaldson. C. 4ft statue of a goddess, 4th cent. B.C.	696

£

1925	Marble vase, 3ft, from Hadrian's Villa and Stowe.	409 10s
	Sir Francis Cook. C. Head of a boy, 1st cent. A.D.	1,050
	Head of Eudamidas, c. 300–250 B.C.	315
	Sir John Leslie. S. Torso of Aphrodite, 5th cent. B.C. (see 1940).	500
	Statuette of Socrates, Alexandrian, 3rd cent. B.C., bought by BM.	1,286
1927	Sevadjan, Paris. Much-restored small statue of a faun, c. 250 B.C. (see 1914).	1,080
1928	S. Aphrodite, 21in figure, c. 300 B.C.	1,500
1930	Harcourt Smith. S. Green porphyry head, Agripinna the elder, 1st cent. A.D.	500
1930	Marquess of Lansdowne. C. A collection of marbles, sold in 1810 for £10,680, which realized	68,502
	Graeco-Roman Hercules from Hadrian's Villa, bought-in (resold to Paul Getty for £6,000; £600 in 1792).	4,830
	The Wounded Amazon, supposed 4th-cent. B.C. Greek statue, bought by Brummer of New York and resold to J. D. Rockefeller, Jnr (an English auction record).	28,350
	Hellenistic Greek head, much made-up by Gavin Hamilton, who sold it in 1769 for £15.	2,415
	Standing Hermes, Roman (£600 in 1792).	1,575
	Stooping Hermes, life-sized Roman (£500 in 1792).	2,100
	Much cannibalized copy of the Discobolus (£200 in 1792).	735
	Athene, 29in Attic relief fragment (£5 in 1771).	2,205
	2nd Attic relief fragment, 25in, head of weeping woman, c. 350 B.C., bought by Brummer, New York (see 1771).	5,250
1932	Sevadjan, Paris. Archaic Greek marble head of an athlete, bought by Louvre.	252
	Head of Athene, marble, over life-size, late Greek.	280
	Torso of an ephebe, 5th cent. B.C.	460
1932	Count Oriola, Amsterdam. Marble torso after Leochares, 4th cent. B.C.	1,500
1933	S. Venus Victrix, Roman life-sized marble statue, 1st cent. A.D.	250
	Viscountess Cowdray. S. The Hope Athene (see 1917), bought-in (see 1937).	200
	2 carved Roman marble urns (£924 in 1917).	125
1936	Gordon. S. Stele in relief from Megaron, c. 420 B.C.	750
	Lord Melchett. S. The Hope Hygeia (see 1917).	589 10s
1937	Lord Lincoln. S. The Hope Athens (see 1917, 1933).	95
1940	S. Torso of Aphrodite, 5th cent. B.C. (see 1925) (Barber Institute, Birmingham).	1,150
1950	S. Fractured porphyry head of a 5th-cent. A.D. Roman emperor.	430
1951	Lady Melchett. C. Marble head of Aphrodite, 5th cent. B.C.	3,400
	S. Marble bust of Caracalla, 3rd cent. A.D.	428

£

1954	Baroness Cassel von Doorn, Paris. Marble torso of Venus, 4ft 8in, possibly Roman republican.	945	
	Basel, Switzerland. Fragment of Attic votive stele, *c.* 460 B.C.	1,200	
1957	Jacob Hirsch, Lucerne. Bust of Caracalla, early 3rd cent. A.D., 21in.	1,140	
	Marble head of a goddess, Alexandrian, 1st cent. B.C.	2,920	
	Roman victory-statue after Myron.	2,850	
	9in marble statuette.	1,375	
1959	S. Statuette, 16½in, about 2nd cent. B.C.	4,000	
1961	Earl of Pembroke, Wilton. C. Gallus, 2nd cent. B.C., marble.	1,155	
	Caracalla, bust, 3rd cent. A.D.	892	10s
	Hellenistic stele, 4th cent. B.C.	1,050	
	Seated empress, 2nd cent. A.D.	682	10s
	Bust of Geta, end of 2nd cent. A.D.	682	10s
1962	S. Marble torso of Venus, 1st cent. A.D.	2,300	
	Head of a smiling faun, 1st cent. B.C., from El Djem, Tunisia.	680	

CLASSICAL

BRONZE, IVORY, SILVER, HARD STONES, GLASS, ETC.

		£
1741	Earl of Oxford (Cock, auctioneer). Venus Genetrix, bronze from the Arundel Coll.	84
	Greek bronze lamp, illustrated by Montfaucon.	105
	Bronze gladiator on pedestal.	31 15s
1768	Warre, picture-dealer and toy-man. C. 7 lots of cameos, the dearest being a head of Seneca on a transparent stone.	33 12s
1769	C. Cornelian bust of Vespasian on agate stand.	3 5s
1772	Marquis Leonori of Pesaro. C. 2 large mounted cameos, gold frames, Galatea and the Rape of Europa. 2 for	34 13s
	Agate cameo of a Caesar.	15 15s
	Greek cornelian intaglio.	9 9s
1773	Adam Brothers (from Rome). 2 table-tops made from mosaics from Hadrian's Villa. 2 for	131 5s
1775	Mariette, Paris. Intaglio on onyx, Sappho and Phaon.	22
1776	Sir George Colebrooke. C. Cameo head of a faun.	17 17s
1783	Blondel d'Azincourt, Paris. Cameo on sardonyx, Apollo and Marsyas.	48
	Cameo on striped onyx, woman worshipping Pallas.	120
	Cameo on sardonyx, Bacchus and Ariadne.	200
	Cameo on brown onyx, Antiope vanquished by Theseus.	88 14s
	Cameo, the Hermaphrodite.	52
1784	Charles Gore. C. Onyx cameo, full-length faun.	36 15s
	"Well-known cabinet from abroad." Cameo, Judgment of Paris.	19 19s 6d
	Sardonyx cameo, a vestal.	13 2s 6d
1785	Fitzhugh. C. Intaglio brought back from Syria, Hercules and the Nemean Lion.	33 12s
	Bronze whole-length Antinous.	51 9s
1786	Duchess of Portland (Skinner and Dyke, auctioneers). The Barberini, or Portland Vase. White cameo on blue paste, 3rd cent. A.D. Bought from Sir William Hamilton, 1771. Bought-in at this sale and also in 1929 (since 1946, BM).	1,029
	Cameo medallion, head of Augustus, bought for George III (BM).	236
	Cornelian intaglio, Heracles in a skiff.	41 5s
	Gentleman resident in Turkey. C. Sardonyx intaglio.	21 10s (d
	Cameo, the infant Hercules.	11 11s
1788	C. A large onyx cameo, undescribed.	37 16s
1789	Oriental Curiosities. C. Cameo on sardonyx, bust of Claudius.	16 16s

362

£

1791	Lebrun, Paris. 6in bronze statuette of Agrippina as Pallas, with silver eyes.	30
1793	"A man of fashion" (Thomas Rumbold). C. 4 bronzes, possibly reproductions, sold as 1 lot.	115 10s
	"The valuable museum." C. 2 female cameo heads.	9 9s
	Cameo, Cupid.	12 1s 6d
	Antique lamp, large bronze, bought by Payne Knight.	42
1796	William Thompson, jeweller. C. Intaglio gem, head of a Scythian.	39 1s 7d
1801	Earl of Bessborough. C. 2 bronzes of gladiators. 2 for	33 12s
1802	Findley (the Oriental Museum). C. Sardonyx intaglio, Anthony and Cleopatra.	16 16s
	Cameo on onyx, Lucius Quietus.	18 18s
	Ditto, Agrippina.	37 15s
	Ditto, Cupid and Aglaia.	39 11s
1808	Nathaniel Middleton. C. Alexander gem in 3-colour cameo on onyx, mounted in gold, a present from Suraj ed Douleh, Nawab of Bengal.	52 10s
1810	Hon. Charles Greville. C. Cornelian intaglio, a faun.	27 16s 6d
	Marquess of Lansdowne. C. Slab of antique mosaic.	110
	Bronze busts of the 12 Caesars. 12 for	290
1811	Archibald Swinton. C. Cameo, Medusa, partly coloured amethyst.	30 19s 6d
1815	C. Bronze tripod candelabrum, 4ft high.	18
1818	The Rubens Vase, Roman 4th cent., carved sardonyx, bought by Beckford in Holland (see 1882, 1899, 1925).	420
1823	Sir H. C. Englefield. C. Cameo, considered Greek, 3-colour onyx.	29 8s
1824	A distinguished connoisseur. C. Fractured onyx intaglio, called Etruscan, Neoptolemus and Polyxena.	26 5s
	Greek ring-intaglio, cornelian.	31 10s
	Page Turner, Battlesden Park. C. Mosaic pavement from the baths of Nero, 10ft square.	165 16s
1835	de Ville. C. Bronze bust of Homer, given by Napoleon to Vivant Denon (ex Denon sale).	94 10s
1838	Monsieur Hertz. C. Bronze athlete, 37in, found at Tivoli, 1812, bought-in.	225
1839	The Poniatowsky Coll. C. 2,639 lots of gems, of which 1,140 were withdrawn and bought by Colonel Tyrrel for £12,000. The remainder made £4,224 18s 6d. It was later discovered that practically the entire coll. was modern Italian (see 1851, 1852, 1853). 86 lots of cameos were sold, among them:	
	Ulysses and Circe, hyacinth intaglio.	48 6s
	Triumph of Bacchus, very large cameo on striated onyx.	136 10s
	Aurora in Her Chariot, onyx cameo.	59 17s
	Head of Faustina, with intaglio on the other side.	52 10s
	Perseus and head of Medusa, onyx cameo.	50 8s

£

1840	Lady Bagot. C. Glass cinerary urn and cover from Carthage, 11in high, perfect.	15 15s
	Prince Louis Bonaparte (afterwards Napoleon III). C. Cameo, Prometheus and the Heavenly Fire.	36 16s
1842	Earl of Upper Ossory. C. Candelabrum, 54in high, Roman bronze.	43 1s
	Waldegrave, Strawberry Hill (*ex* Walpole). Ceres, bronze Roman statuette with silver eyes.	73 10s
1844	Jeremiah Harman. C. Roman candelabrum on lion's feet, 8ft high.	40 19s
	Thomas Thomas. C. Cameo (*ex* Poniatowsky Coll.), Mercury and Hermaphroditus.	38 17s
1845	The Marlborough gems and cameos (739 in number) offered to the BM for £10,000 (see 1875).	
1846	Brunet-Denon, Paris. Etruscan bronze mirror, 9in.	113 8s
	The Rope-dancer, Roman bronze statuette, discovered in Burgundy, 9in high, bought by de Lessert.	342
1848	Duke of Buckingham, Stowe. C. Bronze statuette identical with the above (bought from Bram Hertz, 1838, £80).	9 10s
	Bronze figure of Theseus, 35in high (had cost the Duke £200).	53 11s
1849	Thomas Blaydes. C. Roman bronze tripod in high relief, resting on frogs.	24 3s
1851	Poniatowsky Coll. (Colonel Tyrrell). C. (see 1839). 300 lots were offered, but many were bought-in. The dearest cameos and intaglios made no more than £4, and the total came to £475.	
1852	Poniatowsky Coll. (Colonel Tyrrell). C. Another 235 lots were offered and sold outright for £209 17s 6d. In 1853 a further 250 lots made £297 7s 6d.	
1853	Henry Vint. C. Greek silver disc with engraved figures, 4th cent. B.C., found on the site of Tarentum.	55 13s
1854	Boocke. C. 2 Roman bronze chariot wheels from Hungary, bought-in.	50
1855	Thomas Windus. C. Relief bust of Augustus, carved from a single opal (belonged to "Dog" Jennings), bought-in (see 1859).	136 10s
1856	Samuel Rogers. C. Golden bulla, as worn by Roman patrician boys in republican times, found in 1794, when 100 louis-d'or were refused for it.	56 14s
	Flat glass Roman bottle, blue and yellow.	17
	Small bronze Roman candelabrum, mounted on a seated figure, found in the sea at Pozzuoli.	53 11s
1857	Commendatore Barbetti. C. Roman glass urn and lid.	50
1859	Bram Hertz. S. Bronze statuette of Venus, 13in, from Mugla, Asia Minor, bought by Drury Fortnum.	125
	Head and arms from a bronze Juno.	100
	Relief bust of Augustus carved from a single opal, intaglio of Livia on reverse (see 1855).	175

		£	
1859	Cornelian intaglio, Apollo, 1½in.	90	
	Jupiter and Thetis, 7½in by 6in, regarded as the largest known cameo, but sold as *Cinquecento* (see 1862).	126	
	Red jasper intaglio, depicting a helmet.	89	
	2in onyx cameo, female on a couch.	63	
1861	Mathew Uzielli. C. Roman mille-fleurs glass bowl, 6½in × 3½in.	89	4s
1862	Robert H. Peter. C. The Jupiter and Thetis cameo (see 1859).	90	10s
1863	San Donato (Prince Demidoff), Paris. Cameo head of Augustus (see 1872).	644	
1864	Eugène Piot, Paris. Bronze statuette of Agrippina (24in) from Capua, bought by Louvre.	240	
1865	Pourtalès, Paris. Jupiter tonans, 8in bronze statuette, bought by BM.	480	
	Minerva, 8½in early Roman Imperial bronze, bought by Duc d'Aumale (Musée Condé, Chantilly).	788	
	Napoleon III buys the armour of a gladiator.	520	
	Many other bronze objects bought by BM.		
1868	V & A buys Roman glass bowl in polychrome laticinio.	125	
	Another laticinio bowl, ruby ground.	70	
	Opaque green-glass plaque, Bacchanalian relief.	10	
1869	Alessandro Castellani. C. Rock-crystal amphora, said to be Greek.	84	
1872	Allègre, Paris. The Augustus cameo head (see 1863).	1,000	
1874	V & A buys Graeco-Roman 4in statuette, amethyst-quartz.	100	
1875	Duke of Marlborough. C. 739 cameos and intaglios (see 1845) offered as 1 lot and bought by Agnew in a single bid, acting for Mr Bromilow of Battlesden Park. More than half dated from the Renaissance and later times.	36,750	
1880	Paris. Bronze copy of the Vatican Spinario, excavated at Sparta, 1865, 10in high, 4th cent. B.C., bought by Edmond de Rothschild against the Louvre.	2,800	
1882	Hamilton Palace. Onyx head of Tiberius.	882	
	The Rubens Sardonyx Vase (see 1838, 1899, 1925) (Philadelphia Museum).	1,764	
1884	Allessandro Castellani, Rome. Etruscan bronze figurine.	141	
	Archaic Greek gold earring.	652	
	The Bonus Eventus blue-glass relief plaque (BM).	320	
	Miniature bust in opaque white glass.	320	
	Miniature tragic masque, ditto.	320	
1885	Castellani, Paris sale. Greek bronze bull.	400	
	Greek bronze statuette, Aphrodite.	780	
	Etruscan bronze mirror.	1,070	
	Several Etruscan etched bronze cysts. each	600	
	Greau, Paris. Gallo-Roman bronze boar, bought for Louvre.	560	
1888	Hoffman, Paris. Bronze bull (Louvre underbidding).	780	

£

1890	Tyszkiewicz, Paris. Roman silver dredger with gold encrustations.	1,239
	Eugène Piot, Paris. Roman silver dish, 4th cent. A.D. Hercules and the Nemean Lion, bought by Bibliothèque Nationale.	410
1891	Lebœuf de Montgermant, Paris. Onyx head of Augustus, cameo mounted in a snuff-box.	464
1893	Frederick Spitzer, Paris. Etruscan bronze cyst from Palestrina.	400
1894	Wills. C. Gallo-Roman bronze figurine of Hercules (see 1912).	105
1896	Louvre buys the gold tiara of King Saitaphernes, allegedly a Greek work from S. Russia, *c.* 200 B.C. In fact, a forgery by Israel Rukhumovski of Odessa (Musée des Arts décoratifs).	16,000
1897	Baron Pichon, Paris. 2 Roman silver dishes and a cup from Feltre, associated with Geilamir, a 5th-cent. King of the Vandals (Bibliothèque Nationale). 3 for	615
1899	Hoffman, Paris. The Young Bacchus, 28in bronze statue, found in Rome, 1880.	800
	Morrison. S. The Rubens Vase, Roman sardonyx (see 1818, 1882, 1925).	1,700
	Duke of Marlborough. C. Roman cameo, Cupid and Psyche (Boston Fine Arts Museum).	2,000
	The BM bought 8 cameos—7 Roman and 1 Renaissance; some in 16th-cent. mounts. 8 for	4,000
1902	Mme C. Lelong. Paris. Primitive Greek bronze statuette.	960
1903	Durand-Ruel, Paris. Roman fresco fragments from Boscoreale: 1st century A.D.	
	The Cithera-player.	4,000
	Winged Genius (Louvre).	615
	2 seated figures.	2,000
1904	Somzée, Brussels. Greek bronze figure of a doe.	1,440
1905	Gilhou, Paris. Roman casserole, silver with gilded reliefs and chasing, very elaborate.	1,204
	Philip, Paris. Bronze griffin, 4th cent. B.C.	600
1910	Paris. Etruscan bronze cyst.	360
	Greek ivory cyst, 6th cent. B.C.	640
1911	Nelidow, Paris. Bronze head of Alexander the Great, Graeco-Roman.	680
1912	Paris. Glass cup, figures in opaque white on lapis blue, transparent glass, Worship of Priapus, late Roman.	2,560
	Dattari, Paris. Bronze late Greek statuette, Alexander the Great.	1,760
	Egypto-Greek bronze of an athlete.	1,232
	J. E. Taylor. C. Gallo-Roman bronze Hercules.	1,627 10s
1914	Arthur Sambon, Paris. Late Greek bronze statuette of an archer.	902

		£
	Roman bronze bust of Agrippa.	1,280
1921	Lady Harcourt Smith. S. Greek solid silver patera, dug up in Acharnania, 1895.	1,000
1922	Charles Havilland, Paris. Aphrodite at the Mirror, 3rd cent. B.C., small bronze.	3,825
1925	Sir Francis Cook. C. The Rubens Sardonyx Vase, bought by Walters (Philadelphia Museum) (see 1818, 1882, 1899).	1,732 10s
	Greek bronze mirror, 6th cent. B.C.	1,260
	Augustus and Livia, 1st-cent. Roman cameo, 2½in × 3in.	283
1928	Durighiello, Paris. Venus accroupie, Hellenistic bronze. about	4,000
	S. Bronze statuette of Aphrodite, c. 460 B.C.	4,100
1929	Duke of Portland. C. The Portland Vase, or Barberini Vase, cameo relief on blue opaque glass, bought-in (acquired for a lesser sum by BM in 1945). See 1786.	30,450
1933	Whitcombe Green. C. 1st-cent. Roman bronze bust, 6½in, the Empress Livia, bought-in.	1,260
1936	Emile Tabbagh, New York. Syrian flask, violet glass, 2nd cent.	329
	Millefiori Roman glass bowl.	144
	Iridescent green bowl, 1st cent.	185
	Henry Oppenheimer. C. Bronze hydria, 5th cent. B.C.	441
1944	Eumorfopoulos. S. Part of an early Christian bronze lamp, 4th–5th cent. A.D.	240
1946	S. 2 Etruscan bronze statuettes from Prato, bought by Fitzwilliam Museum. 2 for	1,350
	Bronze statuette of Apollo, c. 460 B.C., found in Thrace, 1921.	1,050
1947	S. Etruscan silver figurine, 6in, recently found near Perugia.	1,300
1948	C. 3in cameo of chalcedone, carved with a Medusa in relief, Roman, 2nd cent. A.D. (ex Marlborough gems, see 1875).	630
1949	S. Graeco-Egyptian glass oenochoe, 9in, with figures in gold.	420
1951	Lady Melchett. S. Late Greek bronze satyr, 16in.	4,600
1954	Parke-Bernet, New York. Etruscan bronze mask, c. 500 B.C.	1,060
1957	Jacob Hirsch, Lucerne. Etruscan bronze vase handle in form of an athlete, 5th cent. B.C.	1,230
	2-handled glass flask, 4th-cent. Christian symbols, 8½in, found at Aleppo.	1,085
	Bronze head of an Antonine emperor, found in the River Tiber, 17in high.	1,870
	S. 1st-cent. glass beaker with gladiator figures, signed Licineus Diceus.	1,500
1960	Fischer, Lucerne. Roman glass beaker en cabouchon (Syria).	325

£

1961 S. Etruscan bronze lion, 2in high. 360
 Silver statuette, Hercules. 340
1962 S. Etruscan bronze statuette of javelin-thrower, 6½in high,
 c. 480 B.C. 980
 C. Bronze male figure, 17in high, 1st–2nd cent. A.D.,
 possibly Adonis. 6,825
 S. Etruscan bronze figurine of a girl, c. 500 B.C. 540
 Sidonian glass bottle, shaped as a human head. 200
 Syrian green glass flask. 240
 Bronze female statuette, c. 460 B.C., 5½in high. 1,500
 Late Celtic buckle from Catterick. 400
 Stukker, Basel. Gold medallion, 2in, c. 320 B.C., portrait
 of Olympias, sea-nymph riding a dolphin. 7,800
1963 S. British bronze collar, late Celtic 2nd cent. A.D. 2,300

CLASSICAL

GREEK PAINTED VASES AND CLAY FIGURES
(*originally called Tuscan or Etruscan*)

		£		
1741	Earl of Oxford. 2 Tuscan vases, bought by Horace Walpole.	2	3s	
1778	T. C. Jennings ("Dog") Jennings). C. A series of 9 bell kraters which had been published by Passerel, described as Etruscan. 9 for	6	2s	
1783	Mathew Nulty. C. A few "Tuscan vases", poorly catalogued, nothing over 2 guineas.			
1795	Thomas Hope buys a collection of more than 180 Greek vases from Sir William Hamilton for £4,724 (see 1917), approximately 25 guineas a vase.			
1800	C. "A very fine Hetruscan vase, richly embellished with figures."	25	4s	
1802	Guy Head. C. Tazza of the early style, black figures on a red ground.	23	2s	
	2 Sicilian amphoras. each	26	5s	
	Vase with winged genius from Nola.	34	2s	6d
	A most capital Nolan vase, Bacchanalian subjects.	31	10s	
	Nolan vase, Bacchus and satyrs.	40	19s	
	James Clark, antiquary of Naples. C. Votive vase, Theseus and Hypolita, bought-in.	43	1s	
	Sicilian black figure vase, Pan ascending in a quadriga.	78	15s	
	Campana vase with many figures.	53	11s	
1805	Gentleman of fashion. C. Sicilian black figure vase, 13½in.	31	10s	
	Campana vase in the late polychrome style.	15	15s	
	Copy of the celebrated Apulian Vase in the coll. of the King of Naples, engraved by Tischbein, 33in high.	27	7s	
1809	Sir William Hamilton. C. Vase of lachrymatory shape from Ghirgenti.	21	10s	6d
1812	William Chinnery of Gilwell, Essex. C. "The much celebrated vase", Combat for the Body of Patroclus, 26in.	180	12s	
	Sicilian vase, 15½in, Amazon combat.	51	19s	
	Pair of 10in Sicilian vases. 2 for	63		
1817	William Beckford. C. Sicilian oval 2-handled vase, 13½in.	33	12s	
1819	Sir John Coghill. C. Noble globular vase, 18in diam., 33 small figures, black on red, on the inside a galley, touches of red and white, c. 500 B.C., bought by Thomas Hope.	63		
	Sicilian 19in hydria, a lectisternium.	59	17s	
	12in 3-handled Nolan vase with a winged Genius.	55	2s	6d

£

		£	s	d
1819	3-handled vase, 13½in, Corinthian black figure, with white and purple.	52	10s	
	1-handled vase, inscriptions, "probably Phoenician in old Greek characters".	45	3s	
	Others at over £20			
1820	Ditto. C. Hydria, 15in, Sicilian.	19	19s	
1823	Sir H. C. Englefield. C. Hydria, 20in.	24	13s	
1826	Earl of Carlisle (ex Henry Tresham). 17½in oviform vase with handles, seated Amazon.	20		
1828	C. Bell krater by the Kalos painter.	16	16s	
	Oenochoe, 15½in, by the Kalos painter.	36	15s	
1834	Lucien Bonaparte, Prince de Canino, Paris. Black figure vase (see 1950).	26		
1840	Samuel Butler, Bishop of Lichfield. C. 2-handled tazza from Nola.	46	4s	
	Ascribed Panathenaeic vase with the words *Athenothen athlon* (see 1845).	30	9s	6d
	Campenari (from Italy). C. Oviform vase, 20in, combat of centaurs.	40	19s	
1844	Jeremiah Harman. C. 47 lots (mostly *ex* Sir John Coghill, 1819):			
	Campana-shaped vase, Theseus received by Venus.	22	1s	
	Nola oviform vase.	28	7s	
	Oviform vase, Theseus seated in a temple.	51	9s	
	Campana vase, Diomed and chariot.	35	3s	6d
	2-handled oviform vase, Pyrrhic dance.	35	14s	
1845	C. Panathenaeic vase (see 1840).	10	10s	
1848	Duke of Buckingham, Stowe. C. Amphora (ex Prince de Canino).	14		
	Red-figure vase (bought in Athens for £100).	24	3s	
	3-handled krater, 19in.	17	17s	
1849	Thomas Blaydes. C. Cup in form of the rostrum of a galley, red-figure.	29	8s	
	Oviform vase, black-figure, 6th cent. B.C., 23in high.	42		
	25in Panathenaeic vase with boxers.	27	6s	
	William Coningham. C. Pelike with Heracles and Deianeira and other subjects, bought-in.	97	13s	
	24in Nolan amphora, Tityus at Delphos, bought-in.	92	8s	
	17in amphora, Death of Achilles.	78	15s	
	2-handled cylix, Minerva, Nesidora, Stephastos.	73	13s	
	Nolan amphora, twisted handles, Telemachus taking Leave of Nestor.	50	8s	
	Oenochoe from the Durand Coll. Faun and Maenad.	45	3s	
	Smaller oenochoe (ex Durand).	38	17s	
1850	Dr Braun of Rome. C. Cylix from Vulci, Theseus and Minotaur.	63		
1856	Samuel Rogers. C. 212 lots of Greek vases which made £2,461:			

£

1856 Corinthian hydria with inscribed figures, signed Hippo-
krates kalos, bought by Samuel Addington. 173 15s

 Aryballos, numerous named figures. 106 1s

 14in black-figure hydria with a chariot and Theseus
slaying Minotaur. 94 10s

 14in stamnos, published by Panofka. 86 2s

 Nolan cylix from Lucien Bonaparte Coll. 53 11s

 Several others at over £50.

 A nobleman (Earl of Orford). C. The Amazonomachia,
a truncated sphere vase, or Dinos, 11in deep and 41in in
circumference, found at Girgenti, 1830, 17 figures, each
over 6in long, late 5th cent. B.C. 128 2s

1859 Bram Hertz. S. Amphora, 20½in, Achilles dragging the
body of Patroclus. 87

1861 Campana Coll. Rome. *The Queen of Vases*, a very late
Campanian hydria from Cumae, *c*. 200 B.C., with gold reliefs
on burnished black, offered by the Papal Government at
£240. Presented to the Russian Government after a block
purchase.

1863 V & A buys rhyton in form of a boar's head, 4th cent. B.C. 60

1864 S. G. Fenton. C. 9in oenochoe, Apollo addressing
Hercules (*ex* Samuel Rogers). 15 4s 6d

1865 Pourtalès, Paris. Oenochoe, rope handles, Theseus and the
Amazons, 14in, bought by Duc d'Aumale (Musée Condé). 408

1879 V & A buys figurines, 4th cent. B.C., from the newly dis-
covered Tanagra Cemetery:

 Seated Venus. 35

 Figure holding mirror. 45

 Paravey, Paris. Oenochoe by Douris and Calliades
(Louvre). 308

1881 Paris. Red-figure oenochoe by Brygos (Louvre). 440

1882 Hamilton Palace. C. Beckford's red-figure krater. 168

1884 Castellani, Paris. 3-handled hydria (Louvre). 1,000

 V & A buys from Alessandro Castellani Tanagra clay
group, amorini playing with Aphrodite. 270 10s

 8 amorini in 1 group, Tanagra. 180 10s

 Tragic mask with painted eyes, Tanagra. 68 10s

 Castellani (Rome sale) Tanagra Figure of Artemis,
bought by Lyons Museum. 212

1892 Van Branteghem, Paris. Very large Tanagra clay group,
Dionysus and the Bull. 330

 Red-figure bowl by Euphronius, found at Viterbo, 1830. 420

1895 Frederick Spitzer, Paris. Tanagra figures which were
later pronounced forgeries:

 Bark of Charon. 440

 Mother nursing Child. 250

1898 Tyszkiewicz, Paris. Polychrome hydria, the Eleusinian
mysteries. 820

£

1899	Hoffmann, Paris. Capuan rhyton, Negro devoured by crocodile.	248
1912	Lambros, Paris. Musée des Beaux Arts buys krater by Brygos.	500
	J. E. Taylor. C. 5th-cent. hydria from Rhodes.	651
	Ditto.	512
1917	Hope heirlooms. C. 151 lots fetched £16,710 (see 1795):	
	20in black-figure amphora, damaged.	1,050
	Red-figure krater, 16½in.	819
	Corinthian opole by Taleides, 11½in.	861
1920	Louvre buys lekythos from Kertch in S. Russia, by Xeno-phontos. about	800
	S. Attic red-figure kylix, c. 460 B.C.	570
1925	De Ferrari. S. Red-figure cup, 5in, Panaitios painter.	650
1926	S. Black-figure Attic amphora, 6th cent. B.C.	410
1928	Sir Wilfrid Peek. S. Black-figure amphora, Heracles and the Nemean Lion, 18½in, c. 530 B.C.	800
	Dillwyn Parrish. S. Red-figure bowl with hunting scenes (restored) 12½in diam., c. 520 B.C.	730
1936	C. Black-figure amphora, 17in high, c. 530 B.C.	194 5s
1948	Earl Fitzwilliam. C. Black-figure amphora by Ando-kides.	997 10s
	Red-figure kylix.	756
1949	S. Oenochoe, c. 530 B.C., with black-figure Maenads.	480
1950	S. Black-figure vase, 18in, Europa and the Bull, c. 530 B.C. (see 1834).	620
	C. 2-headed rhyton by Sotiades, c. 460 B.C.	283 10s
	S. Mycaenean amphora, 13½in, c. 1400 B.C.	320
1951	W. Randolph Hearst, New York. Purchases by Kansas City Museum:	
	Attic red-figure kylix.	1,215
	Black-figure hydria.	880
	Black-figure amphora, 6th cent. B.C.	1,000
1953	Basel, Switzerland. Archaic terracotta Figurine, c. 500 B.C.	3,100
	Black-figure Panathenaic amphora by the "Princeton painter", c. 550 B.C.	2,150
	Kylix by the Makron painter, c. 490 B.C.	1,360
	C. Black-figure amphora, c. 520 B.C.	483
1954	Basel, Switzerland. Attic black-figure pinax, c. 510 B.C.	2,245
	Red-figure hydria, c. 500 B.C.	1,535
	Parke-Bernet, New York. Single Tanagra figure, maiden seated on rock.	300
1957	Jacob Hirsch, Lucerne. Etrusco-Greek stamnos from Chiusi, 9in.	1,112
	Italiate krater from Taranto, 14½in high.	770
1958	Basel. Black-figure amphora, 27in, by the Achelous painter, c. 510 B C.	1,925

£

1959	C. Black-figure oenochoe, *c.* 520 B.C. Ceres and Dionysus.	682	10s
1960	S. Attic red-figure krater.	1,000	
1961	BM buys bell-krater by Altamura painter, 18¼in, *c.* 470 B.C.	2,000	
	S. Attic black-figure amphora, *c.* 600 B.C. (Ashmolean Museum).	560	
1962	S. Romano-British polished red vessel (Castor ware), 10in high, hounds in relief, much repaired (BM).	1,050	
	Red-figure dinos by the Altamura painter, bought by King's College, Newcastle.	600	
	C. Black-figure amphora, *c.* 500 B.C.	782	10s
	S. Prehistoric Cycladic clay figure of a goddess.	820	
	Attic red-figure loutrophoros.	800	

CRYSTAL OBJECTS OF THE RENAISSANCE

16TH–17TH CENTURIES

(For others, see Mediaeval and Near Eastern)

£

1741 Earl of Oxford (Cock, auctioneer). Serpentine dish and
ewer in silver-gilt mounts. 6 6s
 Scalloped salver and cover in Oriental jasper, unmounted. 16 10s 6d

1766 C. Head of Cosimo de'Medici in agate onyx, attributed
to Giovanni da Bologna (compare 1802). 21 10s 6d

1769 C. Agate scalloped dish with jewelled parcel-gilt mount. 6 7s 6d

1770 Erasmus van Harp (jeweller, formerly of Amsterdam). C.
A matchless shell in crystal, the baptistery vessel of the
ancients. 2 10s
 Crystal aquamanile in the form of a bird, "for holy
water". 4 4s
 Large crystal rummer, gold rim. 3
 Crystal sacrament-ewer, mounted in silver. 5 2s 6d
 Amber ewer and salver, carved in relief. 6 6s

1774 Hon. Richard Bateman. C. Crystal crucifix, mounted
in silver-gilt with sapphires. 3 7s

1776 Consul Joseph Smith. C. Lapis lazuli cup, set with
stones. 8 8s

1777 Randon de Boisset, Paris. Gondola-shaped cup of onyx
with handles, modelled as swans, probably Renaissance
work, but heavily mounted in ormolu in the French rocaille
style. 47 4s

1783 Francis Barnard. C. Wrought amber cup, parcel-gilt
mount. 6 16s 6d

1786 Quintin Crawfurd. C. Crystal bowl in shape of a boat. 1 11s 6d
 Gentleman formerly resident in Turkey. C. Basin
formed of "root of emerald". 17 6s 6d
 Duchess of Portland (Skinner, auctioneer). A large crystal
bird, curiously engraved. 10 15s

1791 Lord James Manners. C. "Curious and elaborate per-
formances in rock crystal", 22 lots:
 Carved chalice, mounted in gold. 6 8s
 Boat-shaped chalice, mounted in enamelled gold. 6 10s
 Large engraved vase, enamelled and mounted. 5 10s

1796 William Thompson, jeweller. C. Crystal bottle of
uncommon magnitude, curiously engraved, mounted in
gold. 5 5s

£

1802	Findley (the Oriental Museum). C. Onyx bust of Catherine de' Medici, late 16th-cent. Italian, formerly belonging to Marie Antoinette, £100 paid (compare 1766).	78 15s
1804	Van Leyden, Paris. Agate cup and cover, engraved and heavily mounted in copper-gilt, enamels, etc.	80
1805	C. Dish with covered vase, forming a table-centre, possibly Austrian, formerly belonging to Marie Antoinette.	24 3s
1807	C. Ancient engraved cup in silver-gilt mount, set with emeralds, etc.	24 13s 6d
1814	Lady Mansfield. C. Dolphin carved and hollowed from a single block, mounted in silver-gilt.	49 7s
1818	William Beckford purchases in Paris:	
	Carved crystal bowl by Valerio Belli (see 1882).	21
	Square crystal vase from the *Garde meuble* (see 1882).	21
1819	Beckford buys from Baldock the Caterina Cornaro vase of Hungarian topaz, attributed to Cellini (see 1823).	285
	Sevestre, jeweller, Bond Street. C. Biberon in heavily jewelled mount with spout in the form of a swan's head.	60 18s 6d
	Tazza in form of a scallop shell on silver-gilt stand with baroque gems in the form of tritons.	127 1s
	Biberon in form of a hollowed chimaera, jewelled.	63 11s
	Shell-shaped tazza on silver-gilt stand.	22 1s
	Crystal tankard in a very ancient engraved silver mount.	3
1823	Farquhar, Fonthill (*ex* Beckford) (Philips). The Caterina Cornaro topaz vase (Linskey Coll., New York, per Lord Rothschild).	630
	Shell-shaped cup in mount from the French royal *Garde meuble*.	19 19s
1827	Chevalier Franchi (*ex* Beckford). C. Tazza with figured relief, lapis.	17 17s
	Chalcedon cup, jewelled mount with red coral figure.	48 6s
1838	"A German baronial castle." C. Crystal vase engraved with arabesques, mounted with turquoises.	19 8s 6d
	"A nobleman of high rank." 2 mounted cups of carved agate, "*Cinquecento* design".	42 5s
1839	Prince Poniatowski. C. Oblong cup of topaz *enfumé* with lion's-mouth spout.	95 11s
1842	Acraman, Bristol. C. Agate cup and cover in gold mounts (from Fonthill).	18 7s 6d
	Waldegrave, Strawberry Hill (*ex* Walpole). Crystal tankard and cover in parcel-gilt mounts, bought by A. de Rothschild, Frankfurt.	50 8s
1845	Lady Mary Bagot. C. Vase of crystal, no description.	38 17s
1848	Duke of Buckingham, Stowe. C. 2 mounted agate candlesticks (pronounced to be modern).	48 16s 6d
1850	General J. Macdonald. C. Ewer, silver-gilt dragon handle.	33 13s
	Debruge Dumènil, Paris. Figure of horned sea-horse, rock crystal and agate in jewelled gilt mount.	28

£

			£	
1850	12 Caesars, miniature busts in various stones, 16th cent., with much later mounts.	12 for	136	
	Gadrooned cup and cover, cut out of lapis lazuli, with very rich jewelled gold mounts.		192	8s
	Rock-crystal goblet and platter, gilt-bronze mount.		44	8s
	Parcel-gilt chalice, 14in high, heavily jewelled, with solid figures of lizards and other animals, called Italian, but probably S. German, Jamnitzer school, late 16th cent., bought by Soltykoff.		146	
1852	Sutcliffe & Co. C. Shell-shaped rock-crystal mounted cup, surmounted on the lid by a Neptune and a baroque pearl.		61	
1856	Samuel Rogers. C. Mounted agate cup and cover (bought Franchi sale, 1827, for £5 15s 6d): value multiplied 19 times in 29 years).		110	10s
1855	Bernal. C. Crystal cup and cover in parcel-gilt mount, c. 1540 (see 1937).		32	
	Pair of late 16th-cent. crystal altar candlesticks.	2 for	61	
	Another ditto, c. 1560.		28	
	See Mediaeval Art for the crystal mirror of King Lothair.			
1857	T. A. Trollope. C. Coronation of the Virgin, rock-crystal group by Valerio Belli, late 16th cent., bought-in.		57	15s
1858	David Falcke. C. Pair of crystal altar candlesticks, 18in high, probably Italian, 16th–17th-cent.	2 for	153	11s
	Oblong octagonal dish, 13in × 11½in, made of 9 slabs of engraved crystal for Caterina Cornaro, 1510(?) (from the Giustiniani Palace, Padua), bought-in.		225	15s
1859	Bruschetti, Milan (owner of the Gran Albergo Reale). C. The Gonzaga Casket, 28in × 21in × 18in, made of 313 plates of rock crystal, enamelled on the underside, attributed to Cellini and Bramante, bought-in.		525	
	Unnamed sale. C. Engraved crystal vase and cover in modern gold jewelled mount.		130	
	Rattier, Paris. 2 vases in copper-gilt enamelled mounts, Italian, 16th cent.		{50 {86	
1861	Soltykoff, Paris. 2 mounted burettes with enamelled statuettes, called Italian.	2 for	496	
	Mathew Uzielli. C. Benitier, c. 1570, 12in high, with appliqué silver, enamelled figures.		106	
	Pipe, the bowl forming a Negro's head of onyx, the lid a jewelled turban, German, 17th cent., bought by Lionel de Rothschild.		90	10s
1863	Dowager Countess Ashburnham. C. Oval cup, dolphin handles, with ruby eyes, enamelled copper-gilt stand, 5¾in × 4½in.		210	
1864	V & A buys (ex Soltykoff Coll.) cross composed of engraved plaques, jewelled framing. 2ft 6in long, by Valerio Belli, c. 1520.		210	
	Navette, 5in × 3in, lightly mounted, alleged Spanish.		185	

£

			£	
1865	Earl of Cadogan. C. Oval fluted and scalloped dish, 12in×7in, mounted in enamelled copper-gilt.		194	5s
	Pourtalès, Paris. Vase engraved with dragon handles.		460	
	Another less ornate, 6½in.		352	
1866	C. Ewer and dish, built of crystal slabs, enamelled Neptune jewel on the lid.	2 for	212	
	Salver formed of lapis lazuli slabs with enamelled mounts.		124	10s
1867	V & A buys agate cup, London chased parcel-gilt mounts, 1567.		350	
1868	V & A buys 16th-cent. Italian rock-crystal goblet and cover, 10in high, modern mount.		350	
1871	V & A buys German 16th-cent. rock-crystal cup and mount.		80	
1872	V & A buys bottle, brown onyx, Augsburg, 16th-cent. mount.		250	
	Rock-crystal vase in form of a fish with ruby eyes, 16th-cent. Italian, modern mount.		300	
	Allègre, Paris. German 16th-cent. crystal goblet, gadrooned and engraved.		756	
1877	Robert Napier. C. Oval cup, enamelled dragon handles, Italian.		183	15s
1882	Hamilton Palace. C. Ewer and bowl in jasper, mounted for Beckford (see 1885).	2 for	850	10s
	Aventurine jasper tankard, probably Byzantine, with French royal mounts of 1734.		2,467	
	The Valerio Belli oval crystal bowl (see 1818).		1,207	
	Crystal square vase from the *Garde meuble* (see 1818).		840	
	Agate cup and cover, Italian, 16th-cent. (V & A).		531	
	See also Chinese Jade and Classical Art.			
1884	Fountaine. C. Crystal cup and cover, 9in.		903	
1885	Beckett Denison. C. Ewer and bowl, jasper, mounted for Beckford (see 1882).	2 for	546	
1893	Frederick Spitzer, Paris. Hanging bowl with suspension handles, cut out of 1 piece, German, 16th cent., clear rock-crystal.		2,800	
	Flower-shaped standing cup, jasper, mounted in enamelled gold, Italian, 16th cent.		1,800	
	Pax in the form of an altar, enamels and crystal, Italian, *c.* 1530.		1,600	
	Crystal ewer with 2 tall covered cups, German, enamelled gold mounts and rubies, *c.* 1550.	3 for	2,400	
	Italian biberon and cover with 2 spouts and handles, late 16th cent.		740	
1896	Earl of Warwick. C. Italian pilgrim bottle, engraved.		330	15s
1898	Martin Heckscher. C. Mounted engraved cup (£220 in 1892).		600	
	Spanish mounted crystal reliquary, 16th cent.		1,750	
1902	Gibson Carmichael. S. Gold-mounted agate cup.		700	

£

1904 Marquess of Townshend. C. Rock-crystal ewer, alleged
 to be Chinese (Egypt, Fatimid, 10th cent.?), mounted,
 Edinburgh, 1565, arms of Erskine and Moray (see 1924). 1,000
1905 Quilter. C. 2-handled cup, German, 1550–1600, en-
 graved with figures, but not mounted. 567
 Marquess of Anglesey. C. Pear-shaped ewer, possibly
 Fatimid, mounted as a standing salt, London, c. 1560,
 bought by Duveen. 4,200
 John Gabbitas. C. German crystal biberon in the shape
 of a duck, c. 1560, with sumptuous enamelled gold append-
 ages, 12in high, 16in long (see 1910), bought by Charles
 Wertheimer, and resold to Baron Bruno Schroeder for
 £20,000. 16,275
1908 Marchioness of Conyngham. C. Standing cup and
 cover with enamelled gold French mounts, c. 1600. 1,995
1910 Octavus Coope. C. 16th-cent. 2-handled bowl, Italian. 600
 Baron Schroeder. C. The £20,000 biberon bought back
 by Charles Wertheimer (see 1912). 10,500
1911 von Lanna, Prague. Crystal jar and cover, blue and white
 enamels on gold, on the lid medallion of Leda and the
 swan, Italian mid-16th cent. 3,550
 Carl Meyer Rothschild, Paris. Agate cup, enamel mounts,
 perhaps Italian. 2,000
 Rock-crystal mounted cup. 2,250
1912 Wertheimer. C. The £20,000 biberon (see 1905, 1910). 3,800
1918 Gumbrecht, Berlin. Female bust in solid crystal, attributed
 to Tullio Lombardi, late 15th cent. 2,450
1921 Sandford. S. Elizabethan rock-crystal mounted candle-
 stick. 720

 Heilbronner, Paris. 4 16th-cent. mounted cups. each {250–
 {300

1924 Swaythling heirlooms. C. The Erskine Moray mounted
 ewer (see 1904). 6,000
1925 Sir Francis Cook. C. 2 mounted French rock-crystal
 candlesticks. 2 for 1,575
 For the Rubens Vase, see Classical Art, bronze, etc.
1926 C. Italian 16th-cent. crystal crucifix. 567
1928 Dillwyn Parrish. S. Crystal crucifix, mounted in gilt
 bronze, containing relics, Naples, c. 1620, nearly 5ft high. 130
 Major Morrison. C. Cylindrical cup, engraved classical
 figures, German, London mount, Thomas Bampton, 1572. 1,500
1934 Edmund Philips. C. Rock-crystal biberon, gold lid with
 Paris mark, 1728. 880
1935 Ernest Innes. C. Italian green jasper cup, gold rim. 105
1937 Earl of Lincoln. S. The Hope family green jasper
 mounted bowl, made in 1855 in Renaissance style, heavily
 jewelled (see 1960). 1,200
 Comtesse de la Tour d'Auvergne. S. Carved ewer and
 dish, Italian, c. 1535. 540

£

1937 C. Crystal cup and cover in 16th-cent. Augsburg parcel-gilt mount, now ascribed to Jamnitzer (Bernal sale, 1855, £32, *q.v.*). 125

1938 S. German 16th-cent. biberon with enamelled mounts from the Gruene Gewolbe, Dresden. 600

Mortimer Schiff. C. Crystal nautilus cup, mounted in Cellini style. 472 10s

Durlacher. C. Crystal reliquary, 10in high, Italian, gold mounts, bought by V & A. 535 10s

1943 S. Life-sized rock-crystal skull (Italian, 16th cent.?). 340

1957 C. Biberon, 9½in × 8in, with elaborate baroque enamelled jewel, richly carved, Italian, late 17th cent. 2,100

1960 S. The Hope green jasper vase, 1855 (see 1937). 5,500

S. Bonbonnière and cover, enamelled gold mounts, arms of Catherine de'Medici. 660

1963 Lord Astor of Hever. C. Engraved and mounted crystal cup, 11¾in high, late 16th century Italian. 840

DELFT AND OTHER EUROPEAN POTTERY

(INCLUDING TIN–GLAZE, SALT–GLAZE, SLIPWARE, ETC.)

17th–18th centuries

£

1770 Count de Sielern. C. Rouen dinner service. 104 pieces for 5 10s

1771 Mathew Bradley. C. Bacchus in "Delph ware" brass
cock and cistern on brackets (boy striding barrel). 14s

1788 Count Reventlow. C. "A very rare scarce old Delf dish,
most remarkably painted with a view of Rome." From
the Duchess of Portland's Coll. (Alcora?). 3 10s

1842 Waldegrave, Strawberry Hill (*ex* Walpole) (Robins).
Large blue-and-white Delft dish, dated 1698, and depicting
Abraham and Hagar. 2 15s

 12 dishes painted by Sir John Thornhill with the signs of
the zodiac, 1711, bought by Horace Walpole from
Hogarth's widow in the 1760s (Delft blue-and-white).
12 for 7 7s

1846 Charles Dodd. C. 2 brown dishes dated 1688 and a mug
dated 1660, attributed to Elers; an Astbury figure, etc.
all for 6s

Paris. 5 Rouen polychrome faience busts on pedestals, by
Nicholas Fouquay, 1742 (see 1882). 5 for 56

1848 Duke of Buckingham, Stowe. C. Persian Delft (prob-
ably Nevers ware in *bleu de Perse*), early 18th cent., covered
jar, 2 gourds and 2 beakers, mounted *en rocaille*. 5 for 50

1855 Bernal. C. Lambeth polychrome dish, Fecundity, *c.* 1680,
after Bernard Palissy (see 1911, 1924, 1960). 6

 Blue-ground Nevers pilgrim bottle. 6

1858 V & A buys Nevers pilgrim bottle. 15 4s 6d

1861 Soltykoff, Paris. Avignon brown glazed ewer, late 16th
cent. 14

1863 William Russell. C. William and Mary marriage dish,
1677, slipware, signed Ralph Toft. 4 18s

1870 The Aigoin Coll. Purchases by V & A:

 Nevers plateau, 21in, the Rape of Europa, mainly blue-
and-yellow, before 1660. 132

 2 Rouen ewers, polychrome, before 1700. 2 for 165

 Strassburg clock-case by Hannong, *c.* 1750. 148

 Strassburg wall fountain, 22in. 82

 C. Large Fulham polychrome jug with monogram A.R. 11

1871 V & A buys stoneware funeral effigy of the infant Lydia
Dwight, made by Dwight of Fulham, 1673. 31 10s

£

1879	Mandl, Paris. Rouen faience:			
	Large picture plaque, Chinese jugglers.		65	
	Oblong Rouen platter.		82	
	Large dish, Chinoiserie figures, c. 1740.		102	
	Polychrome sugar castor.		148	
1882	Hamilton Palace. C. 4 Rouen busts on pedestals by Nicolas Fouquay, bought by the Louvre (see 1846). The 5th had been given to V & A.	4 for	2,645	
	Nevers ewer and dish, c. 1680, signed G.S.	2 for	262	10s
	2 dishes, Dutch, "Delft doré", c. 1740.	2 for	59	17s
1883	V & A buys Thomas Toft's slipware dish with lion and unicorn, c. 1670.		20	
1884	Millet, Paris. Delft oval dish, dated 1651, Jupiter thundering.		204	
	le François. Rouen. The Four Seasons on pedestals by Poterat, Rouen, bought-in.		580	
	3 polychrome Rouen dishes.		⎧ 200 ⎨ 240 ⎩ 274	
	Fountaine. C. 2 Nevers ewers, 25in high.	2 for	462	
1885	Lord Stafford. C. Slipware dish signed Thomas Toft, royal arms of Charles II.		26 15s	6d
1887	V & A purchases:			
	Delft jar and cover, Chinese blue-and-white style, Ghisbrecht Kruyk.		40	
	From Felis Coll. Nevers dish, bleu de Perse.		104 10s	
	Dutch polychrome Chinoiserie plaque, c. 1700, 10in × 8in.		130 12s	10d
1888	Marquess of Exeter. C. 2 Nevers ewers in white relief on blue.	2 for	304 10s	
	le François, Rouen. The Four Seasons, busts on pedestals (compare 1882).	4 for	348	
	Niederviller hanging faience clock.		136	
	Nevers water-pot in shape of a shoe.		385	
1891	V & A buys Delft polychrome vase and cover by Louwys Fictoor.		100	
1902	Lord Grimthorpe. C. 2 Nevers ewers.	2 for	204 15s	
1906	Warner (sale at Leicester). Slip ware dish, signed Thomas Toft, 1677.		86	
1907	Yanville, Paris. 2 Nevers pilgrim bottles, white on blue, Louis XVI mounts.		740	
1908	Zelikine, Paris. Same pair.		480	
	Boreel, Amsterdam. Garniture of 4 polychrome Delft vases by Louwys Fictoor, 1690.	4 for	652	
	Garniture of 5 by Cornelis van Eenhorn, dated 1691.	5 for	600	
	S. Staffordshire slipware posset-pot, 1685.		55	
1910	C. Staffordshire salt-glaze mug, figures in a landscape.		75 12s	
	Paris (Singher). Rouen inkstand and fittings, scenes after Teniers, c. 1740.		1,600	

£

1910	Sceaux faience soup-tureen.	600
	Maurice Kann, Paris. Moutiers plaque, Judgment of Paris.	564
1911	Paris. 2 Dutch Delft covered jars in Imari style, signed by Pijnacker.	2 for 1,404
	Bordés, Paris. Alcora dish with a view of Paris.	428
	C. Lambeth Fecundity dish in Palissy style (see 1855, 1924, 1960).	68 5s
	Lambeth sack bottle, crown and cypher, Charles I, 1648.	34 13s
	S. Salt-glaze pink-ground teapot in relief, Staffordshire, c. 1760.	48 6s
	Levaigneur, Paris. Delft polychrome garniture in Pijnacker style.	5 for 1,040
1912	L. M. Solon (at Hanley, Staffs.). Slipware posset-pot with 3 handles, inscribed Mary Shiffilbottom, 1705.	100
	Undated slipware dish, inscribed Thomas Toft.	170
	Ditto, inscribed Ralph Toft; both 16½in.	145
	Welsh tyg, "John Hughes, 1690".	100
	Pew group, 2 figures, height 5in.	205
	Salt-glaze globular teapot, the King of Prussia.	47
	Salt-glaze covered tankard, commemorating Admiral Vernon and Portobello, 1732.	110
	Salt-glaze enamelled ewer, Chinese style 1750.	100
1916	Bukowski, Stockholm. Rorstrand tankard, 1746.	124
	Rorstrand tureen, 1765, repaired cover.	168
	Rorstrand covered urn in relief.	250 16s
	Marieburg shell-shaped basin.	182
	Marieburg fruit basket.	164
1917	C. 2 15in polychrome Delft dishes by Adriaen Pijnacker (resold by James Duveen to Anton Jurgens for £5,000).	2 for 1,832 10s
	C. Astbury equestrian statuette.	341 5s
1920	Bennett-Goldney. S. Lambeth polychrome dish with satyrical subject, dated 1688.	325 10s
1921	Morgan Williams. C. Garniture of 4 Delft polychrome vases and covers, Imari style.	4 for 556 10s
1923	Paris. 2 Delft figures of game-cocks, enamelled in the rare Delft noire colour (see 1925).	1,620
	Bryan Harland. S. Astbury figure of a seated fiddler.	220
	Ralph Wood group, Dutch boy and girl.	115 15s
	Ralph Wood statuette of Jupiter.	99 15s
1924	Mrs Hemming. C. Staffordshire white salt-glaze bell in form of a lady.	267 10s
	Maling. S. Lambeth Palissy Fecundity dish with long inscription of 1661 (see 1911, 1960).	90
1925	Jacques Seligman, Paris. 2 Delft figures of cocks (see 1923).	642
1926	C. Staffordshire salt-glaze pew-group.	210

£

1927	Paris. Large rectangular Delft plaque, polychrome, style of Fictoor.	740
	Gaymard, Paris. Marseilles soup-tureen, *c.* 1740–50, Veuve Perrin factory.	960
	Micah Salt (Butters, auctioneer). Damaged slipware dish, Charles II hidden in the oak, signed William Tailer, *c.* 1670.	330
1928	C. Delft ewer and basin in Kakiemon style by Louwys Fictoor.	1,080
1930	J. S. Taylor. S. Salt-glaze pew-group, Staffordshire.	260
	C. Adam and Eve slipware dish, signed Thomas Toft and dated 1674.	367 10s
	Lambeth Delft dish, marked R.A.M., 1640.	210
	Ralph Wood equestrian figure, 9in high.	178 10s
	Mrs Florence Clements. S. Ralph Wood equestrian figure of Hudibras.	245
1931	Maurice Roquigny, Paris. Rouen tray in polychrome enamels, the Triumph of Amphitrite.	875
1932	S. Staffordshire salt-glaze pew-group, 8in.	285
1933	S. Ralph Wood equestrian figure of the Duke of Cumberland as a Roman emperor.	410
1934	Lord Revelstoke (Puttick and Simpson). Staffordshire slipware charger with conventional portrait of Charles II by Thomas Toft.	115 10s
	The Acland armorial bowl and cover, Bristol tin-glaze, 1709.	231
1936	S. Delft polychrome garniture of 5 vases, 1700, by Louwys Fictoor. 5 for	730
1938	Wallace Elliott S. Staffordshire salt-glaze octagonal teapot, military subjects, 1760–70 (similar piece, see 1955).	290
1943	S. Astbury-Whieldon wedding group.	260
1945	S. Pair of figures of cocks, Staffordshire salt-glaze imitating *famille rose* porcelain. (£900 in 1963.) 2 for	450
1949	S. Strassburg tureen and cover in shape of a pigeon.	210
	Astbury-Whieldon figure of mounted trooper of 1750.	270
	Ditto, pair of lovers.	360
	Ditto, figure based on the Vatican Spinario statue.	220
	Pair of Staffordshire salt-glaze swans.	440
1951	Hamburg. Nuremberg polychrome ewer, *c.* 1700, silver-gilt mount.	335
1952	S. Ralph Wood unique Toby jug.	750
1953	S. Lambeth pill-slab, arms of Apothecaries' Company, 1670 (see 1960).	225
1954	Murray-Ragg. S. Staffordshire salt-glaze pew-group, 2 figures (compare 1912, 1932).	950
1955	Rev. C. F. Sharp. S. Staffordshire salt-glaze teapot, pink ground.	150
	Ditto, octagonal, military subjects (see 1938).	140
	S. Lambeth jug, inscribed Hooper, 1629, the earliest known piece of English blue-and-white.	300

£

1956	Miss Foster. S. Staffordshire polychrome equestrian figure of William III in Roman dress, 15in, by Ralph Wood.	400
	S. Tureen and cover from the Veuve Perrin factory, Marseilles, c. 1750.	300
	The Charles II "Royal Yacht" Lambeth charger, polychrome, dated 1668, 16½in diam.	1,550
	Lambeth Cup, portrait Charles II, 1663.	180
	Ditto, plain sack bottle, 1750, 7¾in.	140
1957	Paris. Rouen Chinoiserie enamelled tray, c. 1700.	1,280
	Octagonal bowl with handle, Rouen.	685
1958	S. Lambeth drug-jar, arms of the Apothecaries' Company, dated 1724.	490
	Paris. 2 Marseilles flower-holders, rococo style, Veuve Perrin factory. 2 for	1,655
1959	Morley Hewitt. S. Crich stoneware Monteith punch-bowl, dated 1704, 11in diam.	410
	Malcolm MacTaggart. S. Lambeth bleeding bowl, 1660, with conventional figure of Charles I.	980
	Lambeth polychrome Adam and Eve dish, 1633–5.	840
	Lambeth Palissy meat-dish with figure of Fecundity, marked CAP., 1635.	200
1960	S. Lambeth pill-slab, late 17th-cent. armorial (in 1915 Sothebys sold one of these with the arms of the Apothecaries' Company for £5 15s). See also 1953.	580
	Lambeth Palissy Fecundity dish, dated 1661 (see 1855, 1911, 1924).	480
1961	Parke-Bernet, New York. Polychrome Dutch Delft, early 18th-cent. fountain in form of drinker astride a barrel.	536
	Double-gourd bottle by Aelbrecht de Keyser.	375
	Bough vase by Cornelis de Keyser.	321
	Pair of jugs in shape of figures. 2 for	536
	Pair of octagonal covered jars, "cachemire" decoration. 2 for	429
	Mimara Topic. S. Strassburg (Hannong) polychrome figure of Harlequin, 14½in high.	2,100
	S. Staffordshire salt-glaze, c. 1740–50, tea-party, arbour group.	3,400
	Lambeth Delft polychrome charger, 1648, with painting of Susanna and the Elders, 18¼in.	2,500
1962	S. Lambeth Delft cup, portrait of William III.	290
	Staffordshire salt-glaze group, Polito's Menagerie.	520
	Wrotham slipware tyg by John Livermore, 1631.	460
	C. 2 lions, Luneville faience, c. 1770.	1,050
	Igo Levi, Munich (Weinmuller). Nuremberg silver-gilt mounted tankard with *Hausmalerei* painting of a stag-hunt by Schmerzenreich, c. 1720.	1,628
	2nd tankard with painting after Teniers.	748
	Schrezheim enamelled faience epergne candlestick.	1,056
	Ditto, candlestick, supported by a Moor.	836

		£		
1748	De Valois, Paris. Egyptian bronze Saitic cat, 18in high.	19	17s	
	Smaller cat, crouching.	2	4s	
	Egyptian priest, 15in, bronze.	2	11s	
	Another ditto.	3		
	Sphinx holding a vase, bronze.	2		
1762	Duc de Sully, Paris. Egyptian alabaster vase, figures in relief.	5		
1775	Prince de Conti, Paris. Priest of Isis in bronze, holding a scroll.	3		
	Mariette, Paris. The Bull of Apis, 5in×6in, bronze (see 1777).	3		
1777	Randon de Boisset, Paris. The same.	34	3s	
1782	C. "An Egyptian Isis in fine bronze from the Prince of Conti's Coll."		17s	6d
1786	"Gentleman lately resident in Turkey." C. 3 figures of Isis in green basaltes. 3 for	1	6s	
1787	Comte de Vaudreuil, Paris. 2 Canopic alabastar jars with lids formed as the head of Anubis. 2 for	35	3s	
1796	A curious museum. C. "5 curious antique Egyptian hieroglyphic *basso-relievos* on black slate." all for		8s	6d
1801	Sir William Hamilton. C. Egyptian basalt lion.	57	15s	
	Earl of Bessborough. C. Canopic vase with hieroglyphics.	20	9s	6d
	A mummy in its case.	21		
1802	Lord Mendip. C. "A most capital Egyptian figure of the scarce granite, 5ft high", bought by Blundell of Ince Hall.	147		
1818	Tuffin. C. Bronze statuette of Osiris.	4		
	A mummy from Cairo.	11	11s	
1821	The Gothic Hall, Pall Mall. C. 2 kneeling granite figures on modern basalt plinths, Egypt. 2 for	13	13s	
1826	William Troward (*ex* Belzoni). C. 23ft papyrus scroll.	21		
1827	C. Egyptian basalt stele with hieroglyphics.	5	10s	
	6 Ushabti figures. 6 for		16s	
	Bronze Saitic cat and another figure. 2 for		6s	
	Mummy, "colours on the case very fresh".	9	11s	6d
1838	Hertz. C. Canopic vase, 18½in, carved with incised figures and hieroglyphics, bought-in.	16	16s	
	Fragment of an Isis statue.	19	8s	6d

£

			£	
1846	de Ville. C. Fine Babylonian cylinder (seal) of red onyx.		2	12s
	Two black ditto.	2 for	2	4s
1856	Samuel Rogers. C. Colossal head of Nephthis, red granite, nearly 5ft high, 5th cent. B.C. (BM).		64	1s
1859	Bram Hertz. S. Saitic bronze hawk, 6th cent. B.C., 17½in.		20	10s
	Ditto, cat, 16in.		10	
1861	Mathew Uzielli. C. Assyrian seal-cylinder, nearly 2in long.		20	
1876	Salt S. Lower part of a Ptolemaic basalt statue, life-size.		19	
1883	Gustave Posno, Paris. Egyptian basalt figure (Louvre).		1,404	
1884	V & A buys Graeco-Bactrian gold armlet, 3rd cent. B.C., from the Oxus treasure.		1,000	
1890	Sabatier, Paris. Black basalt Anubis, 5ft 2in.		520	
	Granite group of a man and woman, Saitic period, 44in.		660	
1898	Tyszkiewicz, Paris. Egyptian basalt statue (Louvre).		903	
1903	Paris. Stele of the Serpent King of Abydos, Egyptian, pre-Dynastic, bought for the Louvre (with commission, £4,132).		3,720	
1905	Paris. Colossal basalt head of Serapis from Akhmim.		588	
1906	Paris. Bust of Amenophis IV.		600	
	4 alabaster vases from Canopus.	4 for	1,800	
	All purchased by the Louvre.			
1908	Louvre buys 2 Egyptian figures of apes in basalt.	2 for	1,800	
1910	Paris. Rose-granite bust of Psorkon I, 22nd Dynasty.		602	
1911	S. Basalt head, 26th Dynasty, only 3in high.		310	
1912	Dattari, Paris. Basalt statuette of the Saitic period.		1,188	
1913	Borelli Bey, Paris. Huge rose-granite lion from Heliopolis.		1,320	
1914	Arthur Sambon, Paris. 3rd Dynasty painted limestone group, seated man and wife.		990	
1920	The Louvre buys granite statue of Tutankhamen, protected by Ammon, much mutilated (250,000 francs). about		5,300	
1921	Lord Amherst of Hackney. S. Middle Kingdom figure, red sandstone, 25in.		1,870	
	Limestone head of Akhenaton, 13in.		1,000	
	18th Dynasty wooden statuette of a lady.		1,000	
1922	Rev. William MacGregor. S. Egyptian antiquities:			
	Games board, blue faience.		500	
	Turquoise faience hippopotamus.		350	
	6in chalice, blue faience, 18th Dynasty.		2,800	
	Pear-shaped vase, blue faience, 18th Dynasty.		450	
	Parts of a Saitic ivory casket.		660	
	26th Dynasty papyrus book of the dead.		370	
	Glass head of Amenhotep III, 2¾in.		520	
	Dr Fouquet, Paris. Egyptian serpentine jar in form of an angry lion.		1,080	
	A priest of Isis from Hermonthis, Graeco-Egyptian, bought by the Louvre.		775	

£

1922	Angela Burdett-Coutts. C. 2 Assyrian basrelief fragments from Nineveh given to the owner by Layard in 1849.

$\begin{cases}483\\210\end{cases}$

1923	Rev. William McGregor, 2nd sale. S. 12th Dynasty hardstone head of Amenenhet, less than 5in high.

10,000

Pre-dynastic black basalt statue, 15½in.

380

1924	Rev. Frankland Hood. S. Head of Hatshepshut, 6½in, black granite.

290

1925	Paris. Wooden statuette of a girl, 11th Dynasty.

1,280

S. Achaemenid Persian relief, 5th cent. B.C., height 25in.

540

1927	A. G. B. Russell. S. Persian Achaemenid relief from Persepolis, 29in × 17in, bought by Fitzwilliam Museum.

360

Assyrian fragment from Nineveh, brought back by Loftus in 1849.

150

Indo-Greek half-length Gandhara figure, 25in.

310

26th Dynasty Egyptian mummy.

3,000

1930	C. Black basalt statue, 26th Dynasty, the scribe Wertehuti, 26in.

2,415

Marquess of Lansdowne. C. 2 Assyrian reliefs from Khorsabad, 22in and 19in high.

$\begin{cases}1,470\\1,312 \text{ 10s}\end{cases}$

Kneeling figure, black basalt, Egyptian, 26th Dynasty, 45in high.

1,627 10s

1931	S. Luristan bronze cheek-piece of a horse's bridle, c. 600 B.C.

620

1932	USSR Government sale (Hermitage Museum). S. Hittite electron statuette.

135

S. 2 fragments of Assyrian reliefs, 17in × 17in and 14in × 9in.

$\begin{cases}210\\90\end{cases}$

1936	Henry Oppenheimer. C. Bronze hawk, Saitic period.

315

1937	Dufferin and Ava. C. Limestone Figure, Amenhetep II.

1,081 10s

1938	S. Assyrian fragment, 2 figures from Nimrud.

810

Ditto with winged figure.

330

Babylonian sardonyx jewel in the form of an eye.

360

Quartzite head of an Egyptian king, 19th Dynasty.

310

1942	Lord Rothermere. S. 2 old Kingdom Egyptian limestone statues, 18¾in and 16½in high.

$\begin{cases}2,000\\2,400\end{cases}$

1946	Earl of Plymouth. S. Assyrian bas-relief from Nineveh, a king and attendants.

3,500

1950	S. Dynastic faience hippopotamus, 7½in.

340

1951	C. Diorite head, Egyptian Middle Kingdom, 9in high.

420

1952	M. A. Mansur, New York. Yellow quartzite head of Akhenaton.

3,038

Limestone head of Thotmes III, 18th Dynasty.

660

S. Bronze cat, Saitic period, 18in.

357

1953	Paris. Seated bronze cat, 15½in high, Egypt, Saitic period.

840

1957	Jacob Hirsch, Lucerne. Bronze falcon of Horus, Saitic, c. 400 B.C.

1,550

£

1959 Canford School. S. Assyrian relief from Nineveh,
4 figures, 32in×26in. 4,400
 Relief with 6 captured women. 4,000
 Others as cheap as £300.
1960 Jacob Hirsch, Lucerne. Egyptian bronze figure of a pacing
goose, c. 1200 B.C. 2,570
Julia Ducane. S. Assyrian relief from Nineveh, 1 half-
length figure, 21in× 10in (Birmingham City Museum). 2,700
Parke-Bernet, New York. Small fragment from Nineveh. 1,607
S. Egyptian basalt figure of Osiris, 18in. 980
1961 Earl of Pembroke, Wilton. C. Egyptian Saitic statuette
of Hekatefnat. 992 10s
 Egyptian red granite head of a king. 682 10s
1962 Albert Stheeman. S. Egyptian bronze cat, Saitic period,
13½in high. 9,500
S. Sassanian silver dish, 7th–8th cent. A.D., 8½in diam. 1,500
Hon. Robert Erskine. S. Silver Graeco-Bactrian bowl,
c. 300–250 B.C., possibly part of the Oxus treasure. 900
1963 Bt. by Berlin Staatliches Museum in London: Akhenaton's
court sculptor with his wife, 18th dynasty granite stele.
 Reported price 75,000

ENAMELLED JEWELS OF THE RENAISSANCE

POMANDERS, PENDANTS, MORSES, HAT–BADGES, ORDERS, BAROQUE PEARLS

£

1766	C. Signum of the order of the Holy Ghost, worn by Mary Queen of Scots on the morning of her execution (see 1923).	12 12s
1775	Princess Augusta of Baden-Baden. Sale at Offenburg. Baroque pearl, formed as a Swiss Guard.	18 12s
	Baroque pearl, formed as a mermaid.	20 18s
1784	Charles Gore. C. Moorish slave, very curious, comprised of a large pearl enriched with diamonds.	8 18s 6d
1786	Duchess of Portland (Skinner, auctioneer). Rosary of 56 carved fruit-stones, said to have belonged to Henrietta Maria, attributed to Cellini.	46 4s
	Rosary of 32 fruit-stones carved and set with 32 mounted pearls, said to have been made by Cellini for Clement VII (see 1794).	81 18s
1794	"The valuable museum." C. The so-called Cellini Rosary (see 1786).	105
1812	"A man of science." C. A triton, the body formed of a very large and fine pearl, the frame engraved and enamelled.	17
1819	Sevestre of Bond Street. 2 baroque pearls enamelled and formed as Cupids on cornelian plinths, bought-in. 2 for	54 12s
	Lusus naturae baroque pearl, formed as a harlequin (jester?) (resold in 1838 for £21).	41 10s
1820	Maurice, Paris. Baroque pearl in form of a satyr.	13 10s
1835	Marchioness of Lansdowne. C. The *Henri Quatre* Jewel. A round gold box, the lid inlaid with a relief in solid gold and enamel of the Sacrifice of Abraham under a crystal plate, inscription of Pope Clement VIII commemorating Henri IV's conversion, 1593 (see 1852).	267 10s
1838	"Monsieur Hertz." C. Cock and hen formed of baroque pearls, enamelled gold, lapis lazuli stands.	31 10s
	"La mère folle" of Dijon, a grotesque female figure formed of 2 baroque pearls, bought-in.	15 15s
	Calvary brooch built up from a single baroque pearl.	15 15s
1839	A nobleman. C. *Lusus naturae*, baroque pearl formed as a mermaid, attributed Cellini, bought-in, but sold later to Garrard for	70
1842	Waldegrave, Strawberry Hill (*ex* Walpole). The Lennox Jewel, 16th-cent. Italian, bought by Queen Victoria (4 allegorical figures).	136
1843	Duke of Sussex. C. Brooch in form of a heart and crown which belonged to Mary Queen of Scots.	37 16s

£

	Miniature MS. prayer-book, bound in enamelled gold and mounted as a pendant, worn by Queen Elizabeth.	147		

1848 Duke of Buckingham, Stowe. C. Benitier of almandine, formed into an elaborate pendant; from the Crown Jewels of Portugal, brought to England by Dom Miguel in 1834. In "Cellini style", but probably early 18th cent., bought by William Russell. 106 1s

Baroque pearl dragon, forming a whistle. 7 15s

Pendant, forming a mounted knight. 16 5 6d

1850 Debruge Dumenil, Paris. Retable containing 4 scenes from the Passion of Christ, enclosed in a pendant 1½in square. 13 15s

Agate cameo head of Buona Sforza with silver incrustations and pendant mount, dated 1558. 66 16s

Annunciation, pendant *en ronde bosse*, Italian, *c.* 1500. 64 16s

Pendant forming 2 allegorical figures, attributed to Benvenuto Cellini, 2¾in high. 66 8s

There were at least 53 items of enamelled Renaissance jewellery, probably the largest single collection ever put on the market.

General J. Macdonald. C. Pendant-reliquaire, the Flight into Egypt and the Riposo. 19 10s

1851 Dawson Damer. C. *Lusus naturae* baroque pearl, George and Dragon. 26

1852 Earl of Liverpool. C. The Henri IV Reliquaire Jewel (see 1835). 115 10s

1854 C. Baroque pearl pendant in form of a ram, bought-in. 26 5s

1855 Bernal. C. Italian pendant, baroque pearl and two shields. 25 10s

German collar of office, 1554, enamelled medallions. 41

W. W. Hope, Paris. 16th-cent. Italian pendant, heads of Christ and the Virgin. 68 8s

1858 David Falcke. C. Cellini jewel, pearl pendant mounted as a triton. 34 5s

1859 Rattier, Paris. S. German pendant or pomander, shaped like a chandelier. 160

1860 "The Vienna Museum." C. "Cellini Jewel", pomander, the Fall of Man. 102 10s

Louis Fould, Paris. The so-called Cellini Belt Pendant, caryatid figures and baroque pearls. 212

1861 Matthew Uzielli. C. Baroque pearl pendant, eagle and serpent. 50

Thomas Fish. C. A Cellini jewel, female riding a dragon. 124

1863 Earl Canning. C. The Canning Jewel, pearl formed as a triton holding a shield; given to Akbar in late 16th cent. (see 1932). 300

1864 John Myers. C. Aigrette or hat jewel, St George and dragon, a baroque pearl attributed to Dinglinger, late 17th cent. 225

£

1864	V & A purchases so-called Cellini miniature bookbinding in gold and translucent enamels, *c.* 1580.	700
1868	V & A purchases Tyrolese pendant from Schloss Ambras, gold and enamels, *c.* 1600, over 3in.	240
1869	V & A purchases Badge and Order of the Garter, *c.* 1630, English, gold and enamel.	100
1870	Sir James Vallentin. C. Pendant with Cupid, enamelled on modelled gold.	77 14s
	V & A purchases Spanish reliquary-pendant of the Crucifixion, set in a rock-crystal egg, *c.* 1600, from the Cathedral Treasury of Saragossa.	84
	15 others from the same source.	
1872	V & A purchases late 15th-cent. German morse, blue enamels and pearls, the Adoration (Webb Coll.).	350
	Allègre, Paris. Miniature enamelled diptych of 2 portraits forming a pendant (Musée Condé, via Duc d'Aumale).	800
	Enamelled octagonal watch set in rock crystal, *c.* 1540.	430
1875	Saint-Seine, Paris. Figure of Charity, formed of a baroque pearl set as a pendant.	292
1881	C. Sackville-Bale. C. The Lyte Jewel, Italian 16th cent., bought by Ferdinand de Rothschild (with commission, £2,340) (BM, Waddesdon Bequest).	2,121
1882	The German Government buys the Hardringen Coll. of Nuremberg jewels, by Anton Eisenholt.	20,000
1886	Lafaulotte, Paris. Italian pendant in form of a chestnut.	1,320
	Mars and Venus, another Italian pendant.	620
	Beresford Hope. C. The Hope Pearl. 4½in × 2in, in a light Italian enamelled gold mount of the 16th cent., said to be the largest baroque pearl in existence.	600
1893	Frederick Spitzer, Paris. Pendant formed of a square jewel in high-relief enamel, believed 16th-cent. Spanish, St James on horseback fighting the infidel (V & A).	1,840
	Pendant, baroque pearl in the form of a ship, Italian (see 1910).	360
	Another ditto, bought by V & A.	157 10s
1902	C. Duveen buys the Armada Jewel, containing miniature portrait of Queen Elizabeth, for J. P. Morgan (see 1935).	5,250
1903	Thewalt, Cologne. Baroque pearl, forming pelican, German pendant, 16th cent.	423
1910	Maurice Kann, Paris. Pendant in form of a ship (see 1893).	964
1912	Charles Wertheimer. C. Italian pendant, 16th cent.	3,150
	J. E. Taylor. C. The Caradosso Morse, made for Pope Alexander VI, bought by Duveen for J. P. Morgan.	4,310
1921	Yates Thompson. S. The *Credo of Charles V*, *c.* 1520: an actual MS. book made into a jewelled pendant, 1in × 1¾in.	800
1925	C. Italian 16th-cent. pendant, lion devouring a horse (baroque pearl).	546
	Seligmann, Paris. Necklace of enamelled gold, Italian, 16th cent.	560

£

1932 Earl of Harewood. S. The Canning Jewel (see 1863),
 given by the Medici family to Akbar. Presented to V & A
 by E. S. Harkness. 10,000
1935 J. Pierpont Morgan, Jnr. C. The Armada Jewel (see
 1902), presented to V & A. 2,835
1936 S. 16th-cent. Italian pendant. 470
 Brooch, Cupid in white enamel and gold. 380
 Baroque pearl in form of a monster. 170
1938 Durlacher. C. 16th-cent. German pendant in shape of a
 ship with sails and oars. 382 10s
 Diana hunting, Italian 16th-cent. blue-and-white enamel,
 rubies. 409 10s
1939 S. Arms of Mary Queen of Scots, gold and enamel in
 crystal egg pendant (National Museum, Edinburgh). 440
1947 Lady Ashburton. C. 4 gold enamelled plaques of the
 Passion, 2½in square, Italian, 16th cent. 4 for 1,680
1960 Desmoni. S. South German mermaid pendant (£200
 in 1936). 3,450
 Alleged Cellini armlet, bought-in. 4,000
 S. South German pendant, dated 1550. 5,800
 S. South German pendant, shape of a pelican. 2,400
 S. Venus and Cupid, style of Daniel Mignot. 2,000
1961 Robert Horst. C. German 16th-cent. pomander. 8,190
 English 16th-cent. pendant. 8,190
 S. German pendant 6in high, c. 1570. 5,880
 Smaller ditto. 3,570
 Italian hat-badge medallion, c. 1570. 2,100
1962 C. Pendant with miniature of Queen Elizabeth by Simon
 Passe and enamelled inscription. 1,650
1963 C. South German pendant in form of a merman. 2,730

FURINTURE



FURNITURE

ENGLISH, 1660–1800

(For earlier furniture, see Furniture, late Gothic and Renaissance)

		£		
	Thomas Chippendale's charges in the 1760s:			
	For carved mahogany chairs.	2–6		
	For commodes and sideboards.	18–35		
1767	The great library table at Nostell Priory.	72	10s	
1769	William Vile, glass cabinet-bookcase, richly carved for George III.	100		
1770	Roger Metcalfe. C. Mahogany bookcase with fretted Gothic pediment.	17	6s	6d
1773	Satinwood commode at Harewood (Chippendale and Haig).	86		
1778	Earl of Kerry. C. Mahogany writing table, ormolu mounts, leather top.	46	4s	
	Wardrobe-bookcase, 12ft by 9ft, painted and part gilt.	43	1s	
1780	An ambassador. C. Sideboard, various inlaid woods, 8ft 2in long, with pedestal urns to correspond (Sheraton?).	48	6s	
1786	John Tait. C. Cabinet-secrétaire, glass doors, side-plates, decorated with "Indian figures" (pseudo-lacquer?).	40	9s	
1791	Semicircular sideboards for Althorp by John King, mahogany. each	17		
1801	Ince and Mayhew. C. New cabinet-secrétaires. from	25–35		
1802	Beckford, Fonthill. C. Pair of carved and gilt secrétaires, the drawers painted by Smirke and the grisaille oval panels painted by Hamilton; recent work (Sheraton?). each	84		
1807	Mrs Scrimshire. C. Mahogany suite (Chippendale?), 12 cabriolet chairs with sofa in green damask and slip-cases (out of fashion). 13 for	7		
1808	Hort, "the Gothic mansion". C. Kneehole writing table, Gothic style.	54	12s	
	C. 2 satinwood bookcases (Sheraton?) with silver fittings and paintings.	52	10s	
1817	William Beckford. C. Stuart marquetry cabinet on 8 legs.	36	15s	
1829	Lord Gwydyr. C. State bed, probably Charles II, frames inlaid with ebony, tortoiseshell and ivory, footboard carved as tritons, etc., headboard with crimson damask hangings and silk brocade. in all	304	10s	
1842	Duchess of Cannizzaro. C. Late Sheraton style; 2 cabinets of satinwood, Chimaera-shaped legs, paintings			

£

1842	of Cupid and Psyche by Smirke on the cupboard doors and drawers (compare 1802). 2 for	17 6s 6d	

Waldegrave, Strawberry Hill. Mahogany four-poster, fluted columns in Chippendale style, *c.* 1750–60. 2 12s 6d

Gothic trellised bookcases, designed by Bentley in the 1750s to fit the round tower. 12s–30s

Gothic table designed by Bentley, with jasper slab, 6ft × 3ft. 19 19s

1848 Stowe, Duke of Buckingham. C. Suite of 6 fauteuils and 2 settees in moulded white gesso, George I (see 1939). 8 for 21

Queen Anne toilet-glass, framed in the boulle style with inset paintings. 41

Duke of Buckingham's silver dressing-table, *c.* 1630. 64 1s

Mirror and sconces to match, bought by Lady Jersey. 84

Chippendale writing-table, bought by Mr Hodge of Sothebys (see 1940). 15

6 high-back chairs, 2 tabourets, English petit-point embroidery, dated 1681. 8 for 36 4s 6d

1855 Bernal. C. Pier-glasses by Chippendale in gilded Rococo taste:

77in × 43in (V & A). 50

86in × 55in (V & A). 36 10s

128in × 80in. 78

1856 Samuel Rogers. C. Joseph Addison's Queen Anne fall-front writing desk, mahogany. 14 3s 6d

1857 Earl of Shrewsbury, Alton Towers. C. Carved pedestal library table, Chippendale. 53 11s

Jacobean cabinet, marquetry and painting on doors depicting a hunt, bought by Lichfield. 65 10s

1858 V & A purchases miniature Queen Anne scroll-marquetry cabinet. ·10

1860 I. K. Brunel. C. Kneehole writing desk, walnut marquetry, ivory and mother-of-pearl inlay. 40 19s

1862 Richard Williams. C. One of the first sales where Chippendale mahogany was sold as such. Round table, carved festoons, pedestal and claws. 16 16s

Joseph Humphrey. 2 carved pedestal-cupboards, called Chippendale. 2 for 28

1864 E. W. Anderson. C. "Old English marqueterie" writing-table, cylinder top, ormolu mounts (Chippendale in French style?). 108 3s

1868 V & A buys satinwood cabinet made for the 1867 Paris Exhibition in Sheraton style, with specially designed Wedgwood jasperware inlays. 800

1870 V & A buys bow-fronted cabinet, satinwood, Sheraton style, Wedgwood jasper-ware inlays. 200

Dressing table, silver fittings and mirror, inset paintings after Angelica Kaufmann. 200

£

1870 C. Elaborate new copy of a carved Chippendale kneehole desk of the Nostell Priory type, made by Annoot of Bond Street. 68 5s

 Satinwood circular table (Sheraton), coloured festoon inlays. 81 18s

 2 Chippendale pier-tables, marble tops. 2 for 80 17s

 Chippendale walnut suite, 11 chairs and 1 settee. 12 for 50 8s

1871 V & A buys 2 semi-oval tables, painted satinwood, c. 1800. 2 for 157 10s

1874 V & A buys 2 carved mahogany pedestals, each with a Wedgwood jasperware plaque, c. 1780. 2 for 200

1878 V & A buys 4 carved Chippendale chairs with tapestry covers. each 4

1880 C. Satinwood cabinet, marquetry panels after Angelica Kauffmann. 294

 Adam sideboard with pedestals, rail and sconces. 105

 2 library tables, satinwood and pearwood, Angelica Kauffmann paintings. 2 for 210

 Wardrobe, Sheraton style, satinwood and tulip. 162

1882 Hamilton Palace. C. 2 satinwood corner cupboards, inset panels painted *en grisaille*, ormolu mounts in French style, Sheraton. 2 for 246 15s

 Chippendale writing-table, lions' feet. 60 18s

 French cabinet with Chippendale stand. 79 16s

 6 William and Mary damask and walnut chairs. 6 for 52 10s

Lady Harriet Hamilton. C. 2 cabinets, Wedgwood plaques (4), French ormolu mounts. 2 for 504

1888 Andrews. C. Sheraton glass-front cabinet. 113 8s

1889 V & A buys Charles II cabinet, inlaid woods. 42

1890 V & A buys ball-and-claw walnut suite, c. 1760–80, settee and 4 chairs. 5 for 60

1891 Cavendish Bentinck. C. Sheraton satinwood cabinet. 136

1893 V & A buys walnut commode, 40in wide, c. 1720. 20

1896 Sir Edward Dean Paul. C. 17 lots of furniture, mostly Chippendale, bought by Leopold Hirsch (see 1934). all for 892 10s

1897 V & A buys mahogany armchair, Chippendale style. 9 18s

1901 C. Satinwood suite of chairs, medallion paintings after Angelica Kauffmann. 8 for 598 10s

1902 2 Chippendale mahogany chairs. 2 for 1,050

 Single ditto. 210

 4 Queen Anne walnut chairs. 157 10s

 Chippendale writing-table. 110 5s

1903 Sir Hugh Adair. C. Pair of Chippendale cabinets. 2 for 840

 Pair of Chippendale chairs. 2 for 399

 Satinwood bureau. 210

 Rev. G. Newbolt (at Winchester). Chippendale wing-bookcase, glazed front. 555

1904 James Orrock. C. Chippendale settee and 11 chairs.
 12 for 1,890

£

1905	C. Pipe organ in Chippendale case.	430	10s
	Single Charles II chair.	315	
	Trustees of Tancred's Charities. C. Queen Anne marquetry cabinet.	357	
	C. H. Huth. Adam sideboard, 72in.	672	
1906	Woods. C. 2 Adam-style pedestals.	546	
1907	C. Chippendale bookcase from Kensington Palace.	304	10s
	Adam cabinet, paintings after Angelica Kauffmann.	272	
1908	Marchioness of Ely. C. Chippendale commode.	483	
	Ismay. C. Suite of 3 Chippendale settees and 5 chairs, Mortlake tapestry seats. 8 for	1,785	
1909	H. P. Dean. C. Chippendale settee, English embroidery.	2,047	10s
	Chippendale glass-front cabinet.	1,478	
	Chippendale cabinet.	787	
	All three pieces had just been published in the 1st edition of Macquoid.		
1910	Earl of Chesterfield (Knight, Frank). Charles II period state bed with hangings.	750	
	Chippendale break-front bureau-bookcase.	2,100	
1911	C. Adam sideboard with pedestals and knife-urns.	1,627	
1913	At Torquay. Sheraton sideboard, inset paintings, and knife-urns.	1,050	
1916	Norris (Puttick's). Red lacquer cabinet, Queen Anne.	945	
1918	Bretby heirlooms. C. 2 Sheraton satinwood cabinets. 2 for	2,357	10s
1919	Sale at Tavistock. 6 Chippendale Gothic chairs. 6 for	1,025	
	Mrs Baring. C. 2 Sheraton satinwood half-moon tables. 2 for	1,470	
	Hamilton Palace (2nd sale; see 1882). C. 2 Chippendale writing-tables. 2 for	1,837	10s
	C. 2 Chippendale armchairs. 2 for	1,837	10s
	Ruxley Lodge. C. Adam satinwood commode.	1,785	
1920	Duke of Leeds. C. Suite of 12 Queen Anne walnut chairs. 12 for	3,045	
	Ditto. 12 for	2,835	
	Two walnut Queen Anne settees.	{1,596 / 1,806}	
	Daybed en suite.	1,869	
	Queen Anne red-lacquer cabinet.	2,331	
1921	Townshend heirlooms (from Raynham). C. Chippendale commode, "the finest ever offered" (see 1960).	3,900	
	A 2nd Chippendale commode (see 1924).	2,000	
1922	Angela Burdett-Coutts. C. Mahogany rococo chair with Shakespearian emblems, said to have been designed by Hogarth for Garrick.	2,100	
1924	Sir James Dewar (Puttick's). Chippendale writing-table with lion masks, 5ft (bought in the early 1900s for £150).	1,680	
	Mulliner. C. Chippendale commode, illustrated 1755, from Raynham (see 1921, Philadelphia Museum).	3,675	

£

1924	Earl of Sandwich. 2 William and Mary damask chairs.		
	2 for	2,677	10s
	Adam writing-table.	997	10s
1925	Sir George Donaldson. C. Queen Anne bureau-bookcase, 9ft, by Samuel Bennet.	1,680	
	At Robinson and Fisher's. Sheraton bow-front cabinet, Angelica Kauffmann paintings.	1,102	10s
	Mrs Macquoid. C. Queen Anne red-lacquer cabinet.	2,310	
1927	Anne Vibart (at Winchester). Set of 8 Queen Anne walnut chairs. 8 for	3,400	
1928	Earl Howe. C. Queen Anne console table with matching wall-mirror and torchères, (highest price for English furniture till 1961).	10,605	
	Leverton Harris. C. Sheraton cabinet bookcase, bought by National Gallery, Melbourne.	3,450	
	Queen Anne red lacquer cabinet.	2,047	10s
	Also Chippendale mahogany commode with French-style ormolu mounts.	2,625	
	4 other pieces in 1928 made £1,000 to £2,000.		
1929	Lord Brownlow. C. Suite of 6 Queen Anne chairs and a settee with Fulham tapestry backs and squabs. 7 for	8,400	
1930	Sir John Ramsden. C. Queen Anne settee and 4 chairs. 5 for	2,940	
	Another Queen Anne settee.	966	
	C. Suite of 6 Queen Anne chairs with needlework panels of flowers in vases. 6 for	4,410	
	Colonel Liddell. C. 2 Chippendale armchairs (for matching settee, see 1937). 2 for	1,995	
	Onslowe Deane. C. Sheraton marquetry commode.	1,417	10s
	Mrs Alfred Noyes. C. Chippendale knee-hole desk.	1,522	10s
	Philip Flayderman, New York. Lady's desk, John Seymour & Sons, c. 1760.	6,230	
	Tea-table by Chippendale, 1763, ordered from America.	5,860	
	Cabinet desk, New England, c. 1770.	2,575	
1931	Henry Hirsch. C. Serpentine writing table, 69in, by Chippendale.	2,415	
	Mahogany settee, cabriole legs.	1,365	
	Chippendale walnut armchair.	1,008	
	Pair of Sheraton half-moon marquetry commodes from Carlton House. 2 for	1,627	10s
1933	C. Chippendale suite of 11 chairs and a settee (illustrated in the *Directory* of 1755) in gros-point embroidery, bought-in (a slump price). 12 for	960	
1934	Leopold Hirsch. C. 17 lots of Chippendale furniture from the Dean Paul sale, 1896 (*q.v.*). 17 lots	5,460	
	S. Cabinet, style of William Kent.	460	
	Moor Park. C. Robert Adam suite of chairs, etc., 20 items, tapestry by Nielson, 1766–9. 20 for	2,803	
1935	Solly Joel. C. Chippendale writing-table.	798	

£

1936	Marsden J. Perry, New York. Chippendale table with pierced gallery.		982	
1937	E. J. Whythes. C. Suite by Grendy of Clerkenwell, 1724, carved mahogany, petit-point covers.	13 for	6,825	
	Cleve Hill, Gloucester. C. Chippendale twin-back, settee (for matching chairs, see 1930).		1,417	10s
1939	Randolph Hearst. C. 6 chairs and 2 settees, George I, white gesso carving (see 1848).	8 for	2,310	
	Dwarf cupboard by Chippendale (illustrated in his *Directory*).		252	
1940	S. Chippendale writing-table (see 1848).		330	
1941	S. 2 Chippendale knee-hole commodes.	2 for	900	
	Lord Mount Edgecumbe. S. Chippendale commode, serpentine front.		520	
	Mrs Henry Walters, New York. 4 Chippendale arm-chairs.	4 for	2,800	
1942	Charles MacKann, New York. Chippendale serpentine knee-hole desk (illustrated, 1755).		750	
1944	Lorimer, New York. American Colonial shell-top high-boy.		1,040	
	5-part cabriole dining-table.		800	
	J. Pierpont Morgan, Jnr. C. Sheraton cabinet in French style.		819	
	2 satinwood commodes.	2 for	1,680	
	2 others in French style.	2 for	1,080	
	Earl of Leven. C. 2 Chippendale commodes.	2 for	1,785	
1945	Marquess of Downshire. C. Part of a gilded bed, made in India in Nabob taste, mid-18th cent.		2,835	
	6ft Chippendale writing-table.		1,365	
	E. O. Raphael. C. Chippendale library table.		1,365	
	Lord Guilford. C. 9 Chippendale chairs, needlework backs and seats.	9 for	6,090	
1946	Aubrey-Fletcher. S. 7 walnut George II chairs, embroidered backs, said to have been ordered for Marie Antoinette.	7 for	3,800	
1947	Late Duke of Kent. C. Queen Anne walnut settee with needlework panel, the Death of Phaeton.		1,785	
	Lord Mildmay of Flete. C. Adam half-moon commode with 6 oval painted panels in Angelica Kauffmann style.		1,417	10s
	Earl of Dartmouth. S. Bombé commode, French style.		2,000	
1948	Miss Agnes Warre. S. Sheraton satinwood break-front secrétaire-cabinet.		1,550	
1949	Sir Bernard Eckstein. S. Bracket clock in ebony case, only 9½in high, by Tompion and Banger.		2,300	
1951	New York. Rhode Island "block-front" knee-hole desk.		4,285	
1952	C. Mahogany commode in the style of William Vile, with huge caryatids by Benjamin Gooder, *c.* 1760.		1,627	10s
	Earl of Shaftesbury. C. Single Chippendale chair.		945	

£

1953 Lady Catherine Ashburnham. S. Library table by William Vile.	4,200
At Ashburnham. 2 Chippendale secrétaires. 2 for	1,750
C. 7ft walnut settee in French style, modern damask.	1,575
1954 C. Chippendale cabinet with picture marquetry and gilt bronze mounts in French style.	3,780
Parke-Bernet, New York. Knee-hole desk, New England, c. 1760.	3,570
Round table, Chippendale style, Philadelphia.	3,215
Egyptian Government (ex King Farouk), Cairo. S. Architectural clock in ebony and gilt bronze by James Fox, dated 1760 on the key.	3,375
1955 At Philips, Son, and Neale. William and Mary cabinet desk, only 2ft wide.	1,800
Earl of Shaftesbury. C. Chippendale marquetry commode, French style, bought for Metropolitan Museum.	5,460
Howard Reed. C. Clothes-press by William Vile, bought for Metropolitan Museum.	4,200
1957 Lord Glenconner. C. Carved and mounted satinwood commode, William Gates, 1780.	5,040
C. Adam mahogany suite, 2 settees, 14 elbow chairs, 2 window seats. 18 for	7,560
Mae Rovensky, New York. Pair of Hepplewhite half-moon console tables in maple and atlas, 59in wide. 2 for	9,100
1959 C. Sheraton satinwood and painted bookcase, 9ft× 7ft.	4,410
1960 C. 8 lyre-backed chairs, c. 1780, by Thomas Chippendale, Jnr. 8 for	5,775
Walter P. Chrysler, New York (Parke-Bernet). Queen Anne suite of 8 chairs in petit-point embroidery from Maddingley Hall. 8 for	6,070
Hepplewhite lady's secrétaire.	575
Chippendale China cabinet.	2,320
Chippendale commode bombé.	2,320
2 Chippendale oval-backed chairs. 2 for	2,500
William Kent library table.	2,140
Long-case clock by Tompion, dated 1690.	2,000
Parke-Bernet, New York. Another, dated 1705.	1,518
1961 Lilian S. Whitmarshe, New York. The Rainham Chippendale Commode (see 1921, saleroom record for an English piece of furniture).	25,000
Serpentine-front inlaid commode.	3,572
Adam gilded demi-lune console.	1,964
Single George II wing armchair, gros-point.	1,517
Countess of Craven. S. Chippendale knee-hole desk, c. 1750.	13,000
Chippendale mahogany writing-table, under 4ft wide.	2,700
Olaf Hambro. C. Marquetry commode, 1770.	3,990
Chippendale black-lacquer commode.	3,570

£

			£
1961	Countess of Cadogan. C. Commode, 1780, inlaid in French style.		7,560
	Duke of Norfolk. C. 2 commodes, c. 1765.	2 for	3,570
	Lady Hague. S. Round Chippendale stand, 26in × 15in.		2,100
	2 library chairs, style of William Kent.		3,000
	S. Clock by Thomas Tompion, c. 1700.		2,700
	George II carved-wood chandelier.		7,800
	Queen Anne japanned cabinet and stand.		3,300
	Set of 9 giltwood chairs in French style.	9 for	5,000
1962	Lady Bailey. S. 8 fauteuils, painted in Louis XV style.	8 for	1,400
	Queen Anne brass chandelier, 3ft 5in high.		1,450
	At Knight, Frank and Rutley. Mid-18th-cent. partner's desk, 4ft 6in.		2,500
	C. Lacquer cabinet, late 17th cent., cream and red on later stand.		1,995
	Sheraton satinwood commode.		1,575
	E. J. S. Ward. C. George II mahogany needlework suite. 8 chairs, 2 armchairs, settee and stool.	12 for	6,090
1963	C. Set of 10 Hepplewhite mahogany dining-room chairs, normal vase-shaped splats (record price)	10 for	9,450
	Marquetry commode by John Cobb, c. 1770, mounted in French style.		9,450

FURNITURE

Regency and Later

		£

1807 C. 2 bamboo sofas. 2 for 13 2s 6d
1808 C. Carlton House desk (sold as second-hand). 14 14s
1809 C. Grand piano in lacquer, with bamboo legs, made to
resemble a Chinese temple. 100
 Bookcase, 9½ft × 5½ft, caryatids, ornaments in relief after
 Greek designs. 52 10s
 Ditto, 7ft × 4ft, Egyptian winged lions, marble top. 57 15s
1817– Dining-room chairs for Brighton Pavilion, japanned to
22 imitate ebony. each 17
 Satinwood sideboards supported by Chinese dragons.
 (Brighton Pavilion) each 590
1823 Farquhar, Fonthill (*ex* Beckford). Modern buffet with
glass doors by Gibbon. 77 14s
 Chimney-glass to match, 72in × 51in. 114 10s
1856 Samuel Rogers. C. Stand, supported on 4 lion-legged
sphinxes, made for Thomas Hope and illustrated in his
Household Furniture, 1808. 18 10s
1908 Marchioness Conyngham. C. Large library table, *c.*
1820. 315
1912 C. 10 chairs in the style of Thomas Hope, with tapestry
backs, *c.* 1807. 10 for 30
1917 Lord Francis Hope. C. 2 giltwood settees, 1807. 9 9s
 Circular table with leopards' heads. 17 17s
 Round table, marble top. 11 11s
 2 X-shaped armchairs. 2 for 3 3s
 Suite of 6 chairs on winged sphinxes. 6 for 24 3s
 2 console tables, bronze caryatids. 2 for 33 12s
 2 bronze girandolles on leopards. 2 for 11 11s
 2 bronze torchéres. 2 for 16 16s
 All the above designed by Thomas Hope and illustrated
 in his *Household Furniture*, 1808.
1932 S. Carlton House desk, 1800–20. 195
1938 S. Writing table from Hartwell, made in 1807 for Louis
XVIII by Holland. 320
 Upright secrétaire from Hartwell by Holland. 210
 Duke of Norfolk. C. Carlton House desk in mahogany,
 c. 1810. 273
1941 Lord Temple. S. 10 japanned and cane-backed arm-
chairs (compare 1962). 10 for 135

£

1942	S. Break-front bookcase, rosewood and satin.		185
	C. E. F. McKann, New York. 2 chairs with V-shaped backs, painted *en grisaille*.	2 for	300
1943	C. Glass-front cabinet-secrétaire, Thomas Hope style.		183 15s
	Countess of Oxford and Asquith. C. 12 chairs, lattice backs, cane-work seats.	12 for	267 10s
1944	J. Pierpont Morgan, Jnr. C. 10 mahogany chairs, lyre backs.	10 for	1,050
	Rorimer, New York. 2 card tables, *c.* 1810, lyre stretchers.	2 for	125
1945	S. Carlton House desk, satinwood.		370
1946	S. Small serpentine sideboard, elm and mulberry.		240
1947	Holme Lacey, Hereford. S. Mahogany Carlton House desk.		1,050
1950	Canfield Place (Knight, Frank). Circular book table, mahogany.		400
1951	Earl of Harewood. C. Carlton House desk, very large.		1,942 10s
	Pair of black lacquer cabinets, 32in × 48in.	2 for	1,312 10s
	2 writing-tables about 5ft wide.	2 for	861
1953	C. Winged bookcase, 10ft wide.		367 10s
1954	S. 2 armchairs, style of Thomas Hope, mahogany, ebony, inlaid stars, etc.	2 for	140
1955	S. Writing-table with ink-wells, 34in wide.		400
1956	C. Couch, mahogany, with the end formed as a shell, dolphin feet.		273
	S. Round bookcase table (compare 1962).		508
	C. Circular bookcase, 6ft 8in high.		580
	Pair of rosewood chiffonniers, 51in.		460
1957	C. 2 black cabinets, only 19½in wide, painted in imitation of Chinese lacquer.		483
1958	S. Rosewood library table, 5ft 5½in × 3ft 3in.		1,300
1960	S. 8 green lacquer chairs from Brighton Pavilion (see 1817–22).	8 for	199 10s
	Carlton House desk, *c.* 1800, 5ft 5in wide.		2,500
	C. Bookcase, style of Thomas Hope, 8ft × 7ft.		609
	Walter Chrysler, New York. Regency sewing-table in shape of Atlas bearing globe.		321 10s
1961	Duke of Leeds. S. Regency drum-top round library table, 3ft 6in diam.		1,800
	Carlton House desk.		1,500
	Regency knee-hole writing-table.		2,600
	S. Secrétaire-bookcase, 32in wide.		290
	Olaf Hambro (at Linton Park). C. Regency chandelier, 6ft wide.		1,470
	2 ditto, 5ft 4in wide.	2 for	1,995
	C. Sofa table, 41in.		357
	Chiffonnier, 52in.		504
	Mahogany Carlton House desk.		1,890

			£
1962	Lady Bailey. S. Book table, 50in wide.		1,400
	Small writing-desk.		460
	S. Set of 8 japanned armchairs, X-shaped splats.	8 for	650
	Upright rosewood and satinwood secrétaire.		420
	Lady's writing-desk, lacquer fire-screen back.		520
	Pair of torchères, style of Thomas Hope.	2 for	420
	Carlton House desk.		1,850
	20ft extension dining-room table, pedestal legs.		680

FURNITURE

£

1741 Earl of Oxford (Cock, auctioneer). Cabinet, ebony and gilt bronze, pillars and sides of engraved rock crystal, bought by Lord Harvey. 22 5s

1766 C. Ebony cabinet, doors and drawers with inset paintings by Rottenhammer and Jan Breughel the Elder. 12 1s 6d

1769 Theed and Picket. C. Large tortoiseshell cabinet, inlaid with ivory garnished with silver. 13 13s

1770 Blondel de Gagny, Paris. Florentine casket, 14in× 5in× 11in, touchstone, lapis lazuli, agate, sardonyx, etc. 51 5s

1773 Marquis de Chevigné, Paris. Florentine cabinet, 5ft 6in high, ebony with painted ivory inlays. 4

1774 "Person of distinction." C. Amber cabinet with ivory devices (in glass case on a stand). 42

1776 Anselm Beaumont. C. Cabinet attributed to Michelangelo and the year 1510, lapis lazuli, agate and amethyst inlays, etc., "having cost in the original construction upwards of 11,000 pounds sterling", bought-in. 21

1777 Thomas Wyndham. C. Ebony cabinet, drawers inlaid with mother-of-pearl and marble mosaics. 30 9s

1788 Count d'Adhemer. C. Cabinet of transparent amber, embellished with a variety of figures, medallions, and a large sapphire, silver frames, bought-in. 68 10s

 Pair of ivory cabinets inlaid and mounted in silver (Spanish vargenos?). 2 for 32

1809 C. 2 tortoiseshell-inlaid cabinets with drawers, possibly 17th cent. { 8 8s { 10

1817 William Beckford. C. "Pier Commode" (credenza?) of the time of the Medicis, with *pietre dure* mosaics of birds and fruits, garnet slab top. 107 2s

 A cabinet to match. 117 12s

1819 C. Elizabethan ebonized elbow chair. 9 19s 6d

 C. Ebony cabinet, drawers inlaid with gems of old Florentine mosaic, forming flowers in relief of jasper, agate, lapis lazuli, etc. (origin not specified). 367 10s

1821 A collector of taste. C. Florentine cabinet, tortoiseshell inlay. 73 10s

 Another with 2 gilt statuettes in niches and architectural mirrored recess, 17th cent. 47 5s

£

1821 Cabinet from the Borghese Palace with a 2-storey palace façade, inlaid in jasper, lapis lazuli, agate, etc., bought for Beckford (see Fonthill sale, 1823). 540

1822 Wanstead House (Robins). Florentine ebony cabinet, inlaid in tortoiseshell and ivory with gouache paintings after Guercino and others, 17th cent. 175 6s

1823 Farquhar, Fonthill (*ex* Beckford). Philips. Inlaid cabinet, allegedly Henry VIII's. 153 6s

Table in *pietre commesse*, Borghese Palace. 189

Florentine marble inlaid commode. 136 10s

Matching secrétaire. 105

Cardinal Wolsey's bed, so alleged. 105

2 Elizabethan carved cabinets. {147 / 157}

Robe-chest of James I. 81 18s

Florentine ebony cabinet, classical subjects in relief (V & A) (see 1821, 1882). 572 5s

German amber-inlaid jewel coffer, dated 1665. 115 10s

Copy of marble-inlaid cabinet of Pope Sixtus V [1521–90] from Stourhead (see 1848). 157 10s

1825 Watson Taylor. C. Florentine credenza, late 16th cent., in ebony and *pietre commesse*. 236 5s

A 2nd ditto. 204 15s

Wardrobe in *Cinquecento* taste. 320 15s

1826 C. Ancient oak coffer carved in Gothic taste, containing a collection of early English deeds. 3 7s 6d

Oak wardrobe in the manner of Holbein from an ancient dwelling in the country. 19 8s 6d

1827 Chevalier Franchi. C. Flemish 17th-cent. ebony and ivory cabinet with inset paintings after Breughel and van Balen. 89 5s

1836 C. Marquetry cabinet, made for Prince Charles of Lorraine, numerous drawers with inset paintings, bought-in (reserve, £350). 215 5s

Coffer in crystal and silver, 245 plates of crystal, 145oz silver. 200 11s

1840 "Recently imported from Germany." C. Gothic oak cornice with figures, part gilt. 43 1s

Prince Louis Napoleon (later Napoleon III). Ebony cabinet, numerous carved drawers, bought-in. 132 3s

1842 Acraman, Bristol. C. Furniture from Fonthill:

Ebony cabinet from the Escorial with inset paintings. 34 13s

Ebony cabinet inlaid in lapis lazuli, jasper, amber, etc., said to have been designed by Bernini. 84

Waldegrave, Strawberry Hill (Robins, auctioneer). 6 carved Elizabethan chairs. from 27 6s to 29 6s

Gothic oak chair from Glastonbury. 73 10s

Florentine jewel coffer, *pietre commesse*. 73 10s

£

		£	
1843	Duke of Sussex. C. Tortoiseshell and ebony cabinet, interior fitted as a temple.	61	19s
	Silver and crystal casket, architectural design, 28in× 17in.	126	
1846	Baron, Paris. Meuble à deux corps in carved ebonized wood (French?), late 16th cent. (*ex* Duchesse de Mazarin).	204	
1847	Robert Vernon. C. Pair of pedestal cabinets in *pietre commese*, bought-in. 2 for	84	
1848	Duke of Buckingham, Stowe. C. Beckford's copy of the Sixtus V Cabinet from Stourhead (see 1823).	89	5s
1849	Town and Emanuel. C. Pair of *pietre dure* cabinets with fruits and flowers in high relief. 2 for	105	
1850	Debruge Dumenil, Paris. Meuble à deux corps, Lyons, 16th cent., with inset painting of St Jerome, *c.* 1500, bought by Soltykoff.	203	
	2 Flemish cabinets in ivory and tortoiseshell, said to have been designed by Rubens for the Duke of Lerna, *c.* 1630. 2 for	280	
1855	Ralph Bernal. C. Italian marquetry table.	80	
	Spanish cabinet, tortoiseshell inlay (vargeno) (see 1856).	108	
	2 Gothic oak cabinets. 2 for	40	
1856	Colonel Sibthorp. C. Spanish ivory-inlaid vargeno, 88in × 44in (see 1855, a rise of 50 per cent. in a year).	160	
1857	Earl of Shrewsbury, Alton Towers. C. Elizabethan carved oak pedestal sideboard, 12ft long, with twisted columns and numerous sculptures.	91	
1858	David Falcke of Bond Street. C. Amber cabinet, German, 24in× 23in× 15in, with numerous busts in various materials and a painted miniature of William III, bought-in.	400	
1860	Jules Soulages of Toulouse. Private purchase by V & A, Milan mirror and stand, damascened and encrusted ironwork, late 16th cent.	200	
	I. K. Brunel. C. Cassone with panels depicting the story of Mutius Scaevola and a portrait alleged to be that of Isabella d'Este, attributed Mantegna, bought-in.	101	
1861	Charles Scarisbrick. C. Milanese cabinet, inlaid with various marbles, on a stand, backed by a mirror, late 16th cent.	267	15s
	Thomas Fish. C. German jewel-cabinet, silver and tortoiseshell inlays, late 17th cent. and very baroque, but described as "in the pure taste of the time of Queen Anne" (illustrated).	260	
	Soltykoff, Paris. 2 Florentine armoires, 9ft high.	660	
	2 Florentine *pliants*, inlaid ivory.	404	
	Milan damascened iron dressing table and mirror with enamels, *c.* 1590 (V & A).	220	
	Iron, gilt, and enamelled chess table, same period (see 1882, 1885) (V & A).	800	
	Milan cabinet in same style (see 1882, 1885).	816	

£

1861	2 Lyons walnut meubles à deux corps in highly Italian style, one dated 1580.	{660 {500
	Swiss counting-house table with numerous drawers, late Gothic, c. 1520.	240
	Lyons School, bed with caryatid columns.	290
1863	Soulages Coll. V & A purchases an elaborately inlaid ebony cabinet by Bachelier of Toulouse, c. 1550–60.	300
	From the 2nd Crystal Palace Exhibition (1862). C. Imitation French oak cabinet with inlays by Jules Fosset, 14ft 10in high and 13ft 10in wide, bought-in.	525
1864	Bishop of Ely. C. Florentine stipo or architectural cabinet of extreme richness, including rock-crystal twisted columns (see 1865).	325 10s
1865	Robert Bristowe. C. The same cabinet.	250
	2 carved-walnut Italian cassone of the early 16th cent., the stories of Esther and Judith. 2 for	137 10s
	V & A buys Spanish 17th-cent. vargeno, inlaid with etched ivories, 1621.	70
1868	Marchese d'Azeglio. C. Florentine cassone by Dello Delli with painting of Lorenzo de'Medici in procession.	120
	Laforge of Lyons, Paris. Carved walnut Lyons table, late 16th cent.	224
	Lyons walnut meuble à deux corps.	188
1869	V & A purchases:	
	2 ebony clavichords with gold scroll-work and carved keys by Marco Jacoba, 1568, and Annibale dei Rossi, 1555. 2 for	300
	Elaborately carved Florentine walnut cassone, dated 1511.	43
	Spinet with ivory and precious stone inlays by Annibale dei Rossi, Milan, 1577, just under 5ft long.	1,200
	C. Cabinet from Venice, architectural design, lapis lazuli, agate, and silver, bought-in.	357
1870	C. Cabinet in *pietre dure*, the top forming a picture inlay of the Annunciation.	404 5s
	San Donato, Paris. Italian table, c. 1650, the top inlaid with tortoiseshell, jasper, lapis lazuli, to form a picture 28in square.	600
	Mirror with frame to match the above, 60in by 40in.	1,280
	Stipo, or architectural cabinet, ebony and Florentine mosaic.	708
	A 2nd stipo, 16th cent.	806
	A pair of 15th-cent. Florentine carved and gilt cassone, each with a single painted panel. 2 for	262
	A 3rd cassone in same style.	86
	Florentine table-top, 17th cent., marble mosaics, 44in × 36in.	660

£

1875	Galitzin, Paris. Chimney-piece, heavily carved walnut, French, 16th cent.	196	
	Saint-Seine, Paris. Lyons meuble à deux corps, 16th cent.	244	10s
	Couvreur, Paris. A specially grand meuble à deux corps with inlaid ebony plaques.	600	
1876	Musée de Cluny buys a Milanese patined iron and inlaid throne, mid-16th cent.	800	
1880	San Donato, Florence. The throne of Giuliano de'Medici, carved walnut.	740	
1882	Hamilton Palace. C. 2 ebony chairs, said to have belonged to Cardinal Wolsey, early 16th cent. (V & A).	136	10s
	Beckford's ebony cabinet with Florentine marble inlays (see 1821, 1823) V & A.	1,018	10s
	Florentine cabinet fitted with a clock, inlaid in lapis lazuli.	378	
	2 Florentine cabinets from the Hermitage Palace, St Petersburg. 2 for	903	
	Iron chess-table, Milan, c. 1540, inlaid with gold and lapis lazuli (see 1861, 1885) (V & A).	3,150	
	Cabinet in the same style (see 1861, 1885).	1,071	
	Milan iron cabinet, gilt bronze caryatids.	1,176	
1884	Basilevsky Coll. Sold to the Hermitage Museum. A Lyons credenza, sold to Basilevsky by Carrand for £4,000, was valued at	10,000	
1885	Beckett Denison. C. The Soltykoff and Hamilton Palace enamelled iron chess-table, bought by the V & A (see 1882).	997	10s
	A cabinet in same style (see 1882).	420	
	Vaisse, Paris. Meuble à deux corps, Lyons, 16th cent.	520	
	Eugène Felix, Leipzig. Elaborately carved walnut cabinet-desk, South German, c. 1550, by Peter Opel.	2,925	
1888	Albert Goupil. Paris. Meubles à deux corps, style of Jean Goujon (a slump price).	160	
1890	C. 2 carved Elizabethan chairs.	262	
	V & A buys Italian 15th-cent. cassone with scenes in painted gesso relief.	467	9s 10d
	English four-poster bed, arms of Courtney, 1593.	357	
	Eugène Piot, Paris. 2 French 16th-cent. meubles à deux corps.	{1,600 / 620	
1893	Frederick Spitzer, Paris. Milan iron cabinets, c. 1550.	{600 / 640	
	Lyons walnut dresser, c. 1530.	1,400	
	Lyons walnut meuble à deux corps (see 1924).	1,200	
	North Italian cassone, part gilt.	480	
	Venetian carved mirror, late 16th cent.	600	
1895	V & A buys walnut virginal, Italian, late 16th cent.	793	9s 11d
	Oak bed from Sizergh Castle, 1568.	860	
	Lyons meuble à deux corps, 5ft high, c. 1550.	460	
	14th-cent. cassone, painted scenes front and lid.	338	5s

£

1897	Emile Gavet, Paris. Flemish oak dresser, 5 tiers, *c.* 1550.	880
	French Gothic walnut dresser with sculptured figures, 15th cent.	904
	French walnut coffer, heavily sculptured in early Renaissance style.	1,000
	About 18 other dressers and coffers.	160–620
	Table in this style, with caryatids, walnut.	660
1899	Charles Stein, Paris. French painted oak dresser, *c.* 1500, flamboyant Gothic tracery and iron fittings.	1,480
1904	Rougier, Paris. Walnut throne, Lyons, 16th cent.	1,600
	Pair of Lyons marriage coffers, 16th cent. 2 for	5,440
	Long bench supported on chimaeras, walnut, Lyons.	1,440
1905	Edward Cheney. C. Throne from Doge's Palace, converted into a confessional.	1,050
	C. Elizabethan carved oak bed.	147
1908	Imrie. C. German 16th-cent. credenza.	273 10s
1912	J. E. Taylor. C. Lyons 16th-cent. walnut credenza.	1,470
	Cassone, winged sphinxes, *c.* 1500.	1,785
	Sculptured credenza by Bandinelli, 1535.	2,120
1916	Garnier, Paris. Lyons walnut meuble à deux corps.	616
1918	Williamson, New York. 16th-cent. carved armorial cassone by Massimo.	1,830
	Stefano Bardini, New York. Carved 16th-cent. Florentine table (see 1942).	2,347
1921	Morgan Williams. C. English triangular oak cabinet, early 16th cent. (Macquoid, Vol. I, page 126).	630
1922	Arthur Newall. C. Carved walnut Italian cassone, 16th cent.	1,522 10s
1923	Succession Salomon de Rothschild, Paris. 2 carved walnut cassones, early 16th-cent. Florentine, bought by Duveen. 2 for about	4,500
	Two others. 2 for	2,250
	Countess of Craven. C. Painted cassone, 16th cent.	1,260
1924	Swaythling heirlooms. C. Lyons walnut meuble à deux corps, dated 1579 (see Spitzer sale, 1893).	2,205
	Duke of Marlborough. C. Elizabethan oak drawer-table (from a farmhouse on the estate).	924
1925	Sir George Donaldson. C. Walnut credenza, Lyons, 16th cent., 6ft.	630
	Elizabethan drawer-table, oak, 12ft.	1,018 10s
	Fireplace and panels for a 16th-cent. room, English.	1,312 10s
	Mrs Macquoid. C. Oak armchair, English or Flemish, *c.* 1500 (the high-water mark of the English oak market).	1,207 10s
1927	Sir George Holford. C. Cassone with processional painting, Florentine, late 15th cent., nearly 7ft long (record saleroom price for a cassone to this day).	7,350
	A smaller cassone of the same type.	5,450
	A ditto without painting.	1,365

£

1928 Huldschinsky, Berlin. Florentine walnut cassapanca, high relief, *c.* 1550. 1,600

 At Philips, Son & Neale. Elizabethan oak and marquetry buffet. 800

1929 Count Pepoli, Paris. 2 Lyons walnut armchairs, late 16th cent. 2 for 1,090

 Brauer. C. Oak cassone with painting, Florence, *c.* 1550. 4,620

 Cassapanca, Florence, *c.* 1500. 1,680

1930 Barnet Lewis. C. Armorial Florentine cassone, high relief. 1,470

 Florentine 16th-cent. walnut table. 1,197

 S. Carved Florentine cassone on mask feet. 840

 Albert Figdor, Berlin. Wood and stucco Florentine cassone, *c.* 1470, paintings attributed to Domenico di Bartolo. 5,750

1932 C. Oak table-desk, 16in × 12in, probably made for Henry VIII, 1525, bought for V & A. 462

 Sevadjan, Paris. Meuble à deux corps, Lyons, *c.* 1550, style of Jean Goujon. 258

1933 T. F. Ryan, New York. Florentine cassone, over 6ft, heavily carved and gilt. 1,080

1934 C. Pair of Florentine walnut cassone, *c.* 1540, very richly carved, 5ft 9in long. 2 for 2,415

1935 Ernest Innes. C. Elizabethan oak drawer-leaf table. 525

 Elizabethan Court cupboard, inlaid woods. 525

1936 C. Cassone with a panel painted in the style of the Master of Anghiari. 598 10s

1939 Randolph Hearst. C. Henry VIII armorial cabinet, oak. 609

1942 Medmenham Abbey. S. Elizabethan oak drawer-table and 3-tier dresser with panelling. 2 for 1,260

 C. E. F. McKann, New York. 2 carved walnut cassone, 16th cent. {44 65

 Florentine carved table (*ex* Stefano Bardini) (see 1918). 110

1946 C. Elizabethan oak table, bulbous legs. 924

 Parke-Bernet, New York. Florentine carved high-backed settle. 46 10s

 Plain cassone, *c.* 1500. 12

1949 Lempertz, Cologne. Florentine walnut cabinet-desk, *c.* 1600, exceptionally elaborate piece. 339

1951 Rudolf, Hamburg. German oak cupboard, linen-fold panels and medallion heads, *c.* 1540, Holbein style. 1,700

1954 Chester Beatty. S. Lyons walnut dressoir, *c.* 1550, very elaborately carved in the style of Hugues Sambin. 230

 Rex Benson. C. Meuble à deux corps in same style (*ex* Holford Coll.). 147

1960 Myron Taylor, New York. Sienese armorial credenza. 393

 Tuscan octagonal table on dolphins. 286

 Florentine credenza. 321 10s

£

1960 Weinmueller, Munich. 15th-cent. German cabinet, elabo-
 rate tracery in maple and larch. 6,600
1961 Lady Shelley-Rolls. C. Florentine gilt cassone, *c.* 1500,
 with painted processional panel. 6,090
1962 S. Flemish painted cabinet, early 17th cent. 1,500
 Stikker, Berne. The "Emerald Clock" of the Electors of
 Saxony, plated in gold and silver and completed about
 1580 (480,000 Swiss francs). Gulbenkian Foundation. 40,000

FURNITURE

FRENCH 18TH-CENTURY

Includes lacquered, veneered, and marquetry furniture with mounts, but excludes drawing-room suites, clocks, chandeliers, and smaller mounted objects, for which see separate lists.

Account-books of Lazare Duvaux, 1748–58

		£	
1748	Secrétaire, elaborately mounted.	10	6s
	Table plaquée, bois satine.	9	10s
	Bureau à quatre pieds, with cartonnière.	40	
	Commode on goat's-feet, vernis rouge.	8	16s
	Gilt carved console table, marble top.	9	12s
1749	Table à écrire.	11	15s
	Secrétaire à abattant.	18	8s
	Commode orné partout, many different woods.	28	
	5ft commode, lacq de Coromandel.	38	8s
1750	2 encoignures, ancien lacq.	64	
	Commode, vernis Coromandel.	38	10s
	Lacquer commode à pagodes, satin linings.	96	
1751	Cabinet-secrétaire, lacq à pagodes.	52	15s
	6½ft bureau with pupitres.	28	16s
	Large writing-table.	40	16s
1753	Gilded and sculptured mirror, 9ft, à deux glaces.	48	
	Clock-bureau (boulle).	60	
	2 encoignures, black and gold lacquer. 2 for	78	
1755	An inlaid secrétaire for the King, with mirrors and silver cornets.	100	
	5½ft commode, ancien lacq.	108	
	Lacquer cabinet à pagodes.	120	
1756	Set of boulle bookcases to line a room.	480	
1757	Secrétaire à abattant, orné partout, inlaid interior fittings.	200	
1758	Commode, lacq à pagodes.	96	

End of Lazare Duvaux accounts

		£	
1755	Duc de Tallard, Paris. Boulle cabinet, reign of Louis XIV.	60	
	Cardinal Polignac's table with green porphyry top.	184	
1760–8	The Grand Bureau of Louis XV, began by Oeben and completed by Riesener (Louvre).	2,515	
1761	de Selle, Paris. 2 40-year-old armoires by Cressant. 2 for	68	
1769	Gaignat, Paris. Writing table, vernis Martin.	62	10s
	Commode by Lacroix, ordered for Mme Victoire.	189	

£

			£	
1769	C. 2 French "lady's secrétaires" in inlaid woods (first French furniture at Christie's).	2 for	29	8s
1771	Ordered from Riesener by M. de Fontanieu, richly mounted bureau-plat (see 1851).	about	200	
	C. Black-and-gold cabinet of the "fine raised gold Japan".		54	12s
	Bookcase, "executed by the famous Boulle's, richly mounted in ormolu".		39	10s
1772	"A nobleman." C. Cabinet (Boulle?) representing the temple of love with its emblems and attributes, elaborately embossed in silver (could also be German 17th-cent.).		195	7s
	Baron de Thiers, Paris. Lacquer and ormolu cabinet.		124	
1770-4	Simon Poirier, *fournisseur*, Orders for Mme du Barry at Louveciennes:			
	English pianoforte, French case, rosewood and Sèvres plaques.		149	5s
	Table, "porcelaine de France", after le Prince.		220	
	Commode, Sèvres door-panels, after Watteau and van Loo.		390	
	Commode, ancien lacq de Japon.		170	10s
1775	Louis XVI on his accession orders a commode from Riesener (Musée Condé, Chantilly) (see 1792).		1,014	
1777	Randon de Boisset, Paris. Commode en tombeau, Louis XIV, by Charles Boulle.		200	
1778	Earl of Kerry. C. Games table, rosewood and ebony.		44	2s
	Commode with inset medallion, marble top.		47	5s
1779	The Bureau du Roi Louis XVI, made by David Roentgen.		3,200	
	Bureau mechanique, ordered by Frederick the Great from Roentgen.		1,800	
	C. Japan cabinet, 14ft high, with 2 attached clocks and other ormolu figures.		99	15s
1782	Duc d'Aumont, Paris. Pair of jasper tables mounted by Gouthière on elaborate gilt-bronze sphinx-legs, bought by Marie Antoinette (Frick Foundation) (originally Gouthière had asked £1,202, plus £96 for the models).	2 for	960	
	Comte de Vaudreuil sale. Old Boulle commode.		133	
	Dressing-table and mirror, constructed entirely of Sèvres plaques, supplied to Mme du Barry.		3,000	
1784	Supplied by Daguerre for the King:			
	Grand secrétaire, heavily lacquered, mounted.		486	15s
	Bureau à cylindre, made by David Roentgen for the Empress Catherine (25,000 roubles).	about	4,000	
	Bureau à cylindre (Louvre), ordered from Riesener by Marie Antoinette (see 1843).		250	
	Bureau de dame, lacquer panels, ordered by Marie Antoinette from Weisweiler, Daguerre, and Gouthière (Louvre) (see 1840, 1865).		130	10s
1785	Commode, inlaid with Sèvres plaques, ordered by Mme du Barry (see 1900).		3,200	

£

		£	
1785–7	Lit à la polonaise for the King at Compiègne (now Petit Trianon), with various additions and painted Pekin hangings by Hauré, Cardin, and others.	320	
1787	Cost of copying a 6ft commode for Marie Antoinette by Hauré and Benemann.	240	
	Lit à la duchesse, or state bed, for Marie Antoinette at Fontainebleau, by Hauré and Séné. Together with the hangings and upholsteries, the cost exceeded £3,000. The woodwork and gilding alone cost	336	5s
1791	"Imported by M. Daguerre." C. An elegant lady's writing-desk with fall-down front, bought by the Prince of Wales.	126	
	Japan lacquer commode.	120	
	2 encoignures, en suite.	85	1s
	Ebony cabinet, inlaid with gems from Florence, brocatella top.	115	10s
	2nd ebony cabinet.	110	5s
	Commode, picture inlays of precious stones.	189	
	Probably these were late 18th-cent. French pieces with Italian marble inlays (Benemann?)		
	Imported for Earl Spencer, at Althorp. Lacquered commode, by Saunier.	100	
1792	Paris. The Bureau du Roi Stanislas offered to William Beckford (may have cost £2,000 in the 1760s).	760	
	"A French lady of high rank." C. Cabinet, inlaid with Sèvres plaques.	78	15s
	Rosewood secrétaire.	75	12s
	Satinwood lady's secrétaire, Sèvres medallion.	43	
	Paris. The King's Commode, by Riesener (see 1775), valued for the Government commissioners.	400	
1793	Government sale, Versailles. The Bureau du Roi Louis XV with a Riesener commode and 2 matching encoignures. 4 for	200	
1794	Versailles. Marie Antoinette's mother-of-pearl inlaid bureau and writing-table (in assignats). 2 for	300	
	"A foreign nobleman." C. Pair of commodes with bronze medallions. 2 for	78	15s
1795	Marie Antoinette's mounted tables in petrified wood (4), bought by Citoyen Gaspard Fabre for £125 and sold to the Louvre for £152 (approximate value of assignats). For another of Marie Antoinette's petrified-wood tables, see 1925, 1929. 4 for	152	
1800	C. Bureau à cylindre with numerous drawers mounted after the antique, said to have come from St Cloud.	210	
1801	C. Bureau à cylindre, formerly Louis XVI's.	190	
1802	Countess of Holderness. C. Pair of "Parisian cabinets" for books or china, plate-glass doors. 2 for	441	
	"Superb Pariasian commode," inlaid marble top.	85	1s
	Pair of pier-tables with 3 shelves, marble top. 2 for	90	6s

£

1802 Matthew Higgins. C. Lady's desk-table, Sèvres porce-
 lain top. 136 10s
 Parisian pier-table with Wedgwood plaques and mirrors. 157 10s
 Pair of Japan cabinets, solid silver mounts. 2 for 210
 French pier-glass and frame, 63in × 106in. 253 1s
 Another, 50in × 90in. 273
 Inlaid secrétaire droite. 141 15s
1805 C. Parisian lady's secrétaire, marble top, inlaid yew-wood. 31 10s
1808 Choiseul-Praslin, Paris. Pair of boulle cabinets on con-
 soles, bought by Prince Demidoff (see 1870). 2 for 56
 Rohan-Chabot, Paris. Boulle china cabinet with 3 plate-
 glass doors. 19 12s
1812 Villers, Paris. Pair of boulle armoires, 8ft high, with
 bronze bas-reliefs. 2 for 86
1813 C. Commode, richly mounted in ormolu. 17 6s 6d
1814 Lady Mansfield. C. 2 boulle cabinets, 9ft × 5ft 3in.
 Possibly the 2 cabinets "of a Solomonian richness" which
 were offered to Beckford the same year for £400, bought- ⎰262 10s
 in. ⎱315

 ⎧127 1s
 3 boulle commodes to match (same sale). ⎨136 10s
 ⎩131 5s

1817 Beckford. C. Ebony cabinet, the doors inlaid with
 pietre dure (may have been Italian). 273
1818 Tuffin. C. Boulle bookcase in the taste of the time of
 Louis XIV, 7ft × 4ft. 73 10s
 Another, 9ft × 8ft 6in. 115
1819 Queen Charlotte. C. Black-and-gold lacquer cabinet
 (Louis XIV), bought by Beckford. 20 9s 6d
1822 Wanstead House (Robins). Lady's writing-table with
 seven Sèvres plaques (Weisweiler?). 25 14s 6d
 Serpentine card-table, heavily mounted, Louis XV. 48 4s
 Boulle commode, 43in, with winged caryatids. 42
1823 Farquhar, Fonthill (*ex* Beckford). Philips. Boulle writing
 table. 25 4s
 2 boulle cabinets, doors of gold lacquer (see 1882). 2 for 193 15s
 The Bureau du Roi Stanislas (see 1792). 179 11s
 Riesener commode from the *Garde meuble*. 120 15s
 Red boulle armoire, made for Louis XV. 236 5s
 Commode with old Japanese lacquer panels. 107 12s
 Another ditto (*ex* Marie Antoinette). 57 15s
 Round boudoir table by Thomire (possibly Empire). 59 17s
1825 Rev. Charles North of Alverstoke (later Earl of Guilford).
 C. Bought for the King? Commode-sideboard nearly 9ft
 long. Sèvres and Vienna porcelain plaques on the 3 doors,
 1 of them 22½in wide. 565
 Watson Taylor. C. "Secrétaire and wardrobe" from
 Compiègne Palace, heavily mounted. 51 9s
 Writing table with inset Sèvres plaques. 81 18s

£

1825 Louis XIV boulle pier-table from Versailles. 48 6s
Bureau à cylindre with sconces and floral marquetry
inlays, made for Louis XVI (by Roentgen?). 107 2s
Mahogany cabinet, 8ft high, Royal arms, "*a chef d'œuvre*
of the ingenious Riesener, sold by the Commissaries of the
French Convention in an early period of the Republic". 420
2 pier-tables, green-and-white marble, 4 huge caryatids, {430 10s
Louis XV. {514 10s
2 smaller Louis XV pier-tables. 2 for 525
Very high prices, since these were mostly purchased for
George IV. They were not exceeded for more than 25
years.

1828 C. Empire table, Florentine marble mosaic round top. 70 17s 6d
1829 Feuchère, Paris. Bookcase by Jacob, Louis XVI, 8ft× 4ft. 28
Lord Gwydyr. C. Coffer and stand by Boulle (see 1888). 94 10s
Boulle library table. 48 10s
Secrétaire with Sèvres plaques by Riesener. 105
Secrétaire droit à abattants, Sèvres plaques. 215 5s
2 boulle pedestals. 2 for 137 10s

1832 Watson Taylor, Erlstoke Park (Robins). Pair of console
tables with precious-stone inlays, probably French Louis
XVI frames; bought back by the dealer Hume, who was
said to have charged 2,000 guineas for them. 2 for 609
Circular table (French Empire?), Florentine marble
mosaic top, bought by Duke of Buccleuch. 378

1834 Marlborough House. C. Pair of boulle coffers. 2 for 89 5s
1836 Brook Greville. C. Secrétaire droit à abattants, Sèvres
plaques. 32 11s
C. Coiffeuse-liseuse with Sèvres plaques, attributed to
Riesener. 5 10s
Bonheur du jour, Sèvres plaques, attributed to Riesener. 16
C. Commode à la Reine, cypher of the House of Condé,
oval plaques after Boucher and Vernet. 67 4s

1838 William Esdaile. C. Secrétaire with 2 oval Sèvres
plaques (*ex* Countess of Holderness). 48 6s

1840 Bought by Prince de Beauvau, Paris (Quai Voltaire),
bureau de dame, made for Marie Antoinette by Weisweiler,
mounts by Gouthière (see 1784, 1865). 140

1842 "Le docteur Petit of Paris." C. 10ft boulle armoire, said
to have been taken from Versailles, bought-in. 157 10s
Acraman, Bristol. C. 2 drop-front secrétaires from
Fonthill with lacquer panels. each 11 11s
Waldegrave, Strawberry Hill (*ex* Walpole). Occasional
table with Sèvres landscape top. 29 8s
Bureau, black Japanese lacquer. 3 3s
Coffer and stand, black lacquer and mother-of-pearl
inlay. 28 17s
Boulle coffer and stand. 44 2s

£ s

1842 2 boulle and lacquer commodes. 2 for 7 15s
 2 Japan lacquered encoignures. 13 13s

1843 Marie Antoinette's bureau à cylindre (see 1784) valued for
 Louis Philippe at St Cloud. 20

 Duke of Sussex. C. Richly mounted secrétaire, bronze
 medallion on convex front, 5ft 3in high, bought by
 Roussel, Paris. 99 15s

 Pair of boulle commodes, ormolu figures on the doors,
 4ft wide, bought by Roussel, Paris. 136 10s

 Table to match. 97 10s

1845 Mme Jaman, Paris. Bureau à quatre faces, boulle, 52in
 long. 31 4s

 Bonheur du jour, boulle. 33 10s

1846 A nobleman. C. Marquetry writing-table, said to have
 belonged to Marie Antoinette, bought by Roussel, Paris. 99

 Baron, Paris. Secrétaire à deux ventaux, made by Riesener
 for Marie Antoinette, damaged by bayonets in the Tuileries
 in 1830. 24

1847 *Le Cousin Pons* published by Balzac. "Un meuble de
 Riesener vaut de trois à quatre mille francs" (£120 to
 £160).

1848 Duke of Buckingham, Stowe. C. Boulle cabinet
 (Marquess of Hertford). 210

 Inlaid ormolu cabinet, possibly German (Meyer Roths-
 child). 246 15s

 Boulle cabinet (Marquess of Hertford). 183 15s

 Carved gilt console table from the Doge's Palace, Italian
 mid-18th cent., marble mosaic, top, bought by Lord
 Hertford (Wallace Coll.). 157 10s

 Table, carved legs, ormolu masks, marquetry top
 illustrating Alexander and Diogenes, bought by Redfern
 for Lord Hertford. 168

 Table, 36in × 27in, malachite slab with inlaid "Roman"
 mosaics, bought by Lord Hertford. 136 10s

1849 Town and Emanuel. C. China cabinet, tulipwood and
 rosewood, 6ft wide, Sèvres plaques with conversations after
 Watteau. 64 1s

 Prince Eugene's Venetian mirror, 11ft high, highly
 carved and gilded, early 18th cent. 73 10s

1850 Debruge Dumenil, Paris. Boulle cabinet on caryatid
 stand, engraved plaque after Berain. 91 12s

1851 Valued for the Government of the 2nd Republic, the
 bureau-plat of M. de Fontanieu (see 1771). 40

 Earl of Pembroke. C. Boulle commode en tombeau, *c.*
 1730–40, bought by Lord Hertford (Wallace Coll.). 231

 2 Boulle coffers on carved stands. {157 10s
 {162 15s

 Round table, marble mosaic top, carved gilt supports,
 probably Italian, early 18th cent. 262

£

1851	Lady's secrétaire, inlaid with Sèvres plaques; possibly the piece by Martin Carlin in the Villafranca sale, 1870.	683	10s
1852	Secrétaire à abattant with Sèvres plaques by Weisweiler, bought by Lord Hertford in Paris (Wallace Coll. F.308).	400	
1854	Sir Henry Payton. C. Boulle pier-table on 6 legs, marble top, gilt bronze masks, etc.	177	
1855	Comtesse de Zichy. C. Gueridon with Sèvres plaques.	189	
	Table, ditto.	260	
	Both bought by Marquess of Hertford (Wallace Coll.).		

Ralph Bernal. C. Boulle furniture, pedestal. ⎫ All bought 205
Table, oblong. ⎬ by Lord 143
Cabinet (Wallace Coll.). ⎭ Hertford. 118

	Small inlaid Louis XVI book-rest.	120	
	Marquetry table.	152	
	Small oval tulipwood table.	22	12s
1856	William Angerstein. C. Secrétaire à abattants, Sèvres panels, 1783, bought by Lord Hertford (Wallace Coll., F.307).	420	
1857	Duchesse de Montebello, Paris. Table à ouvrage with a Sèvres plaque; formerly belonged to Marie Antoinette.	181	
1859	C. Small secrétaire, Sèvres plaques by Schumann, bought by Lord Hertford (Wallace Coll., F.305).	1,206	8s
	C. Upright Louis XVI secrétaire with large Sèvres plaques, bought for Lord Hertford.	328	13s
1861	Earl of Pembroke, Paris. Console table by Charles Boulle, Louis XIV.	780	
	C. Riesener fall-front secrétaire (signed) with large Sèvres plaque on the front and 3 others, bought-in.	294	
1862	Richard Williams. C. Writing-table, Louis XVI, with 10 Sèvres plaques let into the drawer-fronts.	246	15s
1863	James Baillie. C. Louis XIII (XV?) marquetry table, flower designs on 2 drawer-fronts, ormolu mounts, bought by Wallace for Lord Hertford (apparently not in Wallace Coll.).	1,270	10s
1864	Earl of Clare. C. Marquetry writing table by David de Luneville (Roentgen), bought by Richard Wallace.	550	
	Paris. Commode étagére, bought by Lord Hertford (Wallace Coll.).	224	
1865	Earl of Cadogan. C. Library table, legs terminating in sphinx's heads, Louis XVI.	472	10s
	Pier-cabinet with single large Sèvres plaque.	347	10s
	Secrétaire droit à abattant, black-and-gold lacquer.	330	
	Writing table in same lacquer, arranged in 12 plaques.	450	
	V & A buys secrétaire droit in elaborate pictorial inlays, late Louis XIV.	250	
	Prince de Beauvau, Paris. Marie Antoinette's bureau de dame (see 1840, 1784), 32in× 19in, by Weisweiler, mounts by Gouthière, bought by Empress Eugène.	2,400	

£

1865	Slab-sided commode, Marie Antoinette cypher.	1,004
	Riesener console table.	828
1865–8	Marquess of Hertford orders a copy of the Bureau de Louis XV from Dasson; price according to Wallace Catalogue.	3,600
1866	D. M. Davidson. C. Pair of carved and gilded gueridon tables, 39in high, Venetian. 2 for	245
	Countess of Clare. C. Writing table in style of David Roentgen(?), 24 Sèvres plaques.	305 10s
	3-decker gueridon signed by Riesener, bought for Lord Hertford (Wallace Coll., F.313).	67 4s
1868	Captain Charles Ricketts, RN. Oval table by David Roentgen, with marquetry top depicting Aeneas and Anchises.	455
	Toilet glass, gilt-bronze frame by Gouthière.	241 10s
	Didier, Paris. Secrétaire à abattant by Riesener, 1784, bought for Lord Hertford (Wallace Coll., F.302).	412
1869	V & A purchases ebony cabinet inlaid with many woods made by Messrs Fourdinois for the Paris Exhibition of 1867.	2,750
	Also purchases the wood, marble, stucco, and bronze fittings of the boudoir of Mme Serilly, by Rousseau de la Rottière, 1780.	2,100
	Durlacher sells the Marquess of Hertford a lady's secrétaire with Sèvres plaques, by Martin Carlin, 1783 (Wallace Coll., F.327).	2,100
	Marquess of Londonderry. C. Late 18th-cent., long bookcase in boulle style, bought by Durlacher and sold to Lord Hertford for over £4,500 (Wallace Coll., F.58).	3,990
	Gueridon table with Sèvres top.	315
1870	Marjoribanks. C. Boulle knee-hole writing desk.	1,050
	Pair of encoignures by Riesener, 1783 (Wallace Coll.).	1,260
	Bonheur du jour, Louis XVI, with Sèvres plaques of military scenes (V & A, Jones Bequest, 1882).	1,155
	Marquis de Villafranca, Paris. Secrétaire with Sèvres plaques, by Martin Carlin.	1,188
	San Donato, Paris. 2 tall boulle armoires, Louis XIV, with bronze reliefs, Apollo and Daphne and Apollo and Marsyas (see 1808). 2 for	4,440
	Louis XVI commode, Gouthière mounts.	1,840
	Secrétaire en suite.	1,200
	2 encoignures en suite. 2 for	1,160
1871	Bought by Sir Richard Wallace from Durlacher. Pair of patinated iron tables, perhaps by Gouthière (Wallace Coll., F.317–18). 2 for	3,150
	Joseph. C. Toilet table with 8 Sèvres plaques and fitted contents, Louis XVI, made for Queen Sophia Albertina of Sweden, bought-in.	1,522 10s

£

1872	Wallace Coll. purchases: From Miallet: Marie Antoinette's marriage coffer, lacquered gold, by Dubois (F.245).	3,600
	From Beurdeley: a boulle cabinet (F.16).	1,300
1874	Alexander Barker. C. Lady's secrétaire, oval top with marquetry picture by David Roentgen, 1780–90, bought for V & A.	441
c. 1878	Edmond de Rothschild buys the commode of Mme du Barry (c. 1785). According to *Chronique des Arts*, 3 December 1880, the price was 750,000 francs.	30,000
	Or, according to Bonnaffé, *Causeries sur l'Art*, 1878, 600,000 francs.	24,000
1880	Carrington. C. Riesener commode.	493
	San Donato, Florence. Rosewood table with 32 Sèvres plaques by Leleu.	2,000
	Marriage-coffer of the Grand Dauphin, made by Boulle for Louis XIV.	6,000
	(See also Smaller Objects, Clocks, etc.)	
1881	C. Tulipwood commode with mounts.	1,575
1882	Hamilton Palace. C. Pair of boulle cabinets (*ex* Beck- ford) (Louvre; see 1823). 2 for	12,075
	Duc de Choiseul's cartonnier-secrétaire (Musée Condé, Chantilly).	5,565
	Louis XV commode with mounts in high relief (Waddesdon Trust).	6,247 10s
	Small 2-decker writing-table by Riesener, made for Marie Antoinette (Waddesdon Trust).	6,300
	Upright secrétaire, made to match in 1791.	4,620
	Commode, made to match in 1791.	4,305
	(Both in Frick Foundation; see 1915.)	
	Black-and-gold lacquer secrétaire, Gouthière mounts, made for Marie Antoinette towards 1790.	9,450
	Commode to match.	9,450
	(Both in the Metropolitan Museum, per Cornelius Vanderbilt.)	
	Upright secrétaire to match (Waddesdon Trust).	5,460
	(See also Drawing-room Suites, Clocks, Smaller Objects.)	
1883	Duke of Marlborough. C. Small writing-table by Carlin, made for Marie Antoinette, for which Edmond de Rothschild was said to have offered £18,000, bought-in (Huntington Library, San Marino, Cal.).	6,000
1884	Marquis de Osmond, Paris. Late boulle meuble à hauteur d'appui.	1,800
	Baron d'Ivry, Paris. Rosewood secrétaire, Louis XV.	1,556
1885	Becket Denison. C. Louis XIV boulle cabinet with royal medallion head (£2,310 at Hamilton Palace sale).	997 10s
1886	Stein, Paris. Boulle table.	1,440
	2 Riesener encoignures.	480

£

1886	Lafaulotte, Paris. Bureau de dame à dos d'ane, Louis XV.	780
	Sichel, Paris. Régence commode by Caffieri.	460
1887	Orme. C. Louis XVI writing table.	1,837 10s
	Samuel Bernard, Paris. A slump sale. 200 lots made less than £10,000. The dearest was a signed bureau à cylindre by Saunier.	228
1888	Marquess of Exeter. C. Coffer and stand by Boulle (see 1829).	1,522 10s
1890	Achille Seillière, Paris. Secrétaire droit à abattant with Sèvres plaques.	1,800
1891	Lord Frederick Cavendish-Bentinck. C. Louis XV upright secrétaire.	1,050
	2 Louis XVI console tables.	{1,522 {1,491
	Rosewood table, Louis XVI, Sèvres plaques.	462
1892	Samson Wertheimer. C. Louis XVI commode.	1,260
	2 Louis XV encoignures.	2 for 1,648
	2 Louis XV secrétaires.	2 for 1,785
	Riesener console table.	840
	Mme d'Yvon, Paris. See Drawing-room Suites.	
1893	Earl of Essex. C. Boulle secrétaire.	1,575
	Pair of boulle pedestals.	2 for 1,732
	Pair of Louis XIV cabinets.	2 for 1,312
	Earl of Clifden (Robinson, Fisher). Louis XVI writing-table with Sèvres plaques.	2,467
1894	Josse, Paris. Régence table (cost £4,000).	1,420
	Secrétaire à abattant, Louis XV.	1,080
	Pommereau, Paris. Régence cabinet, heavily mounted by Cressent (see 1927).	1,684
1895	Lyne Stephens. C. Louis XVI mahogany cabinet.	1,985
	Louis XVI secrétaire.	1,386
	Louis XV ditto.	1,008
	Earl of Clifden. C. Small secrétaire by Oeben (see 1912).	682
1896	P. de G., Paris. Bureau à cylindre, made by Riesener for Louis XVI, with a key said to have been made by the King.	3,720
1897	Baron Lepic, Paris. Entre-deux with 2 commodes, made en suite by BVRB (Riesenberg) in black and gold lacquer.	3 for 4,520
	Small occasional table to match.	1,690
1897–1901	Particularly bad period for French furniture in the saleroom. Very few prices over £200 except for drawing-room suites.	
1899	Charles Stein, Paris. Bureau à cylindre, Louis XV, with elaborate mounts and polychrome lacquer panels.	456
1901	Duchesse de Clermont-Tonnerre, Paris. Louis XVI heavily-mounted secrétaire by Saunier.	800

Towards 1900 Baron Edmond de Rothschild bought the Bureau du Duc de Choiseul and the Commode of Mme du Barry. The prices were recorded only by hearsay, but M. Maurice Rheims says £48,000 for the former, while

£

1901	Duveen is quoted as saying that £60,000 were paid for the latter to Prince Cheramatieff.	
	Duke of Leeds. C. 2 heavily-mounted Louis XV commodes, covered with foliage branches, signed Joseph, bought by Charles Wertheimer, having been bid-up by Duveen. 2 for	15,000
1902	C. Louis XV commode.	4,100
1903	Sir E. Page-Turner. C. Louis XVI bonheur du jour, only 21in wide (bought 1868, £21).	1,680
	Mme Lelong, Paris. Serpentine table, Louis XV.	2,400
	Small Régence bureau.	1,140
	2 encoignures, Régence period. 2 for	1,724
1905	Duke of Marlborough. C. Riesener signed commode.	3,150
	Massey-Mainwaring. C. Commode by Caffieri, Louis XV.	4,935
	C. 4 massive Louis XIV boulle armoires with sculptured allegories of Religion and Wisdom (the decline of boulle furniture; compare 1882). 4 for	630
	Cronier, Paris. Bureau-plat of the Régence period.	4,600
	Commode, ditto.	1,600
	2 commodes, c. 1770, signed Rubestuck. 2 for	4,800
1906	C. Louis XVI commode, lacquer panels by Weisweiler.	2,205
	Prince Kolchoubey, Paris. Louis XV bureau-plat, signed Joseph.	2,140
	Louis XVI bureau à cylindre.	1,060
1907	Mrs Lewis-Hill. C. Commode by Henson, Caffieri mounts.	3,990
	Chappey, Paris. Secrétaire droit à abattant, Louis XVI.	1,689
1909	Felix Doisteau, Paris. Secrétaire droit, signed RVLC (Vanderkruse), Louis XV.	884
	Paris. Bureau-plat by Kramer, Louis XVI.	1,488
1910	Waller. C. Cabinet with 3 doors by RVLC.	1,680
1911	Lowengard, Paris. 2 boulle marriage coffers, Louis XIV. 2 for	2,560
	Buffon's Louis XVI commode from the Château de Montbard.	3,640
1912	C. Upright secrétaire by Lieutaud, Louis XV.	2,310
	Mme Roussel, Paris. Meuble-secrétaire, Louis XVI, lacq de Chine.	2,250
	Jacques Doucet, Paris. Musée de Beaux Arts buys gilt-bronze table, Louis XV, marble top.	3,600
	Charles Wertheimer. C. Table and commode, attributed to Riesener (according to A. C. R. Carter, Wertheimer paid £44,000 in 1902). 2 for	819
	Jacques Doucet, Paris. Table-bureau, Régence.	3,524
	Bureau de dame, signed BVRB (see 1932).	3,256
	Louis XVI bureau à cylindre by Roentgen.	3,960
	Table-bureau, Louis XVI, by Montigny.	2,552
	Commode by Leleu.	2,200

			£	
1912	Commode by Riesener.		2,398	
	Gueridon-liseuse, Louis XVI, by Carlin.		2,662	
	8 other pieces at over £1,000 each.			
	Mme X, Paris. 2 encoignures by Riesener.	2 for	7,440	
	Console d'entre-deux by Saunier, late Louis XVI.		6,140	
	John Edward Taylor. C. Secrétaire by Oeben, Louis XV (see 1895).		4,200	
	Commode by Saunier, Louis XVI (see 1928, 1939).		5,040	
	Writing table, Louis XVI.		3,780	
	Commode by Kraemer, Louis XVI.		2,100	
1913	Kraemer, Paris. Bureau à cylindre, Louis XV, by Kraemer.		5,509	
1914	Marquise de Biron, Paris. Bureau-plat by Garnier with cartonnière at the narrow end, c. 1780.		6,211	
	Meuble d'entre-deux, Chinese lacquer, by Saunier.		2,200	
	Bureau de dame by Riesener.		2,026	
1915	Commode and secrétaire by Riesener (ex Hamilton Palace; see 1882), bought by Duveen from executors of Pierpont Morgan and sold to H. C. Frick. Price paid by Duveen (believed).	2 for	51,650	
1916	Lady Normanton. C. Louis XVI commode.		1,344	
1917	Lagrange, Paris. Bureau à cylindre with glass-front book-shelf, signed Saunier, Louis XVI.		1,333	
	Levy, Paris. Secrétaire droit by Dubois, Louis XV.		1,562	
	Small bureau, part painted en grisaille, by Dubois, Louis XV.		1,650	
	Duke of Sutherland. C. 2 Louis XVI commodes.	2 for	3,255	
	Louis XV bureau-plat with cartonnière.		1,995	
	Granville Gavine. C. Very elaborate commode by Riesener.		4,725	
	Louis XV commode, mounts by Caffieri.		4,410	
1918	Lady Falle. C. Commode d'entre deux, Louis XVI.		2,047	10s
	Duc d'Artois's commode in boulle style, c. 1780.		1,239	
1919	Ruxley Lodge sale. C. 2 Louis XV encoignures, bought by Duveen.	2 for	9,870	
	2 others.	2 for	5,145	
	Neumann. C. Riesener bureau à surprises (see 1932).		6,190	
1920	Asher Wertheimer. C. Pair of Louis XV marquetry tables (bought at the Oppenheimer sale, 1912, £2,100).	2 for	367	10s
	Edward Arnold. C. Commode by Riesener, bought by Duveen.		4,515	
	Louis XVI secrétaire.		2,479	
	Alfonse Kann, Paris. Meuble d'entre deux, Coromandel lacquer (99,000 francs).		1,900	
	Paris. Provincial bureau à cylindre, Louis XV (95,800 francs).		1,810	
1921	J. H. King. C. Louis XV bureau-plat, 6ft 6in.		3,150	

£

		£	
1922	Marquise de Ganay, Paris.　Commode by BVRB, Louis XV.	2,700	
	Paris.　Bureau à cylindre, ornate, towards 1770.	5,625	
	Burdett-Coutts.　C.　Cabinet-cartonnière by BVRB (with clock).	4,220	
	C.　2 semicircular commodes by Topino.　　2 for	3,937	10s
	Louis XV commode, signed Dubois.	2,047	10s
1923	Anthony de Rothschild.　C.　Table rognon by Peridiez, Louis XV.	2,520	
	Upright desk by Dubois, painted panels.	3,255	
	Bureau à surprises by Cosson.	4,935	
	Circular commode *en grisaille*, Louis XVI.	1,522	10s
	Writing table, signed RVLC, Louis XVI.	3,675	
	The Paris slump.　In December an exceptionally fine Louis XV commode in lacquer of many colours by Criaerd made only	300	
	Brocket Hall.　Lord Walter Talbot-Kerr (Fosters'). 2 5½ft satinwood commodes, signed by Carlin.　　2 for	15,435	
1924	C.　Mme Victoire's Riesener commode, 1791.	2,782	10s
	Himley Hall (Hampton's).　Régence writing-table with bronze mounts.	2,100	
1925	Countess of Carnarvon.　C.　Writing-table with inlaid gouache paintings by Weisweiler.	3,780	
	Riesener secrétaire with Gouthière mounts.	2,835	
	6 other important signed pieces made from £1,050 to £2,100.		
	Earl of Normanton.　C.　Charles I's table-top of fossilized wood, mounted for Marie Antoinette (see 1794, 1929).	1,837	10s
	Gramont, Paris.　Tall armoire by Boulle.	1,350	
	Commode by BVRB.	2,440	
1926	Dutasta, Paris.　Secrétaire de dame by RVLC.	6,080	
	Lord Michelham (Hampton's).　Louis XV upright secrétaire by BVRB (see 1936, the first piece of furniture to make £10,000 in an auction room).	10,237	
	Marquetry commode by Boudin, *c.* 1770.	8,400	
	Writing-table by Caffieri.	5,250	
	Louis XV bureau de dame by Denizot.	4,620	
	Louis XV commode by Benemann.	4,200	
1927	Mrs Louis Raphael.　C.　Riesener-stamped commode, 5ft 3in.	1,102	10s
	Hon. Mrs Yorke.　Louis XV marquetry table.	2,467	10s
	Régence commode bombé.	1,890	
	Viscountess Harcourt.　C.　Louis XVI cabinet, semicircular.	2,520	
	Mme de Polés, Paris.　Secrétaire de dame, signed RVLC, 6ft (bought for the Musée des Beaux Arts).	6,650	
	Table-liseuse-coiffeuse, RVLC.	3,240	
	Bonheur du jour by Topino.	2,450	

£

		£	
1927	Secrétaire droit, Louis XVI (Hamilton Palace, 1882, £1,575).	4,750	
	Heavily mounted armoire, Régence period (see 1894).	2,645	
	Empress Eugénie. C. Two upright cabinets, Sèvres plaques by Michault, Louis XVI. 2 for	4,725	
	Joseph Bardac, Paris. Bureau-plat, stamped Montigny, Louis XVI.	2,640	
1928	Elbert Gary, New York. Table liseuse-poudreuse by Oeben.	5,780	
	Table by Oeben and Lacroix with arms of Pompadour (record price for a piece of furniture in the saleroom till 1959).	14,640	
	Riesener commode (see Bentinck, 1891).	1,130	
	Saunier commode (see Taylor, 1912, 1939).	2,800	
	USSR Government sale, Berlin. David Roentgen, secrétaire, 1783.	3,650	
1929	Ney, Prince de Moskowa, Paris. The Table des Maréchaux, 1810, designed by Isabey for Napoleon as a single Sèvres plaque (ceded by Duveen to a body of subscribers at £2,480 and now in Musée Napoléon, Malmaison).	3,800	
	USSR Government sale, Berlin. 2 circular commodes in lacquer, Louis XV. 2 for	3,650	
	Zambaux, Paris. Louis XV chaise-longue in cane by Cresson.	980	
	Founès, Paris. Charles I's table-top in fossilized wood, mounted for Maria Theresa as a *table de Vienne* in steel and lacquered bronze (*ex* Debruge Dumenil, 1850; see 1794, 1925).	380	
	Meuble d'appui in lacquer by Weisweiller.	380	
	Mrs Baldock (Knight, Frank). Secrétaire, 42in wide, tulipwood and kingwood.	1,890	
	Morrison. C. Writing-table in boulle style by Levasseur, c. 1770, 81in long.	1,627	10s
1930	Barnet Lewis. C. Louis XV commode, 57in, stamped Oeben.	950	10s
	Earl of Balfour. C. Occasional table by Weisweiler with 17in Sèvres plaque as a top.	3,097	10s
	Another, 21in top, by RVLC.	1,312	
	Sir John Ramsden. C. Small escritoire by RVLC, Louis XV.	3,675	
1931	USSR Government sale, Berlin (Stroganoff Coll.). Round ebony table, marble top, by Carlin.	1,500	
	Lord Hastings. C. Upright secrétaire, made for the Trianon with 24 miniatures of Marie Antoinette's family, 41 in wide.	1,995	
	Château Boissy-Saint Leger, Paris. Lady's secrétaire by Martin Carlin.	2,350	
	Octave Homberg, Paris. Meuble à hauteur d'appui by BVRB, lacquer panels on white ground. about	2,000	

£

1932	Grand Duke of Saxony. S. Bureau à surprises by David Roentgen.	2,000
	Earl of Harewood. S. Bureau à cylindre by Riesener (see 1919).	1,300
	Viel, Paris. Bureau de dame à dos d'ane, signed BVRB (see 1912, £3,256).	1,330
	A second ditto by BVRB, "Mouvementée".	1,160
1933	Only 4 pieces exceeded £200 each on the London market.	
1934	C. Bonheur du jour, stamped RVLC, magnificent.	262 10s
1935	Lady Helen Dewar. C. Occasional table, 13in wide, by Boudin, Louis XV.	882
1936	C. Bureau de dame, signed BVRB.	252
	Lord Buckland. C. The Michelham Secrétaire by BVRB (see 1926, £10,237).	1,312 10s
	F. E. Lloyd. C. Louis XV secrétaire table, 20in wide, BVRB.	504
1937	Victor Rothschild. S. Secrétaire by Carlin, bought by Duveen.	8,000
	Louis XV commode, style of Cressent.	3,100
	2 bureaux by Wolff and Durand.	{1,050 / 1,028
	Contesse de Greffulhe. S. Louis XV armoire-buffet.	1,400
1938	Mortimer Schiff. C. 2 Louis XIV marriage coffers by Charles Boulle. 2 for	1,134
	Small marquetry table made for Marie Antoinette.	1,942 10s
	2 secrétaires by Carlin and Weisweiler, sold by Baroness Alphonse de Rothschild to Paul Getty. 2 for	15,000
1939	Randolph Hearst, New York. Commode by Saunier (see Taylor, 1912, and Gary, 1928).	1,112
	Caldwell. S. Secrétaire à abattant by RVLC (see 1959).	300
	S. Louis XV lacquer cabinet by BVRB.	6,000
1941	Mrs Henry Walters, New York. Louis XV tulipwood commode.	3,600
1942	George A. Lockett. C. 2 Louis XV encoignures by Joseph. 2 for	630
	Bureau à cylindre by Roentgen (thought by Cyril Blunt to have been sold with the royal properties in 1794).	472 10s
1946	Drummond-Moray. C. Bonheur du jour by Kramer, Louis XVI.	2,047 10s
	Bonheur du jour with Sèvres plaques.	1,365
	Cosson. S. Bonheur du jour in amaranth.	1,300
	Louis de Rothschild. S. 2 Louis XVI commodes, serpentine inlays. 2 for	3,000
	Duke of Buccleuch. C. Louis XVI commode and 2 encoignures, lacquered. 3 for	7,140
	Lady Ludlow. C. Commode by Riesener.	2,730
	Lacquer escritoire.	2,520
1947	Brigadier R. J. Cooper. C. Bureau de dame, picture inlays, only 19in wide, Louis XV.	2,730

£

1947	Barometer by Passement, Louis XV, Sèvres plaques.	2,047 10s
	Ogilby heirlooms. C. 6-leaf screen by Brizard, Louis XV, Chinoiserie paintings on canvas.	1,890
1948	Countess of Coventry. S. Secrétaire à abattant, signed BVRB.	4,000
1949	Cafetière table, 1761, signed BVRB, green lacquer, Sèvres plaques, bought by Paul Getty from Rosenberg and Stiebel.	5,340
1950	Earl of Wilton. C. Upright secrétaire bombé, black lacquer, Chinoiserie panels by Holthausen and Delorme, bought-in.	3,570
1951	Princess Royal. C. Upright secrétaire, Weisweiler (Sèvres plaques).	3,150
	Jardinière in kingwood by Saunier.	2,310
	Bureau à cylindre by Riesener.	2,310
1953	Lady Catherine Ashburnham. C. Bureau-plat, boulle style, by Dubois.	1,750
	C. Louis XV lady's desk, picture marquetry by Feilt.	2,100
1954	S. Louis XV writing-table, signed Genty.	2,300
	Baroness Burton. C. Commode by Beneman, c. 1790.	1,785
	Baroness Cassel, Paris. 2 rococo commodes, richly mounted by Criaerd, Louis XV.	{3,440 {2,800
	Paris. Secrétaire à doucine, Louis XV.	2,935
	New York. Lady's writing-desk by Boudin, Louis XV, 29in×28in.	2,850
1955	Paris. 8ft commode with lacquer panels by Weisweiler, late Louis XVI.	4,600
	Rechnitzer. C. Bonheur du jour, Louis XV, in black lacquer, by Saunier.	5,460
	Oval table, marquetry picture top, 22in wide, by Boudin.	1,942 10s
	C. Commode with marquetry pictures by Foullet, c. 1770.	2,730
	Vagliano. C. Upright secrétaire by Carlin, Louis XVI.	3,990
1956	Baroness Cassel von Doorn, Paris. Louis XV writing table by BVRB (with tax).	20,245
	Louis XV rococo marquetry commode with extensive ormolu swags.	5,900
	S. Marquetry bureau-plat, Louis XV, signed C. Wolff.	3,850
1957	Parke-Bernet, New York. Commode from Derby House by Beraud, 1761.	6,070
	Table à écrire, kingwood and amaranth.	7,140
	Table à chênet, very plain, Louis XVI.	6,070
	S. Red lacquer commode, Louis XV.	17,500
	Paris. Régence cabinet with full-length doors in Chinese lacquer.	5,400
	Louis XV commode by Dubois with very rococo mounts.	4,100
	Guèridon porte-lumières in 2 stages.	5,320
	Writing desk designed as a meuble d'entre deux by Riesener, Louis XVI.	4,700

£

1957	Mme Belier, Paris. Knee-hole writing-desk, said to have been made by Charles Boulle for Cardinal Mazarin (before 1661).	3,200
	Carved and gilded table of the same date, 33in wide, extremely profuse and hideous.	3,820
	Paris. Régence tall cabinet with Chinese lacquer doors.	5,400
	Commode by Dubois, extremely rococo style.	4,100
1958	Baron Llangattock. C. Secrétaire à rideaux, signed RVLC.	12,075
	Table à dessous coutissant by Oeben, Louis XV, bought by Duchesse de Richelieu.	35,700
	S. 2 plain commodes by Dester, c. 1790. 2 for	6,100
	Blache, Versailles. 2 rococo encoignures by Delorme, c. 1750. 2 for	4,350
1959	Paris. Pair of meubles d'entre deux in Chinese marquetry, ascribed to David Roentgen. 2 for	5,760
	Chrysler-Foy, New York. Lady's desk in black lacquer by Martin Carlin, 30in× 18in top.	9,120
	S. Secrétaire à abattant, signed RVLC (see 1939).	6,500
	C. Table liseuse, Louis XV.	4,620
	Bureau de dame, amaranth and satin, Louis XV.	12,500
	Black and gold lacquer commode by Jacques Caffieri.	17,150
1960	C. Jewel cabinet by BVRB.	5,250
1960	Lady Foley. C. The Hillingdon Coll. (£101,960):	
	3-tier table à ouvrage, Louis XV, by Oeben.	13,650
	Round-topped table with Sèvres plateau by Adam Weisweiler, bought-in.	9,450
	Bureau-plat by Migeon, Louis XV.	8,400
	2 Louis XIV pedestals by Charles Boulle (Hamilton Palace, 1882, £1,575). 2 for	1,155
	Penard y Fernandez, Paris. Meuble d'appui by Peridiez.	8,940
	Galliera, Paris. Marie Antoinette's dog-kennel by Sené.	6,425
	Gueridon table by Carlin.	12,850
	Sèvres-inlaid round table by Martin Carlin.	19,950
	The Misses Mulligan. C. Furniture for £106,600:	
	Vernis Martin green commode, Louis XV.	18,375
	Commode by Dubois in Chinese black lacquer.	6,300
	Commode by Roentgen with elaborate marquetry pictures, c. 1770.	9,975
1961	C. Oval table, 16in, by Topino, c. 1780.	8,610
	Galliera, Paris. Régence writing-table, heavily inlaid. about	15,000
	Gueridon table by Leleu.	9,200
	2 bureaux à dos d'ane by Charles Boulle, Louis XIV. 2 for	4,000
	S. Bureau-plat by Riesener. 2 for	11,500
	Secrétaire en tombeau, black lacquer, Louis XV, by Dubois, 25in wide.	11,000
	Louis XIV table, Chinoiserie style.	8,000

		£
1961	Duke of Leeds. S. Pair of plain vitrines, Louis XV. 2 for	4,000
	Late Lady Harcourt. C. Marquetry table, BVRB.	7,560
	Writing table, RVLC.	6,510
	Kingwood table, BVRB.	7,350
	Poudreuse, or toilet table, 31in, by Peridiez.	8,610
	C. Venetian painted commode bombé.	9,975
	2 smaller, imperfect, *en suite.* 2 for	5,040
	Venetian 7ft mirror.	2,520
1962	Lady Powis. S. Louis XVI ebony commode with picture inlays in Florentine marble by Beneman, *c.* 1780.	33,000
	2 Louis XVI transitional marquetry commodes by Foulet. 2 for	10,500
	Marquetry centre table by Topino.	3,200
	C. Secrétaire à abattant, Louis XV, pedestal-shaped and very rococo, stamp of the Royal Ecuries (Oppenheim sale, 1913, £367).	17,325
	Lord Leigh. Kingwood writing-table by Dubois, Louis XV.	6,300
	C. Pair of Amboyna commodes by Weisweiler, extremely plain, 1780s. 2 for	9,450
	2 small painted commodes, Venice, *c.* 1750. 2 for	6,300
1962	Paris. Armoire by Charles Boulle, Louis XIV, inlaid inside and out.	7,455
	Secrétaire by BVRB, Louis XV (275,000 francs, plus tax). about	23,500
	Another ditto (245,000 francs, plus tax). about	21,000
	Secrétaire à abattant, satinwood, by Garnier, 1742 (160,000 francs and tax).	13,487
	Library table in leaf-marquetry by Montigny, Louis XVI (160,000 francs and tax).	13,487
	Commode by Riesener from Chanteloup with picture marquetry (165,000 francs and tax).	13,900
	Pair of secrétaires à doucine, floral marquetry by BVRB. 2 for	42,500
	Secrétaire à hauteur d'appui by Garnier.	13,180
	Bureau-plat, Louis XVI, by Montigny.	13,180
	Commode à ressaut, stamped Riesener.	13,590

FRENCH 18TH-CENTURY

Drawing-room suites (Ameublements de salon)

£

1764–5 Inventory of Mme Pompadour's furniture:
1 settee, 4 fauteuils, 2 bergères, 3 chairs, Gobelins panels
after Boucher, *Les Jeux d'Enfants*, valued 10 for 36
Settee, 6 fauteuils, Aubusson panels after Coypel, *Fables
of La Fontaine*, valued 7 for 13 12s

1769 C. 8 fauteuils, painted and gilt, Gobelins tapestry, the
bottoms representing fables (*La Fontaine* suite?) and the
backs figures. 8 for 33 12s

1778 Earl of Kerry. C. 10 fauteuils, 2 settees, carved and
gilded with crimson damask upholstery. 12 for 107 2s
Ordered for Mme Elizabeth at Fontainebleau. Suite by
François Foliot, 4 fauteuils, 2 bergères, 4 chairs and a fire-
screen; a settee and a 5th chair added in 1784; price for
frames only (see 1927), Comte de Ganay Coll., 1945.
 13 for 174 5s
Bought in Paris by the Earl of Shrewsbury. 2 settees, 12
fauteuils, new (see 1857). 14 for 567

1780 C. 9 cabriole fauteuils and 2 bergères, white-and-gold
striped damask. 10 for 80 17s

1782 C. Settee, 12 fauteuils, white-and-gold parti-coloured
damask. 13 for 103 19s

1785 Fauteuils by Jacob for the Duc de Provence (per chair
without the tapestry covers). 21 12s

1786 Ordered by Louis XVI for Fontainebleau. 30 chairs, 6
small settees and 1 screen (see 1852; partly in Wallace Coll.).
 37 for 600

1788 Valued for Louis XV at Compiègne (now Louvre).
Specially fine carved and gilt suite by Tilliard, Hauré, and
others, made for King of Sweden in 1784: settee, 6 fauteuils,
2 bergères, 4 chairs, footstool and fire-screen, white satin
(see 1810, 1835). 15 for 318
Count d'Adhemer. C. 12 fauteuils, carved and gilded
with Gobelins tapestry backs and seats. 12 for 100 16s
12 fauteuils, carved and gilt, rich crimson damask to
match curtains. 12 for 132 6s
Carved and gilt suite in blue-and-gold damask by Hauré,
Sené, and others for Marie Antoinette at St Cloud (now
Fontainebleau), consisting of 1 10ft settee, 6 fauteuils, 4

£

			£	
1788	chairs, 2 bergères, folding screen, fire-screen, tabouret, and gondola footstool.	17 for	428	
1790	Duke of Orleans. C. 12 fauteuils, 2 bergères, settee, cabriole legs (Louis XV?), in barré satin.	15 for	70	
1795	Field-Marshal Conway. C. 2 settees, 4 bergères, white-and-gold, cabriole legs, Gobelins tapestry panels.	10 for	41	8s
1799	Earl of Kerry. C. 1 large and 2 small settees, 6 fauteuils, burnished gold, lemon-coloured silk.	9 for	107	
1800	Duke of Leeds. 3 settees, 12 fauteuils, 6 chairs, heavily carved and gilt, satin covers, with curtains and hangings to match, as well as carved pelmets and 2 gilt tripods.	23-plus for	430	10s
1806	C. Gobelins tapestry suite; 2 settees, 6 fauteuils, bought-in.	8 for	105	
1808	C. White and burnished-gold suite: 14 fauteuils, settee, and matching curtains for 3 windows, calico and "rich chintz".	15-plus for	84	
1810	Valued for Louis Bonaparte, Fontainebleau: the King of Sweden Suite, less footstool (see 1788, 1833).	14 for	174	10s
1823	Farquhar Fonthill (ex Beckford) (Philips). 6 gilt fauteuils, purple damask, period not specified.	6 for	175	10s
1829	Lord Gwydyr. C. Settee and 6 fauteuils, white-and-gold, Beauvais pastoral tapestries.	7 for	73	6s
1833	Compiègne. Valued for Louis Philippe: the King of Sweden Suite (see 1788, 1810).	14 for	62	
1842	Waldegrave, Strawberry Hill (Robins). Settee and 8 fauteuils, Aubusson tapestry, probably Louis XV.	9 for	28	8s
	6 tapestry-backed fauteuils, probably Louis XV.	6 for	8	8s
1847	Robert Vernon. C. 2 settees, 6 fauteuils, whole-gilt, embroidered on silk, *Aesop's Fables*, bought-in.	8 for	115	10s
1848	Duke of Buckingham, Stowe. C. 12 fauteuils and a fire-screen, Boucher Gobelins tapestry covers, *Fables of La Fontaine*, sold in lots.	13 for	95	6s
	2 settees, 6 chairs, English in French style, before 1727, modelled in gesso (see 1939).	8 for	18	18s
1852	Duc de Stacpoole, Paris. Suite for Louis XVI from Fontainebleau (see 1786) (now shared between Metropolitan Museum and Wallace Coll.).	37 for	680	
1855	Bernal. C. 8 fauteuils, white-and-gold, crimson damask, period not specified.	8 for	29	16s
1856	Earl of Orford, Wolferton. C. 12 fauteuils, 2 settees, Gobelins tapestry, Louis XV (see 1909).	14 for	220	
1857	Earl of Shrewsbury, Alton Towers. C. The Heythrop Louis XVI damask suite (see 1778):			
	8 fauteuils (£28 12s each, a unique price).	8 for	200	11s
	4 fauteuils.	4 for	114	9s
	Settee.	1 for	115	10s
	Settee.	1 for	110	5s

£

1857	Bought for Lord Hertford (now Wallace Coll.), total 14 for	540 15s
	2 Gobelins tapestry fire-screens. 2 for	91
1863	George Blamire. C. 1 settee, 8 fauteuils in black and gold, Beauvais tapestry, children and animals. 9 for	74 11s
1865	Robert Bristowe. C. 1 settee, 2 fauteuils, 2 matching pairs of curtains, all in Beauvais tapestry. 5 for	101
	1 settee, 8 fauteuils, black-and-gold, Beauvais tapestry, *Fables of La Fontaine.* 9 for	152
1867	Lady of rank. C. 4 fauteuils, 8 chairs, 2 settees, white-and-gold, with Aubusson tapestry, Louis XVI. 14 for	220
1873	Paris. 16 fauteuils and bergères, 1 settee, Louis XV, Aubusson tapestry panels. 17 for	201
1876	Château de Vaux-Praslin, Paris. 10 fauteuils, 2 settees, damask, Louis XV (fauteuils at over £60 each). 12 for	1,080
1880	San Donato, Florence. Louis XV settee with taffeta covers. 1 for	1,180
	Carrington. C. 8 fauteuils, 2 settees, Gobelins tapestry. 10 for	934
1881	Leopold Double, Paris. 11 fauteuils and chairs, 2 settees with Beauvais tapestry after Boucher. 13 for	4,400
	2 settees, 4 fauteuils, 4 chairs by Foliot, 1770, with tapestry suite after Boucher, Beauvais, known as Le Mobilier des Dieux, bought by Double in the 1870s for £3,200; bought by Chauchard and left to the Louvre in 1911. It was proved by Verlet in 1945 that a settee and 3 chairs had been added in the 19th cent., as well as the tapestry covers. 10 for	4,000
1882	Hamilton Palace. C. Louis XVI settee, 13ft long, from Versailles, Gobelins tapestry (Gulbenkian Foundation).	1,176
	12 Louis XV fauteuils, Gobelins tapestry (see 1923). 12 for	892 10s
	10 Louis XV fauteuils and settee. 11 for	766 10s
1884	Baron d'Ivry, Paris. 10 fauteuils, 2 settees, Gobelins tapestry, Louis XV. 12 for	3,240
1885–7	Slump prices.	
1885	Beckett-Denison. C. 6 fauteuils, 1 settee, Louis XVI, Gobelins tapestry (see 1913). 7 for	682 10s
	de la Berraudière, Paris. 12 chairs and fauteuils, 1 settee, Louis XV, Gobelins tapestry. 13 for	520
1887	Samuel Bernard, Paris. Various Louis XV and Louis XVI suites, sold at an average of less than £30 a chair.	
1890	Achille Seillière, Paris. 6 fauteuils and 2 settees, Louis XV, Beauvais panels with battle scenes after Casanova. Resold to Josse for £5,200 (see 1894, 1927). 8 for	3,720
1892	Mme d'Yvon, Paris. 10 fauteuils, tapestry after Oudry, 2 settees, tapestry after Boucher, bought by Chauchard. 12 for	8,880
	Beauvais tapestry folding-screen.	1,240
1893	Earl of Essex. C. 6 Louis XV tapestry fauteuils. 6 for	1,701

£

1894 Josse, Paris. The Casanova Suite (see 1890, 1927). 8 for 3,080
1896 P. de G., Paris. 10 chairs and fauteuils, 2 settees, Beauvais panels after Casanova. 12 for 5,440
1898 Lowengard sells Chauchard the Louvre Boucher Suite (see 1912), 2 settees, 10 fauteuils. 12 for 18,000
1899 Marchioness of Londonderry. C. Settee (tapestry) and 6 fauteuils, Louis XVI. 7 for 630
2 Louis XVI tapestry fauteuils. 2 for 840
1900 Paris. 6 fauteuils from the *Jeux d'Enfants* suite, Beauvais tapestries after Boucher and Oudry. 6 for 4,960
Paris. 1 settee, 8 fauteuils, with Beauvais panels. 9 for 3,840
1901 Lassalle, Paris. 1 settee, 6 fauteuils, Beauvais tapestry. 7 for 3,000
1903 Paris. Beauvais tapestry panels without frames for 2 settees and a chair. 3 for 2,040
Mme Lelong, Paris. 4 Régence tapestry fauteuils, *c.* 1720. 4 for 6,880
6 Louis XVI fauteuils and 1 settee by François Reuze, Beauvais tapestries. 7 for 6,000
Régence banquette, *Fables of La Fontaine*. 2,400
6-leaf screen, Savonnerie tapestry, Louis XV. 3,200
1904 Leclercq, Paris. 4 fauteuils, 1 settee, Beauvais silk tapestries after Boucher and Oudry, Louis XVI. 5 for 2,000
1905 E. Cronier, Paris. Settee, 2 marquises, 4 fauteuils, and footstool, re-covered with Beauvais Casanova tapestry. 8 for 8,200
Louis XV settee and 6 large fauteuils, Beauvais white tapestry with flowers. 7 for 5,640
Screen and 5 fauteuils, Louis XV, Beauvais tapestry after Huet and Oudry. 6 for 3,280
Régence settee, Beauvais tapestry. 1,440
1907 Chappey, Paris. Settee and 10 fauteuils by Jean Baptiste Sené, panels of shepherds and animals (Beauvais) (see 1928, 1938). 11 for 18,000
Rikoff, Paris. 8 fauteuils, 2 settees, tapestry after Huet, about 1770–80. 10 for 4,088
1908 Henry Saye, Paris. Louis XVI settee in Beauvais tapestry. 1,420
1909 Lord Amherst of Hackney. C. 2 settees, 12 fauteuils, Gobelins, Louis XV, *Aesop's Fables* (bought in the 1870s for £220). 14 for 7,770
Settee and 6 fauteuils, ditto. 7 for 3,307
Marquise F. S., Paris. 2 settees, 4 marquises, 8 fauteuils, Beauvais tapestry after Boucher, Fragonard, Leprince, and Baudouin. 14 for 5,024
1910 Lowengard, Paris. Settee, 1 bergère, 5 fauteuils, tapestry, *Les Jeux d'Enfants*, after Leprince, *c.* 1750. The chairs, at least 20 years posterior and partly regilded. 7 for 9,840
1911 Marquis de Carsaux, Paris. Day-bed, screen, and bergère, said to have belonged to Marie Antoinette, by Jacob (see 1923), bought-in. 3 for 7,920

£

1912 Mme Roussel, Paris. Large settee, 4 fauteuils, re-covered
with Gobelins panels of the Régence. 5 for 10,000

 4-leaf tapestry screen, Beauvais, Régence. 7,240

 Late Charles Wertheimer. C. Settee, bergère, 6 fauteuils,
Boucher panels, said to have cost £21,000. 8 for 13,650

 Jacques Doucet, Paris. 6 fauteuils, Beauvais tapestry,
mixed set. 6 for 9,870

 Alcove settee, Louis XV. 2,466

 Fauteuil à poudrer in leather. 1,580

 Suite of settee, 2 bergères, 8 fauteuils, 8 chairs, Beauvais
tapestry by Salembier, c. 1770. 19 for 15,400

 Boucher Beauvais suite, 10 fauteuils and 2 settees, bought
by Chauchard in 1898 for £18,000; given by Mme Bour-
son to the Louvre, 1912; between 1910 and 1912 Lowengard
offered Mme Bourson £73,200 for the 12 pieces, but was
refused.

1913 Oppenheim. C. Settee, 6 fauteuils, Beauvais panels (see
1885). 7 for 9,240

 Louis XV 4-leaf screen, Beauvais silk panels after
Watteau. 6,825

 Beer, Paris. Settee and 6 fauteuils, mixed set, some by
Jacob, partly regilded and re-covered with various Beauvais
panels. 7 for 16,500

1914 Société Seligman, Paris. 6-leaf screen, Savonnerie silk
panels. 6,668

1918 Paris. Settee, 6 fauteuils, 5 chairs, Beauvais floral panels,
wholly gilded. 12 for 6,600

1919 L. Neumann. C. Settee, 8 fauteuils, 4 chairs, Beauvais
panels. 13 for 8,925

 Pasteur-Goulden, Paris. Settee, 6 fauteuils, Gobelins
panels, Cupids, etc., Régence period (38.50 francs to the £1).
 7 for 5,500

1920 Paris. Settee, 10 fauteuils, recovered in various 18th-cent.
tapestries, mixed set (297,000 francs). 11 for 6,320

 Alphonse Kann, Paris. Serpentine settee, Louis XV, rose
velvet. 1,060

1922 Marquise de Ganay, Paris. Settee and 6 fauteuils, Beauvais
panels. 7 for 4,300

1923 Marquis de Carsaux, Paris. Screen, day-bed and bergère
by Jacob, late Louis XVI (see 1911), bought-in. 3 for 2,480

 Lord Leconfield. C. 12 fauteuils, Louis XV, Gobelins
tapestry (see Hamilton Palace, 1882; also 1926). 12 for 9,450

1924 Bloche-Levalois, Paris. Settee, 6 fauteuils, Aubusson
panels after La Fontaine, much restored. 7 for 2,750

 Settee with a panel from the *Tenture des Dieux* after
Claude Audran, exceptional piece. 350

 Jules Porges, Paris. 1 settee, 8 fauteuils, various Beauvais
panels. 9 for 5,250

£

1926	Lord Michelham (Hampton's). 2 settees, 6 fauteuils, Beauvais tapestry after Boucher. The all-time auction record for a tapestry furniture suite. 8 for	27,825
	2 settees, 12 fauteuils and chairs, panels from the Beauvais series, *Les Arts et les Sciences*. 14 for	11,025
	Settee and 10 fauteuils in Aubusson tapestry. 11 for	9,925
	Dutasta, Paris. 12 fauteuils, Louis XV, re-covered with Gobelins panels (see 1882, 1923). 12 for	10,700
1927	Joseph Bardac, Paris. 2 settees, 6 fauteuils, Beauvais panels of military subjects after Casanova (see 1890, 1894), woodwork almost entirely renewed. 8 for	11,150
	Salomon, New York. Settee, 4 fauteuils, 2 bergères, Beauvais panels, the chairs themselves late replacements, the originals having belonged to Marie Antoinette. 7 for	9,070
	Château de Fleury, Paris. Settee, 2 bergères, 4 fauteuils, 2 chairs from Fontainebleau, *c.* 1770, covered *en soie brechée* (see 1778). 9 for	4,280
1928	Paris. Settee, 4 fauteuils, Louis XVI, tapestry (see 1930). 5 for	5,240
	Elbert Gary, New York. Settee and 10 fauteuils by Sené, with Beauvais tapestry panels of 1782 (see Chappey, 1907); a serious decline in value (see also 1938). 11 for	12,350
1929	Paris. Settee by Gourdon, Aubusson tapestry.	1,325
	Viscount D'Abernon. C. 4 fauteuils, 4 chairs, Louis XV, Beauvais panels. 8 for	2,625
	Settee, Louis XV, yellow silk.	1,105
1930	Barnet Lewis. C. 2 settees, 6 fauteuils, Louis XV, Beauvais tapestry. 8 for	850 10s
	Another suite, same size, Aubusson tapestry, seats by Nogaret of Lyons. 8 for	900
	C. 6 fauteuils, part gilt, petit-point covers. 6 for	1,218
	8 fauteuils, Gobelins fruit and flower panels, Louis XV, walnut (Vanderbilt Coll.). 8 for	4,095
	Paris. Settee, 4 fauteuils, Louis XVI, Beauvais tapestry (see 1928, £5,240). 5 for	2,970
	Settee, 6 fauteuils, Louis XV, tapestries with hunting scenes. 7 for	905
1932	Lady Louis Mountbatten. C. Big settee and 8 fauteuils, Louis XV, tapestry from the Aesop and Chinoiserie suites. 9 for	892 10s
1933	Mrs Frank Bibby (J. D. Wood). Several Louis XV and Louis XVI fauteuils with tapestry panels averaged less than £55 each.	
	Viscount Dillon. S. 2 settees, 6 fauteuils, Louis XV, Beauvais panels from the Aesop suite. 8 for	1, 700
1934	Moor Park. C. English suite in French style designed by Robert Adam, tapestry by Neilson, 1766–9: 4 fire-screens, 2 settees, 10 fauteuils, 2 stools, 2 window-seats. 20 for	2,803 10s

£

1935	Solly Joel. C. Settee and 8 fauteuils with Beauvais panels after Oudry.	9 for	2,730
1936	S. Settee, 6 fauteuils, Beauvais panels after Huet, with some matching hangings.	7 for	3,500
1937	Comtesse de Greffulhe. S. 2 settees, 12 fauteuils, Beauvais panels (described in the *Goncourt Journal* for 1891).	14 for	4,900
1938	George Rasmussen. C. Settee, 10 fauteuils, Beauvais panels by Sené, 1782 (see 1907, £18,000, 1928), bought-in.	11 for	3,255
	Rufford Abbey. C. 2 settees, 6 fauteuils, Beauvais panels, Louis XVI.	8 for	1,207 10s
1943	Viscountess Harcourt. C. Settee and 8 chairs, "Louis XV taste", Gobelins tapestry panels after Huet.	9 for	378
1946	Hugo Moser, New York. Pair of tapestry-backed fauteuils Louis XV.	2 for	370
1948	S. 6 fauteuils by Heurtant, Louis XVI, Beauvais panels depicting musical instruments (see 1953).	6 for	2,520
1950	Baroness Burton. C. 12 Louis XV fauteuils, Beauvais panels after Oudry, *Fables of La Fontaine*.	12 for	2,730
	2 giltwood settees, 82in, Beauvais panels after Boucher.	2 for	1,680
	Paris. 2 Louis XV fauteuils with Beauvais floral panels.	2 for	1,219
1953	Sir Oliver Welby. C. 2 Louis XVI gilded settees with brocatelle covers.	2 for	2,205
	Alan Good. S. 6 fauteuils and a settee in French style, Norman of Soho, 1764, covers by Neilson, Gobelins, slightly later.	5 for	1,575
1955	P. E. Rank (Philips). Settee and 6 fauteuils, Louis XVI, cream and gilt, Beauvais panels.	7 for	1,000
	Paris. 2 settees in damask, very rich, Louis XVI, by Tilliard.	2 for	7,500
	Louis XV settee by Avise.		3,500
	8 fauteuils, Louis XV, silk damask, by Delanois.	8 for	3,850
1956	C. 2 Louis XV bergères with panels from the *La Fontaine Fables* suite (see 1950).	2 for	1,890
	Cassel von Doorn, Paris. 2 bergères by Tilliard, damask.	2 for	4,200
1957	Paris. Suite of 5 fauteuils and 1 settee, Régence, à dossier plat.	7 for	6,300
1960	C. 6 painted and carved fauteuils by Lebas, Louis XV, brocade covers.	6 for	7,860
1961	Lilian Whitmarshe, New York. 2 Louis XV bergères, gold brocatelle covers.	2 for	2,320
	Myron C. Taylor, New York. Gilt and painted canapé by Foliot, yellow satin, Louis XVI.		3,748
1962	Paris. 6 flat-backed fauteuils by Delanois, Louis XV Aubusson tapestry, regilded.	6 for	7,440
1963	Paris. 1 settee, 6 fauteuils, damask, Régence period.	7 for	9,120

FURNITURE

Smaller Objects in Gilt Bronze, etc.

Including candelabra, wall lights and mounted marble vessels. Excluding mounted porcelain, for which see under the heading, Porcelain.

£

		£	
1749	Lazare Duvaux accounts. 6-branch candlestick, ormolu and Vincennes porcelain flowers.	76	
1750	Crozat, Paris. Oval porphyry basin and cover, 24in × 24in, gadrooned with satyr-head handles carved from the block.	80	
1755	Duc de Tallard, Paris. Mounted porphyry vase on granite plinth, 22in × 21in (see also 1776), satyr handles carved from the block.	217	
1756	Lazare Duvaux accounts. 2 Medici vases in gilt bronze. 2 for	60	
1767	Julienne, Paris. Pair of porphyry urns fitted with bronze masque handles. "On sait de quelle difficulté est le travail du porphyre" (see 1780). 2 for	520	

1771 Bolton and Fothergill. C. Newly delivered from the workshop, Soho, near Birmingham. Ormolu objects in French taste:

7-light candelabrum on the largest root-of-amethyst vase known, supported by 3 gilt-bronze figures of "Persians" (see 1778), bought-in.	199	10s
Another mounted root-of-amethyst urn.	52	10s
Tripod incense-burner candelabrum.	52	10s
Ditto, designed by "Athenian" Stuart.	50	18s
Amethyst potpourri vase on caryatids.	26	8s
Pair of table candlesticks. 2 for	16	16s

("Root of amethyst" was Derbyshire spa, or blue John, of which Bolton owned the monopoly.)

1771-3 Fittings for the Salon Carré at Louveciennes, made for Mme du Barry by Gouthière:

A feu, or half-fender, with shovel and tongs.	240	
A pair of feus for which the design had been changed. 2 for	560	
2 pairs of wall-lights.	480	
2 girandole candlesticks, figures by Boizot. 2 for	102	
3 multiple wall-lights. 3 for	837	10s
2 tripod incense-burners. 2 for	494	
3 door-knobs and fittings. 3 for	149	
Mounts for 3 doors. each	168	8s

£

1772	Paris. Made by Belanger and Gouthière for the Duc d'Aumont: Red-jasper fluted bowl, 8in wide on a 19in gilt-bronze tripod with a twined serpent (see 1782, 1831, 1865) (Wallace Coll., F.292).	60	
1774	Sir George Colebrooke. C. 2 "amethyst" vases (Bolton and Fothergill?) mounting 6-light gilt-bronze candelabra, bought by Lord Grosvenor. 2 for	66	3s
1776	Blondel de Gagny, Paris. Gondola vase in marble and ormolu after Duplessis, 14in high with cover, lion-masks.	96	10s
	Urn with pineapple lid, gilt-bronze, 19½in.	56	
	2 mounted antique alabaster vases and covers. 2 for	68	9s
	2 vases of verde antica with satyr heads. 2 for	132	
1777	Randon de Boisset, Paris. Mounted porphyry vase, 14in.	60	
	2 others, 30in × 24in. 2 for	274	
	A 3rd on granite plinth, 22in × 21in (see 1755).	144	
	Miniature porphyry urn on turquoise plinth, 9in × 6in.	56	
	Verde antica vase and plinth, heavily mounted, 11in × 10in.	96	
	2 similar "moins fort" (see 1780). 2 for	240	
	Medici vase, the body of ancient serpentine marble, on 40in rose-marble column, gilt-bronze mounts.	80	
	2 heavily mounted rose-marble urns and covers (see 1809).	96	
	Mounted granite basin with 2 gilt-bronze swans, 16in × 19in.	86	
	Lapis lazuli tazza supported by gilt-bronze amorini, 9in × 6in.	73	
	Similar tazza of sanguine jasper (see 1781).	96	
	Gondola vase, supported on dolphins' tails, sea-god masks, and bulrushes.	96	
	Onyx cup (Renaissance?), gondola-shaped, rococo mounts.	47	
1778	Bolton and Fothergill. C. The Persian amethyst candelabrum (see 1771).	54	12s
1780	Poullain, Paris. 2 mounted porphyry vases, 2ft high (see 1767). 2 for	160	
	2 verde antica gondola vases (see 1777). 2 for	80	8s
1781	Ordered by Louis XVI from Pitoin: 2 10in gilt-bronze candlesticks on dolphin's tails and caryatids (Wallace Coll., F.164–5). 2 for	112	
	Duchesse de Mazarin, Paris. Serpentine marble vase, mounted by Gouthière, 14in.	48	
	Bowl of sanguine jasper, mounted on amorini, (see 1777).	96	
1782	Boileau, Paris. Lapis lazuli tazza, 9in diam., on elaborate gilt-bronze supports, 18in high, bought by Marie Antoinette.	86	10s
	Duc d'Aumont, Paris. Bowl of jasper on an elaborate Gouthière tripod mount with a gilt-bronze serpent (see 1831, 1865), bought for Marie Antoinette.	480	

				£	
1782	4 wall-lights by Gouthière, over 6ft long.	4 for		729	
	Bought-in, but subsequently sold to the King.	4 for		800	
	2 Medici vases, mounted porphyry, bought by the King.	2 for		125	10s
	Mounted porphyry column with gilded capital, ditto.			288	
	Mounted Giallo antico column, ditto.			114	10s
1784	Supplied by Daguerre for the King at Compiègne: Plain glass-cylinder lantern with caryatid supports in the form of children.			390	
1785	Count de Merle. C. Vase of Alsatian granite and porphyry, supported on gilt-bronze caryatids.			79	16s
1787	Marie Antoinette orders 2 pairs of wall-lights for Compiègne from Forestier and Thomire (Wallace Coll., F.366–9).	6 for		326	
1788	Count d'Adhemer. C. 2 3-branch candelabra on marble vases, ormolu snake handles.	2 for		44	2s
1789	C. Pair of bronze urns with sea-nymphs and fleurs-de-lis in relief, 5-light ormolu candelabra.	2 for		84	
1790	Consigned from Paris. C. Pair of 3-light candelabra, female figures.	2 for		94	10s
	Ditto, bronze figures on marble plinths, bought by Prince of Wales.	2 for		99	15s
	Pair of 4-light candelabra on bronze vases, bought by Lord Courtney.	2 for		105	
1792	"A French lady of high rank." C. Pair of mounted verde antique chimney vases.	2 for		73	10s
	Pair of mounted alabaster urns.	2 for		44	2s
1795	Recently consigned from Paris. C. Table-centre of 6 lights supported on 3 bronze naiads, made for the late King Louis XVI (see 1825).			91	7s
1800	C. 2 4-light candelabra on female figures, 38in high. 2 for			162	15s
1803	C. "A magnificent branch of lilies for 3 lights, issuing from a bronze urn."			23	2s
1809	Grandpré, Paris. 2 heavily mounted urns in rose granite (see 1777).	2 for		46	
	Schwanburg, Paris. 2 Atheniennes, tripod incense-burners of gilt bronze, the pans supported by Victories, 4ft 6in high.	2 for		124	
	Consigned from abroad. C. Pair of 7-light candelabra on bronze figures, signed by Righetti, Rome, 1795.	2 for		94	10s
1811	Ordered by Napoleon for the Petit Trianon. By Lafonte, gilt-bronze lantern in the style of Gouthière.			220	
1813	C. Table-centre, or plateau, composed of malachite plinths, alabaster figures, cut-glass dish and ormolu candelabra.			210	
1815	Late Count Nerveldt. C. Another plateau with 3 draped bronze figures supporting a basket and lights, said to have cost 350 guineas, withdrawn at			315	

£

1817	William Beckford. C. Pair of candelabra, bronze figures of Apollo and Diana, for 7 lights each.	2 for	101 17s	

1820 Maurice, Paris. Brûle-parfum made for Marie Antoinette, with serpentine bowl, 17in diam., and ormolu stand 28in high, made by Maurice and bought back at the Revolution. 146

1823 Farquhar, Fonthill (*ex* Beckford) (Philips). 2 candelabra urns on marble plinths. 2 for 20 9s 6d

1825 Watson Taylor. C. 2 candelabra on lapis lazuli plinths, Louis XVI(?). 2 for 99 15s

 2 6-branch candelabra supported by bronze groups, Louis XVI (see 1795):
 Flora and Zephyr. 246 15s
 Ceres and Triptolemus. 241 10s

1829 Feuchère, Paris. 4 bras, or wall-lights, supporting 12 lights each. 4 for 94 10s

1831 Fournier, Paris. Jasper brûle-parfum (see 1772, 1782, 1865). 48

1836 C. 2 tripod candelabra from the boudoir of Marie Antoinette. 2 for 8 18s 6d

1841 C. 2 pairs of gilt-bronze candelabra from Versailles, 6ft 6in high, both bought-in. {2 for 105
 {2 for 189

 2 girandoles, 11 lights each, supported by bronze groups of boys, bought-in. 2 for 157 10s

1843 Prince Paul Leven. C. Mounted oval surtout-de-table in malachite, Russian Empire style. 37 16s

1845 Lady Mary Bagot. C. Malachite inkstand given by the Czar to Sir Charles Bagot, Russian Empire style. 29 8s
 Paris. Pair of 5-branch candelabra, Sèvres blue plinths. 2 for 78 5s

1848 Duke of Buckingham, Stowe. C. Pair of candelabra on bronze figures, said to have belonged to Mme Pompadour. 2 for 39 18s

 Pair of candelabra for 10 lights each, mounted on bronze groups of putti (Louis XV?), bought by Robert Holford. 2 for 199 10s

1849 Town and Emanuel. C. Pair of candelabra shaped as lilies and mounted on bronze groups of children (Louis XV?). 2 for 84
 2 12-light candelabra supported by bronze boys (Louis XV or modern?). 2 for 100 16s

1851 Earl of Pembroke. C. Pair of 11-light candelabra mounted on bronze satyrs (Louis XV?). 2 for 178 10s

1855 Bernal. C. 2 girandoles for 3 lights each. 2 for 41
 2 4-light candelabra, sphinxes, etc. 2 for 72
 2 candlesticks on bronze Cupids. 2 for 42

1857 Earl of Shrewsbury, Alton Towers. C. 2 black boulle candelabra, 50in high. 2 for 315
 Duchesse de Montebello, Paris. 4 Louis XVI candelabra on lacquered bronze Bacchantes. 4 for 380

£

1860	Angerstein. C. 2 porphyry vases and covers, 26in, Louis XVI ormolu mounts and handles. 2 for	179	
1864	E. W. Anderson. C. 2 Louis XIV candelabra, supported by bronze putti. 2 for	165	18s
1865	Prince de Beauvau, Paris. Porphyry brûle-parfum mounted by Gouthière (see 1772, 1782, 1831) (Wallace Coll., F.292).	1,276	
	2 candlesticks in the shape of Bacchantes, after Clodion. 2 for	644	
1867	Captain Charles Ricketts, RN. C. Spirally fluted urn, boulle inlays and gilt-bronze Negro heads, arms of Cardinal de Retz, Louis XIV before 1677.	687	15s
1869	Frank Davis. C. Pair of porphyry covered urns, Louis XVI mounts and rams heads, bought-in. 2 for	1,030	
1870	San Donato (Prince Demidoff), Paris. 2 Louis XVI candelabra by Gouthière. 2 for	1,400	
	2 gilt-bronze fire-dogs by Gouthière. 2 for	360	
1871	Forestier, Paris. 2 wall-lights, Louis XVI. 2 for	780	
1872	Wallace Coll., 2 small candelabra bought from Charles Mannheim. 2 for	400	
1880	San Donato, Florence. 2 granite vases, mounted by Forestier. 2 for	2,640	
	2 alabaster mounted vases. 2 for	2,220	
	2 candelabra after Clodion. 2 for	1,448	
	2 torchères after Falconet. 2 for	4,400	
	2 wall-lights after Clodion. 2 for	3,200	
1882	Hamilton Palace. C. 2 pairs of Louis XVI candelabra. 4 for	5,145	
	2 ancient porphyry fluted bowls mounted on ormolu pedestals and handles, etc. 2 for	1,365	
	Ewer of Aventurine jasper, possibly Islamic, in elaborate Louis XV mounts.	2,467	10s
1884	Baron d'Ivry, Paris. 2 Louis XVI candelabra. 2 for	2,640	
1886	Charles Stein, Paris. 2 Louis XVI wall-lights. 2 for	640	
	2 mounted porphyry columns. 2 for	880	
	2 mounted porphyry urns. 2 for	780	
	Lafaulotte, Paris. 2 alabaster vases, Louis XVI mounts. 2 for	484	
	2 candelabra on bronze figures. 2 for	480	
1887	Lonsdale. C. 2 pairs of Louis XVI wall-lights (see 1913). 4 for	1,071	
1889	Secrétan, Paris. 2 8-branch candelabra with Clodion figures. 2 for	1,084	
1893	Earl of Essex. C. 2 Louis XVI candelabra. 2 for	1,155	
1894	Barre, Paris. 2 spherical jars of jasper-agate, Louis XV mounts. 2 for	1,160	
1896	P. de G., Paris. 4 torchères, supported by bronze statues, Louis XVI. 4 for	2,820	
	2 candelabra of 10 lights each to match. 2 for	812	

£

1899	Charles Stein, Paris. 2 3-light candelabra, Louis XVI, bronze figures.	2 for	1,320
1901	Hope-Edwards. C. 2 porphyry urns, mounted on altar tripods, Louis XVI.	2 for	3,675
1907	Rikoff, Paris. 2 gilt-bronze chênets, Vulcan and Venus.	2 for	1,604
	2 candelabra, bronze figures, Louis XVI.	2 for	1,000
1911	Lowengard, Paris. 2 Louis XVI candalabra after Clodion.	2 for	1,560
1912	Doucet, Paris. Mounted marbles:		
	Single porphyry vase, Louis XVI.		1,399
	Oval granite vase, ditto.		1,584
	Alabaster vase, ditto.		1,060
1914	Marquise de Biron, Paris. Brûle-parfum, alabaster, on inlaid tripod, various other marbles, Louis XVI.		1,210
	2 jardinières, white-and-blue marble, mounted in neo-classic style, Louis XVI.	2 for	2,156
1919	C. 2 Louis XVI candelabra, enamelled plinths (see 1942).	2 for	997 10s
1920	Sigismond Bardac, Paris. 2 Louis XVI candelabra, mounted on Clodion bronze statuettes (119,900 francs).	2 for	2,450
	Paris. Pair of candelabra on bronze figures after Falconet (171,600 francs).	2 for	3,720
1922	Marquise de Ganay, Paris. 2 candelabra, white marble plinths, Louis XVI.	2 for	1,080
1923	Anthony de Rothschild. C. 2 specially fine pairs of candelabra with bronze figures after Falconet.	⌠2 for ⌡2 for	378 525
	C. 2 more candelabra, 43in, figures after Clodion (Hamilton Palace, 1882, £141 15s).	2 for	630
1926	Earl of Michelham (Hampton's). 2 gilt-bronze urns by Thomire, c. 1790, on Sèvres Bleu du Roi drums.	2 for	3,570
1927	Mme Polès, Paris. 2 Medici vases in agate and ormolu by Gouthière.	2 for	1,280
	Joseph Bardac, Paris. 2 Louis XVI candelabra on marble plinths.	2 for	1,285
1932	Duc de G., Paris. The same pair.		875
	Princess Royal. S. 2 Louis XVI candelabra, 25in, mounted on Meissen figures of swans.	2 for	845
1942	Lockett. C. 2 Louis XVI candelabra, enamelled plinths (see 1919, £997 10s).	2 for	220 10s
1954	S. 2 ormolu candelabra for 2 lights, Louis XV, style of Meissonier.	2 for	1,350
1962	At Motcomb's Rooms. 2 candelabra on single ormolu figures, 2 lights, Louis XV, painted over in white.	2 for	5,100
	S. Pair of Louis XV candelabra, Meissen bases.	2 for	2,700

£

				£
1962	Pair of Russian malachite vases, early 19th cent.	2 for	3,800	
	Pair of glass vases, Louis XVI mounts.	2 for	1,800	
	Paris. Pair of 2-light candelabra, Louis XV, with Meissen parrot fitted to each arm (145,000 francs and tax), about 2 for		12,400	

FURNITURE

Lustres and Chandeliers

1728	Valuation of a lustre. "Crystal d'Allemagne", with iron branches.	£ 180	
1741	Earl of Oxford (Cock, auctioneer). Rock-crystal lustre (large).	21	5s
1748	Lazare Duvaux accounts. 2 lustres "de Bohème, moyens, plus garnis qu'à ordinaire". 2 for	36	
1749	Ditto. Lyre-shaped lustre in rock-crystal.	187	10s
1750	Ditto. Mme Pompadour's ormolu lantern, 4½ft high.	172	
1751	Ditto. Mme Pompadour's 2 glass lanterns with chandeliers. 2 for	140	
1755	Sale of the Duc de Tallard. Rock-crystal lustre, 160 pieces.	640	
1757	Lazare Duvaux accounts. 6-sided lantern for the King, heavily mounted.	198	
	12-light lustre in the form of a cage with a porcelain parrot.	104	
1769	Gaignat, Paris. Lustre, 6ft.	340	
1770	Accounts of Simon Poirier. Lustre for Mme du Barry, Louveciennes, 6 branches, ormolu and rock crystal.	640	
1776	Blondel de Gagny, Paris. Crystal lustre, 8 branches, 54in × 32in.	720	
1783	Blondel d'Azincourt, Paris. The same lustre.	392	
1791	"Imported by Monsieur Daguerre." C. Glass hall lantern with gilt-bronze branches and caryatid figures, bought for Prince of Wales.	166	
1792	"A French lady of high rank." C. Lustre with ormolu branches.	141	15s
1817	Lustre, 26ft × 14ft, made for George IV, Brighton Pavilion.	5,613	9s
1829	Feuchère, Paris. 2 lustres, "Crysteaux de Mont Cenis":		
	For 36 lights.	134	
	For 32 lights.	128	
1851	Earl of Pembroke. C. Ormolu chandelier, the stem formed as a palm tree, 30 lights in Venetian crystal.	231	
1862	Earl of Pembroke, Paris. 30-light chandelier, Louis XV, ormolu and crystal.	928	
1870	San Donato, Paris. Louis XVI chandelier, 8 lights, by Gouthière.	1,560	
	Rock crystal lustre for 24 lights, described as Italian 16th-cent.	2,440	
	Another for 24 lights.	1,960	
	Louis XVI chandelier, gilt-bronze and some crystal.	920	

£

		£	
1871	Sir Richard Wallace buys from Baron Davillier 2 ormolu chandeliers, *c.* 1750, by Caffieri. 2 for	8,400	
1881	Leopold Double, Paris. Rock-crystal lustre, 16 lights (see 1893).	2,200	
1889	Secrétan, Paris. 2 8-branch chandeliers.	1,084	
1890	Marquis, Paris. Small boulle chandelier, 8 lights, Louis XIV.	880	
1893	Camondo, Paris. Rock-crystal lustre, 16 lights (see 1881).	880	
	Earl of Clifden. C. Small boulle chandelier.	829	10s
1923	H. J. King. C. 2 20-light crystal lustres, Louis XV style. 2 for	756	
1927	Mme de Polès. 8-light lustre, Régence.	1,655	
1950	C. Crystal lustre chandelier with Louis XV ormolu branches, 24 lights, 3 tiers.	1,155	
1955	Parke-Bernet, New York. Régence crystal lustre, 48in high, 12 lights.	1,500	
	Paris. Gilt-bronze chandelier, Louis XV, 8 lights.	1,530	
1957	Parke-Bernet, New York. Crystal lustre, *c.* 1795, 12 lights.	1,550	
1962	Lady Benthall. C. English late 18th-cent. cut-glass lustre with glass branches.	4,200	
1963	C. Chandelier, Louis XV, 52in high.	3,150	

FURNITURE

Clocks

		£
1749	Lazare Duvaux accounts. Chiming clock in ormolu.	22
1756	Monumental gilt-bronze clock for the Chambre de Conseil at Versailles.	256
1766	C. Boulle inlaid long-case 15-day clock.	19 19s
1768	Mme du Barry buys the Three Graces Clock by Falconet (see 1881).	96
1771	Bolton and Fothergill, Soho. C. Horizontal clock in French taste, ormolu group, Venus at the tomb of Adonis.	31 10s
	The Avignon Clock (Wallace Coll.), with gilt-bronze nymph, presented to Marquis de Rochechouart at a cost of	456 10s
	Lauraguais, Paris. Clock in the boulle style, with gilt-bronze figures of Day and Night after Michelangelo (see 1777).	60
1775	Hon. Charles Dillón. C. Clock by Lenoir, with bronze figure of Time, etc.	26 15s 6d
1776	Blondel de Gagny, Paris. Huge sculptural clock by Leloutre.	80
1777	Randon de Boisset, Paris. The Night and Day Clock (see 1771).	78
	Prince de Conti, Paris. Rotating sphere clock by Cassini and Lalande.	140
1778	Harrache. C. By Harrache with figure of Astronomy.	25 14s 6d
	Bolton and Fothergill. C. Clock by Bolton, supported by figure of Urania.	18 18s
	Ditto, Anthony and Cleopatra in marble.	24 3s
1779	C. "Ornamented with jewels and designed by a great architect 50 years ago; cost £2,000."	183 15s
	21-day clock by Jules Leroi.	52 10s
1780	Captain Carr. C. 21-day clock by Leroi with recumbent figure.	45
1782	Duc d'Aumont, Paris. By Berthoud, gilt-bronze, fruit and flowers by Gouthière; charged at £291, reduced to £186 10s and finally knocked down to the Duc de Villeroi at	148
1786	Made by David Roentgen for the Empress Catherine, two clocks containing a mechanical orchestra. 2 for	1,500
1788	"23 French clocks." C. 4 musical clocks on lapis lazuli obelisks and plinths with ormolu statues of Mars and trophies: See next page.	

		£	
1788	2 clocks were sold for each	141	15s
	2 clocks were sold for each	147	
1790	Consigned from France. C. By Robin, with gilt-bronze figure of Contemplation.	120	15s
1791	Imported by Monsieur Daguerre. C. By Soliau, with an elaborately sculptured pedestal, bought for Prince of Wales.	160	
	Second sculptured clock by Soliau.	99	15s
1792	"A French lady of high rank." C. With gilt-bronze group, Cleopatra and the ashes of Mark Antony.	73	10s
	By Manière, with groups of infant Bacchanalians and the Four Seasons.	105	
1793	C. By Manière with porcelain case and gilt-bronze figures.	56	14s
1800	C. With marble liseuse figure.	157	10s
1801	"Recently consigned from abroad." C. Musical clock with figure of Africa carried in a palanquin, Louis XVI.	180	
	Musical clock with sculptural group, the God of Day.	280	
1802	Countess of Holderness. C. A version of the Three Graces Clock.	44	2s
1812	Clos, Paris. Regulator by Robin Père, with figure of Time by Taunay.	126	
1814	"Recently consigned from abroad." C. With group of Aeneas, Dido, and Ascanius.	63	
	With group of interceding Sabine women.	124	19s
1819	C. 8-day clock by Breguet in ormolu case without sculpture, bought by Princess Sophia.	199	10s
1821	A collector of taste. C. 8-day musical clock of the most expensive construction.	152	5s
1823	Farquhar, Fonthill (ex Beckford). Ormolu clock, mounted on a bronze horse.	16	16s
1829	Feuchère, Paris. Long-case clock by Lepauté, with gilt-bronze sculptures by Martincourt, after Pajou, Louis XVI; contained a mechanical flute (out of action).	72	
	Lord Gwydyr. C. Long-case clock of great splendour by Charles Boulle, Louis XIV (see 1888).	147	
	The Four Quarters of the Globe, Louis XVI, ormolu figures.	15	7s
1834	C. By Langlois, with gilt-bronze figures of Astronomy and Navigation on marble plinth, bought-in.	56	14s
1836	C. Regulator clock by Lepauté.	24	3s
1841	C. By Laporte, with bronze figures of Astronomy and History.	25	
	The original globe-clock from Versailles, surmounted by group of boys; horizontal movement.	80	
1842	Waldegrave, Strawberry Hill (ex Walpole). By Leroi, reclining bronze figure.	42	
1843	Duke of Sussex. C. Mounted on bleu du roi vase, hour-hand in brilliants.	65	
	By Rogué, gilt-bronze, Europa and the Bull.	42	

£

1847 Mrs Browne. C. Clock-barometer, etc., Peace, Commerce, and Justice, gilt-bronze group from Versailles, bought-in. 73 10s

1848 Duke of Buckingham, Stowe. C. In white marble with figures after Falconet (Wallace Coll., F.272), bought by Marquess of Hertford. 63

 By Leroi on lapis lazuli plinth. 66 3s

1849 Thomas Blaydes. C. Long-case marquetry clock by Berthaud. 48 6s

1850 Debruge Dumenil, Paris. Long-case clock by Boulle, surmounted with gilt bronze figure of Time, Louis XIV. 44

 By Leroi with magots in lacquered bronze. 16

1855 Bernal. C. Clock in form of a temple, mounted with a Meissen group at the top (probably an addition) and dated 1727, bought by Sir Anthony de Rothschild (see 1923). 120

 Clock by Lenoir with added group of Meissen mastiff and puppy. 110

 W. W. Hope, Paris. Garniture of a clock and 2 urns in mounted *gros bleu* Sèvres with medallions. 284

 Massive boulle clock, Louis XIV, with gilt bronze group, Venus *à la coquille*. 560

1858 G. S. Nicholson. C. By Berthoud, Louis XV, Merit rewarding History and Astronomy, gilt-bronze, 25in high, bought by Jones (V & A). 115 10s

1860 Louis Fould, Paris. Boulle clock, Louis XIV, figure of Time, bought by Achille Seillière. 400

1861 Albert, Paris. Musical clock made for the Dauphine in 1763, bought Hertford (Wallace Coll.). 406

1862 Richard Williams. C. By Anaion, supported on a bronze bull and surmounted with figure of Europe. 123 18s

 Earl of Pembroke, Paris. Long-case clock by Boulle, bought by Lord Hertford. 1,000

1864 John Myers. C. By Kenable, pedestal formed of *bleu du roi* porcelain as a lyre, bought-in. 273

 Earl of Clare. C. With green Sèvres pedestal and surmounting vase, 4 different subjects painted in panels. 577 10s

1865 Samuel Cartwright. C. Horizontal clock, style of Gouthière, surmounted by Venus and Cupid. 357

 Mrs Crockford. C. Louis XIV long-case clock, boulle plinth. 446 5s

1866 The Yverdon allegorical clock of 1770, bought by Frank Davis for the Marquess of Hertford, allegedly for £6,000 (Wallace Coll.). 6,000

1867 Philip Salomons. C. Said to be by Gouthière, with gilt-bronze bust of a Negress; musical movement. 126

 Sir Frederick Roe. By Courieult in *gros bleu* porcelain case, shaped as a lyre (*ex* George IV). 263 11s

 Captain Charles Ricketts. C. Clock and barometer by Balthazard, hanging cases with Sèvres plaques. 2 for 260

£

1869 Lord Ashburton. C. With case in Capodimonte porce-
 lain, shaped as a temple, bought by Lord Lonsdale. 168
 Sigismund Rucker. C. Lyre-shaped pedestal in Sèvres
 porcelain, panels on *rose Pompadour* ground, gilt-bronze
 masque of Apollo; movement by Kenable. 903
1870 H. L. Wigram. C. With gilt-bronze figures and
 pedestal in Sèvres *gros bleu* porcelain. 325 10s
 John Bulteel. C. With Sèvres porcelain pedestal on
 ground of *œuil de perdrix*, Louis XVI. 388 10s
 San Donato (Prince Demidoff), Paris. Marquess of
 Hertford buys the clock called La Nymphe à la Coquille
 by Jolly, *c.* 1760. 1,860
 Also a clock by Robin, 1790 (both Wallace Coll.). 560
 Flat clock by Sautiau, supported on a bronze eagle. 660
 V & A buys long-case clock, gilt copper, silver repoussé
 and enamel, with many sculptural figures by Breghtel (The
 Hague, 1690). 1,200
1873 Paris. The Duke of Richelieu's Clock, Louis XV, with
 Meissen figures as base. 134
1875 Château de Veaux-Praslin, Paris. Regulator clock inlaid
 in ebony, boulle style, Louis XVI. 1,020
1877 Robert Napier. C. Lyre-shaped clock, *gros bleu* porcelain
 stem (see 1903). 2,100
1880 San Donato, Florence. White marble, sculpture by Pajou,
 c. 1790. 1,060
1881 Leopold Double, Paris. The Three Graces Clock, figures
 after Falconet, Louis XV, bought by Camondo and left
 to the Louvre in 1911 (see 1768). This remains to this day
 the saleroom record for an 18th-cent. clock (equivalent to
 £24,000). 4,040
1882 Hamilton Palace. C. Urn-shaped clock, revolving dial,
 Louis XVI. 903
 Clock by Dutertre, Louis XVI. 441
 Clock by Kenable, Louis XVI. 462
 Clock by Degault, Louis XVI. 861
1888 Marquess of Exeter. C. 8ft long-case clock by Charles
 Boulle, Louis XIV (Waddesdon Trust) (see 1829). 1,737 16s
1890 Comte d'Armaillé, Paris. Régence regulator clock by
 Cressant, *c.* 1720. 1,440
 Marquis, Paris. Clock, 2ft high, mounted on a Chinese
 celadon vase, Louis XV. 1,924
1891 Lord Cavendish Bentinck. C. Louis XVI clock by
 Audinet. 1,386
 Regulator clock by Robin. 1,320
1893 Earl of Essex. C. Louis XVI clock by Lepauté. 2,520
1895 Earl of Clifden. C. Louis XV clock, Pierre Leroi. 1,008
1898 M. Goldschmidt, Paris. Sculptured clock, child on a
 cushion, by Pigalle, late Louis XVI. 1,320

£

1902	C. Regulator clock, Louis XVI, gilt-bronze, by Gouthière.	3,256	
	Murat, Paris. Clock with 2nd version of Falconet's Three Graces.	2,040	
1903	Mme Lelong. Paris. Louis XVI clock, La Renommée and la Gloire.	1,520	
	Louis XVI, by Lepauté, mounted on a green Sèvres urn, etc.	1,460	
	Page Turner. C. Lyre-shaped clock, Sèvres base (see 1877).	420	
1905	Cronier, Paris. Louis XV musical clock.	1,320	
1907	Edouard Chappey, Paris. The Four Seasons, white-and-turquoise porcelain.	1,280	
1909	Polovtseff, Paris. Louis XV 2-faced clock, gilt-bronze figures.	1,320	
	Régence long-case regulator with an allegorical gilt-bronze group in relief.	2,540	
1912	Surmont, Paris. By le Loutre, Louis XV, with Dresden Italian comedy supporting figures.	1,600	
	Jacques Doucet, Paris. By Lepauté, Louis XVI, sketching girl crowned by Love.	1,280	
	Charles Wertheimer. C. Louis XVI sphere-shaped clock with figures of Cupid and Time.	3,045	
	Louis XIV, Venus and Cupid on drum-shaped base.	2,835	
	Louis XVI long-case regulator, over 7ft.	2,520	
1922	S. By Leroi, Louis XVI, ormolu, 4ft high.	430	
1923	Sir Anthony de Rothschild. C. With Meissen figures, Mars and Venus (see 1855).	294	
1925	Countess of Carnarvon. C. Louis XVI, by Stollwerck, with Sèvres plaques and candelabra.	2,467	10s
1926	Lord Michelham. Hampton's. Louis XVI by François, marble and ormolu.	2,467	10s
1929	USSR Government sale, Berlin. Long-case clock by Lieutaud.	2,900	
1931	Lord Hastings. C. Long-case clock, 8ft high, lyre-shaped pedestal surmounted with Cupid and Psyche group by Duhamel, Louis XV.	1,050	
1932	Duc de G., Paris. Musical clock by Dutertre, with elaborate Louis XV sculptures (£590 in 1925).	550	
	Lady Louis Mountbatten. C. Clock mounted on a bronze rhinoceros, by Vigier and Gouthière.	325	10s
1936	Cahen d'Anvers. C. Clock supported by 3 terracotta nymphs, after Clodion, dated 1788.	1,522	10s
	S. Clock by Leroi with Chinoiserie bronze figures.	1,050	
1947	C. By Dutertre, Louis XV, gros bleu porcelain case.	997	10s
1955	Paris. Musical clock with monkey orchestra, figures by Kändler of Meissen.	2,700	
1956	Baroness Cassel von Doorn, Paris. By Lieutaud in case of Sèvres rose Pompadour.	1,650	
1958	S. Hanging clock en rocaille, by Etienne Lenoir, Louis XV.	600	

£

1960	C.	By Benoist Gérard with lacquered bronze magots and Vincennes flowers, Louis XV.	2,310
		Lord Hillingdon. C. By Baillou, Louis XV, bronze elephant.	1,575
		By Fillon, Louis XV, Meissen figures.	1,575
		Oscar Dusendschon. S. By Leroi, with Meissen peasant lovers.	3,200
1961	C.	By Herbault and Foullet before 1775.	1,785
	S.	Mantel clock by Michel, Louis XV, Chinoiserie figures.	1,350
1962	S.	On bronze elephant by Delachaux.	1,650
1963	S.	On bronze elephant, porcelain mounts.	1,200
		On bronze elephant, Caffieri style.	1,800

GLASS

(For Arab glass, see Near East; for Roman glass, see Classical bronze, etc.)

£

1833 C. Oviform Murano glass, imitating sardonyx, dolphin
handles, ormolu base. 9

1834 Viscountess Hampden. C. "Beautiful tazza of rare
Venetian glass with ornamented [enamelled?] border",
bought-in. 14 14s

1838 "A German baronial castle." C. Large drinking cup
(Humpe), painted with figures and animals. 3 3s
 2 tumblers, figures of Charles XII of Sweden and
 inscriptions, late 17th cent. 2 for 2 4s
 Laticinio, striped tazza and 2-handled cup. 2 for 2 17s 6d

1840 Lady Bagot. C. A large collection of glass, mainly
formed in Holland. There were 173 lots, mostly under £2
and many bought-in. For the enamelled mosque lamp,
see Near Eastern art:
 Pair of fluted ruby bottles (Bohemia) in metal casings,
 16½in high, wrongly ascribed to the 15th cent., bought-in
 (see 1845), nominally. 2 for 79
 Venetian salver, "laticinio", 20in diam. 27 6s
 Venetian goblet, "frostwork". 15
 Bavarian bocale, 9in high, enamels of the Emperor, King
 of France, and King of Sweden, 17th cent. 15 15s
 Enamelled bocale by Lenhardt of Milckau, 1608. 5 18s
 Bohemian bocale, engraved ruby glass, mounted. 11
 Venetian opal-coloured tall glass, laticinio, 12in high,
 bought by Earl of Cadogan. 19 15s
 Ewer, vitro di Trina. 10 10s
 Enamelled English beaker, c. 1760, by Beilby of New-
 castle, arms of Prince of Orange (compare 1960). 1 1s

1842 Waldegrave, Strawberry Hill (*ex* Walpole). Anglo-
Venetian engraved salver, dated 1580 (compare 1947). 10s

1845 Lady Mary Bagot. C. 2 ruby bottles, mounted (see
1840). 2 for 56 14s

1846 Baron, Paris. Bavarian enamelled electoral humpe, dated
1638, arms of Saxony. 3 17s

1848 Duke of Buckingham, Stowe. C. Pair of blue pilgrim
bottles in parcel-gilt mounts. 2 for 17 17s

1850 Debruge Dumenil, Paris. Venetian waisted ewer (buire),
gold flecks. 9 4s
 Venetian flagon, engraved with tritons. 9 4s

		£		
1850	Violet vase, gold flecks (see 1860).	13	10s	
	Cup and cover, aventurine, gold flecks.	12	15s	
	Venetian enamelled chalice and cover.	12		
	Venetian ewer (hanep), 2 portraits, enamelled on deep blue.	9	15s	
	German Reichsadelhumpe, dated 1706.	5	17s	6d
1854	Sir Henry Peyton. C. Venetian ewer, richly enamelled, but lacking handle.	20		
1855	Bernal. C. 2 of Horace Walpole's Venetian plates, red grisaille painting on opaque white glass (10s each in 1842). 2 for	20		
	Venetian enamelled tazza, bought by Gustave de Rothschild.	54		
	2 ruby glass flagons (Bohemia), bought by Anthony de Rothschild. 2 for	81		
	2 ruby wine-stoops in silver-gilt casing. 2 for	56		
	German Elector's tankard, or Reichsadelhumpe.	6		
	German flagon and cover, enamelled Last Supper.	25	4s	
1858	G. S. Nicholson. C. German (Bohemian?) ruby-glass decanter, silver-gilt mounts.	30	9s	
	David Falcke of Bond Street. C. Venetian blue-glass bottle, 13in high in shape of a peacock.	51	9s	
	Standing cup and cover, 22½in high, called Venetian, with cypher of Charles XII of Sweden.	74		
1860	Loewenstein Bros. of Frankfurt. C. German enamelled Reichsadelhumpe, 1607.	7		
	Louis Fould, Paris. Venetian vase and cover, violet, flecked with gold (see 1850), bought by Alphonse de Rothschild.	59	4s	
	"Buire" with flowers enamelled on blue Venetian glass, early 16th cent., bought by Gustave de Rothschild.	96		
1861	Prince Soltykoff, Paris. 76 lots of Venetian 15th–16th-cent. glass, mostly enamelled (*ex* Debruge Dumenil):			
	Goblet, late 15th cent., with enamel of boy riding a monster (James de Rothschild).	160		
	Cylindrical cup, enamelled frieze of figures.	160		
	Green cylindrical cup, nearly 9in, 2 enamelled portrait medallions, bought by F. Slade.	236		
	See also Near Eastern Art, Enamelled Glass.			
1865	Samuel Cartwright. C. Venetian blue dish with imperial eagle in enamel, 16th cent.	17	10s	
	Earl of Cadogan. Tall opalized Venetian goblet.	68		
	Boat-shaped vessel, surmounted by dragon.	52	10s	
1869	Alessandro Castellani. C. Nuptial chalice, green Venetian glass, portrait of a lady in enamels, *c.* 1500.	160		
	Ditto in blue glass with 2 portraits.	95		
1872	V & A buys Bohemian mounted cup and lid, engraved green glass, dated 1656.	10		
	Reichsadelhumpe, dated 1673.	15		

£

1873 V & A buys Venetian 15th-cent. blue ewer, enamelled with
marine group, 8in high. 60
1882 Hamilton Palace. C. Dutch tankard, 1663, lid inlaid with
medal head of van Tromp. 42
1884 von Parpart, Cologne. 15th-cent. Venetian bowl, classical
putti on blue glass. 1,250
 Another bowl with man's portrait bust in the centre. 445
 Alessandro Castellani, Paris. Purchases by V & A:
 Venetian goblet, pagan figures, enamel dots, nearly 8in
 high, early 16th cent. 162 10s
 15th-cent. cylindrical tumbler, enamels. 320 10s
 Green goblet, late 15th cent., enamelled swans and
 powdered gold. 360 10s
 Cup and cover, late 15th cent., laticinio and cabuchon
 jewels. 360 10s
 16th-cent. agate glass in copper-gilt mount. 209 10s
1886 Charles Stein, Paris. Venetian blue-glass porringer and
cover, 15th-cent. enamels. 525
1892 Hollingworth Magniac. C. Late 15th-cent. Venetian
goblet. 225
 Ditto, flask. 210
1893 Frederick Spitzer, Paris. Venetian 15th-cent. enamelled
goblet, combat of centaurs. 274
 Ditto, pilgrim bottle, David and Goliath. 368
 Armorial Reichsadelhumpe, dated 1672. 280
 Venetian enamelled tazza, 16th cent. (see 1940, 1962). 52 8s
1899 Charles Stein, Paris. 15th-cent. Venetian beaker, cylindri-
cal, legend of the Virgin on blue ground. 480
1903 Thewalt, Cologne. Bavarian enamelled Humpe, dated
1586 (Cologne Museum). 200
 German enamelled ewer with silver mount (Nuremberg
 Museum). 257 10s
1905 Boy, Paris. Venetian 15th-cent. ewer, blue glass, flat sides,
enamelled female heads (equivalent to nearly £13,000 in
1963 and certainly an auction record for a piece of European
glass). 2,120
1911 von Lanna, Prague. 15th-cent. Venetian blue milk goblet,
with enamels. 365
 Late 17th-cent. German goblet, enamels by Schaper,
 after Jacques Callot. 305
1919 S. Young Pretender glass, late 18th cent. 220
1920 Miss Trelawney. S. Jacobite goblet, "revirescit". 395
1927 S. Mid-18th-cent. armorial goblet by Beilby of Newcastle
(compare 1840, 1960). 220
1929 Kirkby Mason. S. Alleged "Luck of Muncaster",
French enamelled beaker, 1520-50, 6⅜in. 240
 Venetian armorial enamelled beaker, c. 1520. 100
 Young Pretender engraved decanter. 148

£

1930	Hamilton Clements. S. Anglo-Venetian goblet, late 16th cent.	180

1930 Hamilton Clements. S. Anglo-Venetian goblet, late 16th cent. 180
 Young Pretender enamelled goblet, 5½in. 160
1935 Joseph Bles. S. The Royal Oak Goblet with engraved royal portraits and arms, 1663. 580
 Jacobite Young Pretender cups, 1752 and 1750. 2 for 240
 Jacobite Amen goblet, 1720. 448
1936 Keuster. S. Potsdam engraved ruby glass goblet by Johann Kuenckel, c. 1700. 54
 15 other Kuenckel glasses at under £30 (compare 1960, 1962).
 S. Newcastle armorial decanter by Beilby, 1765, enamels (compare 1927, 1960). 28
 Silesian cup and cover, c. 1700. 42
1938 S. Dutch engraved green goblet by Greenwood, dated 1747. 320
 German 16th-cent. Humpe, enamelled prunts. 250
1940 Eumorfopoulos. S. Diamond-engraved Venetian dish, 16th cent. 150
 Tazza, Murano, late 15th cent., trionfo in enamels on dark blue, base missing. 305
 Enamelled Venetian glass ewer, c. 1500 (see 1953). 45
 Enamelled Venetian tazza, c. 1500 (see 1893, 1962). 48
1943 Colonel Ratcliff. C. Ravenscroft goblet, honeycomb shape, c. 1680 (was a record price for an English glass). 651
 S. Armorial goblet, c. 1760 (Newcastle, Beilby). 345
1947 S. The earliest date-inscribed English glass. One of 7 surviving by Jacob Vezzellin, incomplete beaker, dated 1576 (compare 1842). 1,400
 Enamelled armorial goblet by Beilby. 250
 Tazza by Ravenscroft, Henley, 1675. 300
1948 S. Beilby Newcastle armorial goblet, royal arms in enamels, dated 1762. 700
1949 S. Bristol opaque vase with Chinese paintings by Michael Edkins. 230
1953 S. Venetian enamelled ewer, c. 1500 (see 1940). 400
1956 S. Ravenscroft decanter-jug, c. 1670, 12½in. 460
 William III goblet with engraved bust portrait. 380
 Lempertz, Cologne. Bavarian 17th-cent. honeycombed beaker. 340
 Bavarian armorial grooved beaker, 1662, 8½in. 260
1958 Duke of Devonshire. C. Venetian goblet, late 15th cent. 1,470
1959 Wombwell. S. The Fairfax Cup. A somewhat crudely enamelled Venetian blue-ground glass, c. 1460, depicting Pyramus and Thisbe. 4,600
1960 S. Cut ruby glass beaker and cover by Gottfried Spiller, Potsdam, style of Kuenckel, early 18th cent. 850
 14in goblet and cover, Petersdorf, c. 1700, intaglio-cut portrait of Augustus the Strong. 900

£

1960	Enamelled English goblet by Beilby of Newcastle, *c.* 1760, with royal arms, 9¼in (see 1927).	1,850
	Jacobite glass, late 18th cent., etched portrait of Flora Macdonald.	800
1962	S. Potsdam goblet and cover, 1730 (£20 in 1936).	260
	Silesian covered goblet, *c.* 1750 (£12 in 1936).	230
	C. Bowl, *c.* 1520, Murano, Medici arms.	315
	Laticinio vase and cover.	294
	S. Venetian enamelled tazza, *c.* 1500, bought by Cassel Museum (see 1893, 1940).	380
1963	Lord Astor of Hever. C. Late 15th cent. Venetian goblet, 7½in high, polka-dot enamels.	1,260

HENRI DEUX WARE, OR ST PORCHAIRE FAIENCE

(Formerly called faience d'Oiron or faience d'Henri et Diane)
About 76 were known to exist in 1952
c. 1530–1580

		£	
1839	First examples rediscovered at Château d'Oiron, and published by Sauvageot.		
1842	Waldegrave, Strawberry Hill (*ex* Walpole) (Robins). Sold as majolica and bought by Sir Anthony de Rothschild:		
	Ewer.	19	19s
	Tripod salt-cellar.	21	
1842(?)	Hollingworth Magniac buys a hanap from Sauvageot (see 1892).	96	
1850	Debruge Dumenil, Paris. Hanap, or ewer, with grotesque mask and handle (see 1931).	20	4s
	Cut-down bowl (see 1917, 1940).	16	
	Lid of an urn.	4	
	Preaux, Paris. Flambeau, called a chandelier (£220, including export duty) (Sir Anthony de Rothschild).	196	
	Little ewer with lizards and frogs.	39	10s
	Cup with alleged device of Diane of Poitiers (Sir Anthony de Rothschild).	52	
	Another cup.	44	4s
	Biberon, arms of France.	98	10s
	Vase ovale à couvercle (see 1861).	62	
1859	Rattier, Paris. Triangular salt with columns, etc. (see 1892).	504	
	A second salt, same shape.	252	
	Hexagonal salt.	400	
	Bowl with masks.	300	
	Hexagonal salt bought in Paris by Duke of Hamilton (see 1882).	280	
1861	Prince Soltykoff, Paris. Drageoir à couvercle (see 1850), V & A.	416	
	Hexagonal salt (see 1893).	244	
1863	V & A buys a large, damaged dish from M. d'Espallat of Le Mans.	140	
	Also a tazza and cover.	450	
	Unnamed Paris sale. Candlestick (see 1864).	540	
1864	V & A acquires:		
	13in candlestick with caryatids (see 1863).	750	
	Tazza without relief figures.	180	
	Salt-cellar with columns (*ex* Robert Napier).	300	

£

		£	
1865	Pourtalès, Paris. Large biberon on sculptured stand (see 1912).	1,100	
	A second, fragmentary.	118	
1872	V & A buys Jardinière and lid, 15in high, made by the firm of Minton in imitation of Henry Deux ware, with damascened iron fittings, ordered in Spain.	210	
1882	Hamilton Palace. C. Salt-cellar (see 1859) V & A, per Salting Bequest	840	
	Biberon (see 1865, 1893).	1,218	
1884	Andrew Fountaine. C. Flambeau supported by Cupids bought for Gustave de Rothschild.	3,675	
	Biberon (see 1893).	1,060	
	Mortar supported on columns (see 1893).	1,575	
1886	Charles Stein, Paris. Salt-cellar, bought-in (see 1897).	480	
1892	d'Yvon, Paris. Salt-cellar shaped like triangular temple (see 1859).	1,020	
	Hollingworth-Magniac. C. Huge hanap or ewer with curving spout and human handle (Cleveland Museum).	3,990	
1893	Frederick Spitzer, Paris. Biberon (see 1884, 1937).	1,280	
	Mortar on columns (see 1884).	800	
	Basin with masques (see 1921).	1,220	
	4 others.	380–	
		440	
	Field. C. Salt-cellar (see 1861).	493	
1899	Charles Stein, Paris. Ewer, semi-Gothic.	1,960	
	Hexagonal salt.	780	
1904	de Somzée, Brussels. Damaged hexagonal fruit-stand (see 1931).	400	
1911	C. Salt-cellar, 6in high (see 1951).	210	
1917	Hope heirlooms. C. Elaborate salt, acquired from Debruge Dumenil family in the 1840s and rediscovered in the pantry at Deepdene by Joseph Duveen, Jnr.	3,780	
	Damaged bowl on iron stand (see 1850, 1940).	240	
1921	Engel-Gros, Paris. Basin with masques (see 1893).	2,200	
1931	Walter S. Burns. S. Hanap (see 1850 and 1935) (ex Alfred de Rothschild), bought-in.	3,200	
	Fruit-dish (see 1904, 1935), bought-in.	2,000	
1935	Mrs Walter Burns. S. Hanap (see 1850, 1931), bought by Cleveland Museum.	1,522	10s
	Fruit-dish (see 1904, 1931).	787	10s
1937	Anthony de Rothschild. S. Biberon (since damaged and restored; see 1884, 1893), bought-in.	1,060	
	Countess of Northbrook. C. Armorial fruit-dish.	420	
1940	Eumorfopoulos. S. The Hope Bowl (restored) (see 1917).	240	
1951	C. Salt-cellar (see 1911).	861	
1952	Burns. C. Salt-cellar (see 1893) (Cleveland Museum).	1,102	10s

HISPANO-MAURESQUE POTTERY

14TH–16TH CENTURIES
(mainly 15th-century in this list)

£

1846 C. G. Dodd. C. Curiously formed Moorish lamp and a piece of Gothic pottery. 2 for 11s
Curious plate of early Moorish manufacture from a celebrated French collection. 3s

1850 Debruge Dumenil, Paris. Dish, arms of Leon (see 1867). 3 5s
Ewer, 12in high, 2 birds in blue. 8 3s

1855 Bernal, C. Dish with mock Gothic characters and a doe in blue, bought by BM (*ex* Eugène Piot Coll.). 18
Armorial dish, late 15th cent. (V & A). 15 10s

1857 Leopold Redpath. C. 19in dish, arms of Castille (*c.* 1470). 6 5s
 C. (According to Marryatt.) Dish, 17½in, coat of arms, spread eagle on the outer side (probably *c.* 1440–50). 13 10s
Briony dish, *c.* 1460–70, 17½in. 11 5s

1858 David Falcke. C. Vase, 4 handles, 8in high, flower decoration, probably 16th cent. 2 7s

1859 Montferrand (of St Petersburg). C. 18in dish, imperfect. 3
18in dish, IHS monogram (*c.* 1470). 2 12s
17in dish, briony pattern. 10 10s

1862 V & A buys:
Bowl and cover, 22in high, *cuerda secca* technique, late 15th cent. 80
From Soulages Coll.: vase with wing-handles, *c.* 1460, 21in high, magnificent. 80

1864 V & A buys platter, *c.* 1450, with mock Arabic inscription, 17in diam. 20
Eugène Piot, Paris. 2 20in vases with wing-handles, *c.* 1450. 2 for 100
Basin with a ship in brown lustre, before 1450, bought for V & A. 54 10s

1867 Joseph Marryatt. C. Dish, arms of Leon and briony pattern (see 1850). 5
Azulejo from the Alhambra, late 14th cent (large tile panel). 8

1875 Mariano Fortuny, Paris. Alhambra vase, nearly 5ft high, Malaga, late 13th cent., bought by Basilevsky (Hermitage Museum, Leningrad). 1,200
Fragment of a 2nd Alhambra vase. 118

459

£

1875	Manises vase with wing-handles, *c.* 1450, bought by Basilevsky (Hermitage Museum, Leningrad) (compare 1862).	400
1878	Alessandro Castellani, Paris. Manises basin, *c.* 1460, sold as Siculo-Arab.	125
1882	Fould, Paris. Dish, *c.* 1500.	48
	Hamilton Palace. C. Dish with briony pattern, 1460–70.	84
1884	Castellani, Rome. 2 dishes, late 15th cent.	{66 93
1886	Paris. Amphora-shaped vase, Alhambra type, possibly *c.* 1300.	330
1888	C. Armorial dish, briony pattern, *c.* 1460.	357
	V & A buys a tinaja, a 33in oviform jar in green relief, lacking its handles, Malaga, 14th cent. (the companion vase was bought in 1895 for £50).	100
	Albert Goupil, Paris. Basin and ewer, late 15th cent.	{94 54
1892	Hollingworth-Magniac. C. Wing-handled vase, 22in, *c.* 1450.	707 10s
1894	Paris. An azulejo, or large tile panel, with coats of arms, 15th cent.	780
	A basin with 2 Gothic figures (1440–50).	292
	7 late 15th-cent. pieces.	116– 204
1897	Tollin, Paris. Dish with imitation Arabic inscriptions.	300
	Late 15th-cent. dishes.	50– 200
1900	Paris. Armorial dish, briony pattern.	168
1902	A. Ionides. C. Dish with coat of arms and Gothic lettering.	132 10s
	C. The Monmouth Dish (see 1948) late 15th cent.	79 16s
	Jacques Doucet, Paris. Deep late 15th-cent. dish with flat rim.	164
1904	Mame, Paris. Dish, coat of arms and briony pattern.	320
	Gaillard, Paris. Briony pattern and IHS monogram.	370
1905	Viscountess Esher. C. Damaged armorial dish, early 15th cent.	73 10s
	Louis Huth. C. 2 18in armorial dishes.	{210 215
1906	Keele heirlooms. C. Late 15th-cent. dish.	315
1907	Paris. Armorial dish with cloison panels, early 15th cent.	628
1909	von Lanna, Prague. Late 15th-cent. dish.	360
1910	C. Basin with pseudo-Arabic inscription and coat of arms, *c.* 1440–50.	787
	Maurice Kann, Paris. Somewhat similar in description to the last.	620
1911	von Lanna, Berlin. 3 armorial dishes, late 15th cent.	{875 875 790

£

1911	Joseph Dixon. C. 15th-cent. dish.	430	10s
1912	Paul Tachard, Paris. Early 15th-cent. dish with Gothic bridal pair.	1,720	
1913	Lydig, New York. Dish, c. 1440, pseudo-Arab inscription.	1,653	
1916	Mrs Millbank. C. Mid-15th-cent. dish with betrothal pair.	126	
1917	S. E. Kennedy. 18in briony dish, c. 1460.	472	10s
1919	Gustave de Rothschild. C. Small 15th-cent. tazza, arms of France.	546	
1922	De Reiset, Paris. Briony pattern dish, c. 1460, coat of arms with crown.	1,640	
	Basin with spread-eagle blazon.	690	
1923	Paris. Briony pattern dish, 18in, with heart in centre.	1,020	
	Francis W. Mark. C. 19in dish with bull, emblem of Pope Calixtus III [1455–8].	325	10s
	15th-cent. tazza and cover.	262	10s
	Small 15th-cent. tazza with heraldic lion.	346	10s
1924	Tandart, Paris. Basin, briony pattern and pointed-shield device.	1,550	
	Flahaut, Paris. Basin, before 1450, with the rare yellow colour as well as lustre and blue, part missing.	1,820	
1925	Sir Francis Cook. C. 15½in dish with sacred monogram, c. 1470.	325	10s
	Paris. Flat-rimmed armorial dish, c. 1460.	1,320	
1928	C. 15½in armorial dish with briony pattern (repaired).	152	5s
1931	Walter Burns. S. Early 15th-cent. armorial dish, mock Arabic inscription in blue (see 1948).	880	
1932	C. 18¼in briony-pattern dish with lion.	441	
1934	Avray Tipping. C. Ewer, 15th cent., bought by Fitzwilliam Museum.	346	10s
1945	R. W. M. Walker. C. Armorial dish, briony pattern.	420	
1948	Sir Alfred Beit. S. 17 15th-cent. pieces of fine quality:		
	Armorial dish with lion (see 1931).	820	
	Dish with blue ostrich-like bird, c. 1450.	660	
	19in briony-pattern dish, IHS monogram.	680	
	Dish, c. 1450, studded rim, baking-pan shape.	640	
	The Feversham Dish, c. 1520, from the Taunton Museum (see 1902).	290	
1949	E. L. Paget. S. Albarillo jar, c. 1470, damaged.	130	
	Dish with bird in blue, c. 1450.	440	
	Ribbed armorial dish (see 1912).	600	
1951	W. Randolph Hearst, New York. Armorial 15th-cent. basin from the Schloss Museum, Berlin.	500	
	15th-cent. basin, arms of Castille and Aragon-Sicily.	572	
1952	S. 15th-cent. dish, briony pattern, IHS monogram, 17½in.	440	
1959	S. 9½in bowl with rabbit on shield, late 15th cent.	650	
1961	S. Deep dish, baking-pan sides, badly damaged, about 19in, c. 1490–1500.	600	

£

1961 S. Lady Monro (*ex* Sir Otto Beit). S. 17in dish, arms
of Crêvecœur, eagle on the reverse, *c.* 1470. 3,400
 Arms of Gentili, Florence, *c.* 1450, 18in diam., bought
 by Fitzwilliam Museum. 3,200
 Dish with close-leaf design and armorial centre. 3,100
 Dish with armorial design, *c.* 1460. 1,800
1962 S. Briony-pattern dish, IHS monogram, 18in. 660
 C. 2 early 16th-cent. gadrooned dishes with close floral
 ornament:
 17¼in. 651
 18½in. 462

ILLUMINATED MANUSCRIPTS
8TH–16TH CENTURIES

		£		
1748	The Abbey of St Geneviève, Paris, buys an English 12th-cent. Bible in 3 folios for 120 livres. about	5		
1755	Dr Meade, London. Horace Walpole buys the *Hours of la Reine Claude*, paintings by Geoffrey Tory, *c.* 1540, gold and enamel binding of great sumptuousness (see 1842, 1925, 1942).	48	6s	
1764	From the library of the Marquis d'Argenson. Private family purchases by the Marquis de Paulmy (all now in the Bibliothèque de l'Arsenale):			
	The *Terence* of Jean duc de Berri, *c.* 1420, with 132 miniatures.	29		
	The *Boccaccio* of Jean sans Peur.	10		
	The *Romuleon*, N. Italian, *c.* 1490, 51 miniatures.	40		
1774	Hon. Richard Bateman. C. Many MSS., described as "illuminated", at a few shillings each:			
	"A missal, beautifully illuminated and bound in red morocco with silver clasps."	5	12s	6d
1775	Paris. M. de Paulmy buys a *Book of Hours* in 2 volumes, by the Maître aux Fleurs (Bibiothèque de l'Arsenale).	2		
1781	Duc de la Vallière, Paris. The *Hours of the Duke of Bedford* "with 5,000 miniatures", bought by Duchess of Portland (see 1786) (BM).	200		
	Receuil des Poesies des Troubadours, 14th-cent. French.	60		
1783	Francis Bernard. C. Petrarch, *Des deux Fortunes*, illuminated.	6	16s	6d
	Apocalypse, illuminated.	4	7s	
	"A most curious Hebrew manuscript with beautiful illuminations in a case. N.B. This matchless book cost £2,000 at Lord Oxford's sale." (!)	115	10s	
	A Missal, "extraordinarily fine, with illuminated borders" (cost £120).	115	10s	
1786	Church of Brunoy, Paris. *Antiphonal*, 28in × 22in with miniatures, given by the Marquis de Brunoy (probably late Renaissance).	184		
	Duchess of Portland (Skinner, auctioneer). *Hours of the Duke of Bedford*, given to Henry VI in 1430, Paris school, illuminated on every page; bought for George III (see 1781) and now in BM.	213	3s	
	Missal, illuminated by Giulio Clovio for the Duc d'Alençon, bought by Horace Walpole (see 1842).	169	1s	

£

1792 The Argenson-Paulmy MSS, (then the property of the Duc d'Artois), valued for the Revolutionary Government:

 Book of Hours by the Maître aux Fleurs (see 1775). 16

 10th-cent. Missal of Wurms Cathedral. 12

 Terence of Jean, Duc de Berri (see 1764). 24

 Decameron of Philippe le Bon, *c.* 1440, 100 miniatures. 48

 Chronique of Renaut de Montauban, 243 miniatures in 5 volumes, painted for Philippe le Bon in 1468–70 by Loyset Lyedet. 5 for 120

 Life of Christ by Jean Mansel (Philippe le Bon). 48

 Histoire Romaine of Jean Mansel (Philippe le Bon). 4 for 120

 Josephus, 2 volumes, 27 big miniatures, *c.* 1480. 2 for 48

 All of these still in Bibliothèque de l'Arsenale.

1801 John Strange. S. *Commentaries of Cardinal Grimani*, large paintings by Giulio Clovio (1530–40) (see 1822, 1833). 76 13s

1804 C. *Missal of Sixtus IV*, painted before 1484, partly by Girolamo dai Libri (see 1838). 231 10s

 Missal with 34 miniatures, including murder of Becket, probably 13th cent. 14 14s

1814 Robert Townley. S. The 2nd volume of the *Antiquités judaiques*, painted by Jean Foucquet, 13 huge miniatures. 35

1816 William Roscoe (in Liverpool). *Bible of Clement VII*, N. Italian, 14th cent., bought by Edward Rushton, 508 illuminated leaves. 178 10s

 Resold to the Earl of Leicester. 210

 Part of a block sale from Holkham to the BM, 1952.

1817 Thomas Grenville buys *Triumphs of Charles V*, with miniatures by Giulio Clovio, *c.* 1540 (Grenville MSS., BM) (bought by Woodburn in Paris in 1814 for £4). 350

1818 Delahante, Paris. The Earl of Leicester buys 4 MSS. which had been looted by the French from the Abbey of Weingarten in 1808. They comprised 2 11th-cent. Anglo-Saxon illuminated Gospels and 2 13th-cent. S. German Missals, all in original bindings of repoussé silver or gilt-copper with precious stones. The price was arranged through the bibliophile Phillips (Pierpont Morgan Library, see 1912). 4 for 105

1819 Marquis of Blandford. S. (White Knights Library.) Florentine *Book of Hours*, *c.* 1490 (see 1921), bought by Lord Ashburnham. 25

 Missal of Diane of Poitiers in silver-filigree encased binding, *c.* 1550, bought by Beckford. 110 5s

 Diodorus Siculus, with Geoffrey Tory's portrait of Francis I, *c.* 1520, bought by Beckford (see 1889). 60

1822 Frederick Webb (Evans, auctioneer). Duke of Buckingham buys *Commentaries of Cardinal Grimani* with Clovio miniatures (see 1801, 1833). 157 10s

1827 C. Boccaccio, *Cas des Nobles malheureux*, 150 miniatures, probably French, *c.* 1440. 11

		£		
1827	*Vie de Romulus*, ditto, 54 miniatures.	7	17s	6d
	Lord Berwick, Attingham Hall (local sale). 15th cent.			
	Flemish *Josephus* with 12 full-page miniatures (Sir John Soane Museum).	147		
1833	Duke of Buckingham sells to Sir John Soane *Commentaries of Cardinal Grimani* (see 1801, 1822). Price included 2 unimportant 15th-cent. Books of Hours (Sir John Soane Museum).	756		
	Lewis Wilson. C., Apocalypse, 97 miniatures, ancient binding, early Gothic or Romanesque.	53	11s	
1838	William Esdaile. C. *Roman de la Rose*, dedicated to Francis I by Girard Acarce, with frontispiece and 104 chapter-heading miniatures, bought by Henry Bohn.	91	7s	
	Horae, 14 16th-cent. Italian miniatures.	60		
	Missal of Sixtus IV, 31 full-page miniatures, *c.* 1480, some signed by Francisco and Girolamo dai Libri of Verona (see 1804).	160		
1842	Waldegrave, Strawberry Hill (*ex* Walpole) (Robins). *Hours of La Reine Claude*, "by Raphael", gold and enamel binding (see 1755, 1925, 1942).	115	10s	
	Psalter dated 1537, 21 large miniatures, ascribed to Giulio Clovio (see 1786) (see also Illuminated Miniatures).	441		
1847	Libri, ex-Inspector of Libraries, Paris. Many stolen MSS., including part of the 7th-cent. Ashburnham Pentateuch, bought by the Earl of Ashburnham (see 1888).			
1848	Rev. T. D. Powell. S. Carthusian Breviary, 12th cent. (see 1902).	141		
1850	Debruge Dumenil, Paris. *Preces piae*, French, late 14th cent., 18 miniatures.	48	10s	
	Another similarly described, 47 miniatures.	48		
	South Italian Breviary dated 1404, 14 large miniatures, many initials.	72		
	French Pontifical, *c.* 1430, painted for *Jouvenel des Oursins*, whose portrait appears. 128 leaves, 2 full-page and 138 other miniatures, bought by Soltykoff (see 1861).	396		
1855	Thomas Windus. C. Missal, believed English, *c.* 1265, 67 miniatures.	42		
	The *Blandford Missal*, 38 miniatures, Flemish 15th-cent. borders of birds, flowers, and insects.	41	9s	6d
1856	Samuel Rogers. C. French 14th-cent. *Book of Hours*, 13 miniatures (see also Single Miniatures).	80		
1857	Thibaudeau, Paris. Missal, 13th cent., 53 miniatures.	40		
	Horae, 15th cent., 68 miniatures, 80 borders with flowers, insects, etc.	16	8s	
1861	S. *Apocalypse of Margaret of York*, Flemish, *c.* 1460, painted *en grisaille* (see 1911).	174		
	Prince Soltykoff, Paris. 12th-cent. German *Gospels* in 2 volumes with 4 frontispieces and silver-gilt plated and engraved book covers, bought by Henry Bohn. 2 for	260		

£

1861 *Pontifical of Jouvenel des Oursins, c.* 1430 (see 1850), bought
by Firmin Didot, but ceded to the city of Paris. Des-
troyed in the Hôtel de Ville during the Commune, 1871. 1,460

1864 Duchesse de Berri, Paris. *Hours* of Henri II and Catherine
de'Medici, mid-16th cent., only 3in × 4in, but containing
55 portraits of the Royal House of France, bought by
Napoleon III (Bibliothèque Nationale). 2,400

 Book of Prayers of Louise de Savoie, late 15th cent. 128
 15th-cent. *Book of Hours* with 107 miniatures. 122
 Livre de Chasse of Gaston Phébus, 90 miniatures, soon
after 1400 (similar to Bibliothèque Nationale MS.). 200

1872 J. C. Robinson sells the *Sforza Book of Hours,* 48 Italian
miniatures, *c.* 1490, and 16 Bruges miniatures, *c.* 1519, to
Malcolm of Poltalloch (see 1893). 2,000

 Paris. *Hours of Bussy Rabutin.* 622

1873 Sir Richard Tufton, Paris. 15th-cent. *Book of Hours.* 1,200
 Perkins. S. 2 folio volumes of a *Bible Historiée,* French,
13th cent., 130 pages of miniatures (see 1929). 490

1874 Carrand of Lyons, Paris. *Hours of Anne of Brittany, c.* 1500
(Bibliothèque Nationale). 640

1878 1st Firmin-Didot sale, Paris (Ambroise Firmin-Didot
[1790–1876]). *Grandes Chroniques de Normandie,* school of
Jean Bourdichon, *c.* 1520, bought by Rouen Public Library
(in 1892 it was resold for £800). 2,040

 Chronicles of the Dukes of Brittany, same school. 820
 Le Debat d'Amour de Marguerite de Navarre, mid-16th
cent., 11 miniatures. 804
 Funerailles d'Anne de Bretagne, 1515, 5 miniatures. 532
 Roman de la Rose, folio, French, 14th cent., 2 large, 62
small miniatures (see 1892). 384
 2 10th-cent. classical MSS. with ornamental initials:
 Juvenal, *Satyres.* 144
 Prudentius, *Psychomachia* (9th cent.?). 150

1879 2nd Firmin-Didot sale, Paris. *La Sainte Abbaie, c.* 1300,
French (BM; see 1919). 424
 Hours of Anne of Austria, c. 1410, 71 miniatures. 1,086
 Commentary of Beatus on the Apocalypse, S. France, *c.*
1100, with 110 miniatures (BM). 1,220
 Luxeuil Gospels, c. 1100. 600
 Life of Christ, 11th cent., 30 miniatures. 1,160
 Gradual of Otterbeuren Abbey, 12th cent. (see 1908). 804
 Missal of Charles VI, c. 1400, 364 leaves, more than 500
miniatures (auction record in 1879) (see 1911). 3,200
 Talbot Book of Hours, c. 1440 (see 1919). 780
 Psalter of Bone of Luxembourg, 14th cent. (see 1948). 400

1881 3rd Firmin-Didot sale, Paris. *Histoire universelle,* 14th
cent., 49 miniatures. 520
 13th-cent., *Josephus* (Musée Condé). 440

£

		£
1881	De Beurnonville, Paris. So-called *Gospels of Charlemagne*, late 10th cent., bought by Spitzer.	1,204
1882	Hamilton Palace. Most of the MSS. sold to Prussian Government for £75,000, including the Botticelli drawings for Dante's *Purgatorio*, the Hamilton *Codex Aureus*, an 11th-cent. *Byzantine Gospels*, a bestiary of 1187, a *Bible Historiee* of 1290, the *Boccaccio* of Jean sans Peur and the *Cité de Dieu* of Charles V. Some resold in London in 1889, *q.v.*	
1884	Sir Hayford Thorold. S. *Psalmorum Codex*, printed on vellum, Mainz, 1459, with numerous illuminations.	4,950
	Negotiations begun for the restitution of some of the Ashburnham MSS. to France (see 1847) as part of a block purchase at £75,000 for the BM.	
	The illuminated Ashburnham Pentateuch, 7th cent. Italian or Spanish, valued for the Bibliothèque Nationale at Hamilton Palace. S. *Book of Hours*, Geoffrey Tory, *c.* 1530.	6,500
		1,230
1886	S. *Breviary of Don Alfonso of Portugal*, Flemish, *c.* 1500 (see 1898).	735
	Paris. Early 15th-cent. *Life of Christ*, painted for Philippe le Bon, 16 miniatures.	406
	Crawford and Balcarres. S. The *Mainz printed Bible of 1462*, with 130 Italian historiated initials (see 1948).	1,025
1887	S. Bodleian Library buys the *Gospel Book of St Margaret*, Anglo-Saxon, 11th cent., 4 miniatures.	6
1889	La Roche-Lacurelle, Paris. 15th-cent. *Horae*, 209 leaves (see 1902).	890
	Prussian Government. S. Resale of part of the Hamilton Palace MSS. (see 1882). The sale totalled £15,189.	
	Cité de Dieu of Charles V, mid-14th cent.	580
	Hours, attributed to Gerard David, *c.* 1470.	540
	Geoffrey Tory, *Diodorus Siculus*, illuminated for Francis I in the 1520s with portrait of the King (see 1819).	1,000
	Geoffrey Tory, *Book of Hours*, 1524, 35 miniatures.	1,230
	Boccaccio of Jean sans Peur (see 1764).	1,700
	The Pierpont Morgan *Codex Purpureus*, 9th cent.	1,500
	Greek Gospels, 11th cent. (see 1919).	480
	Hours of Charles V, mid-14th cent., 29 miniatures.	415
	English 12th-cent. Bestiary (Pierpont Morgan Library).	500
1891	Paris. *Hours* of Pope Alexander VI, Bruges, *c.* 1490.	996
	Book of Hours of Etienne Chevallier, by Jean Foucquet. The 40 detached leaves were sold by Brentano of Frankfurt to the Duc d'Aumale for £10,000, or £250 a leaf (Musée Condé, Chantilly); see also under Illuminated Miniatures 1805, 1856, 1922, 1946.	10,000
1892	Paris. French 14th-cent. *Roman de la Rose* (see Firmin-Didot, 1878).	234
1893	*Sforza Book of Hours*, given to BM by Malcolm of Poltalloch (see 1872).	

£

1894	Andrew Fountaine. S. *Prayer-book of Henry VIII*, Flemish early 16th cent.	640
1898	Martin Heckscher of Vienna. S. *Breviary* of Alfonso V, 167 Bruges miniatures, *c.* 1500 (see 1886).	1,420
1899	William Morris. S. *The Sherbrook Missal*, English, *c.* 1320 (£860 in 1920).	350
	Burgundian 13th-cent. *Josephus*.	305
	Bible, France, early 13th cent.	139
	Boccaccio, dated 1462, 369 leaves.	130
1900	Guyot de Villeneuve, Paris. *Hours of Boucicault*, late 14th cent., 44 miniatures (Musée Jacquemart-André).	2,740
	Preces piae, late 15th cent.	1,424
	Heures de Savoie, early 14th cent., 80 miniatures.	720
1901	Earl of Ashburnham. S. MSS. acquired from Barrois in the 1840s. Arthurian romances, French, 14th cent.:	
	"*Launcelot du Lac*", bought by Yates Thompson (see 1921). Three volumes.	1,800
	N. Italian Psalter, 14th cent.	1,530
	Petrus de Voragine, French, 13th cent.	1,500
	Gestes du Sieur de Guesclin, early 15th cent.	1,500
	Chronique de Jehan de Courcy, 15th cent.	1,420
1902	Pillet, Paris. French *Horae*, late 15th cent. (see 1889).	1,400
	S. Carthusian breviary, 12th cent. (see 1848).	1,810
1903	S. A French 13th-cent. psalter with numerous full-page miniatures.	820
	Paris. *Hours* of Marguerite de Rohan, *c.* 1480, 15 large miniatures.	1,560
1905	Earl of Cork. S. *Livres des Images* of Pierre Croisteur, painted for Charles V of France, late 14th cent., 29 miniatures.	2,600
1906	Sir John Lawson. S. *Life of St Cuthbert*, English, late 12th cent. with 49 small miniatures, bought by Yates Thompson (see 1920) (BM).	1,500
1908	Lord Amherst of Hackney. S. German 13th-cent. *Graduale* (see 1879).	1,650
	Byzantine *Gospels*, 11th cent., 2 miniatures (see 1960).	300
	Braikenridge. S. *Book of Hours*, dated 1442, 42 miniatures (see 1945).	460
1909	C. A French *Book of Hours*, *c.* 1520, school of Geoffrey Tory, 44 miniatures.	790
	M.L.D., Paris. Late 9th-cent. Latin *Gospels* with illuminated initials and canons (see 1919, 1932).	1,204
	French *Hours*, *c.* 1400, 20 full-page miniatures.	1,204
	Château de Troussières, Paris. St Gregory, *Moralia*, in 7th-cent. Latin half-uncial script and rubrics.	848
	Part of a 7th–8th-cent. *Gospels* (see 1957).	800
	Gestes des Romains, *c.* 1460, 29 miniatures *en grisaille* (Tavernier?).	802

£

1910 Paris. *Hours*, school of Bourdichon, Tours, *c.* 1500, 37 half-page miniatures. 1,280

1911 Robert Hoe, New York. A sale which introduced a new scale of prices:

 Pembroke Book of Hours, English, 14th cent. 8,000

 Hours of Anne of Beaujeu, French, *c.* 1500. 4,800

 Missal of Charles VI (see 1879). 3,740

 Book of Hours of the Simon Benninck school, Bruges, 1500–20. 2,340

Henry Huth. S. *Apocalypse of Margaret of York*, 78 miniatures *en grisaille*, school of Lyedet, *c.* 1460–70 (see 1861). 3,550

1912 S. *Grande Chronique de France*, 1383, with many small miniatures. 1,650

Boerner, Leipzig. The *World Chronicle* of Rudolf of Ems, dated 1402, 281 watercolour miniatures on paper. 925

S. Carolingian *Gospels* with a few initials, 9th cent. 500

Earl of Leicester, Holkham. The 4 Weingarten Romanesque MSS. (see 1818) sold to Pierpont Morgan, reported price 4 for 100,000

1913 S. *Gospels*, 9th-cent. school of Tours, 5 full-page miniatures. 500

Henry Huth. S. *Hours* of Philippe of Commines, *c.* 1490, 37 miniatures. 2,000

French *Hours* of *c.* 1420, 26 miniatures. 1,700

1915 C. *Aspremont Book of Hours*, N. French, *c.* 1300 (see 1922). 813 15s

1919 1st Yates Thompson sale. S. *Hours of* Jeanne de Navarre, 1333–48, with 108 half-page and smaller miniatures, Paris school. 11,800

 La Sainte Abbaie, *c.* 1300 (see 1879), bought by BM. 4,200

 Talbot Hours, *c.* 1440 (see 1879). 1,050

 Martyrology of Monte Cassino, *c.* 1150. 1,600

 Liber Trojanus, Italian, 14th cent., 178 miniatures. 1,225

 Pontifical of Andrea Calderini, Italian, late 14th cent., 78 miniatures. 2,000

 Latin *Gospels*, school of Tours, *c.* 850, with a few initials and canons, gold illumination (see 1909, 1932). 1,775

 Byzantine *Gospels*, *c.* 1100, 34 miniatures (see 1889). 3,450

 Latin *Aristotle*, printed by Aldus of Venice, 1483, in 2 volumes on vellum, each with a magnificent whole-page border as a frontispiece, Crivelli school, Ferrara. 2,900

1920 Earl of Wharncliffe. C. *Book of Hours*, *c.* 1460, by Magister Franciscus (Melbourne National Gallery). 4,725

Mostyn. S. English 12th-cent. *Gospels*, 4 large miniatures, many initials (see 1932). 2,250

Pulleyne. S. French *Horae*, *c.* 1460 (see 1932). 1,950

2nd Yates Thompson sale. S. 34 lots, £77,195, of which 13 are listed here:

£

1920 *Life of St Cuthbert* (see 1906), English, 12th cent., bought
by BM, 49 miniatures. 5,000
Carrow Psalter, English, *c.* 1250, from the Ashburnham
Library, 321 leaves, mostly illuminated. 4,100
Salvin Hours, English, before 1300, 168 leaves, several
full-page miniatures. 2,000
English *Apocalypse*, late 13th cent., 152 miniatures,
bought in Rimini, 1899. 5,700
De la Twyere Psalter, English, *c.* 1320, 13 miniatures. 1,950
Psalter of John of Ghent, English, *c.* 1360, 13 miniatures. 4,000
Hours of Elizabeth the Queen, English, *c.* 1400 (BM, 1960,
per Dyson Perrins). 4,000
Wingfield Hours, English, *c.* 1460, 46 miniatures. 2,200
Bible of Jean, Duc de Berri, *c.* 1400, 72 miniatures (*ex*
Ashburnham Library, 1897). 1,250
Vincent of Beauvais, 2 volumes, 564 miniatures, French,
1360–80. 6,700
Boccaccio of Prigent de Coëtivy, *c.* 1410, 48 miniatures. 8,900
Italianate *Psalter*, possibly Bohemian, *c.* 1300, 200
miniatures on 147 leaves. 8,000
Hours of Dianora of Urbino, *c.* 1515, 29 miniatures. 2,700

1921 3rd Yates Thompson sale. S. *Launcelot du lac*, 3 volumes,
French, early 14th cent., 39 big miniatures, 141 historiated
initials (see 1901). 3,500
Hours of Marquess of Blandford, Florence, *c.* 1490, about 18
miniatures (see 1819). 2,600
Antiphonal of Beaupré, French, *c.* 1290, 49 big historiated
initials, many removed by Ruskin (see 1932). 1,510
French *Bible*, written in England, *c.* 1260, 56 miniatures,
very fine, and an unaccountable price. 420
Otterbeuren Collectuary, S. German, *c.* 1150, 27 minia-
tures. 1,000
Engel-Gros, Paris. 15th-cent. Franco-Flemish *horae*, 150
leaves. 4,950

1922 S. The *Aspremont Hours*, N. French, *c.* 1300 (see 1915),
bought by Melbourne National Gallery. 1,600

1924 Sotheby of Ecton. S. French Bible, *c.* 1330, 503 leaves,
81 miniatures. 3,300
Boccaccio in the Lydgate version, English, *c.* 1460, 158 leaves,
56 miniatures. 1,100

1925 Countess of Carnarvon. C. *Missal of La Reine Claude*,
3in × 2¾in, jewelled binding, 16 miniatures attributed to
Giulio Clovio, *c.* 1540 (see 1842). 2,100
1st Earl of Northwick sale. S. (See Illuminated Minia-
tures.) Complete *Chaucer* with illuminated borders, *c.*
1450. 2,700
Naples Breviary, *c.* 1360, 6 large miniatures, etc. (see 1932). 3,300

£

1926 Mme Etienne Malet. S. S. German lectionary, *c.* A.D. 1000.	2,050
Henri Broelmann. S. French *Livy*, early 15th cent., 22 miniatures.	900
14th-cent. *Beauvais Missal*, 4 miniatures.	970
1927 S. *The Anhalt Gospels*, German, 10th cent., with 4 Apostle pictures, numerous decorated canons and initials, bought by Gabriel Wells.	9,000
14th-cent. Hebrew decorated *Haggadah.*	990
Monte Cassino Missal, 11th cent., 5 miniatures.	1,700
French 14th-cent. *Psalter* with 7 magnificent full-page miniatures.	3,500
1928 2nd Earl of Northwick sale. S. (See Illuminated miniatures.) *Hours*, Simon Benninck school, *c.* 1500.	1,500
1929 Lulworth Castle. S. *The Luttrell Psalter*, English, *c.* 1340, 309 leaves, 41 historiated initials; historiated borders on almost every page.	35,000
The Bedford Book of Hours, English, *c.* 1414, 11 large historiated miniatures and numerous smaller ones.	33,000
Both bought through Pierpont Morgan, Jnr, for the BM.	
Sir George Lyndsay Holford. S. *Petrarch, Trionfe*, with 6 frontispieces, Florence, *c.* 1490.	2,200
French *Hours*, *c.* 1420, 4 fine miniatures.	1,900
Bible historiée, *c.* 1300, 1,034 small miniatures (see 1873).	8,000
S. Boccaccio, *Cas des Nobles femmes*, etc., school of Foucquet, 1460–70.	6,800
Duke of Leuchtenberg, Berlin. Livy, *2nd Punic War*, painted for Lionnelle d'Este, 1449, with 10 miniatures.	2,350
1931 S. French *Livy*, *c.* 1400, 30 miniatures, sold to Vienna.	4,400
Lord Hastings. S. *Ordinances of Chivalry*, English, late 15th cent.	1,600
1932 Lord Lothian, New York. *The Tickhill Psalter*, English, 1310–20, bought for New York Public Library.	17,579
The Blickling Homilies in Anglo-Saxon, dated 971, very little ornament.	15,850
Psalter, written at Lincoln towards A.D. 800, no illuminations.	6,628
St Augustine, French, *c.* 1460.	9,077
French *Livy*, 2 volumes, *c.* 1440.	2,593
1st Chester Beatty sale. S. *Mostyn Gospels*, English, 12th cent. (see 1920).	1,500
Antiphonal of Beaupré, *c.* 1290, 3 volumes (see 1921).	1,580
The Ruskin Hours, N. France, *c.* 1320, 128 leaves, nearly all illuminated.	2,900
Histoire ancienne, French, *c.* 1390, 78 miniatures.	1,200
Hours of Prigent de Coëtivy, *c.* 1445, 148 miniatures, 364 leaves, bought-in.	5,000
Hours (ex Holford), Bruges, *c.* 1500, 56 miniatures.	2,800

£

1933 2nd Chester Beatty sale. S. *Carolingian Gospels*, Tours,
 9th cent. (see 1909, 1919), bought-in. 1,500
 Austrian *Gospels* from Seitenstetten, *c.* 1220, 6 full-page
 miniatures, numerous initials. 1,150
 Naples Breviary, *c.* 1360, 6 large miniatures, numerous
 initials (see 1925). 1,250
 French *Hours*, 1420–30, 16 large miniatures (*ex* Robert
 Hoe, New York, 1912). 1,500
 Foucquet school *Hours* (*ex* Holford Library), 25 minia-
 tures. 2,100
 French *Horae*, *c.* 1460 (see 1920). 710
1936 Earl of Dalhousie. S. *The Evesham Psalter*, English, *c.*
 1220, 2 full-page miniatures and numerous initials of the
 highest quality, bought for BM. 2,400
 Sir Philip Payne. S. Flemish *Psalter*, *c.* 1250, 8 large and
 20 small miniatures. 470
1937 Earl of Lincoln. S. *Hours of Isobel of Brittany*, *c.* 1440,
 32 miniatures. 13,500
 Earl of Aldenham. S. *Accaiuoli Missal*, Italian, 15th cent. 2,300
 Missal painted by Niccolo da Bologna, *c.* 1350. 2,000
 Earl of Lonsdale. S. *Psalter of Henry IV*, late 14th cent.,
 47 miniatures. 5,000
1940 Lady Ludlow. S. 2-vol. *Bible* 14th-cent. French, by the
 "Maître aux Boquetaux", 2 large, 70 small miniatures. 2,400
 Flemish *Hours*, 1500–20, school of Simon Benninck. 1,050
1942 Lord Rothermere. S. *Hours of La Reine Claude* in gold
 enamelled binding, size 3in × 2¾in (*ex* Horace Walpole)
 (see 1755, 1842, 1925). The owner was said to have given
 £8,500. 2,400
 Baron James de Rothschild, Red Cross Sale. *Book of Hours*,
 c. 1410, in the style of Pol de Limbourg, 18 full-page, 5
 small miniatures. 5,800
1943 BM buys from the Duke of Rutland the *De Bohun Psalter*,
 English, late 14th cent., 15 large, 132 small initials. 5,000
1945 R. W. M. Walker. C. *Book of Hours*, French, 1442 (see
 1908). 997 10s
1946 S. *Receuil de Poesies provençales*, S. French, with Bologna
 school margin paintings, *c.* 1360. 7,500
1948 Landau-Finaly. S. (Horace de Landau, d. 1903.) *Psalter
 of Bone de Luxembourg* (see 1879), Paris school, *c.* 1340,
 perhaps Jean Pucelle, size 3½in × 5in, 14 half-page minia-
 tures. This may have been the first MS. to make over
 £1,000 a miniature in the saleroom. 16,000
 The Mainz Bible of 1462, printed on vellum with over
 130 contemporary Italian historiated initials (see 1887). 15,400
 Divina Commedia of Dante, dated 1378, with 3 N. Italian
 miniatures. 3,800
 Froissart's *Chronicles*, 20in folio, with 198 miniatures of
 the Rouen school, *c.* 1520. 8,800

£

1948	*Hebrew Bible and Massorah*, N. Italian, 15th cent., profusely decorated.	1,100
	Flemish *Book of Hours* with 40 miniatures *en grisaille* in the style of Tavernier, *c.* 1480.	4,000
1949	BM buys (per N.A.C.F.) the *Sherburn Capitulary*, dated 1146, 2 frontispieces and many initials.	3,800
1950	Earl of Denbigh. S. *Missal*, illuminated in N. France, *c.* 1350 (see 1961).	5,000
1956	Duke of Newcastle. C. French *Froissart*, *c.* 1400, 5 half-page miniatures.	2,100
1957	Otis T. Bradley, New York. 7th-cent. Latin *Gospels* in uncial characters (*ex* Pierpont Morgan) (see 1909).	7,200
1958	Baron Llangattock. C. Franco-Flemish *Hours*, ascribed to Jean Vrelant, 14 miniatures, *c.* 1460.	32,000
	1st Dyson Perrins sale. S. (£326,620). *Graduale of St Katerinental*, Swiss, *c.* 1312, bought by National Museum, Bern.	33,000
	Vidal Major, Spanish illuminations, *c.* 1280.	28,000
	Hours of Earl of Warwick, English, *c.* 1440.	19,000
	History of Thebes and Troy, French, *c.* 1440.	16,600
	Helmershausen Gospels, S. German, *c.* A.D. 1000, with 4 miniatures of Apostles, 9in × 6in.	39,000
	13th-cent. French *Bestiary*.	36,500
1959	2nd Dyson Perrins sale. S. (£293,030.) English *Apocalypse*, illuminated at St Albans by Matthew Paris, early 13th cent., bought by K. R. Kraus of New York.	65,000
	Psalter of King Wenceslas, Paris, 13th cent., bought by Kraus.	29,000
	Bury St Edmunds Bible, English early 13th cent., 49 miniatures with 58 additional 15th-cent. miniatures.	22,000
	Petrus Lombardus, Bremen, dated 1166, historiated initials.	20,000
	5 other MSS. at from £10,000 to £10,700.	
1960	3rd Dyson Perrins sale. S. (£464,350, making a total of a little over £1,000,000.) Bavarian or Swiss 13th-cent. *Psalter*, 17 full-page miniatures, bought by Kraus (Stuttgart Library underbidding).	62,000
	Poems of Gilles li Muisis, Tournai, 1351 (Royal Library, Brussels).	25,000
	Confessions of St Augustine, Bamburg, 1169 (Bamburg Stadtsbibliothek).	19,000
	Fragment of a *Sacramentary* written at Beauvais, *c.* A.D. 1000.	17,000
	Sachsenheim Hours, *c.* 1470–5 (Württemburg State Library).	16,000
	Hours, school of Simon Benninck, 1500–20.	15,000
1961	Apsley Cherry-Garrard. S. N. French *Missal*, *c.* 1360, style of Jean Pucelle (see 1950), bought by Kraus, New York.	22,000
	Lord Tollemache. S. *Helmingham Hall Bestiary*, English, late 15th cent., 150 drawings, bought by Kraus.	33,000

£

1961	Chaucer, early 15th cent., no miniatures.	12,000
	French poems, illuminated, *c.* 1470.	17,000
	Various owners. S. Hebrew *Bible, with Massorah,* N.	
	French, dated 1260, decorated, but not illustrated.	8,000
	14th-cent. *Psalter* written at Laon.	2,800
	French *Froissart, c.* 1410.	3,400

ILLUMINATED MINIATURES: SOLD SEPARATELY

1805 M. Brentano buys 40 Jean Foucquet miniatures from the *Hours of Etienne Chevallier*, in Basle (see 1856, 1891, 1922, 1946). 40 for 200

1825 Abbate Celotti. C. (Catalogued by W. Young Ottley.) Miniatures taken from the Vatican during the French occupation of Rome, 1797–99:

The Crucifixion, 20in × 16in, painted for Pius IV in 1561 and signed by Bonfratellis (see 1856, 1927). 31 10s

The Holy Women at the Sepulchre, companion piece. 31 10s

Frontispieces from an antiphonal, painted for Pius VIII: Nativity. 31 10s

Holy Women at the Cross. 29 8s

The Pope with the 12 Disciples. 21

2 miniatures attributed to Mantegna:

The Crucifixion. 15 14s 6d

The Circumcision. 14 14s

90 lots made £717 2s 6d; another 22 lots sold in 1826.

1827 Chevalier Franchi. C. 3 miniatures from Italian choirbooks. 3 for 10 10s

1838 William Young Ottley. S. The entire sale made only £361 7s. Most miniatures were bought by dealers, who made them up into 3 volumes. One was acquired by Robert Stayner Holford (see 1927), one by Samuel Rogers (see 1856), and one by the BM in 1850. Large N. Italian frontispiece, the Enthronement of St Benedict (see 1927). 37

1842 Waldegrave, Strawberry Hill (*ex* Walpole; Robins, auctioneer). Large painting (Geoffrey Tory?), Audience of Francis I. 42

Miniature described as a Holy Family. 14 14s

1847 Edward Harman. C. 14 leaves with miniatures from a Missal. 11

1850 Debruge Dumenil, Paris. Full-page miniature from a French *Histoire de Troie*, c. 1460, 2 smaller on the reverse. 12

1854 Samuel Woodburn (*ex* William Young Ottley). C. The Last Supper and the Crucifixion, a large frontispiece attributed to Giulio Clovio, c. 1540. 40 18s 6d

14 large frontispiece leaves, 16th cent., believed Spanish. 14 for 93 9s

Single leaf of an Italian Antiphonal, depicting 15 singing children, Florentine, c. 1470. 8

£

1856 Samuel Rogers. C. King David at prayer with Hell in the foreground, from Jean Foucquet's *Hours of Etienne Chevallier* (see 1805, 1922, 1946), bought by Marquess of Breadalbane (BM since 1886). 16 5s 6d

Illuminated diploma scroll of 1494, with Este family portraits, attributed by Waagen to Girolamo dai Libri. 64 1s

Series of frontispieces by Bonfratellis, 1561–4 (see 1825, 1927):

Crucifixion (see 1825). 40

Pietà (see 1825). 43 1s

Via Crucis. 23 2s

Nativity. 21

All these from the Celotti (1825) and Young Ottley (1838) sales.

1882 Hamilton Palace. C. 2 pairs of German 15th-cent. miniatures bought by J. E. Taylor (for one of them, see 1912). $\begin{cases} 2 \text{ for} \\ 2 \text{ for} \end{cases}$ 110 5s / 162 15s

1891 40 Leaves from Foucquet's *Hours of Etienne Chevallier* (see Illuminated Manuscripts). 40 for 10,000

1892 Hollingworth-Magniac. C. 2 leaves from 15th-cent. Flemish missals. $\begin{cases} 262 \\ 273 \end{cases}$

1893 Spitzer, Paris. SS. Cosmas and Damian and Martyrdom of St Paul, Missal paintings in very rich borders made for Clement VII towards 1520 (see 1928). 2 for 264

1894 V & A purchases:

English 12th-cent. page with 42 panels illustrating the Passion of Christ, perhaps from the *Eadwin Psalter*, Trinity College, Cambridge (for a similar leaf, one of 4 surviving, see 1927). 50

Page from an Antiphonal with initial painting signed by Girolamo dai Libri, *c.* 1500. 100

1901 Earl of Ashburnham. S. 6 pages of paintings by William de Brailes, English, *c.* 1220 (see 1932). 6 for 390

1906 J. Pierpont Morgan buys 8 leaves from the *Bible Historiée* (*c.* 1220) of the Toledo Cathedral Chapter (£1,000 a leaf). 8 for 8,000

1909 C. Virgin and Child, style of Simon Benninck, *c.* 1500. 420

1911 Robert Hoe, New York. 3 leaves of the school of Simon Benninck of Bruges, *c.* 1500, exceptionally rich. 3 for 2,340

1912 J. E. Taylor. C. Single 15th-cent. German page of miniatures (see 1882). 1,050

1913 Boerner, Leipzig. German 12th-cent. page, 2 miniatures. 205
J. P. Heseltine, Amsterdam. French leaf, *c.* 1450. 140

1920 E. V. Stanley. S. Single miniature by Jean Bourdichon from the *Hours of Anne of Brittany* (for the MS., see Illuminated Manuscripts, 1874). 1,000

£

1921	Yates Thompson. S. The Battle of Cannae, 10in × 6½in, Foucquet miniature from a lost Livy MS.	500

1922 St Michael and the Dragon, lost miniature from Foucquet's *Hours of Etienne Chevallier*, sold by Maggs in London (now Musée Condé, Chantilly). — 220

1925 1st Earl of Northwick sale. S. (From the Young-Ottley Coll.). Sienese miniature, late 14th cent., Peter and Paul. — 365
 2 16th-cent. Italian miniatures by Bonfratellis: Crucifixion. — 320
 Descent from the Cross. — 265
 Full-page miniature painted for Clement VII, 1523 (see 1893, 1928). — 160

1926 S. Miniature attributed to Simon Benninck. — 590
 Large 13th-cent. Italian historiated initial. — 295

1927 Sir George Holford. S. (48 lots.) (*ex* Young Ottley, 1838). The 4 Evangelists, by Jacopo da Cione, *c.* 1370. — 690
 St Benedict Enthroned, large frontispiece to the same MS., bought by Duveen (see 1838). — 1,120
 16in frontispiece from an English Psalter of about 1170, one of 4 known, and perhaps Young Ottley's greatest acquisition (for companion page, see 1894). — 1,750

1928 2nd Earl of Northwick sale. S. (14 lots.) Burgundian Crucifixion, *c.* 1400, 3in × 3in. — 960
 Adoration, French, *c.* 1520. — 260
 Day of Judgement in elaborate border, painted for Clement VII, 1523, *en suite* with the two Spitzer miniatures (see 1893). — 530
 Crucifixion *en suite* (see 1893). — 470
 Crucifixion and pietà, 16in Italian frontispiece, *c.* 1490–1500. — 600
 The Visitation, Flemish, *c.* 1470. — 450

1932 Chester Beatty. S. 6 leaves by William de Brailes, English, 13th cent. (see 1901), bought by N.A.C.F. for Fitzwilliam Museum. — 6 for 3,500

1946 S. 2 lost miniatures from the *Hours of Etienne Chevallier* (see 1891, 1922). — {2,900 / 1,300}

1954 Gerald Reitlinger. S. 2 pages and half a page from a *Bible Historiée*, E. French, *c.* 1350, Passion of Christ (bought in 1922 for £10). — 440

1959 S. Single leaf by the painter known as Egregius pictor Franciscus, *c.* 1460. — 6,000
 Small, rather worn, miniature, Padua school, *c.* 1460. — 1,300

1960 S. Leaf from 13th-cent Tuscan Bible. — 4,200
 Christ in Glory, attributed to Sano di Pietro, Sienese, *c.* 1450, much cut. — 900
 6 small miniatures, Lorenzo Monaco school. — 6 for 1,200
 Entombment, Padua school, *c.* 1500. — 1,300

£

1961	S. 14th-cent. Italian initial.	550
	12th-cent. German Missal leaf.	550
1962	Sir Kenneth Clark. S. 18 late 14th-cent. cut-out initials by Niccolo da Bologna. 18 for	3,000
	Florentine cut-out initial, *c.* 1470.	580
	Francis Springell. S. 4 small miniatures from an average French *Book of Hours, c.* 1420. 4 for	1,400

IVORY

(Other ivories under Mediaeval Art, Near Eastern Art)

£

1768 Warre, picture-dealer and toy-man. C. Statuette of
Diana. 2 12s 6d

1769 C. Venus carved in ivory. 4 17s

1771 François Boucher, Paris. Tankard, 14in high, with
gilt-bronze mounts, Bacchanalian figures, probably
German. 32

1772 Morgan, jeweller and toy-man, Arlington Street. C.
Tankard with relief of Saul and Agag, mounted in Holland
for M. Braamkamp (see 1775), bought-in. 36

1774 Hon. Richard Bateman. C. 2 busts of Henri IV and
Sully (see 1796). 2 for 5 10s

1775 Anselm Beaumont. C. Mounted tankard, Agag, spared
by Saul (see 1772), bought-in. 21

 Elegant cup, supported by a boy, by Quillinus (Arthur
Quellinus [1609–69]). 19 19s

 Cup, silver-lined and mounted, attributed to Fiammingo,
Virtue overcoming Vice. 33 12s

1776 Sorbet, Paris. Column with amorini in relief, sur-
mounted by armillary sphere, marble base, 18in high. 32 15s

1778 Harrache. C. Tankard in high relief, surmounted with
group of boys "by Fiammingo". 15

1783 St Hilaire, Paris. 2 plaques by Gerhard van Opstal [1595–
1668], Judgment of Solomon, and Birth of the Innocents.
 2 for 48

1784 St Julien, Paris. Plaque, attributed to Fiammingo, Rape
of the Sabines, 5in × 7in. 26 10s

1786 Duchess of Portland (Skinner, auctioneer). · Tankard, Bac-
chanalian scenes and sculptured lid, silver-lined and mounted
in jewelled parcel gilt. 19 8s 6d

1791 Lord James Manners. C. Several mounted cups and
tankards in the Fiammingo style. 3 15s–
 7 10s

1794 "The valuable museum." C. Plaque with Bacchanalian
figures, thought to be after Titian. 15 15s

1796 "A curious museum." C. Busts of Henry IV and Sully
(see 1774) (*ex* Calonne Coll.). 2 for 8 8s

1801 Earl of Bessborough. C. 6 groups of boys, plaques
attributed to Fiammingo, owned by Duke of Buckingham
in Charles I's time. 6 for 141 5s

£

1802 William Beckford, Fonthill. C. · Cup with Bacchanalian
 figures. 21
 Unmounted tankard, Bacchanalians in relief. 11 11s
 Sarazin, Paris. Round pedestal with Bacchantes. 16 12s
1804 Foucquet, Paris. Round pedestal, Venus and nymphs,
 gilt-bronze mounts. 20
1805 C. "Elegant tankard, beautifully sculptured by Cellini,
 mounted in silver-gilt." 25 4s
1807 Nogaret, Paris. 2 round pedestals, Triumphs of Bacchus.
 2 for 40
1810 Archibald Swinton. C. Silver-mounted tankard. 22 1s
1813 C. 2 large plaques, David and Bathsheba and Susanna
 and the Elders. 2 for 56 14s
1814 Lady Mansfield. C. Chalice supported on silver tritons. 45 13s 6d
 Long frieze of figures "by Fiammingo". 44 2s
1816 Duke of Norfolk. C. Silver-mounted tankard, combat
 of lions and bears (cost £80). 63
 Flagon, figures in relief, solid group of lapiths and
 centaurs surmounting the lid, signed Bernhard Straus of
 Marekdorf-am-Bodensee, 1651, said to have cost 150
 guineas, bought by Garrard. 173 5s
1817 William Beckford. C. Scalloped cup with silver rims,
 mythological figures in relief. 30 9s
 "A noble cup of ivory", marine deities in relief, mounted
 on a plinth as a 2-handled vase. 153
1818 Margravine of Ansbach. C. 2 silver-mounted tankards,
 attributed to Fiammingo (see 1823). 2 for 497
1819 Sevestre, jeweller. C. Flagon, equestrian combat in
 relief, bought-in. 16 16s
 "Noble vase", boys in relief, by Fiammingo, silver
 mounts. 97
 Mounted tankard, infant tritons in relief. 37 17s
1823 Farquhar, Fonthill (ex Beckford). German mounted
 tankard, combat of centaurs. 18 18s
 Cup, cover and stand, made for King Maximilian of
 Bavaria by Magnus Berg, late 17th cent. 94 10s
 Mounted tankard, Rape of the Sabines. 55 2s 6d
 The 2 Ansbach tankards (see 1818). 2 for 294
 Sir Masterman Sykes. C. Flagon with sculpture on the
 lid, attributed to Fiammingo. 100
1827 Chevalier Franchi. C. Mounted tankard by Straus, c.
 1650, combat of wild animals. 39 7s 6d
1829 Lord Gwydyr. C. Tankard, cavalry battle, Austrian,
 early 18th cent. 73 10s
1830 Sir Thomas Lawrence. C. Cupid and Psyche, statuettes
 after the antique. 2 for 16 16s
1838 J. B. Varley. C. Tankard with battles of Alexander in
 Cinquecento taste, bought-in. 81 1s

£

		£	
1842	Waldegrave, Strawberry Hill (*ex* Walpole). Silver-mounted cup, Bacchanalia in relief.	39	18s
1848	Duke of Buckingham, Stowe. C. German tankard in elaborate 17th-cent. silver mount, bought by Charles de Rothschild.	184	16s
	Others	40–70	
1850	Debruge Dumenil, Paris. The dagger of Diane Poitiers, ivory sheaf and handle, alleged 16th cent. (see 1865).	80	
	Ewer and plateau, attributed to Fiammingo. 2 for	110	
	Mounted round box, same style.	26	12s
	Medici vase, 2ft high.	64	
1855	Bernal. C. Cup on an elaborate stand, called "Italian; early 16th cent.", but certainly German and after 1600.	35	
	20in standing cup of excessive elaboration from Portugal (bought by Bernal from Pratt for £150).	200	
1856	Colonel Sibthorp. Pedestal with Silenus and attributes in high relief on ormolu base.	218	8s
1858	David Falcke of Bond Street. C. 4 relief plaques of Bacchanalian scenes, 6½in × 3¼in each, attributed to Fiammingo (*ex* Giustiniani Palace, Padua). 4 for	600	
1860	Loewenstein Bros., Frankfurt. C. German mounted tankard, Bacchanalian subjects.	101	
1865	Pourtalès, Paris. 12in statuette of Hercules, attributed to Giovanni Bologna.	656	
	Tankard in Fiammingo style, bought by M. Thiers.	524	
	Earl of Cadogan. C. Dagger of Diane of Poitiers with handle formed as an armed horseman (see 1850).	245	14s
1866	W. F. Morland. German carved tankard, 11in, with mount.	110	10s
1873	V & A buys relief picture, nearly 8 ft high, including contemporary frame, the Judgement of Solomon, by Simon Troger, early 18th cent.	680	
1875	Couvreur, Paris. Round box and cover, attributed Fiammingo.	112	
1877	Robert Napier. C. Relief in Fiammingo style of 3 amorini suspending papal keys.	96	12s
	Relief plaque, attributed to Algardi, Descent from the Cross.	199	10s
	Mounted tankard, Feast of the Gods.	913	10s
	Mounted tankard, Rape of the Sabines.	115	10s
1882	Hamilton Palace. C. Carved pedestal, attributed to Fiammingo.	556	10s
	Its companion.	162	15s
	2 silver tazze on elaborate ivory stands. 2 for	173	15s
1884	Andrew Fountaine. C. 16th-cent. hunting horn carved with St. Hubert scenes, believed to be French, bought by Egger of Vienna for Alphonse de Rothschild.	4,450	
1887	Sebright. C. Tankard, attributed Fiammingo.	205	

£

1888	Londesborough. C. 16th-cent. hunting horn, scenes from the life of St Hubert (Wallace Collection).	1,071
1892	Hollingworth-Magniac. C. Casket, Italian, late 15th cent., Legend of St Eustace.	1,995
	Hunting horn.	231
	Statue, George and Dragon, late Gothic.	294
1893	Field. C. Pedestal, attributed Fiammingo.	378
	2 German 17th-cent. tankards. 2 for	294
	Frederick Spitzer, Paris. Knife and sheaf, ivory reliefs, French, 16th cent.	680
	Pedestal with reliefs for a statuette.	202
	2 mounted tankards. 2 for	240
	Tankard with statuette on mounted lid.	188
1903	Mme Lelong, Paris. Chaplet of 8 death's heads and other emblems, parcel-gilt mounts, German, 16th cent.	1,060
1910	Cottreau, Paris. Tankard, Fiammingo style.	148
1925	Countess of Carnarvon. C. Hunting horn, 16th cent.	162 15s
	Statuettes of Paris and Venus, c. 1700 (see 1962). 2 for	525
1951	Lempertz, auctioneer, Cologne. German mounted tankard, 17th cent.	324
1952	Lempertz, Cologne. Another, ditto.	155
1955	Bukowski, auctioneer, Stockholm. Mounted tankard by Gregor Leiter, c. 1650.	1,100
1962	S. 2 figurines of Venus and Paris by Ignaz Elhafen, c. 1700 (see 1925). 2 for	1,400
	S. Tankard by Elias Adam, Augsburg, c. 1700.	450
	C. Viennese casket, ivory and enamels, early 18th cent.	546

JAPANESE ART

LACQUER, SCULPTURE, METALWORK, IVORY, ETC.

		£	
1745	Comte de La Rocque, Paris. Large lacquer coffer.	56	
1748	Angran de Fonspertuis, Paris. Another, similar.	56	
1750	From Lazare Duvaux. Lacquer casket with figures of cocks, £5 5s spent on mounting (for Mme Pompadour).	14	8s
1753	From Lazare Duvaux. Mme Pompadour's casket of old lacquer, either the Maria van Diemen Casket or the Mazarin casket (see 1776, 1823, 1882, 1916).	200	
	Also for Mme Pompadour, a mounted writing-box (see 1801).	88	
1766	Late Mme Pompadour, Paris. Casket, green ground (see 1776, 1783).	80	
1768	Gaignat, Paris. Mounted lacquer vase, 18in high (see 1801).	100	
	5-decker box on tray with handles, 6in × 9in, 19 figures in gold relief.	44	
	Barrel-shaped lacquer pot, speckled green.	16	
1770	Count de Sielern. C. Nest of oval boxes with trays on a stand, "Very scarce rare old Japan".	46	4s
	Cabinet, "flat Japan" on frame.	25	4s
1771	François Boucher, Paris. 7 little boxes fitted into a tray, 3in × 6in.	28	15s
1772	Morgan, Arlington Street, C. Cabinet, raised gold on glossy black, bought-in.	61	19s
1776	Blondel de Gagny, Paris. Casket, green ground, on the lid wheeled cart and basket of flowers (ex Mme Pompadour, see 1766, 1783).	43	
	Box mounted as an inkstand, bought-in.	27	
1777	Randon de Boisset, Paris. 3 boxes, gold ground, one with a ship, one with chickens, one with tiger and dragon. 3 for	34	5s
	The Maria van Diemen Casket (see 1753, 1882, 1916) (V & A).	270	
	2 pear-shaped bottles, black ground, mounted with chains. 2 for	52	
	Cabinet of 10 drawers, 23in × 25in.	80	
1781	Duchesse de Mazarin, Paris. Fitted inkstand, 9in × 6in (see 1753).	36	12s
	Oval box, 15in long, with mother-of-pearl and other inlays.	31	6s
1783	Blondel d'Azincourt. Paris. Mme Pompadour's casket (see 1776).	19	6s

£

1786	Duchess of Portland (Skinner, auctioneer). Box and cover, coral inlays.	34 13s
	Hexagonal drawer-cabinet with trays.	30 9s
	Brown-and-gold drawer-cabinet.	33 12s
	Box resembling musical instrument.	24 13s 6d
	Box and cover, imitating a melon.	23 2s
1801	*Ex* Duc de Bouillon, Paris. Purchases for William Beckford.	
	The Mazarin coffer (see 1753, 1823, 1882).	51 4s
	The Gaignat vase (see 1768).	8
	Mme Pompadour's writing-box (see 1753).	20
1809	Captured on the passage to Europe. C. Oblong box, rarest brown-and-gold Japan.	36 15s
	Fan "on the talypat leaf, said to be unique".	31 10s
1812	Col. James Brunton. C. Japanese sword and scabbard and one other, captured from Tippo Sultan at Seringapatam.	2 10s
1813	Captured at Batavia. C. 2 elaborate tables in lacquer and mother-of-pearl inlay. each	14 14s
1821	The Gothic Hall, Pall Mall. Suit of scale armour in lacquered horn, said to have belonged to the painter Loutherbourg.	1 16s
1823	Farquhar, Fonthill (*ex* Beckford). Gold-lacquered idol (see 1882).	6 5s
	Numerous lacquer boxes from the Bouillon Coll. 3	6s–8 10s
	The Mazarin Casket (see 1801, 1882, 1916).	131 5s
1844	Jeremiah Harman. C. Lacquer drawer-cabinet, 34in wide.	25 4s
1848	Duke of Buckingham, Stowe. C. Round-topped lacquer cabinet, captured at Vigo, 1719, bought by Lord Holland.	18 18s
	William Beckford (at Lansdowne Tower, Bath). Lacquer cabinet in form of a temple with three drawers.	18 18s
	Drawer-cabinet in glass case.	11 11s
1857	Duchesse de Montebello, Paris. 208 lots of Japanese lacquer (18th-cent. importations):	
	Small drawer-cabinet.	82
	Box with cocks in gold relief on black.	48
	Fitted needlework-box.	76
1859	1st sale at Christie's of objects consigned directly from Japan since the opening of the ports. Lacquer boxes, gold on black in great profusion, mainly at	1 1s
	Small gold lacquered drawer-cabinet.	6 12s 6d
	"10,000 Japanese lacquer trays." They were sold in lots of 12, mostly at 12 for	1 1s
1861	Newly imported from Japan. C. Pair of new red-and-gold lacquer cabinets, lined with drawers. 2 for	140 14s
1863	Earl Canning. C. Suit of lacquer armour.	13 15s
1864	Lourette, Paris. An Inru and its Netsuke.	36
1865	Earl of Cadogan. C. Oblong lacquer casket, gold-and-black, given by Napoleon to Vivant Denon (see 1882).	105

£

1867 C. Pair of large bronze vases, newly imported, birds and trees in relief. 2 for 59

1868 V & A buys lacquer coffer, 17th cent., nearly 1ft long. 140

1875 A. B. Mitford. C. Lacquer box, inlaid mother-of-pearl. 27 10s

 Tortoiseshell cabinet, gilded fittings. 40 19s

 2 cabinets. 2 for 42

 Netsuke, from 5 to 19 guineas; quails on millet, by Okitomo. 19 19s

1876 V & A purchases lacquer medicine chest or Sagutsu, 13in high, said to have been looted in 1868 from Osaka Castle. 110

1877 V & A purchases 19th-cent. statue of the Buddha, 10ft 8in high, cast in bronze (now in the Museum courtyard). 400

1878 V & A purchases collection of sword-guards or tsubas. each 10s

 Edinburgh Museum buys a suit of lacquered wooden armour. 50

1881 V & A buys 2 modern vases in silvered copper, with relief figures of Arhats, 27in high. 2 for 700

 Brazier in similar style, 11in wide. 100

1882 Hamilton Palace. C. The van Diemen Casket (see 1753, 1777, 1916) (V & A). 315

 The Mazarin Coffer, or Casket, 28in long on carved stand (see 1753, 1801, 1823) (now in the V & A). 682 10s

 Napoleon's Japanese coffer (see 1865). 735

 Beckford's gold lacquer Buddha (see 1823). 131 5s

1883 Viel, Paris. Lacquer coffret. 138

 Fan-painting by Chikuden. 37

 Sword-guard, or tsuba. 39

 V & A purchases modern temple incense-burner, gilt-bronze, 7½ft high, including pedestal in shape of a tree root. 1,586 7s 2d

1885 V & A purchases modern 2-fold screen, silver and gold reliefs on polished wood, bought at the International Health Exhibition. 325

1888 V & A purchases collection of 92 tsubas, or sword-guards for 150

1896 Edmond de Goncourt, Paris. Lacquer writing-box by Korin. 174

 Another by Ritsuo. 82

 Lacquer étagère. 82

1902 1st Hayashi sale, Paris. Life-sized giltwood statue, alleged 12th cent. 204

 Alleged 9th-cent. statue of Bodhisatva. 324

 Speckled lacquer box, 15th cent. 204

 2 lacquer cabinet doors. 2 for 320

1903 2nd Hayashi sale, Paris. Bronze 8th-cent. Bodhisatva (Louvre). 160

 Alleged mediaeval Kakemono painting by the priest Genjo Sanzo (withdrawn nominally at £4,000).

 Buddhist Kobodaiji painting of Fudo. 114

£

1903	Kakemono by Utamaro.	284
	Kakemono by Hokusai.	116
1904	Charles Gillot, Paris. 8th-cent. giltwood figure of Amida, bought by the Louvre.	296
	Alleged 14th-cent. Kakemono of the Bodhisatva Kwannon.	236
	Gold-ground lacquer boxes up to £200 each.	
1906	S. Bing, Paris. 12th-cent. wooden statue of Amida.	300
	Lacquer mirror-case, Kamakura period.	332
	17th-cent. writing-box by Sanraku.	260
	Single Inru.	70
1909	Stewart Happer. S. Set of 10 Hokusai prints, Imagery of the Poets.	340
	Kakemono painting by Hiroshige, The Monkey Bridge.	92
1913	Mène, Paris. Iron statue of a crow, signed Shitsubu Murasaki [1688–1735].	553
	Kyoto, Japan. Sale of the contents of the Temple of Nishi Hongwanji by the Otani family:	
	A Cha wan, or tea-ceremony vessel.	2,240
	Kakemono painting by Okyo, The Koto Player.	1,280
	Smoker's lacquer box.	800
	(See also Screen Paintings.)	
1916	Sir Trevor Lawrence. C. The van Diemen Marriage Casket (see 1753, 1777, 1802, 1882) (V & A).	525
1962	Gilou. S. Bronze Buddha, 29in, lotus plinth, Kamakura period, 13th cent.	1,400
	Glendinings Rooms. Carved Netsuke by Hoshin.	145
	S. Single wooden Netsuke by Ittan, 5 horses	230

POTTERY AND PORCELAIN, INCLUDING MOUNTED PIECES

£

1748 Fonspertuis, Paris. "Two hexagonal urns with covers of old coloured porcelain of Japan, commonly called *à la cigogne*, a very rare article, much sought after in Holland" (see 1962). These were almost certainly Kakiemon. 2 for 19 12s
 Several other recognizable items were clearly not Japanese at all, but Chinese.

1750 Mme Pompadour buys 2 *singes de Japon* which move their heads. From Lazare Duvaux. 2 for 38 10s

1755 2 Japan (Imari?) vases with flowers in relief. From Lazare Duvaux. 2 for 2 10s

1765–70 Imari garnitures of 5 fetching £9 to £12 in London sales.

1770 Count de Sielern. C. 2 fine scalloped bowls of the old Japan. 2 for 7 7s

1772 Morgan of Arlington Street. C. Objects from first Gerret Braamkamp sale, Amsterdam:
 62 lots of "very rare coloured Japan of the first class", clearly recognizable as Kakiemon saucers and bowls of well-known types. pair, from 1–3
 49 lots of "the scarce blue Japan with the brown edge", i.e. early Arita Wares in a Kakiemon style with under-glaze blue. pair, about 1–4

1777 Randon de Boisset, Paris. 2 20in urns and covers with 3 panels of the well-known 2 figures with a parasol (certainly Kakiemon). 2 for 140
 Another pair richly mounted (see 1809). 2 for 244

1780 Captain Carr, East Indiaman. C. Imari garniture, 3 octagonal urns and covers, 2 beakers. 5 for 14 14s

1783 An East India Captain. C. Imari garniture of 5 urns and beakers. 5 for 9 9s

1786 Duchess of Portland (Skinner, auctioneer). Octagonal brown-edged bowl, scarlet dragons (Kakiemon?). 4 6s 6d

1788 Count d'Adhemer. C. Pair of large vases and covers in richly-chased and burnished ormolu mounts. 2 for 26 5s

1794 Charles Bond, Chinaman of Wardour Street. C. 3 octagon jars and 2 round ditto with covers, coloured Japan (Imari garniture). 5 for 1 10s
 "The valuable museum." C. Blue-and-white jar and cover, 3ft high, old Japan (possibly an early Arita type, *c.* 1700). 2 2s

£

1802 Countess of Holderness. C. Table service, old coloured
Japan, 217 pieces, including 72 scalloped Imari dishes.

217 for 157 10s

 Pair of brûle-parfums and covers, "old scarlet Japan
mounted in ormolu with real Chinese figures of the old
Japan" (might be Lacquer). 2 for 99 15s

1803 C. Old Japan, pair of barn-yard fowls, possibly lacquer.

2 for 16s

1804 Eastabrook, East India captain. C. 2 jars, 1 large, 1
smaller (Imari). 2 for 6 6s

1807 A collector of taste. C. Large Japan jar, kylin, storks and
various ornaments. 15 15s

 Similar pair (Imari urns). 2 for 28 7s

1808 C. 3 huge jars and beakers. 3 for 32 11s

1809 Baron de Hoorn, Paris. 2 mounted Kakiemon urns and
covers (see 1777). 2 for 40

1817 Beckford writes that Japanese porcelain is of an inferior
quality and generally horribly dear.

1819 C. Imari garniture of 3 jars and covers and 2 beakers,
standard set. 5 for 33 1s 6d

1823 Farquhar, Fonthill (possibly *ex* Beckford). Imari garniture
of 5. 5 for 15 15s

 2nd garniture of 5. 5 for 38 17s

 5 noble Japan jars and beakers. 5 for 42

1824 Page Turner. C. Imari standard garniture of 5. 5 for 33 12s

1845 Lady Mary Bagot. 3 noble jars and covers, surmounted
by parrots (Imari), 1 defective. 3 for 37 10s

1848 Duke of Buckingham, Stowe. C. 18 plates of rich old
Japan. 18 for 1 18s

1857 John Graham. C. Old Japan bell-shaped vase, rich
colours, heavily mounted, 28in high. 18 10s

 2 19in Japan beakers from Fonthill. 9 15s

 2 20in dishes, ditto. 6 15s

 32in standard Imari urn and cover. 6 10s

1859 Direct imports from Japan. C. Newly-made pairs of
vases, 26in high. "On white and crimson ground",
possibly imitations of old export Imari. 2 for {4 4s
 {5 15s 6d

1860 A nobleman. C. Standard Imari garniture, 3 urns and
covers, 38in, 2 beakers, 24in. 5 for 99

 Pair of jars and covers, "old Japan", 27in. 2 for 119 10s

 (Both sets bought by Murray Marks.)

1863 Dowager Countess Ashburnham. C. Standard Imari
garniture, 3 urns and covers, 36in, 2 beakers, 24in. 5 for 88

 Paris. Garniture of 3 Imari urns with Louis XVI giltwood
bases and covers. 3 for 190

1864 C. 1st mention of Satsuma pottery (17 lots). Oviform
vase, mask handles, enamelled flowers, 12in high. 3 17s 6d

 Paris. Large Satsuma enamelled bowl. 28

			£
1867	Received from Japan. C. Satsuma vase, peacocks and pheasants.		
1869	V & A buys a number of Satsuma pieces on grey and cream crackle grounds, exhibited in Paris in 1867.	each	12 15s 8–13
1877	V & A buys pair of Satsuma vases, 27in high.	2 for	35
	Imari vases, 4ft high.	2 for	73 10s
1882	Hamilton Palace. C. 3 pairs of Imari urns about 28in high, with covers.		
		2 for	⌈315 ⟨336 ⌊420
1883	Viel, Paris. A Hizen bottle (Kakiemon?).		27 7s
1885	V & A buys a Satsuma tray, 27in × 17in.		60
1886	Duke of Marlborough. C. Pair of bottles with flowers in sunken medallions, a well-known early Arita type.	2 for	33 12s 6d
1888	Marquess of Exeter. C. Tall Japan vase, 24in, painted with landscapes in medallions (Kutani?).		231
1891	Lord Haldon. C. Imari garniture of 5.	5 for	262
1894	Joseph. C. 2 Imari jars and covers.	2 for	304
1896	Edmond de Goncourt, Paris. Satsuma square vase imitating a well.		40
	Satsuma box with ivory cover.		60
	Bowl described as orange-red, 18th cent.		32
1903	1st Hayashi sale, Paris. 2 bottles described as Kutani.		⌈18 ⌊21
	Mme Lelong, Paris. Imari bowl, mounted *en rocaille*, together with a Worcester ewer.	2 for	1,640
	2nd Hayashi sale, Paris. Figure in Bizen stoneware.		66
	Pottery figure by Koren.		35
1905	C. 2 Imari bowls and covers, 13½in high, Louis XV mounts.	2 for	525
1908	Muckley. C. 2 Imari jars and covers, plain ormolu plinths.	2 for	147
1909	Comte de Buisseret, Paris. Standard Imari garniture of 3 covered urns and 2 beakers.	5 for	780
1911	Lowengard, Paris. 2 Imari jars, Louis XVI mounts.	2 for	1,240
1912	J. E. Taylor. C. 2 Hizen (Kakiemon) quadrangular bottles with parcel-gilt bases and stoppers.		147
1916	Munemoto, Tokyo (according to *Ostasiatische Zeitschrift*). Owari tea-ceremony bowl.		500
	Vase of 14th-cent. Ko Seto stoneware.		800
	Koro (incense-burner), Yamashiro pottery.		2,500
	Chaire, tea-ceremony jar in silk bag, with tea-master commendations.		2,800
1920	Johanneum, Dresden (80 marks to £1). Pair of Imari rouleau vases, 20in.	2 for	150
	Pair of 23in Imari urns and lids.	2 for	180
	Pair of 17in spherical Imari jars.	2 for	375
	Pair of Kakiemon hexagonal jars and covers, 12in (see 1962).	2 for	690

£

1920 Pair of blue-and-white Arita vases in form of bird-cages.
 2 for 696
 All with Johanneum inventory numbers. Prices quoted
 by Hannover.

1920–53 Period of total abeyance. Practically everything obtainable for under £20.

1955 Mrs Tonbridge. S. Kakiemon 5-lobed dish. 100

1958 Sotheby (Ecton). S. Pair of Kakiemon jars and covers,
 hexagonal (see 1748, 1920). 2 for 190

1959 Marquess of Exeter. S. 2 Kakiemon figures of a stag
 and doe, 1 of them damaged, mentioned in an inventory of
 1688. 850

1960 C. Similar pair, perfect. 1,155
 S. Jar described as Kutani. 95

1962 S. Pair of Kakiemon hexagonal jars of Hampton Court
 type, late 17th cent., modern lids. 2 for 230
 Pair of ditto, early 18th cent., with cranes (see 1748),
 1 repaired. 2 for 220
 C. Pair of Arita figures of boys in kimonos, both damaged. 2 for 138 12s
 Fitzwilliam Museum buys Kakiemon figure of a Geisha
 girl. 180
 Freer Gallery, Washington, buys 19in Kutani bottle, 17th
 cent. 800

1963 S. Pair of hexagonal bowls and covers, Kakiemon in
 Louis XV mounts. 2 for 1,350
 Early Arita jar, called Kutani 240

JAPANESE ART

SCREEN PAINTINGS ON PAPER

		£		
1863	Earl Canning. C. 2 6-leaf screens, landscape subjects, 1 on speckled gold ground, the other on brown. 2 for	73	10s	
1875	A. B. Mitford. C. 6-leaf screen with storks and view of Fujiyama.	168		
1892	V & A buys 6-leaf late 16th-cent. screen depicting the landing of the Portuguese in Japan; said to have been made for Hideyoshi; very poor condition.	30		
1900	V & A buys pair of 8-leaf screens, dated 1826, the Gogats Sekiu, or people's festival, a pair. 2 for	59	11s	7d
1902	Hayashi, Paris. 2 6-leaf screens by Sesson, landscape, monochrome. 2 for	620		
1906	S. Bing, Paris. Screen by Sotatse, 4 panels, flowers on silver ground.	600		
1907	Sominokura, Paris. 2-panel screen of pine and cherry tree by Sanraku.	144		
1913	Sale in Kyoto of the contents of the Temple of Nishi Hongwanji by the owners, the Otani family. 2 6-leaf screens by Korin, blue irises on gold, were said to have made £11,000.			
1914	Arthur Sambon, Paris. 6-leaf screen, Kano Yutoku, flowers and trees, gold ground.	114		
1922	BM buys 2-panel screen, young fir and red acacia, signed by Hoitsu [d. 1828].	200		
	Charles Havilland, Paris. 2-leaf screen in Ukiyoye style, dancers on a terrace.	470		
1924	Louis Gonse, Paris. 2-leaf monochrome screen by Okio, 3 cranes (given to the Louvre).	530		
1925	Puttick and Simson. Pair of screens called Tosa school. 2 for	63		
1963	C. Mountains and figures, Tosa style screen, cut down to 4 panels.	315		

LIMOGES ENAMELS ON COPPER

£

1769	C. "curious enamels on copper, the Labours of Hercules." 2 for	1 10s
1770	Erasmus van Harp of Amsterdam. C. Large round copper dish after Giulio Romano, bought by Lord James Manners.	4 4s
1771	C. 2 very curious antique enamellings on copper in frames. The History of Cupid and Psyche (possibly 17th-cent. plaques of the Laudin school). 2 for	14 3s 6d
1772	Thomas Morgan, "Chinaman" of Arlington Street. C. (13 lots.) Altar-piece (triptych) depicting the Pietà with numerous figures (possibly Nardon Penicaud).	4 14s 6d
	2 oval dishes, "history pieces". 2 for	5 5s
	2 "half-length" figures, framed. 2 for	3 3s
	Basin, silver-mounted, Judith and Holofernes.	2 12s
	All of these probably from the Braamkamp sale, Amsterdam.	
1776	Anselm Beaumont. C. The months of the year, 12 dishes. 12 for	6
	Ewer with busts of emperors (see, perhaps, 1807).	3 3s
1778	Harrache. C. At least 30 lots of "the old Roman enamel":	
	Oval dish with History of Abraham after Giulio Romano.	4
	Brûle-parfum, ormolu mounts, after Giulio Romano.	4 14s
1780	A nobleman. C. "A large old enamelled dish, representing the Feast of the Gods by Courtois."	7 17s 6d
	Companion dish.	5
1781	Earl of Harrington. C. An old enamelled dish, The Reading of the Law before King Josiah, from a design of Raphael's.	4 14s 6d
1789	Duchess of Kingston, Thoresby Park. C. Ewer and basin, curiously enamelled on copper. 2 for	21
	Gustavus Brander. C. 6 lots of Limoges enamel:	
	3 copper enamelled vases with covers, "the designs from Raphael". 3 for	4 14s
	2 salvers (tazze), ditto. 2 for	3 15s
	Ewer and basin, ditto. 2 for	7 10s
1791	Lord James Manners. C. 11 lots, described as ancient enamels on copper:	
	Tazza or salver.	3 3s
	Ewer and basin, biblical scenes. 2 for	3

£

1791	2 tazze dated 1552, with 2 others. 4 for	14s
	Oval dish, Scriptural scene, 1556.	16s 6d
1797	Bearcroft. C. Pair of ancient enamels, the Siege of Troy and companion. 2 for	2 5s
	2 portrait plaques and a frame of small plaques.	5 10s
1805	C. Oval dish, Joseph and His Brethren.	15 15s
1807	A collector of taste. C. Cup and cover "of the rare enamel on copper"; outside, the 12 Caesars, inside Dido and Aeneas, dated 1546, sold with a plate. 2 for	18 7s 6d
	A series of plaques, Scriptural and other subjects. from	1 13s–
		3 3s
1817	Miss Hotham. C. Tazza and cover "in the Parmegiano manner", mounted on ormolu tripod.	5 15s 6d
	Tazza in the manner of Raphael, Moses striking Water from the Rock.	7 10s
1818	Panné. C. Crucifixion triptych.	13 2s 6d
	Plaque, 9½in × 14½in, Curtius leaping the Gulf, in a boulle inlay frame.	16 5s 6d
1819	Sevestre, jeweller. C. Large dish of the old enamel, the Brazen Serpent in the Wilderness.	28 17s 6d
	Noble dish "by Jane Courtois".	25 4s
1823	Farquhar, Fonthill (Philips) (ex Beckford). Triptych, c. 1520, by Nardon Penicaud (see 1882).	42
	Elaborate tazza.	31 10s
	Framed single plaque.	6
1827	Chevalier Franchi (probably ex Beckford). C. First notice of the name Limoges. Framed portrait by "Leonard of Limoges".	5 8s
1834	Viscountess Hampden. C. Pair of Plates, signed Pierre Reymond, 1564, Vintage and Harvest. 2 for	4 15s
	Tazza, signed Pierre Reymond, 1544, 12 Caesars.	14 14s
	Ewer, Pharaoh in the Red Sea.	14 14s
	All these bought by the dealer Roussel of Paris.	
1838	William Esdaile. C. Ewer, Moses striking the Rock.	13 2s 6d
	Ewer, royal portrait medallions, including Henri IV.	10 10s
1842	Waldegrave, Strawberry Hill (Robins) (ex Walpole). The St Hubert hunting horn (see 1892) (Metropolitan Museum).	141 15s
	Ewer, Triumph of Diana.	35 11s
	Ewer, battle scene.	29 8s
	2 framed oval portrait plaques by Laudin I, Henri of Navarre and Margaret de Valois (see 1892, 1913, 1938). 2 for	21
	Tazza by Jean Penicaud, History of Samson, dated 1539 (see 1882, 1898).	44 2s
	Candlestick, or flambeau, Labours of Hercules.	26 5s
	Casket in silver-gilt mounts, battle scenes.	47 10s
1846	Baron, Paris. Dish by Pierre Reymond, 1562, Fall of Man.	76 8s
	Brunet-Denon, Paris. Plaque by Jean Penicaud, The Deposition (see 1859).	108

£

1846 Diptych, signed PRH, Life of the Virgin. 74

 2 12in plaques, History of Psyche, after Raphael (see (1850). 3 for 56

1848 Duke of Buckingham, Stowe. C. Elaborate tazza with Scriptural scenes. 31 10s

 C. Salver with biblical subjects, bought by Bandinel (1852, V & A). 52 10s

1849 William Coningham. C. Casket, various Scriptural subjects. 84

 Oval dish, Joseph before Pharaoh, bought-in. 84

1850 Debruge Dumenil, Paris. Entombment, 10in plaque, 15th cent. 7

 Leonard Limousin, 18 small plaques, forming a retable of the Life of Christ (see 1861). 18 for 74

 Leonard Limousin, portrait of Charles IX, 1573, single large plaque. 14 7s

 Casket, 10 plaques on ebony (see 1861). 36

 Casket by Jean Courteys. 43

 Ewer, grisaille and gold. 22 10s

 Landscape-plaque *en grisaille*. 22

 Preaux, Paris. Large grisaille plaques by Leonard Limousin, 1545:

 Funeral of Psyche. 86

 Wedding of Psyche. 62 10s

 Portrait of Henri of Navarre, 1561 (see 1859). 60

 Pierre Reymond, diptych, the Passion (see 1859). 38 4s

1855 Ralph Bernal. C. Tazza and cover, 1545, bought by BM. 80

 Portrait plaque, Catherine de'Medici, 18in × 12in, bought by Gustave de Rothschild. 420

 Small Crucifixion plaque, Leonard Limousin (V & A). 56 10s

 Ewer with battle scene, Jean Courteys. 136 10s

 Casket, the Sibyls, mounted in parcel-gilt (BM, per Ferdinand de Rothschild, 1899). 232

1857 Earl of Shrewsbury, Alton Towers. C. BM buys triptych in the Monvaerni style, before 1500: in the centre The Crucifixion. 365

 V & A buys triptych by Pierre Reymond, The Passion of Christ, painted *en grisaille*, 13½in high. 350

1858 V & A buys plateau and ewer, style of Pierre Reymond, The Gifts of Fortune, 12in high. 400

1859 Rattier, Paris. Plaque, Jean Penicaud III, The Deposition (see 1846, 1890). 600

 Portrait of Henri of Navarre (see 1850). 146

 Diptych, *c.* 1490, Duke of Bourbon and Anne of France adoring St Anne. 280

 Triptych, *c.* 1500, Crucifixion. 400

 12in plaque by Leonard Limousin, The Vendange. 296

1860 De la Sayette of Poitiers, Paris. Large triptych by Martin Didier, History of John the Baptist. 432

£

		£	
1860	Tazza and cover by Leonard Limousin, 1536, Combat of Centaurs and Lapiths.	448	
	Casket by Pierre Courteys.	394	
1861	Soltykoff, Paris. Casket by Jean Penicaud.	618	
	Casket, 16in × 11½in, by Martin Didier, History of Phaeton.	1,120	
	2 flambeaux by Jean Courteys, bought by James de Rothschild. 2 for	1,196	
	2 portrait plaques by Leonard Limousin:		
	La Reine Claude (see 1890).	400	
	Jean, Duc de Bourbon.	711	10s
	Passion of Christ, triptych, Leonard Penicaud.	400	
	Tableau, series of plaques, Passion of Christ,	800	
	Ewer, Dido and Aeneas at Table, 12in.	648	
	Basin, Marriage of Psyche, Jean Penicaud, after Raphael.	840	
	Ewer to match.	640	
	Oval dish with *grottesche*.	460	
	Pierre Reymond, 19in Adam and Eve dish.	640	
	Goblet, Triumph of Diana, 10in, by Pierre Reymond, 1552.	720	
1863	Stewart of Dalguise. C. Retable by Jean Penicaud, *c.* 1500, 24 plaques, Passion of Christ.	178	10s
1864	Paris. Tazza and cover, Leonard Limousin, 1536.	426	
	V & A buys casket of Anne of Austria by Jean Limousin, *c.* 1630.	1,000	
1865	Pourtalès, Paris. The Mary Stewart tazza and cover, signed Jean Court, 1556 (Wallace Coll.).	1,084	
	18in basin, signed Pierre Reymond, 1558.	804	
	Oval dish, Jean Courteys, Destruction of Pharaoh's Host, 22in.	1,200	
	V & A buys tazza and cover by Pierre Reymond, Combat of Centaurs and Lapiths.	448	
1866	W. G. Morland. C. Triptych, Christ Mocked and Scourged, 11in × 19in, bought-in.	273	
1868	Germeau, Paris. Leonard Limousin, portrait plaque of Emanuel Philibert of Savoy.	664	
1869	Frank Davis. C. Candlestick *en grisaille* by Jean Courtois.	146	
1870	Admiral Manners. C. Tazza by Suzanne Court, Abraham and Melchizedek.	125	
1877	V & A purchases:		
	Oval portrait plaque, Charles, Cardinal de Guise, by Leonard Limousin, over 2 ft high, with frame.	2,000	
	Triptych by Nardon Penicaud, *c.* 1500, with kneeling portraits of Louis XII and Anne de Bretagne, 17½in × 19in	2,000	
1882	Hamilton Palace. C. Tazza and cover, 1539 (see 1842, 1898), History of Samson, by Jean Penicaud.	2,100	
	Triptych by Nardon Penicaud, *c.* 1490 (BM) (see 1823).	1,764	
	Adoration of the Magi, square plaque, 6in × 4in, by Jean Penicaud.	1,328	5s

£

1882 Triptych, The Pietà, by Pierre Reymond, 1538 (see
 1912). 1,218
 Oval dish, Feast of the Gods, by Jean Courteys. 1,207 10s
1883 Beurdeley, Paris. Retable composed of 21 plaques, by
 Leonard Limousin. 1,880
 Duke of Marlborough. C. Oval dish by Jean Courteys,
 Vision of St John (V & A). 1,092
 Ewer and dish by Suzanne Court (V & A). 945
 Oval dish by Pierre Reymond, Battle of the Kings. 945
1884 Andrew Fountaine. C. 19in oval dish, by Leonard
 Limousin, 1555, Feast of the Gods, containing portraits of
 Henri II, Catherine de'Medici and Diane of Poitiers,
 bought by Samson Wertheimer for Gustave de Rothschild. 7,350
 21in dish, Moses and the Brazen Serpent. 2,940
 Stumpy ewer by Suzanne Court. 1,312 10s
 2 candlesticks, bought by BM. 1,218
 Basilevsky Coll. sold to the Hermitage Museum, including
 a very large retable, signed by Jean Penicaud, for which
 Adolphe de Rothschild was believed to have offered
 £10,000 (*Chronique des Arts*, 38, 1884).
1885 Vaisse, Paris. Triptych ascribed to Monvaerni, *c.* 1480. 784
1889 Ernest Odiot, Paris. Triptych by Jean Penicaud. 596
1890 Baron Achille Seillière, Paris (*ex* Soltykoff). Oval
 portrait plaque by Leonard Limousin, Louis de Gonzaga,
 bought by Maurice Kann. 3,880
 Ditto of Catherine de'Medici. 2,400
 Ditto of Francis I. 1,000
 Ditto of la Reine Claude (see 1861). 1,280
 Jean Penicaud III, grisaille plaque after Schiavone, The
 Deposition (see 1859). 1,200
 Dish *en grisaille*, Passage of the Red Sea, by Pierre
 Courtois. 980
 Pierre Reymond, dish with battle scene. 1,120
1892 Hollingworth Magniac. C. The St Hubert hunting horn
 (see 1842) (Metropolitan Museum). 6,615
 2 portrait plaques, Henri of Navarre and Margaret de
 Valois (see 1842, 1912). 3,150
 2 portrait plaques, Cardinal de Guise and his mother. 3,040
 2 candlesticks. 1,375
1893 Field. C. 2 salt-cellars, 3½in high, by Jean Limousin,
 c. 1620, bought by V & A. 2 for 518 3s 6d
 Frederick Spitzer, Paris. Triumph of Neptune, 15 plaques
 by Leonard Limousin after Marcantonio (BM, per Fer-
 dinand Rothschild, 1899). 15 for 2,560
 The Adoration, 3in plaque, Jean Penicaud after Dürer. 2,040
 Dish, 16in, Feast of the Gods, Jean Penicaud III. 1,900
 Leonard Limousin, portrait plaque, Mme Montpensier. 1,220
 Early plaques before 1500. from 80–120

£

1898	Martin Heckscher. C. The Jean Penicaud tazza (see 1842, 1882).	1,606 10s
	2 oval dishes, Jean Courteys.	2,100
1899	Charles Stein, Paris. Leonard Limousin plaques:	
	Unknown man.	1,240
	Unknown woman.	1,240
	Triptych, Holy Family and Saints, Jean Penicaud II.	1,200
	Jean Court, Triumph of Ceres dish, 1558.	840
1902	T. Gibson Carmichael Ewer and cover, Jean Courteys (£577 10s in 1892).	1,785
	Casket, Pierre Courtois (£525 in 1894).	1,522
1903	Page Turner. C. Tazza and cover, Pierre Reymond.	420
1905	Boy, Paris. Crucifixion triptych by Nardon Penicaud.	2,560
	Late 15th-cent. plaque by Monvaerni, The Judas Kiss (see 1909).	1,104
1907	Queynaud, Paris. Late 15th-cent. plaque, Monvaerni, The Adoration of the Shepherds.	1,640
1908	Zelikine, Paris. Another Monvaerni plaque of the same subject.	1,480
1909	von Lanna, Prague. Monvaerni plaque, The Judas Kiss (see 1905).	3,400
	The Calvary, 2 Nardon Penicaud plaques. 2 for	2,250
	Lord Amherst of Hackney. C. Death of the Virgin, plaque by Nardon Penicaud.	1,627
	Oval 16th-cent. plaque, Death of the Virgin, translucent enamel.	1,785
	Louvre buys a set of 12 small plaques of the Passion by Monvaerni, late 15th cent. 12 for	4,800
1910	Malcolm of Poltalloch. C. Tazza by Suzanne Court (see 1938).	2,050
	Octavus Coope. C. Tazza by Suzanne Court, Abraham and Melchizedek.	2,050
	2 plaques, Life of Aeneas, by Nardon Penicaud.	1,995
	Cottreau, Paris. Plaque, Agony in the Garden, by Jean Penicaud I, c. 1530, the record price for a single plaque.	4,600
1912	J. E. Taylor. C. Plaque, alleged portrait of Rabelais.	1,200
	Tazza by Henri d'Albert (see 1938).	1,732 10s
	Candlestick en suite with the Fountaine pair (1884) (sold in 1892 for £294), bought by Duveen.	4,305
1913	Malcolm of Poltalloch. C. 2 4-in salt-cellars by Suzanne Court (Fountaine sale, 1884, £451 10s), bought by Duveen (see 1934). 2 for	3,675
	10in dish by Suzanne Court, The Philistines stopping the Wells (Spitzer, 1893, £320).	1,470
	Triptych by Pierre Reymond, 1538 (see 1882).	1,365
	Portrait plaque, Henri of Navarre, late 16th cent., by Laudin I (see 1842, 1892, 1938).	1,732 10s
1914	Société Seligman, Paris. Jean Courteys, oval dish, The Sacrifice of Iphigenia, after Polidoro Caravaggio.	4,950

£

1916	Garnier, Paris. Triptych by Nardon Penicaud.	3,212	
1919	Hamilton Palace. C. Casket, *c.* 1520.	2,835	
	Gustave de Rothschild. C. Set of 4 dishes by Jean Courteys. 4 for	3,990	
	Sir Philip Sassoon. C. The Israelites gathering Manna, oval dish, 1567.	1,837	10s
	Nardon Penicaud, large plaque, Death of the Virgin.	1,785	
	Oval dish, scenes from Genesis.	1,470	
1921	Morgan-Williams. C. Dish by Jean Courteys (see 1942).	819	
	Duke of Newcastle. C. Triptych by Jean Penicaud I.	2,910	
	Oval dish by Jean Reymond.	2,415	
1923	Naylor-Leyland (Knight, Frank). Triptych, *c.* 1500, Life of John the Baptist.	1,470	
	Humphrey Cook. C. 2 plaques by Nardon Penicaud. 2 for	1,312	
1925	Countess of Carnarvon. C. Tableau of 18 plaques by Leonard Limousin. 18 for	1,050	
	Donaldson. C. 2 plaques by Nardon Penicaud, *c.* 1500, 11in × 4½in. 2 for	1,312	10s
1926	Duke of Atholl. S. Oval dish by Jean Courteys, Pharaoh and His Hosts.	840	
1928	S. Oval dish, Assembly of the Gods, by Jean de Court.	540	
1930	Scarsdale heirlooms. C. Grand triptych by Pierre Reymond, 36 5in plaques of the Life of Christ. 36 for	1,680	
1931	Mariczell de Nemès, Munich. Triptych, Adoration, etc., by Jean Penicaud I.	700	
1932	De la Broise, Paris. Oval plaque by Leonard Limousin after Raphael.	610	
1933	Thomas F. Ryan, New York. Entry into Jerusalem, large plaque by Jean Limousin.	1,390	
	Set of 12 small plaques by Nardon Penicaud. 12 for	2,500	
	Royal stag hunt, 17in plaque by Jean Limousin.	1,275	
1934	Leopold Hirsch. C. 2 salts by Suzanne Court (see 1911). 2 for	378	
	2 oval dishes by Pierre Reymond. 2 for	115	10s
	Tazza by Jean de Court.	29	8s
1935	Edward Steinkopf. C. Triptych by Pierre Reymond, *c.* 1530.	966	
	Pair of candlesticks by Jean Courteys. 2 for	483	
	Tazza by Jean Courteys.	152	5s
	C. 4 dishes by Jean Courteys. 4 for	500	
	Crucifixion, early 16th-cent. plaque.	378	
	2 oval plaques by Jean de Court. 2 for	194	5s
1936	Goldschmidt. C. Oval plaque by Pierre Courteys, *c.* 1530–50.	105	
	Casket by Couly Nouailher, *c.* 1550 (see 1949).	325	10s
1938	Mortimer Schiff. C. Triptych by Jean Penicaud I.	819	
	Henry of Navarre, portrait plaque by Laudin I (see 1842, 1892, 1912).	315	

		£	
1938	Tazza by Suzanne Court (see 1910).	283	10s
	Tazza by Henri d'Albert (see 1912).	315	
	Triptych, *c.* 1510 (see 1957).	357	
	2 candlesticks by Suzanne Court. 2 for	399	
1942	G. A. Lockett. C. Dish by Jean Courteys (see 1921).	73	5s
	Charles McKann (Andersons, New York). Drageoir by Pierre Reymond (*ex* J. P. Morgan).	75	
1946	Crawford of Balcarres. C. Casket, *c.* 1520, 8in.	609	
	Lionel de Rothschild. C. 12 dishes by Pierre Reymond, 1559. each	74	6s
1949	S. Casket, *c.* 1550, by Couly Nouailher (see 1936).	370	
1950	S. Casket by Pierre Reymond, The Labours of Hercules, 6in × 6in.	440	
1951	C. 20in triptych, *c.* 1520, Crucifixion, etc.	1,365	
	S. Casket, *c.* 1550, 7½in long.	300	
1954	Rutschi, Berne, Switzerland. 4 plaques, *c.* 1520, style of Nardon Penicaud. 4 for	2,120	
	Portrait plaque by Leonard Limousin, *c.* 1550–60, 10½in high.	855	
1957	C. 20in triptych, *c.* 1510 (see 1938).	1,365	
1959	S. Tazza by Jean Courteys, 10in, The Tower of Babel, *c.* 1540.	800	
1960	S. Single plaque from a triptych, attributed to Monvaerni, The Crucifixion, *c.* 1480.	1,900	

MAIOLICA

£

1757 Scheemakers (Langford, auctioneer). Large vase depicting the Judgement of Paris. 7 7s

1768 Josiah Wedgwood spends 20 guineas on "Raphael bottles", sold by Harrache.

1770 Prince Carafa of Naples. C. 3 lots comprising a large vase, 2 bottles and a ewer. 4 for 10 10s

1771 C. 2 old Roman ware dishes, bought by Horace Walpole. 2 for 2 19s

1774 Hon. Richard Bateman. C. Dish "after Raphael", dated Urbino, 1534, sold with a small tazza. 2 for 4 14s 6d
 Cistern, dated Urbino, 1515. 3 3s

1777 Earl of Strathmore. C. 23 lots of majolica: Oval cauldron supported on male sphinxes from the Duke of Tuscany's Coll., a Roman sea-fight. Pair of tripod basins with the same subject. Obtained from the Pitti Palace in 1763, bought by Horace Walpole, price not recorded. Mounted in ormolu (see 1842).

1780 Captain Carr. C. Old Raphael ware, pair of beakers garnished with landscapes. 2 for 15 4s 6d

1786 Quintin Crawfurd. C. 2 dishes of old Roman ware. $\begin{cases} 2 \\ 3 \end{cases}$ 18s

1789 Duchess of Kingston, Thoresby Park. C. Bottle Raphael's ware, curiously painted. 3 11s
 Gustavus Brander. C. About 16 pieces in lots of 3, averaging barely 10s a piece.

1791 Mrs Catherine French. C. "Old Roman earthenware." 3 bottles, mounted in ormolu. each 4
 Richard Dalton. C. 2 dishes of "Roman or Raphael's ware", bought by Josiah Wedgwood. 2 for 1
 Others at 1½ guineas for a lot of 3.
 Lord James Manners. C. "Ancient Roman or Raphael's earthenware." 19 lots, some bought at the Scheemakers sale of 1757, made £21 for 52 items. 9 had dates from 1518 to 1545. The dearest lot made 36s.

1801 Earl of Bessborough. C. "A pot of old Raffaele ware." 7 17s 6d

1807 A collector of taste. C. 2 flasks, compressed globular shape (Urbino), "ornaments in *Cinquecento* taste", bought-in. 2 for 19 8s 6d

£

1807 A noble vase, satyr masques and handles, arabesque designs, bought-in. 19 19s

1817 Edward Astlee. C. Dish of Raphael ware, Labours of Hercules. 2 5s

1818 Panné. C. 2 ormolu mounted vases (Urbino), marine figures, 12in. 2 for 15 15s

1819 Sevestre. C. Pilgrim bottle, Urbino, Story of David, mounted in ormolu. 19

1821 Marchioness of Thomond. C. Tazza of Raphael ware, Daedalus and Icarus. 5 5s

1823 Farquhar, Fonthill (possibly ex Beckford). 2 Raphael ware plates. 1 17s

 2 dishes, Raphael ware. 3
 Pair of Medici urns, Raphael ware. 7

1824 Sir Masterman Sykes. C. Globular oval vase of Raphael ware with snake handles, painted with marine deities (Urbino), late 16th cent.; a record price. 27 16s 6d

1827 Chevalier Franchi. C. Dish in elaborate frame, battle scene after Giulio Romano. 8 15s

1833 C. Tazza, Story of Marcus Curtius, signed Piere Burgandino (Bergantini) of Faenza, 1500 (almost certainly 1520). 1 11s 6d

1834 Viscountess Hampden. C. Bought at sale of Princess Amelia, sister of George III, late Faenza oval carving dish with arabesque and a trionfo in the centre. 18

1836 "Musée Tiepolo Narni." C. Pair of Urbino dishes. A second-rate trade stock, the dearest lot 2 15s

1839 Edward Gray, Harringay House. C. Urbino vase, battle scene, mounted on a pedestal of jasper and ormolu. 37 16s

 Prince Poniatowsky. C. 19in dish, Martyrdom of St Lawrence, 1551. 21 10s 6d

1842 Waldegrave, Strawberry Hill (ex Walpole) (Robins). Faenza ewer after Giulio Romano, bought by Sir Anthony de Rothschild. 19 19s

 Faenza pilgrim bottle, Diana Hunting. 9 9s
 Faenza dish, Venus and Cupid. 9 9s
 Faenza ewer, marine deities. 13 2s 6d
 22in vase, arms of Cosimo de'Medici. 22 1s
 2 Urbino stoups with Medici arms and Grottesche (V & A, 1854). 2 for 29 8s

 2 cisterns after Giulio Romano (see 1777), bought by Miss Burdett-Coutts. ⎰84
 ⎱81

 2 vases, Urbino, signed by Orazio Fontana, Louis XVI mounts. 2 for 105

1846 C. F. Dodd. C. 1st use of the word "majolica" in a Christie catalogue. Large Faenza tile. 3 5s

1847 Robert Vernon. C. Faenza oval dish with arabesques after Giovanni da Udine. 27 16s 6d

£

1848 Duke of Buckingham, Stowe. C. "Dish in the style of
Raffaele." 10 10s
 Amphora in Della Robbia style, handles replaced in
 silver, battle scene. 52 10s
 Deruta cistern supported by lions, much damaged, from
 the Borghese Palace. 67 4s
1855 Ralph Bernal. C. 2 Deruta ewers, dated 1535, bought
by Alexander Barker. 2 for 420
 Caffaggiolo pitcher, c. 1520 (V & A). 60
 The "Raphael and la Fornarina" dish (Stowe sale, 1848,
 £4) bought by V & A. 120
 Large Bronze-mounted basin bought by BM. 96
 Maestro Giorgio of Gubbio. The so-called Judgement
 of Paris, or Three Graces Dish, actually the Allegory of
 Envy, after Cristofero Robetta (see 1857, 1861, 1884). 142 5s
 374 lots of majolica, but barely a dozen at over £40.
 The future V & A bought 125, the BM 65.
 V & A. J. C. Robinson buys a Florentine oak-leaf jar, c.
 1450, painted with 2 heraldic lions on the Quai Voltaire. 1 12s
 Pourtalès, Paris. Square Faenza tile, Resurrection, after
 Dürer. 126
1857 Lasalle, Paris. The so-called Three Graces Dish (see 1855,
1861, 1884), bought by Roussel. 420
1858 David Falcke of Bond Street. C. The Triumph of Love,
13in dish with Urbino inscription and signature PP,
described as late 15th cent. 205
 Montferrand (of St Petersburg). C. Gubbio lustre tazza
 by Maestro Giorgio, dated 1522. 130
1859 Rattier, Paris. Gubbio lustre dish by Maestro Giorgio,
The Prodigal Son. 168
 Urbino dish, Francesco Xanto, 1538. 180
 Gubbio lustre, c. 1520, St John Baptist. 188
 Casteldurante bowl, arms of Julius II, 1508. 160
1860 Jules Soulages Coll. Purchases by V & A:
 Deruta or Casteldurante dish, 18in diam., with supposed
 portrait of the painter Perugino, challenged by Emil
 Hannover as a forgery (1915). In fact, a genuine dish,
 re-fired. 200
 Maestro Giorgio, Gubbio dish dated 1530. 150
1861 Soltykoff, Paris. Ewer and basin, Urbino, c. 1560 (bought
Beurdeley). 132
 Urbino wine-cistern, 20in wide, Triumph of Bacchus
 and Birth of Venus. 200
 2 Urbino dishes, Francesco Xanto. 112
 Paris. Andrew Fountaine buys the Three Graces Dish (see
 1855, 1857, 1884) from M. Roussel. 480
1862 Jules Soulages Coll. Further purchases by V & A:
 Armorial vase and cover, Gubbio lustre ware, by Maestro
 Giorgio 1515. 200

£

1862 Urbino vase and cover, marked "fatto in Urbino", about 1560, probably Orazio Fontana. 150

1865 Pourtalès, Paris. Urbino stoup with mask handles. 344

1870 San Donato, Paris. Urbino oval dish with grottesche. 446

1875 Saint-Seine, Paris. Lustre bowl, Gubbio, Francesco Xanto. 644

1876 Robert Napier. C. Oblong plaque, 1523, after Marcantonio. 106

1878 Alessandro Castellani, Paris. Maestro Giorgio of Gubbio, lustre dish, Hercules and Antaeus. 600

 Lustre vase with single handle. 620

 Urbino basin supported on a tortoise. 1,000

 Urbino bowl with portrait of Charles V. 800

 2 Urbino mask ewers. 2 for 440

 (See Medici "Porcelain".)

1882 Hamilton Palace. C. Urbino salt-cellar. 141 15s

 Urbino pilgrim bottle. 110 5s

1883 Rusca, Florence. Lustre plaque by Maestro Giorgio. 404

1884 The Basilevsky Coll. sold to the Tsar. It was reported that £2,000 had been offered for a Faenza dish with a portrait of Charles V. Mr Woods of Christie's, however, considered that "the run on blue-and-white" had made majolica out of fashion.

 Castellani, Rome. Lustre vase, Maestro Giorgio. 600

 Large tazza by Maestro Giorgio, 1530. 668

 Andrew Fountaine. C. Faenza dish, Dürer subject, dated 1508. 920

 Urbino oval dish, V & A (No. 846), dated by Rackham 1560–70. 1,333 10s

 Maestro Giorgio of Gubbio, plaque, 1525, after Marcantonio, The Judgement of Paris (see 1885). 766 10s

 Urbino ewer, Orazio Fontana. 575 10s

 Urbino dish, 1533, Francesco Xanto (Bernal sale, 1855, £28 7s). 462

 The so-called Judgement of Paris or Three Graces Dish, now called the Allegory of Envy, after Cristofero Robetta, Gubbio lustre, c. 1525, bought by Durlacher for George Salting. The dish had been bought at the Bernal sale of 1855 by J. C. Robinson for £142 5s, but the sale had been disowned by the Trustees. It was sold in 1861 to Andrew Fountaine for £480. In 1910 it was left to V & A (No. 673). 819

 Deruta portrait dish, Angela Bella, bought by Octavus Coope (see 1910). 475

 Casteldurante dish, Phaedra and Hypolitus (Bernal sale, 1855, £51), bought for V & A (No. 547). 393 15s

1885 Beckett Denison. C. The Gubbio Judgement of Paris plaque (see 1884), bought by V & A. 829 10s

£

1886	Charles Stein (1st sale), Paris. 2 Urbino baluster vases. A record price for the period.	2 for	2,948
	Gubbio lustre bowl, bought-in (see 1899).		792
1888	C. Faenza baluster vase.		1,060 10s
	Francesco Xanto Urbino dish, c. 1530.		630
1892	Mme d'Yvon, Paris. Francesco Xanto bowl, Marcus Curtius.		490
1893	Spitzer, Paris. Signed Caffaggiolo dish from the Carrand Coll., c. 1480, Judith and Holofernes, bought by Salting (since 1910 V & A).		2,288
	Caffaggiolo Leda and the Swan dish, c. 1520 (Salting; 1910, V & A).		2,112
	The Israelites gathering Manna, Urbino dish over 20in.		1,166
	Casteldurante tazza of 1520.		1,122
	14in Maestro Giorgio dish, 1524.		928
	Flanged Maestro Giorgio dish, 1525.		1,100
	There were 225 majolica lots, and 35 of them made over £300 each.		
1899	Charles Stein, Paris. Faenza model of a slipper, c. 1510.		1,069
	Gubbio bowl, 1520 (see 1886).		1,034
1901	Louvre buys a Citta di Castello dish.		1,000
1904	Gaillard, Paris. Large Faenza dish, before 1490.		2,244
1908	Lord Amherst of Hackney. C. Gubbio dish, Death of Dido.		1,365
1910	Octavus Coope. C. Maestro Giorgio armorial dish, 1527 (see 1930).		1,260
	Siena, Story of Narcissus, bought Duveen (English auction record).		3,885
	Gubbio grisaille dish.		1,008
	Deruta portrait dish, Angela Bella (see 1884).		320
1911	Paris. Deruta lustre platter with female portrait (the type rechristened Siena).		2,860
	C. Maestro Giorgio dish, dated 1552.		2,520
1912	J. E. Taylor. C. Maestro Giorgio dated armorial dish of 1524 (bought Duveen for Pierpont Morgan).		2,835
	Faenza dish, 1520, with elaborate border.		1,470
	Caffaggiolo jar, c. 1470, 15in.		945
	(See also Medici "Porcelain".)		
1913	Lydig, New York. Florence or Caffaggiolo 2-handled vase, c. 1470.		1,060
1916	Arthur Sambon, Paris. Drug-jar, female busts, Faenza.		924
1917	Lord Francis Hope. C. Large armorial Caffaggiolo dish.		1,365
1919	Christie-Miller. Florentine oak-leaf jar, c. 1440–50.		250
	Gustave de Rothschild. C. Pair of Siena dishes (attributed).	2 for	3,150
1921	Duke of Newcastle. Casteldurante dish of 1508, with arms of Julius II, by Giovanni Maria, bought by Duveen.		3,255

£

1921	Maestro Giorgio lustre dish, The Prodigal Son, after Dürer (see 1942).	2,520
1921	Morgan Williams, Margam Castle. C. Gubbio lustre dish, Hermes and Hecuba, 1527 (see 1942).	1,627 10s
1922	William Newall. C. Tazza by Maestro Giorgio, 1524.	1,312 10s
1923	Salomon, New York. Reported in *Beaux Arts*, 15 June 1923, that 3 Urbino vases by Frappio Fontana had fetched $101,000 between them (at $4.65 to the £1). 3 for	21,750
1924	Testart, Paris. Deruta dish, embracing couple.	1,180
	C. Oak-leaf jar, c. 1450.	155
1925	Sir Francis Cook. C. (Doughty House.) Maestro Giorgio dish (see 1932).	1,552
	Deruta dish, equestrian battle, c. 1500.	1,417
1926	C. Faenza pharmacy jar with portrait, c. 1470 (see 1932).	1,050
	2 Caffaggiolo dishes, 1514 and 1515.	{1,029 {1,207 10s
1927	Sir George Holford. C. Deruta dish, 1510.	1,155
1929	Fairfax Murray, Florence (sold in Berlin). Deruta dish, c. 1540.	340
	Caffaggiolo armorial pitcher, c. 1500.	375
1930	C. Tazza by Francesco Xanto, Urbino 1533.	460
	Maestro Giorgio of Gubbio lustre dish, 1527 (see 1910, £1,260).	378
1931	Walter Burns. S. Maestro Giorgio 10in lustre dish.	920
1932	Glogowski. S. Maestro Giorgio dish, Judgement of Paris (see 1925).	220
	Faenza pharmacy jar with portrait (see 1926).	461
	Maestro Giorgio dish, 1525 (£675 in 1925).	250
	3 Florentine oak-leaf jars, 1440–50, double handles, over 12in high.	{250 {410 {450
1935	De Zoete. S. 2 pear-shaped Deruta portrait vases, c. 1510, rope handles, exceptionally rare. 2 for	190
	Henry Harris. C. Gubbio dish, before 1535.	609
1936	Henry Oppenheimer. C. Pair of pharmacy jars, Florence, c. 1450. 2 for	672
	Maestro Giorgio dish of 1522.	1,029
	Caffaggiolo round plaque after Dürer.	1,574
	Faenza bust of an old woman.	787 10s
1938	Damiron (of Lyon). S. Caffaggiolo dish, monogram SP.	600
	3 others made over £400 each.	
1939	Pringsheim. S. Pitcher, Florence, c. 1450.	214
	Oak-leaf jar, c. 1440–50.	370
	Maestro Giorgio dish.	320
	Oak-leaf jar with figure of crane.	380
	Diana and Actaeon (Maestro Giorgio).	700
	Francesco Xanto dish, 1534.	420
	Siena pitcher, c. 1500, arms of Piccolomini (see 1962).	95

£

1942	George Lockett. C. Maestro Giorgio lustre dish, The Prodigal Son, 1522 (see 1921, £2,520).	556	10s
	Ditto dish, Hermes and Hecuba (see 1928).	357	
	Sir Alfred Beit. S. Maestro Giorgio dish, 1524, arms of Siena (bought by Cleveland Museum).	820	
	2 Florentine oak-leaf jars, c. 1440–50.	{320 340	
1946	Swaythling heirlooms. S. Gubbio lustre dish.	798	
	Mortimer Schiff, New York. 106 lots, over £40,000, mostly former Bardac and Pierpont Morgan pieces:		
	Florentine oak-leaf jar, c. 1450.	650	
	So-called Siena albarillo.	400	
	Florentine blue-and-white albarillo, c. 1470, in Spanish style.	650	
	27in Orvieto-style dish of about 1420, with horseman in manner of Pisanello (Metropolitan Museum) (probably worth £10,000 today).	4,200	
	18in Orvieto basin, same age, reconstructed.	925	
	Florentine basin, believed before 1400.	1,495	
	The Matthias Corvinus Faenza dish of 1480, 19in.	2,375	
	Companion dish lacking figures.	1,000	
	Maestro Giorgio, Combat of Nude Men, after Pollaiuolo, 10in tazza.	1,125	
1949	E. L. Paget. S. Oak-leaf jar with leaping hound (see 1959).	210	
	2-handled albarillo, Florence, c. 1470.	120	
	(See also Medici "Porcelain".)		
1957	S. Faenza dish by Nicolo Pellipario, c. 1530.	850	
	S. Francesco Xanto dish of 1531 (see 1961).	380	
1959	S. Oak-leaf jar with leaping hound (see 1949).	840	
	Citta di Castello inkstand with sculptured group, St George and Dragon, c. 1480.	3,500	
	Faenza albarillo of 1490 with bird.	1,300	
	Florentine 2-handled albarillo, c. 1460.	2,100	
1961	S. Urbino, Francesco Xanto dish, 1531 (see 1957).	780	
	Gubbio, 1526, arms of Vitelli.	980	
	Faenza albarillo, c. 1480.	500	
1962	S. 2-handled Florence albarillo, c. 1480 (£38 in 1939).	980	
	Siena pitcher, c. 1500, arms of Piccolomini (£95 in 1939).	1,400	
	Faenza albarillo, c. 1470 (£37 in 1939).	750	
	Urbino dish by Francesco Xanto Avelli.	1,000	
	2 Deruta lustre dishes, c. 1525. 2 for	1,300	
	Faenza drug-jar, c. 1520, Cleopatra and the Asp.	920	
	C. Urbino dish, History of Coriolanus, by Guido Merlino, c. 1540 (Pringsheim sale, 1939, £20).	1,785	
	Armorial dish of Piero Pucci, 1532, by Francesco Xanto Avelli of Urbino.	2,735	
	Armorial dish, Pesaro.	1,050	

		£
1962	Paris. Maestro Giorgio lustre dish.	2,920
	Faenza albarillo, *c.* 1490.	1,820
	2 Casteldurante dishes.	{1,350 1,240
	Tondino depicting a hand holding a thunderbolt, Gubbio, *c.* 1520.	3,295

MAIOLICA

MEDICI "PORCELAIN"

(not more than 50 in existence)

		£	
1859	V & A buys a double-spouted bottle from Alessandro Foresi.		10s
1862	V & A buys a large dish.	10	
1870	Lady Charlotte Schreiber sees a Medici vase in Paris offered at	4	4s
1878	Alessandro Castellani, Paris. Basin.	400	
	Saucer-dish.	44	
1890	V & A buys fluted bottle, 2 handles, purple outlines to the blue.	50	
1893	Frederick Spitzer, Paris. Vase with 3 spouts, additional manganese colouring.	166	
1912	J. E. Taylor. C. Stoup with handles, nearly 1ft high.	1,995	
	Egg-shaped ewer, 8in high.	1,312	10s
1935	Ernest C. Innes. Saucer (see 1949).	210	
1946	Mortimer Schiff, New York. Platter.	1,200	
1949	E. L. Paget. S. Saucer (see 1935).	1,100	

MEDIAEVAL ART

ENAMELLED COPPER, BRONZE, MOUNTED CRYSTAL; PARCEL-GILT, ETC.
(*a few textiles included*)

£

1741 Earl of Oxford (Cock, auctioneer). Ancient chalice and patten of silver-gilt. 6 13s

1774 Hon. Richard Bateman of Old Windsor. C. "A Chaise [chasse] of metal-gilt curiously enamelled, of great antiquity", (bt. Gustavus Brander, see 1789). 5 7s 6d

 2 glass shrines with relics of saints, a brass chaise and 2 ancient wooden boxes. 5 for 2 17s

 Ciborium inlaid with curious stones, near the top a fine Oriental agate containing the blood of a saint. 7 17s 6d

 (See also Ivory and Crystal).

1789 Gustavus Brander. C. "A small Gothic chapel in copper enamel" (13th-cent. Limoges chasse) (see 1774). Put in a lot with 3 other objects, but withdrawn and sold to Garrard of Litchfield Street.

1817 William Beckford. C. Casket, said to be English, early 14th-cent. enamels on copper and gold, from Cardinal York's Palace, Rome. 26 5s

1824 Page Turner. C. Chasse, certainly Limoges, early 13th cent., described as enamelled on brass with saints in relief; sold together with 2 fragments of Gothic sculpture. 3 for 1 11s 6d

1827 Chevalier Franchi. C. Romanesque thurible in the shape of a domed building with solid Apostle figures, partly silvered. 7

 Enamelled brass reliquary in the shape of an ancient church (chasse), Virgin and saints in relief. 6 15s

1841 Debruge Dumenil buys chasse of St Calmine, 13th cent., sold by Parish Church of Genou. 10

1842 Waldegrave, Strawberry Hill (*ex* Walpole) (Robins). 13th-cent. chasse, Murder of Becket. 9 9s

1843 Duke of Sussex. C. Case for a missal in silver, high relief, "of Gothic design". 21 10s 6d

1846 Baron, Paris. The chasse of Philippe le Bon, *c.* 1430 (see 1855). 20 4s

 Henry Rhodes. C. Bronze pierced-work candelabrum with Anglo-Saxon inscription around foot. 5 5s

 Casket enamelled on copper, Gothic frieze around foot, perhaps a chasse. 7 7s

1850 P. Cox, "Museum of Mediaeval Art". C. Round enamel plaque, figure of Christ, probably 11th-cent. Byzantine, as described. 2 7s

£

1850	Romanesque enamelled brass crozier-head, said to have been found at Hull.	28	7s
	12th-cent. bronze censer, said to have come from Malta.	21	
	13th-cent. crucifix, Limoges enamel.	18	18s
	Large enamelled plaque from a reliquary, 8¾in × 4½in, Christ in Glory, green enamels, called Byzantine 10th-cent., but probably Limoges 12th–13th cent.	11	0s 6d
	Reliquary, alleged 7th cent. and said to have been given by Charlemagne to the Abbey of St Denis, 16in long, Apostles, etc., in high relief, crystals and other stones, perhaps early Romanesque.	86	2s
	Preaux, Paris. Large 13th-cent. Limoges chasse with Apostles in high relief.	80	
	Debruge Dumenil, Paris. 13th-cent. Limoges chasse, the Adoration.	21	
1854	Boocke. C. Anglo-Saxon cruciform brooch, coloured glass and gold cloisons, 7th cent.	15	4s 6d
	Large round brooch in same technique.	31	10s
	Another ditto.	14	10s
1855	Thomas Windus. C. An oval crystal plaque with the Crucifixion and other figures, described as 4th cent. A.D., but probably mediaeval Byzantine.	21	
	Ralph Bernal. C. Byzantine enamelled dish (Lord Londesborough).	40	
	9th-cent. crystal mirror of King Lothair (BM).	267	
	Reliquaire of Philippe le Bon, 1430 (see 1846) (BM) (Bernal paid £28).	66	
	13th-cent. Becket chasse (see 1856).	28	17s 6d
	Romanesque crozier (BM).	46	
	15th-cent. parcel-gilt Communion cup, bought by Chaffers.	11	11s
	2 late Gothic parcel-gilt chalices (V & A). 2 for	33	
	Parcel-gilt reliquary, c. 1460.	43	
	Flemish 15th-cent. brass chandelier, based on figure of angel supporting a shield, bought by V & A.	13	10s
1856	Colonel Sibthorp. C. Bernal's Becket chasse, 13th cent. (see 1855).	27	16s 6d
	Samuel Rogers. C. Enamelled copper diptych with ivory figures and precious stones "of Byzantine character", probably Rhenish or Limoges, 12th cent.	251	
1858	Earl of Shrewsbury, Alton Towers. V & A purchases German triptych-reliquary in champlevé enamels, 12th cent. (private sale).	450	
	David Falcke of Bond Street. C. Enamelled crozier from Hildesheim Cathedral, the Crucifixion, Rhenish, 12th cent.	70	7s
1859	Bruschetti, Milan. C. Silver pax, 15th cent., bought by Chaffers.	50	

£

1860	V & A purchases in Cologne a 12th-cent. altar cross, 2ft high, in champlevé enamels.	350	
1861	Prince Soltykoff, Paris. German 12th-cent. copper-gilt cross, champlevé enamel figures of archangels (V & A).	109	
	German 14th-cent. crozier, copper-gilt, enamel and precious stones (V & A).	413	
	2 other 14th-cent. croziers (partly ivory) (both bought by V & A).	{265 {241	
	12th-cent. German triptych-reliquary in champlevé enamels (V & A).	342	
	44in wooden cross, richly encased in silver-gilt, German, 15th cent.	680	
	"Grande crosse", 21in high, enamelled on copper, Swiss, dated 1351.	346	
	The Eltenburg Reliquary, ivory, copper-gilt and enamels, 2ft long in the shape of a domed Byzantine church, bought by V & A (including commission).	2,142	
	The gilt bell-metal candlestick of Thomas de Pocé of Gloucester, English, early 12th cent., bought by V & A.	612	
	Limoges enamel chasse, 13th cent.	300	10s
	Gilt enamelled crucifix, kneeling figures.	506	
	Polyptych, 13th cent., 11 enamelled plaques.	800	
	Chasse of St Calmine, 13th cent. (see 1841).	306	
1865	Pourtalès, Paris. French spoon and fork, rock-crystal stems, parcel-gilt and enamels, after 1400 (V & A).	84	5s
	From other sources, V & A buys Casket of Aylmer de Valence, copper-gilt and enamel, c. 1300.	150	
	2 French parcel-gilt dishes with enamel bosses, c. 1330. 2 for	60	
1866	W. G. Morland. C. Enamelled copper triptych, set with crystals, called Byzantine, bought-in.	84	
	Limoges 13th-cent. chasse, 7½in high.	59	
	Ciborium, Limoges enamels, 4in high.	26	5s
1868	Germeau, Paris. Chasse with Murder of Becket, c. 1200.	400	15s
	V & A buys:		
	Green serpentine burette, French mounts, c. 1350.	105	
	German parcel-gilt chalice, solid enamelled figures, height 11in.	800	
1872	V & A purchases beaker and cover, parcel-gilt and open-work enamels, Burgundy, c. 1400.	400	
1884	Castellani, Rome. Hexagonal parcel-gilt and copper-gilt reliquary, 26in high, signed Raffaelle Grimaldo, 1496 (V & A).	1,144	10s
	Parcel-gilt Italian casket, c. 1420 (V & A).	498	10s
	Sale of Basilevsky Coll. to the Tsar. 2 parcel-gilt mon-strances from the Treasury of Basel were said to have cost Basilevsky £2,400.		
	Alessandro Castellani, Paris. Silver-gilt processional cross, c. 1400.	328	

		£	
1884	V & A buys hexagonal 13th-cent. reliquary, enamels, Life of St Catherine.	1,020	
	Fountaine. C. 12th-cent. Irish reliquary of inlaid brass (Dublin Museum).	430	10s
1885	Beresford-Hope. C. 13th-cent. Limoges chasse.	380	
	Pectoral cross, cloisonné enamel.	360	
1886	Stein, Paris. 13th-cent. Limoges chasse (BM, 1899).	484	
1889	Ernest Odiot, Paris. Engraved copper-gilt French statuette of the Virgin, 13th cent.	308	
	13th-cent. Limoges Becket chasse.	120	
1890	Achille Seillière, Paris. 2 German bronze baptismal fonts in high relief, inscribed and dated 1483. 2 for	816	
1892	Hollingworth Magniac. C. Swiss reliquary in shape of a foot, c. 1470.	714	
	2 silver-gilt relief plaques from a 12th-cent. Rhineland chasse.	609	
	Baron Jerôme Pichon. BM buys the Cup of the Constable of Castille, French, 14th cent., enamelled gold cup and cover (bought 1883, £240).	8,000	
1893	Frederick Spitzer, Paris. Reliquary in form of an arm, Spain, 14th cent.	1,600	
	Chalice, Hispano-Flemish, late 14th cent. (Louvre).	1,640	
	The Gospels of St Maurice d'Agaune, 11th-cent. manuscript with a Rhenish-Byzantine binding in cloisonné enamel on copper and precious stones (bought for V & A; with commission, £1,571).	1,440	
	Romanesque cabouchon enamel book-binding (Musée Cluny).	1,004	
	German 12th-cent. portable enamelled altar.	1,120	
	Ditto, partly in ivory, with Apostle figures (see 1903).	960	
	4 Limoges 13th-cent. chasses.	480–668	
1895	V & A buys Limoges enamel pastoral staff, 14th cent.	400	
	Limoges enamel chessboard, late 13th cent.	350	
1897	Emile Gavet, Paris. Bronze cocquemard with female head Dinant, 15th cent.	560	
1898	V & A buys Limoges enamel book-cover with figures in heavy relief, 13th cent.	350	
1899	Charles Stein, Paris. Baiser de paix, silver-gilt and verre eglomisée, Italian c. 1500.	3,600	
	Silver-gilt chef-reliquaire of St Frederick, Flemish, c. 1400.	1,680	
	Copper-gilt and enamel reliquary, Hispano-Flemish, c. 1400.	2,320	
1903	Thewalt, Cologne. 15th-cent. German goblet, grisaille enamels on solid gold, supported on monkeys, a unique object (see 1931).	4,450	
	Copper-gilt head of an Apostle (Cologne Museum).	237	10s
	Niello-silver processional cross, German, 15th cent.	3,500	

£

1903	G. de la D., Paris. Book-binding plaque in champlevé enamel, dated 1306, showing a dedication to Philippe le Bel (see 1921).	1,364
	Sir T. Gibson Carmichael. C. Byzantine enamelled triptych (see 1893).	1,900
	15th-cent. enamelled ciborium.	1,750
1904	Bourgeois Brothers, Cologne. Gilt-copper lectern, 15th cent.	2,425
1905	Charles Bowyer. C. Leaf of 9th-cent.(?) Byzantine diptych, cloisonné enamels.	892 10s
	Boy, Paris. Limoges chasse, c. 1200, Crucifixion and Apostles.	1,490
	Enamel fragments from a belt, Spanish, 15th cent.	820
1906	Pierpont Morgan buys from M. Hoentschel a silver-gilt French 13th-cent. statuette of a king and a 15th-cent. French bronze figure of an angel from the Château de Lude. 2 for	40,000
1908	G. W. Braikenridge. C. 13th-cent. enamelled ciborium from Malmesbury Abbey.	6,000
	Zelikine, Paris. Much-restored 13th-cent. Limoges figure of seated Virgin and Child.	680
1909	von Lanna, Prague. Large Limoges house-shaped reliquary, c. 1200.	6,050
	Ditto, Gospel book-cover.	1,050
1911	Pierpont Morgan buys the Svenigorodskoi Coll. of Byzantine enamel plaques, 9 small 11th-cent. portrait-medallions and some ornamental strips from J. Seligman (since 1917, Metropolitan Museum). Price, according to Aline Saarinnen.	31,160
1912	J. E. Taylor. C. 13th-cent. enamelled pyx, shaped like a dove.	3,255
	N. Italian enamelled diptych on silver, 15th cent., 8½in × 5½in, bought by Duveen.	6,910
	Italian ciborium, 15th-cent., translucent enamels (*verre eglomisée*).	1,417 10s
1916	Basil Oxendon. C. Anglo-Saxon silver-gilt spoon, zoomorphic designs.	325 10s
1918	Richard von Kaufmann, Berlin. Carolingian reliquary.	4,850
	13th-cent. Limoges enamelled monstrance.	3,200
1919	Marcus Keane. C. The Clog an Oir, Irish 10th-cent. bell, gilt-bronze and silver (presented to Royal Irish Academy, Dublin).	1,312 10s
1920	Lord Methuen. C. English parcel-gilt cup and cover with crystal stem and cusp, 15th cent.	3,360
1921	Heilbronner, Paris. 13th-cent. wooden statuette of Virgin, partly plated in silver-gilt (see 1925).	710
	Limoges enamel statue of the Virgin, c. 1200 (see 1925).	980
	Engel-Gros, Paris. Byzantine 11th-cent. cruciform reliquary, copper-gilt and enamelled.	1,520

£

1921	Limoges 14th-cent. enamelled plaque, the scribe Gui de Mevios at the feet of Philippe le Bel (see 1903) (presented to the Louvre).	2,800
1922	S. 8 Chertsey figured encaustic tiles, 13th cent. 8 for Lord O'Hagan. S. *Opus Anglicanum*, 14th-cent. English embroidered vestments:	1,420
	Cope (V & A).	510
	Chasuble.	310
	Dalmatic.	300
1924	Swaythling heirlooms. C. French parcel-gilt chalice dated 1222.	1,200
	German rock-crystal beaker and cover, 14th cent.	1,750
	French 14th-cent. (Rheims) burette with enamelled plaque.	780
	Paris. Limoges 13th-cent. chasse, with the Holy Women at the Tomb.	605
	Ciborium in form of a dove.	540
1925	Seligman, Paris. Brass statuette of Virgin in Limoges enamel, 13th cent. (see 1921).	370
1926	Gibson Carmichael. S. Bronze base for cross, Rhineland, *c.* 1200.	2,000
	Part of a copper-gilt chalice, Lorraine, 12th cent.	1,500
1927	BM buys Georgian gold-and-enamel pendant-reliquary, 11th-12th cent.	1,200
1930	Chase-Meredith. S. The Malmesbury Chasse, early 13th cent., with Crucifixion figure, nearly 1ft long.	9,000
	The Croyland Chasse, conventional late 13th-cent. Limoges chasse with murder of Becket.	4,800
	Albert Figdor, Berlin. German 15th-cent. aquamanile in the form of Samson and the Lion. about	5,000
	Bohemian chef-reliquaire in form of a gilt-bronze head, *c.* 1420.	3,250
	Scandinavian bronze aquamanile, 12th-cent.	1,600
	French chef-reliquaire, *c.* 1250.	1,150
	Pelletier, Paris. Limoges chasse, 13th cent., abnormally large, but in fact made of plates from an earlier crucifix (bought 1927 for about £700).	2,830
1931	Octave Homberg, Paris. Limoges book-cover with Crucifixion, *c.* 1200, bought for the Louvre.	1,445
	Alfred Rutschi, Zürich. Specially good small Becket chasse.	1,430
	Larger chasse with Apostle figures.	1,320
	Solid gold goblet with grisaille enamels, German or Flemish, 15th cent. (see 1903).	3,800
1933	S. Standard 8in Limoges chasse, The Adoration of the Magi, etc. (*ex* Basilevsky Coll., Leningrad), bought-in.	210
	Thomas F. Ryan, New York. 13½in Limoges 13th-cent. chasse, Crucifixion, etc.	1,275

£

1933	Hermitage Museum, USSR. V & A buys the Basilevsky 10th-cent. situla.	7,900
	National Museum, Edinburgh, buys the Monymusk reliquary, miniature Scottish chasse, 12th cent.	2,500
1935	C. 13th-cent. Limoges chasse with Apostle figures, 6in long.	966
1936	Oppenheimer. C. 13th-cent. Limoges chasse.	840
	14th-cent. Burgundian statuette of the Virgin in silver-gilt and enamel.	1,522 10s
1937	Victor Rothschild. S. 4-stage reliquary, copper-gilt and crystal, Spanish, c. 1420.	540
1938	Mortimer Schiff. C. Limoges chasse in shape of a dove, 13th cent.	441
	German 15th-cent. aquamanile with Hebrew inscriptions.	315
1945	R. W. M. Walker. C. Huge aquamanile of brass dinanderie (£504 in 1910).	1,522 10s
	Henry Harris. S. 13th-cent. Limoges plaque, Christ in Glory, under 7in.	105
1946	Swaythling heirlooms. C. 13th-cent. Limoges chasse with conventional murder of Becket scene.	1,627 10s
1949	Joseph Homberg. S. Another Becket chasse.	850
	13th-cent. Limoges chasse with Apostles, 6in long.	350
1951	Lempertz, Cologne. 13th-cent. crucifix, Limoges enamel.	520
	New York. 12th-cent. book-cover in copper-gilt, cabouchon jewels and ivory from Admont, Styria.	5,885
1954	Baroness Cassel von Doorn, Paris. Book-cover, jewelled parcel-gilt on wood, Reichenau, 12th cent., 11in × 8½in.	3,600
1960	S. The Pershore Censer or Thurible of Goderic, Anglo-Saxon pierced bronze, 10th cent. (V & A).	2,600
1961	Robert Horst. C. Limoges 13th-cent. chasse with high-relief Crucifixion, average example.	9,240
	2 Limoges 13th-cent. plaques.	{840 {861
	Sir John Findlay. S. Brass astrolabe, c. 1200, Hispano-Arab or S. Italian, bought by BM.	2,800
	Astrolabe, c. 1425.	1,800
1962	Gilou. S. Limoges 13th-cent. appliqué figure, Christ Crucified (from a chasse).	680

		£	
1741	Earl of Oxford (Cock auctioneer) Ivory altar, sold with three pictures (see 1774).	2	3s
1762	Duc de Sully, Paris. Part of a wing of a consular diptych, 4½in high, 5th or 6th cent.	1	8s
1774	Hon. Richard Bateman. C. Portable ivory altar (Lord Oxford sale, 1741), "Curious and antique", probably a French 14th-cent. triptych.	2	15s
	"Ancient Greek" (Romanesque) Ivory crozier; also the crozier of Seabrook, Bishop of Gloucester, 1457, taken from his coffin. 2 for	1	17s
	Ivory chalice "authenticated in 1520 as being then very ancient".	2	1s
1791	Lord James Manners. C. French diptych, probably 14th cent., described as "the Passion of our Saviour in 16 very small carvings and 2 large ditto, sold with 4 curiosities in metal for 16s".		
1820	C. Jewel-casket of ancient ivory, subjects from the *Roman de la Rose*, described as English, but French early 14th cent., formerly Coll. of Gustavus Brander.	13	5s
1823	Farquhar, Fonthill (*ex* Beckford). 14th-cent. French diptych, The Nativity.	9	15s
1827	Chevalier Franchi. C. Diptych of carved ivory, partly coloured and gilt, sacred subjects in four compartments "of the time of Dagobert" (possibly 14th-cent. French).	14	10s
1841	Masseroni, Florence. C. Statuette of the Virgin, attributed to Orcagna (possibly Italian, early 15th cent.).	42	
1846	C. G. Dodd. C. A curious casket in ivory in the manner of Giotto.		16s
	Baron, Paris. The Chasse de St Ivet, requisitioned at Braisnes, near Soissons, in 1793, Romanesque bone sculpture.	50	12s
	15th-cent. Italian marriage casket.	28	
	Another, larger.	40	8s
	Brunet-Denon, Paris. Wing of a 6th-cent. consular diptych, circus games, nearly 1ft high (see 1861).	40	
	14th-cent. French diptych, The Passion.	26	
1847	Edward Harman. C. Virgin, Child and St John, statue group.	13	
	2 diptychs, early Gothic work. 2 for	1	15s

£

1850 Preaux, Paris. French 14th-cent. mirror-case Le Château
 d'Amour (see 1855, 1861, 1866, 1871–2, 1888, 1901). 23 4s
 2 11th-cent. bookbinding plaques, The Life of Christ in
 small panels. 2 for 36 7s 7d
 P. Cox. C. Crozier head with Gothic figures, perhaps
 14th-cent. French. 16 16s
 Debruge Dumenil, Paris. Carolingian diptych, 9th cent.,
 Life of Christ. 36
 French 14th-cent. triptych. 29 4s
 Venetian ivory retable, nearly 4ft high, with numerous
 plaques, late 14th cent. 52
 4 14th-cent. Italian plaques, decoupés à jour. 4 for 76
 2 other Italian plaques. 2 for 81 4s
1855 Ralph Bernal. C. Large French 14th-cent. diptych, Life
 of Christ (BM). 74 11s
 French 14th-cent. mirror-case (see 1888) Le Château
 d'Amour (Lord Londesborough). 43
 Italian 15th-cent. plaque from a casket (BM). 37
 Thomas Windus. C. Diptych of 6 panels, partly gilt and
 coloured, from Spain, but clearly 14th-cent. French. 37 5s 6d
1856 Colonel Sibthorp. C. Casket lined with 24 narrow ivory
 panels, certainly Italian, c. 1400. 38
1858 Soulages Coll. V & A purchases a French 14th-cent.
 polyptych, 15½in high. 350
 David Falcke of Bond Street. C. Triptych in many
 panels, Italian, 14th cent., 37in × 39in, attributed to Andrea
 del Cione; said to have come from the Imperial Treasury,
 Vienna. 224 14s
 Single plaque in same style, Coronation of the Virgin. 25 14s 6d
1859 Bruschetti, Milan. C. Italian 14th-cent. triptych, 100
 figures in 6 compartments, bought-in. 178 10s
 12th-cent. diptych (book-cover?), Passion of Christ,
 bought-in. 110 5s
1861 Soltykoff, Paris. Christ crowning the Virgin, polychrome
 statuette, c. 1280, bought by the Louvre. 1,206
 Statue, part-coloured, Virgin and Child, c. 1300, bought
 by the Louvre. 608
 English whalebone plaque, The Adoration, c. 1100 (see
 1866) (V & A). 148
 German 10th-cent. book-cover, 14in long, bought by
 Webb (see 1866) (V & A). 400
 11th-cent. Byzantine crucifix on plated wood (V & A). 145
 15th-cent. German hunting horn (V & A). 265
 14th-cent. French triptych. 300
 Byzantine 6th-cent. consular diptych (see also 1846,
 1866), inscribed Gennadius Orestes (V & A). 422
 14th-cent. French mirror-case, Le Château d'Amour
 (see 1866, and compare 1850, 1855, 1871–2, 1888, 1901). 58 15s
 12th-cent. tau cross or ferula. 112 10s

£

1863	Evans-Lombe, Paris. Byzantine diptych, 12th cent.	184
	Belgian Government buys a forgery of the Anastasius consular diptych of the year A.D. 517, made in Liège (see 1871–2).	800
1864	John Watkins Brett. C. An undistinguished sale, which realized only £14,400 in 15 days. Several 13th- and 14th-cent. triptych and diptych plaques fetched under £35 each.	
1865	Pourtalès, Paris. Italian 15th-cent. diptych, The Passion of Christ.	172
	12th-cent. Byzantine book-cover, St Michael and the Dragon.	396
	V & A purchases:	
	The Veroli Casket, 10th-cent. Byzantine, with pagan subjects, bought in Bologna.	420
	The 2nd leaf of the famous 5th-cent. Diptych of the Symmachi (found in 1860 in a well at Moutier-en-Der).	420
	13th-cent. diptych of the Passion from Soissons Cathedral.	308
	French 14th-cent. crozier.	168
1866	W. G. Morland. C. Italian triptych, 14th cent., Life of Christ (*ex* Soltykoff), 8in × 8½in.	200
	C. French 14th-cent. mirror-case, Le Château d'Amour (*ex* Soltykoff) (see 1861).	105
	Romanesque bookbinding plaque, Christ in Glory.	74
	8 plaques from an Italian 14th-cent. retable. 8 for	220
	V & A purchases from Webb:	
	English whalebone plaque, 14in high, *c.* 1100, The Adoration, perhaps Bury St Edmunds (see 1861).	218
	Book-cover, Rhineland, *c.* 900 (see 1861).	588
	Diptych of Consul Gennadius Probus Orestes, Byzantium, A.D. 530 (see 1861).	620
1867	Paquet, Paris. 1 leaf from 6th-cent. consular diptych, circus scenes.	366
	12th-cent. hunting horn.	342
	V & A purchases:	
	14th-cent. French diptych, the Passion.	182
	2 12th-cent. Byzantine plaques. 2 for	198
	Byzantine 11th-cent. plaque in 2 panels, based on the Joshua Rotulus.	46
1871–2	V & A purchases from the Webb Coll.:	
	Leaf from the diptych of Consul Anastasius from Liège Cathedral, A.D. 510 (see 1863).	420
	12th-cent. tau cross from Liège Cathedral.	200
	2 Rhineland book-covers, Byzantine style. 2 for	300
	Anglo-Saxon book-cover, Crucifixion and Resurrection.	75
	14th-cent. French triptych.	225
	Mirror-case, Le Château d'Amour (compare 1850, 1855, 1861, 1866, 1888, 1901), French, 14th-cent.	110

£

1887	Paris. Byzantine 7th (10th?) cent. casket with pagan circus scenes.	124
1888	Lord Londesborough. C. Ivory mirror, Le Château d'Amour (see 1850, 1855, 1861, 1866, 1871–2, 1901).	200
	Hunting horn, Life of St Hubert in compartments, parcel-gilt mount, with arms of Bavaria, bought Wallace (Wallace Coll.), Italian 15th cent.	1,072
1892	Hollingworth-Magniac. C. 12th-cent. hunting horn.	231
	14th-cent. French casket, Life of St Eustace, mounted in parcel-gilt.	1,995
1893	Field. C. Large Milanese diptych, c. 1400 (see 1912).	399
	Bateman. S. 4 small 14th-cent. plaques (see 1903).	393 15s
	Wing of 6th-cent. consular diptych.	182
	Carolingian diptych, mounted in the 13th cent. as a heavily enamelled bookbinding (V & A).	1,000
	Spitzer, Paris. 14th-cent. statue of Virgin, 2ft high.	500
	Ivory saddle, arms of Sicily and Aragon, late 13th cent., believed Italian (Louvre).	3,400
	French 14th-cent. triptych, 14in high.	1,260
	Diptych, leather case, French 14th century.	1,040
	Italian diptych, leather case, late 14th cent.	1,320
	Byzantine 10th-cent. diptych.	860
	10th-cent. Byzantine casket, pagan figures, Veroli type.	388
1894	Henri Baudet, Dijon. Wing of a 5th-cent. consular diptych, Flavius Ariobindus; the other wing since 1889 in the Hermitage Museum. Bought by Musée Cluny.	840
	Byzantine hunting horn, 10th cent.(?).	420
1897	Bonnaffé, Paris. Byzantine 10th-cent. plaque, The Crucifixion.	192
1897	Zschille. C. Saddle with carved deer-horn plaques, Burgundian, c. 1400.	480
1900	Paris Exhibition. La Vierge de Boubon, figure with folding doors containing a retable, 13th cent., sold by M. Sailly (see 1902).	1,360
1901	Hope-Edwards. C. 14th-cent. mirror-case, Le Château d'Amour (see 1850, 1855, 1861, 1866, 1871–2, 1888).	430 5s
1902	Dunn-Gardner. C. 13th-cent. polyptych.	480
	14th-cent. French comb.	195
	Keele Hall. C. Casket, French, late 14th cent.	787
1903	T. Gibson Carmichael. 4 French 14th-cent. plaques from a casket (1893, £393 15s). 4 for	1,245
	La Vierge de Boubon, 13th-cent. figure containing retable, 17in high (see 1900), bought by Duveen for Pierpont Morgan (Metropolitan Museum).	3,800
	Byzantine plaque, 7in×9in.	1,995
1904	Bourgeois Brothers, Cologne. 12th-cent. Rhenish hunting horn.	600
1906	C. Fragment of 12th-cent. diptych, Christ in Glory.	892 10s
	Molinier, Paris. Spanish 12th-cent. plaque, The Virgin.	680

£

1908	Homberg, Paris. Byzantine Crucifixion plaque, 13th cent.	368	
1910	Paris. 12th-cent. crozier, many figures.	560	
	Mounted horn, Italian, 15th cent.	712	
	Cottreau, Paris. 14th-cent. French diptych.	1,480	
1912	J. E. Taylor. C. N. Italian diptych, c. 1430, bought by Duveen (see 1893).	3,675	
	Cologne plaque, 12th cent.	1,365	
1913	Malcolm of Poltalloch. C. French diptych, 14th cent.	1,207	
	Ditto, single plaque.	840	
1918	Paris. Large French 14th-cent. diptych with traces of painting.	1,242	
1921	Engel-Gros, Paris. 11th-cent. Rhineland bookbinding plaque, The Crucifixion.	1,900	
1926	V & A acquires Byzantine plaque, part of casket, 11th cent.	1,200	
	BM acquires 14th-cent. English diptych.	700	
	Gibson Carmichael. S. Statuette of the Virgin, French, 14th cent.	620	
1928	C. Byzantine 12th-cent. plaque, The Crucifixion, leaf of diptych, about 8in × 4in.	2,257	10s
	Virgin and Child, Rhenish, 11th cent.	1,470	
	French 14th-cent. Virgin and Child, 9in statuette.	924	
1929	Justice Otter. C. French 14th-cent. casquet, allegedly mounted in 18th cent.	609	
1931	Octave Homberg, Paris. French 13th-cent. statue of Virgin and Child.	2,800	
1932	S. Flemish Romanesque casket, 11th cent.	240	
1935	S. French Romanesque chessman, c. 1100.	441	
	Ernest Innes. C. Byzantine plaque, the Theotokos, 6¾in, c. 1100.	399	
1936	Henry Oppenheimer. C. French 14th-cent. mirror-case, noble cavalcade.	693	
	French relief plaque of the Virgin, c. 1400.	304	10s
	Byzantine bone casket, 10th–11th cent.	110	5s
1939	Viscount Valentia. S. French 14th-cent. flat casket, bought by Barber Institute.	820	
1940	Eumorfopoulos. S. French 14th-cent. mirror-case.	200	
	Hildesheim 12th-cent. casket.	320	
1949	Joseph Homberg. S. Romanesque flabellum, late 12th cent.	1,400	
	Byzantine 13th-cent. plaque for a book-cover, Crucifixion.	280	
	Fischer, Lucerne. Painted ivory crozier, Rhineland, 13th cent.	455	
1950	S. 14th-cent. French mirror-case with chess-playing and other scenes.	750	
1951	Lempertz, Cologne. Comb, Rhineland, c. 1130, slight reliefs.	1,260	
1953	S. German pax, late 15th cent., copper-gilt mount (£840 in 1913).	1,500	

		£
1955	S. French 14th-cent. diptych, 7½in× 5in.	800
1956	S. 2 small French 14th-cent. diptychs.	{400 270}
1957	Lempertz, Cologne. 11th-cent. house-shaped chasse, ivory-plated, with biblical scenes.	6,550
	S. Portable whale-bone altar, English, 1150–1200, 3¼in × 9in× 6in.	7,500
	Parke-Bernet, New York. Group statue, Virgin and Child, 19½in, *c.* 1390.	1,000
1958	Weinmuller, Munich. French casket, *c.* 1330, with subjects from Romance of Tristram, 8½in long.	2,130
1959	Scandinavian carved and hollowed walrus tusk, *c.* A.D. 1200, mounted as reliquary, bought for BM.	9,500
1960	S. Norse reliquary cross, *c.* 1200.	680
1961	Robert Horst. C. 14th-cent. French triptych.	5,250
	2 ditto diptychs.	{1,470 1,575}
1962	Gilou. S. French 14th-cent. statue of the Virgin, 5½in, traces of paint.	3,600
	S. Second ditto, rather smaller.	1,400

MINIATURES (MAINLY PORTRAITS), SOME IN ENAMEL

		£		
1752	Cottin, Paris. Petitot, Mme de Montpensier in enamel.	32	6s	
1768	Warre, picture-dealer and toy-man. C. Petitot, Prince of Orange in enamel.	2	13s	
1774	Samuel Dickinson, jeweller. C. Petitot, Louis XIV.	6		
1775	Mariette, Paris. Petitot, Duchesse d'Olonne.	120		
1782	Marquis de Menars, Paris. Petitot, Louis XVI at 3 ages. 3 for	16		
	Maria Anna and Maria Theresa of Austria. 2 for	23	10s	
1786	Duchess of Portland (Skinner, auctioneer). Nicholas Hilliard, portraits of Queen Elizabeth and the Duc d'Alençon, forming part of a book of prayers said to be in the hand of Queen Elizabeth, bought for the Queen (BM).	106	1s	
	Sir Walter Raleigh and his son, 2 miniatures forming a locket.	44	2s	
	Petitot, Louis XIV.	31	10s	
	Burrowes. C. General Fairfax, by Samuel Cooper.	7	17s	6d
1789	Lord Dudley and Ward. C. Mme de Maintenon, by Petitot.	8	8s	
1791	Richard Dalton. C. Henry VIII, by Holbein, mounted in gold.	15	15s	
	Lord James Manners. C. Samuel Cooper, unknown man, dated 1658.	5	7s	6d
	Petitot, Louis XIV.	6		
1793	"The valuable museum." C. Zucchero, Queen Elizabeth (water-colour).	7	7s	
1802	"Oriental museum of Mr Findley." 3 portraits of Louis XIV by Petitot, painted in enamel.	99 94 84	10s	
1810	Charles Greville. C. Duc de Grammont, by Petitot, c. 1660–70.	31		
1814	A nobleman. C. Pair by Isaac Oliver, Lady and child. 2 for	9	12s	
	Child, by Isaac Oliver.	15	15s	
1816	C. Samuel Cooper, portrait of Inigo Jones.	9	18s	
1817	Edward Astle. C. George II and Queen Caroline, by Zincke, a pair. 2 for	23	12s	6d
1820	James Edwards. C. Case of 12 royal miniatures, formerly belonging to James II and later Cardinal York, by Nicolas Hilliard and the Oliver family. 12 for	262	10s	

£

1820	James II and his family, by Mignard.	87	3s
	Lord Strafford and his secretary, by Peter Oliver.	18	18s
1828	Earl of Sandwich, by Samuel Cooper.	2	12s 6d
1833	C. Isaac Oliver, Anne of Denmark and Queen Elizabeth. 2 for	8	18s
	Isaac Oliver, Earl of Cumberland and another. 2 for	10	10s
1836	Henry Bone Exors. C. 85 lots of English historical portraits, copied by Bone in enamel, made £2,243 6s 6d.		
	Queen Elizabeth, after Zucchero's portrait at Hatfield House.	130	4s
1842	Waldegrave, Strawberry Hill (ex Walpole) (Robins). So-called Holbein, Catherine of Aragon.	50	8s
	Isaac Oliver, Sir Kenelm and Venetia Digby (see 1882). 2 for	178	10s
	Isaac Oliver, Lady Lucy Percy.	105	
	After Vandyck, Sir Kenelm Digby and family in jewelled case.	241	10s
	Petitot, James, Duke of York.	78	15s
	Petitot, Mrs Middleton.	57	15s
	Petitot, Charles I.	65	2s
	Petitot, Duchess of Orleans, bought by Holford.	141	15s
1847	Edward Harman. C. Isaac Oliver, Earl of Dorset, 1616.	43	1s
1848	Duke of Buckingham, Stowe. C. Samuel Cooper, Charles II as Prince of Wales in 1651, in jewelled case.	105	
1852	Soult, Duc de Dalmatie, Paris. Turenne, by Petitot.	80	
	Catinat, by Petitot.	80	
1855	Bernal. C. Samuel Cooper, Lord Falconberg.	60	
	Clouet, Henri II of France.	163	5s
	Clouet, Henri III of France.	215	5s
	Large equestrian miniatures on vellum, bought by Duc d'Aumale (Musée Condé, Chantilly).		
1857	V & A buys miniature of Queen Elizabeth by Nicolas Hilliard, mounted as a locket, 3¾in × 2¼in.	262	10s
1859	C. Charles II in enamelled filigree frame with royal cypher.	113	15s
	Rattier, Paris. Clouet, portraits on vellum of Henri II, Charles IX, etc. 6 for	480	
1862	Paris. Petitot, Mlle de Montesquieu.	56	
1863	San Donato (Prince Demidoff), Paris. Petitot, portrait of Turenne, mounted in a snuffbox.	185	
	George Blamyre. C. Boit, enamel miniature of Sarah Jennings.	126	
	Samuel Cooper, Waller the poet (ex Strawberry Hill).	85	
1865	Earl of Cadogan. C. Blarenberghe, enamel miniature, landscape with hawking party.	131	
1868	Colonel Boteler. C. Samuel Cooper, Oliver Cromwell in armour.	232	
1870	C. B. Carruthers. C. Cosway, the Ladies Fitzpatrick.	78	15s

£

1872	Allègre, Paris. The Foire de St Germain, 1763, minute scene painted by Blarenberghe as a pendant.		1,204	
1881	Sackvile Bale. C. Isaac Oliver, 3rd Earl of Dorset.		800	
	Isaac Oliver, Earl of Suffolk in jewelled pendant.		2,126	
1882	Hamilton Palace. C. Nicolas Dixon, Charles I (see 1961).		96	12s
	Nicolas Hillyard, James I (in jewelled case).		2,835	
	6 portraits of the French Royal House, Henri II, etc.	6 for	1,758	7s
	Isaac Oliver, Lady Venetia Digby (see 1842).		294	
	Nicolas Hilliard, Arabella Stewart.		273	
	Samuel Cooper, Earl of Sandwich, 1659.		255	
	Philippe Champagne, Coronation of Henri IV.		325	10s
	Petitot, the Dauphin, 1712.		682	10s
	Petitot, Colbert.		241	10s
	Henry Bone, after Antonis Mor, George, Lord Setone, 1548.		131	5s
1886	Levy-Cremieu, Paris. Blarenberghe, The Four Seasons.	4 for	1,160	
	Blarenberghe, Fête de Village.		424	
1892	Earl of Westmorland. C. Hans Holbein the Younger, Lord Abergavenny, water-colour on playing card (Coll. Duke of Buccleuch).		430	10s
1893	Earl of Essex. C. Cosway, the Princess Royal.		262	10s
	Petitot, Mme de Montespan and Mme de Maintenon, 2 oval miniatures in a diamond-set frame.	2 for	320	5s
1896	Goldsmid. C. Cosway, 2 sisters (locket).		427	
1898	Decloux, Paris. Weiller, Comte d'Angiviller, 1780 (see 1913).		644	
1900	Rushout. C. 4 family miniatures in 1 frame by Andrew Plimer.	4 for	3,045	
	3 in 1 frame by John Smart.	3 for	2,300	
1902	Sir Henry Beddingfield. C. Nicolas Hilliard, Queen Elizabeth, 1597.		640	
	Andrew Plimer, lady, 1790.		250	
	Vernon. C. Cosway, Mme du Barry.		1,050	
	Cosway, Duchess of Cumberland.		987	
	Andrew Plimer, Hon. Mrs Cochrane.		420	
	Cosway, Hon. Mrs Dawson Damer (locket).		651	
	Cosway, George IV and Mrs Fitzherbert, pair of lockets.	2 for	546	
	C. The Armada Jewel, containing Hilliard's Queen Elizabeth in elaborate locket, bought by Duveen for Pierpont Morgan (see 1935).		5,250	
	Leverton Harris. C. Cosway, Countess Lubomirski.		790	
	Smart, Mrs St Aubin.		350	
	At Foster's. Palmer, 5th Duke and Duchess of Devonshire.	2 for	609	
1904	C. H. T. Hawkins. C. Nicolas Hilliard, Mary Queen of Scots, painted on a playing card, 1581.		861	
	Holbein school, two children full face.		1,000	

£

1904	Hans Holbein the Younger, Frances, Lady Vere, painted on a playing card.	2,750
	C. Nicolas Hilliard, John Crocker and his wife, Frances.	2,520
1905	Marquess of Anglesey. C. Hoskins, Charles I and Henrietta Maria. 2 for	777
	John Quicke. C. Isaac Oliver, Sophia of Mecklenburg.	714
	C. H. T. Hawkins. C. Holbein, Mrs Pemberton, bought by Duveen for Pierpont Morgan (Salting underbidding) (see 1935).	2,750
1906	C. Nicolas Hilliard, self-portrait, 1577.	1,155
	Nicolas Hilliard, the artist's father, matching piece.	1,155
1908	Braikenridge. C. Nicolas Hilliard, unknown gentleman.	620
1912	Mme Roussel, Paris. J. P. Augustin, Portrait of Mlle Duthé.	2,220
	Cosway, Lady Beechey.	760
	J. Hall, unknown gentleman.	804
	Osias Humphrey, unknown lady.	760
1913	Paris. Weiller, Comte d'Angiviller (see 1898).	1,188
1917	C. Nicolas Hilliard, Sir H. Slingsby, 1595.	409 10s
1928	Edwardes-Heathcote. C. Isaac Oliver, Henry, Prince of Wales (see 1949).	1,155
	Nicolas Hilliard, Mary Queen of Scots.	1,050
	Peter Oliver, Lady Arabella Stewart (see 1949).	997 10s
1932	Sir W. Blount. C. Attributed to Holbein, 2 portraits of Thomas Cromwell, forming a locket.	2,047 10s
1935	Pierpont Morgan Exors. C. The Armada Jewel (see 1902), bought for V & A.	2,835
	Holbein, Mrs Pemberton (see 1905), Kress Foundation. Still (1962) the English auction record for a portrait miniature.	6,180
	Sir Thomas More, attributed to Holbein.	892 10s
	Henry VIII, ditto.	525
	Hoskins, King Charles I and Queen Henrietta.	651
	Petitot, Duchess of Richmond and Lennox.	735
	Cosway, Mrs Parsons.	892 10s
	Pierre Prudhon, Constance Meyer.	787 10s
	Augustin, Mme de Boufflers.	567
	Isaac Oliver, Philip II of Spain(?).	651
	Duke of Buccleuch. Private sale of 4 miniatures by Isaac Oliver to the Fitzwilliam Museum. 4 for	1,300
1949	Harry Seal. C. Isaac Oliver, Henry, Prince of Wales (see 1928), bought by Barber Institute.	651
	Peter Oliver, Lady Arabella Stewart (see 1928), bought by National Museum Stockholm.	630
1955	Sotheby (of Ecton). S. Nicolas Hilliard, Duke of Cumberland.	5,000
	Samuel Cooper, James II as Duke of York.	2,300
1959	Viscount Morpeth. S. Nicolas Hilliard, Sir Walter Raleigh, bought by National Portrait Gall.	5,300

£

1960 Samuelson. C. Samuel Cooper, portrait of Bridget
Cromwell.
 Nicolas Hilliard, Anne of Denmark. 399
 Isaac Oliver, James I. 399
 294
1961 C. Hilliard. Robert Dudley, Earl of Leicester, bought
for National Portrait Gall. 3,675
 Samuel Cooper, Duke of Lauderdale, 1664 (National
Portrait Gall.). 2,100
 Nicolas Dixon, Charles II (see 1882). 1,155
 Nicolas Hilliard, James I. 1,050
 John Smart, Miss Mary Bathurst, 1792. 735
 Jeremiah Meyer, Master George Meyer. 630
 S. John Hoskins, Charles II as a boy. 1,080
 Samuel Cooper, Young man (jewelled frame). 850
1962 C. Cosway, 2-sided miniature, Lady Willoughby
d'Eresby and Lady Georgiana Bertie. 2 for 682 10s
 Unknown, Queen Victoria, jewelled frame. 672
 Isabey, Duchess of Montebello. 525
Rivers-Bulkely. S. Nicolas Hilliard, Mr and Mrs. Mole,
double-sided pendant. 2,000

CARPETS

£

1767	C. Silk Persian carpet, nearly 4yd square, "Intended as a present from the Persian Emperor for the Queen of Spain" (presumably 16th or 17th cent.).	13 13s
1773	C. "A superb Persian carpet", 56ft × 22ft (apparently a genuine price and not bought-in).	210
1807	C. Persian rugs (at this date they would certainly have been antique, and obtained in India):	
	Blue, with olive border, 8ft × 6ft.	25 4s
	Brilliant colours, fawn ground, 11ft 6in × 9ft 6in.	26 5s
	With red flowers and gold, 9ft × 4ft 7in.	13 10s
1819	C. "Rare and ancient Persian rugs":	
	6ft 1in × 4ft 1in.	15 15s
	5ft 9in × 4ft.	13 2s 6d
1848	Duke of Buckingham, Stowe. C. Persian carpet, "shawl pattern", 25ft 6in × 15ft 9in, believed the largest ever imported, and reputed to have cost £200 (almost certainly Turkish).	57 15s
1863	V & A buys the Hans Bock Coll. of mediaeval fabrics, 300 items for less than £1,000, among them 3 Hispano-Mauresque carpets of the 15th–16th cent.	
	Earl Canning. C. "Bombay carpet"; figures of panthers and other animals, 29ft × 21ft (possibly a 17th-cent. Indo-Portuguese carpet).	72 9s
	From the 2nd Crystal Palace Exhibition. C. Cashmire carpet, 5¾in × 3yd, made in the Jail at Lahore.	38 17s
1864	Eugène Piot, Paris. Velvet carpet, Ispahan (see 1875).	192
1868	Maharajah of Kashmir (from the Exposition Universelle of 1867). C. Srinagar (Cashmire) carpet, 30ft × 10½ft; original price asked was £400, bought-in.	157
1875	Séchan, Paris. Ispahan 16th-cent. carpet, "Aujourd'hui je suis entré une minute à la vente Séchan. J'ai vu vendre de vieux morceaux d'harmonieuses couleurs trés passées, des 6,000, des 7,000, des 12,000 francs." (Edmond de Goncourt, Journal).	708
	Saint-Seine, Paris. Velvet carpet, 16th cent. (see 1864).	512
1883	V & A purchases Ispahan hunting carpet, c. 1600, 16ft 9in × 7ft 9in.	308
	South Persian rug, partly mohair, c. 1530, 9ft 4in × 8ft.	250
	Canopy carpet with lappets, 17th cent.	200

£

1888 Albert Goupil, Paris. 2 Persian silver-thread carpets, {1,340
bought by the Union Centrale (now the Louvre). { 800

 2 silk carpets, bought by the Lyons Museum. {540
 {580

1892 Charles T. Yerkes said to have paid £16,000 for a companion to the V & A Ardabil Carpet (see 1910, 1919, 1939).

1893 The great Ardabil Carpet, dated 1535, Ispahan, bought by subscribers for the V & A. 2,500

 Also silk velvet cope, Ispahan, 17th cent. 420

 Also 16th-cent. Ispahan carpet, 12½ft× 10ft. 300

1895 V & A buys S. Persian vase-typed carpet, early 17th cent. 160

1907 V & A buys 2 16th-cent. Anatolian rugs. 2 for 119 4s 9d

 15th-cent. Kairene carpet. 35

 Chappey, Paris. Ispahan 17th-cent. carpet, animals and dragons on deep red ground. 4,800

1909 Anneuil, Paris. Ispahan 16th-cent. carpet. 1,200

 Polovtseff, Paris. 17th-cent. silk carpet. 1,400

1910 Stefano Bardini. C. 16th-cent. silk carpet. 1,200

 Charles T. Yerkes, New York. The companion to the Ardabil Carpet (see 1892, 1919, 1939), £16,000 paid. 11,800

 Silk mosque carpet. 7,100

 Carpet described as 16th-cent. Baghdad, bought for Metropolitan Museum. 3,920

 {6,600

 Other Ispahan 16th-cent. carpets. {5,400
 {2,200
 {1,920

 Hispano-Mauresque 15th–16th-cent. carpet. 1,720

1912 J. E. Taylor. C. Ispahan silk carpet, 8ft× 15ft (at that time the English auction record for an Oriental carpet), bought by Duveen. 5,250

1913 Edouard Aynard, Paris. 16th-cent. Persian carpet. 3,366

 Asia Minor velvet carpet. 906

1919 Marchioness of Graham. C. 2 17th-cent. silk carpets, bought by Duveen. 2 for 13,650

 Delamor, New York. Duveen buys the 2nd Ardabil Carpet (see 1892, 1910, 1939). 13,000

1920 C. 16th-cent. Persian rug, only 7ft. 976 10s

 Pasteur Goulden, Paris. 2 16th-cent. Persian carpets (see {1,809
 1925). {1,050

1921 Engel-Gros, Paris. Silk and silver-thread prayer-rug. 7,200

 Indo-Persian prayer-rug. 1,900

1922 S. Indo-Portuguese late 16th-cent. carpet. 720

1923 V & A buys a panel of Ispahan velvet, early 17th-cent., figures after Riza Abbassi. 2,700

 Crookston. C. Anatolian mosque carpet, Persian style, 19ft 9in× 14ft 10in. 1,890

 Robert Benson. C. Small 16th-cent. Ispahan. 840

 Early 17th-cent. Anatolian rug. 483

£

1924	Adolphe Shrager (Puttick's). 17th-cent. Persian "Polonaise" silk rug.	1,102 10s
	Another about the same size.	714
	22ft Indian Ispahan, 17th cent.	693
1925	Galerie Petit, Paris. 2 16th-cent. Persian carpets (see Pasteur Goulden, 1920).	{510 370
1927	Benguiat, New York. So-called Royal Carpet, Persian, c. 1500, 13ft 4in× 11ft 8in ($100,000).	20,650
1928	Lord Glenarthur. C. Fragment of a late 16th-cent. Ispahan, 18ft 6in× 4ft 8in.	2,100
	From Vienna. C. Ispahan silk-and-wool carpet, 25ft× 10ft 8in, first half of the 16th cent., said to have been given in 1698 by Peter the Great to Leopold I, bought by Duveen (auction record for any carpet, even in 1962).	23,100
	Elbert Gary, New York. 16th-cent. Ispahan carpet, 26ft× 15ft.	21,950
1929	Lord d'Abernon. S. Ispahan, c. 1680, 26ft× 11ft.	10,300
1930	S. The King Edward VII Coronation Carpet, Ispahan, 17th cent., bought by Duveen (see 1939).	6,525
	Albert Figdor, Vienna. 16th-cent. carpet with flowers and animals.	3,800
	17th-cent. Ispahan carpet.	2,800
1931	Octave Homberg, Paris. Velvet prayer carpet, 16th cent., 32in× 30in.	4,120
	Lord Hastings. C. "Polonaise" 17th-cent. silver-thread carpet.	3,990
	"Polonaise" carpet, 7½ft× 4¾ft.	2,205
	Major Morrison. C. 16th-cent. Ispahan, 23ft× 8ft.	1,470
	C. Ispahan, 22ft 10in× 7ft 8in.	997 10s
1932	Brougham Hall (Knight, Frank). 17th-cent. Shah Abbas carpet, 14ft× 6ft 2in.	1,500
1933	Thomas F. Ryan, New York. Ispahan carpet, c. 1600, 32ft 3in× 14ft 2in.	2,675
1936	Emile Tabbagh, New York. Ispahan, 19ft 2in× 8ft 4in.	3,194
	Azerbaijan 17th-cent. arabesque carpet.	2,470
	Ispahan, 23ft× 12ft.	2,240
1937	Brady, New York. Ispahan 16th-cent. carpet.	4,110
1938	Duveen buys a 3rd Ardabil Carpet (see 1893) from the Duke of Anhalt.	20,650
	Holmes (at Bishopton, Scotland). 15th-cent. garden carpet.	3,000
1939	Clarence MacKay. C. 16th-cent. carpet "the Coronation Carpet" (see 1930), bought by Paul Getty.	6,300
	Duveen sells Paul Getty the 2nd Ardabil Carpet (see 1892, 1910, 1919).	14,050
1941	Mrs Henry Walters, New York. Ispahan silk rug, c. 1640.	over 4,000
1943	Sir George Mounsey. S. V & A buys: 15th-cent. Damascus rug, 6ft 2in× 4ft 10in.	270

£

1943	6ft 17th-cent. Ushak.	280
	Anatolian 18th-cent. runner, 13ft (presented to V & A).	180
	16th-cent. Ispahan, 6ft 3in× 4ft 8in.	155
	16th-cent. N.W. Persian, 7ft 10in× 5ft.	480
	16th-cent. Anatolian, 9ft 6in× 5ft 4in.	300
	Siebenburgen or Transylvania carpet (Anatolian), 17th cent., 13ft 5in× 7ft 7in.	450
	Other properties: Ispahan, 16th-cent., a fragment, 11ft× 6ft.	360
	Leonard Gow. S. Ispahan, 16th cent., 22½ft× 9ft.	2,800
	Grace Rayney Rogers, New York. Shah Abbas 17th-cent. silk rug.	4,050
1945	S. Modern silk carpet, Bokhara design, 12ft 7in× 8ft 3in.	710
1947	S. Modern Persian carpet, 21ft× 13ft.	820
	Modern Tabriz carpet, 28ft× 15½ft.	800
1950	Kuppers, Bonn. Early 19th-cent. Kirman, 27½ft× 22½ft, figures in miniature style.	2,320
1951	S. Late 17th-cent. Ushak (Anatolia) 25ft 5in× 12ft 8in.	1,800
1953	Quill-Jones, New York. 17th-cent. silver-thread Polonaise.	966
	Lahore, mille fleurs, c. 1600.	1,321
1954	C. Ispahan 16th-cent., 27ft 7in× 9ft 4in.	3,045
1960	C. Needlework carpet from Goa, made for Lord Clive, 18th cent.	2,995
	Myron C. Taylor, New York. Tabriz medallion carpet, over 20ft.	2,856
	Hispano-Mauresque, 17th cent., over 23ft.	1,606
	14ft hunting carpet, 16th cent.	3,213
1961	S. Ispahan carpet, 1600 (ex Austrian Imperial Family), 23ft× 8ft.	3,000
	Modern silk Tabriz carpet, over 14ft.	1,400
1963	Maharajah of Jaipur. S. 17th century Lahore carpet, 36ft 9in × 12ft 11in.	3,200

ENAMELLED GLASS, 13TH–14TH CENTURIES

£

1840	Lady Bagot. C. Mosque lamp, "probably of the earliest Venetian manufacture, the only others known being in the Great Mosque at Cairo". Obtained from a Jew at Pola in Istria (see 1892) (V & A, Myers Bequest, 1900), bought-in.	2	7s
1845	Lady Mary Bagot. C. The same lamp (see 1892).	19	19s
1861	Soltykoff, Paris. Mosque lamp, identified as Moslem from the examples in St Stefan's Treasury, Vienna.	200	
1864	Unnamed Eastern traveller, Paris. 20in bottle with frieze of animals (see 1879).	61	18s
	2 mosque lamps.	{48 {34	15s
1866	C. Arabic dish, sunk centre, with border of birds in red and blue enamel, 13th cent.	7	12s 6d
1872	Prince Napoleon. C. Mosque lamp, gift of the Khedive of Egypt.	230	
1875	Séchan, Paris. Small mosque lamp.	35	12s
1876	Peploe-Brown. C. Mosque lamp, bought in Damascus.	40	
1879	V & A buys enamelled glass bottle (see 1864).	270	
1882	Hamilton Palace. C. Round-bellied tankard, 7in high, with horsemen and blazon, 13th cent., bought for Alfred de Rothschild (still in family, 1962), called simply "ancient Oriental glass".	2,730	
1883	Beurdeley, Paris. Mosque lamp, dated 1361.	120	
1886	Stein, Paris. Bowl.	480	
	Mosque lamp.	108	
1888	Albert Goupil, Paris. Mosque lamp (Musée des Arts decoratifs).	320	
	Another.	68	10s
	Enamelled glass bowl or tazza.	102	
1892	Hollingworth Magniac. C. Mosque lamp, (see 1840, 1845), V & A.	220	10s
1893	Palmer Marwood. C. Enamelled beaker in mediaeval French copper-gilt mount, bought by F. de Rothschild (BM, Waddesdon Bequest).	1,732	10s
	Spitzer, Paris. Beaker, blue ground, blazon of Baibars I (Édouard de Rothschild).	580	
	Long-necked bottle (ditto).	480	
	Mosque lamps at £288, 244, 166, 156		
	Other long-neck bottles.	{160 {404	

£

1895	Beurdeley, Paris. Long-necked bottle, lightly enamelled.	80
1898	Charles Schefer, Paris. Mosque lamp, long inscription, 14th cent.	160
1899	Charles Stein, Paris. Long-necked bottle.	420
1904	Gaillard, Paris. Mosque lamp.	280
1908	Louvre buys an enamelled beaker.	860
	Homberg, Paris. Enamelled glass goblet.	120
	Mosque lamp.	550
1911	von Lanna, Prague. Trumpet-mouthed beaker with frieze of horsemen, 13th cent. (Despite the huge price, Carl Lamm in 1930 was unable to locate it.)	2,050
1921	Morgan Williams. C. Mosque lamp with inscription of Ibn Kalaun [d. 1341] (see 1940).	2,625
	Engel-Gros, Paris. Beaker with figures and trees (115,500 fr.).	2,400
	Mosque lamp (83,600 fr.).	1,800
1937	Victor Rothschild. S. Long-necked bottle.	480
1940	Eumorfopoulos. S. Mosque lamp, 14th cent. (see 1921, 1944), bought-in.	860
	Beaker, hawks attacking geese, Chinese style, mid-14th cent.	860
	Bowl, inscription of Ibn Kalaun, before 1341.	850
	Bowl with figure medallions.	320
	Persian 14th-cent. bowl, enamelled flowers.	450
1944	Mrs Eumorfopoulos. S. Mosque lamp (see 1940).	950
1945	R. W. M. Walker. C. Beaker with horsemen.	735
1946	Swaythling heirlooms. C. 14th-cent. mosque lamp, Chinese style (Fitzwilliam Museum).	630
1949	Fitzwilliam Museum acquires through subscribers a mosque lamp of c. 1350.	2,000
1958	V & A buys the Luck of Eden Hall, a 14th-cent. beaker in a 15th-cent. English leather stamped satchel, from Sir Nigel Courtenay Musgrave.	5,500
1959	BM buys amber-coloured cut-glass beaker, 12th-cent., so-called St Hedwig's Glass, not mounted or enamelled.	16,000
1961	S. Long-necked enamelled bottle, sparse design.	320

NEAR-EASTERN ART

EXCAVATED GLAZED POTTERY, 9TH–14TH CENTURIES
Mostly Persian: some Syrian

£

1864	V & A buys 4 pieces of 14th-cent. Syrian glazed pottery, described as Siculo-Arab:			
	2 potiche-jars.	2 for	31	12s
	Bowl with radiating pattern.		9	
	Larger potiche-jar.		24	
1873	Paris. Persian gold lustre bowl.		64	
1876	V & A purchases from Dr Richard of Teheran:			
	Part of a *mihrab* in lustre tiles, 31in high.		65	
	3 lustre tiles forming an inscription, 52in long, early 14th cent.	3 for	65	
	Mihrab centre-tile, dated 1308, 18in×14in.		30	
	2 lustre tiles from mosque. of Khunsar, late 13th cent., 15in×17in.	2 for	45	
1888	V & A buys 2 blue-and-gold lustre oviform jars, 15½in high, called Siculo-Arab, but actually Syrian, early 15th cent.	each	200	
1892	V & A buys 8in lustre jar, 13th cent., said to come from Ardabil.		8	8s
1893	Frederick Spitzer, Paris. 13in lustre inscription-tile, *c.* 1320.		220	
	Other large lustre tiles, probably from Kashan.		⎰160 ⎱164	
1898	Dana, New York. Persian lustre dish, bought by Charles Freer.		362	
1905	Louis Huth. C. Persian bottle, lustre on blue.		105	
1906	Paris. Persian lustre bottle with portrait head.		200	
1907	Devaux, Paris. Complete 14th-cent. Anatolian prayer niche in *cuerda secca* tiles.		124	
1909	Paris. Large 13th-cent. lustre dish, restored.		1,120	
	A lustre bowl "sans guarantie".		248	
	New York. Kelekian said to have paid for a single lustre dish.		2,500	
	von Lanna, Prague. Syrian 14th-cent. drug-jar, gold lustre on blue.		1,450	
1911	Louvre buys a lustre dish with swimming fishes.		800	
	Joseph Dixon. C. 13th-cent. lustre tiles, forming top of a prayer niche, Kashan.		420	
1912	J. E. Taylor. C. Blue-and-gold lustre bottle.		273	
	Sultanabad bowl, 14th cent.		147	
	Lajvardina ewer, 13th cent., on blue.		210	

		£
1913	Edouard Aynard, Paris. Pear-shaped lustre bottle.	554
1914	Arthur Sambon, Paris. *Rayy* goblet in "Minai" style.	1,639
	2 ewers in a similar style. each	528
1921	Engel Gros, Paris. Minai bowl, repaired.	1,200
	Other Minai pieces at	450–800
1922	Dr Foucquet of Cairo, Paris. Jar in reddish lustre, Egyptian or Syrian, Fatimid, 11th cent.	1,380
1930	Jacques Doucet, Paris. Raqqa jar with 2-headed eagle, 13th cent., on turquoise ground, bought for Louvre.	770
	Sultanabad bowl with Mongol figures, 14th cent.	238
	Mesopotamian(?) shallow bowl with 2 birds and a tree in purple, 10th cent.	425
1931	S. Rabenou. S. Huge carved jar in lapis lazuli blue, Sultanabad.	780
	Rayy Minai bowl with horsemen, *c.* 1200.	250
1936	Emile Tabbagh, New York. Rayy bowl, figures on turquoise, said to be dated 1186.	597
	Rayy bowl, figures on white, said to be dated 1187.	514
	Another Rayy bowl in the same style.	329
1938	Everett Macey, New York. Rayy lustre dish.	372
	Gabri sgraffiato bowl.	372
	Minai bowl painted on blue ground.	537
1940	Eumorfopoulos. S. Kashan lustre dish, signed and dated 1210.	700
1944	S. 3rd Eumorfopoulos sale. Lakkabi dish with dancers, 11th cent., much restored (bought-in at £250 in 1940).	320
1958	Hauswedel, Hamburg. Squat albarillo, yellowish lustre, Nishapur, 10th cent.	300
	Blue octagonal bowl in relief, Rayy, late 12th cent.	292
	Slip-glaze dish, alleged Samarkand, Kufic characters reserved on brown.	350
1959	Eldred Hiscock. S. Nishapur or Samarkand type bowl.	420
	Rayy bowl, turquoise ground.	280

NEAR-EASTERN ART

£

1792 Mr Simpson, late of the East India Company. C. A book
of astrology in Persian with 36 paintings. 14s

 The poems of Hafiz in Arabic, with beautiful illumina-
tion. 6s

1804 C. A miniature illuminated Koran. 5 14s

1808 Nathaniel Middleton. C. Album of 62 Mughal portraits,
including a court scene of Jehangir and a portrait of the
former owner, Suraj ed Douleh. 199 11s

 Koran, considered the finest extant, given by Suraj ed
Douleh to Middleton. 185

 Koran, given to Jehangir by the Persian Ambassador,
early 17th cent., every page illuminated. 27 6s

 Commentaries of Emperor Baibur, 150 Mughal minia-
tures. 22 1s

 32 Hindu paintings of the *Rigmala*. 23 2s

 Khamsa of Nizami, highly finished Persian miniatures. 17 6s 6d

1809 C. Album of 31 Indian miniatures, bought by Marquess
of Blandford. 60

 Shah Nameh, 76 miniatures. 9 9s

1810 Archibald Swinton. C. Illuminated *Shah Nameh*, 2
folios. 17 6s 6d

 Khamsa of Nizami, 22 miniatures. 26 15s 6d

1829 Lady de Clifford. C. Album of Persian paintings and
calligraphies from Bajii Rao's palace at Sassoor. 5 5s

1831 General Stewart. C. 16 lots of Hindu miniatures at 10s
to £5 a lot.

1845 Miss Impey (*ex* Elijah Impey). C. Many lots at a few
shillings each.

 3 Persian drawings. 3 for 3 9s

1848 Duke of Buckingham, Stowe. C. Album of 17 Mughal
miniatures, once presented to Warren Hastings. 13 10s

1850 Debruge Dumenil, Paris. 8 portraits, Mughal school, of
princes of the House of Timur, and 11 other miniatures. 16

 Akbar period, Mughal school, 2 elephants fighting and
men separating them. 1 3s 6d

 11 portraits of princes of the House of Timur. 7 4s

 General Gordon of Cairness. S. The *Diwan* of Kwaju
Kirmani, profusely illuminated, Baghdad, 1396, bought by
BM. 1 12s

£

1867	Reinaud, Paris. The *Diwan* of Hafiz, with several miniatures.	2	12s
1876	S. *Shah Nameh*, with 67 miniatures.	15	
	16th-cent. illuminated Koran.	12	
1882	Hamilton Palace. About 20 Persian and Indian MSS., sold to Prussian Government.		
1884	Alessandro Castellani, Rome. Persian manuscript with miniatures, *"richement reliée"*.	27	
1885	V & A purchases a collection of 25 book-bindings and MSS., 15th–17th cent., including a *Shah Nameh* with 16 paintings by Riza Abbassi.	200	
1908	Homberg, Paris. Mughal 17th-cent. *Khamsa* of Nizami, 14 miniatures.	114	
	Persian MS., *Bustan of Sa'adi*, 1562, 5 miniatures.	440	
1912	BM buys the large Mughal cotton painting, Timur and His Descendants.	350	
1914	Arthur Sambon, Paris. *Khamsa* of Nizami, Herat school, 16th cent., 9 miniatures.	202	
	16th-cent. *Diwan* of Hafiz, painted by Sultan Muhammad and Mirak.	2,860	
	16th cent. Nizami, painted by Sheikhzadeh.	206	
1916	Garnier, Paris. Miniatures of Mughal notables, from an album made for Akbar, late 16th cent.	⎧167 ⎨123 ⎩110	
1919	Jeunette, Paris. 16th-cent. Persian illuminated MS., *Mujalis al-Ishaq*.	1,800	
	Yates Thompson. S. Persian romances, illuminated in Bukhara 1st half of the 15th cent. (BM, per Dyson Perrins, 1960).	5,000	
1920	Claude Anet. S. Dated MS. of Khusrau Dilhavi, 1515.	1,550	
	Diwan of Hafiz, painted by Sultan Muhammad, Herat, 1524.	700	
	Poems of Jami, painted by Mir Hassan, 1554.	600	
	Poems of Hatifi, 1524, 7 miniatures.	150	
1921	Engel-Gros, Paris. 13th-cent. Baghdad miniature from a treatise on electuaries (bought by Alfonse Kann).	935	
	Album of Mughal and Rajput miniatures, 16th–18th cent.	1,700	
	A very large 17th-cent. Indian miniature of Jehangir and his Court.	350	
	S. Volume from the *Razam Nameh*, painted for Akbar in 1598, 24 miniatures (see 1954).	72	
1923	S. Fragment of a Koran written on leather, said to be dated A.D. 680, signed Husain Dzakai.	135	
1924	Sotheby of Ecton. S. *Gulistan* of Sa'adi, 1537, 13 miniatures.	740	
1925	S. Album of 40 Mughal miniatures, made for Jehangir, mostly 16th cent.	3,950	

£

1927	Sevadjan, Paris. Miniature of the Timurid school. An armed man squatting on the ground.	340
1929	S. Album of 48 miniatures, made for Jehangir, Mughal school, bought by Kelekian.	10,500
	Khamsa of Nizami, Persian late 16th-cent. MS., 20 miniatures.	1,000
1930	Jacques Doucet, Paris. By Bihzad, late 15th cent., a prince of the House of Timur, seated and drawing.	1,265
	Ditto, a captured prince seated and manacled (Comtesse de Behague Coll.).	805
	A dervish meditating, late 16th cent.	402
	A 14th-cent. Shah Nameh painting.	760
	Another from the same MS.	600
	A miniature from Jaziri's treatise on automata, Baghdad, early 13th cent.	300
	Georges Petit, Paris. 16th-cent. portrait miniature, a prince seated and sewing.	1,150
	Early 16th-cent. Persian miniature on silk.	728
1931	S. Shah Nameh, 610 leaves, 28 miniatures, Shiraz ascool, c. 1550, bought-in.	760
1938	Everett Macey, New York. Single page from the Demotte Shah Nameh.	1,980
	2 Dioscorides leaves, Baghdad school, 13th cent.	{ 1,220 / 1,175
1941	Major D. I. Macaulay. S. Miniature on cotton by Bihzad, portrait of Tamerlaine.	440
	15th-cent. MS. of Nizami.	600
	Miniature, attributed to Ali Mirak.	380
	Portrait miniature by Muhammad Nadir.	205
1949	Bernard Eckstein. S. Jehangir on an elephant, 1620, by Meskin.	280
	Huge miniature (damaged) from the Hamza Nameh, c. 1553.	300
	Portrait miniature by Riza Abbassi (Barber Institute, Birmingham).	380
	17th-cent. Shah Nameh MS., 31 miniatures.	1,050
1950	Paris. Audience scene, Mughal school, reign of Jehangir.	182
1954	Gerald Reitlinger. S. Volume from the Razam Nameh, Mughal school, dated 1598, 24 miniatures (BM).	650
	Khamsa of Nizami, Persian, c. 1550, 8 miniatures.	360
1959	Dyson Perrins. S. Fables of Bidhpay, Persian, 16th cent.	6,200
	Volume of Akbar Nameh, Mughal, c. 1580.	5,000
	Diwan of Anwari, Persian, late 16th cent., 15 miniatures.	5,000
1961	S. Gulistan of Sa'adi, c. 1500, 8 miniatures, attributed Bihzad.	6,500
	Single Mughal miniature from the Razam Nameh, 1598 (sold for £3 in 1921).	360
1962	S. Portrait drawing of a poet, signed Riza Abbassi, 1626.	320
	Firdausi, Mughal school, c. 1600, 17 miniatures.	3,900

NEAR-EASTERN ART

METALWORK, IVORY, CRYSTAL

		£	
1772	Marquis Leonori of Pesaro. C. "An Arabian salver, filled with inscriptions and symbols, similar to the famous one in the Museum at Ste Geneviève in Paris" (i.e. the Baptistery of St Louis), Mosul, early 13th cent.(?).	2	2s
1827	Chevalier Franchi. C. (Probably *ex* Beckford.) Ewer and dish, bronze and silver filligree, "Greek or Moorish craftsmanship", said to have been obtained at Granada. 2 for	31	10s
	Moorish copper dishes with minute chasings in the manner of filigree.	4	4s–
		5	5s
1850	Debruge Dumenil, Paris. Cylindrical ewer with top handle, Mosul, *c.* 1200.	4	
	Bowl and cover, Mosul, late 12th cent., signed Zeyn ed-Din, bought by the Musée des Arts decoratifs.	1	10s
1853	Alexandre Decamps, Paris. "Bassin sarrasin damasquiné" (13th–14th cent.?).	10	
1855	Bernal. C. 2 brass candlesticks, chased in arabesque, possibly Syrian work done in Venice, 15th cent. 2 for	20	10s
1856	Emerson. C. Basin or mortar, described as Persian, with inscriptions and figures; at the bottom, a ship.	33	
1864	V & A purchases rock-crystal bottle, cut in relief, described as Byzantine (4½in high), actually Fatimid, 10th–11th cent.	20	
1865	V & A purchases Hispano-Mauresque ivory cyst with inscription of Khalif al-Hakim (A.D. 961–76), 2in× 4in.	112	
1871	M. Joseph. C. Pair of candlesticks on circular feet of rich design, called Persian, probably Cairo, 14th cent. 2 for	10	10s
1876	Peploe Brown. C. 2 pierced-bronze hanging mosque lamps from Damascus, Mamluq, 14th cent.	{25 26	
1880	V & A purchases:		
	Hispano-Mauresque rock-crystal casket, 11th–12th cent., 3¼in× 3¾in.	84	
	Cordova ivory casket dated A.D. 971 and inscribed Riyadh ibn Aflah.	600	
1884	V & A purchases Mamluq damascened bronze candlestick base, 14th cent. (compare 1871).	25	
1888	V & A purchases:		
	Brass 6-sided lamp from the mosque of Kait Bey [1469–95], 5ft 8in high.	80	

£

		£
1888	Brass astrolabe by Abdul Rahman ibn Yusuf, dated A.D. 1202, 10in × 8in (compare 1962).	7 17s 6d
	Damascened brass pail, signed Zeyn ed-Din, Mosul, c. 1200 (compare 1850).	80
1893	Frederick Spitzer, Paris. 2 13th-cent. Mosul candlestick bases, silver inlay on bronze. each	89 10s
	Hispano-Arab 11th-cent. coffer of ivory, inscription of Abdul Rahman (see 1899).	441
	Siculo-Arab ivory cyst and cover, 12th cent.	79
	Persian pierced-ivory box, 16th cent.	22 10s
1897	V & A purchases:	{25
	2 damascened brass pen-cases, late 13th and 14th cent.	{20
	Mosul candlestick base, c. 1200.	100
	Mosul ewer, c. 1200, 17in.	100
1898	V & A purchases:	
	Mosul gold- and silver-inlaid bowl, 17in diam.	400
	Silver inlaid bowl, Arab work, Venice, c. 1500.	392 10s
	Charles Scheffer, Paris. 13th-cent. bronze mosque lamp.	260
	Mosul inlaid bronze candlestick base.	70 8s
1899	Louvre buys Hispano-Arab ivory pyx and cover, dated 968 (see 1893).	2,200
1900	Louvre buys silver-inlaid bronze ewer from Persia, dated 1190.	1,684
1901	Hope Edwards. C. 15th-cent. censor, silver-inlaid brass.	525
1903	Mme Lelong, Paris. Hispano-Arab cyst, ivory, 10th cent.; lacks cover.	1,080
1907	Devaux, Paris. Small rock-crystal ewer, Kufic inscription, perhaps Fatimid, 10th cent.	180
1908	M. O. Homberg, Paris. Mosul bronze and silver-inlaid ewer, inscribed c. 1200.	486
1913	Malcolm of Poltalloch. C. Ivory cyst, Sicilian or Spanish, 10th cent., with the signature "Khalif" (see 1958).	1,837 10s
1914	Arthur Sambon, Paris. Bronze and silver-inlaid footstool, described as Mosul, 13th cent.	836
1916	Garnier, Paris. Brass writing-box, inlaid in silver, Mosul, 13th cent.	215
1924	Swaythling heirlooms. C. Egyptian Mamluq censer, gold- and silver-inlaid, Ibn Kalaun period, before 1341.	525
1925	Sir Francis Cook. C. Mosul damascened bronze censer, 13th cent., with added Italian enamel blazon.	283 10s
1931	S. Persian silver dish, believed Sassanian, 6th-7th cent.	750
	Marble mihrab, 39in high, signed and dated A.D. 1138.	330
1940	Eumorfopoulous. S. Silver-inlaid bronze pilgrim bottle, c. 1200, Freer Institute, Washington.	1,600
1943	S. Persian astrolabe, c. 1600.	210

£

1949 Joseph Homberg. C. Mosul bronze ewer, inlaid with
silver, Christian subjects, *c.* 1200. 420

1958 S. Ivory cyst, Sicilian or Spanish, 10th cent. (see 1913),
bought by V & A. 5,700

1962 Sir Edmund Finlay. S. Brass spherical astrolabe, A.D.
1480, possibly Persian, 3¼in diam. 3,600

NEAR-EASTERN ART

16th–17th Centuries

(Turkish faience, once classed as Rhodian, Damascus,
and Kutahia, now generally sold as Isnik)

£

1810	C. "3 large bottles of Persian make with silver ornaments and mountings". 3 for	5 5s
1846	Baron, Paris. Bottle, "faience bleue fleurie de Perse".	2 14s
1855	Bernal. C. Tankard with comma-like ornaments, ceiling-wax red, *c.* 1570, sold as Persian, but in fact Isnik (V & A).	7 10s
1858	David Falcke of Bond Street. C. 16 lots, described as Turkish ware, but not all were Anatolian, and one was clearly Hispano-Mauresque lustre. Most of them made less than £3.	
	Dish, 15½in, brilliantly coloured flowers, Isnik.	21 10s
1860	V & A purchases:	
	Blue-and-white basin, *c.* 1500–20, earliest style, 18in diam., damaged but magnificent.	4
	2 long-necked bottles, 17in high, in the same style. All these called Persian, but in fact Anatolian. 2 for	29 8s
	Samuel Woodburn. C. Persian 17th-cent. lustre dish, 7½in diam., "of the greatest rarity", bought-in.	7 15s
1861	Matthew Uzielli. C. Bowl, 11in high, 17½in wide, in 2 blues and purple, *c.* 1540, Isnik (Godman Coll.).	39
	Tankard with red carnations (pinks), Isnik.	22 10s
1864	V & A buys 11 Isnik dishes in good mid-16th-cent. style. each	8
	Eugène Piot, Paris. Isnik early 16th-cent. basin in 2 kinds of blue, described as Persian, 18in diam.	65
	Paris. Other sales. 20in bottle with animals on a turquoise ground.	61 8s
	Basin in the early blue-and-white style, 13in.	16 8s
	13in dish, *fond rouge*.	13 4s
1865	V & A buys Persian oviform vase with pomegranate decoration in the Turkish style, 16th–17th cent., 15in.	48
1866	W. G. Morland. C. 2 "Persian" (Isnik) dishes, flowers in colours on a white ground. 2 for	52 10s
1870	G. J. Durrant. C. "Persian ware from the island of Rhodes", exhibited at Leeds (all Isnik). 22 dishes in the later style at £1 16s to £8 each, most of them at about £3.	

£

1870 Appearance of the name Rhodian. V & A buys 12 late
Isnik plates with black outline borders from the island of
Rhodes at 2 guineas each.

1875 Séchan, Paris. Cylinder tankard, Isnik, polychrome. 60 10s
 Large dish, ditto. 66 8s

1876 Peploe-Brown. C. 2 "hanging vases". {6 15s
 {8

 127 late Damascus tiles, called Persian. 12 7s

1877 Larderel, Paris. Dish in purple and green (the 1540 type,
formerly called Damascus). 101

1882 Hamilton Palace. C. Polychrome tankard, Isnik. 21

1885 V & A buys the big Isnik mosque lamp from the mosque of
Suleimaniyeh, Istanbul. 450

1891 V & A buys:
 Persian tile picture, late 17th cent., 7ft 5in × 3ft 7in, a lady
 and attendants in 36 tiles. 275
 Complete tiled chimney-piece from the palace of Fuad
 Pasha, Istanbul, Isnik tiles. 523
 "Rhodian" bowl, 13in ceiling-wax red. 54 12s

1893 Frederick Spitzer, Paris. Blue-and-white long-necked
bottle, "Golden Horn ware", c. 1520–30. 78

1896 Paris. Described as a Persian pot with spiral decoration of
flowers mounted in engraved silver, possibly one of the few
Isnik tankards in 16th-cent. European mounts. 65 10s

1898 V & A buys a panel of Isnik tiles from Istanbul. 250
 Charles Scheffer, Paris. Long-necked bottle in the early
 blue-and-white style. 90

1901 A "Persian" vase bought for the Louvre. 600

1905 Louis Huth. C. Bowl, 17½in diam., called Damascus. 630
 14in dish with hyacinth sprigs. 514 10s
 Tankard, purple and blue on white. 546
 Dish of the same type, called Damascus. 609

1907 Chappey, Paris. Deep blue-ground dish, so-called
Damascus. 600
 De Vaux, Paris. Blue-and-white suspension mosque lamp,
 c. 1520. 520

1908 Octave Homberg, Paris. Blue-and-white suspension
mosque lamp, c. 1500 (see 1931), bought-in. 704
 Panel of tiles (Isnik) from a prayer-niche. 364
 Tiles from the Mosque of Suleimaniyeh (see 1925). 77

1911 Joseph Dixon. C. Dish, "Damascus" type. 315
 Panel of tiles. 420

1913 Edouard Aynard, Paris. Ewer, tulip design. 880
 Long-necked bottle, vase design. 792
 Dish, blue ground. 836
 Dish, prunus sprays on red ground. 550

1914 Arthur Sambon, Paris. Basin, white on blue, c. 1500,
described as Kutahia. 880

£

1917	S. E. Kennedy. C. Dish with "bluebell" pattern.	546
	Pear-shaped bottle.	661
	Another ditto.	399
1919	Jeunette, Paris. Ovoid Isnik vase, tulip pattern.	880
1924	Testart, Paris. Mosque lamp, polychrome (repaired).	1,640
	Swaythling heirlooms. S. Tankard with London parcel-gilt mount, 1586 (V & A).	1,000
1925	Paris. Dish with 4 feluccas sailing (£75 in 1913).	280
	Homberg, Paris. Panel of Mihrab tiles (see 1908).	750
	Tiles from the Mosque of Suleimaniyeh (see 1908).	280
1927	Sevadjan, Paris. So-called Damascus dish.	568
1930	S. Bottle with animals and birds on turquoise ground, described as Damascus, ormolu base.	1,450
1931	S. Dish bought by Kelekian, described as Rhodian.	1,050
	Burn. S. Ewer with long spout, fish-scale ground.	210
	Octave Homberg, Paris. Mosque lamp, blue-and-white, late 15th cent. (see 1908).	685
1938	Everett Macey, New York. Panel of tiles, cypresses, birds, etc., described as Damascus.	475
1948	Tollemache Estates, Ham House. C. Isnik tankard mounted in London in 1592 (Fitzwilliam Museum).	1,050
1954	Mrs Spottiswood. S. Standard 16th-cent. tankard, chrysanthema.	240
1958	Goodheart Rendell. C. Average 16th-cent. dish.	241 10s
1959	Kolkhorst. S. Scale-pattern tankard, 16th cent.	480
1961	S. With a European ship, c. 1620.	240
	12½in 16th-cent. dish, fair quality.	370

NEGRO SCULPTURE

BRONZE, WOOD, IVORY

		£	
1928	Walter Bondy, Paris. Wooden carved stool, Nigeria.	90	
1930	G. W. Neville (at Foster's). 2 brass statues of leopards, Benin. 2 for	735	
	Whole head in bronze, Benin.	493	10s
	Bronze plaque with 3 warriors in relief.	315	
	Other plaques	105–231	
	Colonel Taylor (same day). Whole heads in bronze from Benin.	⎰399 ⎱210	
1931	At Foster's. Standing Benin bronze, chief blowing a war-horn, 26in (present-day value perhaps £5,000).	220	10s
	2 13in vases in shape of rams. 2 for	189	
	Big Benin bronze plaque with figures.	136	10s
	Bronze head in the round.	199	10s
	6ft carved elephant tusk, Benin.	78	15s
1931	De Mire, Paris. Pahouin wooden figure, about 28in.	480	
	Ivory mask, Belgian Congo.	280	
1932	At Foster's. 20 in head in choker collar, Benin bronze.	94	10s
	21½in head, ditto.	89	5s
	Neck-ring in rich bronze relief, Benin.	78	15s
	S. Benin ivory bowl with cover surmounted by a figure.	66	
1939	Bronze head from Ife, bought through NACF for BM.	100	
1949	S. Bronze figure of a cock.	360	
	Head of girl, 12in high, Benin bronze.	210	
1950	S. Benin bronze statue, man blowing a horn.	900	
1952	S. Bronze Benin head, winged headdress, 21in.	720	
1953	Allman. S. (All from Benin.) Bronze statue of a ram.	700	
	Inlaid ivory box and cover.	700	
	Brass stool, formed of catfish.	900	
	Bronze statue of a cock.	1,400	
	Head of a queen in pointed headdress, replica of BM statue, bought for Nigerian Government.	5,500	
	Bronze water-pot of Islamic shape with masks.	600	
1954	Sir Claude Russell. S. Benin bronze relief of a child.	260	
	Edgar Jeans. S. Small bronze head in the round.	310	
	Bronze leopard mask.	210	
	Bronze statue of executioner.	450	
	9in mask.	180	
1955	André Derain and others, Paris. (Prices calculated at 1,200 fr. to the £1, plus 18·2 per cent. tax.) Bronze Benin statue of a warrior in chain-mail, 26in high.	1,770	

£

1955	19in bronze statue of a cock.	885
	Baoulay gold pendant.	562
	Bronze leopard mask, Benin.	255
1957	S. Standing bronze figure of a warrior, 24in.	2,900
1959	S. Gaboon wooden figure.	380
	Senufo wooden mask.	360
	Benin carved ivory armlet.	340
1960	Hauswedel, Hamburg. Gold Coast gold mask.	305
	Kasai ivory mask (Congo).	320
	R. J. Allman and others. S. Ivory mask in perfect condition, Benin.	6,200
	Ivory standing figure, 21in, Benin.	1,800
	2 Benin carved tusks, 6ft and 4ft 4in.	{950 \ 450
	S. Ijaw wood figure, Niger Delta.	640
	Ibibio figure, S. Nigeria.	500
	Both bought for Museum of Primitive Art, NY.	
	Trustees of BM. S. Bronze Benin warrior plaque.	900
1961	Ronald Searle. S. 10in bronze Benin head of an Oba.	2,800
	S. 18in female bronze head.	1,900
	14in bronze plaque with executioner group.	1,300
	2 16in statues of warriors, Benin bronze. each	1,200
	15in bronze plaque with single figure.	1,400
	2 Ashanti gold figures of lions, 2in long. 2 for	980
1962	S. Benin bronze head in choker collar, 9in.	3,000
	2nd ditto, 13½in.	1,350
	Standard small Benin bronze mask.	280

PALISSY WARE

FRENCH 16TH–CENTURY FAIENCE

(some made in the 17th century at Avon)

£

1780 Harrache (a jeweller). C. "3 old embossed Roman ware dishes." 3 for 12s

1791 Lord James Manners. C. "Ancient earthenware embossed." Several lots, which sound like Palissy ware, made less than £1 each.

1829 Feuchère, Paris. Oval dish with masks. 1 5s

1842 Waldegrave, Strawberry Hill (*ex* Walpole). Dish with pierced borders. 4 15s
 Standing salt. 5
 Pair of big dishes with royal arms. 2 for 4 14s 6d
 Dish with frogs and lizards. 7
 Circular dish, 10in, Perseus and Andromeda (see 1945, £12 10s). 26

1846 Baron, Paris. Oval dish, Venus and Loves (see 1859). 36
 Brunet-Denon, Paris. 14in statuette, *le vieilleur*. 30 4s
 Dish imitating a pewter model, by Briot. 32

1848 Roussel. C. (Brought over on account of the Revolution.) Flambeau with masques in relief. 20
 Urn, amorini in relief, ormolu handles. 57 15s
 Beurdeley (of Paris). C. Dish, "Diana of Poitiers, after Jean Goujon". 5 7s 6d

1850 Preaux, Paris. 2 Pierced dishes with the cyphers of Henri II, Catherine de'Medici, and Diane of Poitiers (see 1859). {60 {64
 Ewer with medallions, Faith, Hope, and Charity. 41 10s
 Debruge Dumenil, Paris. 2 oval dishes with pierced borders. 2 for 12 12s
 Dish, completely *decoupé à jour*. 8 14s
 Sauceboat with fecundity figure (V & A). 1 18s
 4 12in reliefs of allegorical figures in contemporary frames. 4 for 14 12s

1854 C. Fountain and basin, supported by tritons, etc. 59 17s

1855 Bernal. C. A smashed dish with lizards, bought by Gustave de Rothschild (bought, restored, in the 1840s for £4). 162 15s
 13in meat-dish, Cupids in relief (V & A). 26
 12in oval dish, Sacrifice of Abraham. 20 10s

£

1859	Rattier, Paris. Oval dish, Venus with Loves (see 1846).	232
	2 pierced dishes with royal cyphers (see 1850).	{260 {240
	Ewer with nymphs and satyrs (*ex* Soulages Coll.).	192
1859–60	V & A purchases from the former Jules Soulages Coll.:	
	Standard oval dish with reptiles.	60
	Stumpy ewer with nymph handle.	200
1861	Prince Soltykoff, Paris. 133 examples of Palissy ware.	
	20in oval dish with *grottesche* (V & A, £193).	160
	20in basin, Diana of Poitiers as the Nymph of Fontaine-bleau (since 1913, Metropolitan Museum).	292
	17in dish after a pewter design by Briot (see 1890).	400
	A 2nd ditto bought by Roussel.	192
1865	Pourtalès, Paris. Hexagonal standing salt.	202
	Oval fecundity dish, Avon period (bought by V & A).	112
1869	Frank Davis. C. Oval dish depicting Henri IV and his family; the illustration looks doubtful; bought-in.	84
1884	Fountaine. C. Version of the Briot ewer in relief, bought for the Louvre.	1,365
	Pair of ewers. 2 for	840
	Pair of candlesticks (Wallace Coll.). 2 for	1,510
	3rd candlestick (bought by the Louvre).	640 10s
	Huge oval cistern with masks, etc., bought by the Louvre at the all-time record price of	1,911
	Smaller cistern, bought by the V & A.	1,102 10s
	Tankard with figure of Diana.	199 10s
	Oval dish, Diana and Hounds.	840
	Dish and ewer with lizards, etc. (see 1940). 2 for	309 10s
	Square plaque with water-nymphs.	761 5s
1889	Stainyforth. C. Marguerite dish, pierced borders.	105
1890	C. Oval dish with fecundity group.	336
	Achille Seillière, Paris. Dish with pierced borders, containing the cyphers of Henri II, Diane of Poitiers, and Catherine de' Medici (see 1919).	920
	17in dish, allegory after Briot, Temperance (see 1861).	500
1893	Frederick Spitzer, Paris. 21in plaque, allegorical of the element Water, bought by the Louvre.	1,080
	Oval dish, figure of Diana (see 1899).	432
	Oval dish, water-nymphs.	400
	73 examples from £5 upwards.	
1899	Charles Stein, Paris. The Spitzer Diana dish (see 1893).	644
1912	Jean Dollfuss, Paris. Recumbent statuette of a dog.	380
1919	Sir Philip Sassoon. C. 2 statuettes, man and wife. 2 for	89 5s
	Tazza with pierced borders and cyphers of Henri II and Diane of Poitiers (see 1890).	336
1921	Hope heirlooms. C. Pair of salt-cellars with figures of Neptune in niches. 2 for	252
1925	Countess of Carnarvon. C. 8in stoop or pilgrim bottle.	131 5s

£

1927	Lindsay Holford. C. Fountain-shaped vase and dish (see 1957). 2 for	399
1931	S. Dish with cypher of Henri III.	300
1940	Eumorfopoulos. S. Dish with lizards (see 1884, £735; see also 1949).	10
	Frog and lizard, group.	4
	Group of Christ and the Woman of Samaria (Fountaine sale, 1884, £105).	24
1945	Viscount Templewood. S. Oval dish with arms of France.	10
	S. Tazza, Perseus and Andromeda (see 1842, Strawberry Hill sale, £26).	12 10s
1946	S. Oval meat-dish, Avon period, c. 1600, Bacchanalian scene.	500
1949	Sir Bernard Eckstein. S. Dish with lizards (see 1884, 1940).	140
1957	Isham. S. Fountain-vase on a dish, 22in high (see 1927).	100

PORCELAIN

ENGLISH

Chelsea and Bow

£

1766 C. Chelsea inkstand for a lady's writing-table. 15s
 Pair of Chelsea candlesticks with tigers hunting and bucks.
 2 for 6 10s
 Basin and ewer of the rich Mazarin blue and gold. 2 for 5 5s
1767 C. 2 figures of Muses on pedestals. 2 for 2 19s
 Thomas Turner, deceased, "chinaman". C. White
 group, shepherd and 2 shepherdesses. 1 10s
 Rabbit-shaped tureen with cover and dish (see 1957). 1 11s 6d
 Apollo, enamelled figure on pedestal. 2
 Tureen in shape of a swan. 1 1s
 Hercules and Omphale, white group (see 1953). 1 1s
 2 groups of the Four Continents. 2 for 1 1s
1770 Sprimont. C. Liquidation of the Chelsea factory stock
 after sale to Duesbury of Derby:
 Dessert service, Mazarin blue and gold borders, bought-
 in. 58 for 130 4s
 Tea and coffee equipage, crimson and gold borders,
 figures after Watteau. 42 for 43 1s
 Dessert service with groups of natural flowers, bought-in.
 62 for 30 9s
 Pair of Mazarin blue urns and covers, pastoral scenes in
 panels. 2 for 26 15s 6d
 Very large brûle-parfums vase, crimson and gold, figured
 panels. 20 9s 6d
 Pôtpourri vase on pedestal, Cupid panels, crimson-and-
 gold ground. 13 18s
 Mazarin blue vase with gold grapes in relief (see 1819). 10 5s
 Figures and groups:
 Sportsman and lady. 2 for 1 17s
 Candlestick, tiger and leopard. 2 for 3
 Roman Charity, very large group. 6 16s 6d
 The Seasons, very large group. 3 10s
 Large group of figures "ornamented with jessamine
 flowers" (en bosquet). 9 19s 6d
 Pair of candlesticks, Cupid and Flora. 2 for 3 18s
 The Music Lesson, after a Vincennes Boucher model (see
 1896, 1911, 1944). 8
1771 Duesbury & Co. C. "Last year's produce of the
 Chelsea and Derby manufactories":

548

£

1771 Essence jar (brûle-parfums), Aeneas sacrificing to Apollo
at Cumae, crimson ground, festoons of flowers (see 1773),
bought-in. 85
Antique urn, Triumph of Bacchus, on crimson and gold,
bought by Morgan (see 1772, 1783). 63
Dessert services of 24 plates, 2 with festooned pattern on
Rose Pompadour ground. each (24) for 63
1 with figures, *bleu celeste* border. 24 for 65
Dessert service, borders in *bleu celeste* and gold. 44 for 70
Egg-shaped jar, highly finished in burnished gold, a
matron playing with children, actually *La maman*, by
Boreman after Greuze (V & A, Jones Bequest, 1882)
(see 1860). 26 6s
2 antique jars, Pompadour ground, festooned pattern,
"painted with Cupids after Busha [Boucher]". 2 for 44
Beaker, Mazarin blue and gold, Triumph of Bacchus (see
1783). 21
Several other single vases at 10 to 15 guineas each.

1772 Thomas Morgan, chinaman. C. The Triumph of
Bacchus vase, bought-in (see 1771, 1783). 39
2 Chelsea-Derby vases from the Ovid *Metamorphoses*
suite (see 1886). 19
Vase, Ulysses and Circe. 19 19s
A nobleman. C. Collection of 8 Chelsea scent-bottles,
mounted (compare 1961). 8 for 5 5s

1773 Duesbury, Chelsea-Derby annual sale. C. Perfume-jar
and cover, Burial of Polyxena. 17 6s 6d
Ovid's *Metamorphoses*, vase in *bleu celeste*. 9 9s
Ditto on crimson-and-gold (see 1886). 14 3s 6d
Large griffin jar on pedestal, crimson ground. 19 19s
Aeneas sacrificing to Apollo (see 1771). 42
Dessert service, *bleu celeste*. 44 for 42

1780 "Produce of the Chelsea and Derby factories." C. Pair
of vases, subjects from Ovid, blue-and-gold ground (gold
anchor period) (see 1771). 2 for 2 12s 6d
Similar pair, mounted with metal arms for lights. 2 for 9 19s 6d

1783 Thomas Morgan, chinaman. C. Vase and pedestal with
gilding, the Triumph of Bacchus, "one of M. Sprimont's
richest productions [see 1771] and a *chef d'œuvre* of the old
Chelsea manufacture". 9 9s
"Remaining stock of the Chelsea porcelain manufactory in
Lawrence Street." C. Dessert service, pink-and-gold
border. 50 for 10 10s
Table service, purple-and-gold border. 103 for 29 10s 6d
3 blue-and-gold vases, figures in compartments. 3 for 14 14s
Garniture of 5 vases, ditto. 5 for 12 12s

1786 C. Tea and coffee equipage, crimson-and-gold, "curi-
ously painted in figures by the ingenious Mr Devivi. No

£

1786	other set was ever made" (by Fidele Duvivier, possibly Worcester, c. 1772). 42 for	30 19s 6d
1791	Vere. C. A very elegant group of a shepherd and shepherdess from Mr Sprimont's Chelsea factory.	4 8s
1793	C. Table and dessert service, complete, Derby. 88 pieces	18 18s
1796	Charles Bond, china-man. C. Pair of very fine old Chelsea cups, covers, and stands, enamelled with medallions. 2 for	3
1800	Duke of Leeds. C. Chelsea dessert service, gilded blue borders. 44 for	19 8s 6d
1803	C. Pair of old Chelsea urns, painted with birds. 2 for	1 9s
1807	Ince. C. Derby groups, Quarters of the Globe. 4 for	3 7s
	Chelsea statue figures, Milton and Shakespeare. 2 for	2
	2 Chelsea candlesticks, sporting figures. 2 for	2 5s
	2 Chelsea-Derby urns, Sèvres style, *bleu celeste* ground. 2 for	6 10s
1808	Derby dinner service, Boreman. 84 for	15 15s
	Coalbrookdale dessert service, Japan style. 45 for	16 16s
1819	Sevestre. C. (Formerly Queen Charlotte's Coll.). Pair of Chelsea caudle cups, covers, and stands, peacocks in gold and Mazarin blue (gold anchor period, c. 1760). 6 for	27 16s 6d
	Pair of bottles with gold grapes in relief on royal blue, satyr handles (see 1770) (similar pair, V & A). 2 for	38 17s
	Chelsea boar's-head tureen with a stand, depicting a fox-hunt. 3 for	15 10s
	Garniture of 3 2-handled urns and covers, panels of birds and flowers on scarlet ground (Chelsea-Derby). 3 for	40
	These were the first rarity prices paid for Chelsea since the 1771 sale.	
1823	Farquhar, Fonthill (perhaps *ex* Beckford). 2 large urns (probably Chelsea-Derby) with figure subjects.	7
1835	C. A pear-shaped vase of "rare old Chelsea" with handles and cover, landscapes and cattle.	16 16s
	Two smaller ones, *en suite*. 2 for	15 15s
	2 compressed-shaped bottles, panels on Mazarin blue (gold anchor period). 2 for	21 10s
1836	Formerly Queen Charlotte's Coll. C. Pair of vases on amaranth ground, bought-in. 2 for	13 2s
	Pair of Mazarin blue vases, bird panels, mounted.	16 16s
1842	Waldegrave, Strawberry Hill (*ex* Walpole) (Robins). 2 ice-pails with grapes and vine leaves in relief (gold anchor). 2 for	30 19s
	12 dessert plates, birds, trees, and insects (Sir Hans Sloane's service?) (see 1957, 1962). 12 for	7 17s 6d
	2 cups, gold figures on blue.	17 17s
1847	Rt. Hon. Thomas Grenville. C. Single cup and saucer with birds and green borders (gold anchor). 2 for	11 0s 6d
1848	Duke of Buckingham, Stowe. C. Pair of urns, Roman history series. 2 for	23 10s

£

1848	Tureen, floral panels on *bleu du roi*.			24	
1849	Formerly Queen Charlotte's Coll. C. Pair of vases and covers, Watteau panels on *bleu du roi*.	2 for		38	17s
1850	James Stewart. C. Pair of tall vases, Chinese figures, flowers in high relief.	2 for		52	10s
1851	Dawson Damer. C. Octagonal vase, *bleu du roi*, 22in high, birds and flowers in panels (gold anchor period).			42	
1855	Bernal. C. Pair of oval dishes, crimson borders, birds, butterflies, etc. (V & A).	2 for		13	13s
	Pair of imitation Sèvres urns (Chelsea, gold anchor), pierced necks and covers.	2 for		110	5s
	Cup and saucer in *rose Pompadour* style.	2 for		21	
	Écuelle, cover and stand in same style.	3 for		27	6s
1856	Rev. William Angerstein. C. Pair of pseudo-Sèvres gold anchor vases, *bleu du roi*.	2 for		105	
	2 square vases, pseudo-*rose Pompadour*.	2 for		149	2s
	Vase and cover, same style, deep crimson.			111	6s
	2 globular pseudo-*rose Pompadour* vases, subjects, Bathsheba and Susanna.	2 for		203	
1860	I. K. Brunel. C. Sèvres-style vase with paintings after Greuze in panel on crimson (Chelsea-Derby) (see 1771).			219	
	Pair oviform vases, crimson ground.	2 for		141	15s
	Pair of crimson-ground vases, myrtle shape.	2 for		133	7s
1861	C. Pair of Chelsea gold anchor vases and covers, pierced necks, Chinese figures in landscapes in gold.	2 for		426	6s
	Oviform vase, Chelsea-Derby, Leda and the Swan in panel on deep blue, bought-in.	2 for		135	6s
1864	Sir Edward Price. C. Pair of openwork vases, claret ground, pseudo-Sèvres.	2 for		316	
1865	Lord Cadogan. C. Large figure, Una and the Lion (see 1910, 1949).			105	
	Openwork vase, rococo handles, gold ground, 17in high.			262	10s
	Mrs Crockford. C. Pair of Derby covered urns, painted *en camaieu*, after Angelica Kaufmann.	2 for		188	2s
	Robert Bristowe. C. 15 plates, *gros bleu* and gold, with birds and fruits in medallions.	15 for		136	10s
1866	John Shaw Philips. C. 3 gold anchor period vases, *gros bleu*, with medallions of playing children.	3 for		420	
	W. Curling of Welshpool. C. Single vase, pierced neck, lake ground, 14½in, pastoral landscape.			132	6s
1867	Lady Webster. C. 10 plates, gold anchor, blue scroll borders.	10 for		94	10s
1868	The Earl of Dudley buys 1 of the 7 gold anchor pseudo-Sèvres vases ordered by George III in 1762. Bought from the Foundling Hospital, it was said to have cost him 3,000 guineas. The remainder, acquired during the next few years, cost him nearly £2,000 apiece (see 1886, 1920).				
	V & A buys Bow coloured figure, based on the Farnese Flora, 15in high.			51	

£

1869 Lord Ashburton. C. Pair of diamond-shaped Chelsea
 vases, painted with playing cards. 100 5s 6d
 A 2nd pair. 104 19s 6d
1870 John Bulteel. C. Pair of Chelsea-Derby urns and covers,
 crimson ground, medallions *en grisaille*. 2 for 372 12s
 2 figures from the 9 Muses set, Terpsichore and Erato
 (see 1919, 1932, 1936). 2 for 97 13s
 Carruthers. C. Chelsea group, gentleman playing hurdy-
 gurdy, with lady and dancing dogs, *en bosquet* (see 1952). 202
 Shepherd and shepherdess under a may tree. 125
1871 Rainey. C. Vase and cover, ruby ground, Venus and
 Adonis. 204 15s
1869-75 Prices for English porcelain figures in Lady Charlotte
 Schreiber's journal:
1869 Amsterdam. 2 large Chelsea-Derby groups *en bosquet* (see
 1930). 15
1873 Paris. 2 similar (very dear!). 14
1874 Brussels. Allegorical figure of Justice, probably Derby,
 15in high. 12 10s
 Amsterdam. Derby figure of Milton (outrageous!). 25
1875 Bought by Lady Charlotte Schreiber at Christie's. Bow
 figures of Woodward and Kitty Clive (see 1937, 1949,
 1961). 2 for 31 10s
1876 C. Pair of Mayflower vases, panels on deep blue. 2 for 170
 Robert Napier. C. Gold anchor Chelsea vase, pierced
 cover, maroon ground. 210
1877 Romaine Callender. C. Goat-and-bee jug of 1745, the
 earliest piece. 34 10s
1879 Charles Dickins of Sunnyside. C. 3 Chelsea-Derby
 vases, painted *en camaieu*. 3 for 1,365
 Turquoise vase, ditto, open-neck. 470
 Beaker, royal blue ground, birds, flowers, etc. 504
 Lord Lonsdale. C. Hexagonal vase and cover, gold
 anchor. 566
1880 Lady Charlotte Schreiber still able to buy 2 Chelsea figures
 in Hamburg for £5.
1881 Sackvile Bale. C. Pair of Chelsea gold anchor vases after
 Boucher. 2 for 504
 Louis Huth. C. Pair of the same (see 1950). 2 for 435 15s
1886 Earl of Dudley. C. Gold anchor vase, subjects from
 Ovid, royal blue, open neck (see 1773). 945
 A pair of 16in vases in the same style, with Watteau
 subjects. 2 for 1,071
 4 of the 7 Dudley vases (see 1868 and 1912), bought-in.
 4 for 4,200
1887 C. Gold anchor period tea service. 460 8s
1894 Earl of Montrose. C. 2 vases and covers in Sèvres style.
 2 for 703

£

1895	Earl of Montrose, 2nd sale. C. Pair of vases and covers in Sèvres style.	2 for	619 10s
1896	Massey-Mainwaring. C. The Music Lesson, after Boucher (see 1770, 1911, 1930, 1944).		483
1899	Lord Methuen. C. Garniture of 3 Sèvres-style vases, royal blue ground.	3 for	2,992 10s
	Marquess of Londonderry. C. Garniture of 2 gold anchor Sèvres-type vases.	2 for	3,150
1901	Hope-Edwards. C. 3 similar vases and covers.	3 for	1,050
	Écuelle and cover, Watteau subjects.		546
	Lord Henry Thynne. C. Gold anchor period garnitures in French taste:		
	The Carnarvon Garniture.	2 for	3,255
	The Warwick Garniture.	4 for	5,400
1902	3rd Massey-Mainwaring sale. C. Chelsea figures exceeding £150 a pair.		
1903	C. A Chelsea boar's-head tureen.		4 10s
	2 square vases with Chinoiserie figures.	2 for	530 5s
1910	Octavus Coope. C. Pair of Chelsea-Derby vases.	2 for	1,260
	C. Una and the Lion group, 26in high (see 1865, 1949).		109 4s
1911	Cockshutt. C. The Music Lesson, after Boucher (see 1770, 1896, 1930, 1944).		1,837 10s
1912	Lord Astor said to have paid £20,000 for 3 of the 7 Dudley vases (see 1868, 1886, 1920).		
1916	Trevor Lawrence. C. Garniture of 3 gold anchor hexagonal vases and covers, royal blue panels, birds, etc.	3 for	1,312 10s
1917	C. 2 vases in Sèvres style, c. 1760, quatrefoil shape, with Watteau subjects.	2 for	735
1919	R. M. Wood. C. Pair of Bow figures en bosquet, Summer and Autumn.	2 for	3,780
	Set of 10 figures "after Roubiliac", Apollo and the Muses. The only complete set, bought by Lord Bearsted (see 1932).	10 for	2,625
	Shepherd-boy and girl, 13½in.	2 for	1,522 10s
	Owl on a tree-trunk (perhaps the 1st high price for a Chelsea "primitive" of the red anchor period).		472 10s
	Pair of Chinese pheasants on tree-trunks.	2 for	451 10s
	Robson. C. 2 Chelsea-Sèvres 20in vases with Watteau scenes, l'Escarpolette and Blind Man's Buff.	2 for	4,620
1920	C. 3 of the 7 Dudley vases (see 1886 and 1912). All 7 now in Lord Bearsted Loan Coll. at V & A.	3 for	6,510
1923	Gerard Lee Bevan. C. Scent-bottles (see 1948, 1961):		
	Hound attacking fox, 3in.		58 16s
	Bonbonnière, 2½in, shepherd-boy.		60 18s
1924	Teesdale. C. Chelsea group after Kaendler, Lovers surprised by Harlequin.		231
1925	Countess of Carnarvon. C. Scent-bottle, a nun, 3¼in.		162 15s

£

1930 At Hurcomb's. Shepherd and shepherdess *en bosquet*,
gilt scrolled base, 16in high. 2 for 3,250
 The Music Lesson (see 1770, 1896, 1911, 1944). 568

1932 C. 2 Chelsea gold anchor groups from the Four Seasons,
Winter and Spring, 13in. 2 for 714
 Humphrey Cook. C. The Chelsea set of 10 after
Roubiliac, known as Apollo and the 9 Muses, gold anchor
period, but with 1 figure missing (see also 1871, 1919, 1936),
bought-in. 9 for 892 10s

1933 C. Chelsea raised anchor figure after Kaendler, Dr
Boloardo, 9½in. 152 5s

1934 C. 2 Bow sweetmeat-stands, figures of Orientals, 8½in. 92 8s

1936 S. 2 "stooping birds", Chelsea, raised anchor mark.
 2 for 190
 Humphrey Cook. S. Chelsea figures, Apollo and 8
Muses (for same series, see 1927; for complete set, see 1919).
 9 for 680
 Chelsea-Derby vase in Sèvres style, Watteau subjects,
claret ground. 115
 C. Figure of a "little owl", raised anchor mark (see 1950). 173 5s

1937 Miss K. Marlowe. C. Pair of elaborate gold anchor
vases. 2 for 1,155
 L. A. Harrison. S. Chelsea, The Seated Fruit-seller. 330
 Chelsea, The Lady Asleep. 290
 Bow, Woodward and Kitty Clive (see 1875, 1949, 1961).
 2 for 120
 S. Ewer and basin, Watteau panels on Mazarin blue,
Chelsea gold anchor period. 2 for 540

1941 Bellamy Gardner. S. Asparagus tureen, early Chelsea
(compare 1952, 1955, 1959, 1962, 1963). 36
 Pair of Chelsea gold anchor vases, painted panels on
claret ground. 2 for 80
 Pineapple tureen and cover (see 1956). 32
 Chelsea white figure, The Gardener's Companion. 190
 Chelsea bottle, 1756, beautifully painted by O'Neale. 95
 Tea cabaret for 2 with similar subjects by O'Neale. 92
 2 gold anchor figures *en bosquet*, The Harvesters. 2 for 42
 Ditto, 3 Cupids dressing up. 3 for 56
 2 other bosquet figures, youth with a birdcage and girl
with a lamb, bought-in. 2 for 155
 White bust of a baby boy after Fiammingo (see 1949,
1962). 16

1942 Lockett. C. Pair of parrots on tree-trunks, Chelsea
raised anchor. 2 for 252
 Shepherd and shepherdess after Roubiliac. 231
 2 rococo vases, Watteau panels, gold anchor (£1,575 in
1921). 2 for 336

1943 Mrs Radford. S. The 4 Continents, Plymouth groups.
 4 for 450

£

1943	Figures of cock and hen, Bow.	2 for	400
	The Map-seller, Chelsea red anchor period figure (see 1959).		250
1944	Humphrey Cook. C. 2 Chelsea jays on tree-trunks, red anchor mark.	2 for	672
	The Music Lesson, after Boucher, large group (see 1770, 1896, 1911, 1930).		1,890
	Pierpont Morgan, Jnr. C. The Music Lesson, after Boucher, identical group sold a few weeks later.		2,047 10s
1945	R. W. M. Walker. S. Sucrier with Chinese figures (see 1949).		605
	Ewer and dish with panels after Lancret, gold anchor (see 1949).		945
	S. 2 green Bow parrots (see 1951).	2 for	890
	Alfred Tyrer. S. Chelsea group of 2 dancers, after Kaendler.		530
1947	S. 2 Bow groups, c. 1760, Price, the fancy rider, performing circus tricks (£800 in 1951).	2 for	700
1948	S. Scent-bottles under 4in high, Chelsea (compare 1923, 1960–1):		
	Girl winding wool from a lamb.		220
	Chinaman holding a bird.		135
	Masked Cupid.		125
	Miss A. M. Warre. S. 2 Chelsea figures of Chinamen in masquerade dress.	2 for	1,300
	Bulteel. C. Ewer and dish after Lancret (see 1945).	2 for	1,207 10s
	Sucrier with Chinese figures (see 1945).		1,102 10s
1949	Bernard Eckstein. S. Bow figure, Kitty Clive in *Lethe* (see 1875, 1937).		390
	Chelsea white bust of a baby boy, 4½in high, with plinth (see 1941, 1962).		640
	Chelsea figures, boy and girl with bunches of grapes.	2 for	650
	2 Chelsea figures of nurses with babies (see 1957).	2 for	1,060
	S. Pair of Chelsea partridges on tree-stumps (see 1951).	2 for	535 10s
	Humphrey Cook. Una and the Lion, rare 26in group (see 1865, 1910), bought privately by Sigmund Katz.		2,000
1950	S. 2 figures of "little owls" (see 1936).	2 for	3,200
	Baroness Burton. C. 2 square gold anchor vases (see 1881).	2 for	2,205
	S. 2 swans, only 5in high, raised anchor mark.	2 for	4,400
	2 Harlequin figures after Kaendler.		{1,700 {1,200
	The Nurse, after Vincennes model by de Bleneud.		1,300
1951	S. Lady holding a mask, raised anchor mark.		2,050
	Pair of Bow green parrots (see 1945).		2,000
	White Chelsea figure of an owl.		3,400

£

| 1951 | 2 Chelsea tawny owls. | 2 for | 2,600 |
| | 2 ditto, less perfect. | 2 for | 1,800 |

Miss Machrey. S. Pair of partridges on tree-stumps (see 1949). 1,300

S. Rabbit-shaped tureen with 14in oval stand (see 1957). 1,050

1952 Earl of Minto. S. The Hurdy-gurdy Player, Chelsea group (see 1870). 1,000

S. Bow figure, The Carpenter, after Kaendler. 1,000

2 tureens in form of bundles of asparagus (compare 1941, 1955, 1962, 1963). {610 480

1953 S. Chelsea white group after Lemoyne, Hercules and Omphale (see 1767). 950

Figure of fisherman on rocky base, Chelsea red anchor period, 8½in high. 2,250

1955 C. Pair of asparagus-bundle tureens (see 1941, 1952, 1959, 1962, 1963) red anchor, before 1758. 2 for 1,417 10s

Sotheby of Ecton. S. Milk-jug, incised triangle mark (£700 in 1951). 950

1956 Sir E. Cadogan. C. Meat-dish, claret-and-gold border, Sèvres style, gold anchor, after 1760. 2,310

Simon Goldblatt. S. 2 "girl in a swing" figures, Chelsea. 2 for 2,500

Mersel. S. Longton Hall copy of the Meissen horse-trainers. 2 for 950

Longton Hall tureen and cover en feuille de choux. 600

Chelsea pineapple tureen (see 1941). 800

S. Chelsea white bust of George II, c. 1750–60, 13in. 1,150

1957 Severne MacKenna. S. Chelsea raised anchor figure Nurse and Child (see 1949). 880

Single "Hans Sloane" plate, 8in red anchor (see 1892, 1962). 360

Mae Rovensky, New York. Rabbit-shaped tureen, red anchor period (in the 1870s, 1 of these was bought by Lady Charlotte Schreiber for £4 10s) (see 1951). Probably a record auction price for a single Chelsea piece. 4,280

Chelsea tureen in form of a pair of pigeons, red anchor period. 3,750

1959 Saunders-Stephens. C. Figure of little hawk owl, 6½in. 997 10s

S. The Jewish Pedlar, after Kaendler, 7½in. 680

The Map-seller, Meissen imitation (see 1943). 520

Malcolm MacTaggart. S. Asparagus tureen, 7½in (see 1941). Later in the year a similar tureen made £620 (see 1962, 1963). 520

1960 S. Pair of crested birds (Wieldon). 2 for 1,500

Dusendschon. S. Tyrolese Dancers, Chelsea copy of an Eberlein Meissen model. (In November, 1959, a similar group made £273, see 1963.) 3,600

£

1960 Scent-bottles (see 1961):
 Harlequin. 320
 Pugdog. 440
1961 S. Acanthus-leaf cream-jug, crown and trident mark. 1,050
 Octagonal teapot by O'Neale (£62 in 1946). 1,000
1962 Otto Blohm. S. 3 sales:
 All the following are scent-bottles or bonbonnières not
 exceeding 3¼in high (see 1923):
 1st sale:
 Parrot and cock. 950
 Harlequin. 850
 Swimming duck (bonbonnière). 780
 Parrot alone. 950
 3rd sale:
 Rooster. 2,200
 Parrot and cock 1,050
 Harlequin (see 1923, 1960). 1,050
 Pugdog (see 1960). 1,000
 Squirrel. 1,000
 S. Oblong fluted saucer-dish, painted by O'Neale. 620
 Bow figure of Woodward in *Lethe* (see 1875, 1937). 450
 S. Set of 6 10in plates of the raised anchor period with
 botanical designs after Hans Sloane (see 1842, 1957). 6 for 2,740
 S. Tureen with eel modelled on the cover (6 guineas paid
 in the 1930s). 1,300
 Strawberry dish, triangle mark (£7 10s in 1951). 1,150
 Teapot and cover, raised anchor period (£17 in 1941;
 £85 in 1945). 1,550
 Milk-jug, earliest period (£8 in 1866). 1,300
 Figure of a hen pheasant, under 5in. 1,050
 Asparagus tureen (see 1941, 1945, 1955, 1959, 1963). 950
 Bow shepherd and shepherdess (£290 in 1947) (inscribed
 I.B., 1757). 2 for 1,220
 Longton Hall melon tureen and cover (£68 in 1947). 900
 Marcel Steele. S. 2 Longton Hall plates, painted by
 James Giles. 2 for 680
 Single Hans Sloane dish (see 1959). 200
 S. 3 copies of an early Chelsea white bust of a baby boy
 after Fiammingo, 4½in high, sold in separate sales (see 1941, ⎧1,200
 £16, and 1949, £640). ⎨1,250
 ⎩2,000

1963 S. 2 Chelsea white groups, Rape of Europa and Rape of
 Ganymede. (£27 in 1941). 2 for 1,120
 Asparagus tureen, the 30th sold since 1945 (see 1941,
 1952, 1955, 1959, 1962). 1,450
 Stewart Grainger. C. The Tyrolese dancers (see 1960). 1,785
 Scent bottle, parrot and cock (see 1961). 997 10

PORCELAIN

ENGLISH

Worcester and Bristol

			£		

1769 Theed and Picket. C. Worcester, Mazarin blue and gold with wheatsheaf pattern, tea and coffee equipage. 35 for — 3 7s

 Dessert service. 45 for — 5

 Combined table service. 91 for — 21 10s 6d

 Garniture of 3 hexagonal jars with covers, birds and insects in panels. 3 for — 8 15s

1782 C. Worcester dessert service, Mazarin blue and gold. 47 for — 15 4s 6d

1803 C. Worcester dessert service, richly gilt. 24 for — 3 13s 6d

1834 Viscountess Hampden. C. Pair of vases, gold on green, English landscapes in panels. 2 for — 7 15s

1848 Duke of Buckingham, Stowe. C. Pair of hexagonal vases and covers, blue-and-gold ground. 2 for — 26 10s

1856 Colonel Sibthorp. C. The same pair. 2 for — 40

 Octagonal vase and cover, 16in. — 21

1858 Duke of Argyll. C. Pair of hexagonal vases and covers, birds and flowers, blue panels, 17in. 2 for — 32

1860 Bristow. C. Pair of hexagonal jars and covers, 16in. 2 for — 108 3s

 Set of 3 ditto. 3 for — 89 5s

1864 Sir Charles Price. C. Single ditto. — 29 18s 6d

1870 H. L. Wigram. C. Bristol teapot with wreath pattern, the Smith Service (see 1877). — 54 12s

 C. H. Carruthers. C. Worcester vase and cover, royal blue ground, garden scene after Boucher. — 141

1871 S. Armorial Bristol teapot, presented to Edmund Burke by Champion (see 1907). — 190

1877 Romaine Callendar. C. Bristol teapot from the Smith Service (see 1957). — 74 11s

 Jane Burke's Teapot (see 1913). — 215 5s

1879 Charles Dickins of Sunnyside. C. Garniture of 3 Worcester rococo vases and covers, paintings after Wouverman (see 1950). 3 for — 566

 Bt. by Lady Charlotte Schreiber: Bristol vase in the same style (V & A). — 75

1891 C. 2 Worcester large hexagon vases. 2 for — 315

1895 Lyne-Stephens. C. 3 ditto. 3 for — 420

1900 Macdonald. C. Worcester coffee-pot, Watteau subjects. — 315

1901 C. Worcester vase and cover, dark blue panels. — 283 10s

£

1906	J. Cheatham Cockshutt. C. 2 Worcester hexagon vases and covers, 15in, scale pattern. 2 for	861
	Garniture of 5 Worcester urns, Sèvres style, pierced necks, mottled blue panels. 5 for	2,625
1909	J. Cheatham Cockshutt. C. 2 Worcester hexagons and covers. 2 for	945
1910	Prices for Worcester, according to J. F. Blacker:	
	Pair of cups (Trapnell sale), Watteau-style, painted scenes. 2 for	157 10s
	2 vases with pea-green backgrounds. 2 for	1,000
	Single hexagon and cover, blue panels.	600
	Dr Wall Tea Service for 5.	345 10s
	Bristol teapot, presented to Edmund Burke (see 1871).	441
	Cup to match (with saucers).	70–90
1913	Trapnell. C. Jane Burke's Bristol Teapot (see 1877).	1,522 10s
1916	Sir Trevor Lawrence. C. Worcester dessert service, 53 pieces. 53 for	483
	3 hexagonal vases and covers, 15in and 11in, birds and insects. 3 for	1,312 10s
1922	Ralph Lambton. C. Single Worcester hexagonal vase and cover, scale pattern and contemporary figure-subjects by Donaldson (see 1948).	2,730
1928	Harrow-Bunn. C. Worcester-Watteau teapot by Donaldson.	194 5s
1930	Douglas Vickers. C. Pair of Worcester hexagons and covers, blue scale pattern and birds and insects, 16in. 2 for	367 10s
1936	S. 3 vases in the rococo style, painted by Donaldson after Watteau. 3 for	460
1938	Wallace Elliot. S. Tankard with silhouette portrait of Dr Wall, 1759.	660
	Worcester figure of a gardener with water-pot.	200
	The Gardener's Companion (see 1949).	155
1944	J. Pierpont Morgan, Jnr. 3 Worcester hexagons with pheasants, etc., between vertical blue panels. 3 for	504
1947	Heathcote. S. Worcester dish, scenes painted by O'Neale reserved on scale blue.	350
	S. Fluted Worcester dish, painted by O'Neale.	200
1948	Humphrey Cook. S. 3 Worcester hexagonal vases by Donaldson (for 1 of them see 1922). 3 for	3,045
1949	Sir Bernard Eckstein. S. Worcester figures, The Gardener and His Companion (see 1938). 2 for	700
	S. The Sportsman and His Companion. 2 for	1,800
1950	S. Worcester teapot by Fidele Duvivier, 1772.	800
	Baroness Burton. C. 3 Worcester vases, O'Neale after Wouverman (see 1879). 3 for	1,260
1957	Severne MacKenna. S. Bristol teapot, 1771, from the Sarah Smith Service (see Romaine Callender, 1877).	135
	Another initialled Bristol teapot, dated 1777.	250

£

1957	D'Arcy Edward Taylor. S. Worcester coffee-pot, painted by Giles.		770
	Worcester pink scale mug, Giles.		740
	Ditto, tea-bowl and saucer, Giles.		430
	Teapot, Dr Wall period.		620
	Pair of Worcester yellow-ground pierced dishes.		550
1959	Mrs Geoffrey Hart. 3½in mug, signed James Rogers, 1757.		600
	Saucer in the Sèvres style, 5½in.		400
1960	S. Worcester "scratch cross" tankard, dated 1754.		720
	Apple-green sauce-tureen.		540
1961	C. The Mark Harford Bristol Tea Service (£75 16s in 1916).		1,683 3s
	Gertrude Hill Gavine, New York. Modern Worcester figures after Audubon's *Birds of America*, by Dorothy Doughty [died 1962]:		
	Redstarts in hemlock, 1935.	2 for	3,750
	Goldfinches on thistles, 1936.	2 for	2,148
	Red cardinals with orange blossom, 1937.	2 for	1,575
	10 other pairs at £450 to £1,450.		
1962	S. Worcester yellow mask jug, coloured transfer decoration.		700
	Yellow-ground Worcester jug, transfer-printed.		850
1963	S. 2 Worcester vases, Sèvres style on deep blue ground: wolf-hunt and buck-hunt by O'Neale after Oudry.	2 for	3,900

PORCELAIN

ENGLISH
Wedgwood Jasper Ware

<table>
<tr><td colspan="2"></td><td>£</td><td></td></tr>
<tr><td>1781</td><td>Wedgwood and Bentley. C. Painted Etruscan vases, sets of 5.</td><td>1</td><td>10s–6</td></tr>
<tr><td></td><td>Bas-relief plaques for chimney-pieces, in jasper ware, set of 3.</td><td>4</td><td>4s</td></tr>
<tr><td></td><td>3 tall painted Etruscan vases. 3 for</td><td>6</td><td>6s</td></tr>
<tr><td>1791</td><td>Copies of the Barberini Vase or Portland Vase (see Classical Art, 1786), less than 50 in number, were sold from the factory for £35 each.</td><td></td><td></td></tr>
<tr><td>1849</td><td>A copy sold for</td><td>20</td><td></td></tr>
<tr><td>1856</td><td>Samuel Rogers. C. Another copy from the 1st series.</td><td>133</td><td>7s</td></tr>
<tr><td></td><td>C. A 2nd copy in an unnamed sale.</td><td>101</td><td>17s</td></tr>
<tr><td>1859</td><td>W. J. Broderip. C. Pair of vases with cameo medallions on basalt ground. 2 for</td><td>106</td><td>1s</td></tr>
<tr><td></td><td>Pair of ice-pails, cameo on blue. 2 for</td><td>56</td><td></td></tr>
<tr><td></td><td>Cameo plaque on blue, The 9 Muses.</td><td>33</td><td></td></tr>
<tr><td>1861</td><td>Edmund Higginson. C. Portland Vase from the 1st series.</td><td>73</td><td>10s</td></tr>
<tr><td>1864</td><td>John Watkins Brett. C. 18in plaque, Virgil reciting before Augustus.</td><td>44</td><td></td></tr>
<tr><td></td><td>23in plaque, infant Bacchanals.</td><td>64</td><td></td></tr>
<tr><td></td><td>13in ditto.</td><td>26</td><td></td></tr>
<tr><td>1865</td><td>Earl of Cadogan. C. Big jasper-ware vase, The Triumph of Venus, bought-in.</td><td>67</td><td></td></tr>
<tr><td></td><td>2 oval plaques, Destruction of Niobe's Children and Death of Adonis. 2 for</td><td>101</td><td></td></tr>
<tr><td>1866</td><td>Thomas de la Rue. C. Sage-green plaque, nymphs sacrificing.</td><td>50</td><td></td></tr>
<tr><td></td><td>Plaque, Sacrifice of Iphigeneia (see 1869, 1887).</td><td>40</td><td>19s</td></tr>
<tr><td></td><td>Pair of 2-handled seaux. 2 for</td><td>39</td><td>18s</td></tr>
<tr><td>1867</td><td>Joseph Marryatt. C. Pair of vases, white figures, black ground. 2 for</td><td>46</td><td></td></tr>
<tr><td></td><td>Copy of an ancient lamp, sage green.</td><td>27</td><td></td></tr>
<tr><td>1868</td><td>V & A buys alabaster mantelpiece covered with Wedgwood jasper plaques by Flaxman, after Herculanean frescoes.</td><td>210</td><td></td></tr>
<tr><td>1869</td><td>Thomas Oldham Barlow. C. Apollo and the Muses, plaque on sage-green ground.</td><td>66</td><td>3s</td></tr>
<tr><td></td><td>Sacrifice of Iphigeneia, ditto (see 1866, 1887).</td><td>121</td><td>6s</td></tr>
</table>

£

1869	Vase on blue ground, Flaxman's Dancing Hours, bought-in.		131	5s
	Pair of vases, sage-green ground, 12in.	2 for	96	
1870	C. B. Carruthers. C. 18in vase, 10 Bacchanalian figures, blue ground.		64	10s
1872	Purnell. C. Copy of the Portland Vase, 1st series.		173	
1875	C. Ditto.		189	
1877	Sibson. C. Apotheosis of Homer, black jar on pedestal, by Webber (10 guineas, new, in the 1790s).		735	
	Several other jasper-ware vases at over £100.			
	Portrait medallion cameos in jasper-ware.	4 4s–27		6s
1880	C. Large plaque, Sacrifice to Hymen		415	
1881	S. 24in vase, Apotheosis of Virgil.		425	
1887	Hicks. C. The George IV Coming of Age Vase, 1774.		315	
	Chimney-piece in pink and white jasper.		210	
	Plaque, Sacrifice of Iphigeneia (see 1866, 1869).		183	15s
1889	Stainyforth. C. Copy of the Portland Vase.		131	
1890	Cox. Plaque, The 9 Muses (see 1902).		141	
	Plaque, Hercules and Nymphs.		180	
	Copy of the Portland Vase.		199	10s
1892	Holt. C. Another copy, ditto.		215	5s
1899	V & A buys pair of jasper ware classical urns, 13in high, late 18th cent.	2 for	62	
1902	Propert. C. Another copy of the Portland Vase.		399	
	2ft plaque, The 9 Muses (see 1890).		262	10s
	Plaque, the Townley Medusa.		94	10s
1905	C. Sacrificing Nymphs, large plaque, blue ground.		257	5s
1923	E. F. L. Wood. C. Copy of the Portland Vase, given by the Prince Regent to Miss Irwin.		110	5s
1924	Tangye. C. Another copy.		168	
1956	Miss Fisher. S. The Portland Vase, perfect copy from 1st series.		480	

PORCELAIN

EUROPEAN
Meissen

Account books of Lazare Duvaux: £

1748	Figure of shepherd and lamb, mounted and *garni* with Vincennes flowers.	38 8s
	24 plates, pierced borders, paintings of birds. each	17 6s
1749	Cabaret with tea service for 6.	4 6s
	Figure of a Dutchman.	1 1s
	Cup and saucer, panels in miniature painting. 2 for	2 17s 6d
	The Hurdy-gurdy Player, figure.	3 7s 6d
	2 candlesticks formed of children groups. each	3 17s 6d
	Painting and Sculpture, 2 groups. 2 for	6 3s 6d
1750	Cup and saucer, miniature painting, Les Jeux d'Enfants. 2 for	1 18s 6d
	Group of children, when mounted with a sculptured ormolu base, rises to	28 16s
1751	Figure of Apollo on pedestal.	3 16s
1752	2 oval tureens, stands and covers, imitating cauliflowers. 2 for	22 8s
1755	2 figures *en biscuit*. 2 for	3 17s 6d
	Cabbage-leaf-shaped dishes. each	1 14s

(End of Duvaux accounts)

1767	C. "4 beautiful Dresden vases representing the 4 seasons", 1st Meissen sold at Christie's. 4 for	25 14s 6d
1769	C. Kaendler figures, The Turk and His Companion. 2 for	2 4s
1772	Thomas Morgan, china-man. C. Dresden dessert service "pink mosaic". 39 for	99 15s
	Another, "with flowers, finely painted". 38 for	110
1779	de Almodovar. C. Pair of horses with "Arabian" grooms (see 1868, 1905, 1930, 1958). 2 for	21
1784	Legère, Paris. 2 11in urns, miniature paintings in panels on yellow ground, mask handles. 2 for	18
1787	Princess Amelia. C. Biscuit statue of Frederick the Great, enamelled plinth, richly gilt.	19 8s 6d
1805	C. The *Affenkapelle*, figures forming an orchestra of 17 monkeys mounted on a satinwood cabinet.	16 16s
	Kaendler figures of the Cooper, Brazier and Potter. 3 for	1 13s

£

1816	Henry Hope. C. Dessert service. 76 for	96 12s
1819	Sevestre of Bond Street. C. Wall fountain, "honey-combed", the tap formed as a swan's head.	19 19s
	Brûle-parfum and cover in elaborate mount.	15 15s
	Tea and coffee equipage, subjects after Watteau. 41 for	60 7s 6d
1823	Farquhar, Fonthill (perhaps *ex* Beckford). Dinner service of 363 pieces, painted in miniature with Dutch towns and harbours, made for the Prince of Orange (see 1878). 363 for	271 15s
1835	Lady of fashion. C. Table service, border of "pink scale and scroll-work", landscape centres. 173 for	115 10s
1833	C. The celebrated figure of Count Bruhl's tailor riding on a goat (see 1877).	9 19s 6d
1842	Waldegrave, Strawberry Hill (*ex* Walpole). Figure of a boy in Boettger's red polished ware, "praised for its rarity".	1 10s
1843	Duke of Sussex. C. 2 Kaendler figures of Masons. 2 for	8
1846	Baron, Paris. 2 Medici vases with Cupids and flowers in relief. 2 for	18
1847	Rt. Hon. Thomas Grenville. C. 4 figured cups with saucers. 8 for	16 16s
1848	Duke of Buckingham, Stowe. C. 2 groups of figures, mounted as 4-light candelabra. 2 for	15 15s
	3 vases with Watteau subjects, mounted with ormolu stands. 3 for	38
	5 white figures, Meissen and *blanc de Chine* 5 for	4 15s
1850	Debruge Dumenil, Paris. 2 Boettger polished stoneware vases in relief. 2 for	6s
	3 Kaendler groups of The Senses. 3 for	24
1851	Earl of Pembroke. C. Garniture of 5 vases with garlands of flowers realistically modelled. 5 for	65 2s
1855	Bernal. C. Mug, cover and stand, crimson scale ground, views of the Elbe *en camaieu*. 3 for	20 10s
	Écuelle and stand, basket ground.	16 16s
	Vase and cover, cup and cover in a rather late style. 2 for	30
	Scalloped écuelle, cover and stand, figures after Watteau. 3 for	29
	(For Meissen figures fitted as candelabra, see French Furniture, Smaller Objects.)	
1856	V & A buys tureen and cover with views of Dresden, Marcolini period.	70
	Robert Field. C. 18in vase, crown and cypher of Poland, Chinese figures and arabesques.	46
1868	C. 2 groups of horses with Turkish attendants (see 1779, 1905, 1930, 1958). 2 for	95 11s
1869	Lady Charlotte Schreiber's journal:	
	At Dresden, a finely-cut Boettger teapot.	1 15s
	In Berlin a Boettger tankard with coat of arms in gold.	1 5s
1870	Colonel Grant. C. Fountain, supported on eagles and painted with Watteau subjects.	225 15s

£

		£	
1870	Count Collaldo. C. 2nd fountain in pure white from the Japanese Palace, Dresden, figures of Neptune, tritons, etc.	48	
1876	C. Leda and Cupid, pair of figures. 2 for	39	
	Masquerader.	16 16s	
	Harlequin.	14 14s	
	Group of 3 children, emblem of music.	40	
	2 groups on ormolu plinths, Summer and Spring. 2 for	128	
1877	Duc de Forli. C. Écuelle, arms of the Dauphin, Watteau panels.	305	
	Crinoline group, Countess de Koesel and pug-dogs.	215	
	Pair of figures of yellow finches. 2 for	40	
	2 groups of bulls attacked by dogs. 2 for	195	
	The tailor riding a goat (see 1833, 1879).	68	
	Europa and the Bull, large group.	61	
	Coffee-pot and cover, river scenes.	105	
	Oval verrière (Swan service?), flowers in relief.	135	
1878	H. G. Bohn. C. The Prince of Orange Service (see 1823), single plates, bought in 1868 for £3 to £5, now costing.	13	
	Brûle-parfum by Boettger, gold on black.	4 10s	6d
	Gilded white cup, dated 1739.	4 10s	
1879	Charles Dickins of Sunnyside. C. Tailor riding a goat (see 1833, 1877).	80	
	Spring and Summer (see 1876), unmounted.	60	
	2 large groups, Neptune and tritons and Venus in the Car of Love, neo-classic. 2 for	336 5s	
	2 crinoline groups.	{260 / 315	
1880	Carrington. C. Spaniel on cushion, ormolu base.	325	
1881	Smith. C. 2 mounted groups, 20in high, nymphs and Bachanalians.	404	
	Leopold Double, Paris. Elaborate centre-piece with ormolu fittings.	480	
1882	Hamilton Palace. C. Another Kaendler crinoline group.	320 5s	
1885	Beckett-Denison. C. Group of 2 parrots, 15½in. 2 for	189	
1887	C. Lady and gentleman at table (see 1902).	347	
	4 Continents, complete set. 4 for	294	
1889	Secrètan, Paris. Large group, Triumph of Apollo.	300	
1891	C. 2-handled tureen.	147	
1899	Jennings. C. Dish in Watteau style.	300	
1901	Hope-Edwards. C. 2 10in busts of baby girls (see 1908).	609	
1902	Earl de Grey. C. Crinoline group with spinet (see 1887).	1,102 10s	
1903	Mme Lelong, Paris. Mounted pieces en rocaille, Louis XV:		
	2 vases with Watteau panels on myosotis ground. 2 for	1,800	
	2 candelabra from the swan service, mounted. 2 for	1,700	
1905	C. Crinoline group.	1,050	
	von Pannwitz, Munich. Augustus III as a carpenter or apprentice.	825	
	The Indiscreet Harlequin: group, mounted as a clock.	1,300	
	Cockatoo perched on a tree.	424	

£

1905	Pair of cocks with Caduceus marks on base.	2 for	650	
	Pair of horse-trainer groups (see 1778, 1868, 1930).	2 for	625	
	Pair of yellow gourd-shaped vases, Chinoiserie panels, mark AR.	2 for	1,505	
1906	C. Crinoline group.		651	
	Augustus III as a Freemason.		294	
	Fischer, Cologne. Pair of caparisoned camels, mounted (see 1949).	2 for	467	
	The Polish Salutation, crinoline group.		375	
	The King and Queen, crinoline group.		230	
	Augustus the Strong, statuette in Boettger's polished red stoneware.		170	
	Pair of hexagonal vases and covers in Kakiemon style (see 1960).	2 for	97	10s
	Set of 12 monkey-musicians.	12 for	234	10s
1908	C. J. Dickins. C. 3 vases, mounted *en rocaille*, Watteau subjects on *semé* ground.	3 for	3,990	
	2 busts of baby girls (see 1901, 1958).	2 for	1,207	10s
	Lady, page and gallant, 6in high.		1,102	10s
	Contesse de Koesel group.		787	10s
	Set of 4 Continents.	4 for	630	
	2 Chinese boys, by Kaendler.	2 for	280	
1909	A. von Lanna, Prague. Boettger figure, The Doctor.		330	
1912	Roussel, Paris. Crinoline group, The Singing Lesson.		1,640	
1920	Ruston Lodge. C. Crinoline group.		1,207	10s
1925	Countess of Carnarvon. C. Several crinoline groups.		500–600	
1928	S. 2 Kaendler figures of Tatars, mounted *en rocaille*.	2 for	195	
1930	C. 2 oviform vases, 17in high, pale green ground, camp-scenes in panels.	2 for	330	10s
	2 groups of horses and grooms on rocaille plinths, 12in (see 1778, 1868, 1905, 1958).	2 for	294	
1931	Goldschmidt-Rothschild, Berlin. 2 figures of peacocks, polychrome.	2 for	690	
	2 vases with Watteau-style panels on claret ground, 9in high.	2 for	2,200	
1932	Lady Louis Mountbatten. C. Crinoline groups.		$\begin{cases}388 \\ 525\end{cases}$	
	S. 2 white figures of goats from the Japanese Pavilion, Dresden, over 2ft long, 1732 (for others, see 1961).		$\begin{cases}105 \\ 210\end{cases}$	
1933	Henry Oppenheimer. C. 2 woodpeckers on trees, 13in.	2 for	183	15s
1943	Viscountess Harcourt. C. 2 Chinese figures, Louis XVI mounts.	2 for	157	10s
1945	R. W. M. Walker. C. Harlequin by Kaendler, bought by V & A.		367	10s
	Harry Manfield. S. Dancing Harlequin by Kaendler.		580	
	Crinoline group, ormolu plinth.		450	

			£	
1946	Lionel de Rothschild. C. 2 13in parrots, rocaille mounts.	2 for	2,310	
	New York. Squatting figure of a pagoda, 1735.		445	
1947	Late Duke of Kent. C. Mounted equestrian figure of Frederick the Great of Prussia.		945	
	Contesse de Koesel and pug-dog.		588	
	Pair of figures, cock and hen, rococo plinths.	2 for	819	
	Pair of parrots on tree-trunks.	2 for	651	
1949	Sir Bernard Eckstein. S. The Tyrolese Dancers, by Eberlein (see 1962).		500	
	Pair of ormolu-mounted camels by Kaendler, 16½in (see 1906).	2 for	420	
1950	Baroness Burton. C. 2 swans mounted as Louis XVI candelabra.	2 for	1,732	10s
	Lord Hastings. S. Coloured figure of a vulture by Kaendler, 22in.		1,350	
	Pair of eagles, white, 22in (see 1959, 1962).	2 for	820	
	Parrot on a tree-trunk, 8in.		640	
1951	S. Augustus the Strong in Polish dress.		400	
	The Swordsmith, by Kaendler.		280	
1954	C. Figure of Empress Elizabeth of Russia riding, on ormolu plinth by Kaendler.		798	
	Catherine Butterworth, New York. 2 Kaendler figures, each mounted up with flowers as 3-light candelabra.	2 for	2,075	
1955	S. Pair of green parrots by Kaendler.	2 for	3,000	
	New York. Pair of bitterns by Kaendler, mounted with flowers, etc., as candelabra, 21in.	2 for	1,750	
1956	S. Goldblatt. S. Baluster vase and cover in Kakiemon style, Augustus Rex mark, 1730.		800	
1957	S. 2 Meissen figures of *Madelkraehe*, or rollers.	2 for	1,700	
	Cream-jug and stand, Augustus Rex mark, 1730.		740	
	Lord Cottesloe. C. Tureen with Chinoiserie figures by Loewenfinck.		2,730	
	S. Crinoline group, The Spanish Lovers, by Kaendler.		260	
	Garniture, 5 yellow-ground hexagonal vases by Höroldt Chinoiserie panels, Augustus Rex mark.	5 for	4,200	
	Mae Rovensky, New York. 2 woodpeckers, modelled by Kaendler, 1735, mounted with Vincennes flowers and ormolu as 3-light candelabra, 18in high (record price for mounted Meissen).	2 for	6,750	
	Parke-Bernet, New York. Pair of pierced gourd-shaped vases, splendidly mounted *en rocaille*, c. 1750.	2 for	5,750	
1958	Stuker, Berne. 2 busts of baby girls by Kaendler (see 1901, 1908).	2 for	1,250	
	S. 2 prancing horses and groom (see 1930, etc.).	2 for	480	
	Kaendler figure of Frohlich, the Court Jester.		620	
1959	C. 2 Kaendler figures, mounted as candelabra with Vincennes flowers.	2 for	3,150	
	S. 2 figures of cockatoos by Kaendler.		4,400	

£

1959	A huge pelican in white porcelain, dated 1732, from the Japanese Pavilion, Dresden, 31in high (for a similar figure of an eagle, see 1962).	2,400
	Parke-Bernet, New York. 2 Kaendler squirrels on ormolu bases, 1746. 2 for	2,860
	Marquess of Exeter. C. Harlequin by Kaendler, 6½in.	1,575
1960	Oskar Dusendschon. S. Snuffbox, Höroldt style.	1,700
	Sultan riding an elephant, by Kaendler, ormolu base.	3,600
	Clock, Louis XV, by Leroi, with Kaendler's peasant lovers.	3,200
	1st Blohm sale. S. Pantaloon in Boettger's red-polished ware, c. 1710, after Callot.	3,000
	Apple-green jar and cover.	2,500
	S. Pair of hexagonal urns and covers in Kakiemon style, ormolu stands (see 1906). 2 for	650
	Paris. Tureen, arms of Count Bruhl, figure of Amphytrite surmounting cover.	3,530
	Weinmueller, Munich.	
	Countess of Koesel Group.	685
1961	Whitmarsh, New York. 2 blue flower-encrusted vases in Louis XV mounts, 1760. 2 for	1,430
	2nd Blohm sale. S. Group of 3 miners.	1,200
	Topic Mimara. S. Cockerel by Kaendler supporting a Louis XV ormolu clock.	1,400
	S. White porcelain figure of a goat and kid, 2ft long (damaged), from the Japanese Pavilion, Dresden, 1732 (Ashmolean Museum).	900
	S. From the Swan Service, made with the arms of Count Bruhl by Kaendler and Eberlein, 1738; tureen and cover, most sumptuous.	3,800
	2 smaller tureens *en suite*. 2 for	2,950
	2 verrières, Monteith shape. 2 for	2.950
1962	C. The Tyrolese Dancers, by Eberlein, single-group, Louis XV mount (1955, £409 10s). 1 for	1,890
	S. Kaendler figure, The Scowling Harlequin. 1 for	2,700
	Augustus Rex vase by Loewenfinck, yellow ground.	2,950
	White figure of eagle, 22in high, by Kirchner, 1732 (see 1959).	2,200
	Parke-Bernet, New York. White sculpture by Kaendler for the Japanese Pavilion, 1730.	
	Crane, 29in high.	2,860
	Nanny goat and kid, 20in high.	3,395
	C. Figure of a monkey by Kirchner.	3,460
1963	C. The *Affenkapelle* or monkey-orchestra, 19 small figures by Kaendler (£50 8s in 1935). 19 for	3,150

PORCELAIN

Other Factories: Germany, Italy, Austria, France, etc.,
excluding Sèvres and Meissen.

		£		
1774	James Giles, enameller, Cockspur Street. C. Nymphenburg tea service, bought-in.	16	15s	6d
	Ditto, dessert service, bought-in. 44 for	34	13s	
	Pair of Nymphenburg vases, flowers and striped gold. 2 for	8	10s	
	Frankenthal déjeuner, enamelled with insects.	2	8s	
1778	Earl of Kerry. C. Chantilly table and dessert service, *c.* 1760, basket borders and blue-sprig pattern. 288 for	76	13s	
1794	Count Redeen. C. Combined Berlin service. 205 for	99	15s	
1802	Count Weddell. C. Copenhagen vase, neo-classic, 3ft high.	32	11s	
	Copenhagen déjeuner.	49	17s	6d
1805	C. Berlin dinner-dessert services:			
	170 pieces.	99	15s	
	310 pieces.	184	16s	
1809	C. Vienna dessert service, blue-and-gold borders. 68 for	141	5s	
1814	C. Berlin dessert service. 61 for	168		
1816	Henry Hope. C. Copenhagen service (defective). 166 for	106	1s	
1819	C. Kettle, lamp and stand, Furstenburg.	8	18s	6d
	Déjeuner for 2, Vienna, with painted onyx gem, Apotheosis of Augustus ("cups of Etruscan shape").	93	9s	
	4 Vienna vases, 31in high, triumphant processions in panels on green and gold. 4 for	51		
1824	Page Turner. C. Another Vienna déjeuner with the onyx cameo design, given by the Emperor to Queen Charlotte.	27	16s	6d
1827	Townsend. C. Berlin déjeuner for 2 with cameo heads of emperors.	12	12s	
1838	"Monsieur Hertz." C. Pair of Berlin Medici vases, 18in high, given by the King of Prussia to the Empress Josephine, bought-in. 2 for	70	7s	
1842	Waldegrave, Strawberry Hill (*ex* Walpole). Vienna Dupaquier tea service, painted *en grisaille*, victories over the Turks.	4	14s	
1845	Paris. 2 tall Berlin vases with hunting scenes, formerly given to Napoleon by the King of Prussia. 2 for	48		

£

1846 Dodd. C. Frankenthal group, Cronensburg mark. 1 14s
 Henry Rhodes. C. Basin and ewer, Capo di Monte.
 2 for 5 15s 6d

1847 Mrs Russell. C. Vienna déjeuner, Sorgenthal period,
 after antique cameos. 30
 Rt. Hon. Thomas Grenville. C. 2 centre vases and
 covers with bouquets on deep blue ground, Berlin porce-
 lain, a present from the King of Prussia. $\left\{ \begin{array}{l} 105 \\ 52 \ 10s \end{array} \right.$

1848 Duke of Buckingham, Stowe. Pair of Chantilly barrel-
 shaped pots with handles of leafy branches, covers and
 stands. 2 for 2 12s

1849 Lady Blessington. C. Capo di Monte cup and saucer. 18 18s
 Ewer and cover. 27 8s
 Smaller ditto, classical subjects. 25

1853 King Louis Philippe. C. Large Berlin vase, early 19th
 cent., with view of Potsdam. 34

1855 Bernal. C. Frankenthal coffee-pot with portrait of King
 Theodore, nymphs, etc. 20
 Frankenthal tankard and cover. 12
 Nymphenburg basin with battle *en grisaille*. 10
 Berlin dish after van der Werff. 17
 Vienna dish, neo-classic Sorgenthal period. 37 16s
 Tournai plateau and basin. 2 for 42
 Capo di Monte (or Doccia):
 A number of single pieces at £30 average for a cup and
 saucer.
 Compotier and cover, mythological subjects. 51 10s

1858 David Falcke. C. Capo di Monte (Doccia?) ewer with
 sea-gods and monsters in relief, 25in. 70
 Group of young Bacchanalians, 12in high. 25 15s 6d

1867 David Falcke. C. Capo di Monte group of Bacchanals
 (Doccia copy). 26 5s
 C. 4 Doccia copies of Capo di Monte, neo-classic plaques.
 4 for 103 10s
 Joseph Marryatt. C. Ewer and basin formed of shells
 with coral reliefs, Capo di Monte. 2 for 190

1868 C. Russian porcelain (Popov, Moscow?), pair of urns,
 battle scenes in panels on green ground "by Nicolas
 Kounilow, the Russian Wouvermans". 2 for 147

1869 V & A buys Capo di Monte benitier in the form of a shell,
 supported by Cupids. 40
 3 Vienna (Sorgenthal) plates, painted with neo-classic
 scenes. 3 for 40
 John Mawdsley. C. Pair of Buen Retiro vases. 2 for 21 10s

From Lady Charlotte Schreiber's Diaries:

1869 In Venice. Garniture of 5 Vezzi ice-pails, 1770. 5 for 50

1870 From Oppenheim, Paris. A St Cloud white group,
 Astronomy, "almost too heavy to carry". 1 8s

£

1875 In Brussels. Fulda white statue of the Virgin on pedestal, "one of the gems of our collection". 13
End of Diary entries.

1870 Lord Auckland. C. Vienna tray, Dupaquier period, Diana and Calisto, after Boucher. 36 15s
 Sir H. Tyrwhitt. C. Shell-shaped dish, Capo di Monte. 41
 Thomas Allcard. C. Buen Retiro tea and coffee service.
 30 pieces 105

1874 V & A buys pair of neo-classic urns, 2ft high, Buen Retiro, 1800–20. 2 for 250

1875 Paris. Capo di Monte, 2 oval beakers in coloured relief.
 2 for 103 12s

1876 V & A buys Angoulême neo-classic vase, 3ft high, with marble base, painted *en grisaille* on gold ground, *c.* 1800. 17 19s

1879 V & A buys 14in Capo di Monte(?) neo-classic vase with amorini in high relief. 86 6s
 C. J. Dickins. C. Vienna, Sorgenthal plateau and cabaret. {21
 {23
 Nove, vase with Roman history subjects. 50
 Mennecy, group of children. 18

1882 Hamilton Palace. C. 2 Nymphenburg figures, ecclesiastics. 2 for 17 17s
 A large white Furstenburg figure of a dancer. 7 17s 6d
 A Höchst figure of an actor. 12 12s
 Ludwigsburg group, lovers at an altar. 17 6s 6d
 Big Buen Retiro vase in Sèvres style. 28 7s

1885 Beckett Denison. C. 2 Buen Retiro flower vases. 2 for 50
 Vienna plateau. 41

1905 von Pannwitz, Munich (see Meissen). Nymphenburg groups:
 The Impetuous Lover. 270
 Minuet Dancer. 195
 Lady carrying Wine-flagon. 280

1907 d'Yanville, Paris. Frankenthal group, the Rhine. 194
 White Mennecy bust of Louis XV and pedestal. 1,700

1909 Adalbert von Lanna, Prague. 2 Vienna (Sorgenthal) barrel-shaped goblets, painted *en grisaille* with commemorative scenes. 2 for 450
 Fitzhugh, Paris. Chantilly figure of a magot supporting a globe, mounted *en rocaille.* 1,060
 Mennecy group, dog and monkey. 640

1911 von Lanna, Prague. Vienna cup and saucer, Sorgenthal, elaborate commemorative painting. 400

1912 Jacques Doucet, Paris. 2 Chantilly magots, heavily mounted. 2 for 1,720
 J. E. Taylor. C. Savona, 2 busts of children (see 1932).
 2 for 493 10s

£

1913	C. Frankenthal statue-figure of Frederick the Great.		525
	Höchst figure, youth binding nymph to a tree.		630
	Ludwigsburg group, Diana and Actaeon.		420
1917	Höchst group of 5 figures, The Toilet.		609
	Frankenthal group, The Chinese Summer-house.		609
1927	Viscount Harcourt. C. 2 Fulda figures, 1750–60, a boy and girl in Court costume.	2 for	411
1928	Brasseur, Paris. 2 Mennecy groups, monkey and child riding on dogs.	2 for	1,417
1932	Lady Louis Mountbatten. C. Savona, 2 busts of children (see 1912).	2 for	99 15s
	Nymphenburg Bustelli figure of a lady, 8in.		399
	At Puttick's. Nymphenburg figure, lady singing from a score.		246 15s
1945	R. W. M. Walker. C. Nymphenburg figure by Bustelli, Ottavia, 1757, bought for V & A.		567
1946	S. 2 Mennecy groups of child musicians.	2 for	650
1949	Sir Bernard Eckstein. S. Nymphenburg opera figure by Bustelli, *Voi sapete*.		890
	Ditto, figure of Pantaloon (see 1954, 1962).		720
	2 Nymphenburg parrots by Audiczek.	2 for	420
	Fulda group of lady and gentleman shooting.		420
	Ludwigsburg group from the Venetian Fair.		160
1950	Baroness Burton. S. Mennecy group, boy and girl in Russian costume.		924
1951	Lempertz, auctioneer, Cologne. Höchst figure of a parrot.		630
1953	Weinmüller, Munich. 2 white busts of children by Bustelli, Nymphenburg.	2 for	460
1954	Baroness von Zuylen. C. £35,647 for 9 Nymphenburg Bustelli figures.		
	Harlequin and Lalage, a pair. Record auction price for European porcelain figures.	2 for	11,130
	Slightly damaged figure of Lucinda bought for V & A.		2,500
	Corinne reading a *billet doux*, 7½in.		4,410
	Julia in a Green Coat, 8in.		4,830
	Pierrot holding a Lamp, 7¾in.		4,410
	Pantaloon (see 1962).		1,622 5s
1956	C. More Bustelli figures:		
	Lucinda (one finger missing).		4,830
	Isabella.		2,100
	Capitano Spavento.		2,100
	Others at 1,000 guineas each.		
	Goldblatt. S. 2 Furstenburg figures by Feilner (see 1960).	2 for	430
1957	S. Pair of Mennecy figures of magots mounted as candlesticks with flowers.	2 for	4,500
	C. Tournai écuelle, Watteau subjects, *gros bleu* ground.		1,050

£

1958	S. 2 Nymphenburg figures of Chinamen, repaired at the factory.	2 for 1,500
1959	Egerton. C. 2 Mennecy figures of magots mounted as candelabra.	3,045
1960	Blohm (1st sale). S. 15 8in Furstenburg figures by Simon Feilner sold in lots.	15 for 15,000

2 Vienna Dupaquier tureens. {1,800
 {1,700

Capo di Monte group, The Spaghetti-eaters (see also 3rd sale, 1961). 2,000

Paris. St Cloud pommade box *en camaieu bleu*. 1,090

1961 Miss Philips. S. 2 Chantilly magots supporting jars on simple ormolu plinths. 2 for 3,600

Blohm (2nd sale). S. Vienna, Dupaquier tureen. 2,300

Capo di Monte group, The Rabbit-catchers. 4,000

Capo di Monte, The Wounded Soldier. 1,900

Höchst figure of a parrot. 3,000

2 Frankenthal monkeys. 2 for 2,700

Furstenburg figures, Harlequin and Columbine. 2 for 2,600

Blohm (3rd sale). S. Pair of Nymphenburg figures (*ex* Berlin Schloss Museum), Columbine (part damaged) and Harlequin. 2 for 7,000

Capo di Monte figure, dancing Harlequin. 3,400

Capo di Monte group, The Spaghetti-eaters. 3,400

Frankenthal figure, Harlequin, by Lanz. 2,300

Zürich, equestrian lady. 1,550

Furstenburg, Pantaloon, by Feilner. 1,200

1962 At Philips, Son, and Neale. Vienna teapot and cover by Dupaquier. 480

S. Capo di Monte figure, The Bird-Catcher. 1,750

Nymphenburg Bustelli figure, Harlequin's companion. 5,000

C. Nymphenburg Bustelli figure of Pantaloon (see 1949, 1954). 3,150

Augsburg cabaret (Meissen Boettger paste). 23 for 1,890

PORCELAIN

EUROPEAN
Sèvres *(including Vincennes)*

£

From the account-books of Lazare Duvaux:

1748	A Monture, composed of a white vase, 2 parrots and numerous Vincennes flowers.		15	10s
1749	2 urns, *gros bleu* ground, mounted.	2 for	24	
1750	2 seaux, *fond bleu*, mounted for Mme Pompadour.	2 for	78	15s
1751	Vincennes group, The Flute-player, after Boucher.		5	17s
1753	Seaux à verres with landscapes *en camaieu*, price unmounted. each		1	19s
	For the King, cabaret of 6 cups and saucers.	12 for	8	14s
1754	Biscuit figures. each		1	12s
1755	Milk goblet, miniature panels on lapis lazuli ground.		6	15s
	2 big jattes or flower bowls with children painted *en camaieu*.		{12 / 24}	
	Déjeuner, *bleu celeste*.		19	3s
	2 oval vases, floral panels on *bleu celeste*, heavily mounted with Vincennes flower bouquets.	2 for	112	
1756	Caisse or square vase on feet, painted with birds, a characteristic Vincennes shape (unmounted price).		33	12s
	Bleu celeste à cartouches dinner service.	per plate	2	6s
	Pot à l'oille, unmounted.		52	15s
1757	Prices for pieces on *bleu celeste* ground from the new factory at Sèvres:			
	Milk goblet.		7	13s
	2 garniture urns (mounted).	2 for	70	
	Garniture of 5 for the Russian Court, urns on ormolu plinths.	5 for	92	
	2 tureens with platters.	2 for	33	
1758	Cost of a tea service:			
	Plates, *décor à rubans*.	each	2	10s
	Cup and saucer.		3	17s
	Teapot.		4	7s
	Cream-jug.		3	17s
	Sugar-castor and platter.		9	12s
	Slop-bowl.		14	8s

End of Lazare Duvaux accounts.

1758	Factory bills for the Maria Theresa service:			
	Pot à l'oille with plateau.		72	
	2 tureens with stands and covers.	each	60	

£

1763	Factory bills for Duke of Bedford service:			
	Pot à l'oille.		33	12s
	Tureen, stand and cover.		24	
1765	Horace Walpole pays 10 guineas in Poirier's shop for a coffee-cup, saucer and soucoupe (*A Journal of My Journey to Paris*, by the Rev. William Cole).			
1768	Gaignat sale, Paris. Pair of garniture-urns, fully mounted, panel-paintings on *bleu celeste* ground, 8½in.	2 for	11	
1769	Roussel, Paris. Garniture of 3 urns, lapis lazuli ground.	3 for	8	
1769–79	Factory prices for 12in plaques after modern paintings (according to Marryatt).		48–60	
1771	C. 2 elegant vases and covers, painted from the designs of Boucher (first Sèvres at Christie's).	2 for	40	19s
	Blondel de Gagny, Paris. Garniture of 3 urns on marble bases, painted after Boucher.	3 for	20	
	Factory orders for Mme du Barry:			
	Déjeuner (coffee for 2 with plateau).		24	
	Garniture de cheminée, 3 urns, *fond vert.*	3 for	60	10s
	Factory orders for the Court:			
	Pairs of urns, miniature paintings, *fond bleu* (for King of Sweden).		{15 {29	
	Single vase d'ornement for Louis XV.		48	
1772	Ordered by Mme du Barry:			
	Biscuit group, Amour et Amitié after Boizot.		14	8s
1773	Biscuit group, Conversation Espagnole		17	6s 8d
	Ordered for the Prince de Rohan (see 1870):			
	112 plates at		1	10s
	24 compotiers at		1	18s
	4 seaux à glaces at		10	1s 6d
	2 punch-bowls at		24	
	360 pieces cost in all		831	
1774	Samuel Dickinson. C. Pair of urns, green ground, mythological subjects in panels.	2 for	37	16s
1775	Stephen, Lord Holland. C. Dessert service, painted in flowers, white ground.	136 for	120	15s
1777	Orders for the Russian Court through Prince Bariatinsky, the Empress Catherine Service (see 1877, etc.), 744 pieces, *fond bleu celeste à l'or.*		13,120	
	Each dessert plate cost		9	12s
	The tureens, seaux, jattes, sûrtouts de table, etc., from £100 to £200 each.			
1780	Ordered by Gustavus III of Sweden. Urn on *bleu du roi* ground with seaport scenes by Leguay (see 1880).		28	16s
	Captain Carr. C. Dessert service, birds and flowers, *bleu celeste* and gold borders, 70 pieces.	70 for	82	19s
	Garniture of 3 potpourri vases and covers, Cupid panels, Mazarin blue.	3 for	15	15s
	3 jardinières in same style.	3 for	16	5s 6d

£

1780	Single vase, Venus, Cupid and satyr on Mazarin blue ground.	16 16s
1781	Comtesse de Mazarin sale, Paris. Garniture of 3 urns, *gros bleu*. 2 for	20
	2 urns with military scenes, 16in and 20in each. 2 for	44
1782	Sales from the factory of *porcelaine à émaux*, or jewelled Sèvres, to the King:	
	Garniture of 2 covered urns. 2 for	96
	Garniture of 3 ditto.	120
	Garniture of 5. 5 for	240
	Orders for furniture-plaques. The Hunts of Louis XV, after Oudry, 9 plaques, over 20in each, ordered by Louis XVI (restored to Versailles in 1906). 9 for	960
	Marquis de Menars, Paris. Vaisseau à mâts, painted on a turquoise ground, probably 25 years old.	11 5s
1783–92	Factory bills for Louis XVI's last service:	
	Soup tureen with stand and cover.	120
	Porringer and cover (écuelle).	48
	Punch-bowl.	192
1784	Ordered by Louis XVI for Prince Henry of Prussia (*porcelaine à émaux*):	
	Cabaret with plateau.	60
	Pair of covered urns with stands. 2 for	120
1788	Ordered by Louis XVI for Tippoo Sultan. Cylindrical vase and cover, *bleu du roi*, with painting after Boucher (see 1870).	38 5s
1789	C. Cabaret, Mazarin blue and gold. 13 for	50 8s
1790	Waldegrave. C. Dessert service of 86 pieces, including 48 plates, *bleu du roi* borders.	44
	Consigned from Paris. C. Pair of covered urns, panels of Cupids on Mazarin blue ground. 2 for	34 3s
	Garniture of 3, Mazarin blue and ormolu. 3 for	31 10s
	Dessert service, straw ground, flowers and grapes.	110 5s
	Angoulême Service, festoons of roses (Barbeau pattern). 154 for	68 15s
1791	Imported by Monsieur Daguerre. C. Pair of urns, elaborately mounted with goats' heads. 2 for	52 10s
1792	"Just imported from France." C. Biscuit busts of Rousseau and Voltaire. 2 for	17 6s 6d
	Cost of services: dinner services, 50–60 pieces, £23–25. Dessert services, 36 pieces, £9–£11.	
1793	"Consigned from the manufactory, Paris." C. Dessert service, 46 pieces. 46 for	32
	Corbeille of flowers in biscuit porcelain, elaborate piece in glass case.	10 5s
	The Buffon Service (see 1960), each plate depicting a different zoological specimen, still in production. per plate	2 17s 6d

£

1793 The Queen's vaisseau à mâts valued by the *commissaires-priseurs* of the Revolutionary Government at 1,000 fr. (assignats). probably 16

1794 "Assortment of French porcelain." C. Table-service, lemon border, richly embellished with gold and small sprays, 142 pieces. 64

 Dessert service of 57 pieces to match. 21

 "A foreign nobleman." Pair of urns with painted panels. 2 for 30 9s

1795 C. 2 more pairs of urns, neo-classic style, lilac and gold stripes. {2 for 23 2s {2 for 25 4s

1796 "Recently consigned from Hamburg." C. Angoulême service (probably from the factory), 180 pieces, Barbeau garland pattern. 108 7s

 Pair of urns, Mazarin blue floral panels. 2 for 52 10s

 Pair of ditto after Teniers, chased gilt handles. 2 for 54 12s

1799 C. Dessert service, bouquets and gilded borders, "One of the most elegant and complete services of the kind that has been bought from the factory", 46 pieces (Angoulême?). 70 7s

1800 C. Écuelle and stand, bought in Paris for 2,000 fr. 5 5s

 Picture plaque, Ladies of the Harem, said to come from St Cloud, 15½in × 15½in (resold next year for £42). 26 5s

1802 Countess of Holderness. C. Pair of Roman-shaped urns and covers, mounted. 2 for 63

 Matthew Higgins. C. Pair of mounted "Seve Grecian ewers". 2 for 136 10s

 "Pair of magnificent Seve vases, elegantly formed with painted panels from designs of D. Teniers." 2 for 122 17s

 Bought by an English collector in Paris during the Peace, according to Joseph Marryatt, The Death of Dugesclin, picture plaque by Pithou after Brenet, 1787. 145

1803 C. Angoulême (Paris) table service with the Barbeau garland pattern. 191 for 68

 Urn, richly gilt, mounted on ormolu and marble plinth. 19 8s 6d

1805 Robert Heathcote (Philips). Dinner service, crimson-and-gold borders, bought by the Prince Regent through Lord Yarmouth (one of several services in the present Royal Coll.) 315

1807 Villeminot, Paris. 2 mounted urns, painted in panels on lilac ground. 2 for 96 10s

 The Olympic Service, ordered by Napoleon for the Tsar of Russia: average plates. each 14 8s

1808 C. Sèvres dessert service. 61 for 105

1809 Journal of Mary Berry. Robert Fogg of Bond Street sells Lord Gwydyr a dessert service (see 1829, 1878). 600

1810 C. Bowl in streaked colours, olive green and Mazarin blue mounted on lions' feet. 51 9s

 Garniture of 3, Apulian shape, Mazarin blue and floral panels, on plinths. 3 for 99 15s

£

1813	Newly consigned from Paris. Pair of urns, historical paintings in indian ink.	2 for	55	13s
1814	A nobleman. C. Pair of heavily mounted bell-shaped vases, cameo figures from antique on scarlet ground.	2 for	141	15s
	Former Ambassador in Paris. C. Table service, not Sèvres, but Tournai, 182 pieces, painted with birds of America and borders gilded on blue, bought by 3rd Marquess of Hertford for George IV.	182 for	777	
	Jardinière given by Louis XVI to Tippoo Sultan.		136	10s
1815	C. Pair of Medici vases, 21in, paintings after Teniers and Angelica Kaufmann.	2 for	104	19s
1819	Sèvestre. C. (Probably from Queen Charlotte's Coll.) Pair of square cassolettes, light blue and gold, with paintings of birds in compartments.	2 for	77	14s
	Déjeuner, landscapes in panels on grass-green ground (coffee-pot missing), only 7 pieces, including the plateau.	7 for	105	
	Second déjeuner, complete.	9 for	63	
1822	Wanstead House (Robins). Pair of Mazarin blue ewers on square plinths, with masks and handles in ormolu.	2 for	65	2s
1823	Farquhar, Fonthill (perhaps *ex* Beckford). 24 dessert plates.	24 for	1	16s
	Bleu du roi urn, depicting *Molière chêz Ninon* in 2 medallions.		10	10s
	2 mounted urns, flower medallions on lilac ground.	2 for	18	7s 6d
	Complete déjeuner with plateau.		15	4s 6d
	Modern Sèvres service, Mazarin blue borders, 49 pieces, including ice-pails and corbeilles.		162	15s
	Pair of mounted urns, Mazarin blue ground, harbour scenes by Dodin after Vernet.	2 for	47	5s
1828	A nobleman. C. Verrière in *bleu caillouté*, paintings of poultry, ormolu handles.		26	15s
1829	Feuchère, Paris. Pair of Sèvres urns, grisaille panels on blue, mounted in bronze, *doré mat*.	2 for	33	12s
	Lord Gwydyr. C. Single urn and cover, Louis XVI, Mazarin blue, white and gold, with painted conversation piece, handles in form of doves with suspended cameos (possibly the highest price paid for a single Sèvres urn before 1851).		163	15s
	Pair of urns, pea-green and gold, with painted panels in the form of shields.	2 for	263	11s
	Dessert service, *rose Pompadour, c.* 1757, 77 pieces (bought by Sir C. Dering, for whose sale see 1878; see also 1809).	77 for	350	
1830	Bernal's pair of urns bought from Henry Baring (see 1855).	2 for	200	
	Pair of urns bought from Brummel in Calais for George IV (by Dodin).	2 for	300	
	Complete cabaret, ditto.		210	

£

		£	
1834	Viscountess Hampden. C. 2 mounted urns, green and gold, dolphin handles. 2 for	43	10s
1835	Howell and James of Regent Street. C. 3 urns, 18in high, *bleu du roi*, Vernet seaports and pastoral scenes, bought-in. 3 for	147	
	2 modern Sèvres vases, Brogniart period, 33in high, Continence of Scipio and Darius before Alexander, made for 1833 Exhibition (reserve, £315), bought-in. 2 for	283	10s
1836	C. Pair of Republican urns and covers, 17in, figures of Liberty and Phrygian Caps, bought-in. 2 for	49	7s
	C. Pair of mounted Medici ewers, turquoise ground, by Micault, 1782, bought-in. 2 for	41	9s
	Pair of mounted urns and covers, *bleu du roi*, seaport panels, after Vernet (*ex* Lord Glenlyon; cost £178), bought-in. 2 for	137	11s
	Brook Greville. C. Potpourri and cover, ormolu mount supported by dolphins.	84	
	Consigned from Spain. C. Dessert service, *bleu du roi*, birds and flowers, previously sold by Don Carlos at the Royal Palace, Madrid; sold in separate lots. 95 for	173	6s
1839	A nobleman. C. Jardinière à eventail, turquoise ground, bought by Baldock.	45	
1842	Strawberry Hill (*ex* Walpole). Pair of tall, mounted "Graecian urns", 21in high, blue and gold, bought by Baldock. 2 for	168	
	Pair of mounted brûles-parfums, *bleu celeste*, bought by Marquess of Lansdowne. 2 for	31	10s
	Complete déjeuner.	24	3s 6d
	Biscuit figure of Cupid after Falconet, mounted.	22	1s
	Pair of seaux, bought by Lionel de Rothschild.	17	6s 6d
1847	Robert Vernon. C. Pair of vases painted with festoons on *bleu du roi*, mounted in ormolu. 2 for	126	
	Rt. Hon. Thomas Grenville. C. Dessert service, *bleu du roi* and exotic birds in panels. 58 for	210	
	Dinner service, blue scalloped edges, bouquets of flowers. 149 for	266	15s
1848	Duke of Buckingham, Stowe. C. 2 pairs of seaux, painted on *bleu celeste*. {2 for	47	5s
	{2 for	38	17s
	Pair of tureens, *bleu celeste* and powdered gold. 2 for	35	14s
	Bedside cabaret by Leguay, bought by Bernal (see 1855).	65	
	Chocolate cup, cover and saucer.	47	5s
	Salver or plateau mounted as a table.	105	
	Ewer and basin, *bleu celeste*.	80	17s
1849	Town and Emanuel. C. Pair of globular *bleu du roi* vases and covers, paintings of Louis XVI and his family on panels, royal arms and ormolu handles. 2 for	85	1s
	William Coningham. C. Écuelle with its cover and stand in *rose Pompadour*, Cupids in panels. 3 for	61	19s

£

1849 Déjeuner and plateau, *bleu du roi* spangled with gold,
lacking coffee-pot. 11 for 165
Jardinière en eventail, after Vernet. 42
1850 Sir John McDonald. C. Mounted jardinière with
landscape panels on *bleu du roi*, after Vernet. 68
Ewer and dish, "jewelled Sèvres". 55 13s
1851 Earl of Pembroke. C. Garniture of 3 urns, *bleu du roi*,
seascapes by Dodin after Vernet (see 1895). 3 for 1,020
Garniture of 3, *bleu celeste*; panels after Wouverman.
3 for 698 5s
Pair of urns, *bleu du roi*, seaport scenes. 2 for 445
Dawson Damer. C. Incomplete turquoise-and-gold
cabaret with panels after Boucher, tray, teapot, sucrier, and
cover, 2 cups and saucers. 9 for 157 10s
C. Single plateau or tray for *à déjeuner*, painted with the
Rape of Europa. 127 6s
1855 Bernal. C. 254 lots of Sèvres:
Pair of *rose Pompadour* urns on plinths, petalled rims,
panels of Cupids, bt. for Lord Hertford. 2 for 1,942 10s
Another pair with pastoral scenes (Wallace Coll). 2 for 1,417 10s
A single *bleu du roi* urn, 18in (Wallace Coll.). 871
Pair of urns, Roman history subjects, bought by Sir
Anthony de Rothschild. 2 for 900
Pair of urns on *gros bleu* ground, panels after Boucher,
the lids made in England, bought by Marquess of Bath
(see 1859). 2 for 590
Cabaret by Leguay, bought by Marquess of Bath (see
1848, 1859). 465
1856 V & A buys 2 plates from the Empress Catherine Service
(see also 1777, 1875, 1881, 1886). each 15
J. Angerstein. C. Garniture of 3, apple green, pastorales
after Boucher. 3 for 498 15s
Pair of vases and covers, Bacchante panels on striped
blue, 13½in, painted by Desayes. 2 for 525
1857 Vernon Utterson. C. Single coffee cup and saucer, *gros
bleu*, Children at Play, by Asseler after Boucher. 138
Leopold Redpath. C. 30in urn and cover by Morin,
ormolu stand. 261
John Graham. C. Pair of jardinières, 1768, 7½in high,
medallion panels on *gros bleu*. 2 for 425 5s
1859 Marquess of Bath. C. Cylindrical vase and cover, *gros
bleu* (see 1855) (V & A, Jones Bequest, 1882). 445
Urn and cover after Boucher (see 1855) (V & A, Jones
Bequest). 590
Pair of oviform vases and covers, 13in (see 1855) (V & A,
Jones Bequest). 2 for 565
Cabaret by Leguay (see 1848, 1855). 345
Paris (according to Joseph Marryatt). Garniture of 3 small
flower-vases. 3 for 638

		£	
1860	Angerstein. C. *Rose pompadour* dinner service of 107 pieces, bought-in.	1,150	
1861	C. Pair of Campana vases, pea-green ground, bought-in. 2 for	525	
	2 jardinières en eventail, panels after David Teniers. 2 for	357	18s
1862	Richard Williams. C. Pair of seaux on ground of *œuil de perdrix*, celebrating marriage of the Dauphin, 1770, 7½in high. 2 for	236	15s
	Earl of Pembroke, Paris. Pair of jardinières en eventail, seascapes after Joseph Vernet, *rose Pompadour* ground. 2 for	590	
	A 3rd in the same style, Cupids in medallions.	315	
1863	Dowager Lady Ashburnham. C. Cabaret in *rose Pompadour* (lacks teapot), captured from Tippoo Sultan at Seringapatam, 1799. 9 for	341	15s
1864	Hon. Edward Lygon. C. 945 lots of Continental porcelain, mainly Sèvres:		
	Brûle-parfum and pedestal, panels on apple green.	435	15s
	Pair of 38in urns and covers, Morin and Boulanger after Vernet, *gros bleu*, 1773, bought-in. 2 for	1,365	
1865	Pourtalès, Paris. Pair of urns, plain *gros bleu,* heavily mounted.	398	
	Pair of jardinières en eventail, 1758. 2 for	344	
1867	Captain Ricketts. C. Single vase, *bleu du roi,* fishing scenes after Boucher, bought for Lord Hertford.	1,417	10s
	J. Marryatt. Bowl from Empress Catherine Service (see 1856, 1875).	21	
	David Falcke. C. 2 plates from a service, *gros bleu* and gold borders, classical scenes in centre.	{101 {112	1s
	Sir Frederick Roe. C. 3 jardinières en eventail, white with green ribbons, Cupids, etc. 3 for	1,860	
1868	C. Centre vase and cover in flat Greek-lamp shape, Boucher Cupid panels on *gros bleu*.	1,008	
	2 *gros bleu* urns and covers, grisaille medallions. 2 for	682	10s
	George Hibbert. C. Jardinière en eventail on perforated stand.	714	
	Gros bleu urn, sportsmen after Berchem.	535	10s
1869	Lord Ashburton. C. Garniture of 3 urns, conversations in panels on *œuil de perdrix* ground (see 1870). 3 for	1,375	
	The Montcalm Vase, originally one of a pair, *rose Pompadour* ground, the storming of a fortress in panel; cover with perforated sceptre, bought by Lyne Stephens (see 1895).	1,732	10s
	The 2 jardinières en eventail *en suite*, bought by Lyne Stephens (see 1895). 2 for	819	
	Marchioness of Londonderry. C. Cabaret of 6 pieces, Boucher Cupid panels on green-and-gold ground. 6 for	362	5s

£

1869	Urn and cover, 14in *bleu celeste* ground, with seaport panel by Morin after Vernet.	903
	Sigismund Rucker. C. Cup and saucer, conversation pieces on *gros bleu* by Dodin, 1765 (a record price).	288 15s
	Gros bleu urn, 16½in, Venus and Adonis, by Pavon (Bernal sale, 1855, £233 2s).	945
1870	H. L. Wigram. C. Vase with pierced cover, birds and peacocks' feathers, green ground.	1,081 10s
	Pair of urns, *bleu celeste* ground, elephant handles, mounts by Duplessis, bought by Earl of Dudley. 2 for	1,680
	Cylindrical vase, *gros bleu* ground, Diana and Calisto (see 1788; V & A, Jones Bequest, 1882).	1,081 10s
	John Bulteel. C. The Ashburton Garniture (see 1869), bought-in. 3 for	1,417 10s
	Cabaret by Vieillard. 7 for	535
	San Donato, Paris. The Rohan Service (see 1772). bt. for the Earl of Dudley. 168 for	10,200
	Apple-green urn, biscuit medallions, lid formed as a crown, made for Louis XV.	1,600
	Another apple-green urn with Watteau scenes.	620
1872	V & A buys picture-plaque by Dodin, dated 1765, Birth of a Child, 9in × 10in.	250
	Allègre, Paris. Pair of jardinières en eventail. 2 for	644
	Pair of glacières from the Rohan Service (see 1870). 2 for	676
1873	Dowager Countess of Londonderry. C. 3 jardinières en eventail, forming a *rose Pompadour* garniture, bought-in. 3 for	4,150
1874	V & A buys late 18th-cent. biscuit vase in blue and white in the Wedgwood style.	232
	Earl of Coventry. C. Garniture in *rose Pompadour* of a vaisseau à mâts and 2 jardinières en eventail, bought by the Earl of Dudley (see 1895, 1913). 3 for	10,500
1875	Baron Thibon, Paris. Pair of biscuit figures, called "*garde à vous*". 2 for	340
	Plate from Empress Catherine's Service (see 1856).	96
	Bought by the Earl of Dudley from William Goding. Pair of fluted potpourri jars and covers, apple green and *rose Pompadour*, 11¼in high, *c.* 1757 (see 1886, 1963). 2 for	6,825
1878	Dering. C. The Gwydyr Service, *rose Pompadour*, 57 pieces (see 1809, 1829, 1902). 57 for	4,039 14s
	Including 2 seaux. 2 for	1,103 10s
1880	4th San Donato sale, Paris. Garniture of 3 urns by Dodin, 1758. 3 for	3,780
	Bleu du roi urn by Leguay (see 1780) (V & A, Jones Bequest, 1882).	1,240
1881	Leopold Double, Paris. The 2 Fontenoy or Montcalm Vases, battle scenes on green ground (Waddesdon Trust). 2 for	6,800

£

			£	
1881	An Empress Catherine dinner plate (see 1856, 1875, 1886).		256	
	The Buffon Dinner Service (see 1793).		3,800	
1882	Hamilton Palace. C. Pair of plain *gros bleu* urns, mounted by Gouthière.	2 for	1,680	
	Urn and cover, *bleu celeste* ground, by Dodin.		1,585	
1884	Marquis d'Osmond, Paris. Pair of urns in Louis XV mounts, panels on celadon ground.	2 for	3,444	
	Single urn, same type.		2,044	
	Jardinière en eventail by Grison, *rose Pompadour*, 1757.		2,364	
	C. Pair of urns by Dodin after Teniers, *rose Pompadour* ground, Louis XV mounts ("as good as banknotes in the right quarter").	2 for	1,680	
1886	Late Earl of Dudley. C. The Goding pair of jardinières (see 1875 and 1963), bought-in.	2 for	2,625	
	Garniture of a vaisseau à mâts and 2 tulip-shaped vases, grounds of apple green and *gros bleu* (*ex* Alexander Barker) (see 1910).	3 for	2,787	10s
	3 jardinières en eventail by Alonde (*ex* Lord Otho Fitzgerald).	3 for	1,732	10s
	A plate from the Empress Catherine Service (see 1777, 1856, 1875, 1881).		148	
	The Prince Torlonia apple-green service (27 lots).		3,437	11s
	Urn by Morin, turquoise ground (see 1903).		735	
1887	C. Dinner service made for Mme du Barry.		1,811	
1889	Secrètan, Paris. Pair of urns, turquoise and apple-green grounds, bought-in.	2 for	1,584	
	Ayert, Paris. Single urn by Morin, seaport scene, 13in.		920	
1893	Earl of Essex. C. Urn by Leguay.		1,260	
	Pair of oviform urns by Morin.	2 for	1,990	
1894	Barre, Paris. 2 "false urns" with simulated covers, *bleu du roi* and *œil de perdrix*.	2 for	1,180	
1895	Mrs Lyne Stephens. C. 3 oviform vases, ormolu mounts, seaport scenes by Dodin and Morin on *bleu du roi* ground (see 1851).	3 for	5,250	
	The Montcalm Vase (see 1869).		1,995	
	2 matching jardinières after Boucher (see 1869, 1910).	2 for	1,995	
	W. J. Goode. C. The Coventry Garniture (see 1874), bought-in. See also 1913.	3 for	8,400	
1896	Paris. Dinner service *à feuille de choux*.		1,600	
1898	Leopold Double, Paris. Potpourri-jar by Gomery, 1758.		1,352	
1899	Stein, Paris. 2 jardinières, 1761, in *rose caillouté* by Dodin.		1,440	
	2 potpourris and covers after Teniers.		1,480	
1900	Gregory. C. 2 biscuit statues, mounted as candelabra.	2 for	2,415	
	Moore. C. Rose-water dish and ewer (£420 in 1884).	2 for	2,362	10s
1901	Hope-Edwards. C. Cupid and Psyche, biscuit group.		777	

£

1902	Willoughby-Loudon. C. Pair of orange tubs. 2 for	1,102	10s
	Rose Pompadour dessert service (ex Lord Gwydyr), bought		
	by Duveen, 18 plates (see 1809, 1829, 1878). 18 for	3,360	
1903	Mme Lelong, Paris. 2 biscuit groups, Prometheus and		
	Pygmalion. 2 for	1,188	
	Cabaret, dated 1761.	1,160	
	2 refraichissoirs, 1765. 2 for	1,440	
	Sir Hugh Adair. C. Urn by Morin (see 1886).	1,995	
	Cabaret, 1766.	2,100	
	Page Turner. C. 2 biscuit figures after Falconet, La		
	Baigneuse and La Surprise (bought in 1870 for £150). 2 for	2,205	
	Single urn by Morin.	2,362	10s
1905	C. A single urn and cover by Dodin, 1763, bought by		
	Partridge.	4,200	
	Duke of Cambridge. C. Écuelle, rose Pompadour, with		
	cover and stand.	1,365	
1906	The Prince Cherimatieff Garniture of 3, by Dodin, rose		
	Pompadour, 1764, bought by Asher Wertheimer and valued		
	at £20,000.		
	C. 2 pairs of rose Pompadour vases, bought by Duveen.		
	⎰2 for	2,310	
	⎱2 for	2,150	
1907	Chappey, Paris. Vaisseau à mâts fond bleu celeste.	1,840	
	Pair of urns, pierced covers, bleu celeste. 2 for	2,880	
1908	Marchioness of Conyngham. C. White oviform vase,		
	mounted, with elephant handles by Duplessis, 13½in (see		
	1946).	2,310	
	Mounted garniture of 4 plain gros bleu vases. 4 for	3,780	
	Marchioness of Ely. C. Pair of urns by Tandart, 1763.		
	2 for	1,732	10s
	Earl of Lauderdale. C. Pair of urns with river scenes on		
	gros bleu. 2 for	3,780	
	J. H. Dickins, deceased. C. Jardinière, gros bleu ground,		
	oval seaport panels by Morin, 1763.	3,050	
	Garniture of 3 urns, 1779. 3 for	3,200	
	Pair of seaux by Dodin and Leguay, 1770. 2 for	3,360	
1910	Octavus Coope. C. 2 ice-pails and covers, 1778, from		
	the Empress Catherine Service, by Boulanger and Leguay.		
	2 for	2,835	
	Baron Schroeder. C. Reappearance of the 2nd Dudley		
	Garniture with vaisseau à mâts, etc. (see 1886), bought by		
	Duveen for Pierpont Morgan. 3 for	9,450	
	Reappearance of the Montcalm Garniture (see 1869,		
	1895). 3 for	9,450	
	Urn and cover, seascape, Morin after Vernet (see 1921).	2,362	10s
1911	Wilde. C. Garniture of 3 Teniers subjects. 3 for	5,040	
	Garniture of 3 by Morin (bought recently in the country		
	for £73 10s). 3 for	3,360	

£

1913 Unnamed, Paris. Group of 2 Chinoiserie white figures,
Vincennes, 1740. 2 for 1,476
Sir John Murray-Scott. C. Pair of gondola-shaped bowls
in plain *gros bleu*, heavily mounted *en rocaille*. 2 for 2,100
The Coventry Garniture (see 1874, 1895), bought by the
Metropolitan Museum from the Pierpont Morgan Estate.
3 for 15,500
1915 Lord Huntersfield. C. 2 urns, pierced covers, panels with
hunting scenes on *bleu celeste*. 2 for 1,470
1917 Levy, Paris. 2 soupières en feuille de choux by Rosset,
1761. 2 for 572
2 Directoire vases in the Etruscan style. 2 for 695
1921 Asher Wertheimer. C. Single urn, by Morin (see
1910). 420
1925 Countess of Carnarvon. C. Plateau on a tripod. 1,785
3 urns and covers after Wouverman. 3 for 2,100
2 urns and covers, 17in, Cupid and Psyche. 2 for 2,835
The slump in Sèvres begins, 1925–1946.
1928 C. Jardinière en eventail, *rose Pompadour*. 441
1929 Founès, Paris. Service of 147 pieces, green-and-gold
borders, 1770–2, bought by Duveen (see 1959). 1,045
1930 C. Jardinière à eventail by Taillandier, 1758, children in
landscapes, white ground. 94 10s
Lady Miller. C. 2 seaux, apple-green ground by
Thevenet *père*, 8in diam., 1765. 2 for 220 10s
Earl of Balfour. C. Dessert service, 1757, 50 pieces. 483
Gerard Tharp. C. 92-piece dessert service, turquoise-
and-gold borders. 1,050
1931 Goldschmidt-Rothschild, Berlin. Soup-tureen and cover,
rose Pompadour, 1757 (see 1957). 1,160
1932 Comte de G., Paris. 2 mounted urns and covers, *œuil de
perdrix* (bought in 1925 for about £700). 2 for 310
1936 Mme d'Hainaut. S. Ewer and basin, *rose Pompadour*
ground, 1761. 2 for 410
Sucrier and cover, ditto, 1764, panels of children after
Boucher. 253
C. Garniture of 3 urns in plain *gros bleu*. 3 for 630
1938 Duveen sells the Hillingdon Garniture to Mrs Walter P.
Chrysler. The cost of a vaisseau à mats and 2 matching
jardinières in *rose Pompadour* was reported at £120,000.
1943 Viscountess Harcourt. C. Pair of *gros bleu* tazzas and
covers, Louis XVI mounts. 2 for 304 10s
1944 J. Pierpont Morgan, Jnr. C. Coffee cup and saucer by
Leguay, with enamels imitating jewels. 2 for 262 10s
1946 Late Lord Swaythling. C. Écuelle, 1760, *rose Pompadour*. 504
Lionel de Rothschild. C. Garniture of 3 urns, military
subjects. 2 for 1,732 10s

585

£

1946	Single oviform vase, mounted with elephant handles (see 1908).	1,680
	The long-delayed return of the market, in eclipse since 1925.	
1950	Baroness Burton. C. 2 ice-pails by Baudouin and Leguay. 2 for	3,150
	2 Boucher figures, mounted as candlesticks. 2 for	2,416
	2 statuettes *en biscuit* after Falconet. 2 for	1,763
1956	S. Enamelled plaque, portrait of Louis XVI.	2,300
	Simon Goldblatt. S. Vincennes white candlestick group.	1,800
1957	Henry Walters, New York. Soup-tureen, *rose Pompadour*, dated 1757 (see 1931, £1,160).	10,360
	Sainsbury. S. Pair of Vincennes white figures, Chasseur d'Oiseaux and Chasseur de Lièvre. 2 for	710
	2 Vincennes jardinières, white ground. 2 for	400
	2 Vincennes cachepots, 1745, 4in high. 2 for	740
1958	Parke-Bernet, New York. Pair of potpourri vases, floral panels, *rose Pompadour* grounds, 1757 and 1759. 2 for	1,640
1959	Chrysler-Foy, New York. 36 plates from the Founès Service (see 1929), green-and-gold borders, 36 for	21,420
	1770–2, sold in lots. per plate	598
1960	C. Candelabra and wall-lights of mounted Sèvres:	
	Pair of candelabra. 2 for	3,150
	Pair of wall-lights. 2 for	2,835
	Pair of candelabra. 2 for	2,520
	Pair of urns, *bleu du roi*, shipping scenes by Morin. 2 for	1,102
	S. Early Vincennes group, Les Mangeurs de Raisin.	2,100
	Paris. Tureen and cover, apple-green ground by Aloncle, panels of flowers.	4,870
	2 cachepots by Aloncle, from the Buffon Service (see 1793). 2 for	1,800
1961	Jules Strauss, Paris. Equestrian statuette of Louis XV in *biscuit de Vincennes*, 14in.	2,280
1962	S. Pair of *gros bleu* urns, harbour scenes by Fabius after Vernet. 2 for	1,000
	Paris. Covered écuelle and stand, Vincennes, turquoise ground, 1755 (23,500 fr. and tax).	2,017
	Tall cup and saucer, 1757, blue cameo on yellow by Vieillard (16,000 fr. and tax). about	1,400
1963	S. 2 pot-pourri jars and covers by Dodin, 1760, *ex* Earl of Dudley (see 1875, 1886), rediscovered after 50 years in storage. 2 for	5,800

SCULPTURE

Gothic and Renaissance
before 1600.

(see also Ivory)

£

1780 Picard, Paris. 2 Gothic retables in relief, painted alabaster.
 2 for 5s
1794 At Hautes Bruyères. The marble tomb of Francis I, sold
 to Citoyen Percheron. 2 2s
1804 Musée des Monuments Français buys stone relief, Holy
 family, attributed to Dürer. 18
1805 Musée des Monuments Français buys 13th-cent. statues of
 Clovis and Clothilde from the Abbey of Corbie. 2 for 2 17s 6d
 Thomas Bankes. C. Gothic figures from the old
 Guildhall, Gog and Magog, 2 pairs. {2 for 49 7s
 {2 for 47 5s
1817 William Beckford. Set of South German relief plaques in
 pearwood, dated 1554, allegorical compositions by Peter
 Flotner:
 Grammar and Poetry. 2 for 16 5s 6d
 Arithmetic and Chemistry. 2 for 18 14s 6d
 Music and Architecture. 2 for 15 15s
1821 A collector of taste. C. Adoration of the Magi, a fine
 piece of old Flemish sculpture (probably Gothic retable). 6 10s
1838 "Monsieur Hertz." C. Christ and the Samaritan
 Woman, carving, dated 1513, attributed Dürer. 4 4s
1841 C. Sculptured chimney-piece with mounts of gilt-bronze,
 "time of Francis I" (the attribution seems doubtful),
 bought-in. 84
1842 Waldegrave, Strawberry Hill (*ex* Walpole). (Robins.)
 Stone bust of Henry VIII. 67 4s
 Alleged Dürer stone relief of a tournament, actually Hans
 Dollinger (see 1887). 27 6s
 German Gothic statue of a saint, bronze, 34in. 3 5s
1845 Paris. Marble bust of Henri IV. 20
1846 Baron, Paris. 4 marble early 15th-cent. statues from the
 tombs of the Dukes of Burgundy at Dijon, published by
 Du Sommerard (see 1859). 4 for 46 8s
1850 Debruge Dumenil, Paris. Part of a wooden 13th-cent.
 saddle with reliefs. 41 10s
 Michael Wohlgemuth, Crucifixion, wood. 8

587

		£	
1850	Flemish 15th-cent. retable, 27 personages.	18	12s
	Speckstein relief, Henry VIII receiving Charles V, by Hans Dollinger.	164	
1855	W. W. Hope, Paris. Diane Chasseresse, marble bas-relief, attributed to the French 16th-cent. sculptor, Jean Goujon.	243	10s
1859	Rattier, Paris. 2 early 15th-cent. statues from the tombs of the Dukes of Burgundy at Dijon (see 1846), bought by the Duke of Hamilton and given to the Musée Cluny in 1861. 2 for	62	
	Christ before Pilate, German 16th-cent. wooden relief, attributed to Dürer.	160	
1861	Soltykoff, Paris. French painted wooden retable, c. 1500.	212	12s
	A 2nd ditto, described as Flemish.	220	
1865	Pourtalès, Paris. Life-sized bronze bust of Charles IX [d. 1574].	1,800	
1872	Paris. Marble bust of Diane de Poitiers after Jean Goujon.	480	
1873	V & A purchases huge painted wooden triptych in relief, German, 15th cent., from Boppard.	250	
1875	Paris. 16th-cent. French statue of the Virgin (Louvre).	480	
1881	Château de Montal. Paris. Baron de Hirsch buys a French sculptured chimney-piece, 1527–34.	1,000	
	A 2nd ditto (see 1893, 1903).	800	
1884	Marquis de Osmond, Paris. Life-sized bronze bust of Henri IV, c. 1600.	600	
1886	Triquetie, Paris. 2 German wooden roundels of portrait heads in high relief, c. 1520, bought by Adolphe de Rothschild. 2 for	2,400	
1887	Eugène Felix, Leipzig. Hans Dollinger, Speckstein relief, meeting of Charles V and Ferdinand I in armour (see 1842, 1899).	2,600	
	Hans Schwarz, The Entombment, stone relief.	600	
	Bronze medallion head of Albert Dürer.	980	
1893	Frederick Spitzer, Paris. St George and Dragon, German 15th-cent. wood relief.	336	8s
	2 French chimney-pieces from the Château de Montal, c. 1527–34 (see 1881).	{1,232 620	8s
	Bronze 16th-cent. German statue, alleged self-portrait of Peter Visscher at work.	1,936	
	French 16th-cent. statue of the Virgin.	528	
	V & A buys English 14th-cent. oak relief, St George and Dragon, 4ft 9in × 2ft 1in (disputed piece).	206	
1897	Edmond Bonnaffé, Paris. Numerous wooden fragments bought by V & A:		
	German wooden portrait figure of Wenzel Jamnitzer, mid-16th cent.	210	
1899	Charles Stein, Paris. French 14th-cent. Virgin, gilded marble.	900	

£

1899 Meeting of Charles V and Ferdinand I (see 1842, 1887),
now attributed to Hans Kelch. 2,920

Stone relief bust portrait, signed M.L., dated 1534. 564

1900 Miller-Eichholz, Vienna. German painted wooden statue,
St Florian, by Matthias Bacher. 300

1903 Hochon, Paris. 2 doors from the Château de Gaillon,
before 1515, very richly carved. 1,120

Château de Montal, Paris (see 1881). Busts of Robert de
Balsac and Nine de Montal [c. 1525–34] bought for the
Louvre. {620 / 604

2 carved door-surrounds. {688 / 700

Stone frieze (Musée des Arts decoratifs). 694

1905 Boy, Paris. German bronze statuette of St Sebastian, 16th
cent. 2,440

1906 Baronne de Hirsch, Paris. Early 16th-cent. chimney-piece
from the Château de Montal (see 1881). 1,680

1907 Queyrand, Paris. Taking of Christ, Bavarian stone relief. 600

1908 Marchioness of Conyngham. C. Flemish stone relief,
Charles V and Isabella, c. 1530. 462

1910 Hans Schwarz, Zürich. 2 painted wooden relief figures,
Flemish, c. 1520. 1,175

3 painted wooden ronde-bosses, Life of St John, school
of Wohlgemut, 15th cent. 3 for 1,750

Wooden statue of St Anne, Franconia, c. 1500. 3,200

Tyrolese stone altar, style of Michael Pacher. 1,700

High-relief wooden Virgin, Tilmann Riemenschneider. 880

1911 Von Lanna, Prague. Bas-relief, Kelheim stone, the
Emperor Maximilian on horseback, about 1520. 3,625

The Deposition, bas-relief in boxwood by Hans Leinber-
ger, 16th cent. 1,530

Boxwood medallion portrait of Wolfgang Gamersfelder,
dated 1531. 1,400

1912 Louis Mohl, Paris. Painted wooded female bust, described
as Hispano-Flemish, 16th cent. 1,600

J. E. Taylor. C. Brass Flemish statuette, c. 1400, 22in. 1,312 10s

2 Nottingham alabaster groups, 15th cent., over 2ft. 1,412 10s

Tilmann Riemenschneider, wooden relief. 735

1913 Oertel, Munich. Painted wooden Madonna from Bangol-
sheim, Alsace, 15th cent. (resold to Kunstgewerbe Museum,
Berlin, for £3,500, the price having been inflated by
patriotic competition with France). 2,600

1919 Manzi, Paris. Early Gothic French stone sculpture from
Moutiers-St Jean, Côte d'Or. (38 fr. to the £1):

Bearded bust of a king. 1,765

2 whole-length kings. 2 for 5,885

1920 Roybet, Paris. Painted statue of the Virgin, 14th cent. 1,550

£

1921	Heilbronner, Paris. St Martin and the Beggar, large stone statue, French, c. 1520.	1,870
	Flemish 15th-cent. retable, The Nativity.	1,460
	Unnamed, Paris. Life of Christ, painted wooden retable, Flemish, 15th cent.	1,825
1923	Grosvenor Thomas. S. Nottingham alabaster 15th-cent. relief, St John and *Agnis Dei*, 28in.	240
1925	Seligman, Paris. 13th-cent. wooden statue of the Virgin, part-lined in parcel-gilt.	920
1926	S. Pair of German bronze andirons with marine monsters and figures, 5ft high, Hildesheim, 16th cent. 2 for	1,300
1930	Breitmeyer. C. Carved wood reredos, German, early 16th cent.	819
	Albert Figdor, Berlin. Nativity, Burgundian, 14th cent., wood.	2,325
	Nativity, Brabant, c. 1450, wood.	2,450
	2 saints, West German, 15th cent., stone.	2,000
	Monell, New York (just at the beginning of the slump). Veit Stoss, 3ft wooden Crucifixion group, c. 1510.	1,120
1931	Aicard, Paris. Marble 14th-cent. statue of the Virgin from Carcassonne, 3ft high. about	1,000
1932	Sevadjan, Paris. Madonna and Child, French, 14th cent., marble.	620
	Ste Claire, 14th-cent. marble, Rheims school.	775
1937	Durlacher. C. German bronze group, Hercules and the Nemean Lion, late 15th cent.	567
1939	Clarence McKay. C. Nottingham alabaster group in relief, 15th cent., The Coronation of the Virgin.	787 10s
1941	S. Marble statue of the Virgin by Beauneveu of Valenciennes, c. 1390 (V & A).	270
1946	S. Nottingham alabaster altarpiece in 5 panels, 15th cent.	1,000
1950	Lempertz, Cologne. 4ft statue of the Virgin in limestone, Alsace, c. 1400.	730
	French alabaster statue of the Virgin, 20in high, c. 1350.	1,280
1952	Wilm (Lempertz, Cologne). Walnut statue of the Virgin by Adolf Daucher, S. German, 16th cent.	2,400
1957	Jacob Hirsch, Lucerne. French wooden Virgin, c. 1300–30, 2ft high.	8,300
1958	Paris. Romanesque wooden statue of Virgin and Child from Auvergne.	3,220
1960	S. Tilmann Riemenschneider, 3 saints in wood.	6,200
	10in wooden head of Christ, 12th cent.	1,200
	German painted wooden group, c. 1460.	1,200
	Parke-Bernet, New York. Retable, alabaster and parcel-gilt, from the Monastery of Poblet, Hispano-Flemish, c. 1440.	5,713
	Myron C. Taylor, New York. French portrait bust of a lady, painted wood, c. 1450.	1,072
	Limestone French statue of St Catherine, c. 1420–40.	1,250

1962 S. Pair of bronze does, probably German, late 15th cent. £
 (£22 in 1952). 2 for 1,100
 Samson with a lion's head, S. German, *c.* 1520. 2,800
 C. 2 pearwood plaques by Peter Flotner, 1543. 504
 Guggenheim Foundation. S. South German Madonna,
 limewood, 49in, late 15th cent. 2,100

SCULPTURE

Marble and Terracotta (before 1650)

£

1741 Earl of Oxford (Cock, auctioneer). Algardi [1602–54], life-sized marble Hercules. — 17 17s

1751 President de Tugny, Paris. Head of John the Baptist, marble fragment, attributed to Michelangelo. — 6

1772 Messrs. Adam (from Rome). C. Marble figure, attributed Baccio Bandinelli, boy riding a dolphin. — 26 5s

1785 Fitzhugh. C. 2 basso relievos of a woman and the Adoration of the Magi, "by Baldassare Peruzzi". 2 for — 13s

Bernini, wax modello for the Fontana Navona, and his drawing for the same, bought by Nollekens. 2 for — 7s
(See also Della Robbia Ware.)

1821 C. "A fine *Cinquecento* relief in the style of Rosso Fiorentino" (see 1838), Meleager presenting the Boar's head to Atalanta. — 21 10s 6d

1822 Sir George Beaumont buys in Rome the unfinished Michelangelo roundel relief of the Holy Family, 1504, price reported as £1,500 (see 1830).

1823 Nollekens. C. 4 terracotta reliefs by Giovanni Bologna, said to be designed for the doors of the Duomo at Pisa (see 1847). 4 for — 53 11s

1830 The Michelangelo Holy Family (RA Diploma Gallery), valued by Christie's for probate. — 600

Sir Thomas Lawrence, R.A. C. Terracotta models:
Attributed to Michelangelo, Pietà (see 1854). — 16 5s 6d
Figure of Night from the San Lorenzo Chapel. — 62 10s
Wax version of the same. — 14 3s 6d
Venus with her foot on a dolphin. — 57 15s
Attributed to Giovanni Bologna:
Massacre of Innocents. — 6 6s
Rape of the Sabines. — 13 13s
Female nude (wax). — 16 16s
Attributed to Perino della Vaga, Battle of Amazons. — 7 17s 6d
Attributed to Cellini 2 bas-reliefs. 2 for — 11 0s 6d
Attributed to Donatello, St John the Baptist. — 1 4s

1838 "Monsieur Hertz." C. Atalanta and Meleager, bas-relief, 17in×21in, attributed to Baccio Bandinelli (see 1821), bought-in. — 63

1842 Waldegrave, Strawberry Hill (*ex* Walpole). Marble relief, Eleonora d'Este. — 6 15s 6d

£

1842	Head of Henry VIII (Torrigiani?).	27	6s	
	Alleged Donatello statuette of St John (see 1932).	5	15s	5d
1847	Mrs Russell. C. 4 terracottas, attributed to Giovanni Bologna (see 1823). 4 for	30		
1850	Debruge Dumenil, Paris. Marble bust of Beatrice d'Este [d. 1497], attributed to Desiderio da Settignano, bought by Louvre.	256		
1854	Samuel Woodburn. C. Black-marble relief of the Holy Family, attributed to Donatello.	66	3s	
	Attributed to Michelangelo, terracotta pietà (see 1830).	43	1s	
1856	Samuel Rogers. C. Attributed to Michelangelo, terracotta figure for tomb of Lorenzo di Medici (ex William Locke).	29	8s	
1859	Rattier, Paris (ex Eugène Piot). Marble bas-relief bust of Scipio, early 16th cent.	500		

V & A purchases:

Altarpiece 12ft high, with tabernacle, 5ft, by Andrea Ferrucci of Fiesole, c. 1490.	490	
4 14th-cent. marble figures of saints, school of Niccolo Pisano, bought in Bologna. 4 for	10	
Sandstone chimney-piece in high relief, attributed to Desiderio da Settignano.	230	
1860	Louis Fould, Paris. 2 early 17th-cent. marble vases in relief. 2 for	240

1861 Marquis de Campana. Purchases by the V & A of the property (former Gigli Coll.) sequestered by the Municipality of Rome.

Terracotta bust of a saint, attributed to Donatello, but later condemned as a forgery.	100
Donatello, low relief in marble, the body of Christ supported by angels in the Sepulchre.	1,000
Desiderio da Settignano, Holy Family, bas-relief.	200
Ghiberti, terracotta bust, John the Baptist.	100
Bas-relief, Holy Family and angels, school of Donatello.	60
Rossellino, terracotta bust dated 1456.	110
School of Donatello, terracotta head of an angel.	100
Terracotta crucifix, attributed to Verrocchio.	30

Altogether £6,000 were spent on the collection. See also Bronzes and Della Robbia Ware.

From other sources, V & A purchases altarpiece and tabernacle from Sta Chiara, Florence, by Leonardo del Tasso, c. 1500, and Desiderio da Settignano, c. 1480.	386	
1863	De Nolivos, Paris. Alleged 15th-cent. terracotta bust of Benivieni, actually a newly-made work of Giovanni Sebastianini, bought by Baron de Nieuwekerke for the Louvre.	530
1864	Soulages Coll. V & A purchases a chimney-piece, 7½ft high, by Tullio Lombardi, c. 1480.	400
	Eugène Piot, Paris. Donatello, marble bust of a child.	354

£

1864	Mino da Fiesole, bust of Diotisalvi Nerone (refused by the Louvre in 1849 at £52). Cloisters Museum, N.Y., 1934.	228
	Rossellino, female bust.	136
	Benedetto da Maiano, bas-relief, Virgin and Child.	134
	Donatello (ascribed), marble fountain figure, child carrying a fish.	160
	Tullio Lombardi, child riding a snail.	184
	See also Bronze Sculpture.	
1865	Marble bust of Philippo Strozzi bought for the Louvre by Baron de Neuwekerke, and for a time challenged as a modern forgery.	2,000
1869	V & A purchases:	
	Marble tabernacle, 9ft × 5ft, by Civitale of Lucca, dated 1498.	240
	Marble group of 3 angels by Maderno of Pavia, c. 1500.	150
1870	V & A purchases Milanese chimney-piece, relief sculpture in green-and-white marble, c. 1600.	350
1875	Coureur, Paris. A complete monument in 28 marble relief slabs, attributed to Antonio Lombardi (see 1893).	4,000
1878	Berlin Museum buys 2 marble busts by Desiderio da Settignano:	
	Maddalena Strozzi.	2,000
	Unknown man.	2,000
1883	Rusca, Florence. Marble bust-portrait of Bindo Peruzzi.	168
	Relief by Desiderio da Settignano, angels supporting a device.	720
1884	Alessandro Castellani, Rome. Bernini's terracotta model for the Fontana di Navona (see 1785).	240
1885	Marquess of Stafford. C. N. Italian altar, 7 slabs in relief of the Life of Christ.	78 15s
1887	Raoul Richards, Paris. Marble bust of Pietro Soderini, 1501 (Florence).	110
1888	Albert Goupil, Paris. Mino da Fiesole, marble bust of a man, bought by Lyons Museum.	500
	Goldschmidt, Paris. Painted wooden bust of Isotta da Rimini, 15th cent. (given to the Louvre in 1893).	580
1889	V & A buys 3 small terracotta panels by Benedetto da Maiano and Andrea della Robbia. 3 for	1,348 13s 9d
1890	Achille Seillière, Paris. High-relief figure of a man in armour, attributed to Donatello.	660
1891	V & A buys pearwood relief in 2 tiers from Placenza, c. 1500, ascribed to Otevetono.	1,377 19s 1d
1893	Frederick Spitzer, Paris. Monument in 28 slabs by Antonio Lombardi (see 1875).	2,000
	Marble bust of Ottavio Farnese, late 16th cent.	564
	Infant Jesus asleep on a throne, painted and coloured wood, called Spanish, 16th cent.	616

£

1897	Emile Gavet, Paris. Terracotta by Verrocchio, St John in the Desert.	620
	Marble Holy Family, Mantegazzo.	348
	Mino da Fiesole, Virgin adoring Child, painted stucco.	276

1900 Messrs. Pardo and Sanguinetti prosecuted by the Italian Government for exporting the bust of Bindo Altoviti, attributed to Cellini. For this they were alleged to have received £5,600.

1901	Antocolsky, Paris. Soft-stone 16th-cent. N. Italian relief, Adam and Eve.	600
1902	Lelong, Paris. St Jerome, soft stone, N. Italian, 16th cent.	432
1907	M.X., Paris. Retable in alabaster, late 15th cent., said to be "Flemish, but made in Florence".	3,800
	16th-cent. carved shrine, Italian.	1,004

Italian Government stops the export of the small marble St John of Donatello, a possession of the Martelli family of Florence since the early 15th cent. (see 1913). It was believed that Pierpont Morgan had offered £120,000 (*Chronique des Arts*, 19 July 1913).

1909	Kaiser Friedrich Museum buys a wax bust of Flora, attributed by Bode to Leonardo, but actually by Richard Cockle Lucas.	9,000
1911	Lowengard, Paris. Bas-relief, Virgin and Child, attributed to Verrocchio.	1,800
1913	Italian Government buys the Donatello St John from the Martelli family (see 1907) (Bargello Museum, Florence).	14,500
	Aynard, Paris. Relief, Agostino di Duccio, Holy Family and Angels.	1,232
	Statuette of a child, Desiderio da Settignano.	1,324
	Donatello school, terracotta relief, Holy Family.	1,639
1916	Arthur Sambon, Paris. Attributed to Mino da Fiesole, high-relief, Virgin and Child.	2,178
1918	Stefano Bardini, New York. Terracotta relief by Rossellino.	1,580
1920	S. Terracotta bust, Lorenzo the Magnificent, late 15th cent.	2,050
1921	Engel-Gros, Paris. Rossellino, stucco bust of St John.	705
1925	C. Armorial plaque, Holy Family, school of Donatello, marble.	945
1926	V & A acquires a flat relief by Agostino di Duccio per NACF.	3,000
1927	V & A acquires a Madonna, a marble plaque by Desiderio da Settignano, 11in×6½in, found in the library at Himley Hall (Earl of Dudley).	2,625
	James Simon, Amsterdam. Civitale, Virgin in Prayer, terracotta.	3,000
1928	Huldschinsky, Berlin. Sansovino, 2 marble statues forming an Annunciation.	2,350

£

1929 Simon, Berlin. Pietro Lombardi, marble bust of a young
 girl. 7,450
 Riccio, large terracotta Madonna. 6,450
 A series of 4 carved portals with their marquetry doors,
 school of Sansovino. 1,650–2,500
 Late 15th-cent. chimney-piece. 1,680
1930 Albert Figdor, Berlin. Andrea Riccio, half-length relief of
 St Sebastian. 7,500
 Ascribed to Verrocchio, 2 kneeling angels, terracotta.
 2 for 4,100
 Desiderio da Settignano, terracotta bust of a lady. 2,551
1932 C. Horace Walpole's alleged Donatello bust of St John
 (see 1842). 168
1933 C. School of Donatello, painted terracotta relief, the Holy
 Family. 546
 Thomas F. Ryan, New York. Laurana, bust of a Princess
 of Aragon, c. 1470, 16½in high, bought by Duveen. 21,000
 Bust of a prince of Aragon by a pupil of Laurana, c. 1470,
 16½in high (see 1934). 3,290
1934 Sales by Duveen to J. D. Rockefeller, Jnr, from the Gustave
 Dreyfus Coll. (according to Behrman). 3 busts by
 Verocchio, Donatello, and Desiderio at half a million
 dollars each, or £103,300. According to Saarinnen, Du-
 veen later sold Rockefeller the 2 busts by Laurana, also at
 £103,300 each (see 1933).
1936 Henry Oppenheimer. C. Terracotta statuette after
 Michelangelo's slave. 525
1938 Mortimer Schiff. C. Terracotta relief, Holy Family,
 attributed to Giovanni della Robbia. 567
1949 S. Head of a man in armour in low relief, marble,
 attributed to Verrocchio. 3,800
1954 Catherine Butterworth, New York. Marble round relief,
 the Holy Family, attributed to Benedetto da Maiano. 715
1957 Jacob Hirsch, Lucerne. Madonna and Child, marble, part
 coloured, c. 1450–70, 2ft high. 2,450
1959 Parke-Bernet, New York. Giovanni Bologna, marble sta-
 tue of Venus, 78in. 3,035
 Late Charles Loeser. S. Tino da Camaino, 18in, marble,
 low relief. 3,800

SCULPTURE

*Larger bronzes, including Life-sized Busts
before 1700*

		£
1747	Duc de Pontchartrain, Paris. Alessandro Algardi, globe surmounted by Juno and Jupiter riding a peacock and eagle, large bronze monument, *c.* 1650.	248
1767	Julienne, Paris. Giovanni Bernini [1598–1680], Apollo and Daphne, group, 34in.	66
1762	Duc de Sully. After Giovanni Bologna [1524–1608], Mercury, copy of the Florence statue, 5ft high, damaged.	60
1777	Randon de Boisset. Bernini, Apollo and Daphne, single group (see 1809).	102
1792	Sir Joshua Reynolds' Exors. Lord Yarborough buys the Bernini Neptune (see 1950).	500
1793	Sir Thomas Rumbold. C. A large figure of Mercury, attributed to Giovanni Bologna (see 1848).	26 5s
1809	Baron de Hoorn, Paris. Bernini, Apollo and Daphne, 32in (see 1777).	83 6s
1810	Marquess of Lansdowne. 2 andirons, probably Venetian, late 16th cent. ascribed to Cellini. 2 for	210
1811	Duke of San Pietro. C. Bust of Condé, perhaps by Le Sueur, bought-in.	472 10s
1821	Marchioness of Thomond. C. Nessus and Deianeira, 31in high.	78 18s
1824	Sir Masterman Sykes. C. 2 tall candelabra, very elaborate tripod shapes on pyramid bases, ascribed to Cellini, but probably Venetian, *c.* 1600.	{66 13s 4d / 59 6s 6d
	Bronze bust, alleged portrait of Michelangelo.	46 4s
1825	G. Watson Taylor. Full-sized bronze busts, bought in Paris after they had been looted from the Spanish palaces (possibly by Leone Leoni [1509–90]):	
	Charles V in armour.	89 5s
	Duke of Alva.	115 10s
	Philip II of Spain.	52 10s
1830	Sir Thomas Lawrence, R.A. C. Full-sized portrait bust of Michelangelo.	42
1835	De Ville. C. From the Vivant-Denon and Delagrange sales. 138 lots of bronze sculpture, obtained in Italy, 1795–9, of which the best were withdrawn and negotiated privately—but see 1846.	

£

1835 The withdrawn lots:
Four busts by Bernini of Turenne, Condé, Henri IV and
Louis XIII, bought from ex-King Stanislas in 1795 for
£2,600. Although Christie's were "offered" £1,166,
they remained unsold till 1856, when they made £52 10s
each. 2 groups, 3ft high, from the Pitti Palace, Rapes
of Proserpine and Eurydice, attributed to Donatello.
Delagrange was said to have paid £3,500 in 1795 in
Florence. Christie's were offered £1,166 for the 2.
Hercules and Omphale from the Borghese Palace,
attributed to Michelangelo. £2,640 believed paid in
1798. Christie's were offered £875 for the 2.
Ewer, 2ft high, said to have been made for Cardinal
Aldobrandini by Cellini; cost £3,400 in 1798(!).
Christie's were offered £980 (entry by the sales clerk).
From the Vivant-Denon sale, 1826; lots sold by Christie's:

Attributed to Ghiberti:

2 groups of slaves holding horses.	2 for	49 7s
Dying Gladiator, 30in high.		34 13s
Wrestlers from the Pitti Palace, bought-in.		32 11s

Attributed to Michelangelo:

Group of Prometheus Enchained, a gift from Napoleon, bought-in.		99 15s
By Bernini, equestrian Louis XIV, 24in.		21 5s
Howell and James of Regent Street. C. 2 ewers, 36in high, "in finest *Cinquecento design*", bought-in.		283 10s

1837 C. 2 large bronzes attributed to Giovanni Bologna:

Mercury.	52 10s
Copy of the Capitoline Apollo.	40 17s

1840 Aeneas and Anchises, 3ft group, attributed to Bernini, bought-in. 87 3s

1846 James de Ville. C. (see 1835). Bronzes from Denon and Delagrange sales:

Bernini, Aeneas carrying off Anchises, 20in.		21
2 alleged Cellini bronze ewers (see 1835).	2 for	51 9s
Attributed Michelangelo, Milo rending the Oak, 28in high, bought by Lord Hastings.		63
Attributed Michelangelo, Hercules and Omphale (see 1835), bought-in.		45
2 bronze basins supported by Amorini, 3ft high (*ex* King Stanislas), bought by R. S. Holford.	2 for	150

1848 Duke of Buckingham, Stowe. C. Giovanni Bologna, Mercury (see 1793). 112

1859 Baron de Cordes. C. Florentine ewer in high relief, bought-in. 370

1864 Eugène Piot, Paris. Contemporary bust of Michelangelo (bought in Bologna, 1855, for £100; later sold by Piot to the Louvre), bought-in. 240

£

		£	
1865	Earl of Cadogan. C. Pair of Venetian late 16th-cent. andirons, 42in, a warrior and a lady. 2 for	304	10s
1872	Prince Napoleon. C. Bronzes from the Litta Palace, Milan, late 16th-cent.:		
	Bacchus and Venus, life-sized. 2 for	2,772	
	2 fountain figures of Aeolus. 2 for	1,260	
1882	Hamilton Palace. C. Late Renaissance copy of the Laocoon in Louis XVI ormolu mounts.	850	10s
	Rape of Proserpine after Giovanni Bologna, ditto.	1,428	
	Set of 5 large copies of ancient statues, made for Francis I in Rome, early 16th cent., sold separately. 5 for	2,551	10s
1883	Beurdeley, Paris. 2 tall chênet figures, Venice, c. 1600.	600	
1890	Achille Seillière, Paris. Adrianus Friess, dated 1610, a large group of Glory vanquishing Vice.	2,460	
1893	Frederick Spitzer, Paris. 2 Venetian chênets, Mercury and Apollo (see 1912), by Alessandro Vittoria [1525-1608]. 2 for	2,244	
	Bust of a smiling young man, Venice, c. 1480.	1,640	
	Bust of an old woman, ditto (bought for the Louvre. Spitzer had bought them from Basilevsky in the 1880s for £280).	800	
1898	M. Goldschmidt, Paris. Life-size bust, Marescale Trivulzio, late 15th cent.	1,100	
1900	Miller-Eichholz, Vienna. Citadella, life-sized bust of Pietro Aretino.	3,260	
1902	Stefano Bardini. C. Riccio, bust of Marcantonio Passari.	2,750	
1905	von Pannwitz, Munich. Bust of a girl, Florentine, c. 1510.	890	
1911	Lowengard, Paris. Antonius Gallus, Venetian bronze bust after the antique, early 16th cent.	7,400	
	C. Leone Leoni, portrait-bust of Marquis of Villafranca, late 16th cent.	1,627	10s
1912	J. E. Taylor. C. 2 Venetian chênets (see 1893), now called Alessandro Vittoria. 2 for	9,660	
1922	Arthur Newall. C. Neptune, 44in, late 16th cent.	1,890	
1925	Sir Francis Cook. C. 2 Venetian chênets by Alessandro Vittoria (see 1893, 1912).	1,680	
1931	S. Leone Leoni. Bust of Alfonso d'Este, 1570.	100	
1933	Thomas F. Ryan, New York. 2 life-size figures of saints by Alonzo Cano [1601-67], Spanish, early 17th cent. 2 for	4,150	
1948	S. Fountain group of Neptune and tritons, 17th-cent. N. Italian.	310	
1950	V & A buys Bernini, Neptune and Glaucus, over 6ft high (see 1792).	15,000	
1962	Lady Powis. S. Hubert le Sueur, life-size bust of Lord Herbert of Cherbury, 1631.	6,200	

SCULPTURE

ITALIAN RENAISSANCE
Smaller Bronzes, 15th–17th centuries

£

1741	Earl of Oxford (Cock, auctioneer). Bronze urn in relief, attributed Fiammingo, bought by Horace Walpole (see 1842).	16 16s
	Copy of Farnese Hercules, bought by Horace Walpole.	13 13s
	Hercules and Antinous, ormolu base.	23 2s
	Hercules and the sons of Neptune, ditto.	21 10s 6d
	Replica of the Laocoon.	23 2s
1772	Marquis Lenori of Pesaro. C. A group of bronzes attributed to Sansovino, the dearest, a pair, Bacchus and Jupiter Tonans. 2 for	11 0s 6d
	Unnamed figure, attributed to Giovanni Bologna.	23 2s
1784	Baron de St Julien, Paris. Fiammingo, 2 bronze groups, Embarkment of Helen; Psyche conducted to Olympus, 25in high. 2 for	60
1787	Comte de Vaudreuil, Paris. Renaissance copies of the 2 bronze urns of the Villa Medici, 20in high. 2 for	68
1794	"The valuable museum." C. 3 small elegant Cupids by Algardi of the 15th (in fact, 17th) cent. 3 for	1 7s
	"2 elegant mules by Sansovino of the 15th cent." 2 for	1 8s
1799	Earl of Kerry. C. 2 bronze boys by Fiammingo on ormolu plinths. 2 for	12 16s
1801	Earl of Bessborough. C. Bernini, statue of David.	18 18s
1807	Earl of Halifax. C. 2 large bronze gladiators. 2 for	309
1809	Baron de Hoorn, Paris. Giovanni Bologna, Rape of the Sabines, group, 8in high.	56 8s
1810	Marquess of Lansdowne. C. Small bronze busts of the 12 Caesars, most probably Renaissance copies. 12 for	290
	Duke of San Pietro. C. Replica of the Laocoon.	367 10s
	Hercules and the Horn of Achelous.	325 10s
	Hercules and Nessus.	357
	Hercules and the Erymanthian Boar.	199 10s
	Practically the entire sale, including a 3,000-guinea alleged Leonardo portrait, was bought-in; probably not genuine bidding.	
1811	C. Pair of wrestlers.	42
1817	Edward Astle. C. Bronze replicas, 19in, of the Medici and Borghese vases. 2 for	58 5s
1819	Sevestre. C. Door-knocker from an Italian palace. Peleus and Thetis "in the Parmegianesque taste".	34 13s

£

1823	Farquhar, Fonthill (*ex* Beckford). 2 bronze ewers in relief, ascribed to Cellini.	2 for	18 18s	
1833	C. Faun bearing a kid on his shoulder, 26in.		27 16s 6d	
1834	Viscountess Hampden. C. Rape of the Sabines, 2 small groups, attributed to Giovanni Bologna.	2 for	69 6s	
1835	C. Silver-gilt figure of a horse (Augsburg?), ascribed to Giovanni Bologna.		46 9s 3d	
	Marchioness of Lansdowne. C. 2 Venetian andirons or chênets.	2 for	52 10s	
	Deville. C. 2 bronze ewers, ascribed to Fiammingo.	2 for	69 6s	
1842	Waldegrave, Strawberry Hill. Bronze ewer after Fiammingo (see 1741).		21	
	Apollo and Daphne after Bernini, 34in.		22 10s	
	Giovanni Bologna, Rape of the Sabines, 28in. (see 1942).		39 18s	
	Moses, after Michelangelo, bought by Earl of Derby.		52 10s	
1846	Brunet-Denon, Paris. Florentine bronze tripod, 16th cent.		37 16s	
	28in group after Giovanni Bologna, The Rape of the Sabines.		68	
1848	Duke of Buckingham, Stowe. C. Inkstand in the style of Andrea Riccio, said to have belonged to Sixtus V.		36 4s 6d	
1849	Eugène Piot offers 3 15th-cent. bronzes to the Louvre, who refuse, at £50 each.			
1850	Debruge Dumenil, Paris. Ganymede, after Michelangelo.		36	
1851	C. 2 late Renaissance bronzes:			
	Rape of Proserpine.		73	
	Boreas and Orythaea.		75	
1854	Samuel Woodburn. C. *Cinquecento* bust of Florentine gentleman, head of silver, dress copper-gilt, forming a casket (see, perhaps, 1959).		42 10s	
1855	Bernal. C. Late 15th-cent. Florentine sculptured tripod, 14in.		31 10s	
	Inkstand in the style of Riccio.		40	
1856	Samuel Rogers. C. Replicas of Michelangelo's Night and Day, 17in long.	2 for	189	
1857	Lasalle, Paris. 14in bronze figure after Giovanni Bologna, Architecture.		160	
1859	Earl of Northwick (Philips). Apollo, 36in high.		43 1s	
	Pair of 16th-cent. sculptured vases and covers.	2 for	43 1s	
1861	Prince Soltykoff, Paris. 2 Venetian sculptured andirons, late 16th cent.	2 for	240	
	Baron de Monville, Paris. Venus riding a sea monster, by Algardi.		322 15s	
	Nessus and Deianeira, large group.		113 10s	
	Lamp, triton riding a sea monster, Riccio school (*ex* Horace Walpole).		74 10s	
1863	Jules Soulages of Toulouse. Purchases by V & A:			
	2 Venetian andirons, 3ft high, style of Alessandro Vittoria, Venus and Adonis.	2 for	300	

£

1863	Small bronze relief of the Pietà, about 2ft square, c. 1420, attributed to Donatello.	140	
	Purchased from the Martelli family, Florence: The Martelli sculptured bronze mirror-case, 9in × 7½in, then attributed to Donatello.	650	
1864	V & A purchases:		
	Cupid carrying a dolphin, 15in high, school of Donatello.	160	
	Soulages Coll. 2 late 15th-cent. bronze candlesticks (Padua?), 10in. 2 for	250	
	Lamp in shape of a galley, 8in long, Padua.	163	
	Eugène Piot, Paris. 15th-cent. sculptured vase (V & A).	200	
	2 bronze sculptured tazzas, 15th cent. 2 for	240	
1865	Soulages Coll. V & A buys 2 candlesticks, N. Italian, c. 1480–1500. 2 for	250	
	Pourtalès, Paris. Ceres searching for Proserpine, Giovanni Bologna school, c. 1600, 21in high, bought for V & A.	280	
	Earl of Cadogan. C. Riccio school, lamp in form of a galley with Cupid riding a dolphin.	160	
	The Flagellation, group of 3.	142	16s
1870	San Donato, Paris. 2 bronze door-knockers after Giovanni Bologna. 2 for	140	
1873	Paris. Hercules and the Hydra, Florentine, c. 1550.	644	
	Perseus and the Chimaera, matching.	644	
1875	Saint-Seine, Paris. Venus Victrix, Florentine, early 16th cent.	280	
1879	Lord Lonsdale. C. Copy of the Vatican Spinario statue (see 1888, 1907, 1912).	89	5s
1880	San Donato, Florence. Giovanni Bologna, Mercury abducting Pandora.	264	
	Bernini, Neptune.	600	
	Attributed to Verrocchio, winged Bacchante.	124	
	V & A buys:		
	Bronze roundel reliefs, c. 1480, 13in diam., by Sperandio [1430–1500]:		
	Hercules and the Serpents.	1,000	
	Hercules carrying the Erymanthian Boar.	1,000	
1882	Hamilton Palace. C. Infant Bacchus riding a centaur.	367	10s
	Baccio Bandinelli, Farnese Hercules, 1556.	54	12s
	Lady Harriet Hamilton. C. Hercules, Centaur and Nymph, a pair. 2 for	220	10s
	Achille Fould, Paris. David and Goliath, after Donatello.	682	
1883	Beurdeley, Paris. Tacca, 2 winged genii kneeling. 2 for	476	
	Copy of Medici Venus.	310	
	2 Venetian chênets. 2 for	600	
1884	Joseph Fau, Paris. Syren riding a fish.	288	
1886	Paris. 2 chênet figures, Peace and War. 2 for	588	
1888	Marquess of Exeter. C. Padua inkstand by Moderno (see 1912).	204	15s

£

1888	M. Goldschmidt, Paris. Panther on marble plinth.			440
	Bacchante, late 16th-cent.			420
	Copy of the Spinario (see 1879, 1907, 1912).			340
1889	Secrètan, Paris. 2 boys riding dolphins, late 16th cent.			
			2 for	444
1890	Eugène Piot, 2nd sale, Paris. 2 angels supporting candlesticks, 15th cent.		2 for	2,000
	Venetian sculptured vase, 15th cent.			2,000
1892	The Louvre pays £1,600 for a faked bronze figure of a naked athlete, Donatello school.			
1893	Frederick Spitzer, Paris. Riccio, Roman horseman, 16in high (with tax).			2,046
	2 9in flambeaux, N. Italian, c. 1500.		2 for	1,386
	N. Italian inkstand, late 15th cent.			880
1894	Cozier. C. Copies of Michelangelo's Night and Day.		2 for	435
	2 Venetian candlesticks.		2 for	262
	Earl of Essex. C. Neptune and Sea-horse, Paduan school.			635
1898	Martin Heckscher. C. 16th-cent. Italian mortar in relief.			628
	15th-cent. Roman horseman.			600
1900	Miller-Eichholz, Vienna. Dacchi, bronze boar, green patina.			784
	Nude figure of Adam, attributed to Pollaiuolo.			800
1901	Hope-Edwards. C. 16in figure of Bacchus.			682 10s
1902	Lord Grimthorpe. C. 16th-cent. figure of Cupid drawing bow.			1,522
	T. Gibson-Carmichael. C. Seated infant, 15th cent.			1,600
	Stefano Bardini. C. Hercules, attributed to Pollaiuolo (Duveen).			6,000
	Samson and Philistines, 16th cent.			1,200
	Beckett. C. Early 16th-cent. Paduan Cupid.			1,522 10s
1904	De Sivry, Paris. Orpheus and Meleager, c. 1600.		2 for	764
	Satyr supporting a lamp, after Riccio.			384
1905	Capel-Cure. C. Pluto and Cerberus, attributed to Cellini, bought by Sir G. Donaldson.			903
	2 plaques, style of Riccio.		2 for	800
	Inkstand, boy riding a dolphin.			483
1906	C. Hercules and Cacus, Florentine, late 16th cent.			1,050
1907	Romer. C. The Spinario (see 1879, 1888, 1912).			315
1908	Another Spinario figure, bought by the Louvre.			616
1909	Adolf Hommel, Zürich. Mortar in relief, ascribed to Donatello.			268
	Model of Michelangelo's Day, good example (see 1894).			272
1910	Charles T. Yerkes, New York. Boston Museum buys Bacchante, early 16th cent.			1,600
	Cottreau, Paris. Love on a Galloping Horse, Florentine, 16th cent.			1,204
	Child and butterfly, ditto.			940
	Venus and Hercules, late 16th cent.		2 for	1,100

£

1910	Isaac Falcke. C. Venetian fountain-head figure.	4,100
	Roman horseman by Riccio (see 1893).	3,700
	7 others at 1,000 to 3,000 guineas.	
	Maurice Kann, Paris. Negress, school of Giovanni Bologna (see 1922).	1,344
1911	Lowengard, Paris. 2 peasant figures with attributes, N. Italian, 16th cent. 2 for	2,800
	Lady Amelius Beauclerk. C. Virtue overcoming Vice, attributed to Cellini (see 1912).	3,045
1912	Jacques Doucet, Paris. Bull, Padua, school of Riccio, on late Louis XVI mount.	2,640
	J. E. Taylor. C. 2 candelabra by Sansovino, Venice, early 16th cent. 2 for	1,365
	David, by Bartolommeo Bellano, Padua, 15th cent.	1,942 10s
	Candelabra, school of Donatello.	1,480 10s
	Padua, inkstand, Moderno, c. 1500 (see 1888).	3,255
	Equestrian figure, Milan, 16th cent.	3,465
	Virtue triumphing over Vice, ascribed to Cellini (see 1911).	3,255
	Andromeda, by Riccio of Padua.	3,885
	The Spinario, Riccio school (see 1879, 1888, 1907).	1,680
1913	Mannheim, Paris. 2 leaping lionesses, Florentine, early 16th cent. 2 for	4,290
	Aynard, Paris. Bronze plaque, Holy Family, attributed to Donatello.	3,498
1918	Richard von Kaufmann, Berlin. Sansovino, Neptune.	3,575
	Padua school, late 15th cent., she-wolf.	4,000
	Vase in relief by Riccio.	3,400
1922	Marquise de Ganay, Paris. Negress, school of Giovanni Bologna (see 1910).	1,180
	Arthur Newall. C. Door-knocker, Andrea Riccio.	2,362 10s
	Panther, Paduan, after 1520.	1,732 10s
1925	Sir Francis Cook. C. Bronze group, ascribed to Bellano.	504
1929	Brauer. C. Hercules and the Centaur, Paduan.	442
	Simon, Berlin. Lion, Paduan, 16th cent.	3,350
	Giovanni Bologna, 2 groups, Hercules and Bacchus and Hercules and Antaeus. 2 for	3,045
	School of Antico, Venus.	810
	2 Venetian candlesticks, Alessandro Vittoria.	780
1930	Figdor, Berlin. Silvered bronze mirror-frame, attributed to Luca Della Robbia.	2,800
	Sir John Ramsden. C. Donatello school, Aeolus.	1,071
1931	Henry Hirsch. C. School of Riccio, Panther.	735
	School of Riccio, Goat.	441
1932	Sir John Ramsden, 2nd sale. C. School of Riccio, satyr riding seahorse.	504
	School of Giovanni Bologna, 3ft Neptune.	525
	School of Giovanni Bologna, Ceres seated.	399
	School of Michelangelo, Sibylla, 20in.	283 10s

		£	
1933	Whitcombe Greene. C. Inkstand, school of Riccio.	131	5s
1934	Leopold Hirsch. C. Giovanni Bologna, statuette of Mercury.	787	10s
	2 Riccio school inkstands.	{84	
		{52	10s
	Bernini group, Conversion of Constantine.	178	10s
1936	Henry Oppenheimer. C. Boy with a skull and hourglass, Padua, late 15th cent.	609	
	Running Hercules, N. Italian, c. 1500.	283	10s
	Several good-quality Paduan bronzes at less than £100 each.		
1938	S. Roman horseman after Leonardo (see 1949).	280	
1942	Lockett. C. Running horse, Paduan (£625 in 1919).	231	
	Charles McKann, New York. Giovanni Bologna, Rape of the Sabines, 34½in. (compare 1842).	325	
1946	C. Padua school, Roman horseman.	241	10s
1948	Sir Alfred Beit. S. Antico, Apollo, 18in.	1,200	
	Faun astride a goat, by Riccio, 7in.	1,000	
	S. Door-knocker by Alessandro Vittortia, c. 1580–1600.	280	
1949	E. L. Paget. S. Roman horseman after Leonardo.	780	
	Figure of pacing horse, 16th cent.	400	
1950	Henry Harris. S. Rustici, fountain-head of c. 1500 with a 19in figure of Mercury.	3,200	
	Hercules and Nemean Lion, 11in (Barber Institute).	2,900	
1958	Duke of Devonshire. C. Riccio, lamp with grotesque figures, 14in.	2,835	
	Pair of inkstands, late 16th-cent. by Leone Leoni. 2 for	2,310	
1959	Late Charles Loeser. S. Venetian bust in silver-gilt, about 1480, under 10in high (see 1854).	2,600	
1960	S. School of Riccio, goat, 3in high.	1,450	
	V & A buys a parcel-gilt figure of Meleager by Antico.	4,000	
1961	S. Riccio, kneeling satyr.	2,300	
	Girolamo Campagna, salt-cellar, kneeling man.	1,550	
	Giovanni Bologna, bull.	1,300	
	Hercules and a bull, 9½in, Augsburg(?), 1560–70.	3,500	
1962	Gilou. S. Paduan school, panther, 5½in.	620	
	S. 2 Venetian andirons, early 17th cent. 2 for	950	
	School of Riccio, Venus holding a mirror.	2,700	
	Lion attacking a centaur, Florence, late 16th cent.	900	
	Panther, N. Italian, c. 1500.	4,000	
	Vittore Camelio, Hercules and Antaeus, early 16th cent.	3,800	
	C. Door-knocker, Neptune and Tritons, by Alessandro Vittoria, late 16th cent.	630	
	Fitzwilliam Museum buys Tiziano Aspetti, Mercury and Argus, c. 1590.	475	

SCULPTURE

Della Robbia Ware: Glazed Statues and Reliefs

£

1785 Fitzhugh. C. "Three models of heads in earthware by Luke della Robbia, who lived 100 years before Michelangelo", bought by the painter Cosway. 3 for 8 8s
 Other della Robbia reliefs at a few shillings each.

1840 Prince Poniatowsky. C. "Head of Venus de Medici", by Luca della Robbia (subject seems improbable, but the title-page of the catalogue mentions examples of the "terra de la Robia"). 2 17s

1846 Baron, Paris. Roundel, Holy Family. 11
 2 bas-reliefs, martyrdoms of SS. Catherine and John. 2 for 15 16s
 Brunet-Denon, Paris. Holy Family, 32in relief. 48

1850 Debruge Dumenil, Paris. St John writing the Gospel, 17in relief. 17 10s

1854 Samuel Woodburn. C. Holy Family, coloured relief, arched top, bought-in (see 1860). 17
 Joly de Bammeville. C. Statue of charity in white ware by Andrea della Robbia. 157 10s

1855 W. Williams Hope, Paris. Bust of a Roman emperor. 128
 Bust of a child in medallion relief. 56

1856 Lady of rank. C. Annunciation relief with unglazed faces. 32 11s

1857 Lasalle, Paris. Half-length relief, Holy Family. 96

1859 V & A purchases the Stemma of Réné d'Anjou from the top of the Torre dei Pazzi, Florence, 9ft diam. 90
 Jules Soulages. V & A purchases a very late roundel plaque, *c.* 1550, 21in diam. 55

1860 V & A purchases:
 The Salutation, relief in white, 8ft× 4½ft, attributed to Andrea Della Robbia, *c.* 1520. 150
 Altar-piece from the Cagniani Chapel, 9ft × 5ft 10in, attributed to Andrea della Robbia. 120
 Samuel Woodburn. C. Nativity, altar-piece with 4 figures, arched top (see 1854), "the largest specimen in this country", bought by Durlacher. 180

1861 Marquis de Campana. V & A purchases from the Collection, sequestered by the Municipality of Rome:
 The 12 Months of the Year in blue grisaille, each 12in diam., some badly damaged, *c.* 1520. 12 for 720

£

1861	Life-sized relief, seated Virgin and Child, blue-and-white, attributed to Andrea della Robbia.	200	
	Soltykoff, Paris. Holy Family, roundel (see 1890).	78	15s
1864	V & A purchases 4 medallion-busts from the Guadagni Palace, Florence, 33in diam. 4 for	290	
1870	San Donato, Paris. Virgin, Child and St John, 38in roundel.	90	
1871	Joseph. C. Altar-piece, Holy Family and saints, dated 1517.	40	19s
1878	Castellani, Paris. Virgin adoring Holy Child, large relief.	184	
1880	San Donato, Florence. Madonna with apple, white statue.	322	
1882	Hamilton Palace. C. Madonna and Child, roundel.	52	10s
1884	Fountaine. C. Ditto, 31in.	425	5s
1889	V & A buys unglazed group.	474	
	Odiot, Paris. Holy Family in blue-and-white.	626	
1890	Baron Achille Seillière, Paris. Virgin adoring the Child (see 1861).	564	
	Pietà.	460	
	Eugène Piot, Paris. Holy family, terracotta.	700	
	2 glazed child-busts in roundels.	880	
1893	Frederick Spitzer, Paris. Holy Family, 2 angels, small roundel.	404	
1897	Emile Gavet, Paris. Holy Family, roundel.	200	
1899	Charles Stein, Paris. Ditto.	364	
1903	Mme Lelong, Paris. Giovanni della Robbia, Eve tempting Adam, full colours.	960	
1909	Lord Amherst of Hackney. C. Statue of St Lawrence.	399	
	von Lanna, Prague. Holy Family and figures, roundel, Andrea della Robbia.	750	
	Descent from the Cross, 4 figures, blue-and-white, rectangular panel.	1,050	
1910	Maurice Kann, Paris. Virgin adoring Child, oblong relief.	1,232	
	Tympanum, coat of arms supported by cherubim.	1,840	
1911	Casella. C. Pomona, white glazed statue, 30in.	577	
1912	J. E. Taylor. C. 2 plaques, 14in × 20in. 2 for	651	
1913	F. von Lippmann, Berlin. Holy Family, roundel.	655	
	Andrea della Robbia, c. 1500, Leda and the Swan, bought by Staedel Institut, Frankfurt.	1,300	
1914	Société Seligman, Paris. Christ on the Mount of Olives, high-relief panel.	1,244	
1916	Arthur Sambon, Paris. Andrea della Robbia, Virgin adoring the Child.	615	
1918	Stefano Bardini, New York. White glazed relief by Andrea della Robbia.	2,388	
1919	Simon, Berlin. Madonna and Child, half-length statue in the round, white, glazed and part gilded, by Luca della Robbia, and among his masterpieces (bought by Detroit Museum).	7,750	
	A 2nd Madonna and Child in white relief.	2,550	

£

1921	Heilbronner, Paris. Large Madonna and Child by a late follower.	3,255
	Round relief, Allegory of Prudence.	2,325
	High relief, Virgin enthroned.	1,550
1922	William Newall. C. Virgin and Child, 26½in× 19½in, Luca della Robbia.	1,365
	Humphrey Cook. C. Roundel, Holy Family.	105
1925	C. 2 busts, 32in high.	152 5s
1926	Carmichael. S. Coat of arms and supporter figures, 3ft high.	490
	C. 2 figures in the round of boys carrying birds. 2 for	966
1929	Brauer. C. Madonna and Child, arched panel in blue-and-white.	1,990
1930	Vieweg, Berlin. Lunette by Andrea della Robbia, The Archangel Michael holding the Scales (see 1960).	4,400
	Kneeling Virgin, unglazed figure.	735
	S. 2 standing figures of angels, 24in, Giovanni della Robbia. 2 for	520
	Holy Family, white relief on blue, 45in× 32in.	350
	Breitmeyer. C. Holy Family, relief, arched top, 5ft 8in × 3ft 10in.	735
1931	Ruskin relics. S. Virgin adoring child, arched top, 4ft high.	780
1932	Count Oriola, Amsterdam. Plain relief, Virgin adoring Child, original work of Andrea della Robbia.	1,350
	Andrea della Robbia, white glazed statue of John the Evangelist.	1,100
1934	S. Coloured glaze shrine, numerous figures.	1,140
	Roundel, Holy Family, blue-and-white.	410
1935	De Zoete. S. Virgin and Child, statuette, blue-and-white.	145
	Late school piece, relief, Holy Family.	64
1942	Edmund Davis, Chilham Castle. C. Virgin and Child, arcade relief, full colours, bought for Barber Institute, Birmingham.	420
	S. Blue-and-white plaque, Virgin, Child and Dove.	200
1945	C. Arched panel, Holy Family and Cherubs.	304 10s
	Henry Harris. S. 2 angels, white glaze, 28in high. 2 for	360
	S. Holy Family, large roundel.	460
1960	Myron C. Taylor, New York. Archangel Michael holding the Scales, large relief, by the master hand of Andrea della Robbia (see 1930).	14,280
1963	Berwynd, New York. Holy family, arcade-panel, 27½in high, after Andrea della Robbia.	1,072
	S. Seated statuette of St John the Baptist, 17in high, c. 1520.	700

SCULPTURE

FRENCH 18TH-CENTURY

(including some late 17th-century works in Louis XIV style)

£

1741	Earl of Oxford (Cock, auctioneer). François Girardon [1628–1715], bust of Flora, marble.	14 3s 6d
	François Girardon, bust of Matthew Prior.	10 10s

Orders for the King of France, 1749–1757.

1749	Pigalle, Venus and Mercury, marble, life-size.	2 for	960
1750	Laurent Adam, Hunting and Fishing, 2 marble groups in a single block, given by Louis XV to Frederick the Great.		2,080
	Bouchardon, L'Amour, marble (Louvre).		840
	Pigalle, L'Amour.		960
1753	Falconet, France embracing Bust of Louis XV, bronze.		362
1753–7	Pigalle, Tomb of Maréchal de Saxe.	contracted at	3,408
1750	Crozat, Paris. François Girardon, 2 bronze urns in relief, 4ft high.	2 for	126
1755	Duc de Tallard, Paris. Marble statue of Louis XIV as Apollo, by Girardon.		132
1762	Edmé Bouchardon [1698–1762] (decease sale). A collection of numerous modelli in terracotta and plaster.	all for	2 16s
	Fountain modello, wood and wax(?), 2ft high, with equestrian Louis XV.		10s
1765	Carl van Loo, Paris. Falconet, Crucifixion, terracotta.		12
1767	Julienne, Paris. Girardon, 2 bronzes, Proserpine and Rape of Sabines (see 1787).	2 for	40
	Bouchardon, 2 terracottas, Lion-tamer and Bear-tamer.	2 for	26
	Pigalle, Mercury, terracotta, 26in high.		40
	Falconet, Massacre of Innocents, terracotta.		16
	Clodion, 2 6in figures, terracotta.	2 for	10
1768	de Bourg. C. (First French sculpture at Christie's). Bronze gladiator after the antique by Bridan.		35 14s
	4 bronze busts of the Four Quarters of the World (Girardon?).	4 for	35 14s
1770	Lalive de Jully, Paris. Pierre Legros, Marsyas tied to a Tree, marble, 27in.		36
	Pigalle, Sleeping Hercules, marble, 32in high.		56 15s
	Falconet, Cupid drawing his Bow, 24in high.		66
	Falconet, Milo of Croton and the Lion, terracotta group, 22in high.		13 6s
	Pierre Puget [1622–94], original terracotta modelli for the Marly Horses (see 1835).	2 for	10

£

1771 François Boucher, Paris. Clodion, terracotta Vestal after
the antique. 8
1773 Marquis de Chevigné, Paris. Pajou, Pluto restraining
Cerberus, terracotta, 25in. 24
 Pajou, terracotta modello for statue of Henri IV, 12in. 19 5s
1775 Pierre-Jean Mariette, Paris. Bouchardon, Cupid drawing
his Bow, 12in terracotta, mounted on plinth. 36
 Clodion, terracotta relief vase with playing amorini, 9in
high on marble plinth (see 1777). 24
1776 Duc de St Aignan, Paris. Slodtz, the infant Julia, marble
copy after the antique. 120
 Blondel de Gagny, Paris. Jacques Saly [d. 1776], Cupid
testing his Arrows, marble, made for Mme Pompadour. 200
 (According to Mariette, Saly received £6,000 in 1752 for
making a modello for an equestrian statue of the King of
Denmark.)
 Tassart, woman with flowers and a quiver, marble. 128
 Anonymous, 2 busts of Negroes in polychrome marbles.
2 for 100
1777 Randon de Boisset, Paris. Falconet, Cupid drawing his
Bow, marble, 30in high. 200
 Larue, after Boucher, Rout of Silenus, terracotta relief. 36 12s
 Prince de Conti. Clodion, terracotta relief urn, and
another (see 1775, 1789). 2 for 39 2s
1788 John Blackwood. C. François Roubiliac, marble bust of
Handel. 13 2s 6d
 Conte de Luc, Paris. Coustou, Nile and Tiber, 2 28in
bronze figures (see 1780, 1850, 1911). 100
1779 Abbé Terray, Paris. Caffieri jeune, Friendship embracing
Love (see 1856) and Love vanquishing Pan, bronzes, pair,
16in. 2 for 40
1780 Poullain, Paris. Coustou, bronzes, Nile and Tiber (see
1778, 1850, 1911). 2 for 39 12s
 Prault, Paris. Falconet, Friendship, terracotta, 26in high on
plinth. 20
1782 Dubois, Paris. Equestrian bronze statue of Louis XIV by
Girardon, 3ft high. 50 10s
 Bailly de Breteuil, Paris. Clodion, Cleopatra, marble
statue, 22in. 40
 C. "A large bust [bronze] of Dr Franklin, done at Paris,
esteemed a great likeness", presumably by Houdon, bought
by Caleb Whitefoord. 5 15s 6d
1783 Blondel d'Azincourt, Paris. Houdon, Love and Friend-
ship, small double bust in gilt bronze. 12
 Belisard, Paris. After Puget, the Marly Horses, bronze,
20in (see 1809, 1813). 2 for 32 15s
 Duc de Caylus, Paris. Houdon, Diane Chasseresse, terra-
cotta. 14 10s

£

1783 Clodion frères, Paris. Clodion, terracotta single figures,
mostly at 20s to 25s.
Vase with playing children in relief in terracotta (com-
pare 1775, 1777). 2 17s 6d
1784 Conte Merle, Paris. Pigalle, infant with birdcage, bronze
(gilt), 17in. 40
Legère, Paris. Girardon, equestrian Louis XIV in bronze,
39in (with plinth, over 7ft). 120
1787 Comte de Vaudreuil, Paris. Louis XIV bronzes:
Girardon, sleeping child, bronze, 6in × 12in. 9
Girardon, Rape of Proserpine, 40in, bronze (see 1767). 16
Girardon, Neptune riding a Sea-horse, bronze. 21 5s
1788 Count d'Adhemer. C. Pair of bronze boys, each support-
ing 2 lights. 2 for 60 18s
1789 Tronchin, Paris. 2 terracotta urns in relief by Clodion
(see 1775, 1777, 1858). 2 for 39 5s
1791 J. B. Lebrun, Paris. Clodion, 2 Bacchantes, terracotta
group under glass dome. 2 for 20
1792 "Just imported from France." C. Busts of Rousseau and
Voltaire *en biscuit*. 2 for 17 6s 6d
1793 C. Bronze busts of Rousseau and Lafayette on pedestals
(after the execution of Louis XVI, reduced terms). 2 for 1 15s
Citoyen la Reynière, Paris. Girardon, 2 bronze groups,
19in high, Rape of Proserpine and Bacchus and Ariadne
(see 1767, 1787). 2 for 29
1801 Recently consigned from abroad. C. Equestrian bronzes
on marble pedestals:
Louis XIV (see, perhaps, 1782). 63
Louis XV. 95
1802 Lately consigned from Paris. Cupid (marble?), by
Falconet. 42
Musée des Monuments Français. Houdon, marble head of
Voltaire, bought from a dealer. 20
1804 C. Roubiliac, marble bust of Shakespeare, bought-in. 178 10s
Loréz, Paris. Bouchardon, marble bust of his mistress. 11 4s
Falconet, marble baigneuse. 12
1805 Maurin, Paris. Clodion, terracotta group, mother and
child fleeing from a serpent. 6 2s
Thomas Bankes. C. Roubiliac, original terracotta for
Tarquin and Lucretia, "undoubted", bought-in. 105
1806 de St Martin, Paris. Houdon, Le Baiser, group in gilt-
bronze on base of coloured marbles. 12
1807 Nogaret, Paris. Bouchardon, Venus nursing sleeping
Cupid, marble group. 24
Pajou, 2 marble urns in relief. 2 for 12 5s
1808 Choiseul-Praslin, Paris. Houdon, bust (marble?) of
Voltaire. 31
1809 Schwanburg, Paris. The Marly Horses, after Puget,
bronze (see 1783, 1813). 61

£

1809	Guyot, Paris. Houdon, bust of Mirabeau, marble.	14	4s
	de Hoorn, Paris. Clodion, 2 marble bowls supported by groups of the Three Graces in gilt bronze, hand-finished by Clodion.	2 for 40	
1810	Comtesse de Fourcroy, Paris. Pajou, terracotta, little girl attacked by a rooster.		17s 6d
1811	C. Bouchardon, small bronze Cupid.	4	4s
1812	Villers, Paris. Chaudet, the blind Belisarius and his guide, bronze group, 17in.	80	
	Clos, Paris. Houdon, first marble bust of Voltaire, 1778 (see 1825, 1931).	28	
	Thomire, gilt-bronze busts of Voltaire and Rousseau, hand-finished.	2 for 11	
1813	C. Pair of bronze horses on wooden pedestals, based on the Marly Horses bought by 3rd Marquess of Hertford (see 1783, 1809, 1833).	2 for 199	10s
1819	C. Flying bronze Cupid, after Bouchardon.	11 os	6d
	2 bronze infant tritons, "after Boucher".	27 16s	6d
1825	G. Watson Taylor. C. Houdon, marble bust of Voltaire (see 1812, 1931).	69	6s
	Courevoix, bust of Marshal Vauban (removed from the Invalides during the Revolution).	106	1s
1828	Sir J. Pultney, Wanstead House. C. The Tuileries Horses, bronze on marble plinths.	2 for 52	10s
	Lemoyne, Paris. Clodion, 3 terracotta figures, 12in high, on wooden pedestals.	3 for 5	4s
1829	Feuchère, Paris. Bronzes after Girardon and Coyzevox (Louis XIV), Les Renommées (probably cast by Feuchère).	2 for 48	14s
1832	Watson Taylor, Erlstoke Park (Robins). Roubiliac, marble bust of Pope, bought by Sir Robert Peel (see 1900).	73	10s
1833	C. The Marly Horses, bronze, after Puget, Louis XIV (see 1813).	2 for 52	10s
1835	de Ville. C. Puget's alleged terracotta models for the same (see 1770).	2 for 48	6s
	Clodion, Satyr and Bacchante, bronze group (ex King Stanislas).	69	6s
	After Charles Lebrun [1619–90], 4 pearwood reliefs of the battles of Alexander, bought-in.	4 for 210	
1840	de Ville (?) or Roussel. C. A stock of garden bronzes from the confiscated châteaux, imported into England in 1838:		
	2 fountain basins on Cupids and dolphins, 3½ft high, bought by Duke of Sutherland.	2 for 169	1s
	2 sculptured bronze urns from Fontainebleau.	2 for 171	3s
	2 urns, "Cinquecento design", from the Château d'Arnes.	2 for 179	11s
	Fountain from the laiterie at Rambouillet, supported by 3 bronze figures.	152	5s

£

1840	Pair of bronze statues of lions destroying serpents from the park at Neuilly. 2 for	372	15s
	2 bronze groups by Clodion, The Nursing of Pan and Bacchus, bought-in. 2 for	51	10s
	Group of stag attacked by dogs, by Desportes.	59	17s
1841	C. 2 terracotta bas-reliefs by Clodion, Venus and the Graces, Jupiter and Leda, bought-in. 2 for	9	9s
	Faun and Bacchante, two Clodion bronzes, bought-in. 2 for	42	
1842	le Docteur Petit. C. Clodion, Bacchanalian boy in marble, bought-in.	18	17s 6d
	Falconet, marble baigneuse, alleged to be Mme du Barry, bought-in.	30	9s
1845	Paris. Houdon, Diana, signed marble statue (Louvre).	61	12s
1846	James de Ville. C. Bronzes by Clodion (ex Vivant Denon):		
	Satyr and Bacchantes reclining.	14	
	Bacchante and satyr on a rock.	23	2s
	Bacchante, satyr carrying infant.	18	18s
	Brunet-Denon, Paris. Clodion, Triumph of Flora, terracotta relief.	14	16s
1848	Duke of Buckingham, Stowe. C. Roubiliac, marble bust of Matthew Prior.	136	10s
1849	Paris. Clodion, 2 terracotta Bacchantes. 2 for	20	
1850	Debruge Dumenil, Paris. Bust of Marie Antoinette, marble, 7½in.	6	16s
	2 marble baigneuses, 10in, Louis XV. 2 for	23	5s
	Pigalle, bronze bust of a baby, 6in.	2	8s
	General Sir J. Macdonald. C. 2 Louis XIV allegorical bronzes on ormolu plinths, Tiber and Nile (see 1778, 1780, 1911). 2 for	91	7s
1851	Earl of Pembroke. C. 2 marble Bacchantes, 4ft high, Louis XIV, by Coustou, bought by Lord Hertford. 2 for	500	
1852	C. Clodion, marble Bacchante carrying infant, 3ft 6in.	51	9s
1856	Samuel Rogers. C. Roubiliac, the original terracotta, made in the presence of Flaxman's father, for the marble bust of Pope (see 1832, 1900).	143	17s
	Lady of rank. C. Caffieri jeune, 1777, L'Amitié Surpris par l'Amour, bronze table group (see 1779).	24	3s
	Colonel Sibthorp. C. Clodion, terracotta Bacchante.	32	11s
1858	David Falcke. C. Clodion, terracotta relief vase, 14½in (see 1775, 1778, 1789).	75	
	Veron, Paris. Houdon, marble bust, Mme Victoire, aunt of Louis XVI (see 1933).	477	10s
	Houdon, marble bust, Sophie Arnould, bought Wallace (later Murray Scott and Sackville Coll.).	552	
1861	Earl of Pembroke, Paris. Falconet, Fidelity, marble figure, 33½in.	120	

£

1861	Falconet, allegorical figure, marble.	100	
	Falconet, marble busts of Achilles and Minerva. 2 for	108	
1865	Pourtalès, Paris. Clodion, 2 candlestick groups of Bacchantes, bronze.	644	
	Clodion, 2 mounted marble groups, Nessus and Deianeira. 2 for	480	
1867	Paris. F. Masson, marble figure of a girl, dated 1802, nearly 4ft high.	317	
	Paris Exposition Universelle. The Triumph of Montgolfier, 1783, tinted terracotta, exhibited by Beurdeley (Clodion). The price paid, according to Edmond de Goncourt, was £1,000.		
1869	Peter Norton. C. Clodion, terracotta relief, Birth of the Dauphin.	32	0s 6d
1870	Marjoribanks. C. Clodion, Triumph of Amphitrite, terracotta relief.	150	
	San Donato, Paris. 2 Louis XIV bronzes, 62in high without the pedestals, Apotheoses of Juno and Jupiter, bought by Gustave de Rothschild. 2 for	1,680	
	Coyzevox, Louis XIV, Apotheosis of Jupiter, marble.	268	
	Falconet, mounted marble group, Toilet of Venus.	160	
	Falconet, Amour assis, bronze.	320	
1875	Baron Thibon, Paris. Clodion, tinted terracotta group.	564	
1880	San Donato, Florence. François Girardon [d. 1715], Venus Triumphant, bronze.	1,017	
	Clodion, Autumn, terracotta group.	780	
	Pajou, Marie Antoinette and the Dauphin in biscuit.	816	
	Walferdin, Paris. Houdon, bust of Marie Chenier.	760	
1881	Leopold Double, Paris. 2 fountain figures, lead, part gilt, made by Falconet for Mme Pompadour. 2 for	2,040	
	Château de Menars, Paris. Garden sculpture in marble, Louis XV period:		
	Adam l'ainé, Abondance (Waddesdon Manor).	3,040	
	Vinache, Aurora.	2,442	
	Pigalle, 2 marble Medici vases. 2 for	3,800	
	Lemoyne, marble group, Fear of Love.	2,560	
	Bousseau, 3 figures, Cupid, Flora and Zephyr. 3 for	3,680	
1882	Hamilton Palace. C. Houdon, Voltaire in marble, 18in (bought by Anthony de Rothschild).	1,050	
	Diana, life-sized bronze from Versailles.	523	
	Marin, terracotta bust, Mme Elizabeth, 1791 (see 1908).	441	
	Pigalle, bust of Voltaire in bronze.	367	10s
1884	de Ginzbourg, Paris. Houdon, marble bust of Marie Adelaide Servat.	1,760	
1885	Prince de Chimay, Paris. Coustou, 2 children, marble.	820	
	Clodion, Bacchante, terracotta.	228	
	de la Berraudière, Paris. Bronze Farnese Hercules, Louis XIV period.	560	

£

1885 Lemoyne, marble bust of Mme Pompadour (Ferdinand de
Rothschild, now Waddesdon Manor Trust). 656
1886 Château de Langeais, Paris. Lemoyne, bust of a lady,
1712. 1,040
1887 De Salvarte, Paris. Pajou, terracotta female bust, 1785. 320
1888 Devismes, Paris. Pigalle, child with a bird (marble). 784
1889 Secrétan, Paris. Falconet. Triumph of Empress Cather-
ine (marble). 800
 Gautier, 2 small marble figures. 2 for 824
 Clodion, Sacrifice to Love (marble). 440
 Clodion, Bacchante (see 1925). 157
1890 Edward Smith, Paris. 4 terracotta sphinxes, Mme
Parabère as the Four Seasons, c. 1720 (called wrongly the
Four Mistresses of Louis XIV). 4 for 920
D'Armaillé, Paris. Houdon, bust of Lefèvre de Caumartin,
1779, marble. 720
van Lede (style of Clodion), la Source, marble bust. 1,060
1891 Houdon, marble bust of Diana (see 1910), inherited by
Duchesse de Greffulhe. According to E. de Goncourt, the
previous owner had refused an offer of £4,000.
1892 Mme d'Yvon, Paris. Falconet, Pygmalion and Galatea,
marble. 796
1894 Pommereau, Paris. Pajou. Life-sized terracotta bust of a
girl. 364
Josse, Paris. 2 terracotta groups by Clodion. 2 for 1,420
1899 Talleyrand, etc., Paris. Houdon, life-sized marble bust of
Molière. 1,200
 2 small bronze busts, Louis XIV period. 2 for 980
Vaissé, Paris. Marble bust of a little girl, 1767. 828
1900 Moore. C. Clodion, Autumn, terracotta. 780
Morrison. C. Houdon, bronze head of Voltaire. 694 10s
Peel heirlooms. C. Roubiliac, bust of Pope (see 1832). 535 10s
Louvre buys a marble baby's head by Houdon. 800
1901 C. 2 terracotta nymphs by Falconet. 2 for 1,029
1902 Lord Grimthorpe. C. Pigalle, baby girl, terracotta. 3,100
 Clodion, running girl, terracotta. 1,650
1903 Mme Lelong, Paris (see 1923, 1927). Pajou, bust of Mme
Fourcroy, 1789, marble. 4,220
 2 marble groups by Lemoyne, Bacchus and Venus.
2 for 1,180
1904 Mame, Paris. Clodion, Bacchante, terracotta. 1,080
1906 Kotchoubey, Paris. Pigalle, Juno, small bronze, 1772. 880
Louvre buys 2 terracotta busts by Houdon of his wife and
the baby Sabina. 2 for 2,000
1907 Muhlbacher, Paris. Clodion, nymph and satyr, terracotta
group. 1,962
Massey-Mainwaring. C. Pigalle, 2 bronze babies. 2 for 1,365
C. Clodion, 2 terracottas, nymphs and satyrs, 1798. 2 for 1,050

£

1908	Quilter. C. Marin, Mme Elizabeth, terracotta (see 1882).	2,730
1909	Felix Doisteau, Paris. Pajou, marble bust of "un parlementaire".	1,200
	Terracotta bust of J. F. Duas.	1,604
1910	Yerkes, New York. Houdon, Diana, marble, bought by Duveen (see 1891).	10,200
	Louvre purchases:	
	Coyzevox, marble bust, Antoine Coypel.	3,000
	Lemoyne, terracotta bust, Nicolas Coypel.	3,000
	Pigalle, little girl with a bird, marble.	2,000
	Octavus Coope. C. Bronze bust of Molière.	3,150
1911	Lowengard, Paris. Tiber and Nile, Louis XIV bronzes (see 1778, 1780, 1850). 2 for	1,960
	Decourcelle, Paris. Clodion, terracotta, Leda and the Swan (see 1924).	1,346
	Houdon, the baby Sabina, plaster.	889
	Houdon, Jean Jacques Rousseau, terracotta.	1,100
	Houdon, Claudine Houdon, plaster bust (for others, see 1912, 1922, 1925).	2,110
	Pajou, Mme du Barry, terracotta.	8,710
	Paris. Unsigned marble group, Rape of Europa.	2,156
1912	Jacques Doucet, Paris. Clodion, 2 stucco caryatids.	3,400
	L'Ivresse du baiser, terracotta (£184 in 1883).	8,910
	L'Ivresse du vin, terracotta.	4,400
	2 women supporting globe, terracotta.	5,480
	Innocence, terracotta.	5,200
	Houdon, magistrate, marble bust.	3,080
	Houdon, the baby Sabina Houdon at ten months, marble bust (see 1928), bought by Duveen; in 1912 the highest price ever paid at an auction for a work of sculpture.	19,800
	Houdon, Claudine Houdon, plaster bust (others, 1911, 1922, 1925).	2,900
	Coustou, Le Rhone, patined bronze.	2,000
	Delarue, 2 terracotta urns, Summer and Winter. 2 for	3,764
	Lemoyne, terracotta bust, Robbe de Beauveset (£112 in 1896).	2,680
	Lemoyne, Marèchâle de Saxe, terracotta bust (£112 in 1886).	2,720
	Theophile Roland, bust of M. le Roy, terracotta.	2,800
	Vasse, marble bust of a child.	3,004
	J. Marin, bronze bust of Richelieu.	5,208
	Pajou, terracotta bust of P. J. Laurent.	1,840
	Unsigned lead vase, Triumph of Galatea.	1,600
	J. E. Taylor. C. Falconet, baigneuse, rose terracotta (see 1938).	3,150
	The Louvre buys:	
	Caffieri, marble bust of Helvetius.	6,500
	Houdon, marble bust of Malesherbes.	6,500
	Caffieri, marble monument to Mme Favard.	4,400

£

1913	Murray-Scott. C. Falconet, Cupide menacant, bronze, 35in.	7,350
	Metropolitan Museum values 2 Houdon marbles, *ex* Pierpont Morgan, The Bought Kiss and The Given Kiss. 2 for	20,650
1914	Perrin-Houdon, Paris. Houdon, self-portrait, terracotta bust.	1,544
	Marquise de Biron, Paris. Lemoyne, Maréchal de Lowendal, terracotta bust.	1,617
1917	Levy, Paris. Lemoyne, marble bust, Mme Adelaide, 1768.	2,200
	Terracotta bust of girl by Pajou.	1,870
	4 plaster relief figures by Falconet.	2,200
1918	Paris. Houdon, marble bust of the Comte de Guibert,	
.	1791.	6,380
1920	Alfred Beurdeley, Paris. Clodion, nymph and satyr, terracotta, 1762 (50 fr. to the £1).	2,992
1921	Gaston le Breton, Paris. Caffieri *jeune*, idealized bust of Molière, terracotta, dated 1785 (138,600 fr.).	2,550
1922	Paris. Houdon, bust of the infant Claudine Houdon in tinted plaster (for others, see 1911, 1912, 1925).	705
1923	William Salomon, New York. Pajou, marble bust of Mme Fourcroy, dated 1744 (see 1903, 1928).	9,880
	Lord Wimborne. C. Bouchardon, Cupid bending His Bow, bought-in (see 1938).	3,750
1924	Beuret, Paris. Clodion, terracotta, Leda and the Swan (see 1911, £1,346).	455
1925	Lehmann, Paris. Clodion, Bacchante, terracotta (see 1889).	1,350
	Guillaume, Paris. Coustou, Venus à la Pomme, marble.	1,915
	Boulland, Paris. Houdon, Plaster bust of Claudine Houdon (see 1911, 1912, 1922).	1,072
1926	Late Lord Michelham (Hampton's). Bronze nymph by Falconet.	5,040
	S. Roubiliac, self-portrait, marble bust.	620
1927	Joseph Bardac, Paris. Pajou, marble bust of a lady.	1,420
1928	Salomon, New York. Pajou, Mme Fourcroy (see 1903, 1923).	5,750
	Elbert Gary, New York. Houdon, the baby Sabina, marble (see 1912), bought by Knoedler, and sold to Edward Harkness, Duveen underbidding.	50,650
	Falconet, Toilet of Venus, marble.	6,800
	Venus whipping Cupid, marble 18½in.	5,350
1929	Private sale through Duveen to Andrew Mellon (*ex* G. Locker-Lampson). Houdon, marble bust of Washington (National Gallery, Washington).	52,500
1930	Comtesse de Sabran, New York. Terracotta group by Houdon.	1,785
	Comtesse de la Berraudière, New York. Marble bust of the Comtesse de Sabran by Houdon, 1785, 28in.	16,000
1931	USSR Government sale, Berlin (Stroganoff). Houdon, marble bust of Diderot.	2,150

£

1931	Falconet, L'Amour, marble, 3ft high.	3,080
	Houdon, marble bust of Voltaire, 1778 (see 1812).	1,260
1933	Stathatos. S. Houdon, marble bust of Mme Adelaide (see 1858), bought-in.	2,400
	T. F. Ryan, New York. Houdon, marble bust, Fillette inconnue.	1,600
1934	Leopold Hirsch. C. Falconet, 2 marble statuettes, Spring and Autumn. 2 for	1,050
	S. Signed marble statuette of a vestal by Houdon.	430
1938	Durlacher. C. Ascribed Falconet, baigneuse, 17½in, terracotta (£3,150 at the Taylor sale, 1912).	241 10s
	S. Lemoyne, Snr, marble bust of Jean-Jacques Rousseau.	235
	Mortimer Schiff. C. J. C. Marin, Maternity, 14in terracotta group.	997 10s
	S. Bouchardon. Cupid bending His Bow, bought by Paul Getty (see 1923).	3,885
1941	Mrs Henry Walters, New York. Clodion, nymph and satyr, terracotta.	3,150
	Falconet, Venus, marble.	2,750
	Houdon, marble bust, Voltaire.	3,000
1948	V & A buys marble bust of Voltaire by Houdon, 20in, 1781.	4,000
1949	Sir Bernard Eckstein. C. Terracotta bust by Houdon of Sabina Houdon at the age of 4 (£430 in 1937).	620
	Falconet, Mercury, 32in marble.	300
1953	S. 2 8in marble busts of Voltaire and Rousseau by Rosset, 1769–70.	{340
		{420
	Paris. Seated marble figure of Voltaire in a gown, by Houdon, 52in high.	1,820
1954	Paris. Clodion, signed, terracotta, La Source, 10½in high.	1,950
1955	Paris. Clodion, terracotta group, The Bacchantes, 2ft high, specially magnificent.	7,550
1957	Jacob Hirsch, Lucerne. Houdon, marble bust of Dorothea von Rodde.	2,720
1959	Thelma Chrysler Foy, New York. Clodion, nymph and satyr, tinted terracotta on drum.	4,120
	S. 2 terracotta groups by Joseph Marin. 2 for	4,400
	V & A buys bronze bust of Perronnet by Pigalle.	2,400
1962	Lady Bailey. S. 2 marble sphinxes, c. 1760, English wooden stands. 2 for	950
	S. Lemoyne, bronze bust of Louis XV, 1750.	1,000

SCULPTURE

Late 18th and Early 19th centuries

		£		
1807	C. Mantelpiece by Righetti, Rome, 1795.	420		
	Atalanta, modern Roman bronze from antique.	141	3s	6d
1810	Moitte, Paris. Napoleon, equestrian bronze by Moitte, 19in high without pedestal.	40		
	Marquess of Lansdowne. Thomas Bankes, bust of Warren Hastings.	111	6s	
	Bust of Pope Clement VII by Canova.	83		
1811	Canova makes an enormous marble group of Hercules and Lichas for Prince Torlonia.	3,600		
1815	Marquess of Lansdowne buys Canova's Sleeping Nymph, marble (see 1930).	525		
1816	Canova resells to the Duke of Wellington a life-sized nude marble figure of Napoleon.	2,625		
1823	C. Canova, colossal head of Napoleon, bronze.	52	10s	
	Farquhar, Fonthill (*ex* Beckford), Philips. Carbonneaux, full-sized bronze replica of the Laocoon, made in 1814 for £2,000 (see 1848, 1882).	735		
1830	Sir Thomas Lawrence, R.A., C. Flaxman, busts of Raphael and Leonardo, modelled in plaster. 2 for	74	11s	
	E. H. Bailey, bust of Fuseli.	53	11s	
1931	Sir F. Baker. C. Canova, Venus, original marble on painted pedestal.	120	15s	
1833	C. E. H. Bailey, life-size group, maternal affection.	210		
1840	Prince Louis Bonaparte. C. Canova, bust of Napoleon, marble, dated 1804, scagliola pedestal.	232	1s	
1843	Aguado, Paris. Gottfried Schadow, Sleeping Nymph, 1801.	184		
	Canova, Magdalen, life-size marble.	2,380		
	C. Sleeping Nymph, marble, by Gott.	131	5s	
	Chantrey, bronze bust of Horne Tooke, bought-in.	131	5s	
	Chantrey, bronze bust of Nollekens.	85	1s	
	Canova, The Amorini, marble group made for Lord Cawdor.	304	10s	
1844	Jeremiah Harman. C. Flaxman, marble bust of Homer.	94	10s	
1845	Sir Charles Bagot. C. Marble bust of Napoleon as 1st Consul, partly by Canova.	59	17s	
	Paris. Canova, small marble group, Cupid and Psyche.	48		
1847	Mrs Russell. C. Nollekens, Venus pouring Ambrosia on Her Hair, marble, whole length.	267	15s	

£

1848	Duke of Buckingham, Stowe. C. Canova's Pauline Bonaparte.	74	11s
	Carbonneaux's Laocoon (see 1823, 1882).	567	
1851	Earl of Pembroke. C. J. Gott, greyhound and puppies, marble.	141	5s
	Viscount Middleton. C. J. Gott, Bacchante dancing, marble.	199	10s
1852	Earl of Liverpool. C. Canova, Reclining Magdalen, marble, bought-in.	250	
1854	A nobleman. C. Robert Wyatt, marble group, Ino and Bacchus.	378	
	Tadolini, 2 statuettes. each	215	5s
1856	Samuel Rogers. C. Flaxman, marble statuette of Cupid.	115	
	Psyche, pair to the above.	194	5s
	Thomas Emerson. C. Flaxman, chimney-piece with busts, made for Cosway, bought-in.	312	
1857	Mrs Huskisson. C. Robert Wyatt, reclining nymph with kid, life-sized marble.	230	
1861	Late Robert Wyatt. C. Wyatt's statue, The Nymph stepping into the Bath, life-size, marble.	325	10s
1862	Contents of Flaxman's studio. C. Flaxman, terracotta models for figures of Raphael and Michelangelo. 2 for	16	5s 6d
	Marble chimney-piece designed for his own house.	53	11s
1863	Earl Canning. C. Robert Wyatt, full-sized marble nymph.	567	
1864	John Watkins Brett. C. Flaxman, self-portrait, terracotta modelled roundel, dated with Latin inscription, 1788.	161	14s
1865	Earl of Cadogan. C. J. Gott, youth holding a greyhound, marble.	178	10s
1866	Samuel Boddington. C. Small marble statuettes by Thorwaldsen:		
	Mercury.	81	
	Shepherd and dog.	68	
	Thomas Delarue. C. Hyram Power (creator of "the Greek slave"), marble bust, Proserpine.	170	2s
1867	Lady Webster. C. Canova, marble bust of Venus.	158	11s
1869	Lord Howard de Walden. C. Chantrey, marble bust of Canning.	189	
1881	Lady Harriet Hamilton. C. Canova, marble statuette, Venus with the Apple.	105	
1882	Hamilton Palace. C. Thorwaldsen, marble bust of Napoleon.	640	10s
	Carbonneaux, bronze replica of the Laocoon (see 1823, 1848).	504	
1890	Walter Long. C. John Gibson, The Tinted Venus, 1854 (see 1916, 1929).	1,837	10s
1894	C. A Canova Venus sold for	157	
1898	Succession Talleyrand, Paris. Talleyrand in marble, by Bosio.	1,604	

		£	
1898	Canova, pedestal in relief and bust of Paris.	480	
	Canova, bust of Napoleon, marble.	147	
1916	Thomas Barratt. C. John Gibson, The Tinted Venus (see 1890, 1929).	630	
1917	Hope heirlooms. C. Danish Government buys Thorwaldsen's Jason.	2,730	
	Canova, Venus, full-size, marble.	1,155	
1918	C. Canova, marble Venus.	409	10s
1920	S. Thorwaldsen, Ganymede, life-size, marble.	775	
1923	S. Canova, marble bust of Napoleon.	68	
1928	At Godstone (Foster's). Chantrey, bust of James Watt, 1841.	120	15s
1929	S. John Gibson, The Tinted Venus, life-size 2nd version (see 1890, 1916).	165	
1930	Marquess of Lansdowne. C. Canova, Sleeping Nymph (see 1815), bought by V & A.	630	
1932	C. Thorwaldsen, Venus Triumphant, life-size.	357	
	Thorwaldsen, Day and Night, 2 small reliefs.	267	15s
	Thorwaldsen, Cupid and 3 Graces, large relief.	294	
	Thorwaldsen, life-size statue, The Angel of Baptism.	52	10s
1937	Earl of Lonsdale. C. (at Clumber). Franzoni, full-length Napoleon as a Roman emperor, 1806.	220	
	Westmacott, Euphrosyne, life-size.	115	
1949	S. Thorwaldsen. 3 Graces listening to the Song of Cupid, marble relief, 17in × 12in.	400	
1954	Paris. Canova, bust of Lucien Bonaparte, marble, 20in.	230	
1961	S. Thorwaldsen. Ganymede and the Eagle, 1817.	1,150	
1962	Bought for the V & A through subscribers, Canova, Theseus and the Minotaur, marble.	3,000	

SCULPTURE

MODERN

(i.e. not more than a hundred years old)

£

1913	J. B. Carpeaux, executors, Paris. Contents of Carpeaux's studio:	
	La Danse, terracotta (see 1957).	10,100
	Ugolino terracotta.	3,960
	La Genie de Danse, stucco model.	2,040
	The 3 Graces, trial bronze.	1,984
	63 lots of sculpture sold for £32,800, or about £200,000 in today's money.	
	George MacCulloch. C. Rodin, bronze figure, The Kiss.	3,045
1914	Antoine Roux, Paris. Rodin sculpture:	
	La Femme à la Fleur, stone.	1,452
	L'Homme au Serpent, bronze.	1,424
	Original stucco model for the same.	1,104
	L'Idylle, bronze.	788
1918	Paris. Rodin, Le Sommeil, marble.	1,617
1920	Alfred Beurdeley, Paris. Carpeaux, 2 marble busts, Spring and Autumn. each	858
1921	Chantrey Bequest buys an Epstein bronze bust.	200
1924	Leclanché, Paris. Rodin, Eve, marble.	650
	Raffaelli, Paris. Rodin, Luxury and Avarice, bronze.	335
1932	S. Epstein bronze busts:	
	Mrs MacEvoy, 1910.	135
	Lydia, 1931.	100
1933	T. F. Ryan, New York. Rodin marble bust (1910), Napoleon dreaming.	1,440
1934	Chantrey Bequest buys Epstein's self-portrait in bronze.	525
1938	C. 4 Epstein bronzes for £317 2s, including Chaim Weizmann.	84
	In the following month, bust of Meum and a child's head sold as 1 lot. 2 for	60 18s
1940	Eumorfopoulos. S. Bronze Epstein head, Betty May.	34
1948	S. Epstein, bronze head of Bernard Shaw (see 1963).	300
1954	Paris. Renoir, Judgement of Paris, original tinted plaster, 36in × 30in.	1,150
	Stuttgart. Matisse, Nu couché, bronze.	600
1957	Weinberg, New York. Picasso, Head of a Man, bronze (so described).	1,050

£

1957	Daumier, 6 small bronze figurines, about 7in. 6 for	2,400
	Degas, La Masseuse, bronze.	1,245
	Ballet dancer, 4th position, bronze, 16in.	1,900
	Georges Lurcy, New York. Carpeaux, La Danse, 1874, terracotta, 32in high (see 1913, when it made £10,100).	1,250
1958	S. Jacob Epstein, Genesis, marble statue, 64in.	4,200
	Henry Moore, Reclining Figure, 6½in high.	700
	Parke-Bernet, New York. Rodin bronzes:	
	Man with a Broken Nose.	1,160
	Death of Adonis.	1,070
1959	S. Henry Moore. Seated Girl, stone, 18in.	2,800
	Paris. Picasso, bronze head of a woman.	2,550
1960	Parke-Bernet, New York. Brancusi, The Blonde Negress, polished bronze, 15½in high.	14,270
	Museum for Modern Art benefit sale. Maillol, La Jeunesse, bronze.	5,380
	Henry Moore, Reclining Nude, bronze, 28in.	3,380
	Henry Moore, Mother and Child, stone, 34in.	2,400
	Lempertz, Cologne. Rodin, bronze head of Balsac.	1,550
	S. Daumier, Ratapoil, 17¼in bronze.	1,900
	S. Epstein, lead model for the Llandaff Christ.	800
	Epstein, bronze bust, Morna.	800
	C. Epstein, bronze bust, Sholem Asch.	819
	S. Rodin, Romeo and Juliet, marble.	5,500
	Theodore Ahrenburg. S. Matisse bronzes: 49 bronzes were sold for £109,600.	
	Seated Nude.	11,000
	Nude figure.	8,000
	Les Deux Negresses.	5,200
	Gladys Lloyd Robinson, New York. Brancusi, 2 penguins, marble.	11,602
	Epstein, bronze head, Kathleen.	1,250
	S. Henry Moore, reclining female figure, stone.	5,775
	Henry Moore, mother and child, bronze, 1956.	1,500
1961	S. Degas, horse in bronze.	4,000
	Gauguin, painted wooden head.	11,500
	Pierre Brache. S. Brancusi, bronze, 1914.	8,000
	Juvilier, New York. Henry Moore, reclining figure, stone.	6,430
	The Louvre buys Daumier's Les Emigrés, model for a huge bas-relief in plaster.	10,200
	S. Bronze bust of Bernard Shaw by Rodin.	1,350
1962	S. Henry Moore, bronze seated high-relief figure, 1957.	2,200
	Henry Moore, torso in African wood.	1,400
	Henry Moore, 2 seated women and a child, bronze.	2,700
	Epstein, bronze head of Field-Marshal Smuts.	1,100
	Henry Moore, bronze seated figure, 1957.	2,050
	Giacometti, bronze head.	2,500

		£
1962	Giacometti, plaster project.	2,400
	Manzu, ebony female, over life-size.	2,800
	C. Lehmbruch, terracotta female bust.	3,675
1963	S. Epstein, bronze head of Bernard Shaw (see 1948).	1,000
	Henry Moore, girl seated against a square wall, bronze, 1958.	2,800

SILVER

16th and 17th centuries

£

1771 C. A clockwork silver figure of Diana hunting round a table, by Wenzel Jamnitzer of Nuremberg (see 1880). 24 13s 6d

1772 Thomas Morgan, "chinaman." C. (*ex* Braamcamp of Amsterdam). Engraved nautilus shell in a very elaborate sculptural mount, said to have belonged to the first Stadtholder of the Netherlands. 5 5s

1775 Princess Augusta of Baden-Baden. Sale at Offenburg. Silver-gilt ewer, "15th century", with portraits enamelled in black. 53 6s

 "Le widrecome des Favoris", a huge tankard in 8 detachable sections, each with the arms of Bohemian noble houses. 24 8s

1776 Nathaniel St André. C. 4 mounted nautilus shells. 3 11s–4 10s

1780 C. Engraved nautilus shell, parcel-gilt mount. 1 8s

1791 Lord James Manners. C. Nautilus shell, engraved and mounted. 1 14s

1802 Sir Robert Cotton. C. 12 engraved silver dishes, The Labours of Hercules, said to have belonged to Charles I, "in the early manner of the German school" (actually by Peter Maes, Cologne, 1567) (see 1858, 1947), bought-in.
 12 for 9 6s

1814 "Recaptured from the French army in Spain." C. "Noble chalice of silver-gilt elaborately engraved and chased." 38 17s

1816 Duke of Norfolk. C. German 17th-cent. heavily chased tankard and lid with several mythological subjects (bought by Kensington Lewis, cost 150 guineas). 57 10s

1818–22 Beckford buys 2 parcel-gilt Columbine cups, Nuremburg, 1580 (for one of them, see 1882). 2 for 210

1819 M. Sevestre, jeweller. C. Standing cup and cover "in the taste of Holbein", The Judgement of Paris. 56 14s

 Silver tankard, enamelled panels, dated 1533. 22 19s 4d

1823 Farquhar, Fonthill (*ex* Beckford). Nautilus-shell standing cup with enamelled jewel of Neptune riding a dolphin (see 1848). 63

 Pair of 15th-cent. parcel-gilt salvers, German. { 59 9s
 { 49 19s

£

1823 12 embossed Dutch silver dishes depicting the labours of Hercules, said to have belonged to Charles I (*not* the Cotton dishes; see 1802, 1858). 12 for 126

1825 G. Watson Taylor. C. Tankard, chased with battle scene, men in armour. 39 17s 6d

Lady of fashion. C. Tankard in the style of Rubens, nymphs, satyrs, etc., 76oz (probably Augsburg, late 17th cent.). 95

1827 Late Duke of York. C. Sideboard dish, Roman triumph in the style of Jordaens, 130oz 15dwt at 21s an ounce. 163 5s 6d

Pair of pitchers and covers, "*Cinquecento* taste", about 58oz each 50 1s 10d

Pair of tazze, subjects in compartments on termini "in *Cinquecento* taste" (Augsburg or Nuremburg), late 16th cent., 49oz 10dwt at 26s an ounce. 2 for 63 9s

Chalice and cover, 23in, 56oz 10dwt. 2 for 73 9s

1829 Lord Gwydyr. C. "Ancient baronial salt-cellar", cover surmounted with a warrior, 14oz 15dwt. 15 12s 10d

1831 Ball Hughes. C. German chased tankard, very elaborate. 45 18s

1834 Thomas Hamlet (Robins). 12 engraved parcel-gilt tazze containing solid silver statuettes of the Caesars, called Cellini but in fact late 16th-cent. Augsburg work (see 1861, 1893, 1914, 1922, 1935, 1945). 12 for 1,050

1842 C. Silver-gilt tazza, 3 figures supporting stem, probably German, but ascribed to Cellini, bought-in. 19 19s

Rundle, Bridge and Rundell. C. Mounted nautilus shell, handle formed of Neptune on a sea-horse, the stem set with precious stones. 59

Waldegrave, Strawberry Hill (*ex* Walpole) (Robins). Nautilus shell mounted with enamels and statue. 37 15s

Anne Boleyn's silver clock, largely remounted, bought by Queen Victoria. 110 5s

12 Dutch repoussé dishes by van de Pass, depicting mythological scenes, 1610. 12 for 116 11s

Clement VII's silver bell, attributed to Cellini. 252

1843 Late Duke of Sussex. C. German 16th-cent. chased silver tankard and cover, Triumph of Silenus, 69oz at 15s an ounce. 52 6s 2d

Statuette of a musketeer, 21oz at 76s an ounce. 80 4s 4d

2 tazze, Scriptural subjects in compartments in "*Cinquecento* taste". 34 6s 2d

Baronial salt in 2 compartments, with attached spoons, 11oz 13dwt at 156s an ounce. 42 10s 8d

Another larger salt in "*Primaticciesque* taste", 19oz 17dwt at 156s an ounce (silver-gilt). 150 18s 7d

Chased tankard and cover, Bacchanalian subjects, with infant Bacchus surmounting lid (see 1853), 49oz at 28s an ounce. 88 9s

£

		£		
1843	Statuette of a pedlar with his pack and dog (probably the figure by Hiller of Breslau, sold in 1961, *q.v.*).	65	14s	
	Pine-shaped chalice with enamelled Cupid on the cover.	36	14s	
	Parcel-gilt claret-pitcher and cover with satyr-mask and caryatid handle.	194	3s	3d
	Chalice with figures in relief and Latin inscription 1612.	156	15s	
	Pearl nautilus shell, mounted on a triton, surmounted with figure of Amphitrite (*ex* Marchioness of Downshire).	74	11s	
	Another nautilus, mounted with sea-god masks.	87		
	Statuette of St George and Dragon, 33oz at 58s an ounce.	95	14s	
	Peg-tankard on ball feet, embossed and chased.	89	18s	6d
	Tankard with Triumph of Neptune, high relief (see 1853).	106	1s	
1848	Duke of Buckingham, Stowe. C. Augsburg pineapple cup and cover, 25oz 3dwt at 29s an ounce.	36	9s	4d
	Chalice and cover, apparently 16th cent., 71oz at 28s an ounce.	99	8s	
	Chased ewer and dish, ascribed to Viani (Vianen of Utrecht, early 17th cent.?), 81oz 15dwt at 57s an ounce. 2 for	232	19s	9d
	Pair of elaborately mounted nautilus shells, 196oz at 17s 4d an ounce. 2 for	69	17s	4d
1850	Debruge Dumenil, Paris. Heavily chased Augsburg tank-and lid, *c.* 1550, with busts and arms of Electors.	18		
	Nautilus cup mounted with baroque pearls, late 17th cent.	15		
	James Stewart. C. Nuremberg tankard, arabesque chasing.	33	14s	6d
	General Sir J. Macdonald. C. Pair of nautilus shells, elaborately mounted as a single standing cup.	24	3s	
	Set of 6 silver-gilt statuettes representing the senses, called Fiammingo style (probably Augsburg, late 16th or 17th cent.). 6 for	244	18s	
1851	The Coronation nef of Henri III, 1575, silver, with some of the figures enamelled on gold, bought back by the Chapter of Rheims Cathedral.	40		
1853	C. 2 Augsburg chased tankards (*ex* Duke of Sussex sale, 1843, *q.v.*), 250oz, bought-in. 2 for	135	4s	6d
1854	Samuel Woodburn. C. Oblong salver, chased with story of Vertumnus and Pomona, alleged to have belonged to Mary Queen of Scots.	51		
	Large chased silver plaque, Christ healing the sick (probably German 16th cent., but called early Florentine).	69	6s	
1855	Ralph Bernal. C. Parcel-gilt chased tankard, described as Italian, mid-16th cent., bought by Henry Hope.	131		
	Mounted nautilus shell, 1606.	15		
	Tazza, The Judgement of Solomon, by Adam van Vianen of Utrecht, *c.* 1600 (V & A).	45	10s	
	Nuremberg standing cup and cover, inscribed "Werli von Berenfels", 1541 (see 1875).	45		

£

1855 2 nefs, Augsburg, 1662. 2 for 42
Augsburg tankard, elaborately chased, bought by James
de Rothschild. 41
Several other standing cups and salts, 15in to 21in high,
made from £30 to £40 each.

1857 Vernon Utterson. C. Part-enamelled, chased silver
tankard, described as Venetian and the property of Henry
VIII. 167

1858 David Falcke. C. Cut-glass tankard in elaborate German
mount, called Italian, 6½ in (ex Colonel Sibthorp. 102 18s
Pineapple cup, ascribed to Jamnitzer. 51
V & A buys an Augsburg nautilus cup with statue of
Neptune, dated 1580. 40
Earl of Denbigh. C. 12 chased dishes, silver-gilt borders,
The Labours of Hercules, inherited from Sir John Cotton
(see 1802, 1947), bought-in. 12 for 500

1860 Messrs. Loewenstein of Frankfurt. C. Standing cup in
the form of Atlas supporting a globe, 24in high, said to have
been described by Goethe, probably Nuremberg. 370
Louis Fould, Paris. Nuremberg tankard, parcel-gilt
heavily modelled with solid statuette. 96

1861 Charles Scarisbrick. C. 12 tazze with statues of the
Caesars, attributed to Cellini (see 1834, 1893, etc.). 12 for 1,280
Pair of étagéres, attributed to Cellini. 2 for 173
Prince Soltykoff, Paris. Parcel-gilt cup and cover,
Augsburg, c. 1600, signed HDG, supported on 3 figures of
savages (V & A). 122
Augsburg covered cup, parcel-gilt and enamels, arms of
Swiss cities, c. 1540, a record price for a piece of Renais-
sance silver in 1861. 440

1863 V & A buys Augsburg tankard, 20in high, heavily chased. 138
C. Oval alms dish, chased Scriptural subjects in borders
(Dutch, c. 1600?), 170oz at 29s 6d an ounce. 91 13s 5d
Countess Ashburnham. C. Triangular salt, 12in high,
very elaborately mounted on figures and monsters, once
ascribed to Cellini. 79 16s

1865 Earl of Cadogan. C. Pair of tazze with 2 handles, chased
with allegorical figures (Nuremberg?), 13in high, 210oz at
26s an ounce. 2 for 273 15s 7d

1866 C. 2 terrestrial globe cups and lids supported by figures ⎰64 10s
of Atlas. S. German, mid-16th cent. ⎱37 10s
W. Curling. C. Tankard chased with Triumph of
Neptune (see 1843, 1853). 90 5s

1870 Colonel Grant. C. Pair of parcel-gilt pineapple cups
with wedding dates, 1579, 1593, 1632, about 50oz at 86s 1d
an ounce. 2 for 215 5s
Wigram. C. Peg-tankard with pomegranate feet,
armorial, 33oz at 51s 6d an ounce. 85 19s 3d

£

		£	
1870	San Donato, Paris. Oval dish with battle scene, Augsburg, *c.* 1640, heavily chased.	188	
	Tall nautilus cup, Augsburg, bought by Spitzer.	784	
	Augsburg cup and cover, 33in high, *c.* 1580.	194	
	Augsburg ewer, *c.* 1630, heavily chased.	228	
	Dutch chased oval dish, 17in, by van Vianen, *c.* 1600, with Scriptural subjects.	124	12s
1871	John Rainey. C. Triangular salt borne by solid figures, Amsterdam mark, early 17th cent., 28oz 12dwt at about 150s an ounce.	204	15s
1872	V & A purchases:		
	Columbine cup, stem formed of statues of the gods, attributed to Wenzel Jamnitzer.	150	
	Pineapple cup and cover, presented to the Augsburg Weavers' Guild, *c.* 1520.	85	
	Augsburg parcel-gilt goblet.	130	
1875	Sir George Dasent. C. Standing cup and cover, Augsburg, 1541, inscribed "Werli von Berenfels" (see 1855).	300	
1880	San Donato, Florence. Diana at the Hunt. Mechanical group of figures by Wenzel Jamnitzer, bought by Meyer Rothschild (see 1771).	2,280	
	The Jamnitzer Table Centre. The Merkel family of Nuremberg sell to Meyer Charles Rothschild of Frankfurt a standing cup by Wenzel Jamnitzer, *c.* 1550, parcel-gilt with 2 kinds of enamels, supported by a figure called Earth on a base covered with insects and reptiles (*Chronique des Arts*, December, 1880). Inherited by Henri de Rothschild, 1895.	32,000	
1882	Hamilton Palace. C. Parcel-gilt bottle in form of a cock crowing, Augsburg, 1601.	99	15s
	Oval rose-water dish, *c.* 1550.	787	10s
	Ewer *en suite*.	493	10s
	One of the 2 "Columbine covered cups" from Fonthill (see 1818–23), inscribed "Georgen Roemer" (bought for Baron Charles de Rothschild).	3,244	10s
	17th-cent. Augsburg cup and cover.	740	5s
1886	Eugène Felix, Leipzig. Mounted nautilus shell.	480	
	Elaborate Augsburg standing cup with figure of a warrior, *c.* 1550.	684	
	Big Augsburg covered tankard, chased.	208	
	Late 15th-cent. chalice with engraved Passion of Christ.	800	
1888	Marquess of Exeter. C. Dutch parcel-gilt salver, mythological figures, high relief, early 17th cent.	1,207	10s
1892	Hollingworth Magniac. C. Inscribed Augsburg chalice, 1574.	294	
1893	Frederick Spitzer, Paris. 6 of the "12 Caesars" tazze, Augsburg, late 16th cent. (see 1834, 1861, 1898, 1914, 1922, 1935, 1945) (V & A). 6 for	2,770	
	Columbine cup and cover, late 16th cent.	860	

		£	
1893	Parcel-gilt ewer and basin, Augsburg.	652	
	Fantastic 2-tiered salt, French(?), *c.* 1550.	804	
	Chased Augsburg tankard, part enamelled (see 1910).	360	
1896	Fitzroy. C. Urn and cover, Jacob Frohlich, Augsburg, 1555.	760	
1898	Wencke, Hamburg. 1 of the "12 Caesars" tazze (see 1834, 1861, 1893, 1914, 1922, 1935, 1945).	480	
1903	Thewalt, Cologne. Augsburg 16th-cent. hanap with masques.	860	
	Standing cup (Cologne Museum).	602	10s
	Hanap with lid (Cologne Museum).	402	1s
1904	Bourgeois Brothers, Cologne. Parcel-gilt tankard in form of a bear, by David Kramer, Nuremberg, before 1550.	444	
1905	von Pannwitz, Munich. Owl-shaped Augsburg goblet.	308	
	Standing cup and cover, Augsburg.	490	
	Richly-chased ewer, Heinrich Straub, Nuremberg, 1600.	1,025	
	Vase in shape of leaping stag, part enamelled.	825	
1907	Massey Mainwaring. C. Nautilus shell, 16th-cent. Augsburg mount.	441	
1908	Marchioness of Conyngham. C. Augsburg sculptural group, Diana hunting, *c.* 1630.	1,312	10s
1909	von Lanna, Prague. Breslau ewer (pewter), highly elaborate, dated 1574.	1,650	
1910	Octavus Coope. C. Mounted nautilus shell, Augsburg.	480	
	2 Apostle spoons, *c.* 1500.	1,050	
	Waller. C. Cup by Eberlein Kossman, Nuremberg, 1575.	640	
	Maurice Kann, Paris. Augsburg tankard, part enamelled (see 1893).	840	
	Another Augsburg tankard, parcel-gilt.	1,164	
1911	Carl Meyer Rothschild of Frankfurt (deceased), Paris. Augsburg silver (89 lots):		
	Ewer, 16th cent., part gilt.	1,920	
	Parcel-gilt hanap with lid, part enamelled.	3,600	
	Parcel-gilt porringer and cover on feet, Luebeck.	2,200	
	Ewer and platter, part gilt.	2,680	
	Bocale double, by Gaspar Beutmuller, Nuremberg.	1,484	
	Bocale double, by Hans Petzolt, Nuremberg.	4,600	
	Dutch Corporation tankard, *c.* 1600.	1,400	
	Ditto, Hanau, after 1600.	2,284	
	Fountain, Nuremberg, Jeremias Ritter.	3,240	
	Bowl, supported on an elephant, Nuremberg, 17th cent.	1,580	
	Dutch 17th-cent. Corporation standing cup.	1,800	
1912	von Parpart, Berlin. Chased dish by Abraham Gessner of Zürich, late 16th cent., The Massacre of the Niobids.	1,250	
1914	Earl of Ashburnham. C. Reappearance of one of the "12 Caesars" dishes, or tazze, formerly attributed to Cellini, The Life of Titus (see 1834, 1861, 1893, 1898, 1922, 1935, 1945).	680	

£

1919	Thomas-Peter. C. The Drake Cup, Abraham Gessner, Zürich, 1571 (see 1942).	3,800
	E. D. Malcolm. C. A Strassburg nef, early 17th cent., 20in.	3,300
	Earl of Home. C. Tankard by Moringer of Augsburg, 1550.	900
	2nd Hamilton Palace sale. C. The Mary Queen of Scots Casket, French, early 16th cent., bought-in.	2,835
	Standing cup, 18½in high, with reliefs illustrating silver-making, by Hans Petzolt of Nuremberg, late 16th cent., bought-in.	2,415
	(Both now on loan to Edinburgh Museum.)	
	Montague-Thorold. C. 2 French tazze, 1598 (see 1934). 2 for	3,570
1922	S. The Titus Dish, so-called Cellini (see 1834, 1861, 1893, 1898, 1914, 1935, 1945).	456
1923	Rosenheim. S. The Fugger Cup, Augsburg, 1527.	580
	2 altar cruets, Luebeck, 1518. 2 for	680
1927	Sir George Holford. C. Standing salt by Christof Ritter of Nuremberg, with enamelled Crucifixion, 1577.	3,200
1930	Foxcroft. S. Nautilus shell, sumptuous Augsburg mounts and enamels, c. 1580.	1,500
1931	Duke of Hamilton. C. 6 parcel-gilt cups by Hopherr of Ulm, dated 1548. 6 for	240
	Augsburg beaker and cover, c. 1520, formed as a St Sebastian tied to a tree.	400
	Early 16th-cent. tankard, embossed with masks.	400
	Elaborate standing cup and cover, Luebeck, 1554.	220
1934	Edward Philips. C. 2 French tazze, 1598 (see 1919). 2 for	1,470
	S. Richly-chased tankard, Augsburg, 1607.	999 12s
1935	S. The Ashburnham "Cellini" Titus dish, Augsburg, late 16th cent. (see 1834, 1861, 1893, 1898, 1914, 1922, 1945).	280
1936	C. Elaborate Augsburg tankard, c. 1550.	110
	Several good quality 17th-cent. tankards at under £50 each.	
1937	Ivar Kamke. Parcel-gilt statuette of a steinbock by Laubermann of Augsburg, c. 1620.	420
	Parcel-gilt figure of a bear, nearly 1ft long, by Melchior Bayer, 1625.	400
	About 28 fair examples of 16th- and 17th-cent. work made from £60 to £140 each.	
	Victor Rothschild. C. Terrestrial-globe standing cups:	
	By Gessner of Zürich.	2,700
	By Christof Jamnitzer, Nuremberg.	2,900
	Crystal and gilt double cup, Strasbourg.	2,000
	Many other German 16th-cent. pieces exceeding £1,000.	
	C. Lord Rochdale. Covered tankard, 1597.	1,950
	S. The Airthrey Cup, late 16th-cent. terrestrial globe.	
	After the sale it was attacked by von Falcke.	1,700

£

1940 Anthony de Rothschild. S. Augsburg rose-water ewer
and dish by Christof Lenker, 1590, 99oz. 245
 17th-cent. Augsburg statuettes of a stag and a unicorn. {76
 {68

1942 Charles MacKann, New York. Several 17th-cent. German
pieces at £50 to £70.
 G. A. Lockett. C. The Drake Cup (see 1919), bought by
Plymouth Gallery. 2,100
 2 other globe cups, not Zürich, but Nuremberg (Andreas
Bergmann, 1620). 2 for 980

1945 S. 1 of the "12 Caesars" tazze, Life of Titus, Nuremberg,
late 16th cent. (see also 1834, 1861, 1893, 1898, 1914, 1922,
1935). 230

1946 Lionel de Rothschild. S. Pair of terrestrial-globe cups by
Johannes Pulter, Nuremberg, 1622. 2,600

1947 Late J. Pierpont Morgan, New York (see 1802, 1853). 12
parcel-gilt engraved dishes, Labours of Hercules, by Pieter
Maes of Cologne, c. 1570. 12 for 7,750
 Rose-water ewer and dish by Pieter Maes, Old Testament
scenes. 2 for 4,375

1951 W. Randolph Hearst, New York. The von Hohenstein
Cup, inlaid with classical gold coins, Nuremberg, 1526. 2,140
 Standing cup attributed to Cellini, formerly Earl of
Warwick and Pierpont Morgan Colls. 3,750
 Lempertz, Cologne. Nautilus shell, mount by Jorg Ruel,
c. 1600. 362

1952 C. Parcel-gilt rose-water ewer and dish, heavily chased,
Amsterdam, 1624, by Adriaen van Vianen. 2 for 1,550

1956 C. 2 heavily chased and pictured tazze, Delft, 1604 and
1606, 42oz 17dwt.). 2 for 2,600
 Duke of Buccleuch. S. Augsburg rose-water ewer and
dish by Hans Ment, c. 1580. 2 for 2,900

1957 S. Augsburg standing cup, 1573, crystal columns. 2,500

1959 Marquess of Exeter. S. French nef, 1505 (bought for
V & A). 8,500
 Augsburg cup and cover, c. 1550, 17in, 75oz. 2,300
 Dreeseman, Amsterdam. 2 elaborate salts by van Vianen,
1620. 2 for 9,700
 2 chandeliers, 1663, 14in high, 66oz. 3 for 3,400

1960 Rutschi, Berne. Columbine cup by Hans Petzolt. 735
 Spik, Berlin. Nuremberg parcel-gilt Columbine cup, very
elaborate. 420

1961 Statuette of a pedlar with his pack and dog, by Hiller of
Breslau, c. 1575 (see 1843). 1,150

1962 S. Augsburg circular table clock, story of Orpheus and
Eurydice chased on the drum, c. 1585. 5,200
 Sir Andrew Noble. C. Rose-water ewer and dish,
Augsburg, c. 1560, 1080oz. 4,000

		£
1962	Statuette, leaping stag, Biermann the Elder, Basel, 1640, 23oz 15dwt.	1,550
	S. Norwegian peg-tankard by Albertszenn of Bergen, 1625, engraved with animal figures.	2,100

SILVER

ENGLISH, 16TH AND 17TH CENTURIES

(before 1660)

£

1816 Duke of Norfolk. C. Pair of snuffers with inscription
of reign of Edward VI [1547–53]. 2 for 35 14s
 Pair of parcel-gilt one-handled cups and salvers, chased
with marine deities and nymphs, probably rose-water
ewers and basins, date not ascertainable; they were said
to have cost 100 guineas each. 55 13s

1827 Late Duke of York. C. Oak tankard with silver liner
and medal of Young Pretender, the tankard dated 1536. 47 5s
 Charles II tankard with inlaid medals, 55oz. 57 15s

1838 Zachary. C. 3 Apostle spoons, early 16th cent. 17 15s

1842 Waldegrave, Strawberry Hill (ex Walpole). Elizabethan
standing salt with statuette of Mercury. 33 12s
 English Apostle spoons, early 16th cent. 2 2s– 3 13s 6d

1843 Late Duke of Sussex. C. Turnover drinking cup in the
shape of a bell-skirted Elizabethan lady. 10 18s 2d
 2 sideboard dishes with the crown and cypher of Charles
I, adapted as candelabra, 267oz. 2 for 123 7s 5d
 Pair of square candlesticks, crown and cypher of Charles
I, 40oz at 44s an ounce. 2 for 88
 Elizabethan standing salt, "The gift to the city for ever,
Thomas Varham". 100 0s 3d
 (See also English Silver, 1660–1820.)

1855 Bernal. C. The Blacksmith's Cup with English inscrip-
tion, 1625 (see 1911). 37 10s
 (See also Mounted Coconuts and Stoneware Jugs.)

1858 David Falcke. C. Set of 12 Apostle spoons, year-mark
1592. Presented by the City of London to Sir Robert
Tichbourne, 1657. This was the first time that a year-
mark was catalogued (compare 1838 and 1842). 12 for 430

1859 V & A buys cup and cover, 18½in, dated 1611, hunting
scenes engraved. 260

1860 Sir George Staunton. C. Set of 12 Apostle spoons,
called 15th cent., bought-in. 43

1861 C. 4 Scottish pledging cups which had belonged to
James VI of Scotland, late 16th cent., at 15s an ounce.
4 for 77 16s 2d

1869 Lord Willoughby de Eresby. C. Shell-shaped casket,
dated 1570. 130

£

1869	Pair of salts, strapwork relief, dated 1606, 37oz at 56s an ounce.	2 for	103	12s
	Pair of beakers, ditto.	2 for	116 18s	2d
1870	V & A buys mace of the Corporation of Chichester, 1620.		35	
1875	Sir George Webbe Dasent. C. 4 16th-cent. salts from Serjeants' Inn.	4 for	195	
	The Bacon Salt, 1553.		200	
	3 parcel-gilt spice-boxes, 1599.	3 for	200	
	The Norwich Steeple-cup, 1625.		390	
	Henry VIII parcel-gilt bowl, no mark.		220	
	Rose-water ewer, 1609.		330	
	Apostle spoons.	each about	12	
1884	V & A buys 2 salt-cellars, 6in high, by Matthew of Exeter, 1560–80.	2 for	125	
1886	V & A buys standing salt, 18½in, London, 1586–7, and 3 salt-castors, 4½in to 6in, 1563, 1566, 1577.	4 for	2,100	
1889	Ashford. C. Tankard, London, 1579, 8in.		370	
1893	C. Steeple-cup and cover, James I (see 1938).		366	
1894	Cozier. C. The Londesborough Standing Salt, c. 1570.		630	
1895	Lyne Stephens. C. Tazza, London, 1565.		300	
1901	Lord Dormer. C. Standing salt, London, 1595.		1,380	
	Sir Henry Lennard. C. Tazza, parcel-gilt, London, 1577.		737	10s
1902	C. The Farriers' Cup, London, 1586.		1,270	
	Dunn Gardner. C. The Great Seal of Ireland Cup, 1604 (see 1960).		4,200	
	Parcel-gilt cup, 1521 (see 1924).		4,100	
	Another, plain, hallmarked 1525.		880	
	Inscribed spoon, 1488 (see 1943), highest priced English spoon for more than 40 years.		690	
	C. The Stonyhurst Standing Salt (see 1943, 1957).		2,000	
1903	C. Set of 13 spoons, London, dated 1536.	13 for	4,900	
1904	C. The Chancellor Bacon Cup, made of the Great Seal of England, 1574, 11½in.		2,500	
	Crystal ewer (Fatimid?) mounted as a standing cup, Edinburgh, 1567 (see 1924).		1,000	
	Seal-Hayne. C. Commonwealth standing cup and cover, 1653, 18½in.		1,052	5s
1905	Louis Huth. C. Rose-water ewer and dish, heavy relief, London, dated 1607.	2 for	4,050	
	C. 2 rose-water flagons, 1597 (see 1939).		3,500	
1906	C. Elizabethan cup and cover, formed as a gourd, 1598.		870	
	Corporation of Boston. C. 2 tazze, London, 1582, arms of Boston (bought for Boston Museum, USA).	2 for	2,900	
	Standing salt, 1600, arms of Boston.		1,520	
1907	At Robinson, Fisher's. Parcel-gilt tankard and cover, London, 1599.		2,300	
1908	Marchioness of Conyngham. C. Rose-water ewer and dish, James I (see 1930).	2 for	4,200	

£

1910	C. London standing cup, 1578.	2,350
	2 Apostle spoons, c. 1500. 2 for	1,050
1911	Joseph Dixon. C. The Blacksmiths' Cup, 1625 (see 1855, £37 10s).	4,100
	Mrs Cator. C. The Armada Service, 22 dishes and plates, 480oz, various late 16th-cent. English marks, arms of Sir Christopher Harris. 22 for	11,500
1912	J. E. Taylor. C. Silver-gilt tazza of 1564, London.	1,450
	Ditto, dated 1565.	1,200
	Elizabethan fruit-basket (see 1950).	700
	London tankard, 1582.	1,850
1913	Plomer-Ward. C. The Merchant Taylors' Cup and Cover, 1620 (bought by Christ's College, Cambridge).	4,500
	Ewer and dish, 1627. 2 for	1,650
1914	Chandos-Pole. C. 2 Elizabethan ewers, 1597. 2 for	2,750
1923	C. Steeple-cup and cover, marked HC, London, 1610.	2,000
1924	Swaythling heirlooms. C. The Leathersellers' Bowl, with the oldest London hallmark, c. 1500, bought-in at £9,500, but subsequently acquired for the V & A by subscribers for	10,000
	The Rodney Cup and Cover, late 15th cent.	7,600
	London tankard, dated 1556.	6,000
	The Erskine Ewer, rock crystal mounted in parcel-gilt, Edinburgh, 1564 (see 1904).	6,000
	Silver-gilt cup, dated 1520 (see 1902).	3,800
	Ewer and dish, 1583.	2,800
	Ditto, 1610.	2,991 5s
	London marked tankards, 1618 and 1591.	{1,900 / 2,400}
	London marked Jacobean salts (steeple cups), 1656 and 1626.	{1,350 / 1,450}
	Irish 15th-cent. chalice.	1,200
	(See also Ostrich Eggs and Ming Porcelain.) 134 lots, £82,000.	
	John Holme. C. Silver-gilt cup, 1521 (see 1902).	3,800
1925	V & A buys the Vyvyan Salt.	3,500
1928	Dunraven heirlooms. C. Standing salt by IFG, London, 1589, 12in.	2,047 10s
1930	George Wilbraham. C. Gourd-shaped cup and cover, 1585, 12in (see 1960).	3,275 5s
	S. Steeple-cup and cover, F.W., 1619, 19in (ex Lord Montagu of Beaulieu).	3,300
	C. Bell-shaped salt and cover, 1586, arms of Chorley.	1,600
	Sir John Ramsden. C. Tazza by Henry Sutton, 1573, 5in × 6½in.	1,710
	Lord Delamere. C. Rose-water dish, 19in, 1599, enamelled centre.	5,800
	Lord Glentanar. C. Rose-water ewer and dish by F. Terry, 1618 (see 1908, 1938). 2 for	3,200

£

1931 Duke of Norfolk. C. The Howard Grace Cup, English, early 16th cent., incorporating an ivory bowl and enamel chasse, bought by Lord Wakefield and given to the V & A. 11,000
At Hurcomb's Rooms. Rose-water ewer and dish, 1602, bought-in. 4,000
Adrian Bethell. C. Scallop-shell-shaped spice-box, 1598. 1,114

1932 C. Standing salt on solid figures, 1585. 714 17s 6d
S. The Lennard Bowl (David Foundation), Ming blue-and-white porcelain in mount predating 1569. 1,100

1933 C. London parcel-gilt chalice and pattern, 1535, weighing only 5½oz. 1,100

1934 Lord Mount Temple. C. Rose-water ewer and dish, 1615. 2,450
1935 H. D. Ellis. S. Edward VI spoon, 1550. 205
Sir Arthur Evans. S. Other 15th- and early 16th-cent. spoons at £215 and £260 (dated 1507).
C. Tazza, 1552, 5½in high. 1,020

1936 S. Inscribed London tazza, 1560. 890
Maidenhead spoon, London, 1485. 225

1937 Duke of St Albans (Puttick's). Spoon by Nicolas Bartholomew, 1550. 240
Lord Rochdale. C. Tankard and cover, 1587. 1,950

1938 Thomas Taylor. C. James I steeple cup and cover (£366 in 1893). 1,985 15s
3 parcel-gilt wine-cups, c. 1610 (£225 in 1899). 3 for 876 10s
William Randolph Hearst. C. James I rose-water ewer and dish, dated 1618 (see 1908, 1930). 2 for 1,950
Porringer and cover, 1655 (£1,511 in 1930). 1,000
(See Mazers and Horns.)

1939 Randolph Hearst sale, New York. 2 rose-water flagons, 1597 (see 1905). 2 for 1,473
1941 Mrs Sydney Loder. S. Steeple cup and cover, 1604. 1,000
Lord Rothermere. C. (December, the first sale at which silver at Christie's was not sold by the ounce.) Ewer and cover by Peter Petersen of Norwich 1570, unique domed shape. 2 for 1,200
Mrs How. S. Spice-box with scallop-shell cover, 1610 (see 1962). 600

1942 George Lockett. C. Covered cup, 1590 (see 1960). 1,080
2 plain tankards, 1636 and 1632. {530, 620}

1943 Sir Andrew Noble. S. The Stonyhurst Salt (see 1902, 1957), bought-in. 2,800
The Sutton Cup, 1573 (see 1949). 2,000
Colonel Ratcliff. S. Apostle spoon, 1481, highest price since 1901. 1,400

1945 Marquess of Downshire. C. Porringer, 1660. 1,300
R. W. M. Walker. S. Standing salt, 7¾in, with rock-crystal container, 1549. 5,700
Flagon, 1594. 3,100

£

1945	Tankard by Isaac Sutton, 1578.	3,300
	Cup and cover, 1640.	2,200
	Bell-shaped salt-cellar, domed cover, 1586.	1,950
	6 other pieces at over £1,000 each.	
1946	Lord Swaythling. C. 12 Apostle spoons, 1524–53. 12 for	3,400
	Cup and cover, 1619 (see 1924).	1,600
	Captain Frederick Montague. S. 6 fruit-dishes, engraved with Scriptural subjects in the style of Adriaen Collaert, London hallmark, 1573, bought for V & A. 6 for	7,000
	S. Standing salt, 1581.	2,300
1947	Prince Duleep Singh. S. Henry VIII chalice and patten (see 1924), bought for V & A. 2 for	2,500
	Late J. Pierpont Morgan, New York. Set of 12 Apostle spoons, 1617. 12 for	3,875
	Rose-water dish and ewer, 1604. 2 for	2,500
	2 wine goblets, 1582, arms of Boston. 2 for	2,120
1949	Sir Bernard Eckstein. S. The Butleigh Salt, 1606, shaped like a fountain (1946, £4,800).	4,400
	S. The Sutton Cup (see 1943).	2,400
1950	C. Fruit-basket, 1597, base restored (see 1919).	1,250
1953	C. The Arlington Tazza, 1532, 27oz, arms of Chichester of Arlington.	5,800
1955	C. Hour-glass salt, 6½in high, year-letter 1516, 16oz 3dwt.	3,500
1956	Rowland Winn. C. Dish, re-chased in England from plate captured at Nieuport, 1600.	3,400
	S. The Byron "Magdalen" Cup, early 16th cent.	4,100
1957	S. 15in dish, dated 1616, silver-gilt, 41oz 10dwt.	3,400
	Dr Wilfrid Harris. C. Henry VIII spoon with finial figure of St James the Less.	1,350
	English spoon, alleged year-letter for 1463.	1,600
	Sir John Noble. S. The Stonyhurst Salt (see 1943), with rock-crystal cylinder and mounted stones.	4,500
	The Hutton Cup, dedicated by Queen Elizabeth in 1592.	8,000
1959	C. Early 15th-cent. marked English spoon with gauntlet finial (auction record for a silver spoon).	1,800
1960	C. Spoon with mace finial, dated 1514, London.	1,050
	S. Spice-box in shape of a scallop shell, 1599.	3,900
	Covered cup, dated 1590 (£1,080 in 1942).	6,500
	The Wilbraham Cup, gourd-shaped, dated 1585 (ex Randolph Hearst) (see 1930).	2,700
	English spoon with diamond finial, c. 1350.	1,450
	C. Standing salt, 1600.	3,400
	Lord Harburton, Pilaton Hall. C. Patten and chalice, 1530, bought for V & A. 2 for	5,350
	Marquess of Ely. C. The Great Seal of Ireland Cup, 1593, bought by Belfast City Gallery (see 1902, £4,200).	7,000
1961	Mrs Robert Makower. S. 6-sided cup and cover, 1650, 48oz (£1,750 in 1945).	6,500

£

		£
1961	Tankard by James Plummer of York, 1649 (£529 in 1931).	3,200
	Duke of Leeds. S. 2 London tankards of 1602, 42oz. 2 for	9,200
1962	C. Plain wine-cup, 1639 (Melbourne Gallery).	1,450
	Plain beaker, 1579, 4in.	2,400
	S. Steeple cup and cover, 1613, illustrating a hunt (bought by Leicester Museum).	1,500
	Absolutely plain dish, 18in, London, 1631.	2,800
	Knight, Frank, and Rutley. Spice-box with scallop-shell cover, 1610 (see 1941).	3,000

SILVER

£

1770	Erasmus van Harp. C. Pair of carved and mounted coconuts. 2 for	3
1782	C. Coconut, engraved after sacred history, silver-gilt mount.	2 12s 6d
1843	Late Duke of Sussex. C. Coconut, carved and mounted in *Cinquecento* taste.	5 15s
	Another with subjects "after Dürer".	7
1848	Duke of Buckingham, Stowe. C. Standing cup, ostrich egg.	10 10s
1850	Debruge Dumenil, Paris. Standing cup, coconut.	8
1851	C. Ostrich egg in elaborate 14in mount, many solid human figures.	10 2s 6d
1855	Bernal. C. Coconut cup, 1561, silver and enamels.	19
	Coconut cup, Elizabethan, very elaborate.	10 15s
	Coconut cup, carved with story of Judith and Holofernes (bought by Lord Londesborough).	30
	Coconut cup, dated 1585, signed A.B. (V & A).	46 10s
	Coconut cup, mount believed to be Italian, *c.* 1500 (V & A).	40
	3 others at less than £20 each.	
1858	David Falcke. C. Coconut cup, 11in, 1628, called Italian.	67
	V & A buys coconut cup in English mount, 1576.	80
1865	V & A buys carved coconut, Flemish mount, *c.* 1600.	50
1882	Hamilton Palace. C. 2 mounted ostrich-egg cups and covers. 2 for	64 1s
1886	Eugène Felix, Leipzig. Elaborate coconut standing cup, Augsburg.	318
1893	Spitzer, Paris. Coconut standing cup, Augsburg, 16th cent.	144
	Ditto, *c.* 1590.	147
	Several others at £100 and under.	
	Ostrich egg, late Gothic Nuremburg mounts, *c.* 1520.	122
1894	Cozier. C. The Bath Coconut Cup, Elizabethan.	252
1902	Dunn-Gardner. C. Coconut standing cup, London, 1615.	950
1903	Thewalt, Cologne. Augsburg standing cup, coconut.	405
	C. Coconut, London mount, 1586.	245
1905	C. Coconut, London mount, 1574.	800

£

1910	Octavus Coope. C. Coconut, Augsburg 16th-cent. mount.	380
1912	C. Coconut, mount dated 1590, London.	700
1919	C. Coconut, very elaborate Augsburg mount, 16th cent.	1,800
1924	Swaythling heirlooms. C. Ostrich egg mounted as standing cup, London, *c.* 1570 (see 1951).	5,700
1933	C. Coconut, late 15th-cent. Augsburg mount, 12in.	310
1936	C. Coconut, mounted by Ritter of Nuremberg, *c.* 1560.	122
1937	Victor Rothschild. C. Ostrich-egg cup by Geier of Leipzig.	2,900
	Carved coconut, London mount, 1577.	200
1943	Custodian of Enemy Property. S. Painted ostrich egg as standing cup by Geier of Leipzig, 1590.	820
1951	Randolph Hearst, New York. Ostrich-egg standing salt (see 1924).	4,240
1959	Earl of Ducie. C. Ostrich-egg standing cup, 1584.	4,400
1960	C. Gourd mounted as an Elizabethan standing cup.	2,700

SILVER

Unless otherwise stated, the jugs are of Rhineland stoneware and the parcel-gilt mounts English.

£

1843	Late Duke of Sussex. C. An "old Delph" tankard with Apostles in relief and lamb-and-flag device (surely Raeren or Cologne), dated 1635, chased lid.	15 4s 6d
1855	Bernal. C. Jug dated and inscribed 1570, with relief of Hercules and Cerberus on the lid (V & A).	30
	4 others at £10 to £22.	
1865	Earl of Cadogan. C. 2 Brown wine-bottles, mounted with chains, etc. (see 1869). 2 for	25 10s
1866	Countess of Clare. C. Brown jug, mounted with masks, shields, fruits and flowers, monogram and date 1586 on handle.	124 10s
	W. G. Morland. C. Brown jug, London mount by Easton, 1599.	57
1869	V & A purchases 2 stoneware sack-bottles, elaborate English mounts, late 17th cent. (see 1865). 2 for	150
1870	C. Brown jug, undated, Elizabethan mount.	13 10s
1875	Sir G. W. Dasent. C. Undated, tigerware jug in English mount.	54 14s
1881	V & A buys tigerware jug, mounted 1580.	80
1889	Stainyforth. C. Tigerware jug, very rich undated Elizabethan mount.	178
	Ditto, mount dated 1584.	215
	English purple tin-glaze tankard (the Malling Jug), mount dated 1549 (V & A).	105
1892	Hollingworth Magniac. C. Fluted and polished jug resembling agate, London mount dated 1572–3 (see 1913).	567
1903	C. So-called Malling Jug in several mottled colours, mount dated 1581.	1,522 10s
	Tigerware jug, mount dated 1577.	360
1905	Louis Huth. C. Tigerware jug, undated mount.	660
	C. Tigerware jug, dated 1588.	350
1912	J. E. Taylor. C. 5 tigerware jugs, mounts of different dates (see 1940) (made £1,535 in all). dearest	460
1913	Malcolm of Poltalloch. C. Fluted so-called Malling Jug dated 1572 (see 1892).	1,995
1924	C. Tigerware jug, Barnstaple mark, 1575.	75
1930	Wilbraham. C. Arms of Wilbraham and date 1566 on an ordinary tigerware jug.	600

£

1933 C. Aubergine coloured jug, probably English, mount marked E.S., 1610. 220

1934 Powell and Powell, Bath. Cologne jug, London mount, 1556. 230

 C. Tigerware jug, London mark, 1568. 140

1935 Ernest Innes. C. Tigerware jug, mounted 1577. 215

 Rare double-handled Cologne or Raeren flagon, mount by Nicolas Sutton, 1565. 205

1936 C. Tigerware jug, mounted 1557. 500

1937 Airthrey. S. Tigerware jug, Barnstaple mark, 1570. 300

1939 W. Randolph Hearst, S. Tigerware jug, mounted 1580 (see Taylor sale, 1912). 215

1940 Sir W. Hicking. C. 3 tigerware jugs, mounted 1566, 1570, 1582. 3 for 238

1943 Colonel Ratcliffe. S. 3 tigerware jugs, mounted by W.C., 1576. 3 for 255

1951 W. Randolph Hearst, New York. Tall 3-handled jug, richly mounted 1581. 425

1954 English brown-glazed tankard, Malling type, mounted c. 1560, bought for Fitzwilliam Museum. 250

1962 S (ex Andrew Noble). Raeren brown ewer with clenched-fist spout, English mount unmarked, but late 16th cent. 650

SILVER

MOUNTED WOODEN MAZERS AND HUNTING HORNS, MOSTLY 15TH OR EARLY 16TH CENTURY

		£
1855	Bernal. C. "Early British" cow's horn, carved and mounted.	15
1856	Colonel Sibthorp. C. Wooden bowl, mounted with arms of James I, date 1610.	42 10s
1858	V & A buys a maplewood mazer with English 15th-cent. mount.	6
1861	Soltykoff, Paris. Mazer, German mount, 1492.	46
1866	V & A buys mazer with French late 15th-cent. mount.	33 12s
1875	Sir George Dasent. C. Mazer, 15th-cent. Irish mount.	87
1893	Spitzer, Paris. Drinking horn, German, 15th-cent. Gothic mount.	164
	Drinking horn, early 16th-cent. Augsburg mount.	92
1905	C. Mazer, early 16th-cent., lightly mounted.	500
1908	Braikenridge. C. Mazer, "Master Toukers", mounted 1534.	2,450
1914	Chandos-Pole. C. Mazer, dated 1527, enamelled centre boss (see 1942).	400
1924	Swaythling heirlooms. C. London mazer of 1510.	580
	Scottish mazer, late 15th cent.	580
1927	At Hurcombs' Rooms. Scottish mazer, 15th cent. mount, early mediaeval lid, bought-in.	10,000
1928	At Hurcombs' Rooms. Mazer, allegedly dated 1501.	800
1929	S. The Saffron Walden Mazer, 1507.	2,900
1930	S. The Fergusson Scottish Mazer, 1516 (see 1938).	6,000
1934	Viscount Halifax. S. The Temple Newsam Mazer, mounted c. 1470 (see 1938).	850
1935	D. E. Ellis. S. The Pewsey Horn (see 1938).	1,900
1936	S. The Robert Drane Mazer, c. 1500.	620
	Drinking horn, Norwegian mount, 1628.	125
1938	William Randolph Hearst. C. Fergusson Mazer (see 1930).	1,100
	Gifford Mazer.	350
	Temple Newsam Mazer (see 1934).	500
	Robert Drane Mazer (£620 in 1936).	290
	The Pewsey Horn, bought by V & A.	1,900
1942	G. A. Lockett. C. Mazer, mounted 1527, with enamelled boss (see 1914).	270
	S. Watson Mazer, c. 1550, partly remounted.	460

£

1951 C. Mazer, *c.* 1490. 370

 Ditto, with Gothic inscription on silver rim. 420

1954 S. Galloway Mazer, mounts by Gray of Canongate, 1569. 11,000

1956 S. English drinking-horn, part-painted, mounts dated 1560. 1,000

1963 Morgan, New York. English maplewood mazer, early 15th cent., Latin inscription, diam. 4¾ in (£200 in 1904). 800

£

			£		

1788 Count d'Adhemer. C. Pair of oval tureens, covers and
stands (French?) at 12s an ounce. 2 for 426 19s 10d
 Another pair of the same size, at 11s 6d an ounce. 2 for 394 6s 10d
1802 Countess of Holderness. C. 2 tureens, stands and covers
(French?) 338oz at 9s 6d an ounce, brought over from
Holland in 1795. 2 for 160 10s 8d
1814 A former Ambassador to Paris. C. Pair of ice-pails at
9s an ounce. 2 for 129 15s 3d
1816 Duke of Norfolk. Pair of chased ice-pails with dolphin
handles, 348oz at 15s 6d an ounce. 2 for 278 8s
 Candelabrum, 6 branches, supported by 2 female figures,
 359oz (cost, £300). 127
 Tureen and plateau, 427oz, the tureen on lamb supports
 with richly modelled cover, probably French. 252
1817 William Beckford. C. Jewel-casket by Auguste after
Moitte, with sleeping figure of Morpheus on the lid, 230oz,
bought by Marquess of Hertford. 157 10s
 2 candelabra by Auguste after Moitte, each 160oz, may ⎰120 15s
 have been made for Beckford in 1802. ⎱116 11s
1823 Farquhar, Fonthill (*ex* Beckford) (Philips). By Auguste,
Paris, dated 1802, 17s 6d an ounce:
 Pair of ewers. 2 for 178 12s 6d
 Pair of 2-handled tazze. ⎰115 16s
 ⎱121 19s
1827 Late Duke of York. C. Chased oval dish, 21in, Dutch,
The Triumphs of William III, 105oz. 84
1828 Michael Nolan. C. 2 tureens and covers made for Duke
of York by Auguste, probably after 1800, 237oz and 260oz ⎰58 14s
at 4s 6d an ounce. ⎱57 19s 5d
1840 C. Salver and ewer with medals of emperors and bishops,
by Ignatius de Wecks, Osnabruck, 1729, 210oz at 14s an
ounce. 135
1841 Duchess of Canizzaro. C. Salver, chased with Sacrifice
of Iphigeneia and arms of the Medicis, bought-in. 241 10s
1843 Late Duke of Sussex. C. Tureen in form of a rigged ship,
supported on dolphins, arms of Prussia, 209oz at 6s 8d an
ounce. 69 16s 8d
1847 Robert Vernon. C. Tankard, heavy-relief marine deities,
top and foot gilded. 42 7s 6d

£

1848　Lord Reay. C. Tankard, Bacchanalian subjects after
　　　Rubens, 72oz.　　　　　　　　　　　　　　　　　　51　6s
　　　Duke of Buckingham, Stowe. C. Pair of heavily chased
　　　tankards, Alexander's battles, after Lebrun (*ex* Duke of
　　　York) (see 1861), early 18th cent., 140oz at 16s and 142oz　{112
　　　at 20s an ounce.　　　　　　　　　　　　　　　　　　{142　5s
　　　　2 stoops on rococo stands in the style of Roettiers, silver-
　　　gilt, 311oz 5dwt at 40s an ounce, bought for Lord Hert-
　　　ford.　　　　　　　　　　　　　　　　2 for　　622　10s
　　　　Pair of statuary flower-stands, one probably French, late
　　　18th cent., the other a copy, sold to Lord Hertford,
　　　120oz 3dwt at 57s an ounce.　　　　　2 for　　342　8s
1860　Lowenstein Bros. of Frankfurt. C. Coronation cabinet
　　　casket of the Emperor Charles VI, a fantastic silver and
　　　jewelled construction by Dinglinger, early 18th cent.,
　　　bought-in.　　　　　　　　　　　　　　　　　120
1861　Charles Scarisbrick. C. 2 French or Flemish chased
　　　tankards, early 18th cent., battle scenes after Charles　{132
　　　Lebrun (*ex* Stowe sale, see 1848).　　　　　　　{140
　　　　C. Helmet-shaped ewer with rose-water dish, dated 1698,
　　　17s 6d an ounce.　　　　　　　　　　2 for　112　2s 6d
1880　San Donato, Florence. Chased tureen, Paris mark, 1720,
　　　huge and elaborate.　　　　　　　　　　　　1,600
　　　　Ewer by Thomas Germain, *c*. 1770.　　　　　1,440
　　　　Chocolate ewer, ditto.　　　　　　　　　　440
1882　Hamilton Palace. C. Chased oval dish, Roettiers style,
　　　arms of Cardinal York, *c*. 1750.　　　　　　　787　10s
　　　　Ewer *en suite*.　　　　　　　　　　　　493　10s
1884　Eudel, Paris. Louis XV silver ewer after Berain.　　280
　　　　Cup and cover, rocaille stand, arms of Farnese (see 1907).　740
　　　　Tureen, arms of Demidoff, late 18th-cent. French.　520
1888　Marquess of Exeter. C. 2 sconces, 1715 (see 1956). 2 for　120　15s
1889　Paris. Travelling toilet-set of Mariana of Portugal, *c*. 1680.
　　　　　　　　　　　　　　　　　19 for　1,000
1890　Seillière, Paris. 2 rococo Louis XV flambeaux.　2 for　360
1892　Failly, Paris. 2 huge seaux with Roman emperor heads,
　　　1687, about 350oz each (value today possibly in the region
　　　of £30,000).　　　　　　　　　　　2 for　416
1896　Paris. Vegetable dish and cover, style of Jean Roettiers.　1,000
1897　Baron Pichon, Paris. Sauce-boat made by Julien Boethe
　　　for Mme Pompadour in 1755.　　　　　　　228
　　　　More than 200 pieces of 18th-cent. French silver, few of
　　　which made over £100.
1907　Chasles, Paris. Silver-gilt porringer and cover, François
　　　Germain, 1733, arms of Farnese (see 1884), bought by
　　　Louvre.　　　　　　　　　　　　　　　660
1909　Polovsteff, Paris. The Duke of Kingston's surtout de
　　　table from Thoresby, flanked by 2 tureens *en suite* by
　　　Meissonier and Huquier, 1735.　　　　3 for　7,040

£

1912	De Mouchy, Paris. 2 Louis XV tureens on platters with inlaid medallions.	2 for	1,600
1922	Paris. 2 Louis XV tureens, style of Roettiers.		598
1923	Paume, Paris. Rouge-box, François Germain, 1750.		518
	2 powder-boxes, François Joubert.	2 for	745
1924	Swaythling heirlooms. C. Écuelle and cover, Claude Ballin, c. 1680.		810
1929	Metzer, Paris. Soup-tureen, Louis XV, by Ronde de Gogly.		410
1930	Scarsdale heirlooms. C. 2 huge urns and lids, Paris, 1710, 1,490oz.		4,000
1934	Godfrey Phillips. C. 2 mustard-pots and stands, Caen, 1767, very rococo.		365
	2 parcel-gilt castors by Besnier, 1728.		430
	4 parcel-gilt fruit-dishes by Villeclerc, 1743.		750
1936	Mme d'Hainaut. S. 2 tureens, covers and stands, 6230z, by Robert Auguste, c. 1780.	2 for	2,200
1942	G. A. Lockett. S. Rose-water ewer and dish by du Rollery, 1765.	2 for	370
1948	Paris. Sugar-urn and cover by Germain, 1775.		1,750
1951	Rudolf, Hamburg. Augsburg tureen, cover and stand, Roettiers style, 1755.		235
	Tureen cover and stand, St Petersburg, 1774.		340
1954	Duke of Richmond. S. The Lennoxlove Toilet Service, Paris, parcel-gilt, 1672–6, 13 pieces in original case.	13 for	17,000
1955	C. Swedish coffee-pot by Lampa, 1760, 170z 10dwt.		1,850
	Paris. 2 oval soup-tureens and covers by François Thomas Germain, c. 1750–60.	2 for about	8,500
1956	Heywood-Lonsdale. C. 2 sconces, 1715, Paris mark (see 1888).	2 for	4,600
1957	S. Swedish *Kallskul* tankard, Stockholm, 1715, monogram of Charles XII, 86oz.		8,300
	Parke-Bernet, New York. Service made for Napoleon, 1814, 48 plates, 3 dish-warmers, stands and covers, quite plain.	57 for	9,000
1958	Lempertz, Cologne. Dish, cover and warming-stand, Berlin, 1735, part of the Frederick the Great Service, 800z.	3 for	3,175
1959	Stuker, Berne. Solid silver toilet-mirror made by Odiot for the Empress Josephine, 1804–8, weight over 90lb, together with toilet service of 40 articles.	whole for	80,000
	Solid gold tea service made by Keibel of Petersburg for Alexander I of Russia, c. 1820.		20,800
1960	S. Swedish tankard, ball-feet, 1691.		1,150
	Earl of Berkeley's Executors. The Berkeley Castle Dinner Service, by Jean Roettiers, 1735–8 (168 pieces), weighing ¾ ton (to USA, Louvre underbidding).	168 for	207,000
	Penard y Fernandez, Paris. Ewer and stand by Nicolas de Launay, 1704.	2 for	12,370
	Baluster ewer by Boursin, 1681.		3,520

£

1960 2 candlesticks by Jacques Roettiers, from the Orloff
 Service, 1771. 2 for 3,400

1961 Mrs Makower. S. 2 tazze by Tessier, 1688. 2 for 3,000

 C. Engraved casket, 11in, by Besnier, 1714. 2,900

1963 S. Napoleon's parcel-gilt tea and coffee service, by
 Biennais, 1808, 128oz 7dwt. 10,200

 Lord Astor of Hever. C. Toilet-set, partly glass and
 Sèvres porcelain, by François Riel, 1770–1, bought-in.

 18 for 14,500

SILVER

£

1791 "A nobleman." C. Epergne with 4 branches, tureen and
cover, with other appliances, decorated with stags, clusters
of grapes, vine branches, etc. (Thomas Heming?). The
whole weighed 1,200oz at 18s an ounce. 1,120 15s

 Pair of huge ice-pails, 1,520oz at 6s 6d an ounce. 503 1s

1794 Countess of Shelbourne. C. Pair of tureens, covers and
stands, 303oz at 5s 7d an ounce. 2 for 76 10s 10d

1823 Farquhar, Fonthill (*ex* Beckford) (Philips). 2 silver
sconces with the device of William and Mary. 2 for 40

1827 Late Duke of York. C. 45,153oz of silver made
£22,438 11s.

Modern silver:

Kensington Lewis, cistern with combats of gladiators in
high relief, 811oz at 11s an ounce, bought back by Lewis
(cost £1,500). 446 6s 6d

Kensington Lewis, surtout de table, Hercules attacking
the Hydra, with 9 lights, 1,144oz at 6s an ounce. 343 5s 6d

Kensington Lewis, candelabrum supported by figure of
Neptune, 548oz at 6s 8d an ounce. 180 13s 4d

Rundell, Bridge and Rundell, the Flaxman Shield,
Homeric subjects, silver-gilt, 634 oz, 1 of several examples
costing £2,000 each, bought back at 33s 6d an ounce
by Thomas Bridge. 1,050

Other modern tureens and ice-pails made 6s and 7s an
ounce.

Inherited or antique silver:

Pair of chased firedogs, monogram of William III,
148oz at 16s an ounce. 118 8s

Queen Anne's toilet service (now at Windsor), bought
for George IV at 52s an ounce, 192oz 10dwt. 500 10s

Queen Anne's sugar-basin and cover, 35oz. 31 14s 6d

1842 Rundell, Bridge and Rundell. C. Plateau with Bacchana-
lian figures, designed by Stothard (in the early 1800s) for
Thomas Bridge, 13ft long, 4ft diam., 2,400oz at 8s an ounce. 976

Waldegrave, Strawberry Hill (*ex* Walpole). 14in tazza by
Paul Lamerie, Triumph of George I. 40 9s 3d

 19in ditto, dated 1728, 135oz (see 1955). 101 2s 6d

 2-handle porringer, parcel-gilt, late 17th cent. 50 14s 1d

		£		
1842	The Newmarket Cup, 1713.	105	3s	
	Octagonal soup-tureen and cover (Lamerie?).	126	2s	3d
	2 sconces by Lamerie, 1716 (see 1881, 1914).	40	11s	9d
	Inkstand by Lamerie, 36s an ounce, bought by Sir Robert Peel.	175	19s	
	Surtout de table, mythological sculptures.	244	10s	
	A 2nd with masques and arabesques (these possibly French), bought by Sir W. Middleton.	342	11s	
	2 wine-coolers by William Lukin, 1706 (see 1914). 2 for	196	4s	
	2 waiters on 4 feet by Lamerie, 1728 (see 1933). 2 for	21		
1843	Late Duke of Sussex. C. Salver, 24in, masks of Silenus, 256oz at 7s an ounce, described as *Cinquecento* taste (probably recent).	89	15s	6d
	Punch-bowl, Chinese subjects, probably late 17th cent., 104oz at 8s 9d an ounce.	45	13s	6d
	Salver, arms of Lord Hawke, 30in, 233oz at 9s an ounce.	104	17s	
	Chased monteith, dated 1707, 101oz at 12s an ounce.	60	10s	1d
	2-handled cup and cover, presented by the City of London to John Wilkes, 126oz at 7s 2d an ounce.	45	6s	7d
	Tea-urn, said to have been Queen Anne's, 2ft high, "in the beautiful taste of Paul l'Emery [Lamerie]", 263oz at 8s 9d an ounce.	113	17s	2d
	Pair of 4-light candelabra mounted on dolphins, lions and eagles, made for the Duke of York (probably Thomas Bridge, *c.* 1820), 653oz at 12s 3d an ounce.	399	10s	
	Another candelabrum, 38in high, 399oz at 12s 3d.	241	13s	9d
	Salver with medallions of William and Mary, silver-gilt, 48oz at 43s an ounce.	102	2s	6d
1846	C. Monteith and wine-cooler, richly chased, 220oz at 9s 7d an ounce. 2 for	105	8s	4d
1847	Robert Vernon. C. Queen Anne tea-urn, £5 piece let into the cover, 263oz at 8s 8d an ounce.	114	3s	8d
1848	C. Coffee-pot by Lamerie, 14s an ounce.	26	3s	2d
	Duke of Buckingham, Stowe. C. Wine-cooler "time of Queen Anne", 696oz at 9s 6d an ounce.	330	12s	
	Pair of silver-gilt sideboard urns, 311oz 10dwt at 40s an ounce, probably mid-18th cent., bought by Redfern for Lord Hertford. 2 for	622	10s	
	Basket-epergne, mid-18th cent., 386oz 15dwt at 8s an ounce.	174	0s	9d
	Recently completed table sculptures by Robert Garrard, based on Walter Scott episodes:			
	Balfour and Bothwell, 365oz 10dwt at 17s 11d an ounce.	327	8s	6d
	Death of Colonel Gardiner, 287oz 15dwt at 17s 3d an ounce.	248	3s	8d
	Death of Sir Bevil Grenville, 1,591oz 10dwt at 10s 5d an ounce (bought back by Garrard; resold for £978 18s).	828	18s	8d

£

1850 James Stuart. C. 2-handled cup and cover by Lamerie, 1739, 93oz 10dwt at 7s 7d an ounce. 35 9s
 22in salver by Lamerie, 1742, 143oz 10dwt at 8s 1d an ounce. 57 19s 11d

1854 Lord Charles Townshend (over 20,000oz sold). C. 2 fluted circular tureens with stands and covers, surmounted with a cauliflower and crayfish, Lamerie period (if not Continental) (*ex* Lord Reay), 15s 2d an ounce. 2 for 196 18s 8d

1955 Bernal. C. Salvers with masques and vine-chasing, apparently in the Lamerie style:
 18in, 78oz. 30 6s 5d
 25½in, 215 oz. 64 13s
 Monteith punch-bowl, Queen Anne or George I. 28 12s

1858 Duke of Argyll. C. 2 oval Queen Anne(?) tureens, cauliflower and leaf handles, 315 oz at 8s an ounce, bought-in. 2 for 126

1861 V & A buys salver, 26in × 21in, London hallmark, 1772. 130
 Earl of Pembroke, Paris. Dessert service by Storr and Mortimer, *c.* 1820–30, 7,335oz at 11s 4d an ounce (see 1930). 4,120

1862 A Lady. C. 15 tankards, London hallmarks, 1621–1726, including flat-topped tankard, 1661, at 9s 10d an ounce. 17 16s 5d

1863 Dowager Countess Ashburnham. C. 3 large castors, ascribed to the time of Queen Anne, 70oz 10dwt at 38s 7d an ounce. 3 for 136 10s

1864 V & A buys:
 2 tureens, stands and covers, height 7½in, London hallmark, 1779–80. 2 for 51 2s
 Repoussé cup and cover, 1676, 9½in high. 40

1865 Earl of Cadogan. C. Pair of candelabra, each in the form of a female figure for 2 lights, from Strawberry Hill, probably George II in French taste, 118oz 5dwt at 61s an ounce. 2 for 360 13s 3d

1867 C. 3 tea-caddies by Lamerie with Chinoiserie figures in landscape, 48oz 3dwt, bought-in. 73 10s

1869 Lord Willoughby de Eresby. C. Sconce, 1665, engraved with Chinoiserie figures, 27oz at 53s an ounce. 72 1s 7d
 Fluted monteith, 1703, 65oz at 27s an ounce. 87 19s
 Fluted bowl, 1690, 36oz at 28s an ounce. 50 9s 4d
 Claret jug, 1702, spirally fluted, 43oz at 23s an ounce. 49 13s 7d
 Complete cruet, 1737, 67oz at 20s 6d an ounce. 68 13s 6d
 Tea-kettle stand and lamp by Lamerie, 1748, 35oz at 21s an ounce. 37 0s 3d
 Melon-shaped tea-kettle, 1722, said to have been decorated by Hogarth, 119oz at 61s an ounce. 362 19s
 Cup and cover by Lamerie, 1740, silver-gilt, 85oz 10dwt at 27s an ounce. 115 8s 6d
 V & A buys Mace of the Cork Trades Guild, 1690, 15in. 75 10s

1870 Wigram. C. 2 26in candelabra for 4 lights each (Stowe sale, 1848, £92 10s 1d). 2 for 220

£

1870	San Donato, Paris. Charles II potiche-jar and cover, heavily chased, Chinese shape, height 23in.	200	

1870 San Donato, Paris. Charles II potiche-jar and cover, heavily chased, Chinese shape, height 23in. 200
 3 tea-caddies with Chinoiserie figures, *c.* 1700. 3 for 68
1871 C. Salver, 1733, 18in, 89oz at 36s an ounce, said to have been decorated by Hogarth. 161 5s 7d
1875 G. W. Dasent. C. Chocolate-ewer, 1737. 107
 Porringer and cover, 1713. 165
 Pair of castors, 1707. 2 for 200
1881 Sackvile Bale. C. 2 Queen Anne sconces, arms of Pelham (see 1842, 1914). 2 for 433
1887 Sebright. C. Ewer by Paul Crespin, helmet-shaped, 1720. 614 5s
1888 Marquess of Exeter. C. The Pierre Harrache Toilet Service, 1695, 18 pieces (see 1960). 18 for 1,215
1892 C. 3 caddies by Lamerie, 1738. 3 for 1,030
1893 Lord Revelstoke. C. Sideboard dish, 1749, 351oz at 60s an ounce. 1,053
 2 candelabra by Lamerie (see 1924). 2 for 308
1901 Hope-Edwards. C. William III monteith punch-bowl. 277 10s
 2 Lamerie sauce-boats. 2 for 143
 Queen Anne porringer and cover. 209 2s
 Rose-water ewer by Willaume, *c.* 1700. 250
1905 Dunn-Gardner. C. Vase and cover by Nelme, William III, scenes from Roman history, 167oz at 130s an oz. 1,086 16s
 C. 2 porringers and covers by Fleurant, 1725, dedicated by George I to the Townshend family. 2 for 717
 C. H. Huth. C. Plain tankard and cover by Gawthorne, *c.* 1700 (a revolutionary price). 2,050
1907 A. M. Harris. C. Plain coffee-pot, godrooned edge, by Harrache, 1695. 184 4s
1908 Marchioness of Conyngham. C. George II Toilet Service, 381oz. 871
 C. Punch-bowl, 1717. 235 4s
 2 plain ewers, 1712. 386 8s
1912 C. Oblong salver by Lamerie, 1731. 1,074
 Bread-basket *en suite.* 445 16s 3d
1914 Earl of Ashburnham. Toilet service, 1719, by Benjamin Pyne (see 1947, 1957) (mirror and 22 other pieces). 6,100
 Horace Walpole's jardinières by William Lukin, 1716 (see 1842), 300s an ounce (8s 6d an ounce in 1842). 2 for 3,684
1916 C. 2 pilgrim bottles by Pierre Harrache, 1699, 290s an ounce. 2 for 3,000
1918 Sir Ernest Cassel. C. (Red Cross sale). Porringer and cover, 1675. 2,600
1919 Newdigate, S. Surtout de table by Lamerie, 1743, bought for V & A. 2,974 13s 9d
 Epergne by Lamerie. 1,890
1920 Lord Methuen. C. 2 George I porringers and covers. 2 for 2,987

£

1920	Duke of Leeds. Toilet service by Mettayer, 1714.		5,589
1921	Bradley Martin (Robinson and Fisher). 6 sconces by Peter Archambo, 1730.	6 for	3,100
1923	Paume, Paris. 2 ewers by Simon Pantin, 1713 (see 1929, 1938).	2 for	4,200
	Asher Wertheimer. C. Toilet service by Willaume, c. 1700, 695oz.		3,700
1924	Swaythling heirlooms. 2 candelabra by Lamerie, 400s an ounce (see 1893).	2 for	3,003
1928	(Harrods). Plain oblong inkstand, 1694.		740
1929	S. Porringer and cover, 1661.		3,010
	Lord Brownlow. C. 2 Scalloped dishes, 1665 (bought by Hearst, see 1939).	2 for	3,300
	2 ewers, Samuel Pantin, 1713 (see 1923, 1938).	2 for	4,200
	2 tazze by Benjamin Pyne, 1698.	2 for	4,700
	Panter. S. Chocolate-pot, Dublin, 1708.		1,286
	Loving cup, 1694.		2,571
	S. The Saltby Free Plate, 1708, by Pyne.		1,621 8s
1930	Scarsdale heirlooms. C. 2 wine-cisterns, 1695, sold with 2 sets of urns and covers, one of them French, 1710, the whole weighing 1,490oz.	4 for	4,000
	Earl of Balfour. C. Paul Storr dinner service, made between 1809 and 1829 and weighing 7,355oz at 9s 6d an ounce (compare 1861, when the service made 11s 4d an ounce).		3,600
	Guy Fairfax. S. The Gibraltar Cup, 1705, 67oz (448s an ounce).		1,480
	C. Plain sugar-basin and cover, Adrian Brancker, New York, 1730.		640
	Flayderman, New York. Colonial silver:		
	Monteith by Jabez Browne of Boston, c. 1750.		1,137
	Standing cup by Vernon of Newport, Long Island, before 1770.		928
	C. Pair of 2-handled cups and covers, Robert Leeke, 1695.	2 for	3,990
1931	Page-Croft. S. Pair of 2-handled cups and covers by Pyne and Hood, 1685, 196oz (see 1937).	2 for	3,038
1933	Lord Hillingdon. C. Horace Walpole's Lamerie square waiters, 1728, 52oz 16dwt (see 1842 when they were bought by Charles Mills).	2 for	263
1934	Elbert Gary, New York. Very ornate monteith by Samuel Lee, 1705, 79oz (Minneapolis Institute of Arts).		575
1935	C. The Galway Corporation Sword and Mace, 1709 (see 1938).		5,000
1936	Bigelow, New York. Plain tankard by Peter van Dyck of New York, c. 1720.		1,000
	Mrs Miles White, Jnr, New York. Plain tankard by Christopher Robert of New York, c. 1730.		1,214
	C. Rose-water ewer by Lamerie, 1736, 78oz.		1,002 3s

£

1936	Elaborate inkstand, Benjamin Pyne, 1718.	398
	S. 2 fire-dogs, 1670, standing figures, 18½in. 2 for	360
1937	C. The Mace of the Irish House of Commons, 1765 (bought by the Bank of Ireland).	3,100
	S. Pair of cups and covers by Samuel Hood and Benjamin Pyne, 1685 (see 1931). 2 for	2,650
	George Gebelein, New York. Monteith punch-bowl by John Coney of Boston [d. 1722], very rich and baroque.	6,200
1938	W. Randolph Hearst. S. 2 ewers by Pantin, 1713 (see 1923, 1929).	1,400
	The Galway Corporation Mace, 1709 (see 1935), bought-in.	1,950
1939	W. Randolph Hearst, St Donat's sale. S. 2 wine-coolers by Mettayer, 1714, 229oz (see 1941). 2 for	880
	2 scalloped dishes, 1665 (see 1929).	3,300
1940	Anthony de Rothschild. Monteith punch-bowl by Benjamin Pyne, 1715, 192oz (see 1962, £3,600).	530
	Bullet-shaped teapot by Fainell, 1720.	182
	Rosneath Castle (Dowells, Edinburgh). Bullet-shaped teapot by Lamerie, 1746.	260
1941	Earl Temple. S. Tazza, 1712, by David Willaume, 70oz.	470
	Lord Rothermere. C. Tankard, 1671, 111oz (£767 in 1926).	1,900
	2 pilgrim flasks, 1686, 196oz. 2 for	1,000
	Inkstand by Lamerie, 1734 (see 1952).	510
	S. 2 wine-coolers by Mettayer, 1714 (see 1939). 2 for	660
	4 strawberry dishes, Paul Crespin, 1734, 84oz. 4 for	560
	Hot-water jug, 1727, by Lamerie.	450
1942	George A. Lockett. C. Kettle on lamp, stand, etc., by John Stockar, 1703, 96oz.	760
	2 toilet boxes by John Boddington, 1713.	460
	Bowl and cover, Pierre Platel, 1704.	440
	Porringer and cover, 1661.	450
	Monteith punch-bowl, 1688, by Garthorne.	680
	Pearson Gregory. C. 2-handled cup and cover by Lamerie, 1727.	720
	Octagonal plain teapot by Nelme, 1709.	450
1944	T. H. Cobb. S. Toilet service, 1696, 18 pieces, 301oz (bought 1938, £2,000). 18 for	3,500
	Tray by Auguste Courtauld, 1721, 125oz. (bought in 1943 for £850).	1,700
	Pear-shaped teapot by Penstone, 1713, 18oz.	560
	Casket by Frailon, 1716, 20oz.	480
1945	C. Teapot with ornate domed cover by Samuel Pant in, 1710, 17oz (was then a record price for a silver teapot).	780
	Marquess of Downshire. C. Sideboard dish, 1693 (bought by National Museum of Wales).	1,300
	Lady Bagot. S. Ornate tray by Nash, 1724, 100oz.	1,620

£

1946 Swaythling heirlooms. S. Queen Anne tea-kettle, lamp
 and stand, John Backe, 1706 (see 1950). 2,100
 Lady Violet Melchett. C. Toilet service, 17 pieces,
 178oz. 17 for 1,950

1947 Duke of Norfolk. S. The Ashburnham Toilet service
 by Benjamin Pyne, 1719, with additional items (see 1914,
 1957). 31 for 7,800
 S. 12-sided teapot, David King of Dublin, 1715. 900
 Duke of Kent. C. 2 tea-caddies by Smith and Sharpe,
 1766, 22oz. 900
 2 plain round-bellied beer-jugs by Godfrey, 1753, 500z.
 2 for 880
 J. Pierpont Morgan, New York. Monteith punch-bowl
 with Chinoiserie reliefs, 1685. 1,350
 Rose-water ewer and dish by Lamerie, 1726, rechased with
 arms of Anson. 2 for 2,250

1948 Earl of Strathmore. C. Huge and ornate stand for a
 kettle by Samuel Pantin, 1724, 2250z. 3,200
 S. Queen Anne kettle, lamp and stand by Samuel
 Margas, 109oz (see 1954). 2,600

1950 C. Kettle, lamp and stand by John Backe, 1706 (see 1946). 2,000

1951 Lord Glentanar. C. Plain teapot by Seth Lofthouse,
 1719, 31oz. 1,900

1952 S. Inkstand by Lamerie, 1734, 33oz (see 1941). 750
 C. 7-sided teapot by Isaac Ribouleau, 1724 (see 1960). 1,800

1953 Parke-Bernet, New York. Small tripod bowl by John
 Coney of Boston, c. 1720. 1,700

1954 S. Armorial tea-kettle, lamp and stand by Samuel Margas,
 1715 (see 1948). 2,900
 "Fire of London", plain engraved tankard, 1675, with
 Royal arms (only 2 others known). 2,600
 5-piece tea service by Rollos, 1718, Royal arms. 5 for 12,500

1955 Colin Davey. C. The Walpole Salver, by Lamerie,
 1728 (see 1842), bought for V & A, the price having gone
 up from 15s an ounce in 1842 to nearly 1,200s. 7,800
 S. Dessert dish, 1725, by Lamerie, 58oz. 1,900
 Set of candelabra by Parker and Wakelin, late 18th cent.
 4 for 2,500
 Rose-water dish and ewer by Samuel Hood, 1699. 1,800
 Tea-kettle and lamp-stand by Sleath, 1715, 95oz. 1,500

1956 S. 2 fruit-baskets, 12in wide, by Lamerie, 1739. 2 for 2,700
 2 tureens and covers, 11in wide, by Lamerie, 1722. 2 for 2,200
 Heywood-Lonsdale. C. 2 sconces, c. 1709 (see 1881).
 2 for 2,100
 Lord Irwin. S. William III's shaving dish, 33oz (made
 for 17 guineas). 2,700

1957 Mae Rovensky, New York. The Ashburnham Toilet
 Service, by Pyne, 1719, with additional pair of candlesticks
 and tazze since 1914 (see 1947). 31 for 17,850

£

1957	Princess Royal. C. Toilet set, Chinoiserie style, part marked 1675, 226 oz at 619s an ounce.	7,000
	C. Soup-tureen, 1738, by Lamerie, 267oz 17dwt.	1,450
1958	S. 4 wall-sconces by John Boddington, 1710, 163oz. 4 for	7,000
	Duke of Devonshire. C. Toilet service, dated 1688.	7,000
	William III ewer and dish, 251oz. 2 for	5,500
	C. 2 soup-tureens by Robert Garrard, 1829, at 57s an ounce. 2 for	680
1959	Soup-tureen by Lamerie, 1741.	1,850
	Soup-tureen by Willaume, 1714.	1,750
	Marquess of Exeter. C. Toilet set by Willaume, 1734.	5,200
1960	S. Canteen and 2 caddies by Lamerie (£1,500 in 1954).	6,600
	Fitted inkstand by Lamerie, 9in long.	3,600
	Casket by Pierre Harrache, 1695, 10½in×8in (for complete service, see 1888).	8,000
	S. Sideboard dish by John Charteris, 1707 (£460 in 1941).	4,100
	Cup and cover by Lamerie, 1744 (£350 in 1941).	2,500
	Cup and cover, 1696 (£600 in 1942).	4,800
	3 scallop-shell epergnes by Lamerie (£225 in 1942).	3,200
	Inkstand by Lamerie (£285 in 1942).	3,600
	C. Pair of candlesticks by Lamerie, 88oz.	5,600
	Sideboard ewer, ditto, 79oz.	4,200
	Tureen and cover, ditto.	3,400
	Coffee-pot, 1743.	1,800
	7-sided teapot by Ribouleau, 1710 (see 1952).	2,500
	S. Lamerie, 2-handled cup and cover.	1,500
	Lamerie, 2 cake-baskets, 203oz. 2 for	3,600
	John Clifton, cup and cover, 1709.	2,500
	2 James II tankards (£1,800 in 1954). 2 for	4,600
1961	Lilian S. Whitmarsh, New York. Toilet service, 1761.	2,235
	C. Sugar-box by John Coney of Boston, c. 1700, 16oz at 8,130s an ounce.	6,500
	Queen Anne chocolate-pot on lions' feet.	2,150
	Duke of Leeds. S. 2 sauce-boats by Huddell, 1720.	2,930
	2 covered bowls, c. 1750.	2,800
	2 salvers by Lamerie.	2,100
	Duke of Sutherland Executors. C. Wine-cistern by Lamerie, 1719, arms of Gower, 38in wide, 700oz at 772s an ounce.	27,000
	2-handled cup and cover by Lamerie, c. 1728.	2,800
	4 wine-coolers by Philip Rundell, 1819 and 1822, 429oz at 80s an ounce. 4 for	1,700
	The wine-cistern was the costliest piece of plate ever sold, but its bullion value on 29 November 1961 was under £250 at 87½d per ounce fine.	
	Lady Craven. S. 2 candelabra by Schofield, 1783, 145oz. 2 for	3,600
	Toilet service by Smith and Sharp, 1783, 12 pieces, 437oz. 12 for	9,600

£

1961 Chamber-pot by Isaac Liger, 1737, 29oz. 2,600
Mrs Robert Makower. S. Charles II taper-winder or
wax-jack (£395 in 1937). 3,600
Ewer, 1666, London marks. 3,800

1962 S. Monteith by Benjamin Pyne, 1715 (see 1940) (value
multiplied by more than 6 in 22 years). 3,600
Parcel-gilt ewer, 1671 (see 1954). 3,200
Salver, 1671 (£310 in 1954). 1,600
2 soup-tureens and covers by Lamerie, 1734–7, 359oz.
 2 for 6,300
S. Koss. S. Octagonal tea-kettle and stand by Humphrey
Payne, 1711–14, stand unmarked, wooden handles, 9in,
27oz 9dwt. 3,100
Octagonal milk-jug by Edward Barnett, 1717, 8oz 11dwt
at 4,420s an ounce. 1,950
C. Octagonal coffee-pot by George Bayley, 1718, 24oz
5dwt, the plainest ever sold. 1,600
2 pilgrim bottles by Edward Farrell, 1823, massive silver,
225oz 15dwt. 2 for 1,550
2 plain pear-shaped beer-jugs by Videau, 1751. 2 for 2,300
Monteith by Isaac Dighton, 1699 (Temple Newsam
Gallery). 1,250
Dozen each, silver-gilt knives, spoons and forks, 1712
(£172 in 1910). 36 for 4,000
Octagonal castor by Lamerie, 1724. 3,200
Plain cone coffee-pot, 1709, Simon Pantin. 2,800
Tankard by Lamerie, 1716, 28oz 18dwt (1931, £80). 3,300
Sir Edward Packe. C. 2-handled wine-cistern by James
and Eliza Bland, 1794, 1,150oz (£400 in 1947). 3,400
Baron Eric de Kusel. C. Pair of candlesticks by Lamerie,
28oz 1dwt (£112 in 1924). 2,800
Plain cream-jug by David Willaume, 1718, 8oz 10dwt. 1,200
S. Pair of ginger-jars with covers and octagonal stands,
London, 1682, under 10in high overall, 5,000s an ounce. 2 for 18,000
Punch-bowl, Hester Bateman, 1784, bought by Chester
Corporation. 1,500
14-piece toilet service, Anthony Nelme, 1705. 14 for 5,200
Multifoil epergne by Willaume, 1722. 3,400
Major E. W. Hasell. S. 8 strawberry dishes by Lamerie,
George II, 83oz 14dwt. 8 for 9,000
S. Oblong tea-tray by Lamerie, George II, 182oz 13dwt. 8,500
2 more Lamerie strawberry dishes, 43oz. 5,000
Oblong tray by Simon Pantin, 57oz 12dwt (£650 in
1942). 2,200
Coffee-pot by Jacob Margas, 34oz 3dwt. 2,400
Candle-sconce, Chinoiserie figures, 1665. 3,000

1963 Lord Bury. C. The Young Pretender's parcel-gilt
canteen by Oliphant of Edinburgh, 1740: captured at
Culloden. 7,200

£

1750	Accounts of Lazare Duvaux, Paris. Cornelian box, chased gold, for Comte d'Egmont.	46
1752	Charles Coypel, Paris. Round gold box, portrait of the Regent.	23
	Square box by Burgau, gold incrustations.	20
1755	Duc de Tallard, Paris. Square box, round corners, lapis lazuli and gold.	43
1757	Lazare Duvaux accounts, for Mme Pompadour. Box, engraved gold and enamels.	45 12s
	Box, black lacquer, doubled with gold.	56
1769	Theed and Picket. C. Oval box in chased gold.	14 3s 6d
	Oval box, enamelled with blue flowers on chased gold.	20 9s 6d
1771	C. Enamelled gold box set with diamonds.	50
1773	Princess Royal. C. Oval gold box, painted in compartments.	27 16s 6d
1777	Prince de Conti, Paris. Double box with 3 classical cameos, inset in gold.	85
1778	Harrache, jeweller. C. In gold of 2 colours.	25 14s 6d
	Oval, parti-coloured gold.	29 8s
1782	Devisme. C. Gold box, the lid set with brilliants and inlaid with miniature of the Elector of Saxony.	56 14s
	Oval gold box, containing miniature portrait.	26 6s
1793	Hon. Mr St John. C. Round box, enamelled, with pearls.	21 6s
1794	"A valuable museum." C. Lapis lazuli box by Govers of Paris.	6 10s
1807	C. Silver-gilt, with painting by George Morland in oil on copper.	31 10s
1808	Choiseul-Praslin, Paris. Box containing a watch by Breguet.	52
	C. Oval box, malachite and petrified wood, set in gold.	34 13s
1812	C. Oval box enamelled on gold, Telemachus and Mentor, given by Marie Antoinette to Mme de la Motte.	34 13s
1818	Panné. C. Musical box, diamonds on blue enamel.	27 6s
1819	Sèvestre of Bond Street. C. Root of amethyst box, double carved, gold mount.	28 7s
	"Handsome old French taste", musical box with trophies in coloured gold.	31 10s
	Gold box shaped as a book, with oval miniature.	21 10s 6d
	Box with onyx cameo and agate base, "Mocoa" stones.	43 1s
1821	Dutreuil-Lenoir, Paris. In tortoiseshell with miniature portraits of Louis XIV and his brother by Petitot (see 1863).	83 6s

£

		£		
1821	With portrait of Turenne by Petitot on tortoiseshell doubled with gold (see 1863).	92		
	With portrait of Catinat, ditto.	111		
	With portrait of Ninon de Lenclos, ditto.	160	15s	
	With portrait of La Belle Armande, ditto.	162		
	All on tortoiseshell, doubled with gold.			
1823	Sir H. C. Englefield. C. Scallop-shaped, tortoiseshell, with miniature of Leda and the Swan.	33	1s	6d
1825	Thomas Gray, jeweller. C. Massive gold of different colours, mosaic picture of cat and spaniel.	48	16s	6d
1835	C. With 6 subjects of nymphs after Boucher.	20	9s	6d
	Massive gold, aventurine lid, 2 miniatures by Zincke.	29	8s	
1836	Late Sir Francis Freeling. C. Gold box, Louis XVIII cipher and crown, set in brilliants (after 1815?).	78		
	Gold box, cipher of Nicolas I, heavily chased and set with 31 brilliants, after 1826.	210		
1837	General Sir H. Cooke. C. Agate box with gold chasings in Louis XV taste.	21	10s	6d
1838	Prince Rasoumofsky, Vienna. C. Tortoiseshell box, gold-lined, 2 Petitot miniatures set in the lid, bought-in.	21		
1842	Rundle, Bridge and Rundle. C. Chased gold with Coronation medals of William IV.	35	3s	6d
	Tortoiseshell boxes with miniatures in enamel by Petitot, as follows:			
	The Duke of Orleans.	15	10s	
	Louis XIV.	15	15s	
	Gold box with miniature after Greuze.	22	11s	6d
	Waldegrave, Strawberry Hill (ex Walpole). Gold box to fit Hilyard's miniatures of Elizabeth and James I.	51	9s	
	Gold box with Mme de Sevigné's portrait.	28	7s	
	Rape of Europa, enamel on gold.	36	15s	
1843	Duke of Sussex. C. Square box in chased gold with enamelled miniatures.	60		
	Oval gold box, enamelled with sea-ports.	66		
	Gold box, enamel figures and brilliants.	60	18s	
1847	Edward Harman. C. By Petitot, enamel miniature of Mme de Montespan.	30	9s	
1848	Mme S. L., Paris. With a *fête de village* by Blarenberghe, *garni en or*.	34	10s	
	With portrait of Louis XIV by Petitot, enamelled on gold.	56		
	With portrait of Richelieu by Petitot on tortoiseshell and gold.	60		
1850	Debruge Dumenil, Paris. In tortoiseshell with a *fête de village* in medallion by Blarenberghe.	12		
	Oval, enamelled on gold after Teniers, *c.* 1760.	38	10s	
	Gold bonbonnière with medallion by Demailly.	28		
	Gold, enamelled lapis lazuli blue with onyx cameo, Louis XVI.	25	2s	

£

		£	
1851	Earl of Pembroke. C. Oval gold box, Chinoiserie figures.	57	15s
	Octagonal box, 6 miniatures of the apartments at the Tuileries on gold, said to have cost George III £600, bought-in.	257	5s
1852	Duc de Stacpoole, Paris. Egyptian jasper, richly gilded.	40	16s
1855	Bernal. C. Oval box, views of Dresden by Marcolini on porcelain, gold mounts.	40	
	Numerous boxes at from £4 to £21.		
	W. Williams Hope, Paris. Gold, enamelled blue, with 6 miniatures by Blarenberghe.	96	6s
1857	James Goding. C. Chased gold, 6 sea-port scenes by Blarenberghe (see 1880).	146	
1859	C. Double box, Oriental agate, chased gold and brilliants.	141	
1860	Edmund Higginson. C. Gold box with miniatures and several slabs of hard-stone, given by King of Naples to Sir W. Drummond, late 18th cent., bought-in.	168	
1861	Thomas Fish. C. Louis XV oblong box, view of a palace chased in gold, set with brilliants.	116	15s
1863	San Donato (Prince Demidoff), Paris. With portrait of Turenne by Petitot (see 1821).	185	
	With portrait of Louis XIV by Petitot (see 1821).	260	18s
	Louis XV box, champlevé enamels on gold.	168	
	Gold box, Louis XV, richement ciselé, with miniature of the Marchande des Fritures after Greuze.	460	
	Gold box with miniature of the Château de Bellevue, 1782, by Blarenberghe (Wallace Coll.).	440	
	3 other Blarenberghe boxes at	300–430	
1865	V & A buys ivory and gold box, c. 1760, with 6 French portrait miniatures.	130	
1867	William Sandes. C. Gold box with 8 figures en grisaille on pink (bought by C. H. T. Hawkins).	256	
	By Neuber of Dresden, gold on plates of various stones, pietra dura.	80	
1869	Frank Davis. C. In sardonyx with cameo figures and cage mounting in gold.	128	10s
1872	Allègre, Paris. Oval box, 1767, with 7 miniatures by Blarenberghe.	1,088	
	Louis XV box by Bourgoin.	408	
	Louis XVI box by Glachant, 1778.	604	
1873	C. Bonbonnière by Petitot, c. 1660, given by Louis XVI to Prince Besborodko.	600	
1880	3rd San Donato sale (Florence). Octagonal gold box set with rubies.	466	
	Oblong box enamelled en plein.	440	
	Gold-mounted box in Sèvres porcelain by Fossin after Boucher.	1,140	

£

			£	
1880	The Goding Coll., 190 boxes, sold to Samson Wertheimer for £40,000 after 4 years in V & A. "Nous avons changé tout ça–on donne un million pour 180 tabatières" (Edmond Bonnaffé).			
1881	Carrington. C. Louis XVI oblong box, amethyst panels in gold setting.		125	
	Leopold Double, Paris. Oval box, chased in gold, Louis XVI.		1,206	
	Chiselled gold and pearls, Louis XVI.		804	
	Louis XIV box by Petitot.		568	
	Boxes by Blarenberghe.	from to	460 520	
1882	Hamilton Palace. C. Oblong box, painted *en plein* in 6 panels.		535	10s
1885	Sapia de Lencia, Paris. Louis XV box with paintings after van Loo on gold mounts *à quatre couleurs*.		400	
1891	Lebœuf de Montgermont, Paris. Louis XV box, enamelled *en plein* after Teniers and Boucher.		600	
	A 2nd with mythological scenes.		600	
	Gold box with *champlevé* enamels.		676	
1895	Lyne Stephens. C. Oval box, Louis XVI, gold and opals (see 1910, 1912.)		483	
	Earl of Somerset. C. Oval gold Louis XVI box, 4 panels after Boucher.		1,000	
	Oblong gold box.		800	
1896	C. H. T. Hawkins, 1st sale. C. Louis XVI gold box, set with brilliants.		1,800	
	2 other chiselled gold boxes with jewel settings.		{ 1,400 1,100	
	Dreyfus, Paris. Louis XV box by Bourgoin, mythological scenes (see 1907).		660	
1898	Martin Heckscher. C. Oval box, enamelled *en plein* with subjects after Fragonard, Louis XVI (Pierpont Morgan).		3,400	
	Square box, painted with flowers *en plein*.		700	
1901	Marquis de Thugny, Paris. Oblong gold box, *c.* 1780, with oblong scene of a public celebration by Blarenberghe.		840	
1902	Dunn Gardner. C. Oblong box, enamelled on gold by Hainelin, Louis XVI.		820	
	C. The Music Party, box with 6 panels painted *en plein*, relief gold borders.		1,995	
1903	C. Oval box dated 1765, painted by Cheset.		997	10s
1904	Cocker. C. Louis XV box, 6 panels, History of Gil Blas; box "captured" at the Battle of Salamanca.		1,942	10s
	C. H. T. Hawkins, 2nd sale. C. 4-day sale of snuff-boxes totalling £54,019:			
	Oblong box, painted *en plein* with flowers by Hainelin, 1758, the gold borders set with brilliants (Pierpont Morgan).		6,400	

		£	
1904	Box by George, Louis XV.	1,900	
	Box by Chardin, Louis XVI.	1,550	
	Box with oval miniature of Maria Leczinska (see 1944).	1,460	
1905	C. H. T. Hawkins, 3rd sale. C. (£77,662.) 3 more boxes made over £1,000 each.		
	Duke of Cambridge. C. Louis XV box with hunting subjects *en plein*.	2,000	
	Louis XV box painted *en grisaille*.	1,600	
1906	Prince Kolchoubey, Paris. On gold, 5 panels by Blarenberghe.	1,958	
1907	R. T. Gill. C. Agate patch-box, Louis XV, jewelled gold mount.	2,150	
	Rikoff, Paris. By Bourgoin, mythological scenes (see 1896).	1,204	
1910	Octavus Coope. C. Louis XV, 6 panels by Schendler (see 1912).	1,732	10s
	Baron Schroeder. C. Louis XV, by Chalier after Boucher (see 1912).	4,000	
1912	Charles Wertheimer. C. With royal portraits by Prevost, 1762.	1,350	
	Box by Schendler after Teniers (see 1910).	1,450	
	Box by Julien Alaterre, 1768.	1,400	
	Box by Prevost, 1762, hunting scenes.	3,200	
	Box by Prevost, peasants and fishermen.	2,550	
	By Chalier after Boucher (see 1895, 1910).	2,660	
1922	Marshall Hall. C. Bonbonnière by Fossin with Sèvres plaques by Dodin after Boucher.	4,000	
1927	Mme Polès, Paris. Painted *en plein* by Blarenberghe, gold borders.	1,020	
1928	USSR Government, Berlin. Painted *en plein* by Blarenberghe.	1,800	
	C. H. T. Hawkins, 4th sale. C. Oblong, painted *en plein* after Teniers, Louis XV.	1,312	10s
	C. With portrait of Mme Pompadour, given by Louis XV in 1758, jewelled gold.	3,360	
1931	E. H. Scott. S. London gold box, 1779, with miniature family group and Cosway portrait.	280	
	Louis XV box in gold with mythological scenes.	195	
1932	C. Gold box, English, chased by Moser, 1741.	241	10s
1936	Mrs J. E. Hawkins. C. (Late C. H. T. Hawkins, 5th sale: see 1896, 1904, 1905, 1928.) Gold oval snuff-box with miniature portrait.	320	5s
	Ditto with grisaille panels by Alaterre, *c.* 1770.	141	15s
	Gold snuff-box with pencil drawings, 1787.	204	15s
1938	Durlacher. C. Round box, gold with grisaille enamels by de Mailly, 1765.	309	15s
	S. Oval box, enamel panels on chased gold by Jean Formey, 1762.	440	

£

1939 C. Rectangular chased gold box, inscribed Eloy Brichard, 1759. 78

1941 A. G. Hughes. C. Oval gold box with blue enamels and classical scene, Louis XVI, from the Hermitage Museum. 530

1942 C. Gold box with painted inlays by Drais, Louis XVI. 420

1944 S. Louis XIV gold box, miniature of Maria Leczinska after Nattier (see 1904). 670

1945 R. W. M. Walker. C. By Eloy Brichard, 1760, chased gold and enamels. 651

1947 Fulford, Castle Headingham. C. Berlin gold box engraved with hunting scenes. 945

Lady Ashburton. C. Gold box chased with hunting scenes, Bergs, Stockholm, 1755. 1,627

Paris box *en plein*, 1756, made for Antoine Leschaudelle. 1,155

By Neuber of Dresden, inlaid with hard-stones. 997 10s

1948 Sir Bernard Eckstein. S. Gold and mother-of-pearl, figures of Chinese astronomers by Jean Fremin, 1756. 1,800

1951 Lempertz, Cologne. Oval box, 1772, enamelled flowers, chased gold background. 860

Square box, chased gold, 1745. 764

C. Round box in chased gold without enamel by Louis Denay, 1762. 651

1953 C. By Henri Clavel, 1780, brilliants set in blue enamel on gold. 2,257 10s

By Bittmer, Strassburg, 1762, chased gold. 3,360

By Ducrolloy, 1740, enamelled on gold. 1,155

Emil Wertheimer. S. Berlin box, enamels and brilliants on herring-bone gold (bought 1927, £1,650). 4,400

English necessaire by Robert Allam, *c.* 1760, in agate and jewelled gold cage-work. 3,000

Oval Louis XV gold box from Hermitage Museum, with miniature portrait. 1,250

Gold and mother-of-pearl square Louis XVI box by Robeneau. 1,500

1954 Lempertz, Cologne. By J. Prevost, 1765, brilliants on gold with miniature scenes. 1,180

French *en plein* enamels, Russian mounts, *c.* 1770. 1,360

Egyptian Government, Cairo (*ex* King Farouk). S. Frederick the Great's snuff-box, smothered in brilliants and gold. 12,000

Berlin box, enriched with diamonds. 11,500

1956 S. Cameo miniatures on green ground, enamelled on gold, Louis XVI. 1,400

By Alaterre, 1773, green enamel, miniature set in diamonds on the lid. 1,700

Gold box, Paris, 1778. 2,200

1957 Mae Rovensky, New York. By Ambroise Briceau, 1740, theatrical scene in carved gold, set with diamonds. 6,075

£

1957	Dresden, *c.* 1740, bloodstone-jasper panels, and diamonds.	5,340
	Twin box, gold and pietra dura, Paris, 1750.	2,700
1958	S. Dresden gold box by Neuber with portrait of Augustus I in pietra dura mosaic, *c.* 1770.	1,350
1959	Parke-Bernet, New York. Similar box by Neuber, coat of arms in pietra dura.	1,330
	Stuker, Berne. Necessaire by Bauché-Retoré, Paris, 1810, made for Queen of Holland, mother-of-pearl, chased-gold bands. approximately	15,000
1960	Weinmueller, Munich. Chased gold box by Neuber, Dresden, portrait of Gustavus Adolphus, pietra dura.	1,280
	S. Scottish oblong box, Edinburgh, 1796, solid gold, 14½oz.	2,450
	S. Gold and lacquer box, 1752.	2,150
	Gold, enamelled with brilliants, 1760.	2,800
	Chiselled gold, 1746.	3,200
	Box painted *en plein* by Blarenberghe, Louis XVI.	2,500
	Dusendschon. S. Meissen box, gold borders.	1,700
1961	Blohm. S. Box by Helcher with Vienna (Dupaquier) porcelain panels, *c.* 1750.	1,000
	Chester Beatty. S. 172 snuff-boxes and watches made £124,029.	
	Architectural relief, 4-colour gold, *c.* 1735.	8,500
	By Wirgman and Moser, London, 1772 (£350 in 1942).	4,000
	By De Mailly, Paris, 1787, enamels on gold.	6,200
	German, landscapes in gold and mother-of-pearl.	5,500
	Ducrollay after Teniers, 1759, on gold.	5,400
	Enamelled *en plein* by Blarenberghe, 1767.	5,800
	6 others at £1,000 to £3,000.	
	S. By Vachette, *c.* 1789, black lacquer and gold.	2,200
1963	Lord Brownlow. C. Patchbox of Mary II, 1690, diamonds on enamelled gold, 2⅛in diam.	8,500

STONEWARE, GERMAN

16TH AND 17TH CENTURIES

*Formerly known as Grès de Flandre or Grès
including Hafner Ware*

(Numerous examples will be found under the heading "Silver,
Mounted Stoneware Jugs and Tankards")

£

1807 C. A jug of "brown Dutch ware" (Raeren) with the
story of Susanna in relief, dated 1584, sold with a Delft
puzzle jug and a blue-and-white Chinese jug. 3 for 2 3s

1824 Sir Masterman Sykes. C. Siegburg white schnelle,
silver-mounted, with allegory of Justice, inscribed "*gereech-
tigkeit*", dated 1573. 2 15s

1846 C. G. Dodd. C. Tankard with figure in Charles I dress,
dated 1654, Kreussen. 1 3s

 Baron, Paris. Kreussen humpe with the gods of Olympus,
1681. 4 15s

 Westerwald flagon, hunting scenes and blazons, 1651. 4 16s

1850 Debruge Dumenil. Nuremberg ewer by Paul Preuning in
silver mounts. 2 14s

 Raeren ewer in blue-and-grey. 5 12s

1852 The future V & A buys a 20in Raeren jug with electoral
arms, dated 1602. 20

1855 Bernal. C. Siegburg cylindrical white ewer, field sports,
high relief, *c.* 1570 (BM). 44 10s

 Westerwald ring vase, 1602. 29 8s

 Raeren jug, flat-sided, touches of blue, dated 1597 (BM). 21 10s

 Pilgrim bottle, arms of Paris, blue-and-purple, Wester-
wald, late 17th cent. 25

1857 Earl of Shrewsbury, Alton Towers. C. Pilgrim bottle,
grey-and-blue, dated 1589, certainly Raeren. 30

1859 Rattier, Paris. Raeren armorial ewer of 1573. 13

1862 V & A buys a white Sieburg ewer of 1590 with silver
mount. 33

1868 V & A buys 60 pieces from the dealer Gambart:

 Le Roi des Vases, fountain vase in blue-and-purple by
Kalb of Grenzau, *c.* 1630, 28in high: blown to pieces by a
gas explosion, but bought, reassembled, for 84 10s

 Unique 3-handled Siegburg jar, 22in. 33 10s

 From other sources. Hafner ware stove, nearly 8ft high,
by Hans Kraut, S. Germany, 1578, part polychrome
relief, the Triumph of Mordecai. 240

£

1882	Hamilton Palace. C. **Westerwald** pilgrim bottle, blue-and-grey (V & A).	42
1886	Eugène Felix, Leipzig. Siegburg flat, gourd-shaped vase with animal handles, *c.* 1550.	716
	Westerwald ring vase, arms of von Essen, 1633.	480
	2 large Raeren masked ewers.	{400 420
	A 2nd ring vase.	480
1893	Frederick Spitzer, Paris. Pear-shaped tankard by Baldems Mennecken, 17in, Raeren, dated 1579.	330
	Nuremberg pitcher, polychrome enamels, style of Hirschvogel, *c.* 1550, 24in.	264
	Raeren blue-and-grey ewer, Triumphs of the Gods, dated 1589, 23in.	228
	Cologne square ewer with 2 spouts and relief bust medallions, dated 1559.	176
	Siegburg tankard, arms of the Empire, 1580.	140 18s
1903	Thewalt, Cologne. Tall Siegburg tankard (Cologne Museum).	235
	Enamelled relief jug by Paul Preuning of Nuremberg, 1550.	815
1904	Bourgeois Bros., Cologne. Cologne relief jug, 1560 (Cologne Museum).	302 10s
1909	von Lanna, Prague. Hafner ware:	
	Nuremburg jugs, school of Paul Preuning:	
	Adam and Eve.	580
	Jonah and the Whale.	580
	Purse-shaped jug with imperial busts.	615
	Wine-cistern, The Return of the Spies (used as a latrine, bought for 18 kronen).	605
	Hafner ware stove-panels:	
	Samson and the Lion, early 16th cent.	600
	With Imperial blazon, before 1550.	550
	Series of 7 panels from St Stefan's Sacristy, Vienna (Oesterreichisches Museum). 7 for	2,000
	2 Salzburg stove panels, 1570. 2 for	900
	Salzachstal stove-panel, 1570.	600
	Panel with figure of armed knight (Prague Museum).	510
	Kreussen polychrome ware:	
	Hunting tankard.	325
	Waldenburg (Saxony) tankard by Hans Glier.	200
	Siegburg stoneware: Schnelle, signed LW.	300
1910	Frohne, Copenhagen. Siegburg white schnelle with figure of Mars.	201
1911	Anton Hess, Munich. Complete Hafner ware stove, *c.* 1600.	275
	Nuremberg stove, *c.* 1620.	240
1917	Oppenheim, Berlin. Miniature model of a Hafner ware stove, 12in.	420

£

1917	Paul Preuning jug, Judgement of Paris.	1,050
	Hafner ware jug, before 1550, with Imperial busts and The Fall of Man.	2,050
	Pyramidical brown-and-blue Raeren jug, 38in high, by Baldems Mennecken, c. 1580 (said to be in Oslo).	1,325
	Huge Raeren pitcher, 1576, Combat of Centaurs.	1,175
	Cologne (Maximinenstrasse) owl-jug, c. 1550.	455
	Cologne (Engelstein) 3-sided ewer.	330
	Siegburg ewer by Christian Knutgen.	350
	Siegburg schnelle, The Passion, signed LW.	355
	Ditto with Solomon and the Idol.	280
	Westerwald musketeer-jug, c. 1600.	150
	Kreussen tankard, 1668, The Planets.	100
	Hope heirlooms. C. Flagon, Raeren, 1577, signed Baldems Mennecken.	120 15s
1918	Murray Marks. C. Siegburg ewer, c. 1570, fluting and trellis-work.	47 5s
1921	Engel-Gros, Paris. Siegburg armorial pilgrim bottle, c. 1570.	225
	C. Siegburg tankard with figures.	50 8s
1925	Sir Francis Cook. C. Hafner ware owl-shaped jar and cover, 1544.	294
1940	S. Preuning vase, Sacrifice of Isaac.	43
1946	S. Hafner ware jar by Paul Preuning.	41
1948	Lempertz, Cologne. Siegburg schnelle, 11in, late 16th cent.	34
1958	Earl of Powis. S. Mask-vase, 18in, Raeren, dated 1598.	36
1962	Igo Levi, Munich (Weinmueller). 2 Hafner ware stove tiles, c. 1550, forming niches with full-length reliefs of Duke and Duchess of Landshut. 2 for	3,256

TAPESTRY

£

1778 Old Somerset House. Haman and Mordecai, late 15th-
cent. panel, 20ft×10ft, offered at 1 11s 6d

1797 Sale by the French Military Commissioners, Rome. The
10 panels from the Vatican, Raphael's Acts of the Apostles,
Flanders, 1519. 10 for 3,000

1807 The Vatican Raphael tapestries sold back to the Pope,
having cost the vendor (Devaux) for part of the series. 7 for 325

1820 From the Painted Chamber, Westminster, removed in 1799.
The Great History of Troy, suite of 5, 140 ft long, late 15th
cent., sold to Charles Yarnold (now lost). 5 for 10

1843 Mgr Angebault, Bishop of Angers, buys back the Apoca-
lypse Tapestry from the civil administration for 300 fr.
Made between 1377 and 1388, original length 478ft (now
Angers Museum). all for 12

1846 Baron, Paris. A single Flanders panel, "temps de Louis
XII", Adoration of the Magi, presumably before 1515.
Probably the first late Gothic tapestry to fetch real money
(see 1859). 84

1848 Stolen panel from the 7 Vices at Hampton Court, sold for
a few shillings (see 1910).

1853 Ex-King Louis Philippe. C. The Hunts of Maximilian,
suite woven by François Guebels towards 1550, after
Bernard van Orley, Brussels; still partly Gothic in spite of
the date (acquired by the Louvre in 1878) (see 1900). 10 for 250
Another Brussels set of 6 of possibly the same period.
6 for 32

1856 V & A purchases German long panel, c. 1470, 11¼ft×3ft
scenes from the life of a female monastic saint. 10

1858 David Falcke. C. "The celebrated Plantaganet Tapes-
try", 10ft×22ft, 22 figures, variously described as the
Marriage of Henry VI and the Marriage of Henry VII.
Had belonged to Charles Yarnold and may have formed
part of the Westminster Palace suite (see 1820). 15
A smaller late Gothic panel, 9ft×6ft. 5 10s

1859 Jules Soulages Coll. V & A buys 3 moderate-sized
Brussels panels, c. 1500–20. ⌠2 for 50
⌡1 for 18
Rattier, Paris. The Baron Adoration Panel (see 1846). 87 10s

1860 The French Government gives £160 towards the restora-
tion of the Angers 14th-cent. tapestries (see 1843).

669

£

1866 V & A purchases 2 Flemish panels, *c.* 1500:

 Judgement of Solomon, 12ft× 9ft. 9 9s 5d

 Eather and Ahasueras, 9ft× 6½ft. 5 5s 2d

1868 Marchese d'Azeglio. C. The Triumphs of Andrea Doria, said to have been designed by Perino della Vaga in the manner of the Raphael Tapestries, *c.* 1540, bought-in.

 4 for 43 10s

1870 Signor Cerri. C. 2 Brussels panels, 1st half 16th cent., after Bernard van Orly:

 Triumph of Life. 33 10s

 Triumph of Death. 11 5s

 San Donato, Paris. Brussels panel, dated 1558, in style of van Orley, Absalom at the Chase, 11ft 3in× 10ft 4in. 60

1872 V & A buys Susanna and the Elders, Flanders panel, largely in silk, *c.* 1510, with arms of Augsburg families. 200

1874 The Chapter of Angers Cathedral buys a fragment of the Life of St Maurille, 1461. 3 4s

1875 Séchan, Paris. 4 panels from the Tournai Series, The Months of the Year, *c.* 1520. 4 for 1,000

1877 Marquess of Stafford. C. Gothic tapestry, The Crucifixion, 18ft long. 31 10s

 Duke of Berwick and Alba, Paris. Italian tapestries, early 16th cent.:

 Ferrara, Entombment, gold and silver. 600

 Ferrara, 9 allegorical figures. 672

 Florence, Crucifixion, 7½ft× 8ft. 804

 Flemish tapestries, Passion of Christ, Tournai suite of 4, *c.* 1520, viz.:

 Baptism of Christ, 41 figures, *c.* 1520 (1st panel to cost over £1,000 in a sale-room). 1,365

 Agony in the Garden. 720

 Via Crucis. 1,000

 Crucifixion. 1,000

1878 Paris. 15th-cent. panel of a shepherd and shepherdess, with amusing verses in old French, used recently as a shelter for a donkey. 60

1880 Carrington. C. The Triumph of Justice, mid-16th-cent. Brussels tapestry after Mantegna, 3 panels. {189 147 136

1881 Paris. 4 Oudenarde panels, late 15th cent., fruit and flowers on a vast scale. per panel 66

1883 La Dame au Licorne. Suite of 6 Tournai panels sequestered from the Château de Boussac in 1793 and bought from the Municipality by the Musée de Cluny, *c.* 1460–70 (a later and inferior version was sold in 1923, *q.v.*). 6 for 1,000

 V & A buys 3 panels from a gold-thread Tournai suite of 1507: The Triumph of Fame, Death, and Chastity after Petrarch. 3 for 2,800

£

1885 Vaissé, Paris. Single panel, St Ambrose of Ravenna, *c.* 1520, bought by Lyons Museum. 1 for 1,202

Large 15th-cent. tapestry with 94 personages in rich costumes. 124

1887 de Salvarte, Paris. Passage of the Red Sea, numerous figures, before 1500. 320

Unnamed sale. The History of Vulcan, Brussels, 16th cent., bought-in. 4 for 4,000

V & A buys from M. Jubinal, The Adventures of Penthesilaa from the suite, The Wars of Troy, Tournai, *c.* 1470 (formerly Bibliothéque Nationale). 1 for 1,200

1889 Belgian Government buys the Romulus and Remus Suite, Brussels, *c.* 1520. 8 for 7,000

Tollin, Paris. Late 15th-cent. panel, Adoration of the Magi. 660

V & A buys Adoration of the Magi, small panel, *c.* 1510. 1,176 9s 5d

1890 V & A buys pane from the Hampton Court Combat of Vices and Virtues Suite (see 1910), Pity restraining Justice, Brussels, *c.* 1520. 550

1892 Hollingworth Magniac. C. Garden panel, Aubusson, early 16th cent. 693

1893 V & A buys The Courts of War, Love and Religion, single Brussels panel, *c.* 1521, 13½ft × 8ft. 315

1893 Frederick Spitzer, Paris. Miracles of Our Lady of Sablons, suite of 2 large and 6 small panels, Brussels, 1518:

 Arrival of the Image in Brussels (Brussels Museum). 3,280

 Cost of the whole series (see 1963). 8 for 6,000

 The Riposo, Tournai, *c.* 1500 (see 1912, 1934). 2,800

 Adoration, Italian, *c.* 1520. 2,040

 Annunciation, Italian, *c.* 1520. 1,460

1894 Malcolm. C. Brussels suite, early 16th cent. 8 for 1,020

1896 V & A buys Brussels panel from the Courts of Love, etc., *c.* 1500. 595

1898 V & A buys 2 modern tapestries in late mediaeval style by Edward Burne-Jones, woven at Merton Abbey:

 8ft × 6ft 8in. 225

 15½ft × 7¼ft. 405

(Country sale.) English 15th-cent. panel (see 1928, 1946). 98

Martin Heckscher. C. Life of Christ, late 15th cent., Tournai. 3 for 680

Perseus, Burgundian, *c.* 1480, 11ft square. 590

Eudel, Paris. Triumph of Prudence, Brussels, *c.* 1520. 1,080

1900 Moreau-Nelaton, Paris. A panel from the Hunts of Maximilian, *c.* 1550 (see 1853). 680

Lequiers. C. Early 16th-cent. Brussels. 5 for 2,330

1901 de Somzée, Brussels. The Passion of Christ, late 15th-cent. Tournai panel, bought for Brussels Museum. 2,800

 Roland at Roncevaux (before 1450), bought for Brussels Museum. 780

£

1901	Bathesheba at the Fountain, Brussels, after 1500 (see 1904).		3,000
	Stories of Eresichthon and Mestra, Brussels, both bought-in (see 1904).	2 for	3,120
	The Resurrection, Brussels, after 1500.		1,280
1902	Aubusson suite, garden scenes, c. 1500.	5 for	4,000
	C. Mme Lelong, Paris. 2 15th-cent. panels, Tournai or Oudenard.	2 for	1,600
	With silver thread, numerous figures, Brussels, early 16th cent.		2,440
	Another Hunt of Maximilian panel, c. 1530 (see 1853, 1900).		1,860

Record price for a single tapestry panel: Duveen buys in Bordeaux a single panel, formerly belonging to Cardinal Mazarin, The Adoration of God the Father, Tournai or Arras, c. 1500, mainly carried out in gold and silver threads. 12,000
Sold by Duveen Bros. the same year to J. Pierpont Morgan (now Washington National Gallery), price, according to James Duveen, £65,000; according to Francis Taylor, £72,055.

1905	C. Burgundian late 15th-cent. suite, bought-in.	6 for	4,725
1904	de Somzée, Brussels. Eresichthon and Mestra (see 1901).	2 for	4,600
	Bathsheba at the Fountain, Flemish, early 16th cent., over 50 figures (see 1901).		4,000
1909	James Garland, New York. 15th-cent. French panel, The Pietà.		3,400
	Metropolitan Museum buys La Baillée des Roses, French, before 1460.	3 for	14,000
1910	Lowengard, Paris. 15th-cent. panel, Bible scenes.		2,400
	The Prodigal Son, 15th cent.	2 for	16,160
	At Puttick and Simsons. Late 15th-cent. panel from Hampton Court, The Seven Vices (see also 1890), bought by Marquess of Anglesey (presented to Hampton Court by subscribers, 1921).		6,600
1911	J. Pierpont Morgan buys 8 panels of gold-ground Tournai tapestry from Lord Sackville, Knole, through Duveen. (Valued for the Metropolitan Museum on Morgan's death in 1913 at £115,000 for the suite of 8.)	8 for	67,100
1912	J. E. Taylor. C. The Riposo, Tournai, c. 1500 (see 1893, 1934).		8,190
	Jean Dollfuss, Paris. History of Troy, c. 1470, single panel.		3,160
	The Credo and The Crucifixion, Brussels, after Bernard van Orley, c. 1520–30, bought by Seligman for Pierpont Morgan.	2 for	12,000

Duveen buys from Leopold Hirsch The Nine Worthies, a series of 14th-cent. panels and fragments, formerly at Les Aygalades; resold to Pierpont Morgan, price reputedly £100,000 (New York Cloisters Museum) (see 1932).

£

1913	Lydig, New York. Single Tournai panel, *c.* 1510, Noli me Tangere, bought by Duveen.	8,500
	Sir Lionel Philips. C. 15th-cent. Burgundian suite. 4 for	14,700
	Aynard, Paris. Panel from The History of Alexander, *c.* 1520.	5,700
	Nativity, Flemish, after 1500.	4,400
1916	The Pierpont Morgan tapestries (see 1912). The Credo and The Crucifixion sold by Duveen to Joseph Widener. 2 for	103,300
1918	Paris. The Month of November, single panel from the Hunts of Maximilian (see 1853, 1900, 1902), after Bernard van Orley, *c.* 1530–50.	3,430
1919	Pasteur-Goulden, Paris. Tournai, *c.* 1500, a tournament scene.	5,880
	An audience scene, same period (38.50 fr. to £1).	6,200
	(December.) Manzi, Paris. Single mid-15th cent. panel with figures and verses (368,500 fr.).	8,200
1920	Cahen d'Anvers, Paris. Cupids in various occupations, Ferrara suite by Jean Karcher after Giovanni da Udine, gold thread, *c.* 1540. 6 for	22,700
1921	Lord St John of Bletso. S. 2 English needlework tapestries, *c.* 1520, 17ft and 13ft long (see 1930), bought-in. 2 for	3,100
	Engel-Gros, Paris. Swiss 15th-cent. suite of small panels, lovers in gardens, forming a frieze. 5 for	10,650
	Le Breton, Paris. Brussels, after Bernard van Orley, *c.* 1530. 3 for	6,200
1922	Howard Carter. C. The Lutterell armorial "table carpet", Flemish, *c.* 1520, from Dunster Castle.	5,565
1923	J. D. Rockefeller, Jnr, buys a second series of La Dame au Licorne, Tournai or Aubusson, *c.* 1509–16 (see 1883) (price, according to Metropolitan Museum *Bulletin*, $1,100,000), at that time 6 for	245,000
1924	Paris. French panel, *c.* 1500, 3 people hunting, bought by Duveen.	4,950
1926	Paris. 2 fragments, French, *c.* 1470. 2 for	2,700
1927	H. Symonds. S. Early 16th-cent. Burgundian panel, a queen enthroned.	5,000
1928	Sir Hercules Reed. C. English 15th-cent. panel (see 1898, 1946).	4,200
	C. Italian *verdure* panel, 16th cent.	1,575
1929	S. S German panel, *c.* 1500, 8ft 10in× 5ft.	3,200
	Paris. Small panel, *c.* 1520, arms of England and France.	1,420
	Brauer. C. French *verdure* panel, *c.* 1520.	7,350
	Weinberger, Berlin. Tournai panel, dated 1435, an allegory of Honour, 9ft× 8ft.	8,250
1930	Breitmeyer. C. 2 Brussels panels, *c.* 1520, David and Bathsheba, Aeneas and Dido, 11ft 6in× 13ft 6in. 2 for	7,350

£

1930	Lord St John of Bletso (at Hurcomb's). 2 English needle-work tapestries, c. 1520 (see 1921). 2 for	5,250
	Albert Figdor, Vienna. Brussels panel, c. 1500.	5,850
	Tournai gold-thread panel, late 15th cent., a king receiving tribute at the gate of a town. about	20,000
	Small 15th-cent. Nuremberg panels:	
	The Three Kings of the East.	2,800
	The Death of the Virgin.	4,000
	Fischer Auction Rooms, Lucerne. Tournai panel, c. 1515, episodes in the life of Octavianus Augustus.	8,000
	Vieweg, Berlin. Brussels panel, c. 1520, Madonna and 2 saints.	2,350
1931	Edmond Dollfuss, Paris. The Tree of Justice, 15th-cent. panel, 4ft × 8ft.	2,870
	Seaport with Oriental figures from the suite, The Conquest of the Indies, Brussels, c. 1520 (see 1938).	1,680
	Continental source (said to be USSR). C. A small 15th-cent. panel of the Adoration, 9ft × 7ft 8in, believed Brussels, bought by Prince Paul of Jugoslavia.	17,850
	Brussels panel, c. 1500, The Jesse Tree, nearly 15ft long (same purchaser).	6,090
	Denzil Cope. S. 2 Brussels panels, c. 1520, from a Life of the Virgin suite. 2 for	6,000
1932	Purchases for the Metropolitan Museum:	
	King Arthur, missing panel from the late 14th-cent. series, The Nine Worthies (see 1912).	15,000
	The Fall of Troy, dated 1472, Tournai panel, nearly 16ft, gold thread.	17,500
	S. Alsatian panel, The Pietà, c. 1480, 5ft × 3ft.	1,350
1933	S. Thuringian long tapestry strip, 15th cent.	1,200
	T. F. Bradley, New York. Single small Brussels panel, c. 1520.	2,250
1934	Leopold Hirsch. C. The Riposo, Tournai panel, c. 1500 (see 1893 Spitzer sale and 1912 Taylor sale).	5,670
	Howard. S. Altar frontal, Holy Family, Flemish, c. 1500.	3,400
1935	Edison Bradley. C. Panel from the Great History of Troy, c. 1520.	3,465
	Ira Haupt, New York. Small panel, Brussels, c. 1510.	2,675
1937	Bradey, New York. 3 Tournai panels, c. 1500, The Seasons. 3 for	2,130
1938	Durlacher. C. Altar frontal, Arras, late 15th cent., arms of Ferdinand and Isabella.	1,995
	Rufford Abbey. C. 2 panels from the allegory of Chastity, Brussels, c. 1520–30.	{ 808 10s { 819
	S. Suite from the Conquest of the Indies, Brussels, 1st half 16th cent. (see 1931). 4 for	2,050

£

		£
1942	Charles McKann, New York. Triumph of Scipio Africanus, huge Brussels panel, Pannemaker, c. 1540.	1,375
1946	Humphrey Noble. S. English 15th-cent. panel (see 1928), only 3ft× 4ft.	5,400
1947	Humphrey Cook. C. Brussels panel, c. 1520, court scene.	1,260
1949	Paris. 19ft Aubusson panel, c. 1500, with hunting figures. about	2,400
1950	Paris. Brussels gold-thread panel, c. 1520, The Court of Love. about	12,200
1952	Quill-Jones, New York. 15th-cent. Arras panel, The Unicorn.	1,585
1954	Catherine Butterworth, New York. Single panel, c. 1480, by Jean le Quien, Tournai, 12ft 5in× 7ft.	1,950
1956	Baroness Cassel von Doorn, Paris. 2 panels. Tournai, c. 1520, with hunting and hawking scenes:	
	10ft 10in× 14ft.	7,750
	11ft× 11ft.	6,820
1962	S. V & A buys fragment dated 1455 from the Chanson de Roland Suite, 85in× 74in, The Battle of Roncesvaux.	2,300
	Tournai panel illustrating Book of Revelation, 1525.	3,200
	Tournai *mille fleurs* panel, 10½ft.× 9ft, The Lady and the Falconer, c. 1510.	2,200
1963	Paris. Single Brussels panel, early 16th cent.	6,200
	Lord Aster of Hever. C. 3 panels from the Miracles of Our Lady of Sablons, Brussels, 1518 (see 1893, Spitzer sale, £1,320). 3 for	5,250
	Roland at Roncesvaux, French upright panel, c. 1470 (compare, 1901, 1962).	3,780

TAPESTRY

LATE RENAISSANCE (1550–1660)

Mainly Brussels
also Fontainebleau, Sheldon, Mortlake, etc.

£

1781 Sheldon (at Weston, Warwickshire). 5 tapestry maps of English counties, made by the Sheldon Weavers, late 16th and early 17th cent., bought by Horace Walpole (now Bodleian Library and V & A) (see 1842, 1920, 1937, 1960).
 5 for 31 10s

1842 Waldegrave, Strawberry Hill (*ex* Walpole). Sheldon Weavers, Map of part of Warwickshire, *c.* 1647 (see 1781, 1920, 1960). 12

1866 C. Panel of allegorical figures, 24ft× 11½ft, by van Schoor, an Oudenarde weaver of the early 17th cent. 16 2s 6d

1869 V & A purchases Gerusalemme Liberata, 2 panels and 3 strips, Italian, 17th cent. 5 for 200
 Hospice d'Angers. ˉ 10 late 16th and 17th cent. panels, bought for Cathedral Chapter by Canon Joubert. 10 for 48 10s

1877 Duke of Berwick and Alba, Paris. Victories of the Duke of Alva, Brussels, *c.* 1580. per panel, 200–320

1885 Vaissé, Paris. Cupid and Psyche, late 16th cent. 4 for 1,100

1890 Craven. C. Brussels Teniers tapestry, late 17th cent. 367

1892 Roudillon, Paris. Brussels Teniers panel. 684

1893 C. Brussels, Ovid's *Metamorphoses, c.* 1600. 5 for 890

1894 Attenborough. C. Brussels Teniers suite. 8 for 1,150
 Brussels suite. 8 for 1,659

1894 Paris. Brussels suite after Giulio Romano, History of Scipio Africanus, mid-16th cent. 3 for 800

1897 The Four Quarters of the Globe, by Beurcht Brussels, late 16th cent. (V & A). 4 for 1,732
 Braquenié, Paris. Paris tapestries, *c.* 1650, by Lefebvre, Rape of the Sabines, 12ft× 14½ft. 384

1898 V & A buys Mortlake panel from the History of Vulcan, device of Charles II as Prince of Wales, *c.* 1640. 800

1900 Paris. Suite, Triumphs of Charles V, Brussels, *c.* 1600.
 7 for 2,400

1905 C. Brussels, late 17th-cent. suite. 5 for 4,515
 Rochard, Paris. Single Brussels panel, *c.* 1650. 1,320

1920 Quenby Hall (Knight, Frank). Tropical Hunts, Brussels, *c.* 1570. 4 for 4,300

1921 Stowe. C. Triumphs of the Gods, Brussels suite by V. Leyniers, early 17th cent. 5 for 8,400

£

1921	Birkbeck. S. Map of Warwickshire, 1647, made by the Sheldon Weavers (see 1781, 1842, 1960).	1,010
1924	Duke of Cumberland. Battle of the Issus, signed by V. Leyniers, Brussels, late 16th cent.	1,207 10s
	At Anderson's, New York. Band, 17½ft× 3ft, German, dated 1554.	3,100
1925	Lesieur-Manset, Paris. Bed-cover, Fontainebleau Weavers, c. 1580.	2,400
1926	C. Brussels suite by Jean Raes, late 16th cent., Story of Tobias. 5 for	3,517 10s
1927	Hon. Mrs Yorke. C. Pluto and Proserpine, mid-17th-cent. panel by Leyniers, 12ft 7in× 14ft 8in.	1,417 10s
	Paris. History of Diana, suite by van der Dries after Rubens. 5 for	3,040
1928	Battle Abbey. C. Tancred and Clarinda, Paris suite, c. 1660. 6 for	1,780
1929	Colonel Lowther, Herstmonceux. C. Single panel, History of Alexander the Great by Leyniers, Brussels, mid-17th cent.	1,522 10s
	Lord Yarborough. S. Brussels suite by de Vos after Teniers, late 17th cent. 4 for	2,150
1930	C. Musicians, single panel by the Sheldon Weavers, English, c. 1560.	1,008
	Brussels panel, over 18ft, winter scene after Lucas van Leyden, c. 1660.	2,577 10s
1933	Viscountess Cowdray. S. Late 16th-cent. Brussels suite by Geubels after Raphael, Vertumnus and Pomona, bought-in. 4 for	1,800
1934	Col. Henry Howard. S. Sheldon Weavers, bed-valence, made in 1560, bought-in.	1,750
1936	Earl of Dudley. C. Sheldon Weavers, 2 portions of a map of Gloucestershire, 1647 (see 1920, 1960), bought by E. D. Guiness. 2 for	1,008
1943	Mrs Harris Lebus. C. The Hunts of Diana, Brussels suite by Anwercx and van Leefdael, c. 1600. 7 for	3,360
1945	R. W. M. Walker. C. Suite of garden panels by Frans Coppens, late 16th cent. 3 for	1,785
1946	C. Sheldon Weavers, English armorial panel, associated with Yarmouth.	756
	Table-cover, c. 1560, fruit and flowers.	630
1947	Hanbury. C. Mortlake suite, c. 1660, after Raphael's Vatican cartoons. 8 for	1,732 10s
	Brussels, de Vos after Teniers, c. 1660–80. 2 for	1,417 10s
1949	S. 2 cut-down county maps by the Sheldon Weavers, 1647. 2 for	520
1958	S. The Lewknor Table Carpet, tapestry made by the Sheldon Weavers, 1562, bought-in.	16,500

£

1960 Yorkshire Philosophical society. Map of Warwickshire,
 1647, made by the Sheldon Weavers (see 1781, 1842, 1920)
 (V & A). 6,000
1961 Cedars of Lebanon Hospital, Los Angeles. S. Life of
 Alexander the Great, 4 panels after de Vos, Brussels, early
 17th cent. 4 for 1,500
 C. V & A buys Bath of Diana after Toussaint Dubreuil,
 12ft × 20ft, c. 1600 (Fontainebleau). 1,522
 Norwegian 17th-cent. armorial tapestry. 1,470
1962 C. 2 Brussels panels, 11ft × 16½ft, Roman battle scenes,
 early 17th cent. 2 for 1,785
1963 S. Brussels panel, 13ft 6in × 15ft 4in, mid 17th cent.
 Story of Perseus. 1,800
 Lord Astor of Hever. C. Enghien panel, c. 1550, fruit
 and flowers, 13½ft. × 15½ft. 4,725

TAPESTRY

LOUIS XIV–LOUIS XVI (AFTER 1660)
Gobelins and Beauvais (some Brussels and English included)

£

1756 Duc de Tallard, Paris. Flemish suite (Brussels), History of David, narrow strips, 65ells× 4ells. 11 for 120

1770 Beringhen, Paris. Beauvais suite after Oudry, a hunt. 4 for 72

Count de Sielern. C. A suite of 6 "historical", bought-in. 6 for 59 10s

Suite of 4, The 4 Quarters of the Globe (compare 1788), with 2 unconnected panels, Justice and Turkey, all of large size. 6 for 22

Earl of Blessington. C. Suite of 4 after Watteau, Rural Amusements (possibly the known Watteau suite of this subject by Bradshaw of Soho). 4 for 22 1s

1772 A person of rank. C. 3 pieces with Chinese figures (possibly part of Boucher's Tenture Chinoise, first woven in 1743). 3 for 21

1773 C. "The beauties of the animal creation." Not identified (perhaps The Terrestrial Paradise, by Jan Laniers), Brussels, late 17th cent., suite of 4, 16½ft× 13½ft each, bought-in. 4 for 357

5 panels, probably after Teniers, including a frost scene and a fish-market. 5 for 53 11s

1774 C. Mixed suite of 5 "amusements of the Flemings in their respective seasons" (probably after Teniers). 4 for 23 2s

1776 Nathaniel de St André. C. Brussels hunting suite of 4, 11ft to 17ft× 10ft 3in. 4 for 52 10s

Gobelins suite, Triumphs of Alexander, after Charles Lebrun, bought-in (see 1779). 5 for 126

Teniers, Brussels suite, Rural Occupations, bought-in. 4 for 309 15s

1778 Lady of fashion. C. The 4 Quarters of the Globe (see 1770), "Fine condition", bought-in. 4 for 178 10s

1779 Nathaniel de St André. C. The Triumphs of Alexander the Great, Gobelins, after Charles Lebrun (see 1776). 5 for 52 10s

1787 Princess Amelia. C. Suite of 5, ruins and landscapes after Zuccarelli, each about 10ft square (almost certainly by Paul Saunders, Soho). 5 for 21 10s 6d

C. Gobelins suite of 5 floral panels with 2 portiéres. 7 for 20 9s 6d

Brussels suite after Teniers. 4 for 125

£

1788　Count d'Adhemer.　C.　Gobelins suite, The 4 quarters
of the Globe, each 14½ft× 13½ft high (see 1793), bought-
in, nominally.　　　　　　　　　　　　　　　4 for　483
　　　Lyde Brown.　C.　Brussels suite after Teniers.　4 for　105

1792　"A lady retiring at her villa, called Great Frogmore."　C.
Gobelins panels after Teniers, probably early 18th cent.:
　　　Suite of 4, each 12½ft by 9ft　　　　　　4 for　147
　　　Suite of 4, 17½ft× 12ft (presumably damaged or worn-
out).　　　　　　　　　　　　　　　4 for　8　8s
　　　2 allegorical panels, each 16ft× 10ft.　　　2 for　8　18s　6d

1793　Count d'Adhemer.　C.　Suite of 4, The 4 Quarters of the
Globe, each 14½ft× 13½ft (see 1788) (may have been fairly
new Gobelins, woven by Menou, or 17th-cent. Brussels by
van de Borch).　　　　　　　　　　　　　4 for　45　10s

1794　C.　A historical suite, each 12ft× 16ft.　　5 for　63

1801　Recently consigned from abroad.　C.　2 panels after
Teniers (Brussels?).　　　　　　　　　　2 for　5　7s　6d

1803　C.　Soho suite of 4, "made by the famous Paul Saunders
for Lord Bertie".　　　　　　　　　　　4 for　26　5s
　　　Francis Tyssen, Narborough House.　C.　Brussels suite
after David Teniers, "brilliant and finely preserved". 4 for　225　15s

1808　C.　Set of 5 Gobelins panels, mixed set, but all 10ft high,
one of them 28ft long, Apollo and the Muses, The Vintage,
Shipbuilding, Diana at the Chase, Vertumnus and Pomona.
　　　　　　　　　　　　　　　　　　5 for　7

1819　C.　Gobelins, landscape and mythological figures, 19ft× 7ft
(possibly after Claude Audran, Metamorphoses Suite, first
woven in 1717):
　　　Vertumnus and Pomona.　　　　　　　　　　5
　　　Pyramus and Thisbe.　　　　　　　　　　4　14s　6d
　　　Narcissus.　　　　　　　　　　　　　4　14s　6d

1821　C.　Gobelins mixed suite:
　　　Perseus and Andromeda, 15ft× 12½ft.　　　5　10s
　　　Allegory of Commerce, 10½ft× 10½ft.　　　11　0s　6d
　　　Dido entertaining Aeneas, 38ft× 12½ft.　　31　10s
　　　Brussels Teniers panel, The Village Kermesse.　16　6s　6d

1822　Wanstead House (Robins).　Described as Gobelins:
　　　2 panels, Romance of Alexander.　　　　2 for　27
　　　Alexander's Passage of the Granicus.　　　　63
　　　Calypso and Telemachus.　　　　　　　　43
　　　Venus descending on Earth.　　　　　　　44　2s
　　　Vulcan presenting Thunderbolts to Jove.　　42

1823　Farquhar, Fonthill (ex Beckford) (Philips).　Feast of the
Gods, 20ft× 13ft.　　　　　　　　　　　42
　　　Entry of Alexander into Babylon, after Charles Lebrun,
15ft× 13ft (see 1834, 1838).　　　　　　　40　19s
　　　Fête de Village, 25ft× 10ft, after Teniers.　　34　13s
　　　Gobelins version of one of the Raphael Vatican cartoons,
15ft× 9ft (compare 1852).　　　　　　　18　18s

£

1834 C. Commerce, allegorical Brussels suite late 17th cent.,
49ft× 8ft 9in (see 1838). 4 for 11 0s 6d
Le Brun, Alexander's entry into Babylon (perhaps the
Fonthill panel: see 1823; see also 1838). 9 9s 6d
Darius brought before Alexander (see 1838), same suite,
10ft× 11ft. 6 16s 6d
The following are Beauvais panels from the Tenture des
Dieux by Neilson after Boucher, 1770 or later:
Triumph of Neptune. 17 17s
Venus and Adonis and Venus rising from the Sea (all these
en medaillon). 2 for 21 11s 11d
1838 C. Commerce, Brussels suite (see 1834). 4 for 4
Alexander's Entry into Babylon (see 1834). 2 12s 6d
Darius before Alexander (see 1834), Lebrun suite (com-
pare 1877). 3
1844 Thomas Thomas. C. Brussels suite of 4. 4 for 17 15s
1848 Duke of Buckingham, Stowe. C. 2 Beauvais lambre-
quins after Boucher.

 {21
 {37 16s

1849 Thomas Blaydes. C. Portrait tapestry panel, the Regent
Duke of Orleans, Gobelins, *c.* 1720, in carved frame,
bought-in. 17 17s
Town and Emanuel. C. Sacrifice of Iphigeneia, woven
at Gobelins for Napoleon, with crown and N cypher,
bought-in. 200
1852 William Cox. C. The Death of Ananias, Gobelins
panel, 16ft 6in × 9ft 6in. 1 of several suites, late 17th or early
18th cent., imitating Raphael's Acts of the Apostles Suite
in the Vatican. (See 1854, 1876. Apparently the first
tapestry panel to make £100 at Christie's.) 109 18s
Henry Vint. C. 4 Gobelins panels, 10ft high, 10ft–17ft
wide, illustrating the loves of the gods. 4 for 29 18s
Duc de Stacpoole, Paris. 2 Beauvais panels from La noble
Pastorale after Boucher (see 1881, 1905, 1908, 1916, 1927).
 2 for 496
 4 portières or door-panels, *en suite* with the above. 4 for 224
1853 King Louis Philippe. C. Hangings from the Château
d'Eu, described as Beauvais, but period not specified:
Pair of portières. 2 for 43 1s
4 lambrequins and 8 cantonnières. 12 for 131 8s
1854 C. Death of Ananias (see 1852), 16ft 6in× 9ft 6in. 6
Pan and Flora, Gobelins, 18ft × 12ft, bought-in. 7 17s 6d
1857 King Louis Philippe. C. Beauvais hangings, described as
modern, from the Duchesse d'Orleans: 1 lambrequin and
2 cantonnières. 3 for 152 5s
A great many other curtain strips, etc.
The de Goncourt Journal: "Des lambrequins de Gobelins
à 3,500 francs." (£140.)

£

1862	Paris. 2 Don Quixote Gobelins panels after Coypel. 2 for	20	
1863	Voisin, Angers. Lord Hertford buys 4 Louis XV portière panels, Music, Dancing, etc. 4 for	320	
	Single Beauvais panel, over 20ft long, from the *Garde Meuble*, after Watteau.	124	8s
1863	William Russel. C. Mortlake Raphael tapestry, late 17th cent., Christ's Charge to Peter, 15ft 8in × 10ft 3in.	3	10s
1864	Earl of Clare. C. Europa and the Bull, Beauvais Boucher panel from Les Amours des Dieux, 1757, 8ft 10in × 7ft 10in, bought-in at £13, but sold privately to Pratt (see 1928) for	20	
1866	C. Suite of 4, illustrating Homer, each 10ft × 8½ft, possibly by Audran after the Coypel Brothers, *Iliad* suite of 1722–32 (see 1963). 4 for	70	5s
1868	Unnamed sale, Paris. 6 lambrequins by Neilson, 1778. 6 for	656	
	Gobelins, c. 1700, Louis XIV holding an audience, with Royal blazon in border.	200	
1869	Frank Davis. C. 2 Curtain-sets (*ex* Château d'Eu), Beauvais, early 19th cent., bought-in. 2 for	115	10s
1870	Marjoribanks. C. 15 small curtain and furnishing pieces from the Château d'Eu (*ex* Louis Philippe). 15 for	162	15s
	San Donato, Paris. Brussels suite, c. 1680, Life of St Paul, after Jean Berain. 5 for	240	
1872	Paris. 5 Gobelins panels, Months of the Year (Berain?), c. 1680. 5 for	546	
1873	Paris. Gobelins suite after Boucher, with medallion heads on white, c. 1770. 4 for	183	
1876	C. 5 Gobelins panels, dated 1734, after Raphael's Vatican cartoons. 5 for	715	
	5 Don Quixote panels after Audran. 5 for	220	
1877	Marquess of Stafford. C. A panel from the Triumphs of Alexander, after Charles Lebrun, c. 1700.	199	10s
	Duke of Berwick and Alba, Paris. 4 Gobelins panels, Louis XV, the Tenture des Indes, after Desportes. 4 for	980	
1878	Paris. Mme de Montespan's suite of Gobelins from the Château d'Oiron, some signed Lefebvre, c. 1670. 5 for	302	
1881	Marquis de Salamanca. C. The History of Jason, Claude Audran after de Troy, Gobelins, c. 1740, the 1st tapestry to make £1,000 a panel at Christie's (see 1950). 4 for	4,882	10s
	Paris. 2 panels after Claude Audran. 2 for	1,160	
	2 representing *châteaux*, after Charles Lebrun. 2 for	1,416	
	Leopold Double, Paris. 2 Boucher Beauvais panels (see 1852), bought by Schneider. 2 for	2,400	
	Single Don Quixote panel (see 1925).	418	
1882	2 huge tapestries, Gobelins, after Charles Lebrun, Fire and Water, valued for the Paris Hôtel de Ville (compare 1918).	{2,720 {2,900	

£

1882 Hamilton Palace. C. Gobelins suite of 8, Gerusalemme
Liberata, by Nouzou, 1735, and Ferloni. 8 for 3,013 10s
 The dearest panels, 12ft×21½ft. ⎰882
 ⎱488 5s
1884 C. 2 Beauvais Chinoiserie panels. 766 10s
de Ginzbourg, Paris. 5 Don Quixote panels after Charles
Coypel, Gobelins (see 1905) (1st tapestries to make £1,400
a panel). 5 for 7,000
 Brussels panel, dated 1660. 500
 Gobelins, 12 months of the Year, by Jean Berain, 1680
 (compare single panels, 1893, 1930). 12 for 2,480
Paris. 2 panels, Daphnis and Chloe, by Jaus and Lefebvre
after Antoine Coypel, c. 1715. 2 for 2,920
1885 Hughe. C. Rinaldo and Armida, late 17th cent. 6 for 1,050
Mme Lucie Dekerme, Paris. Beauvais suite, The History
of Psyche, after Boucher (see 1887, 1905, 1919, 1925). 4 for 1,600
de la Berraudière, Paris. Single Boucher panel, La
Cueillette de Cerises. 276
1886 Lippmann, Paris. Gobelins garden suite after Lenôtre and
Berain, late 17th cent. 5 for 1,100
1887 Samuel Bernard, Paris. 5 Boucher panels from The Story
of Psyche (see 1885, 1905, 1919, 1925). 5 for 1,504
 Aubusson, suite, Royal châteaux after Oudry. 4 for 564
Paris. Petit point suite, silver thread, after Audran, late
17th cent. 6 for 1,800
1888 Hamburger, Paris. By Delacroix after Vandermeulen,
Gobelins, c. 1720, Siege of a Town. 1,000
1889 Secrètan, Paris. Actors and Acrobats, by Jean Berain,
Gobelins, after 1700. 5 for 3,400
1890 Lancey, Paris. Triumph of Amphitrite, Gobelins panel
after Boucher. 1,040
1892 Mme d'Yvon, Paris. By Duchaine, Gobelins, c. 1720,
3 panels. ⎧1,040
 ⎨1,240
 ⎩1,600
1893 Paris. Fête Champêtre, single scene on 2 panels. 1,480
 By Neilson, c. 1770, a series of 6. 6 for 2,476
Frederick Spitzer, Paris. Bacchanalia, by Lefebvre,
Gobelins, 1660. 4 for 1,880
Camondo, Paris. Large panel, Gobelins, dated 1670, Le
Château de Montceaux en Decembre. 1,482
1896 D. de G., Paris. Single panel from l'Histoire du Roi by
Lebrun, c. 1710, The Treaty with the Swiss. 3,200
Bacchus, by Cozette after Audran, from La Tenture des
Dieux. 1,680
Contrepartie of the same. 1,080
Ceres, from the same suite. 1,440
Venus and Vulcan from a Gobelins suite (see 1898).
 3 for 1,800

£

1898 Paris. Les Scénes d'Opera, by Michel Audran after
Charles Coypel, 1763–5. 4 for 6,520
Le Tenture des Dieux (see 1896), Cozette after Audran.
 4 for 6,680
London. V & A buys a single Mortlake panel, early 18th
cent. 800

1900 de Falbe. C. 4 Gobelins panels. 4 for 1,874
Pallavicino–Grimaldi, Genoa. The Armida and Orlando
Suite, by Monmergué and Lefebvre after Coypel, 1762,
bought by Henri de Rothschild, the 1st suite to reach
£5,000 a panel in open auction (see for this suite, 1926).
 4 for 23,400

1902 de Falbe. C. Single Beauvais panel after Boucher. 3,675

1903 Reginald Vaile. C. Les Fêtes italiennes, Beauvais suite
after Boucher (see 1923). 4 for 23,415
Chadordy, Paris. The Months of the Year after Lucas van
Leyden, single Gobelins panel, c. 1670 (see 1906). 1,200
Triumphs of Louis XIV, the Capture of Marsal, 1663,
Gobelins. 1,480
Mme Lelong, Paris. Orythaea abducted by Boreas, single
Beauvais panel from Les Amours des Dieux after Boucher
(see 1909). 5,680

1905 Don Quixote Suite, Gobelins, after Coypel, c. 1730 (ex King
of Spain). Said to have been sold by Duveen to Pierpont
Morgan at over £20,000 a panel (see 1884). 4 for 80,000
E. Cronier, Paris. The History of Psyche, Louis XV
Beauvais, after Boucher:
(1) The Sisters of Psyche. 12,000
(2) L'Abandon. 3,240
(3) Le Vanneur. 4,080
La Noble pastorale, after Boucher:
(1) La Pêche (see 1908). 4,080
(2) Les Plaisirs Champêtres. 5,000
Don Quixote, Gobelins suite after Coypel, Régence, 2
panels and 2 strips. 4 for 8,000
Comèdie Italienne after Watteau and Gillot, Gobelins
Louis XV suite. 2 for 6,320

1906 Baronne de Hirsch, Paris. The Gods of the Sea, Beauvais
suite, before 1700, Behagle after Berain. 2 for 15,840
Prince de Beauvau, Paris. Triumphs of Louis XIV, single
panel. 1,995
Meurice, Paris. The Month of May, Gobelins, late 17th
cent. Lucas van Leyden suite (see 1903). 2,560

1907 Paris. Tenture des Dieux, after Audran, c. 1720 (see 1896). 2,489
Rikoff, Paris. Beauvais panels, Les Pastorales, after J. B.
Huet, c. 1770 (see 1957). 4 for 6,600

1908 Mme Debacker, Paris. Single panel from La Noble
Pastorale (see 1905). 4,820

£

1908 Henry Saye, Paris. 2 door-panels after Audran le Jeune,
from the suite Les Portières des Dieux (see 1937). 2 for 4,680
1909 Lord Amherst of Hackney. C. Triumphs of Louis XIV,
by Lebrun and Behagle after van der Meulen, c. 1680 (from
Schloss Moritzberg). 8 for 12,600
Polovtseff, Paris. The 4 Seasons, by Cozette, Gobelins,
1781. 4 for 15,004
Les Amours des Dieux, by Besnier, Oudry and Charron
after Boucher, c. 1750 (4 out of suite of 9):
Bacchus and Ariadne (see 1939). 19,100
Mars and Venus (see 1913). 6,050
Boreas and Orythaea (see 1903). 5,500
Vulcan and Venus (see 1927). 9,900
At least 6 sets were produced.
1910 Lowengard, Paris. Daphnis and Chloe, Gobelins, made
for the Regent, c. 1715, signed Lefebvre (see 1884). 4 for 14,040
1911 Parissot, Paris. Single panel from the Tenture des Chinois,
Besnier and Oudry after Boucher, Beauvais, 1743. 5,680
1912 Jacques Doucet, Paris. A single Boucher Beauvais panel
from Les Fêtes Italiennes. 5,960
1913 Murray Scott. C. 4 narrow Beauvais panels, 1740–50,
birds and animals. 4 for 18,900
Paris. Single panel from Les Amours des Dieux (see 1909,
1925), The Abduction of Proserpine, after Boucher. 7,084
Société Seligman, Paris. Single panel from Les Amours
des Dieux (see 1909, 1925), Mars and Venus. 7,744
Single panel from Les Bohémiens, by Charron after
Casanova, Louis XVI. 7,400
1915 Executors of J. Pierpont Morgan (to French & Co., New
York). Mass purchase for $2,500,000 (£515,000), mainly
of late Gothic tapestries, but including 3 Beauvais panels
from the Oudry suite illustrating Molière (see 1957), and 4
from the Coypel Don Quixote suite (see 1905). The
average price per panel for 40 pieces was close on £13,000,
but the Beauvais panels cost considerably more.
1916 C. English panel of birds and flowers, signed J. Morris,
1723. 2,047 10s
5 Boucher Beauvais panels from the suite called La Noble
Pastorale, sold by Duveen to Henry A. Huntington for
more than £20,000 a panel (for other panels from the suite
see 1927; also 1852, etc.). 5 for 103,300
1918 Duchesse de Trevise, Paris. The Elements, early Louis XV
Gobelins suite (compare 1882). 3 for 7,600
1919 C. Soho, single Chinoiserie panel. 4,725
Duveen sells Mrs Hamilton-Rice 5 panels from the suite,
The Story of Psyche, after Boucher, at over £30,000 a
panel (for other sales of this suite see 1887, 1905, 1925).
 5 for 155,000

£

1920 C. No outstanding prices for 18th-cent. tapestry, but 32
tapestry lots were sold in a single season at over £1,000
each, an all-time record.

1921 Le Breton, Paris. La Collation, a single panel from the
suite, Les Fêtes Italiennes (see 1903, 1912, 1923, 1926, 1927). 5,680

1922 Lord Craven. C. Louis XIV needlework panels made by
the ladies of St Cyr. 6 for 8,820
Marquise de Ganay, Paris. Single panel from Les Jeux
Russes, Beauvais, after Leprince, c. 1770 (see 1928). 4,000

1923 Sir Joseph Robinson. C. Les Fêtes Italiennes, after
Boucher (see 1903, 1912, 1921, 1926, 1927) bought-in. 4 for 18,900
Anthony de Rothschild. C. 4 Boucher panels, 8ft× 14ft,
Beauvais. 4 for 15,750
Unnamed. C. Single Boucher Gobelins panel, 10ft× 12ft. 3,990

1924 Château de Lailly, Paris. The 4 Seasons, Gobelins after
Lebrun, early 18th cent. 4 for about 4,000
Duke of Cumberland. C. Garden panel, 10ft× 12ft, said
to have been made at Chapel Izod, near Dublin, c. 1700. 1,350
Earl of Guilford. S. Set of Mortlake Chinoiserie panels,
varying sizes, early 18th cent. 4 for 6,800

1925 Gramont, Paris. The Toilet of Psyche from the Beauvais
series, The History of Psyche, much repaired, with modern
borders (630,000 fr. at 89 to the £1, plus 18%). See 1919. 8,300
Lehmann, Paris. Apollo and Clytie from the Beauvais
series, Les Amours des Dieux, after Boucher, part restored. 4,250
Don Quixote, Gobelins panel after Audran (see 1881). 3,100
4 white-ground Aubusson hangings, Louis XV, with
medallion portraits. 4 for 6,200

1926 Dutasta, Paris. La Curiosité from the Boucher Beauvais
series, Les Fêtes Italiennes (see 1903, 1912, 1921, 1923, 1927). 14,550
Late Lord Michelham (Hampton's). Single panel from the
Louis XVI Beauvais suite, Orlando Furioso, Clement Bayle
after Coypel. This is still (1963) the auction record for a
single panel; bought by Duveen. 19,950

1927 Unnamed, Paris. Further panels from the suite, Les Fêtes
Italiennes (see 1926), after Boucher:
La Danse. 14,640
La Musique. 12,400
La Chante (Musée Jacquemart André). 7,650
The Series of 6 made £48,000, with tax.
Cecil Rhodes. C. Soho suite, The 4 Continents, after
Van Schoor, 12ft× 12ft (see 1932). 4 for 3,150
Joseph Bardac, Paris. Small oval tapestry picture by
Cozette after van Loo, signed and dated 1763, La Peinture. 2,460
Château de Fleury, Paris. Vulcan and Venus, 23ft× 12ft,
from Les Amours des Dieux (see 1909), signed and dated
1749. 6,120
Mme de Polès, Paris. The Flute Lesson, from the suite, La
Noble Pastorale, after Boucher (see 1916). 11,200

£

1927	Princesse Eugènie. C. Gobelins Don Quixote suite after Audran. 7 for	14,170
1928	Marquis de X, Paris. Suite of 4 Beauvais panels after Oudry. 4 for	22,400
	Le Repas, from the Beauvais suite, Les Jeux Russes (see 1922).	3,925
	USSR Government sale, Berlin. From Les Amours des Dieux, The Rape of Europa (see 1864).	5,750
	Lord Glenarthur. C. Gobelins floral suite, 2 large, 4 small. 6 for	5,040
1929	C. Panel after Charles Coypel from the Tenture de l'Opèra, signed Cozette, 1766, Gobelins.	4,312 10s
	Lord Yarborough. S. 4 Mortlake panels by Vanderbank after Berain. 4 for	3,800
	Olympus, from the Gobelins suite, La Tenture des Dieux.	1,850
	(October.) The beginning of the world recession. A single panel from Les Amours des Dieux, Jupiter and Antiope, had been ordered from Messrs. French by Henry Walters of Baltimore at over £50,000. Sale cancelled (see 1931).	
	Vicomtesse d'Audigne, Paris. A Coypel Don Quixote panel with a reserve of £1,650, bought-in.	814
	Desfosses, Paris. Set of 4 Gobelins Chinoiserie panels after Leprince. 4 for	3,900
1930	C. Ovid's Metamorphoses, by Janssen, c. 1770, 4 small Gobelins, panels, 8ft× 10ft. 4 for	3,780
	Baumgarten, New York. Beauvais panel, Adventures of Telemachus, from the suite, The Temple of Love, after Arnault, c. 1680.	1,680
	Berlin. Gobelins panel, The Month of June, by Jaus after Berain, c. 1690 (see 1884, 1893).	2,920
	Paris. La Collation, from the suite, La Tenture Chinoise (see 1911), Beauvais, after Boucher.	790
1931	Banque Pacquement, Paris. Aubusson suite, c. 1770, after Huet, The Swing, The See-Saw, etc., each about 13ft wide. 4 for	1,400
	Duc de Vendôme, Paris. Les Portières des Renommées, suite of vertical panels in architectural setting by le Blond after Charles Coypel, c. 1720. 4 for	4,800
	S. The 4 Continents, supposed Boucher suite, said to have cost £3,150. 4 for	1,570
	Jupiter and Antiope (see 1929) finally sold to Paul Getty (compare panel sold in 1957).	13,450
1932	C. Soho suite, The 4 Continents (see 1927). 4 for	1,575
1933	C. 4-leaf screen with 8 Beauvais panels, The 4 Seasons, after Jean Berain (see 1954), bought-in.	1,554
1936	Cuthbert Quilter. C. Gobelins suite after Jules Berain, c. 1670. 4 for	5,250

£

1937 C. 3 door-panels from Les Portières des Dieux, Nielson
after Audran, c. 1770 (see 1908). 3 for 2,257 10s
Contesse de Greffulhe. S. Carved fire-screen with panel
from Les Fêtes Italiennes, after Boucher, Louis XV. 2,500
 22ft Beauvais panel from Les Fêtes Italiennes, by Besnier
 after Oudry, c. 1750. 1,750

1938 Ogden Mills, New York. From the Beauvais Boucher
suite, Les Fêtes Italiennes (see 1903, 1912, 1923, 1926, 1927):
Le Jardinier. 392
La Musique. 352
Mortimer Schiff. C. The Italian Grotesques, by Philippe
Behagle after Jules Berain, Gobelins, 1700. 5 for 3,045

1939 Mrs St George. S. Bacchus and Ariadne, from Boucher's
Les Amours de Dieux, bought by Paul Getty (see 1909). 2,700
 Similar panel was said to have been sold in the 1920s to
 Clarence McKay for over £20,000.
Clarence McKay. C. The Italian Grotesques (see 1938).
 4 for 1,522 10s

1940 Rosneath Castle (Dowells', Edinburgh). Narrow panels
with architectural figures of Bacchus, Jupiter, and Venus,
Beauvais, c. 1680. 3 for 997 10s

1943 S. Single panel from the Don Quixote suite, Gobelins
after Coypel, Louis XV (see 1905). 560

1947 Earl of Cadogan. C. 2 square Beauvais Chinoiserie
panels from La Première Tenture Chinoise, by Filleul Bros.,
c. 1750. 2 for 3,150

1948 Lord Rothschild. S. Brussels Don Quixote suite by van
de Hecke, late 17th cent. 6 for 2,900

1949 Sir Bernard Eckstein. S. Apollo and Corycia, from Les
Amours des Dieux, Beauvais panel by Charron, c. 1755–60,
after Boucher, 11ft × 10ft (Fitzwilliam Museum). (For
other panels in the suite, see 1903, 1909, 1913, 1925, 1927–9,
1931, 1939.) 2,400

1950 Hunstanton Hall. C. Lille suite, c. 1660–80, by Werniers
after Teniers. 4 for 1,575
C. The History of Jason, Gobelins suite after de Troy,
Louis XV (see 1881). 7 for 2,100
Paris. Aubusson suite, The Triumphs of the Gods after
Huet, c. 1770, 10ft panels. 5 for 2,450

1951 S. Beauvais Chinoiserie panel, 8ft × 14ft. 820

1952 S. The Grotesque Months of the Year, small Gobelins
Chinoiserie suite, 11ft × 7ft. 4 for 2,000
Tyrwhitt Drake. C. 3 very rich Soho panels by Vander-
bank, 1710. 3 for 2,100
Glen-Coats. C. 2 Beauvais panels, Flora and Zephyr,
Cupid and Psyche. 2 for 1,155
Lady Baron. C. Single Beauvais panel by Philippe
Behagle, c. 1690, from the Tenture Chinoise suite, Beauvais. 1,300

£

1953 Darley, Aldby Park. C. Europa and the Bull, from the
Gobelins Ovid suite, The Metamorphoses, mid-18th cent. 997 10s
Diana Resting and Cupid and Psyche, smaller Gobelins
panels. 2 for 1,050
S. The Grotesque Months (see 1952), 4 panels. 4 for 1,500
1954 Longuey-Higgins. C. 3 Soho panels, *c.* 1700, peasant
scenes after Teniers. 3 for 1,365
Marquis de V., Paris. Complete Don Quixote suite,
Gobelins after Charles Coypel, *c.* 1730 (see 1905), 13ft 7in
high, from 4ft 4in to 8ft 4in wide. 15 for about 29,000
Catherine Butterworth, New York. Single panel from the
smaller Don Quixote suite, after Audran, 11ft 10in × 9ft 2in. 2,500
Lempertz, Cologne. Single Beauvais panel, *c.* 1730, from
the Grand Mogul suite by Dumont. 1,028
Paris. 2 panels from the Scenes Militaires suite, *c.* 1715,
Brussels, Le Bivouac and Les Ordres de Bataille. 2 for 2,050
C. 4 panels, mythological scenes, Brussels, *c.* 1680, 11ft 8in
high. 4 for 2,625
Beauvais 4-leaf screen with small panels after Jean Berain,
c. 1740 (see 1933). 1,155
1956 C. Suite of architectural grotesques in the Raphael style
by Philippe Behagle after Berain and Monnoyer, *c.* 1700.
6 for 10,500
Paris. Single panel after Oudry, *c.* 1730, 11½ft × 15ft. 3,420
Parke-Bernet, New York. Soho panels by Joshua Morris,
dated 1723 and 1725, about 8ft × 14ft each. 2 for 6,080
1957 S. Philippe Behagle, Les Scènes d'Opera, Beauvais suite,
9ft 8in × 6ft 6in. 2 for 4,050
Gobelins suite, Summer and Autumn, 12ft 4in × 8ft 10in.
2 for 5,200
Jupiter and Antiope from Les Amours des Dieux, 11ft 6in
× 10ft 6in, after Boucher (for another example, see 1929,
1931). 3,400
Mae Rovensky, New York. The Molière suite after Oud-
ry, Beauvais, 1732 (*ex* Pierpont Morgan, see 1915), 10ft 8in
× 8ft 5in:
Le Malade Imaginaire. 13,250
Le Depit Amoureux. 9,660
L'Ecole des Maris. 6,450
Paris. Beauvais suite, Les Pastorales, after J. B. Huet (see
1908, etc.). 4 for 7,120
1959 C. 2 small panels, Soho Chinoiserie, early 18th cent. 2 for 5,670
Paris. Set of Gobelins Chinoiserie panels, dated 1721. 4 for 21,400
Set of 5 ditto, Aubusson, style of Boucher, narrow strips.
5 for 10,300
1960 C. Gobelins panel, *c.* 1720, after Teniers. 2,205
1961 S. Beauvais panel, Boucher style, nearly 16ft long, The
Polish Village. 3,000

£

1961 Olaf Hambro. S (at Linton Park). Lille panel, *c.* 1700, 17ft. 2,100

 The Arts of War, Gobelins panel after Audran, *c.* 1730. 5,370

1962 Lady Bailey (Cape Town). S. 2 panels from The Loves of the Gods (not the Boucher series, but a Gobelin suite after Audran), *c.* 1700. {1,750 / 1,450

 C. Brussels panel, The Fish Quay, after Teniers, *c.* 1700 (£378 in 1952). 2,100

 Paris. 2 Don Quixote panels, Audran after Charles Coypel, 1780. 2 for 7,125

1963 Paris. Fury of Achilles, Gobelins Iliad suite, *c.* 1720–30, 23½ft × 15½ft (see 1866). 1,895

 Lady Portarlington. S. Story of Diogenes, Mortlake, early 18th cent. 4 for 2,400

BIBLIOGRAPHY

The following list does not contain the many hundreds of printed catalogues which I have had to consult—for instance, the complete run of Christie's sales of objets d'art between 1766 and 1871. It has however been possible in the case of sales during the past hundred years to use abridged reports, the sources for which I have indicated. Month-to-month reports are found in *Chronique des Arts* from 1861 onwards and in the *Connoisseur* from 1903. Year-to-year reports were published by A. C. R. Carter in *The Year's Art* between 1882 and 1947. Excellent international reports are found in the volumes of *Kustpreisverzeichnis* since the last war. Other titles are of works which shed light on a variety of episodes, but I have purposely excluded standard works of art history which are not concerned with market matters.

ALEXANDER, BOYD *Life at Fonthill*. London, 1958.
 England's Wealthiest Son. London, 1962.
American Art News Mainly for the years 1910–20.
AVENEL, VISCOMTE D' *La Fortune privée à Travers les Siècles*. Abridged Edition, Paris, 1895.
AUDLEY, G., AND BOWES, J. *Japanese Pottery and Porcelain*. London, 1875.
BALZAC, HONORÉ *Le cousin Pons*. Paris, 1847.
BAUMGARTEN, SANDOR *La Crepuscule néo-classique, Thomas Hope*. Paris, 1958.
BECKFORD, WILLIAM *See* Alexander, Chapman, Melville, Oliver.
BEHRMAN, S. N. *Duveen*. London, 1952.
BLACKER, J. F. *An ABC of Collecting Old English China*. London, Second Edition, 1915.
BLANC, CHARLES *Le trésor de la curiosité, tiré des catalogues de vente*. 2 vols., Paris, 1857–8.
BOEHN, MAX VON *Das Empire*. Berlin, 1925.
BOHN, HENRY *A Guide to the Knowledge of Pottery, Porcelain, etc., comprising an Illustrated Catalogue of the Bernal Collection*. London, 1857.
BONNAFFÉ, EDMOND *Causeries sur l'Art et la Curiosité*. Paris, 1878.
 Etudes sur l'Art et la Curiosité. Paris 1902.
 La plus grande Vente du Siècle. Introduction to the illustrated folio catalogue of the Spitzer sale. Paris, 1893.
BRIMO, RÉNÉ *L'évolution du Goût aux Etats-Unis*. Paris, 1938.
CARTER, A. C. R. *Sales reports in The Year's Art, 1882–1947.
 Let Me Tell You. London, 1942.
CHAPMAN, GUY *Beckford*. London, 1937.
Chronique des Arts (originally *Chronique de l'Art et de la Curiosité*) Paris sales

reports and a few foreign sales, 1861–1922, continued to 1942 as *Beaux Arts* and thereafter as *Les Arts*.

Connoisseur, the Sales reports, 1903–56. Mainly London; a few foreign.

COURAJOD, LOUIS *Alexandre Lenoir, son Journal et le Musée des Monuments français*. Paris, 1878.

Introductory volume to *Le Livre Journal de Lazare Duvaux*. Paris, 1873.

CRIPPS-DAY, F. H. *A Record of Armour Sales, 1881–1924*. London, 1925.

DARCEL, ALFRED "La vente Soltykoff", *Gazette des beaux arts*, Vol. IX, 1861. Paris.

DAVILLER, BARON CHARLES "La Vente du Mobilier de Versaille pendant le Terreur", *Gazette des beaux arts*, Vol. XIV. Paris, 1867.

Les Porcelaines de Sèvres de Mme du Barry. Paris, 1870.

DORÉZ, LEON *Les MSS. à Peintures à Holkham Hall*. Paris, 1909.

DUNN, W. TREFFRY *Recollections of Rossetti and His Circle*. London, 1904.

DUPLESSIS, GUSTAVE VICTOR *La Vente des Tableaux au Dix-huitième Siècle*. Paris, 1874.

DU SARTEL, OSMOND *La Porcelaine de la Chine*. Paris, 1881.

DUVAUX, LAZARE *Le Livre Journal de Lazare Duvaux*. Ed. Louis Courajod, Paris, 1873.

DUVEEN, JAMES *The Rise of the House of Duveen*. London, 1957.

Secrets of an Art Dealer. London, 1937.

FARRINGTON, WILLIAM *The Farrington Diary, 1793–1817*. Ed. James Greig, 8 vols. London, 1922–8.

FORSTER, HENRY ROMSEY *The Stowe Catalogue, Priced and Annotated*. London, 1848.

FRANKS, AUGUSTUS WOLLASTON *Japanese Pottery, a Native Report*. South Kensington Museum Handbooks on Art. London, 1880.

GALBRAITH, J. K. *The Great Crash, 1929*. New York, 1959.

GONCOURT, EDMOND DE *La Maison d'Un Artiste*. 2 vols. Paris, 1881.

GONCOURT, EDMOND AND JULES DE *Journal des Goncourts, Mémoires de la Vie litteraire, 1856–1896*. 9 vols., Paris, 1881–96.

GRANDMAISON, CHARLES DE *Gaignières, ses Correspondents et ses Collections de Portraits*. Niort, 1892.

GULLAND, W. G. *Chinese Porcelain*. 2 vols. London, 1898, 1900.

HANNOVER, EMIL *Pottery and Porcelain*. 3 vols. London, 1923–5. (Considerable information on prices.)

HAZLITT, WILLIAM Critical articles in the *London Magazine*, 1823. Reprinted in Vol. XVIII of the Centenary Edition of Hazlitt's complete works, London, 1934.

HEWINS, RALPH *Paul Getty*. London, 1959.

HOBHOUSE, CHRISTOPHER *1851 and the Crystal Palace*. London, 1950.

HOLMES, SIR CHARLES, AND E. COLLINS BAKER *The Making of the National Gallery*. London, 1924.

HONEY, WILLIAM BOWYER *Old English Porcelain*. London, 1928.

HUTH, HANS *Abraham und David Roentgen*, Berlin, 1928.

JACQUEMART AND LE BLANT *Histoire artistique, industrielle et commerciale de la Porcelaine.* Paris, 1862.

JOURDAIN, MARGARET *Regency Furniture.* London, 1934.

JULIEN, STANISLAS *Histoire et Fabrication de la Porcelaine chinoise (the Ching tè Chên tao lu).* Paris, 1856.

KING, WILLIAM *Victoria and Albert Museum. Catalogue of the Jones Collection.* London, 1924.

KUNSTPREISVERZEICHNIS Vols. 1–17, Munich, 1939–61. International auction reports, with currency conversion tables.

LANE, ARTHUR "Queen Mary's porcelain collection, Hampton Court", *Proceedings, Oriental Ceramic Society,* Vol. 25, 1949–50.

LABARTE, JULES *Collection Debruge Dumènil, Catalogue raisonné.* Paris, 1847.

LENOIR, ALEXANDRE *Description du Musée des Monuments français.* 3 vols, Paris, 1812. *See also* Courajod.

LUGT, FRITS *Les Marques des Collectionneurs.* 2 vols. Amsterdam, 1921, 1956. *Repertoire des Catalogues de Vente, 1600–1865.* 2 vols. The Hague, 1938.

MACQUOID, PERCY *A History of English furniture.* 4 vols. London, 1903–8.

MARILLIER, H. C. *Christie's, 1766 to 1925.* London, 1926.

MARRYATT, JOSEPH, *Porcelain and Pottery.* 2nd edition, 2 vols. London, 1868.

MARTIN, HENRI, AND LAUER, PHILIPPE *Les principaux Manuscrits à Peintures de la Bibliothèque de l'Arsenale.* Paris, 1929. (Eighteenth-century prices.)

MAUPASSANT, GUY DE *Une Vie.* Paris, 1881.

MELVILLE, LEWIS *The Life and Letters of William Beckford.* London, 1910.

MICHAELIS, PROFESSOR A. *Ancient Marbles in Britain.* London, 1882. *A Century of Archaeological Discoveries.* London, 1908.

MILLS, JOHN *D'Horsay or the Follies of the Day.* London, 1844.

MOLINIER, EMILE *Le Mobilier au 17me et au 18me siècles.* Paris, 1898.

NATIONAL ART COLLECTIONS FUND *Reports,* 1903–57. London.

OLIVER, J. W. *The Life of William Beckford.* London, 1937.

PENNELL, JOSEPH *The Life of James McNeill Whistler.* 2 vols. London, 1908.

PENZER, N. M. "The Warwick Vase." Articles in the *Apollo Magazine,* London, 1955–6.

RACKHAM, BERNARD *Victoria and Albert Museum Catalogue of Italian Maiolica.* 2 vols. London, 1940.

REDFORD, GEORGE *Art Sales, a History of Sales of Pictures and Other Works of Art.* (Vol. 1 only.) London, 1888.

RHEIMS, MAURICE *La Vie mystèrieuse des Objets.* Paris, 1959.

ROBERTS, HENRY D. *A history of the Royal Pavilion, Brighton.* London, 1939.

ROBERTS, W. L. *Memorials of Christie's.* A record of art sales from 1766 to 1896. 2 vols. London, 1896.

ROBIQUET, JEAN *Gouthière, Sa vie, son œuvre.* Paris, 1912.

SAARINNEN, ALINE *The Proud Possessors.* New York, 1958.

SAUNIER, CHARLES "Les conquètes artistiques de la France sous Napolèon," *Gazette des Beaux Arts,* Vol. XXV. Paris, 1901.

SCHREIBER, LADY CHARLOTTE *Journals, 1869–1885.* Ed. by her son, Montague J. Guest, 2 vols. London, 1911.

SMITH, JOHN THOMAS *Nollekens and His Times.* Notes added by Wilfred Whitten. 2 vols. London, 1920. *A book for a rainy day*; recollections of the last sixty-six years, 1833.

SOUTH KENSINGTON Inventory of the objects of the Art Division of the Museum at South Kensington. *Annual Accession Reports,* Vols. 1–9, 1852–1901. London.

STRAHAN, EDWARD *Mr Vanderbilt's House and Collection.* 3 vols., folio. New York, 1883.

Art Treasures of America. 3 vols. Philadelphia, 1886.

SYMONDS, R. M. *Masterpieces of English Furniture.* 1940. "The Casting of Plate Glass," *Connoisseur,* 1936. London.

TAYLOR, FRANCIS HENRY *Pierpont Morgan as Collector and Patron.* New York, 1957.

THOMSON, W. G. *A History of Tapestry.* Revised and enlarged edition. London, 1930.

TIPPING, H. AVRAY (edited by) *English Homes.* 8 vols., folio. London, 1921–6.

TORRINGTON, JOHN BYNG, VISCOUNT *Diaries, 1781–1794.* Ed. C. Bruyn Andrews, 4 vols. London, 1934–7.

VATEL, CHARLES *Madame du Barry.* 3 vols. Versailles, 1889.

VERLET, PIERRE *Le Mobilier royale français.* Vol. I, Paris, 1945; Vol. II, 1959.

WALLACE COLLECTION *Catalogue of Furniture.* By F. J. B. Watson, London, 1956.

WALPOLE, HORACE *Letters of Horace Walpole, 4th Earl of Orford.* Ed. by Peter Cunningham. 9 vols. Edinburgh, 1906.

WATSON, F. J. B. *Louis XVI Furniture.* London, 1956.

"French Tapestry Chair Coverings," *Connoisseur,* October, 1961. London.

"The Taste of Angels," *The Times Literary Supplement,* 1 July, 1960, London.

(*See also* Wallace Collection.)

WHISTLER, JAMES ABBOTT MCNEILL *The Gentle Art of Making Enemies.* London, 1890.

WHITLEY, WILLIAM *Artists and Their Friends in England, 1700–1799.* 2 vols. London, 1928.

Art in England. Vol. I, 1800–20; Vol. II, 1821–37. Cambridge, 1928, 1930.

WILENSKY, REGINALD *The Meaning of Modern Sculpture.* London, 1932.

WILDENSTEIN, GEORGES *Les rapports d'experts, 1712–1791.* Paris, 1921.

INDEX

(Dates after collectors' names refer to principal sales)

Acraman, 1842, 127
Adam l'Aîné, sculptor, 187
Adam style, 173
Addington, Samuel, 1865, 158, 169
Adhemer, Comte d', 1788, 1793, 39, 66, 145, 176
African art, 60, 292
Alabaster carvings, 74–5
Aguado, 1843, 183
Alexander, triumphs of, 177
Alexandra, Queen, 149
Albert, Prince Consort, 96
Algardi, sculptor, 63
Alhambra vases, 36
Allman, 1960, 292
Althorp furniture, 46
Altmann, Benjamin, 192, 228, 232
Alton Towers, *see* Shrewsbury
Amazon, the wounded, 246
America, first impact on the market, 225–8
American colonial furniture, 264
Amber cabinets, 9, 66
Ambras, Schloss, 77
Amiens, Peace of, 50, 85
Amours des Dieux, tapestry, 178, 180, 255, 270
Anet, chateau, 91
Angebault, Mgr, 69
Angelico, Fra, 10, 140
Angers, tapestry, 14, 69
Angran de Fonspertuis, 1748, 36, 322
Angoulême porcelain, 50
Ansbach, Margravine, 1819, 64
Ansidei Madonna, 4
Annoot and Gale of Bond St, 133, 152
Antiquarians, 70–2
Antonello da Messina, 136
Antinous statues, 245
Anzio Priestess, 244
Apollo and the Muses, Chelsea set, 263
Apocalypse of Matthew Paris, 290
Apsley House, 52
Argenson, Duc d', 1764, 72
Arita porcelain, 222

Armada jewel, 230, 233
Armour, 62, 76–7, 80, 108–9, 113, 121–2, 231, 243, 249, 251, 270
Arsenale, library, 72
" Art as an investment ", 282
Art nouveau, 151
Ashburnham, 1914, 267
Ashburnham, 1953, 284
Ashburnham Salt, the, 241
Ashburton, Lord, 1869, 157, 159, 162
Ashridge Chapel, 1929, 260
Assignats, 31, 45, 100
Assyrian reliefs, 245
Auction sales, early development, 37–9
Aubrey, John, 77
Aubusson carpets, 59, 95
Audley and Bowes, 217
Augusta of Baden-Baden, 1775, 65
Augustus cameo, 63
Augsburg Silver, 64, 67, 237
Aumont, Duc d', 1782, 35, 39–41
Automata, 43–4, 116
Avelli, Fra Xanto, 289
Avenel, Vicomte d', 24
Avignon clock, 42, 134
Aynard, 1913, 242

Bacon salt, the, 116
Bacchus and Ariadne, enamel, 108
Bagot, Lady, 1845, 163
Baldock of Bond Street, 87
Balzac, Honoré, 95, 115, 129–30
Bandinel Collection, 1852, 97
Bankes, Thomas, 1805, 75
Barberini Palace, 62
Bardini, Stafano, 1902, 233
Bariatinsky, Prince, 31
Baring, Francis, 159
Baring, Henry, 157
Barker, Alexander, 1874, 1879, 104, 162, 253
Barnard, Francis, 1783, 72
Barnett and Duveen, 208
Baron, 1846, 122

Baroque jewels, 65, 102, 121
Barry, Mme du, 5, 31, 41–2, 45–7, 50, 136, 183–4
Basilevsky, 1884, 92, 113, 117, 119–20
Bastard swords, 108, 251
Bateman, Richard, 1774, 56, 68
Bath, Marquess of, 1859, 158
Bayswater ceremonies, 144
Beaumont, Sir George, 101
Beauvais, *see* Tapestry, French
Beauvau, Prince de, 1864, 129
Bearsted, Lord, 263
Beckett, Denison, 1885, 140
Beckford, Alderman, 174
Beckford, William, 1823, 26, 39–40, 43, 58, 64, 65–6, 75–6, 78–9, 81–8, 94–5, 98, 116, 125, 128, 136–7, 145, 194, 197–8, 221, 234, 269
Beckford vase, the, 191
Bedford book of hours, 1929, 260, 290
Bedford, Dukes of, 62
Bedford, hours of the Duke of, 73
Beerbohm, Max, 139
Bellamy, Gardner, 1941, 272
Bellevue, château, 27
Bemrose, Derby, 1909, 171
Benares brass, 196
Benemann, cabinet-maker, 48, 66
Bennett, Reginald, 1912, 214–15
Bennet, Sir William, 210
Benois Madonna, 1, 240–1
Benson, Robert, 1924, 252
Bentley, William, furniture, 151
Berlin porcelain, 52, 166
Bernal, Ralph, 1855, 17, 97, 99, 103–9, 117, 128, 152, 157–8, 165, 167, 169, 193, 237, 243
Bernal-Osborne, Capt., 103
Bernard, Samuel, 1887, 141–2
Bernini, 64, 288
Berry, Mary, 157
Berwick and Alba, 1877, 122, 178
Bessborough, Lady, 128
Betew, Panton, 64n
Beurdeley, Alfred, 1921, 186, 249
Bing, 1906, 242
Blanc, Charles, 56
Blanc de Chine, 35–6, 39, 159
Blandford, Marquess of, 1819, 58, 72
Blenheim Palace sales, *see* Marlborough
Blessington, Lady, 1849, 163, 167
Bleu celeste, 29, 193, 201
Blodgett, 1876, 227–8
Blohm, Otto, 1961, 286

Blondel de Gagny, 1776, 19, 35–6, 39, 42
Blue-and-white porcelain (Chinese), 35, 58, 117, 202–10, 268, 278
"Blue Nankeen", 196
Bode, Wilhelm von, 115, 187, 192, 225
Boer War, impact of, 233
Bohn, Henry, 1878, 104, 106, 157, 165, 194
Bolton and Fothergill, 1771, 1778, 36
Bombay blackwood furniture, 219
Bone, Henry, miniaturist, 1836, 108
Bonnaffé, Edmond, 9, 12n, 41, 74, 116, 120–1, 165, 186
Böttger's red stoneware, 286
Bouchardon, sculptor, 269
Boucher, François, 29, 35, 70, 147, 171, 174, 177, 179–81, 212, 234, 248, 255, 275
Bouguereau, W., 172
Boulle, Charles André, 42, 61, 135, 137
Boulle furniture, 20, 27, 86, 127–9, 140, 284
Bourson, Mme, 148
Bow figures, 33, 171, 247
Braamen van, 1799, 58
Bradly, Edison, 1933, 262
Bradshaw, 1798, 58
Brady, 1937, 269
Brameld, J. W., 53
Brandenburg, Duke of, 66
Brander, Gustavus, 1789, 56
Breadalbane, 1917, 243
Brenet, 156, 176
Brighton, Pavilion, furniture, 65, 125, 128, 197
Briot ewer, 118
Bristol porcelain, 33, 241
British Museum, birth of, 57
Brocket Hall, 1923, 250
Bromilow, Mr, 173
Brook, Greville, 1836, 127
Brownlow, Lord, 1929, 264–5
Brummel, G. B., 157
Buccleuch, Duke of, 127
Buckingham, Duke of, 1848 (*see* Stowe sale), 74, 94
Buffon service, Sèvres, 31, 156
Bulmer, William, 58
Bulteel, 1870, 133
Burdett-Coutts, Angela, 1922, 80
Burke, Edmund, 33
Burke, Jane, tea service, 24

Burleigh House, 1888, see Exeter,
Burne-Jones, Sir E., tapestries, 123
Burnett, H. K., 1941, 272
Burslem, 173
Burton, Lord, 170
Burty, Philippe, 126, 201, 218
Bushell, Dr of Peking, 19
Bustelli, Franz Anton, 167, 276, 286

Cabbage-leaf plates, 33
Cabinets des curieux, 20, 36, 57, 89
Cadogan, Lady, 1865, 169
Caffaggiolo faience, 104-5
Caffieri family, sculptors, 135, 138,
 141, 188, 243, 262, 274
Calonne, M. de, 1795, 39
Cameos, classical and modern, 63, 172
Camondo, Isaac, 134, 142, 148, 186
Campana, Marchese, 1861, 109-10,
 113, 121
Canning jewel, 1931, 261
Canopic vases, 91
Canova, 172, 183-4, 245-6
Canton enamellers, 196
Cantonese pictures, 58
Capodimonte porcelain, 167-8, 287
Carlin, Martin, cabinet-maker, 132,
 140, 250, 269
Caradosso morse, the, 240
Carlo Alberto of Savoy, 80
Carlton House, 125
Carlton House desks, 285
Carnarvon, Countess of, 1925, 263
Carpets, European, 52
Carpets, Oriental, 58, 247
Carrand of Lyons, 1871, 112
Cassel von Doorn, 1956, 283
Cassones, 241, 253-4
Casteldurante faience, 252
Castellani, Alessandro, 1878, 1884, 112,
 117
Caterina, Cornaro, topaz vase, 85, 87
Catherine the Great, 21
 bureau of, 44
Cavendish-Bentinck, 1891, 141
Celadon (mounted), 37, 39, 86, 198,
 215, 237, 274, 284
Cellini, Benvenuto, 7, 62, 64, 101-2,
 126, 216, 267
Cézanne, 238
Chambre des comptes, 22
Champion, Thomas, 33
Chantilly book of hours, 71, 277
Charbonneaux, M., 244
Charlotte, Queen, 1819, 34, 168

Chasse of Philippe le Bel, 100, 106
 of Malmesbury and Croyland, 1930,
 230
 of St Yvet, 101
Chauchard, M., 142, 148
Chaulnes, Duc de, 36
Chelsea porcelain, 29, 33-4, 168-71,
 263, 272, 275, 279-80, 285-6
Chelsea-Derby porcelain, 170
Chêng-hua mark, 191-2
Cheramatieff, 1906, 235
Chester-Beatty, A., 1932-3, 261-2
Chevallier, Etienne, see Chantilly
Chevallier, Paul, auctioneer, 121
Ch'ien Lung, emperor, 194
Chinese art, market decline in 1920s,
 260
 Bronze, 272, 275
 Cloisonné enamel, 199-201, 291
 Jade, 200, 269, 275, 278
 Pottery figures, 252, 272
 porcelain, 34-7, 39, 190-5, 202-41,
 262, 272, 275, 291
 Sung Wares, 191, 242, 252
Ching-té Chên, 206
Ching-té Chên Tao lu, 190
Chinnery, W., 1812, 63
Chippendale, Thomas, 46, 151-4, 249,
 264, 273, 284
Choiseul, Duc of, writing table, 3, 138,
 239
Christie, James I, 28, 57
Christie, James II, 74
Chronique des Arts, 98, 112, 115-16,
 131, 144, 179
Chrysler, Walter, 1960, 161, 264
Chun ware, 37, 192, 242, 252
Cicero on auction sales, 9
Citta di Castello, faience, 289
Classical sculpture, 56, 61-3, 243-7,
 292
Clock, Anne Boleyn's, 78
Clocks, French 18th-century, 42, 44,
 134
Clocks, musical, 44
Clock, Tompion's for Bey of Algiers,
 42-3
Clodion, 182-8, 287
Clovio, Giulio, 72, 79
Clumber, 1937, 269
Cluny Museum, 72-3, 123
Codex Crippsianus, 73
Cole, Henry, 96, 108
Colonna Madonna, 4
Columbine cups, 116

Commune, Paris, 1871, 102, 112, 135
Condé Duc de, 54
Condé, Musée, 43
Coney, John of Boston, 269
Connoisseur, the, 60, 141
Conquest of Tunis, tapestry, 16, 123
Consular diptychs, 99–100, 111
Conway, Field-Marshal, 1795, 145
Cook, Sir Francis, 1925, 252–3
Cook, Humphrey, 1944, 275
Coope, Octavus, 1910, 236
Corbie Abbey, sculptures, 75
Cosson, Baron de, 1885, 109
Courajod, Louis, 20, 56, 89–90
Courevoix, sculptor, 184
Court, Suzanne, enameller, 107, 237
Court, Jean, enameller, 267, 269
Courteys, Jean, enameller, 289
Courteys, Pierre, enameller, 92, 274
Coustou, sculptor, 184
Couvreur, 1875, 113
Coventry garniture, 1874, 160
Cowdray, Lady, 1933, 244
Coypel, Charles, 174, 178–9
Coyzevox, sculptor, 63
Cozette, weaver, 179
Crackled porcelain, 193
Craven, Earl of, 1922, 109, 254
Crawford of Balcarres, 1929, 262
Créquy, Marquise de, 193–4
Cressent, Charles, mount-maker, 138
Crinoline, influence of, 1861, 131
Crinoline groups, Meissen, 165–6
Crockford, auctioneer, 157
Cromwell, Oliver, 177
Cronier, 1905, 180
Crozat, Pierre de, 1772, 62, 70
Crystal vessels, Renaissance, 65, 106,
 121, 234, 239, 269
Curiosities or Curios, 56–9, 84

Daguerre, 1791, 46, 50, 66
Dalhousie, Earl of, 1936, 268
Dalton, Dr, 1792, 56, 77
Dame au licorne, tapestry, 123, 254
Darcel, Henri, 98
Dasent, Sir W. G., 1875, 59
Dasson, Henri, cabinet-maker, 12, 133
David, Jacques Louis, 66, 85, 90, 92
David Foundation, 278
Davillier, Baron C., 30, 31, 135, 160
Davison, Henry P., 188
Day, Justice, 1910, 237
Dean, H. Percy, 1909, 154
Dean Paul, Sir J., 1896, 153

Debruge Dumènil, 1850, 84, 93,
 101–3, 111, 115, 185, 190, 200
Deffand, Mme. de, 62, 76, 79
De Grey, Lord, 1902, 166
Delft ware, 203, 207
Della Robbia ware, 56, 110, 288
Demidoff family (*see* San Donato),
 113, 132
Denmark, King of, Sèvres service, 30
Denys, Mlle, 83
Derbyshire Spa, 36
Desiderio da Settignano, 101, 115, 187
Desmalter, Jacob, cabinet-maker, 51
Desportes, tapestry designs, 178
De Ville, James, 1835, 1846, 101–3
Devonshire, Duke of, 123
Diane of Poitiers, 91–2, 119
Dickens, Charles, 1873, 60
Dickins, C., 1879, 166, 169–70
Dickins, J., 1908, 165–6
Diderot, 176
Didier, 1868, 137
Didier, Martin, enameller, 111
Dijon, tomb figures, 100
Dino, Duc de, 121
Directoire government sales, 48–9, 176
Directoire style in England, 125
Discobolus copies, 63
Disraeli, Benjamin, 15, 103, 164
Doccia porcelain, 167–8
Dodin, Sèvres painter, 157, 162
Dog of Fo figures, 37, 193–4
Dollinger, Hans, 115
Donaldson, Worcester painter, 170
Donatello, 101, 110, 230
Don Carlos service, 1836, 157
Don Quixote tapestries, 180
Double, Leopold, 1881, 132, 134, 146,
 163, 186
Doucet, Jacques, 1912, 121, 187, 237–8,
 251
Doughty, Dorothy, 291
Doyle, Richard, 191
Drake Cup, the, 273
Drawing-room suites, French, 81,
 144–151, 228, 256, 274
Dresden porcelain, *see* Meissen
Dreyfus, Gustave, 1930, 102
Drottningholm castle, 36
Drouot, Hotel, 110, 143–4
Dudley, 3rd Earl, 1886, 30, 101, 105,
 113, 159, 162, 169–70
Duesbury, Thomas, 34, 168
Duncombe, Charles 63
Dunkirk, 271

Dunn, Nathan, 190
Dunn, Treffrey, 203
Dunn-Gardner, 1902, 233, 274
Duplessis, Gustave, 38
Duplessis, J. C., mount-maker, 41
Duquesnoy, F., see Fiammingo
Durer, Albrecht, 67, 115, 129
Durlacher, 132
Du Sartel, Osmond, 192, 223

Eastlake, Sir Charles, 60, 109
Eberlein figures, 286
Edwards, Lionel, 1945, 275
Eglinton tournament, 68, 77, 80, 108
Egmont, Comte d', 30
Egyptian art, 82, 274
Elgin, marbles, 1816, 246
Elhafen, Ignaz, ivory-cutter, 67
Elizabeth, Mme of France, 145
Elizabethan revival, 203
Eltenburg reliquary, 13, 98, 110
Empire, French furniture, 51
Empress Catherine service, Sèvres, 31, 52, 162–3
Empress dowager of China, 212
Engine-turning, 88
Entrecolles, Père d', 206
Epinay, château, 180
Esdaile, 1838, 73, 168
Essex, Earl of, 1893, 141
Este family, portrait busts, 100, 101
Evelyn, John, 9, 66
Evesham psalter, 1936, 268, 290
Eugénie, ex Empress, 1927, 129, 138, 256
Eumorfopoulos, 1940, 214, 271–2
Ewart, William, 96
Exeter, Marquess of, 1888, 1959, 212, 221, 223
Export tax, French, 249–50
Exposition universelle, 1867, 5, 13, 131, 138, 152, 167
 1878, 121, 127–8

Fabergé, Carl, 87, 278, 291
Faenza ware, 105, 117
Fa-hua pottery, 242, 252, 272
Falconet, sculptor, 163, 182–8, 241, 256, 269
Famille verte and Famille rose, 29, 36, 165, 196, 207–8, 262, 291
Famille jaune, 210, 213, 240
Famille noire, 35, 210–15, 262, 274, 276
Farren, Gaspard, 210
Farquhar, John, 1823, 85, 88
Fauntleroy, Henry, 1829, 163

Fauteuils à la Reine, 52–3
Feast of the Gods dish, Limoges, 119
Fenelosa, 224
Ferdinand, Archduke Coll., 77
Fermiers généraux, 25, 175
Fesch, Cardinal, 101
Fêtes Italiennes, tapestry, 255
Fiammingo, 64n, 76, 87
Figdor, Albert, 1930, 254, 260
Filigree silver, 59
Fischer, 1906, 234
Flambé porcelain, 29, 37, 193, 242
Flayderman, 1930, 264–5
Flaxman, John, 64, 244
Florentine cabinets, 113
Florentine marbles, 66
Fogg, china merchant, 52, 86, 157
Foliot, cabinet-maker, 145
Fontana, Orazio, 80
Fontaine and Percier, designers, 51
Fonthill, 58, 85
Fonthill sale, 1823, 82–7, 100, 125, 146, 157, 165, 177
Fornarina, la, 105
Fortune, Robert, 1852–61, 191–2, 194, 200
Foster, Romsey, 152
Foucquet, Jean, 71, 277
Foundling hospital vase, 169
Founès, 1929, 256, 263
Fountaine, Andrew, 1884, 71, 105, 241
Fourcrois, Mme, 187, 234
Fourdinois cabinet, 1867, 131
Franc, fall of, 248, 250
Francesca, Piero della, 200
Franchi, 1827, 84, 221
Francis I, armour, 62, 76, 80, 122
 tomb, 75
Franco-German war, effects, 112–13, 115, 135
Frankenthal porcelain, 167
Franks, Sir A. W., 99, 118, 218, 222
Frederick the Great, furniture orders, 44
Frederick V of Denmark, 183
Frederick William of Prussia, 52
Freer, Charles L., 242, 251
French Revolution and the market, 40, 48–9, 75, 89–92, 176
French Messrs, tapestry sales, 254–5
Frick, Henry C., 1, 137, 213, 235–6, 241, 243
Fulda porcelain, 166
Furniture, English, Elizabethan, 79, 81, 253, 288

Furniture—*contd.*
English, 17th–18th century, 151–4, 247, 249, 264, 284
English, Regency, 281, 285
French, 17th–18th century, 5, 12, 14, 18–9, 26–8, 43–50, 125, 142, 144–51, 238–9, 243, 247, 256–7, 264, 266, 283–4
Renaissance, 61, 86, 111, 121, 127, 241, 253, 288
Fuertwangler, Professor, 244

Gabbitas, 1904, 234
Gaigniéres, F. de, 71
Galbraith, J. K., 258
Gallièra, Duc de, 1862, 159
Garde Meuble, French royal, 43, 48, 137, 176, 244, 284
Gardiner, Isabella, 228
Garland, James, 207, 213
Garrard, Robert, silversmith, 95
Gary, Elbert, 1928, 187–8, 239, 256, 262
Gaûtier, Theophile, 201
Gaya sculpture, 1831, 195
Gennadius Orestes diptych, 111
George III, antiquities purchased, 63, 73
 furniture ordered, 47
 porcelain ordered, 34, 169
George IV, Chinoiserie favoured, 197
 Coronation armour, 108
 furniture purchases, 53, 125–6
 porcelain purchases, Sèvres, 156
 tapestry purchases, 177
German influences, 67
German stoneware, 115
Gersaint, art dealer, 190
Getty, Paul, 255, 270
Gibson, John, sculptor, 172
Gilbert, W. S., 54, 219
Gilding, cost of, 27
Gilou, 1962, 258
Ginori, Marchese, 167
Ginzbourg, 1882, 187
Giulio Romano, 73
Gladstone, W. E., 1863, 142, 164, 173
Glass, duty on, 28
 Arab, 269, 276, 278
 Roman, 292
 Venetian, 111
Glogowsky, 1932, 271
Glomy, J. B., 74
Gobelins factory (*see also* tapestry, French), 175

Goding, Charles, 1875, 160, 162
Gog and Magog statues, 75
Goldschmidt-Rothschild, 1931, 263
Goncourt, Edmond de, 5, 49, 123, 130–2, 178, 186, 191, 216–8
Goode, china merchant, 160
Gorer, Edgar, 213–5
Gothic sculpture, 68, 74–5
Goujon, Jean, 20
Gouthière, Pierre, mount-maker, 27, 39, 40–42, 47, 183, 186
Grandidier Collection, 199
Grant, General Sir Hope, 199
Great Exhibition, 1851, 96–7, 103, 107, 198
Greek vases, 63, 109, 173, 244, 292
Grès de Flandre, 115
Greuze, 124, 169
Grimthorpe, Lord, 1902, 187
Grosvenor Gallery, 214
Gubbio lustre ware, 252
Guild system, French, 38
Guildhall sculptures, 75
Gulland, W. G., 192, 204
Gwydyr, Lord, 1829, 126, 156, 161

Hainauer, Oskar, 1906, 235
Hamburg consignments, 1794, 49, 177
Hamilton, Gavin, 55, 62, 244, 246
Hamilton, 10th Duke of, 86
 11th Duke, 100, 106, 111
 12th Duke, 87
Hamilton Palace, 1882, 21, 26, 87, 117, 120–1, 136–40, 153, 162, 191, 201, 211, 220–1, 243, 284
 1919, 154, 238, 247
Hamilton, Sir W., 62
Hamlet, Thomas, 1834, 126
Hampton Court, cartoons, 69
 porcelain Collection, 197
Hannover, Emil, 31, 163, 167, 212
Harcourt, Viscountess, 1943, 274
Hardwicke Hall tapestries, 123
Harewood, 1931, 261
Harkness, E. S., 261
Hauré, cabinet-maker, 48
Hawkins, C. T., 1904, 234
Hawthorn jars, 206–7, 268
Hayashi, 1903, 222, 224
Hazlitt, William, 60, 82–85
Hearn, Lafcadio, 224
Hearst, W. Randolph, 1938–9, 265, 270
Heathcote, Robert, 1805, 125, 156
Heckscher, Martin, 1896, 144

Hebray, M. de, 1831, 80
Henri II, 92
Henri Deux ware or St Porchaire, 103, 119–20, 165, 173, 243, 268–9, 277
Hepplewhite, Thomas, 47, 151
Hertford, 3rd Marquess, 125, 128, 156
Hertford, 4th Marquess, 12, 17–18, 86, 94, 112, 128, 132–5, 137, 146, 150, 178, 184, 156–7, 159
Herz, Bram, 1838, 1857, 167
Heythrop furniture, 145
Higgins, Matthew, 1802, 156
Hillingdon, 1938, 161, 265
Hirsch, Maurice de, 1906, 114
Hirsch, Leopold, 1934, 114, 267
Hispano-Mauresque pottery, 241, 268, 276
Hizen, Daimyo of, 1867, 218
Hoenschel, 1911, 231
Holbein, 5, 268
Holderness, Countess of, 1802, 50, 128
Holford, G. L., 1927–8, 239, 253–4, 261, 288
Holkham MSS, 68, 231
Holland, Henry, 125
Holland House, 132
Holland, King of, 1850, 110
Hollingworth-Magniac, 1892, 99, 120
Homburg, Octave, 1931, 260
Hope, Thomas, 1816, 1917, 53, 244, 282–5
Hôtel de Ville, Paris, 102, 112, 179
Houdon, sculptor, 182–8, 231
Houdon, the baby Sabina, 188, 238, 256–7
Houghton Hall, 1779, 6
Hours of Isobel of Brittany, 269
Hours of Jeanne of Navarre, 247–8
Hours of Prigent de Coëtivy, 261
Hours of la Reine Claude, 79
Howard grace cup, 1931, 261
Howe, Earl, 1928, 264
Hsien-Fêng, Emperor, 198–9
Huet, tapestries, 274
Hume of Bond Street, 127
Huntington, Collis P., 147, 177–8
Huntington, Henry, 232, 249, 251
Huth, Louis, 1905, 204, 206, 210, 234

Ice-crackle pattern, 206
Ife, bronze head, 292
Illuminated manuscripts, 71–3, 79, 83–4, 235, 241, 247–8, 260–2, 269, 277, 290–1
Imari porcelain, 35, 87, 220–222

Impressionism, impact of, 12, 241
Indian art, painting, 58
 sculpture, 59, 95
 silver, 59
Industrial arts, 96–8
Inru Japanese, 224
Intendants de finance, 25, 175
"Introductions", 83n, 85
Isabey, 51
Ivory, Chinese, 58
Ivory, Renaissance tankards, 64, 67, 87, 188–9
Ivory, mediaeval, 99, 109, 111

Jabach garniture, 209
Jacob, cabinet-maker, 145
Jacquemart and Leblant, 191–2, 207–8, 216, 223
Jade, 36, 58, 200
Jameson, Mrs, 78
Jamnitzer, Wenzel, 5, 44, 116
Japanese art, 215–24
 bronze, 216, 218
 lacquer, 26, 217, 219–20
 porcelain, 35, 39, 87, 220–3
 pottery, 222
Japanese drawing-rooms, 151, 219
Jasper ware, Wedgwood, 172–3
Jenkins, Thomas, 62, 246
Jennings, H. C., 1786, 63
Jersey, Lady, 152
Jeux d'enfants furniture suites, 147
Joel, S., 1935, 266
Johanneum, Dresden, 1920, 221
Jolliot, art dealer, 190
Jones, John (V. and A. bequest), 1882, 133, 158
Joseph, cabinet maker, 141
Josephine, Empress, 51–2, 54
Jouvenel des Oursins, Pontifical, 73, 102
Julien, Stanislas, 190
Julienne, 1766, 193

Kaendler figures, 36, 165, 286
Kakiemon porcelain, 39, 195, 222–3
K'ang Hsi reign of, 191, 205–6
Kann, Rodolphe, 1907, 230
Kansas City Museum, 251
Kaufmann, Angelica, 152
Keats, John, 173
Kelekian, D. K., 242
Kensington Lewis, silversmith, 87
Khmer sculpture, 272
King, John, cabinet-maker, 46
Kinnaird, Lord, 1813, 108

Knole tapestries, 1911, 231
"Korean" porcelain, 223
Kounilov, Nicolas, 167
Kress, Samuel, 259
Kuan ware, 191
Kuan Yin figures, 35, 213, 291
Kutani porcelain, 222

Labarte, Jules, 92, 190
Lacroix, Roger (RVLC), cabinet-
 maker, 43, 256–7, 266
Lacquer, 26, 217, 219–20
Lalive de Jully, 27
Lambeth Palissy ware, 73
Lamerie, Paul, silversmith, 247, 265
Landseer, Sir E., 81, 108
Lane, Arthur, 197
Langdon, William, 190
Langford, auctioneer, 74
Lanna von, 1911, 167, 237
Lansdowne, 1930, 63, 245–6, 292
Lansdowne tower (Beckford) 1845, 84
Laocoon copies, 95
Lascelles, Edward, 47
Lavallière, Duc de, 1781, 73
Laurana busts, 267
Law, John, 25
Lawrence, Sir T., 1831, 65, 101, 124,
 251
Lawson, 1906, 235
Lebrun, Auguste, 128, 137
Lebrun, Charles, tapestries, 70, 176–7,
 179
Leeds, Duke of, 1901, 13–14, 274
Le Gaigneur, Louis, cabinet-maker, 61,
 127
Leicester, Earl of, 84, 231
Leighton, Lord, 172
Lelong, Mme, 1903, 142, 187, 234
Limoges chasses, 13th century, 92
Limoges enamels, 15th–17th centuries,
 36, 71, 73, 76, 81, 92, 107–8, 111,
 117, 119–21, 237, 240, 253, 267,
 269, 274, 289
Limousin, Jean, enameller, 267
Limousin, Leonard, enameller, 119,
 253
Lincoln, Earl of, 1937, 245
Liverpool, Lady, 169
Livre, value of, 24
Llangattock, 1958, 17, 46, 283
Locke-King, R. J., 169
Lockett, George A., 1942, 273
Lombardi, Antonio, sculptor, 115, 121
Londesborough, Lord, 1884, 1887, 108

Londonderry, Lord, 1869, 133
Long Elizas, 207
Lothair, crystal of, 1855, 17, 106
Lothian, Earl of, 1932, 261
Louis XIV, furniture orders, 136
 Triumphs of, tapestry, 179
Louis XV, porcelain orders, 29
 writing desk, 43–8
Louis XVI, sales of Sèvres porcelain,
 32
 his purchases, 41, 43
 his furniture-budget, 47–8
Louis Philippe, 178, 198
Louveciennes, pavillon, 41, 45, 47
Louvre, origins as a museum, 89–90,
 93
Lowengard, 1911, 237
Lulu Quinze style, 150
Lusitania, sinking of, 215
Lustres, 27, 42, 113
Luttrell Psalter, 1929, 260
Lydig, 1913, 241
Lygon, 1864, 158
Lyne Stephens, 1895, 141, 157, 159,
 162
Lysippus, 246
Lyte jewel, the, 116

Macaulay, Lord, 78, 197
Macquoid, Percy, 154, 285
Madrid, château, 92
Maddingly Hall furniture, 1960, 264
Maiolica, 36, 71, 73–4, 80–1, 104–5,
 117, 237, 252–3, 270, 289–90
Maestro Giorgio, potter, 240, 252, 268,
 273
Malcolm, 1884, 209
Mandarin vases, 86, 196–8, 243, 262
Manners, Lord James, 1791, 56, 65, 74
Mannheim, Charles, dealer, 130, 134
Mantegna, 240
Maria Theresa service, Sèvres, 32
Marie Antoinette, 42–5, 49, 129, 136–8,
 182–3, 185, 243
Marie Louise, Empress, 51–2, 86
Marin, sculptor, 183
Marks, Murray, 203, 207, 209, 212, 221
Marlborough, Duke of, 1875, 1883,
 1885–6, 118, 140, 171–2, 205, 226
Marlborough House, 97, 104
Marly horses, copies, 184
Marmontel, M., 42
Marryatt, Joseph, 1867, 105, 117, 156–
 7, 168–9, 193, 202, 205, 211
Martial on Roman auction sales, 9

Martelli family of Florence, 1907, 230
Mary II, her porcelain, 197
her amber cabinet, 9, 66
Maskell, Alfred, 111
Maupassant, Guy de, 123, 148
Margam Castle, 1921, 273
Maximilian fluted armour, 109
Mazarin blue, 29, 157, 241
Mazarin coffer, 26, 220
Mazarin, Duchesse de, 1781, 32
Mazarin tapestry, 4, 122, 230
McKay, Clarence, 1939, 249, 270
Mckim, Meade and Whyte, 178–9
Meade, Dr, 1755, 80
Mecklenburg service, Chelsea, 34
Medici Catherine de', 107, 119
Medici porcelain, 240, 277
Meissen porcelain (Dresden), 28, 33, 39, 165–6, 263–4, 278, 284
Meissonier, Ernest, 10
Melchett, Lady, 1936, 245
Mellon, Andrew, 232, 259, 268
Menars, château, 1881, 187
Menars, Marquise de, 1782, 31
Mercury-gilding, 27
Methuen, Lord, 1899, 1920, 170, 248
Mettayer, silversmith, 273
Metternich, Prince, 3, 338
Meubles à deux corps, 113
Meyrick, S. J., 80
Michaelis, Professor A., 246
Michelangelo, 66, 101
Michelham, Lord, 1926, 149, 250, 255–6, 268
Mikado, operetta, 1885, 219
Milanese iron furniture, 111, 113, 140
Millais, Sir J., 236
Millet, J. F., 10
Mills, Ogden P., 1938, 255
Ming period porcelain, 35
blue and white, 204–5, 252, 291
stoneware, 252, 272
Miniatures (portrait), 79, 266, 268
Mino de Fiesole, sculptor, 102
Minton porcelain copies, 165, 172, 186
Mississippi scheme, 1720, 25
Mitford, 1875, 192, 224, 287
Mobilier des Dieux, 1881, 146, 148
Modelli, sculptors', 65, 182
Molière tapestries, 181
Mona Lisa, theft of, 248
Montal, château de, 1884, 1903, 114
Montcalm vases, 157, 159, 162
Montauban, General, 199

Montebello, Duchesse de, 1851, 185, 220
Montgolfier, Triumph of, 186
Monvaerni, enameller, 289
More, Sir Thomas's candlesticks, 106
Morgan, James Pierpont, Snr, 4, 69, 84, 112, 122, 137, 160, 179–80, 188, 207, 210, 213, 228–233, 236, 240, 243, 254, 287, 291
Morgan, James Pierpont, Jnr, 1935, 1944, 260, 266, 275
Morgan, T., "Chinaman", 34
Morgan, William de, 252
Morren, Paul, 1879, 211
Morris, William, 1899, 106, 123, 151
Morrison, Alfred, 1936, 262
Mortlake tapestries, 177
Mostyn Gospels, 261
Mounted porcelain, relative values, 39–40
Mounting, cost of, 27
Mughal miniatures, 58, 102, 251
Murillo, 5, 112, 116
Murray-Scott, 1913, 241
Museum of ornamental art, 97
Musée des monuments français, 91–2

"Nankeen" services, 202
Napier, Robert, 1877, 134
Napoleon I, 6, 51, 58, 183–4
Napoleon III, 5, 110, 130
National Art collections fund, 1903, 233
National Gallery, Royal Commission, 60
Natural History Museum, 57
Nautilus cups, 95, 116–7
Nazarener school, 67
Necker, M., 47
Negroni, Capt., 200
Negroli casque, 231
Neo-classic movement, 60–1, 77, 176
Netsuke, 216, 224
Neuilly statues, 1840, 184
Neuwied furniture, 44
Neuwekerke, Baron de, 102, 112
Neumann, 1919, 247
Newcastle, Duke of, 1921, 252
Ney, Princesse, 1929, 52n
Nielson tapestries, 178
Nine Worthies tapestry, 70, 231
Nizami manuscripts, 58
Nollekens, Joseph, 62, 64, 244
Norfolk, Duke of, 1816, 67, 235, 260
North, Rev Charles, 1825, 126

Northwick, Earl of, 1925, 261
Nostell Priory writing table, 47, 152
Nove porcelain, 166
Nymphenburg figures, 164, 167, 264, 276, 286

Oeben, cabinet maker, 43, 46, 256
Odiot, E., 1889, 120
Odiot, designer, 51
Oiron, château, 71, 103, 119
Okitomo, Netsuke cutter, 224
Old Curiosity Shop, 95, 160
Olympic service, Sèvres, 52
Opium war, 166
Oppenheim, Paris dealer, 241, 283
Oppenheim, 1913, 253, 267, 268
Oppenheimer, Henry, 1935–6, 190, 200
Orchardson, W. Quiller, 139, 150
Orford, Earl of, 1856, 146
Oriental curios, 58, 201
Orlando Furioso tapestry, 180, 255
Orleans, Gallery, 6, 55
Orrock, James, 1886, 208–9
Ossian, 72
Ostia excavations, 244
Ostrich eggs, mounted, 251, 269
Ottema, Dr Nanne, 212
Oudry tapestries, 287
Oxford, Earl of, 1741, 76

Page-Croft, 1931, 265
Page Turner, Sir E., 1903, 133–4
Paiva, Mme de, 5
Pajou, sculptor, 182–3, 187–8
Palissy ware, 15, 73, 92, 100, 105–6, 118–9, 121, 252
Pallavicino-Grimaldi, 1900, 180, 255
Pannemaker, Willem, weaver, 16
Pantechnicon fire, 1864, 135
Pantin, Samuel, silversmith, 265
Partridge, Robert, 210
Pâtureau, 1857, 159
Paulmy, Marquis de, 20, 72, 79
Payne, Knight, 246
Peel, Sir Robert, 60
Pembroke, Earl of, 1814, 184
 1851, 129, 132
 1861, 159, 185
 1917, 1921, 243, 249
Penicaud, Jean, enameller, 117, 120, 253
Penicaud, Nardon, enameller, 100, 243
Perugino portrait dish, 117
Percy, Bishop, 72

Persian carpets, 82–3, 247, 251, 270
Persian painting, 58, 196, 242
Persian pottery, 243
Petits Augustins, convent, 90–1
Petzoldt, Hans, silversmith, 116, 237
Pheidias, 244
Phené, Dr, 114
Philadelphia Exhibition, 1878, 218, 222
Philip II of Spain, 16, 23
Philips, auctioneer, 82–3, 85
Picart, 1780, 74
Picasso, 11–2, 238
Pigalle, sculptor, 182, 185, 187
Pig-faced bascinet, 270
"Pinkie", 256
Piot, Eugène, 1864, 1890, 102, 115
Pistrucci, 15
Pius IX, 110
Plate glass, cost of, 27–8, 47, 152
Pollaiuolo, sculpture, 230
Pollock, Jackson, 17, 161
Polovtseff, 1909, 180
Poirier, Simon, art dealer, 45, 183
Pompadour, Mme de, 14, 20–1, 25–7, 30, 35, 37, 39, 71, 95, 147–8, 191, 193
Pons, le cousin, 14, 50, 67, 85, 115, 129–30, 142, 159, 198
Porcelain, see under separate factories
Porcelaine de France, 28
Porcelaine à émaux, 32, 45, 275
Porphyry, cost of, 9, 27
Porter, Walsh, 1810, 125
Portland, Duchess of, 1786, 57, 73, 79
Portland vase, 1786, 1929, 63, 172–3, 260
Portobello Road, 21
Pot à l'oille, Sèvres shape, 30, 32
Pound, fall of, 248, 250, 260, 277
Powder-blue porcelain, 208
Power, Hiram, sculptor, 172
Powis, Earl of, 1962, 46, 283
Pratt of Bond Street, 106, 108, 122, 178
Première qualité de Japon, 223
Pre-Raphaelites, 77, 109
Pringsheim, Otto, 1939, 270, 289
Prior, Matthew, bust of, 185
Provence, Duc de, 43, 145
Psalter of Bonne of Luxembourg, 277
Psyche, Story of, tapestry, 248, 255

Queen Anne revival, 59, 151, 219
Quilter, 1936, 268–9

Randon de Boisset, 1777, 26, 39, 42, 222
Raphael, 4, 74, 105, 118, 131
Raphael tapestries, 69
Raphael's ware, 56, 61, 73
Rattier, 1859, 115
Raynham commode, 1921, 1961, 249, 284
Rayy pottery, 242
Redding, Cyrus, 78
Redford, George, 136, 162
Redgrave, Richard, 97
Reed, Sir C. H., 1928, 277
Regency style, evolution, 53, 151
Regency furniture, 285
Reliquaries, 68, 92, 120, 240
Rembrandt, 58, 94, 268
Renaissance art, 18th-century attitude, 56
 French national cult, 92, 113
 furniture revival, 65–6, 79
 sculpture revival, 63–5
Reymond, Jean, enameller, 253
Reymond, Pierre, enameller, 278
Reynolds, Sir Joshua, 9, 60, 64, 81, 247
Revoil Collection, 93
Rhinoceros horn cups, 35
Rhinoceros vases, 1827, 53
Rhodian faience, 165
Rice, Mrs Hamilton, 248
Ricci, Seymour de, 276
Riccio bronzes, 121, 267
Richelieu Collection, 55, 74
Ricketts, 1867, 129
Riesener, cabinet-maker, 5–6, 40, 44, 47, 49, 126–7, 130, 137, 239, 243, 247
Roberts, W. E., 133
Robetta, Christofero, 105
Robins, George, auctioneer, 78, 83n, 108, 126, 267
Robinson, Sir J. C., 97–8, 118, 255
Rockefeller, J. D., Jnr, 102, 123, 213, 245, 267, 254
Rockingham porcelain, 6, 53, 198
Rodin, 182
Roentgen, David, 5–6, 43–4, 238, 266, 274
Rogers, Samuel, 1856, 109, 124, 173, 282
Rohan service, Sèvres, 30, 113, 134, 160–1
Roland, Jean Marie, 84
Romanesque art, 84, 99–100, 109

Romantic movement, 68, 76–7, 81
Romney, George, 248
"Root of Amethyst", 36
Rossellino, 102
Rossetti, D. G., 203
Rothermere, Lord, 1941, 273–4
Rothschild family,
 Adolphe de, 95, 119, 135, 141
 Alfred de, 1946, 278
 Alphonse de, 120
 Antony, 1940, 165, 237
 Edmond de, 3, 12, 45–6, 136, 138, 140
 Ferdinand de, 14, 113, 116, 132, 136–9
 Gustave de, 106–7, 119
 Henri de, 179, 180
 James de, 111, 119
 Karl Meyer, 1911, 5, 116, 237
 Lionel de, 1946, 237, 284
 Meyer, 128, 158
 Victor, 1937, 269
Roubiliac, sculptor, 185
Rousseau de la Rottière, decorator, 131
Roussel, Paris dealer, 128
Rovensky, Mae, 1957, 286
Roxburghe, Duke of, 1812, 72
Royal Academy, 96
RVLC, see Lacroix
Rucker, Sigismund, 1869, 160
Rundell, Bridge and Rundell, 6
Ruskin, John, 81, 106
Russell, 1935 and 1946, 279, 291
Ruxley Lodge, 1919, 247
Ryan, T. F., 1933, 266–7

Saarinnen, Aline, 213
St Albans, Duke of, 104
St Aubin, Gabriel de, 41
St Cloud, palace, 52
St Cuthbert, life of, 235
St Hubert hunting horns, 81, 120
St Porchaire, see Henri Deux ware
St Victor, Paul de, 49
Salamanca, Marquis de, 1881, 179
Salting, George, 99, 105, 117, 119, 122, 192, 207–8, 211, 236
Saly, J. F., sculptor, 183
Sambon, 1914, 242
Samson porcelain, 165, 212
San Francisco earthquake, 179
San Donato (Demidoff), 1870, 14, 21, 30, 113, 116, 184–5 (1880), 186, 228

San Donato shield, 113
Sardou, Victorien, 1909, 254
Sartel, Osmond du, 39
Satinwood furniture, 151–4
Satsuma pottery, 165, 196, 217, 218
Saunders, Paul, weaver, 174
Sauvaget Collection, 103–4
Savile Club, 150
Savonerie carpets, 58
Saxony, Grand Duke, 1932, 266
Schatzkaemmer, 65
Scheemakers, 1757, 74
Schiff, Mortimer, 1938, 1946, 253, 269, 289
Schreiber, Lady Charlotte, 104, 131, 160, 164, 166, 171, 208, 286
Schroeder, Baron, 1910, 234, 249
Sciarra Palace, 244
Scott, Sir Walter, 53–4, 76, 95, 151, 161n
Sculpture, Italian Renaissance, 100–2, 110, 115, 121, 229, 266–7, 287–8
Italian bronze, 121
Classical, 6, 61–3, 243–7
Gothic, 100, 288
French 18th century, 182–8, 269
Second Empire style, 130–1, 182
Seillière, Achille, 110
Selfridge, Gordon, 244
Seligman, J., 188, 240
Sené, cabinet-maker, 145
Serilly, Mme, her boudoir, 131
Sèvres porcelain, 17, 28, 30–3, 50–2, 104, 155–163, 219, 235, 249, 275
Sèvres biscuit sculpture, 182, 185–6
Sèvres, furniture plaques, 46, 54, 126, 132–3
Seymour, John, cabinet-maker, 264
Sforza, Francesco, armour, 80
Shaw, Norman, 153
Shearer, Thomas, cabinet-maker, 47
Sheraton, Thomas, 47, 53, 151–4, 285
Sherborne Missal, the, 71
Shioda and Ninagawa, 218
Shrewsbury, Earl of, 1857, 109, 145, 152, 185
Shuldham, E. B., 1880, 209
Sibson, 1877, 173
Sibthorp, Colonel C., 1856, 107
Sidonian glass, 292
Siena faience, 237
Siegburg ware, 115
Silver, bulk value, 24
American, 269
Dutch, 95

English 16th-century, 116, 251, 265, 270, 273, 276
English 17th–18th century, 247, 264–5, 273
English 19th-century, 95
French, 51
German Renaissance, 5, 67, 95, 115–6, 237, 267, 273
Oriental, 59
Roman, 9
Sistine Chapel, 69
Sistine Madonna, 3
Sixtus IV, missal of, 73
Skipper, 1884, 162
Sloane, Sir Hans, 46, 94
Smith, J. T., 168
Snuffboxes, 79, 234
Soane, Sir J., 79
Society of Arts, 96
Soho tapestries, 174
Solon, M. L., 172
Soltykoff, Prince Peter, 1861, 68, 93–4, 98–9, 102, 110–1
Somerset House, 68, 96
Sommerard, du, 76, 84, 93
Somzée, 1901, 123
Soulages Collection, 98, 104, 117
Soviet government sales, 1931, 178, 256
Speckstein reliefs, 115
Spencer, Earl, 46
Spitzer, Frederick, 1893, 1895, 112, 114, 116–17, 120–2, 186, 228, 240
Spode earthenware, 53
Spoons, earliest, 274
Sprimont, Nicolas, 168–9
Stacpoole, Duc de, 1852, 146, 177
Stained glass revival, 70, 79, 260
Stanislas, King, his bureau, 43, 86, 133
Stewart, A. T., 1887, 228
Stotesbury, E. T., 1958, 210, 262
Stonyhurst Salt, the, 275
Stowe, 1848, 94–5, 104–5, 128, 152, 165, 170, 185, 190, 196, 200, 202
Strahan, Edward, 147, 229
Strathmore, Earl of, 1777, 36, 80
Strawberry Hill, 76
sale, 1842, 15, 77–82, 86, 127, 146, 151, 157, 202, 265
Stuart, "Hindoo", 1831, 195
Suraj ed-Douleh, 58
Sussex, Duke of, 1843, 100, 115, 128, 165, 202
Summer Palace, loot, 1860, 194, 199
Sung pottery, 242

Svenigorodskoi, 1911, 231
Swan service, Meissen, 165, 286
Swaythling, 1924, 1946, 251, 278
Sweebach and Bergeret, designers, 51
Swinton, 1810, 58

Table des Marèchaux, Sèvres, 51
T'ang figures, 18, 242, 272
Tallard, Duc de, 27
Talleyrand, 138
Tao Kuang, emperor, 198
Tapestry, Gothic, 4, 68–70, 100, 122–3,
 231, 240, 254, 260, 269
Tapestry, Renaissance, 15, 16, 69
Tapestry, English, 174, 177, 277
Tapestry, French 18th-century, 12,
 174–181, 234, 248
Tapestry-backed furniture, 14, 144,
 147–9, 264, 274
Tapestry, works cost, 15–6, 23, 175,
 179
Taylor, J. E., 1912, 213, 239, 253, 269
Taylor, Francis H., 28–9
Tatlock, R. A., 250
Teniers tapestries, 176
Ten-o-clock Lecture, 205
Tenture des dieux, tapestry, 177, 179
Testart, 1924, 251, 276
Thêvenet, Sèvres painter, 161
Thibon, 1875, 185
Thiers, 1865, 67, 289
Thomire, mount maker, 256
Thomson, W. G., 180
Thompson, Sir H., 1880, 209
Thorwaldsen, sculptor, 183
Three Graces clock, 45, 134, 183, 186
Three Graces dish, 105
Thynne, Lord H., 1901, 170
Tickyll psalter, the, 1932, 261
Times pronouncements on art, 60, 78,
 119, 160
Tippoo Sultan, 32, 162
Titian, 61, 108
Tivoli excavations, 62, 244
Tompion, Thomas, 42
Topaz vase (Beckford), 65, 87
Torrington diaries, 68, 77, 145
Tournai pound, 24
Tournai porcelain, 156
Towneley, Charles, 1792, 246
Tsuba, sword-guards, 224
Turkish faience, 234, 251
Turner, J. M., 81
Tweedmouth, Lord, 170
Tzu-chi, Empress Dowager, 212

Urbino ware, 74, 80, 104, 118, 252

Vaile, Reginald, 1903, 234, 255
Vaisseaux à mâts, 31, 156, 160–2, 280
Valdarfa Decameron, 1812, 72
Vanderbilt, Cornelius, 228
Vanderbilt, W. H., 147, 228
Van Diemen casket, 26, 88, 219
Van Zuylen, 1954, 286
Vasari, Giorgio, 8
Vatel, Charles, 42
Vathek, 83, 87
Vatican tapestries, 15, 69
Veaux-Praslin, 1876, 146
Velazquez, 136
Venus de Milo, 244
Verlet, Pierre, 148
Vernet, Joseph, 158, 163
Vernis Martin, 26
Veron, 1858, 185
Veronese, 282
Verrue, Mme, 1739, 37
Verrocchio, 102
Versailles sales, 1793–4, 48
Vianen of Utrecht, 95
Victoire, Mme, 43, 185
Victoria, Queen, purchases, 78, 139
Victoria and Albert Museum, Genesis,
 97
 1860s, purchases, 110–1
 1870s, purchases, 114
 first tapestry acquisitions, 122
 Milanese iron furniture, 140
 modern furniture, 1867, 152
 Indian purchases, 195
 blue and white China, 209
 Japanese purchases, 218, 220
Vienna porcelain, 166–7
Vièrge de Boubon, 111
Vièrge de Sablons, tapestry, 122
Vigée-Lebrun, Mme, 6
Vile, William, cabinet-maker, 47
Villafranca, Marquis, 1870, 132
Vinaches, sculptor, 187
Vincennes porcelain, 28–9, 163
Vittoria, Alessandro, 240
Vivant-Denon, 1826, 84–5, 92–3, 101,
 110
Voltaire, statues, 19, 183–4, 187

Waddesdon Manor, 49, 132, 137, 141,
 150
Wages in China, 23–4
Wages, gilders', 27
Wages, weavers', 23, 175

Waldegrave, 1842, *see* Strawberry Hill
Walker, R. W. M., 1945, 275–6
Wall Street crash, 1929, 257
Wallace Collection, 1897, 17, 42, 86, 154, 158, 181
Walpole, Horace, 33–4, 36, 45, 57, 62, 68, 75–80, 100, 120, 122
Walters, Henry, 1941, 1957, 255, 263, 273
Wanstead House, 1822, 126, 177
Warwick, Earl of, 1895, 171
Warwick vase, the, 62
Washington, George, busts, 188
Watson, F. J. B., 44, 148, 159
Watteau, 85, 129–30
Weddell, William, 62
Wedgwood, cream-ware, 34
 furniture plaques, 13, 152
 Jasper ware, 172–3, 186
Weingarten manuscripts, 68, 84, 231
Weisweiler, cabinet-maker, 132, 275
Wellington, Duke of, 52, 184
Wertheimer, Asher, 1921, 235, 249
Wertheimer, Charles, 1912, 238–9
Wertheimer, Samson, 119, 137–8, 162
West, Benjamin, 181
Whistler, J. A. M., 202–5, 217
Widener, P. A. B., 213–4

Wilbraham salt, the, 1930, 1960, 265
Wilensky, Reginald, 244
William III, 37, 42
William IV, 6, 53
Wilton House, 1917, 1961, 243, 245
Wimborne, Lord, 1923, 269
Woburn, 62
Wolsey, Cardinal, his hat, 78
Wood, Ralph and Enoch, 100
Wood, R. M., 1919, 247, 263
Woods, T. H. (of Christies), 117
Worcester porcelain, 169–70, 275
Wouverman, 170
Wyatt, Robert, sculptor, 184

Yarnald, Charles, 100
Yates Thompson, H., 1919–21, 247–8, 235, 290
Year's Art, The, 236, 266
Yerborough, Lord, 64
Yerkes, Charles, 1910, 187
Young England movement, 80
Young Ottley, W., 1838, 261
Yuan Ming Yuan, 199, 201

Zoffany, 55
Zuccarelli, 83